Martial Rose Library Tel: 01962 827306

An In Histo

Pro

To be returned on or before the day marked above, subject to recall:

UNIVERSITY OF WINCHESTER LIBRARY

WADSWORTH CENGAGE Lear

ngapore • Spain

An Introduction to the History of Psychology, Sixth Edition B. R. Hergenhahn

Publisher: Michele Sordi

Assistant Editor: Rachel Guzman

Managing Technology Project

Manager: Amy Cohen

Executive Marketing Manager: Kim

Russell

Marketing Assistant: Melanie Cregger

Marketing Communications Manager:

Linda Yip

Project Manager, Editorial Production:

Charlene M. Carpentier

Creative Director: Rob Hugel

Art Director: Vernon Boes

Print Buyer: Linda Hsu

Permissions Editor: Roberta Broyer

Image Permissions Editor: Deanna

Ettinger

Production Service: Bharathi Sanjeev,

Newgen-Austin

Photo Researcher: Terri Miller

Copy Editor: Tess Roach

Cover Designer: Roger Knox

Cover Image: The cover illustration is a detail of the head of Venus from "The Bath of Venus and Mars," Giulio Romano,

Palazzo del Té, Mantua, Scala/Art Resource, N.Y.

Compositor: Newgen

© 2009, 2005 Wadsworth, Cengage Learning

ALL RIGHTS RESERVED. No part of this work covered by the copyright herein may be reproduced, transmitted, stored, or used in any form or by any means graphic, electronic, or mechanical, including but not limited to photocopying, recording, scanning, digitizing, taping, Web distribution, information networks, or information storage and retrieval systems, except as permitted under Section 107 or 108 of the 1976 United States Copyright Act, without the prior written permission of the publisher.

For product information and technology assistance, contact us at Cengage Learning Customer & Sales Support,
1-800-354-9706.

For permission to use material from this text or product, submit all requests online at **cengage.com/permissions**. Further permissions questions can be e-mailed to **permissionrequest@cengage.com**.

Library of Congress Control Number: 2007940585

ISBN-13: 978-0-495-50621-8

ISBN-10: 0-495-50621-4

Wadsworth

10 Davis Drive Belmont, CA 94002-3098

USA

UNIVERSITY OF WINCHESTER
03026558 150.9
HER

Cengage Learning is a leading provider of customized learning solutions with office locations around the globe, including Singapore, the United Kingdom, Australia, Mexico, Brazil, and Japan. Locate your local office at **international.cengage.com/region**.

Cengage Learning products are represented in Canada by Nelson Education, Ltd.

For your course and learning solutions, visit academic.cengage.com

Purchase any of our products at your local college store or at our preferred online store **www.ichapters.com**

We have found a strange footprint on the shores of the unknown. We have devised profound theories, one after another, to account for its origin. At last, we have succeeded in reconstructing the creature that made the footprint. And lo! it is our own.

—ARTHUR STANLEY EDDINGTON

Brief Contents

xxii
Introduction 1
The Early Greek Philosophers 29
After Aristotle: A Search for the Good Life 67
The Beginnings of Modern Science and Philosophy 101
Empiricism, Sensationalism, and Positivism 133
Rationalism 183
Romanticism and Existentialism 207
Early Developments in Physiology and the Rise of Experimental Psychology 232
Voluntarism, Structuralism, and Other Early Approaches to Psychology 262
The Darwinian Influence and the Rise of Mental Testing 293
Functionalism 334
Behaviorism 384
Neobehaviorism 423
Gestalt Psychology 456
Early Diagnosis, Explanation, and Treatment of Mental Illness 486
Psychoanalysis 515
Early Alternatives to Psychoanalysis 552
Humanistic (Third-Force) Psychology 570
Psychobiology 606
Cognitive Psychology 623
Contemporary Psychology 643

Contents

PREFACE xxii

Chapter 1	Introduction 1
	Problems in Writing a History of Psychology 2
	Where to Start 2
	What to Include 2
	Choice of Approach 4
	Why Study the History of Psychology? 4
	Perspective 4
	Deeper Understanding 1
	Recognition of Fads and Fashions 5
	Avoiding Repetition of Mistakes 6
	A Source of Valuable Ideas 6
	Curiosity 6
	What Is Science? 7
	A Combination of Rationalism and Empiricism 7
	The Search for Laws 8
	The Assumption of Determinism 8
	Revisions in the Traditional View of Science 9
	Karl Popper 9
	Thomas Kuhn 11
	Paradigms and Psychology 13
	Popper versus Kuhn 13

Chapter 2

Is Psychology a Science? Determinism, Indeterminism, and Nondeterminism Persistent Questions in Psychology What Is the Nature of Human Nature? How Are the Mind and the Body Related? Nativism versus Empiricism 19 Mechanism versus Vitalism Rationalism versus Irrationalism How Are Humans Related to Nonhuman Animals? What Is the Origin of Human Knowledge? Objective versus Subjective Reality 22 The Problem of the Self 22 Universalism versus Relativism 23 The Early Greek Philosophers The World of Precivilized Humans Animism and Anthropomorphism 29 Magic 30 Early Greek Religion 30 The First Philosophers 31 Thales 31 Anaximander 32 Heraclitus 32 Parmenides 33 34 Pythagoras **Empedocles** 36 37 Anaxagoras Democritus 37 Early Greek Medicine Alcmaeon Hippocrates 39 The Relativity of Truth 41

Protagoras 42
Gorgias 42

Xenophanes 43

Socrates 44

Plato 46

The Theory of Forms or Ideas The Analogy of the Divided Line 47 The Allegory of the Cave The Reminiscence Theory of Knowledge The Nature of the Soul Sleep and Dreams Plato's Legacy 50 Aristotle 50 The Basic Difference between Plato and Aristotle Causation and Teleology The Hierarchy of Souls Sensation 54 Common Sense, Passive Reason, and Active Reason Memory and Recall 56

Imagination and Dreaming 56

Motivation and Happiness 57

The Emotions and Selective Perception 58

The Importance of Early Greek Philosophy 59

Chapter 3 After Aristotle: A Search for the Good Life 67

Skepticism and Cynicism 67

Skepticism 68

Cynicism 69

Epicureanism and Stoicism 70

Epicureanism 70

Stoicism 72

Neoplatonism 73

Philo 74

Plotinus 75

Emphasis on Spirit 76

Jesus 76

St. Paul 77

Emperor Constantine 79

St. Augustine 80

The Dark Ages 83

The Islamic and Jewish Influences 84

Avicenna 85

Averroës 86

Maimonides 86

Reconciliation of Christian Faith and Reason 87

St. Anselm 87

Peter Lombard 88

Scholasticism 88

Peter Abelard 88

St. Albertus Magnus 91

St. Thomas Aquinas 92

Limitations of Scholastic Philosophy 94

William of Occam: A Turning Point 94

The Spirit of the Times before the Renaissance 95

Chapter 4 The Beginnings of Modern Science and Philosophy 101

Renaissance Humanism 101

Major Themes 101

Francesco Petrarch 102

Giovanni Pico 103

Desiderius Erasmus 103

Martin Luther 104

Michel de Montaigne 106

Further Challenges to Church Authority 107

Ptolemy, Copernicus, Kepler, and Galileo 108

Ptolemy 108

Nicolaus Copernicus 109

Johannes Kepler 111

Galileo 112

Isaac Newton 115

Principles of Newtonian Science 116

Francis Bacon 117

Baconian Science 118

Science Should Provide Useful Information 120

René Descartes 121

Descartes's Search for Philosophical Truth 121

Innate Ideas 123

The Reflex 124

Descartes's Explanation of Sleep and Dreams 125

The Mind-Body Interaction 125

Descartes's Contributions to Psychology 126

Descartes's Fate 127

Chapter 5 Empiricism, Sensationalism, and Positivism 133

British Empiricism 134

Thomas Hobbes 134

John Locke 138

George Berkeley 143

David Hume 146

David Hartley 153

James Mill 156

John Stuart Mill 158

Alexander Bain 162

French Sensationalism 166

Pierre Gassendi 166

Julien de La Mettrie 167

Étienne Bonnot de Condillac 170

Claude-Adrien Helvétius 171

Positivism 172

Auguste Comte 172

A Second Type of Positivism 176

Chapter 6 Rationalism 183

Baruch Spinoza 185

Nature of God 185

Mind-Body Relationship 186

Denial of Free Will 186

Self-Preservation as the Master Motive 187

Emotions and Passions 187

Spinoza's Influence 188

Nicolas de Malebranche 189

Gottfried Wilhelm von Leibniz 189

Disagreement with Locke 189

Monadology 191

Mind-Body Relationship 192

Conscious and Unconscious Perception 192

Thomas Reid 194

Common Sense 194

Direct Realism 195

Faculty Psychology 195

Immanuel Kant 196

Categories of Thought 197

Causes of Mental Experience 198

The Categorical Imperative 199

Kant's Influence 200

Johann Friedrich Herbart 200

Psychology as a Science 201

Psychic Mechanics 201

The Apperceptive Mass 202

Educational Psychology 203

Herbart's Influence 203

Georg Wilhelm Friedrich Hegel 203

The Absolute 204

Dialectic Process 204

Hegel's Influence 206

Chapter 7 Romanticism and Existentialism 207

Romanticism 208

Jean-Jacques Rousseau 209

Johann Wolfgang von Goethe 212

Arthur Schopenhauer 213

Existentialism 217

Søren Kierkegaard 217

Friedrich Wilhelm Nietzsche 220

Kierkegaard and Nietzsche 227

Chapter 8 Early Developments in Physiology and the Rise of Experimental Psychology 232

Individual Differences 232

Discrepancy between Objective and Subjective Reality 233

Bell-Magendie Law 234

Doctrine of Specific Nerve Energies 235

Johannes Müller 235

Hermann von Helmholtz 236

Helmholtz's Stand against Vitalism 237

Principle of Conservation of Energy 237

Rate of Nerve Conduction 238

Theory of Perception 239

Theory of Color Vision 239

Theory of Auditory Perception 240

Theory of Signs 241

Helmholtz's Contributions 241

Ewald Hering 242

Space Perception 242

Theory of Color Vision 242

Christine Ladd-Franklin 243

Early Research on Brain Functioning 244

Phrenology 244

Pierre Flourens 247

Paul Broca 248

Gustav Fritsch, Eduard Hitzig, and David Ferrier 250

The Rise of Experimental Psychology 250

Ernst Heinrich Weber 251

Gustav Theodor Fechner 252

Chapter 9 Voluntarism, Structuralism, and Other Early Approaches to Psychology 262

Voluntarism 264

Wilhelm Maximilian Wundt 264

Psychology's Goals 266

Wundt's Use of Introspection 267

Elements of Thought 267

Perception, Apperception, and Creative Synthesis 268

Mental Chronometry 268

Psychological Versus Physical Causation 270

Völkerpsychologie 271

The Historical Misunderstanding of Wundt 271

Edward Bradford Titchener 272

Titchener's Paradoxical Relationship with Female

Psychologists 274

Psychology's Goals 275

Titchener's Use of Introspection 275

Mental Elements 276

Law of Combination 276

Neurological Correlates of Mental Events 277

Context Theory of Meaning 277

The Decline of Structuralism 277

Other Early Approaches to Psychology 278

Franz Clemens Brentano 278

Carl Stumpf 280

Edmund Husserl 281

Oswald Külpe 283

Hans Vaihinger 285

Hermann Ebbinghaus 286

Chapter 10 The Darwinian Influence and the Rise of Mental Testing 293

Evolutionary Theory before Darwin 293

Jean Lamarck 294

Herbert Spencer 294

Charles Darwin 297

The Journey of the Beagle 298

Back in England 298

Darwin's Theory of Evolution 300

Darwin's Influence 301

Sir Francis Galton 302

The Measurement of Intelligence 303

The Word-Association Test 305

Mental Imagery 305

Anthropometry 305

The Concept of Correlation 306

Galton's Contributions to Psychology 307

Intelligence Testing after Galton 307

James McKeen Cattell 307

Alfred Binet 309

Charles Spearman and the Concept of General Intelligence 313

Cyril Burt 314

The Binet-Simon Scale in the United States 315

Henry Herbert Goddard 315 Lewis Madison Terman 317

Leta Stetter Hollingworth 321

Intelligence Testing in the Army 323

Robert M. Yerkes 323

The Deterioration of National Intelligence 324

Chapter 11 Functionalism 334

Early U.S. Psychology 334

Stage One: Moral and Mental Philosophy (1640–1776) 335

Stage Two: Intellectual Philosophy (1776–1886) 335

Stage Three: The U.S. Renaissance (1886–1896) 335

Stage Four: U.S. Functionalism (1896 to Present) 336

Characteristics of Functionalistic Psychology 336

William James 337

James's Crisis 338

Opposition to Wundt's Approach to Psychology 340

Stream of Consciousness 341

Habits and Instincts 342

The Self 343

Emotions 344

Free Will 345

Pragmatism 346

James's Contributions to Psychology 347

Hugo Münsterberg 347

Münsterberg's Applied Psychology 349

Münsterberg's Fate 349

Mary Whiton Calkins 350

Granville Stanley Hall 353

President of Clark University 354

Recapitulation Theory 355

Hall's Magnum Opus 355

Religious Conversion 356

Sublimation 356

Hall's Opposition to Coeducation 356

Francis Cecil Sumner 358

Psychology at Clark University 362

Functionalism at the University of Chicago 362

John Dewey 362

James Rowland Angell 364

Harvey Carr 366

Functionalism at Columbia University 367

James McKeen Cattell 367

Robert Sessions Woodworth 368

Edward Lee Thorndike 369

The Fate of Functionalism 376

Chapter 12 Behaviorism 384

The Background of Behaviorism 384

Russian Objective Psychology 385

Ivan M. Sechenov 385

Ivan Petrovich Pavlov 388

Vladimir M. Bechterev 394

John B. Watson and Behaviorism 397

Watson's Adult Life 398

Watson's Objective Psychology 403

Watson's Influence 411

William McDougall: Another Type of Behaviorism 412

McDougall's Definition of Psychology 413

Purposive Behavior 414

The Importance of Instincts 414

The Battle of Behaviorism 415

Chapter 13 Neobehaviorism 423

Positivism 423

Logical Positivism 424

Operationism 425

Physicalism 425

Neobehaviorism 426

Edward Chace Tolman 426

Purposive Behaviorism 428

Tolman's Use of Rats 429

The Use of Intervening Variables 430

Tolman's Position on Reinforcement 431

Learning versus Performance 431

Tolman's Influence 433

Clark Leonard Hull 434

Hull's Hypothetico-Deductive Theory 436

Reinforcement 437

Reaction Potential 437

Hull's Theory in General 437

Hull's Influence 437

Edwin Ray Guthrie 438

The One Law of Learning 439

One-Trial Learning 439

Why Practice Improves Performance 439

The Nature of Reinforcement 440

Forgetting 440

Breaking Habits 441

Punishment 441

Drives and Intentions 441

The Formalization of Guthrie's Theory 441

B. F. Skinner 442

Skinner's Positivism 444

Functional Analysis of Behavior 444

Operant Behavior 445

The Nature of Reinforcement 446

The Importance of the Environment 446

The Positive Control of Behavior 447

Skinner's Attitude toward Theory 448

Applications of Skinnerian Principles 448

Behaviorism Today 449

Chapter 14 Gestalt Psychology 456

Antecedents of Gestalt Psychology 457

Immanuel Kant 457

Ernst Mach 457

Christian von Ehrenfels 457

William James 458

Act Psychology 458

Developments in Physics 458

The Founding of Gestalt Psychology 458

Max Wertheimer 459

Kurt Koffka 460

Wolfgang Köhler 461

Isomorphism and the Law of Prägnanz 463

Application of Field Theory 464

Psychophysical Isomorphism 464

Opposition to the Constancy Hypothesis 465

Analysis: Top Down, Not Bottom Up 465

The Law of Prägnanz 466

Perceptual Constancies 467

Perceptual Gestalten 468

The Figure-Ground Relationship 468

Gestalt Principles of Perceptual Organization 468

Subjective and Objective Reality 470

The Gestalt Explanation of Learning 471

Cognitive Trial and Error 471

Insightful Learning 471

Transposition 473

Productive Thinking 474

Memory 476

Memory Processes, Traces, and Systems 476

Lewin's Field Theory 477

Aristotelian versus Galilean Conception of Science 477

Life Space 478

Motivation 478

Conflict 479

Group Dynamics 480

The Impact of Gestalt Psychology 481

Chapter 15 Early Diagnosis, Explanation, and Treatment of Mental Illness 486

What Is Mental Illness? 486

Harmful Behavior 486

Unrealistic Thoughts and Perceptions 487

Inappropriate Emotions 487

Unpredictable Behavior 487

Early Explanations of Mental Illness 487

Biological Explanations 488

Psychological Explanations 488

Supernatural Explanations 488

Early Approaches to the Treatment of Mental Illness 489

The Psychological Approach 490

The Supernatural Approach 490

The Biological Approach 491

The Return of the Supernatural Approach - 493

Gradual Improvement in the Treatment of Mental Illness 495

Philippe Pinel 496

Benjamin Rush 498

Dorothea Lynde Dix 498

Emil Kraepelin 499

Lightner Witmer 500

The Tension between the Psychological and Medical Models of Mental Illness 502

The Use of Hypnotism 504

Franz Anton Mesmer 504

Marquis de Puységur 506

John Elliotson, James Esdaile, and James Braid 507

The Nancy School 507

Charcot's Proposed Explanation of Hypnosis and Hysteria 508

Chapter 16 Psychoanalysis 515

Antecedents of the Development of Psychoanalysis 516

Sigmund Freud 518

The Cocaine Episode 519

Early Influences on the Development of Psychoanalysis 520

Josef Breuer and the Case of Anna O. 520

Freud's Visit with Charcot 522

The Birth of Free Association 523

Studies on Hysteria 524

Project for a Scientific Psychology 524

The Seduction Theory 525

Freud's Self-Analysis 525

Analysis of Dreams 526

The Oedipus Complex 527

The Psychopathology of Everyday Life 528

Humor 529

Freud's Trip to the United States 530

A Review of the Basic Components of Freud's Theory of

Personality 531

The Id, Ego, and Superego 531

Anxiety and the Ego Defense Mechanisms 533

Psychosexual Stages of Development 534

Freud's View of Human Nature 536

Religion 537

Freud's Fate 537

Revisions of the Freudian Legend 538

The Reality of Repressed Memories 540

Evaluation of Freud's Theory 544

Criticisms 544

Contributions 545

Chapter 17 Early Alternatives to Psychoanalysis 552

Anna Freud 552

Anna Freud's and Melanie Klein's Conflicting Views on Child

Analysis 553

Ego Psychology 554

Carl Jung 555

Libido 556

The Ego 556

The Personal Unconscious 556

The Collective Unconscious and the Archetypes 556

The Attitudes 557

Causality, Teleology, and Synchronicity 557

Dreams 558

The Importance of Middle Age 558

Criticisms and Contributions 559

Alfred Adler 559

Organ Inferiority and Compensation 560

Feelings of Inferiority 560

Worldviews, Fictional Goals, and Lifestyles 560

The Creative Self 561
Karen Horney 561

General Disagreement with Freudian Theory 562

Basic Hostility and Basic Anxiety 563

Adjustments to Basic Anxiety 563

Feminine Psychology 564

Chapter 18 Humanistic (Third-Force) Psychology 570

The Mind, the Body, and the Spirit 570

Antecedents of Third-Force Psychology 571

Phenomenology 572

Existential Psychology 573

Martin Heidegger 573

Ludwig Binswanger 575

Rollo May 577

George Kelly 580

Humanistic Psychology 584

Abraham Maslow 584

Carl Rogers 590

Comparison of Existential and Humanistic Psychology 595

Evaluation 596

Criticisms 596

Contributions 597

Chapter 19 Psychobiology 606

Karl S. Lashley 606

Mass Action and Equipotentiality 607

In Search of the Engram 607

Donald O. Hebb 608

Cell Assemblies and Phase Sequences 609

Roger W. Sperry 610

The Split-Brain Preparation 611

Behavioral Genetics 612

Ethology 613

Sociobiology 613

Noam Chomsky's Influence 616

The Misbehavior of Organisms 616

Genetic Influences on Intelligence and Personality 617

Chapter 20 Cognitive Psychology 623

Developments before 1950 624

Developments during the 1950s 625

Developments after the 1950s 626

Artificial Intelligence 628

The Turing Test 629

Weak versus Strong Artificial Intelligence 629

Searle's Argument against Strong Artificial Intelligence 629

Are Humans Machines? 630

Information-Processing Psychology 631

The Return of Faculty Psychology 633

The Return of the Mind-Body Problem 633

New Connectionism 635

Antecedents 635

Neural Networks 636

Back-Propagation Systems 637

Chapter 21 Contemporary Psychology 643

The Diversity of Contemporary Psychology 643

Divisions of the American Psychological Association 644

The Tension Between Pure, Scientific Psychology and Applied Psychology 644

Controversy Concerning the Training of Clinical Psychologists 650

Psychology's Two Cultures 652

Psychology's Status as a Science 653

Postmodernism 655

Ludwig Wittgenstein 656

Is There Anything New in Psychology? 659

Preface

As with the first five editions of *An Introduction to the History of Psychology*, the primary purpose of the sixth edition is to provide introductory students with a comprehensive overview of the history of psychology. This purpose is achieved by showing that most of the concerns of contemporary psychologists are manifestations of themes that have been part of psychology for hundreds, or even thousands, of years.

In addition to updates to the suggestions for further reading throughout, major changes made in this edition include the following:

- Chapter 1: The sections describing the necessity of utilizing both historicism and presentism in reporting history, on history as a valuable source of ideas, and on Feyerabend's "anarchistic" description of science were expanded.
- Chapter 2: Evidence was provided that the Hippocratic oath is of Pythagorean origin; Xenophanes' views on religion and skepticism were expanded; Plato's thoughts on sleep and dreaming were added and their relationship to Freud's later views was discussed; Aristotle's description of what would later be called an approach—approach conflict was added; and evidence that Aristotle supported slavery and believed males to be superior to females was provided.
- Chapter 3: Coverage of Constantine's influence on early Christianity was expanded, and it was noted that the New Testament as it exists today was first canonized in 367 A.D.; that Martin Luther, as well as John Calvin, embraced Augustine's doctrine of predestination; and that Anselm's ontological argument for the existence of God was highly influential.
- Chapter 4: Sections describing Luther's thoughts on marriage and his debate
 with Erasmus concerning the existence of human free will were added; the
 similarity between Montaigne's critical analyses of the classics and those of

- Derrida was noted; and biographical information on Descartes was expanded.
- Chapter 5: A discussion of Condillac's analysis of language was added, and the similarity between his analysis and Wittgenstein's later analysis was noted.
- Chapter 6: A section describing the similarity between Kant's reasons for believing that God necessarily exists and Aristotle's reasons for believing that an unmoved mover must necessarily exist was added.
- Chapter 7: The discussions of the Enlightenment, of Lou Andreas–Salomé's involvement with the Freudian inner circle, and of Nietzsche's contention that "God is dead" were expanded. A section describing Nietzsche's distinction between opinions and convictions was added.
- Chapter 8: The discussion of Ferrier's contributions to cortical localization research was expanded.
- Chapter 9: It was noted that, although Wundt found it to be ineffective, Donders's use of reaction time to measure mental events was rediscovered in the 1960s and used effectively.
- Chapter 10: The biographical information on Darwin was expanded; the fact that Thomas Huxley became the primary spokesman for Darwin's theory of evolution was noted; a section on the debate Darwinians had with church authorities concerning the age of the earth was added; and Darwin's contention that women are intellectually inferior to men was further documented.
- Chapter 11: Coverage of G. Stanley Hall was substantially expanded, and the biographical information on Kenneth Clark was updated.
- Chapter 12: Bertrand Russell's general support for Watson's behaviorism was noted, and evidence was provided that McDougall continued to believe that his hormic psychology would become the foundation of all the social sciences until shortly before he died.
- Chapter 13: The similarity between Tolman's approach to studying mental events and that of contemporary cognitive psychology was elaborated, and the continuing influence of behaviorism on contemporary psychology was noted.
- Chapter 14: A history of research on apparent motion prior to Wertheimer's was added.
- Chapter 15: Sections describing Kraepelin's pioneering research in psychopharmacology, and the widespread influence of mesmerism in the United States, were added.
- Chapter 17: The relationship between Anna Freud's proposed ego defense mechanism of altruistic surrender and the Stockholm syndrome was noted.

- Chapter 18: Further evidence for the compatibility between May's contention that myth guides most human behavior and contemporary narrative therapy was provided; the observation that Kelly's fixed-role therapy provides an early version of narrative therapy was added; evidence for the continuing influence of Maslow's ideas was provided; and coverage of positive psychology was expanded to include the concept of flourishing, and the similarity between that concept and those introduced by earlier humanistic psychologists, was noted.
- Chapter 19: A section discussing the debate as to whether the fields of sociobiology and evolutionary psychology can be equated was added.
- Chapter 20: Coverage of cognitive science was revised and expanded.
- Chapter 21: APA divisional and overall membership numbers were updated; the fact that Louisiana became the second state to grant clinical psychologists prescription privileges was noted; the discussion of psychology's efforts to become a unified discipline was expanded, as was Kimble's vision of psychology as a unified science; and a section describing Wittgenstein's concept of family resemblance was added.

ACKNOWLEDGMENTS

I wish to thank the following reviewers for their helpful comments and suggestions:

Steve Donohue, Ph.D, Grand Canyon University
John "Jay" Holden, Ph.D, California State University, Northridge
Daniel McConnell, Ph.D, Wichita State University
Craig Nagoshi, Ph.D, Arizona State University
James R. Prather, Ph.D., Western Kentucky University
Susana Urbina, Ph.D, University of North Florida
Criss Wilhite, M.A., B.C.B.A., Califorinia State University, Fresno

B. R. Hergenhahn

Introduction

The definition of psychology has changed as the focus of psychology has changed. At various times in history, psychology has been defined as the study of the psyche or the mind, of the spirit, of consciousness, and more recently as the study of, or the science of, behavior. Perhaps, then, we can arrive at an acceptable definition of modern psychology by observing the activities of contemporary psychologists:

- Some seek the biological correlates of mental events such as sensation, perception, or ideation.
- Some concentrate on understanding the principles that govern learning and memory.
- Some seek to understand humans by studying nonhuman animals.
- Some study unconscious motivation.
- Some seek to improve industrial-organizational productivity, educational practices, or child-rearing practices by utilizing psychological principles.
- Some attempt to explain human behavior in terms of evolutionary theory.
- Some attempt to account for individual differences among people in such areas as personality, intelligence, and creativity.
- Some are primarily interested in perfecting therapeutic tools that can be used to help individuals with mental disturbances.
- Some focus on the strategies that people use in adjusting to the environment or in problem solving.
- Some study how language develops and how, once developed, it relates to a variety of cultural activities.
- Some explore computer programs as models for understanding human thought processes.

 Still others study how humans change over the course of their lives as a function of maturation and experience.

These are just a few of the activities that engage contemporary psychologists.

Clearly, no single definition of psychology can take into consideration the wide variety of activities engaged in by the more than 148,000 members and affiliates of the American Psychological Association, not to mention the many other psychologists around the world. It seems best to say simply that psychology is defined by the professional activities of psychologists. These activities are characterized by a rich diversity of methods, topics of interest, and assumptions about human nature. A primary purpose of this book is to examine the origins of modern psychology and to show that most of the concerns of today's psychologists are manifestations of themes that have been part of psychology for hundreds or, in some cases, thousands of years.

PROBLEMS IN WRITING A HISTORY OF PSYCHOLOGY

Historiography is the study of the proper way to write history. The topic is complex, and there are no final answers to many of the questions it raises. In this section, we offer our answers to a few basic questions that must be answered in writing a history.

Where to Start

Literally, *psychology* means the study of the psyche, or mind, and this study is as old as the human species. The ancients, for example, attempted to account for dreams, mental illness, emotions, and fantasies. Was this psychology? Or did psychology commence when explanations of human cognitive experience, such as those proposed by the early Greeks, became more systematic? Plato and

Aristotle, for example, created elaborate theories that attempted to account for such processes as memory, perception, and learning. Is this the point at which psychology started? Or did psychology come into existence when it became a separate science in the 19th century? It is common these days to begin a history of psychology at the point where psychology became a separate science. This approach is unsatisfactory for two reasons: (1) It ignores the vast philosophical heritage that molded psychology into the type of science that it eventually became; and (2) it omits important aspects of psychology that are outside the realm of science. Although it is true that since the mid-19th century, psychology has, to a large extent, embraced the scientific method, many highly influential psychologists did not feel compelled to follow the dictates of the scientific method. Their work cannot be ignored.

This book's coverage of the history of psychology will not go back to the conceptions of the ancients. I believe that such conceptions are within the domain of psychology, but space does not permit such a comprehensive history. Rather, this book starts with the major Greek philosophers whose explanations of human behavior and thought processes are the ones that philosophers and psychologists have been reacting to ever since.

What to Include

Typically, in determining what to include in a history of anything, one traces those people, ideas, and events that led to what is important now. This book, too, takes this approach by looking at the way psychology is today and then attempting to show how it became that way. There is at least one major danger in using the present state of psychology as a guide in writing its history, however. Stocking (1965) calls such an approach to history **presentism**, as contrasted with what he calls **historicism**—the study of the past for its own sake without attempting to show the relationship between the past and present. Copleston (2001) describes historicism as it applies to philosophy:

If one wishes to understand the philosophy of a given epoch, one has to make the attempt to understand the mentality and presuppositions of the men who lived in that epoch, irrespective of whether one shares that mentality and those presuppositions or not. (p. 11)

On the other hand, presentism attempts to understand the past in terms of contemporary knowledge and standards. Presentism implies that the present state of a discipline represents its highest state of development and that earlier events led directly to this state. In this view, the latest is the best. Although I use present psychology as a guide to what to include in psychology's history, I do not believe that current psychology is necessarily the best psychology. The field is simply too diverse to make such a judgment. At present, psychology is exploring many topics, methods, and assumptions. Which of these explorations will survive for inclusion in future history books is impossible to say. Using psychology's present as a frame of reference. therefore, does not necessarily assume that psychology's past evolved into its present or that current psychology represents the best psychology. In general, then, I assume historicism provides a better framework for understanding psychology's history than presentism. However, I agree with Lovett (2006) that no matter how much historicism is emphasized, presentism cannot be completely avoided when reporting history:

To try to understand what historical events were like for those who participated in those events is reasonable and desirable, but to conduct historical research—from the selection of projects to the evaluation of sources to the interpretation of findings—without any regard for present knowledge is counterproductive. The present trend of "historical contextualization" supports this assertion as soon as we ask what object we are historically contextualizing: psychological research and practice. If we ever hope to know where progress has happened and

where it has not happened, even if we only want to observe change, some level of presentism is necessary; without the present, the very concept of "history" would be meaningless. (p. 33)

Although contemporary psychology provides a guide for deciding what individuals, ideas, and events to include in a history of psychology, there remains the question of how much detail to include. If, for example, we attempted to trace all causes of an idea, we would be engaged in an almost unending search. In fact, after attempting to trace the origins of an idea or a concept in psychology, we are left with the impression that nothing is ever entirely new. Seldom, if ever, is a single individual solely responsible for an idea or a concept. Rather, individuals are influenced by other individuals, who in turn were influenced by other individuals, and so on. A history of almost anything, then, can be viewed as an unending stream of interrelated events. The "great" individuals are typically those who synthesize existing nebulous ideas into a clear, forceful viewpoint. Attempting to fully document the origins of an important idea or concept in a history book would involve so many details that the book would become too long and boring. The usual solution is to omit large amounts of information, thus making the history selective. Typically, only those individuals who did the most to develop or popularize an idea are covered. For example, Charles Darwin is generally associated with evolutionary theory when, in fact, evolutionary theory existed in one form or another for thousands of years. Darwin documented and reported evidence supporting evolutionary theory in a way that made the theory's validity hard to ignore. Thus, although Darwin was not the first to formulate evolutionary theory, he did much to substantiate and popularize it, and we therefore associate it with his name. The same is true for Freud and the notion of unconscious motivation.

This book focuses on those individuals who either did the *most* to develop an idea or, for whatever reason, have become closely associated with an idea. Regrettably, this approach does not do justice

to many important individuals who could be mentioned or to other individuals who are lost to antiquity or were not loud or lucid enough to demand historical recognition.

Choice of Approach

Once the material to be included in a history of psychology has been chosen, the choice of approach remains. One approach is to emphasize the influence of such nonpsychological factors as developments in other sciences, political climate, technological advancement, and economic conditions. Together, these and other factors create a Zeitgeist, or a spirit of the times, which many historians consider vital to the understanding of any historical development. An alternative is to take the great-person approach by emphasizing the works of individuals such as Plato, Aristotle, Descartes, Darwin, or Freud, Ralph Waldo Emerson (1841/1981) embraced the great-person approach to history, saying that history "resolves itself very easily into the biography of a few stout and earnest persons" (p. 138). Another approach is the historical development approach, showing how various individuals or events contributed to changes in an idea or concept through the years. For example, one could focus on how the idea of mental illness has changed throughout history.

In his approach to the history of psychology, E. G. Boring (1886-1968) stressed the importance of the Zeitgeist in determining whether, or to what extent, an idea or viewpoint will be accepted. Clearly, ideas do not occur in a vacuum. A new idea, to be accepted or even considered, must be compatible with existing ideas. In other words, a new idea will be tolerated only if it arises within an environment that can assimilate it. An idea or viewpoint that arises before people are prepared for it will not be understood well enough to be critically evaluated. The important point here is that validity is not the only criterion by which ideas are judged; psychological and sociological factors are at least as important. New ideas are always judged within the context of existing ideas. If new ideas are close enough to existing ideas, they

will at least be understood; whether they are accepted, rejected, or ignored is another matter.

The approach taken in this book is to combine the Zeitgeist, the great-person, and the historical development approaches to writing history. This book will attempt to show that sometimes the spirit of the times seems to produce great individuals and that sometimes great individuals influence the spirit of the times. I will also show how both great individuals and the general climate of the times can change the meaning of an idea or a concept. In other words, I take an **eclectic approach** that entails using whatever approach seems best able to illuminate an aspect of the history of psychology.

WHY STUDY THE HISTORY OF PSYCHOLOGY?

Perspective

As we have seen, ideas are seldom, if ever, born full-blown. Rather, they typically develop over a long period of time. Seeing ideas in their historical perspective allows the student to more fully appreciate the subject matter of modern psychology. However, viewing the problems and questions currently dealt with in psychology as manifestations of centuries-old problems and questions is humbling and sometimes frustrating. After all, if psychology's problems have been worked on for centuries, should they not be solved by now? Conversely, knowing that our current studies have been shared and contributed to by some of the greatest minds in human history is exciting.

Deeper Understanding

With greater perspective comes deeper understanding. With a knowledge of history, the student need not take on faith the importance of the subject matter of modern psychology. A student with a historical awareness knows where psychology's subject matter came from and why it is considered

important. Just as we gain a greater understanding of a person's current behavior by learning more about that person's past experiences, so do we gain a greater understanding of current psychology by studying its historical origins. Boring (1950) made this point in relation to experimental psychologists:

The experimental psychologist ... needs historical sophistication within his own sphere of expertness. Without such knowledge he sees the present in distorted perspective, he mistakes old facts and old views for new, and he remains unable to evaluate the significance of new movements and methods. In this matter I can hardly state my faith too strongly. A psychological sophistication that contains no component of historical orientation seems to me to be no sophistication at all. (p. ix)

Recognition of Fads and Fashions

While studying the history of psychology, one is often struck by the realization that a viewpoint does not always fade away because it is incorrect; rather, some viewpoints disappear simply because they become unpopular. What is popular in psychology varies with the Zeitgeist. For example, when psychology first emerged as a science, the emphasis was on "pure" science—that is, on the gaining of knowledge without any concern for its usefulness. Later, when Darwin's theory became popular, psychology shifted its attention to human processes that were related to survival or that allowed humans to live more effective lives. Today, one major emphasis in psychology is on cognitive processes, and that emphasis is due, in part, to recent advances in computer technology.

The illustrious personality theorist Gordon W. Allport (1897–1967) spoke of fashions in psychology.

Our profession progresses in fits and starts, largely under the spur of fashion.... We never seem to solve our problems or exhaust our concepts; we only grow tired of them

Fashions have their amusing and their serious sides. We can smile at the way bearded problems receive tonsorial transformation. Having tired of "suggestibility," we adopt the new hairdo known as "persuasibility." Modern ethnology excites us, and we are not troubled by the recollection that a century ago John Stuart Mill staked down the term to designate the new science of human character Reinforcement appeals to us but not the age-long debate over hedonism. The problem of freedom we brush aside in favor of "choice points." We avoid the body-mind problem but are in fashion when we talk about "brain models." Old wine, we find, tastes better from new bottles.

The serious side of the matter enters when we and our students forget that the wine is indeed old. Picking up a recent number of the Journal of Abnormal and Social Psychology, I discover that the twenty-one articles written by American psychologists confine 90 per cent of their references to publications of the past ten years, although most of the problems they investigate have gray beards Is it any wonder that our graduate students reading our journals conclude that literature more than a decade old has no merit and can be safely disregarded? At a recent doctoral examination the candidate was asked what his thesis on physiological and psychological conditions of stress had to do with the body-mind problem. He confessed that he had never heard of the problem. An undergraduate said that all he knew about Thomas Hobbes was that he sank with the Leviathan when it hit an iceberg in 1912. (1964, pp. 149–151)

With such examples of how research topics move in and out of vogue in science, we see again that "factuality" is not the only variable determining whether an idea is accepted. By studying the emotional and societal factors related to the accumulation of knowledge, the student can place currently accepted knowledge into a more realistic perspective. Such a perspective allows the student to realize that the process through which a body of knowledge is accepted as important or as "true" is at least partially subjective and arbitrary. As Zeitgeists change, so does what is considered fashionable in science, and psychology has not been immune to this process.

Avoiding Repetition of Mistakes

George Santayana said, "Those who cannot remember the past are condemned to repeat it." Such repetition would be bad enough if it involved only successes because so much time and energy would be wasted. It is especially unfortunate, however, if mistakes are repeated. As we will see in this text, psychology has had its share of mistakes and dead ends. One mistake was the embracing of phrenology, the belief that personality characteristics could be understood by analyzing the bumps and depressions on a person's skull (see Chapter 8). One dead end may have been the entire school of structuralism, whose members attempted to study the elements of thought by using the introspective method (see Chapter 9). It is generally thought that the efforts of the structuralists, although extremely popular at the time, were sterile and unproductive. Yet it was important for psychology that such an effort was made, for we learned that such an approach led to little that was useful. This and other important lessons would be lost if the errors of the past were repeated because of a lack of historical information.

A Source of Valuable Ideas

By studying history, we may discover ideas that were developed at an earlier time but, for whatever reason, remained dormant. The history of science offers several examples of an idea taking hold only after being rediscovered long after it had originally been proposed. This fact fits nicely into the Zeitgeist interpretation of history, suggesting that some conditions are better suited for the acceptance of an idea than others. The notions of evolution, unconscious motivation, and conditioned responses had been proposed and reproposed several times before they were offered in an atmosphere that allowed their critical evaluation. Even Copernicus's "revolutionary" heliocentric theory had been entertained by the Greeks many centuries before he proposed it. A final example is that of lateralization of brain function. Many believe that the idea that the two cerebral hemispheres function in radically different ways is a new one. However, over 100 vears ago, Brown-Séquard's article "Have We Two Brains or One?" (1890) was one of many written on the topic. In fact, important scientific ideas can be rejected more than once before they are finally appreciated. Feverabend (1987) said,

The history of science is full of theories which were pronounced dead, then resurrected, then pronounced dead again only to celebrate another triumphant comeback. It makes sense to preserve faulty points of view for possible future use. The history of ideas, methods, and prejudices is an important part of the ongoing practice of science and this practice can change direction in surprising ways. (p. 33)

No doubt, many potentially fruitful ideas in psychology's history are still waiting to be tried again under new, perhaps more receptive, circumstances.

Curiosity

Instead of asking the question, Why study the history of psychology? it might make more sense to ask, Why not? Many people study U.S. history because they are interested in the United States, and younger members of a family often delight in hearing stories about the early days of the family's elder members. In other words, wanting to know as much as possible about a topic or person of interest, including a topic's or a person's history, is natural. Psychology is not an exception.

WHAT IS SCIENCE?

At various times in history, influential individuals (such as Galileo and Kant) have claimed that psychology could never be a science because of its concern with subjective experience. Many natural scientists still believe this, and some psychologists would not argue with them. How a history of psychology is written will be influenced by whether psychology can be considered a science. To answer the question of whether psychology is a science, however, we must first attempt to define science. Science came into existence as a way of answering questions about nature by examining nature directly rather than by depending on church dogma, past authorities, superstition, or abstract thought processes alone. From science's inception, its ultimate authority has been empirical observation (that is, the direct observation of nature), but there is more to science than simply observing nature. To be useful, observations must be organized or categorized in some way, and the ways in which they are similar to or different from other observations must be noted. After noting similarities and differences among observations, many scientists take the additional step of attempting to explain what they have observed. Science, then, is often characterized as having two major components: (1) empirical observation and (2) theory. According to Hull (1943), these two aspects of science can be seen in the earliest efforts of humans to understand their world:

Men are ever engaged in the dual activity of making observations and then seeking explanations of the resulting revelations. All normal men in all times have observed the rising and setting of the sun and the several phases of the moon. The more thoughtful among them have then proceeded to ask the question, "Why? Why does the moon wax and wane? Why does the sun rise and set, and where does it go when it sets?" Here we have the two essential elements of modern science: The making of observations constitutes the empirical or factual component, and the

systematic attempt to explain these facts constitutes the theoretical component. As science has developed, specialization, or division of labor, has occurred; some men have devoted their time mainly to the making of observations, while a smaller number have occupied themselves with the problems of explanation. (p. 1)

A Combination of Rationalism and Empiricism

What makes science such a powerful tool is that it combines two ancient methods of attaining knowledge: rationalism and empiricism. The rationalist believes that mental operations or principles must be employed before knowledge can be attained. For example, the rationalist says that the validity or invalidity of certain propositions can be determined by carefully applying the rules of logic. The empiricist maintains that the source of all knowledge is sensory observation. True knowledge, therefore, can be derived from or validated only by sensory experience. After centuries of inquiry, it was discovered that, by themselves, rationalism and empiricism had limited usefulness. Science combined the two positions, and knowledge has been accumulating at an exponential rate ever since.

The rational aspect of science prevents it from simply collecting an endless array of disconnected empirical facts. Because the scientist must somehow make sense out of what he or she observes, theories are formulated. A scientific theory has two main functions: (1) It organizes empirical observations, and (2) it acts as a guide for future observations. The latter function of a scientific theory generates confirmable propositions. In other words, a theory suggests propositions that are tested experimentally. If the propositions generated by a theory are confirmed through experimentation, the theory gains strength; if the propositions are not confirmed by experimentation, the theory loses strength. If the theory generates too many erroneous propositions, it must be either revised or abandoned. Thus

scientific theories must be testable. That is, they must generate hypotheses that can be validated or invalidated empirically. In science, then, the direct observation of nature is important, but such observation is often guided by theory.

The Search for Laws

Another feature of science is that it seeks to discover lawful relationships. A scientific law can be defined as a consistently observed relationship between two or more classes of empirical events. For example, when X occurs, Y also tends to occur. By stressing lawfulness, science is proclaiming an interest in the general case rather than the particular case. Traditionally, science is not interested in private or unique events but in general laws that can be publicly observed and verified. That is, a scientific law is general and, because it describes a relationship between empirical events, it is amenable to public observation. The concept of public observation is an important aspect of science. All scientific claims must be verifiable by any interested person. In science, there is no secret knowledge available only to qualified authorities.

There are two general classes of scientific laws. One class is correlational laws, which describe how classes of events vary together in some systematic way. For example, scores on intelligence tests tend to correlate positively with scores on creativity tests. With such information, only prediction is possible. That is, if we knew a person's score on an intelligence test, we could predict his or her score on a creativity test, and vice versa. A more powerful class of laws is causal laws, which specify how events are causally related. For example, if we knew the causes of a disease, we could predict and control that disease—preventing the causes of a disease from occurring prevents the disease from occurring. Thus, correlational laws allow prediction, but causal laws allow prediction and control. For this reason, causal laws are more powerful than correlational laws and thus are generally considered more desirable.

A major goal of science is to discover the causes of natural phenomena. Specifying the causes

of natural events, however, is highly complex and usually requires substantial experimental research. It cannot be assumed, for example, that contiguity proves causation. If rain follows a rain dance, it cannot be assumed that the dance necessarily caused the rain. Also complicating matters is the fact that events seldom, if ever, have a single cause; rather, they have multiple causes. Questions such as, What caused the Second World War? and What causes schizophrenia? are still far from answered. Even simpler questions such as, Why did John quit his job? or Why did Jane marry John? are, in reality, enormously complex. In the history of philosophy and science, the concept of causation has been one of the most perplexing (see, for example, Clatterbaugh, 1999).

The Assumption of Determinism

Because a main goal of science is to discover lawful relationships, science assumes that what is being investigated is lawful. For example, the chemist assumes that chemical reactions are lawful, and the physicist assumes that the physical world is lawful. The assumption that what is being studied can be understood in terms of causal laws is called determinism. Taylor (1967) defined determinism as the philosophical doctrine that "states that for everything that ever happens there are conditions such that, given them, nothing else could happen" (p. 359). The determinist, then, assumes that everything that occurs is a function of a finite number of causes and that, if these causes were known, an event could be predicted with complete accuracy. However, knowing all causes of an event is not necessary; the determinist simply assumes that they exist and that as more causes are known, predictions become more accurate. For example, almost everyone would agree that the weather is a function of a finite number of variables such as sunspots, highaltitude jet streams, and barometric pressure; yet weather forecasts are always probabilistic because many of these variables change constantly and others are simply unknown. The assumption underlying weather prediction, however, is determinism. All sciences assume determinism.

REVISIONS IN THE TRADITIONAL VIEW OF SCIENCE

The traditional view is that science involves empirical observation, theory formulation, theory testing, theory revision, prediction, control, the search for lawful relationships, and the assumption of determinism. Some prominent philosophers of science, however, take issue with at least some aspects of the traditional view of science. Among them are Karl Popper and Thomas Kuhn.

Karl Popper

Karl Popper (1902–1994) disagreed with the traditional description of science in two fundamental ways. First, he disagreed that scientific activity starts with empirical observation. According to Popper, the older view of science implies that scientists wander around making observations and then attempt to explain what they have observed. Popper (1963/2002a) showed the problem with such a view:

Twenty-five years ago I tried to bring home [this] point to a group of physics students in

Karl Popper

Vienna by beginning a lecture with the following instructions: "Take pencil and paper: carefully observe, and write down what you have observed!" They asked, of course, what I wanted them to observe. Clearly the instruction, "Observe!" is absurd.... Observation is always selective. It needs a chosen object, a definite task, an interest, a point of view, a problem. (p. 61)

So for Popper, scientific activity starts with a problem, and the problem determines what observations scientists will make. The next step is to propose solutions to the problem (conjectures) and then attempt to find fault with the proposed solutions (refutations). Popper saw scientific method as involving three stages: problems, theories (proposed solutions), and criticism.

Principle of Falsifiability. According to Popper, the demarcation criterion that distinguishes a scientific theory from a nonscientific theory is the principle of falsifiability. A scientific theory must be refutable. Contrary to what many believe, if any conceivable observation agrees with a theory, the theory is weak, not strong. Popper spent a great deal of time criticizing the theories of Freud and Adler for this reason. Without exception, everything a person does can be seen as supportive of either of these theories. This is because those theories are so vague that no matter what happens, their verification can be claimed. According to Popper, it is also vagueness that prevents a meaningful test of the horoscopes created by astrologers (1963/2002a, p. 49). Popper contrasted such theories with that of Einstein, which predicts precisely what should or should not happen if the theory is correct. Thus, Einstein's theory, unlike the theories of Freud and Adler and astrological predictions, was refutable and therefore scientific.

Thus, for Popper, for a theory to be scientific, it must make risky predictions—predictions that run a real risk of being incorrect. Theories that do not make risky predictions or that explain phenomena after they have already occurred are, according to Popper, not scientific. In addition to vagueness, another major problem with many psychological theories (such as Freud's and Adler's) is that they

engage more in **postdiction** (explaining phenomena after they have already occurred) than in prediction. Whether due to vagueness or the emphasis on postdiction, these theories make no *risky* predictions and are in no danger of being falsified. They are, therefore, unscientific.

According to Popper, it is a theory's incorrect predictions, rather than its correct ones, that cause scientific progress. This idea is nicely captured by Marx and Goodson (1976):

In real scientific life theories typically contribute not by being right but by being wrong. In other words, scientific advance in theory as well as experiments tends to be built upon the successive corrections of many errors, both small and large. Thus the popular notion that a theory must be right to be useful is incorrect. (p. 249)

In Popper's view, *all* scientific theories will eventually be found to be false and will be replaced by more adequate theories; it is always just a matter of time. For this reason, the highest status that a scientific theory can attain, according to Popper, is *not yet disconfirmed*. Popperian science is an unending search for better and better solutions to problems or explanations of phenomena. Brett (1912–1921/1965) made this point effectively:

We tend to think of science as a "body of knowledge" which began to be accumulated when men hit upon "scientific method." This is a superstition. It is more in keeping with the history of thought to describe science as the myths about the world which have not yet been found to be wrong. (p. 37)

Does this mean Popper believed that nonscientific theories are useless? Absolutely not! He said,

Historically speaking all—or very nearly all—scientific theories originate from myths, and ... a myth may contain important anticipations of scientific theories.... I thus [believe] that if a theory is found to be non-scientific, or "metaphysi-

cal" ... it is not thereby found to be unimportant, or insignificant, or "meaningless," or "nonsensical." (1963/2002a, p. 50)

Popper used falsification as a demarcation between a scientific and a nonscientific theory but not between a useful and useless theory. Many theories in psychology fail Popper's test of falsifiability either because they are stated in such general terms that they are confirmed by almost any observation or because they engage in postdiction rather than prediction. Such theories lack scientific rigor but are often still found to be useful. Freud's and Adler's theories are examples.

Thomas Kuhn

Until recently, it was widely believed that the scientific method guaranteed objectivity and that science produced information in a steady, progressive way. It was assumed that the world consists of knowable "truths" and that following scientific procedures allowed science to systematically approximate those truths. In other words, scientific activity was guided by the **correspondence theory of truth**, "the notion that the goal, when evaluating scientific laws or theories, is to determine whether or not they correspond to an external, mind-independent world" (Kuhn, 2000a, p. 95). **Thomas Kuhn (1922–1996)** changed that conception of science by showing science to be a highly subjective enterprise.

Paradigms and Normal Science. According to Kuhn, in the physical sciences one viewpoint is commonly shared by most members of a science. In physics or chemistry, for example, most researchers share a common set of assumptions or beliefs about their subject matter. Kuhn refers to such a widely accepted viewpoint as a paradigm. Although Kuhn used the term paradigm in several ways, most typically he defined it as "the entire constellation of beliefs, values, techniques, and so on shared by the members of a given [scientific] community" (1996, p. 175). For those scientists accepting a paradigm, it becomes the way of looking

at and analyzing the subject matter of their science. Once a paradigm is accepted, the activities of those accepting it become a matter of exploring the implications of that paradigm. Kuhn referred to such activities as normal science. Normal science provides what Kuhn called a "mopping-up" operation for a paradigm. While following a paradigm, scientists explore in depth the problems defined by the paradigm and utilize the techniques suggested by the paradigm while exploring those problems. Kuhn likened normal science to puzzle solving. Like puzzles, the problems of normal science have an assured solution, and there are "rules that limit both the nature of acceptable solutions and the steps by which they are to be obtained" (Kuhn, 1996, p. 38). Kuhn saw neither normal science nor puzzle solving as involving much creativity: "Perhaps the most striking feature of ... normal research problems ... is how little they aim to produce major novelties, conceptual or phenomenal" (1996, p. 35). Although a paradigm restricts the range of phenomena scientists examine, it does guarantee that certain phenomena are studied thoroughly.

By focusing attention upon a small range of relatively esoteric problems, the paradigm forces scientists to investigate some part of nature in a detail and depth that would otherwise be unimaginable.... During the period when the paradigm is

Thomas S. Kuhn

successful, the profession will have solved problems that its members could scarcely have imagined and would never have undertaken without commitment to the paradigm. And at least part of that achievement always proves to be permanent. (Kuhn, 1996, pp. 24–25)

That is the positive side of having research guided by a paradigm, but there is also a negative side. Although normal science allows for the thorough analysis of the phenomena on which a paradigm focuses, it blinds scientists to other phenomena and perhaps better explanations for what they are studying.

Mopping-up operations are what engage most scientists throughout their careers. They constitute what I am here calling normal science. Closely examined, whether historically or in the contemporary laboratory, that enterprise seems an attempt to force nature into the preformed and relatively inflexible box that the paradigm supplied. No part of the aim of normal science is to call forth new sorts of phenomena; indeed, those that will not fit the box are often not seen at all. Nor do scientists normally aim to invent new theories, and they are often intolerant of those invented by others. Instead, normalscientific research is directed to the articulation of those phenomena and theories that the paradigm already supplies. (Kuhn, 1996, p. 24)

A paradigm, then, determines what constitutes a research problem *and* how the solution to that problem is sought. In other words, a paradigm guides all of the researcher's activities. More important, however, is that researchers become emotionally involved in their paradigm; it becomes part of their lives and is therefore very difficult to give up.

How Sciences Change. How do scientific paradigms change? According to Kuhn, not very easily. First, there must be persistent observations that a currently accepted paradigm cannot explain; these are

called **anomalies**. Usually, a single scientist or a small group of scientists will propose an alternative viewpoint, one that will account for most of the phenomena that the prevailing paradigm accounts for and will also explain the anomalies. Kuhn indicated that there is typically great resistance to the new paradigm and that converts to it are won over very slowly. Eventually, however, the new paradigm wins out and displaces the old one. According to Kuhn, this describes what happened when Einstein challenged the Newtonian conception of the universe. Now the Einsteinian paradigm is generating its own normal science and will continue to do so until it is overthrown by another paradigm.

Kuhn portrayed science as a method of inquiry that combines the objective scientific method and the emotional makeup of the scientist. Science progresses, according to Kuhn, because scientists are forced to change their belief systems; and belief systems are very difficult to change, whether for a group of scientists or for anyone else.

The Stages of Scientific Development. According to Kuhn, the development of a paradigm that comes to dominate a science occurs over a long period of time. Prior to the development of a paradigm, a science typically goes through a preparadigmatic stage during which a number of competing viewpoints exist. During this period, which Kuhn referred to as prescientific, a discipline is characterized by a number of rival camps or schools, a situation contrary to unification and that results in, essentially, random fact gathering. Such circumstances continue to exist until one school succeeds in defeating its competitors and becomes a paradigm. At this point, the discipline becomes a science, and a period of normal science begins. The normal science generated by the paradigm continues until the paradigm is displaced by a new one, which in turn will generate its own normal science. Kuhn saw sciences as passing through three distinct stages: the preparadigmatic stage, during which rival camps or schools compete for dominance of the field; the paradigmatic stage, during which the puzzle-solving activity called normal science occurs; and the revolution**ary stage**, during which an existing paradigm is displaced by another paradigm.

Paradigms and Psychology

What has all of this to do with psychology? Psychology has been described as a preparadigmatic discipline (Staats, 1981) because it does not have one widely accepted paradigm but instead several competing schools or camps that exist simultaneously. For example, in psychology today we see camps that can be labeled behavioristic, functionalistic, cognitive, psychobiological, psychoanalytic, evolutionary, and humanistic. Some see this preparadigmatic situation as negative and insist that psychology is ready to synthesize all of its diverse elements into one unified paradigm (for example, Staats, 1981, 1989, 1991). Other psychologists do not agree that psychology is a preparadigmatic discipline but claim that psychology is a discipline that has, and perhaps has always had, several coexisting paradigms (or, at least, themes or research traditions). For these psychologists, there has never been, nor has there been a need for, a Kuhnian type of revolution (for example, Koch, 1981, 1993; Leahey, 1992; Royce, 1975; Rychlak, 1975). The latter psychologists view the coexistence of several paradigms in psychology as healthy, productive, and perhaps inevitable because psychology studies humans.

Mayr (1994) notes that Kuhn was a physicist and says that perhaps his analysis of scientific change applied to that science but not others. For example, Mayr observes that several paradigms have always existed simultaneously in biology, and there was a kind of Darwinian competition for the acceptance of ideas among them. Successful ideas, no matter what their source, survived, and unsuccessful ideas did not. This natural selection among ideas is called evolutionary epistemology, and it conflicts with Kuhn's concept of paradigm shifts. The question remains as to whether psychology is more like biology or like physics in this regard. In this text, it is assumed that psychology is a multiparadigmatic discipline rather than a discipline at the preparadigmatic stage of development.

Since Kuhn first published *The Structure of Scientific Revolutions* in 1962 (the second edition was published in 1970 and the third in 1996), psychologists have generally embraced Kuhnian concepts and terminology in describing the status and history of their discipline. Driver-Linn (2003) discusses the possible reasons for Kuhn's widespread usage among psychologists and some of the ambiguities and disagreements resulting from that usage.

Popper versus Kuhn

A major source of disagreement between Kuhn and Popper concerns Kuhn's concept of normal science. As we have seen, Kuhn says that once a paradigm has been accepted, most scientists busy themselves with research projects dictated by the paradigm—that is, doing normal science.

For Popper, what Kuhn called normal science is not science at all. Scientific problems are not like puzzles because there are no restrictions either on what counts as a solution or on what procedures can be followed in solving a problem. According to Popper, scientific problem solving is a highly imaginative, creative activity, nothing like the puzzle solving described by Kuhn. Furthermore, for Kuhn, science cannot be understood without considering psychological and sociological factors. For him, there is no such thing as a neutral scientific observation. Observations are always made through the lens of a paradigm. In Popperian science, such factors are foreign; problems exist, and proposed solutions either pass the rigorous attempts to refute them or they do not. Thus, Kuhn's analysis of science stresses convention and subjective factors, and Popper's analysis stresses logic and creativity. D. N. Robinson (1986) suggests that the views of both Kuhn and Popper may be correct: "In a conciliatory spirit, we might suggest that the major disagreement between Kuhn and Popper vanishes when we picture Kuhn as describing what science has been historically, and Popper asserting what it ought to be" (p. 24). However, it should be noted that there is a basic difference between Popper's and Kuhn's philosophies of science. Popper believed that there are truths about the physical world that

science can approximate. In other words, Popper accepted the correspondence theory of truth. Kuhn, on the other hand, rejected this theory, saying instead that the paradigm accepted by a group of scientists creates the "reality" they explore. For this reason, Kuhn "was led to the radical view that truth itself is relative to a paradigm" (Okasha, 2002, p. 88).

Other philosophers of science claim that any attempt to characterize science is misleading. For them, there is no one scientific method or principle, and any description of science must focus on the creativity and determination of individual scientists. In this spirit, the illustrious physicist Percy W. Bridgman (1955) said that scientists do not follow "any prescribed course of action.... Science is what scientists do and there are as many scientific methods as there are individual scientists" (p. 83). In his book Against Method: Outline of an Anarchistic Theory of Knowledge (1975), Paul Feyerabend (1924-1994) aligned himself with those philosophers of science who claim that scientists follow no prescribed set of rules. In fact, he said that whatever rules do exist must be broken in order for scientific progress to occur. Feyerabend (1975) summarized this position as follows:

My thesis is that anarchism helps to achieve progress in any one of the senses one cares to choose. Even a law-and-order science will succeed only if anarchistic moves are occasionally allowed to take place. (p. 27)

For nobody can say in abstract terms, without paying attention to idiosyncrasies of person and circumstances, what precisely it was that led to progress in the past, and nobody can say what moves will succeed in the future. (p. 19)

In his book *Farewell to Reason*, Feyerabend (1987) continued his "anarchistic" description of science:

There is no one "scientific method," but there is a great deal of opportunism;anything goes—anything, that is, that is liable to advance knowledge as understood by a particular researcher or research tradition. In practice science often oversteps the boundaries some scientists and philosophers try to put in its way and becomes a free and unrestricted inquiry. (p. 36)

Successful research does not obey general standards; it relies now on one trick, now on another, and the moves that advance it are not always known to the movers. A theory of science that devises standards and structural elements of *all* scientific activities and authorizes them by reference to some rationality-theory may impress outsiders—but it is much too crude an instrument for the people on the spot, that is, for scientists facing some concrete research problem. (p. 281)

Even with the revisions suggested by Popper, Kuhn, and Feyerabend, many traditional aspects of science remain. Empirical observation is still considered the ultimate authority, lawful relationships are still sought, theories are still formulated and tested, and determinism is still assumed.

For an excellent historical review of conceptions of science and a discussion of those that currently exist, see *Science Wars: What Scientists Know and How They Know It* by S. L. Goldman (2006).

IS PSYCHOLOGY A SCIENCE?

The scientific method has been used with great success in psychology. Experimental psychologists have demonstrated lawful relationships between classes of environmental events (stimuli) and classes of behavior, and they have devised rigorous, refutable theories to account for those relationships. The theories of Hull and Tolman are examples, and there are many others. Other psychologists work hand in hand with chemists and neurologists who are attempting to determine the biochemical correlates of memory and other cognitive processes. Still other psychologists are working with evolutionary biologists and geneticists in an effort to understand

evolutionary origins of human social behavior. In fact, we can safely say that scientifically oriented psychologists have provided a great deal of useful information in every major area of psychology—for example, learning, perception, memory, personality, intelligence, motivation, and psychotherapy. However, although some psychologists are clearly scientists, many, if not most, are not. We will see the reasons for this shortly.

Determinism, Indeterminism, and Nondeterminism

Determinism. Scientifically oriented psychologists are willing to assume determinism while studying humans. Although all determinists believe that all behavior is caused, there are different types of determinism. Biological determinism emphasizes the importance of physiological conditions or genetic predispositions in the explanation of behavior. For example, evolutionary psychologists claim that much human behavior, as well as that of nonhuman animals, reflects dispositions inherited from our long evolutionary past. Environmental determinism stresses the importance of environmental stimuli as determinants of behavior. The following illustrates the type of determinism that places the cause of human behavior in the environment:

Behavior theory emphasizes that environmental events play the key role in determining human behavior. The source of action lies not inside the person, but in the environment. By developing a full understanding of how environmental events influence behavior, we will arrive at a complete understanding of behavior. It is this feature of behavior theory—its emphasis on environmental events as the determinants of human action-which most clearly sets it apart from other approaches to human nature.... If behavior theory succeeds, our customary inclination to hold people responsible for their actions, and look inside them to their wishes, desires, goals, intentions, and so on, for explanations of their actions, will be replaced by an entirely different orientation ... one in which responsibility for action is sought in environmental events. (Schwartz and Lacey, 1982, p. 13)

Sociocultural determinism is a form of environmental determinism, but rather than emphasizing the physical stimuli that cause behavior, it emphasizes the cultural or societal rules, regulations, customs, and beliefs that govern human behavior. For example, Erikson (1977) referred to culture as "a version of human existence" (p. 79). To a large extent, what is considered desirable, undesirable, normal, and abnormal is culturally determined; thus, culture acts as a powerful determinant of behavior.

Other determinists claim that behavior is caused by the interaction of biological, environmental, and sociocultural influences. In any case, determinists believe that behavior is caused by antecedent events and set as their job the discovery of those events. It is assumed that, as more causes are discovered, human behavior will become more predictable and controllable. In fact, the prediction and control of behavior is usually recognized as an acceptable criterion for demonstrating that the causes of behavior have been discovered.

Although determinists assume that behavior is caused, they generally agree that it is virtually impossible to know all causes of behavior. There are at least two reasons for this limitation. First, behavior typically has many causes. As Freud said, much behavior is overdetermined; that is, behavior is seldom, if ever, caused by a single event or even a few events. Rather, a multitude of interacting events typically causes behavior. Second, some causes of behavior may be fortuitous. For example, a reluctant decision to attend a social event may result in meeting one's future spouse. About such meetings Bandura (1982) says, "Chance encounters play a prominent role in shaping the course of human lives." He gives the following example:

It is not uncommon for college students to decide to sample a given subject matter only to leave enrollment in a particular course to the vagaries of time allocation and course scheduling. Through this semifortuitous process some meet inspiring teachers who have a decisive influence on their choice of careers. (p. 748)

Fortuitous circumstances do not violate a deterministic analysis of behavior; they simply make it more complicated. By definition, fortuitous circumstances are not predictable relative to one's life, but when they occur they are causally related to one's behavior.

Fortuity is but one of the factors contributing to the complexity of the causation of human behavior. Determinists maintain that it is the complexity of the causation of human behavior that explains why predictions concerning human behavior must be probabilistic. Still, determinists believe that as our knowledge of the causes of behavior increases, so will the accuracy of our predictions concerning that behavior.

What biological, environmental, and sociocultural determinism all have in common is that the determinants of behavior they emphasize are directly measurable. Genes, environmental stimuli, and cultural customs are all accessible and quantifiable and thus represent forms of physical determinism. However, some scientific psychologists emphasize the importance of cognitive and emotional experience in their explanation of human behavior. For them, the most important determinants of human behavior are subjective and include a person's beliefs, emotions, sensations, perceptions, ideas, values, and goals. These psychologists emphasize psychical determinism rather than physical determinism. Among the psychologists assuming psychical determinism are those who stress the importance of mental events of which we are conscious and those, like Freud, who stress the importance of mental events of which we are not conscious.

Besides accepting some type of determinism, scientific psychologists also seek general laws, develop theories, and use empirical observation as their ultimate authority in judging the validity of those theories. Psychology, as it is practiced by these psychologists, is definitely scientific, but not all psychologists agree with their assumptions and methods.

Indeterminism. First, some psychologists believe that human behavior is determined but that the causes of behavior cannot be accurately measured. This belief reflects an acceptance of Heisenberg's uncertainty principle. The German physicist Werner Karl Heisenberg (1901-1976) found that the very act of observing an electron influences its activity and casts doubt on the validity of the observation. Heisenberg concluded that nothing can ever be known with certainty in science. Translated into psychology, this principle says that, although human behavior is indeed determined, we can never learn at least some causes of behavior because in attempting to observe them we change them. In this way, the experimental setting itself may act as a confounding variable in the search for the causes of human behavior. Psychologists who accept this viewpoint believe that there are specific causes of behavior but that they cannot be accurately known. Such a position is called **indeterminism**. Another example of indeterminacy is Immanuel Kant's (1724-1804) conclusion that a science of psychology is impossible because the mind could not be objectively employed to study itself. MacLeod (1975) summarized Kant's position as follows:

Kant challenged the very basis of a science of psychology. If psychology is the study of "the mind," and if every observation and every deduction is an operation of a mind which silently imposes its own categories on that which is being observed, then how can a mind turn in upon itself and observe its own operations when it is forced by its very nature to observe in terms of its own categories? Is there any sense in turning up the light to see what the darkness looks like [italics added]? (p. 146)

Nondeterminism. Some psychologists completely reject science as a way of studying humans.

These psychologists, usually working within either a humanistic or an existential paradigm, believe that the most important causes of behavior are self-generated. For this group, behavior is freely chosen and thus independent of physical or psychical causes. This belief in **free will** is contrary to the assumption of determinism, and therefore the endeavors of these psychologists are nonscientific. Such a position is known as **nondeterminism**. For the nondeterminists, because the individual freely chooses courses of action, he or she alone is responsible for them.

Determinism and Responsibility. Although a belief in free will leads naturally to a belief in personal responsibility, one version of psychical determinism also holds humans responsible for their actions. William James (1884/1956) distinguished between hard determinism and soft determinism. With hard determinism, he said, the causes of human behavior are thought to function in an automatic. mechanistic manner and thus render the notion of personal responsibility meaningless. With soft determinism, however, cognitive processes such as intentions, motives, beliefs, and values intervene between experience and behavior. The soft determinist sees human behavior as resulting from thoughtful deliberation of the options available in a given situation. Because rational processes manifest themselves prior to actions, the person bears responsibility for those actions. Although soft determinism is still determinism, it is a version that allows uniquely human cognitive processes into the configuration of the causes of human behavior. Soft determinism, then, offers a compromise between hard determinism and free will—a compromise that allows for human responsibility. (For examples of contemporary psychologists who accept soft determinism, see Bandura, 1989; Robinson, 1985; and Sperry, 1993.)

Whether we consider psychology a science depends on which aspect of psychology we focus on. One highly respected psychologist and philosopher of science answers the question of whether psychology is a science in a way that stresses psychology's nonscientific nature:

Psychology is misconceived when seen as a coherent science or as any kind of coherent discipline devoted to the empirical study of human beings. Psychology, in my view, is not a single discipline but a collection of studies of varied cast, some few of which may qualify as science, whereas most do not. (Koch, 1993, p. 902)

Sigmund Koch (1917–1996) argued that psychology should embrace both science and the humanities in its effort to understand humans. Koch's more comprehensive view of psychology has been highly influential, and most of the May 2001 issue of *American Psychologist* explores its implications.

Psychology should not be judged too harshly because some of its aspects are not scientific or even antiscientific. Science as we now know it is relatively new, whereas the subject matter of most, if not all, sciences is very old. What is now studied scientifically was once studied philosophically or theologically, as Popper noted. First came the nebulous categories that were debated for centuries in a nonscientific way. This debate readied various categories of inquiry for the fine tuning that science provides.

In psychology today, there is inquiry on all levels. Some concepts have a long philosophical heritage and are ready to be treated scientifically; other concepts are still in their early stages of development and are not ready for scientific treatment; and still other concepts, by their very nature, may never be amenable to scientific inquiry. All these levels and types of inquiry appear necessary for the growth of psychology, and all sustain one another.

PERSISTENT QUESTIONS IN PSYCHOLOGY

The questions that psychology is now attempting to answer are often the same questions it has been trying to answer from its inception. In many cases, only the methods for dealing with these persistent questions have changed. We have already encountered one of psychology's persistent questions: Is human behavior freely chosen or is it determined? In the following section, we will review additional persistent questions and, in so doing, preview much of what will be covered in the remainder of this text.

What Is the Nature of Human Nature?

A theory of human nature attempts to specify what is universally true about humans. That is, it attempts to specify what all humans are equipped with at birth. One question of interest here is, How much of our animal heritage remains in human nature? For example, are we inherently aggressive? Yes, say the Freudians. Is human nature basically good and nonviolent? Yes, say members of the humanistic camp, such as Rogers and Maslow. Or is our nature neither good nor bad but neutral, as the behaviorists such as Watson and Skinner claim? The behaviorists maintain that experience makes a person good or bad or whatever the person is. Do humans possess a free will? Yes, say the existential psychologists; no, say the scientifically oriented psychologists. Associated with each of psychology's paradigms is an assumption about the nature of human nature, and each assumption has a long history. Throughout this text, we will sample these conceptions about human nature and the methodologies they generate.

How Are the Mind and the Body Related?

The question of whether there is a mind and, if so, how it is related to the body is as old as psychology itself. Every psychologist must address this question either explicitly or implicitly. Through the years, almost every conceivable position has been taken on the mind-body relationship. Some psychologists attempt to explain everything in physical terms; for them, even so-called mental events are ultimately explained by the laws of physics or chemistry. These individuals are called **materialists** because

they believe that matter is the only reality, and therefore everything in the universe, including the behavior of organisms, must be explained in terms of matter. They are also called monists because they attempt to explain everything in terms of one type of reality-matter. Other psychologists are at the opposite extreme, saying that even the so-called physical world consists of ideas. These individuals are called idealists, and they, too, are monists because they attempt to explain everything in terms of consciousness. Many psychologists, however, accept the existence of both physical and mental events and assume that the two are governed by different principles. Such a position is called dualism. The dualist believes that there are physical events and mental events. Once it is assumed that both a physical and a mental realm exist, the question becomes how the two are related. For the monist, of course, there is no mind-body problem.

Types of Dualism. One form of dualism, called interactionism, claims that the mind and body interact. That is, the mind influences the body, and the body influences the mind. According to this interactionistic conception, the mind is capable of initiating behavior. This was the position taken by Descartes and is the one taken by most members of the humanistic-existential camp. The psychoanalysts, from Freud to the present, are also interactionists. For them, many bodily ailments are psychogenic, caused by mental events such as conflict, anxiety, or frustration. A currently popular way of explaining mind-body relationships is through emergentism, which claims that mental states emerge from brain states. One kind of emergentism claims that once mental events emerge from brain activity, the mental events can influence subsequent brain activity and thus behavior. Because of the postulated reciprocal influence between brain activity (body) and mental events (mind), this kind of emergentism represents interactionism. Sperry (1993), for example, accepted this kind of emergentism.

Another form of emergentism that is not interactionist is **epiphenomenalism**. According to the

epiphenomenalist, the brain causes mental events but mental events cannot cause behavior. In this view, mental events are simply behaviorally irrelevant by-products (epiphenomena) of brain processes.

Another dualist position is that an environmental experience causes both mental events and bodily responses *simultaneously* and that the two are totally independent of each other. This position is referred to as **psychophysical parallelism**.

According to another dualist position, called double aspectism, a person cannot be divided into a mind and a body but is a unity that simultaneously experiences events physiologically and mentally. Just as heads and tails are two aspects of a coin, mental events and physiological events are two aspects of a person. Mind and body do not interact, nor can they ever be separated. They are simply two aspects of each experience we have as humans. Other dualists maintain that there is a preestab**lished harmony** between bodily and mental events. That is, the two types of events are different and separate but are coordinated by some external agentfor example, God. Finally, in the 17th century, Nicolas de Malebranche (1638-1715) suggested that when a desire occurs in the mind, God causes the body to act. Similarly, when something happens to the body, God causes the corresponding mental experience. Malebranche's position on the mindbody relationship is called occasionalism.

All the preceding positions on the mind-body problem are represented in psychology's history, and we will therefore encounter them throughout this text. Figure 1-1 shows Chisholm's whimsical summary of the proposed mind-body relationships.

Nativism versus Empiricism

To what extent are human attributes such as intelligence inherited and to what extent are they determined by experience? The **nativist** emphasizes the role of inheritance in his or her explanation of the origins of various human attributes, whereas the empiricist emphasizes the role of experience. Those who consider some aspect of human behavior instinctive or who take a stand on human nature

as being good, bad, gregarious, and so on are also nativists. Empiricists, on the other hand, claim that humans are the way they are largely because of their experiences. Obviously, this question is still unresolved. The nativism-empiricism controversy is closely related to the question concerning the nature of human nature. For example, those who claim that humans are aggressive by nature are saying that humans are innately predisposed to be aggressive.

Most, if not all, psychologists now concede that human behavior is influenced by both experience and inheritance; what differentiates nativists from empiricists is the emphasis they place on one or the other.

Mechanism versus Vitalism

Another persistent question in psychology's history is whether human behavior is completely explicable in terms of mechanical laws. According to **mechanism**, the behavior of all organisms, including humans, can be explained in the same way that the behavior of any machine can be explained—in terms of its parts and the laws governing those parts. To the mechanist, explaining human behavior is like explaining the behavior of a clock except that humans are more complex. In contrast, according to **vitalism**, life can never be completely reduced to material things and mechanical laws. Living things contain a vital force that does not exist in

FIGURE 1.1

Chisholm's depictions of various mind-body relationships. The bird drawn with the broken line represents the mind, and the bird drawn with the unbroken line represents the body.

SOURCE: Redrawn from Taylor (1963, p. 130). Used by permission of Roderick M. Chisholm.

inanimate objects. In ancient times, this force was referred to as a soul, spirit, or breath of life, and it was its departure from the body that caused death.

The mechanism-vitalism debate has been prominently featured in psychology's history, and we will encounter it in various forms throughout this text.

Rationalism versus Irrationalism

Rationalistic explanations of human behavior usually emphasize the importance of logical, systematic, and intelligent thought processes. Perhaps for this reason, most of the great contributions to mathematics have been made by philosophers in the rationalistic tradition, such as Descartes and Leibniz. Rationalists tend to search for the abstract universal principles that govern events in the empirical world. Most of the early Greek philosophers were rationalists, and some went so far as to equate wisdom with virtue. When one knows the truth, said Socrates, one acts in accordance with it. Thus, wise humans are good humans. The greatest passion, to the Greeks, was the passion to know. There are other passions, of course, but they should be rationally controlled. Western philosophy and psychology has, to a large extent, perpetuated the glorification of the intellect at the expense of emotional experience.

It was not always agreed, however, that the intellect is the best guide for human thought and behavior. At various times in history, human emotionality has been appreciated more than the human intellect. This was the case during the early Christian era, during the Renaissance, and at various other times under the influence of existential-humanistic philosophy and psychology. All these viewpoints stress human feeling over human rationality and are therefore referred to as irrational.

Any explanation of human behavior that stresses unconscious determinants is also irrational. The psychoanalytic theories of Freud and Jung, for example, exemplify **irrationalism** because they claim that the true causes of behavior are unconscious and as such cannot be pondered rationally.

The tension between conceptions of humans that stress intellect (reason) and those that stress the emotions or the unconscious mind (spirit) has appeared throughout psychology's history and still manifests itself in contemporary psychology.

How Are Humans Related to Nonhuman Animals?

The major question here is whether humans are qualitatively or quantitatively different from other animals. If the difference is quantitative (one of degree), then at least something can be learned about humans by studying other animals. The school of behaviorism relied heavily on animal research and maintained that the same principles governed the behavior of both nonhumans and humans. Therefore, the results of animal research could be readily generalized to the human Representing the other extreme are the humanists and the existentialists who believe that humans are qualitatively different from other animals, and therefore nothing important about humans can be learned by studying nonhuman animals. Humans, they say, are the only animals that freely choose their courses of action and are therefore morally responsible for that action. It thus makes sense to judge human behavior as good or bad. Similar judgments of animal behavior are meaningless. Without the ability to reason and to choose, there can be no guilt. Most psychologists can be placed somewhere between the two extremes, saying that some things can be learned about humans by studying other animals and some things cannot.

What Is the Origin of Human Knowledge?

The study of knowledge is called **epistemology** (from the Greek *episteme*, meaning "to know or understand"). The epistemologist asks such questions as, What can we know? What are the limits of knowledge? and How is knowledge attained? Psychology has always been involved in epistemology because

one of its major concerns has been determining how humans gain information about themselves and their world. The radical empiricist insists that all knowledge is derived from sensory experience, which is somehow registered and stored in the brain. The rationalist agrees that sensory information is often, if not always, an important first step in attaining knowledge but argues that the mind must then actively transform this information in some way before knowledge is attained. Some nativists would say that some knowledge is innate. Plato and Descartes, for example, believed that many ideas were a natural part of the mind.

In answering epistemological questions, the empiricists postulate a passive mind that represents physical experiences as mental images, recollections, and associations. In other words, the passive mind is seen as reflecting cognitively what is occurring, or what has occurred, in the physical world. Physical experiences that occur consistently in some particular pattern will be represented cognitively in that pattern and will tend to be recalled in that pattern. The rationalists, however, postulate an active mind that transforms the data from experience in some important way. Whereas a passive mind is seen as representing physical reality, the active mind is seen as a mechanism by which physical reality is organized, pondered, understood, or valued. For the rationalist, the mind adds something to our mental experience that is not found in our physical experience.

For the empiricist then, knowledge consists of the accurate description of physical reality as it is revealed by sensory experience and recorded in the mind. For the rationalist, knowledge consists of concepts and principles that can be attained only by a pondering, active mind. For some nativists, at least some knowledge is inherited as a natural component of the mind. The empiricist, rationalist, and nativist positions, and various combinations of them, have always been part of psychology; in one form or another, they are still with us today. In this text, we will see how these three major philosophical positions have manifested themselves in various ways throughout psychology's history.

Objective versus Subjective Reality

The difference between what is really present physically (physical or objective reality) and what we actually experience mentally (subjective or phenomenal reality) has been an issue at least since the early Greeks. Some accept naive realism, saying that what we experience mentally is exactly the same as what is present physically. Many others, however, say that at least something is lost or gained in the translation from physical to phenomenal experience. A discrepancy between the two types of experience can exist if the sense receptors can respond only partially to what is physically present for example, to only certain sounds or colors. A discrepancy can also exist if information is lost or distorted as it is being transmitted from the sense receptors to the brain. Also, the brain itself can transform sensory information, thus creating a discrepancy between physical and phenomenal reality. The important question here is, Given the fact that there is a physical world and a psychological world, how are the two related? A related question is, Given the fact that all we can ever experience directly is our own subjective reality, how can we come to know anything about the physical world? We are confronted here with the problem of reification, or the tendency to believe that because something has a name it also has an independent existence. J. S. Mill (1843/1874) described this fallacy:

The fallacy may be enunciated in this general form—Whatever can be thought of apart exists apart: and its most remarkable manifestation consists in the personification of abstractions. Mankind in all ages have had a strong propensity to conclude that wherever there is a name, there must be a distinguishable separate entity corresponding to the name; and every complex idea which the mind has formed for itself by operating upon its conceptions of individual things, was considered to have an outward objective reality answering to it. (p. 527)

Throughout human history, entities such as souls, minds, gods, demons, spirits, and selves have been imagined and then assumed to exist. Of course, in more recent times, procedures have been available to determine whether imagined entities have referents in the empirical world. As we have seen, scientific theory attempts to correlate words and symbols with empirical observations. In the case of reification, however, the relationship between the imagined and the real is simply assumed to exist. The tendency toward reification is a powerful and persistent one, and we will encounter it often.

The Problem of the Self

Our physical experiences are highly diverse, and yet we experience unity among them. Also, we grow older, gain and lose weight, change locations, exist in different times; yet with all of this and more, our life's experiences have continuity. We perceive ourselves as the same person from moment to moment, from day to day, and from year to year even though little about us remains the same. The question is, What accounts for the unity and continuity of our experience? Through the centuries, entities such as a soul or a mind have been proposed. More recently, the self has been the most popular proposed organizer of experience.

The self has often been viewed as having a separate existence of its own, as is implied by the phrase "I said to myself." Besides organizing one's experiences and providing a sense of continuity over time, the self has often been endowed with other attributes, such as being the instigator and evaluator of action. Other experiences that contribute to the belief in an autonomous self include the feeling of intentionality or purpose in one's thoughts and behavior, the awareness of being aware, the ability to selectively direct one's attention, and moments of highly emotional, insightful experiences. As we will see, to postulate a self with autonomous powers creates a number of problems that psychology has struggled with through the years and still does. Clearly, whether an autonomous self or mind is proposed as the organizer of experience or as the instigator of behavior, one is confronted with the mind-body problem.

Universalism versus Relativism

Throughout the histories of philosophy, science, and psychology there have been individuals who sought, and some who claimed to have discovered, universal truths about the world in general or about people in particular. The goal of such universals is to describe the general laws, principles, or essences that govern the world and our perception of it. Likewise, there have been individuals who claim that such universal truths either do not exist or, if they do, that they cannot be known. These relativists say that humans always influence what they observe and, therefore, the search for universals that exist independently of human existence must be in vain. Instead, they say all "truth" must be relative to individual or group perspectives. For them, there is no one truth, only truths. This debate concerning universalism versus relativism was articulated by the early Greek philosophers (see Chapter 2) and, as we will see, has been an ongoing theme in the history of philosophy and psychology. We have already seen one example of this debate when we reviewed Popper's and Kuhn's philosophies of science. Although Popper believed scientific knowledge must always be tentative, he assumed the existence of a physical world and that knowledge of that world can be approximated by engaging in the kind of science he described. Popper, then, was a universalist. On the other hand, Kuhn believed that scientific activity is always guided by a paradigm and any conclusions reached about the world tend to be in accordance with the dictates of that paradigm. In other words, according to Kuhn, conceptions of the world change as paradigms change, and therefore it makes no sense to talk about a world that exists independently of human observation. Kuhn was a relativist.

In Chapter 21 we will see that the tension between modernism and postmodernism in contemporary philosophy and psychology is the most current manifestation of the ancient tension between universalism and relativism.

As we will see throughout this text, the positions psychologists have taken on the preceding issues have represented a wide variety of assumptions,

interests, and methodologies, and this continues to be the case in contemporary psychology.

SUMMARY

Psychology is best defined in terms of the activities of psychologists, and those activities have changed through the centuries. Although psychology goes back at least to the dawn of civilization, our version of the history of psychology begins with the early Greeks. The approach to writing this text exemplifies presentism because current psychology is used as a guide in determining what to cover historically. However, in general, historicism is considered the more valid approach to understanding psychology's history. In presenting the history of psychology, this text combines coverage of great individuals, persistent ideas, the spirit of the times, and contributions from other fields. Such a combined approach is referred to as eclectic. By studying the history of psychology, a student gains perspective and a deeper understanding of modern psychology. Also, he or she will learn that sometimes sociocultural conditions determine what is emphasized in psychology. Finally, by studying the history of psychology, previous mistakes can be avoided, potentially important ideas can be discovered, and the natural curiosity about something thought to be important can be satisfied.

Traditionally, science was viewed as starting with empirical observation and then proceeding to the development of theory. Theories were then evaluated in terms of their ability to generate predictions that either were or were not supported by experimental outcome. Theories that generated predictions that were confirmed became stronger, and those making erroneous predictions were revised or abandoned. By linking empirical observation and theory, science combined the philosophical schools of empiricism and rationalism. Science assumes determinism and seeks general laws. Popper disagreed with the traditional view of science, saying that scientific activity does not start with empirical observa-

tion but with a problem of some type that guides the scientist's empirical observations. Furthermore, Popper maintained that if a scientific theory is consistently confirmed, it is more likely a bad theory than a good one. A good theory must make risky predictions that, if not confirmed, refute the theory. To be classified as scientific, a theory must specify in advance the observations that, if made, would refute it. What distinguishes a scientific theory from a nonscientific theory is the principle of falsifiability. A scientific theory must run the risk of being incorrect, and it must specify the conditions under which it would be. In psychology, theories such as those of Freud and Adler are too vague to allow precise testing, and they emphasize postdiction rather than prediction. For both reasons, they violate the principle of falsifiability. Kuhn also disagreed with the traditional view of science. Kuhn's analysis of science stresses sociological and psychological factors. At any given time, scientists accept a general framework within which they perform their research, a framework Kuhn called a paradigm. A paradigm determines what constitutes research problems and how those problems are solved. For Popper, scientific activity is guided by problems, whereas for Kuhn, scientific activity is guided by a paradigm that scientists believe to be true. For Popper, science involves creative problem solving; for Kuhn, it involves puzzle solving. According to Kuhn, scientific progress occurs in three stages: the preparadigmatic, the paradigmatic, and the revolutionary. A fundamental distinction between Popper's and Kuhn's conceptions of science is reflected in the fact that Popper accepted the correspondence theory of truth and Kuhn did not. Other philosophers of science, such as Feyerabend, claim that it is misleading to characterize science or scientific method in any particular way. For them, science is what

scientists do, and any existing rules and regulations must be violated for scientific progress to occur.

Some aspects of psychology are scientific, and some are not. Psychologists who are willing to assume physical or psychical determinism while studying humans are more likely to have a scientific orientation than are those who are unwilling to make that assumption. Nondeterminists assume that human behavior is freely chosen and therefore not amenable to traditional scientific analysis. The indeterminist believes that human behavior is determined but that the determinants of behavior cannot always be known with certainty. Psychology need not apologize for its nonscientific aspects because those aspects have often made significant contributions to the understanding of humans. Also, in some cases, the concepts developed by nonscientific psychologists are later fine-tuned by psychologists using the scientific method.

Many questions that have persisted throughout psychology's history were summarized, including the following: To what extent are humans free,

and to what extent is their behavior determined by knowable causes? What is the nature of human nature? How are the mind and body related? To what extent are human attributes determined by heredity (nativism) as opposed to experience (empiricism)? Can human behavior be completely understood in terms of mechanistic principles, or must some additional vitalistic principle be postulated? To what extent is human behavior rational as opposed to irrational? How are humans related to nonhuman animals? What is the origin of human knowledge? What is the difference between what exists physically and what is experienced mentally, and how is this difference to be known and accounted for? How has the concept of self been used throughout psychology's history to account for one's continuity of experience over time, and what are the problems associated with the concept of self? Are there knowable universal truths about the world in general or about people in particular. or must truth always be relative to individual or group perspectives?

DISCUSSION QUESTIONS

- Discuss the choices that must be made before writing a history of psychology. Include in your answer a distinction between presentism and historicism.
- 2. What is gained by studying the history of psychology?
- 3. Summarize the major characteristics of science.
- 4. Discuss why psychology can be described both as a science and as a nonscience. Include in your answer the characteristics of science that some psychologists are unwilling to accept while studying humans.
- 5. In what ways did Popper's view of science differ from the traditional view?
- 6. According to Popper, what are the two primary reasons that theories such as those of Freud and Adler are unscientific?

- 7. Summarize Kuhn's views on how sciences change. Include in your answer the definitions of the terms *preparadigmatic discipline*, *paradigm*, *normal science*, and *scientific revolution*.
- 8. Within the realm of science, what is the correspondence theory of truth? Explain why it can be said that Popper accepted this theory and Kuhn did not.
- 9. Summarize Feyerabend's view of science.
- 10. Should psychology aspire to become a single-paradigm discipline? Defend your answer.
- 11. Is psychology a science? Defend your answer.
- 12. Define the terms physical determinism, psychical determinism, indeterminism, and nondeterminism.
- 13. Distinguish between hard determinism and soft determinism.

- 14. What does a theory of human nature attempt to accomplish?
- 15. Summarize the various proposed answers to the mind-body problem. Include in your answer definitions of the terms monism, dualism, materialism, idealism, emergentism, interactionism, psychophysical parallelism, epiphenomenalism, preestablished harmony, double aspectism, and occasionalism.
- 16. Discuss the nativist and empiricist explanations of the origin of human attributes.
- 17. First describe the positions of mechanism and vitalism, and then indicate which of the two positions you accept and why.
- 18. Discuss rationalism and irrationalism as they apply to explanations of human behavior.

- 19. Describe how each of the following would explain how we gain knowledge: the empiricist, the rationalist, and the nativist.
- 20. Discuss the problems involved in discovering and explaining discrepancies that may exist between what is physically before us and what we experience subjectively. Define and give an example of reification.
- 21. For what reasons has a concept of self been employed by psychologists? What problems does this concept solve, and what problems does it create?
- 22. Summarize the debate between universalism and relativism concerning the nature of truth.

SUGGESTIONS FOR FURTHER READING

- Churchland, P. M. (1998). Matter and consciousness: A contemporary introduction to the philosophy of mind (rev. ed.). Cambridge: MIT Press.
- Honderich, T. (1993). How free are you? The determinism problem. New York: Oxford University Press.
- Klemke, F. D., Hollinger, R., & Kline, A. D. (Eds.). (1988). *Introductory readings in the philosophy of science*. Buffalo, NY: Prometheus Books.
- Kuhn, T. S. (1996). *The structure of scientific revolutions* (3rd ed.). Chicago: University of Chicago Press.
- Kuhn, T. S. (2000). The road since Structure: Philosophical Essays, 1970–1993, with an autobiographical interview
 (J. Conant & J. Haugeland, Eds.). Chicago: University of Chicago Press.
- Okasha, S. (2002). Philosophy of science: A very short introduction. New York: Oxford University Press.
- Popper, K. (1982). Unended quest: An intellectual autobiography. La Salle, IL: Open Court.

- Popper, K. (1996). Knowledge and the body-mind problem: In defence of interaction (M. A. Notturno, Ed.). New York: Routledge.
- Popper, K. (2002a). Conjectures and refutations: The growth of scientific knowledge. New York: Routledge. (Original work published 1963)
- Raphael, F. (1999). Popper. New York: Routledge.
- Robinson, D. N. (1982). Toward a science of human nature: Essays on the psychologies of Mill, Hegel, Wundt, and James. New York: Columbia University Press.
- Robinson, D. N. (1985). *Philosophy of psychology*. New York: Columbia University Press.
- Stevenson, L., & Haberman, D. L. (1998). *Ten theories of human nature* (3rd ed.). New York: Oxford University Press.

GLOSSARY

Active mind A mind that transforms, interprets, understands, or values physical experience. The rationalists assume an active mind.

Anomalies Persistent observations that cannot be explained by an existing paradigm. Anomalies eventually cause one paradigm to displace another.

Biological determinism The type of determinism that stresses the biochemical, genetic, physiological, or anatomical causes of behavior.

Causal laws Laws describing causal relationships. Such laws specify the conditions that are necessary and sufficient to produce a certain event. Knowledge of causal laws allows both the prediction and control of events.

Confirmable propositions Within science, propositions capable of validation through empirical tests.

Correlational laws Laws that specify the systematic relationships among classes of empirical events. Unlike causal laws, the events described by correlational laws do not need to be causally related. One can note, for example, that as average daily temperature rises, so does the crime rate without knowing (or even caring) if the two events are causally related.

Correspondence theory of truth The belief that scientific laws and theories are correct insofar as they accurately mirror events in the physical world.

Determinism The belief that everything that occurs does so because of known or knowable causes and that if these causes were known in advance, an event could be predicted with complete accuracy. Also, if the causes of an event were known, the event could be prevented by preventing its causes. Thus, the knowledge of an event's causes allows the prediction and control of the event.

Double aspectism The belief that bodily and mental events are inseparable because they are two aspects of every experience.

Dualist Anyone who believes that there are two aspects to humans, one physical and one mental.

Eclectic approach Taking the best from a variety of viewpoints. The approach to the history of psychology taken in this text is eclectic because it combines coverage of great individuals, the development of ideas and concepts, the spirit of the times, and contributions from other disciplines.

Emergentism The contention that mental processes emerge from brain processes. The interactionist form of emergentism claims that once mental states emerge, they can influence subsequent brain activity and thus behavior. The epiphenomenalist form claims that emergent mental states are behaviorally irrelevant.

Empirical observation The direct observation of that which is being studied in order to understand it.

Empiricism The belief that the basis of all knowledge is experience.

Environmental determinism The type of determinism that stresses causes of behavior that are external to the organism.

Epiphenomenalism The form of emergentism that states that mental events emerge from brain activity but that mental events are subsequently behaviorally irrelevant.

Epistemology The study of the nature of knowledge. **Feyerabend, Paul (1924–1994)** Argued that science cannot be described by any standard set of rules, principles, or standards. In fact, he said, history shows that scientific progress occurs when individual scientists violate whatever rules, principles, or standards existed at the time.

Free will See Nondeterminism.

Great-person approach The approach to history that concentrates on the most prominent contributors to the topic or field under consideration.

Historical development approach The approach to history that concentrates on an element of a field or discipline and describes how the understanding or approach to studying that element has changed over time. An example is a description of how mental illness has been defined and studied throughout history.

Historicism The study of the past for its own sake, without attempting to interpret and evaluate it in terms of current knowledge and standards, as is the case with presentism. (*See also* **Presentism**.)

Historiography The study of the proper way to write history.

Idealists Those who believe that ultimate reality consists of ideas or perceptions and is therefore not physical.

Indeterminism The contention that even though determinism is true, attempting to measure the causes of something influences those causes, making it impossible to know them with certainty. This contention is also called Heisenberg's uncertainty principle.

Interactionism A proposed answer to the mind-body problem maintaining that bodily experiences influence the mind and that the mind influences the body.

Irrationalism Any explanation of human behavior stressing determinants that are not under rational control—for example, explanations that emphasize the importance of emotions or unconscious mechanisms.

Kuhn, Thomas (1922–1996) Believed that the activities of members of a scientific community are governed by a shared set of beliefs called a paradigm. This paradigmatic, or normal, science continues until an existing

paradigm is displaced by another paradigm. (See also Paradigm, Normal science, and Puzzle solving.)

Materialists Those who believe that everything in the universe is material (physical), including those things that others refer to as mental.

Mechanism The belief that the behavior of organisms, including humans, can be explained entirely in terms of mechanical laws.

Monists Those who believe that there is only one reality. Materialists are monists because they believe that only matter exists. Idealists are also monists because they believe that everything, including the "material" world, is the result of human consciousness and is therefore mental.

Naive realism The belief that what one experiences mentally is the same as what is present physically.

Nativist Anyone who believes that important human attributes such as intelligence are largely inherited.

Nondeterminism The belief that human thought or behavior is freely chosen by the individual and is therefore not caused by antecedent physical or mental events

Normal science According to Kuhn, the research activities performed by scientists as they explore the implications of a paradigm.

Occasionalism The belief that the relationship between the mind and body is mediated by God.

Paradigm A viewpoint shared by many scientists while exploring the subject matter of their science. A paradigm determines what constitutes legitimate problems and the methodology used in solving those problems.

Paradigmatic stage According to Kuhn, the stage in the development of a science during which scientific activity is guided by a paradigm. That is, it is during this stage that normal science occurs. (*See also* **Normal science**.)

Passive mind A mind that simply reflects cognitively one's experiences with the physical world. The empiricists assume a passive mind.

Physical determinism The type of determinism that stresses material causes of behavior.

Popper, Karl (1902–1994) Saw scientific method as having three components: problems, proposed solutions to the problems (theories), and criticisms of the proposed solutions. Because all scientific theories will eventually be found to be false, the highest status any scientific theory can attain is not yet disconfirmed. (*See also* **Principle of falsifiability** and **Risky predictions**.)

Postdiction An attempt to account for something after it has occurred. Postdiction is contrasted with prediction, which attempts to specify the conditions under which an event that has not yet occurred will occur.

Preestablished harmony The belief that bodily events and mental events are separate but correlated because both were designed to run identical courses.

Preparadigmatic stage According to Kuhn, the first stage in the development of a science. This stage is characterized by warring factions vying to define the subject matter and methodology of a discipline.

Presentism Interpreting and evaluating historical events in terms of contemporary knowledge and standards.

Principle of falsifiability Popper's contention that for a theory to be considered scientific it must specify the observations that, if made, would refute the theory. To be considered scientific, a theory must make risky predictions. (*See also* **Risky predictions**.)

Psychical determinism The type of determinism that stresses mental causes of behavior.

Psychophysical parallelism The contention that experiencing something in the physical world causes bodily and mental activity simultaneously and that the two types of activities are independent of each other.

Public observation The stipulation that scientific laws must be available for any interested person to observe. Science is interested in general, empirical relationships that are publicly verifiable.

Puzzle solving According to Kuhn, normal science is like puzzle solving in that the problems worked on are specified by a paradigm, the problems have guaranteed solutions, and certain rules must be followed in arriving at those solutions.

Rationalism The philosophical belief that knowledge can be attained only by engaging in some type of systematic mental activity.

Reification The belief that abstractions for which we have names have an existence independent of their names.

Relativism The belief that because all experience must be filtered though individual and group perspectives, the search for universal truths that exist independently of human experience must be in vain. For the relativist, there is no one truth, only truths.

Revolutionary stage According to Kuhn, the stage of scientific development during which an existing paradigm is displaced by a new one. Once the displacement is

complete, the new paradigm generates normal science and continues doing so until it too is eventually displaced by a new paradigm.

Risky predictions According to Popper, predictions derived from a scientific theory that run a real chance of showing the theory to be false. For example, if a meteorological theory predicts that it will rain at a specific place at a specific time, then it must do so or the theory will be shown to be incorrect.

Science Traditionally, the systematic attempt to rationally categorize or explain empirical observations. Popper described science as a way of rigorously testing proposed solutions to problems, and Kuhn emphasized the importance of paradigms that guide the research activities of scientists. Feyerabend believed it is impossible to give a generalized conception of science or scientific method.

Scientific law A consistently observed relationship between classes of empirical events.

Scientific theory Traditionally, a proposed explanation of a number of empirical observations; according to Popper, a proposed solution to a problem.

Sociocultural determinism The type of environmental determinism that stresses cultural or societal rules, customs, regulations, or expectations as the causes of behavior.

Uncertainty principle See Indeterminism.

Universalism The belief that there are universal truths about ourselves and about the physical world in general that can be discovered by anyone using the proper methods of inquiry.

Vitalism The belief that life cannot be explained in terms of inanimate processes. For the vitalist, life requires a force that is more than the material objects or inanimate processes in which it manifests itself. For there to be life, there must be a vital force present.

Zeitgeist The spirit of the times.

The Early Greek Philosophers

THE WORLD OF PRECIVILIZED HUMANS

Imagine living about 15,000 years ago. What would your life be like? It seems safe to say that in your lifetime you would experience most of the following: lightning, thunder, rainbows, the phases of the moon, death, birth, illness, dreams (including nightmares), meteors, eclipses of the sun or moon, and perhaps one or more earthquakes, tornadoes, floods, droughts, or volcanic eruptions. Because these events would touch your life directly, it seems natural that you would want to account for them in some way, but how? Many of these events—for example, lightning—cannot be explained by average citizens even today. But we have faith that scientists can explain such events, and we are comforted and less fearful. However, as an early human, you would have no such scientific knowledge available. As mentioned in the previous chapter, thoughtful humans have always made empirical observations and then attempted to explain those observations. Although observation and explanation became key components of science, the explanations early humans offered were anything but scientific.

Animism and Anthropomorphism

Humans' earliest attempts to explain natural events involved projecting human attributes onto nature. For example, the sky or earth could become angry or could be tranquil, just as a human could. Looking at all of nature as though it were alive is called **animism**, and the projection of human attributes onto nature is called **anthropomorphism**; both were involved in early attempts to make sense out of life (Cornford, 1957; Murray, 1955). Early humans made no distinctions between animate (living) and inanimate objects or between material and immaterial things.

Another approach used to explain the world assumed that a ghost or spirit dwelt in everything, including humans, and that these spirits were as real as anything else. The events in both nature and human conduct were explained as the whims of the spirits that resided in everything. The word spirit is derived from the Latin word for "breath." Breath (later spirit, soul, psyche, or ghost) is what gives things life, and when it leaves a thing, death results. This vital spirit can sometimes leave the body and return, as was assumed to be the case in dreaming. Also, because one can dream of or think of a person after his or her biological death, it was assumed that the person must still exist, for it was believed that something that could be thought of must exist (reification). With this logic, anything the mind could conjure up was assumed to be real; therefore, imagination and dreams provided an array of demons, spirits, monsters, and, later, gods, who lurked behind all natural events.

Magic

Because an array of spirits with human qualities was believed to exist, attempting to communicate with the spirits and otherwise influence them seemed a natural impulse. If, for example, a spirit was providing too much or too little rain, humans made attempts to persuade the spirit to modify its influence. Similarly, a sick person was thought to be possessed by an evil spirit, which had to be coaxed to leave the body or be driven out. Elaborate methods, called **magic**, evolved that were designed to influence the spirits. People believed that appropriate words, objects, ceremonies, or human actions could influence the spirits. As rudimentary as these beliefs were, they at least gave early humans the feeling that they had some control over their fate.

Humans have always needed to understand, predict, and control nature. Animism, anthropomorphism, magic, religion, philosophy, and science can all be seen as efforts to satisfy those needs. Waterfield (2000) elaborates this point:

All systems of belief evolve to elucidate the order of things and to make sense of the

world. In this sense, science is just as much a myth as anything else; it is a framework or model designed to explain and form reality for those people who accept it—that is, for those people who voluntarily become members of that society—and for only as long as there are enough people to accept it. If this is so, then so far from banishing gods, science has merely been the matrix for a new generation of scientific gods, children of the old gods. (p. xxxii)

EARLY GREEK RELIGION

In the fifth and sixth centuries B.C., the Greeks' explanations of things were still predominately religious in nature. There were two major theologies to choose from: the Olympian and the Dionysiac-Orphic. Olympian religion consisted of a belief in the Olympian gods as described in the Homeric poems. The gods depicted typically showed little concern with the anxieties of ordinary humans. Instead, they tended to be irascible, amoral, and little concerned with the immortality of humans. Within Olympian religion, it was believed that the "breath-soul" did survive death but did so without any of the memories or personality traits of the person whose body it had occupied. Such a belief concerning life after death encouraged living one's life in the fullest, most enjoyable way. Typically, the ideal life was seen as involving the pursuit of glory through the performance of noble deeds: "In the thought of glory most Greeks found a consolation for the shadowy doom which awaited them in the grave" (Bowra, 1957, p. 51). The Olympian gods also personified orderliness and rationality and valued intelligence. In short, the Olympian gods tended to have the same characteristics and beliefs as the members of the Greek upper class; it hardly seems surprising that the Greek nobility favored the Olympian religion.

The major alternative to Olympian religion was **Dionysiac-Orphic religion**. The wealthy Greek

upper class was made possible, to a large extent, by a large class of peasants, laborers, and slaves whose lives were characterized by economic and political uncertainty. To these relatively poor, uneducated individuals, the Dionysiac-Orphic religion was most appealing. This religion was based on the legend of Dionysus, the god of wine and frenzy, and his disciple Orpheus. Central to Dionysiac-Orphic religion was the belief in the transmigration of the soul. One version of this belief was that during its divine existence, at which time it dwelled among the gods, the soul had committed a sin; as punishment, the soul was locked into a physical body, which acted as its prison. Until the soul was redeemed, it continued a "circle of births," whereby it may find itself first inhabiting a plant, then an animal, then a human, then a plant again, and so on. What the soul longed for was its liberation from this transmigration and a return to its divine, pure, transcendent life among the gods. The rites that were practiced in hopes of freeing the soul from its prison (the body) included fasting, special diets, dramatic ceremonies, and various taboos.

Later in history, the Orphic idea that the soul seeks to escape its contaminated, earthly existence and enter into a more heavenly state following death gained enormous popularity and indeed became an integral part of our Judeo-Christian heritage.

In their efforts to make sense out of themselves and their world, the early Greeks had the Olympian and Dionysiac-Orphic religions from which to choose. Then, as now, which types of explanations individuals found congenial was as much a matter of temperament and circumstances as it was a matter of rational deliberation.

As we will see next, many of the first Greek philosophers leaned toward the relative rationality of Olympian religion. A few highly influential philosophers, however, embraced the mysticism of Dionysiac-Orphic religion; Pythagoras and Plato are two prominent examples.

THE FIRST PHILOSOPHERS

Magic, superstition, and mysticism, in one form or another, dominated attempts to understand nature

for most of early history. It was therefore a monumental step in human thought when natural explanations were offered instead of supernatural ones. Such explanations, although understandably simple, were first offered by the early Greeks. Philosophy (literally, the love of knowledge or wisdom) began when natural explanations (logos) replaced supernatural ones (mythos). Waterfield (2000) uses Kuhnian terminology to describe the importance of this development: "The presocratic revolution was a genuine revolution—a paradigm shift of the first importance" (p. xxiii). The first philosophers were called cosmologists because they sought to explain the origin, the structure, and the processes governing the cosmos (universe). However, the Greek word kosmos did not only refer to the totality of things but also suggested an elegant, ordered universe. The aesthetic aspect of the meaning of the term kosmos is reflected in the English word cosmetic. Thus, to the early Greek cosmologists, the universe was ordered and pleasant to contemplate. The assumption of orderliness was extremely important because an orderly universe is, at least in principle, an explicable universe.

Thales

As noted in Chapter 1, seldom, if ever, is an idea fully developed by a single individual. Thales (ca. 625-547 B.C.), often referred to as the first philosopher, had a rich intellectual heritage. He traveled to Egypt and Babylonia, both of which enjoyed advanced civilizations that no doubt influenced him. For example, the Egyptians had possessed for centuries the knowledge of geometry that Thales demonstrated. In Egypt and Babylonia, however, knowledge was either practical (geometry was used to lay out the fields for farming) or used primarily in a religious context (anatomy and physiology were used to prepare the dead for their journey into the next world). Thales was important because he emphasized natural explanations and minimized supernatural ones. That is, in his cosmology, Thales said that things in the universe consist of natural substances and are governed by natural principles; they do not reflect the whims of the gods.

The universe is therefore knowable and within the realm of human understanding.

Thales searched for that one substance or element from which everything else is derived. The Greeks called such a primary element or substance a **physis**, and those who sought it were **physicists**. Physicists to this day are searching for the "stuff" from which everything is made. Thales concluded that the physis was water because many things seem to be a form of water. Life depends on water, water exists in many forms (such as ice, steam, hail, snow, clouds, fog, and dew), and some water is found in everything. This conclusion that water is the primary substance had considerable merit.

The most important of Thales' views is his statement that the world is made of water. This is neither so far fetched as at first glance it might appear, nor yet a pure figment of imagination cut off from observation. Hydrogen, the stuff that generates water, has been held in our time to be the chemical element from which all other elements can be synthesized. The view that all matter is one is quite a reputable scientific hypothesis. As for observation, the proximity of the sea makes it more than plausible that one should notice that the sun evaporates water, that mists rise from the surface to form clouds, which dissolve again in the form of rain. The earth in this view is a form of concentrated water. The details might thus be fanciful enough, but it is still a handsome feat to have discovered that a substance remains the same in different states of aggregation. (Russell, 1959, pp. 16-17)

Besides this achievement, Thales also predicted eclipses, developed methods of navigation based on the stars and planets, and applied geometric principles to the measurement of such things as the heights of buildings. He is even said to have cornered the market on olive oil by predicting weather patterns. Such practical accomplishments brought great fame to Thales and respectability to philosophy. Thales

showed that a knowledge of nature, which minimized supernaturalism, could provide power over the environment, something humans had been seeking since the dawn of history.

Perhaps the most important thing about Thales, however, was the fact that he offered his ideas as speculations and welcomed criticism. With his invitation for others to criticize and improve on his teachings, Thales started the *critical tradition* that was to characterize early Greek philosophy: "I like to think that Thales was the first teacher who said to his students: 'This is how I see things—how I believe that things are. Try to improve upon my teaching'" (Popper, 1958, p. 29). We will have more to say about the importance of this critical tradition later in this chapter.

Anaximander

Anaximander (ca. 610-547 B.C.), who studied with Thales, argued that even water was a compound of more basic material. (Notice that Anaximander took the advice of his teacher and criticized him.) According to Anaximander, the physis was something that had the capability of becoming anything. This "something" he called the boundless or the indefinite. Anaximander also proposed a rudimentary theory of evolution. From a mixture of hot water and earth, there arose fish. Because human infants cannot survive without a long period of protection, the first human infants grew inside these fish until puberty, at which time the carrier fish burst and humans that were developed enough to survive on their own emerged. Anaximander urged us not to eat fish because they are, in a sense, our mothers and fathers. We can see how the physical environment can influence one's philosophizing. Both Thales and Anaximander lived near the shores of the Mediterranean Sea, and its influence on their philosophies is obvious.

Heraclitus

Impressed by the fact that everything in nature seemed to be in a constant state of flux, or change,

Heraclitus (ca. 540–480 B.C.) assumed fire to be the physis because in the presence of fire everything is transformed into something else. To Heraclitus, the overwhelming fact about the world was that nothing ever "is"; rather, everything is "becoming." Nothing is either hot or cold but is becoming hotter or colder; nothing is fast or slow but is becoming faster or slower. Heraclitus's position is summarized in his famous statement: "It is impossible to step twice into the same river" (Waterfield, 2000, p. 41). Heraclitus meant that the river becomes something other than what it was when it was first stepped into.

Heraclitus believed that all things existed somewhere between polar opposites—for example, night-day, life-death, winter-summer, up-down, heat-cold, sleeping-waking. For him, one end of the pole defined the other, and the two poles were inseparable. Only through injustice can justice be known, and only through health can illness be known.

Heraclitus raised an epistemological question that has persisted to this day: How can something be known if it is constantly changing? If something is different at two points in time and therefore not really the same object, how can it be known with certainty? Does not knowledge require permanence? It was at this point in history that the senses became a questionable means of acquiring knowledge because they could provide information only about a constantly changing world. In answer to the question, What can be known with certainty? empirical events could not be included because they were in a constant state of flux. Those seeking something unchangeable, and thus knowable, had two choices. They could choose something that was real but undetectable by the senses, as the atomists and the Pythagorean mathematicians did (discussed later), or they could choose something mental (ideas or the soul), as the Platonists and the Christians did. Both groups believed that anything experienced through the senses was too unreliable to be known. Even today, the goal of science is to discover general laws that are abstractions derived from sensory experience. Scientific laws as abstractions are thought to be flawless; when manifested in

the empirical world, however, they are only probabilistic.

Heraclitus's philosophy clearly described the major problem inherent in various brands of empiricism. That is, the physical world is in a constant state of flux, and even if our sense receptors could accurately detect physical objects and events, we would be aware only of objects and events that change from moment to moment. It is for this reason that empiricists are said to be concerned with the process of becoming rather than with being. Being implies permanence and thus at least the possibility of certain knowledge, whereas a knowledge of empirical events (because they are becoming) can be only probabilistic at best. Throughout psychology's history, those claiming that there are certain permanent and therefore knowable things about the universe or about humans have tended to be rationalists. Those saying that everything in the universe, including humans, is constantly changing and thus incapable of being known with certainty have tended to be empiricists.

Parmenides

Taking a view exactly the opposite of Heraclitus's, **Parmenides (born ca. 515 B.C.)** believed that all change was an illusion. There is only one reality; it is finite, uniform, motionless, and fixed and can be understood only through reason. Thus, for Parmenides, knowledge is attained only through rational thought because sensory experience provides only illusion. Parmenides supported his position with logic. Like the earliest humans, he believed that being able to speak or think of something implied its existence because we cannot think of something that does not exist (reification). The following is a summary of Parmenides' argument:

When you think, you think of something; when you use a name, it must be of something. Therefore both thought and language require objects outside themselves, and since you can think of a thing or speak of it at one time as well as another, whatever can be thought or spoken

of must exist at all times. Consequently there can be no change, since change consists in things coming into being and ceasing to be. (Russell, 1945, p. 49)

Zeno of Elea (ca. 495-430 B.C.), a disciple of Parmenides, used logical arguments to show that motion was an illusion. He said that for an object to go from point A to point B, it must first go half the distance between A and B. Then it must go half the remaining distance, then half of that distance, and so on. Because there is an infinite number of points between any two points, the process can never stop. Also, the object must pass through an infinite number of points in a finite amount of time, and this is impossible. Therefore, it is logically impossible for the object ever to reach point B. The fact that it seems to do so is a weakness of the senses. This reasoning, usually known as Zeno's paradox, is often expressed in the following form: If one runner in a race is allowed to leave slightly before a second runner, the second runner can never overtake the first runner, no matter how slow the first runner or how swift the second.

We have in Parmenides and Zeno examples of how far unabated reason can take a person. They concluded that either logic, mathematics, and reason were correct or the information provided by the senses was, and they opted for logic, mathematics, and reason. The same mistake has been made many times in history. Other misconceptions can result from relying exclusively on sensory data. It was not until science emerged in the 16th century that rationalism and empiricism were wed and sensory information provided that which was reasoned about. Science therefore minimized the extremes of both rationalism and empiricism.

Pythagoras

Largely through his influence on Plato, **Pythagoras** (ca. 580–500 B.C.) has had a significant influence on Western thought. It is said that Pythagoras was the first to employ the term *philoso-phy* and to refer to himself as a philosopher (Guthrie, 1987, p. 19). Pythagoras postulated that

the basic explanation for everything in the universe was found in numbers and in numerical relationships. He noted that the square of the hypotenuse of a right-angle triangle is exactly equal to the sum of the squares of its other two sides. Although this came to be called the Pythagorean theorem, it had probably been known to the Babylonians previously. Pythagoras also observed that a harmonious blending of tone results when one string on a lyre is exactly twice as long as another. This observation that strings of a lyre must bear certain relationships with one another to produce pleasant, harmonious sounds was, perhaps, psychology's first psychophysical law. Indeed, physical events (relationships between strings on musical instruments) were demonstrated to be systematically related to psychological events (perceived pleasantness of sounds). In fact, the Pythagoreans expressed this psychophysical relationship in mathematical terms.

Just as pleasant music results from the harmonious blending of certain tones, so too does health depend on the harmonious blending of bodily elements. The Pythagoreans thought illness resulted from a disruption of the body's equilibrium, and medical treatment consisted of attempts to restore that equilibrium. (We will see later that the Pythagorean approach to medicine was to be extremely influential.) Pythagoras took these and several other observations and created a school of thought that glorified mathematics. He and his followers applied mathematical principles to almost every aspect of human existence, creating "a great muddle of religious mysticism, music, mathematics, medicine, and cosmology" (Esper, 1964, p. 52).

According to the Pythagoreans, numbers and numerical relationships, although abstract, were nonetheless real and exerted an influence on the empirical world. The world of numbers existed independently of the empirical world and could be known in its pure form only through reason. When conceptualized, the Pythagorean theorem is exactly correct and applies to all right-angle triangles that ever were or ever will be. As long as the theorem is applied rationally to imagined triangles, it is flawless; when applied to actual triangles,

however, the results are not absolutely correct because there are no perfect triangles in the empirical world. In fact, according to the Pythagoreans, *nothing* is perfect in the empirical world. Perfection is found only in the abstract mathematical world that lies beyond the senses and therefore can be embraced only by reason.

The Pythagoreans assumed a dualistic universe: one part abstract, permanent, and intellectually knowable (like that proposed by Parmenides) and the other empirical, changing, and known through the senses (like that proposed by Heraclitus). Sensory experience, then, cannot provide knowledge. In fact, such experience interferes with the attainment of knowledge and should be avoided. This viewpoint grew into outright contempt for sensory experiences and for bodily pleasures, and the Pythagoreans launched a crusade against vice, lawlessness, and bodily excess of any type. Members of this school imposed on themselves long periods of silence to enhance clear, rational thought. Moreover, they attempted to cleanse their minds by imposing certain taboos and by hard physical and mental exercise. The taboos included eating flesh and eating beans. Among other things, beans cause excessive flatulence, a condition contrary to the tranquility of mind necessary for seeking the truth. In a sense, the Pythagoreans introduced an early version of the belief "You are what you eat"; they believed that "each kind of food that is introduced into the human body becomes the cause of a certain peculiar disposition" (Guthrie, 1987, p. 107).

The Pythagoreans believed that the universe was characterized by a mathematical harmony and that everything in nature was interrelated. Following this viewpoint, they encouraged women to join their organization (it was *very* unusual for Greeks to look upon women as equal to men in any area), argued for the humane treatment of slaves, and, as mentioned, developed medical practices based on the assumption that health resulted from the harmonious workings of the body and illness resulted from some type of imbalance or discord.

The belief that experiences of the flesh are inferior to those of the mind—a belief that plays such an important role in Plato's theory and is even more

important in early Christian theology—can be traced directly to the Pythagoreans. Eventually, Plato became a member of their organization. He based his Academy on Pythagorean concepts, and a sign above the entrance read, "Let no one without an understanding of mathematics enter here."

Pythagoras postulated two worlds, one physical and one abstract, the two interacting with each other. Of the two, the abstract was considered the better. Pythagoras also postulated a dualism in humans, claiming that, in addition to the flesh of the body, we have reasoning powers that allow us to attain an understanding of the abstract world. Furthermore, reasoning is a function of the soul, which the Pythagoreans believed to be immortal. Pythagoras' philosophy provides one of the first clear-cut mind-body dualisms in the history of Western thought.

We see many elements in common between Dionysiac-Orphic religion and Pythagorean philosophy. Both viewed the body as a prison from which the soul should escape; or, at the very least, the soul should minimize the lusts of the vile body that houses it by engaging in the rational contemplation of unchanging truths. Both accepted the notion of the transmigration of souls, and both believed that only purification could stop the "circle of births." The notion of transmigration fostered in the Pythagoreans a spirit of kinship with all living things. It is for this reason that they accepted women into their organizations, argued for the humane treatment of slaves, and were opposed to the maltreatment of animals. It is said of Pythagoras that "when he passed a puppy that was being whipped ... he took pity on it and made this remark: 'Stop, do not beat it; for it is the soul of a dear friend"" (Barnes, 2001, p. 29). It was for the same reason that the Pythagoreans were vegetarians. The origin of other Pythagorean taboos is more difficult to determine—for example, "Do not urinate towards the sun" (Guthrie, 1987, p. 146).

We will see later in this chapter that Plato borrowed much from the Pythagoreans. It was through Platonic philosophy that elements of the Dionysiac-Orphic religion became part of the heritage of Western civilization.

Empedocles

Empedocles (ca. 490–430 B.C.) was a physician and a disciple of Pythagoras. He claimed his soul had been migrating for quite a while: "For already have I become a boy and a girl and a bush and a bird and a silent fish in the sea" (Barnes, 2001, p. 157). Instead of one physis, Empedocles suggested four elements from which everything in the world is made: earth, fire, air, and water. Humans, too, he thought, consist of these four elements, with earth forming the solid part of the body, water accounting for the liquids in the body, air providing the breath of life, and fire providing our reasoning ability.

Besides the four elements, Empedocles postulated two causal powers of the universe: love and strife. Love is a force that attracts and mixes the elements, and strife is a force that separates the elements. Operating together, these two forces create an unending cosmic cycle consisting of four recurring phases. In phase one, love dominates and there is a perfect mixture of the four elements ("one from many"). In phase two, strife disrupts the perfect mixture by progressively separating them. In phase three, strife has managed to completely separate the elements ("many from one"). In phase four, love again becomes increasingly dominant, and the elements are gradually recombined. As this cvcle recurs, new worlds come into existence and then are destroyed. A world consisting of things we would recognize could exist only during the second and fourth phases of the cycle, when a mixture of the elements can exist. Along with the four elements, humans also possess the forces of love and strife, and these forces wax and wane within us just as they do in other material bodies. When love dominates, we have an urge to establish a union with the world and with other people; when strife dominates, we seek separation. Clearly, the ingredients are here for the types of intrapersonal and extrapersonal conflicts described by Freud and others much later in human history.

For Empedocles, the four elements and the forces of love and strife have always existed. In fact, all that can ever be must be a mixture of the elements and the two forces. Nothing beyond these

mixtures is possible. He said, "From what does not exist nothing can come into being, and for what exists to be destroyed is impossible and unaccomplishable" (Barnes, 2001, p. 131). This is similar to the modern law of conservation of energy, which states that energy can take different forms but cannot be created or destroyed.

Empedocles also offered a theory of evolution that was more complex than the one previously suggested by Anaximander. In the phase when there is a mixture of love and strife, all types of things are created, some of them very bizarre. Animals did not form all at once but part by part, and the same was true of humans: "Many neckless heads sprang up.... Naked arms wandered, devoid of shoulders, and eyes strayed alone, begging for foreheads" (Barnes, 2001, p. 142). As these various body parts roamed around, they were combined in a random fashion: "Many grew double-headed, double-chested-man-faced oxen arose, and again ox-headed men—creatures mixed partly from male partly from female nature" (Barnes, 2001, p. 143). Elsewhere, Empedocles described what happens when the four elements are acted on by love and strife: "As they mingled, innumerable types of mortal things poured forth, fitted with every sort of shape, a wonder to see" (Barnes, 2001, p. 128). Most random pairings resulted in creatures incapable of surviving, and they eventually perished. Some chance unions produced viable creatures, however, and they survived—humans among them. What we have here is an early version of natural selection by the survival of the fittest (Esper, 1964, p. 97).

Empedocles was also the first philosopher to offer a theory of perception. He assumed that each of the four elements was found in the blood. Objects in the outside environment throw off tiny copies of themselves called emanations, or **eidola** (singular *eidolon*), which enter the blood through the pores of the body. Because like attracts like, the eidola will combine with elements that are like them. The fusion of external elements with internal elements results in perception. Empedocles believed that the matching of eidola

with their corresponding internal elements occurred in the heart.

Because Empedocles was the first to attempt to describe how we form images of the world through a process similar to sensory perception, he is sometimes referred to as the first empirical philosopher. His view was that we perceive objects by internalizing copies of them.

To the Pythagorean notion that health reflected a bodily equilibrium, Empedocles added the four elements. Health occurs when the four elements of the body are in proper balance; illness results when they are not. Shortly we will see that the medical theories of Pythagoras and Empedocles were to be highly influential on later thinkers.

Anaxagoras

Anaxagoras (ca. 500-428 B.C.), a close friend and mentor of Pericles, taught that all things in the world as we know it were originally mixed together. Furthermore, everything in our world. including humans, continues to be aggregates of that primordial mixture. Like Empedocles, Anaxagoras believed nothing can come from nothing. However, whereas Empedocles postulated four elements from which everything is derived, Anaxagoras postulated an infinite number of elements that he referred to as "seeds." As examples of these elements or seeds Anaxagoras listed water, fire, hair, bread, meat, air, wet, dry, hot, cold, thin, thick, wood, metal, and stone. However, these elements or seeds do not exist in isolation. Every element contains all the other elements. How then do objects become differentiated? Waterfield (2000) explains: "Everything is present in every seed and in every item of the universe, but in different proportions" (p. 118). It is the difference in the proportion of the seeds present that give objects their characteristics: "Things appear to be that of which they contain the most. Thus, for example, everything contains fire, but we only call it fire if that element predominates" (Russell, 1945, p. 62).

There was a single exception to Anaxagoras's claim that everything contains everything. Mind, he said, is pure in the sense that it contains no other

elements. Also, mind is not necessarily present in other elements. Where it is present, life exists. For example, mind is present in humans and other living things but not in such things as stones or rivers. Anaxagoras was, therefore, a vitalist.

There was no providence in Anaxagoras's philosophy, and he said little about ethics and religion. He was accused of atheism by his contemporaries and, according to Russell (1945, p. 63), this accusation was probably true.

Democritus

Democritus (ca. 460-370 B.C.) was the last of the early Greek cosmologists; later philosophers were more concerned with human nature than with the nature of the physical universe. Democritus said that all things are made of tiny, indivisible parts called atoms (from the Greek atomos, meaning "indivisible"). The differences among things are explained by the shape, size, number, location, and arrangement of atoms. Atoms themselves were believed to be unalterable, but they could have different arrangements; so although the actual atoms do not change, the objects that are made of them can change. Humans, too, are bundles of atoms, and the soul or mind is made up of smooth, highly mobile fire atoms that provide our mental experiences. For Democritus, therefore, animate, inanimate, and cognitive events were reduced to atoms and atomic activity. Because the behavior of atoms was thought to be lawful, Democritus's view was deterministic. It also exemplified physical monism (materialism) because everything was explained in terms of the arrangement of atoms and there was no separate life force; that is, he denied vitalism. Democritus's view also incorporated elementism because no matter how complex something was, Democritus believed it could be explained in terms of atoms and their activity. Finally, Democritus's philosophy exemplified reductionism because he attempted to explain objects and events on one level (observable phenomena) in terms of events on another level (atoms and their activity). Reductionism is contrasted with elementism in that the former involves two different

domains of explanation, whereas the latter attempts to understand a complex phenomenon by separating it into its simpler component parts. Attempting to explain human behavior in terms of biochemical processes would exemplify reductionism, as would attempting to explain biochemical processes in terms of physics. Attempting to understand human thought processes by isolating and studying one process at a time or attempting to understand complex human behavior by isolating specific habits or stimulus-response associations would exemplify elementism. Democritus was both a reductionist and an elementist.

The explanations of sensation and perception offered by Empedocles and Democritus both emphasized the importance of eidola (emanations). However, for Democritus, sensations and perceptions arise when atoms (not tiny replicas) emanate from the surfaces of objects and enter the body through one of the five sensory systems (not bodily pores) and are transmitted to the brain (not the heart).

Upon entering the brain, the emanations sent by an object cause the highly mobile fire atoms to form a copy of them. This match between eidola and atoms in the brain causes perception. Democritus stressed that eidola are not the object itself and that the match between the eidola and the atoms in the brain may not be exact. Therefore, there may be differences between the physical object and the perception of it. As noted in Chapter 1, one of the most persistent problems in psychology has been determining what is gained or lost as objects in the environment are experienced through the senses. Democritus was well aware of this problem (Waterfield, 2000, pp. 176–177).

Democritus placed thinking in the brain, emotion in the heart, and appetite in the liver. He discussed five senses—vision, hearing, smell, touch, and taste—and suggested four primary colors—black, red, white, and green—from which all colors were derived. Because he believed that all bodily atoms scattered at death, he also believed that there was no life after death. His was the first completely naturalistic view of the universe, devoid of any supernatural considerations. Although his view contained no gods or spirits to guide human action,

Democritus did not condone a life of hedonism (pleasure seeking). He preached moderation, as did his disciple Epicurus 100 years later.

EARLY GREEK MEDICINE

In The Odyssey, Homer described medical practitioners as roaming around selling their services to anyone needing them. The successful practitioners gained a reputation that preceded them; a few became viewed as godlike, and after their deaths, temples were erected in their honor. Other temples were named in honor of Asclepius, the Greek god of medicine. Asclepius was believed to be the son of Apollo and the father of Hygeia, the goddess of health. An ancient statue of Asclepius shows him with a snake wrapped around a rod. The snake symbolized mystery, power, and knowledge and was employed in several healing rituals. The rod and snake continue to symbolize the medical profession. At these temples, priests practiced medicine in accordance with the teachings of the famous deceased practitioners. The priests kept such teachings secret and carefully guarded. This temple medicine became very popular, and many wonderful cures were claimed. In fact, insofar as the ailments treated were psychosomatic, it is entirely possible that temple medicine was often effective because such medicine was typically accompanied by an abundance of ritual and ceremony. For example, patients would need to wait before being seen by a priest, drink "sacred" water, wear special robes, and sleep in a sanctuary. During the period of sleep—a high point in treatment—the patient (it was claimed) often had a dream in which a priest or god would directly cure the patient or tell him or her what to do in order to be cured. Thus, any healing that took place was essentially faith healing, and medical practices were magical.

Alcmaeon

Among the first to move away from temple medicine and toward more rational, naturalistic medicine was

Alcmaeon (fl. ca. 500 B.C.). Alcmaeon (perhaps a Pythagorean) equated health with a balance of such qualities as warm and cold, moist and dry, and bitter and sweet. If one or more qualities dominates a person's system, sickness results. According to Alcmaeon, the physician's job is to help the patient regain a lost equilibrium, thereby regaining health. For example, a fever represented excess heat, and the treatment involved cooling the patient; excessive dryness was treated with moisture; and so forth. Diagnosis involved discovering the source of the disturbance of equilibrium, and treatment involved a procedure that would restore equilibrium. This Pythagorean view of health as a balance, or a harmony, was to have a profound influence on medicine and has persisted to the present time.

In addition to promoting naturalistic medicine, Alcmaeon was important for other reasons. He was among the first (if not the first) to dissect human bodies. One of the important things he learned from these dissections was that the brain was connected to the sense organs. For example, he dissected the eye and traced the optic nerve to the brain. Unlike later thinkers such as Empedocles and Aristotle, who placed mental functions in the heart, Alcmaeon concluded that sensation, perception, memory, thinking, and understanding occurred in the brain. Alcmaeon's feats were truly remarkable, considering when they occurred. He did much to rid medicine of superstition and magic, and he used physiological information to reach conclusions concerning psychological functioning. As a physician interested in psychological issues, Alcmaeon started an illustrious tradition later followed by such individuals as Helmholtz, Wundt, James, and Freud.

Hippocrates

Hippocrates (ca. 460–377 B.C.) was born on the Greek island of Cos into a family of priests and physicians. He was educated at a famous school in Cos and received medical training from his father and other medical practitioners. By the time Hippocrates moved to Athens, he had acquired remarkable proficiency in the diagnosis, prognosis,

and treatment of disease. He kept detailed records that gave precise accounts of mumps, epilepsy, hysteria, arthritis, and tuberculosis, to name only a few. From his training and observations, Hippocrates concluded that all disorders (both mental and physical) were caused by natural factors such as inherited susceptibility to disease, organic injury, and an imbalance of bodily fluids. Hippocrates is often referred to as the father of medicine, but this is only correct if we view him as "a culmination rather than a beginning" (Brett, 1912-1921/1965, p. 54). Several important physicians before Hippocrates (such as Alcmaeon and Empedocles) had challenged medical practices based on superstition and magic. However, Hippocrates' great accomplishment was that he took the development of naturalistic medicine to new heights.

As with Pythagoreans, it is difficult to separate what Hippocrates actually said from what his followers said. However, there is a corpus of ancient material consistent enough to be referred to as Hippocratic writings (see, for example, Lloyd, 1978). Therefore, we will hereafter refer to the Hippocratics rather than to Hippocrates.

The Hippocratics forcefully attacked the vestiges of supernatural medicine that still existed in their day. For example, epilepsy was called the sacred disease, suggesting possession by an evil spirit. The Hippocratics disagreed, saying that all illnesses had natural and not supernatural causes. Supernatural causes, they said, were postulated in order to mask ignorance.

I do not believe that the "Sacred Disease" is any more divine or sacred than any other disease but, on the contrary, has specific characteristics and a definite cause. Nevertheless, because it is completely different from other diseases, it has been regarded as a divine visitation by those who, being only human, view it with ignorance and astonishment.... It is my opinion that those who first called this disease "sacred" were the sort of people we now call witch-doctors, faith-healers, quacks and charlatans. These are exactly the people who

pretend to be very pious and to be particularly wise. By invoking a divine element they were able to screen their own failure to give suitable treatment and so called this a "sacred" malady to conceal their ignorance of its nature. (Lloyd, 1978, pp. 237–238)

The Hippocratics agreed with Empedocles that everything is made from four elements—earth, air, fire, and water—and that humans, too, are made up of these elements. However, the Hippocratics also associated the four elements with four humors in the body. They associated earth with black bile, air with yellow bile, fire with blood, and water with phlegm. Individuals for whom the humors are properly balanced are healthy; an imbalance among the humors results in illness.

The Hippocratics strongly believed that the body has the ability to heal itself and that it is the physician's job to facilitate this natural healing. Thus, the "cures" the Hippocratics recommended included rest, proper diet, exercise, fresh air, massage, and baths. According to the Hippocratics, the worst thing a physician could do would be to interfere with the body's natural healing power. They also emphasized treating the total, unique patient and not a disease. The Hippocratic approach to treatment emphasized an understanding physician and a trusting, hopeful patient. The Hippocratics also advised physicians not to charge a fee if a patient was in financial difficulty.

Sometimes give your services for nothing, calling to mind a previous benefaction or present satisfaction. And if there be an opportunity of serving one who is a stranger in financial straits, give full assistance to all such. For where there is love of man, there is also love of the art. For some patients, though conscious that their condition is perilous, recover their health simply through their contentment with the goodness of the physician. (W. H. S. Jones, 1923, Vol. 1, p. 319)

Other maxims concerning the practice of medicine are contained in the famous Hippocratic oath which reads, in part, as follows:

I will use my power to help the sick to the best of my ability and judgment; I will abstain from harming or wronging any man by it.

I will not give a fatal draught to anyone if I am asked, nor will I suggest any such thing. Neither will I give a woman means to procure an abortion.

I will be chaste and religious in my life and in my practice....

Whenever I go into a house, I will go to help the sick and never with the intention of doing harm or injury. I will not abuse my position to indulge in sexual contacts with the bodies of women or of men, whether they be freemen or slaves.

Whatever I see or hear, professionally or privately, which ought not to be divulged, I will keep secret and tell no one. (Lloyd, 1978, p. 67)

But is the Hippocratic oath really Hippocratic? After careful examination of the oath, Ludwig Edelstein (Temkin and Temkin, 1987) argued that it was written in the fourth century B.C. and reflects the strong influence of Pythagorean philosophy. For example, he noted that of the prevailing philosophies at the time, only the Pythagoreans had prohibitions against abortion and physician-assisted suicide, believing both to be an affront to the gods. For this and other reasons, Edelstein's conclusion was unequivocal:

I can say without hesitation that the socalled Oath of Hippocrates is a document uniformly conceived and thoroughly saturated with Pythagorean philosophy. In spirit and letter, in form and content, it is a Pythagorean manifesto. The main features of the Oath are only understandable in connection with Pythagoreanism; all its details are in complete agreement with this system of thought. (Temkin and Temkin, p. 53)

However, questioning the origin of the "Hippocratic oath" does nothing to diminish the importance of the Hippocratics to the history of medicine. Most agree with V. Robinson that the work of the Hippocratics "marks the greatest revolution in the history of medicine" (1943, p. 51). We will have more to say about the Hippocratics when we review the early treatment of the mentally ill in Chapter 15.

About 500 years after Hippocrates, **Galen (ca. A.D. 130–200)** associated the four humors of the body with four temperaments (the term *temperament* is derived from the Latin verb *temperare* meaning "to mix"). If one of the humors dominates, the person displays the characteristics associated with that humor (see Table 2.1). Galen's extension of Hippocrates' views created a rudimentary theory of personality, as well as a way of diagnosing illness that was to dominate medicine for about the next 14 centuries. In fact, within the realm of personality theory, Galen's ideas continue to be influential (see, for example, Eysenck and Eysenck, 1985; Kagan, 1994).

TABLE 2.1 Galen's Extension of Hippocrates' Theory of Humors

Humor	Temperament	Characteristic
Phlegm	Phlegmatic	Sluggish, unemotional
Blood	Sanguine	Cheerful
Yellow bile	Choleric	Quick-tempered, fiery
Black bile	Melancholic	Sad

THE RELATIVITY OF TRUTH

The step from supernatural explanations of things to natural ones was enormous, but perhaps too many philosophers took it. Various philosophers found the basic element (physis) to be water, fire, numbers, the atom, and the boundless, and some philosophers found more than one basic element.

Some said that things are constantly changing, others that nothing changes, and still others that some things change and some do not. Furthermore, most of these philosophers and their disciples were outstanding orators who presented and defended their views forcefully and with convincing logic. Where does this leave the individual seeking the truth? Such an individual is much like the modern college student who goes to one class and is convinced of something (such as that psychology is a science), only to go to another class to be convinced of the opposite (psychology is not a science). Which is true?

In response to the confusion, one group of philosophers concluded that there is not just one truth but many. In fact, they believed that anything is true if you can convince someone that it is true. Nothing, they said, is inherently right or wrong, but believing makes it so. These philosophers were called Sophists. The Sophists were professional teachers of rhetoric and logic who believed that effective communication determined whether an idea was accepted rather than the idea's validity. Truth was considered relative, and therefore no single truth was thought to exist. This belief marked a major shift in philosophy. The question was no longer, What is the universe made of? but, What can humans know and how can they know it? In other words, there was a shift toward epistemological questions.

Protagoras

Protagoras (ca. 485–410 B.C.), the first and best-known Sophist, summarized the Sophists' position with his famous statement: "Man is the measure of all things—of the things that are, that they are, and of things that are not, that they are not" (Waterfield, 2000, p. 211). This statement is pregnant with meaning. First, truth depends on the perceiver rather than on physical reality. Second, because perceptions vary with the previous experiences of the perceiver, they will vary from person to person. Third, what is considered to be true will be, in part, culturally determined because one's culture influences one's experiences. Fourth,

to understand why a person believes as he or she does, one must understand the person. According to Protagoras, therefore, each of the preceding philosophers was presenting his subjective viewpoint rather than the objective "truth" about physical reality. Paraphrasing Heraclitus's famous statement, Protagoras said, "Man never steps into the same river once," because the river is different for each individual to begin with. Protagoras emphasized the importance of rhetorical skills in getting one's point of view considered and, perhaps, to prevail. For a fee, which was typical of the Sophists, he taught his students to take both sides of an argument and created debating competitions where he introduced the disputants to the tricks of the trade. Critics accused Protagoras of teaching how to "make the weaker argument stronger" or "to make the worse or morally more unsound argument defeat the more sound one" (Waterfield, 2000, pp. 205-206). However, Protagoras was primarily interested in teaching the skills necessary for effective communication, and under the Periclean democracy in which he lived, the value of such skills was considerable.

In the direct democracy that prevailed in Athens at the time, speeches could make or break a political career, and the constitution almost guaranteed that every prominent figure was likely to find himself in court at some time or other, where again a good speech could save his life, or at least prevent the loss of property and prestige. (Waterfield, 2000, p. 207)

Although Protagoras taught that nothing is false, he believed that some beliefs are more valuable than others. For example, in the political sphere, some beliefs are more conducive to utilitarian harmony than others and, he believed, effective argumentation would demonstrate this (Waterfield, 2000, p. 209).

Concerning the existence of the Greek gods, Protagoras was an agnostic. He said, "Where the gods are concerned, I am not in a position to ascertain that they exist, or that they do not exist. There are many impediments to such knowledge, including the obscurity of the matter and the shortness of human life" (Waterfield, 2000, p. 211).

With Protagoras, the focus of philosophical inquiry shifted from the physical world to human concerns. We now had a theory of *becoming* that was different from the one offered by Heraclitus. *Man* is the measure of all things, and therefore there is no universal truth or code of ethics or anything else. In Chapter 21, we will see that the extreme relativism of the Sophists has much in common with the contemporary movement called postmodernism.

Gorgias

Gorgias (ca. 485–380 B.C.) was a Sophist whose position was even more extreme than Protagoras's. Protagoras concluded that, because each person's experience furnishes him or her with what seems to be true, "all things are equally true." Gorgias, however, regarded the fact that knowledge is subjective and relative as proof that "all things are equally false." Furthermore, because the individual can know only his or her private perceptions, there can be no objective basis for determining truth. Gorgias's position, as well as Protagoras's, exemplified nihilism because it stated that there can be no objective way of determining knowledge or truth. The Sophist position also exemplifies solipsism because the self can be aware of nothing except its own experiences and mental states. Thus, Gorgias reached his three celebrated conclusions: Nothing exists; if it did exist, it could not be comprehended; and if it could be comprehended, it could not be communicated to another person.

Insofar as Gorgias was referring to the physical world when he said, "Nothing exists," he was inconsistent, sometimes saying that it does (Waterfield, 2000, p. 223). However, on the last two points of his argument, he was entirely consistent. First, he argues that if there is a physical world, we can experience it only through sense impressions, and the relationship between the physical world and sense impressions cannot be known. Second, we do not think in terms of sense impres-

sions but in terms of the words used to describe those impressions. Therefore, there is an unbridge-able gap between the sensory events caused by the physical world and the words used to describe those events. And third, because the meaning of the words that are used to express thoughts are unique to each individual, there is an unbridgeable gap between one person's thoughts and those of another. Therefore, accurate communication among individuals is impossible.

Gorgias, like the other Sophists, emphasized the power of the spoken word. He likened the effect of words on the mind to the effect of drugs on the body (Waterfield, 2000, p. 223). However, he believed that words were essentially deceitful. That is, words do not describe things as they are in the physical world but only beliefs about such things. Beliefs consist of words and therefore can be manipulated by words—thus the importance of rhetorical techniques.

The Sophists clearly and convincingly described the gulf that exists between the physical world and the perceiving person. They also called attention to the difficulties in determining the relationships among terms, concepts, and physical things. In fact, as we have seen, the Sophists were well aware of the difficulty in demonstrating the external (physical) existence of anything. We saw in Chapter 1 that humans have always had a strong tendency toward reification—that is, to believe that because something has a name it exists. Concerning this belief, Gorgias said,

If things considered [thought about] are existent, all things considered exist, and in whatever way anyone considers them, which is absurd. For if one considers a flying man or chariot racing in the sea, a man does not straightway [sic] fly nor a chariot race in the sea. (Kennedy, 1972, p. 45)

The Sophists also raised the thorny question of what one human consciousness can know about another human consciousness. No satisfactory answer has ever been provided.

Xenophanes

Even before the Sophists, **Xenophanes** (ca. 560–478 B.C.) had attacked religion as a human invention. He noted that the Olympian gods acted suspiciously like humans. They lie, steal, philander, and even murder: "Homer ... attributed to the gods all the things which among men are shameful and blameworthy—theft and adultery and mutual deception" (Barnes, 2001, p. 42). Xenophanes also noted that dark-skinned people had light-skinned gods and light-skinned people had light-skinned gods. He went so far as to say that if animals could describe their gods, they would have the characteristics of the animals describing them:

Mortals think that the gods are born, and have clothes and speech and shape like their own ... But if cows and horses or lions had hands and drew with their hands and made the things men make, then horses would draw the forms of gods like horses, cows like cows, and each would make their bodies similar in shape to their own. (Barnes, 2001, p. 43)

With regard to religion, Xenophanes can be seen as an early Sophist. Not only do humans create whatever "truth" exists, but they also create whatever religion exists. Moral codes, then, are not divinely inspired; they are human inventions.

However, it would be incorrect to conclude that Xenophanes was an atheist. What made him most controversial was that he postulated a supreme god with characteristics unlike those of any of the gods that were so popular at the time. Waterfield (2000, pp. 26–27) summarizes those characteristics:

One god, greatest among gods and men, In no way similar to mortal men in body or in thought.

Complete he sees, complete he thinks, complete he hears.

He remains for ever in the same place, entirely motionless,

Nor is it proper for him to move from one place to another.

But effortlessly he shakes all things by thinking with his own mind.

Interestingly, Xenophanes was skeptical even of his own teachings:

And the clear truth no man has seen nor will anyone know concerning the gods and about all the things of which I speak; For even if he should actually manage to say what is the case, nevertheless he himself does not know it; but belief is found over all. (Barnes, 2001, p. 41)

Let these things be believed as approximations to the truth. (Waterfield, 2000, p. 30)

The relativist nature of truth on which the Sophists insisted was distasteful to many who wanted truth to be more than the projection of one's subjective reality onto the world. As we will see, this debate became a constant theme in the history of philosophy and continues to be.

Socrates was the first to provide a serious challenge to the relativism of the Sophists, with whom he both agreed and disagreed.

Socrates

Socrates (ca. 470-399 B.C.) agreed with the Sophists that individual experience is important. He took the injunction "Know thyself," inscribed on the portals of the temple of Apollo at Delphi, to indicate the importance of knowing the contents of one's own mind or soul (Allen, 1991, p. 17). He went so far as to say, "The life which is unexamined is not worth living" (Jowett, 1988, p. 49). However, he disagreed with the Sophists' contention that no truth exists beyond personal opinion. In his search for truth. Socrates used a method sometimes called inductive definition, which started with an examination of instances of such concepts as beauty, love, justice, or truth and then moved on to such questions as, What is it that all instances of beauty have in common? In other words, Socrates asked what it is that makes something beautiful, just, or true. In this way, he sought to discover general concepts by examining

isolated examples. It was thought that these concepts transcend their individual manifestations and are therefore stable and knowable. What Socrates sought was the essence of such things as beauty, justice, and truth. The essence of something is its basic nature, its identifying, enduring characteristics. To truly know something, according to Socrates, is to understand its essence. It is not enough to identify something as beautiful; one must know why it is beautiful. One must know what all instances of beauty have in common; one must know the essence of beauty. It is important to note that although Socrates sought the essence of various concepts, he did not believe that essences had abstract existence. For him, an essence was a universally acceptable definition of a concept a definition that was both accurate and acceptable to all interested parties. Once such definitions were formulated, accurate communication among concerned individuals was possible. Contrary to the Sophists, who believed truth to be personal and noncommunicable, Socrates believed truth could be general and shared. Still, the essences that Socrates sought were verbal definitions, nothing more.

For Socrates, the understanding of essences constituted knowledge, and the goal of life was to gain knowledge. When one's conduct is guided by knowledge, it is necessarily moral. For example, if one knows what justice is, one acts justly. For Socrates, knowledge and morality were intimately related; knowledge is virtue, and improper conduct results from ignorance. Unlike most of the earlier philosophers, Socrates was concerned mainly with what it means to be human and the problems related to human existence. It is because of these concerns that Socrates is sometimes referred to as the first existential philosopher.

In 399 B.C., when Socrates was 70 years old, he was accused of disrespect for the city gods and of corrupting the youth of Athens. Socrates was charged with corrupting the youth of Athens because he caused them to question all things, including many cherished traditional beliefs. Perhaps on the latter charge he was guilty. In any case, Socrates was found guilty on both charges and sentenced to death. However, the end of his trial coincided with a religious observance during which executions

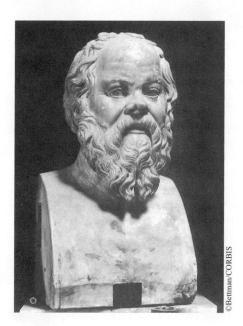

Socrates

were unlawful. During the month-long delay, Socrates was imprisoned but met regularly with his friends. Apparently, it would have been easy for Socrates to escape from Athens at this time, and he was encouraged by his friends to do so. It is even suggested that Socrates' escape would have been condoned by the authorities, "to whom the execution of such a prominent figure may well have been an embarrassment" (Taylor, 1998, p. 11). Socrates preferred death over exile from his beloved Athens and, in the end, he consumed a drink containing deadly hemlock, thus fulfilling the order of the court.

What Were the Real Reasons for Socrates' Conviction? In the *Apology* (Jowett, 1988), Plato has Socrates, while awaiting his self-administered execution, recall a story explaining how he (Socrates) came to be considered the wisest of men. According to the story, a friend of Socrates went to the oracle of Delphi and asked if there was any man wiser than Socrates and the oracle said no. Socrates was amazed to hear this because he considered himself ignorant. He set out to find men wiser

than himself so that he could refute the oracle. In his quest, Socrates questioned anyone who had the reputation of being wise. After many such encounters, Socrates concluded that these individuals really knew nothing, although they thought they did. Socrates, on the other hand, neither knew anything nor thought he did. Perhaps, Socrates reflected, it was for this reason that the oracle proclaimed him to be the wisest of men.

So why was Socrates convicted? After the defeat of Athens by Sparta, democracy in Athens was replaced by the regime of the Thirty Tyrants, some of whom were associated with Socrates. When democracy was restored in 403 B.C., Socrates may have been seen, because of his association with the tyrants, as a subversive (Roochnik, 2002, lecture 8). Also, Socrates' method of inquiry was abrasive. In his search for a person wiser than himself, Socrates questioned many of the leading citizens of Athens, including a number of politicians. As was the case with the youth of Athens, these encounters challenged many cherished beliefs such as those concerning justice, courage, and even democracy. So, in addition to perhaps being viewed as subversive, leading "Athenians may just have been sick and tired of Socrates' endless questioning" (Roochnik, 2002, lecture 8).

Following his death, it was Socrates' famous student, Plato, who perpetuated and greatly elaborated his philosophy.

PLATO

The writings of **Plato** (ca. 427–347 B.C.) can be divided into two periods. During the first period, Plato essentially reported the thoughts and methods of his teacher, Socrates. When Socrates died, however, Plato went into self-imposed exile in southern Italy, where he came under the influence of the Pythagoreans. After he returned to Athens, he founded his own school, the Academy, and his subsequent writings combined the Socratic method with mystical Pythagorean philosophy. Like Socrates, Plato wished to find something permanent

that could be the object of knowledge, but his search for permanence carried him far beyond the kind of essences for which Socrates had settled.

The Theory of Forms or Ideas

As we have seen, the Pythagoreans believed that although numbers and numerical relationships were abstractions (they could not be experienced through the senses), they were nonetheless real and could exert an influence on the empirical world. The result of the influence, however, was believed to be inferior to the abstraction that caused the influence. As already mentioned, Pythagorean theorem is absolutely true when applied to abstract (imagined) triangles but is never completely true when applied to a triangle that exists in the empirical world (for example, one that is drawn on paper). This discrepancy exists because, in the empirical world, the lines making up the right angle will never be exact.

Plato took an additional step. According to his theory of forms, everything in the empirical world is a manifestation of a pure form (idea) that exists in the abstract. Thus, chairs, chariots, rocks, cats, dogs, and people are inferior manifestations of pure forms. For example, the thousands of cats that one encounters are but inferior copies of an abstract idea or form of "catness" that exists in pure form in the abstract. This is true for every object for which we have a name. What we experience through the senses results from the interaction of the pure form with matter; and because matter is constantly changing and is experienced through the senses, the result of the interaction must be less perfect than the pure idea before that idea interacts with matter. Plato replaced the essence that Socrates sought with the concept of form as the aspect of reality that was permanent and therefore knowable. That is, Socrates accepted the fact that a thorough definition specified an object's or a concept's essence; whereas for Plato, an object's or a concept's essence was equated with its form. For Plato, essence (form) had an existence separate from its individual manifestations. Socrates and Plato did

agree, however, that knowledge could be attained only through reason.

The Analogy of the Divided Line

What, then, becomes of those who attempt to gain knowledge by examining the empirical world via sensory experience? According to Plato, they are doomed to ignorance or, at best, opinion. The only true knowledge involves grasping the forms themselves, and this can be done only by rational thought. Plato summarized this viewpoint with his famous **analogy of the divided line**, which is illustrated in Figure 2.1.

Imagining is seen as the lowest form of understanding because it is based on images—for example, a portrait of a person is once removed from the person. Reflections in the water are also images because they are a step removed from the objects reflected. We are slightly better off confronting the objects themselves rather than their images, but the best we can do even when confronting objects directly is to form beliefs or opinions about them.

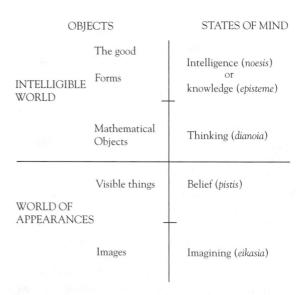

FIGURE 2.1

Plato's analogy of the divided line.

SOURCE: Cornford's translation of Plato's Republic (1941/1968, p. 222.)

Beliefs, however, do not constitute knowledge. Still better is the contemplation of mathematical relationships, but mathematical knowledge is still not the highest type because such knowledge is applied to the solution of practical (empirical) problems, and many of its relationships exist only by definition. That is, mathematical relationships are assumed to be true, but these assumptions could conceivably be false. To think about mathematics in the abstract, however, is better than dealing with images or empirical objects. The highest form of thinking involves embracing the forms themselves, and true intelligence or knowledge results only from an understanding of the abstract forms. The "good" or the "form of the good" constitutes the highest form of wisdom because it encompasses all other forms and shows their interrelatedness. The form of the good illuminates all other forms and makes them knowable. It is the highest truth. Later, in Christian theology, the form of the good is equated with God.

The Allegory of the Cave

In the allegory of the cave (Jowett, 1986), Plato described fictitious prisoners who have lived their entire lives in the depths of a cave. The prisoners are chained so they can look only forward. Behind them is a road over which individuals pass, carrying a variety of objects. Behind the road a fire is blazing, causing a projection of shadows of the travelers and the objects onto the wall in front of the prisoners. For the prisoners, the projected shadows constitute reality. This corresponds to the lowest form of understanding in the divided line just discussed. Plato then described what might happen if one of the prisoners were to escape his bondage and leave the cave. Turning toward the fire would cause his eves to ache, and he might decide to return to his world of shadows. If not, he would eventually adjust to the flames and see the individuals and objects of which he had previously seen only shadows. This represents an understanding of empirical events in the divided line. The fire is like the sun, which illuminates those events. Plato then asks us to suppose that the prisoner continues his journey and leaves the cave. Once in the "upper world," the prisoner would be blinded by true reality. Only after a period of adjustment could he see things in this world and recognize that they were more real than the shadows that he had experienced in the cave. Finally, Plato asks us to imagine what might happen to the escaped prisoner if he went back into the cave to enlighten his fellow prisoners. Still partially blinded by such an illuminating experience, the prisoner would find it difficult to readjust to the previous life of shadows. He would make mistakes in describing the shadows and in predicting which objects would follow which. This would be evidence enough for his fellow prisoners that no good could come from leaving the world of shadows. In fact, anyone who attempted to lead the prisoners out of the shadowy world of the cave would be killed (Jowett, 1986, p. 257).

The bound prisoners represent humans who confuse the shadowy world of sense experience with reality. The prisoner who escapes represents the individual whose actions are governed by reason instead of sensory impressions. The escaped prisoner sees the real objects (forms) responsible for the shadows and objects in the cave (sensory information) and thus embraces true knowledge. After such an enlightening experience, an effort is often made to steer others away from ignorance and toward wisdom. The plight of Socrates is evidence of what can happen to the individual attempting to free others from the chains of ignorance.

The Reminiscence Theory of Knowledge

How does one come to know the forms if they cannot be known through sensory experience? The answer to this question involves the most mystical aspect of Plato's theory. Plato's answer was influenced by the Pythagorean notion of the immortality of the soul. According to the Pythagoreans, the highest form of thought was reason, which was a function of the immortal soul. Plato expanded this idea and said that before the soul was implanted in the body, it dwelled in pure and complete knowledge; that is, it dwelled among the

forms. After the soul entered the body, sensory information began to contaminate this knowledge. The only way to arrive at true knowledge is to ignore sensory experience and focus one's thoughts on the contents of the mind. According to Plato's reminiscence theory of knowledge, all knowledge is innate and can be attained only through introspection, which is the searching of one's inner experiences. At most, sensory experience can only remind one of what was already known. Therefore, for Plato, all knowledge comes from reminiscence, from remembering the experiences the soul had before entering the body. In the Meno, Plato clearly presents his reminiscence theory of knowledge:

Thus the soul, since it is immortal and has been born many times, and has seen all things both here and in the other world, has learned everything that is. So we need not be surprised if it can recall the knowledge of virtue or anything else which, as we see, it once possessed. All nature is akin, and the soul has learned everything, so that when a man has recalled a single piece of knowledge ... there is no reason why he should not find out all the rest, if he keeps a stout heart and does not grow weary of the search, for seeking and learning are in fact nothing but recollection. (Hamilton and Cairns, 1961, p. 364)

We see, then, that Plato was a nativist as well as a rationalist because he stressed mental operations as a means of arriving at the truth (rationalism) and that the truth ultimately arrived at was inborn (nativism). He was also an idealist because he believed that ultimate reality consisted of ideas or forms.

The Nature of the Soul

Plato believed not only that the soul had a rational component that was immortal but also that it had two other components: the courageous (sometimes translated as emotional or spirited) and the appetitive. The courageous and appetitive aspects of the soul were part of the body and thus mortal. With

his concept of the three-part soul, Plato postulated a situation in which humans were almost always in a state of conflict, a situation not unlike the one Freud described many centuries later. According to Plato, the body has appetites (needs such as hunger, thirst, and sex) that must be met and that play a major motivational role in everyday life. Humans also have varied emotions such as fear, love, and rage. However, if true knowledge is to be attained, the person must suppress the needs of the body and concentrate on rational pursuits, such as introspection. Because bodily needs do not go away, the person must spend considerable energy keeping them under control—but they must be controlled. It is the job of the rational component of the soul to postpone or inhibit immediate gratifications when it is to a person's long-term benefit to do so. The person whose rational soul dominates is not impulsive. His or her life is dominated by moral principles and future goals, not the immediate satisfaction of biological or emotional needs. The supreme goal in life, according to Plato, should be to free the soul as much as possible from the adulterations of the flesh. In this he agreed with the Pythagoreans.

Plato realized that not everyone is capable of intense rational thought; he believed that in some individuals the appetitive aspect of the soul would dominate, in others the courageous (emotional) aspect of the soul would dominate, and in still others the rational aspect would dominate. In his Republic, he created a utopian society in which the three types of individuals would have special functions. Those in whom the appetitive aspect dominated would be workers and slaves, those in whom courage (emotion) dominated would be soldiers, and those in whom reason dominated would be philosopher-kings. In Plato's scheme, an inverse relationship exists between concern with bodily experiences and one's status in society. In Book V of the Republic, Plato forcibly stated his belief that societies have little chance of survival unless they are led by individuals with the wisdom of philosophers:

Until philosophers are kings, or the kings and princes of this world have the spirit and power of philosophy, and political greatness and wisdom meet in one, and those of commoner natures who pursue either to the exclusion of the other are compelled to stand aside, cities will never have rest from their evils.... Then only will this our state have a possibility of life and behold the light of day. (Jowett, 1986, p. 203)

We see that Plato was a nativist not only where knowledge was concerned but also where character or intelligence was concerned. He felt that education was of limited value for children of low aptitude. To a large extent then, whether one was destined to be a slave, a soldier, or a philosopher-king was a matter of inheritance. With his discussion of the three character types, Plato created a rudimentary theory of personality. He also had a highly developed philosophy of education that combined his theory of forms with his belief in character types. This philosophy is prominently featured in his *Republic* (Jowett, 1986).

Sleep and Dreams

According to Plato, while awake some individuals are better able to rationally control their appetites than are others; during sleep, however, it's another matter. Even with otherwise rational individuals, the baser appetites manifest themselves as they sleep. When asked to which appetites he was referring, Plato answered,

Those that are aroused during sleep, I said, whenever the rest of the soul, the reasonable, gentle, and ruling part, is slumbering; whereas the wild and animal part, full of food and drink, skips about, casts off sleep, and seeks to find a way to its gratification. You know that there is nothing it will not dare to do at the time, free of any control by shame or prudence. It does not hesitate, as it thinks, to attempt sexual intercourse with a mother or anyone else—man, god, or beast; it will commit any foul murder and does not refrain from any kind of food. In a word, it will commit any foul or

shameless deed.... What we want to establish is this: that there is a dangerous, wild, and lawless kind of desire in everyone, even the few of us who appear moderate. This becomes obvious in our sleep. (Grube, 1974, pp. 220–221)

Plato doesn't specifically mention dreams, but it seems clear that he is referring to them and that he anticipates many of the things Freud says about them many centuries later (see Chapter 16).

Plato's Legacy

Because science depends on empirical observation, Plato's philosophy did little to promote science and much to inhibit it. Plato created a dualism that divided the human into a body, which was material and imperfect, and a mind (soul), which contained pure knowledge. Furthermore, the rational soul was immortal. Had philosophy remained unencumbered by theological concerns, perhaps Plato's theory would have been challenged by subsequent philosophers and gradually displaced by more tempered philosophic views. Aristotle, in fact, went a long way in modifying Plato's position, but the challenge was aborted. The mysticism of early Christianity was combined with Platonic philosophy, creating unchallengeable religious dogma. When Aristotle's writings were rediscovered centuries later, they were also carefully modified and assimilated into church dogma. It was not until the Renaissance that Platonism (and Aristotelianism) was finally questioned openly and largely discarded.

ARISTOTLE

Aristotle (384–322 B.C.) was born in the obscure Macedonian city of Stagira, located between the Black Sea and the Aegean Sea. His father was court physician to King Amyntas II of Macedon. Although his father died when Aristotle was a young boy and Aristotle was raised by a guardian, it is assumed that he received training in medicine. In 367 B.C., Aristotle journeyed to Athens and

soon established himself as one of Plato's most brilliant students; he was 17 years old at the time, and Plato was 60. Aristotle continued to study at the Academy until he was 37 years old. When Plato died in 347 B.C., Aristotle moved to Asia Minor, where he engaged in biological and zoological fieldwork. In 343 B.C., Aristotle returned to Macedon and tutored the son of King Philip II, the future Alexander the Great, for about four years. After a few more journeys, Aristotle returned to Athens where, at the age of 48, he founded his own school called the Lyceum. Because the Lyceum had many teachers, regular lectures, a substantial library, and large natural science collections, it is considered the world's first university (Esper, 1964, p. 128). When Alexander the Great died in 323 B.C., Aristotle fled Athens and died a year later in Chalcis at the age of 63.

Why did Aristotle flee Athens? Macedon, where Aristotle was born, was an ancient Greekspeaking country to the north of Greece. With the goal of unifying diverse Greek communities into a powerful Greco-Macedonian nation, King Philip of Macedon invaded and conquered a number of Greek city-states, including Athens. When Philip was assassinated in 336 B.C., his 19year-old son Alexander (Aristotle's ex-student) became ruler, and his subsequent military accomplishments are legendary. Although Aristotle had many disagreements with Alexander, both preferred "Greek solidarity to city patriotism" (Durant, 1926/1961, p. 94). When Alexander died in 323 B.C. at the age of 32, the Macedonian party was overthrown in Athens and Athenian independence was again proclaimed. Undoubtedly because of his association with the Macedonians, Aristotle faced the trumped-up charge of impiety brought against him. He was accused of having taught that prayer and sacrifice were ineffective. This, of course, is reminiscent of what happened to Socrates. Unlike Socrates, however. Aristotle chose to flee Athens rather than meet his inevitable fate, saying, "He would not give Athens a chance to sin a second time against philosophy" (Durant, 1926/1961, p. 94).

Aristotle was the first philosopher to extensively treat many topics that were later to become

part of psychology. In his vast writings, he covered memory, sensation, sleep, dreams, geriatrics, and learning. He also began his book *De Anima* (*On the Soul*) with what is considered to be the first history of psychology. Taken alone, Aristotle's contributions to psychology were truly impressive. It must be realized, however, that with the possible exception of mathematics, he made contributions to every branch of knowledge. The influence of his thoughts on such philosophical and scientific topics as logic, metaphysics, physics, biology, ethics, politics, rhetoric, and poetics have lasted to the present time. It is often said that Aristotle was the last human to know everything that was knowable during his lifetime.

The Basic Difference between Plato and Aristotle

Both Plato and Aristotle were primarily interested in essences or truths that went beyond the mere appearance of things, but their methods for discovering those essences were distinctly different. For Plato. essences corresponded to the forms that existed independently of nature and that could be arrived at only by ignoring sensory experience and turning one's thoughts inward (that is, by introspection). For Aristotle, essences existed but could become known only by studying nature. He believed that if enough individual manifestations of a principle or phenomenon were investigated, eventually one could infer the essence that they exemplified. In the opening passage of his Metaphysics, Aristotle demonstrates that his attitude toward sensory information was much friendlier than was Plato's.

All men by nature desire to know. An indication of this is the delight we take in our senses; for even apart from their usefulness they are loved for themselves; and above all others the sense of sight. For not only with a view to action, but even when we are not going to do anything, we prefer sight to almost everything else. The reason is that this, most of all the senses, makes us know and brings to light many

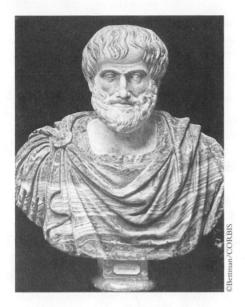

Aristotle

differences between things. (Barnes, 1984, Vol. 2, p. 1552)

Aristotle's philosophy shows the difficulty that is often encountered when attempting to clearly separate the philosophies of rationalism and empiricism. As was noted in Chapter 1, the rationalist claims that logical, mental operations must be used to gain knowledge, and the empiricist emphasizes the importance of sensory information in gaining knowledge. Aristotle embraced both rationalism and empiricism. He believed that the mind must be employed before knowledge can be attained (rationalism) but that the object of rational thought was the information furnished by the senses (empiricism). Aristotle's position is not unique, however. Throughout history, most rationalists have recognized and accepted the importance of sensory experience, and most empiricists have postulated one or more mental operations that are presumed to act on sensory information. In other words, finding a pure rationalist or empiricist is very difficult, and a philosopher is usually categorized as one or the other depending on whether he or she emphasizes mental operations or sensory experience. With this

in mind, we can say that Aristotle was more of a rationalist than he was an empiricist.

The general principles that Plato and Aristotle (and other philosophers) thought were real and knowable have been referred to in different ways through the years—for example, as first principles, essences, or universals. In each case, it was assumed that something basic existed that could not be discovered by studying only individual instances or manifestations of the abstract principle involved. Some type of rational activity was needed to find the principle (essence) underlying individual cases. The search for first principles, essences, or universals characterized most early philosophy and, in a sense, continues in modern science as the search for laws governing nature. In Chapter 21, we will examine Ludwig Wittgenstein's criticism of the concept of essence and his proposed alternative to it.

For Plato, first principles were arrived at by pure thought; for Aristotle, they were attained by examining nature directly. For Plato, all knowledge existed independently of nature; for Aristotle, nature and knowledge were inseparable. In Aristotle's view, therefore, the body was not a hindrance in the search for knowledge, as it was for Plato and the Pythagoreans. Also, Aristotle disagreed with Plato on the importance of mathematics. For Aristotle, mathematics was essentially useless, his emphasis being on the careful examination of nature by observation and classification. Here we see again the empirical component of Aristotle's philosophy. In Aristotle's Lyceum, an incredibly large number of observations of physical and biological phenomena were made. Categories into which the observations fit were then determined. Through this method of observation, definition, and classification, Aristotle compiled what has been called an encyclopedia of nature. He was interested in studying the things in the empirical world and learning their functions. Because Aristotle sought to explain several psychological phenomena in biological terms, he can be considered the first physiological psychologist (D. N. Robinson, 1986, pp. 81-82).

Plato's philosophy followed in the Pythagorean, mathematical tradition and Aristotle's in the Hippocratic, biological tradition. The views of Plato and Aristotle concerning the sources of knowledge set the stage for epistemological inquiry that has lasted to the present time. Almost every philosopher, and most psychologists, can be evaluated in terms of their agreement or disagreement with the views of Plato or Aristotle.

Causation and Teleology

To truly understand anything, according to Aristotle, we must know four things about it. That is, everything has the following four causes.

- Material cause is the kind of matter of which an object is made. For example, a statue is made of marble.
- Formal cause is the particular form, or pattern, of an object. For example, a piece of marble takes on the form of Venus.
- **Efficient cause** is the force that transforms the matter into a certain form—for example, the energy of the sculptor.
- **Final cause** is the purpose for which an object exists. In the case of a statue, the purpose may be to bring pleasure to those who view it. The final cause is that for the sake of which something exists. Thus, although I have listed it last, the final cause (a thing's purpose) actually precedes the other three causes.

Aristotle's philosophy exemplified teleology because, for him, everything in nature exists for a purpose. By purpose, however, Aristotle did not mean conscious intention. Rather, he meant that everything in nature has a function built into it. This built-in purpose, or function, is called entelechy. Entelechy keeps an object moving or developing in its prescribed direction until its full potential is reached. For example, the eye exists to provide vision, and it continues developing until it does so. The final cause of living things is part of their nature; it exists as a potentiality from the organism's very inception. An acorn has the potential to become an oak tree, but it cannot become a frog or an olive tree. In other words, the purpose, or entelechy, of an acorn is to become an oak tree.

Nature is characterized by the change and motion that occurs as objects are slowly transformed from their potentialities to their actualities—that is, as objects move toward their final causes or purposes, such as when an acorn becomes an oak tree. Aristotle also saw the final cause, or purpose, of something as its essence.

According to Aristotle, all natural things, both animate and inanimate, have a purpose built into them. In addition, however, nature itself has a grand design or purpose. Although Aristotle believed that the categories of things in nature remain fixed, thus denying evolution, he spoke of a grand hierarchy among all things. The scala naturae refers to the idea that nature is arranged in a hierarchy ranging from neutral matter to the unmoved mover, which is pure actuality and is the cause of everything in nature. For Aristotle, the unmoved mover is what gives all natural objects their purposes. In his scala naturae, the closer to the unmoved mover something is, the more perfect it is. Among animals, humans were closest to the unmoved mover, with all other animals at various distances behind us. Although Aristotle did not accept evolution, his scala naturae does create a phylogenetic scale of sorts, making it possible to study "lower" animals in order to understand humans. Such information will always be of limited value, however, because for Aristotle, humans were unique among the animals. Again, Aristotle's position was thoroughly teleological: All objects in nature have a purpose, and nature itself has a purpose.

The Hierarchy of Souls

For Aristotle, as for most Greek philosophers, a soul is that which gives life; therefore, all living things possess a soul. According to Aristotle, there are three types of souls, and a living thing's potential (purpose) is determined by what type of a soul it possesses.

- A vegetative (or nutritive) soul is possessed by plants. It allows only growth, the assimilation of food, and reproduction.
- A sensitive soul is possessed by animals but not plants. In addition to the vegetative func-

tions, organisms that possess a sensitive soul sense and respond to the environment, experience pleasure and pain, and have a memory.

 A rational soul is possessed only by humans. It provides all the functions of the other two souls but also allows thinking or rational thought.

Because it is the soul that gives a living organism its distinctive properties, to ask whether body and soul exist independently was, for Aristotle, a meaningless question: "We can dismiss as unnecessary the question whether the soul and the body are one: it is as though we were to ask whether the wax and its shape are one" (Barnes, 1984, Vol. 1, p. 657).

Sensation

Aristotle said that information about the environment is provided by the five senses: sight, hearing, taste, touch, and smell. Unlike earlier philosophers (such as Empedocles and Democritus), Aristotle did not believe objects sent off tiny copies of themselves (eidola). Rather, he thought that perception was explained by the motion of objects that stimulate one of the senses. The movement of environmental objects created movements through different media, and each of the five senses was maximally sensitive to movements in a certain medium. For example, seeing resulted from the movement of light caused by an object, hearing and smelling resulted from the movement of air, and taste and touching resulted from movement of the flesh. In this way, Aristotle explained how we could actually sense environmental objects without those objects sending off physical copies of themselves. Unlike Plato, Aristotle believed we could trust our senses to yield an accurate representation of the environment.

Common Sense, Passive Reason, and Active Reason

As important as sensory information was to Aristotle, it was only the first step in acquiring knowledge. In other words, sensory experience was a necessary, but not a sufficient, element in the attainment of knowledge. In the first place, each sensory system provides isolated information about the environment that by itself is not very useful. For example, seeing a baby tossing and turning provides a clue as to its condition, hearing it cry provides another clue, smelling it may give a clue as to why it is so uncomfortable, and touching may reveal that it has a fever. It is the combined information from all the senses that allows for the most effective interactions with the environment.

Aristotle postulated a common sense as the mechanism that coordinated the information from all the senses. The common sense, like all other mental functions, was assumed to be located in the heart. The job of common sense was to synthesize sensory experience, thereby making it more meaningful. However, sensory information, even after it was synthesized by common sense, could provide information only about particular instances of things. Passive reason involved the utilization of synthesized experience for getting along effectively in everyday life, but it did not result in an understanding of essences, or first principles. The abstraction of first principles from one's many experiences could be accomplished only by active reason, which was considered the highest form of thinking. Aristotle therefore delineated levels of knowing or understanding much like Plato's divided line:

- *Active reason:* The abstraction of principles, or essences, from synthesized experience
- Passive reason: Utilization of synthesized experience
- Common sense: Synthesized experience
- Sensory information: Isolated experience

To see how these levels of understanding are related, consider how electricity is experienced through the various senses: sight (seeing an electrical discharge), pain (being shocked), and hearing (hearing the electrical discharge). These experiences would correspond to the level of sense reception.

UNIVERSITY OF WINICHESTER LIBRARY The common sense would indicate that all these experiences had a common source—electricity. Passive reason would indicate how electricity could be used in a variety of practical ways, whereas active reason would seek the laws governing electricity and an understanding of its essence. What started as a set of empirical experiences ends as a search for the principles that can explain those experiences.

The active reason part of the soul provides humans with their highest purpose. That is, it provides their entelechy. Just as the ultimate goal of an acorn is to become an oak tree, the ultimate goal of humans is to engage in active reason. Aristotle also believed that acting in accordance with one's nature caused pleasure and that acting otherwise brought pain. In the case of humans, engaging in active reason was the source of greatest pleasure. On this matter, Aristotle was essentially in agreement with Socrates and Plato. Also, because Aristotle postulated an inner potential in humans that may or may not be reached, his theory represents psychology's first self-actualization theory. The selfactualization theories of Jung, Maslow, Rogers reflect Aristotle's thoughts on the human entelechy.

With his concept of active reason, Aristotle inserted a mystical or supernatural component into an otherwise naturalistic philosophy. The active reason part of the soul was considered immortal, but when it left the body upon death, it carried no recollections with it. It was considered a mechanism for pure thought and was believed to be identical for all humans. It was not judged in accordance with the moral character of its prior possessor, and there was no union or reunion with God. The active reason part of the soul went neither to heaven nor to hell. Later, however, the Christianized version of the Aristotelian soul was to be characterized by all these things.

Another mystical component in Aristotle's theory was his notion of the unmoved mover. As stated earlier, for Aristotle, everything in nature had a purpose that was programmed into it. This purpose, or entelechy, explained why a thing was like it was and why it did what it did. But if everything in nature has a purpose, what causes that purpose? As we have seen, Aristotle postulated an unmoved mover, or that which caused everything else but was not caused by anything itself. For Aristotle, the unmoved mover set nature in motion and did little else; it was a logical necessity, not a deity. Along with Aristotle's notion of the immortal aspect of the soul, the Christians also found his unmoved mover very much to their liking.

Memory and Recall

In keeping with the empirical aspect of his philosophy, Aristotle, in his On Memory, explained memory and recall as the results of sense perception. This contrasts with Plato's explanation, which was essentially nativistic. Remembering, for Aristotle, was a spontaneous recollection of something that had been previously experienced. For example, you see a person and remember that you saw that person before and perhaps engaged in a certain conversation. Recall, however, involves an actual mental search for a past experience. It was in conjunction with recall that Aristotle postulated what have been called his laws of association. The most basic law of association is the law of contiguity, which states that when we think of something, we also tend to think of things that were experienced along with it. The law of similarity states that when we think of something, we tend to think of things similar to it. The law of contrast states that when we think of something, we also tend to think of things that are its opposite. Aristotle said that on rare occasions a strong association can be formed between two events after experiencing them together just once. More typically, however, the more often events are experienced together, the stronger will be their association. Thus, Aristotle implied the law of frequency, which states that, in general, the more often experiences occur together, the stronger will be their association. According to Aristotle, events can be associated naturally, such as when thunder follows lightning, or by custom, such as learning the letters of the alphabet or associating a certain

name with a certain person. In both cases, it is generally the frequency of occurrence that determines the strength of association. In *On Memory*, Aristotle said, "For as one thing follows another by nature, so too that happens by custom, and frequency creates nature" (Barnes, 1984, Vol. 1, pp. 718–719).

Aristotle's laws of association were to become the basis of learning theory for more than 2,000 years. In fact, the concept of mental association is still at the heart of most theories of learning. The belief that one or more laws of association can be used to explain the origins of ideas, the phenomena of memory, or how complex ideas are formed from simple ones came to be called **associationism**.

Imagination and Dreaming

We have seen that Aristotle's philosophy had both rational and empirical components. For example, his account of memory and recall was empirical. We see that component again in his explanation of imagination and dreaming. According to Aristotle, when sensations occur, they create images that long outlast the stimulation that caused them. The retention of these images is what constitutes memory. These images also create the important link between sensation and rational thought because it is the images provided by experience that are pondered by the passive and active intellects. Imagination, then, is explained as the lingering effects of sensory experience. Aristotle did question the reliability of the products of imagination. Sensations, he said, tend to be free of error because of the close relationship between objects of sense and the sense organs. Because imagination is removed from this relationship, it is much more susceptible to error.

Aristotle also explained dreaming in terms of the images of past experience. During sleep, the images of past experience may be stimulated by events inside or outside the body. The reasons that our residual impressions (images) may seem odd during a dream are that (1) during sleep, the images are not organized by reason; and (2) while awake, our images are coordinated with or controlled by ongoing sensory stimulation, which

interacts with the images of previous experience, but during sleep this does not occur.

Aristotle was extremely skeptical about a dream's ability to provide information about future events. Most often we dream about activities in which we have recently engaged, but it is possible that a course of action is dreamed about so vividly that it will suggest an actual course of action in the dreamer's life. However, according to Aristotle, most cases of apparent prophecy by dreams are to be taken as mere coincidences:

[Just as] mentioning a particular person is neither token nor cause of this person's presenting himself, so, in the parallel instance, the dream is, to him who has seen it, neither token nor cause of its fulfillment, but a mere coincidence. Hence the fact that many dreams have no "fulfillment," for coincidences do not occur according to any universal or general law.... For the principle which is expressed in the gambler's maxim: "If you make many throws your luck must change," holds good [for dreams] also. (Barnes, 1984, Vol. 1, p. 737)

It is interesting to note that the eminent Roman statesman and philosopher Cicero (106–43 B.C.) agreed with Aristotle's analysis of dreams:

From the visions of drunkards and madmen one might, doubtless, deduce innumerable consequences by conjecture, which might seem to be presages of future events. For what person who aims at a mark all day long will not sometimes hit it? We sleep every night; and there are very few on which we do not dream; can we wonder then that what we dream sometimes comes to pass? (Yonge, 1997, p. 251)

There was a sense, however, in which Aristotle believed dreams were capable of predicting important future events. Because sensations are often exaggerated in dreams, subtle bodily changes may be reflected in dreams but not during wakefulness. For this reason, it makes sense for physicians to analyze dreams to detect the early signs of disease (Barnes, 1984, Vol. 1, pp. 736–737).

Motivation and Happiness

Happiness, for Aristotle, was doing what is natural because doing so fulfills one's purpose. For humans, our purpose is to think rationally, and therefore doing so brings the greatest happiness. However, humans are also biological organisms characterized by the functions of nutrition, sensation, reproduction, and movement. That is, although humans are distinct from other animals (because of our reasoning ability), we do share many of their motives. As with other animals, much human behavior is motivated by appetites. Action is always directed at the satisfaction of an appetite. That is, behavior is motivated by such internal states as hunger, sexual arousal, thirst, or the desire for bodily comfort. Because the existence of an appetite causes discomfort, it stimulates activity that will eliminate it. If the activity is successful, the animal or person experiences pleasure. Much human behavior, then, like all animal behavior, is hedonistic; its purpose is to bring pleasure or to avoid pain.

Unlike other animals, however, we can use our rational powers to inhibit our appetites. Furthermore, our greatest happiness does not come from satisfying our biological needs. Rather, it comes from exercising our rational powers to their fullest. Given the fact that humans have both appetites and rational powers, conflict often arises between the immediate satisfaction of our appetites and the more remote rational goals. On the portals of the temple of Apollo at Delphi, there were two inscriptions. One was "Know thyself," which, as we have seen, so inspired Socrates. The other was "Nothing in excess." The latter reflects the high esteem with which the Greeks held self-control, and Aristotle was no exception. In Nicomachean Ethics (Ross. 1990), Aristotle described the best life as one lived in moderation; that is, one lived according to the golden mean. As examples, he described courage as the mean between cowardice and foolhardiness, temperance as the mean between abstinence and self-indulgence, and generosity as the mean between meanness (stinginess) and extravagance. A life of moderation requires the rational control of one's appetites. Even the best of humans, however, are capable of acting hedonistically rather than rationally: "For desire is a wild beast, and passion perverts the minds of rulers, even when they are the best of men" (Barnes, 1984, Vol. 2, p. 2042). According to Aristotle, the lives of many humans are governed by nothing more than the pleasure and pain that come from the satisfaction and frustration of appetites. These people are indistinguishable from animals. Appetites and reason are part of every human, but his or her character is revealed by which of the two dominates.

Interestingly, Aristotle described what would much later be called an approach-approach conflict and the problem such a conflict can cause. The traditional example of this conflict is a hungry donkey starving to death between two equally desirable stacks of hay. Aristotle said, "[Consider] the man who, though exceedingly hungry and thirsty, and both equally, yet being equidistant from food and drink, is therefore bound to stay where he is" (Barnes, 1984, Vol. 1, p. 486).

The Emotions and Selective Perception

In general, in Aristotelian philosophy, the emotions had the function of amplifying any existing tendency. For example, people might run more quickly if they were frightened than if they were merely jogging for exercise. Also, the emotions provide a motive for acting—for example, people might be inclined to fight if they are angry. However, the emotions may also influence how people perceive things; that is, they may cause *selective perception*. Aristotle gave the following examples:

We are easily deceived respecting the operations of sense-perception when we are excited by emotion, and different persons according to their different emotions; for example, the coward when excited by fear and the amorous person by amorous desire; so that with but little resemblance to go upon, the former thinks he sees his foes approaching, the latter that he sees the object of his desire; and the more deeply one is under the influence of the emotion, the less similarity is required to give rise to these impressions. Thus, too, in fits of anger, and also in all states of appetite, all men become easily deceived, and more so the more their emotions are excited. (Barnes, 1984, Vol. 1, p. 732)

We can engage here in a bit of presentism and note that Aristotle made several mistakes. For example, he assigned thinking and common sense to the heart and claimed that the main function of the brain was to cool the blood. He believed that the number of species of living things in the world was fixed and thereby denied evolution. He also believed the earth to be the center of the universe. Also, like most others at the time, he justified slavery and argued that males are superior to females.

The male is by nature superior, and the female inferior; and one rules, and the other is ruled; this principle, of necessity, extends to all mankind. Where then there is such a difference as that between soul and body, or between men and animals (as in the case of those whose business is to use their body, and can do nothing better), the lower sort are by nature slaves, and it is better for them as for all inferiors that they should be under the rule of a master. For he who can be. and therefore is, another's, and he who participates in reason enough to apprehend, but not to have, is a slave by nature. (Barnes, 1984, Vol. 2, p. 1990)

Although many of his observations were eventually shown to be incorrect, Aristotle did promote empirical observation as a means of attaining knowledge, and in doing so, he brought Greek philosophy to new heights.

THE IMPORTANCE OF EARLY GREEK PHILOSOPHY

To realize the significance of the early Greek philosophers, remembering Popper's philosophy of science is important. As we saw in Chapter 1, Popperian science consists of specifying a problem, proposing solutions to the problem, and attempting to refute the proposed solutions. What survives in such a process is a solution to a problem that, at the moment, cannot be refuted. Again, the highest status that a proposed solution to a problem can ever attain is "not yet disconfirmed." The assumption in Popper's view of science is that all scientific "facts" and "theories" eventually will be found to be false.

What has this to do with the importance of early Greek philosophy? In Popper's view, science began when humans first began to question the stories they were told about themselves and the world. According to Brett, "The Greek cosmologists were important because they broke loose from the accepted religious traditions and produced what they considered to be better stories about the origin and stuff of the world. They speculated" (1912-1921/1965, p. 38). Not only did the Greek philosophers speculate, but they also respected the speculations of others. With the exception of the Pythagoreans, who created a secretive cult designed to perpetuate dogma, the Greek philosophers engaged in open, critical discussions of one another's ideas. For Popper, this willingness to engage in critical discussion was the beginning of an extremely important tradition:

Here is a unique phenomenon, and it is closely connected with the astonishing freedom and creativeness of Greek philosophy. How can we explain this phenomenon? What we have to explain is the rise of a tradition. It is a tradition that allows or encourages critical discussions between various schools and, more surprisingly still, within one and the same school. For nowhere outside the Pythagorean school do we find a school devoted to the

preservation of a doctrine. Instead we find changes, new ideas, modifications, and outright criticism of the master. (1958, p. 27)

As we have seen, Popper attributed the founding of this new tradition of freedom to Thales, who not only tolerated criticism but encouraged it. According to Popper, this was a "momentous innovation" because it broke with the dogmatic tradition that permitted only one true doctrine by allowing a plurality of doctrines, all attempting to approach the truth via critical discussion. Coupled with this tradition of free, critical discussion is the realization that our inquiries are never final but always tentative and capable of improvement. Popper said of this tradition,

It ... leads, almost by necessity, to the realization that our attempts to see and to find the truth are not final, but open to improvement; that our knowledge, our doctrine, is conjectural; that it consists of guesses, of hypotheses, rather than of final and certain truths; and that criticism and critical discussion are our only means of getting nearer to the truth. It thus leads to the tradition of bold conjectures and of free criticism, the tradition which created the rational or scientific attitude, and with it our Western civilization. (1958, p. 29)

Aristotle's death, in 322 B.C., marked the end of the Golden Age of Greece, which had started about 300 years earlier with the philosophy of Thales. Most, if not all, of the philosophical concepts that have been pursued since the Golden Age were produced during this period. After Aristotle's death, philosophers either began to rely on the teachings of past authorities or turned their attention to questions concerning models for human conduct. It was not until the Renaissance, many centuries after Aristotle's death, that the critical tradition of the early Greek philosophers was rediscovered and revived.

SUMMARY

Primitive humans looked upon everything in nature as if it were alive, making no distinction between the animate and the inanimate—this view was called animism. Moreover, they tended to project human feelings and emotions onto nature, and this was called anthropomorphism. A spirit or ghost was thought to reside in everything, giving it life. An array of magical practices evolved that were designed to influence various spirits. These practices gave humans the feeling that they had some control over nature. Early Greek religion was of two main types: Olympian, which consisted of a number of gods whose activities were very much like those of upper-class Greeks, and Dionysiac-Orphic, which preached that the soul was a prisoner of the body and that it longed to be released so that it could once again dwell among the gods. Whereas Olympian religion tended to be the favorite of the wealthier Greeks, Dionysiac-Orphic religion tended to be favored by the lower classes.

The first philosophers emphasized natural explanations instead of supernatural ones. They sought a primary element, called the physis, from which everything was made. For Thales, the physis was water; for Anaximander, it was the boundless: for Heraclitus, it was fire; for Parmenides, it was the "one" or "changelessness"; for Pythagoras, it was numbers; for Democritus, it was the atom; for Hippocrates and Empedocles, there were four primary elements—water, earth, fire, and air; and for Anaxagoras, there was an infinite number of elements. The earliest Greek philosophers were called cosmologists because they sought to explain the origin, structure, and processes of the universe (cosmos). Along with the four elements, Empedocles postulated the forces of love, which tends to bring the elements together, and strife, which tends to separate them. When the mixture of elements and forces is just right, parts of animals and humans form and combine into almost all possible arrangements. Only a limited number of the random arrangements were capable of survival, and humans were among them.

The debate between Heraclitus, who believed everything was constantly changing, and Parmenides, who believed nothing ever changed, raised a number of epistemological questions such as, What, if anything, is permanent enough to be known with certainty? and, If sensory experience provides information only about a continually changing world, how can it be a source of knowledge? These and related questions have persisted to the present.

Most of the first philosophers were monists because they made no distinction between the mind and the body; whatever element or elements they arrived at were supposed to account for everything. In Pythagoras, however, we have a full-fledged dualism between the mind and the body and between the physical and the abstract. Numbers were abstractions but were real, and they could be known only by rational thought, not by sensory experience. Sensory experience could only inhibit attainment of abstract knowledge and was to be avoided. The mind, or soul, was thought to be immortal.

Early Greek medicine was temple medicine based on superstition and magical practices. Through the efforts of such individuals as Alcmaeon and Hippocrates, medical practice became objective and naturalistic. Displacing such beliefs as that illness was due to the possession of spirits was the belief that health resulted from a balance among bodily elements or processes and illness from an imbalance.

The Sophists concluded that there were many equally valid philosophical positions. "Truth" was believed to be a function of a person's education, personal experiences, culture, and beliefs; and whether this truth was accepted by others depended on one's communicative skills. There is much in common between what the Sophists taught and contemporary postmodernism. Socrates agreed

with the Sophists that truth was subjective, but he also believed that a careful examination of one's subjective experiences would reveal certain concepts that were stable and knowable and that, when known, would generate proper conduct.

Plato, influenced by the Pythagoreans, took Socrates' belief an additional step by saying that ideas, or concepts, had an independent existence, just as the Pythagorean number did. For Plato, ideas or forms were the ultimate reality, and they could be known only by reason. Sensory experience leads only to ignorance—or at best, opinion—and should be avoided. The soul, before becoming implanted in the body, dwells in pure and complete knowledge, which can be remembered if one turns one's thoughts inward and away from the empirical world. For Plato, knowledge results from remembering what the soul experienced prior to its implantation in the body. This is called the reminiscence theory of knowledge. Plato believed that the rational powers of the mind (rationalism) should be turned inward (introspection) to rediscover ideas that had been present at birth (nativism).

Aristotle was also interested in general concepts instead of isolated facts, but unlike Plato, he believed that the way to arrive at these concepts was to examine nature. Instead of urging the avoidance of sensory experience, he claimed that it was the source of all knowledge. Aristotle's brand of rationalism relied heavily on empiricism because he believed that concepts are derived from the careful scrutiny of sensory observations. He believed that all things contained an entelechy, or purpose. An acorn, for example, has the potential to become an oak tree, and its purpose is to do so. There are three categories of living things: those possessing a vegetative soul, those possessing a sensitive soul, and those possessing a rational soul. Humans alone possess a rational soul, which has two functions: passive reason and active reason. Passive reason ponders information from the five senses and from the common sense, which synthesizes sensory information. Active reason is used to isolate enduring concepts (essences) that manifest themselves in sensory experience. Aristotle considered active reason immortal. He also postulated an unmoved mover that was the entelechy for all of nature; it caused everything else but was not itself caused by anything. Aristotle believed that nature was organized on a grand scale ranging from formless matter to plants, to animals, to humans, and finally to the unmoved mover. Because humans have much in common with other animals, we can learn about ourselves by studying them.

Aristotle distinguished between memory, which was spontaneous, and recall, which was the active search for a recollection of a past experience. It was with regard to recall that Aristotle postulated his laws of association—the laws of contiguity, similarity, contrast, and frequency. Aristotle explained imagination and dreaming as the pondering of images that linger after sensory experience has ceased. Contrary to what almost everyone else at the time believed, Aristotle believed that dreams do not foretell the future, and if they appear to do so it is simply coincidence. However, because minute bodily events are exaggerated in dreams, dreams can be used to detect the early signs of dis-

ease. Humans are motivated by their very nature to engage their rational powers in an effort to attain knowledge. However, humans have appetites not unlike those of other animals. The presence of an appetite stimulates behavior that will satisfy it. When an appetite is satisfied, the person or animal experiences pleasure; when it is not satisfied, pain is experienced. Human rationality can and should be used to control appetites and emotions, but both sometimes overwhelm even the best of humans. The best life is one lived in accordance with the golden mean—a life of moderation. Emotions amplify ongoing thoughts and behavior and sometimes cause people to selectively perceive or misperceive events in the environment. Although Aristotle made several mistakes, his empirical approach to attaining knowledge brought Greek philosophy to new heights.

Early Greek philosophy was significant because it replaced supernatural explanations with naturalistic ones and because it encouraged the open criticism and evaluation of ideas.

DISCUSSION QUESTIONS

- Describe some of the events that may have concerned primitive humans, and discuss how they accounted for and attempted to control those events.
- 2. Summarize the major differences between Olympian and Dionysiac-Orphic religion.
- 3. What distinguishes the attempts of the first philosophers to understand nature from the attempts of those who preceded them?
- 4. What did the cosmologists attempt to do?
- Why were the first philosophers called physicists? List the physes arrived at by Thales,
 Anaximander, Heraclitus, Parmenides,
 Pythagoras, Empedocles, Anaxagoras, and
 Democritus.
- 6. Summarize Empedocles' view of the universe.

- 7. Summarize Empedocles' view of how species of animals, including humans, came into existence.
- 8. What important epistemological question did Heraclitus's philosophy raise?
- Give examples of how logic was used to defend Parmenides' belief that change and motion were illusions.
- 10. Differentiate between elementism and reductionism and give an example of each.
- 11. What were the major differences between temple medicine and the type of medicine practiced by Alcmaeon and the Hippocratics?
- 12. How did the Sophists differ from the philosophers who preceded them? What was the Sophists' attitude toward knowledge? In what way did Socrates agree with the Sophists, and in what way did he disagree?

- 13. What observations did Xenophanes make about religion?
- 14. What, for Socrates, was the goal of philosophical inquiry? What method did he use in pursuing that goal?
- 15. What are the charges brought against Socrates by the Athenians? What were perhaps the real reasons Socrates was convicted and sentenced to death?
- 16. Describe Plato's theory of forms or ideas.
- 17. In Plato's philosophy, what was the analogy of the divided line?
- 18. Summarize Plato's cave allegory. What points was Plato making with this allegory?
- Discuss Plato's reminiscence theory of knowledge.
- 20. Compare Aristotle's attitude toward sensory experience with that of Plato.
- 21. Discuss the similarity between Plato's analysis of dreams and Freud's later analysis.
- 22. Provide evidence that Aristotle's philosophy had both rational and empirical components.
- 23. According to Aristotle, what were the four causes of things?

- 24. Discuss Aristotle's concept of entelechy.
- 25. Describe Aristotle's concept of *scala naturae*, and indicate how that concept justifies a comparative psychology.
- 26. Discuss Aristotle's concept of soul.
- 27. Discuss the relationship among sensory experience, common sense, passive reason, and active reason.
- 28. Summarize Aristotle's views on imagination and dreaming.
- 29. Discuss Aristotle's views on happiness. What, for him, provided the greatest happiness? What characterized the life lived in accordance with the golden mean?
- 30. Discuss Aristotle's views on emotions.
- 31. In Aristotle's philosophy, what was the function of the unmoved mover?
- 32. Describe the laws of association that Aristotle proposed.
- 33. Summarize the reasons Greek philosophy was important to the development of Western civilization.

SUGGESTIONS FOR FURTHER READING

- Allen, R. E. (Ed.). (1991). Greek philosophy: Thales to Aristotle (3rd ed.). New York: Free Press.
- Annas, J. (2003). *Plato: A very short introduction*. New York: Oxford University Press.
- Barnes, J. (2001). Early Greek philosophy (rev. ed). New York: Penguin Putnam.
- Bremmer, J. N. (1993). The early Greek concept of the soul. Princeton, NJ: Princeton University Press.
- Cartledge, P. (1999). Democritus. New York: Routledge.
- Guthrie, K. S. (Comp. and Trans.). (1987). The Pythagorean sourcebook and library: An anthology of ancient writings which relate to Pythagoras and Pythagorean philosophy. Grand Rapids, MI: Phanes Press.

- Hicks, R. D. (Trans.). (1991). Aristotle de anima. Buffalo, NY: Prometheus Books.
- McLeish, K. (1999). Aristotle. New York: Routledge.
- Robinson, D. N. (1989). *Aristotle's psychology*. New York: Columbia University Press.
- Robinson, T. M. (1995). *Plato's psychology*. (2nd ed.). Toronto: University of Toronto Press.
- Ross, D. (Trans.). (1990). Aristotle: The Nicomachean ethics. New York: Oxford University Press.
- Taylor, C. C. W. (1998). Socrates: A very short introduction. New York: Oxford University Press.
- Waterfield, R. (2000). The First Philosophers: The Presocratics and Sophists. New York: Oxford University Press.

GLOSSARY

Active reason According to Aristotle, the faculty of the soul that searches for the essences or abstract concepts that manifest themselves in the empirical world. Aristotle thought that the active reason part of the soul was immortal.

Alcmaeon (fl. ca. 500 B.C.) One of the first Greek physicians to move away from the magic and superstition of temple medicine and toward a naturalistic understanding and treatment of illness.

Allegory of the cave Plato's description of individuals who live their lives in accordance with the shadows of reality provided by sensory experience instead of in accordance with the true reality beyond sensory experience.

Analogy of the divided line Plato's illustration of his contention that there is a hierarchy of understanding. The lowest type of understanding is based on images of empirical objects. Next highest is an understanding of empirical objects themselves, which results only in opinion. Next is an understanding of abstract mathematical principles. Then comes an understanding of the forms. The highest understanding (true knowledge) is an understanding of the form of the good that includes a knowledge of all forms and their organization.

Anaxagoras (ca. 500–428 B.C.) Postulated an infinite number of elements (seeds) from which everything is made. He believed that everything contains all the elements and that a thing's identity is determined by which elements predominate. An exception is the mind, which contains no other element but may combine with other elements, thereby creating life.

Anaximander (ca. 610–547 B.C.) Suggested the infinite or boundless as the physis and formulated a rudimentary theory of evolution.

Animism The belief that everything in nature is alive. **Anthropomorphism** The projection of human attributes onto nonhuman things.

Aristotle (384–322 B.C.) Believed sensory experience to be the basis of all knowledge, although the five senses and the common sense provided only the information from which knowledge could be derived. Aristotle also believed that everything in nature had within it an entelechy (purpose) that determined its potential. Active reason, which was considered the immortal part of the human soul, provided humans with their greatest potential, and therefore fully actualized humans engage in

active reason. Because everything was thought to have a cause, Aristotle postulated an unmoved mover that caused everything in the world but was not itself caused. (See also Unmoved mover.)

Associationism The philosophical belief that mental phenomena, such as learning, remembering, and imagining, can be explained in terms of the laws of association. (*See also* **Laws of association**.)

Becoming According to Heraclitus, the state of everything in the universe. Nothing is static and unchanging; rather, everything in the universe is dynamic—that is, becoming something other than what it was.

Being Something that is unchanging and thus, in principle, is capable of being known with certainty. Being implies stability and certainty; becoming implies instability and uncertainty.

Common sense According to Aristotle, the faculty located in the heart that synthesizes the information provided by the five senses.

Cosmology The study of the origin, structure, and processes governing the universe.

Democritus (ca. 460–370 B.C.) Offered atoms as the physis. Everything in nature, including humans, was explained in terms of atoms and their activities. His was the first completely materialistic view of the world and of humans.

Dionysiac-Orphic religion Religion whose major belief was that the soul becomes a prisoner of the body because of some transgression committed by the soul. The soul continues on a circle of transmigrations until it has been purged of sin, at which time it can escape its earthly existence and return to its pure, divine existence among the gods. A number of magical practices were thought useful in releasing the soul from its bodily tomb.

Dreaming For Plato, the manifestation of numerous irrational impulses that, while awake, would be under rational control. For Aristotle, the experience of images retained from waking experience. Dreams are often bizarre because the images experienced during sleep are neither organized by our rational powers nor supported by ongoing sensory experience. That dreams sometimes correspond to future events was, for Aristotle, mere coincidence. However, because bodily processes are exaggerated in dreams, physicians can sometimes use dreams to detect the early signs of disease.

Efficient cause According to Aristotle, the force that transforms a thing.

Eidola (plural, eidolon) A tiny replication that some early Greek philosophers thought emanated from the surfaces of things in the environment, allowing the things to be perceived.

Elementism The belief that complex processes can be understood by studying the elements of which they consist.

Empedocles (ca. 490–430 B.C.) Postulated earth, fire, air, and water as the four basic elements from which everything is made and two forces, love and strife, that alternately synthesize and separate those elements. He was also the first philosopher to suggest a theory of perception, and he offered a theory of evolution that emphasized a rudimentary form of natural selection.

Entelechy According to Aristotle, the purpose for which a thing exists, which remains a potential until actualized. Active reason, for example, is the human entelechy, but it exists only as a potential in many humans.

Essence That indispensable characteristic of a thing that gives it its unique identity.

Final cause According to Aristotle, the purpose for which a thing exists.

Formal cause According to Aristotle, the form of a thing.

Forms According to Plato, the pure, abstract realities that are unchanging and timeless and therefore knowable. Such forms create imperfect manifestations of themselves when they interact with matter. It is these imperfect manifestations of the forms that are the objects of our sense impressions. (*See also* **Theory of forms**.)

Galen (ca. A.D.130–200) Associated each of Hippocrates' four humors with a temperament, thus creating a rudimentary theory of personality.

Golden mean The rule Aristotle suggested people follow to avoid excesses and to live a life of moderation.

Gorgias (ca. 485–380 B.C.) A Sophist who believed the only reality a person can experience is his or her subjective reality and that this reality can never be accurately communicated to another individual.

Heraclitus (ca. 540–480 B.C.) Suggested fire as the physis because in its presence nothing remains the same. He viewed the world as in a constant state of flux and thereby raised the question as to what could be known with certainty.

Hippocrates (ca. 460–377 B.C.) Considered the father of modern medicine because he assumed that disease had natural causes, not supernatural ones. Health prevails when the four humors of the body are in balance, disease when there is an imbalance. The physician's task was to facilitate the body's natural tendency to heal itself.

Imagination According to Aristotle, the pondering of the images retained from past experiences.

Inductive definition The technique used by Socrates that examined many individual examples of a concept to discover what they all had in common.

Introspection The careful examination of one's subjective experiences.

Law of contiguity A thought of something will tend to cause thoughts of things that are usually experienced along with it.

Law of contrast A thought of something will tend to cause thoughts of opposite things.

Law of frequency In general, the more often events are experienced together, the stronger they become associated in memory.

Law of similarity A thought of something will tend to cause thoughts of similar things.

Laws of association Those laws thought responsible for holding mental events together in memory. For Aristotle, the laws of association consisted of the laws of contiguity, contrast, similarity, and frequency.

Magic Various ceremonies and rituals that are designed to influence spirits.

Material cause According to Aristotle, what a thing is made of.

Nihilism The belief that because what is considered true varies from person to person, any search for universal (interpersonal) truth will fail. In other words, there is no one truth, only truths. The Sophists were nihilists.

Olympian religion The religion based on a belief in the Olympian gods as they were described in the Homeric poems. Olympian religion tended to be favored by the privileged classes, whereas peasants, laborers, and slaves tended to favor the more mystical Dionysiac-Orphic religion.)

Parmenides (born ca. 515 B.C.) Believed that the world was solid, fixed, and motionless and therefore that all apparent change or motion was an illusion.

Passive reason According to Aristotle, the practical utilization of the information provided by the common sense.

Physicists Those who search for or postulate a physis. **Physis** A primary substance or element from which everything is thought to be derived.

Plato (ca. 427–347 B.C.) First a disciple of Socrates, came under the influence of the Pythagoreans, and postulated the existence of an abstract world of forms or ideas that, when manifested in matter, make up the objects in the empirical world. The only true knowledge is that of the forms, a knowledge that can be gained only by reflecting on the innate contents of the soul. Sensory experience interferes with the attainment of knowledge and should be avoided.

Protagoras (ca. 485–410 B.C.) A Sophist who taught that "Man is the measure of all things." In other words, what is considered true varies with a person's personal experiences; therefore, there is no objective truth, only individual versions of what is true.

Pythagoras (ca. 580–500 B.C.) Believed that an abstract world consisting of numbers and numerical relationships exerted an influence on the physical world. He created a dualistic view of humans by saying that in addition to our body, we have a mind (soul), which through reasoning could understand the abstract world of numbers. Furthermore, he believed the human soul to be immortal. Pythagoras' philosophy had a major influence on Plato and, through Christianity, on the entire Western world.

Rational soul According to Aristotle, the soul possessed only by humans. It incorporates the functions of the vegetative and sensitive souls and allows thinking about events in the empirical world (passive reason) and the abstraction of the concepts that characterize events in the empirical world (active reason).

Recall For Aristotle, the active mental search for the recollection of past experiences.

Reductionism The attempt to explain objects or events in one domain by using terminology, concepts, laws, or principles from another domain. Explaining observable phenomena (domain1) in terms of atomic theory (domain2) would be an example; explaining human behavior and cognition (domain1) in terms of biochemical principles (domain2) would be another. In a sense, it can be said that events in domain1 are *reduced* to events in domain2.

Remembering For Aristotle, the passive recollection of past experiences.

Reminiscence theory of knowledge Plato's belief that knowledge is attained by remembering the experiences the soul had when it dwelled among the forms before entering the body.

Scala naturae Aristotle's description of nature as being arranged in a hierarchy from formless matter to the unmoved mover. In this grand design, the only thing higher than humans was the unmoved mover.

Sensitive soul According to Aristotle, the soul possessed by animals. It includes the functions provided by the vegetative soul and provides the ability to interact with the environment and to retain the information gained from that interaction.

Socrates (ca. 470–399 B.C.) Disagreed with the Sophists' contention that there is no discernible truth beyond individual opinion. Socrates believed that by examining a number of individual manifestations of a concept, the general concept itself could be defined clearly and precisely. These general definitions are stable and knowable and, when known, generate moral behavior.

Solipsism The belief that a person's subjective reality is the only reality that exists and can be known.

Sophists A group of philosopher-teachers who believed that "truth" was what people thought it to be. To convince others that something is true, one needs effective communication skills, and it was those skills that the Sophists taught.

Teleology The belief that nature is purposive. Aristotle's philosophy was teleological.

Temple medicine The type of medicine practiced by priests in early Greek temples that was characterized by superstition and magic. Individuals such as Alcmaeon and Hippocrates severely criticized temple medicine and were instrumental in displacing such practices with naturalistic medicine—that is, medicine that sought natural causes of disorders rather than supernatural

Thales (ca. 625–547 B.C.) Often called the first philosopher because he emphasized natural instead of supernatural explanations of things. By encouraging the critical evaluation of his ideas and those of others, he is thought to have started the Golden Age of Greek philosophy. He believed water to be the primary element from which everything else was derived.

Theory of forms Plato's contention that ultimate reality consists of abstract ideas or forms that correspond to all objects in the empirical world. Knowledge of these abstractions is innate and can be attained only through introspection.

Transmigration of the soul The Dionysiac-Orphic belief that because of some transgression, the soul is compelled to dwell in one earthly prison after another until it is purified. The transmigration may find the soul at various times in plants, animals, and humans as it seeks redemption.

Unmoved mover According to Aristotle, that which gave nature its purpose, or final cause, but was itself uncaused. In Aristotle's philosophy, the unmoved mover was a logical necessity.

Vegetative soul The soul possessed by plants. It allows only growth, the intake of nutrition, and reproduction.

Xenophanes (ca. 560–478 B.C.) Believed people created gods in their own image. He noted that dark-

skinned people created dark-skinned gods and light-skinned people created light-skinned gods. He speculated that the gods created by nonhuman animals would have the characteristics of those animals. He postulated the existence of one all-powerful god without human characteristics but warned that all beliefs are suspect, even his own.

Zeno's paradox The assertion that in order for an object to pass from point A to point B, it must first traverse half the distance between those two points, and then half of the remaining distance, and so forth. Because this process must occur an infinite number of times, Zeno concluded that an object could logically never reach point B.

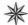

After Aristotle: A Search for the Good Life

A fter Sparta defeated Athens in the Peloponnesian War (431–404 B.C.), the Greek city-states began to collapse, and the Greek people became increasingly demoralized. In this postwar atmosphere, Socrates, Plato, and Aristotle flourished, but a gulf was beginning to develop between philosophy and the psychological needs of the people. Shortly after Aristotle's death (322 B.C.), the Romans invaded Greek territory, making an already unstable situation even more uncertain. In this time of great personal strife, complex and abstract philosophies were of little comfort. A more worldly philosophy was needed—a philosophy that addressed the problems of everyday living. The major questions were no longer, What is the nature of physical reality? or What and how can humans know? but rather, How is it best to live? or What is the nature of the good life? or What is worth believing in? What emerged in response to the latter questions were the philosophies of the Skeptics, Cynics, Epicureans, Stoics, and, finally, the Christians.

SKEPTICISM AND CYNICISM

Both Skepticism and Cynicism were critical of other philosophies, contending that they were either completely false or irrelevant to human needs. As a solution, Skepticism promoted a suspension of belief in anything, and Cynicism promoted a retreat from society.

Skepticism

Pyrrho of Elis (ca. 360–270 B.C.) is usually considered the founder of the school of **Skepticism**, although Skeptics had much in common with the earlier Sophists. There are no extant writings of Pyrrho, and most of what is known of his ideas comes from his disciple Sextus Empiricus, who wrote *Outlines of Pyrrhonism* (Bury, 1990) in the third century A.D.

The Skeptics' main target of attack was dogmatism. For them, a dogmatist was anyone claiming to have arrived at an indisputable truth. The Skeptics believed that the arguments for and against any philosophical doctrine were equally compelling. Because all claims of truth appeared equivocal, the Skeptics advocated a suspension of judgment. They were not dogmatic in their beliefs, however, saying always, This is how things appear to us or This is how things appear to me. They were not affirming or denying any belief; they were only claiming that they were unaware of any reliable criteria for distinguishing among various claims of truth. They held "that no one at all could know anything at all; and with commendable consistency they proceeded to deny that they themselves knew even that distressing fact" (Barnes, 1982, p. 136).

The Skeptics noted that because no matter what one believed it could turn out to be false, one could avoid the frustration of being wrong by simply not believing in anything. By refraining from making judgments about things that could not truly be understood, the Skeptics sought a life of "quietude," "tranquility," or "imperturbability." It was the dogmatists who fought among themselves and lived lives of agitation. So if "truth" did not guide the lives of the Skeptics, what did? They had two primary guides for living: appearances and convention. By appearances, the Skeptics meant simple sensations and feelings. By convention, they meant the traditions, laws, and customs of society. They acknowledged that various substances tasted sweet or bitter, for example, but the essence of "sweetness" or "bitterness" was beyond their comprehension and thus their concern. They acknowledged that various actions brought pleasure or pain,

but concepts of moral goodness or badness were beyond their grasp. In general, appearances (basic sensations and emotions) were acceptable as guides for living, but judgments or interpretations of appearances were not. Their willingness to live in accordance with societal conventions was an extension of their commonsense philosophy.

A modern disciple [of Skepticism] would go to church on Sundays and perform the correct genuflection, but without any of the religious beliefs that are supposed to inspire these actions. Ancient Skeptics went through the whole pagan ritual, and were even sometimes priests; their Skepticism assured them that this behaviour could not be proved wrong, and their common sense ... assured them that it was convenient. (Russell, 1945, p. 233)

Conventions that the Skeptics were willing to accept included "Instruction of the Arts" (Bury, 1990, p. 23; Hankinson, 1995, pp. 293–294). Here, arts refers to the trades and professions available for economic survival within a culture. However, for the Skeptic, work was work and he or she sought in it no ultimate meaning or purpose.

Sextus Empiricus, who was a physician as well as a Skeptic, saw dogmatism as a form of disease that needed to be cured. Some forms of dogmatism were severe and needed powerful treatment (forceful opposing arguments), and others were less severe and could be treated with milder remedies (less forceful arguments) (Bury, 1990, p. 283).

Interestingly, the early Christians were able to use the widespread Skepticism of the Roman world to their advantage: "If the philosopher says that nothing is true or false and that there are not reliable standards of judging, then why not accept Christian revelation and why not revert to faith and custom as the sources of inspiration?" (Kurtz, 1992, p. 41).

The theme of doubt concerning the universal truths exemplified by the Sophists and Skeptics will manifest itself again in romanticism and existentialism (see Chapter 7), in humanistic (third-force)

psychology (see Chapter 18), and in postmodernism (see Chapter 21).

Cynicism

Antisthenes (ca. 445-365 B.C.) studied with the Sophist Gorgias and later became a companion of Socrates. According to Plato, Antisthenes was present at Socrates' death. At some point, however, Antisthenes completely lost faith in philosophy and renounced his comfortable upper-class life. He believed that society, with its emphasis on material goods, status, and employment, was a distortion of nature and should be avoided. Showing a kinship to both the Sophists and Skeptics, Antisthenes questioned the value of intellectual pursuits, saying, for example, "A horse I can see, but horsehood I cannot see" (Esper, 1964, p. 133). Antisthenes preached a back-to-nature philosophy that involved a life free from wants, passions, and the many conventions of society. He thought that true happiness depended on selfsufficiency. It was the quest for the simple, independent, natural life that characterized Cynicism. The following is an account of the type of life that Antisthenes lived after he renounced his aristocratic life:

He would have nothing but simple goodness. He associated with working men, and dressed as one of them. He took to openair preaching, in a style that the uneducated could understand. All refined philosophy he held to be worthless; what could be known, could be known by the plain man. He believed in the "return to nature," and carried this belief very far. There was to be no government, no private property, no marriage, no established religion. His followers, if not he himself, condemned slavery.... He despised luxury and all pursuit of artificial pleasures of the senses. (Russell, 1945, pp. 230–231)

The considerable fame of Antisthenes was exceeded by his disciple **Diogenes** (ca. 412–323

B.C.), the son of a disreputable moneychanger who had been sent to prison for defacing money. Diogenes decided to outdo his father by defacing the "currency" of the world. Conventional labels such as king, general, honor, wisdom, and happiness were social currencies that needed to be exposed —that is, defaced. In his personal life, Diogenes rejected conventional religion, manners, housing, food, and fashion. He lived by begging and proclaimed his brotherhood with not only all humans but also animals. It is said that Alexander the Great once visited him and asked if he could do him any favor; "Only to stand out of my light" was his answer (Russell, 1945, p. 231). Legend also has it that Alexander was so impressed by Diogenes' selfsufficiency and shamelessness that he said, "Had I not been Alexander, I would have liked to be Diogenes" (Branham, 1996, p. 88). Interestingly, Diogenes is reputed to have died in Corinth on June 13, 323 B.C., the same day that Alexander died in Babylon (Long, 1996, p. 45).

Diogenes lived an extremely primitive life and was given the nickname Cynic, which literally means "doglike" (Branham and Goulet-Cazé, 1996, p. 4). In fact, the Cynics argued that nonhuman animals provide the best model for human conduct. First, all the needs of nonhuman animals are natural and, therefore, the satisfaction of those needs is straightforward. Second, nonhuman animals do not have religion.

To Diogenes and his disciples religion seemed to be an obstacle to human happiness, which is why the Cynics considered the state of an irrational creature far preferable to that of men, who suffer the misfortune of having a concept of the gods. (Goulet-Cazé, 1996, p. 64)

Clearly, the primary message of the Cynics was that nature, not social conventions, should guide human behavior. Social conventions are human inventions, and living in accordance with them causes shame, guilt, hypocrisy, greed, envy, and hate, among other things. Therefore, "the Cynic rejects the family and all the distinctions based on sex,

birth, rank, race, or education" (Moles, 1996, p. 116). Also, making sacrifices for others, patriotism, and devotion to a common cause were considered by the Cynics as just plain foolish. Besides individualism, the Cynics typically advocated free love and viewed themselves as citizens of the world rather than of any particular country.

To make his point that "nothing natural can be bad," Diogenes often engaged in what was considered outrageous behavior, "farting loudly in crowded places; urinating, masturbating, or defecating in sight of all" (Krueger, 1996, p. 222). About his habit of masturbating in public, Diogenes said, "I only wish I could be rid of hunger by rubbing my belly" (Branham, 1996, p. 98). Of course, Diogenes rejected the conventional distinction his audience was making between acceptable "private" and "public" activities. Instead, he was demonstrating his belief that "natural desires are best satisfied in the easiest, most practical, and cheapest way possible" (Branham, 1996, p. 89). Again, by rejecting bodily control, Diogenes was rejecting social control (Krueger, 1996, p. 237).

Cynicism became a consistent theme in the history of philosophy. During the time of the Roman Empire, reactions to the character of Diogenes were ambivalent: "Pagans and Christians alike praised Diogenes for his life of voluntary poverty and condemned him for obscenity" (Krueger, 1996, p. 225). We will see later manifestations of Cynicism in the philosophies of Rousseau and Nietzsche (see Chapter 7) and in humanistic psychology (see Chapter 18).

STOICISM

Epicureanism and **Stoicism** were responses to the Skeptics' and Cynics' claims that philosophy had nothing useful to say about everyday life. Both philosophies spoke directly to the moral conduct of humans, and both were based on experience in the empirical world.

Epicureanism

Epicurus of Samos (ca. 341-270 B.C.) based his philosophy on Democritus's atomism but rejected his determinism. According to Epicurus, the atoms making up humans never lose their ability to move freely; hence, he postulated free will. It is important to realize, however, that it was the nature of atoms and atomic activity that gave humans their freedom. not a disembodied soul. Like Democritus, the Epicureans were materialists, believing that "the universe is eminently physical, and that includes the soul of man" (O'Connor, 1993, p. 11). Epicurus also agreed with Democritus that there was no afterlife because the soul was made up of freely moving atoms that scattered upon death. Atoms were never created or destroyed; they were only rearranged. It followed that the atoms constituting an individual would become part of another configuration following the individual's death. However, it was assumed that nothing was retained or transferred from one configuration to another. In this way, Epicurus freed humans from one of their major concerns: What is life like after death, and how should one prepare for it? The good life must be attained in this world, for there is no other. In general, Epicurus believed that postulating supernatural influences in nature was a source of terror for most people and that the idea of immortality destroyed the only hope most people had for finally escaping pain. Epicurus did believe in the Olympian gods, but he thought that they did not concern themselves with the world or with human affairs. The Epicureans preferred naturalistic explanations to supernatural ones, and they strongly protested against magic, astrology, and divination. It was this disbelief in supernatural influences that led Epicurus's passionate disciple Lucretius (ca. 99-55 B.C.) to proudly refer to Epicurus as a "destroyer of religion." In his book On the Nature of Things, Lucretius lamented what he considered the superficial religious practices of his day:

[It is not] piety for a man to be seen, with his head veiled, turning towards a stone, and drawing near to every altar; or to fall prostrate on the ground, and to stretch out

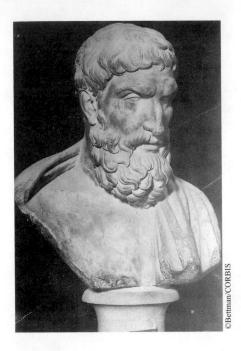

Epicurus

his hands before the shrines of the gods; or to sprinkle the altars with copious blood of four-footed beasts, and to add vows to vows; but it is rather piety to be able to contemplate all things with a serene mind. (J. S. Watson, 1997, p. 236)

Epicurus and his followers lived simple lives. For example, their food and drink consisted mainly of bread and water, which was all right with Epicurus: "I am thrilled with pleasure in the body when I live on bread and water, and I spit on luxurious pleasures, not for their own sake, but because of the inconveniences that follow them" (Russell, 1945, p. 242). Intense pleasure was to be avoided because it was often followed by pain (such as indigestion following eating or drinking too much) or because such uncommon pleasure would make common experiences less pleasant. Thus, the type of **hedonism** (seeking pleasure and avoiding pain) prescribed by Epicurus emphasized the pleasure that results from having one's basic needs satisfied. In this sense, the good life for the Epicurean consisted more of the absence of pain than the presence of pleasure—at least, intense pleasure. Epicurus urged his followers to avoid power and fame because such things make others envious, and they may become enemies. Wise individuals attempt to live their lives unnoticed (O'Connor, 1993, p. 11). Insofar as the Epicureans have been characterized as fun-seeking hedonists, that characterization is inaccurate. Concerning sexual intercourse, Epicurus said, "[It] has never done a man good and he is lucky if it has not harmed him" (Russell, 1945, p. 245). For Epicurus, the highest form of social pleasure was friendship.

We see then that, according to Epicurus, the goal of life was individual happiness, but his notion of happiness was not simple hedonism. He was more interested in a person's long-term happiness, which could be attained only by avoiding extremes. Extreme pleasures are short-lived and ultimately result in pain or frustration; thus, humans should strive for the tranquility that comes from a balance between the lack of and an excess of a thing. Therefore, humans cannot simply follow their impulses to attain the good life; reason and choice must be exercised in order to provide a balanced life, which in turn provides the greatest amount of pleasure over the longest period of time. For Epicurus, the good life was free, simple, rational, and moderate.

Epicureanism survived with diminishing influence for 600 years after the death of Epicurus. As people became increasingly oppressed by the miseries of life, however, they looked to philosophy and religion for greater comfort than was provided by Cynicism, Skepticism, and Epicureanism. The philosophers and theologians responded by becoming increasingly mystical. By the time Christianity emerged, it was believed that the best life was the one beyond the grave, thus completely reversing the Epicurean position.

Stoicism

Because **Zeno of Citium (ca. 335–263 B.C.)** taught in a school that had a *stoa poikile*, or a painted porch, his philosophy came to be known as Stoicism

(Annas, 1994, p. 12). Zeno believed that the world was ruled by a divine plan and that everything in nature, including humans, was there for a reason. The Stoics believed that to live in accordance with nature was the ultimate virtue. The most important derivative of this "divine plan" theory was the belief that whatever happens, happens for a reason; there are no accidents; and all must simply be accepted as part of the plan. The good life involved accepting one's fate with indifference, even if suffering was involved. Indeed, courage in the face of suffering or danger was considered most admirable. You must die, but you need not die groaning; you must be imprisoned, but you need not whine; you must suffer exile, but you can do so with a smile, with courage, and at peace. Your body can be chained, but not your will. In short, a Stoic is a person who may be sick, in pain, in peril, dying, in exile, or disgraced but is still happy: "Every man is an actor in a play, in which God has assigned the parts; it is our duty to perform our part worthily, whatever it may be" (Russell, 1945, p. 264).

The Stoics did not value material possessions highly because they could be lost or taken away. Virtue alone was important. All people were expected to accept their stations in life and perform their duties without question. The joy in life came in knowing that one was participating in a master plan, even if that plan was incomprehensible to the individual. The only personal freedom was in choosing whether to act in accordance with nature's plan. When the individual's will was compatible with natural law, the individual was virtuous. When it was not, the individual was immoral. The Stoics did not solve the problem of how the human will can be free in a completely determined universe. The same problem reemerges within Christianity because an all-knowing, all-powerful God is postulated along with the human ability to choose between good and evil. In fact, both the Stoics and the Christians had trouble explaining the existence of both evil and sinners. If everything in the universe was planned by a beneficent providence, what accounts for evil, the ability to choose evil, and those humans who do so?

Although the Stoics spoke of an individual's ability to choose, their philosophy was (as was that of the Epicureans) completely materialistic. Rational choices were made by a person's soul, which was equated with *pneuma*, a physical substance. It was the properties of *pneuma* that made choice and other psychological events possible. *Pneuma* and body interacted, but this did not represent a mind-body dualism. Rather, it was a body-body dualism: "Only bodies interact; soul and body interact; therefore, soul is body" (Annas, 1994, p. 41).

In the Roman Empire, Stoicism won out over Epicureanism, perhaps because Stoicism was compatible with the Roman emphasis on law and order. The widespread appeal of Stoicism can be seen in the fact that it was embraced by Seneca (ca. 4 B.C.-A.D. 65), a philosopher; Epictetus (ca. A.D. 55-135), a slave; and Marcus Aurelius (A.D. 121-180), an emperor. As long as the Roman government provided minimal happiness and safety, Stoicism remained the accepted philosophy, but the Roman Empire began to fail. There was government corruption, crop failures, economic problems, and barbarian invasions could not be stopped. The people sought a new definition of the good life, one that would provide comfort and hope in perilous times. It was time to look toward the heavens for help.

Before we turn to the Christian alternative, however, let's look briefly at another philosophy that became part of Christian thought.

NEOPLATONISM

Besides Stoicism and Epicureanism, renewed interest in Plato's philosophy appeared in Rome. **Neoplatonism**, however, stressed the most mystical aspects of Plato's philosophy and minimized its rational aspects. The following two examples of Neoplatonist philosophers should make it easy to see why Neoplatonism was very appealing to Christian theologians who sought a philosophical basis for their religion.

One brand of Neoplatonism combined Platonic philosophy with Judaism and, in so doing, created two things lacking in the prevailing religions and philosophies—a concern with individual immortality and human passion.

In spite of the lofty aspirations of Plato and the equally lofty resignation of the Stoic, the literature of the West lacked something [and] no Greek could have named the deficiency.... It required a temper of a different make; it required a people whose God was jealous and whose faith was a flaming fire; in a word, the Greek had thought about himself until he was indifferent to all things and desperately skeptical; the Hebrew had still the fire of passion and the impetuosity of faith: with these he made life interesting and fused in one molten mass the attractive elements of every known doctrine. The result was preeminently unintelligible, but it was inspired. The strength of the new influence lay exactly in that strange fervour which must have seemed to the Greek a form of madness. (Brett, 1912-1921/1965, p. 171)

We see this blending of Platonism and Judaism for the first time in the philosophy of Philo.

Philo

Nicknamed the Jewish Plato, **Philo** (ca. 25 B.C.-A.D. 50) took the Biblical account of the creation of man as the starting point of his philosophy. From that account, we learn that the human body was created from the earth but that the human soul was part of God himself: "Then the Lord God formed man of dust from the ground, and breathed into his nostrils the breath of life; and man became a living being" (Genesis 2:7). Thus, humans have a dual nature: The body is lowly and despicable, and the soul is a fragment of the divine being or, at least, a ray of divine light. The life of an individual human can develop in one of

two directions: downward, away from the inner light and toward the experiences of the flesh; or upward, away from experiences of the flesh and toward the inner light. Philo, like the Pythagoreans and Plato before him, condemned sensory experience because it could not provide knowledge. To this, however, Philo added the belief that sensory experience should be condemned because such experience interferes with a direct understanding of and communication with God.

According to Philo, all knowledge comes from God. To receive God's wisdom, however, the soul (mind) must be purified. That is, the mind must be made free of all sensory distractions. Real knowledge can be attained only when a purified, passive mind acts as a recipient of divine illumination. Humans by themselves know nothing, nor can they ever know anything. God alone has knowledge, and he alone can impart that knowledge.

We see, then, that Philo agreed with Pythagoras and Plato that knowledge cannot be attained via sensory experience. Indeed, for all three philosophers, sensory experience inhibits the attainment of knowledge. Unlike Pythagoras and Plato, however, Philo did not believe that introspecting on the contents of the soul would reveal knowledge. For Philo, knowledge came from a direct, personal relationship with God. Philo described his own experience of receiving the word of God:

Sometimes when I come to my work empty, I have suddenly become full, ideas being in an invisible manner showered upon me and implanted in me from on high; so that through the influence of Divine Inspiration I have become greatly excited, and have known neither the place in which I was nor those who were present, nor myself, nor what I was saying, nor what I was writing; for then I have been conscious of a richness of interpretation and enjoyment of light, a most penetrating sight, a most manifest energy in all that was to be done, having such an effect on my mind as the clearest ocular demonstration would have on the eyes. (Brett, 1912-1921/1965, p. 178)

This statement represented a new view of knowledge, one that would have been foreign to the Greeks. Rather than knowledge being sought rationally, it was revealed by God, but only to souls that were prepared to receive it—that is, to souls that through intense meditation had purged themselves of all influences of the flesh. Again, humans can know only that which God provides. Besides meditation, the soul can receive knowledge from God in dreams and trances because during both the mind is divorced from matters of the world. Thus, to the Pythagorean-Platonic mistrust and dislike of sensory information and the glorification of rationality, Philo added the belief that the soul (mind) is the breath of God within humans and is the means by which God makes himself and his wisdom known to man.

Brett (1912–1921/1965) made the following important observation regarding the philosophy of Philo and all the subsequent philosophies and religions that emphasized the importance of intense, inner experience:

Psychology is lived as well as described; personal experiences go to make its history; to the mind that will strive and believe new worlds may be opened up, and if we find little enough in these writers on the senses or attention or such subjects, they are a mine of information on the life of the spirit... A history of psychology is a history of two distinct things: first, the observation made by men upon one another; secondly, the observations which now and again the more powerful minds are able to make upon themselves. For many a long century after Philo we shall have to record the progress of psychology in both senses. It would be unwise to begin with any prejudices against those subjective data which are incapable of proof; they may seem at last to be the axioms of all psychology. (p. 171)

It would pay to keep Brett's comments regarding the importance of subjective data in mind while reading the remainder of this chapter, if not for the remainder of the book.

Plotinus

Plotinus (ca. 205–270), like Philo, found refuge from a world of woe in the spiritual world: "He was in harmony with all the most serious men of his age. To all of them, Christians and pagans alike, the world of practical affairs seemed to offer no hope, and only the Other World seemed worthy of allegiance" (Russell, 1945, p. 284). Because Plotinus always diverted attention away from his personal life and toward his philosophy, few of the details of his life are known. Only one fact of his early life was confided to his close friends: "That his infantile compulsion to suck his nurse's breast continued till the age of eight, finally surrendering to ridicule" (Gregory, 1991, p. 3).

Plotinus arranged all things into a hierarchy, at the top of which was the One, or God. The One was supreme and unknowable. Next in the hierarchy was the Spirit, which was the image of the One. It was the Spirit that was part of every human soul, and it was by reflecting on it that we could come close to knowing the One. The third and lowest member of the hierarchy was the Soul. Although the Soul was inferior to the One and to the Spirit, it was the cause of all things that existed in the physical world. From the One emanated the Spirit, and from the Spirit emanated the Soul, and from the Soul emanated nature. When the Soul entered something material, like a body, it attempted to create a copy of the Spirit, which was a copy of the One. Because the One was reflected in Spirit, the Spirit was reflected in the Soul, and the Soul created the physical world, the unknowable One was very much a part of nature. Although Plotinus was generally in agreement with Plato's philosophy, he did not share Plato's low opinion of sensory experience. Rather, he believed that the sensible world was beautiful, and he gave art, music, and attractive humans as examples. It was not that the sensible world was evil; it was simply less perfect than the spiritual world.

Even though Plotinus's philosophy was more congenial to sensory information than was Platonism, Plotinus still concluded that the physical world was an inferior copy of the divine realm. He also followed Plato in believing that when the soul entered the body, it merged with something inferior to itself, and thus the truth that it contained was obscured. We must aspire to learn about the world beyond the physical world, the abstract world from which the physical world was derived. It is only in the world beyond the physical world that things are eternal, immutable, and in a state of bliss.

The step from Neoplatonism to early Christianity was not a large or difficult one. To the Christian, the Other World of the Neoplatonists became the kingdom of God to be enjoyed after death. There was to be an important and unfortunate revision in Plotinus's philosophy, however: "[T]here is in the mysticism of Plotinus nothing morose or hostile to beauty. But he is the last religious teacher, for many centuries, of whom this can be said" (Russell, 1945, p. 292).

Like Plato and all other Neoplatonists, Plotinus saw the body as the soul's prison. Through intense meditation, the soul could be released from the body and dwell among the eternal and the changeless. Plotinus believed that all humans were capable of such transcendental experiences and encouraged them to have them because no other experience was more important or satisfying. To the Stoic's definition of the good life as quiet acceptance of one's fate and the Epicurean's seeking of pleasure, we can now add a third suggestion—the turning away from the empirical world in order to enter a union with those eternal things that dwell beyond the world of flesh. Plotinus's theory was not itself Christian, but it strongly influenced subsequent Christian thought.

EMPHASIS ON SPIRIT

The Roman Empire began when Augustus became emperor in 27 B.C., and it lasted for more than 400 years. In 410, the "eternal city" of Rome was sacked

by the Visigoths, and shortly thereafter almost all of the empire was under Germanic control. On September 4, 476, the last Roman emperor—the 16-year-old Romulus Augustulus—was disposed by Odoacer, leader of the German mercenaries. It has become traditional to date the fall of the Roman Empire to 476, although it had been in serious decline for more than 50 years prior to that date.

At the height of its influence, the Roman Empire included the entire Western world, from the Near East to the British Isles. The imperial expansion of the Roman Empire, and then its collapse, brought a number of influences to bear on Roman culture. One such influence came from the religions of India and Persia. Indian Vedantism, for example, taught that perfection could be approximated by entering into semiecstatic trances. Another example is Zoroastrianism, which taught that individuals are caught in an eternal struggle between wisdom and correctness on one hand and ignorance and evil on the other. All good things were thought to derive from the brilliant, divine sun and all bad things from darkness. Also influential were a number of ancient mystery religions that entered the Greek and Roman worlds primarily from the Near East. Three examples are the cults of Magna Mater (Great Mother), Isis, and Mithras (Angus, 1975). The mystery religions (or cults) had several things in common: secret rites of initiation, ceremonies (such as some form of sacrifice) designed to bring initiates into communion with the patron deity or deities, an emphasis on death and rebirth, rituals providing purification and forgiveness of sins (such as confession and baptism in holy water), the confession of sin, sacramental dramas providing initiates the exaltation of a new life, and the providing of a feeling of community among believers. Clearly, there was much in common between the mystery religions and early Christianity (Angus, 1975). Incidentally, the popular god Mithras was said to have been born on December 25 in the presence of shepherds.

Another influence on the early Roman Empire was Greek culture. Generally, the Romans recognized the importance of Greek scholarship and sought to preserve and disseminate it. Although

both Stoicism and Epicureanism became Roman philosophies, they originated in Greek philosophy; this was also true of Neoplatonism. Another major influence on Roman thought was Judaism. The Jews believed in one supreme god who, unlike the rather indifferent Olympian and Roman gods, was concerned with the conduct of individual humans. The Jews also had a strict moral code, and if an individual's conduct was in accordance with this code, God rewarded the person; if it was not, God punished the person. Thus, individuals were responsible for their transgressions. It was from this mixture of many influences that Christianity emerged. The city of Alexandria, in Egypt, provided the setting in which the Eastern religions, the mystery religions, Judaism, and Greek philosophy all combined to form early Christian thought.

Jesus

Although many of the details of his life are subject to debate (see, for example, Wells, 1991, 1996), the Christian religion is centered around **Jesus (ca. 6 B.C.-A.D. 30)**. Jesus taught, among other things, that knowledge of good and evil is revealed by God and that, once revealed, such knowledge should guide human conduct. But Jesus himself was not a philosopher; he was a simple man with limited goals:

Jesus himself had no speculative interest, his concern being primarily with the religious development of the individual. In his attitude to the learned he typified the practical man of simple faith and intuitive insight who trusts experience rather than a book and his heart rather than his head. He knew intuitively what to expect from people and the influences which shape their development of character. A brilliant diagnostician and curer of souls, he had little interest in formalizing or systematizing his assumptions. (Brett, 1912–1921/1965, pp. 143–144)

None of those who formalized Jesus' teachings ever met him. How much of Jesus' original intent

survived the various attempts to formalize his ideas is still a matter of speculation. In any case, those who claimed that Jesus was the son of God came to be called Christians. But before it was to become a dominant force in the Western world, Christianity needed a philosophical basis, and this was provided to a large extent by Plato's philosophy. The early Christian church is best thought of as a blending of the Judeo-Christian tradition with Platonism or, more accurately, with Neoplatonism. This blending occurred gradually and reached its peak with Augustine (discussed later). As the blending of the Judeo-Christian tradition and the Platonic philosophy proceeded, a major shift in emphasis occurred from the rational (emphasized by Greek philosophy) to the spiritual (emphasized in the Judeo-Christian tradition).

St. Paul

The many influences converging on early Christianity are nicely illustrated in the work of St. Paul (ca. A.D.10-64), the first to claim and preach that Jesus of Nazareth was the Messiah. While on the road to Damascus, Paul is said to have had a vision that Jesus was the Messiah foretold by Hebrew prophets. Upon this vision, Saul of Tarsus was converted to Paul, Jesus became the Christ, and Christianity was born. Paul was a Roman citizen whose education involved both Judaic teachings and Greek philosophy. From Judaic tradition, he learned that there was one god who created the universe and shapes the destiny of humans. God is omniscient (knows everything), omnipresent (is everywhere), and omnipotent (has unlimited power). Humans fell from a state of grace in the Garden of Eden, and they have been seeking atonement ever since for this original sin. To these beliefs, Paul added the belief that God had sacrificed his son to atone for our shared transgression—that is, original sin. This sacrifice made a personal reunion with God possible. In a sense, each individual was now able to start life with a clean slate: "For as in Adam all die so also in Christ shall all be made alive" (I Corinthians 15:22). Acceptance of Christ as the savior was the only means of redemption.

In his training in Greek philosophy, St. Paul was especially influenced by Plato. Paul took Plato's notion that true knowledge can be attained only by escaping from the influence of sensory information and transformed it into a battle between the soul, which contains the spark of God, and the desires of the flesh. But then he did something that most Greek philosophers would have found abhorrent: He placed faith above reason. Faith alone can provide personal salvation. The good life is no longer defined in terms of rationality but in terms of our willingness to surrender our existence to God's will. God is the cause of everything, knows everything, and has a plan for everything. By believingby having faith—we affiliate ourselves with God and receive his grace. By living a life in accordance with God's will, we are granted the privilege of spending eternity in God's grace when our mortal coil is shed. For many, given their earthly conditions, this seemed to be a small price to pay for eternal bliss.

Paul's efforts left major questions for future theologians to answer. Given the fact that God is all knowing and all powerful, is there any room for human free will? And given the importance of faith for salvation, what is the function or value of human reason? These questions can be stated in slightly different terms: Given the fact that everything is determined by God's will, why did God apparently give humans the ability to choose? And if we are incapable of understanding God's plan-and, indeed, if it is not necessary for us to do so-why do we possess reasoning powers? There was also a third question: Given the fact that God is perfect and loving, what accounts for the evil in the world? Following St. Paul, theologians were to agonize over these and related questions for many centuries.

The human was now clearly divided into three parts: the body, the mind, and the spirit. As it was for the Pythagoreans, Platonists, and Neoplatonists, the body was the major source of difficulty for early Christians. The spirit was the spark of God within us and was the most highly valued aspect of human nature. Through our spirit, we were capable of becoming close to God, and the spirit was viewed

as immortal. The mind, the rational part of humans, was seen as caught between the body and the spirit—sometimes serving the body, which is bad, and at other times serving the spirit, which is good.

Humans, then, are caught in an eternal struggle between sinful, bodily urges and God's law. The law can be understood and accepted and a desire can exist to act in accordance with it, but often the passions of the body conflict with the law, and they win the struggle. To know what is moral does not guarantee moral behavior. This perpetual struggle results from the fact that humans are animals who possess a spark of God. We are partly animalistic and partly divine; conflict is the necessary consequence. For Paul, all physical pleasure was sinful, but most sinful of all was sexual pleasure. This state of conflict involving the good, the bad, and the rational is very much like the one described by Freud many centuries later.

Paul's Attitude toward Women. It is often said that Paul was guilty of misogyny (hatred of women). This is partly because of his negative attitude toward sex. He glorified celibacy and only reluctantly sanctioned sex even within marriage: "It is a good thing for a man to have nothing to do with women; but because there is so much immorality, let each man have his own wife and each woman her own husband" (1 Corinthians 7:1–3). However, this negative attitude went beyond sex. Paul said,

Let a women learn in silence and with all submissiveness. I permit no woman to teach or to have authority over men; she is to keep silent. For Adam was formed first, then Eve; and Adam was not deceived, but the women was deceived and became a transgressor. (1 Timothy 1:11–14)

And elsewhere Paul said:

As in all the churches of the saints, the women should keep silent in the churches. For they are not permitted to speak, but should be subordinate, as even the law says. If there is anything they desire to

know, let them ask their husbands at home. For it is shameful for a woman to speak in church. (1 Corinthians 14:34–35)

Furthermore, Paul said, man "is the image and glory of God; but woman is the glory of man ... for man was not made from woman, but woman from man (1 Corinthians 11:7–8).

On the other hand, there are elements of gender equality in Paul's writing. For example, he said, "There are no such things as a Jew and Greek, slave and freeman, male and female; for you are all one person in Christ Jesus" (Galatians 3:28). In any case, insofar as Paul believed women were socially and intellectually inferior to men, he was reflecting a belief that was prevalent throughout Roman history (Fagan, 1999, lecture 40). For more on Paul's sometimes conflicting attitudes toward women, see Ehrman, 2003, pp. 38–39; and Maccoby, 1986, pp. 200–203.

In the 300 years following the death of Jesus, there was a gradual increase in the acceptance of Christianity within the Roman Empire. At first, Christianity was mainly the type described by St. Paul—that is, a combination of Judaism and Neoplatonism. Salvation was attained by living a simple, pure life and recognizing the poverty of material things. Concerning the latter, "it has been argued that the Cynics provided an important pagan model for early Christian communities" (Branham and Goulet-Cazé, 1996, p. 19). A confession of sin and ignorance paved the way for eternal salvation through God's grace. As Christianity became increasingly sophisticated, many debates occurred within the church concerning what was true Christian belief and what was heretical. We will sample these debates shortly. Outside the church, pagans (originally the term *pagan* meant "peasant" but came to mean "non-Christian") tended to view Christians as atheists, magicians, and nonconformists (Benko, 1984; Wilken, 2003). As the number of Christians increased, their nonconformity was viewed as a threat by some Roman emperors, and they were sometimes severely persecuted. The first 300 years of Christianity were anything but tranquil.

Emperor Constantine

In 312, the emperor Constantine (ca. 272-337) was said to have had a vision that changed the course of Christian history. Supposedly, just before a major battle (the Battle of the Milvian Bridge), he visualized the Christian cross in the sky accompanied by the words, "By this sign you shall conquer." Kousoulas (1997, pp. 239-244) provides evidence that Constantine actually had no vision but invented it to inspire his troops. In any case, he instructed his soldiers to mark their shields with an abbreviation, in Greek, of the word "Christ," and the next day, although his troops were greatly outnumbered, they won the battle decisively. Constantine attributed his victory to the god of the Christians and, thereafter, concerned himself with Christian affairs. In 313, Constantine signed the Edict of Milan, making Christianity a tolerated religion in the Roman Empire. It should be emphasized that the Edict of Milan did not make Christianity the official religion of the Roman Empire, as is often claimed. Although Constantine clearly came to favor the Christian religion, the purpose of his Edict was to promote religious tolerance within the empire, and he never varied from that position. It was Theodosius I (emperor 379-395) who made Christianity the official religion of the Roman Empire (Ehrman, 2003, p. 251).

In Constantine's time, there were several conflicting versions of Christianity, and this was unacceptable to him. For example, there was debate concerning the nature of Jesus: Was God the Father superior to Jesus the Son, did they have equal status, or was Jesus simply an exceptional individual? To decide the matter, Constantine convened at Nicaea, in 325, a meeting of bishops from throughout the Roman Empire. The Nicaean Council concluded after much bitter debate that God the Father and Jesus the Son had equal status. Thereafter, it was heresy to suggest otherwise. Also, in Constantine's time there was no universally accepted set of documents concerning the life and teachings of Jesus. Rather, different Christian communities used different documents to define their faith. For example, in addition to the four gospels that eventually became

part of the New Testament, there were many that did not. It's not possible to know with certainty how many gospels there were, but 25 to 30 noncanonical Gospels still survive. At the time, the various Christian communities had no uniformity as to gospels these were "Scripture" (Ehrman, 2005, lecture 7). This too was unacceptable to Constantine, and he charged the bishops with the task of arriving at a single set of documents to be used by all Christian communities. Thus was created the "Constantine Bible," which, unfortunately, is lost to history, so its contents are unknown. So what is the origin of the New Testament as we know it today? In fact, it wasn't until 367 that Athanasius (296-373), the controversial and influential bishop of Alexandria, first decreed the 27 books that now constitute the New Testament and only those books be regarded as ca-Although continued nonical. debate Athanasius concerning which books should be included in the New Testament, his decree ultimately became orthodoxy (Ehrman, 2005, lecture 12).

In spite of his deep involvement in the affairs of the Christian church, Constantine continued to embrace a number of pagan beliefs, and it has often been argued that his sympathy toward Christianity was more a matter of political expediency than religious conviction. The Edict of Milan reduced much social turmoil and significantly increased Constantine's power. Also, Constantine was baptized a Christian only on his deathbed, in 337. Scarre (1995) suggests the truth lies somewhere between true belief and political expediency: "There is certainly no reason to doubt that Constantine was a man of sincere religious conviction. But he was also an able propagandist, a gifted military commander, and an unscrupulous and determined manipulator" (p. 213).

Before Constantine, Christianity was very much a minority religion. It has been estimated that Christians constituted only about 5 percent of the population of the Roman Empire and pagans about 95 percent (Ehrman, 2002, lecture 13). However, after Constantine, and largely due to his efforts, a single set of beliefs and documents defined Christianity, and this helped promote its

popularity. Christianity became widely known not only among common people but among intellectuals as well. This awareness by intellectuals caused the further questioning of the tenets of Christianity, and before long it was not enough to accept Christian beliefs simply on faith. Such beliefs needed to be explained, defended, and justified. In other words, Christianity needed a philosophical framework, and it was Augustine, more than anyone, who provided that framework.

For excellent reviews of the intellectual criticisms of Christianity to which Augustine and others responded, see Benko, 1984, and Wilkins, 2003.

St. Augustine

Once Christianity was a tolerated religion, a debate ensued within the church concerning the status of non-Christian (pagan) beliefs. On one side was St. Jerome (ca. 347-420), who argued that non-Christian philosophy should be condemned. On the other side was St. Ambrose (ca. 340-397), who argued that the elements of other philosophies compatible with Christianity should be accepted by the church. St. Ambrose's position was victorious, and its greatest spokesman was St. Augustine (ca. 354-430). It was Augustine who combined Stoicism, Neoplatonism, and Judaism into a powerful Christian worldview that would dominate Western life and thought until the 13th century. The authoritative, theological works of Augustine are often taken as marking the beginning of the Middle Ages, also called the medieval period of history (from the Latin medius, meaning "middle," and aevium, meaning "age").

Augustine concentrated almost exclusively on human spirituality. About the physical world, we need only know that God created it. Augustine shared with the Pythagoreans, Platonists, Neoplatonists, and earlier Christians a contempt for the flesh. When thoughts are focused on God, there is little need for worldly things. Arrival at true knowledge requires the passage from an awareness of the body to sense perception, to an internal knowledge of the forms (universal ideas), and, finally, to an awareness of God, the author of the

forms. For Augustine, as for the earlier Christians, ultimate knowledge consisted of knowing God. The human was seen as a dualistic being consisting of a body not unlike that possessed by animals and a spirit that was close to or part of God. The war between the two aspects of human nature, already present in Platonic philosophy, became the Christian struggle between heaven and hell—that is, between God and Satan.

The Will. God speaks to each individual through his or her soul, but the individual need not listen. According to Augustine, individuals are free to choose between the way of the flesh (Satan), which is sinful, and the way of God. The human ability to choose explains why evil is present in the world: evil exists because people choose it. This, of course, raises the thorny question, Why did God give humans the ability to choose evil? For example, why did God allow the original sin to occur in the Garden of Eden? Concerning such questions Augustine said, "We ought not try to understand more than should be understood" (Bourke, 1993, p. 241).

According to Augustine, people have an **internal sense** that helps them evaluate their experiences by providing an awareness of truth, error, personal obligation, and moral right. Deviation from this internal sense causes the feeling of guilt. In fact, one need not actually *act* contrary to this internal sense to feel guilty but only ponder doing so. Just thinking about doing something sinful will cause as much guilt as actually doing something sinful. All this results in behavior being controlled internally rather than externally. That is, instead of controlling behavior through externally administered rewards and punishments, it is controlled by personal feelings of virtue or guilt.

Does being baptized a Christian and consistently choosing good over evil grant a person access to heaven after his or her death? Not according to Augustine. Since the fall in the Garden of Eden, *all* humans have inherited original sin and are, therefore, worthy of eternal damnation. This is true whether or not we are Christians and choose good over evil in our lifetime. However, according

to Augustine, certain people are, before they are born, chosen by God to eventually enter heaven. In other words, there is nothing people can do in their lifetime that allows them to eventually enter the kingdom of God. Entrance into heaven is determined by God's grace alone. The reason for God's choice concerning those who go to heaven (the elect) and those who do not is incomprehensible to humans and must forever remain a mystery. The fact that some humans are damned is only just because we are all worthy of damnation; the fact that some are granted salvation demonstrates God's mercy. Augustine's doctrine of predestination raised many questions that were never satisfactorily answered. For example, if salvation is a gift from God independent of one's actions, what prevents moral carelessness? (Chadwick, 2001, p. 124). In the centuries following Augustine's death, the doctrine of predestination was frequently debated by Christian theologians. In most cases, the doctrine was rejected in favor of the belief that all humans can earn salvation by accepting Christ as their savior and by avoiding sin during their lifetime. The theologies of Martin Luther (1483-1546) and John Calvin (1509–1564) are examples to the contrary. Both accepted Augustine's doctrine of predestination. We will elaborate Luther's thoughts on this matter in the next chapter. Interestingly, throughout the long history of this debate, both those supporting the doctrine and those opposing it use scripture to defend their positions.

Augustine's Confessions. Augustine was instrumental in shifting the locus of control of human behavior from the outside to the inside. For him, the acceptance of free will made personal responsibility meaningful. Because individuals are personally responsible for their actions, it is possible to praise or blame them, and people can feel good or bad about *themselves* depending on what choices they make. If people periodically chose evil over good, however, they need not feel guilty forever. By disclosing the actual or intended sin (as by confession), they are forgiven and again can pursue the pure, Christian life. In fact, Augustine's *Confessions* (written about 400) describes a long series of his own sins

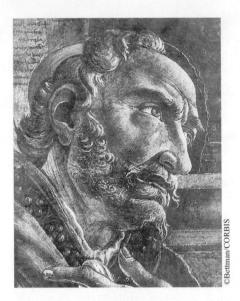

St. Augustine

ranging from stealing for the sake of stealing to the sins of the flesh. The latter involved having at least two mistresses, one of whom bore him a child. When Augustine's mother decided it was time for him to marry, he was forced to abandon his mistress, an event that caused Augustine great anguish.

My concubine being torn from my side as a hindrance to my marriage, my heart which clave unto her was torn and wounded and bleeding. [She left] vowing unto Thee never to know any other man, leaving with me my son by her. (Pusey, 1961, p. 94)

Augustine's marriage had to be delayed for two years because his bride-to-be was so young; however, he took another mistress in the meantime. Augustine was beginning to realize that he was a "wretched young man," and he prayed to God, "Give me chastity and continency, only not yet." His explanation to God for such a prayer was, "I feared lest Thou shouldest hear me too soon, and soon cure me of the disease of [lust], which I wished to have satisfied, rather than extinguished" (Pusey, 1961, p. 125). It was not until he was 32

that Augustine abandoned his lusty ways and converted to Christianity. Following his conversion, Augustine was consumed by the passion to know God, and the rest of his life was lived to that end.

The Christian ideology had wide appeal. To people suffering hunger, plague, and war, a religion that focused on a more perfect, nonphysical world was comforting. To slaves and others with low status, a feeling of justice came from knowing that all humans were created in God's image. The poor were consoled by learning that material wealth was irrelevant to living the good life. Criminals did not need to remain criminals; they could be forgiven and were as likely as anyone to be granted salvation. All humans were part of a brotherhood; our origins were the same, as was our ultimate goal.

Knowing God. For Augustine, it was not necessary to wait for the death of the body to know God; knowledge of God was attainable within an individual's lifetime. Before arriving at this conclusion, Augustine needed to find something about human experience of which he could be certain. He searched for something that could not be doubted and finally concluded that the fact that he doubted could not be doubted. In Book 20, Chapter 10, of *On the Trinity*, Augustine said,

Who ever doubts that he himself lives, and remembers, and understands, and wills and thinks, and knows, and judges? Seeing that even if he doubts, he lives; if he doubts, he remembers why he doubts; if he doubts, he understands that he doubts; if he doubts, he wishes to be certain; if he doubts, he thinks; if he doubts, he knows that he does not know; if he doubts, he judges that he ought not to assert rashly. Whosoever therefore doubts about anything else, ought not to doubt of all these things; which if they were not, he would not be able to doubt of anything. (Hadden, 1912, pp. 133–134)

Thus, Augustine established the validity of inner, subjective experience. (As we will see in Chapter 4,

Descartes used the same technique to arrive at his famous conclusion "I think, therefore I am.") The internal sense, not outer (sensory) experience, could be trusted. For Augustine then, a second way of knowing God (the first being the scriptures) was introspection, or the examination of one's inner experiences. We see here the influence of Plato, who also believed that truth must be attained through introspection. Augustinian introspection, however, became a means of achieving a personal communion with God. According to St. Augustine, the feeling of love that one experiences when one is contemplating God creates an ecstasy unsurpassed among human emotions. Such a feeling is the primary goal of human existence; anything that is compatible with achieving such a state of ecstasy is good, whereas anything that distracts from its achievement is bad. Faith and a personal, emotional union with God were, for Augustine, the most important ingredients of human existence. Reason, which had been supreme for the Greeks, became inferior not only to faith but also to human emotion. Reason remained in an inferior position for almost 1,000 years, during which time the writings of Augustine prevailed and provided the cornerstone of church dogma. Augustine had demonstrated that the human mind could know itself without confronting the empirical world. Because the Holy Spirit dwelled in this realm of pure thought, intense, highly emotional introspection was encouraged. Such introspection carried the individual farther away from the empirical world.

Augustine's Analysis of the Experience of Time. Augustine's *Confessions* is an extended conversation with God in which he often asks God's help in solving the mysteries of human existence. One such mystery is the experience of time. God, he observed, has no sense of time because he lives in the eternal present. Mortals, however, have conceptions of the past, present, and future, and therein lies the mystery. We claim to measure how long in the past an event occurred, but past events no longer exist and therefore cannot be measured. We claim to measure how far in the future a forthcoming event is, but future events do not yet exist and therefore cannot be measured. Even the present, which is the fleeting

moment between the future and the past, occurs too quickly to be measured. "We measure neither times to come, nor past, nor present, nor passing; and yet we do measure times" (Pusey, 1961, p. 203). It was clear to Augustine that the terms past, present, and future could not refer to the physical world. What then accounts for the human experiences of past, present, and future? Augustine's answer was surprisingly modern.

It is in thee, my mind, that I measure times.... The impression, which things as they pass by cause in thee, remains even when they are gone; this it is which still present, I measure, not the things which pass by to make this impression. (Pusey, 1961, p. 203)

For Augustine, then, the experience of time depended on sensory experience and the memory of sensory experience. In a sense, humans, like God, experience only the present. The past is the presence in the mind of things remembered, and the future is the present anticipation of events based on the memory of past experience. The present is simply current sensory experience.

Augustine wrote extensively on memory, and some of his observations were not unlike those that emerged later in modern empiricism (see Chapter 5). An example is his concept of the memory trace, which he described as follows:

Although when past facts are related, there are drawn out the memory, not the things themselves which are past, but words which, conceived by the images of the things, they, in passing, have through the senses left as traces in the mind. (Pusey, 1961, p. 197)

THE DARK AGES

Some historians mark the beginning of that portion of the Middle Ages known as the Dark Ages with the sack of Rome by the Visigoths in 410; others with the death of Augustine in 430; and others with the

abdication of the last Roman emperor in 476. In any case, it is about this time in history when Greek and Roman books were lost or destroyed; little or no progress was made in science, philosophy, or literature; uniform Roman law collapsed and was replaced by a variety of local customs; and villages armed themselves against attack from both their neighbors and invaders from afar. During all this uncertainty, or perhaps because of it, the Christian church became increasingly powerful. From about 400 to 1000, Europe was dominated by mysticism, superstition, and anti-intellectualism; Europe was generally dark.

Because church dogma was no longer challengeable, it wielded tremendous power during the Dark Ages. The questions with which the church grappled concerned inconsistencies within church doctrine. The question of what was true had already been answered, and there was no need to look elsewhere. People were either believers or heretics, and heretics were dealt with harshly. The church owned vast properties; the pope could make or break kings; and priests controlled the behavior, feelings, and thoughts of the citizens. The eight crusades (1095–1291) against the Muslims showed Christianity's power to organize its followers to stop the Islamic influence that had been spreading so rapidly throughout Europe.

It was during these "holy wars" that Aristotle's writings were rediscovered. Many centuries earlier, mainly because of the conquests of Alexander the Great, the Greek influence had been spread over a large area in which Greek philosophy, science, and art came to flourish. In fact, many believe that the Greeks overextended themselves and were thus unable to control their empire. When the Romans began to invade this empire, Greek scholars fled into territories later conquered by the Muslims. These scholars carried with them many Greek works of art and philosophy, among them the works of Aristotle. Aristotle's works were preserved in the great Islamic universities and mosques and were used to develop Islamic philosophy, religion, mathematics, and medicine. The Muslim armies moved west, and the Christian armies moved east. The clash between the two resulted in the bloody holy wars, but it also brought the West back into

contact with Aristotle's philosophy. At first, church authorities welcomed Aristotle's writings; then, after more careful analysis, they banned the works. It was clear that for Aristotle's thoughts to be "accepted," they needed to be Christianized.

Long before Aristotle's writings were rediscovered by the West, however, the Muslims were benefiting greatly from them. In fact, more than 200 years before the West attempted to Christianize Aristotle's philosophy, several Muslim philosophers busied themselves attempting to make it compatible with Islam.

THE ISLAMIC AND JEWISH INFLUENCES

Although the years between about 400 and 1000 are often referred to as the Dark Ages, they are dark only with reference to the Western world. During this time, Islam was a powerful force in the world. Muhammad was born in Mecca in 570, and in middle age, believers say he received a revelation from God instructing him to preach. He called his religion Islam, which means "surrender to God," and his followers were called Muslims (or Moslems). His teachings are contained in the Koran. Islam spread with incredible speed, and within 30 years of Muhammad's death in 632, the Muslims had conquered Arabia, Syria, Egypt, Persia, Sicily, and Spain. Within 100 years after the prophet's death, the Islamic empire extended over an area larger than that of the Roman Empire at its peak (R. I. Watson, 1978, p. 106). This expansion brought the Muslims into contact with ancient works long lost to the Western world. Islamic philosophers translated, studied, and expanded on the ancient wisdom of Greece and Rome, and the writings of Aristotle were of special interest. By utilizing this wisdom, the Muslims made great strides in medicine, science, and mathematics-subjects that were of greatest interest during the expansion of the Islamic empire because of their practical value. When conditions stabilized, however, there was greater interest in making the ancient wisdom compatible with Islam. Although these efforts focused mainly on Aristotle's philosophy, Neoplatonism was also examined. The Arabic translations of the Greek and Roman philosophers, and the questions raised in attempting to make this ancient wisdom compatible with Islam, were used many years later when the Christians attempted to make them compatible with Christianity. In a surprising number of ways, the two efforts were similar.

Avicenna

There were many outstanding Muslim philosophers, but we will briefly consider only two. Avicenna (Persian name, Ibn Sinä; 980–1037) was a child prodigy who had memorized the Koran by the age of 10. As an adolescent, "he had read Aristotle's Metaphysics forty times and could practically recite it by heart" (Goodman, 1992, p. 38). He became a physician before he was 20, and as a young adult was considered the best of the Muslim physicians (Alexander and Selesnick, 1966, p. 63). He wrote books on many topics, including medicine, mathematics, logic, metaphysics, Islamic theology, astronomy, politics, and linguistics. His book on medicine, The Canon, was used in European universities for more than five centuries (S. Smith, 1983). In most of his work, he borrowed heavily from Aristotle, but he made modifications in Aristotle's philosophy that persisted for hundreds of years.

In his analysis of human thinking, Avicenna started with the five external senses-sight, hearing, touch, taste, and smell. Then he postulated seven "interior senses," which were arranged in a hierarchy. First is the common sense, which synthesizes the information provided by the external senses. Second is retentive imagination, the ability to remember the synthesized information from the common sense. The third and fourth are compositive animal imagination and compositive human imagination. Compositive imagination allows both humans and animals to learn what to approach or avoid in the environment. For animals, this is a strictly associative process. Those objects or events associated with pain are subsequently avoided, and those associated with pleasure are subsequently

approached. Human compositive imagination, however, allows the creative combination of information from the common sense and from the retentive imagination. For example, humans can imagine a unicorn without ever having experienced one; nonhuman animals do not possess this ability. Fifth is the estimative power, the innate ability to make judgments about environmental objects. Lambs may have an innate fear of wolves, and humans may have an innate fear of spiders and snakes, or there may be a natural tendency to approach the things conducive to survival. Sixth is the ability to remember the outcomes of all the information processing that occurs lower in the hierarchy, and seventh is the ability to use that information.

Although Aristotle postulated only three internal senses (common sense, imagination, and memory) and Avicenna seven, Avicenna was essentially an Aristotelian. His major departure from Aristotle's philosophy concerns the active intellect. For Aristotle, the active intellect was used in understanding the universal principles that could not be gained by simply observing empirical events. For Avicenna, the active intellect took on supernatural qualities; it was the aspect of humans that allowed them to understand the cosmic plan and to enter into a relationship with God. For Avicenna, an understanding of God represented the highest level of intellectual functioning.

As a physician, Avicenna employed a wide range of treatments for physical and mental illnesses. For example, he attempted to treat melancholic patients by reading to them or by using music as therapy. At times, he even tried to frighten patients out of their ailments. Alexander and Selesnick (1966) give the following example:

When one of his patients claimed he was a cow and bellowed like one, Avicenna told the patient that a butcher was coming to slaughter him. The patient was bound hand and foot; then Avicenna proclaimed that he was too lean and had to be fattened, and untied him. The patient began to eat enthusiastically "gained strength, gave up the delusion, and was cured." (p. 64)

Avicenna's work had great significance for subsequent philosophical development in the West: "Had it not been for Avicenna and his colleagues in the Islamic world of the eleventh century, the philosophical achievements of twelfth- and thirteenth-century Europe—achievements based so sturdily upon Aristotelianism—are nearly unimaginable" (D. N. Robinson, 1986, p. 145).

Averroës

Averroës (Persian name, Ibn Rushd; 1126–1198) disagreed with Avicenna that human intelligence is arranged in a hierarchy with only the highest level enabling humans to have contact with God. According to Averroës, all human experiences reflect God's influence. In almost everything else, though, Averroës agreed with Avicenna, and he too was basically an Aristotelian. Averroës's writings are mainly commentaries on Aristotle's philosophy, with special emphasis on Aristotle's work on the senses, memory, sleep and waking, and dreams. Also, following Aristotle, Averroës said that only the active intellect aspect of the soul survives death,

Courtesy or t

Avicenna

and because the active intellect is the same for everyone, nothing personal survives death. This was, of course, contrary to Christian thought, and Averroës's interpretation of Aristotle was labeled Averroism and was severely attacked by later Christian philosophers.

Although Averroës was known primarily for his philosophical work, he also made a number of impressive scientific contributions. For example, Crombie (1961) credits him with discovering that the retina, not the lens, is the light-sensitive part of the eye. He was also among the first to observe that those afflicted with smallpox and who survived were thereafter immune to the disease, thus suggesting inoculation as a way of preventing disease.

Maimonides

Maimonides (or Moses ben Maimon; 1135–1204) was a Jew born on March 30 in Cordova, Spain, where, at the time, Jews and Muslims lived in harmony. (Incidentally, Averroës was also born in Cordova at about the same time as Maimonides.) Maimonides, in addition to being a biblical and talmudic scholar, was a physician who, among other things, anticipated the modern concern with psychosomatic disorders by showing the relationship between ethical living and mental health (Alexander and Selesnick, 1966, p. 64).

As the writings of ancient philosophers, especially those of Aristotle, became more widely available, tension increased between philosophy and religion. Maimonides wrote The Guide for the Perplexed (Friedländer, 1956) for scholars who were confused by the apparent conflict between religion and the scientific and philosophical thought of the day. Specifically, Maimonides sought a reconciliation between Judaism and Aristotelian philosophy. He attempted to show that many passages from the Old Testament and the Talmud could be understood rationally and, therefore, need not be taken on faith alone. Other passages were to be understood only as allegory and not taken as literally true. Maimonides went so far as to say that if something is demonstrably false, it should be rejected, even if it is stated as true in the Bible or the Talmud. For example, when he was asked his opinion of astrology, which is mentioned in the Bible and the Talmud as true, Maimonides said,

Man should only believe what he can grasp with his intellectual faculties, or perceived by his senses, or what he can accept on trustworthy authority. Beyond this nothing should be believed. Astrological statements, not being founded on any of these sources of knowledge must be rejected. (Friedländer, 1956, p. xxv)

Like the Muslim philosophers, Maimonides' efforts to reconcile faith and reason, or more specifically, Judaism and Aristotelianism, were to substantially influence Christian theologians when they would later attempt to do the same for their religion.

It was almost time for the Western world to assimilate Aristotelianism into its religious beliefs, but an intermediate step needed to be taken. Human reasoning powers, which had been minimized in St. Augustine's philosophy but were so important in Aristotle's philosophy, had to be made respectable again. Reason and faith had to be made compatible. We will cover only two of the philosophers who took on this important task.

RECONCILIATION OF CHRISTIAN FAITH AND REASON

St. Anselm

In Faith Seeking Understanding, (Deane, 1962), St. Anselm (ca. 1033–1109) argued that perception and reason can and should supplement Christian faith. Although St. Anselm was basically an Augustinian, his acceptance of reason as a means of understanding God represented a major departure from Christian tradition, which had emphasized faith. St. Anselm exemplified how reason could be used within the Christian faith with his

famous ontological argument for the existence of God (see Deane, 1962). This is a complex argument, but essentially it says that if we can think of something, something must be causing the thought. That is, when we think of things, there must exist real things corresponding to those thoughts (reification). St. Anselm beckoned us to continue thinking of a being until we could think of no better or greater a being "than which nothing greater can be conceived." This perfect being that we have conjured up is God, and because we can think of him. he exists. Of course, the existence of the devil can be "proved" by applying the same logic in reverse. St. Anselm was one of the first Christian theologians to attempt to use logic to support religious belief. St. Anselm, like all the Christian theologians at the time, was attempting to support what he already believed to be true. In other words, faith preceded efforts to understand. Addressing God, St. Anselm said,

I long to understand in some degree thy truth, which my heart believes and loves. For I do not seek to understand that I may believe, but I believe in order to understand. For this also I believe—that unless I believe, I should not understand. (Deane, 1962, p. 53)

St. Anselm's ontological argument for the existence of God was highly influential and was later accepted by such notable philosophers as Descartes and Leibniz (Treash, 1994, p. 12). On the other hand, the argument has been a target of criticism for centuries (see, for example, Deane, 1962) and continues to be (see, for example, Bencivenga, 1993). Others, however, believe Anselm's argument has been misunderstood and has considerable validity (see, for example, Hartshorne, 1965).

Peter Lombard

Also an Augustinian, **Peter Lombard (ca. 1095–1160)** argued even more forcefully for the place of reason within Christianity than did St. Anselm. Perhaps even more important, Lombard insisted

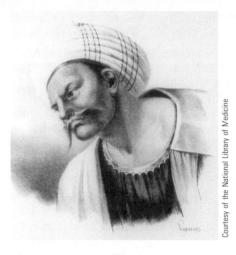

Averroës

that God could be known by studying his works. There is no need to escape from the empirical world to understand God; one can learn about God by studying the empirical world. Thus, for Lombard, there were three ways to learn about God: faith, reason, and the study of God's works (the empirical world). Philosophers such as St. Anselm and Lombard helped create a receptive atmosphere for the works of Aristotle, which were about to have a major and long-lasting impact on Western philosophy.

SCHOLASTICISM

The holy wars had brought the Western world into contact with the works of Aristotle. The question now was what to do with those works. The reaction of the church to the recovered works from antiquity occurred in three stages. At first the works were welcomed, but when the inconsistencies with church dogma were realized, the works were condemned as pagan. Finally, efforts were made to modify the works, especially those of Aristotle, and in modified form, they were incorporated into church dogma. Some of the keenest minds in the history of Western thought took on the monumental tasks of synthesizing Aristotle's philosophy

and Christian theology and showing what implications that synthesis had for living one's life. This synthesis came to be called **Scholasticism**.

Peter Abelard

Peter Abelard (1079-1142) marks the shift toward Aristotle as the philosopher in Western philosophy. In addition to translating Aristotle's writings, Abelard introduced a method of study that was to characterize the Scholastic period. In his book Sic et Non (sometimes translated as For and Against and sometimes as Yes and No), Abelard elaborated his dialectic method. He listed some 158 theological questions that were answered in contradictory ways by scripture and by various Christian theologians. Abelard believed that examining arguments and counterarguments was a good way of clarifying issues and of arriving at valid conclusions. His goal was not to contradict church dogma but to overcome inconsistencies in the statements made by theologians through the years. Using his dialectic method, he pitted conflicting authorities against one another; but through it all, the authority of the Bible was expected to prevail. The dialectic method was controversial because it sometimes seemed to question the validity of religious assumptions. Abelard was not overly concerned about this issue, however, because he believed that God existed and therefore all methods of inquiry should prove it. The believer, then, has nothing to fear from logic, reason, or even the direct study of nature.

Realism versus Nominalism. During Abelard's time, there was great debate over whether universals existed—that is, whether there really are essences such as "catness," "humanness," or "sweetness" independent of individual instances of such things. One side said yes, such essences do exist in pure form and individual members of such classes differ only by accident. Those claiming that universals and essences had a real, independent existence were called realists. The other side said that what we call universals are nothing more than verbal labels allowing the grouping of

objects or events that resemble one another. To these nominalists, what others call universals are nothing more than convenient verbal labels that summarize similar experiences. The debate was profound because both the philosophies of Plato and Aristotle accepted **realism**. **Nominalism** was much more in accordance with empirical philosophy than it was with rationalism.

At this time, the cathedral school of Notre Dame, in Paris, was the most famous school in Christendom, and William of Champeaux was its most famous teacher. His lecture hall was typically filled with students from all over Europe, and "the excitement produced by his brilliant discourses sometimes ran so high that the civil authorities were obliged to interfere in the interests of good order" (Luddy, 1947, p. 3). At the age of 20, Abelard decided to debate William on the matter of realism versus nominalism. William was a devout and informed realist, but Abelard, using his considerable skills in rhetoric and logic, skillfully exposed the fallacies in William's position. The main thrust of Abelard's argument was that we should not confuse words with things. The conclusions reached when logic is applied to words do not necessarily generalize to the physical world. When applied to the debate concerning universals, this meant that just because we use words to describe and understand universals, and even use words to logically deduce their existence, it does not necessarily follow that they actually exist. Abelard argued that logic and physics were two different disciplines, and he wanted to keep them sharply separate. Abelard accused William of confusing the two disciplines, and in the process, committing the fallacy of reification (believing that if you can name something, there must necessarily be something real that corresponds to the name).

In a way reminiscent of Socrates, and somewhat of Aristotle, Abelard proposed **conceptualism** as a compromise between realism and nominalism. He argued that universal essences do not exist but similarities among categories of experiences do. For example, all instances of things we call beautiful have something in common. Based on the commonalities, we form the *concept* of beauty. Thus, concepts summarize individual ex-

periences (nominalism) but, once formed, concepts, in a sense, exist apart from the individual experiences upon which they were formed (realism). Radice (1974) summarizes Abelard's conceptualism as follows: "Universals were neither realities nor mere names but the concepts formed by the intellect when abstracting the similarities between perceived individual things" (p. 14). Abelard's position has been referred to as moderate realism, but clearly it was more in the nominalist's camp than it was in the realist's.

At first, William was full of admiration for Abelard as a promising young student, but he became increasingly annoyed: "The upshot of the matter was that the world's most famous professor felt obliged to modify his doctrine under pressure from this ... stripling of twenty" (Luddy, 1947, p. 4). Having conquered William, Abelard decided to study theology with the famous Anselm, and Abelard was not impressed by him either.

A few lectures gave him enough of the Doctor of Doctors [Anselm], whom ... he found eloquent enough, but utterly devoid of sense and reason. He compares the unfortunate professor to a barren fig-tree, abounding in leaves, but bare of fruit; and to a greenwood fire that blinds us with smoke instead of giving us light. (Luddy, 1947, p. 5)

Anselm suffered greatly from his clash with Abelard and died soon afterward.

Abelard decided to open his own school, and as a teacher he displayed "a most amazing originality, vivacity and versatility" (Luddy, 1947, p. 6). Soon Abelard, or "Master Peter" as his students called him, was so famous a teacher that the classrooms of the older professors were essentially empty:

His eloquence, wit and power of luminous exposition, his magnificent voice, noble bearing, and beauty of face and figure, his boldness in criticising the most venerable authorities and attempting a natural solution of the mysteries of faith: all combined to make him beyond comparison the most

popular teacher of his age. (Luddy, 1947, pp. 6–7)

Abelard's Relationship with Heloise. And so continued Abelard's fame and glory until, at the age of 42, he met Heloise, a girl of 17. As a canon of Notre Dame, Abelard's fame and influence as a teacher brought him wealth and distinction, which pleased his friends but angered his enemies, such as his old teacher, William of Champeaux. However, for Abelard success created a problem:

Success always puffs up fools with pride, and worldly security weakens the spirit's resolution and easily destroys it through carnal temptations. I began to think myself the only philosopher in the world, with nothing to fear from anyone, and so I yielded to the lusts of the flesh. (Radice, 1974, p. 65)

Heloise was the bright and beautiful niece of another canon of Notre Dame named Fulbert. By his own admission, when Abelard first saw Heloise, he set out to seduce her. Heloise's uncle, who loved her dearly, was very much interested in continuing her education, and being aware of Abelard's considerable skill as a scholar and teacher, he struck a deal with Abelard. The uncle offered Abelard room and board in his (and Heloise's) home if Abelard would agree to tutor his niece. Abelard was astonished at the canon's naïveté: "I was amazed by his simplicity—if he had entrusted a tender lamb to a ravening wolf it would not have surprised me more" (Radice, 1974, p. 67). Abelard described what happened next:

With our lessons as a pretext we abandoned ourselves entirely to love. Her studies allowed us to withdraw in private, as love desired, and then with our books open before us, more words of love than our reading passed between us, and more kissing than teaching. My hands strayed oftener to her bosoms than to the pages; love drew our eyes to look on each other more than reading kept them on our texts. To avert

suspicion I sometimes struck her, but these blows were prompted by love and tender feeling rather than anger and irritation, and were sweeter than any balm could be. In short, our desires left no stage of love-making untried, and if love could devise something new, we welcomed it. We entered on each joy the more eagerly for our previous inexperience, and were the less easily sated. (Radice, 1974, pp. 67–68)

The "tutoring" went on for several months before Heloise's uncle found out what was really happening and threw Abelard out of the house. When Heloise announced her pregnancy, Abelard took her to his sister's home where she eventually gave birth to their son. Astralabe. Abelard offered to marry Heloise, but she at first refused because she believed that marriage would damage his chances of advancement within the church. In addition, both had a low opinion of marriage and cited scripture, church authorities, and a number of practical concerns to support that opinion. So, Heloise would have preferred to remain Abelard's mistress, saving that she preferred "love to wedlock and freedom to chains" (Radice, 1974, p. 114). To emphasize her point, Heloise famously said,

God is my witness that if Augustus, Emperor of the whole world, thought fit to honour me with marriage and conferred all the earth on me to possess for ever, it would be dearer and more honourable to me to be called not his Empress but your whore. (Radice, 1974, p. 114)

The situation became so complicated, however, that marriage became necessary, and they were married in Paris. For various reasons, Abelard wanted to keep the marriage a secret, and Heloise's uncle wanted it known for fear of Heloise's reputation. Finally, Abelard could stand the strain no longer, and he dressed Heloise in a nun's habit and took her to a convent, where she could appear to be a nun without actually taking vows. There, Abelard would secretly visit his loved one from time to time.

Believing that Abelard had forced Heloise to become a nun to cover his own sins, her uncle's wrath became uncontrollable. Abelard described the action taken by the uncle and some of his aides:

One night as I slept peacefully in an inner room in my lodging, they bribed one of my servants to admit them and took cruel vengeance on me of such appalling barbarity as to shock the whole world; they cut off the parts of my body whereby I had committed the wrong of which they complained. (Radice, 1974, p. 75)

Other than for the obvious reasons, this particular form of punishment for his sins was especially distressing for Abelard because he recalled passages of the Bible that condemned castrated individuals. For example, "He whose testicles are crushed or whose male member is cut off shall not enter the assembly of the Lord (Deuteronomy 23:1). Incidentally, two of those responsible for Abelard's castration were caught, blinded, and themselves castrated" (Radice, 1974, p. 75).

Abelard became a monk, Heloise became a nun, and their future intercourse was limited to romantic and spicy love letters.

After recovering from his ordeal, Abelard resumed his studies and his teaching using the dialectic method. This controversial method and his abrasive manner again led to trouble with church authorities. In 1140, Pope Innocent II ordered Abelard to stop teaching and writing, and within a few years he died a lonely and bitter man. Heloise became the widely respected and influential abbess of the Paraclete, a school and monastery founded many years earlier by Abelard. The Paraclete survived as a center of learning until the French Revolution. Heloise outlived Abelard by some 21 years and was buried beside him at the Paraclete. Little is known about the fate of their son (Radice, 1974, p. 43).

St. Albertus Magnus

St. Albertus Magnus (ca. 1200–1280) was one of the first Western philosophers to make a comprehensive review of both Aristotle's works and the Islamic and Jewish scholars' interpretations of them. This was no mean feat, considering that the church still regarded Aristotle as a heretic. Magnus presented Aristotle's views on sensation, intelligence, and memory to the church scholars and attempted to show how human beings' rational powers could be used to achieve salvation. Following Aristotle, Magnus performed detailed observations of nature, and he himself made significant contributions to botany. He was among the first since the Greeks to attempt to learn about nature by making careful, empirical observations. But as instrumental as Abelard and Magnus were in bringing Aristotle's philosophy into the Christian tradition, the greatest Scholastic of all was St. Thomas Aquinas.

St. Thomas Aquinas

St. Thomas Aquinas (1225-1274) was a large, introspective person, whom his fellow students referred to as the dumb ox. He came from a distinguished, aristocratic family, and his father had considerable influence at the Benedictine abbey of Monte Cassino, which was only a few miles from their castle home. It was assumed that following his training for the priesthood, Aquinas would return to Monte Cassino, where the family's influence would help him become abbot. Instead, he joined the Dominican order and became a begging friar. With this decision, Aquinas turned his back on family wealth and power and reduced his chances of advancement within the church hierarchy. His father had already died, but his mother was so angered by Aquinas's choice that she and a group of relatives kidnapped and imprisoned him in their family castle for about a year. Strangely enough, the imprisonment did not anger him. In fact, he spent the time attempting to convert his family members. Aquinas did become angry, however, when his brothers tested his willingness to remain chaste by slipping a seductive prostitute into his prison quarters. He drove her from the room with a hot iron from the fire. He was more upset that his brothers believed that something so mundane would tempt him than he was by the temptation itself. In 1245, Aguinas was set free by his family,

and he returned to the Dominicans. As a student, Aquinas was prodigious. The University of Paris had a rule that a doctorate in theology could not be earned until after one's 34th birthday. An exception was made in Aquinas's case, however, and the degree was given to him at the age of 31. He was then appointed to one of the two Dominican chairs at the University of Paris.

Aquinas did as much as anyone to synthesize Aristotle's philosophical works and the Christian tradition. This was a major feat, but it had an important negative aspect. Once Aristotle's ideas were assimilated into church dogma, they were no longer challengeable. In fact, Aristotle's writings became almost as sacred as the Bible. This was unfortunate because much of what Aristotle had said later turned out to be false. With Aristotle, as earlier with Plato, the church emphasized those ideas that were most compatible with its theology. Ideas that were not compatible were either changed or ignored. Although this Christianization was easier to perform with Plato's philosophy than with Aristotle's, Aristotle had said several things that, with minor shifts and embellishments, could be construed as supporting church doctrine—for example, his thoughts on the immortality of active reason, on the scala naturae (the hierarchical design of nature), on the earth being the center of the universe, and on the unmoved mover.

The Reconciliation of Faith and Reason. Aristotelian emphasis on reason was so great that it could not be ignored. After all, the huge body of information Aristotle had generated was a product of empirical observation guided by reason. This emphasis on reason placed the church in a difficult position because, from its inception, it had emphasized revelation, faith, and spiritual experience and minimized empirical observation and rationality. It turned out that Aguinas's greatest task (and achievement) was the reconciliation of faith and reason, which he accomplished by arguing effectively that reason and faith are not incompatible. For him, as for the other Scholastics, all paths led to the same truth—God and his glory. Thus, God could now be known through revelation; through scripture; through examination of inner experience;

or through logic, reason, and the examination of nature.

Although sensory information was again accepted as an accurate source of knowledge, Aguinas, following Aristotle, said that the senses could provide information only about particulars, not about universals, which reason must abstract from sensory information. Reason and faith cannot conflict because both lead to the same ultimate reality, God. The philosopher uses logical proof and demonstration to verify God's existence, whereas the Christian theologian takes the existence of God on faith. Each arrived at the same truth but by different means. Aguinas spent considerable time discussing the differences between humans and lower animals. The biggest difference he recognized was that nonhuman animals do not possess rational souls and therefore determined that salvation is not available to them.

Aguinas's synthesis of Aristotelian and Christian thought was bitterly argued within the church. Earlier in this chapter, we saw that the conservative members of the early Christian church (such as St. Jerome) argued that non-Christian philosophers should be condemned and ignored. Augustine argued, however, that as much non-Christian philosophy as possible should be assimilated into church dogma. Augustine won the debate. Now, some 900 years later, we have a similar debate over the works of Aristotle. One of the most influential voices of conservatism was St. Bonaventure (ca. 1217-1274), who condemned the works of Aristotle. Bonaventure, following Augustine, believed that one comes to know God through introspection, not through reasoning or by studying nature. Aguinas's position prevailed, however, and was finally accepted as official church doctrine. With some modifications, it remains the philosophical cornerstone of Catholicism to this day. The view represented by Bonaventure lives on in Protestantism. where scripture is valued more highly than reason and a personal relationship with God is valued more highly than ritual and church prescriptions.

Aquinas's Influence. Aquinas's work eventually had several effects: It divided reason and faith, mak-

ing it possible to study them separately. It made the study of nature respectable. And it showed the world that argument over church dogma was possible. Although his goal was to strengthen the position of the church by admitting reason as a means of understanding God, Aquinas's work had the opposite effect. Several philosophers following Aquinas argued that faith and reason could be studied without considering its theological implications. Philosophy without religious overtones was becoming a possibility—a possibility that had not existed for well over a thousand years.

Aquinas at least partially shifted attention away from the heavens and back to earth, although his emphasis was still on the heavens. This shift had to occur before the Renaissance could take place. The Renaissance was still in the future, however, and the church still controlled most human activities.

Limitations of Scholastic Philosophy

It is one thing to examine nature and try to arrive at the principles that seem to govern it, as most Greek philosophers did; it is another thing to assume that something is true and then attempt to make nature conform to that truth. The Christian theologians attempted to do the latter. During the time from Augustine to and including Aquinas, scholarship consisted of demonstrating the validity of church dogma. New information was accepted only if it could be shown to be compatible with church dogma; if this was not possible, the information was rejected. "The truth" had been found, and there was no need to search elsewhere.

Although the Scholastics were outstanding scholars and hairsplitting logicians, they offered little of value to either philosophy or psychology. They were much more interested in maintaining the status quo than in revealing any new information. Certainly, there was little concern with physical nature, except for those aspects that could be used to prove God's existence or to show something about God's nature. As with the major Greek philosophers who preceded them, the Scholastics searched for the universal truths or prin-

ciples that were beyond the world of appearance. For the Pythagoreans, it was numerical relationships; for Platonists, it was the pure forms, or ideas; for Aristoteians, it was the entelechy, which gave a class of things its essence; and for the Scholastics, it was God. All assumed that there was a higher truth beyond the one that could be experienced through the senses.

As mentioned earlier, once Aquinas separated faith and reason, it was only a matter of time before there would be those wishing to exercise reason while remaining unencumbered by faith. William of Occam was one who took this step.

WILLIAM OF OCCAM: A TURNING POINT

William of Occam (sometimes spelled *Ockham*; ca. 1285–1349), a British-born Franciscan monk, accepted Aquinas's division of faith and reason and pursued the latter. Occam believed that in explaining things, no unnecessary assumptions should be made—in other words, that explanations should always be kept as parsimonious (simple) as possible. This belief that extraneous assumptions should be "shaved" from explanations or arguments came to be known as Occam's razor. In his extensive writings, Occam stated his principle in several ways—for example, "It is futile to do with many what can be done with fewer" and "Plurality should not be assumed without necessity" (Kemp, 1998, p. 280).

Occam applied his "razor" to the debate concerning the existence of universals. As we have seen, some scholars believed that universal ideas or principles existed and that individual empirical experiences were only manifestations of those universals. Again, those believing in the independent existence of universals were called realists. Conversely, scholars believing that so-called universals were nothing more than verbal labels used to describe groups of experiences that had something in common were called nominalists. Because Occam saw the assumption that universals had an independent existence as unnecessary, he sided with

St. Thomas Aquinas

the nominalists, arguing forcefully that so-called universals were nothing more than verbal labels. For example, because all cats have certain features in common, it is convenient to label all objects with those features as cats. The same thing is true for dogs, trees, books, or any other class of objects or experiences. According to Occam, the fact that experiences have features in common allows us to use general labels to describe those experiences; but the use of such labels does not mean that there is a pure idea, essence, or form that exists beyond our experiences. Occam believed we can trust our senses to tell us what the world is really like, that we can know the world directly without needing to worry about what lurks beyond our experience.

Occam changed the question concerning the nature of knowledge from a metaphysical problem

to a psychological problem. He was not concerned with a transcendent reality that could be understood only by abstract reasoning or intense introspection. For him, the question was how the mind classifies experience, and his answer was that we habitually respond to similar objects in a similar way. We apply the term *female* to a person because that person has enough in common with others we have called female.

Previously, we saw that Abelard offered a similar solution to the realism-versus-nominalism problem. That is, universals are nothing but concepts by which we organize our experiences. Occam reached the same conclusion by applying his razor. For Occam, the assumption that essences exist was unnecessary. We can simply assume that nature is as we experience it.

In his empiricism, Occam went beyond Aristotle. Aristotle believed that sensory experience was the basis of knowledge but that reason needed to be applied to extract knowledge of universals and essences from individual experiences. For Occam, sensory experience provided information about the world—period. Occam's philosophy marks the end of Scholasticism. Despite the church's efforts to suppress them, Occam's views were widely taught and can be viewed as the beginning of modern empirical philosophy. Indeed, we see in Occam a strong hint of the coming Renaissance. Despite radical empiricism, Occam was still a Franciscan monk, and he believed in God. He did say, however, that God's existence could never be confirmed by studying nature because there was nothing in nature that directly proved his existence. God's existence, then, must be accepted on faith.

THE SPIRIT OF THE TIMES BEFORE THE RENAISSANCE

During the 14th and 15th centuries, philosophy still served religion, as did everyone and everything else. There were two classes of people: believers and nonbelievers. The latter, if they could not be converted, were physically punished, imprisoned, or

killed, and they were considered either stupid or possessed by the devil. There was no in-between. If the God contemplated through introspection was real, so must other objects of thought be real, such as demons, devils, and monsters. Astrology was extremely popular, and magic was practiced almost everywhere and by almost everyone. Superstition was not confined only to the peasant but also characterized kings, scholars, and clergy.

Clearly, this was not a time of open inquiry. To use Kuhn's (1996) terminology, inquiry was characterized by a single paradigm: the Christian conception of humans and the world. Although Kuhn was mainly concerned with science, his notion of paradigms can also be applied to other fields of inquiry. As with other paradigms, the Christian paradigm determined what was acceptable as a problem and what counted as a solution. Philosophers were engaged in "normal philosophy," which, like nor-

mal science, is concerned only with exploring the implications of the accepted paradigm. Little creativity is involved in either normal science or normal philosophy. Kuhn tells us that for there to be a paradigm shift, anomalies must arise within the accepted paradigm; that is, consistent observations that cannot be explained must occur. As the anomalies persist, a new paradigm gradually gains recruits and eventually overthrows the old paradigm. The process is long, difficult, and often traumatic for the early dissenters from the old paradigm. In the period before the Renaissance, anomalies were appearing everywhere in Christian doctrine, and it was clear that church authority was on the decline. For centuries there had been little philosophical, scientific, or theological growth. For progress to occur, the authority of the church had to be broken, and the cracks were beginning to appear almost everywhere.

SUMMARY

After Aristotle's death, philosophers began to concern themselves with principles of human conduct and asked the question, What constitutes the good life? Pyrrho of Elis preached Skepticism. To him, nothing could be known with certainty, so why believe anything? The Skeptic did not commit himself or herself to any particular belief. Life should be guided by simple sensations, feelings, and the conventions of one's society. Antisthenes and Diogenes advocated a back-to-nature approach to life because they viewed society as a distortion of nature that should be rejected. A simple life, close to nature and free of wants and passions, was best. The position of Antisthenes and Diogenes was later called Cynicism. Epicurus of Samos said the good life involved seeking the greatest amount of pleasure over the longest period of time. Such pleasure did not come from having too little or too much but from a life of moderation. Zeno of Citium, the founder of Stoicism, claimed that the good life involved living in harmony with nature, which was designed in accordance with a divine plan. Because

everything happens for a reason, one should accept whatever happens with courage and indifference. The Stoics believed material possessions to be unimportant, and they emphasized virtue (the acceptance of one's fate).

Clearly, the preceding moral philosophers were often contradictory, and they lacked a firm philosophical base. This problem was "solved" when philosophers switched their attention from ethics to religion. In Alexandria, Greek philosophy, Judaic tradition, Eastern religions, and mystery religions coexisted. Philo, a Neoplatonist, combined Judaism with Plato's philosophy and created a system that glorified the spirit and condemned the flesh. Plotinus, another Neoplatonist, believed that from the One (God) emanates the Spirit, from the Spirit emanates the Soul, and from the Soul emanates the physical world. The Soul then reflects the Spirit and God. Like all the Neoplatonists, Plotinus taught that it is only by pondering the contents of the Soul that one can embrace eternal, immutable truth. St. Paul claimed that Jesus was the son of God

and thereby established the Christian religion. In 313, Emperor Constantine made Christianity a tolerated religion in the Roman Empire, and under his leadership the many diverse versions of Christianity that existed at the time were transformed into a standard set of documents and beliefs. However, it was Bishop Athanasius who, in 367, first canonized the New Testament as we know it today.

St. Augustine said that humans can know God through intense introspection. The ecstasy that comes from cognitively embracing God was considered the highest human emotion and could be achieved only by avoiding or minimizing experiences of the flesh. By postulating human free will, Augustine accomplished several things: He explained evil as the result of humans choosing evil over good, humans became responsible for their own destiny, and personal guilt became an important means of controlling behavior. Augustine claimed that an internal sense reveals to each person how he or she should act as a Christian. Acting contrary to this internal sense, or even intending to act contrary to it, causes guilt. However, living a life free of sin does not guarantee eternal life in heaven. That can only be provided by God's grace. Augustine argued that the experiences of the past, present, and future are accounted for by memories, ongoing sensory impressions, and anticipations, respectively.

During the Dark Ages, Islamic culture flour-ished and expanded throughout Europe. Muslim and Jewish scholars translated the works of the Greek and Roman philosophers and used this wisdom to make great advances in medicine, science, and mathematics. Avicenna and Averroës concentrated mainly on the works of Aristotle, translating and expanding them and attempting to make them compatible with Islam. Maimonides attempted, among other things, to reconcile Aristotelianism with Judaism.

Before the Western world could embrace Aristotle's philosophy, human reasoning powers had to be made respectable. St. Anselm and Lombard were instrumental in showing that reason and faith were compatible, whereas Abelard and St. Albertus Magnus were among the first Western philosopher-theologians to embrace the work of Aristotle. Within the church, there was a debate between the realists and the nominalists. The realists believed in the existence of universal (essences), of which individual, empirical events were only manifestations. The nominalists believed that so-called universals were nothing more than verbal labels applied to classes of experiences. Abelard offered a compromise solution to the problem. According to his conceptualism, concepts were viewed as less than essences but more than mere words.

Those who attempted to synthesize Aristotle's philosophy with the Christian religion were called Scholastics. The greatest Scholastic was St. Thomas Aquinas, and the major outcome of his work was the acceptance of both reason and faith as ways of knowing God. Before Aquinas, faith alone had been emphasized. The acceptance of reason as a means of knowing God made respectable the examination of nature, the use of logical argument, and even debate within the church itself. It is widely believed that Aquinas inadvertently created an atmosphere that led ultimately to the decline of church authority and therefore to the Renaissance.

Concerning the realism-nominalism debate, William of Occam sided with the nominalists by explaining universals as simply verbal labels. He took this position because it required the fewest assumptions. Occam's razor is the belief that of two or more adequate explanations, the one requiring the fewest assumptions should be chosen.

In the heyday of early Christianity, a largely negative social climate prevailed in the Western world. There was widespread superstition, fear, and persecution of nonbelievers. The church had absolute power, and any dissension from church dogma was dealt with harshly. Clearly, the spirit of the times was not conducive to open, objective inquiry. For such inquiry to occur, a paradigm shift was required, and one was on the horizon.

DISCUSSION QUESTIONS

- Briefly state what constituted the good life according to Skepticism, Cynicism, Epicureanism, and Stoicism.
- 2. What did the Skeptics mean by *dogmatism*, and why did they oppose it?
- 3. In what sense were Epicureanism and Stoicism materialistic philosophies?
- 4. Describe the factors that contributed to the development of early Christian theology.
- 5. What characterized St. Paul's version of Christianity?
- 6. Summarize the philosophy of Neoplatonism.
- 7. Discuss how Constantine influenced the history of Christianity.
- 8. Discuss the importance of free will in Augustine's philosophy.
- 9. How did Augustine change the locus of control of human behavior from forces outside the person to forces inside the person?
- 10. Describe the doctrine of predestination.
- 11. What did Augustine feel humans could be certain of, and how did he arrive at his conclusion? How, according to Augustine, could humans experience God, and what type of emotion resulted from this experience?
- 12. According to Augustine, what allows humans to have a sense of the past, present, and future?

- 13. In what way were the Dark Ages dark? Explain.
- 14. What was the importance of Avicenna's, Averroës's, and Mainonides' philosophies to Western thought?
- 15. How did the works of St. Anselm and Lombard prepare the Western world for the acceptance of Aristotle's philosophy?
- 16. What was St. Anselm's ontological argument for the existence of God?
- 17. What was the significance of the work of Abelard and Magnus?
- 18. Summarize the debate between the realists and the nominalists. What was Abelard's position in this debate?
- 19. How, according to Aquinas, can humans know God? What are some of the implications of Aquinas's position?
- 20. What was Scholasticism? Give an example of what the Scholastics did.
- 21. Why does William of Occam represent an important turning point in the history of psychology?
- 22. Was William of Occam a realist or a nominalist? Explain.
- 23. What is Occam's razor?

SUGGESTIONS FOR FURTHER READING

- Annas, J. E. (1994). *Hellenistic philosophy of mind*. Berkeley: University of California Press.
- Bourke, V. J. (1993). Augustine's quest of wisdom: His life, thought, and works. Albany, NY: Magi Books.
- Branham, R. B., & Goulet-Cazé, M.O. (Eds.) (1996). The Cynics: The Cynic movement in antiquity and its legacy. Berkeley, CA: University of California Press.
- Bury, R. G. (Trans.). (1990). Sextus Empiricus: Outlines of Pyrrhonism. Buffalo, NY: Prometheus Books.
- Chadwick, H. (2001). Augustine: A very short introduction. New York: Oxford University Press.
- Copleston, F. C. (2001). *Medieval philosophy: An intro-duction*. Mineola, NY: Dover. (Original work published 1952)
- Deane, S. N. (Trans.). (1994). St. Anselm: Basic writings. La Salle, IL: Open Court.
- Grane, L. (1970). Peter Abelard: Philosophy and Christianity in the Middle Ages (F. Crowley & C. Crowley, Trans.). New York: Harcourt, Brace & World.

UNIVERSITY OF WINCHESTER LIBRARY

- Gregory, J. (1991). The Neoplatonists. London: Kyle Cathie.
- Hankinson, R. J. (1998). *The Sceptics*. New York: Routledge.
- Kurtz, P. (1992). The new Skepticism: Inquiry and reliable knowledge. Buffalo, NY: Prometheus Books.
- McInerny, R. (1990). A first glance at St. Thomas Aquinas: A handbook for peeping Thomists. South Bend, IN: University of Notre Dame Press.
- O'Connor, E. (Trans.). (1993). The essential Epicurus: Letters, principal doctrines, Vatican sayings, and fragments. Buffalo, NY: Prometheus Books.

- Pusey, E. B. (Trans.). (1961). The confessions of St. Augustine. New York: Macmillan.
- Saunders, J. L. (Ed.). (1966). Greek and Roman philosophy after Aristotle. New York: The Free Press.
- Schoedinger, A. B. (Ed.). (1996). Readings in medieval philosophy. New York: Oxford University Press.
- Theissen, G. (1987). Psychological aspects of Pauline theology (J. P. Galvin, Trans.). Edinburgh: T & T Clark.
- Wilken, R. L. (2003). The Christians as the Romans saw them (2nd ed.). New Haven: Yale University Press.

GLOSSARY

Abelard, Peter (1079–1142) One of the first Western philosopher-theologians to emphasize the works of Aristotle.

Anselm, St. (ca. 1033–1109) Argued that sense perception and rational powers should supplement faith. (See also Ontological argument for the existence of God.)

Antisthenes (ca. 445–365 B.C.) Founder of Cynicism.

Aquinas, St. Thomas (1225–1274) Epitomized Scholasticism. He sought to "Christianize" the works of Aristotle and to show that both faith and reason lead to the truth of God's existence.

Augustine, St. (354–430) After having demonstrated the validity of inner, subjective experience, said that one can know God through introspection as well as through the revealed truth of the scriptures. Augustine also wrote extensively on human free will.

Averroës (1126–1198) A Muslim physician and philosopher who, among other things, wrote commentaries on Aristotle's work on the senses, memory, sleep and waking, and dreams.

Avicenna (980–1037) A Muslim physician and philosopher whose translations of, and commentaries on, the works of Aristotle strongly influenced subsequent Western philosophers.

Bonaventure, St. (ca. 1217–1274) A contemporary of St. Thomas Aquinas who argued that Christianity should remain Augustinian and should reject any effort to assimilate Aristotelian philosophy into church dogma.

Conceptualism Abelard's proposed solution to the realism-nominalism debate. Abelard argued that concepts do not have independent existence (realism), but that, being abstractions, they are more than mere names (nominalism).

Constantine (ca. 272–337) Roman Emperor whose Edict of Milan in 313 made Christianity a tolerated religion within the Roman Empire. Under Constantine's leadership, widely diverse Christian writings and beliefs were formalized, thus facilitating the widespread acceptance of Christianity.

Cynicism The belief that the best life is one lived close to nature and away from the rules and regulations of society.

Dialectic method The technique used by Abelard in seeking truth. Questions are raised, and several possible answers to those questions are explored.

Diogenes (ca. 412–323 B.C.) Like his mentor Antisthenes, advocated natural impulse as the proper guide for action instead of social convention.

Dogmatist According to the Skeptics, any person claiming to have arrived at an indisputable truth.

Epicureanism The belief that the best life is one of long-term pleasure resulting from moderation.

Epicurus of Samos (ca. 341–270 B.C.) Founder of Epicureanism.

Hedonism The belief that the good life consists of seeking pleasure and avoiding pain.

Internal sense The internal knowledge of moral right that individuals use in evaluating their behavior and thoughts. Postulated by St. Augustine.

Introspection The examination of one's inner experiences.

Jesus (ca. 6 B.C.-A.D. 30) A simple, sensitive man who St. Paul and others claimed was the Messiah. Those who believe Jesus to be the son of God are called Christians.

Lombard, Peter (ca. 1095–1160) Insisted that God could be known through faith, reason, or the study of his work in nature.

Magnus, St. Albertus (ca. 1200–1280) Made a comprehensive review of Aristotle's work. Following Aristotle's suggestion, he also made careful, direct observations of nature.

Maimonides (1135–1204) Jewish physician and philosopher who attempted to reconcile Aristotelian philosophy and Judaism.

Mystery religions Ancient religions (cults) that were characterized by secret rites of initiation; ceremonies designed to bring initiates closer to a deity or deities, to symbolize death and rebirth, to offer purification and forgiveness of sins, and to cause the exaltation of a new life; the confession of sin; and a strong feeling of community among members.

Neoplatonism Philosophy that emphasized the most mystical aspects of Plato's philosophy. Transcendental experiences were considered the most significant type of human experience.

Nominalism The belief that so-called universals are nothing more than verbal labels or mental habits that are used to denote classes of experience.

Occam's razor The belief that of several, equally effective alternative explanations, the one that makes the fewest assumptions should be accepted.

Ontological argument for the existence of God St. Anselm's contention that if we can think of something, it must be real. Because we can think of a perfect being (God), that perfect being must exist.

Paul, St. (ca. 10–64) Founded the Christian church by claiming that Jesus was the son of God. Paul placed the soul or spirit in the highest position among the human faculties, the body in the lowest, and the mind in a position somewhere between.

Philo (ca. 25 B.C.-A.D. 50) A Neoplatonist who combined Jewish theology with Plato's philosophy. Philo differentiated between the lower self (the body) and a spiritual self, which is made in God's image. The body is the source of all evil; therefore, for the spiritual self to develop fully, one should avoid or minimize sensory experience.

Plotinus (205–270) A Neoplatonist who emphasized the importance of embracing the soul through introspection. These subjective experiences were more important and informative than physical experiences.

Predestination The belief that God has preordained, even before birth, which people will be granted salvation (the elect) and which are condemned to eternal damnation.

Pyrrho of Elis (ca. 360–270 B.C.) Founder of Skepticism.

Realism The belief that abstract universals (essences) exist and that empirical events are only manifestations of those universals.

Scholasticism The synthesis of Aristotelian philosophy with Christian teachings.

Skepticism The belief that all beliefs can be proved false; thus, to avoid the frustration of being wrong, it is best to believe nothing.

Stoicism The belief that one should live according to nature's plan and accept one's fate with indifference or, in the case of extreme hardship, with courage.

Vedantism The Indian religion that emphasized the importance of semiecstatic trances.

William of Occam (ca. 1285–1349) Denied the contention of the realists that what we experience are but manifestations of abstract principles. Instead, he sided with the nominalists who said that so-called abstract principles, or universals, were nothing more than verbal labels that we use to describe classes of experiences. For Occam, reality is what we experience directly; there is no need to assume a "higher" reality beyond our senses.

Zeno of Citium (ca. 335–263 B.C.) Founder of Stoicism.

Zoroastrianism The Persian religion that equated truth and wisdom with the brilliance of the sun and ignorance and evil with darkness.

The Beginnings of Modern Science and Philosophy

he Renaissance is generally dated from approximately 1450 to 1600, although many historians would date its beginning much earlier. Renaissance means "rebirth," and during this period, the tendency was to go back to the more open-minded method of inquiry that had characterized early Greek philosophy. It was a time when Europe gradually switched from being God-centered to being human-centered. If God existed, he existed in nature; therefore, to study nature was to study God. Also, because God had given humans the ability to create works of art, why not exercise that ability to the fullest? The new view was that there was more to humans than their souls: They had reliable sensory systems, so why not use them? They had reasoning powers, so why not exercise them? And they had the capacity for enjoyment, so why not enjoy? After all, God, in his infinite wisdom, must have given humans these attributes for a reason. Attention was diverted from the heavens, where the Pythagoreans, Platonists, and early Christians had focused it, to humans living in the world. Nowhere is this spirit of the times better illustrated than in the work of the Renaissance humanists.

RENAISSANCE HUMANISM

Major Themes

The term *humanism*, as it applies to the Renaissance, does not mean "humanitarianism." That is, it does not refer to a deep concern about the welfare of humans. Nor does it refer to humaneness—treating one's fellow humans with

respect, sensitivity, and dignity. As it applies to the Renaissance, **humanism** denotes an intense interest in human beings, as if we were discovering ourselves for the first time. During this time, interest was focused on a wide range of human activities. How do we think, behave, and feel? Of what are we capable? These and related questions are reflected in the four major themes that characterized Renaissance humanism.

- Individualism. There was great concern with human potential and achievement. The belief in the power of the individual to make a positive difference in the world created a spirit of optimism.
- Personal religion. Although all Renaissance humanists were devout Christians, they wanted religion to be more personal and less formal and ritualistic. They argued for a religion that could be personally experienced rather than one that the church hierarchy imposed on the people.
- Intense interest in the past. The Renaissance humanists became enamored with the past. The works of the early Greek and Roman poets, philosophers, and politicians were of special interest. Renaissance scholars wanted to read what the ancients had really said, instead of someone's interpretation. They sought to assign correct authorship to old manuscripts because the authorship of several manuscripts had been assigned incorrectly, and they attempted to expose forgeries. These activities introduced Renaissance scholars to a wide range of viewpoints from the past, and many of these views found considerable support among the humanists. For example, much that was previously unknown of Plato's philosophy was discovered, resulting in a wave of interest in Plato. In 1462, Marsilio Ficino (1433-1499) founded a Platonic academy in Florence. He sought to do for Plato's philosophy what the Scholastics had done for Aristotle's. Among the humanists, almost every early Greek and Roman philosophy had its adherents, but Plato was especially influential. Even some extremely old Eastern

- religions were rediscovered, stimulating great interest in the occult.
- Anti-Aristotelianism. Many of the humanists believed that the church had embraced Aristotle's philosophy to too great an extentto the point where Aristotle's philosophy was as authoritative as the Bible. Passages from Aristotle commonly settled theological disputes. To the humanists, this was ridiculous because Aristotle had been only human, and like any human, he was capable of error. To the regret of the humanists, Aristotle's philosophy, along with Christian theology, had been used to create a set of rules, regulations, and beliefs that one had to accept in order to be a Christian. Accepting church dogma became more important than one's personal relationship with God; therefore, the humanists attacked church dogma harshly. Although there were many interesting Renaissance humanists, space permits only a brief review of a few of them.

Francesco Petrarch

So influential was Francesco Petrarch (1304-1374) that many historians argue that his writings mark the beginning of the Renaissance. Clearly, all the themes discussed above are found in Petrarch's work. Above all else, Petrarch was concerned with freeing the human spirit from the confines of medieval traditions, and the main target of his attack was Scholasticism. He believed that the classics should be studied as the works of humans and not be interpreted or embellished by others. He had a low opinion of those who used the classics to support their own beliefs, saying of these interpreters, "Like those who have no notion of architecture. they make it their profession to whitewash walls" (R. I. Watson, 1978, p. 138). An obvious example of this type of interpreter was the Scholastic.

As most Renaissance humanists did, Petrarch urged a return to a personal religion like that described by St. Augustine—a religion based on the Bible, personal faith, and personal feelings. He

thought that Scholasticism, in its attempt to make religion compatible with Aristotelian rationalism, had made it too intellectual. Petrarch also argued that a person's life in this world is at least as important as life after death. God wanted humans to use their vast capabilities, not inhibit them, Petrarch argued. By actualizing the potential God has given to us, we can change the world for the better. By focusing on human potential, Petrarch helped stimulate the explosion of artistic and literary endeavors that characterized the Renaissance.

Petrarch did not create anything new philosophically, but his challenge of religious and philosophical authority helped open the door for individuals such as Copernicus, Kepler, and Galileo. In other words, Petrarch's skepticism toward all forms of dogma helped pave the way for modern science.

Giovanni Pico

Giovanni Pico (1463–1494) argued that God had granted humans a unique position in the universe. Angels are perfect and thus have no need to change, whereas nonhuman animals are bound by their instincts and cannot change. Humans alone, being between angels and animals, are capable of change. We can choose to live sensual, instinctive lives, thereby becoming brutish, or to exercise our rationality and intelligence, thereby becoming more angelic and godlike.

Our freedom not only allows us to choose from a variety of lifestyles, but it also permits us to embrace almost any viewpoint. Pico insisted that all philosophies have common elements; for example, they reflect human rationality and individuality. He argued further that, if properly understood, the major philosophical viewpoints (for example, those of Plato and Aristotle) were essentially in agreement. All viewpoints therefore should be studied objectively with the aim of discovering what they have in common. Pico urged that all philosophical perspectives be studied and assimilated into the Christian worldview. Clearly, Pico sought peace among philosophical and religious rivals. All human works, he said, should be respected. Had Pico's plea for individuals with different viewpoints to understand each other been heeded, perhaps the Inquisition could have been averted. This was not to be, however, and only the fact that Pico died so young spared him the sight of his books being burned.

Desiderius Erasmus

Desiderius Erasmus (1466–1536) was born at Rotterdam on October 27. He was the illegitimate son of a priest and a physician's daughter, a fact that depressed him all of his life (Winter, 2005, p. vi). He was eventually ordained a priest but had no taste for a monastic life, preferring instead a life of study, travel, and independence. While earning a living as a tutor, his travels throughout Europe brought him into contact with Europe's leading scholars. He died at Basle at the age of 69.

Erasmus was opposed to a fanatical belief in anything. He was fond of pointing out mistakes in the classics, claiming that anything created by humans could not be perfect. He exposed exorcism and alchemy as nonsense, attacking these and other forms of superstition. He begged people to take their lessons from the simple life of Jesus instead of from the pomp and circumstance of the organized church. He believed that war was caused by fanaticism and was nothing more than homicide, and he was especially disturbed by bishops who became rich and famous because of war. Eclectic and practical, Erasmus was a keen observer of the world and its problems. Concerning women, Erasmus had both traditional and progressive views. He commended women for their role as caregivers but argued, contrary to the prevailing view, that they should have access to education. He also argued against the idea that celibacy is superior to marriage (Rummel, 1996, p. 3).

Erasmus completed his book *The Praise of Folly* (1512/1994) in 1512 while staying with his friend Sir Thomas More in England. The book caused a sensation and was reprinted 40 times in his lifetime. In it he attacked the church and the papacy, philosophers, nobility, and superstitions of all kinds. He made the case that fools are better off than so-called wise persons because fools live in accordance with their true feelings instead of religious or philosoph-

ical doctrines. Fools, he said, are also happier because they do not fear death; they are not tormented by guilt; they do not fear ghosts, spirits, and goblins; and they are not concerned about the future. Also, like nonhuman animals, drunkards, and young children, fools are spontaneous and speak the truth. Clearly, Erasmus's philosophy had much in common with ancient Cynicism.

Erasmus was so critical of the excesses of Catholicism that the adage developed that "Erasmus laid the [Reformist] egg and Luther hatched it" (J. Wilson, 1994, p. vii). Erasmus's criticisms of the Catholic church of his day closely paralleled those of Luther:

The pope had far too much power; the preaching of indulgences had degenerated into shameless money-making; the veneration of saints had been corrupted to superstition; church buildings were stuffed full of images; the music in services was more fitting for a wedding or a drinking party; the mass was served by priests who lived godless lives and served it as a shoemaker practices his trade; confession had become money-making and skirt-chasing; priests and monks were shameless tyrants. (Augustijn, 1991, pp. 159–160)

Perhaps in an effort to silence him, the Catholic church secretly offered to make Erasmus a cardinal (Augustijn, 1991, p. 173). This having failed, all of Erasmus's works were eventually placed on the Catholic church's index of forbidden books.

When the Reformation did occur (see "Martin Luther" below), Erasmus was equally repelled by its excesses and was condemned by both the Catholics and Protestants.

Martin Luther

Martin Luther (1483–1546), an Augustinian priest and biblical scholar, was disgusted by what Christianity had become in his day. Like those of the other humanists, his view of Christianity was much more in accordance with St. Paul's and St. Augustine's views than with those of St. Thomas

Aquinas. Human intentions are inspired either by God or by Satan: the former results in doing God's work, the latter in sin. People should not be able to escape the consequences of sin through penance or absolution; if they have sinned, they should suffer the consequences, which could be eternal damnation. In the spirit of Augustinian theology, Luther insisted on an intensely personal religion in which each person is answerable only to God, a religion that deemphasized ritual and church hierarchy.

Traditionally, the **Reformation** is said to have begun in 1517 when Luther nailed his Ninety-five Theses (challenges to church dogma and hierarchy) to the door of the castle church in Wittenberg. Aside from the issues already mentioned, Luther was especially opposed to the Catholic church's sale of indulgences, which allowed sinners to reduce the retribution for their sins by paying a fee to church officials. God alone, he preached, determined what was sinful and how sinfulness was to be treated. In Luther's eyes, the church had drifted far from the teachings of Jesus and the Bible. Jesus had preached the glory of the simple life, devoid of luxury and privilege, but the church had come to value these things and to engage in too many formal rituals. For Luther, a major reason for the downfall of Catholicism was its assimilation of Aristotle's philosophy.

Luther on Marriage. Luther also disagreed with the Catholic church over the compulsory celibacy of nuns and priests. First he noted that many church leaders "lived in open liaisons with mistresses and fathered illegitimate children" and, like his contemporary Erasmus, he denounced "the lawless clergy who went whoring or kept concubines" (Marty, 2004, p. 102). Second, Luther believed that married couples are as capable of doing God's work as any nun or priest: "The mother suckling the baby and washing diapers, the farmer at work, the couple having sex were as likely to be engaged in Godpleasing activities as was any nun engaged in prayer" (Marty, 2004, p. 104). On June 13, 1525, at the age of 42, Luther married Katherina von Bora, a former nun. By 1534 the Luthers had produced six children, four of whom survived.

Luther celebrated sexual enjoyment within marriage and even entertained some erotic thoughts (Marty, 2004, p. 107). But what if a wife persistently denies her husband sexual satisfaction? In such a case, Luther said, perhaps surprisingly, "The husband might then turn to the household maid or someone else for sexual relations" (Marty, 2004, p. 108). Concerning a woman who wed an impotent man who, nonetheless, desires children, Luther gave this provocative advice:

[She] with the consent of the man (who is not really her husband, but only a dweller under the same roof with her) should have intercourse with another, for example her husband's brother. They were to keep this "marriage" secret and ascribe any children to the "so-called putative father." Such a woman would be in a saved state and would not be displeasing to God. (Marty, 2004, p. 108)

Luther's Denial of Free Will. Luther and Erasmus had several disagreements, but perhaps the most intense was over free will. In 1524 Erasmus wrote The Free Will, and in 1525 Luther responded with The Bondage of the Will (both reprinted, in part, in Winter, 2005). Erasmus defined free will as "the power of the human will whereby man can apply to or turn away from that which leads unto eternal salvation" (Winter, 2005, p. 17). Erasmus quoted numerous Biblical passages where God indicates to humans what is good and what is evil and encourages them to choose the former. This, he pointed out, was clearly true in the Garden of Eden, and "the entire Holy Scripture is filled with such exhortations" (Winter, 2005, p. 28). Erasmus asked, "Doesn't the reader of such passages ask: why do you [God] make conditional promises, when it depends solely on your will? Why do you blame me, when all my works, good or bad, are accomplished by you, and I am only your tool? ... Why bless me, as if I had done my duty, when everything is your achievement? Why do you curse me, when I have merely sinned through necessity?" (Winter, 2005, p. 29). Without free will, humans cannot be held responsible for any of their actions: "Inasmuch as man can never be the author of good works, he can also never be called the author of evil ones" (Winter, 2005, p. 75). Erasmus argued that even if, contrary to what he believed, human actions are predestined rather than freely chosen, that "truth" should not be shared with the people. Doing so, he believed, would "worsen the already excessive laxness of humanity by impressing it on them that everything depended on God" (Augustijn, 1991, p. 131). In other words, "it would be dangerous to reveal such a doctrine to the multitude, for morality is dependent on the consciousness of freedom" (Huizinga, 1924/2001, p. 163). Erasmus's solution to the apparent contradiction between predestination and free will was to combine free will and God's grace. That is, those who choose well in their lifetime are granted eternal salvation.

Contrarily, Luther said, "God ... foresees, purposes and does all things according to His immutable, eternal and infallible will. This thunderbolt throws free will flat and utterly dashes it to pieces" (Winter, 2005, p. 93). Why then do humans perform evil deeds? Luther answered, "The human will is like a beast of burden. If God rides it, it wills and goes whence God wills.... If Satan rides, it wills and goes where Satan wills. Nor may it choose to which rider it will run, nor which it will seek. But the riders themselves contend who shall have and hold it" (Winter, 2005, p. 97). He continued, "In all things pertaining to salvation or damnation, man has no free will, but is captive, servant and bondslave, either to the will of God, or to the will of Satan" (Winter, 2005. p. 98). Still, God is all knowing (omniscient), all powerful (omnipotent), and present everywhere (omnipresent), so how can He allow evil to exist? This, of course, raises interesting questions about God, and Luther was well aware of them.

Of course, this seems to give the greatest offense to common sense or natural reason, that God, who is proclaimed as being so full of mercy and goodness, should of His own mere will abandon, harden and damn men, as though delighted in the sins and

eternal torments of the miserable. It seems iniquitous, cruel, intolerable to think thus of God. It has given offense to so many and many great men down the ages. And who would not be offended? I myself have been offended at it more than once, even unto the deepest abyss of despair, so far that I wished I had never been made a man. (Winter, 2005, pp. 113–114)

Even with these concerns, Luther insisted, "If the foreknowledge and omnipotence of God are admitted, we must be under necessity" (Winter, 2005, p. 114). According to Luther, in the final analysis, why God allows evil to exist is unfathomable to humans and, therefore, must remain a mystery. In other words, God only knows.

Luther both agreed and disagreed with Augustine (see Chapter 3). Augustine attributed free will to humans but argued that salvation is granted only by God's grace and independently of human endeavors (predestination). Luther denied free will but agreed that salvation is attained by God's grace alone.

Throughout his debate with Luther, Erasmus was, as was typical of him, respectful, kind, and conciliatory. For example, he conceded, "When one has arrived at this view, others at that view, both reading the same Scripture, it is due to the fact that each looked for something else and interpreted that which he read for his own purpose" (Winter, 2005, p. 68). However, Luther was, with few exceptions. mean, disrespectful, and dogmatic. He insisted, for example, that his interpretation of scripture was the only correct one, and he ended the debate by praying that the Lord would enlighten Erasmus on the subject of free will (Winter, 2005, p. 119). It should be noted that despite his reputation for tolerance. Erasmus, like Luther, was fiercely anti-Semitic (Marty, 2004, p. 169-174).

It is interesting to note that on the issue of free will, subsequent Lutheranism developed more in accordance with Erasmus's views than with Luther's (Augustijn, 1991, p. 145).

When Luther was excommunicated in 1521, the protest that he represented grew into a new religious movement, **Protestantism**, and Luther was its leader. The new religion denied the authority of the pope and insisted that every individual had the right to interpret the Bible for himself or herself. To facilitate the latter, Luther translated the Bible into the German vernacular. The Catholic church's response to the criticisms of Luther and others was to make Aquinas's Christianized version of Aristotle's philosophy official church dogma, which all Christians were expected to follow. The dispute over which version of Christianity was correct soon divided Europe.

Early Protestantism had at least two negative aspects. First, as a religion, it was grim, austere, harsh, and unforgiving. In terms of individual happiness, it is difficult to imagine its adherents being any better off than those embracing Catholicism. Second, Protestantism insisted on accepting the existence of God on faith alone; attempting to understand him through reason or empirical observations was foolish and to be avoided. Thus, if one believes that the acceptance of reason and the observation of nature as ways of knowing God exemplified progress, then Protestantism exemplified regression. On the positive side, however, Protestantism was a liberating influence in the sense that it challenged the authority of the pope and of Aristotle; replacing them was the belief that individual feelings can provide the only truth needed in living one's life.

It is interesting to note that although the portrayal of Luther is often grim, he was known to have an earthly sense of humor. For example, he once observed, "My enemies examine all that I do. If I break wind in Wittenberg they smell it in Rome" (P. Smith, 1911, p. 355).

For additional information concerning Luther's colorful life, including his confrontations with Erasmus, and his influential theology, see Cary, 2004, and Marty, 2004.

Michel de Montaigne

With the recovery of classical knowledge, there arose a concern that had occupied the Greek and Roman Skeptics: With so many claims of truth, is there any valid way of distinguishing among them?

The Skeptics answered in the negative, and we see indications of Skepticism in the works of Petrarch, Pico, and especially Erasmus. Luther demonstrated Skepticism, at least toward Aristotelian philosophy and the religious practices that developed since the time of Augustine. It is in the work of **Michel de Montaigne (1533–1592)**, however, that we find the extreme Skepticism that had been represented earlier by Pyrrho of Elis (see Chapter 3). In a series of influential essays, Montaigne questioned the very possibility of indisputable knowledge. Like Erasmus, he argued that both Catholic and Protestant theologies were equally indefensible on rational grounds and that the only justifiable basis for a religious conviction was faith.

In sharp contrast to most earlier Renaissance humanists, Montaigne did not glorify human rationality, nor did he believe humans to be superior to other animals (in this he was in agreement with Erasmus). In fact, he argued that it was human rationality that caused most human problems (such as the Holy Wars) and that because nonhuman animals lack rational powers, they are superior to humans. He analyzed the most famous philosophical doctrines, pointed out the contradictions within and among them, and showed them to be open to multiple interpretations. This is similar to what the French philosopher Jacques Derrida (1930-2004) became famous for doing many years later. Montaigne rejected science as a means of attaining reliable knowledge because scientific "truth" is in constant flux. He even went beyond the Greek and Roman Skeptics by denying that simple sensations can act as reasonable guides for living. Sensations, he said, are often illusory, and even if they were not, they are influenced by our bodily conditions and personal histories. It should be clear that Montaigne did not share the optimism expressed by the earlier Renaissance humanists concerning the human potential to make a positive difference in the world.

Montaigne's Skepticism stimulated a number of attempts to disprove it. For example, Popkin (1967) argues that both Francis Bacon and René Descartes (both covered later in this chapter) responded to Montaigne's doubts concerning human knowledge by creating philosophical systems they believed were impervious to such doubt.

There were many other Renaissance humanists. Some manifested the power of the individual in art (Leonardo da Vinci, 1452-1519), some in politics (Niccolò Machiavelli, 1469-1527), some in education (Juan Luis Vives, 1492-1540), and some in literature (William Shakespeare, 1564-1616). The emphasis was always the same—on the individual. Now people were seen as having the power to change things for the better rather than simply accepting the world as it was or hoping that it would become better. Although the Renaissance humanists added nothing new to philosophy or psychology, the belief that individuals could act upon the world to improve it was conducive to the development of science. During the Renaissance, art, literature, and architecture benefited, but the age of science was still in the future.

To say the least, the Renaissance was a paradoxical time. On one hand, there was an explosion of interest in human potential coupled with great human achievements. In this respect, Renaissance resembled classical Greece and Rome. On the other hand, it was a time of persecution, superstition, witch hunting and execution, fear, torture, and exorcism. Although astrologers and alchemists were generally highly regarded and popular, abnormal individuals were treated with extreme harshness. Wars destroyed much of France and Germany, the Black Death cut Europe's population by about a third, major famines occurred, and syphilis was epidemic. Yet despite all this trouble, there was almost unparalleled creativity. The Renaissance displayed the best and worst of humanity—the stuff from which modern philosophy and science emerged.

FURTHER CHALLENGES TO CHURCH AUTHORITY

The Renaissance and the breakdown of church authority went hand in hand. Church dogma consisted of fixed truths: there are exactly seven heav-

enly bodies in the solar system, the earth is the center of the universe, and humans are created in God's image, for example. Gradually, these "truths" were challenged, and each successful challenge focused suspicion on other "truths." Once begun, the questioning escalated rapidly, and the church tried desperately to discourage these challenges to its authority. Church scholars attempted to show that contradictions were only apparent. Failing in this, they attempted to impose censorship, but it was too late; the challenging spirit was too widespread. The decline in the church's authority was directly related to the rise of a new spirit of inquiry that took as its ultimate authority empirical observation instead of the scriptures, faith, or revelation. Gradually, church dogma was replaced by the very thing it had opposed the most—the direct observation of nature without the intervention of theological considerations. But the transition, although steady, was slow and painful. Many Renaissance scholars were caught between theology and science because of either personal beliefs or fear of retaliation by the church. They reported their observations with extreme caution: in some cases, they requested that their observations be reported only after their death.

There is no single reason for this reawakening of the spirit of objective inquiry; several factors are believed responsible. One was Aquinas's acceptance of reason and the examination of nature as ways of knowing God. Once sanctioned by the church, the human capacity to reason was focused everywhere, including on church dogma. Another factor was the work of the humanists, which recaptured the spirit of open inquiry reflected in the classics. The humanists also stressed the human potential to act upon the world and change it for the better. In addition, the following events are considered factors in the acceptance of the objective study of nature because they weakened the authority of the church:

- The explorations of central Asia and China from 1271 to 1295 by Marco Polo (ca. 1254–1324).
- Johannes Gutenberg's (ca. 1397–1468) invention of metal moveable type (ca. 1436–1440),

- thus creating modern printing techniques. It was Gutenberg's techniques that were used to print the vernacular Bibles that played a major role in the Reformation.
- Discovery of the New World by Christopher Columbus (1492).
- Martin Luther's challenge to Catholicism (1517).
- Circumnavigation of the globe by Ferdinand Magellan's expedition (1519–1522).

These and other events vastly expanded the known world. The discovery that the earth was filled with strange peoples with strange customs created many problems for the church. For example, a long debate occurred concerning whether "savages" found in America had rational souls (it was decided that they did). The printing press made the widespread, accurate, and rapid exchange of ideas possible. And, as we have seen, Luther's challenge to Catholicism resulted in the development of the Protestant movement, which argued against centralized church authority and for increased individualism within the Christian religion.

As influential as the above events were, however, the work of a few astronomer-physicists was most detrimental to church dogma and most influential in creating a new way of examining nature's secrets. That new way was called science.

PTOLEMY, COPERNICUS, KEPLER, AND GALILEO

Ptolemy

In the second century A.D., **Ptolemy**, a Greco-Egyptian, summarized the mathematical and observational astronomy of his time and that of antiquity in his *Almagest*. The **Ptolemaic system** included the beliefs that the heavenly bodies, including the earth, were spherical in shape and that the sun, moon, and planets travel around the earth in orbits that are circular and uniform. Although this system

reflected the views of most astronomers, including those of Aristotle, there were exceptions. A notable exception was **Aristarchus of Samos (ca. 310–230 B.C.)**, the brilliant astronomer of the Alexandrian school. Aristarchus believed that the earth rotated on its own axis and that the earth and the other planets revolved around the sun. In other words, Aristarchus arrived at the basic assumptions of the Copernican system about 1,700 years before Copernicus. Despite a few such dissenters, the view of the universe reflected in the Ptolemaic system prevailed until the 17th century. The Ptolemaic system was resilient for at least three reasons:

- It accorded well with the testimony of the senses (the earth does appear to be the fixed center of the universe).
- It allowed reasonable astronomical predictions
- Later, it was congenial to Christian theology because it gave humans a central place in the universe and thus was in agreement with the biblical account of creation.

For a complete description of Ptolemy's system, including its mystical components and ethical implications, see Taub, 1993.

In medieval theology, many of the teachings of Ptolemy, like those of Aristotle, became part of official church dogma and were therefore unchallengeable. The worldview based on the Ptolemaic system became deeply entrenched in philosophy, theology, science, and everyday life.

Nicolaus Copernicus

It was not until a devout canon of the Roman Catholic church named **Nicolaus Copernicus** (1473–1543), born on February 19, at Torun, Poland, published his book *De Revolutionibus Orbium Coelestium* (*The Revolutions of the Heavenly Spheres*) that the Ptolemaic system was seriously challenged. Although reports on Copernicus's heliocentric theory had been circulating since about 1515, his *De Revolutionibus* was not published until 1543, the year he died. The book was dedicated to

"the most holy lord, Pope Paul III" and promised to solve a major problem with which the church had been struggling; namely, the creation of a more accurate calendar. The book, then, did not appear to be unfriendly toward the church. Furthermore, when De Revolutionibus was published, its contents could be understood only by the most sophisticated mathematicians and astronomers of the day. Perhaps because of its apparent compatibility with church dogma and its esoteric nature, the book was not immediately viewed as a threat by the church (although it was eventually condemned). In any case, in De Revolutionibus Copernicus did argue successfully that, rather than the sun revolving around the earth (the geocentric theory), the earth revolved around the sun (the heliocentric theory). This argument, of course, was a clear contradiction of church dogma. Only gradually was it realized that Copernicus's heliocentric theory questioned the traditional place of humankind in the universe. Once this realization occurred, a number of related questions followed: Were we favored by God and therefore placed in the center of the universe? If not, why not? If the church was wrong about this vital fact, was it wrong about other things? Were there other solar systems that contained life? If so, how were they related to ours, and which did God favor? Because Copernicus's heliocentric theory challenged a deeply held worldview going back at least to Aristotle, it was considered revolutionary (Kuhn, 1957). Common sense dictated the acceptance of the geocentric theory, and those rejecting it were considered either misinformed or insane. Within the church, to challenge the geocentric theory was to challenge church dogma and was therefore heretical.

Giordano Bruno (1548–1600) was a former Dominican priest who converted to the ancient philosophy of Hermetism. Among other things, Hermetism professed the divinity of humans, the existence of magical forces that can be used to benefit humankind, and a harmony among humans, stars, and planets. The Hermetic tradition also held that in the universe there are innumerable inhabited worlds (that is, solar systems) and in each of these worlds, including our own, the sun is divine. For Bruno, "The Copernican sun heralds the full

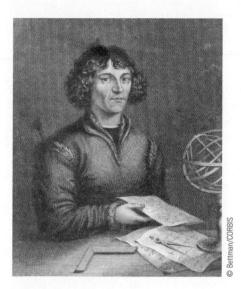

Nicolaus Copernicus

sunrise of the ancient and true philosophy after its agelong burial in dark caverns" (Yates, 1964, p. 238). Bruno, therefore, accepted Copernicus's heliocentric theory not for scientific reasons but because it restored the divine status given to the sun by the ancients. For Bruno, the magical religion of the ancients was the only true religion that both Judaism and Christianity had obscured and corrupted (Yates, 1964, p. 11). All of this was too much for the church, and Bruno was brought before the Inquisition in Venice on May 26, 1592, and charged with eight counts of heresy. At first he recanted his beliefs and asked for mercy from the judge, but later he changed his mind, arguing that he had never been a heretic. Eight years after his imprisonment, Bruno was convicted as a relapsed heretic and on February 17, 1600, was burned at the stake. It should not be concluded. however, that Bruno was a martyr for science. In the charges brought against him, Copernicus was not even mentioned (M. B. Hall, 1994, p. 125).

Often the reformers were as violent as those they were attempting to reform. For example, the Protestant John Calvin ordered the famous anatomist Michael Servetus (1511–1553) to be burned at the stake because he "described the Holy Land as a barren wilderness (which it was),

thus contradicting the scriptural description of it as a land of 'milk and honey'" (Watson and Evans, 1991, p. 151). The fate of individuals like Bruno and Servetus helps explain the caution exhibited by scientists and philosophers during these times.

Copernicus was aware that Aristarchus had proposed a theory very similar to his many centuries before and took some comfort in knowing this. Nonetheless, he realized that the heliocentric theory was nothing short of revolutionary, and he was justifiably worried. Furthermore, Copernicus knew that despite the theological and philosophical turmoil caused by his theory, nothing in terms of scientific accuracy was gained by it. That is, the astrological predictions made by his theory were no more accurate than the ones made under the Ptolemaic system. Also, all known celestial phenomena could be accounted for by the Ptolemaic system; there were no major mysteries that needed explanation. The only justification for accepting Copernicus's heliocentric theory was that it cast the known astrological facts into a simpler, more harmonious mathematical order.

In the Ptolemaic system, it was necessary to make a number of complex assumptions concerning the paths of the planets around the earth. Once these assumptions were made, however, predictions concerning the paths of the planets and eclipses of the sun and moon could be made with considerable accuracy. What Copernicus's system did was to reduce the number of assumptions needed to make those same predictions. As we have seen, a strong resurgence of interest in Platonic philosophy arose in the 15th and 16th centuries, and the Pythagorean aspect of Platonism was stressed during this revival. Working in favor of accepting the Copernican viewpoint was the Pythagorean-Platonic view that the universe operated according to mathematical principles and that those principles are always the simplest and most harmonious possible. It is no accident that the first to accept Copernicus's theory were mathematicians who, like himself, embraced the Pythagorean-Platonic worldview. To those embracing nonmathematical Aristotelian philosophy, the idea of contradicting observation in favor of mathematical simplicity was ridiculous.

We have in the Ptolemaic-Copernican debate the first scientific revolution, to use Kuhn's (1957, 1996) terminology. The Ptolemaic system represented the accepted scientific paradigm of the day. Like any paradigm, it defined problems, specified solutions, and provided those accepting it with a worldview. The Copernican paradigm focused on different problems, different methods of solution, and a distinctly different worldview. Because to follow Copernicus was to reject the prevailing view of the universe, the opposition to his view was widespread and harsh.

Converts to Copernicus's heliocentric theory came slowly. Among the first was Johannes Kepler, a Pythagorean-Platonic mathematician.

Johannes Kepler

Johannes Kepler (1571-1630) was born on December 27 at Weil, in the Duchy of Württemberg, in what is now Germany. He first studied to become a Lutheran minister but, unable to accept the rigidity of Lutheran doctrine, switched to the study of mathematics and astronomy. Kepler was fortunate to have a teacher, Michael Maestlin, who encouraged a critical evaluation of both Ptolemaic and Copernican astronomy in spite of the fact that Luther had condemned the heliocentric theory as a flagrant contradiction of biblical teachings. For example, Luther said, "The fool will turn the whole science of astronomy upside down. But as Holy Writ declares, it was the Sun and not the earth which Joshua commanded to stand still" (M. B. Hall, 1994, p. 126). Other Protestant leaders joined in the rejection of Copernicus. Calvin cited the opening verse of the 93rd Psalm—"The earth is established, it shall never be moved,"-and asked, "Who will venture to place the authority of Copernicus above that of the Holy Spirit?" (Kuhn, 1957, p. 192). Thus, there was risk in embracing Copernican theory even for a Protestant, but embrace it is what Kepler did. There appear to be two reasons Kepler took the risk. First, he, like Copernicus, was a Platonist seeking the simple mathematical harmony that describes the universe. Second, like Bruno, Kepler was a sun

worshipper and, as such, he was attracted to the greater dignity given the sun in the Copernican system. Throughout his life, when he gave his reasons for accepting Copernican theory, the enhanced position given the sun by that theory was always cited, and it was usually cited first. In keeping with his Pythagorean-Platonic philosophy, Kepler believed that *true* reality was the mathematical harmony that existed beyond the world of appearance. The sensory world, the world of appearance, was an inferior reflection of the certain, unchanging mathematical world.

Armed with a mixture of Platonic philosophy, mysticism, and Copernican theory, Kepler not only made a living as an astrologer (he believed the heavenly bodies affect human destiny) but also made significant contributions to astronomy. He worked out and proved many of the mathematical details of the Copernican system, thereby winning its further acceptance. Through mathematical deduction and observation, he found that the paths of the planets around the sun were elliptical rather than circular (as Copernicus had believed). He observed that the velocities of the planets vary inversely with their distance from the sun, thus anticipating Newton's concept of gravitation. Finally, he demonstrated that all the different planetary motions could be described by a single mathematical statement. Perhaps Kepler's most important contribution to science, however, was his insistence that all mathematical deductions be verified by empirical observation.

Kepler also studied vision directly and found that environmental objects project an inverted image onto the retina. This observation contrasted with earlier theories that explained vision as the result of the projection of exact copies of objects directly into the sense receptors. Kepler also questioned humans' ability to perceive things correctly when the image projected onto the retina is upside down, but he left that problem for others to solve.

Galileo

Galileo Galilei (1564–1642), known simply as **Galileo**, was born at Pisa, Italy, on February 15 into a family of impoverished nobility. He was a

brilliant mathematician who, at the age of 25, was appointed professor of mathematics at the University of Pisa. Like Copernicus and Kepler, Galileo viewed the universe as a perfect machine whose workings could be understood only in mathematical terms:

Philosophy is written in that great book which ever lies before our eyes—I mean the universe—but we cannot understand it if we do not first learn the language and grasp the symbols in which it is written. This book is written in the mathematical language, and the symbols are triangles, circles, and other geometric figures, without whose help it is impossible to comprehend a single word of it; without which one wanders in vain through a dark labyrinth. (Burtt, 1932, p. 75)

Also like Copernicus and Kepler, Galileo saw his task as explaining the true mathematical reality that existed beyond the world of appearances. Armed with these Pythagorean-Platonic beliefs, Galileo set out to correct a number of misconceptions about the world and about heavenly bodies. He challenged Aristotle's contention that heavy objects fall faster than lighter ones because of their inherent tendency to do so by demonstrating that both fall at the same rate. He accepted the Copernican heliocentric theory and wrote a book in which he demolished all arguments against it. In 1609, Galileo used his modified version of the newly invented telescope to discover the mountains of the moon, sunspots, and the fact that the Milky Way is made up of many stars not visible to the naked eye. He also discovered four moons of Jupiter, which meant that there were at least 11 bodies in the solar system instead of 7, as claimed by the church.

Most people refused to look through Galileo's telescope because they believed that to do so was an act of heresy. Galileo shared one such experience with his friend Kepler:

Oh, my dear Kepler, how I wish that we could have one hearty laugh together! Here at Padua is the principal professor of philosophy, whom I have repeatedly and urgently requested to look at the moon and planets through my glass, which he perniciously refuses to do. Why are you not here? What shouts of laughter we should have at this glorious folly! And to hear the professor of philosophy at Pisa laboring before the Grand Duke with logical arguments, as if with magical incantations, to charm the new planets out of the sky. (Burtt, 1932, p. 77)

Others refusing to look through Galileo's telescope asserted "that if God meant man to use such a contrivance in acquiring knowledge, He would have endowed men with telescopic eyes" (Kuhn, 1957, p. 226). Others who did look through the telescope acknowledged the phenomena observed "but claimed that the new objects were not in the sky at all; they were apparitions caused by the telescope itself" (Kuhn, 1957, p. 226).

With his studies of the dynamics of projectiles, Galileo demonstrated that the motions of all bodies under all circumstances are governed by a single set of mathematical laws. His studies showed that notions of "animation" were unnecessary for explaining physical events. That is, because behavior of objects and events can be explained in terms of external forces, there is no need to postulate "natural places," "passions," "ends," "essences," or any other inherent properties.

Before Galileo's time, much had been written on the subject of motion, but no one had actually measured the motions of falling bodies:

When Galileo was born, two thousand years of physics had not resulted in even rough measurements of actual motions. It is a striking fact that the history of each science shows continuity back to its first use of measurement, before which it exhibits no ancestry but metaphysics. That explains why Galileo's science was stoutly opposed by nearly every philosopher of his time, he having made it as nearly free from metaphysics as he could. That was

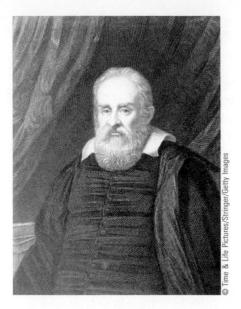

Galileo

achieved by measurements, made as precisely as possible with the means available to Galileo or that he managed to devise. (Drake, 1994, p. 233)

However, in his attitude toward experimentation, we again see Galileo's Pythagorean-Platonic beliefs. For Galileo, discovering a physical law was like discovering a Platonic form. Observation suggests that a lawful relationship may exist, and an experiment is performed to either confirm or disconfirm the possibility. Once a law is discovered, however, further experimentation is not necessary; mathematical deduction is used to precisely describe all possible manifestations of the law. Galileo believed that, besides being useful in verifying the existence of laws, experiments could also function as demonstrations that help convince those skeptical about the existence of certain laws. Galileo, then, relied much more on mathematical deduction than he did on experimentation. On the question of realism versus nominalism, he was clearly on the side of realism. Actual laws (forms) existed, and those laws acted on the physical world. Like a true Platonist, Galileo said that the senses can provide only a hint about the nature of reality. The ultimate explanation of reality must be in terms of the rational order of things; that is, the ultimate explanation must be mathematical.

Objective and Subjective Reality. Galileo made a sharp distinction between objective and subjective reality. Objective reality exists independently of anyone's perception of it, and its attributes are what later in history were called primary qualities. Primary qualities are absolute, objective, immutable, and capable of precise mathematical description. They include quantity, shape, size, position, and motion or rest. Besides the primary qualities (which constitute physical reality), another type of reality is created by the sensing organism; this reality consists of what came to be called secondary qualities. Secondary qualities (which constitute subjective reality) are purely psychological experiences and have no counterparts in the physical world. Examples of secondary qualities include the experiences of color, sound, temperature, smell, and taste. According to Galileo, secondary qualities are relative, subjective, and fluctuating. Of primary qualities (like Plato's forms), we can have true knowledge; of secondary qualities, there is only opinion and illusion.

Although secondary qualities may seem as real as primary qualities, they are not. Primary qualities are real, but secondary qualities are merely names we use to describe our subjective (psychological) experiences:

Hence I think that these tastes, odours, colours, etc., on the side of the object in which they seem to exist, are nothing else than mere names, but hold their residence solely in the sensitive body; so that if the animal were removed, every such quality would be abolished and annihilated. Nevertheless, as soon as we have imposed names on them ... we induce ourselves to believe that they also exist just as truly and really as the [primary qualities]. (Burtt, 1932, p. 85)

In studying the physical world, secondary qualities are, at best, irrelevant. If one physical object hits another, the color, smell, or taste of the objects

is irrelevant in determining their subsequent paths. For Galileo, it was physical reality, not subjective reality, that could be and should be studied scientifically.

The Impossibility of a Science of Conscious Experience. Because so much of our conscious experience consists of secondary qualities, and because such qualities can never be described and understood mathematically, Galileo believed that consciousness could never be studied by the objective methods of science. Galileo's position marked a major philosophical shift concerning man's place in the world. Almost without exception, all philosophers and theologians prior to Galileo gave humans a prominent position in the world. If there were good things and bad things in the world and if there were changing and unchanging things in the world, those things also existed in humans. Humans were viewed as a microcosm that reflected the vast macrocosm: "Till the time of Galileo it had always been taken for granted that man and nature were both integral parts of a larger whole, in which man's place was the more fundamental" (Burtt, 1932, p. 89). With Galileo, this view of humans changed. Those experiences that are most human—our pleasures; our disappointments; our passions; our ambitions; our visual, auditory, and olfactory experiences—were now considered inferior to the real world outside of human experience.

At best, humans can come to know the world of astronomy and the world of resting and moving terrestrial objects. However, this knowledge can never be attained by sensory experience alone. It can be attained only by rationally grasping the mathematical laws that exist beyond sensory experience. For the first time in history, we have a view of human conscious experience as secondary, unreal, and totally dependent on the senses, which are deceitful. What is real, important, and dignified was the world outside of man: "Man begins to appear for the first time in the history of thought as an irrelevant spectator and insignificant effect of the great mathematical system which is the substance of reality" (Burtt, 1932, p. 90).

Thus, Galileo excluded from science much of what is now included in psychology, and many modern natural scientists refuse to accept psychology as a science for the same reason that Galileo did not accept it. There have been many efforts to quantify cognitive experience since the time of Galileo, and insofar as these efforts have been successful, Galileo's conclusions about the measurement of secondary qualities were incorrect. How successful these efforts have been, however, has been and is widely disputed.

As we have seen, Aristotle was Galileo's prime target. Using empirical observation and mathematical reasoning, Galileo discredited one Aristotelian "truth" after another, thus attacking the very core of church dogma. At the age of 70, crippled by rheumatism and almost blind, Galileo was brought before the Inquisition and made to recant his scientific conclusions. He lived his remaining years under house arrest and, although his works had been condemned, he continued to write in secret. The work Galileo considered his best, Dialogues Concerning Two New Sciences (1638), was completed under these circumstances and was smuggled out of Italy. Galileo died on January 9, 1642. It was not until October 31, 1992, that the Catholic church officially absolved Galileo of his "transgressions" (Reston, 1994, p. 283).

With the work of Copernicus, Kepler, and Galileo, the old materialistic view of Democritus was resurrected. The universe appeared to consist of matter whose motion was determined by forces external to it. God had become minimally important in the scheme of things, and now even the place of man was seriously questioned. Are humans part of the natural world? If so, they should be explicable in terms of natural science. Or is there something special about humans that sets them apart from the natural world? If so, how are humans special, and what special laws govern human behavior? The new science favored the view of humans as natural phenomena. Newton's epic-making accomplishments furthered the materialistic view of the universe and encouraged the generalization of that view to humans. Soon the universe and everything in it would be viewed as materialistic and machinelike, including humans.

ISAAC NEWTON

Isaac Newton (1642-1727) was born on December 25 the year Galileo died, in the village of Woolsthorpe, England. His father died before Newton's birth and, when his mother remarried, he was sent to live with his maternal grandmother in a neighboring town. In school, Newton was a mediocre student but showed great aptitude for building mechanical contrivances such as windmills and water clocks. When her second husband died, Newton's mother removed him from school and brought him back to Woolsthorpe hoping he would become a farmer. Recognizing his potential, one of Newton's teachers prevailed upon his mother to prepare Newton for entrance into Cambridge University. Newton entered Trinity College, Cambridge, in 1661 under the tutelage of Isaac Barrow, professor of mathematics, and obtained his degree four years later. Newton's greatest work, The Mathematical Principles of Natural Philosophy (1687/1995) was written in 18 months and was immediately hailed as a masterpiece. Newton was well aware of the fact that he benefited from the work of those who preceded him and said, "If I have seen further it is by standing on the shoulders of giants" (Blackburn, 1994, p. 260). In Newton's case, those giants included Copernicus, Kepler, and Galileo.

In 1703 Newton was elected the president of the Royal Society, and in 1705 he was knighted by Queen Anne. He was also twice a member of parliament. It is interesting to note that with all his accomplishments, Newton cited his lifelong celibacy as his greatest achievement (D. N. Robinson, 1997, lecture 27). Also, although we remember Newton most for his scientific achievements, he wrote much more about theology and alchemy than about science (Honderich, 1995, p. 618). For Newton, however, the three topics were inseparable.

Like Galileo, Newton conceived of the universe as a complex, lawful machine created by God. Guided by these conceptions, Newton developed differential and integral calculus (Leibniz made the same discovery independently), developed the universal law of gravitation, and did pioneer work in optics. Newton created a conception of the universe that was to prevail in physics and astronomy for more than two centuries, until Einstein revised it. His methods of verification, like those of Galileo, included observation, mathematical deduction, and experimentation. Newton, who was deeply religious, we have a complete reversal of the earlier faith-oriented way of knowing God: Because God made the universe, studying it objectively was a way of understanding God. In this he agreed with most of the Scholastics and with Copernicus and Kepler.

Although Newton believed in God as the creator of the universe, Newton's work greatly diminished God's influence. God created the universe and set it in motion, but that exhausted his involvement. After Newton, it was but a short step to removing God altogether. Soon **deism**, the belief that God created the universe but then abandoned it, became popular. For the deist, the design of the universe was God's work, but revelation, religious dogma, prayer, and all forms of supernatural commerce with God were considered fruitless (Blackburn, 1994, p. 97). Similarly, it was only a matter of time before humans, too, would be viewed and analyzed as just another machine that operated in accordance with Newtonian principles.

Perhaps Newton's most significant contribution was his universal law of gravitation. This law synthesized a number of previous findings, such as Kepler's observation that planetary motion is elliptical and Galileo's measurements of the acceleration of falling bodies. According to the law of gravitation, *all* objects in the universe attract each other. The amount of attraction is directly proportional to the product of the masses of the bodies and inversely proportional to the square of the distance between them. This single law was able to explain the motion of all physical bodies everywhere in the universe. Although the universe was a machine that

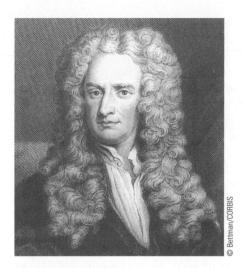

Isaac Newton

God had created, it operated according to principles that humans could discover, and Newton found that these principles could be expressed precisely in mathematical terms—thus his conclusion that "God was a mathematician."

Principles of Newtonian Science

The powerful and highly influential principles of Newtonian science can be summarized as follows:

- Although God is the creator of the world, he does not actively intervene in the events of the world (deism). It is therefore inappropriate to invoke his will as an explanation of any particular thing or event in the material world.
- The material world is governed by natural laws, and there are no exceptions to these laws.
- There is no place for purpose in natural law, and therefore Aristotle's final causes must be rejected. In other words, natural events can never be explained by postulating properties inherent in them. Bodies fall, for example, not because of an inherent tendency to fall, as Aristotle had assumed, but because of various forces acting on them. That is, as a Newtonian scientist, one must not invoke teleological explanations.

- Occam's razor is to be accepted. Explanations must always be as simple as possible. In Book III of his Principles (1687/1995), Newton gives this advice: "We are to admit no more causes of natural things than such as are both true and sufficient to explain their appearances" (p. 320). This is the principle that led Copernicus and many of his fellow mathematicians to reject the geocentric system in favor of the heliocentric system. Because with God, the simplest is always the best, so too should it be with mathematicians and scientists. Newton's conception of the universe could not have been simpler. Everything that happens can be explained in terms of (1) space, consisting of points; (2) time, consisting of moments; (3) matter, existing in space and possessing mass; and (4) force, that which provides change in the motion of matter. Newton and his followers believed that the entire physical universe could be explained in terms of these four constructs. In fact, an explanation of any natural event meant restating it mathematically in terms of space, time, matter, and force.
- Natural laws are absolute, but at any given time our understanding is imperfect. Therefore, scientists often need to settle for probabilities rather than certainty. This is because of human ignorance, not because of any flexibility in natural laws.
- Classification is not explanation. To note that chasing cats seems to be a characteristic of dogs does not explain *why* dogs tend to chase cats. To understand why anything acts as it does, it is necessary to know the physical attributes of the object being acted on (such as its mass) and the nature of the forces acting on it. Again, no purpose of any type can be attributed to either the object or to the forces acting on it.

The success of Copernicus, Kepler, Galileo, and Newton with empirical observation and mathematical deduction stimulated scholars in all fields and launched a spirit of curiosity and experimentation that has persisted until the present. Similarly, the success that resulted from viewing the universe as a machine was to have profound implications for

psychology. Science had become a proven way of unlocking nature's secrets, and it was embraced with intense enthusiasm. In many ways, science was becoming the new religion:

For centuries the Church had been impressing on man the limitations of his own wisdom. The mind of God is unfathomable. God works in a mysterious way his wonders to perform. Man must be content with partial understanding; the rest he must simply believe. For a Galileo or a Newton such a restriction of human curiosity was unacceptable. The scientist was willing to concede that some things may be ultimately unintelligible except on the basis of faith; but as he stubbornly continued to observe, measure and experiment, he discovered that more and more of the puzzles of nature were becoming clear. He was actually explaining in natural terms phenomena that had hitherto been unintelligible. Small wonder, then, that the new science began to generate a faith that ultimately science would displace theology. There is little evidence that in the sixteenth and seventeenth centuries such a faith was more than a dim hope. Nevertheless the seeds had been sown; scientists were uncovering more and more of the secrets of nature; and more and more explanations were now being given "without benefit of clergy." (MacLeod, 1975, p. 105)

FRANCIS BACON

Francis Bacon (1561–1626) was born into a distinguished political family on January 22 in London. After studying three years at Cambridge, he moved to France, where he worked for an ambassador. He returned to England to practice law, and in 1584 he was elected to parliament. Shortly after publication of his most influential work,

Novum Organum (New Method) (1620/1994), he was impeached by parliament for accepting bribes. He was levied a heavy fine (which he never paid) and served a brief prison sentence (four days) in the Tower of London. His forced retirement from legal and legislative matters, at 60 years of age, allowed him to concentrate on science and philosophy, and a number of significant books soon followed.

Bacon has traditionally been listed as the main spokesman for the new science in its revolt against past authorities, especially Aristotle. His sharp wit and brilliant writing style have tempted some to speculate that he was the true author of the Shakespearean plays. He was a contemporary of Galileo, followed Copernicus by almost 100 years, and was 35 years older than Descartes (whom we will consider next). Bacon was a radical empiricist who believed that nature could be understood only by studying it directly and objectively. Accounts of how nature should be based on scripture, faith, or any philosophical or theological authority would only hamper one's efforts to learn how the world actually functions. Bacon authored the following satirical story, which clearly demonstrates his own positivistic approach and his disdain for authority:

In the year of our Lord 1432, there arose a grievous quarrel among the brethren over the number of teeth in the mouth of a horse. For 13 days the disputation raged without ceasing. All the ancient books and chronicles were fetched out, and a wonderful and ponderous erudition, such as was never before heard of in this region, was made manifest. At the beginning of the 14th day, a youthful friar of goodly bearing asked his learned superiors for permission to add a word, and straightway, to the wonderment of the disputants, whose deep wisdom he sore vexed, he beseeched them to unbend in a manner coarse and unheard-of, and to look in the open mouth of a horse and find answer to their questionings. At this, their dignity being grievously hurt, they waxed exceedingly wroth and joining in a mighty

uproar, they flew upon him and smote his hip and thigh, and cast him out forthwith. For, said they, surely Satan hath tempted this bold neophyte to declare unholy and unheard-of ways of finding truth contrary to all the teachings of the fathers. After many days of grievous strife the dove of peace sat on the assembly, and they as one man, declaring the problem to be an everlasting mystery because of a grievous dearth of historical and theological evidence thereof, so ordered the same writ down. (Baars, 1986, p. 19)

Baconian Science

Although Bacon and Galileo were contemporaries, their approaches to science were very different. Galileo sought general principles (laws) that could be expressed mathematically and from which deductions could be made, an approach that actually required very little experimentation. For Galileo, discovering the laws that governed the physical world was important. Once such laws had been isolated and expressed mathematically, a large number of manifestations of those laws could be deduced (deduction involves predicting a particular event from a general principle); Bacon, on the other hand, demanded science based on induction. According to Bacon, science should include no theories, no hypotheses, no mathematics, and no deductions but should involve only the facts of observation. He believed that anyone doing research with preconceived notions would tend to see nature in light of those preconceptions. In other words, Bacon thought that accepting a theory was likely to bias one's observations, and he offered Aristotle as an example of a biased researcher. Bacon said that because Aristotle had assumed that the objects in nature were governed by final causes, his research confirmed the existence of final causes: "[Bacon] declared that when we assume 'final causes' and apply them to science, we are carrying into nature what exists only in our imagination. Instead of understanding things, we dispute

about *words*, which each man interprets to suit himself" (Esper, 1964, p. 290).

Bacon distrusted rationalism because of its emphasis on words, and he distrusted mathematics because of its emphasis on symbols: He said, "Words are but the images of matter.... To fall in love with them is [like falling] in love with a picture" (1605/1878, p. 120). Bacon trusted only the direct observation and recording of nature. With his radical empiricism, Bacon made it clear that the ultimate authority in science was to be empirical observation. No authority, no theory, no words, no mathematical formulation, no belief, and no fantasy could displace empirical observation as the basis of factual knowledge. Later in history, Bacon's approach to science would be called **positivism**.

But Bacon did not avoid classifying empirical observations. He believed that after many observations, generalizations could be made, and similarities and differences among observations noted. These generalizations could be used to describe classes of events or experiences. In Baconian science, one proceeds from observation to generalization (induction); in Galilean science, and later in Newtonian science, one proceeds from a general law to the prediction of specific, empirical events (deduction). Bacon did not deny the importance of the rational powers of the mind, but he believed that those powers should be used to understand the facts of nature rather than the figments of the human imagination. What Bacon (1620/1994) proposed was a position intermediate between traditional empiricism (simply fact gathering) and rationalism (the creation of abstract principles):

Empiricists, like ants, merely collect things and use them. The Rationalists, like spiders, spin webs out of themselves. The middle way is that of the bee, which gathers its material from the flowers of the garden and field, but then transforms and digests it by a power of its own. And the true business of philosophy is much the same, for it does not rely only or chiefly on the powers of the mind, nor does it store the material supplied by natural history and

Francis Bacon

practical experiments untouched in its memory, but lays it up in the understanding changed and refined. Thus from a closer and purer alliance of the two faculties—the experimental and the rational, such as has never yet been made—we have good reason for hope. (p. 105)

According to Bacon, scientists should follow two cardinal rules: "One, to lay aside received opinions and notions, and the other, to restrain the mind for a time from the highest generalizations" (1620/1994, p. 132). Again, Bacon was not against generalization, only premature generalization.

Bacon (1620/1994) summarized the four sources of error that he believed could creep into scientific investigation in his famous "idols":

- The idols of the cave are personal biases that arise from a person's intellectual endowment, experiences, education, and feelings. Any of these things can influence how an individual perceives and interprets the world.
- The idols of the tribe are biases due to human nature. All humans have in common the abilities to imagine, to will, and to hope, and these human attributes can and usually do distort perceptions. For example, it is common for people

- to see events as they would like them to be rather than how they really are. Thus, to be human is to have the tendency to perceive selectively.
- The idols of the marketplace are biases that result from being overly influenced by the meaning assigned to words. Verbal labels and descriptions can influence one's understanding of the world and distort one's observations of it. Bacon believed that many philosophical disputes were over the definitions of words rather than over the nature of reality. We see in this latter observation similarity between Bacon's philosophy and contemporary postmodernism (see Chapter 21).
- The **idols of the theater** are biases that result from blind allegiance to any viewpoint, whether it be philosophical or theological.

Science Should Provide Useful Information

Bacon also thought that science could and should change the world for the better. Science would furnish the knowledge that would improve technology, and improved technology would improve the world. As evidence for the power of technical knowledge, Bacon (1620/1994) offered the inventions of printing, gunpowder, and the magnetic compass:

These three [inventions] have changed the whole face and condition of things throughout the world, in literature, in warfare and in navigation. From them innumerable changes followed, so much so, that no empire, no sect, no star has been seen to exert more power and influence over the affairs of men than have these mechanical discoveries. (p. 131)

The practical knowledge furnished by science was so important for the betterment of society that Bacon believed that scientific activity should be generously supported by public funds. With his interest in practical knowledge, it is interesting that

Bacon died on April 9, 1629, from complications from a chill he experienced after stuffing a chicken with snow in order to test the effect of cold temperatures on the preservation of meat (Bowen, 1993, p. 225).

Although Bacon believed that science should always be judged by its practical consequences, he also believed that "human knowledge and human power come to the same thing, for where the cause is not known the effect cannot be produced. We can only command Nature by obeying her" (1620/1994, p. 43). Thus, Bacon reached his celebrated conclusion, "Knowledge ... is power" (Urbach, 1987, p. 59). For Bacon, then, understanding nature precedes any attempt to command it. By "understanding nature," Bacon meant knowing how things are causally related; once these relationships are known, their practical implications could be explored. Bacon, then, proposed two different types of experiments: experimenta lucifera (experiments of light) designed to discover causal relationships, and experimenta fructifera (experiments of fruit) designed to explore how the laws of nature might be utilized. Whether it involved experiments of light or fruit, Bacon's approach to science was inductive; in both cases, one needed to guard against the idols. Experiments will yield nature's secrets and provide practical information only if they are performed correctly. For Bacon, this meant in an unbiased manner.

Bacon was ahead of his time in insisting that scientists purge their minds of their biases. He was observing that scientists are human too, and, as with anyone else, their preconceptions can influence their observations. Kuhn (1996) points out the same thing with his concept of paradigm; currently, it is generally agreed that the observations of all scientists (or anyone else) are "theory-laden." That is, one's theory influences what one observes and how one interprets what one observes.

History has shown that Bacon's inductive approach to science was largely ignored and that the deductive approach of Galileo and Newton was highly influential. Contrary to what Bacon believed, productive science required bold theory and hypothesis testing. It is not bad to have hunches

or even beliefs about how things are; what *is* bad is not modifying those hunches or beliefs if the data require it. Popper noted that important scientific discoveries never come from induction, as Bacon had believed: "Bold ideas, unjustified anticipations, and speculative thought, are our only means for interpreting nature ... our only instrument for grasping her.... [The] experiment is planned action in which every step is guided by theory" (Popper, 1935/2002b, p. 280).

Most scientists since the time of Bacon have rejected his extreme reliance on the method of induction, but not all. In psychology, Skinner and his followers (see Chapter 13) have adopted Bacon's atheoretical philosophy. In 1950 Skinner wrote an article titled "Are Theories of Learning Necessary?" and his answer was no. In 1956 Skinner described his approach to experimentation. The approach involved trying one thing and then another, pursuing those things that showed promise, and abandoning those that did not. In the Skinnerian approach to research, there is no theory, no hypotheses, no mathematical analysis, and (supposedly) no preconceptions. Also in the Baconian spirit, the Skinnerians believe that the main goal of science should be to improve the human condition.

Bacon is a pivotal figure because of his extreme skepticism concerning all sources of knowledge except the direct examination of nature. He urged that nature itself be the only authority in settling epistemological questions. We see in Bacon an insistence that observations be made without any philosophical, theological, or personal preconceptions. Skepticism concerning information from the past also characterized the first great philosopher of the new age, René Descartes, to whom we turn next.

RENÉ DESCARTES

Born on March 31 of wealthy parents in La Haye, France, **René Descartes (1596–1650)** was truly a Renaissance man; at one time or another, he was a soldier, mathematician, philosopher, scientist, and psychologist. In addition, he was a man of the

world who enjoyed gambling, dancing, and adventure. But he was also an intensely private person who preferred solitude and avoided emotional attachments with people. At a time when his fame had begun to grow, he moved to Holland; while he was there, he moved 24 times without leaving a forwarding address so that he would not be bothered.

Descartes's mother died when he was barely a year old while giving birth to another son, who died three days later (Rodis-Lewis, 1998, p. 4). Because his father, a wealthy lawyer, practiced law some distance from the home. Descartes was reared mainly by his grandmother, a nurse, and an older brother and sister. As one might expect, Descartes was a very bright child. He was enrolled in a Jesuit school at La Flèche when he was 10 years old and graduated when he was 16. While at La Flèche, he, like other students at the time, studied the writings of Plato, Aristotle, and the early Christian philosophers. At that time, education consisted of logically demonstrating the validity of revealed truths (Scholasticism). As a student, Descartes was especially fond of mathematics, and by the time he was 21, he knew essentially everything there was to be known on the subject.

After his graduation from La Flèche, Descartes roamed freely and sampled many of life's pleasures, finally taking up residence in St. Germain, a suburb of Paris. It was there that Descartes observed a group of mechanical statues, which the queen's fountaineers had constructed for her amusement. The statues contained a system of water pipes that, when activated by a person stepping on a hidden floor plate, caused a series of complex movements and sounds. As we will see shortly, this idea of complex movement being caused by a substance flowing through pipes was to have a profound influence on Descartes's later philosophy.

Descartes's Search for Philosophical Truth

About the time Descartes moved to St. Germain, he experienced an intellectual crisis. It occurred to

him that everything he had ever learned was useless, especially philosophy. He noted that philosophers had been seeking truth for centuries but had been unable to agree among themselves about anything; he concluded that nothing in philosophy was beyond doubt. This realization thrust Descartes into deep depression. He decided that he would be better off learning things for himself instead of from the "experts": "I resolved to seek no other knowledge than that which I might find within myself, or perhaps in the great book of nature" (1637/1956, p. 6). Like Francis Bacon before him, Descartes sought an "intellectual fortress capable of withstanding the assaults of the skeptics" (Popkin, 1979, p. 173).

Descartes's method of self-exploration was productive almost immediately. Usually, Descartes explored his many new ideas during intense meditation while lying in bed; during one of these meditations, one of his greatest insights occurred. Descartes invented analytic geometry after watching a fly in his room. He noted that he could precisely describe the fly's position at any given instance with just three numbers: the fly's perpendicular distances from two walls and from the ceiling. Generalizing from this observation, Descartes showed how geometry and algebra could be integrated, making it possible to represent astronomical phenomena such as planetary orbits with numbers. More generally, Descartes had discovered an exact correspondence between the realm of numbers and the realm of physics. However complicated, all natural events were now describable in mathematical terms. Like Copernicus, Kepler, and Galileo before him and like Newton after him. Descartes reached the conclusion that ultimate knowledge is always mathematical knowledge. With the invention of analytic geometry, it was now possible to precisely describe and measure essentially all known physical phenomena. In this way, Descartes further substantiated the Pythagorean-Platonic conception of the universe that had been accepted by Copernicus, Kepler, and Galileo and that was about to be elaborated further by Newton.

Next, Descartes sought other areas of human knowledge that could be understood with the same certainty as analytic geometry. Stimulated by

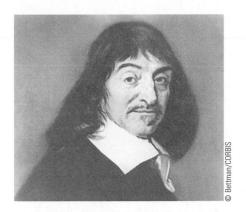

René Descartes

his success in mathematics, Descartes (1637/1956) summarized his four rules for attaining certainty in any area:

The first rule was never to accept anything as true unless I recognized it to be evidently as such: that is, carefully to avoid all precipitation and prejudgment, and to include nothing in my conclusions unless it presented itself so clearly and distinctly to my mind that there was no reason or occasion to doubt it.

The second was to divide each of the difficulties which I encountered into as many parts as possible, and as might be required for an easier solution.

The third was to think in an orderly fashion, beginning with the things which were simplest and easiest to understand, and gradually and by degrees reaching toward a more complex knowledge, even treating, as though ordered, materials which were not necessarily so.

The last was always to make enumerations so complete, and reviews so general, that I would be certain that nothing was omitted. (p. 12)

Thus began Descartes's search for philosophical truth. He resigned himself to doubt everything that could be doubted and to use whatever was certain,

just as one would use axioms in mathematics. That is, that which was certain could be used to deduce other certainties. After a painful search, Descartes concluded that the only thing of which he could be certain was the fact that he was doubting; but doubting was thinking, and thinking necessitated a thinker. Thus, he arrived at his celebrated conclusion "Cogito, ergo sum" (I think, therefore I am). Descartes established the certainty of his own thought processes, a certainty that, for him, made the introspective search for knowledge valid. It may be remembered that Augustine had used the same method of doubt to validate his subjective experiences over a thousand years earlier (see Chapter 3).

Innate Ideas

Descartes further analyzed the content of his thought and found that some ideas were experienced with such clarity and distinctiveness that they needed to be accepted as true, and yet they had no counterparts in his personal experience. Descartes thought that such ideas were innate; that is, they were natural components of the mind. For example, he observed that even though he was imperfect, he still entertained ideas that were perfect. Because something perfect could not come from something imperfect, Descartes concluded that he could not have been the author of such ideas: "The only hypothesis left was that this idea was put in my mind by a nature that was really more perfect than I was, which had all the perfections that I could imagine, and which was, in a word, God" (1637/1956, p. 22). Descartes included among the innate ideas those of unity, infinity, perfection, the axioms of geometry, and God.

Because God exists and is perfect and will not deceive humans, we can trust the information provided by our senses. However, even sensory information must be clear and distinct before it can be accepted as valid. *Clear* means that the information is represented clearly in consciousness, and *distinct* means that the conscious experience cannot be doubted or divided for further analysis. Descartes gave the example of seeing a stick partially

submerged in water and concluding that it is bent. Seeing the apparently bent stick provides a clear, cognitive experience, but further analysis, such as removing the stick from the water, would show that the experience was an illusion. Thus, Descartes concluded (1) that rational processes were valid and that knowledge of the physical world gained through the senses could be accepted because God would not deceive us, but (2) that even sensory information had to be analyzed rationally in order to determine its validity.

Descartes's method, then, consisted of intuition and deduction. Intuition is the process by which an unbiased and attentive mind arrives at a clear and distinct idea, an idea whose validity cannot be doubted. Once such an idea is discovered, one can deduce from it many other valid ideas. An example would be first arriving at the idea that God exists and then deducing that we can trust our sensory information because God would not deceive us. It is important to note that Descartes's method restored the dignity to purely subjective experience, which had been lost because of Galileo's philosophy. In fact, Descartes found that he could doubt the existence of everything physical (including his own body) but could not doubt the existence of himself as a thinking being. The first principles of Descartes's philosophy were cognitive in nature and were arrived at by intuition. There is also no mathematical concept any more certain than Cogito, ergo sum; this being so, we can turn our attention inward to the mind (self, soul, ego) and examine such subjective experiences as thinking, willing, perceiving, feeling, and imagining. Thus, although Descartes was a rationalist (he stressed the importance of logical thought processes) and a nativist (he stressed the importance of innate ideas), he was also a phenomenologist; he introspectively studied the nature of intact, conscious experience. Descartes's method of intuition and deduction was believed to be as valid when directed toward the world of inner experience as when directed toward the physical world.

Although Descartes's philosophy was anchored in rational and phenomenological processes, he had

an entirely mechanistic conception of the physical world, of all animal behavior, and of much human behavior. In his view, animals responded to the world in a way that could be explained in terms of physical principles. To understand these principles, we must recall Descartes's observation of the statues in St. Germain.

The Reflex

Descartes took the statues at St. Germain as his model in explaining all animal behavior and much human behavior (that is, Descartes explained both the behavior of the statues and the behavior of animals in terms of mechanical principles). The sense receptors of the body were like the pressure plates that started the water flowing through the tubes and activated the statues. Descartes thought of the nerves as hollow tubes containing "delicate threads" that connected the sense receptors to the brain. These threads were connected to the cavities or ventricles of the brain, which were filled with animal spirits. The concept of animal spirits was popular among the early Greeks (such as Aristotle) and was perpetuated by the highly influential physician Galen (ca. 129–199). By believing that the presence of animal spirits distinguished the living from the nonliving, these philosophers and physicians embraced a form of vitalism (see Chapter 1). Descartes described animal spirits as a gentle wind or a subtle flame. The delicate threads in the nerves were ordinarily taut, but when an external event stimulated a sense organ, the threads were tightened further and opened a "pore" or "conduit" in the corresponding brain area; the pore then released animal spirits into the nerves. When the animal spirits flowed to the appropriate muscles, they caused the muscles to expand and thus caused behavior. Descartes gave as an example a person's foot coming near a flame. The heat causes a pull on the threads connected to cavities of the brain containing animal spirits. The pull opens one or more of these cavities, allowing animal spirits to travel down small, hollow tubes (nerves) to the foot muscles, which in turn expand and withdraw the foot

from the flame. This was the first description of what was later called a reflex. That is, an environmental event (heat) automatically causes a response (foot withdrawal) because of the way the organism is constructed (nerves, muscles, and animal spirits).

By saying that both animal and human interactions with the environment were reflexive, Descartes made it legitimate to study nonhuman animals to learn more about the functioning of the human body. He did a great deal of dissecting and concluded from his research that not only could interactions with the environment be explained through mechanical principles but so could digestion, respiration, nourishment and growth of the body, circulation of the blood, and even sleeping and dreaming. In 1628 the British physiologist William Harvey (1578-1657) demonstrated that the heart was a large pump that forced blood into the arteries, then into the veins, then into the lungs, and then back into the arteries. In other words, Harvey discovered that the heart caused the circulation of blood and that the heart's function could be explained using the same mechanical and hydraulic principles that apply to inorganic systems. Descartes took Harvey's discovery as further evidence that many (if not all) bodily functions are mechanical in nature.

Even in Descartes's lifetime, evidence showed that his analysis of reflexive behavior was incorrect. There was fairly conclusive evidence that nerves were not hollow, and there was growing evidence that there were two distinctly different types of nerves: sensory nerves carrying information from the sense receptors to the brain and motor nerves carrying information from the brain to the muscles. It also had been commonly observed that several animals continued to move and react to certain types of stimulation even after they were decapitated, and it was common knowledge that animals could acquire new responses. Although all these observations posed problems for Descartes's analysis of reflexive behavior, he never modified his position. Before long, however, others would make the necessary corrections in Cartesian theory (Cartesian and Cartesianism are terms used when referring to

some aspect of Descartes's philosophy or methodology).

Descartes's Explanation of Sleep and Dreams

Descartes's explanation of sleep begins by noting that while organisms are awake, the cavities of the brain are so filled with animal spirits that the brain tissue engulfing a cavity expands, slightly increasing the tautness of the delicate threads and thus making them maximally responsive to sensory stimulation. Through the day, the amount of animal spirits in the brain cavities diminishes, and the tissue surrounding them becomes lax, whereupon the delicate threads become slack. Under these conditions, the organism is not very responsive to the environment, and we say it is asleep. Animal spirits flow randomly in the cavities, and every now and then isolated cavities will be filled, their connecting threads becoming tight. This causes the random, disconnected experiences we refer to as dreams.

The Mind-Body Interaction

As mentioned, Descartes believed that all animal behavior and internal processes could be explained mechanically, as could much human behavior and many human internal processes. There was, however, an important difference between humans and other animals. Only humans possessed a mind that provided consciousness, free choice, and rationality. Furthermore, the mind was nonphysical and the body physical; that is, the body occupied space but the mind did not. In the process of arriving at the first principle of his philosophy—"I think, therefore I am"—Descartes believed that he had discovered the fact that the mind was nonmaterial. Descartes (1637/1956) described what he next deduced from this first principle:

I then examined closely what I was, and saw that I could imagine that I had no body, and that there was no world nor any

place that I occupied, but that I could not imagine for a moment that I did not exist. On the contrary, from the very fact that I doubted the truth of other things, it followed very evidently and very certainly that I existed. On the other hand, if I had ... ceased to think while all the rest of what I had ever imagined remained true, I would have had no reason to believe that I existed: therefore I concluded that I was a substance whose whole essence or nature was only to think, and which, to exist, has no need of space nor of any material thing. Thus it follows that this ego, this soul, by which I am what I am, is entirely distinct from the body and is easier to know than the latter, and that even if the body were not, the soul would not cease to be all that it now is. (p. 21)

By saying that the nonphysical mind could influence the physical body, Descartes confronted the ancient mind-body problem head on. What had been implicit in many philosophies from the time of Pythagoras was explicit in Descartes's philosophy. He clearly stated that humans possess a body that operates according to physical principles and a mind that does not and that the two interact (influence each other). So, on the mind-body problem, Descartes was a **dualist**, and the type of dualism that he subscribed to was **interactionism** (sometimes referred to as Cartesian dualism). The question, of course, is how this interaction occurs.

Because the mind was thought of as nonphysical, it could not be located anywhere. Descartes believed that the mind permeated the entire body. That the mind is not housed in the body as a captain is housed in a ship is demonstrated by the fact that our sensory experiences embellish our cognitive experiences—with color for example—and by the fact that we consciously feel bodily states such as hunger, thirst, and pain. None of these experiences or feelings would be possible if the mind were not closely related to the body. Still, Descartes sought a place where the mind exerted its influence on the

body. He sought a structure in the brain because the brain stored the animal spirits. Also, the structure had to be unitary because our conscious experience, although often resulting from stimulation coming from the two eyes or two ears, is unitary. Finally, the structure had to be uniquely human because humans alone possess a mind. Descartes chose the pineal gland because it was surrounded by animal spirits (what we now call cerebrospinal fluid), it was not duplicated like other brain structures, and (he erroneously believed) it was found only in the human brain. It was through the pineal gland that the mind willed the body to act or inhibited action. When the mind willed something to happen, it stimulated the pineal gland, which in turn stimulated appropriate brain areas, causing animal spirits to flow to various muscles and thus bringing about the willed behavior.

Because the mind is free, it can inhibit or modify the reflexive behavior that the environment would elicit mechanically. Emotions are related to the amount of animal spirits involved in a response; the more animal spirits, the stronger the emotion. Emotions are experienced consciously as passions such as love, wonder, hate, desire, joy, anger, or sadness. According to Descartes, the will can and should control the passions so that virtuous conduct results. If, for example, anger is experienced and angry behavior is appropriate, the mind will allow or even facilitate such behavior. If, however, such behavior is seen as inappropriate, the mind will attempt to inhibit it. In the case of an intense passion, the will may be unable to prevent the reflexive behavior, and the person will act irrationally.

Descartes was well aware of the difficulties in explaining how a nonphysical mind could interact with a physical body. After several attempts to explain this interaction, he finally decided that it could not be explained logically. Rather, he supported his argument for separate but interacting mind-body entities with common sense. Everyone, he said, has both bodily and conscious experiences and senses the fact that the two influence each other. Thus, the supreme, rational philosopher supported one of his most basic conceptions by appealing to everyday experience (Tibbetts, 1975).

Descartes's Contributions to Psychology

Descartes attempted a completely mechanistic explanation of many bodily functions and of much behavior. His mechanistic analysis of reflexive behavior can be looked on as the beginning of both stimulus-response and behavioristic psychology. He focused attention on the brain as an important mediator of behavior, and he specified the mind-body relationship with such clarity that it could be supported or refuted by others. Reactions to his notion of innate ideas were so intense that they launched new philosophical and psychological positions (modern empiricism and modern sensationalism). By actually investigating the bodies of animals to learn more about their functioning and thus about the functioning of human bodies, he gave birth to both modern physiological and comparative psychology. By making purely subjective experience respectable again, Descartes paved the way for the scientific study of consciousness. His work on conflict did not focus on sinful-versus-moral behavior but on animal-versus-human, rationalversus-irrational behavior: he was interested in the type of conflict that Freud later studied. Finally, because of his use of introspection to find clear and distinct ideas, Descartes can be looked on as an early phenomenologist.

After Descartes, some philosophers elaborated on the mechanical side of his theory by saying that humans were *nothing but* machines and that the concept of mind was unnecessary. Others stressed the cognitive side of his philosophy, saying that consciousness was the most important aspect of humans. In any case, what followed Descartes was, in one way or another, a reaction to him; for that reason, he is often considered the father of modern philosophy in general and of modern psychology in particular.

Controversy concerning Descartes's religious beliefs clearly reflects the transitional period in which he lived. If one accepts at face value what Descartes said, he undoubtedly believed in the existence of God and accepted the authority of the church (see especially Descartes, 1642/1992).

However, Descartes was caught between his loyalty to the Catholic church and his objective search for truth. Between 1629 and 1633, Descartes worked on his book The World, which supported many of the conclusions that Galileo had reached in his Dialogue Concerning the Two Chief World Systems (1632). Although Descartes believed Galileo's arguments to be valid, he decided to suppress publication of The World when he learned of Galileo's fate at the hands of the Inquisition. In a letter to his friend Marin Mersenne. Descartes said that he agreed with Galileo's views but that "I would not wish, for anything in the world, to maintain them against the authority of the church" (Kenny, 1970, p. 26). The World was published in 1664, 14 years after Descartes's death. From all this, one might assume that Descartes was a devout believer. However.

the opposite hypothesis, that Descartes was essentially atheistic, may be argued with greater plausibility than the first assumption. According to this hypothesis, Descartes was a pure naturalist caught in a social situation where nonconformity meant persecution and even death. He had no taste for martyrdom, and consequently disguised those of his views which might get him into trouble, and embellished the remainder with a show of piety that must be understood, quite literally, as life insurance. (Lafleur, 1956, p. xviii)

Descartes's Fate

Despite efforts to appease the church, Descartes's books were placed on the Catholic index of forbidden books in the belief that they led to atheism. As a result, Descartes slowed his writing and instead communicated personally with small groups or individuals who sought his knowledge. One such individual was Queen Christina of Sweden, who in 1649 invited Descartes to be her philosopher-in-residence, and he accepted. Unfortunately, the queen insisted on being tutored at five o'clock

each morning, and one day Descartes had to travel to the palace before sunrise during a severe Swedish winter. After only six months in Sweden, Descartes caught pneumonia and died on February 11, 1650. Descartes was first buried in Sweden in a cemetery for distinguished foreigners, but there is more to this unfortunate story:

Sixteen years later, his body was exhumed, as it had been decided by various friends and disciples that it would be more fitting for his bodily remains to rest in France; perhaps they did not respect as seriously as he might have wished, Descartes's belief in the possibility of a disembodied spirit and the existence of mental processes in the absence of any brain. The French ambassador to Sweden took charge and first cut off Descartes's right forefinger as a personal souvenir. It was then found that the special copper coffin provided for transporting the

body was too short. So the neck was severed and skull removed to be shipped separately. The coffin returned safely to Paris and Descartes's headless body was reburied with great pomp. The skull had a more sordid fate: it was stolen by an army captain, passed from one Swedish collector to another, and took 150 years to reach Paris, where it was awkwardly shelved in the Academie des Sciences and has apparently remained there ever since. (Boakes, 1984, p. 88)

On a lighter note, D. N. Robinson (1997, lecture 26) relates a joke circulating among philosophers concerning Descartes's proclamation "I think, therefore I am": Descartes was at a bar finishing a drink, and the bartender asked if he cared for another. "I think not," said Descartes, and he disappeared.

SUMMARY

Renaissance humanism had four major themes: a belief in the potential of the individual, an insistence that religion be more personal and less institutionalized, an intense interest in the classics, and a negative attitude toward Aristotle's philosophy. The humanists did much to break the authority of the organized church and of Aristotle's philosophy; this had to happen before a scientific attitude could develop. Although the Renaissance was a troubled time, it was a time of great curiosity and creativity. As the power of the church deteriorated, inquiry became increasingly objective because findings no longer needed to fit church dogma. Before Copernicus, the Ptolemaic system, which claimed that the earth was the stationary center of the solar system (and the universe), essentially was universally accepted. Copernicus demonstrated that the earth was not the center of the solar system. Kepler found that the paths of the planets were not circular but elliptical. Galileo found, among other things, that all material bodies fall at the same rate; and using a

telescope, he discovered four of Jupiter's moons. Galileo concluded that the universe was lawful and that the results of experiments could be summarized mathematically. He also concluded that a science of psychology was impossible because of the subjective nature of human thought processes.

Newton viewed the universe as a complex, lawful, knowable machine that had been created and set in motion by God. Newton's science was highly theoretical and stressed deduction. Newton's success in explaining much of the physical universe in terms of a few basic laws had a profound influence on science, philosophy, and eventually psychology. In fact, Newtonian science was so successful that people began to believe science had the potential to answer all questions. In a sense, science was becoming a new religion.

Bacon wanted science to be completely untainted by past mistakes and therefore urged that scientific investigations be inductive and devoid of theories, hypotheses, and mathematical formula-

tions. Bacon also wanted science to be aimed at the solution of human problems. He described four sources of error that can creep into scientific investigation: the idols of the cave, or biases resulting from personal experience; the idols of the tribe, or biases resulting from human nature; the idols of the marketplace, or biases due to the traditional meanings of words; and the idols of the theater, or blind acceptance of authority or tradition.

Like Bacon, Descartes wanted a method of inquiry that would yield knowledge that was beyond doubt. Descartes doubted everything except the fact that he doubted and thus concluded that introspection was a valid method for seeking truth. Descartes also decided that sensory information could be trusted because God had created our sensory apparatus and would not deceive us. Taking his inspiration from mechanical statues that he had observed. Descartes concluded that all animal behavior and much human behavior was mechanical. He likened sense receptors to pressure plates that, when stimulated, pulled on tiny strings in the nerves. When pulled, the strings opened pores in the brain that allowed animal spirits to move down the nerves into the muscles, causing them to expand. The expanding muscles, in turn, caused behavior. Descartes saw the mind and body as separate but interacting; that is, the body can influence the mind, and the mind can influence the body. Descartes's version of dualism is called interactionism. Descartes also believed that the mind contained several innate ideas and that emotional behavior, experienced consciously as a passion, was determined by the amount of animal spirits involved in the behavior. Descartes brought much attention to the mind-body relationship, caused great controversy over innate ideas, introspectively studied the phenomena of the mind, stimulated animal research (and thus physiological and comparative psychology), and was the first to describe the reflex—a concept that was to become extremely important in psychology.

The philosophers and scientists of the 16th and 17th centuries reviewed in this chapter were transitional figures. In their lives, we see a mixture of religious subjectivity and the need to be completely objective. These thinkers were not antireligion; they were antidogma. Most of them believed that their work was revealing God's secrets. What made them different from those who had preceded them was their refusal to allow past beliefs or methods to influence their inquiries; and, in fact, their investigations were motivated by apparent errors in previously accepted dogma.

DISCUSSION QUESTIONS

- Describe the four themes that characterized Renaissance humanism and give an example of each.
- 2. Why is the Renaissance referred to as a paradoxical period?
- 3. What arguments did Erasmus offer in support of free will, and what arguments did Luther offer in opposition to it?
- 4. In what way did Montaigne's Skepticism stimulate the philosophical systems developed by Bacon and Descartes?

- 5. Describe the Ptolemaic astronomical system and explain why that system was embraced by Christian theologians.
- 6. On what basis did Copernicus argue that his heliocentric theory should replace Ptolemy's geocentric theory?
- 7. On what philosophical conception of the universe was the work of Copernicus, Kepler, and Galileo based? Explain.
- 8. Summarize the theological implications of Copernicus's heliocentric theory.

- 9. In what way(s) can the clash between the Ptolemaic and Copernican systems be likened to a Kuhnian scientific revolution?
- Discuss the implications for psychology of Galileo's distinction between primary and secondary qualities.
- 11. What is deism?
- 12. What was Newton's conception of science?
- 13. Summarize Bacon's view of science.
- 14. Describe the idols of the cave, marketplace, theater, and tribe.
- 15. Distinguish between Bacon's experiments of light and experiments of fruit and describe how the two are related.
- 16. What was it that Descartes thought he could be certain of? Once this certainty was arrived at, how did Descartes use it in further developing his philosophy?

- 17. Why did Descartes reach the conclusion that some ideas are innate? Give examples of ideas that he thought were innate.
- 18. Summarize Descartes's view of the mind-body relationship.
- 19. Describe the importance of intuition and deduction in Descartes's philosophy.
- 20. Why is it appropriate to refer to Descartes as a phenomenologist?
- 21. How did Descartes reach the conclusion that the mind is nonmaterial and has an existence independent of the body?
- 22. What were Descartes's contributions to psychology?
- 23. In general, what attitude toward religion did individuals covered in this chapter have?

SUGGESTIONS FOR FURTHER READING

- Augustijn, C. (1991). Erasmus: His life, works, and influence (J. C. Grayson, Trans.). Toronto: University of Toronto Press.
- Bacon, F. (1994). *Novum organum* (P. Urbach & J. Gibson, Eds. and Trans.). La Salle, IL: Open Court. (Original work published 1620)
- Bacon, F. (2001). *The advancement of learning*. New York: Modern Library. (Original work published 1605)
- Bowen, C. D. (1993). Francis Bacon: The temper of a man. New York: Fordham University Press.
- Cottingham, J. (Ed.). (1992). The Cambridge companion to Descartes. New York: Cambridge University Press.
- Crew, H., & De Salvio, A. (Trans.). (1991). Galileo Galilei: Dialogues concerning two new sciences. Buffalo, NY: Prometheus Books. (Original work published 1638)
- Drake, S. (1994). *Galileo: Pioneer scientist.* Toronto: University of Toronto Press.
- Hall, M. B. (1994). The scientific renaissance: 1450–1630. New York: Dover.

- Kuhn, T. S. (1957). The Copernican revolution: Planetary astronomy in the development of Western thought.

 New York: MJF Books.
- Lafleur, L. J. (Ed. and Trans.) (1956). Rene Descartes: Discourse on method.Indianapolis: Bobbs-Merrill. (Original work published 1637)
- Losee, J. (2001). A historical introduction to the philosophy of science (4th ed.). New York: Oxford University Press.
- Marty, M. (2004). *Martin Luther*. New York: Viking Penguin.
- Rodis-Lewis, G. (1999). *Descartes: His life and thought* (J. M. Todd, Trans.). Ithaca, NY: Cornell University Press.
- Rummel, E. (Ed.). (1996). *Erasmus on women*. Toronto: University of Toronto Press.
- Sorell, T. (2000). *Descartes: A very short introduction*. New York: Oxford University Press.
- Taub, L. B. (1993). Ptolemy's universe: The natural philosophical and ethical foundations of Ptolemy's astronomy. La Salle, IL: Open Court.

Tibbetts, P. (1975). An historical note on Descartes's psychophysical dualism. *Journal of the History of the Behavioral Sciences*, 9, 162–165.

Urbach, P. (1987). Francis Bacon's philosophy of science: An account and a reappraisal. La Salle, IL: Open Court.

Wilson, J. (Trans.). (1994). Desiderius Erasmus: The praise of folly. Amherst, NY: Prometheus Books. (Original work published 1512)

Winter, E. F. (Ed. & Trans.). (2005). Erasmus & Luther: Discourse on free will. New York: Continuum.

Yates, F. A. (1964). Giordano Bruno and the hermetic tradition. Chicago: University of Chicago Press.

GLOSSARY

Animal spirits The substance Descartes (and others) thought was located in the cavities of the brain. When this substance moved via the nerves from the brain to the muscles, the muscles swelled and behavior was instigated.

Aristarchus of Samos (ca. 310–230 B.C.) Sometimes called the Copernicus of antiquity, speculated that the planets, including the earth, rotate around the sun and that the earth rotates on its own axis, and he did so almost 1,700 years before Copernicus.

Bacon, Francis (1561–1626) Urged an inductive, practical science that was free from the misconceptions of the past and from any theoretical influences.

Bruno, Giordano (1548–1600) Accepted the mystical non-Christian philosophy of Hermetism and Copernicus's heliocentric theory because he mistakenly believed that it supported Hermetism. He was burned at the stake for his beliefs.

Copernicus, Nicolaus (1473–1543) Argued that the earth rotated around the sun and therefore the earth was not the center of the solar system and the universe as the church had maintained.

Deduction The method of reasoning by which conclusions must follow from certain assumptions, principles, or concepts. If there are five people in a room, for example, one can deduce that there are also four; or if it is assumed that everything in nature exists for a purpose, then one can conclude that humans, too, exist for a purpose. Deductive reasoning proceeds from the general to the particular.

Deism The belief that God's creation of the universe exhausted his involvement with it.

Descartes, René (1596–1650) Believed that much human behavior can be explained in mechanical terms, that the mind and the body are separate but interacting entities, and that the mind contains innate ideas. With

Descartes began comparative-physiological psychology, stimulus-response psychology, phenomenology, and a debate over whether innate ideas exist. Descartes also focused attention on the nature of the relationship between the mind and the body.

Dualist One who believes that a person consists of two separate entities: a mind, which accounts for one's mental experiences and rationality, and a body, which functions according to the same biological and mechanical principles as do the bodies of nonhuman animals.

Erasmus, Desiderius (1466–1536) A Renaissance humanist who opposed fanaticism, religious ritual, and superstition. He argued in favor of human free will.

Ficino, Marsilio (1433–1499) Founded a Platonic academy in 1462 and sought to do for Plato's philosophy what the Scholastics had done for Aristotle's.

Galileo (1564–1642) Showed several of Aristotle's "truths" to be false and, by using a telescope, extended the known number of bodies in the solar system to 11. Galileo argued that science could deal only with objective reality and that because human perceptions were subjective, they were outside the realm of science.

Geocentric theory The theory, proposed by Ptolemy, that the sun and planets rotate around the earth.

Heliocentric theory The theory, proposed by Copernicus, that the planets, including the earth, rotate around the sun.

Humanism A viewpoint that existed during the Renaissance. It emphasized four themes: individualism, a personal relationship with God, interest in classical wisdom, and a negative attitude toward Aristotle's philosophy.

Idols of the cave Bacon's term for personal biases that result from one's personal characteristics or experiences.

Idols of the marketplace Bacon's term for error that results when one accepts the traditional meanings of the words used to describe things.

Idols of the theater Bacon's term for the inhibition of objective inquiry that results when one accepts dogma, tradition, or authority.

Idols of the tribe Bacon's term for biases that result from humans' natural tendency to view the world selectively.

Induction The method of reasoning that moves from the particular to the general. After a large number of individual instances are observed, a theme or principle common to all of them might be inferred. Deductive reasoning starts with some assumption, whereas inductive reasoning does not. Inductive reasoning proceeds from the particular to the general.

Innate ideas Ideas, like perfection and the axioms of geometry, that Descartes believed could not be derived from one's own experience. Such ideas, according to Descartes, were placed in the mind by God.

Interactionism The version of dualism that accepts the separate existence of a mind and a body and claims that they interact.

Intuition In Descartes's philosophy, the introspective process by which clear and distinct ideas are discovered.

Kepler, Johannes (1571–1630) By observation and mathematical deduction, determined the elliptical paths of the planets around the sun. Kepler also did pioneer work in optics.

Luther, Martin (1483–1546) Was especially disturbed by corruption within the church and by the church's emphasis on ritual. He believed that a major reason for the church's downfall was its embracing of Aristotle's philosophy, and he urged a return to the personal religion that Augustine had described. He accepted Augustine's concept of predestination but denied human free will. His attack of the established church contributed to the Reformation, which divided Europe into warring camps.

Montaigne, Michel de (1533–1592) Like the earlier Greek and Roman Skeptics, believed there was no objective way of distinguishing among various claims of truth. His doubts concerning human knowledge stimulated a number of subsequent thinkers such as Bacon and Descartes.

Newton, Isaac (1642–1727) Extended the work of Galileo by showing that the motion of all objects in the

universe could be explained by his law of gravitation. Although Newton believed in God, he believed that God's will could not be evoked as an explanation of any physical phenomenon. Newton viewed the universe as a complex machine that God had created, set in motion, and then abandoned.

Petrarch, Francesco (1304–1374) A Renaissance humanist referred to by many historians as the father of the Renaissance. He attacked Scholasticism as stifling the human spirit and urged that the classics be studied not for their religious implications but because they were the works of unique human beings. He insisted that God had given humans their vast potential so that it could be utilized. Petrarch's views about human potential helped stimulate the many artistic and literary achievements that characterized the Renaissance.

Phenomenologist One who introspectively studies the nature of intact conscious experience. Descartes was a phenomenologist.

Pico, Giovanni (1463–1494) Maintained that humans, unlike angels and animals, are capable of changing themselves and the world. He believed that all philosophical positions should be respected and the common elements among them sought.

Positivism The belief that only those objects or events that can be experienced directly should be the object of scientific inquiry. The positivist actively avoids metaphysical speculation.

Primary qualities Attributes of physical objects: for example, size, shape, number, position, and movement or rest.

Protestantism The religious movement that denied the authority of the pope and of Aristotle. It argued against church hierarchy and ritual and instead wanted a simple, deeply personal, and introspective religion like that described by St. Paul and St. Augustine.

Ptolemaic system A conception of the solar system that has the earth as its center. During the Middle Ages, the Ptolemaic system was widely accepted because it (1) agreed with everyday experience; (2) was able to predict and account for all astronomical phenomena known at the time; (3) gave humans a central place in the universe; and thus agreed with the biblical account of creation.

Ptolemy (fl. second century A.D.) The Greco-Egyptian astronomer whose synthesis of earlier and contemporary astronomical works came to be called the Ptolemaic system. (*See also* **Ptolemaic system**.)

Reformation The attempt of Luther and others to reform the Christian church by making it more Augustinian in character. This effort resulted in the division of western European Christianity into Protestantism and Roman Catholicism.

Renaissance The period from about 1450 to about 1600 when there was a rebirth of the open, objective

inquiry that had characterized the early Greek philosophers.

Secondary qualities Those apparent attributes of physical objects that in fact exist only in the mind of the perceiver—for example, the experiences of color, sound, odor, temperature, and taste. Without a perceiver, these phenomena would not exist.

Empiricism, Sensationalism, and Positivism

D escartes was so influential that most of the philosophies that developed after him were reactions to some aspect of his philosophy. The major reactions were concentrated in several regions of Europe. The British and the French philosophers denied Descartes's contention that some ideas are innate, saying instead that all ideas are derived from experience. These philosophers attempted to explain the functioning of the mind as Newton had explained the functioning of the universe. That is, they sought a few principles, or laws, that could account for all human cognitive experience.

The German philosophers made an active mind central to their conception of human nature. In general, they postulated a mind that could discover and understand the abstract principles that constitute ultimate reality. Instead of envisioning a mind that simply recorded and stored sensory experiences, they saw the mind as actively transforming sensory information, thereby giving that information meaning it otherwise would not have. For these German rationalists, knowing the operations of this active mind was vital in determining how humans confront and understand their world.

Scattered throughout Europe, the romantic philosophers rebelled against the views of the empiricists and rationalists. According to the romantics, both of these philosophies concentrated on one aspect of humans and neglected others. The romantics urged a focus on the total human, a focus that included two aspects the other philosophies either minimized or neglected: human feelings and the uniqueness of each individual. The romantics also advocated living a simple, natural life and thus had much in common with the Cynics (see Chapter 3) and with some of the Renaissance humanists, such as Erasmus (see Chapter 4).

After Descartes, and to a large extent because of him, the ancient philosophies of empiricism, rationalism, and romanticism were presented more clearly and in greater detail than they had ever been before. It was from the modern manifestations of these philosophies that psychology as we know it today emerged. In this chapter, we focus on British empiricism and French sensationalism. We will review German rationalism in Chapter 6 and romanticism in Chapter 7.

BRITISH EMPIRICISM

An empiricist is anyone who believes that knowledge is derived from experience. The importance of experience is usually stressed instead of innate ideas, which are supposed to emerge independently of experience. Empiricism, then, is a philosophy that stresses the importance of experience in the attainment of knowledge. The term experience, in the definition of empiricism, complicates matters because there are many types of experience. There are "inner" experiences such as dreams, imaginings, fantasies, and a variety of emotions. Also, when one thinks logically, such as during mathematical deduction, one is having vivid mental (inner) experiences. It has become general practice, however, to exclude inner experience from a definition of empiricism and to refer exclusively to sensory experience. Yet, even after focusing on sensory experience, there is still a problem in the definition of empiricism because it is implied that any philosopher who claims sensory experience to be important in attaining knowledge can be labeled an empiricist. If this were true, even Descartes could be called an empiricist because, for him, many ideas came from sensory experience. Thus, acknowledging the importance of sensory experience alone does not qualify one as an empiricist.

Before discussing what *does* qualify one as an empiricist, an additional source of confusion surrounding the term *empiricism* must be mentioned. In psychology, empiricism is often contrasted with

mentalism; this is a mistake, however, because most modern empiricists were also mentalistic. In fact, their main research tool was introspection, and their main goal was to explain mental phenomena (ideas). What then is an empiricist? In this text, we will use the following definition of empiricism:

Empiricism ... is the epistemology that asserts that the evidence of sense constitutes the primary data of all knowledge; that knowledge cannot exist unless this evidence has first been gathered; and that all subsequent intellectual processes must use this evidence and only this evidence in framing valid propositions about the real world. (D. N. Robinson, 1986, p. 205)

It is important to highlight a number of terms in Robinson's definition. First, this definition asserts that sensory experience constitutes the primary data of all knowledge; it does not say that such experience alone constitutes knowledge. Second, it asserts that knowledge cannot exist until sensory evidence has first been gathered; so for the empiricist, attaining knowledge begins with sensory experience. Third, all subsequent intellectual processes must focus only on sensory experience in formulating propositions about the world. Thus, it is not the recognition of mental processes that distinguishes the empiricist from the rationalist; rather, it is what those thought processes are focused on. Again, most epistemological approaches use sensory experience as part of their explanation of the origins of knowledge; for the empiricist, however, sensory experience is of supreme importance.

Thomas Hobbes

Although he followed in the tradition of William of Occam and Francis Bacon, **Thomas Hobbes** (1588–1679) is often referred to as the founder of British empiricism. Hobbes was educated at Oxford and was friends with both Galileo and Descartes. He also served as Bacon's secretary for a short time. Hobbes was born on April 5 in Malmesbury, Wiltshire, England. He often joked that he and fear were born twins because his mother attributed his premature birth to her learning of the

Thomas Hobbes

approach of the Spanish Armada. Hobbes's father, an Anglican vicar, got into a fight in the doorway of his church and thereafter disappeared. The care of his children was left to a prosperous brother who eventually provided Hobbes with an Oxford education, but Hobbes claimed that he learned little of value from that education. Hobbes noted that Oxford had a strong Puritan tradition but also had an abundance of "drunkenness, wantonness, gaming, and other such vices" (Peters, 1962, p. 7). Hobbes lived a long, productive, and influential life. He played tennis until the age of 70, and at 84 he wrote his autobiography. At 86 he published a translation of The Iliad and The Odyssey just for something to do. Prior to his death, he amused himself by having his friends prepare epitaphs for him. Hobbes achieved great fame in his lifetime: "Indeed, like Bernard Shaw, by the time of his death he had become almost an English institution" (Peters, 1962, p. 16).

Humans as Machines. Hobbes did not become serious about psychology and philosophy until the age of 40, when he came across a copy of Euclid's *Elements*. This book convinced him that humans could be understood using the techniques of geometry. That is, starting with a few undeniable premises, a number of undeniable conclusions could

be drawn. The question was what premises to begin with, and the answer came from Galileo. After visiting Galileo in 1635, Hobbes became convinced that the universe consisted only of matter and motion and that both could be understood in terms of mechanistic principles. Why, asked Hobbes, could not humans too be viewed as machines consisting of nothing but matter and motion? Galileo was able to explain the motion of physical objects in terms of the external forces acting on them—that is, without appealing to inner states or essences. Are not humans part of nature, wondered Hobbes, and if so, cannot their behavior also be explained as matter in motion? This became the self-evident truth that Hobbes needed to apply the deductive method of geometry: Humans were machines. Humans were viewed as machines functioning within a larger machine (the universe): "For seeing life is but motion of limbs... . For what is the heart but a spring; and the nerves but so many strings; and the joints but so many wheels, giving motion to the whole body" (Hobbes, 1651/1962, p. 19).

It is interesting to note that although Hobbes was a close friend of Bacon and had himself a considerable reputation, Hobbes was never asked to join the prestigious British Royal Society (founded in 1660). The reason was that the society was dominated by Baconians, and Hobbes had nothing but contempt for Bacon's inductive method. He accused the Baconians of spending too much time on gadgets and experiments and of preferring their eyes, ears, and fingertips to their brains. Instead, Hobbes chose the deductive method of Galileo and Descartes. With Hobbes, we have the first serious attempt to apply the ideas and techniques of Galileo to the study of humans.

Government Protects Humans from Their Own Destructive Instincts. Hobbes's primary interest was politics. He was thoroughly convinced that the best form of government was an absolute monarchy. He believed that humans were innately aggressive, selfish, and greedy; therefore, democracy was dangerous because it gives too much latitude to these negative natural tendencies. Only when people and the church are subservient to a monarch, he

felt, could there be law and order. Without such regulation, human life would be "solitary, poor, nasty, brutish, and short" (Hobbes, 1651/1962, p. 100). Hobbes's infamous conclusion, Homo homini lupus (Man is a wolf to man), was later quoted sympathetically by Schopenhauer (see Chapter 7) and by Freud (see Chapter 16). It is, according to Hobbes, fear of death that motivates humans to create social order. In other words, civilization is created as a matter of self-defense; each of us must be discouraged from committing crimes against the other. Unless interfered with, humans would selfishly seek power over others so as to guarantee the satisfaction of their own personal needs: "I put for a general inclination of all mankind, a perpetual and restless desire of power after power, that ceaseth only in death" (1651/1962, p. 80). The monarch was seen by Hobbes as the final arbitrator in all matters of law, morals, and religion, and the freedom of a person consisted only in those activities not forbidden by law. The laws are determined and enforced by the monarch. Hobbes offended all types of Christians by saying that the church should be subservient to the state and that all human actions could be explained mechanically, and therefore free will was an illusion. Hobbes's most famous work, Leviathan (1651), was mainly a political treatise, an attempt to explain and justify rule by an absolute monarch. Hobbes began Leviathan with his views on psychology because it was his belief that to govern effectively, a monarch needed to have an understanding of human nature.

Leviathan became viewed as the work of an atheist, and in 1666 a motion was made in parliament to burn Hobbes as a heretic. The plague of 1665 and the great fire of London the following year were believed by many to be God's revenge on England for harboring Hobbes. King Charles II came to his rescue, however, and, as mentioned before, Hobbes went on to live a long, productive life. He died on December 4, 1679, at the age of 91.

Hobbes's Empiricism. Although Hobbes rejected Bacon's inductive method in favor of the deductive method, he did agree with Bacon on the importance of sensory experience:

The [origin of all thoughts] is that which we can *sense*, for there is no conception in a man's mind, which hath not at first, totally, or by parts, been begotten upon the organs of sense. The rest are derived from that original. (Hobbes, 1651/1962, p. 21)

Although Hobbes accepted Descartes's deductive method, he rejected his concept of innate ideas. For Hobbes, all ideas came from experience or, more specifically, from *sensory experience*.

Hobbes's Materialism. Following in the tradition of Democritus, Hobbes was a materialist. Because all that exists is matter and motion, Hobbes thought it absurd to postulate a nonmaterial mind, as Descartes had done. All so-called mental phenomena could be explained by the sense experiences that result when the motion of external bodies stimulates the sense receptors, thereby causing internal motion. What others refer to as "mind," for Hobbes, was nothing more than the sum total of a person's thinking activities—that is, a series of motions within the individual. Concerning the mind-body problem, Hobbes was a physical monist; he denied the existence of a nonmaterial mind.

Explanation of Psychological Phenomena. Attention was explained by the fact that as long as sense organs retain the motion caused by certain external objects, they cannot respond to others. Imagination was explained by the fact that sense impressions decay over time. Hobbes said, "Imagination therefore is nothing but decaying sense; and is found in men, and many other living creatures, as well sleeping as waking" (1651/1962, p. 23). When a sense impression has decayed for a considerable amount of time, it is called memory; "So ... imagination and memory are but one thing which for divers considerations hath divers names" (1651/1962, p. 24). Dreams too have a sensory origin: "The imaginations of them that sleep are those we call dreams. And these also, as all other imaginations, have been before, either totally or by parcels, in the sense" (Hobbes, 1651/1962, p. 25). The reason that dreams are typically so vivid is because during sleep

there are no new sensory impressions to compete with the imagination.

Explanation of Motivation. Hobbes argued that external objects not only produce sense impressions but also influence the vital functions of the body. Those incoming impressions that facilitate vital functions are experienced as pleasurable, and the person seeks to preserve them or to seek them out. Conversely, sense impressions incompatible with the vital functions are experienced as painful, and the person seeks to terminate or avoid them. Human behavior, then, is motivated by appetite (the seeking or maintaining of pleasurable experiences) and aversion (the avoidance or termination of painful experiences). In other words, Hobbes accepted a hedonistic theory of motivation. According to Hobbes, we use terms such as love and good to describe things that please us and terms such as hate and evil to describe things toward which we have an aversion. By equating good with pleasure and evil (bad) with pain, Hobbes was taking a clear stand on moral issues: "Having insinuated this identity, Hobbes had both stated and explained moral relativism: there were no objective moral properties, but what seemed good was what pleased any individual or was good for him" (Tuck, 2002, p. 65).

Denial of Free Will. In Hobbes's deterministic view of human behavior, there was no place for free will. People may believe they are "choosing" because at any given moment one may be confronted with a number of appetites and aversions and therefore there may be conflicting tendencies to act. Hobbes referred to the recognition of such conflicting tendencies as "deliberation" and to the behavioral tendency that survives that deliberation as will: "In deliberation, the last appetite, or aversion, immediately adhering to the action, or to the omission thereof, is that we call the will. ... [A]nd beasts that have deliberation must necessarily also have will" (1651/1962, p. 54). In other words, will was defined as the action tendency that prevails when a number of such tendencies exist simultaneously. What appears to be choice is nothing more than a verbal label we use to describe the attractions and aversions we experience while interacting with the environment. Once a prevalent behavioral tendency emerges, "freedom" is simply "the condition of having no hindrance to the securing of what one wants" (Tuck, 2002, p. 57).

Complex Thought Processes. So far, we have discussed sense impressions, the images and memories derived from them, and the general, hedonistic tendency to seek pleasure and avoid pain. Now we consider how Hobbes explained more complex "thought processes" within his materialistic, mechanistic philosophy. For example, Hobbes attempted to explain "trains of thought," by which he meant the tendency of one thought to follow another in some coherent manner. The question was how such a phenomenon occurs, and Hobbes's answer reintroduced the law of contiguity first proposed by Aristotle. That is, events that are experienced together are remembered together and are subsequently thought of together. All the British empiricists who followed Hobbes accepted the concept of association as their explanation as to why mental events are experienced or remembered in a particular order.

To summarize Hobbes's position, we can say that he was a materialist because he believed that all that existed was physical; he was a mechanist because he believed that the universe and everything in it (including humans) were machines; he was a determinist because he believed that all activity (including human behavior) is caused by forces acting on physical objects; he was an empiricist because he believed that all knowledge was derived from sensory experience; and he was a hedonist because he believed that human behavior (as well as the behavior of nonhuman animals) was motivated by the seeking of pleasure and the avoidance of pain. Although, as we will see, not all the empiricists that followed Hobbes were as materialistic or mechanistic as he was, they all joined him in denying the existence of innate ideas.

John Locke

John Locke (1632–1704) was born on August 29 at Wrington in Somerset, England, six years after the

John Locke

death of Francis Bacon. His father was a Puritan, a small landowner, and an attorney. Locke was a 17-year-old student at Westminster School when, on January 30, 1649, King Charles I was executed as a traitor to his country. The execution, which Locke may have witnessed, took place in the courtyard of Whitehall Palace, which was close to Locke's school. Locke was born 10 years before the outbreak of civil war, and he lived through this great rebellion that was so important to English history. It was at least partially due to the Zeitgeist, then, that Locke, as well as several of his fellow students, was to develop a lifelong interest in politics. Indeed, Locke was to become one of the most influential political philosophers in post-Renaissance Europe.

In 1652 Locke, at age 20, obtained a scholar-ship from Oxford University, where he earned his bachelor's degree in 1656 and his master's degree in 1658. His first publication was a poem that he wrote, when he was an undergraduate, as a tribute to Oliver Cromwell. Locke remained at Oxford for 30 years, having academic appointments in Greek, rhetoric, and moral philosophy. He also studied medicine and empirical philosophy, and on his third attempt, he finally attained his doctorate in medicine in 1674. It was through his medical and

empirical studies that Locke met Robert Boyle (1627-1691), who was to have a major influence on him. Boyle was one of the founders of the Royal Society and of modern chemistry. Locke became Boyle's friend, student, and research assistant. From Boyle, Locke learned that physical objects were composed of "minute corpuscles" that have just a few intrinsic qualities. These corpuscles can be experienced in many numbers and arrangements. Some arrangements result in the experience of primary qualities and some in the experience of secondary qualities. We will see shortly that Boyle's "corpuscular hypothesis" strongly influenced Locke's philosophy. Locke became a member of the Royal Society, and as a member performed some studies and demonstrations in chemistry and meteorology. Newton was only 10 years old when Locke arrived at Oxford, but in 1689 the two men met and Locke referred to him as the "incomparable Mr. Newton." Locke corresponded with Newton for the rest of his life, primarily on theological matters (both were deeply religious men).

Among Locke's lesser known works were his editing of Boyle's General History of the Air, an edition of Aesop's Fables designed to help children learn Latin, and a book on money and interest rates (Gregory, 1987). His most famous work, however, and the one most important to psychology was AnEssay Concerning Human Understanding (1690). Locke worked on the Essay for 17 years, and it was finally published when Locke was almost 60 years old. After its original publication, Locke revised the Essay several times, and it eventually went into five editions. The fifth edition appeared posthumously in 1706, and it is on this final edition that most of what follows is based. Locke had published very little before the Essay, but afterward he published prolifically on such topics as education, government, economics, and Christianity. Voltaire (1694-1778) greatly admired Locke and compared him favorably to Newton. Voltaire did much to create a positive impression of Locke on the continent, especially in France.

Although Hobbes was clearly an empiricist, it was Locke who influenced most of the subsequent British empiricists. For example, most of the British

empiricists followed Locke in accepting a mindbody dualism; that is, they rejected Hobbes's physical monism (materialism). Whereas Hobbes equated mental images with the motions in the brain that were caused by external motions acting on the sense receptors, Locke was content to say that *some*how sensory stimulation caused ideas. Early in the Essay, Locke washed his hands of the question as to how something physical could cause something mental—it just did.

Opposition to Innate Ideas. Locke's Essay was, in part, a protest against Descartes's philosophy. It was not Descartes's dualism that Locke attacked but his notion of innate ideas. Despite Hobbes's efforts, the notion of innate ideas was still very popular in Locke's time. Especially influential was the belief that God had instilled in humans innate ideas of morality. Because it was mainly clergymen who accepted the innateness of morality, by attacking the existence of innate ideas, Locke was attacking the church. Locke observed that if the mind contained innate ideas, then all humans should have those ideas, and clearly they do not. Humans, he said, are not born with any innate ideas, whether they be moral, theological, logical, or mathematical.

Where, then, do all the ideas that humans have come from? Locke's (1706/1974) famous answer was as follows:

Let us then suppose the mind to be, as we say, white paper, void of all characters, without any ideas; how comes it to be furnished? Whence comes it by that vast store which the busy and boundless fancy of man has painted on it with an almost endless variety? Whence has it all the materials of reason and knowledge? To this I answer, in one word, from experience. In that all our knowledge is founded, and from that it ultimately derives itself. Our observation employed either about external sensible objects, or about the internal operations of our minds perceived and reflected on by ourselves, is that which supplies our understandings with all the

materials of thinking. These two are the fountains of knowledge, from whence all the ideas we have, or can naturally have, do spring. (pp. 89–90)

Sensation and Reflection. For Locke, an idea was simply a mental image that could be employed while thinking: "Whatsoever the mind perceives in itself, or is the immediate object of perception, thought, or understanding, that I call idea" (1706/1974, pp. 111–112). For Locke, all ideas come from either sensation or reflection. That is, ideas result either by direct sensory stimulation or by reflection on the remnants of prior sensory stimulation. Reflection, the second fountain of knowledge referred to in the preceding quotation, is the mind's ability to reflect on itself.

Thus, the source of all ideas is sensation, but the ideas obtained by sensation can be acted on and rearranged by the operations of the mind, thereby giving rise to new ideas. The operations the mind can bring to bear on the ideas furnished by sensation include "perception, thinking, doubting, believing, reasoning, knowing, and willing" (Locke, 1706/1974, p. 90). Locke is often said to have postulated a passive mind that simply received and stored ideas caused by sensory stimulation. This was true, however, only of sensations. Once the ideas furnished by sensation are in the mind, they can be actively transformed into an almost endless variety of other ideas by the mental operations involved in reflection.

It is important to note that it is Locke's insistence that *all* knowledge is ultimately derived from sensory experience that allows him to be properly labeled an empiricist. However, although the *content* of the mind is derived from sensory stimulation, the operations of the mind are not. The operations of the mind are part of human nature; they are innate. Thus, Locke's philosophy, although labeled empirical, is partially nativistic. Locke opposed the notion of specific innate ideas but not innate operations (faculties) of the mind. Simple ideas concerning the physical world come from sensation (such as whiteness, bitterness, motion), and simple ideas

concerning our minds come from reflection (such as perceiving, willing, reasoning, remembering).

Simple and Complex Ideas. Simple ideas, whether from sensation or reflection, constitute the atoms (corpuscles) of experience because they cannot be divided or analyzed further into other ideas. Complex ideas, however, are composites of simple ideas and therefore can be analyzed into their component parts (simple ideas). When the operations of the mind are applied to simple ideas through reflection, complex ideas are formed. That is, through such operations as comparing, remembering, discriminating, combining and enlarging, abstracting, and reasoning, simple ideas are combined into complex ones. As Locke (1706/1974) explained,

Simple ideas, the materials of all our knowledge, are suggested and furnished to the mind only by ... sensation and reflection. When the understanding is once stored with these simple ideas, it has the power to repeat, compare, and unite them, even to an almost infinite variety, and so can make at pleasure new complex ideas. But it is not in the power of the most exalted wit or enlarged understanding, by any quickness or variety of thought, to invent or frame one new simple idea in the mind, not taken in by the ways before mentioned: nor can any force of the understanding destroy those that are there. I would have anyone try to fancy any taste which had never affected his palate, or frame the idea of a scent he had never smelt: and when he can do this. I will also conclude that a blind man hath ideas of colours, and a deaf man true distinct notions of sounds. (pp. 99–100)

The mind, then, can neither create nor destroy ideas, but it can arrange existing ideas in an almost infinite number of configurations.

Emotions. Locke maintained that the feelings of pleasure or pain accompany both simple and complex ideas. He believed that the other passions

(emotions)—like love, desire, joy, hatred, sorrow, anger, fear, despair, envy, shame, and hope—were all derived from the two basic feelings of pleasure and pain. Things that cause pleasure are good, and things that cause pain are evil (note similarity to Hobbes). For Locke, the "greatest good" was the freedom to think pleasurable thoughts. Like Hobbes, his theory of human motivation was hedonistic because it maintained that humans are motivated by the search for pleasure and the avoidance of pain. For Locke then, the information that the senses provided was the stuff the mind thought about and had emotional reactions toward.

Primary and Secondary Qualities. The distinction between primary and secondary qualities is the distinction that several early Greeks, and later Galileo, made between what is physically present and what is experienced psychologically. However, it was Locke's friend and teacher Robert Boyle who introduced the terms primary qualities and secondary qualities, and Locke borrowed the terms from him (Locke, 1706/1974). Unfortunately, primary and secondary qualities have been defined in two distinctively different ways through the centuries. One way has been to define primary qualities as attributes of physical reality and secondary qualities as attributes of subjective or psychological reality. That is, primary qualities refer to actual attributes of physical objects or events, but secondary qualities refer to psychological experiences that have no counterparts in the physical world. We followed this approach in our discussion of Galileo in Chapter 4 Boyle and Locke took a different approach. For them, both primary and secondary qualities referred to characteristics of the physical world; what distinguished them was the type of psychological experience they caused. Following Boyle, Locke referred to any aspect of a physical object that had the power to produce an idea as a quality. Primary qualities have the power to create in us ideas that correspond to actual physical attributes of physical objects—for example, the ideas of solidity, extension, shape, motion or rest, and quantity. With primary qualities, there is a match between what is physically present and

what is experienced psychologically. The secondary qualities of objects also have the power to produce ideas, but the ideas they produce do not correspond to anything in the physical world. The ideas produced by secondary qualities include those of color, sound, temperature, and taste.

Both primary and secondary qualities produce ideas. With primary qualities, the physical stimulation is substantial enough to cause an idea that matches the physical attribute that caused it. With secondary qualities, however, it is only fractions (minute particles) of physical bodies that stimulate us. This fractional stimulation emanates from the physical body stimulating us, but our sensory apparatus is not refined enough to note the physical nature of such stimulation. Instead, we experience something psychologically that is not present (as such) physically. The difference between the ideas caused by primary and secondary qualities thus comes down to a matter of the acuteness of the senses.

Locke's paradox of the basins dramatically demonstrated the nature of ideas caused by secondary qualities. Suppose we ask, Is temperature a characteristic of the physical world? In other words, Is it not safe to assume that objects in the physical world are hot or cold or somewhere in between? Looked at in this way, temperature would be a primary quality. Locke beckoned his readers to take three water basins: one containing cold water (basin A), one containing hot water (basin B), and the other containing warm water (basin C). If a person places one hand in basin A and the other in basin B, one hand will feel hot and the other cold, supporting the contention that hot and cold are properties of the water (that is, that temperature is a primary quality). Next, Locke instructed the reader to place both hands in basin C, which contains the warm water. To the hand that was previously in basin A (cold water), the water in basin C will feel hot; to the hand that was previously in basin B (hot water), the water will feel cold, even though the temperature of the water in basin C is physically the same for both hands. Thus, Locke demonstrated that the experience of hot and cold depended on the experiencing person, and temperature therefore reflected secondary qualities.

For Locke, the important point was that some of our psychological experiences reflected the physical world as it actually was (those experiences caused by primary qualities) and some did not (those experiences caused by secondary qualities). He did not say, as Galileo had, that subjective reality was inferior to physical reality. For Locke, subjective reality could be studied as objectively as physical reality, and he set out to do just that.

Association of Ideas. Associationism is "a psychological theory which takes association to be the fundamental principle of mental life, in terms of which even the higher thought processes are to be explained" (Drever, 1968, p. 11). According to this definition, it is possible to reject associationism and still accept the fact that associative learning does occur. Such was the case with Locke. In fact, Locke's discussion of association came as an afterthought, and a short chapter titled "Association of Ideas" did not appear until the fourth edition of Essay. Even then, association was used primarily to explain errors in reasoning.

As we have seen, Locke believed that most knowledge is attained by actively reflecting on the ideas in the mind. By comparing, combining, relating, and otherwise thinking about ideas, we attain our understanding of the world, morality, and ourselves. Where, then, does association enter into Locke's deliberations? Locke used association to explain the faulty beliefs that can result from accidents of time or circumstance. Locke called the beliefs that resulted from associative learning "a degree of madness" (1706/1974, p. 250) because they were in opposition to reason. In addition to ideas that are clustered in the mind because of some logical connection among them, some ideas are naturally associated, such as when the odor of baking bread causes one to have the idea of bread. These are safe and sure types of associations because they are determined by natural relationships. The types of associations that constitute a degree of madness are learned by chance, custom, or mistake. These associations lead to errors in understanding, whereas natural associations cannot.

Locke believed that ideas that succeeded each other because of natural or rational reasons represented true knowledge but that ideas that became associated fortuitously, because of their contiguity, could result in unreasonable beliefs. As examples of unreasonable beliefs, Locke (1706/1974, pp. 252-254) included the following: A person who eats too much honey becomes sick and thereafter avoids even the thought of honey (today we call the subsequent avoidance of substances that cause illness the Garcia Effect); a child whose maid associates darkness with evil spirits and goblins will grow up with a fear of darkness; a person undergoing painful surgery will develop an aversion to the surgeon; and children who are taught reading by harsh corrective methods will develop a lifelong aversion to reading.

Following Drever's (1968) definition of associationism as an attempt to reduce all mental activity to associative principles, Locke's philosophy certainly did not exemplify associationism. Although his short chapter on the association of ideas did mention the learning of natural associations, he focuses on the learning of those that are unnatural. As we shall see, for the British empiricists and French sensationalists who followed Locke, the laws of association took on a greater significance. In their efforts to become "Newtons of the mind," they argued that ideas corresponded to Boyle's corpuscles and that the laws of association provided the gravity that held ideas together.

Education. Locke's book *Some Thoughts Concerning Education* (1693/2000) had a profound and long-lasting influence on education throughout the Western world. By insisting that nurture (experience) was much more important than nature (innate ability) for character development, his views on education were in accordance with his empirical philosophy.

For Locke, important education took place both at home and at school. He encouraged parents to increase stress tolerance in their children (a process he called hardening) by having them sleep on hard rather than soft beds. Exposing children to moderate amounts of coldness and wetness would also increase tolerance for the inevitable hardships of life. Crying should be discouraged with physical punishment, if necessary. Parents should provide their children with sufficient sleep, food, fresh air, and exercise because good health and effective learning are inseparable.

Concerning classroom practices, mild physical punishment of students was advocated but severe physical punishment was not. Teachers, Locke believed, should always make the learning experience as pleasant as possible so that learning beyond school will be sought. If learning occurs under aversive conditions, it will be avoided both in school and beyond. A step-by-step approach to teaching complex topics was recommended to avoid overwhelming and thus frustrating students. For the same reason, excessive and overly rigorous assignments should be avoided. The primary job of the teacher should be to recognize and praise student accomplishments.

How does one deal with a child's irrational fears? Locke used a child with a fear of frogs to exemplify his technique:

Your child shrieks, and runs away at the sight of a Frog; Let another catch it, and lay it down at a good distance from him: At first accustom him to look upon it; When he can do that, then come nearer to it, and see it leap without Emotion; then to touch it lightly when it is held fast in another's hand; and so on, till he can come to handle it as confidently as a Butter-fly, or a Sparrow. By the same way any other vain Terrors may be remov'd; if Care be taken, that you go not too fast, and push not the Child on to a new degree of assurance, till he be thoroughly confirm'd in the former. (Locke, 1693/2000, pp. 177–178)

The advice given by Locke for dealing with irrational fears was remarkably similar to the kind of behavioral therapy employed many years later by Mary Cover Jones (see Chapter 12).

With the exception of teaching stress tolerance, Locke's ideas concerning education now appear rather routine. They were, however, anything but routine when he first proposed them.

Government by the People and for the People. Locke attacked not only the notion of innate ideas but also the notion of innate moral principles. He believed that much dogma was built on the assumption of one innate moral truth or another and that people should seek the truth for themselves rather than having it imposed on them. For this and other reasons, empiricism was considered to be a radical movement that sought to replace religion based on revelation with natural law. Very influential politically, Locke challenged the divine right of kings and proposed a government by and for the people. His political philosophy was accepted enthusiastically by the 19th-century utilitarians, and it was influential in the drafting of the U.S. Declaration of Independence.

George Berkeley

George Berkeley (1685-1753) was born on March 12 in Kilkenny, Ireland. He first attended Kilkenny College; then in 1700 at the age of 15, he entered Trinity College (University of Dublin), where he earned his bachelor's degree in 1704 at the age of 19 and his master's degree in 1707 at the age of 22. He received ordination as a deacon of the Anglican church at the age of 24. Also when he was 24, he published An Essay Towards a New Theory of Vision (1709), and a year later he published what was perhaps his most important work, A Treatise Concerning the Principles of Human Knowledge (1710). His third major work, Three Dialogues Between Hylas and Philonous, was published during his first trip to England in 1713. Berkeley's fame was firmly established by these three books before he was 30 years old. He continued on at Trinity College and lectured in divinity and Greek philosophy until 1724, when he became involved in the founding of a new college in Bermuda intended for both native and white colonial Americans. In 1728 he sailed to Newport, Rhode Island, where he waited for funding for his project. The hoped-for government grants were not forthcoming, however, and Berkeley returned to London. Berkeley's home in Whitehall (near Newport) still stands as a museum containing artifacts of his visit to colonial America. For the last 18 years of his life, Berkeley was an Anglican bishop of Cloyne in County Cork, Ireland. He died suddenly on January 14, 1753, at Oxford, where he had been helping his son enroll as an undergraduate. Just over a hundred years later, the site of the first University of California campus was named for Bishop Berkeley.

Opposition to Materialism. Berkeley observed that the downfall of Scholasticism, caused by attacks on Aristotle's philosophy, had resulted in widespread religious skepticism, if not actual atheism. He also noted that the new philosophy of materialism was further deteriorating the foundations of religious belief. While at Trinity College, Berkeley studied the works of such individuals as Descartes, Hobbes, Locke, and Newton, and he held these individuals responsible for the dissemination of materialistic philosophy. The worldview created by the materialistic philosophy, Berkeley felt, was that all matter is atomic or corpuscular in nature and that all physical events could be explained in terms of mechanical laws. The world becomes nothing but matter in motion, and the motion of moving objects is explained by natural laws, which are expressible in mathematical terms. Berkeley correctly perceived that materialistic philosophy was pushing God farther and farther out of the picture, and thus it was dangerous, if not potentially fatal, to both religion and morality. Berkeley therefore decided to attack materialism at its very foundation—its assumption that matter exists.

"To be is to be perceived." Berkeley's solution to the problem was bold and sweeping; he attempted to demonstrate that matter does not exist and that all claims made by materialistic philosophy must therefore be false. In Berkeley's denial of matter, he both agreed and disagreed with Locke. He agreed with Locke that human knowledge is based *only* on ideas. However, Berkeley strongly disagreed with Locke's contention that all ideas are derived from interactions

George Berkeley

with the empirical world. Even if there were such a world, Berkeley said, we could never know it directly. All things come into existence when they are perceived, and therefore reality consists of our perceptions and nothing more.

Only Secondary Qualities Exist. In his discussion of primary and secondary qualities, Berkeley referred to the former as the supposed attributes of physical things and to the latter as ideas or perceptions. Having made this distinction, he then rejected the existence of primary qualities. For him, only secondary qualities (perceptions) exist. This, of course, follows from his contention that "to be is to be perceived." Berkeley argued that materialism could be rejected because there was no physical world.

Berkeley Did Not Deny the Existence of External Reality. Of course, Berkeley's contention that everything that exists is a perception raises several questions. For example, if reality is only a matter of perception, does reality cease to exist when one is not perceiving it? And, on what basis can it be assumed that the reality one person perceives is the same reality that others perceive? First, we must realize that Berkeley did not deny the existence of external reality. What he did deny

was that external reality consisted of inert matter, as the materialists maintained:

I do not argue against the existence of any one thing that we can apprehend, either by sense or reflection. That the things I see with my eyes and touch with my hands do exist, really exist, I make not the least question. The only thing whose existence we deny is that which *philosophers* call Matter or corporeal substance. (Armstrong, 1965, p. 74)

What creates external reality is God's perception. It is the fact that external reality is God's perception that makes it stable over time and the same for everyone. The so-called laws of nature are ideas in God's mind. On rare occasions, God may change his mind and thus vary the "laws of nature," creating "miracles," but most of the time his perceptions remain the same.

What we experience through our senses, then, are the ideas in God's mind; with experience, the ideas in our minds come to resemble those in God's mind, in which case it is said that we are accurately perceiving external reality. "To be is to be perceived," and God perceives the physical world, thus giving it existence; we perceive God's perceptions, thus giving those perceptions life in our minds as ideas. If secondary qualities are understood as ideas whose existence depends on a perceiver, then all reality consists of secondary qualities.

Principle of Association. According to Berkeley, each sense modality furnishes a different and separate type of information (idea) about an object. It is only through experience that we learn that certain ideas are always associated with a specific object:

By sight I have the ideas of light and colours, with their several degrees and variations. By touch I perceive hard and soft, heat and cold, motion and resistance; and of all these more and less either as to quantity or degree. Smelling furnishes me with odours; the palate with tastes; and hearing conveys sounds to the mind in all their variety of tone and composition.

And as several of these are observed to accompany each other, they come to be marked by one name, and so to be reputed as one *thing*. Thus, for example, a certain colour, taste, smell, figure and consistence having been observed to go together, are accounted one distinct thing, signified by the name apple; other collections of ideas constitute a stone, a tree, a book, and the like sensible things; which as they are pleasing or disagreeable excite the passions of love, hatred, joy, grief, and so forth. (Armstrong, 1965, p. 61)

Thus, the objects we name are aggregates of sensations that typically accompany each other. Like Locke, Berkeley accepted the law of contiguity as his associative principle. Unlike Locke, however, he did not focus on fortuitous or arbitrary associations. For Berkeley, *all* sensations that are consistently experienced together become associated. In fact, for Berkeley, objects were aggregates of sensations and nothing more.

Berkeley's Theory of Distance Perception. Berkeley agreed with Locke that if a person who was born blind was later able to see, he or she would not be able to distinguish a cube from a triangle. Such discrimination requires the association of visual and tactile experiences. Berkeley went further by saying that such a person would also be incapable of perceiving distance. The reason is the same. For the distance of an object to be judged properly, many sensations must be associated. For example, when viewing an object, the person receives tactile stimulation while walking to it. After several such experiences from the same and from different distances, the visual characteristics of an object alone suggest its distance. That is, when the object is small, it suggests great distance, and when large, it suggests a short distance. Thus, the cues for distance are learned through the process of association. Also, stimulation from other sense modalities becomes a cue for distance for the same reason. Berkeley gave the following example:

Sitting in my study I hear a coach drive along the street; I look through the casement and see it; I walk out and enter into it. Thus, common speech would incline one to think I heard, saw, and touched the same thing, to wit, the coach. It is nevertheless certain the ideas intromitted by each sense are widely different, and distinct from each other; but, having been observed constantly to go together, they are spoken of as one and the same thing. By the variation of the noise, I perceive the different distances of the coach, and that it approaches before I look out. Thus, by the ear I perceive distance just after the same manner as I do by the eye. (Armstrong, 1965, pp. 302-303)

With his empirical theory of distance perception, Berkeley was refuting the theory held by Descartes and others that distance perception was based on the geometry of optics. According to the latter theory, a triangle is formed with the distance between the two eyes as its base and the object fixated on as its apex. A distant object forms a long, narrow triangle, and a nearby object forms a short, broad triangle. Also, the apex angle of the triangle will vary directly with the distance of the object attended to; the greater the distance, the greater the apex angle and vice versa. The convergence and divergence of the eyes are important to this theory, but only because it is such movement of the eyes that creates the geometry of distance perception.

According to Berkeley, the problem with the theory of distance perception based on "natural geometry" is that people simply do not perceive distance in that way. The convergence and divergence of the eyes were extremely important in Berkeley's analysis but not because of the visual angles that such movement created. Rather, they were important because the sensations caused by the convergence and divergence of the eyes became associated with other sensations that became cues for distance:

And, *first*, it is certain by experience, that when we look at a near object with both eyes, according as it approaches or recedes from us, we alter the disposition of our eyes, by lessening or widening the interval between the pupils. This disposition or turn of the eyes is attended with a sensation, which seems to me to be that which in this case brings the idea of greater or lesser distance into the mind. (Armstrong, 1965, p. 288)

The analysis of the perception of magnitude (size) is the same as for distance perception. In fact, the meaning that any word has is determined by the sensations that typically accompany that word. We have already seen this in the case of *apple*. Berkeley gave other examples as well:

As we see distance so we see magnitude. And we see both in the same way that we see shame or anger, in the looks of a man. Those passions are themselves invisible; they are nevertheless let in by the eye along with colours and alterations of countenance which are the immediate object of vision, and which signify them for no other reason than barely because they have been observed to accompany them. Without which experience we should no more have taken blushing for a sign of shame than of gladness. (Armstrong, 1965, p. 309)

Berkeley's empirical account of perception and meaning was a milestone in psychology's history because it showed how all complex perceptions could be understood as compounds of elementary sensations such as sight, hearing, and touch. Atherton (1990) provides a more detailed account of Berkeley's theory of perception and a justification for referring to it as revolutionary.

David Hume

Born on April 26 in Edinburgh, Scotland, **David Hume** (1711–1776) was educated at the

University of Edinburgh, where he studied law and commerce but left without a degree. Given relative freedom by an inheritance, Hume moved to La Flèche in France, where Descartes had studied as a young man. It was at La Flèche that Hume. before the age of 28, wrote his most famous work, Treatise of Human Nature, Being an Attempt to Introduce the Experimental Method of Reasoning into Moral Subjects, the first volume of which was published in 1739 and the second volume in 1740. About his Treatise, Hume said, "It fell deadborn from the press, without reaching such distinction as even to excite a murmur among the zealots" (Flew, 1962, p. 305). In 1742 Hume published his Philosophical Essays, which was well received. Hume was always convinced that his Treatise was poorly received because of its manner of presentation rather than its content, and in 1748 he published an abbreviated version of the Treatise titled An Enquiry Concerning Human Understanding. Much of what follows is based on the posthumous 1777 edition of the Enquiry.

Unlike many of the other philosophers of his time, Hume was never a university professor. He was nominated for an academic position twice, but the opposition of the Scottish clergy denied him the posts. Hume was skeptical of most religious beliefs, and friction with the church was a constant theme in his life. About religion Hume said, "The whole is a riddle, an enigma, an inexplicable mystery. Doubt, uncertainty, suspense of judgment appear the only result of our most accurate scrutiny, concerning the subject" (Yandell, 1990, p. xiv). However, Hume did not suspend his judgment concerning religion. He argued that religion was both irrational and impractical:

In the first place, fear of God and the expectations of an afterlife have less day-to-day effect upon our conduct than is generally supposed. In the second place, religions do positive harm. They invent mortal sins like suicide, which have no natural depravity, and they create "frivolous merits" which partake in no natural good, like abstaining from certain foods or

attending ceremonies. Moreover, ... religions result in cruel persecutions, bigotry, strife between sects or between sects and civil power, and the hunting down of unorthodox opinions. (Gaskin, 1998, p. xvii)

Rather than becoming involved in the sometimes furious quarrels over religious beliefs, Hume sought refuge in "the calm, though obscure, regions of philosophy" (Yandell, 1990, p. xiv).

Toward the end of his life, Hume left the manuscript for his *Dialogues Concerning Natural Religion* with his friend, the famous economist Adam Smith, with the understanding that Smith would arrange for its publication. However, when Hume died in 1776, Smith, perhaps fearing reprisal against himself, advised against the publication of the book. It did not appear until 1779, and then without the publisher's name (Steinberg, 1977).

Hume's Goal. According to Hume, "It is evident, that all the sciences have a relation, greater or less, to human nature; and that, however wide any of them may seem to run from it, they still return back by one passage or another" (Flew, 1962, p. 172). Under the heading of science, Hume included such topics as mathematics, natural philosophy (physical science), religion, logic, morals, criticism, and politics. In other words, all important matters reflect human nature, and understanding that nature is therefore essential. In developing his science of man, Hume followed in the empirical tradition of Occam, Bacon, Hobbes, Locke, and Berkeley: "As the science of man is the only solid foundation for the other sciences, so, the only solid foundation we can give to this science itself must be laid on experience and observation" (Flew, 1962, p. 173).

Hume, however, was very impressed by the achievements of Newtonian science, and he wanted to do for "moral philosophy" what Newton had done for "natural philosophy."

Hume believed that he could bring about a reform in moral philosophy comparable to the Newtonian revolution in physics by following the very method of inquiry that Newton had followed. He aspired to be the Newton of the moral sciences. His achievement would in fact surpass Newton's. The science of man is not only the indispensable foundation of natural philosophy, but is also of "greater importance" and "much superior in utility." (E. F. Miller, 1971, p. 156)

In Hume's day, *moral philosophy* referred roughly to what we now call the social sciences, and *natural philosophy* referred to what we now call the physical sciences.

Besides being an empirical science, the science of man would also be an "experimental" science. Because experiments were so useful in the physical sciences, they would also be used in the science of man. However, Hume did not employ experiments in his science of man the same way that they were employed by physical scientists. For the physical scientists, an experiment involved purposely manipulating some environmental variable and noting the effect of that manipulation on another variable. Both variables were observable and measurable. As we will see, the major determinants of behavior in Hume's system were cognitive and not directly observable. For Hume, the term experience meant cognitive experience. What, then, could the term experiment mean to Hume? By experiment, Hume meant careful observation of how experiences are related to one another and how experience is related to behavior. Hume noted that his experimental science of human nature would be different from the physical sciences, but different did not mean "inferior." In fact, his science might even be superior to the other sciences (Flew, 1962, p. 175).

Hume's goal, then, was to combine the empirical philosophy of his predecessors with the principles of Newtonian science and, in the process, create a science of human nature. It is ironic that with all of Hume's admiration for Newton, Hume tended to use the Baconian inductive method more so than the Newtonian deductive method. The major thrust of Hume's approach was to make careful observations and then carefully gener-

David Hume

alize from those observations. Hume occasionally did formulate a hypothesis and test it against experience, but his emphasis was clearly on induction rather than deduction.

Impressions and Ideas. Like the empiricists that preceded him, Hume believed that the contents of the mind came only from experience. Also, like his predecessors, he believed that experience (perception) could be stimulated by either internal or external events. Hume agreed with Berkeley that we never experience the physical directly and can have only perceptions of it:

It is a question of fact, whether the perceptions of the senses be produced by external objects, resembling them: How shall this question be determined? By experience surely; as all other questions of a like nature. But here experience is, and must be entirely silent. The mind has never any thing present to it but the perceptions, and cannot possibly reach any experience of their connexion with objects. The supposition of such a connexion is, therefore, without any foundation in reasoning. (Steinberg, 1977, p. 105)

Hume did not deny the existence of physical reality; he denied only the possibility of knowing it

directly. Although the ultimate nature of physical reality must necessarily remain obscure, its existence, according to Hume, must be assumed in all rational deliberations: "Tis in vain to ask, Whether there be body or not? That is a point, which we must take for granted in all our reasonings" (Mossner, 1969, p. 238).

Hume distinguished between **impressions**, which were strong, vivid perceptions, and ideas, which were relatively weak perceptions:

All the perceptions of the human mind resolve themselves into two distinct kinds, which I shall call *impressions* and *ideas*. The difference betwixt these consists in the degrees of force and liveliness, with which they strike upon the mind, and make their way into our thought or consciousness. Those perceptions which enter with most force and violence, we may name *impressions*; and, under this name, I comprehend all our sensations, passions, and emotions, as they make their first appearance in the soul. By *ideas*, I mean the faint images of these in thinking and reasoning. (Flew, 1962, p. 176)

Simple and Complex Ideas and the Imagination. Hume made the same distinction that Locke had made between simple ideas and complex ideas. Although, according to Hume, all simple ideas were once impressions, not all complex ideas necessarily correspond to complex impressions. Once ideas exist in the mind, they can be rearranged in an almost infinite number of ways by the imagination:

Nothing is more free than the imagination of man; and though it cannot exceed that original stock of ideas, furnished by the internal and external senses, it has unlimited power of mixing, compounding, separating, and dividing these ideas, in all the varieties of fiction and vision. It can feign a train of events, with all the appearance of reality, ascribe to them a particular time and place, conceive them as existent, and

paint them out to itself with every circumstance, that belongs to any historical fact, which it believes with the greatest certainty. Wherein, therefore, consists the difference between such a fiction and belief? It lies not merely in any peculiar idea, which is annexed to such a conception as commands our assent, and which is wanting to every known fiction. For as the mind has authority over all its ideas, it could voluntarily annex this particular idea to any fiction, and consequently be able to believe whatever it pleases; contrary to what we find by daily experience. We can, in our conception, join the head of a man to the body of a horse; but it is not in our power to believe, that such an animal has ever really existed. (Steinberg, 1977, p. 31)

It is interesting to note that, for Hume, the only difference between fact and fiction is the different feelings an experience produces. Ideas that have been consistently experienced together create the *belief* that one will follow the other. Such beliefs, for us, constitute reality. Ideas simply explored by the imagination do not have a history of concordance, and therefore they do not elicit a strong belief that one belongs to the other (like a blue banana). What distinguishes fact from fantasy, then, is the degree of belief that one idea belongs with another, and such belief is determined only by experience.

Again, the contents of the mind come only from experience, but once in the mind, ideas can be rearranged at will. Therefore, we can ponder thoughts that do not necessarily correspond to reality. Hume gave the idea of God as an example: "The idea of God, as meaning an infinitely intelligent, wise, and good Being, arises from reflecting on the operations of our own mind, and augmenting, without limit, those qualities of goodness and wisdom" (Steinberg, 1977, p. 11).

To understand Hume, it is important to remember that all human knowledge is based on simple impressions. Hume stated this fact in the form of a

general proposition: "That all our simple ideas in their first appearance, are derived from simple impressions, which are correspondent to them, and which they exactly represent" (Flew, 1962, p. 178).

The Association of Ideas. If ideas were combined only by the imagination, they would be "loose and unconnected," and chance alone would join them together. Also, the associations among ideas would be different for each person because there would be no reason for them to be similar. Hume, however, observed that this was not the case. Rather, a great deal of similarity exists among the associations of all humans, and this similarity must be explained.

Hume considered his account of the association of ideas as one of his greatest achievements: "If anything can entitle the author to so glorious a name as that of an 'inventor,' it is the use he makes of the principle of the association of ideas, which enters into most of his philosophy" (Flew, 1962, p. 302). Hume seems to have overlooked the fact that the laws of association go back at least as far as Aristotle and were employed by Hobbes, to a lesser extent by Locke, and extensively by Berkeley. It is true, however, that Hume depended on the principles of association to the point where his philosophy can be said to exemplify associationism. For Hume, the laws of association do not cement ideas together so that their association becomes immutable. As we have already seen, the imagination can reform the ideas in the mind into almost any configuration. Rather, Hume saw the laws of association as a "gentle force," which creates certain associations as opposed to others.

Hume discussed three laws of association that influence our thoughts. The **law of resemblance** states that our thoughts run easily from one idea to other similar ideas, such as when thinking of one friend stimulates the recollection of other friends. The **law of contiguity** states that when one thinks of an object, there is a tendency to recall other objects that were experienced at the same time and place as the object being pondered, such as when remembering a gift stimulates thoughts of

the giver. The law of cause and effect states that when we think of an outcome (effect), we tend to also think of the events that typically precede that outcome, such as when we see lightning and consequently think of thunder. According to Hume, "There is no relation which produces a stronger connexion in the fancy, and makes one idea more readily recall another, than the relation of cause and effect betwixt their objects" (Mossner, 1969, pp. 58-59). Because Hume considered cause and effect to be the most important law of association, we will examine it in more detail.

Analysis of Causation. From the time of Aristotle through Scholasticism and to the science of Hume's day, it was believed that certain causes by their very nature produced certain effects. To make the statement "A causes B" was to state something of the essences of A and B; that is, there was assumed to be a natural relation between the two events so that knowing A would allow for the prediction of B. This prediction could be made from knowing the essences of A and B without having observed the two events together. Hume completely disagreed with this analysis of causation. For him, we can never know that two events occur together unless we have experienced them occurring together. In fact, for Hume, a causal relationship is a consistently observed relationship and nothing more. Causation, then, is not a logical necessity; it is a psychological experience.

It was not Hume's intention to deny the existence of causal relationships and thereby undermine science, which searches for them. Rather, Hume attempted to specify what is meant by a causal relationship and how beliefs in such relationships develop. Hume described the observations that need to be made in order to conclude that two events are causally related:

- 1. The cause and effect must be contiguous in space and time.
- The cause must be prior to the effect.
- There must be a constant union betwixt the cause and effect. It is chiefly this quality that constitutes the relation.

The same cause always produces the same effect, and the same effect never arises but from the same cause. (Flew, 1962, p. 216)

Thus, it is on the basis of consistent observations that causal inferences are drawn. Predictions based on such observations assume that what happened in the past will continue to happen in the future, but there is no guarantee of that being the case. What we operate with is the belief that relationships observed in the past will continue to exist in the future, and such a belief is accepted on faith alone. Also, even if all conditions listed above are met, we could still be incorrect in drawing a causal inference, such as when we conclude that the sunset causes the sunrise because one always precedes the other and one never occurs without the other first occurring. According to Hume then, it is not rationality that allows us to live effective lives, it is cumulative experience, or what Hume called custom:

Custom, then, is the great guide of human life. It is that principle alone, which renders our experience useful to us, and makes us expect, for the future, a similar train of events with those which have appeared in the past. Without the influence of custom, we should be entirely ignorant of every matter of fact, beyond what is immediately present to the memory and senses. We should never know how to adjust means to ends, or to employ our natural powers in the production of any effect. There would be an end at once of all action, as well as of the chief part of speculation. (Steinberg, 1977, p. 29)

Analysis of the Mind and the Self. As mentioned in Chapter 1, a persistent problem throughout psychology's history has been to account for the unity of experience. Although we are confronted with a myriad of changing situations, our experience maintains a continuity over time and across conditions. The entities that most often have been postulated to explain the unity of experience are a mind or a self. It was a significant event in psychology's history, then, when Hume claimed that there is neither a mind nor a self.

All beliefs, according to Hume, result from recurring experiences and are explained by the laws of association. All metaphysical entities, such as God, soul, and matter, are products of the imagination as are the so-called laws of nature. Hume extended his skepticism to include the concept of mind that was so important to many philosophers, Descartes, Locke, and Berkeley. According to Hume, the "mind" is no more than the perceptions we are having at any given moment: "We may observe, that what we call a mind, is nothing but a heap or collection of different perceptions, united together by certain relations, and suppos'd, tho' falsely, to be endow'd with a perfect simplicity and identity" (Mossner, 1969, p. 257).

Just as there is no mind independent of perceptions, there is also no self independent of perceptions:

For my part, when I enter most intimately into what I call *myself*, I always stumble on some particular perception or other, of heat or cold, light or shade, love or hatred, pain or pleasure. I never can catch *myself* at any time without a perception, and never can observe anything but the perception. When my perceptions are removed for any time, as by sound sleep, so long am I insensible of *myself*, and may truly be said not to exist. And were all my perceptions removed by death, and could I neither think, nor feel, nor see, nor love, nor hate, after the dissolution of my body, I should be entirely annihilated. (Flew, 1962, p. 259)

The Passions (Emotions) as the Ultimate Determinants of Behavior. Hume pointed out that throughout human history, humans have had the same passions and that these passions have motivated similar behaviors:

It is universally acknowledged, that there is a great uniformity among the actions of men, in all nations and ages, and that human nature remains still the same, in its principles and operations. The same motives always produce the same actions: The same events follow from the same causes. Ambition, avarice, self-love, vanity, friendship, generosity, public spirit; these passions, mixed in various degrees, and distributed through society, have been, from the beginning of the world, and still are, the source of all the actions and enterprises, which have ever been observed among mankind. (Steinberg, 1977, p. 55)

Hume noted that even though all humans possess the same passions, they do not do so in the same degree and, because different individuals possess different patterns of passions, they will respond differently to situations. The pattern of passions that a person possesses determines his or her character, and it is character that determines behavior. It is a person's character that allows for his or her consistent interactions with people. It is through individual experience that certain impressions and ideas become associated with certain emotions. It is the passions elicited by these impressions and ideas, however, that will determine one's behavior. This is another application of the laws of association, only in this case the associations are between various experiences and the passions (emotions) and between passions and behavior. In general, we can say that individuals will seek experiences associated with pleasure and avoid experiences associated with pain.

The fact that human behavior is at times inconsistent does not mean that it is free any more than the weather being sometimes unpredictable means that the weather is free:

The internal principles and motives may operate in a uniform manner, notwithstanding these seeming irregularities; in the same manner as the winds, rain, clouds, and other variations of the weather are supposed to be governed by steady principles; though not easily discoverable by human sagacity and enquiry. (Steinberg, 1977, p. 58)

Humans learn how to act in different circumstances the same way that nonhuman animals do—through the experience of reward and punishment. In both cases, reasoning ability has nothing to do with it:

This is ... evident from the effects of discipline and education on animals, who, by the proper application of rewards and punishments, may be taught any course of action, the most contrary to their natural instincts and propensities. Is it not experience, which renders a dog apprehensive of pain, when you menace him, or lift up the whip to beat him? Is it not even experience, which makes him answer to his name, and infer, from such an arbitrary sound, that you mean him rather than any of his fellows, and intend to call him, when you pronounce it in a certain manner, and with a certain tone and accent? ... Animals, therefore, are not guided in these inferences by reasoning: Neither are children: Neither are the generality of mankind, in their ordinary actions and conclusions: Neither are philosophers themselves, who, in all the active parts of life, are, in the main, the same with the vulgar, and are governed by the same maxims. (Steinberg, 1977, pp. 70–71)

It is not ideas or impressions that cause behavior but the passions associated with those ideas or impressions. It is for this reason that Hume said, "We speak not strictly and philosophically when we talk of the combat of passion and of reason. Reason is, and ought only to be the slave of the passions, and can never pretend to any other office than to serve and obey them" (Mossner, 1969, p. 462).

Hume's Influence. Hume vastly increased the importance of what we now call psychology. In fact, he reduced philosophy, religion, and science to psychology. Everything that humans know is learned from experience. All beliefs are simply ex-

pectations that events that have been correlated in the past will remain correlated in the future. Such beliefs are not rationally determined, nor can they be rationally defended. They result from experience, and we can have faith only that what we learned from experience will be applicable to the future. According to Hume then, humans can be certain of nothing. It is for this reason that Hume is sometimes referred to as the supreme Skeptic.

Hume accepted only two types of knowledge: demonstrative and empirical. Demonstrative knowledge relates ideas to ideas such as in mathematics. Such knowledge is true only by accepted definitions and does not necessarily say anything about facts or objects outside the mind. Demonstrative knowledge is entirely abstract and entirely the product of the imagination. This is not to say that demonstrative knowledge is useless, because the relations gleaned in arithmetic, algebra, and geometry are of this type and represent clear and precise thinking. Such knowledge, however, is based entirely on deduction from one idea to another; therefore, it does not necessarily say anything about empirical events. Conversely, empirical knowledge is based on experience, and it alone can furnish knowledge that can effectively guide our conduct in the world. According to Hume, for knowledge to be useful, it must be either demonstrative or empirical; if it is neither, it is not real knowledge and therefore is useless:

When we run over libraries, persuaded of these principles, what havoc must we make? If we take in our hand any volume; of divinity or school metaphysics, for instance; let us ask, *Does it contain any abstract reasoning concerning quantity or number?* No. *Does it contain any experimental reasoning concerning matter of fact and existence?* No. Commit it then to the flames: For it can contain nothing but sophistry and illusion. (Steinberg, 1977, p. 114)

Hume's insistence that all propositions must be either demonstrably or empirically true places him

clearly in the positivistic tradition of Bacon. We will have more to say about positivism later in this chapter.

David Hartley

David Hartley (1705–1757), the son of a clergyman, had completed his training as a minister at the University of Cambridge before an interest in biology caused him to seek a career as a physician. Hartley remained deeply religious all his life, believing that understanding natural phenomena increased one's faith in God. It took several years for Hartley to write his long and difficult Observations on Man, His Frame, His Duty, and His Expectations (1749). This ponderous book is divided into two parts; the first part (concerning the human frame) contains his contributions to psychology, and the second (concerning the duty and expectations of humans) is almost totally theological.

Hartley's Goal. Although Hartley's Observations appeared several years after Hume's Treatise on Human Nature (1739–1740), Hartley had been working on his book for many years and appears not to have been influenced by Hume. His two

David Hartley

major influences were Locke and Newton. Hartley accepted Newton's contention that nerves are solid (not hollow, as Descartes had believed) and that sensory experience caused vibrations in the nerves. These vibrations were called impressions. The impressions reach the brain and cause vibrations in the "infinitesimal, medullary particles," which cause sensations. Newton had also observed that vibrations in the brain show a certain inertia; that is, they continue vibrating after the impressions causing them cease. This, according to Newton, was why we see a whirling piece of coal as a circle of light. For Hartley, it was the lingering vibrations in the brain following a sensation that constituted ideas. Ideas, then, were faint replications of sensations. Hartley's goal was to synthesize Newton's conception of nerve transmission by vibration with previous versions of empiricism, especially Locke's.

Hartley's Explanation of Association. As we have seen, Hartley believed that sense impressions produced vibrations in the nerves, which traveled to the brain and caused similar vibrations in the "medullary substance" of the brain. The brain vibrations caused by sense impressions give rise to sensations. After sense impressions cease, there remain in the brain diminutive vibrations that Hartley called **vibratiuncles**. It is the vibratiuncles that correspond to ideas. Ideas, then, are weaker copies of sensations. Vibratiuncles are like the brain vibrations associated with sensations in every way except they (the vibratiuncles) are weaker. So much for how sense impressions cause ideas; now the question is, How do ideas become associated?

Any Sensations A, B, C, [etc.] by being associated with one another a sufficient Number of Times, get such a Power over the corresponding Ideas a, b, c, [etc.] that any one of the Sensations A, when impressed alone, shall be able to excite in the Mind, b, c, [etc.] the Ideas of the rest. (Hartley, 1749/1834, p. 41)

Hartley's notion that experiences consistently occurring together are recorded in the brain as an

interrelated package and that experiencing one element in the package will make one conscious of the entire package is remarkably modern. We will see in Chapter 19 that Donald Hebb reached essentially the same conclusion about 200 years later.

Although Hartley distinguished between simultaneous and successive associations, both are examples of the *law of contiguity*. Successive experiences follow each other closely in time, and simultaneous events occur at the same time; both exemplify a type of contiguity. As with most accounts of association then, the law of contiguity was at the heart of Hartley's. What made Hartley's account of association significantly different from previous accounts was his attempt to correlate all mental activity with neurophysiological activity.

Simple and Complex Ideas. Unlike Locke, who believed that complex ideas are formed from simple ideas via reflection, Hartley believed that all complex ideas are formed automatically by the process of association. For Hartley, there were no active mind processes involved at all. Simple ideas that are associated by contiguity form complex ideas. Similarly, complex ideas that are associated by contiguity become associated into "decomplex" ideas. As simple ideas combine into complex ideas and complex ideas combine to form decomplex ideas, it may be difficult to remember the individual sensations that make up such ideas. However, for Hartley, all ideas, no matter how complex, are made up of sensations. Furthermore, association is the only process responsible for converting simple ideas into complex ones.

The Laws of Association Applied to Behavior. Hartley attempted to show that so-called voluntary behavior developed from involuntary, or reflexive, behavior. He used the law of association to explain how involuntary behavior gradually becomes voluntary and then becomes almost involuntary (automatic) again. Involuntary behavior occurs automatically (reflexively) in response to sensory stimulation. Voluntary behavior occurs in response to one's ideas or to stimuli not originally associated with the behavior, and

voluntary behavior itself can become so habitual that it too becomes automatic, not unlike involuntary behavior. The basic assumption in Hartley's explanation is that all behavior is at first involuntary and gradually becomes voluntary through the process of association. In the following example, we can see that Hartley's (1749/1834) explanation of the development of voluntary behavior comes very close to what was later called a conditioned reflex:

The fingers of young children bend upon almost every impression which is made upon the palm of the hand, thus performing the action of grasping, in the original automatic manner. After a sufficient repetition of the motory vibrations which concur in this action, their vibratiuncles are generated, and associated strongly with other vibrations or vibratiuncles, the most common of which, I suppose, are those excited by the sight of a favourite plaything which the child uses to grasp, and hold in his hand. He ought, therefore, according to the doctrine of association, to perform and repeat the action of grasping, upon having such a plaything presented to his sight. But it is a known fact, that children do this. By pursuing the same method of reasoning, we may see how, after a sufficient repetition of the proper associations, the sound of the words grasp, take hold, [etc.] the sight of the nurse's hand in a state of contraction, the idea of a hand, and particularly of the child's own hand, in that state, and innumerable other associated circumstances, i.e. sensations, ideas, and motions, will put the child upon grasping, till, at last, that idea, or state of mind which we may call the will to grasp, is generated, and sufficiently associated with the action to produce it instantaneously. It is therefore perfectly voluntary in this case; and, by the innumerable repetitions of it in this perfectly voluntary state, it comes, at last, to obtain a sufficient connection with so many diminutive sensations, ideas, and

motions, as to follow them in the same manner as originally automatic actions do the corresponding sensations, and consequently to be automatic secondarily. And, in the same manner, may all the actions performed with the hands be explained, all those that are very familiar in life passing from the original automatic state through the several degrees of voluntariness till they become perfectly voluntary, and then repassing through the same degrees in an inverted order, till they become secondarily automatic on many occasions, though still perfectly voluntary on some, viz. whensoever an express act of the will is exerted. (pp. 66-67)

Thus, behavior is first involuntary, and then it becomes increasingly voluntary as, through the process of association, more and more stimuli become capable of eliciting the behavior. Finally, when performing the voluntary action becomes habitual, it is said to be "secondarily automatic." It should be clear that Hartley did not employ the term *voluntary* to mean "freely chosen." For him, voluntary behavior is determined by the law of contiguity and, therefore, no free choice is involved.

Hartley's effort to explain the relationship between ideas and behavior was rare among philosophers of his time and practically unheard of before his time. We see in Hartley's explanation much that would later become part of modern learning theory.

The Importance of Emotion. In general, Hartley believed that excessive vibrations caused the experience of pain and that mild or moderate vibrations caused the experience of pleasure. Again, association plays a prominent role in Hartley's analysis. Through experience, certain objects, events, and people become associated with pain and others with pleasure. We learn to love and desire those things that give us pleasure, hope for them when they are absent, and experience joy when they are present. Similarly, we learn to hate and avoid those things that give us pain, fear their eventuality, and

experience grief when they are present. It was Hartley's disciple Joseph Priestley (1733–1804), the famous chemist and codiscoverer of oxygen, who explored the implications of Hartley's analysis of emotions for education. Priestley also wrote Hartley's Theory of the Human Mind: On the Principle of the Association of Ideas (1775), which did much to promote the popularity of Hartley's ideas.

Hartley's Influence. Hartley took the speculations concerning neurophysiology of his time and used them in his analysis of association. His effort was the first major attempt to explain the neurophysiology of thought and behavior since Descartes. The neurophysiological mechanisms that Hartley postulated were largely fictitious, but as more became known about neural transmission and brain mechanisms, the more accurate information replaced the older fictions. Thus, Hartley started the search for the biological correlates of mental events that has continued to the present.

Earlier in this chapter, associationism was defined as any psychological theory that has association as its fundamental principle (Drever, 1968). Under this definition, neither Hobbes's nor Locke's philosophies qualify. Hume probably qualifies, but "Hartley ... was the first man to whom the term associationist can be applied without qualification" (Drever, 1968, p. 14). Hartley's brand of associationism became highly influential and was the authoritative account for about 80 years, or until the time of James Mill.

James Mill

James Mill (1773–1836), a Scotsman born on April 6, was educated for the ministry at the University of Edinburgh. In 1802 he moved to London to start a literary career, becoming editor of the *Literary Journal* and writing for various periodicals. With the publication of perhaps his greatest literary achievement, *The History of British India*, which he began writing in 1806 and finished in 1817, Mill entered a successful career with the East India Company. Mill's most significant contribution to psychology was *Analysis of the Phenomena*

of the Human Mind, which originally appeared in 1829 and was revised under the editorship of his son John Stuart Mill in 1869. We use the 1869 edition of Analysis as the primary source in this summary of Mill's ideas. Mill's Analysis is regarded as the most complete summary of associationism ever offered. As we will see, Mill's analysis of association was influenced by Hume and especially by Hartley.

Utilitarianism and Associationism. In 1808, James Mill met Jeremy Bentham (1748–1832), and the two became close, lifelong friends. Bentham was the major spokesman for the British political and ethical movement called utilitarianism. Bentham rejected all metaphysical and theological arguments for government, morality, and social institutions and instead took the ancient concept of hedonism (from the Greek word hedone, meaning "pleasure") and made it the cornerstone of his political and ethical theory:

Nature has placed mankind under the governance of two sovereign masters, *pain* and *pleasure*. It is for them alone to point out what we ought to do, as well as to determine what we shall do. On the one hand the standard of right and wrong, on the other the chain of causes and effects, are fastened to their throne. They govern us in all we do, in all we say, in all we think: every effort we can make to throw off their subjection will serve but to demonstrate and confirm it. (Bentham, 1781/1988, p. 1)

Thus, Bentham defined human happiness entirely in terms of the ability to obtain pleasure and avoid pain. Similarly, the best government was defined as one that brought the greatest amount of happiness to the greatest number of people. Although utilitarianism was implicit in the philosophies of a number of the earlier British empiricists, it was Bentham who applied hedonism to society as a whole. Bentham's efforts were highly influential and resulted in a number of reforms in legal and social institutions.

In psychology, Bentham's "pleasure principle" showed up later not only in Freudian theory but also in a number of learning theories—for example, in the reinforcement theories of Thorndike (see Chapter 11) and Skinner (see Chapter 13).

James Mill was one of Bentham's most enthusiastic disciples, and we will see shortly how utilitarianism entered Mill's version of associationism. Mill is best known, however, for his Newtonian, mechanistic, and elementistic view of the mind.

James Mill's Analysis of Association. Following Hartley, Mill attempted to show that the mind consisted of only sensations and ideas held together by contiguity. Also following Hartley, Mill said that complex ideas are composed of simple ideas. However, when ideas are continuously experienced together, the association among them becomes so strong that they appear in consciousness as one idea:

The word gold, for example, or the word iron, appears to express as simple an idea, as the word colour, or the word sound. Yet it is immediately seen, that the idea of each of those metals is made up of the separate ideas of several sensations; colour, hardness, extension, weight. Those ideas, however, present themselves in such intimate union, that they are constantly spoken of as one, not many. We say, our idea of iron, our idea of gold; and it is only with an effort that reflecting men perform the decomposition... . It is to this great law of association, that we trace the formation of our ideas of what we call external objects; that is, the ideas of a certain number of sensations, received together so frequently that they coalesce as it were, and are spoken of under the idea of unity. Hence, what we call the idea of a tree, the idea of a stone, the idea of a horse, the idea of a man. (J. S. Mill, 1869/1967, pp. 91-93)

In fact, all things we refer to as external objects are clusters of sensations that have been consistently experienced together. In other words, they are complex ideas and, as such, are reducible to simple ideas.

Mill explicitly pointed out what was more implicit in the philosophies of other "Newtonians of the mind," like Locke, Berkeley, Hume, and Hartley. That is, no matter how complex an idea becomes, it can always be reduced to the simple ideas of which it is constructed. Simple ideas can be added to other simple ideas, making a complex idea; complex ideas can be added to complex ideas, making a still more complex idea; and so forth. Still, at the base of all mental experience are sensations and the ideas they initiate.

The Determinants of the Strength of Associations. Mill believed that two factors caused variation in strengths of associations: *vividness* and *frequency*. That is, the more vivid sensations or ideas form stronger associations than less vivid ones do; and more frequently paired sensations and ideas form stronger associations than do those paired less frequently. Mill referred to frequency or repetition as "the most remarkable and important cause of the strength of our associations" (J. S. Mill, 1869/1967, p. 87).

As far as vividness is concerned, Mill said that (1) sensations are more vivid than ideas, and therefore the associations between sensations are stronger than those between ideas; (2) sensations and ideas associated with pleasure or pain are more vivid and therefore form stronger associations than sensations and ideas not related to pleasure or pain; and (3) recent ideas are more vivid and therefore form stronger associations than more remote ideas.

James Mill's Influence. Mill's Analysis is regarded as the most complete summary of associationism ever offered. As we have seen, he attempted to show that the mind consisted of only sensations and ideas held together by contiguity. He insisted that any mental experience could be reduced to the simple ideas that made it up. Thus, he gave us a conception of the mind based on Newtonian physics. For Newton, the universe could be understood as consisting of material elements held together by physical forces and behaving in a predictable manner. For Mill,

the mind consisted of mental elements held together by the laws of association; therefore, mental experience was as predictable as physical events.

James Mill added nothing new to associationism. His professed goal was to provide evidence for associationism that was lacking in Hartley's account. This he did, and in so doing, he carried associationism to its logical conclusion; many believe, however, that Mill's detailed elaboration of associationism exposed it as an absurdity. In any case, the mind as viewed by Mill (and by Hartley) was completely passive; that is, it had no creative abilities. Association was the only process that organized ideas, and it did so automatically. This conception of the mind, sometimes referred to as "mental physics" or "mental mechanics," essentially ended with James Mill. In fact, as we see next, James Mill's son John Stuart Mill was among the first to revise the purely mechanistic, elementistic view of his father.

John Stuart Mill

James Mill's interest in psychology was only secondary. He was a social reformer and, like Hobbes, he believed social, political, and educational change is facilitated by an understanding of human nature. He believed that Benthamism, coupled with associationism, justified a radical, libertarian political philosophy. James Mill and his followers were quite successful in bringing about substantial social change. He also tried his theory of human nature on a smaller, more personal scale by using it as a guide in rearing his son John Stuart Mill (1806-1873), born on May 20. James Mill's attempt at using associative principles in raising his son must have been at least partially successful because John Stuart had learned Greek by the time he was 3 years old, Latin and algebra by age 8, and logic by age 12. Perhaps as a result of his father's intense educational practices, J. S. Mill suffered several bouts of depression in his lifetime. Perhaps it was also because, as he noted in his autobiography (1873/1969, pp. 32, 33), his parents lacked tenderness toward each other and their children. However, J. S. Mill himself was able to have at least one loving relationship. He met Harriet Taylor when he was 25 and she was 23. At the time, Harriet was married with two children, and for more than 20 years J. S. Mill's relationship with Harriet was close but platonic. In 1851, two years after Harriet was widowed, she and J. S. Mill were married. Harriet died just seven years later at the age of 50.

J. S. Mill's most famous work was A System of Logic, Ratiocinative and Inductive: Being a Connected View of the Principles of Evidence, and the Methods of Scientific Investigation (1843). This book was an immediate success, went through eight editions in Mill's lifetime, and remained a best seller throughout the 19th century. Mill's book was considered must reading for any late-19th-century scientist. (The following summary of Mill's work uses the eighth edition of his System of Logic, which appeared in 1874.) In An Examination of Sir William Hamilton's Philosophy (1865), J. S. Mill responded to criticisms of his philosophy and elaborated and defended the views of human nature he had presented in his System of Logic. In 1869 he published a new edition of his father's Analysis, adding numerous footnotes of his own that extended and clarified his father's views on associationistic psychology and sometimes criticized his father's ideas.

J. S. Mill did as much as anyone at the time to facilitate the development of psychology as a science. This he did by describing the methodology that should be used by all sciences and by showing in great detail how that methodology could be used in a science of human nature. In fact, he believed that the lawfulness of human thought, feeling, and action was entirely conducive to scientific inquiry.

Mental Chemistry versus Mental Physics. In most important respects, J. S. Mill accepted his father's brand of associationism. J. S. Mill believed that (1) every sensation leaves in the mind an idea that resembles the sensation but is weaker in intensity (J. S. Mill called ideas secondary mental states, sensations being primary); (2) similar ideas tend to excite one another (James Mill had reduced the law of similarity to the law of frequency, but J. S. Mill accepted it as a separate law); (3) when sensations or ideas are frequently experienced together, either

simultaneously or successively, they become associated (law of contiguity); (4) more vivid sensations or ideas form stronger associations than do less vivid ones; and (5) strength of association varies with frequency of occurrence. With only the minor exception of the law of similarity, this list summarizes James Mill's notion of "mental physics" or "mental mechanics," a view that J. S. Mill accepted to a large extent.

John Stuart took issue with his father on one important issue, however. Instead of agreeing that complex ideas are *always* aggregates of simple ideas, he proposed a type of **mental chemistry**. He was impressed by the fact that chemicals often combine and produce something entirely different from the elements that made them up, such as when hydrogen and oxygen combine to produce water. Also, Newton had shown that when all the colors of the spectrum were combined, white light was produced. J. S. Mill believed that the same kind of thing sometimes happened in the mind. That is, it was possible for elementary ideas to fuse and to produce an idea that was different from the elements that made it up.

J. S. Mill's contention that an entirely new idea, one not reducible to simple ideas or sensations, could emerge from contiguous experiences, emancipated associationistic psychology from the rigid confines of mental mechanics. However, if one is seeking an active, autonomous mind, one must look elsewhere. When a new idea does emerge from the synthesis of contiguous ideas or sensations, it does so automatically. Just as the proper combination of hydrogen and oxygen cannot help but become water, a person experiencing the rapid, successive presentation of the primary colors cannot help but experience white. Certainly, the observation that sometimes a phenomenon akin to mental chemistry occurred did nothing to dampen Mill's enthusiasm over the development of a science of human nature (psychology).

Toward a Science of Human Nature. Others before him (such as Locke, Hume, and Hartley) had as their goal the creation of a mental science on par with the natural sciences. It was J. S. Mill,

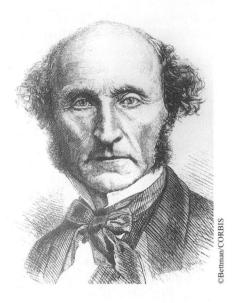

John Stuart Mill

however, speaking from the vantage point of perhaps the most respected philosopher of science of his day, who contributed most to the development of psychology as a science.

J. S. Mill began his analysis by attacking the common belief that human thoughts, feelings, and actions are not subject to scientific investigation in the same way that physical nature is. He stressed the point that any system governed by laws is subject to scientific scrutiny, and this is true even if those laws are not presently understood. Mill gave the example of meteorology. He indicated that no one would disagree that meteorological phenomena are governed by natural laws, and yet such phenomena cannot be predicted with certainty, only probabilistically. Even though a number of the basic laws governing weather are known (such as those governing heat, electricity, vaporization, and elastic fluids), a number are still unknown. Also, observing how all causes of weather interact to cause a meteorological phenomenon at any given time is extremely difficult, if not impossible. Thus, meteorology is a science because its phenomena are governed by natural laws, but it is an inexact science because knowledge of those laws is incomplete and

measurement of particular manifestations of those laws is difficult. Sciences, then, can range from those whose laws are known and the manifestations of those laws easily and precisely measured to those whose laws are only partially understood and the manifestations of those laws measured only with great difficulty. In the latter category, Mill placed sciences whose primary laws are known and, if no other causes intervene, whose phenomena can be obmeasured, and predicted precisely. However, secondary laws often interact with primary laws, making precise understanding and prediction impossible. Because the primary laws are still operating, the overall, principal effects will still be observable, but the secondary laws create variations and modifications that cause predictions to be probabilistic rather than certain. Mill (1843/1874) gave the example of tidology:

It is thus, for example, with the theory of the tides. No one doubts that Tidology ... is really a science. As much of the phenomena as depends on the attraction of the sun and moon is completely understood, and may, in any, even unknown, part of the earth's surface, be foretold with certainty; and the far greater part of the phenomena depends on those causes. But circumstances of a local or causal nature, such as the configuration of the bottom of the ocean, the degree of confinement from shores, the direction of the wind, etc., influence, in many or in all places, the height and time of the tide; and a portion of these circumstances being either not accurately knowable, not precisely measurable, or not capable of being certainly foreseen, the tide in known places commonly varies from the calculated result of general principles by some difference that we can not explain, and in unknown ones may vary from it by a difference that we are not able to foresee or conjecture. Nevertheless, not only is it certain that these variations depend on causes, and follow their causes by laws of unerring uniformity; not only,

therefore, is tidology a science, like meteorology, but it is, what hitherto at least meteorology is not, a science largely available in practice. General laws may be laid down respecting the tides, predictions may be founded on those laws, and the result will in the main, though often not with complete accuracy, correspond to the predictions. (p. 587)

Thus, meteorology and tidology are sciences, but they are not *exact* sciences. An inexact science, however, might become an exact science. For example, astronomy became an exact science when the laws governing the motions of astronomical bodies became sufficiently understood to allow prediction of not only the general courses of such bodies but also apparent aberrations. It is the inability of a science to deal with secondary causation that makes it inexact.

Mill viewed the science of human nature (psychology) as roughly in the same position as tidology or astronomy before secondary causation was understood. The thoughts, feelings, and actions of individuals cannot be predicted with great accuracy because we cannot foresee the circumstances in which individuals will be placed. This in no way means that human thoughts, feelings, and actions are not caused; it means that the primary causes of thoughts, feelings, and actions interact with a large number of secondary causes, making accurate prediction extremely difficult. However, the difficulty is understanding and predicting the details of human behavior and thought, not predicting its more global features. Just as with the tides, human behavior is governed by a few primary laws, and that fact allows for the understanding and prediction of general human behavior, feeling, and thought. What the science of human nature has then is a set of primary laws that apply to all humans and that can be used to predict general tendencies in human thought, feeling, and action. What the science of human behavior does not have is a knowledge of how its primary laws interact with secondary laws (individual characters and circumstances) to result in specific thoughts, feelings, and actions. Mill believed that it would just be a matter of time before "corollaries" would be deduced from the primary (universal) laws of human nature, which would allow for more refined understanding and prediction of human thought, feeling, and action. What are these primary (universal) laws of human nature on which a more exact science of human nature will be deduced? They are the laws of the mind by which sensations cause ideas and by which ideas become associated. In other words, they are the laws established by the British empiricists, in general, but more specifically by Hume, Hartley, and James Mill. What J. S. Mill added was the notion of mental chemistry.

J. S. Mill's Proposed Science of Ethology. In Chapter 5, Book VI, of his System of Logic, Mill argued for the development of a "science of the formation of character," and he called this science ethology. It should be noted that Mill's proposed science of ethology bore little resemblance to modern ethology, which studies animal behavior in the animal's natural habitat and then attempts to explain that behavior in evolutionary terms. As Mill saw it, ethology would be derived from a more basic science of human nature. That is, first the science of human nature (psychology) would discover the universal laws according to which all human minds operate, and then ethology would explain how individual minds or characters form under specific circumstances. The science of human nature would furnish the primary mental laws, and ethology would furnish the secondary laws. Putting the matter another way, we can say that the science of human nature provides information concerning what all humans have in common (human nature). and ethology explains individual personalities (individual differences).

What Mill was seeking, then, was the information necessary to convert psychology from an inexact science, like tidology or early astronomy, into an exact science. In other words, he wanted to explain more than general tendencies; he also wanted to explain the subtleties of individual behavior in specific circumstances.

It is interesting that Mill did little more than outline his ideas for ethology. He never personally attempted to develop such a science himself, and although most other sections of his System of Logic were substantially revised during its many editions, the section on ethology was never developed further or substantially modified. According to Leary (1982), Mill's attempt to develop a science of ethology failed because the science of human nature from which it was to be deduced was itself inadequate. Mill's theory of human nature was excessively intellectual. That is, it stressed how ideas become associated. It is difficult to imagine how something like character (personality), which to a large extent is emotional, could be deduced from a philosophy stressing the association of ideas. Mill's science of ethology was to sink or swim on the basis of the adequacy of his theory of human nature, and sink it did. It did not sink completely, however. Ethology reemerged in France as the study of individual character. The French approach placed greater emphasis on emotional factors than Mill and his followers had, and their approach was somewhat more successful. Leary (1982) tracks the French efforts to study character and the influence of those efforts on later psychology.

Social Reform. Like his father, J. S. Mill was a dedicated social reformer. His causes included freedom of speech, representative government, and the emancipation of women. He began his book *The Subjection of Women* (1861/1986) with the following statement:

The object of this Essay is to explain, as clearly as I am able, the grounds of an opinion which I have held from the very earliest period when I had formed any opinions at all on social or political matters, and which, instead of being weakened or modified, has been constantly growing stronger by the progress of reflection and the experience of life: That the principle which regulates the existing social relations between the two sexes—the legal subordination of one sex to the other—is wrong

in itself, and now one of the chief hindrances to human improvement; and that it ought to be replaced by a principle of perfect equality, admitting no power or privilege on the one side, nor disability on the other. (p. 7)

J. S. Mill went on to note that male chauvinism was often defended on the basis of natural law (females are biologically inferior to males) or on the basis of some religious belief or another. Mill considered both defenses invalid and believed that a sound science of human nature (psychology) would provide the basis for social equality. Sexism, he said, would fall "before a sound psychology, laying bare the real root of much that is bowed down to as the intention of nature and the ordinance of God" (1861/1986, p. 10). As might be expected, Mill's book was met with considerable male hostility.

Like his father, J. S. Mill embraced Bentham's utilitarianism: One should always act in a way that brings the greatest amount of pleasure (happiness) to the greatest number of people. This principle should consider both short- and long-term pleasure and treat the happiness of others as equal in value to our own. Societies can be judged by the extent to which they allow the utilitarian principle to operate.

Although J. S. Mill accepted Bentham's general principle of utilitarianism, his version of it differed significantly from Bentham's. In Bentham's calculation of happiness, all forms of pleasure counted equally. For example, sublime intellectual pleasures counted no more than eating a good meal. J. S. Mill disagreed, saying that, for most humans, intellectual pleasures were far more important than the biological pleasures we share with nonhuman animals. J. S. Mill said, "It is better to be a human dissatisfied than a pig satisfied; better to be Socrates dissatisfied than a fool satisfied" (1861/1979, p. 10).

Alexander Bain

Born in Aberdeen, Scotland, **Alexander Bain** (1818–1903) was a precocious child whose father was a weaver; from an early age, Bain himself had

to work at the loom to earn money for his education. He was fortunate to be living in perhaps the only country (Scotland) where, at the time, any student showing intellectual promise was provided a university education. He attended Marischal College, which in 1858 became the University of Aberdeen. Following graduation, Bain moved to London, where he worked as a freelance journalist. While in London, Bain joined a lively intellectual circle, which included John Stuart Mill, and the two became close, lifelong friends. The year before J. S. Mill published his famous System of Logic (1843), Bain assisted him with the revision of the manuscript. Bain also helped J. S. Mill with the annotation of the 1869 edition of James Mill's Analysis. In addition, Bain wrote biographies of both James and J. S. Mill.

While in London, Bain tried repeatedly to obtain a university appointment but without success. He finally distinguished himself, however, with the publication of his two classic texts in psychology: The Senses and the Intellect (1855) and Emotions and the Will (1859). These were to be a two-volume work published together, but the publisher delayed publishing the second volume (Emotions) for four years because the first volume sold so poorly. In any case, in 1860 at the age of 42, with his reputation established, he finally obtained an academic post at the University of Aberdeen. He returned to his alma mater as a professor of logic and rhetoric; he remained there, in this and a variety of honorary positions, for the remainder of his long, productive life.

Bain is often referred to as the first full-fledged psychologist. His books *The Senses* and *Emotions* are considered the first systematic textbooks on psychology. These books underwent three revisions each and were standard texts in psychology on both sides of the Atlantic for nearly 50 years. Until William James's *Principles of Psychology* (1890), Bain's two volumes provided many with their first experience with psychology. Besides writing the first textbooks in psychology, Bain was also the first to write a book exclusively dedicated to the relationship between the mind and the body (*Mind*

and Body, 1873); and in 1876 he founded Mind, which is generally considered the first journal devoted exclusively to psychological issues.

Bain's Goal. Bain's primary goal was to describe the physiological correlates of mental and behavioral phenomena. In preparation for writing *The Senses*, Bain made it a point to digest the most current information on neurology, anatomy, and physiology. He then attempted to show how these biological processes were related to psychological processes. His text was modern in the sense that it started with a chapter on neurology, a practice many introductory psychology textbooks have followed ever since.

After Bain, exploring the relationships between physiological and psychological processes became an integral part of psychology. Bain was the first to attempt to relate real physiological processes to psychological phenomena. Hartley had earlier attempted to do this, but his physiological principles were largely imaginary.

Laws of Association. For Bain, the mind had three components: feeling, volition, and intellect. The intellect was explained by the laws of association. Like the other British empiricists, Bain stressed the law of contiguity as the basic associative principle. According to Bain (1855/1977a), the law of contiguity applied to sensations, ideas, actions, and feelings:

Actions, sensations, and states of feeling, occurring together or in close succession, tend to grow together, or cohere, in such a way that, when any one of them is afterwards presented to the mind, the others are apt to be brought up in idea. (p. 318)

As was common among the British empiricists, Bain supplemented the law of contiguity with the law of frequency. What was unusual about Bain's presentations of the laws of contiguity and frequency was his suggestion that both laws had their effects because of neurological changes, or what we would now call changes in the synapses between neurons:

"For every act of memory, every exercise of bodily aptitude, every habit, recollection, train of ideas, there is a specific grouping, or co-ordination, of sensation and movements, by virtue of specific growth in the cell junctions" (Bain, 1873/1875, p. 91).

Like John Stuart Mill, Bain also accepted the law of similarity as one of his associative principles. Whereas the law of contiguity associates events that are experienced at the same time or in close succession, the law of similarity explains why events separated in time can come to be associated. That is, the experience of an event elicits memories of similar events even if those similar events were experienced under widely different times and circumstances.

To the traditional laws of association, Bain added two of his own: the law of compound association and the law of constructive association. The law of compound association states that associations are seldom links between one idea and another. Rather, an idea is usually associated with several other ideas either through contiguity or similarity. When this is true, we have a compound association. With such associations, sometimes experiencing one element, or perhaps even a few elements, in the compound will not be enough to elicit the associated idea. However, if the idea is associated with many elements and several of those elements are present, the associated idea will be recalled. Bain thought that this law suggested a way to improve memory and recall: "Past actions, sensations, thoughts, or emotions, are recalled more easily, when associated either through contiguity or through similarity, with more than one present object or impression" (1855/1977a, p. 545).

With his **law of constructive association**, Bain inserted a creative element into associationism in much the way Hume had done. Both Bain and Hume insisted that the mind had imaginary powers. In discussing his law of constructive association, Bain said, "By means of association the mind has the power to form new combinations or aggregates different from any that have been presented to it in the course of experience" (Bain, 1855/1977a, p. 571). In other words, the mind can rearrange memories of various experiences into an almost infinite

number of combinations. Bain thought that the law of constructive association accounted for the creativity shown by poets, artists, inventors, and the like.

Voluntary Behavior. In his analysis of **voluntary behavior**, Bain made an important distinction between reflexive behavior, which was so important to the physiology of his time, and **spontaneous activity**. Reflexive behavior occurred automatically in response to some external stimulus because of the structure of an organism's nervous system. Conversely, organisms sometimes simply act spontaneously. In the terminology of modern Skinnerians, Bain was saying that some behavior is emitted rather than elicited.

Spontaneous activity is one ingredient of voluntary behavior; the other ingredient is hedonism. We have seen that James Mill was strongly influenced by Jeremy Bentham, as was the former's son John Stuart Mill. Bain too accepted the fundamental importance of pleasure and pain in his psychology and especially in his analysis of voluntary behavior. Apparently, the thought of combining spontaneous behavior and the emotions of pleasure and pain in his analysis first occurred to Bain when, while accompanying a shepherd, he observed the first few hours of the life of a lamb. He noted that the lamb's initial movements appeared to be completely random relative to its mother's teat, but as chance contact occurred with the mother's skin and eventually with her teat, the lamb's behavior became increasingly "purposive."

Six or seven hours after birth the animal had made notable progress.... The sensations of sight began to have a meaning. In less than twenty-four hours, the animal could at the sight of the mother ahead, move in the forward direction at once to come up to her, showing that a particular image had now been associated with a definite movement; the absence of any such association being most manifest in the early movements of life. It could proceed at once to the teat and suck, guided only

Alexander Bain

by its desire and the sight of the object. (Bain, 1855/1977a, p. 406)

Bain (1859/1977b) used hedonism to explain how spontaneous activity is converted into voluntary behavior:

I cannot descend deeper into the obscurities of the cerebral organization than to state as a fact, that when pain co-exists with an accidental alleviating movement, or when pleasure co-exists with a pleasuresustaining movement, such movements become subject to the control of the respective feelings which they occur in company with. Throughout all the grades of sentient existence, wherever any vestiges of action for a purpose are to be discerned, this link must be presumed to exist. Turn it over as we may on every side, some such ultimate connexion between the two great primary manifestations of our nature—pleasure and pain, with active instrumentality—must be assumed as the basis of our ability to work out our ends. (p. 349)

With voluntary behavior, we still have the laws of association at work. Some spontaneous actions become associated with pleasure and therefore repeated; others are associated with pain and therefore reduced in frequency of occurrence. Also, in accordance with the law of frequency, the tendencies to repeat pleasurable responses or to avoid painful ones increase with the frequency of pleasurable or painful consequences. As was the case earlier with Hartley, it is important to note that for Bain, voluntary did not mean "free." So-called voluntary behavior was as deterministically controlled as reflexive behavior; it was just controlled differently. Bain said, "The actions of the will, or volition ... I consider to be nothing else than action stimulated, and guided, by feeling" (D. N. Robinson, 1977, p. 72). To summarize, Bain explained the development of voluntary behavior as follows:

- When some need such as hunger or the need to be released from confinement occurs, there is random or spontaneous activity.
- Some of these random movements will produce or approximate conditions necessary for satisfying the need, and others will not.
- 3. The activities that bring need satisfaction are remembered.
- 4. The next time the organism is in a similar situation, it will perform the activities that previously brought about need satisfaction.

Actions that are performed because of their previous effectiveness in a given situation are voluntary rather than reflexive.

Bain essentially described trial-and-error learning, which was to become so important to Thorndike several years later. He also described Skinner's operant conditioning. According to Skinner, operant behavior is simply emitted by an organism; that is, it is spontaneous. Once emitted, however, operant behavior is under the control of its consequences. Responses resulting in pleasurable consequences (reinforcement) tend to be repeated under similar circumstances, and responses resulting in painful consequences (punishment) tend not to

be. For a more detailed account of Bain's explanation of voluntary behavior, see Greenway, 1973.

With his effort to synthesize what was known about physiology with associationism and his treatment of voluntary behavior, Bain brought psychology to the very brink of becoming an experimental science.

FRENCH SENSATIONALISM

French philosophers also aspired to be Newtonians of the mind, and they had much in common with their British counterparts. The French Newtonians of the mind have been referred to as naturalists, mechanists, empiricists, materialists, and sensationalists. Any, or all, of these labels capture the spirit of the French philosophers to be considered here and would be equally applicable to the majority of the British philosophers whose work we just reviewed. The goal for both the French and British philosophers was to explain the mind as Newton had explained the physical world—that is, in a way that stressed the mind's mechanical nature, that reduced all mental activity to its basic elements, that used only a few basic principles, and that minimized or eliminated metaphysical speculation. All the French and British philosophers considered in this chapter had these goals in common. We refer to the French philosophers as sensationalists because some of them intentionally stressed the importance of sensations in explaining all conscious experience and because the label provides a convenient way of distinguishing between the British and the French philosophers. In general, however, the French and the British philosophers were more similar than they were different. Besides both being influenced by Newton (or Galileo in Hobbes's case), they the rationalism strongly opposed Descartes, especially his beliefs in innate ideas and in an autonomous mind. All ideas, said both the British empiricists and the French sensationalists, came from experience, and most, if not all, mental activity could be explained by the laws of association acting on those ideas.

The question asked by both the British empiricists and the French sensationalists was, If everything else in the universe can be explained in terms of mechanical laws, why should not humans, too, obey those laws? Although the metaphor of human beings as machines was suggested by the work of Copernicus, Kepler, Galileo, and Newton, it was further stimulated by Descartes. Descartes's dualistic conception of humans meant that our bodies act according to mechanical principles (our bodies are machines) but our minds do not. Without the autonomous mind that Descartes had postulated, however, humans were equated with nonhuman animals, and both could be understood as machines. It was this metaphor of humans as machines that especially appealed to the French sensationalists. In fact, many believed that Descartes himself saw the possibility of viewing humans as machines but that he avoided revealing this belief because of what happened to Galileo and a number of other natural philosophers (scientists) of his time. There was still reason to fear the church in France in the mid-18th century, but the French sensationalists pursued their metaphor of man as a machine with courage and boldness despite intense opposition from the church.

Pierre Gassendi

Pierre Gassendi (1592-1655), a contemporary of both Descartes and Hobbes, lived the quiet life of a studious priest and was respected as a mathematician and philosopher. Both Locke and Newton acknowledged a debt to Gassendi, whose major goal was to denounce Descartes's purely deductive (axiomatic) and dualistic philosophy and replace it with an observational (inductive) science based on physical monism. Gassendi offered several criticisms of Descartes's proposed mind-body dualism, the most telling of which was the observation that the mind, if unextended (immaterial), could have no knowledge of extended (material) things. Only physical things, he said, can influence and be influenced by physical things. He also could not understand why Descartes spent so much time proving that he existed when it was obvious, to Gassendi, that

anything that moves exists. Descartes could have said, "I move, therefore I am." In fact, according to Gassendi, such a conclusion would have been a vast improvement over "I think, therefore I am." Continuing his attack on Descartes, Gassendi asked, why could "lower" animals move themselves quite well without the aid of a mind, and yet humans needed one? Why not, Gassendi asked, ascribe the operations attributed to the mind to the functions of the brain (which is physical)? In other words, Gassendi saw no reason for postulating an unextended (immaterial) mind to explain any human activity.

Gassendi concluded that humans are nothing but matter and therefore could be studied and understood just as anything else in the universe could. Gassendi suggested a physical monism not unlike the one that the early Greek atomists, such as Democritus and later the Epicureans, had suggested. In fact, Gassendi was especially fond of Epicurus and the later Epicurean philosophers, and he was responsible for reviving interest in them. For example, he accepted the Epicurean principle of long-term hedonism as the only reasonable guide for human conduct. For these reasons, Gassendi is often considered the founder of modern materialism, but that honor could as easily be given to Gassendi's contemporary Hobbes.

Gassendi had a number of prominent followers, three of whom are reviewed next.

Julien de La Mettrie

Julien de La Mettrie (1709–1751) was born on December 25. His father intended him to become a priest until a local doctor pointed out that a mediocre physician would be better paid than a good priest. Upon receiving his medical degree, La Mettrie soon distinguished himself in the medical community by writing articles on such topics as venereal disease, vertigo, and smallpox. He was widely resented because of professional jealousy, his tendency to satirize the medical profession, and his quick temper. In 1742 he obtained a commission as physician to the regiment of guards serving in the war between France and Austria. During

a military campaign, La Mettrie contracted a violent fever; while convalescing, he began to ponder the relationship between the mind and the body.

Upon recovery from his illness, La Mettrie wrote *The Natural History of the Soul* (1745), which stressed that the mind is much more intimately related to the body than Descartes had assumed. If the mind is completely separate from the body and influences the body only when it chooses to do so, how can the effects of such things as wine, coffee, opium, or even a good meal on one's thoughts be explained? In fact, La Mettrie was among the first modern philosophers to suggest that "you are what you eat."

Raw meat makes animals fierce, and it would have the same effect on man. This is so true that the English who eat meat red and bloody, and not as well done as ours, seem to share more or less in the savagery due to this kind of food, and to other causes which can be rendered ineffective by education only. This savagery creates in the soul, pride, hatred, scorn of other nations, indocility and other sentiments which degrade the character, just as heavy food makes a dull and heavy mind whose usual traits are laziness and indolence. (La Mettrie, 1748/1912, p. 94)

To La Mettrie, it was clear that whatever influences the body influences the so-called thought processes, but La Mettrie went further. He believed that there is nothing in the universe but matter and motion. Sensations and thoughts are also nothing but movements of particles in the brain. Thus, La Mettrie, like Hobbes and Gassendi, was a thorough-going materialist.

La Mettrie's book *The Natural History of the Soul* (1745) was harshly criticized by the French clergy. The feelings against him were so intense that he was forced into exile in Holland. While in Holland, he wrote his most famous book, *L'Homme Machine* (*Man a Machine*, 1748). This book so upset the Dutch clergy that La Mettrie was also forced to leave Holland. Fortunately, Frederick the Great

offered La Mettrie a pension and refuge in Berlin. There, La Mettrie continued writing on medical topics until his death on November 11, 1751, at the age of 41.

Man a Machine. La Mettrie was one who believed that Descartes was a mechanist, even as far as humans were concerned, and that his published thoughts on God and the soul were designed to hide his true feelings from the clergy and to save himself from persecution (La Mettrie, 1748/1912, p. 143). In any case, La Mettrie believed that if Descartes had followed his own method, he (Descartes) would have reached the conclusion that humans, like nonhuman animals, were automata (machines). La Mettrie, then, set out to either correct Descartes's misunderstanding of humans or to do what Descartes wanted to do but refrained from doing because of fear of persecution.

La Mettrie concluded Man a Machine with the statement, "Let us then conclude boldly that man is a machine, and that in the whole universe there is but a single substance differently modified" (1748/1912, p. 148). The single substance, of course, was matter, and this belief that every existing thing, including humans, consists of matter and nothing else makes La Mettrie a physical monist. For La Mettrie, to believe in the existence of an immaterial soul (mind) was just plain silly. According to La Mettrie, only a philosopher who was not at the same time a physician could postulate the existence of an immaterial soul that is independent from the body. The overwhelming evidence for the dependence of so-called mental events on bodily states available to physicians would (or should) preclude them from embracing dualism.

Human and Nonhuman Animals Differ Only in Degree. La Mettrie (1748/1912) equated intelligence and some personality characteristics with the size and quality of the brain:

I shall draw the conclusions which follow clearly from ... incontestable observations: 1st, that the fiercer animals are, the less brain they have; 2nd, that this organ seems

to increase in size in proportion to the gentleness of the animal; 3rd, that nature seems here eternally to impose a singular condition, that the more one gains in intelligence the more one loses in instinct. (pp. 98–99)

If humans can be considered superior to non-human animals, it is because of education and the development of language. Because the primate brain is almost as large and as complex as ours, it follows that if primates could be taught language, they would resemble humans in almost all respects. The question is, Can primates learn a language?

Among animals, some learn to speak and sing; they remember tunes, and strike the notes as exactly as a musician. Others, for instance the ape, show more intelligence, and yet can not learn music. What is the reason for this, except some defect in the organs of speech? In a word, would it be absolutely impossible to teach the ape a language? I do not think so. (La Mettrie, 1748/1912, p. 100)

With proper training, humans and apes could be made remarkably similar.

Such is the likeness of the structure and functions of the ape to ours that I have very little doubt that if this animal were properly trained he might at last be taught to pronounce, and consequently to know, a language. Then he would no longer be a wild man, nor a defective man, but he would be a perfect man, a little gentleman, with as much matter or muscle as we have, for thinking and profiting by his education. (La Mettrie, 1748/1912, p. 103)

According to La Mettrie, intelligence was influenced by three factors: brain size, brain complexity, and education. Humans are typically superior in intelligence to other animals because we have bigger, more complex brains and because we are better educated. However, by *education*, La

Mettrie did not mean only explicit instruction but also the effects of everyday experience—for example, our interactions with other people.

To say that humans are morally superior to nonhuman animals is to overlook the seamier human activities like cannibalism, infanticide, and wars in which "our compatriots fight, Swiss against Swiss, brother against brother, recognize each other, and yet capture and kill each other without remorse, because a prince pays for the murder" (La Mettrie, 1748/1912, p. 117). Religion, grounded in the belief in a supreme being, certainly has not improved the human condition. It is possible, according to La Mettrie, that atheism could encourage humans to be more humane.

In any case, humans differ from nonhuman animals only in degree, not in type: "Man is not molded from a costlier clay; nature has used but one dough, and has merely varied the leaven" (La Mettrie, 1748/1912, p. 117). And this observation was made over 100 years before Darwin published *The Origin of Species* (1859).

Acceptance of Materialism Will Make for a Better World. According to La Mettrie, belief in the uniqueness of humans (dualism) and in God are not only incorrect but also responsible for widespread misery. Humans would be much better served by

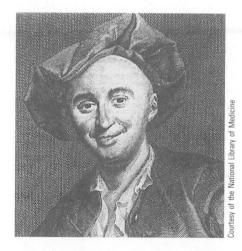

Julien de La Mettrie

accepting their continuity with the animal world. That is, we should accept the fact that, like other animals, humans are machines—complex machines, but machines nonetheless. La Mettrie (1748/1912) described how life would be for the person accepting the materialistic–mechanistic philosophy:

He who so thinks will be wise, just, tranquil about his fate, and therefore happy. He will await death without either fear or desire, and will cherish life (hardly understanding how disgust can corrupt a heart in this place of many delights); he will be filled with reverence, gratitude, affection, and tenderness for nature, in proportion to his feeling of the benefits he has received from nature; he will be happy, in short, in feeling nature, and in being present at the enchanting spectacle of the universe, and he will surely never destroy nature either in himself or in others. More than that! Full of humanity, this man will love human character even in his enemies. Judge how he will treat others. He will pity the wicked without hating them; in his eyes, they will be but mis-made men. But in pardoning the faults of the structure of mind and body, he will none the less admire the beauties and the virtues of both.... In short, the materialist, convinced, in spite of the protests of his vanity, that he is but a machine or an animal, will not maltreat his kind, for he will know too well the nature of those actions, whose humanity is always in proportion to the degree of the analogy proved above [between human beings and animals]; and following the natural law given to all animals, he will not wish to do to others what he would not wish them to do to him. (pp. 147-148)

La Mettrie dared to discuss openly those ideas that were held privately by many philosophers of the time. In so doing, he offended many powerful individuals. Although it is clear that he influenced many subsequent thinkers, his works were rarely cited or his name even mentioned. The fact that he died of indigestion following overindulgence of a meal of pheasant and truffles was seen by many as a fitting death for a misled, atheistic philosopher.

Étienne Bonnot de Condillac

Étienne Bonnot de Condillac (1714-1780) was born on September 30 into an aristocratic family at Grenoble. He was the contemporary of Hume and Rousseau, who were about his age, and with Voltaire, who was about 20 years older. He was educated at a Jesuit seminary in Paris, but shortly after his ordination as a Roman Catholic priest, he began frequenting the literary and philosophical salons of Paris and gradually lost interest in his religious career. In fact, he became an outspoken critic of religious dogma. Condillac translated Locke's Essay into French, and the title of his first book indicates a deep appreciation for Locke's empirical philosophy: Essay on the Origin of Human Knowledge: A Supplement to Mr. Locke's Essay on the Human Understanding (1746). Eight years later, in his Treatise on the Sensations (1754), Condillac suggested that Locke had unnecessarily attributed too many innate powers to the mind. Condillac was convinced that all powers Locke attributed to the mind could be derived simply from the abilities to sense, to remember, and to experience pleasure and pain.

The Sentient Statue. To make his point, Condillac (1754/1930) asked his readers to imagine a marble statue that can sense, remember, and feel but has only the sense of smell. The mental life of the statue consists only of odors; it cannot have any conception of things external to itself, nor can it have sensations of color, sound, or taste. The statue does have the capacity for attention because it will attend to whatever odor it experiences. With attention comes feeling because attending to a pleasant odor causes enjoyment and attending to an unpleasant odor causes an unpleasant feeling. If the statue had just one continuous pleasant or unpleasant experience, it could not experience desire because it

would have nothing with which to compare the experience. If, however, a pleasant sensation ended, remembering it, the statue could desire it to return. Likewise, if an unpleasant experience ended, remembering it, the statue could desire that it not return. For Condillac then, all desire is based on the experiences of pleasure and pain. The statue loves pleasant experiences and hates unpleasant ones. The statue, given the ability to remember, can not only experience current odors but also remember ones previously experienced. Typically, the former provide a more vivid sensation than the latter.

When the statue smells a rose at one time and a carnation at another, it has the basis for comparison. The comparison can be made by currently smelling one and remembering the other or by remembering both odors. With the ability to compare comes the ability to be surprised. Surprise is experienced whenever an experience the statue has departs radically from those it is used to: "It cannot fail to notice the change when it passes suddenly from a state to which it is accustomed to a quite different state, of which it has as yet no idea" (Condillac, 1754/1930, p. 10). Also with the ability to compare comes the ability to judge. As with remembering in general, the more comparisons and judgments the statue makes, the easier making them becomes. Sensations are remembered in the order in which they occur; memories then form a chain. This fact allows the statue to recall distant memories by passing from one idea to another until the most distant idea is recalled. According to Condillac, without first recalling intermediary ideas, distant memories would be lost. If the statue remembers sensations in the order they occurred, the process is called retrieval. If they are recalled in a different order, it is called imagination. Dreaming is a form of imagination. Retrieving or imagining that which is hated causes fear. Retrieving or imagining what is loved causes hope. The statue, having had several sensations, can now notice that they can be grouped in various ways, such as intense, weak, pleasant, and unpleasant. When sensations or memories are grouped in terms of what they have in common, the statue has formed abstract ideas, for example, pleasantness. Also by noting that some sensations or memories last longer than others, the statue develops the idea of *duration*.

When our statue has accumulated a vast number of memories, it will tend to dwell more on the pleasant ones than on the unpleasant. In fact, according to Condillac, it is toward the seeking of pleasure or the avoidance of pain that the statue's mental abilities are ultimately aimed: "Thus it is that pleasure and pain will always determine the actions of [the statue's] faculties" (Condillac, 1754/1930, p. 14).

The statue's self, ego, or personality consists of its sensations, its memories, and its other mental abilities. With its memories, it is capable of desiring sensations other than the one it is now having; or by remembering other sensations, it can wish its present sensation to continue or terminate. Experiences (in this case, odors) never experienced cannot become part of the statue's mental life, which consists only of its sensations and its memories of sensations.

Clearly, Condillac was not writing about statues but was discussing how human mental abilities could be derived from sensations, memories, and a few basic feelings. Humans, of course, have more than one sense modality; that fact makes humans much more complicated than the statue, but the principle is the same. There was no need therefore for Locke and others to postulate a number of innate powers of the mind. According to Condillac (1754/1930), the powers of the mind develop as a natural consequence of sensation:

If we bear in mind that recollecting, comparing, judging, discerning, imagining, wondering, having abstract ideas, and ideas of number and duration, knowing general and particular truths, are only different modes of attention; that having passions, loving, hating, hoping, fearing, wishing, are only different modes of desire; and finally that attention and desire have their origin in feeling alone; we shall conclude that sensation contains within it all the faculties of the soul. (p. 45)

In his analysis of language, Condillac (1746/2001) argued that the meaning of words is determined exclusively by how they are habitually used:

To understand how mankind came to agreement among themselves about the signification of words they wished to put into use, it is sufficient to observe that they pronounced them in circumstances in which everyone was obliged to refer to the same perceptions. By that means they fixed the meaning with greater exactness in proportion as the circumstances, by frequent repetition, habituated the mind to connect particular ideas to particular signs. The language of action removed the ambiguities and double meanings which in the beginning would occur very often. (p. 156)

Aarsleff (2001, pp. xxxiv–xxxviii) notes the considerable similarity between Condillac's analysis of language and Wittgenstein's later analysis, which we discuss in Chapter 21.

Claude-Adrien Helvétius

Claude-Adrien Helvétius (1715–1771) was born in Paris and educated by Jesuits. He became wealthy as a tax collector, married an attractive countess, and retired to the countryside where he wrote and socialized with some of Europe's finest minds. In 1758 he wrote Essays on the Mind, which was condemned by the Sorbonne and burned. His posthumous A Treatise on Man: His Intellectual Faculties and His Education (1772) moved Jeremy Bentham to claim that what Francis Bacon had done for our understanding of the physical world, Helvétius had done for our understanding of the moral world. Also, James Mill claimed to have used Helvétius's philosophy as a guide in the education of his son, John Stuart.

Helvétius did not contradict any of the major tenets of British empiricism or French sensationalism, nor did he add any new ones. Rather, he explored in depth the implication of the contention that the contents of the mind come only from experience. In other words, control experiences and you control the contents of the mind. The implications of this belief for education and even the structure of society were clear, and in the hands of Helvétius, empiricism became radical *environmentalism*. All manner of social skills, moral behavior, and even genius could be taught through the control of experiences (education). Russell (1945) said of Helvétius, "His doctrine is optimistic, since only a perfect education is needed to make men perfect. There is a suggestion that it would be easy to find a perfect education if the priests were got out of the way" (p. 722).

Because Helvétius too was a hedonist, education in general terms could be viewed as the manipulation of pleasurable and painful experiences. Today we might state this as reinforcing desirable thoughts and behavior and either ignoring or punishing undesirable thoughts and behavior. In this sense, Helvétius's position has much in common with that of the modern behaviorists.

POSITIVISM

The British empiricists and the French sensationalists had in common the belief that all knowledge comes from experience; that is, that there are no innate ideas. They also shared a distaste for metaphysical speculation. All knowledge, they said, even moral knowledge, was derived from experience. If the denial of innate moral principles did not place the empiricists and the sensationalists in direct opposition to religion, it certainly placed them in direct opposition to religious dogma.

As the successes of the physical and mental sciences spread throughout Europe, and as religious doctrine became increasingly suspect, a new belief emerged—the belief that science can solve all human problems. Such a belief is called **scientism**. To those embracing scientism, scientific knowledge is the only valid knowledge; therefore, it provides the only information one can believe. For these individuals, science itself takes on some of the char-

acteristics of a religion. One such individual was Auguste Comte.

Auguste Comte

Auguste Comte (1798–1857), born in the French city of Montpellier on January 19, grew up in the period of great political turmoil that followed the French Revolution of 1789-1799. In school. Comte was an excellent student and a troublemaker. In August 1817, Comte met the social philosopher Henri de Saint-Simon (1760-1825), who converted Comte from an ardent advocate of liberty and equality to a supporter of a more elitist view of society. The two men collaborated on a number of essays, but after a bitter argument, they parted company in 1824. In April 1826, Comte began giving lectures in his home on his positivist philosophy—that is, the attempt to use the methods of the physical sciences to create a science of history and human social behavior. His lectures were attended by a number of illustrious individuals, but after only three lectures, Comte suffered a serious mental collapse. Despite being treated in a hospital for a while, he fell into deep depression and even attempted suicide. He was unable to resume his lectures until 1829. Financial problems, lack of professional recognition, and marital difficulties combined to drive Comte back into isolation. Between 1830 and 1842, his time was spent mainly on writing his six-volume work, Cours de Philosophe Positive (The Course of Positive Philosophy, 1830-1842). Comte's Cours was translated into English by the philosopher-feminist Harriet Martineau (1802-1876) in 1853. As a result of the Cours, Comte began to attract a few admirers, among them John Stuart Mill. However, soon after the publication of the Cours, Comte's wife left him. In 1844 he met and fell in love with Clotilde de Vaux, and although she died of tuberculosis soon after they met, he vowed to dedicate the rest of his life to her memory. Soon afterward he began writing Système de Politique Positive (System of Positive Politics), in which Comte introduced his religion of humanity (discussed later). The Système cost Comte most of his influential followers, including

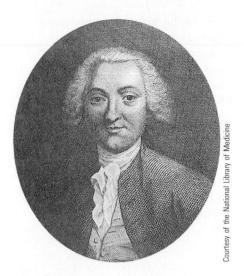

Claude Helvétius

John Stuart Mill. Undaunted, Comte continued to concentrate on his new religion, of which he installed himself as high priest. Comte spent his later years attempting to gain converts to his religion. He even tried to recruit some of the most powerful individuals in Europe, including Czar Nicholas I and the head of the Jesuits.

Comte's Positivism. According to Comte, the only thing we can be sure of is that which is publicly observable—that is, sense experiences that can be shared with other individuals. The data of science are publicly observable and therefore can be trusted. For example, scientific laws are statements about how empirical events vary together, and once determined, they can be experienced by any interested party. Comte's insistence on equating knowledge with empirical observations was called positivism.

Comte was a social reformer and was interested in science only as a means of improving society. Knowledge, whether scientific or not, was not important unless it had some practical value. Comte wrote, "I have a supreme aversion to scientific labors whose utility, direct or remote, I do not see" (Esper, 1964, p. 213). According to Comte, science should seek to discover the lawful relationships among physical phenomena. Once such laws are

known, they can be used to predict and control events and thus improve life. One of Comte's favorite slogans was "Know in order to predict" (Esper, 1964, p. 213). Comte's approach to science was very much like the one suggested earlier by Francis Bacon. According to both Comte and Bacon, science should be practical and nonspeculative. Comte told his readers that there are two types of statements: "One refers to the objects of sense, and it is a scientific statement. The other is nonsense" (D. N. Robinson, 1986, p. 333).

It should be pointed out that positivistic thinking had been around in one form or another since at least the time of the early Greeks:

The history of positivism might be said to extend from ancient times to the present. In ancient Greece it was represented by such thinkers as Epicurus, who sought to free men from theology by offering them an explanation of the universe in terms of natural law, and the Sophists, who wished to bring positive knowledge to bear on human affairs. The cumulative successes of the scientific method in the seventeenth and eighteenth centuries increasingly favored the acceptance of the positivistic attitude among intellectuals. In England, the empirical philosophy, beginning with Francis Bacon and culminating in Hume and John Stuart Mill, became an essential part of the positivist tradition. (Esper, 1964, pp. 212-213)

In fact, because all the British empiricists and French sensationalists stressed the importance of sensory experience and avoided metaphysical and theological speculation, they all could be said to have had at least positivistic leanings.

The Law of Three Stages. According to Comte, societies pass through stages that are defined in terms of the way its members explain natural events. The first stage, and the most primitive, is *theological*, and explanations are based on superstition and mysticism. In the second stage, which is

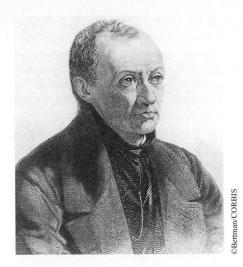

Auguste Comte

metaphysical, explanations are based on unseen essences, principles, causes, or laws. During the third and highest stage of development, the scientific description is emphasized over explanation, and the prediction and control of natural phenomena becomes all important. In other words, during the scientific stage, positivism is accepted. Comte used the term **sociology** to describe the study of how different societies compared in terms of the three stages of development.

Comte described the events that characterize the transition from one stage to another in much the same way that Kuhn (1996) described paradigmatic shifts in science. According to Comte, the beliefs characteristic of a particular stage become a way of life for the people within a society. It is only a few of the society's wisest individuals who glimpse the next stage and begin to pave the way for it. There follows a critical period during which a society is in transition between one stage and another. The beliefs characterizing the new stage then become a way of life until the process is repeated. As with a paradigmatic shift in science, there are always remnants of earlier stages in the newly established one.

As evidence for his law of three stages, Comte observed that individuals also pass through the same stages:

The progress of the individual mind is not only an illustration, but an indirect evidence of that of the general mind. The point of departure of the individual and of the race being the same, the phases of the mind of a man correspond to the epochs of the mind of the race. Now, each of us is aware, if he looks back upon his own history, that he was a theologian in his childhood, a metaphysician in his youth, and a natural philosopher in his manhood. All men who are up to their age can verify this for themselves. (Martineau, 1853/1893, p. 3)

Religion of Humanity. By the late 1840s, Comte was discussing positivism as if it were religion. To him, science was all that one needed to believe in and all that one should believe in. He described a utopian society based on scientific principles and beliefs and whose organization was remarkably similar to the Roman Catholic Church. However, humanity replaced God, and scientists and philosophers replaced priests. Disciples of the new religion would be drawn from the working classes and especially from among women:

The triumph of positivism awaited the unification of three classes: The philosophers, the proletariat, and women. The first would establish the necessary intellectual and scientific principles and methods of inquiry; the second would guarantee that essential connection between reality and utility; the third would impact to the entire program the abiding selflessness and moral resolution so natural to the female constitution. (D. N. Robinson, 1982, pp. 41–42)

Comte's religion of humanity was one of the reasons that John Stuart Mill became disenchanted with him. Comte's utopia emphasized the happiness of the group and minimized individual happiness. In Mill's version of utilitarianism, the exact opposite is true.

The Hierarchy of the Sciences. Comte arranged the sciences in a hierarchy from the first developed and most basic to the last developed and most comprehensive as follows: mathematics, astronomy, physics, chemistry, physiology and biology, and sociology. It is of special interest to note that psychology did not appear on Comte's list of sciences. If what is meant by psychology is "the introspective analysis of the mind," then Comte believed that psychology was metaphysical nonsense. Science, for Comte, dealt with what could be publicly observed, and that excluded introspective data. He had harsh words to say about introspection, and in saving them, he differentiated himself from essentially all the British empiricists and French sensationalists who relied almost exclusively on introspection in their analysis of the mind:

In order to observe, your intellect must pause from activity; yet it is this very activity you want to observe. If you cannot effect the pause you cannot observe; if you do effect it, there is nothing to observe. The results of such a method are in proportion to its absurdity. After two thousand years of psychological pursuit, no one proposition is established to the satisfaction of its followers. They are divided, to this day, into a multitude of schools, still disputing about the very elements of their doctrine. This internal observation gives birth to almost as many theories as there are observers. We ask in vain for any one discovery, great or small, which has been made under this method. (Martineau, 1853/1893, p. 10)

For Comte, two methods, however, were available by which the individual could be studied objectively. One way was to embrace phrenology, which was an effort to relate mental events to brain anatomy and processes (we will discuss phrenology in Chapter 8). Phrenological analysis essentially reduced psychology to physiology. The second way was to study the mind by its products—that is, to study the mind by studying overt behavior,

especially social behavior. The study of human social behavior is a second sense in which Comte used the term *sociology*. So, the first objective way of studying humans reduced psychology to physiology, and the second reduced it to sociology. In the latter case, there was no studying "me," only "us." We now see two more reasons that J. S. Mill distanced himself from Comte. First, Mill's analysis of the mind was highly dependent on introspection; second, Mill rejected phrenology (and history indicates that he was correct in having done so).

A Second Type of Positivism

Comte insisted that we accept only that of which we can be certain, and for him, that was publicly observable data. For Comte, introspection was out because it examined only private experiences. Another brand of positivism emerged later, however, under the leadership of the physicist Ernst Mach (1838-1916). Mach, like Comte, insisted that science concentrate only on what could be known with certainty. Neither Comte nor Mach allowed metaphysical speculation in their views of science. The two men differed radically, however, in what they thought scientists could be certain about. For Comte, it was physical events that could be experienced by any interested observer. Mach, however, agreed with the contention of Berkelev and Hume—that we can never experience the physical world directly. We experience only sensations or mental phenomena. For Mach, the job of the scientist was to note which sensations typically cluster together and to describe in precise mathematical terms the relationships among them. According to Mach, "There can be no a priori knowledge of the world, only experiences that, when systematically organized, can lay claim to the status of scientific knowledge" (D. N. Robinson, 2000, p. 1020). In agreement with Hume, Mach concluded that so-called causeand-effect relationships are nothing more than functional relationships among mental phenomena. Although for Mach the ultimate subject matter of any science was necessarily cognitive, this fact need

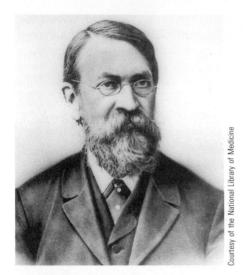

Ernst Mach

not prevent scientists from doing their work objectively and without engaging in metaphysical speculation. In his influential book *The Science of Mechanics* (1883/1960), Mach insisted that scientific concepts be defined in terms of the procedures used to measure them rather than in terms of their "ultimate reality" or "essence." In doing so, Mach anticipated Bridgman's concept of the operational definition (see Chapter 13). Einstein often referred to Mach as an important influence on his life and work. Thus, both Comte and Mach were positivistic, but what they were positive about differed.

Positivism was revised through the years and was eventually transformed into *logical positivism*. It was through logical positivism that positivistic philosophy had its greatest impact on psychology. We will discuss logical positivism and its impact on psychology in Chapter 13.

SUMMARY

A group of British philosophers opposed Descartes's notion of innate ideas, saying that all ideas were derived from experience. Those who claimed that experience was the basis of all knowledge were called empiricists. Hobbes insisted that all human activity was ultimately reducible to physical and mechanistic principles; thus, he was a materialist and a mechanist as well as an empiricist. He believed that the function of a society was to satisfy the needs of individuals and to prevent individuals from fighting among themselves. He also believed that all human behavior was ultimately motivated by the seeking of pleasure and the avoidance of pain.

Locke was an empiricist who distinguished between the primary qualities of objects, which caused ideas that actually resembled attributes of those objects, and secondary qualities, which caused psychological experiences that had no counterpart in the physical world. Locke believed that all ideas are derived from sensory experience but that existing ideas could be rearranged by the mind into numerous configurations. Locke postulated a mind

that was well stocked with mental abilities such as believing, imagining, reasoning, and willing. Like most of the other empiricists, Locke believed that all human emotions are derived from the two basic emotions of pleasure and pain. Locke used the laws of association primarily to explain the development of "unnatural" associations. Locke's views on education were compatible with his empirical philosophy and were highly influential.

Berkeley denied the existence of a material world, saying instead that all that exists are perceptions. Although an external world exists because God perceives it, we can know only our own perceptions of that world. We can assume that our perceptions of the world accurately reflect external reality, however, because God would not allow our senses to deceive us. Berkeley also proposed an empirical theory of distance perception.

Hume agreed with Berkeley that the only thing we experience directly is our own subjective experience but disagreed with Berkeley's faith that our perceptions accurately reflect the physical world. For Hume, we can never know anything

about the physical world because all we ever experience is thought and habits of thought. Like Locke, Hume postulated an active imagination that could arrange ideas in countless ways. Unlike Locke. however, Hume made the laws of association the cornerstone of his philosophy. He postulated three such laws: the law of contiguity, which states that events experienced together are remembered together; the law of resemblance, which states that remembering one event tends to elicit memories of similar events; and the law of cause and effect. which states that we tend to believe that the circumstances that consistently precede an event cause that event. Hume reduced both mind and self to perceptual experience. According to Hume, it is the passions (emotions) that govern behavior, and because people differ in their patterns of emotions, individual behavior differs. A person's pattern of emotions determines his or her character.

Hartley attempted to couple empiricism and associationism with a rudimentary conception of physiology. Hartley was among the first to show how the laws of association might be used to explain learned behavior. According to his analysis, involuntary (reflexive) behavior gradually becomes associated with environmental stimuli, such as when a child's grasping becomes associated with a favorite toy. When this association is made, the child can voluntarily grasp when he or she sees the toy. Through repeated experience, voluntary behavior can become almost as automatic as involuntary behavior. In accordance with the tradition of empiricism, Hartley believed pleasure and pain govern behavior, and it was his disciple Priestley who saw the implications of Hartley's hedonism for educational practices.

James Mill pushed empiricism and associationism to their logical conclusion by saying that all ideas could be explained in terms of experience and associative principles. He said that even the most complex ideas could be reduced to simpler ones. John Stuart Mill disagreed with his father's contention that simple ideas remained intact as they combined into more complex ones. He maintained that at least some simple ideas underwent a fusion and that the complex idea they produce

could be quite different from the simpler ideas that make it up. J. S. Mill's idea of fusion was called mental chemistry. J. S. Mill believed that a mental science could develop that would eventually be on par with the physical sciences. According to J. S. Mill, the primary laws governing behavior are already known; what is needed to make mental science an exact science is an understanding of the secondary laws that determine how individuals act under specific circumstances. J. S. Mill proposed a science of ethology to study the secondary laws governing behavior. J. S. Mill was dedicated to several social causes, including the emancipation of women. He accepted Bentham's utilitarianism but, unlike Bentham, emphasized the quality rather than the quantity of pleasurable experiences.

Alexander Bain was the first to write psychology textbooks, to write an entire book on the relationship between the mind and the body, to use known neurophysiological facts in explaining psychological phenomena, and to found a psychology journal. He explained voluntary behavior in terms of spontaneous behavior and hedonism, and he added the laws of compound association and constructive association to the list of traditional laws of association.

Like the British empiricists, the French sensationalists believed that all ideas are derived from experience and denied the existence of the type of autonomous mind proposed by Descartes. The sensationalists were either materialists (like Hobbes) denying the existence of mental events, or they were mechanists believing that all mental events could be explained in terms of simple sensations and the laws of association, Gassendi believed that Descartes's division of a person into a material body and a nonmaterial mind was silly. All so-called mental events, he said, result from the brain, not the mind. Like Hobbes, Gassendi concluded that all that exists is matter, and this includes all aspects of humans. In his book Man a Machine, La Mettrie proposed that humans and nonhuman animals differ only in degree of complexity and that both could be understood as machines. If we viewed ourselves as part of nature, said La Mettrie, we would be less inclined to abuse the environment, nonhuman animals, and our fellow

humans. Condillac, using the example of a sentient statue with only the sense of smell, the ability to remember, and the ability to feel pleasure and pain, proposed to show that all human cognitive and emotional experience could be explained; thus, there was no need to postulate an autonomous mind. Helvétius applied empiricism and sensationalism to the realm of education, saying that by controlling experience, you control the content of the mind.

With the widespread success of science, some people believed that science could solve all problems and answer all questions. Such a belief was called scientism, and it was very much like a religious belief. Accepting scientism, Comte created a position called positivism, according to which only scientific information could be considered valid. Anything not publicly observable was suspect and was rejected as a

proper object of study. Comte suggested that cultures progressed through three stages in their attempt to explain phenomena: the theological, the metaphysical, and the scientific. Comte did not believe psychology could become a science because studying the mind required using the unreliable method of introspection. People, he said, could be objectively studied by observing their overt behavior or through phrenological analysis. Years following Comte, Mach proposed another type of positivism based on the phenomenological experiences of scientists. For Mach, the job of the scientist was to precisely describe the relationships among cognitive events. Mach's brand of positivism allowed (even depended on) introspective analysis; Comte's did not. Like Comte, Mach wanted to rid science of metaphysical speculation.

DISCUSSION QUESTIONS

- 1. Define *empiricism*. What was it in other philosophies that the empiricists opposed most?
- 2. Discuss why Hobbes can accurately be referred to as an empiricist, a mechanist, and a materialist.
- 3. What functions did Hobbes see government as having?
- 4. What was Hobbes's explanation of human motivation?
- 5. Explain why it is incorrect to say that Locke postulated a passive mind. List a few powers of the mind that Locke postulated.
- 6. According to Locke, what was the difference between primary and secondary qualities? How did the paradox of the basins demonstrate this difference?
- 7. How did Locke use the laws of association in his philosophy?
- 8. Explain Berkeley's statement "To be is to be perceived." Did Berkeley deny the existence of external reality? Explain.
- 9. Summarize Berkeley's explanation of distance perception.

- 10. Discuss the function of the faculty of imagination in Hume's philosophy.
- Discuss the associative principles of contiguity, resemblance, and cause and effect as Hume used them.
- 12. Summarize Hume's analysis of causation.
- 13. How did Hume define mind? Self?
- 14. What, for Hume, were the ultimate determinants of behavior? Explain.
- 15. Did Hume believe in a physical world beyond subjective reality? If so, what did he say we could know about that world?
- 16. What was Hartley's philosophical goal?
- 17. Summarize Hartley's explanation of association.
- 18. How, according to Hartley, was involuntary behavior transformed into voluntary behavior?
- 19. What part did the emotions play in Hartley's philosophy?
- 20. Summarize James Mill's version of associationism. Why is it believed that Mill's treatment of associationism exposed its absurdity?

- 21. Compare the "mental physics" of James Mill with the "mental chemistry" of his son John Stuart Mill.
- 22. Why did J. S. Mill believe a science of human nature was possible? What would characterize such a science in its early stages of development? In its later stages? Include in your answer a discussion of primary and secondary laws.
- 23. Discuss J. S. Mill's proposed science of ethology. Why did efforts to develop such a science fail?
- 24. What was Bain's philosophical goal?
- 25. Summarize Bain's contributions to psychology. Include in your answer the new laws of association that he added and his explanation of how spontaneous activity is transformed into voluntary behavior.
- 26. What were the major features of French sensationalism?
- 27. In what ways was Gassendi's philosophy similar to Hobbes's?
- 28. Why did La Mettrie believe that it was inappropriate to separate the mind and body?

- 29. What did La Mettrie believe humans and nonhuman animals have in common?
- 30. Why did La Mettrie believe accepting a materialistic philosophy would result in a better, more humane world?
- 31. How did Condillac use the analogy of a sentient statue to explain the origin of human mental processes? Give the examples of how attention, feeling, comparison, and surprise develop.
- 32. How did Helvétius apply empiricism and sensationalism to education?
- 33. What did Comte mean by positivism?
- 34. Describe the stages that Comte believed cultures (and individuals) went through in the way they attempted to explain phenomena.
- 35. Did Comte believe psychology could be a science? Why or why not?
- 36. What, according to Comte, are two valid ways of studying humans?
- 37. Compare Mach's version of positivism with Comte's.

SUGGESTIONS FOR FURTHER READING

- Armstrong, D. M. (Ed.). (1965). Berkeley's philosophical writings. New York: Macmillan.
- Berman, J. (1999). Berkeley. New York: Routledge.
- Bricke, J. (1974). Hume's associationist psychology. *Journal of the History of the Behavioral Sciences*, 10, 397–409.
- Condillac, E. B. de (2001). Essay on the origin of human knowledge (H. Aarsleff, Ed. & Trans.). New York: Cambridge University Press. (Original work published 1746)
- Dancy, J. (1987). Berkeley: An introduction. New York: Basil Blackwell.
- Flew, A. (Ed.). (1962). David Hume: On human nature and the understanding. New York: Macmillan.
- Gaskin, J. C. A. (1998). *David Hume: Principal writings on religion*. New York: Oxford University Press.

- Grayling, A. C. (1986). *Berkeley: The central arguments*. LaSalle, IL: Open Court.
- Greenway, A. P. (1973). The incorporation of action into associationism: The psychology of Alexander Bain. *Journal of the History of the Behavioral Sciences*, 9, 42–52.
- Herbert, G. B. (1989). Thomas Hobbes: The unity of scientific and moral wisdom. Vancouver: University of British Columbia Press.
- Hobbes, T. (1962). *Leviathan*. New York: Macmillan. (Original work published 1651)
- La Mettrie, J. O. de. (1912). L'Homme machine (Man a Machine). (M. W. Calkins, Trans.). La Salle, IL:
 Open Court. (Original work published 1748)
- Locke, J. (1974). An essay concerning human understanding. A. D. Woozley (Ed.). New York: New American Library. (Original work published 1706)

- Mill, J. S. (1986). The subjection of women. Buffalo, NY: Prometheus Books. (Original work published 1861)
- Mill, J. S. (1988). *The logic of the moral sciences*. La Salle, IL: Open Court. (Original work published 1843)
- Miller, E. F. (1971). Hume's contribution to behavioral science. *Journal of the History of the Behavioral Sciences*, 7, 154–168.
- Pappas, G. S. (2000). Berkeley's thought. Ithaca, NY: Cornell University Press.
- Popkin, R. H. (Ed.). (1980). *David Hume: Dialogues con*cerning natural religion. Indianapolis: Hackett Publishing Company. (Original work published 1779)

- Rogers, G. A. J., & Ryan, A. (Eds.). (1990). Perspectives on Thomas Hobbes. New York: Oxford University Press.
- Steinberg, E. (Ed.). (1977). David Hume: An enquiry concerning human understanding. Indianapolis: Hackett Publishing Company. (Original work published 1777)
- Tuck, R. (2000). *Hobbes: A very short introduction*. New York: Oxford University Press.
- Wilson, F. (1990). Psychological analysis and the philosophy of John Stuart Mill. Toronto: University of Toronto Press.

GLOSSARY

Associationism The belief that the laws of association provide the fundamental principles by which all mental phenomena can be explained.

Bain, Alexander (1818–1903) The first to attempt to relate known physiological facts to psychological phenomena. He also wrote the first psychology texts, and he founded psychology's first journal (1876). Bain explained voluntary behavior in much the same way that modern learning theorists later explained trial-and-error behavior. Finally, Bain added the law of compound association and the law of constructive association to the older, traditional laws of association.

Bentham, Jeremy (1748–1832) Said that the seeking of pleasure and the avoidance of pain governed most human behavior. Bentham also said that the best society was one that did the greatest good for the greatest number of people.

Berkeley, George (1685–1753) Said that the only thing we experience directly is our own perceptions, or secondary qualities. Berkeley offered an empirical explanation of the perception of distance, saying that we learn to associate the sensations caused by the convergence and divergence of the eyes with different distances. Berkeley denied materialism, saying instead that reality exists because God perceives it. We can trust our senses to reflect God's perceptions because God would not create a sensory system that would deceive us.

Complex ideas Configurations of simple ideas.

Comte, Auguste (1798–1857) The founder of positivism and coiner of the term *sociology*. He felt that cul-

tures passed through three stages in the way they explained phenomena: the theological, the metaphysical, and the scientific.

Condillac, Étienne Bonnot de (1714–1780) Maintained that all human mental attributes could be explained using only the concept of sensation and that it was therefore unnecessary to postulate an autonomous mind.

Empiricism The belief that all knowledge is derived from experience, especially sensory experience.

Ethology J. S. Mill's proposed study of how specific individuals act under specific circumstances. In other words, it is the study of how the primary laws governing human behavior interact with secondary laws to produce an individual's behavior in a situation.

Gassendi, Pierre (1592–1655) Saw humans as nothing but complex, physical machines, and he saw no need to assume a nonphysical mind. Gassendi had much in common with Hobbes.

Hartley, David (1705–1757) Combined empiricism and associationism with rudimentary physiological notions.

Helvétius, Claude-Adrien (1715–1771) Elaborated the implications of empiricism and sensationalism for education. That is, a person's intellectual development can be determined by controlling his or her experiences.

Hobbes, Thomas (1588–1679) Believed that the primary motive in human behavior is the seeking of pleasure and the avoidance of pain. For Hobbes, the function of government is to satisfy as many human needs as

possible and to prevent humans from fighting with each other. Hobbes believed that all human activity, including mental activity, could be reduced to atoms in motion; therefore, he was a materialist.

Hume, David (1711–1776) Agreed with Berkeley that we could experience only our own subjective reality but disagreed with Berkeley's contention that we could assume that our perceptions accurately reflect the physical world because God would not deceive us. For Hume, we can be sure of nothing. Even the notion of cause and effect, which is so important to Newtonian physics, is nothing more than a habit of thought. Hume distinguished between impressions, which are vivid, and ideas, which are faint copies of impressions.

Idea A mental event that lingers after impressions or sensations have ceased.

Imagination According to Hume, the power of the mind to arrange and rearrange ideas into countless configurations.

Impressions According to Hume, the relatively strong mental experiences caused by sensory stimulation. For Hume, impression is essentially the same thing as what others called sensation.

La Mettrie, Julien de (1709–1751) Believed humans were machines that differed from other animals only in complexity. La Mettrie believed that so-called mental experiences are nothing but movements of particles in the brain. He also believed that accepting materialism would result in a better, more humane world.

Law of cause and effect According to Hume, if in our experience one event always precedes the occurrence of another event, we tend to believe that the former event is the cause of the latter.

Law of compound association According to Bain, contiguous or similar events form compound ideas and are remembered together. If one or a few elements of the compound idea are experienced, they may elicit the memory of the entire compound.

Law of constructive association According to Bain, the mind can rearrange the memories of various experiences so that the creative associations formed are different from the experiences that gave rise to the associations.

Law of contiguity The tendency for events that are experienced together to be remembered together.

Law of resemblance According to Hume, the tendency for our thoughts to run from one event to similar

eventsthe same as what others call the law, or principle, of similarity.

Locke, John (1632–1704) An empiricist who denied the existence of innate ideas but who assumed many nativistically determined powers of the mind. Locke distinguished between primary qualities, which cause sensations that correspond to actual attributes of physical bodies, and secondary qualities, which cause sensations that have no counterparts in the physical world. The types of ideas postulated by Locke included those caused by sensory stimulation, those caused by reflection, simple ideas, and complex ideas, which were composites of simple ideas.

Mach, Ernst (1838–1916) Proposed a brand of positivism based on the phenomenological experiences of scientists. Because scientists, or anyone else, never experience the physical world directly, the scientist's job is to precisely describe the relationships among mental phenomena, and to do so without the aid of metaphysical speculation.

Mental chemistry The process by which individual sensations can combine to form a new sensation that is different from any of the individual sensations that constitute it.

Mill, James (1773–1836) Maintained that all mental events consisted of sensations and ideas (copies of sensations) held together by association. No matter how complex an idea was, Mill felt that it could be reduced to simple ideas.

Mill, John Stuart (1806–1873) Disagreed with his father James that all complex ideas could be reduced to simple ideas. J. S. Mill proposed a process of mental chemistry according to which complex ideas could be distinctly different from the simple ideas (elements) that constituted them. J. S. Mill believed strongly that a science of human nature could be and should be developed.

Paradox of the basins Locke's observation that warm water will feel either hot or cold depending on whether a hand is first placed in hot water or cold water. Because water cannot be hot and cold at the same time, temperature must be a secondary, not a primary, quality.

Positivism The contention that science should study only that which can be directly experienced. For Comte, that was publicly observed events or overt behavior. For Mach, it was the sensations of the scientist.

Primary laws According to J. S. Mill, the general laws that determine the overall behavior of events within a system.

Quality According to Locke, that aspect of a physical object that has the power to produce an idea. (*See also* **Primary qualities** and **Secondary qualities**.)

Reflection According to Locke, the ability to use the powers of the mind to creatively rearrange ideas derived from sensory experience.

Scientism The almost religious belief that science can answer all questions and solve all problems.

Secondary laws According to J. S. Mill, the laws that interact with primary laws and determine the nature of individual events under specific circumstances.

Sensation The rudimentary mental experience that results from the stimulation of one or more sense receptors.

Simple ideas The mental remnants of sensations.

Sociology For Comte, a study of the types of explanations various societies accepted for natural phenomena. He believed that, as societies progress, they go from

theological explanations, to metaphysical, to positivistic. By *sociology*, Comte also meant the study of the overt behavior of humans, especially social behavior.

Spontaneous activity According to Bain, behavior that is simply emitted by an organism rather than being elicited by external stimulation.

Utilitarianism The belief that the best society or government is one that provides the greatest good (happiness) for the greatest number of individuals. Jeremy Bentham, James Mill, and John Stuart Mill were all utilitarians.

Vibratiuncles According to Hartley, the vibrations that linger in the brain after the initial vibrations caused by external stimulation cease.

Voluntary behavior According to Bain, under some circumstances, an organism's spontaneous activity leads to pleasurable consequences. After several such occurrences, the organism will come to voluntarily engage in the behavior that was originally spontaneous.

Rationalism

n Chapter 5 *empiricism* was defined as the belief that experience is the basis of all knowledge. All the empiricists and sensationalists assumed the importance of sensory information, though most used introspection to analyze what happened to that information after it arrived in the mind. Clearly, the term *empiricism* is not to be contrasted with *mentalism*. With the exception of Hobbes, Gassendi, and La Mettrie, all the empiricists and sensationalists postulated a mind in which such events as association, reflection, imagination, memory, and generalization took place. What distinguished the empiricists from the rationalists, then, was not whether they postulated a mind but the *type* of mind they postulated.

The empiricists tended to describe a **passive mind**, that is, a mind that acts on sensations and ideas in an automatic, mechanical way. The rationalist tended to postulate a much more active mind, a mind that acts on information from the senses and gives it meaning that it otherwise would not have. For the rationalist, the mind added something to sensory data rather than simply passively organizing and storing it in memory. Typically, the rationalist assumed innate mental structures, principles, operations, or abilities that are used in analyzing the content of thought. Furthermore, the rationalist tended to believe that there are truths about ourselves and about the world that cannot be ascertained simply by experiencing the content of our minds; such truths must be arrived at by such processes as logical deduction, analysis, argument, and intuition. In other words, the rationalist tended to believe in the existence of truths that could not be discovered through sensory data alone. Instead, the information provided by the senses must be digested by a rational system before such truths could be discovered. For the rationalist, it was important not only to understand the contents of the mind, part of which may indeed come from experience, but also to know

how the mechanisms, abilities, or faculties of the mind process that content to arrive at higher philosophical truths.

For the empiricist, experience, memory, association, and hedonism determine not only how a person thinks and acts but also his or her morality. For the rationalist, however, there are rational reasons that some acts or thoughts are more desirable than others. For example, there are moral principles, and if they are properly understood and acted on, they result in moral behavior. The empiricist tends to emphasize mechanistic causes of behavior, whereas the rationalist tends to emphasize reasons for behavior. Although the debate between the causes of, versus the reasons for, actions can be complex, perhaps a simplistic example would help clarify the rationalist's position. If a driver is stopped and asked why she was driving within the posted speed limit, she might say, "I didn't want to get a speeding ticket" or "I always obey the law." Can we say that the speed limit caused the driver to drive at a certain speed? No, in the sense that she was compelled to do so by the laws of nature. Yes, in the sense that he or she pondered the consequences of not doing so and decided to avoid them. Those emphasizing reasons for behavior over causes usually embrace the concept of free will. That is, they say causes of behavior act mechanically and automatically but reasons are freely chosen. However, as we saw in Chapter 1, it is possible to postulate reasons for behavior and thus personal responsibility and still reject the notion of free will. Shortly we will see that Spinoza was a rationalist who denied free will.

Whereas the empiricist stresses *induction* (the acquisition of knowledge through sensory experience and the generalizations from it), the rationalist stresses *deduction*. Given certain sensory data and certain rules of thought, certain conclusions must

follow. It should be no surprise that mathematics (especially geometry) and logic (a type of linguistic geometry) have almost always been more important to the rationalists than to the empiricists.

Do not be left with the impression that a clear distinction always exists between empiricism and rationalism; it does not. Some empiricists postulated a mind that was anything but passive (as did Locke), and most, if not all, rationalists accepted the importance of sensory information in the quest for knowledge and truth. In most cases, the difference between an empiricist and a rationalist was a matter of emphasis. The empiricist (and the sensationalist) emphasized the importance of sensory information and postulated a relatively passive mind that tended to function according to mechanistic laws. The rationalist emphasized the importance of innate structures, principles, or concepts and postulated an active mind that transforms, in important ways, the data provided by the senses.

Even the difference between empiricism and rationalism concerning nativism is relative. Clearly, the empiricists and the sensationalists were united in their opposition to the notion of innate ideas; many rationalists had no such opposition. Conversely, many empiricists and sensationalists relied heavily on innate emotions (such as pleasure and pain) and mental abilities (such as reflection, imagination, association, and memory). Again, empirical and nativistic components exist in most philosophical positions, and what distinguishes one position from another is a matter of emphasis.

Just as Bacon is usually looked on as the founder of modern empiricism, Descartes is usually considered the founder of modern rationalism. Both Bacon and Descartes had the same motive: to overcome the philosophical mistakes and biases of the past (mainly those of Aristotle and his Scholastic interpreters and sympathizers). Both the

empiricists and rationalists sought objective truth that withstood the criticism of the Skeptics; they simply went about their search differently.

In the remainder of this chapter, we sample the work of several of the rationalists who helped shape modern psychology.

BARUCH SPINOZA

Baruch (sometimes Benedict) Spinoza (1632-1677) was born of Portuguese Jewish parents on November 24 in the Christian city of Amsterdam. When Spinoza was growing up, Holland was a center of intellectual freedom and attracted such individuals as Descartes and Locke, who had experienced persecution elsewhere in Europe. Spinoza was initially impressed by Descartes's philosophy, and one of Spinoza's first books was an account of Cartesian philosophy. Eventually, however, Spinoza rejected Descartes's contention that God, matter, and mind were all separate entities. Instead, Spinoza proposed that all three were simply aspects of the same substance. In other words, for Spinoza, God, nature, and the mind were inseparable. His proposal ran contrary to the anthropomorphic God image of both the Jewish and Christian religions, and he was condemned by both. When he was 27 years old, the rabbis accused Spinoza of heresy and urged him in vain to repent. On July 27, 1656, he was excommunicated and the following edict was issued:

We ordain that no one may communicate with him verbally or in writing, nor show him any favour, nor stay under the same roof with him, nor be within four cubits of him, nor read anything composed or written by him. (Scruton, 2002, p. 10)

The civil authorities, acting on the advice of the rabbis and the Calvinist clergy, banished Spinoza from Amsterdam. After a short time, however, he returned to the city and supported himself by giving private lessons in Cartesian philosophy and grinding and polishing lenses. He consistently refused to accept gifts and money offered to him by his admirers, one of whom was the great philosopher Leibniz (discussed later). He even rejected the chair of philosophy at the University of Heidelberg because accepting the position would preclude his criticism of Christianity (Alexander and Selesnick, 1966).

Spinoza carried on extensive correspondence with many major thinkers of his day, but only one of his books was published during his lifetime (and that book was published anonymously). His major work, Ethics: Demonstrated in Geometrical Order, was published posthumously in 1677. A number of his other works were collected by his friends and were published shortly after his death. Spinoza contracted a lung disease, perhaps from his lens-grinding activities, and died on February 21 at the age of 44. As the full title of Spinoza's Ethics implies, he was deeply impressed with the deductive method of geometry. In his faith that the methods of geometry could be used to discover truth in nonmathematical areas, Spinoza agreed with Descartes and Hobbes. In his Ethics, Spinoza presented a number of "self-evident" axioms from which he proposed to deduce other truths about the nature of reality. His ultimate goal was to discover a way of life that was both ethically correct and personally satisfying.

Nature of God

As we have seen, Descartes was severely criticized for conceptualizing God as a power that set the world in motion and then was no longer involved with it (deism). Those who followed Descartes thus could study the world without theological considerations, and this is essentially what Newton did. For Spinoza, God not only started the world in motion but also was continually present everywhere in nature. To understand the laws of nature was to understand God. For Spinoza, God was nature. It follows that he embraced **pantheism**, or the belief that God is present everywhere and in everything. With his pantheism, Spinoza embraced a form of primitive animism, discussed in Chapter 2. By

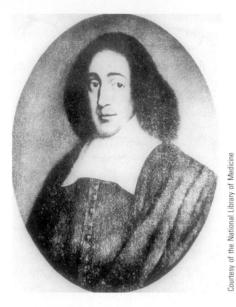

Baruch Spinoza

equating God and nature, Spinoza eliminated the distinction between the sacred and the secular. He denied demons, revelation, and an anthropomorphic God. Such beliefs caused his works to be condemned by essentially all religious leaders even in his liberal homeland of Holland. Later in history, however, when his works were more fully digested, Spinoza was referred to as a "God-intoxicated man" (Delahunty, 1985, p. 125).

Mind-Body Relationship

Dualists, like Descartes, who maintained that there was a material body and a nonmaterial mind, were obliged to explain how the two were related. Conversely, materialists were obliged to explain the origin of those things that we experience as mental events (ideas). Spinoza escaped the difficulties experienced by both dualists and materialists by assuming that the mind and body were two aspects of the same thing—the living human being. For Spinoza, the mind and the body were like two sides of a coin. Even though the two sides are different, they are two aspects of the same coin. Thus, the mind and body are inseparable; anything happening to the body is experienced as emotions and

thoughts; and emotions and thoughts influence the body. In this way, Spinoza combined physiology and psychology into one unified system. Spinoza's position on the mind-body relationship has been called psychophysical double aspectism, double-aspect monism, or simply **double aspectism** (see Chapter 1, Figure 1.1).

Spinoza's position on the mind-body relationship followed necessarily from his concept of God. God's own nature is characterized by both extension (matter) and thought (which is nonextended), and because God is nature, all of nature is characterized by both extension and thought. Because God is a thinking, material substance, everything in nature is a thinking, material substance. Humans, according to Spinoza, being part of nature, are thinking, material substances. Mental activity was not confined to humans nor even to the organic world. Everything, organic and inorganic, shared in the one substance that is God, and therefore everything had both mental and physical attributes. For Spinoza, the unity of the mind and body was but one manifestation of an all-encompassing unity of matter and thought. Spinoza's pantheism necessitated a panpsychism; that is, because God is everywhere, so is mind.

Denial of Free Will

God is nature, and nature is lawful. Humans are part of nature, and therefore human thoughts and behavior are lawful; that is, they are determined. Although humans may believe that they are free to act and think any way they choose, in reality they cannot. According to Spinoza, free will is a fiction:

In the mind there is no absolute or free will; but the mind is determined to wish this or that by a cause, which has also been determined by another cause, and this last by another cause, and so on to infinity. (Elwes, 1955, p. 119)

Elsewhere, Spinoza said that it is human ignorance of the causes of events that makes us believe that we possess free will: "Men think themselves

free inasmuch as they are conscious of their volitions and desires, and never even dream, in their ignorance, of the causes which have disposed them so to wish and desire" (Elwes, 1955, p. 75).

Our "freedom," then, consists in knowing that everything that is must necessarily be and everything that happens must necessarily happen. Nothing can be different because everything results from God. To understand the necessity of nature results in the highest pleasure because one views oneself as part of the eternal. According to Spinoza, it makes no sense to view God as the cause of all things and, at the same time, to believe that humans possess a free will.

Although Spinoza's God did not judge humans, Spinoza still considered it essential that we understand God. That is, Spinoza insisted that the best life was one lived with a knowledge of the causes of things. The closest we can get to freedom is understanding what causes our behavior and thoughts: "The free man is one conscious of the necessities that compel him" (Scruton, 2002, p. 91). The murderer is no more responsible for his or her behavior than is a river that floods a village. If the causes of both were understood, however, the aversive events could be controlled or prevented.

Self-Preservation as the Master Motive

Spinoza was a hedonist because he claimed that what are commonly referred to as good and evil are "nothing else but the emotions of pleasure and pain" (Elwes, 1955, p. 195). By pleasure, however, Spinoza meant "the entertaining of clear ideas." A clear idea is one that is conducive to the mind's survival because it reflects an understanding of causal necessity. That is, it reflects a knowledge of why things are as they are. When the mind entertains unclear ideas or is overwhelmed by passion, it feels weak and vulnerable and experiences pain. The highest pleasure, then, comes from understanding God, because to do so is to understand the laws of nature. If the mind dwells only on momentary perceptions or passions, it is being passive

and not acting in a way conducive to survival; such a mind experiences pain. The mind realizes that most sense perceptions produce ideas that are unclear and therefore inadequate because they lack the clarity, distinctiveness, and self-evident character of true (clear) ideas. Because unclear ideas do not bring pleasure, the mind seeks to replace them with clear, adequate ideas through the process of reasoned reflection. In other words, clear ideas must be sought by an active mind; they do not appear automatically. We know intuitively that the body must be maintained because of its inseparable connection to the mind. Thus, the body, just like the mind, will attempt to avoid things harmful to itself and will seek those things that it needs to survive

According to Spinoza then, the good life consists of

that which is most "useful"—favourable—to our nature; the bad life that which is most opposed to it. Vice and wickedness are to be avoided, not because they are punished by God (who engages in no such absurd endeavors) but because they are at variance with our nature and lead us to despair. (Scruton, 2002, p. 78)

Emotions and Passions

Many believe that Spinoza's discussion of the emotions was his most significant contribution to psychology. Starting with a few basic emotions such as pleasure and pain, Spinoza showed how as many as 48 additional emotions could be derived from the interactions between these basic emotions and various situations encountered in life. We will examine a few examples of how emotions are derived from everyday situations momentarily, but first we discuss Spinoza's important distinction between *emotion* and *passion*.

Spinoza thought that the experience of passion is one that reduces the probability of survival. Unlike an emotion, which is linked to a specific thought, passion is not associated with any particular thought. A child's love for its mother is an emotion,

whereas a general emotional upheaval exemplifies passion because it is not directed at anything specific. Because passion can cause nonadaptive behavior, it must be harnessed by reason. Behavior and thoughts guided by reason are conducive to survival, but behavior and thoughts guided by passion are not. By understanding the causes of passion, reason gives one the power to control passion, just as knowing why rivers flood villages allows the control of floods. Spinoza's insistence that we can improve ourselves by clarifying our ideas through an analysis of them and by rationally controlling our passions comes very close to Freudian psychoanalysis. In fact, if we replace the term passion with unconscious determinants of behavior, we see how similar Spinoza's position is to Freud's. Alexander and Selesnick (1966, p. 96) actually refer to Spinoza as the greatest of the pre-Freudian psychologists.

A few examples show how the basic emotions interact with one another and how they can be transferred from one object or person to another. Spinoza (Elwes, 1955) said that if something is first loved and then hated, it will end up being hated more than if it were not loved in the first place. If objects cause us pleasure or pain, we will not only love and hate those objects, respectively, but will also love and hate objects that resemble them. Pondering ideas of events that have caused both pleasure and pain arouses the conflicting emotions of love and hate. Images of pleasurable or painful events remembered from the past or projected into the future cause as much pleasure or pain as those events would in the present. If anything produces pleasurable feelings in an object of our love, we will tend to love that thing, or conversely, if something causes pain in something we love, we will tend to hate that thing. If someone creates pleasure in something we hate, we will hate him or her, or conversely, if someone causes pain in something we hate, we will tend to love him or her.

Spinoza (Elwes, 1955) discussed the following emotions and showed that all involve the basic emotions of pleasure or pain: wonder, contempt, love, hatred, devotion, hope, fear, confidence, despair, joy, disappointment, pity, indignation, jealousy, envy, sympathy, humility, repentance, pride,

honor, shame, regret, gratitude, revenge, cowardice, ambition, and lust. No one prior to Spinoza had treated human emotions in so much detail.

Spinoza's Influence

Descartes's philosophy is usually cited as the beginning of modern psychology, yet with the possible exception of what Descartes said about reflexive behavior, most of his ideas have not been amenable to scientific analysis—for example, his mind-body dualism, his beliefs concerning animal spirits and the pineal gland, his beliefs in free will and innate ideas, and the teleological and theological bases of much of his theorizing. Bernard (1972) believes that Spinoza should be given more credit than Descartes for influencing the development of modern psychology: "Considering just the broad general scientific principles that are at the basis of modern scientific psychology, we find them paramount in Spinozistic but lacking in Cartesian thought" (p. 208). Bernard offers Spinoza's belief in psychic determinism as a principle that stimulated a scientific analysis of the mind:

One of these important principles [from Spinoza's philosophy] is that of *psychic determinism*, the assumption of which clearly leads to the scientific attitude that the processes of the mind, too, are subject to natural laws, and that these laws can be consequently investigated and studied. Thus Spinoza, combating the teleological notion that nature acts "with an end in view," goes on to speak of a strict determinism ruling all psychological processes. (p. 208)

Bernard concludes his review of Spinoza's contributions to modern psychology by saying that they were substantial and far greater than Descartes's. R. I. Watson (1978) also referred to Spinoza's pioneering efforts:

Spinoza was perhaps the first modern thinker to view the world, including man, from a strictly deterministic standpoint. Both mind and body are of equal status, and both are subject to natural law. Spinoza saw clearly that his deterministic view of man required that there be laws of nature which are applicable to man. (p. 167)

We have already noted the similarity between Spinoza's philosophy and psychoanalytic thinking. Both stress that unclear thoughts should be made clear and that the passions should be controlled by the rational mind. We will see in Chapters 8 and 9 that Spinoza's philosophy had a strong influence on two individuals who were instrumental in launching psychology as an experimental science: Gustav Fechner and Wilhelm Wundt.

Before turning to other rational philosophers and psychologists, we first briefly review another position on the mind-body relationship that was espoused in Spinoza's time. We mention Malebranche's position mainly to show that almost every conceivable relationship between the mind and body has been proposed at one time or another.

NICOLAS DE MALEBRANCHE

mystically oriented priest, **Nicolas** Malebranche (1638-1715) accepted Descartes's separation of the mind and body but disagreed with his explanation of how the two interacted. For Malebranche, God mediated mind and body interactions. For example, when a person has a desire to move an arm, God is aware of this desire and moves the person's arm. Similarly, if the body is injured, God is aware of this injury and causes the person to experience pain. In reality, there is no contact between mind and body, but there appears to be because of God's intervention. A wish to do something becomes the occasion for God to cause the body to act, and for that reason this viewpoint became known as occasionalism. This view of the mind-body relationship can be referred to as a parallelism with divine intervention. Without divine intervention, the activities of the mind and body would be unrelated, and we would have psychophysical parallelism. (Malebranche's position on the

mind-body relationship is depicted in Figure 1.1.) Malebranche reverted to a much earlier explanation of the origins of knowledge, suggesting that ideas are not innate and that they do not come from experience. Instead, they come only from God, and we can know only what God reveals to our souls.

GOTTFRIED WILHELM VON LEIBNIZ

Like several of the rationalists, Gottfried Wilhelm von Leibniz (1646–1716), born on July 1 in Leipzig, Germany, was a great mathematician. In fact, he developed differential and integral calculus at about the same time that Newton did, although he did so independently of Newton. Leibniz lived during intellectually stimulating times. He was a contemporary of Hobbes, Spinoza, and Locke; Malebranche died a year before Leibniz, and Newton died just 11 years later. His father was a professor of moral philosophy at the University of Leipzig, which Leibniz entered at the age of 15. His early education included the Greek and Roman classics and the works of Bacon, Descartes, and Galileo. He earned a doctorate in law at the age of 20.

Disagreement with Locke

Although Descartes died when Leibniz was 4 years old, Descartes's philosophy still dominated Europe when Leibniz entered into his productive years. Leibniz's first work, however, was a criticism of Locke's *Essay* (1690). Although his rebuttal of Locke's philosophy, *New Essays on the Understanding*, was completed in 1704, it was not published until almost 50 years after Leibniz's death in 1765. The delay was caused by Locke's death in 1704; Leibniz saw little point in arguing with the deceased (Remnant and Bennett, 1982).

Focusing on Locke's description of the mind as a *tabula rasa* (blank tablet), Leibniz attributed to Locke the belief that there is nothing in the mind that is not first in the senses. Leibniz misread Locke

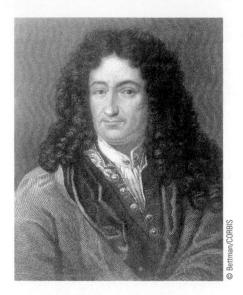

Gottfried Wilhelm von Leibniz

believing that if the ideas derived from experience were removed from the mind, nothing would remain. We saw in Chapter 5, however, that Locke actually postulated a mind well stocked with innate abilities. In any case, Leibniz endeavored to correct Locke's philosophy as he understood it. Leibniz said that there is nothing in the mind that is not first in the senses, except the mind itself. Instead of the passive mind that Leibniz believed Locke proposed, Leibniz postulated a highly active mind, but he then went even further. Leibniz completely rejected Locke's suggestion that all ideas come from experience, saying instead that no ideas come from experience. Leibniz believed that nothing material (such as the activation of a sense receptor) could ever cause an idea that is nonmaterial. Leibniz beckons us to imagine a machine capable of thinking (of having ideas). Then he asks us to imagine increasing the size of the machine to the point where we could enter it and look around. According to Leibniz, our exploration would yield only interacting, physical parts. Nothing we would see, whether examining the machine or a human being, could possibly explain the origin of an idea. Because ideas cannot be created by anything physical like a brain, they must be innate. What is innate, however, is

the *potential* to have an idea. Experience can cause a potential idea to be actualized, but it can never create an idea. Leibniz (1765/1982) made this point with his famous metaphor of the marble statue:

Reflection is nothing but attention to what is within us, and the senses do not give us what we carry with us already.... I have ... used the analogy of a veined block of marble, as opposed to an entirely homogeneous block of marble, or to a blank tablet—what the philosophers call a tabula rasa. For if the soul were like such a blank tablet then truths would be in us as the shape of Hercules is in a piece of marble when the marble is entirely neutral as to whether it assumes this shape or some other. However, if there were veins in the block which marked out the shape of Hercules rather than other shapes, then that block would be more determined to that shape and Hercules would be innate in it, in a way, even though labour would be required to expose the veins and to polish them into clarity, removing everything that prevents their being seen. This is how ideas and truths are innate in us-as inclinations, dispositions, tendencies, or natural potentialities. (pp. 45-46)

Monadology

Leibniz combined physics, biology, introspection, and theology into a worldview that was both strange and complex. One of Leibniz's goals was to reconcile the many new, dramatic scientific discoveries with a traditional belief in God. As we have seen, Spinoza attempted to do much the same thing by equating God and nature, thus eliminating any friction between religion and science. Leibniz's proposed solution to the problem was more complex.

With the aid of the newly invented microscope, Leibniz could see that life exists everywhere, even where the naked eye cannot see it. He believed that the division of things into living

or nonliving was absurd. Instead, he concluded that everything was living. The universe consisted of an infinite number of life units called monads. A monad (from the Greek monas, meaning "single") is like a living atom, and all monads are active and conscious. There is a hierarchy in nature, however, similar to the scala naturae Aristotle proposed. Although all monads are active and conscious, they vary in the clarity and distinctiveness of the thoughts they are capable of having. In other words, monads differ in intelligence. What is sometimes called inert matter is made up of monads incapable of all but extremely muddled thoughts. Then, on a scale of gradually increasing intelligence, come plants, microbes, insects, animals, humans, and God. Differences among all things in the universe, then, are quantitative, not qualitative. All monads seek to clarify their thoughts, insofar as they are capable, because clear thinking causes pleasure. Here is an important point of agreement between Aristotle and Leibniz, because Leibniz viewed a monad as a potential seeking to become actualized. In other words, each monad, and therefore all of nature, was characterized by a final cause or purpose.

Next to God, humans possess the monads capable of the clearest thinking. However, because humans consist of all types of monads ranging from those possessed by matter, plants, and animals, our thoughts are not always clear; and in most cases, they are not. As humans, however, we have the potential for clear thinking, second only to God's. It was Leibniz's claim, then, that organisms are aggregates of monads representing different levels of awareness (intelligence). However, again following Aristotle, he believed that each organism had a soul (mind) that dominated its system; it is this dominant monad that determines an organism's intellectual potential. It is the nature of humans' dominant monad (soul) that provides them with intellectual potential inferior only to God's. The fact that humans possess many monads of a lower nature, and that ideas provided by our dominant monad exist only as potentialities, explains why we experience ideas with varying degrees of clarity. Monads, according to Leibniz, can never be influenced by anything outside of themselves. Therefore, the only way that they can change (become clearer) is by internal development—that is, by actualizing their potential.

Mind-Body Relationship

As we have seen, Leibniz believed experience was necessary because it focused attention on the thoughts already in us and allowed us to organize our thoughts and act appropriately, but experience cannot cause ideas. The confrontation between sense organs and the physical world can in no way cause something purely mental (an idea). For this reason, Leibniz rejected Descartes's mind-body dualism. That is, he rejected Descartes's interactionism because it is impossible for something physical to cause something mental. Leibniz also rejected occasionalism because he thought that it was untenable to believe that the mind and body were coordinated through God's continuous intervention. of Descartes's interactionism place Malebranche's occasionalism, Leibniz proposed a psychophysical parallelism based on the notion of preestablished harmony. Leibniz believed that monads never influence each other; it only seems as if they do. Whenever we perceive in one monad what seems to be the cause of something, other monads are created in such a way as to display what appear to be the effects of that cause. The entire universe was created by God to be in perfect harmony, and yet nothing in the universe actually influences anything else. There is a correspondence between each monad's perceptual state and the conditions external to it, but those perceptions can be said only to "mirror" the external events rather than be caused by them. Similarly, the monads that make up the mind and those that make up the body are always in agreement because God planned it that way, but they are not causally related. Leibniz asks that we imagine two identical. perfect clocks that have been set to the same time at the same moment. Afterward, the clocks will always be in agreement but will not interact. According to Leibniz, all monads, including those

constituting the mind and the body, are like such clocks. (Figure 1.1 depicts Leibniz's preestablished-harmony form of psychophysical parallelism.)

Leibniz's monadology has been criticized for several reasons, and only a few of its essential features influenced later developments in philosophy and psychology. One criticism was that monadology suggested that because God created the world, it cannot be improved on. In Voltaire's *Candide*, Leibniz is portrayed as a foolish professor who continues to insist, even after observing tragedy after tragedy, that "this is the best of all possible worlds."

Conscious and Unconscious Perception

For Leibniz, the notion of "insensible perceptions" was as useful to psychology as the notion of insensible atoms was to physics. In both cases, what is actually experienced consciously is explained in terms of events beyond the realm of conscious experience. Leibniz (1765/1982) summarized this belief in his **law of continuity** (not to be confused with the law of contiguity):

Nothing takes place suddenly, and it is one of my great and best confirmed maxims that nature never makes leaps. I called this the Law of Continuity.... There is much work for this law to do in natural science. It implies that any change from small to large, or vice versa, passes through something which is, in respect of degrees as well as of parts, in between; and that no motion ever springs immediately from a state of rest, or passes into one except through a lesser motion; just as one could never traverse a certain line or distance without first traversing a shorter one. Despite which, until now those who have propounded the laws of motion have not complied with this law, since they have believed that a body can instantaneously receive a motion contrary to its preceding one. All of which supports the judgment that noticeable

perceptions arise by degrees from ones which are too minute to be noticed. To think otherwise is to be ignorant of the immeasurable fineness of things, which always and everywhere involves an actual infinity. (p. 49)

To demonstrate the fact that there are no leaps even in the realm of perception, Leibniz (1765/1982) used the example of perceiving the roar of the sea:

To give a clearer idea of these minute perceptions which we are unable to pick out from the crowd, I like to use the example of the roaring noise of the sea which impresses itself on us when we are standing on the shore. To hear this noise as we do, we must hear the parts which make up this whole. that is the noise of each wave, although each of these little noises makes itself known only when combined confusedly with all the others, and would not be noticed if the wave which made it were by itself. We must be affected slightly by the motion of this wave, and have some perception of each of these noises, however faint they may be; otherwise there would be no perception of a hundred thousand waves, since a hundred thousand nothings cannot make something. Moreover, we never sleep so soundly that we do not have some feeble and confused sensation; some perception of its start, which is small, just as the strongest force in the world would never break a rope unless the least force strained it and stretched it slightly, even though that little lengthening which is produced is imperceptible. (p. 47)

Leibniz called perceptions that occurred below the level of awareness **petites perceptions** (little perceptions). As petites perceptions accumulate, their combined force is eventually enough to cause awareness, or what Leibniz called **apperception**. Therefore, a continuum exists between unconscious and conscious perception. Leibniz was perhaps the first philosopher to clearly postulate an unconscious mind. Leibniz also introduced the concept of limen, or threshold, into psychology. We are aware of experiences above a certain aggregate of petites perceptions, but experiences below that aggregate (threshold) remain unconscious. Leibniz's concept of threshold was to become extremely important when psychology became a science in the late 1800s. We will see later in this chapter that Leibniz's philosophy had a strong influence on Johann Friedrich Herbart, who in turn influenced many others. The implications of Leibniz's notion of unconscious perception for the development of psychoanalysis is clear. With his notion of the hierarchy of consciousness, Leibniz encouraged the study of consciousness in animals, a study that was not possible within Descartes's philosophy. It was not until Darwin, however, that the study of animal consciousness and intelligence was pursued intensely.

Leibniz's philosophy has received mixed reviews from historians of psychology. On the negative side, we have Esper's (1964) assessment:

In Leibniz ... we have the classic example of what happens to "psychology" at the hands of a philosopher whose main interests and intellectual apparatus are theology, mathematics, and logic, and who uses the concepts of physical and biological science in the service of metaphysical speculation; we have in Leibniz a seventeenth-century Parmenides. (p. 224)

Continuing in a negative vein, Esper (1964) says, "It is, I think, obvious that Leibniz foisted upon psychology a vast tangle of linguistic blind alleys which occupied its attention and its books and journals down until the 1920s, and which still determine much of its nonexperimental, intuitive literature" (p. 228).

On the positive side, Brett (1912–1921/1965) said, "The work of Leibniz was so brilliant and so full of inspiration that it has often seemed to be the spontaneous birth of German philosophy" (p. 406). It was Leibniz's view of the human mind (soul) that dominated German rationalistic philosophy for many years. Brett (1912–1921/1965) described that view: "Leibniz emphasized the spontaneity of

the soul; for him the work of the mind was something more than a mere arranging, sorting, and associating of the given; it was essentially productive, creative, and freely active" (p. 407). Similarly, Fancher and Schmidt (2003) say, "Leibniz offered a strong argument that the human mind cannot be understood simply as a passive reflector of the things it experiences, but rather is itself an important contributor to its experience" (p. 16). Leibniz's disciple Christian von Wolff (1679–1754) was among the first to use the term psychology in a book title (Empirical Psychology, 1732; and Rational Psychology, 1734). It was also Wolff who was among the first modern philosophers to describe the mind in terms of faculties or powers. Wolff's faculty psychology had a significant influence on Immanuel Kant (discussed later in this chapter).

THOMAS REID

Thomas Reid (1710-1796) was born on April 26 in Strachan, a parish about 20 miles from Aberdeen. Scotland, where his father served as a minister for 50 years. His mother was a member of a prominent Scottish family, and one of his uncles was a professor of astronomy at Oxford and a close friend of Newton. Like Hume, Reid was a Scotsman; but unlike Hume, Reid represented rationalism instead of empiricism. Reid defended the existence of reasoning powers by saying that even those who claim that reasoning does not exist are using reasoning to doubt its existence. The mind reasons and the stomach digests food, and both do their jobs because they are innately disposed to do so. Reid thought that reason is necessary so that we can control our emotions, appetites, and passions and understand and perform our duty to God and other humans.

Hume argued that because all we could ever experience were sense impressions, everything that we could possibly know must be based on them alone. For Hume then, knowledge of such things as God, the self, causality, and even external reality was simply unattainable. Reid emphatically disagreed with Hume, saying that because we do have such

knowledge, Hume's argument must be faulty. Reid presented his arguments against Hume and the other empiricists in An Inquiry into the Human Mind on the Principles of Common Sense (1764), Essays on the Intellectual Powers of Man (1785), and Essays on the Active Powers of the Human Mind (1788). Reid put forth his commonsense philosophy mainly in the first of these and his faculty psychology mainly in the last two.

Common Sense

Reid argued that because all humans were convinced of the existence of physical reality, it must exist. Furthermore, in courts of law, eyewitness testimony is highly valued:

By the laws of all nations, in the most solemn judicial trials, wherein men's fortunes and lives are at stake, the sentence passes according to the testimony of eye or ear witnesses of good credit. An upright judge will give a fair hearing to every objection that can be made to the integrity of a witness, and allow it to be possible that he may be corrupted; but no judge will ever suppose that witnesses may be imposed upon by trusting to their eyes and ears. And if a sceptical counsel should plead against the testimony of the witnesses, that they had no other evidence for what they declared but the testimony of their eyes and ears, and that we ought not to put so much faith in our senses as to deprive men of life or fortune upon their testimony, surely no upright judge would admit a plea of this kind. I believe no counsel, however sceptical, ever dared to offer such an argument; and, if it was offered, it would be rejected with disdain.

Can any stronger proof be given that it is the universal judgment of mankind that the evidence of sense is a kind of evidence which we may securely rest upon in the most momentous concerns of mankind; that it is a kind of evidence against which we ought not to admit any reasoning; and,

therefore that to reason either for or against it is an insult to common sense?

The whole conduct of mankind in the daily occurrences of life, as well as the solemn procedure of judicatories in the trial of causes civil and criminal, demonstrates this.... It appears, therefore, that the clear and distinct testimony of our senses carries irresistible conviction along with it to every man in his right judgment. (Beanblossom and Lehrer, 1983, pp. 161–163)

If Hume's logic led him to conclude that we could never know the physical world, then something was wrong with Hume's logic, said Reid. We can trust our impressions of the physical world because it makes *common sense* to do so. We are naturally endowed with the abilities to deal with and make sense out of the world. According to Reid, "When a man suffers himself to be reasoned out of the principles of common sense, by metaphysical arguments, we may call this *metaphysical lunacy*" (Beanblossom and Lehrer, 1983, pp. 118–119).

Reid described what life would be like if we did not assume that our senses accurately reflect reality:

I resolve not to believe my senses. I break my nose against a post that comes in my way; I step into a dirty kennel; and after twenty such wise and rational actions I am taken up and clapped into a madhouse. (Beanblossom and Lehrer, 1983, p. 86)

People may say that they do not know if their sensations accurately reflect the physical world as Hume did, but everyone—including Hume—assumes that they do. To assume otherwise, according to Reid, is grounds for confinement.

Direct Realism

To Reid, our sensations not only accurately reflect reality but also do so immediately. The belief that the world is as we immediately experience it is called **direct realism** (sometimes also called nave realism; see Henle, 1986). Although, as we see next, Reid was clearly a rationalist, he did not believe

that the rational mind needed to be employed in experiencing the environment accurately; nor did he believe that the associationistic principles of the empiricists were employed. In other words, Reid did not believe that consciousness was formed by one sensation being added to another or to the memory of others. Rather, we experience objects immediately as objects because of our innate power of perception. We perceive the world *directly* in terms of meaningful units, not as isolated sensations that are then combined via associative principles. We will see this belief again in Kant's philosophy (discussed shortly) and later in Gestalt psychology (Chapter 14).

Reid (1785/1969) explained why he believed reasoning ability could not be a prerequisite for the accurate perception of the world:

The Supreme Being intended, that we should have such knowledge of the material objects that surround us, as is necessary in order to our supplying the wants of nature, and avoiding the dangers to which we are constantly exposed; and he has admirably fitted our powers of perception to this purpose. [If] the intelligence we have of external objects were to be got by reasoning only, the greatest part of men would be destitute of it; for the greatest part of men hardly ever learn to reason; and in infancy and childhood no man can reason. Therefore, as this intelligence of the objects that surround us, and from which we may receive so much benefit or harm, is equally necessary to children and to men, to the ignorant and to the learned, God in his wisdom conveys it to us in a way that puts all upon a level. The information of the senses is as perfect, and gives as full conviction to the most ignorant, as to the most learned. (p. 118)

Faculty Psychology

In elaborating the reasoning powers of the mind, Reid discussed several *faculties*; thus, he can be de-

scribed as a faculty psychologist. Faculty psychologists (or philosophers) are those who refer to various mental abilities or powers in their descriptions of the mind. Through the years, faculty psychology has often been misunderstood or misrepresented. Frequently, it has been alleged that faculty psychologists believed that a faculty of the mind was housed in a specific location in the brain. Except for the phrenologists (see Chapter 8), however, this was seldom the case. It was also alleged that faculties were postulated instead of explaining a complex mental phenomenon. People perceive, for example, because they have the faculty of perception. However, it was most often the case that faculty psychologists or philosophers neither believed that faculties corresponded to various parts of the brain nor used them to explain mental phenomena. Most often the term faculty was used to denote a mental ability of some type, and that was all:

The word "faculty" was in frequent use in 17th century discussions of the mind. Locke himself used it freely, being careful to point out that the word denoted simply a "power" or "ability" to perform a given sort of action (such as perceiving or remembering), that it did not denote an agent or substance, and that it had no explanatory value. To Locke and to all subsequent thinkers a "faculty" was simply a classificatory category, useful only in a taxonomic sense. (Albrecht, 1970, p. 36)

Although Albrecht's observation that faculty psychologists used the term *faculty* as only a classificatory category may be generally true, it was not true of Reid. For Reid, the mental faculties were active powers of the mind; they actually existed and influenced individuals' thoughts and behavior. For Reid, however, the mental faculties were aspects of a single, unifying mind, and they never functioned in isolation. That is, when a faculty functioned, it did so in conjunction with other faculties. For Reid, the emphasis was always on the unity of the mind:

The most fundamental entity in Reid's psychology is the mind. Although

introspection reveals many different types of thoughts and activities, Reid assumed—in common with most other faculty psychologists—the existence of a unifying principle. This principle he termed mind or soul; the mind might have a variety of powers, but these are only different aspects of the same substance. (Brooks, 1976, p. 68)

To summarize, we can say that Reid believed the faculties were aspects of the mind that actually existed and influenced human behavior and thought. All the faculties were thought to be innate and to function in cooperation with other faculties. After a careful review of Reid's works, Brooks (1976) concluded that Reid had referred to as many as 43 faculties of the mind, including abstraction, attention, consciousness, deliberation, generalization, imitation, judgment, memory, morality, perception, pity and compassion, and reason. In Chapter 8 we will discuss how faculty psychology influenced the development of the infamous field of phrenology.

IMMANUEL KANT

Immanuel Kant (1724–1804) was born on April 22 in Königsberg, Prussia. He was the fourth of nine children born to a poor harness maker and his wife, both of whom were devout Lutherans. Interestingly, Kant never traveled more than 40 miles from his birthplace in the 80 years of his life (Boring, 1950, p. 246). Wolman (1968a) nicely summarizes the type of life that Kant lived:

Several armchairs played an important role in the history of human thoughts, but hardly any one of them could compete with the one occupied by Immanuel Kant. For Kant led an uneventful life: no change, no travel, no reaching out for the unusual, not much interest outside his study-room and university classroom. Kant's life was a life of thought. His pen was his scepter, desk his kingdom, and armchair his throne.

Kant was more punctual and more precise than the town clocks of Königsberg. His habits were steadfast and unchangeable. Passersby in Königsberg regulated their watches whenever they saw Herr Professor Doktor Immanuel Kant on his daily stroll. Rain or shine, peace or war, revolution or counterrevolution had less affect on his life than a new book he read, and certainly counted less than a new idea that grew in his own mind. Kant's thoughts were to him the center of the universe. (p. 229)

Kant was educated at the University of Königsberg and taught there until he was 73, when he resigned because he was asked to stop including his views on religion in his lectures. He became so famous in his lifetime that philosophy students came from all over Europe to attend his lectures, and he had to keep changing restaurants to avoid admirers who wanted to watch him eat his lunch. When Kant died, on February 12, 1804, his funeral created gridlock in Königsberg. The city bells tolled and a procession of admirers, numbering in the thousands, wound its way to the university cathedral. Kant's famous books Critique of Pure Reason (1781/1990) and Critique of Practical Reason (1788/1996) set the tone of German rationalist philosophy and psychology for generations.

Kant started out as a disciple of Leibniz, but reading Hume's philosophy caused him to wake from his "dogmatic slumbers" and attempt to rescue philosophy from the skepticism that Hume had generated toward it. Hume had argued that all conclusions we reached about anything were based on subjective experience because that was the only thing we ever encountered directly. According to Hume, all statements about the nature of the physical world or about morality were derived from impressions, ideas, and the feelings that they aroused, as well as from the way they were organized by the laws of association. Even causation, which was so important to many philosophers and scientists, was reduced to a habit of the mind in Hume's philosophy. For example, even if B always follows A and the interval between the two is always the same, we can never conclude that A causes B because there is no way for us to verify an actual, causal relationship between the two events. For Hume, rational philosophy, physical science, and moral philosophy were all reduced to subjective psychology. Therefore, nothing could be known with certainty because all knowledge was based on the interpretation of subjective experience.

Categories of Thought

Kant set out to prove Hume wrong by demonstrating that some truths were certain and were not based on subjective experience alone. He focused on Hume's analysis of the concept of causation. Kant agreed with Hume that this concept corresponds to nothing in experience. In other words, nothing in our experience proves that one thing causes another. But, asked Kant, if the notion of causation does not come from experience, where does it come from? Kant argued that the very ingredients necessary for even thinking in terms of a causal relationship could not be derived from experience and therefore must exist a priori, or independent of experience. Kant did not deny the importance of sensory data, but he thought that the mind must add something to that data before knowledge could be attained; that something was provided by the a priori (innate) categories of thought. According to Kant, what we experience subjectively has been modified by the pure concepts of the mind and is therefore more meaningful than it would otherwise have been. Kant included the following in his list of a priori pure concepts, or categories of thought: unity, totality, time, space, cause and effect, reality, quantity, quality, negation, possibility-impossibility, and existence-nonexistence.

Without the influence of the categories, we could never make statements such as those beginning with the word *all* because we never experience all of anything. According to Kant, the fact that we are willing at some point to generalize from several particular experiences to an entire class of events merely specifies the conditions under which we employ the innate category of totality, because the word *all* can

never be based on experience. In this way, Kant showed that, although the empiricists had been correct in stressing the importance of experience, a further analysis of the very experience to which the empiricists referred revealed the operations of an active mind. For Kant, "a mind without concepts would have no capacity to think; equally, a mind armed with concepts, but with no sensory data to which they could be applied, would have nothing to think about" (Scruton, 2001, p. 35).

Because Kant postulated categories of thought, he can be classified as a faculty psychologist. He was a faculty psychologist in the way that Reid was, however. That is, he postulated a single, unified mind that possessed various attributes or abilities. The attributes always interacted and were not housed in any specific location in the mind and certainly not in the brain.

Causes of Mental Experience

Kant agreed with Hume that we never experience the physical world directly, and therefore we can never have certain knowledge of it. However, for Hume, our cognitions consist only of sense impressions, ideas, and combinations of these arranged by the laws of association or by the imagination. For Kant, there was much more. Kant believed our sensory impressions are always structured by the categories of thought, and our phenomenological experience is therefore the result of the interaction between sensations and the categories of thought. This interaction is inescapable. Even when physical scientists believe that they are describing the physical world, they are really describing the human mind. For Kant, the mind prescribed the laws of nature. Kant, in this sense, was even more revolutionary than Copernicus because, for Kant, the human mind became the center of the universe. In fact, our mind, according to Kant, creates the universe—at least as we experience it. Kant called the objects that constitute physical reality "things-in-themselves" or noumena, and it is noumena about which we are forever and necessarily ignorant. We can know only appearances (phenomena) that are regulated and modified by the categories of thought. Aware of the radical nature of his

Immanuel Kant

assertions, Kant himself said that they represented a "Copernican revolution" in philosophy (Scruton, 2001, p. 39).

Perception of Time. Even the concept of time is added to sensory information by the mind. On the sensory level, we experience a series of separate events, such as the image provided by a horse walking down the street. We see the horse at one point and then at another and then at another and so forth. Simply looking at the isolated sensations, there is no reason to conclude that one sensation occurred before or after another. Yet this is exactly what we do conclude; and because there is nothing in the sensations themselves to suggest the concept of time, the concept must exist a priori. Similarly, there is no reason—at least no reason based on experience—that an idea reflecting a childhood experience should be perceived as happening a long time ago. All notions of time such as "long ago," "just recently," "only yesterday," "a few moments ago," and so forth cannot come from experience; thus, they must be provided by the a priori category of time. All there is in memory are ideas that can vary only in intensity or vividness; it is the mind that superimposes over these experiences a sense of time. Thus, in a manner reminiscent of Augustine (see Chapter 3), Kant concluded that the experience of time could be understood only as a creation of the mind.

In fact, Kant indicated that Hume's description of causation as perceived correlation depended on the concept of time. That is, according to Hume, we develop the habit of expecting one event to follow another if they typically are correlated. However, without the notion of before and after (that is, of time), Hume's analysis would be meaningless. Thus, according to Kant, Hume's analysis of causation assumed at least one innate (a priori) category of thought.

Perception of Space. Kant also believed that our experience of space was provided by an innate category of thought. Kant agreed with Hume that we never experience the physical world directly, but he observed that it certainly seems that we do. For most, if not all, humans, the physical world appears to be laid out before us and to exist independently of us. In other words, we do not simply experience sensations as they exist on the retina or in the brain. We experience a display of sensations that seem to reflect the physical world. The sensations vary in size, distance, and intensity and seem to be distributed in space, not in our retinas or brains. Clearly, said Kant, such a projected spatial arrangement is not provided by sensory impressions alone. Sensations are all internal; that is, they exist in the mind alone. Why is it, then, that we experience objects as distributed in space as external to the mind and the body? Again, Kant's answer was that the experience of space, like that of time, was provided by an a priori category of thought. According to Kant, the innate categories of time and space are basic because they provide the context for all mental phenomena, including (as we have seen) causality.

It must be emphasized that Kant did not propose specific innate *ideas*, as Descartes had done. Rather, he proposed innate *categories* of thought that organized all sensory experience. Thus, both Descartes and Kant were nativists, but their brands of nativism differed significantly.

The Categorical Imperative

Kant also attempted to rescue moral philosophy from what the empiricists had reduced it to-utilitarianism. For Kant, it was not enough to say that certain experiences feel good and others do not; he asked what rule or principle was being applied to those feelings that made them desirable or undesirable. He called the rational principle that governs or should govern moral behavior the categorical imperative, according to which, "I should never act except in such a way that I can also will that my maxim should become a universal law" (Kant, 1785/1981, p. 14). Kant gave as an example the maxim "Lying under certain circumstances is justified." If such a maxim were elevated to a universal moral law, the result would be widespread distrust and social disorganization. On the other hand, if the maxim "Always tell the truth" were made a universal moral law, social trust and harmony would be facilitated. According to Kant, if everyone made their moral decisions according to the categorical imperative, the result would be a community of free and equal members. Of course, Kant realized that he was describing an ideal that could only be approximated. He also realized that he was not adding anything new to moral philosophy. His categorical imperative was similar to older moral precepts such as the golden rule ("Do unto others as you would have them do unto you"). Kant's intent was to clarify the moral principle embedded in such moral precepts as the golden rule (Scruton, 2001, p. 86).

Whereas the empiricists' analysis of moral behavior emphasized hedonism, Kant's was based on a rational principle and a belief in free will. For Kant, the idea of moral responsibility was meaningless unless rationality and free will were assumed. We have here a clear example of the distinction between the reasons for, and the causes of, behavior. For the empiricists, behavior (moral or otherwise) is caused by feelings of pleasure and pain (hedonism). For Kant, there is a reason for acting morally and, if that reason is freely chosen, moral behavior results.

Kant wrote an essay (1763/1994) purporting to rationally demonstrate God's existence. His argu-

ment diverged from a number of traditional arguments, such as the ontological argument (see Chapter 3) and, therefore, he was critical of both Descartes and Leibniz, who had both accepted a version of that argument. The details need not concern us here but, in general, Kant's argument for the necessity of God's existence was similar to Aristotle's argument for the necessity of an unmoved mover (see Chapter 2). Kant arrogantly claimed that all arguments except his were invalid. The essay received considerable acclaim, but the Catholic church was not impressed and placed the essay on its index of forbidden books (Treash, 1994, p. 9).

Kant's Influence

Kant's rationalism relied heavily on both sensory experience and innate faculties. Kant has had a considerable influence on psychology, and since Kant's time, a lively debate in psychology has ensued concerning the importance of innate factors in such areas as perception, language, cognitive development, and problem solving. The modern rationalistically oriented psychologists side with Kant by stressing the importance of genetically determined brain structures or operations. The empirically oriented psychologists insist that such psychological processes are best explained as resulting from sensory experience, learning, and the passive laws of association, thus following in the tradition of British empiricism and French sensationalism.

Although Kant's influence was clearly evident when psychology emerged as an independent science in the late 1800s, Kant did not believe that psychology could become an experimental science. First, Kant claimed the mind itself could never be objectively studied because it is not a physical thing. Second, the mind cannot be studied scientifically using introspection because it does not stand still and wait to be analyzed; it is constantly changing and therefore cannot be reliably studied. Also, the very process of introspection influences the state of the mind, thus limiting the value of what is found through introspection. Like most philosophers in the rationalistic tradition, Kant believed that to be

a science, a discipline's subject matter had to be capable of precise mathematical formulation, and this was not the case for psychology. It is ironic that when psychology did emerge as an independent science, it did so as an experimental science of the mind, and it used introspection as its primary research tool (see Chapter 9).

Kant defined psychology as the introspective analysis of the mind, and he believed that psychology so defined could not be a science. There was a way of studying humans, however, that, although not scientific, could yield useful information; that way was to study how people actually behave. Such a discipline, which Kant called anthropology, could even supply the information necessary to predict and control human behavior. Kant was very interested in his field of anthropology and lectured on it for years before publishing Anthropology from a Pragmatic Point of View (1798/ 1912). Anthropology is a most interesting and even amusing book. It includes among its many topics insanity, gender differences, suggestions for a good marriage, clear thinking, advice to authors, human intellectual faculties, personality types, human appetites, and the imagination.

Kant's most direct influences on contemporary psychology are seen in Gestalt psychology, which we will consider in Chapter 14, and in information-processing psychology, which we will consider in Chapter 20.

JOHANN FRIEDRICH HERBART

Johann Friedrich Herbart (1776–1841) was born on May 4 in Oldenburg, Germany. As a result of an accident during infancy, he was a frail child and did not attend school until he was 12; instead, he was tutored by his mother. He was a precocious child who developed an early interest in logic. At 12 years of age, he began attending the Oldenburg *Gymnasium* (high school) where, at age 16, Kant's philosophy impressed him deeply. At the age of 18,

he entered the University of Jena, where he pursued his interest in Kantian philosophy. After three years at Jena, he left and became a private tutor in Switzerland. It was this chance experience with tutoring that created in Herbart a lifelong interest in education. In fact, before leaving Switzerland, Herbart consulted with the famous Swiss educational reformer J. H. Pestalozzi (1746-1827). After two years as a tutor, at the age of 23, Herbart moved to the city of Bremen, where he studied and pondered philosophical and educational issues for three years. In 1802, he moved to the University of Göttingen, where he obtained his doctorate and then remained as a dozent (instructor) until 1809. Although originally attracted to Kant's philosophy, Herbart criticized Kant in his doctoral dissertation and began developing his own philosophy, which was more compatible with Leibniz's thinking.

As testimony to his success, Herbart was invited to the University of Königsberg in 1809 to occupy the position previously held by Kant. Herbart was only 33 at the time, and he remained at Königsberg for 24 years, after which he returned to the University of Göttingen because the Prussian government had shown antagonism toward his educational research. He remained at Göttingen until his death eight years later in 1841.

Herbart's two most important books for psychology were his short *Textbook in Psychology* (1816) and his long and difficult *Psychology as a Science Based on Experience, Metaphysics, and Mathematics* (1824–1825).

Psychology as a Science

Herbart agreed with Kant's contention that psychology could never be an experimental science, but he believed that the activities of the mind could be expressed mathematically; in that sense, psychology could be a science. The reason Herbart denied that psychology could become an experimental science was that he believed experimentation necessitated dividing up its subject matter; and because the mind acted as an integrated whole, the mind could not be

fractionated. For this reason, Herbart was very much opposed to faculty psychology, which was so popular in his day. He was also opposed to physiological psychology for the same reason; that is, he believed it fractionated the mind. After discussing his major ideas, we will examine more closely Herbart's attempt to mathematize psychology.

Psychic Mechanics

Herbart borrowed his concept of idea from the empiricists. That is, he viewed ideas as the remnants of sense impressions. Following Leibniz, however, he assumed that ideas (like monads) contained a force or energy of their own, and the laws of association were therefore not necessary to bind them. Herbart's system has been referred to as psychic mechanics because he believed that ideas had the power to either attract or repel other ideas, depending on their compatibility. Ideas tend to attract similar or compatible ideas, thus forming complex ideas. Similarly, ideas expend energy repelling dissimilar or incompatible ideas, thus attempting to avoid conflict. According to Herbart, all ideas struggle to gain expression in consciousness, and they compete with each other to do so. In Herbart's view, an idea is never destroyed or completely forgotten; either it is experienced consciously or it is not. Thus, the same idea may at one time be given conscious expression and at another time be unconscious.

Although ideas can never be completely destroyed, they can vary in intensity, or force. For Herbart, intense ideas are clear ideas, and all ideas attempt to become as clear as possible. Because only ideas of which we are conscious are clear ideas, all ideas seek to be part of the conscious mind. Ideas in consciousness are bright and clear; unconscious ideas are dark and obscure. Herbart used the term self-preservation to describe an idea's tendency to seek and maintain conscious expression. That is, each idea strives to preserve itself as intense, clear, and conscious. This tendency toward self-preservation naturally brings each idea into conflict with other, dissimilar ideas that are also seeking conscious expression. Thus, Herbart viewed the mind as a

battleground where ideas struggle with each other to gain conscious expression. When an idea loses its battle with other ideas, rather than being destroyed, it momentarily loses some of its intensity (clarity) and sinks into the unconscious.

Herbart's position represented a major departure from that of the empiricists because the empiricists believed that ideas, like Newton's particles of matter, were passively buffeted around by forces external to them—for example, by the laws of association. Herbart agreed with the empiricists that ideas were derived from experience, but he maintained that once they existed they had a life of their own. For Herbart, an idea was like an atom with energy and a consciousness of its own—a conception very much like Leibniz's conception of the monad. Conversely, Herbart's insistence that all ideas are derived from experience was a major concession to empiricism and provided an important link between empiricism and rationalism.

The Apperceptive Mass

Not only was Herbart's view of the idea very close to Leibniz's view of the monad, but Herbart also borrowed the concept of apperception from Leibniz. According to Herbart, at any given moment compatible ideas gather in consciousness and form a group. This group of compatible ideas constitutes the **apperceptive mass**. Another way of looking at the apperceptive mass is to equate it with attention; that is, the apperceptive mass contains all ideas to which we are attending.

It is with regard to the apperceptive mass that ideas compete with each other. An idea outside the apperceptive mass (that is, an idea of which we are not conscious) will be allowed to enter the apperceptive mass only if it is compatible with the other ideas contained there at the moment. If the idea is not compatible, the ideas in the apperceptive mass will mobilize their energy to prevent the idea from entering. Thus, whether an idea is a new one derived from experience or one already existing in the unconscious, it will be permitted conscious expression only if it is compatible with the ideas in the apperceptive mass.

Johann Friedrich Herbart

Herbart used the term *repression* to describe the force used to hold ideas incompatible with the apperceptive mass in the unconscious. He also said that if enough similar ideas are repressed into the unconscious, they could combine their energy and force their way into consciousness, thereby displacing the existing apperceptive mass. Repressed ideas continue to exist intact and wait for an opportunity to be part of consciousness. They must wait either for a more compatible apperceptive mass to emerge or for the time that they can join forces with similar repressed ideas and force their way into consciousness, thereby creating a new apperceptive mass.

Herbart used the term *limen* (threshold) to describe the border between the conscious and the unconscious mind. It was Herbart's goal to mathematically express the relationships among the apperceptive mass, the limen, and the conflict among ideas. Herbart's mathematics came from the two individuals who probably influenced him the most, Leibniz and Newton. In fact, one of Herbart's primary goals was to describe the mind in mathematical terms just as Newton had described the physical world. Herbart's use of calculus to quantify complex mental phenomena made him one of the first to apply a mathematical model to

psychology. Although the details are beyond the scope of this book, the interested reader can see how Herbart applied mathematics to his study of the mind by consulting Herbart's *Psychology as a Science* (1824–1825); Boring (1950); Boudewijnse, Murray, and Bandomir, (1999, 2001); or Wolman (1968b).

Educational Psychology

Besides considering Herbart as one of the first mathematical psychologists, many consider him to be the first educational psychologist. He applied his theory to education by offering the following advice to teachers:

- 1. Review the material that has already been learned.
- 2. Prepare the student for new material by giving an overview of what is coming next. This creates a receptive apperceptive mass.
- 3. Present the new material.
- Relate the new material to what has already been learned.
- 5. Show applications of the new material and give an overview of what is to be learned next.

For Herbart, a student's existing apperceptive mass, or mental set, must be taken into consideration when presenting new material. Material not compatible with a student's apperceptive mass will simply be rejected or, at least, will not be understood. Herbart said, "The educator who demands that a student attend [to material] without relevant preparation ... beforehand is playing on a musical instrument that has some of its strings missing" (1812/1888, p. 150). Herbart's theory of education comes very close to the more modern theory of Jean Piaget. Piaget said that for teaching to be effective, it must start with what a student can assimilate into his or her cognitive structure. If information is incompatible with a student's cognitive structure, it simply will not be learned. If we substitute the term apperceptive mass for cognitive structure, we see a great deal of similarity between the theories of Herbart and Piaget. (Piaget's theory will be presented in greater detail in Chapter 20.)

Herbart's Influence

Herbart influenced psychology in a number of ways. First, his insistence that psychology could at least be a mathematical science gave psychology more status and respectability than it had received from Kant. Despite Herbart's denial that psychology could be an experimental science, his efforts to quantify mental phenomena actually encouraged the development of experimental psychology. Second, his concepts of the unconscious, repression, and conflict and his belief that ideas continue to exist intact even when we are not conscious of them found their way into Freud's psychoanalytic theory. Also finding its way into Freudian theory was Herbart's notion that unconscious ideas seeking conscious expression will be met with resistance if they are incompatible with ideas already in consciousness. Third, Herbart's (and Leibniz's) concept of limen (threshold) was extremely important to Gustav Fechner (see Chapter 8), whose psychophysics was instrumental in the development of psychology as a science. Fourth, Herbart influenced Wilhelm Wundt, the founder of psychology as a separate scientific discipline, in a number of ways. For example, Wundt relied heavily on Herbart's (and Leibniz's) concept of apprehension. In Chapter 9, we will examine Herbart's influence on Wundt more fully.

GEORG WILHELM FRIEDRICH HEGEL

Georg Wilhelm Friedrich Hegel (1770–1831) was born on August 27 in Stuttgart and learned Latin from his mother. Later, at the University of Tübingen, he concentrated on the Greek and Roman classics and theology. After receiving his doctorate in 1793, he studied the historical Jesus and what the best minds through history had thought the meaning of life to be. In 1799 Hegel's father died and left him a modest inheritance. He moved to the University of Jena, where he supplemented his income with the small fees he

collected from lecturing there. In Jena he fathered an illegitimate son; the mother was his landlady. In 1811, aged 41, he married the daughter of a prominent family who was about half his age. Hegel and his wife had two sons of their own and also raised his illegitimate son (Singer, 2001, p. 11). Hegel was forced to change teaching jobs several times because of political unrest in Europe, but in 1818 he accepted one of the most prestigious academic positions in Europe—the chair in philosophy at the University of Berlin. Hegel remained at Berlin until he contracted cholera during an epidemic; he died on November 14, 1831, at the age of 61.

The Absolute

Like Spinoza, Hegel saw the universe as an interrelated unity, which he called **the Absolute**. The only true understanding, according to Hegel, is an understanding of the Absolute. True knowledge can never be attained by examining isolated instances of anything unless those instances are related to the "whole." Russell (1945) described this aspect of Hegel's philosophy as follows:

The view of Hegel, and of many other philosophers, is that the character of any portion of the universe is so profoundly affected by its relation to the other parts and to the whole, that no true statement can be made about any part except to assign its place in the whole. Thus, there can be only one true statement; there is no truth except the whole truth. And similarly nothing is quite real except the whole, for any part, when isolated, is changed in character by being isolated, and therefore no longer appears quite what it truly is. On the other hand, when a part is viewed in relation to the whole, as it should be, it is seen to be not self-subsistent, and to be incapable of existing except as part of just that whole which alone is truly real. (p. 743)

The process Hegel proposed for seeking knowledge was the one Plato had proposed. First, one must

recognize that sense impressions are of little use unless one can determine the general concepts that they exemplify. Once these concepts are understood, the next step is to determine how those concepts are related to one another. When one sees the interrelatedness of all concepts, one experiences the Absolute, which is similar to Plato's form of the good. Although Plato did not equate the form of the good with God, Hegel did equate the Absolute with God: "On its highest plane philosophy contemplates the concept of all concepts, the eternal absolute—the God who is worshipped in religion. Philosophy then culminates in speculative theology" (Hegel, 1817/1973, sec. 17). Although Hegel often disagreed with the details of church dogma (for example, he did not believe in miracles), two of his early books, The Life of Jesus (1795) and The Spirit of Christianity (1799), indicate a general sympathy toward Christian theology.

Hegel's belief that the whole is more important than particular instances led him to conclude that the state (government) was more important than the individuals that composed it. In other words, for Hegel, people existed for the state. This is exactly the opposite of Locke's position, which stated that the state existed for the people. Russell (1945) nicely summarized Hegel's view of the relationship between the individual and the state: "Hegel conceives the ethical relation of the citizen to the state as analogous to that of the eye to the body: In his place the citizen is part of a valuable whole, but isolated he is as useless as an isolated eye" (p. 743).

Dialectic Process

Hegel believed that both human history in general and the human intellect in particular evolved toward the Absolute via the **dialectic process**. Although the term *dialectic* has been used by philosophers in several ways, it generally means the attempt to arrive at truth by back-and-forth argumentation among conflicting views (for example, see Chapter 3 for Abelard's use of the dialectic method). In studying Greek history, Hegel observed that one philosopher would take a position that another philosopher

would then negate; then a third philosopher would develop a view that was intermediate between the two opposing views. For example, Heraclitus said constantly changing, everything was that Parmenides said that nothing ever changed, and Plato said that some things changed and some did not. Hegel's version of the dialectic process involved a thesis (one point of view), an antithesis (the opposite point of view), and a synthesis (a compromise between the thesis and the antithesis). When a cycle is completed, the previous synthesis becomes the thesis for the next cycle, and the process repeats itself continually. In this manner, both human history and the human intellect evolve toward the Absolute.

In a sense, Hegel did to Kant what Kant had done to Hume. As we saw, Kant agreed with Hume that nothing in experience proves causation and vet we are convinced of its existence. Kant's explanation was that there is an a priori category of thought, which accounts for our tendency to structure the world in terms of cause and effect. Hegel accepted all Kant's categories of thought and added several more of his own. However, he raised an all-important question that Kant had missed: Why do the categories of thought exist? Kant began his philosophy by attempting to account for our notion of causation because he agreed with Hume that such a notion cannot be derived from experience. Similarly, Hegel began his philosophy by attempting to account for the existence of Kant's categories. Hegel's answer was that the categories emerged as a result of the dialectic process and, for that reason, they bring humans closer to the Absolute. For Hegel, then, the categories exist as a means to an end—the end being moving closer to the Absolute. Through the dialectic process, all things move toward the Absolute, including the human mind.

Hegel's Influence

We find Hegel's influences in a number of places in psychology. As we will see in Chapter 8, Hegel strongly influenced Fechner and thereby the development of psychophysics. Some see Freud's con-

Georg Wilhelm Friedrich Hegel

cepts of the id, ego, and superego as manifestations of the dialectic process (see, for example, D. N. Robinson, 1982). Others see the roots of self-actualization theory (such as the theories of Jung, Rogers, and Maslow) in Hegel's philosophy. Others see in it the beginnings of phenomenology, which ultimately manifested itself in Gestalt, humanistic, and existential psychology.

Also, the concept of *alienation*, or self-estrangement, plays a central role in Hegel's philosophy. By *alienation*, Hegel meant the mind's realization that it exists apart from the Absolute, apart from that which it is striving to embrace. Insofar as the mind has not completed its journey toward the Absolute, it experiences alienation. (The Marxists

later used the term *alienation* to describe the separation of people from their government or from the fruits of their labor, but that is not how Hegel used the term.) Variations on Hegel's concept of alienation were to be seen later in the theories of Erich Fromm and Carl Rogers. Fromm used the term *alienation* to describe the separation of humans from their basic roots in nature, and he claimed that a major human motive was to reestablish a sense of "rootedness," or belonging. Rogers used the term *alienation* to describe the separation of the self from the biologically based urge toward self-actualization.

Because Hegel's philosophy was meant to show the interconnectedness of everything in the universe, it did much to stimulate attempts to synthesize art, religion, history, and science. Russell (1945) commented on Hegel's widespread popularity: "At the end of the nineteenth century, the leading academic philosophers, both in America and Great Britain, were largely Hegelians. Outside of pure philosophy, many Protestant theologians adopted his doctrines, and his philosophy of history profoundly affected political theory" (p. 730).

The rationalists of the 17th, 18th, and 19th centuries perpetuated the tradition of Plato, Augustine, Aquinas, and Descartes, a tradition that is still very much alive in psychology. All theories that postulate the mind's active involvement in intelligence, perception, memory, personality, creativity, or information processing in general have their origins in the rationalist tradition. In fact, insofar as modern psychology is scientific, it is partially a rational enterprise. As mentioned in Chapter 1, scientific theory is a combination of empiricism and rationalism.

SUMMARY

British empiricism emphasized sensory experience and the laws of association in explaining the intellect, and if a mind was postulated at all, it was a relatively passive mind. The French sensationalists

tended to go further, saying there was no need to postulate an autonomous mind at all and claiming that sensation and the laws of association were all that were necessary to explain all cognitive experience. The rationalists, on the other hand, besides accepting the importance of sensory information, postulated an active mind that not only transformed information furnished by the senses, thus making it more meaningful, but also could discover and understand principles and concepts not contained in sensory information. For the rationalists, then, the mind was more than a collection of ideas derived from sensory experience and held together by the laws of association. In their explanations of behavior, the rationalists tended to emphasize reasons whereas the empiricists tended to emphasize causes. In their search for knowledge, the rationalists tended to emphasize deduction whereas the empiricists tended to emphasize induction.

Spinoza equated God with nature and, for doing so, was excommunicated from both the Jewish and the Christian communities. Spinoza believed God is nature and nature is lawful. Because humans are part of nature, human behavior and thought are also lawful; that is, they are determined. Thus, free will does not exist. For Spinoza, there was only one basic reality (God), and it was both material and conscious; everything in the universe possessed these two aspects, including humans. A human was therefore seen as a material object from which consciousness (mind) could not be separated. This proposed relationship between mind and body was called psychophysical double aspectism, or simply double aspectism. According to Spinoza, the greatest pleasure comes from pondering clear ideas—that is, ideas that reflect nature's laws. Spinoza believed that emotions were desirable because they did not interfere with clear thinking, but passions were undesirable because they did interfere with such thinking. Spinoza showed how a large number of emotions could be derived from the basic emotions of pleasure and pain and was among the first to perform a detailed analysis of human emotions. Spinoza offered an entirely deterministic account of human thoughts, actions, and emotions and helped pave the way for the development of a science of psychology.

Malebranche believed that there was a mind and a body but that they did not interact. Rather,

God coordinated them. That is, if there was an idea in the mind, God was aware of it and caused the body to act appropriately. Such a belief became known as occasionalism.

Leibniz emphatically disagreed with Locke that all ideas come from sensory experience, saying instead that the mind innately contains the potential to have ideas and that that potential is actualized by sensory experience. Leibniz suggested that the universe is made up of indivisible entities called monads. All monads are self-contained and do not interact with other monads. Furthermore, all monads contain energy and possess consciousness. The harmony among monads was created by God and therefore cannot be improved on. Leibniz's contention that the monads of the mind were perfectly correlated with those of the body was called preestablished harmony. Experiencing one minute monad, or a small number of minute monads, creates petites perceptions, which take place below the level of awareness. If, however, enough minute monads are experienced together, their combined influence crosses the limen (or threshold), and they are apperceived, or experienced, consciously. Thus, for Leibniz, the difference between a conscious and an unconscious experience depends on the number of monads involved. Like Spinoza, Leibniz believed that all matter possesses consciousness but that physical bodies vary in their ability to think clearly. The ability to think clearly is greatest in God, then in humans, then in animals, then in plants, and finally in inert matter. Because humans possess monads in common with all the previously mentioned things, sometimes their thinking is clear and sometimes not.

Reid was strongly opposed to Hume's skepticism. He thought that we could accept the physical world as it appears to us because it makes common sense to do so. Reid's contention that reality is as we experience it is called direct realism, or naive realism. The great variety of human conscious experience could not be explained by assuming that one sensation was added to another via the laws of association. Rather, Reid postulated powers of the mind or mental faculties to account for various conscious phenomena.

Kant agreed with Hume that any conclusions we reach about physical reality are based on subjective experience. However, Kant asked where concepts such as cause and effect come from if we never directly experience causal relationships. His answer was that several categories of thought are innate and that sensory information is modified by those categories. What we experience consciously is determined by the combined influences of sensory information and the innate categories of thought. Because our experiences of such things as totality, causality, time, and space are not found in sensory experience, they must be imposed on such experience by the mind. The categorical imperative is an innate moral principle, but people can choose whether or not to act in accordance with it: those who choose to do so act morally, and those who do not act immorally. According to Kant's categorical imperative, the maxims governing one's behavior should be such that they could form the basis of a universal moral law. However, because they posses free will, individuals can either accept these maxims or not. For Kant the concept of morality was meaningless without freedom of choice. Kant did not believe that psychology could be a science because he believed that subjective experience could not be measured with mathematical precision. He did believe that human behavior could be beneficially studied, however, and he called such study anthropology. Kant's influence on psychology is seen mainly in Gestalt psychology and in modern cognitive psychology.

Herbart disagreed with the empiricists, who likened an idea to a Newtonian particle whose fate was determined by forces external to it. Rather, Herbart likened an idea to a Leibnizian

monad; that is, he saw ideas as having an energy and a consciousness of their own. Also, he saw ideas as striving for conscious expression. The group of compatible ideas of which we are conscious at any given moment forms the apperceptive mass; all other ideas are in the unconscious. It is possible for an idea to cross the threshold between the unconscious and the conscious mind if that idea is compatible with the ideas making up the apperceptive mass; otherwise, it is rejected. Herbart attempted to express mathematically the nature of the apperceptive mass, the threshold, and the conflict among ideas, making him among the first to apply mathematics to psychological phenomena. He is also considered to be the first educational psychologist because he applied his theory to educational practices. He said, for example, that if a student was going to learn new information, it must be compatible with the student's apperceptive

Like Spinoza, Hegel believed the universe to be an interrelated unity. For Hegel, the only true knowledge was that of unity, which he called the Absolute. Hegel believed that the human intellect advanced by the dialectic process, which for him involved a thesis (an idea), an antithesis (the opposite of that idea), and a synthesis (a compromise between the original idea and its opposite). The synthesis then becomes the thesis of the next stage of development. As this process continues, humans approximate an understanding of the Absolute.

The popularity of such topics as information processing, decision making, Gestalt psychology, and science in general is evidence of the rationalists' influence on modern psychology.

DISCUSSION QUESTIONS

- 1. In general, what are the basic differences among empiricism, sensationalism, and rationalism? Include in your answer a distinction between a passive and an active mind.
- 2. Assume a person robs a bank. Give the general tenor of an explanation of that person's behavior based on reasons and then on causes. In which type of explanation would holding the

- person responsible for his or her actions make the most sense? Explain.
- 3. What was Spinoza's conception of nature? What was his position on the mind-body relationship?
- 4. Summarize Spinoza's position on the issue of free will versus determinism.
- 5. How did Spinoza distinguish between emotions and passions? Give an example of each.
- What, for Spinoza, was the master motive for human behavior? Explain how this motive manifests itself.
- 7. In what way did Spinoza's philosophy encourage the development of scientific psychology?
- 8. What was Malebranche's position on the mind-body relationship?
- 9. Leibniz disagreed with Locke's contention that all ideas are derived from experience. How did Leibniz explain the origin of ideas?
- 10. Summarize Leibniz's monadology.
- 11. Discuss Leibniz's proposed solution to the mind-body problem.
- 12. Discuss Leibniz's law of continuity.
- 13. Describe the relationship among petites perceptions, limen, and apperception.
- Summarize Reid's philosophy of common sense. Include in your answer a definition of direct realism.

- 15. What is faculty psychology? What major misconceptions of faculty psychology have been perpetuated through the years?
- 16. What did Kant mean by an a priori category of thought? According to Kant, how do such categories influence what we experience consciously?
- 17. Briefly summarize Kant's explanation of the experiences of causality, time, and space.
- 18. Discuss the importance of the categorical imperative in Kant's philosophy.
- 19. Did Kant believe that psychology could become a science? Why or why not?
- 20. How did Herbart's concept of idea differ from those of the empiricists?
- 21. Discuss Herbart's notion of the apperceptive mass. For example, how does the apperceptive mass determine which ideas are experienced consciously and which are not? Include in your answer the concept of the limen, or threshold.
- 22. How did Herbart apply his theory to educational practices?
- 23. Discuss Hegel's notion of the Absolute.

 Describe the dialectic process by which Hegel felt the Absolute was approximated.
- 24. Give an example of how rationalistic philosophy has influenced modern psychology.

SUGGESTIONS FOR FURTHER READING

- Beanblossom, R. E., & Lehrer, K. (Eds.). (1983). *Thomas Reid's inquiry and essays*. Indianapolis: Hackett.
- Bernard, W. (1972). Spinoza's influence on the rise of scientific psychology: A neglected chapter in the history of psychology. *Journal of the History of the Behavioral Sciences*, 8, 208–215.
- Brooks, G. P. (1976). The faculty psychology of Thomas Reid. *Journal of the History of the Behavioral Sciences*, 12, 65–77.
- Elwes, R. H. M. (Trans.). (1955). Benedict de Spinoza: On the improvement of the understanding; the ethics; and correspondence. New York: Dover.
- Fancher, R. E., & Schmidt, H. (2003). Gottfried Wilhelm Leibniz: Underappreciated pioneer of psychology. In G. A. Kimble & M. Wertheimer (Eds.), Portraits of pioneers in psychology (Vol. 5, pp. 1–17). Washington, DC: American Psychological Association.

- Guyer, P. (Ed.). (1992). The Cambridge companion to Kant. New York: Cambridge University Press.
- Kant, I. (1977). Prolegomena to any future metaphysics. (J. W. Ellington, Trans.). Indianapolis: Hackett Publishing Company. (Original work published 1783)
- Scruton, R. (2001). *Kant: A very short introduction*. New York: Oxford University Press.
- Scruton, R. (2002). Spinoza: A very short introduction. New York: Oxford University Press.

- Singer, P. (2001). Hegel: A very short introduction. New York: Oxford University Press.
- Wolman, B. B. (1968a). Immanuel Kant and his impact on psychology. In B. B. Wolman (Ed.), Historical roots of contemporary psychology (pp. 229–247). New York: Harper & Row.
- Wolman, B. B. (1968b). The historical role of Johann Friedrich Herbart. In B. B. Wolman (Ed.), *Historical roots of contemporary psychology* (pp. 29–46). New York: Harper & Row.

GLOSSARY

Absolute, The According to Hegel, the totality of the universe. A knowledge of the Absolute constitutes the only true knowledge, and separate aspects of the universe can be understood only in terms of their relationship to the Absolute. Through the dialectic process, human history and the human intellect progress toward the Absolute.

Active mind A mind equipped with categories or operations that are used to analyze, organize, or modify sensory information and to discover abstract concepts or principles not contained within sensory experience. The rationalists postulated such a mind.

Anthropology Kant's proposed study of human behavior. Such a study could yield practical information that could be used to predict and control behavior.

Apperception Conscious experience.

Apperceptive mass According to Herbart, the cluster of interrelated ideas of which we are conscious at any given moment.

Categorical imperative According to Kant, the moral directive that we should always act in such a way that the maxims governing our moral decisions could be used as a guide for everyone else's moral behavior.

Categories of thought Those innate attributes of the mind that Kant postulated to explain subjective experiences we have that cannot be explained in terms of sensory experience alone—for example, the experiences of time, causality, and space.

Commonsense philosophy The position, first proposed by Reid, that we can assume the existence of the physical world and of human reasoning powers because it makes common sense to do so.

Dialectic process According to Hegel, the process involving an original idea, the negation of the original idea, and a synthesis of the original idea and its negation. The synthesis then becomes the starting point (the idea) of the next cycle of the developmental process.

Direct realism The belief that sensory experience represents physical reality exactly as it is. Also called naive realism.

Double aspectism Spinoza's contention that material substance and consciousness are two inseparable aspects of everything in the universe, including humans. Also called psychophysical double aspectism and double-aspectmonism.

Faculty psychology The belief that the mind consists of several powers or faculties.

Hegel, Georg Wilhelm Friedrich (1770–1831) Like Spinoza, believed the universe to be an interrelated unity. Hegel called this unity the Absolute, and he thought that human history and the human intellect progress via the dialectic process toward the Absolute. (*See also* **The Absolute**.)

Herbart, Johann Friedrich (1776–1841) Likened ideas to Leibniz's monads by saying that they had energy and a consciousness of their own. Also, according to Herbart, ideas strive for consciousness. Those ideas compatible with a person's apperceptive mass are given conscious expression, whereas those that are not remain below the limen in the unconscious mind. Herbart is considered to be one of the first mathematical and educational psychologists.

Kant, Immanuel (1724–1804) Believed that experiences such as those of unity, causation, time, and space could not be derived from sensory experience and therefore must be attributable to innate categories of thought. He also believed that morality is, or should be, governed

by the categorical imperative. He did not believe psychology could become a science because subjective experience could not be quantified mathematically.

Law of continuity Leibniz's contention that there are no major gaps or leaps in nature. Rather, all differences in nature are characterized by small gradations.

Leibniz, Gottfried Wilhelm von (1646-

1716) Believed that the universe consists of indivisible units called monads. God had created the arrangement of the monads, and therefore this was the best of all possible worlds. If only a few minute monads were experienced, petites perceptions resulted, which were unconscious. If enough minute monads were experienced at the same time, apperception occurred, which was a conscious experience. (See also Petites perceptions.)

Limen For Leibniz and Herbart, the border between the conscious and the unconscious mind. Also called threshold.

Malebranche, Nicolas de (1638–1715) Contended that the mind and body were separate but that God coordinated their activities.

Monads According to Leibniz, the indivisible units that compose everything in the universe. All monads are characterized by consciousness but some more so than others. Inert matter possesses only dim consciousness, and then with increased ability to think clearly come plants, animals, humans, and, finally, God. The goal of each monad is to think as clearly as it is capable of doing. Because humans share monads with matter, plants, and animals, sometimes our thoughts are less than clear.

Occasionalism The belief that bodily events and mental events are coordinated by God's intervention.

Pantheism The belief that God is present everywhere and in everything.

Passive mind A mind whose contents are determined by sensory experience. It contains a few mechanistic principles that organize, store, and generalize sensory

experiences. The British empiricists and the French sensationalists tended to postulate such a mind.

Petites perceptions According to Leibniz, a perception that occurs below the level of awareness because only a few monads are involved.

Preestablished harmony Leibniz's contention that God had created the monads composing the universe in such a way that a continuous harmony existed among them. This explained why mental and bodily events were coordinated.

Psychic mechanics The term used by Herbart to describe how ideas struggle with each other to gain conscious expression.

Psychophysical parallelism The contention that bodily and mental events are correlated but that there is no interaction between them.

Rationalism The philosophical position postulating an active mind that transforms sensory information and is capable of understanding abstract principles or concepts not attainable from sensory information alone.

Reid, Thomas (1710–1796) Believed that we could trust our sensory impressions to accurately reflect physical reality because it makes common sense to do so. Reid attributed several rational faculties to the mind and was therefore a faculty psychologist.

Spinoza, Baruch (1632–1677) Equated God with nature and said that everything in nature, including humans, consisted of both matter and consciousness. Spinoza's proposed solution to the mind-body problem is called double aspectism. The most pleasurable life, according to Spinoza, is one lived in accordance with the laws of nature. Emotional experience is desirable because it is controlled by reason; passionate experience is undesirable because it is not. Spinoza's deterministic view of human cognition, activity, and emotion did much to facilitate the development of scientific psychology.

Romanticism and Existentialism

C tarting with the Renaissance humanists (see Chapter 4), the authority of the I church began to be questioned and a period of more objective inquiry concerning the world and humans ensued. The work of such individuals as Copernicus, Kepler, Galileo, Hobbes, Newton, Bacon, and Descartes ushered in the period in philosophy referred to as the Enlightenment. The term enlightenment was used to contrast the period with the darkness of irrationality and superstition that was thought to characterize the Dark Ages. Increasing skepticism concerning religious dogma and the Enlightenment were closely related: "Serious concerns about the historical accuracy of the Bible began to appear during the Enlightenment, when supernatural doctrines of divine revelation that guaranteed the truth of Scripture became matters of scholarly debate" (Ehrman, 2003, p. 168). For Enlightenment thinkers, who tended to be either deists or outright atheists, "beliefs are to be accepted only on the basis of reason, not on the authority of priests, sacred texts, or tradition" (Inwood, 1995, p. 236). Furthermore, knowledge was power. Knowledge meant understanding the abstract principles governing the universe, and power meant applying that knowledge to improve society. During the Enlightenment it was widely believed that societal perfection could be approximated through the application of objective (for example, scientific) knowledge and, therefore, the period was characterized by considerable optimism.

Clearly, for the Enlightenment thinkers the most important human attribute was rationality. Individual differences among humans were viewed as less important than their shared rationality:

The Enlightenment devalues prejudices and customs, which owe their development to historical peculiarities rather than to the exercise of reason. What matters to the Enlightenment is not whether one is French or German, but that one is an individual man, united in brotherhood with all other men by the rationality one shares with them. (Inwood, 1995, p. 236)

Also, Enlightenment thinkers devalued the irrational aspects of human nature, such as the emotions. It is no wonder that the Enlightenment is often referred to as the Age of Reason (Inwood, 1995, p. 236).

According to Inwood (1995, p. 237) it is not clear exactly when the Enlightenment began; it is even less clear when it ended, if it ever did. In any case, Enlightenment ideals were embraced by the British empiricists (especially by Hobbes, Locke, and J. S. Mill), the French sensationalists, and the positivists (see Chapter 5). Enlightenment epistemology glorified sensory experiences and rationality, the two primary components of science. In fact, as was noted in Chapter 5, the British and French empiricists attempted to apply Newtonian science to an understanding of human nature. That is, they attempted to explain human nature objectively in terms of a few basic principles.

Although the philosophies of Hume (see Chapter 5) and Kant (see Chapter 6) shared many of the ideals of the Enlightenment, their philosophies did much to show the limitations of human rationality. For example, Hume and Kant demonstrated that physical reality could never be experienced directly and therefore could never be known. Other philosophers began to see the search for the universal, abstract principles governing human behavior as not only cold and impersonal but also misleading. Human behavior, they said, is not governed by universal, abstract principles but by personal experience and individual perspectives. By denying universal truths and insisting instead on many individual truths, these philosophers had much in common with the ancient Sophists (see Chapter 2) and Skeptics (see Chapter 3). Two of the most influential criticisms of Enlightenment philosophy were romanticism and existentialism, and those philosophies are the focus of this chapter.

ROMANTICISM

Some philosophers began to argue that humans consist of more than an intellect and ideas derived from experience. Humans, they said, also posses a wide variety of irrational feelings (emotions), intuitions, and instincts. Those philosophers emphasizing the importance of these irrational components of human nature were called romantics. They believed that rational thought had often led humans astray in their search for valid information and that empiricism reduced people to unfeeling machines. According to the romantics, the best way to find out what humans are really like is to study the total person, not just his or her rational powers or empirically determined ideas. For the romantic, "a return to the lived world and to childlike openness was needed" (Schneider, 1998, p. 278). As mentioned in Chapter 5, aspects of romanticism were found in ancient Cynicism and in Renaissance humanism.

Of course, the empiricists and sensationalists did not totally neglect human emotionality. Their coverage of the topic, however, was either minimal or secondary to other concerns. The empiricists and sensationalists generally believed that all human emotions were derived from the feelings of pleasure and pain. They also generally believed that emotions become associated with various sensations and ideas by the same mechanical laws of association that bind ideas together. Neither did the rationalists neglect the topic of human emotions. Spinoza, for example, shared the belief that most, if not all, human emotions are derived from the feelings of pleasure or pain. In addition, Spinoza, like many other rationalists, believed that emotional experience is often destructive if not controlled by

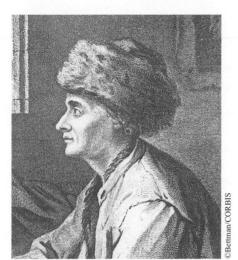

Jean-Jacques Rousseau

rational processes. The romantics sought to elevate human emotions, intuitions, and instincts from the inferior philosophical position they had occupied to one of being the primary guides for human conduct.

The rational, empirical, and positivistic philosophers (that is, the philosophers of the Enlightenment) had attempted to create political and moral systems based on their philosophies, and their efforts had failed. According to the romantics, they failed because they viewed humans mainly as either victims of experience or vehicles by which some grandiose, rational principle was manifested. During the romantic movement, in the late 18th to mid-19th century, the good life was defined as one lived honestly in accordance with one's inner nature. The great philosophical systems were no longer to be trusted; in general, science was also seen as antithetical—or at best irrelevant—to understanding humans. Rousseau is usually thought of as the father of romanticism, and it is to his philosophy that we turn next.

Jean-Jacques Rousseau

Jean-Jacques Rousseau (1712–1778) was born on June 28 in Geneva, the son of a watchmaker, and raised a Calvinist. His mother died soon after

giving birth to him-for which his father never forgave him. In fact, Rousseau's father abandoned him when he was 10 years old, and he was brought up by relatives. Suffering from poor health all his life, Rousseau left school at the age of 12 and moved from place to place and from job to job. Once, he was so hungry that he converted to Catholicism in order to receive free food and lodging in a Catholic church. He said of this act, "I could not dissemble from myself that the holy deed I was about to do was at bottom the act of a bandit" (Russell, 1945, p. 685). As a young adolescent. Rousseau was filled with sexual desire but didn't know what to do about it: "My heated blood incessantly filled my brain with girls and women; but, ignorant of the relations of sex, I made use of them in my imagination in accordance with my distorted notions" (1781/1996, p. 84). For example, young Rousseau sought sexual satisfaction through exhibitionism: "I haunted dark alleys and hidden retreats, where I might be able to expose myself to women in the condition in which I should liked to have been in their company" (1781/1996, p. 84). On one such occasion, Rousseau was caught but lied his way out of trouble. He told the man who caught him that he was of good birth but suffered a brain affliction for which his family was about to confine him. He had run away, Rousseau continued, in an effort to escape this confinement. So, he told the man, his actions were of a desperate young man and should not be judged too harshly. Much to his amazement, Rousseau was released after only a brief reprimand.

When Rousseau was 15, he met Madame de Warens, a Swiss baroness who was 28 and had converted to Catholicism. Madame de Warens was well educated in religion, literature, and philosophy, and for 10 years she was Rousseau's lover and tutor. Following his relationship with Madame de Warens, Rousseau spent several years as a vagabond, making money any way he could—sometimes illegally or by deception. In 1745 Rousseau began a relationship with Thérèse Le Vasseur, a maid in his hotel in Paris. He lived with her (and her mother) the rest of his life, and

they had five children, all of whom were sent to a foundling home (an orphanage). Rousseau had been a womanizer and remained one during his relationship with Thérèse. Understanding why he chose this person to share his life is difficult. She was uneducated and relatively unattractive. When they first met, she could neither read nor write and did not know the names of the months. Rousseau eventually did teach her to write but not to read. Later in their relationship, Thérèse took to drinking and running after stable boys. Russell (1945, p. 687) speculates that Rousseau maintained his relationship with Thérèse because she made him feel intellectually and financially superior. There is a question as to whether Rousseau ever married Thérèse. Russell (1945, p. 687) says he did not, but Wokler (1995, p. 3) says he did.

Arriving in Paris at the age of 30, Rousseau joined a group of influential Parisian intellectuals, although he himself had had no formal education. Rousseau was an intensely private person and did not like the social life of the city. In 1756 he left Paris for the quiet of the country, but the 1762 publication of his two most famous works, The Social Contract and Emile, ended Rousseau's tranquil country life. Within a month of the publication of these two books, the city of Paris condemned them, and Rousseau's hometown of Geneva issued a warrant for his arrest. He was forced to spend the next four years as a refugee. Finally, in 1765 David Hume offered Rousseau refuge in England. Eventually, opposition to Rousseau's ideas faded and Rousseau returned to Paris, where he remained until his death. He died in poverty, and suicide was suspected (Russell, 1945, p. 691).

Feelings versus Reason. Rousseau began *The Social Contract* with this statement: "Man is born free and yet we see him everywhere in chains" (1762/1947, p. 5). His point was that all governments in Europe at the time were based on a faulty assumption about human nature—the assumption that humans need to be governed. The only justifiable government, according to Rousseau, was one that allowed humans to reach their full potential

and to fully express their free will. The best guide for human conduct is a person's honest feelings and inclinations: "Let us lay it down as an incontrovertible rule that the first impulses of [human] nature are always right; there is no original sin in the human heart" (Rousseau, 1762/1974, p. 56). In his of untouched human nature, idealization Rousseau had much in common with the ancient Cynics (see Chapter 3). In fact, his contemporaries called him "a new Diogenes" (Niehues-Pröbsting, 1996, p. 340). Rousseau distrusted reason, organized religion, science, and societal laws as guides for human conduct. His philosophy became a defense for Protestantism because it supported the notion that God's existence could be defended on the basis of individual feeling and did not depend on the dictates of the church.

In Chapter 18, we will see that Rousseau's trust of inner feelings as guides for action was shared by the humanist psychologist Carl Rogers.

The Noble Savage. Looking at natural impulses to understand humans was not new with Rousseau; we saw in Chapter 5 that Hobbes did the same thing. The major difference between Hobbes and Rousseau is in the conclusions they reached about the nature of human nature. For Hobbes, human nature was animalistic and selfish and needed to be controlled by government. This view of human nature was also accepted by many theologians and philosophers who said that reason had to be almost constantly employed to control brutish human impulses. Rousseau completely disagreed, saying instead that humans were born basically good. He reversed the doctrine of original sin by insisting that humans are born good but are made bad by societal institutions.

Rousseau claimed that if a **noble savage** could be found (a human not contaminated by society), we would have a human whose behavior was governed by feelings but who would not be selfish. Rousseau believed that humans were, by nature, social animals who wished to live in harmony with other humans. If humans were permitted to develop freely, they would become happy, fulfilled,

free, and socially minded. They would do what is best for themselves and for others if simply given the freedom to do so.

The General Will. Even though the conceptions of human nature accepted by Hobbes and Rousseau were essentially opposite, the type of government that the two proposed was quite similar. Rousseau conceded that to live in civilized societies, humans had to give up some of their primitive independence. The question that he pondered in his *Social Contract* is how humans could be governed and still remain as free as possible. It is in answer to this question that Rousseau introduced his notion of the general will. According to Rousseau, the general will describes what is best within a community, and it is to be "sharply distinguished" from an individual's will or even a unanimous agreement among individuals:

This general will is to be kept sharply distinguished from what the members of a society may, by majority vote or even by unanimous agreement, decide is their good. Such a decision, which Rousseau distinguished from the general will by calling it "the will of all," may be wrong. The general will, by definition, cannot be wrong because it is the very standard of right. (Frankel, 1947, p. xxiv)

Each individual has both a tendency to be selfish (private will) and a tendency to act in ways beneficial to the community (general will). To live in harmony with others, each person is obliged to act in accordance with his or her general will and inhibit his or her private will.

The "social contract," then, can be summarized as follows: "Each of us places in common his person and all of his power under the supreme direction of the general will; and as one body we all receive each member as an indivisible part of the whole" (Rousseau, 1762/1947, p. 15). In Rousseau's "utopia," if a person's private will is contrary to the general will, he or she can be forced to follow the general will. Also, there are no elections and no private prop-

erty: "The state, in relation to its members, is master of all their wealth" (Rousseau, 1762/1947, p. 20). The governments that Rousseau encouraged were anything but democratic.

Education. Rousseau began *Emile* (1762/1974) the same way that he began *The Social Contract*, that is, by condemning society for interfering with nature and with natural human impulses:

God makes all things good; man meddles with them and they become evil. He forces one soil to yield the products of another, one tree to bear another's fruit. He confuses and confounds time, place, and natural conditions. He mutilates his dog, his horse, and his slave. He destroys and defaces all things; he loves all that is deformed and monstrous; he will have nothing as nature made it, not even man himself, who must learn his paces like a saddlehorse, and be shaped to his master's taste like the trees in his garden. (p. 5)

According to Rousseau, education should take advantage of natural impulses rather than distort them. Education should not consist of pouring information into children in a highly structured school. Rather, education should create a situation in which a child's natural abilities and interests can be nurtured. For Rousseau, the child naturally has a rich array of positive instincts, and the best education is one that allows these impulses to become actualized.

In *Emile* (1762/1974), a treatise on education in the form of a novel, Rousseau described what he considered the optimal setting for education. A child and his tutor leave civilization and return to nature; in this setting, the child is free to follow his own talents and curiosities. The tutor responds to the child's questions rather than trying to impose his views on the child. As the child matures, his abilities and interests change, and thus what constitutes a meaningful educational experience changes. It is always the child's natural abilities and interests, however, that guide the educational process. Rousseau

(1762/1974) described how education should be responsive to each particular student's interests and abilities.

Every mind has its own form, in accordance with which it must be controlled: and the success of the pains taken depends largely on the fact that he is controlled in this way and no other. Oh, wise man, take time to observe nature; watch your scholar well before you say a word to him; first leave the germ of his character free to show itself, do not constrain him in anything, the better to see him as he really is.... The wise physician does not hastily give prescriptions at first sight, but he studies the constitution of the sick man before he prescribes anything; the treatment is begun later, but the patient is cured, while the hasty doctor kills him. (p. 58)

In modern times the humanistic psychologist Carl Rogers (see Chapter 18) expressed a philosophy of education very similar to that of Rousseau.

Johann Wolfgang von Goethe

Born on August 28, the poet, dramatist, scientist, and philosopher Johann Wolfgang von Goethe (1749-1832) was one of the most revered individuals in the intellectual life of Germany in the late 18th and early 19th centuries. Goethe is usually thought of as the initiator of the Sturm und Drang (storm and stress) period in literature; in his literary works and philosophy, he viewed humans as being torn by the stresses and conflicts of life. He believed life consisted of opposing forces such as love and hate, life and death, and good and evil. The goal of life should be to embrace these forces rather than to deny or overcome them. One should live life with a passion and aspire continuously for personal growth. Even the darker aspects of human nature could provide stimulation for personal expansion. The idea of being transformed from one type of being (unfulfilled) into another type (fulfilled) was common within the romantic movement. We will

see later that Nietzsche was strongly influenced by Goethe's philosophy of life.

In 1774, Goethe wrote The Sorrows of Young Werther, a novella about a young man with love problems. These problems were so vividly portrayed that several suicides were attributed to them (Hulse, 1989). In 1808 Goethe published Part I of his dramatic poem Faust; Part II was published posthumously in 1833 (Kaufmann, 1961, offers both parts under one cover). Faust is widely considered one of the greatest literary works of all time. As Faust begins, old Dr. Faust is filled with despair and is contemplating suicide. Satan appears and makes a deal with him: Satan could take Faust's soul if Faust had an experience he wished would continue eternally. With that bargain sealed, Satan transforms Faust from an old man into a wise and handsome youth. The young Faust then begins his search for a source of happiness so great that he would choose to experience it forever. Faust finally bids time to stand still when he encounters people allowed to express their individual freedom. He views human liberty as the ultimate source of happiness.

Although most of the romantics were antiscience, Goethe was not. He made important discoveries in anatomy and botany, and he wrote Science of

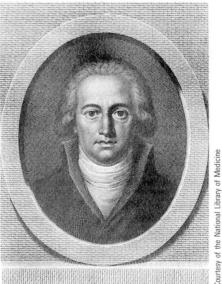

Johann Wolfgang von Goethe

Colors (1810), in which he attempted to refute Newton's theory of color vision and proposed his own theory in its place. Although Goethe's theory proved to be incorrect, his methodology had a major impact on later psychology. Goethe demonstrated that sensory experiences could be objectively studied by introspection. Furthermore, he insisted that intact, meaningful psychological experience should be the object of study rather than meaningless, isolated sensations. This insistence that whole, meaningful experiences be studied came to be called phenomenology. An example is the color-contrast effect known as Goethe's shadows. Goethe observed that when a colored light is shown on an object, the shadow produced appears to be complementary to the colored light (Gregory, 1987). This phenomenon was to be instrumental in the development of Edwin Land's theory of color vision (see Land, 1964, 1977). Many years before Darwin, Goethe also proposed a theory of evolution according to which one species of living thing could gradually be transformed into another. Goethe even employed a form of what is now called behavior therapy to alleviate a number of his own personal problems and those of a depressed theology student who came to Goethe for help (Bringmann, Voss, and Balance, 1997). Rather than denying the importance of science, Goethe saw science as limited; he believed that many important human attributes were beyond the grasp of the scientific method. Goethe died on March 22, 1832, at the age of 82.

Goethe's Influence. D. N. Robinson (1982) nicely summarizes Goethe's influence as follows:

To him ... goes much of the credit for awakening scholars to the problem of *esthetics* and for infusing German philosophical writing with a conscientious regard for what is creative and dynamic in the human psyche. In the Goethean presence, every important philosophical production in the Germany of the nineteenth century would reserve a special place for art. Indeed, Romanticism itself is to be understood as

the unique melding of esthetics and metaphysics. (p. 97)

Because of his significant influence on the entire German culture, Goethe has had many influences on the development of psychology. One famous psychologist whom Goethe's writings influenced directly was Jung, a colleague of Freud.

In my youth (around 1890) I was unconsciously caught up by this spirit of the age, and had no methods at hand of extricating myself from it. *Faust* struck a cord in me and pierced me through in a way that I could not but regard as personal. Most of all, it awakened in me the problems of opposites, of good and evil, of mind and matter, of light and darkness. (Jung, 1963, p. 235)

Goethe's writings also influenced Freud. Both Jung's and Freud's theories emphasize the conflicting forces operating in one's life, and both theories focus on conflict, frustration, and perpetual struggle between animal impulses and civilized behavior. Also, both Freud and Jung maintained that animalistic urges were not to be totally eliminated but instead harnessed and used to enhance personal growth. All these ideas appeared in Goethe's writings.

Arthur Schopenhauer

The important German philosopher Arthur Schopenhauer (1788–1860) was born on February 22 in Danzig (now Gdansk, Poland). His father was a banker and his mother a famous novelist. After his father died in 1805 (probably of suicide), his mother, Johanna, established an artistic and intellectual salon that was frequented by many of the luminaries of the day, including Goethe. Arthur benefited considerably from his relationships with these individuals. However, his relationship with his mother became increasingly stormy, and in 1814 she threw him out of the house and never saw him again (Janaway, 1994, p. 3). Schopenhauer was educated at the Universities of Göttingen and Berlin, becoming a teacher at the

latter. While at Berlin, Schopenhauer tested his ability to attract students by scheduling his lectures at the same time as Hegel's; however, he was so unsuccessful at drawing away Hegel's students that he gave up lecturing. Schopenhauer was most influenced by Kant and by ancient philosophies from India and Persia; his study displayed a bust of Kant and a bronze statue of Buddha.

Viewing women as inferior to men was not uncommon at the time, but Schopenhauer was particularly harsh toward women. He said, for example, "Throughout their lives, women remain children, always see only what is nearest to them, cling to the present, take the appearance of things for reality, and prefer trivialities to the most important affairs" (Janaway, 1994, p. 52). Those "trivialities" include love, dress, cosmetics, dancing, and winning a man. Schopenhaeur did concede that women have more "loving kindness" and practicality than men, but he consistently said that women's reasoning powers and character were inferior to those of men.

Schopenhauer never married, but he had a healthy sexual appetite. Most of his relationships were casual and involved prostitutes and servant girls, one of whom bore him a child (Magee, 1997, pp. 18, 258). However, his affair with Caroline Richter, a chorus girl at the National Theatre of Berlin, lasted

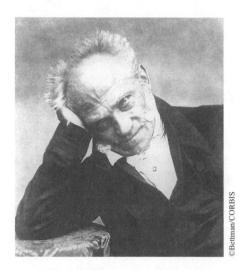

Arthur Schopenhauer

for 10 years. Their friendship continued for the remainder of Schopenhauer's life, and she was a beneficiary in his will (Magee, 1997, p. 258).

Will to Survive. Schopenhauer published the two volumes of his most famous work, *The World as Will and Representation*, in 1818, when he was about 30. Schopenhauer believed that in this work he had unveiled the mysteries of the world, but nearly 17 years after its publication the book had still sold very few copies (Magee, 1997, pp. 19–20). Eventually, however, the book was considered a masterpiece.

Schopenhauer took Kant's philosophy as a basis for his own. Most importantly, he accepted Kant's distinction between the noumenal world (things in themselves) and the phenomenal world (conscious experience). Schopenhauer equated the noumenal world with "will," which he described as a blind, aimless force which cannot be known. In humans, this force manifests itself in the will to survive, which causes an unending cycle of needs and need satisfaction. For Schopenhauer, the powerful drive toward self-preservation-not the intellect and not morality—accounts for most human behavior. Most human behavior, then, is irrational. To satisfy our will to survive, we must eat, sleep, eliminate, drink, and engage in sexual activity. The pain caused by an unsatisfied need causes us to act to satisfy the need. When the need is satisfied, we experience momentary satisfaction (pleasure), which lasts only until another need arises, and on it goes. Schopenhauer's pessimism toward the human condition is clearly shown in the following quotation:

All willing springs from lack, from deficiency, and thus from suffering. Fulfillment brings this to an end; yet for one wish that is fulfilled there remain at least ten that are denied.... No attained object of willing can give a satisfaction that lasts and no longer declines; but it is always like the alms thrown to a beggar, which reprieves him today so that his misery may be prolonged till tomorrow. Therefore, so long as our consciousness is filled by our will, so

long as we are given up to the throng of desires with its constant hopes and fears, so long as we are the subject of willing, we never obtain lasting happiness or peace. (1818/1966, Vol. 1, p. 196)

Momentary pleasure is experienced when a need is satisfied, but when all needs are satisfied, we experience boredom. With Schopenhauer's characteristic pessimism, he said that we work six days a week to satisfy our needs and then we spend Sunday being bored (Viktor Frankl called this boredom Sunday neurosis).

Intelligent Beings Suffer the Most. Suffering varies with awareness. Plants suffer no pain because they lack awareness. The lowest species of animals and insects suffer some, and higher animals still more. Humans, of course, suffer the most, especially the most intelligent humans:

Therefore, in proportion as knowledge attains to distinctness, consciousness is enhanced, pain also increases, and consequently reaches its highest degree in man; and all the more, the more distinctly he knows, and the more intelligent he is. The person in whom genius is to be found suffers most of all. (1818/1966, Vol. 1, p. 310)

Schopenhauer quoted from the book of Ecclesiastes in the Bible to support his contention that intelligent people suffer more than unintelligent people: "In much wisdom there is much grief; and he that increaseth knowledge increaseth sorrow" (1851/1995a, p. 41). Schopenhauer believed that the suffering caused by wisdom had a nobility associated with it but that the life of a fool was simply without higher meaning. There is little doubt which sort of life Schopenhauer believed was most desirable.

According to Schopenhauer, highly intelligent people seek solitude, and vulgar (common) people are gregarious: "The more a man has in himself, the less others can be to him" (1851/1995b, p. 27). For the intellectually gifted, solitude has

two advantages. First, it allows him or her to be alone with his or her own thoughts. Second, it prevents needing to deal with intellectually inferior people, and they, according to Schopenhauer, constitute the vast majority. "Almost all our sufferings," said Schopenhauer, "spring from having to do with other people" (1951/1995b, p. 30). On more than one occasion, Schopenhauer used the same phrase that Hobbes had used to describe the relationship among humans. That is, *homo homini lupus* (man is a wolf to man).

A Life-and-Death Struggle. According to Schopenhauer (1818/1966), another way of viewing life is as the postponement of death. In this life-and-death struggle, however, death must always be the ultimate victor:

The life of our body [is] only a constantly prevented dying, an ever-deferred death.... Every breath we draw wards off the death that constantly impinges on us. In this way, we struggle with it every second, and again at longer intervals through every meal we eat, every sleep we take, every time we warm ourselves, and so on. Ultimately death must triumph, for by birth it has already become our lot, and it plays with its prey only for a while before swallowing it up. However, we continue our life with great interest and much solicitude as long as possible, just as we blow out a soap-bubble as long and as large as possible, although with the perfect certainty that it will burst. (1818/1966, Vol. 1, p. 311)

According to Schopenhauer (1818/1966, Vol. 1, pp. 312–313), most people do not cling to life because it is pleasant. Rather, they cling to life because they fear death.

Sublimation and Denial. Even though these powerful, irrational forces are a natural part of human existence, humans can and should attempt to rise above them. With great effort, humans are capable of approaching nirvana, a state characterized

by freedom from irrational strivings. Schopenhauer anticipated Freud's concept of sublimation when he said that some relief or escape from the irrational forces within us can be attained by immersing ourselves in activities that are not need-related and therefore cannot be frustrated or satiated, activities such as poetry, theatre, art, music, Platonic philosophy, or unselfish, nonsexual, sympathetic love. Also, one can attempt to counteract these irrational forces, especially the sex drive, by living a life of asceticism.

As we have seen, Schopenhauer believed that humans suffer more than other animals because our superior intellect allows us to detect the irrational urges within us. This same intellect, however, provides what little relief is possible from the needneed satisfaction cycle—that is, by pursuing intellectual activities, instead of biological ones. Or we can attack the will head on, depriving it of fulfillment as much as possible. Because, for Schopenhauer, will is the cause of everything, to deny it is to flirt with nothingness. Coming as close as possible to nonexistence is as close as one can get to not being totally controlled by one's will. The will must be served if life is to continue, but one can be a reluctant servant.

Although Schopenhauer was an atheist, he realized that his philosophy of denial had been part of several great religions; for example, Christianity, Hinduism, and Buddhism. In such religions, saints and mystics have been revered for living lives impervious to food, drink, bodily and mental comfort, sex, and worldly goods. In all cases, the aim of this denial is to grasp the illusory nature of the phenomenal world and to free the self from its bondage. Having done this, these saints and mystics come as close to experiencing the noumenal world as possible. What Schopenhauer calls the noumenal world (will), they often refer to as God.

Schopenhauer considered his contribution to these transcendental matters to be a discussion of them within the context of philosophy and without appeal to religious faith or revelation (Magee, 1997, p. 225). Schopenhauer's philosophy raises a number of complex questions concerning human morality, character, and freedom. These questions are ad-

dressed by Atwell, 1990. For an excellent historical review of the complex relationships among free will, determinism, and moral responsibility, see Schopenhauer, 1841/2005.

In reading Schopenhauer, suicide as an escape from human misery comes to mind. Most individuals resist such an adjustment, however, because it is diametrically opposed to the will to survive. This is why, according to Schopenhauer, even a person suffering from a painful, terminal disease finds it very difficult to take his or her life, even when this might be the rational thing to do. Furthermore, Schopenhauer believed that a major goal for humans is to gain insight into their existence. For Schopenhauer the essence of human existence was the relationship between the noumenal (the powerful, aimless will) and the phenomenal (consciousness). As we have seen, this relationship causes an unending cycle of need and need satisfaction. However, for Schopenhauer the proper adjustment to this tragic condition is to struggle to rise above it or, at least, to minimize it. Suicide evades this noble effort and is therefore, according to Schopenhauer, a mistake.

The Importance of the Unconscious Mind. Anticipating Freud, Schopenhauer observed that all humans have positive (intellectual, rational) and negative (animalistic) impulses:

In an excellent parable, Proclus, the Neoplatonist, points out how in every town the mob dwells side by side with those who are rich and distinguished; so, too, in every man, be he never [sic] so noble, and dignified, there is in the depths of his nature, a mob of low and vulgar desires which constitute him an animal. It will not do to let this mob revolt or even so much a peep forth from its hiding-place. (1851/1995b, p. 43)

Elsewhere, Schopenhauer said, "Consciousness is the mere surface of our mind, and of this, as of the globe, we do not know the interior, but only the crust" (1818/1966, Vol. 2, p. 136).

Schopenhauer also spoke of repressing undesirable thoughts into the unconscious and of the resistance encountered when attempting to recognize repressed ideas. Freud credited Schopenhauer as being the first to discover these processes, but Freud claimed that he had discovered the same processes independently of Schopenhauer. In any case, a great deal of Schopenhauer's philosophy resides in Freud's psychoanalytic theory. Besides the ideas of repression and sublimation, Freud shared Schopenhauer's belief that irrational (unconscious) forces were the prime motivators of human behavior and that the best we could do was minimize their influence. Both men were therefore pessimistic in their views of human nature.

EXISTENTIALISM

The romantics were not the only philosophers who rebelled against rationalism, empiricism, and sensationalism (that is, against Enlightenment philosophy). Another philosophy also emphasized the importance of meaning in one's life and one's ability to freely choose that meaning. **Existentialism** stressed the meaning of human existence, freedom of choice, and the uniqueness of each individual. For the existentialists, the most important aspects of humans are their personal, subjective interpretations of life and the choices they make in light of those interpretations. Like the romanticists, the existentialists viewed personal experience and feeling as the most valid guides for one's behavior.

Although it is possible to trace the origins of existential philosophy at least as far back as Socrates, who embraced the Delphic dictate "Know thyself" and said, "An unexamined life is not worth living," one of the first modern existential philosophers was Søren Kierkegaard.

Søren Kierkegaard

The Danish theologian and philosopher **Søren Kierkegaard** (1813–1855) was born on May 5 in Copenhagen. He was the youngest child of a large

family, but he and his older brother were the only children to survive. His father, who was 56 when Kierkegaard was born, was a prosperous, Godfearing merchant. Kierkegaard's mother was his father's servant before he made her his second wife. Kierkegaard said very little about his mother. His father was a stern teacher of religion, and for many years Kierkegaard equated his father with God. It caused a "great earthquake" when in 1835 Kierkegaard's father confessed to sexual excesses, and Kierkegaard responded by rebelling against both his father and religion. He accepted both back into his heart on his 25th birthday, which caused him to experience "indescribable joy." His father died shortly afterward, leaving him a substantial fortune. In deference to his father's wishes, Kierkegaard began a serious study of theology, although he never became a minister.

At the University of Copenhagen, Kierkegaard studied first theology and then literature and philosophy. He had no financial worries and lived a carefree life. About this time, Kierkegaard decided to ask Regina (sometimes spelled Regine) Olsen, whom he had known for several years, to marry him. After a two-year engagement, Kierkegaard felt there was a "divine protest" because the wedding was based on something untrue (he never said what), and in 1841 he wrote a letter to Regina terminating their engagement:

It was a time of terrible suffering: To have to be so cruel and at the same time to love as I did. She fought like a tigress. If I had not believed that God had lodged a veto she would have been victorious. (Bretall, 1946, p. 17)

Kierkegaard went to Regina and asked her forgiveness. He described their farewell:

She said, "promise to think of me." I did so. "Kiss me," she said. I did so, but without passion. Merciful God! And so we parted. I spent the whole night crying in my bed.... When the bonds were broken my thoughts were these: either you throw yourself into the wildest kind of life—or

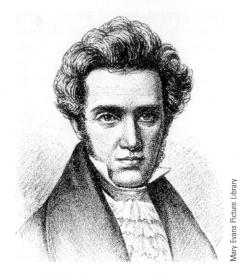

Søren Kierkegaard

else become absolutely religious. (Bretall, 1946, pp. 17–18)

Kierkegaard did the latter. It is interesting to note that Kierkegaard often described a proper relationship with God as a love affair:

Repeatedly Kierkegaard likened the individual's relationship with God to a lover's experience. It is at once painful and happy, passionate but unfulfilled, lived in time yet infinite. Once he had separated himself from Regin[a] Ols[e]n he was free to enter upon his "engagement to God." (Hubben, 1952, p. 24)

After Kierkegaard broke his engagement with Regina, he went to Berlin, where he thrust himself into the study of philosophy and finished his first major book, *Either/Or* (1843).

All his life, Kierkegaard was melancholy and withdrawn. Many entries in his diary (journals) referred to the fact that even when others saw him as happy, he was actually crying inside. The following entry from 1836 exemplifies the difference between Kierkegaard's private and public selves: "I have just returned from a party of which I was the life and soul; wit poured from my lips, everyone

laughed and admired me—but I went away ... and wanted to shoot myself' (Bretall, 1946, p. 7). Some Kierkegaard scholars attribute his melancholia and introversion to his having a hunchback. However, Hubben (1952) believes that the influence of his deformity was probably minimal:

[Kierkegaard] was weak and sickly and he is likely to have derived from his physical impairment the same spirit of bravado that distinguished Dostoevsky and Nietzsche. But whatever the truth about the hunchback may be, it seems safe to remain conservative toward any of its psychological and religious interpretations. (p. 17)

Kierkegaard is generally considered the first modern existentialist, although, as we shall see, Nietzsche developed similar ideas a little later and independently of him. Kierkegaard's ideas received scant attention in his lifetime. He was ridiculed by other philosophers, the public press, and his fellow townspeople, who considered him eccentric. As a student, Kierkegaard rejected Christianity and was a devout follower of Hegel. Later, the situation reversed; he rejected Hegel embraced Christianity. The Christianity Kierkegaard accepted, however, was not that of the institutionalized church. He was an outspoken critic of the established church for its worldliness and its insistence on the acceptance of prescribed dogma. He said that the most meaningful relationship with God was a purely personal one that was arrived at through an individual's free choice, not one whose nature and content were dictated by the church.

Kierkegaard's most influential books include Either/Or (1843), Fear and Trembling (1843), Repetition (1843), Two Edifying Discourses (1843), Philosophical Fragments (1844), The Concept of Anxiety (1844), Stages on Life's Way (1845), Concluding Unscientific Postscript (1846), The Present Age (1846), Edifying Discourses in Various Spirits (1847), Works of Love (1847), The Point of View for My Work as an Author (1848), The Sickness Unto Death (1849), Training in Christianity (1850), Two Discourses at the Communion

on Fridays (1851), The Attack Upon "Christendom" (1854–1855), and The Unchangeableness of God (1855).

Considering his volume of work and its subsequent influence on philosophy and religion, it is incredible to note that Kierkegaard died at the age of 44 on November, 11, 1855.

Religion as Too Rational and Mechanical. In Kierkegaard's time, the Lutheran church was the official church of Denmark. The state considered it its duty to protect and promote Lutheranism, which it did by requiring religious training in all schools and by elevating the clergy to the status of civil servants. Kierkegaard felt strongly that such a system of state control and protection was against the basic tenets of Christianity. The intensely individual nature of the religious experience was, he thought, discouraged by such a system. Kierkegaard ultimately rejected Hegel's philosophy because it placed too much emphasis on the logical and the rational and not enough on the irrational, emotional side of human nature. For the same reason, Kierkegaard rejected science as too mechanistic: he thought it prevented us from viewing humans as emotional and choosing beings. The ultimate state of being, for Kierkegaard, was arrived at when the individual decided to embrace God and take God's existence on faith without needing a logical, rational, or scientific explanation of why or how the decision was determined.

Kierkegaard was deeply concerned that too many Christians, rather than having a true relationship with God, were praying reflexively and accepting religious dogma rationally instead of allowing it to touch them emotionally. Although Kierkegaard would certainly not have agreed with Nietzsche that God is dead (see the next section), he would have agreed that for most people a genuine, personal, emotional relationship with God does not exist and, for those people, it seems that God is dead.

Truth is Subjectivity. According to Kierkegaard, truth is always what a person believes privately and emotionally. Truth cannot be taught by logical argument; truth must be experienced. In the realm of

religion, the more logical we are in our attempt to understand God, the less we comprehend him. Believing in God is a "leap of faith," a choosing to believe in the absence of any factual, objective information. God, who is unlimited and eternal, cannot be explained, understood, or proved logically. He must be taken on faith, and that is a very personal, subjective choice. Attempting to understand Jesus objectively reveals a number of paradoxes. Christ is both God and man; he is eternal truth existing in finite time; he lived almost two thousand years ago but also exists presently; and he violates natural law with his miracles. Facts or logic do not remove these paradoxes; they create them. Belief alone can resolve them; subjectivity, not objectivity, is truth. Christian faith is something that must be lived; it must be felt emotionally. For it can be neither understood nor truly appreciated as a rational abstraction. For Kierkegaard, it is precisely because we cannot know God objectively that we must have faith in his existence:

Without risk there is no faith. Faith is precisely the contradiction between the infinite passion of the individual's inwardness and the objective uncertainty. If I am capable of grasping God objectively, I do not believe, but precisely because I cannot do this I must believe.... Without risk there is no faith, and the greater the risk, the greater the faith; the more objective security, the less inwardness (for inwardness is precisely subjectivity), and the less objective security, the more profound the possible inwardness. (Bretall, 1946, pp. 215, 219)

In Fear and Trembling (1843), Kierkegaard recalled the biblical account of Abraham preparing to sacrifice his son at God's command. The moment that Abraham lifted the knife to kill his son captures what Kierkegaard meant by religious faith. Such faith is a leap into the darkness accompanied by fear, dread, and anguish. It is precisely the discrepancy existing between human understanding and ultimate truth that creates a paradox. The paradox is the understanding that there are things we

can never know, and the greatest paradox of all (the "absolute paradox") is God. We know that God exists, and at the same time, we know that we cannot comprehend him; that is a paradox. Fortunately, God gave humans a way of dealing with such paradoxes, including the absolute paradox, and that was *faith*. We must have faith in eternal truths because there is no way for us to embrace them objectively. The paradox that God became a finite being in the person of Christ can never be explained rationally; it must be taken on faith.

A Love Affair with God. As mentioned previously, Kierkegaard, perhaps reflecting on his ill-fated relationship with Regina Olsen, often referred to an individual's relationship with God as a love affair; it is simultaneously passionate, happy, and painful. He also said that one should read the Bible as one would read a love letter. That is, the reader should let the words touch himself or herself personally and emotionally. The meaning of the words are the emotional impact they have on the reader:

Imagine a lover who has received a letter from his beloved—I assume that God's Word is just as precious to you as this letter is to the lover. I assume that you read and think you ought to read God's Word in the same way the lover reads this letter. (Kierkegaard, 1851/1990, p. 26)

As you do not read a love letter using a dictionary to determine the meaning of its words, neither should you read the Bible that way. The meaning of both the Bible and a love letter is found in the feelings it causes the reader to have. No one should tell you what to feel as you read a love letter or the Bible, nor should anyone tell you what the correct interpretation of either should be. Your feelings and your interpretation define what in the experience is true for you. Truth is subjectivity—your subjectivity.

Approximations to Personal Freedom. *In Either/Or* (1843), Kierkegaard said that the approx-

imation of full personal freedom occurs in stages. First is the aesthetic stage. At this stage, people are open to experience and seek out many forms of pleasure and excitement, but they do not recognize their ability to choose. People operating at this level are hedonistic, and such an existence ultimately leads to boredom and despair. Second is the ethical stage. People operating at this level accept the responsibility of making choices but use as their guide ethical principles established by others—for example, church dogma. Although Kierkegaard considered the ethical level higher than the aesthetic level, people operating on the ethical level are still not recognizing and acting on their full personal freedom. Kierkegaard referred to the highest level of existence as the religious stage. At this stage, people recognize and accept their freedom and enter into a personal relationship with God. The nature of this relationship is not determined by convention or by generally accepted moral laws but by the nature of God and by one's self-awareness. People existing on this level see possibilities in life that often run contrary to what is generally accepted, and therefore they tend to be nonconformists.

Friedrich Wilhelm Nietzsche

Friedrich Wilhelm Nietzsche (1844-1900), born on October 15 near Leipzig, was the son of a Lutheran minister and grandson of two clergymen. Nietzsche was 5 years old when his father died, and he grew up in a household consisting of his mother, sister, two maiden aunts, and his grandmother. He was a model child and an excellent student; by the time he was 10, he had written several plays and composed music. At the age of 14, he entered the famous Pforta Boarding School, where religion was one of his best subjects; he also excelled in his study of Greek and Roman literature. In 1864, he entered Bonn University. where he expressed disgust for the beer drinking and carousing behavior of his fellow students. When Nietzsche's favorite teacher (Friedrich Ritschl) transferred from Bonn to the University

of Leipzig, Nietzsche followed him there. Nietzsche's student days ended when, at the age of 24, he accepted an offer he received from the University of Basel to teach classical philology (the study of ancient language and thought) even before he had received his doctorate. He taught at Basel for 10 years before poor health forced his retirement at the age of 35. His most influential books followed his academic retirement.

During his years at Basel, Nietzsche wrote *The Birth of Tragedy: Out of the Spirit of Music* (1872) and *Untimely Meditations* (1873–1876), both strongly influenced by and supportive of Schopenhauer's philosophy. After his retirement, his books began to reflect his own thoughts. The most influential of those books were *Human*, *All-Too-Human* (1878), *The Dawn of Day* (1881), *The Gay Science* (1882), *Thus Spoke Zarathustra* (1883–1885), *Beyond Good and Evil* (1886), *Toward a Genealogy of Morals* (1887), *The Twilight of the Idols* (1889), *The Antichrist* (1895), and *Nietzsche Contra Wagner* (1895). His last books, *The Will to Power* (1904) and his autobiography *Ecce Homo* (1908), were published posthumously.

In April 1882, at the age of 37, Nietzsche began a relationship with Lou Salomé, the attractive, intelligent, 21-year-old daughter of a Russian general. Hollingdale (1969) described this relationship as "the one wholly serious sexual involvement of Nietzsche's life" (p. 20). Nietzsche looked upon

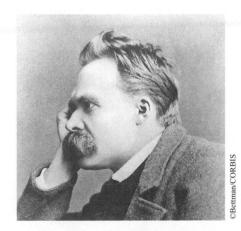

Friedrich Wilhelm Nietzsche

Lou as his intellectual equal and envisioned continuing his life's work with her as his partner. He proposed marriage twice, once through a friend and once directly. In both cases Lou said no. Tanner (2000) refers to this rejection as "the single most devastating experience of Nietzsche's life" (p. 67). It was in the aftermath of this experience that Nietzsche began work on Thus Spoke Zarathustra. Some see a relationship between Nietzsche's rejection by Lou Salomé and the tone of Zarathustra. For example, Tanner (2000) says, "Zarathustra is prone to depressions, collapses, coma, and paralyzing selfdoubt, all of which make identification of him with his author irresistible" (p. 68). Also, as we will see, Nietzsche himself believed that all philosophy is autobiographical. Incidentally, Lou Salomé eventually married Friedrich Carl Andreas, an orientalist. Later in life, Lou Andreas-Salomé developed an interest in psychoanalysis and became one of Freud's most valued friends and disciples (Gay, 1988, pp. 192-193; Weber and Welsch, 1997). For some of the more colorful details concerning Lou Andreas-Salomé's involvement in the Freudian inner circle, see Roazen, 1992, pp. 311–322. For an insight into Lou Andreas-Salomé's personal involvement with psychoanalysis and her firsthand accounts of the schisms that occurred during its formative years, see Leavy, 1964.

From about 1880, Nietzsche became increasingly isolated from everyday life. On the morning of January 3, 1889, Nietzsche saw a cab driver beating his horse. In sympathy he tearfully threw his arms around the horse's neck and then collapsed. Later he was taken to an asylum where he began identifying himself as such individuals as the Duke of Cumberland, the Kaiser, Dionysus, "The Crucified," and even God (Haymen, 1999, pp. 54-55). According to Hubben (1952), "Medical opinions about his illness have always been divided, but the syphilitic infection and subsequent paresis are likely to have been among the determining factors in his breakdown" (p. 99). Nietzsche's condition continued for 11 years. He died on August 25, 1900, a few weeks before his 56th birthday. He was buried in his hometown in the

Mary Evans/Sigmund Freud Copyrights

Lou Andreas-Salomé

cemetery of the church where his father had baptized him.

The Apollonian and Dionysian Aspects of Human Nature. Nietzsche believed that there are two major aspects of human nature, the Apollonian and the Dionysian. The Apollonian aspect of human nature represents our rational side, our desire for tranquility, predictability, and orderliness. The Dionysian aspect of human nature represents our irrational side, our attraction to creative chaos and to passionate, dynamic experiences. According to Nietzsche, the best art and literature reflect a fusion of these two tendencies, and the best life reflects controlled passion. Nietzsche believed that Western philosophy had emphasized the intellect and minimized the human passions. and the result was lifeless rationalism. Nietzsche saw as one of his major goals the resurrection of the Dionysian spirit. Do not just live, he said, live with passion. Do not live a planned, orderly life; take chances. Even the failures that may result from taking chances could be used to enhance personal growth. Thus, what Nietzsche was urging was

not a totally irrational, passionate life but a life of reasonable passion, a life worthy of both Apollo and Dionysus.

Nietzsche the Psychologist. Nietzsche viewed himself as primarily a psychologist: "That a psychologist without equal speaks from my writing, is perhaps the first insight reached by a good reader—a reader as I deserve him" (Golomb, 1989, p. 13). Indeed, as we shall see, much of what would later appear in Freud's writings appeared first in Nietzsche's. Furthermore, Freudian and Nietzschian psychology shared the goal of helping individuals gain control of their powerful, irrational impulses in order to live more creative, healthy lives.

At the heart of Nietzsche's psychology is the tension between Apollonian and Dionysian tendencies. The Dionysian tendency, which he referred to as "barbarian," could not express itself unabated without destroying the individual. Nietzsche anticipated Freud by referring to these barbarian urges as das es, or the id. For Dionysian impulses (what Freud called primary processes) to gain expression, they must be modified (sublimated) by Apollonian rationality (what Freud called secondary processes). For both Nietzsche and Freud, this sublimation explains works of art and other cultural achievements, and it also explains the content of dreams. Dreams provide an example of barbarian chaos modified by Apollonian rationality, the modification creating what we remember as a dream. Without the Dionysian influence, the Apollonian aspect of personality would be without emotional content: "Apollo could not live without Dionysus" (Golomb, 1989, p. 48). Likewise, without the Apollonian influence, the Dionysian aspect of personality would remain formless. If Dionysian impulses become too threatening, Apollonian rationality can repress them. Nietzsche often discussed the concept of repression, which later was to become the cornerstone of Freudian psychoanalysis. For example, Beyond Good and in (1886/1998a) Nietzsche said, "'I have done that,' says my memory. 'I cannot have done that,' says my pride and remains unshakeable. Finally memory yields" (p. 58).

A major disagreement between Nietzschian and Freudian psychologies concerns determinism; Freud accepted determinism and Nietzsche did not. In clear anticipation of modern existential philosophy, Nietzsche said, "Every man is a unique miracle"; "We are responsible to ourselves for our own existence"; and "Freedom makes us responsible for our characters just as artists are responsible for their creations" (Golomb, 1989, pp. 123, 128, 129). We are, however, only potentially free. Personality is an artist's creation, but some people are better artists than others. If people use their will to power (see below) to mold the ingredients available to them into an authentic, unique personality, they are free. If they live in accordance with moral standards not of their own creation, they are slaves. The difference, then, between freedom and slavery is a matter of choice: "Everyone who wishes to become free must become free through his own endeavor.... Freedom does not fall into any man's lap as a miraculous gift" (Golomb, 1989, p. 244).

The Death of God. In The Gay Science (1882/ 2001, pp. 119-120), Nietzsche has a madman proclaim that "God is dead" and hail this as one of the most significant events in human history. When people ignore him, the madman concludes, "I come too early.... My time is not yet." He continues, "This deed is still more remote to them than the remotest stars—and yet they done it themselves." Nietzsche (1889/1998b) asked, "Is man just one of God's mistakes? Or is God just one of man's?" (p. 5). In any case, Nietzsche announced that God was dead and that we had killed him. By we he meant the philosophers and scientists of his day. Because we humans had relied on God for so long for the ultimate meaning of life and for our conceptions of morality, we are lost now that he is dead. Where do we now look for meaning? For moral ideals? The same philosophers and scientists who killed God also took purpose from the universe, as was found in Aristotle's teleological philosophy, and stripped humans of any special place in the world. Evolutionary theory, for example, showed that humans have the same lowly origin as other living organisms and share the same fate: death.

Furthermore, evolutionary principles are without purpose. Natural selection simply means that organisms possessing traits that allow adaptation to the environment will survive and reproduce. Thus, humans cannot even take pride or find meaning in the fact that they have survived longer or differently than other species. Evolution in no way implies improvement. Nietzsche described Darwinian theory as "true but deadly" (Golomb, 1989, p. 138). Astronomy too had shown that humans do not occupy a special place in the universe. The earth is simply a medium-size ball of clay revolving around one of hundreds of billions of suns.

Thus, there is no God who cares for us, our species occupies no significant station in the animal kingdom, and the earth is just one more meaningless heavenly body. With the death of God came the death of his shadows (metaphysics) as well. Without religion, science, and metaphysics, humans are left in a "cosmic tabula rasa" without transcendental principles or forces to guide them. According to Nietzsche, the absence of these traditional sources of meaning and morality means that humans are on their own. For Nietzsche, there are no abstract truths waiting to be discovered by all; there are only individual perspectives. Even the various philosophies that have been created through the ages are to be understood as elaborations of individual perspectives: "Every great philosophy to date has been the personal confession of its author, a kind of unintended and unwitting memoir" (1886/1998a, p. 8). Thus, according to Nietzsche, all philosophies, including his own, are autobiographical.

Of course, Nietzsche's **perspectivism** was directly contrary to Enlightenment philosophy and is seen, by many, as the forerunner of postmodernism (see Chapter 21).

Opinions versus Convictions. In *Human, All Too Human* (1878/2006), Nietzsche said, "Convictions are more dangerous enemies of truth than lies" (p. 209). He defined *conviction* as the "belief in the possession of absolute truth on any matter of knowledge" (p. 236). It is, according to Nietzsche, **convictions** that have caused countless humans to sacrifice themselves throughout history. In the realm of

religion, convictions are common and are unchallengeable for those entertaining them because "To allow their belief to be wrested from them probably meant calling in question their eternal salvation" (p. 237). **Opinions** are different because they are tentative, challengeable, and easily modified in light of new information. In other words, convictions are thought to reflect Truth and opinions truth; convictions reflect certainty, opinions probability. It is, according to Nietzsche, convictions that cause fanaticism, not opinions.

It is not the struggle of opinions that has made history so turbulent; but the struggle of belief in opinions,—that is to say, of convictions. If all those who thought so highly of their convictions, who made sacrifices of all kinds for them, and spared neither honour, body, nor life in their service, had only devoted half of their energy to examining their right to adhere to this or that conviction and by what road they arrived at it, how peaceable would the history of mankind now appear! How much more knowledge would there be! (p. 237)

Will to Power. According to Nietzsche, the answer to our predicament can be found only within ourselves. Humans need to acquire knowledge of themselves and then act on that knowledge. Meaning and morality cannot (or should not) be imposed from the outside; it must be discovered within. Such self-examination reveals that the most basic human motive is the will to power. Like Schopenhauer, Nietzsche believed that humans are basically irrational. Unlike Schopenhauer, however, Nietzsche thought that the instincts should not be repressed or sublimated but should be given expression. Even aggressive tendencies should not be totally inhibited. The will to power can be fully satisfied only if a person acts as he or she feels—that is, acts in such a way as to satisfy all instincts: "The will to power is the primitive motive force out of which all other motives have been derived" (Sahakian, 1981, p. 80). Even happiness, which the utilitarians and

others claimed to be so important as a motive, is the result of the increase in one's power: "The only reality is this: The will of every centre of power to become stronger—not self-preservation, but the desire to appropriate, to become master, to become more, to become stronger" (Sahakian, 1981, p. 80). And in The Gay Science, Nietzsche said, "The great and the small struggle always revolves around superiority, around growth and expansion, around power—in accordance with the will to power which is the will of life" (1882/1974, p. 292). For Nietzsche, then, all conceptions of good, bad, and happiness are related to the will to power:

What is good? Everything that heightens the feeling of power in man, the will to power, power itself. What is bad? Everything that is born of weakness. What is happiness? The feeling that power is growing, that resistance is overcome. (Kaufmann, 1982, p. 570)

Thus, Nietzsche disagreed with anyone who claimed that the master human motive was self-preservation (such as Spinoza and Schopenhauer). Humans do not attempt to preserve themselves; rather they attempt to become more than they were, or at least, according to Nietzsche, this is what they should attempt.

Supermen. The will to power is the tendency to gain mastery over one's self and one's destiny. If given expression, the will to power causes a person to seek new experiences and to ultimately reach his or her full potential. Such individual growth cannot (or should not) be inhibited by conventional morality and thus must go "beyond good and evil." People approaching their full potential are **supermen** because standard morality does not govern their lives. Instead, they rise above such morality and live independent, creative lives. Nietzsche declared that "All gods are dead: now we want the Superman to live" (1883–1885/1969, p. 104).

It is in *Thus Spoke Zarathustra* that Nietzsche most fully described his concept of the superman. (It should be noted that Nietzsche's term

Übermensch can be translated as "overman," "higherman," or "superman.") After 10 years of solitude and contemplation in the mountains, Zarathustra decides to return to civilization and share his insights with his fellow humans (it should be clear that the character Zarathustra was speaking Nietzsche's thoughts):

I teach you the Superman. Man is something that should be overcome. What have you done to overcome him? ... What is the ape to men? A laughing-stock or a painful embarrassment. And just so shall man be to the Superman: A laughing-stock or a painful embarrassment. You have made your way from worm to man, and much in you is still worm.... Behold, I teach you the Superman. The Superman is the meaning of the earth. Let your will say: The Superman shall be the meaning of the earth! I entreat you, my brothers, remain true to the earth, and do not believe those who speak to you of superterrestrial hopes! They are poisoners, whether they know it or not. They are despisers of life, atrophying and self-poisoned men, of whom the earth is weary; so let them be gone! (Nietzsche, 1883–1885/1969, pp. 41–42)

Humans are in a precarious position. We are no longer animals, we are not yet supermen, and God, being dead, cannot help us: "Man is a rope, fastened between animal and Superman—a rope over an abyss. A dangerous going-across, a dangerous wayfaring, a dangerous looking-back, a dangerous shuddering and staying-still" (Nietzsche,1883–1885/1969, p. 43). The problems characterizing the human condition are solved one person at a time. If every individual strove to be all that he or she could be, more general human problems would solve themselves. A prerequisite, then, for an improvement in the human condition is self-improvement or self-love:

Physician, heal yourself: Thus you will heal your patient too. Let his best healingaid be to see with his own eyes him who makes himself well. There are a thousand paths that have never yet been trodden, a thousand forms of health and hidden islands of life. Man and man's earth are still unexhausted and undiscovered.... Truly, the earth shall yet become a house of healing! And already a new odour floats about it, an odour that brings health—and a new hope! (Nietzsche, 1883–1885/1969, pp. 102–103)

The superman, as we have seen, exercises his will to power by expressing all thoughts, even negative ones:

Let us *speak* of this, you wisest men, even if it is a bad thing. To be silent is worse; all suppressed truths become poisonous. And let everything that can break upon our truths—break! There is many a house still to build! (Nietzsche, 1883–1885/1969, p. 139)

Like Goethe, Nietzsche did not believe that negative experiences or impulses should be denied. Rather, one should learn from such experiences. Nietzsche believed that the journey toward one's personal heaven often requires traveling through one's personal hell. Nietzsche (1889/1998b) said, "Whatever does not kill me makes me stronger" (p. 5) and gave the following example:

I have often asked myself whether I am not more heavily obligated to the hardest years of my life than to any others.... And as for my long sickness, do I not owe it indescribably more than I owe to my health? I owe it a higher health—one which is made stronger by whatever does not kill it. I also owe my philosophy to it. Only great pain is the ultimate liberator of the spirit.... Only great pain, that long, slow pain in which we are burned with green wood, as it were-pain which takes its time—only this forces us philosophers to descend into our ultimate depths and to put away all trust, all good-naturedness, all that would veil, all mildness, all that is

medium—things in which formerly we may have found our humanity. I doubt that such a pain makes us "better," but I know that it makes us more *profound*. (Kaufmann, 1982, pp. 680–681)

The notion of supermen was Nietzsche's answer to the human moral and philosophical dilemma. The meaning and morality of one's life come from within oneself. Healthy, strong individuals seek self-expansion by experimenting, by living dangerously. Life consists of an almost infinite number of possibilities, and the healthy person (the superman) explores as many of them as possible. Religions or philosophies that teach pity, humility, submissiveness, self-contempt, self-restraint, guilt, or a sense of community are simply incorrect. On the other hand, Nietzsche very much admired the ancient Cynics (see Chapter 3) and referred to them often in his works. What he especially appreciated about Cynicism was its criticism of conventional morality (Pröbsting-Niehues, 1996, p. 359). For Nietzsche, the good life is ever-changing, challenging, devoid of regret, intense, creative, and risky. It is self-overcoming. Acting in accordance with the will to power means living a life of becoming more than vou were, a life of continual self-renewal. Science, philosophy, and especially religion can only stifle the good life—the life of the superman. Any viewpoint that promotes herd conformity as opposed to individuality should be actively avoided. Nietzsche believed that repressive civilization is the primary cause of humans' mental anguish, a belief later shared by Freud.

The meaning of life, then, is found within the individual, and the daring, the supermen, will find it there: "Only dare to believe in yourselves—in yourselves and in your entrails! He who does not believe in himself always lies" (Nietzsche, 1883–1885/1969, p. 146). To be a superman, one must necessarily be intensely individualistic; and yet, all supermen have in common the same philosophy of life: "I am Zarathustra the godless: Where shall I find my equal? All those who give themselves their own will and renounce all submission, they are my equals" (Nietzsche, 1883–1885/1969, p. 191).

Thus, Nietzsche advised people to use their will to power to combine their Dionysian and Apollonian tendencies in their own unique way. This artistic creation is the only meaningful basis of morality. Beyond this concept, Nietzsche gave living. general formula for Through Nietzsche (1883–1885/1969) re-Zarathustra, sponded to those looking to him for a philosophy of life: "'This ... is ... my way: where is yours?' Thus I answered those who asked me 'the way.' For the way—does not exist!" (p. 213). And earlier through Zarathustra, Nietzsche said, "One repays a teacher badly if one remains only a pupil" (p. 103).

For Nietzsche then, it was important for each individual to find the meaning in his or her own life and then to live in accordance with that meaning. Very much in accordance with what was later called existentialism, Nietzsche said, "If you have your *why?* for life, then you can get along with almost any *how?*" (1889/1998b, p. 6).

Misunderstanding of Nietzsche's Supermen. Throughout history, scientific and philosophical works have often been distorted in order to support political ideologies. Nietzsche's philosophy is an example. His philosophy was embraced by the German National Socialists (the Nazis), who claimed that the German people were the supermen to whom Nietzsche referred. For the Nazis, supermen meant "superior men," and the Germans were, they believed, superior. Nothing could have been more alien to Nietzsche than the thought of national or racial superiority. Nietzsche dissolved his close relationship with the famous German composer Richard Wagner partly because Wagner held strong nationalistic and anti-Semitic views (Blackburn, 1994, p. 262). Each individual, according to Nietzsche, has the potential to be a superman. What differentiates the superman from the nonsuperman is passion, courage, and insightnothing else. As examples of supermen, Nietzsche offered the historical Jesus, Goethe (from whom superman), term Nietzsche borrowed the Dostoevsky, and himself. Freud agreed that Nietzsche should be on the list of supermen: "[Freud] said of Nietzsche that he had a more penetrating knowledge of himself than any other man who ever lived or was ever likely to live. From the first explorer of the unconscious this is a handsome compliment" (Jones, 1955, p. 344).

Again, both Schopenhauer and Nietzsche believed that irrational instincts strongly influence human behavior. But whereas Schopenhauer believed that such instincts should be repressed, Nietzsche thought that they should be largely expressed. In this regard, Freud was influenced most by Schopenhauer, whereas one of Freud's early followers, Alfred Adler, was influenced more by Nietzsche. Not only did Adler stress the gaining of power in order to overcome feelings of inferiority, he also shared Nietzsche's belief that weak individuals often gain power over others by eliciting their pity or by hurting them with their suffering. Freud also recognized this phenomenon in his concept of "secondary gains" from neuroses. Freud's colleague Carl Jung was also influenced by Nietzsche. In Jung's famous distinction between introversion and extroversion, the introvert was viewed as dominated by the Apollonian tendency and the extrovert by the Dionysian tendency (Golomb, 1989, p. 35).

KIERKEGAARD AND NIETZSCHE

Nietzsche was apparently unaware of Kierkegaard's work, yet he developed ideas that were in many ways similar to Kierkegaard's. Like Kierkegaard, Nietzsche rejected what was conventionally accepted, such as the organized church and science.

For both men, Hegelian philosophy was a favorite target, and both men preached reliance on direct, personal experience. The major difference between the two was that Kierkegaard accepted the existence of God, whereas for Nietzsche God did not exist. Both Kierkegaard and Nietzsche alienated almost everyone, especially the establishment. For example, almost no one bought Kierkegaard's books when they were published. Three years after the publication of his *Philosophical Fragments* (1844/1985), it had sold 229 copies from a printing of 525 (Hong and Hong, 1985, p. xix). Now *Fragments* is highly regarded and considered one of Kierkegaard's finest, most influential works.

The romantic and early existential philosophers had much in common. Indeed, Nietzsche is as often described as a romantic as he is an existentialist. The themes running through both philosophies are an emphasis on human emotions; the importance of subjective experience; a deep respect for individuality; a belief in free will; and a distrust of the grandiose theories of human nature created by the rationalists, empiricists and sensationalists, and natural scientists. The latter theories, they believed, minimized the importance of the individual attempting to make sense out of his or her life and freely acting upon his or her interpretations of life's meaning.

Today romanticism and existentialism have combined to form the third-force movement in psychology, exemplified by the theories of Rogers, Maslow, May, and Kelly, which we will explore in Chapter 18. Also, many of the concerns of the romantic and existential philosophers are echoed in postmodernism, which will be discussed in Chapter 21.

SUMMARY

The accomplishments of individuals such as Hobbes, Bacon, Descartes, and Newton ushered into Western philosophy a period called the Enlightenment. The Enlightenment was characterized by skepticism toward religious dogma and

other forms of traditional authority. There was widespread optimism that the principles governing the universe could be discovered and applied to the betterment of humankind. Under the umbrella of the Enlightenment, the philosophies of empiricism,

sensationalism, and rationalism pictured humans as complex machines, products of experience, or highly rational beings operating in accordance with lofty, abstract principles. In the opinion of some, all these philosophies left something important out of their analyses—the irrational aspect of humans. Those philosophers stressing the importance of human irrationality were called romantics. In general, the romantics emphasized inner, personal experience and distrusted both science and the philosophers who pictured humans as products of experience, as machines, or as totally rational beings.

Rousseau is usually considered the father of modern romanticism. He believed that humans are born free and good but are soon contaminated by society. As a guide for living and for believing, the natural impulses of the "heart" could be trusted. Rousseau believed that humans have both an individual will and a general will and that for government to work, people must deny their individual will. Education should take into consideration a child's natural curiosity rather than attempting to mold a child as if he or she were a lump of clay or a blank tablet. Goethe, a scientist, poet, and philosopher, viewed life as consisting of choices between conflicting forces (such as good and evil, love and hate). He believed that the best life is one lived with passion and that results in selfexpansion. He also believed that the physical sciences, although effective in providing useful information about the physical world, are of limited value when it comes to understanding people.

Following Kant, Schopenhauer distinguished between the noumenal world (things in themselves) and the phenomenal world (consciousness). What Kant called the noumenal world, Schopenhauer called the universal will. When manifested in an individual human, the universal will becomes the will to survive, which is the most powerful motive for human behavior. Life, according to Schopenhauer, consists of an unending cycle of needs and need satisfaction. Because intelligent organisms are most aware of their needs, they suffer more than unintelligent organisms do. Satisfying our needs simply postpones death, which is inevita-

ble. The only way to minimize human suffering is to deny or minimize one's needs. Needs can be sublimated into such pursuits as music, art, and poetry. Also, the rational mind can repress undesirable thoughts and hold them in the unconscious mind. For Schopenhauer, the rational mind could and should inhibit the powerful needs related to biological survival. Schopenhauer's philosophy had a considerable influence on Freud's psychoanalytic theory.

Another reaction against Enlightenment philosophy was existentialism. The existentialist stressed meaning in life, freedom of choice, subjective experience, personal responsibility, and the uniqueness of the individual. Kierkegaard is generally considered the first modern existential philosopher. He believed that rationalistic philosophy, science, and the organized church discouraged people from having a deep, personal relationship with God. Logic and facts have nothing to do with such a relationship, which must be based on faith alone. By one's accepting God on faith, God becomes a living, emotional reality in one's subjective experience. For Kierkegaard, the only truth is subjective truth—that is, truth that exists as a personal belief. Furthermore, accepting the reality of God reveals a number of logical paradoxes that cannot be resolved logically. The existence of God cannot and need not be proved by rational argument; it can only be taken on faith. One should become emotionally involved with God and read his word (the Bible) as one would read a love letter.

Nietzsche agreed with Schopenhauer that many human desires are irrational but disagreed with him that they should be repressed or sublimated. For Nietzsche, the basic human motive is the will to power, which is satisfied when a person acts as he or she feels. Acting on irrational instincts causes a person to have new experiences and thus to develop greater potential as a person. According to Nietzsche, science, religion, rationalism, and empiricism stifle irrationality and thereby inhibit human development. Nietzsche believed that rational philosophy and science had emphasized the Apollonian, or rational, aspect of human nature at the expense of the Dionysian aspect. He believed that giving reasonable

expression to both aspects of human nature is best. He also believed that science and philosophy had made it impossible for people to accept religious superstition as a guide for living. As a substitution, Nietzsche proposed individually determined values and beliefs. The only source of information for what is good or bad, desirable or undesirable, is the individual. According to Nietzsche, there are no universal truths, only individual perspectives. There is considerable similarity between Nietzsche's perspectivism and contemporary postmodernism. Nietzsche distinguished between opinions and convictions.

Opinions are tentative beliefs that are modified in light of new information. Convictions are beliefs thought to reflect some absolute truth and are immutable and dangerous. Nietzsche referred to humans who have the courage to live in accordance with their own values, thus rising above conventional morality, as supermen (higher men). Supermen experiment with life and are constantly in the process of becoming something other than what they were.

The influence of romanticism and existentialism in modern psychology is seen in psychoanalysis, humanistic psychology, and postmodernism.

DISCUSSION QUESTIONS

- What was romanticism a reaction against?
 Discuss the major features of the romantic movement.
- 2. What assumptions did Rousseau make about human nature? What did he mean by his statement "Man is born free yet we see him everywhere in chains"?
- 3. What did Rousseau and Hobbes have in common? In what ways did they disagree?
- 4. Discuss Rousseau's distinction between the individual will and the general will.
- 5. Summarize Rousseau's views on education.
- 6. How did Goethe view life? What was his attitude toward science? What were his contributions to psychology?
- 7. For Schopenhauer, what is the primary motive for human behavior? Discuss the implications of this motive for human existence.
- 8. Why is Schopenhauer's philosophy generally referred to as pessimistic?
- 9. What did Schopenhauer suggest we could do to minimize the influence of the powerful, irrational forces within us?
- 10. What is existentialism? How does existentialism differ from romanticism?
- 11. What type of religion did Kierkegaard oppose? Which type did he promote?

- 12. What did Kierkegaard mean by his statement "Truth is subjectivity"?
- 13. Describe the type of relationship Kierkegaard believed individuals should have with God.
- 14. Describe what Kierkegaard referred to as the three stages toward full personal freedom.
- 15. What were the important aspects of Freudian psychoanalysis anticipated by Nietzsche?
- Discuss the importance of innate Dionysian and Apollonian tendencies for Nietzsche's psychology.
- 17. Discuss Nietzsche's views on personal freedom.
- 18. What, according to Nietzsche, were the implications of the death of God (and his "shadows") for human existence?
- 19. Discuss Nietzsche's perspectivism in relation to Enlightenment philosophy.
- 20. Discuss Nietzsche's distinction between opinions and convictions. Which did he believe had a negative influence on human history?
- 21. According to Nietzsche, what are supermen? Give an example of how Nietzsche's conception of supermen has been misunderstood.
- 22. Of what, according to Nietzsche, would a rich, meaningful life consist?
- 23. What did the philosophies of romanticism and existentialism have in common?

SUGGESTIONS FOR FURTHER READING

- Gardiner, P. (2002). *Kierkegaard: A very short introduction*. New York: Oxford University Press.
- Golomb, J. (1989). Nietzsche's enticing psychology of power. Ames, IA: Iowa State University Press.
- Hayman, R. (1999). Nietzsche. New York: Routledge.
- Janaway, C. (2002). Schopenhauer: A very short introduction. New York: Oxford University Press.
- Kaufmann, W. (Ed. and Trans.). (1982). The portable Nietzsche. New York: Viking Books/Penguin Press.
- Magee, B. (1997). *The philosophy of Schopanhauer* (rev. ed.). New York: Oxford University Press.
- Nietzsche, F. (1969). *Thus Spoke Zarathustra*. (R. J. Hollingdale, Trans.). New York: Viking

- Books/Penguin Press. (Original work published 1883–1885)
- Rousseau, J. J. (1947). *The social contract.* (C. Frankel, Trans.). New York: Macmillan. (Original work published 1762)
- Rousseau, J. J. (1974). *Emile*. (B. Foxley, Trans.). (Original work published 1762) London: Dent.
- Tanner, M. (2000). Nietzsche: A very short introduction. New York: Oxford University Press.
- Watkin, J. (1997). Kierkegaard. New York: Geoffrey Chapman.
- Wokler, R. (1995). Rousseau. New York: Oxford University Press.

GLOSSARY

Aesthetic stage According to Kierkegaard, the first stage in the growth toward full personal freedom. At this stage, the person delights in many experiences but does not exercise his or her freedom.

Apollonian aspect of human nature According to Nietzsche, that part of us that seeks order, tranquillity, and predictability.

Convictions According to Nietzsche, beliefs that are thought to correspond to some absolute truth and, as such, are immutable and dangerous. (*See also* **Opinions**.)

Dionysian aspect of human nature According to Nietzsche, that part of us that seeks chaos, adventure, and passionate experiences.

Enlightenment A period during which Western philosophy embraced the belief that unbiased reason or the objective methods of science could reveal the principles governing the universe. Once discovered, these principles could be used for the betterment of humankind.

Ethical stage According to Kierkegaard, the second stage in the growth toward full personal freedom. At this stage, the person makes ethical decisions but uses principles developed by others as a guide in making them.

Existentialism The philosophy that examines the meaning in life and stresses the freedom that humans have to choose their own destiny. Like romanticism, existentialism stresses subjective experience and the uniqueness of each individual.

General will According to Rousseau, the innate tendency to live harmoniously with one's fellow humans.

Goethe, Johann Wolfgang von (1749–1832) Believed that life is characterized by choices between opposing forces and that much about humans is forever beyond scientific understanding.

Kierkegaard, Søren (1813–1855) Believed that religion had become too rational and mechanical. He believed that a relationship with God should be an intensely personal and a highly emotional experience, like a love affair. Taking the existence of God on faith makes God a living truth for a person; thus Kierkegaard contended that truth is subjectivity.

Nietzsche, Friedrich Wilhelm (1844–1900) Claimed that humans could no longer rely on religious superstition or metaphysical speculation as guides for living; instead, they must determine life's meaning for themselves. By exercising their will to power, people can continue to grow and overcome conventional morality. The term superman described those who experimented with life and feelings and engaged in continuous self-overcoming.

Noble savage Rousseau's term for a human not contaminated by society. Such a person, he believed, would live in accordance with his or her true feelings, would not be selfish, and would live harmoniously with other humans.

Opinions According to Nietzsche, beliefs that are tentative and modifiable in light of new information and, therefore, reasonable. (*See also* **Convictions**.)

Perspectivism Nietzsche's contention that there are no universal truths, only individual perspectives.

Religious stage According to Kierkegaard, the third stage in the growth toward full personal freedom. At this stage, the person recognizes his or her freedom and chooses to enter into a personal relationship with God.

Romanticism The philosophy that stresses the uniqueness of each person and that values irrationality much more than rationality. According to the romantic, people can and should trust their own natural impulses as guides for living.

Rousseau, Jean-Jacques (1712–1778) Considered the father of modern romanticism, Rousseau believed that human nature is basically good and that the best society is one in which people subjugate their individual will to the general will. The best education occurs when education is individualized and when a student's natural abilities and curiosity are recognized.

Schopenhauer, Arthur (1788–1860) Believed that the will to survive is the most powerful human motive. Life is characterized by a cycle of needs and need satisfaction, and need satisfaction simply postpones death. The most people can do is to minimize the irrational forces operating within them by sublimating or repressing those forces.

Supermen The name Nietzsche gave to those individuals who have the courage to rise above conventional morality and herd conformity and to follow their own inclinations instead. The German word *Übermensch* can be translated as "overman," "higherman," or "superman."

Will to power According to Nietzsche, the basic human need to become stronger, more complete, more superior. While satisfying the will to power, a person continually becomes something other than he or she was.

Will to survive According to Schopenhauer, the powerful need to perpetuate one's life by satisfying one's biological needs.

Early Developments in Physiology and the Rise of Experimental Psychology

S cientific achievements of the 17th and 18th centuries allowed ancient philosophical questions to be examined in new, more precise ways. Much had been learned about the physical world, and it was now time to direct scientific method toward the study of the mechanisms by which we come to know the physical world. Basically, the question was, By what mechanisms do empirical events come to be represented in consciousness? Everything from sense perception to motor reactions was studied intensely, and this study eventually gave birth to experimental psychology. If we are interested in discovering the origins of psychology, we need to go back to the early Greeks. If, however, we are interested in the origins of *experimental* psychology, we must look to early developments in physiology, anatomy, neurology, and even astronomy.

INDIVIDUAL DIFFERENCES

It was astronomers who first realized that the type of knowledge human physiology provided might be useful to all sciences. In 1795, astronomer Nevil Maskelyne and his assistant David Kinnebrook were setting ships' clocks according to when a particular star crossed a hairline in a telescope. Maskelyne noticed that Kinnebrook's observations were about a half-second slower than his. Kinnebrook was warned of his "error" and attempted to correct it. Instead, however, the discrepancy between his observations and Maskelyne's increased to

8/10ths of a second, and Kinnebrook was relieved of his duty. Twenty years later, the incident came to the attention of the German astronomer Friedrich Bessel (1784-1846), who speculated that the error had not been due to incompetence but to individual differences among observers. Bessel set out to compare his observations with those of his colleagues and indeed found systematic differences among them. This was the first reaction-time study, and it was used to correct differences among observers. This was done by calculating personal equations. For example, if 8/10ths of a second was added to Kinnebrook's reaction time, his observations could be equated with Maskelyne's. Bessel found systematic differences among individuals and a way to compensate for those differences, but his findings did not have much impact on the early development of experimental psychology. As we will see, the early experimental psychologists were interested in learning what was true about human consciousness in general; therefore, individual differences found among experimental subjects were generally attributed to sloppy methodology. Later in psychology's history (after Darwin), the study of individual differences was to be of supreme importance.

Bessel did show, however, that the observer influenced observations. Because all of science was based on observation, it was now necessary to learn more about the processes that converted physical stimulation into conscious experience.

DISCREPANCY BETWEEN OBJECTIVE AND SUBJECTIVE REALITY

Of course, the demonstration of *any* discrepancy between a physical event and a person's perception of that event was of great concern to the natural scientists, who viewed their jobs as accurately describing and explaining the physical world. The problem created by Galileo's and Locke's distinction between primary and secondary qualities could

be avoided by simply concentrating on primary qualities—that is, concentrating on events for which there was a match between their physical qualities and the sensations that they create. It was becoming increasingly clear, however, that the mismatch between physical events and the perceptions of those events was widespread. Newton (1704/1952) had observed that the experience of white light is really a composite of all colors of the spectrum, although the individual colors themselves are not perceived. In 1760 Van Musschenbroek discovered that if complementary colors such as yellow and blue are presented in proper proportions on a rapidly rotating disc, an observer sees neither yellow nor blue but gray. It was evident that often there was not a pointto-point correspondence between physical reality and the psychological experience of that reality. Because the most likely source of the discrepancy was the responding organism, the physical scientists had reason to be interested in the new science of physiology, which studied the biological processes by which humans interact with the physical world. Physiologists studied the nature of nerves, neural conduction, reflexive behavior, sensory perception, brain functioning, and, eventually, the systematic relationship between sensory stimulation and sensation. It was the work of physiologists that provided the link between mental philosophy and the science of psychology.

Besides showing the influence of the observer on observations, the personal equation was important because the quantitative assessment that it allowed began to cast doubt on the claims of Kant and others that psychology could not be a science because mathematics could not be applied to psychological phenomena. In general, however, it was noting the discrepancy between physical and psychological (subjective) reality that made anatomy, physiology, and, eventually, psychology important aspects of science. In a sense, the physical sciences made scientific psychology inevitable:

Once the physical sciences were started and well under way, it was inevitable that scientific psychology should arise. The older sciences themselves made it necessary. Investigators were repeatedly having their attention drawn to the observing organism and to the necessity of taking its reactions into consideration in order to make their own accounts exact and complete. (Heidbreder, 1933, p. 74)

We will see in this chapter that the question concerning how the makeup of humans influences what humans observe was addressed mainly by physiologists. Later, this concern was incorporated into the new science of psychology. Thus, to a large extent, both the content of what was to become psychology and the methodologies used to explore that content were furnished by physiology.

We turn next to a summary of the major observations made by physiologists that eventually gave birth to the new science of psychology.

BELL-MAGENDIE LAW

Until the 19th century, two views prevailed about what nerves contained and how they functioned. One was Descartes's view that a nerve consisted of fibers that connected sense receptors to the brain. These fibers were housed in hollow tubes that transmitted the "animal spirits" from the brain to the muscles. The second was Hartley's view that nerves were the means by which "vibrations" were conducted from the sense receptors to the brain and from the brain to the muscles. In 1811 the great British physiologist Charles Bell (1774-**1842)** printed and distributed to his friends 100 copies of a pamphlet that was to radically change the view of neural transmission. His pamphlet summarized his research on the anatomical and functional discreteness of sensory and motor nerves. Operating on rabbits, Bell demonstrated that sensory nerves enter the posterior (dorsal) roots of the spinal cord and the motor nerves emerge from the anterior (ventral) roots. Bell's discovery separated nerve physiology into the study of sensory and motor functions—that is, into a study of sensation and

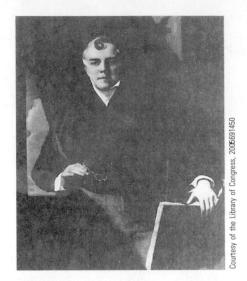

Charles Bell

movement. Bell's finding was significant because it demonstrated that specific mental functions are mediated by different anatomical structures. That is, separate nerves control sensory mechanisms and responses. Bell himself speculated that there was a much more detailed relationship between sensory nerves and sensation, but Johannes Müller actually supported Bell's speculations with experimental evidence. Müller's extension of Bell's findings is reviewed shortly.

That there are sensory and motor nerves is an ancient idea going back as far as Eristratus of Alexandria (ca. 300 B.C.) and Galen in the second century A.D. In fact, both Descartes and Hartley speculated about the possibility. It was Bell, however, who substantiated the idea with clear-cut, experimental evidence. As mentioned, Bell circulated his findings only among his friends. This can explain why the prominent French physiologist François Magendie (1783-1855) could publish results similar to Bell's 11 years later without being aware of Bell's findings. A heated debate arose among Bell's and Magendie's followers about the priority of the discovery of the distinction between sensory and motor nerves. History has settled the issue by referring to the discovery as the Bell-Magendie law. (For the details on the

François Magendie

Bell-versus-Magendie controversy, see Cranefield, 1974.)

After Bell and Magendie, it was no longer possible to think of nerves as general conveyers of vibrations or spirits. Now a "law of forward direction" governed the nervous system. Sensory nerves carried impulses forward from the sense receptors to the brain, and motor nerves carried impulses forward from the brain to the muscles and glands. The Bell–Magendie law demonstrated separate sensory and motor tracts in the spinal cord and suggested separate sensory and motor regions in the brain.

DOCTRINE OF SPECIFIC NERVE ENERGIES

As we have just seen, the Bell–Magendie law indicated that nerves were neither hollow tubes transmitting animal spirits to and from the brain nor general structures performing both sensory and motor functions. Bell and Magendie had verified two different types of nerves with two different functions. As mentioned, Bell had also suggested that there are different types of sensory nerves. In fact, Bell suggested, but did not prove, that each of the

five senses was served by a separate type of sensory nerve.

Johannes Müller

Born on July 14 in Koblenz, Germany, the great physiologist Johannes Müller (1801-1858) expanded the Bell-Magendie law by devising the doctrine of specific nerve energies. After receiving his doctorate from the University of Bonn in 1822, Müller remained there as professor until 1833, when he accepted the newly created chair of physiology at the University of Berlin. The creation of this chair at Berlin marked the acceptance of physiology as a science (R. I. Watson, 1978). Following Bell's suggestion, Müller demonstrated that there are five types of sensory nerves, each containing a characteristic energy, and that when they are stimulated, a characteristic sensation results. In other words, each nerve responds in its own characteristic way no matter how it is stimulated. For example, stimulating the eye with light waves, electricity, pressure, or by a blow to the head will all cause visual sensations. Emil Du Bois-Reymond, one of Müller's students, went so far as to say that if we could cut and cross the visual and auditory nerves, we would hear with our eyes and see with our ears (Boring, 1950, p. 93).

Müller's detailed experimental research put to final rest the old emanation theory of perception, according to which tiny copies of physical objects went through the sensory receptors, along the nerves, and to the brain, causing an image of the object. According to this old view, any sensory nerve could convey any sensory information to the brain.

Adequate Stimulation. Although Müller claimed that various nerves contain their own specific energy, he did not think that all the sense organs are equally sensitive to the same type of stimulation. Rather, each of the five types of sense organs is maximally sensitive to a certain type of stimulation. Müller called this "specific irritability," and it was later referred to as adequate stimulation. The eye is most easily stimulated by light waves, the ear by

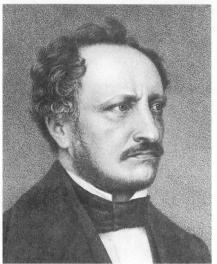

Johannes Müller

sound waves, the skin by pressure, and so on. The eye can be stimulated by pressure, but pressure is a less adequate stimulus for vision than is a light wave. As we experience the environment, this differential sensitivity of the various senses provides an array of sensations. In this way, a "picture" of the physical environment is formed, but the nature of the picture—for example, how articulated it is-depends on the sensory systems that humans possess.

For Müller, then, the correspondence between our sensations and objects in the physical world is determined by our senses and their specific irritability. Müller agonized over the question of whether the characteristics of the nerve itself or the place in the brain where the nerve terminates accounts for specificity. He concluded that the nerve was responsible, but subsequent research proved that brain location is the determinant.

We Are Conscious of Sensations, Not of Physical Reality. The most significant implication of Müller's doctrine for psychology was that the nature of the central nervous system, not the nature of the physical stimulus, determines our sensations. According to Müller, we are aware not of objects in the physical world but of various sensory

impulses. It follows that our knowledge of the physical world must be limited to the types of sense receptors we possess.

An ardent Kantian, Müller believed that he had found the physiological equivalent of Kant's categories of thought. According to Kant, sensory information is transformed by the innate categories of thought before it is experienced consciously. For Müller, the nervous system is the intermediary between physical objects and consciousness. Kant's nativism stressed mental categories, whereas Müller's stressed physiological mechanisms. In both cases, sensory information is modified, and therefore what we experience consciously is different from what is physically present. For Müller, however, sensations did not exhaust mental life. In his famous Handbuch der Physiologie der Menschen (Handbook of Human Physiology, 1833-1840), in a section titled "Of the Mind," he postulated a mind capable of attending to some sensations to the exclusion of others. Thus, even in his otherwise mechanistic system, Müller found room for an active mind, again exposing his allegiance to Kant.

Müller was one of the greatest experimental physiologists of his time. His Handbuch summarized what was known about human physiology at the time. Müller also established the world's first Institute for Experimental Physiology at the University of Berlin. In addition, Müller anticipated what would become the close relationship between physiology and psychology. He said, "Nobody can be a psychologist, unless he first becomes a physiologist" (Fitzek, 1997, p. 46).

Most of those destined to become the most prominent physiologists of the 19th century studied with Müller, including Helmholtz, to whom we turn next.

HERMANN VON HELMHOLTZ

Many consider Hermann von Helmholtz (1821-**1894)** to be the greatest scientist of the 19th century. As we will see, he made significant contributions in physics, physiology, and psychology. Helmholtz, born on August 31 in Potsdam, Germany, was a frail child and a mediocre student who was especially poor at foreign languages and poetry. Helmholtz's apparent mediocrity as a student, however, seemed to reflect the inadequacy of his teachers because he spent his spare time reading scientific books and working out the geometrical principles that described the various configurations of his play blocks. His father was a teacher who did not have enough money to pay for the scientific training that his son desired. Fortunately, the government had a program under which talented students could go to medical school free if they agreed to serve for eight years as army surgeons following graduation. Helmholtz took advantage of this program and enrolled in the Berlin Royal Friedrich-Wilhelm Institute for Medicine and Surgery when he was 17 years old. While in his second year of medical school, he began his studies with Johannes Müller.

Helmholtz's Stand against Vitalism

Although Helmholtz accepted many of Müller's conclusions, the two men still had basic disagreements, one of them over Müller's belief in vitalism. In biology and physiology, the vitalism-materialism problem was much like the mind-body problem in philosophy and psychology. The vitalists maintained that life could not be explained by the interactions of physical and chemical processes alone. For the vitalists, life was more than a physical process and could not be reduced to such a process. Furthermore, because it was not physical, the "life force" was forever beyond the scope of scientific analysis. Müller was a vitalist. Conversely, the materialists saw nothing mysterious about life and assumed that it could be explained in terms of physical and chemical processes. Therefore, there was no reason to exclude the study of life or of anything else from the realm of science. Helmholtz sided with the materialists, who believed that the same laws apply to living and nonliving things, as well as to mental and nonmental events. So strongly did Helmholtz and several of his fellow students believe in materialism that they signed the following oath (some say in their own blood):

No other forces than the common physical-chemical ones are active within the organism. In those cases which cannot at the time be explained by these forces one has either to find the specific way or form of their action by means of the physical mathematical method, or to assume new forces equal in dignity to the physical-chemical forces inherent in matter, reducible to the force of attraction and repulsion. (Bernfeld, 1949, p. 171)

In addition to Helmholtz, others who signed the oath were Du Bois-Reymond (who became a professor of physiology at the University of Berlin when Müller died), Karl Ludwig (who became a professor of physiology at the University of Leipzig, where he influenced a young Ivan Pavlov), and Ernst Brücke (who became a professor of physiology at the University of Vienna, where he taught and befriended Sigmund Freud). What this group accepted when they rejected vitalism were the beliefs that living organisms, including humans, were complex machines (mechanism) and that these machines consist of nothing but material substances (materialism). The mechanistic-materialistic philosophy embraced by these individuals profoundly influenced physiology, medicine, and psychology.

Principle of Conservation of Energy

Helmholtz obtained his medical degree at the age of 21 and was inducted into the army. While in the army, he was able to build a small laboratory and to continue his early research, which concerned metabolic processes in the frog. Helmholtz demonstrated that food and oxygen consumption were able to account for the total energy that an organism expended. He was thus able to apply the already popular **principle of conservation of energy** to living organisms. According to this principle, which previously had been applied to physical phenomena, energy is never created or lost in a system but is only transformed from one form to another. When applied to living organisms, the principle was

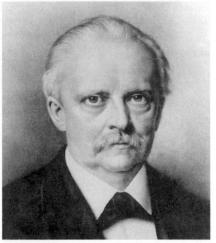

Psychology Archives-The University of Akron

Hermann von Helmholtz

clearly in accordance with the materialist philosophy because it brought physics, chemistry, and physiology closer together. In 1847 Helmholtz published a paper titled "The Conservation of Force," and it was so influential that he was released from the remainder of his tour of duty in the army.

In 1848 Helmholtz was appointed lecturer of anatomy at the Academy of Arts in Berlin. The following year, he was appointed professor of physiology at Königsberg, where Kant had spent his entire academic life. It was at Königsberg that Helmholtz conducted his now famous research on the speed of nerve conduction.

Rate of Nerve Conduction

Helmholtz disagreed with Müller not only over the issue of vitalism but also over the supposed speed of nerve conduction. Müller had maintained that nerve conduction was almost instantaneous, making it too fast to measure. His view reflected the ancient belief, still very popular during Müller's time, that there was a vital, nonmaterial agent that moved instantaneously and determined the behavior of living organisms. Many earlier philosophers had believed that the mind or the soul controlled bodily actions and that, because the mind and soul were inspired by God, their effect throughout the

entire body was instantaneous. Those believing in animal spirits, a vital force, or in a nonmaterial mind or soul believed that measuring the speed of nerve conduction was impossible.

Helmholtz, however, excluded nothing from the realm of science, not even the rate of nerve conduction. To measure the rate of nerve conduction, Helmholtz isolated the nerve fiber leading to a frog's leg muscle. He then stimulated the nerve fiber at various distances from the muscle and noted how long it took the muscle to respond. He found that the muscular response followed more quickly when the motor nerve was stimulated closer to the muscle than when it was stimulated farther away from the muscle. By subtracting one reaction time from the other, he concluded that the nerve impulse travels at a rate of about 90 feet per second (27.4 meters per second). Helmholtz then turned to humans, asking his subjects to respond by pushing a button when they felt their leg being stimulated. He found that reaction time was slower when the toe was stimulated than when the thigh was stimulated; he concluded, again by subtraction, that the rate of nerve conduction in humans was between 165 and 330 feet per second (50.3–100.6 meters per second). This aspect of Helmholtz's research was significant because it showed that nerve impulses are indeed measurable—and, in fact, they are fairly slow. This was taken as further evidence that physical-chemical processes are involved in our interactions with the environment instead of some mysterious process that was immune to scientific scrutiny.

Although the measure of reaction time was extremely useful to Helmholtz in measuring the speed of nerve conduction, he found that it varied considerably among subjects and even for the same subject at different times. He concluded that reaction time was too unreliable to be used as a valid measure and abandoned it. Support for his doubts came years later when more precise measurements indicated that the nerve conduction speeds he had reported were too slow. But this does not detract from the importance of Helmholtz's pioneering research.

Theory of Perception

Although he believed that the physiological apparatus of the body provides the mechanisms for sensation, Helmholtz thought that the past experience of the observer is what converts a sensation into a perception. Sensations, then, are the raw elements of conscious experience, and perceptions are sensations after they are given meaning by one's past experiences. In explaining the transformation of sensations into perceptions, Helmholtz relied heavily on the notion of unconscious inference. According to Helmholtz, to label a visual experience a "chair" involves applying a great deal of previous experience, as does looking at railroad tracks converging in the distance and insisting that they are parallel. Similarly, we see moving pictures as moving because of our prior experience with events that create a series of images across the retina. And we learn from experience that perceived distance is inversely related to the size of the retinal image. Helmholtz decided that the perception of depth arises because the retinal image an object causes is slightly different on the two retinas. Previous experience with such retinal disparity causes the unconscious inference of depth. Helmholtz was very reluctant to use the term unconscious inference because it suggested the type of mysterious process that would violate his oath, but he could not find a better term.

Helmholtz supported his empirical theory of perception with the observation that individuals who are blind at birth and then acquire sight need to learn to perceive, even though all the sensations furnished by the visual apparatus are available. His classic experiments with lenses that distorted vision provided further evidence. Helmholtz had subjects wear lenses that displaced the visual field several inches to the right or left. At first, the subjects would make mistakes in reaching for objects; but after several minutes perceptual adaptation occurred, and even while wearing the glasses, the subjects could again interact accurately with the environment. When the glasses were removed, the subjects again made mistakes for a short time but soon recovered.

One by one, Helmholtz took the supposed innate categories of thought Kant had proposed and showed how they were derived from experience. Concerning the axioms of geometry, which Kant had assumed were innate, Helmholtz said that if our world were arranged differently, our experience would be different, and therefore, our axioms would be different.

Helmholtz and Kant agreed, however, on one important point: The perceiver transforms what the senses provide. For Kant this transformation was accomplished when sensory information was structured by the innate faculties of the mind. For Helmholtz the transformation occurred when sensory information was embellished by an individual's past experience. Kant's account of perception was therefore nativistic and Helmholtz's was empiricistic. With his notion of unconscious inference, Helmholtz came very close to what would later be considered part of psychology. That is, for unconscious inference to convert a sensation into a perception, memories of previous learning experiences must interact with current sensations. Although the processes of learning and memory were later to become vital to psychology, Helmholtz never considered himself a psychologist. He believed that psychology was too closely allied with metaphysics, and he wanted nothing to do with metaphysics.

Theory of Color Vision

Helmholtz performed his work on vision between 1853 and 1868 at the Universities of Königsberg, Bonn, and Heidelberg, and he published his results in the three-volume *Handbook of Physiological Optics* (1856–1866). Many years before Helmholtz's birth, Thomas Young (1773–1829) had proposed a theory of color vision very similar to Helmholtz's, but Young's theory had not been widely accepted. Helmholtz changed Young's theory slightly and buttressed it with experimental evidence. The theory we present here has come to be called the **Young-Helmholtz theory of color vision** (also called the trichromatic theory).

In 1672 Newton had shown that if white sunlight was passed through a prism, it emerged as a band of colored lights with red on one end of the band, then orange, yellow, green, blue, indigo, and, finally, violet. The prism separated the various wavelengths that together were experienced as white. Early speculation was that a different wavelength corresponded to each color and that different color experiences resulted from experiencing different wavelengths. However, Newton himself saw difficulties with this explanation. When he mixed various wavelengths, it became clear to him that the property of color was not in the wavelengths themselves but in the observer. For example, white is experienced either if all wavelengths of the spectrum are present or if wavelengths corresponding to the colors red and blue-green are combined. Similarly, a person cannot distinguish the sensation of orange caused by the single wavelength corresponding to orange from the sensation of orange caused by mixing red and yellow. The question was how to account for the lack of correspondence between the physical stimuli present and the sensations they cause.

Helmholtz's answer was to expand Müller's doctrine of specific nerve energies by postulating three different types of color receptors on the retina. That is, instead of saying that color vision had one specific nerve energy associated with it, as Müller had thought, Helmholtz claimed it involved three separate receptors, each with its own specific energy. It was already known that various combinations of three colors—red, green, and blue-violet, the additive primary colors—could produce all other colors. Helmholtz speculated that there are three types of color receptors corresponding to the three primary colors. If a red light is shown, the so-called red receptors are stimulated, and one has the sensation of red; if a green light is shown, the green receptors are stimulated, and one has the experience of green; and so on. If all these primaries are shown at once, one experiences white. If the color shown is not a primary color, it would stimulate various combinations of the three receptors, resulting in a subjective color experience corresponding to the combination of wavelengths present. For example, presenting a red and a green light simultaneously would produce the subjective color experience of yellow. Also, the same color experience could be caused by several different patterns of the three receptor systems firing. In this way, Helmholtz explained why many physical wavelengths give rise to the same color experience.

The Young-Helmholtz theory of color vision was extremely helpful in explaining many forms of color blindness. For example, if a person lacks one or more of the receptor systems corresponding to the primary colors, he or she will not be able to experience certain colors subjectively, even though the physical world has not changed. The senses therefore actualize elements of the physical world that otherwise exist only as potential experiences.

Helmholtz was continually amazed at the way physiological mechanisms distort the information a person receives from the physical world, but he was even more amazed at the mismatch between physical events and psychological sensations (such as the experience of color). Helmholtz expressed his feelings as follows:

The inaccuracies and imperfections of the eye as an optical instrument, and the deficiencies of the image on the retina, now appear insignificant in comparison with the incongruities we have met with in the field of sensation. One might almost believe that Nature had here contradicted herself on purpose in order to destroy any dream of a preexisting harmony between the outer and the inner world. (Kahl, 1971, p. 192)

Theory of Auditory Perception

For audition, as he had done for color vision, Helmholtz further refined Müller's doctrine of specific nerve energies. He found that the ear is not a single sense receptor but a highly complex system of many receptors. Whereas the visual system consists of three types of nerve fibers, each with its own specific nerve energy, the auditory system contains thousands of types of nerve fibers, each with its

own specific nerve energy. Helmholtz found that when the main membrane of the inner ear, the basilar membrane, was removed and uncoiled, it was shaped much like a harp. Assuming that this membrane is to hearing what the retina is to seeing, Helmholtz speculated that the different fibers along the basilar membrane are sensitive to differences in the frequency of sound waves. The short fibers respond to the higher frequencies, the longer fibers to the lower frequencies. A wave of a certain frequency causes the appropriate fiber of the basilar membrane to vibrate, thus causing the sensation of sound corresponding to that frequency. This process was called sympathetic vibration, and it can be demonstrated by stimulating a tuning fork of a certain frequency and noting that the string on a piano corresponding to that frequency also begins to vibrate. Helmholtz assumed that a similar process occurs in the middle ear and that, through various combinations of fiber stimulation, one could explain the wide variety of auditory experiences we have. This theory is referred to as the resonance place theory of auditory perception. Variations of Helmholtz's place theory persist today.

Theory of Signs

Although Helmholtz was an empiricist in his explanations of sensation and perception, he did reflect the German Zeitgeist by postulating an active mind. According to Helmholtz, the mind's task was to create a reasonably accurate conception of reality from the various "signs" that it receives from the body's sensory systems. Helmholtz assumed that a dynamic relationship exists among volition, sensation, and reflection as the mind attempts to create a functional view of external reality. Helmholtz's view of the mind differed from that of Kant because Kant believed that the mental categories of thought automatically present a conception of reality. Helmholtz's view of the mind also differed from that of most of the British empiricists and French sensationalists because they saw the mind as largely passive. For Helmholtz the mind's job was to construct a workable conception of reality given the

incomplete and perhaps distorted information furnished by the senses (Turner, 1977).

Helmholtz's Contributions

Although Helmholtz did postulate an active mind, he accepted the empirical explanation of the origins of the contents of that mind. In his explanations of sensation (the mental event that results from sensory stimulation) and perception (sensation plus unconscious inference), Helmholtz was emphatically empirical. In studying physiological and psychological phenomena, he was unequivocally scientific. He showed that nerve transmission is not instantaneous, as had previously been believed, but that it is rather slow and reflects the operation of physical processes. More than anyone before him, Helmholtz showed with experimental rigor the mechanisms by which we do commerce with the physical world—mechanisms that could be explained in terms of objective, physical laws. Although he found that the match between what is physically present and what is experienced psychologically is not very good, he could explain the discrepancy in terms of the properties of the receptor systems and the unconscious inferences of the observer. No mystical, unscientific forces were involved. Helmholtz's work brought physics, chemistry, physiology, and psychology closer together. In so doing, it paved the way for the emergence of experimental psychology, which was in many ways an inevitable step after Helmholtz's work. (For an excellent discussion of Helmholtz's contributions to modern science and of the cultural climate in which they were made, see Cahan, 1994.)

Helmholtz realized a lifelong ambition when he was appointed professor of physics at the University of Berlin in 1871. In 1882 the German emperor granted him noble status, and thereafter his name was Hermann von Helmholtz. In 1893 Helmholtz came to the United States to see the Chicago World's Fair and to visit with William James. On his way back to Germany, he fell aboard ship and suffered cuts and bruises but was apparently not badly injured. Following the accident, however, he complained of a general lack of

energy. The next year he suffered a cerebral hemorrhage and died on September 8, 1894.

EWALD HERING

In Helmholtz's time, there was intense controversy over whether perceptual phenomena were learned or innate. Helmholtz, with his notion of unconscious inference, sided with those who said perceptions were learned. Ewald Hering (1834-1918) sided with the nativists. After receiving his medical degree from the University of Leipzig, Hering stayed there for several years before accepting a post as lecturer at the Vienna Military Medical Academy, where he worked with Josef Breuer (1842-1925), who was later to be instrumental in the founding of psychoanalysis (see Chapter 16). Working together, Hering and Breuer showed that respiration was, in part, caused by receptors in the lungs-a finding called the Hering-Breuer reflex. In 1870 Hering was called to the University of Prague, were he succeeded the great physiologist Jan E. Purkinje (1787–1869). Like Goethe, to whom Purkinje dedicated one of his major works, Purkinje was a phenomenologist. He believed that the phenomena of the mind, arrived at by careful introspective analysis, should be what physiologists attempt to explain. According to Purkinje, the physiologist is obliged to explain not only "normal" sensations and perceptions but "abnormal" ones as well, such as illusions and afterimages. Among the many phenomena that Purkinje observed was that the relative vividness of colors is different in faint light than it is in bright light. More specifically, as twilight approaches, hues that correspond to short wavelengths such as violet and blue appear brighter than hues corresponding to longer wavelengths such as yellow and red. This change in relative vividness, as a function of luminance level, is known as the Purkinje shift. Hering also was a phenomenologist, and his theory of color vision, which will be considered shortly, was based to a large extent on the phenomenon of negative afterimages.

Space Perception

On the matter of space perception, we have seen that Helmholtz believed that it slowly develops from experience as physiological and psychological events are correlated. Hering, however, believed that, when stimulated, each point on the retina automatically provides three types of information about the stimulus: height, left-right position, and depth. Following Kant, Hering believed that space perception exists a priori. For Kant space perception was an innate category of the mind; for Hering it was an innate characteristic of the eye.

Theory of Color Vision

After working on the problem of space perception for about 10 years, Hering turned to color vision. Hering observed a number of phenomena that he believed either were incompatible with the Young-Helmholtz theory or could not be explained by it. He noted that certain pairs of colors, when mixed together, give the sensation of gray. This was true for red and green, blue and yellow, and black and white. He also observed that a person who stares at red and then looks away experiences a green afterimage; similarly, blue gives a yellow afterimage. Hering also noted that individuals who have difficulty distinguishing red from green could still see yellow; also, it is typical for a color-blind person to lose the sensation of both red and green, not just one or the other. All these observations at least posed problems for the Young-Helmholtz theory, if they did not contradict it.

To account for these phenomena, Hering theorized that there are three types of receptors on the retina but that each could respond in two ways. One type of receptor responds to red-green, one type to yellow-blue, and one type to black-white. Red, yellow, and white cause a "tearing down," or a *catabolic process*, in their respective receptors. Green, blue, and black cause a "building up," or an *anabolic process*, in their respective receptors. If both colors to which a receptor is sensitive are experienced simultaneously, the catabolic and ana-

4eprinted by permission of Open Court Publishing Company, a division of Carcus Publishing Company, from Philosophical Portrait Series, © 1898 by Dpen Court Publishing Company.

Ewald Hering

bolic processes are canceled out, and the sensation of gray results. If one color to which a receptor is sensitive is experienced, its corresponding process is depleted, leaving only its opposite to produce an afterimage. Finally, Hering's theory explained why individuals who cannot respond to red or green can still see yellow and why the inability to see red is usually accompanied by an inability to see green.

For nearly 50 years, lively debate ensued between those accepting the Young–Helmholtz theory and those accepting Hering's; the matter is still far from settled. The current view is that the Young–Helmholtz theory is correct in that there are retinal cells sensitive to red, green, and blue but that there are neural processes beyond the retina that are more in accordance with Hering's proposed metabolic processes.

CHRISTINE LADD-FRANKLIN

Born on December 1, Christine Ladd (1847–1930) graduated from the then new Vassar College in 1869. She pursued her interest in mathematics at the also new Johns Hopkins University and, although she completed all the requirements for a doctorate in 1882, the degree was not granted

because she was a woman. She was, however, given an honorary degree by Vassar in 1887. When the social climate became less discriminating against women, she was granted her doctorate from Johns Hopkins in 1926, 44 years after she had completed her graduate work (she was nearly 80 years old at the time).

In 1882 Vassar married Fabian Franklin, a mathematics professor at Johns Hopkins. During her husband's sabbatical leave in Germany, Christine Ladd-Franklin was able to pursue an interest in psychology she had developed earlier (she had published a paper on vision in 1887). Although, at the time, women were generally excluded from German universities, she managed to be accepted for a year (1891–1892) in Georg E. Müller's laboratory at Göttingen, where Hering's theory of color vision was supported. After her year under Müller's influence, she studied with Helmholtz at the University of Berlin, where she learned about his trichromatic theory of color vision.

Before leaving Europe, Ladd-Franklin was ready to announce her own theory of color vision, which she believed improved upon those of Helmholtz and Hering. She presented her theory at the International Congress of Experimental Psychology in London in 1892. Upon returning to the United States, Ladd-Franklin lectured on logic and psychology at Johns Hopkins until she and her husband moved to New York, where she lectured and promoted her theory of color vision at Columbia University from 1910 until her death in 1930.

Ladd-Franklin's theory of color vision was based on evolutionary theory. She noted that some animals are color blind and assumed that achromatic vision appeared first in evolution and color vision came later. She assumed further that the human eye carries vestiges of its earlier evolutionary development. She observed that the most highly evolved part of the eye is the fovea, where, at least in daylight, visual acuity and color sensitivity are greatest. Moving from the fovea to the periphery of the retina, acuity is reduced and the ability to distinguish colors is lost. However, in the periphery

Christine Ladd-Franklin

of the retina, night vision and movement perception are better than in the fovea. Ladd-Franklin assumed that peripheral vision (provided by the rods of the retina) was more primitive than foveal vision (provided by the cones of the retina) because night vision and movement detection are crucial for survival. But if color vision evolved later than achromatic vision, was it not possible that color vision itself evolved in progressive stages?

After carefully studying the established color zones on the retina and the facts of color blindness, Ladd-Franklin concluded that color vision evolved in three stages. Achromatic vision came first, then blue-yellow sensitivity, and finally red-green sensitivity. The assumption that the last to evolve would be the most fragile explains the prevalence of red-green color blindness. Blue-yellow color blindness is less frequent because it evolved earlier and is less likely to be defective. Achromatic vision is the oldest and therefore the most difficult to disrupt.

Ladd-Franklin, of course, was aware of Helmholtz's and Hering's theories, and, although she preferred Hering's theory, her theory was not offered in opposition to either. Rather, she attempted to explain in evolutionary terms the origins of the anatomy of the eye and its visual abilities.

After initial popularity, Ladd-Franklin's theory fell into neglect, perhaps because she did not have adequate research facilities available to her. Some believe, however, that her analysis of color vision still has validity (see, for example, Hurvich, 1971). For interesting biographical sketches of Ladd-Franklin, see Furumoto (1992) and Scarborough and Furumoto (1987).

EARLY RESEARCH ON BRAIN FUNCTIONING

Toward the end of the 18th century, it was widely believed that a person's character could be determined by analyzing his or her facial features, body structure, and habitual patterns of posture and movement. Such an analysis was called **physiognomy** (Jahnke, 1997, p. 30). One version of physiognomy that became extremely popular was phrenology.

Phrenology

Not long after Reid and others (see Chapter 6) had listed what they thought were the faculties of the mind, others were to revise faculty psychology substantially. One was **Franz Joseph Gall** (1758–1828). Gall accepted the widely held belief that faculties of the mind acted on and transformed sensory information, but he made three additional claims that changed the history of faculty psychology:

- The mental faculties do not exist to the same extent in all humans.
- The faculties are housed in specific areas of the brain.
- If a faculty is well developed, a person would have a bump or protrusion on the corresponding part of the skull. Similarly, if a faculty is underdeveloped, a hollow or depression would be on the corresponding part of the skull.

Thus, Gall believed that the magnitude of one's faculties could be determined by examining the bumps and depressions on one's skull. Such an anal-

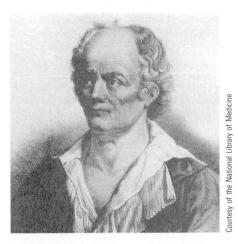

Franz Joseph Gall

ysis was called **phrenology**. Gall's idea was not necessarily a bad one. In fact, Gall was among the first to attempt to relate certain personality traits and overt behavior patterns to specific brain functions. The problem was the type of evidence he accepted to demonstrate this relationship. He would observe that someone had a pronounced personality characteristic and a well-developed brain structure and then attribute one to the other. After observing such a relationship in one individual, he would generalize it to all individuals. In their research on the mental faculties, some of Gall's followers exceeded even his shoddiness:

If Gall was cavalier in his interpretations of evidence, he attracted some followers who raised that tendency to an art form. When a cast of Napoleon's right skull predicted qualities markedly at variance with the emperor's known personality, one phrenologist replied that his dominant side had been the left—a cast of which was conveniently missing. When Descartes's skull was examined and found deficient in the regions for reason and reflection, phrenologists retorted that the philosopher's rationality had always been overrated. (Fancher, 1990, p. 79)

Although Gall is usually reviewed negatively in the history of psychology, he made several positive contributions to the study of brain functioning. For example, he studied the brains of several animal species, including humans, and was the first to suggest a relationship between cortical development and mental functioning. He found that larger, better-developed cortices were associated with more intelligent behavior. In addition, he was the first to distinguish the functions of gray matter and white matter in the brain. These discoveries alone qualify Gall for recognition in the history of psychology, but there is more. As the 19th century began, the idea that different cortical regions are associated with different functions was becoming popular. This, in large part, was due to Gall: "In the minds of most historians, Gall, more than any other scientist, put the concept of cortical localization into play" (Finger, 1994, p. 32).

The Popularity of Phrenology. The term phrenology was actually coined by Thomas Foster in 1815 (Bakan, 1966). Gall rejected the term (he preferred physiognomy), but it was accepted and made popular by his student and colleague Johann Kaspar Spurzheim (1776–1832). The dissemination of phrenology into English-speaking countries was facilitated by Spurzheim's The Physiognomical System of Drs. Gall and Spurzheim (1815) and by the translation of Gall's On the Functions of the Brain and Each of Its Parts: With Observations on the Possibility of Determining the Instincts, Propensities, and Talents, or the Moral and Intellectual Dispositions of Men and Animals, by the Configuration of the Brain and Head (1835).

Phrenology became enormously popular and was embraced by some of the leading intellectuals in Europe (such as Bain and Comte). One reason for the popularity of phrenology was Gall's considerable reputation. Another was that phrenology provided hope for an objective, materialistic analysis of the mind: "The central theme that runs through all of the phrenological writings is that man himself could be studied scientifically, and in particular that the phenomena of mind could be studied

objectively and explained in terms of natural causes" (Bakan, 1966, p. 208).

Phrenology was also popular because, unlike mental philosophy, it appeared to offer practical information. For these reasons phrenology was also embraced enthusiastically in the United States. For example, the Central Phrenological Society was founded in Philadelphia in 1822 by Charles Caldwell (1772–1853). In 1824 Caldwell published Elements of Phrenology, the first American textbook on phrenology. In 1827 a second edition of Elements was published. Because of the popularity of phrenology, when Spurzheim arrived in the United States on August 4, 1832, he was given a

hero's welcome. He lectured at some of the nation's leading universities, such as Harvard and Yale, and his appreciative audiences included physicians, ministers, public educators, college professors, and asylum superintendents. O'Donnell (1985) points out that these and other individuals were looking to phrenology for the type of information that some would later seek in the school of behaviorism (see Chapter 12):

With or without bumps, phrenology's theory of human nature and personality recommended itself to emerging professional groups searching for "positive"

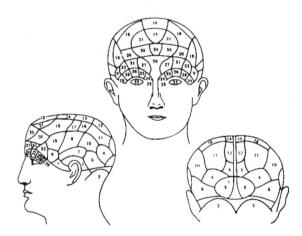

Affective Faculties

Intellectual Faculties

Propensities	Sentiments	Perceptive	Reflective
? Desire to live	10 Cautiousness	22 Individuality	34 Comparison
 Alimentiveness 	11 Approbativeness	23 Configuration	35 Causality
1 Destructiveness	12 Self-Esteem	24 Size	,
2 Amativeness	13 Benevolence	25 Weight and resistance	
3 Philoprogenitiveness	14 Reverence	26 Coloring	
4 Adhesiveness	15 Firmness	27 Locality	
5 Inhabitiveness	16 Conscientiousness	28 Order	
6 Combativeness	17 Hope	29 Calculation	
7 Secretiveness	18 Marvelousness	30 Eventuality	
8 Acquisitiveness	19 Ideality	31 Time	
9 Constructiveness	20 Mirthfulness	32 Tune	
	21 Imitation	33 Language	

FIGURE 8.1

The phrenology chart suggested by Spurzheim (1834) showing the "powers and organs of the mind."

knowledge." ... [They] found in phrenology an etiological explanation of aberrant human behavior; a predictive technology for assessing character, temperament, and intellect; and a biological blueprint for social reform. The social engineers of the twentieth century, together with their patrons and subscribers, would demand no less of modern experimental behaviorism. When the new psychology [behaviorism] arrived on the American stage an eager audience anticipated the role it was to play. Gall, Spurzheim ... and their followers had already written the script. (p. 78)

Spurzheim died shortly after he came to the United States, and on the day of his funeral (November 17, 1832), the Boston Phrenological Society was formed. Such societies soon sprang up all over the nation (Bakan, 1966), and numerous journals devoted to phrenology emerged in Europe and the United States. One, *Phrenological Journal*, started publishing in 1837 and continued until 1911.

A number of "phrenology charts" began to appear after the publication of Gall's and Spurzheim's books. Proposed numbers of faculties ranged from 27 (suggested by Gall) to as many as 43 suggested by later phrenologists. Figure 8.1 shows the chart Spurzheim proposed.

Formal Discipline. Phrenology also became highly influential in the realm of education. Several phrenologists made the additional claim that the faculties become stronger with practice, just as muscles do. This belief influenced a number of educators to take a "mental muscle" approach to education. For them education meant strengthening mental faculties by practicing the traits associated with them. One could improve one's reasoning ability, for example, by studying mathematics. The belief that educational experiences could be arranged so that they strengthen certain faculties was called **formal discipline**. Although Edward L. Thorndike systematically eval-

uated the educational claims of the phrenologists and found them to be false (see Chapter 11), the belief that educational experiences can be arranged to strengthen specific mental faculties persists to the present. For example, Frances Rauscher, Gordon Shaw, Linda Levine, and Katherine Ky (see Martin, 1994) found that studying or listening to music for as little as 10 minutes a day significantly increased spatial reasoning skills in children. The explanation was that the improvement occurs because musical experience and spatial reasoning involve similar cortical activity and, therefore, training in one (music) facilitates the other (spatial reasoning).

For reasons that we review next, the specific claims of the phrenologists were found to be incorrect, but phrenology did influence subsequent psychology in a number of important ways: It argued effectively that the mind and brain are closely related; it stimulated intense research on the localization of brain functions; and it showed the importance of furnishing practical information.

Pierre Flourens

By the turn of the 19th century, it was generally conceded that the brain is the organ of the mind. Under the influence of Gall and the other phrenologists, the brain-mind relationship was articulated into a number of faculties housed in specific

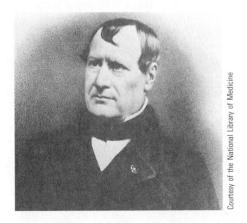

Pierre Flourens

locations in the brain. Thus, the phrenologists gave birth to the concern of localization of functions in the brain. Although popular among scientists, including neurophysiologists, phrenology was far from universally accepted. A number of prominent physicians questioned the claims of the phrenologists. It was not enough, however, to claim that the phrenologists were wrong in their assumptions: the claim had to be substantiated scientifically. This was the goal of Pierre Flourens (1794-1867), who used the method of extirpation, or ablation, in brain research. This method involves destroying part of the brain and then noting the behavioral consequences of the loss. As did Gall, Flourens assumed that the brains of lower animals were similar in many ways to human brains, so he used organisms such as dogs and pigeons as his research subjects. He found that removal of the cerebellum disturbed an organism's coordination and equilibrium, that ablation of the cerebrum resulted in passivity, and that destruction of the semicircular canals resulted in loss of balance.

When he examined the entire brain, Flourens concluded that there is some localization, but that contrary to what the phrenologists believed, the cortical hemispheres do not have localized functions. Instead, they function as a unit. Seeking further evidence of the brain's interrelatedness, Flourens observed that animals sometimes regained functions that they had lost following ablation. Thus, at least one part of the brain had the capacity to take over the function of another part. Flourens's fame as a scientist, and his conclusion that the cortex functioned as a unit, effectively silenced the phrenologists within the scientific community. Subsequent research, however, would show that they had been silenced too quickly.

Paul Broca

Paul Broca (1824–1880), using the clinical method, cast doubt on Flourens's conclusion that the cortex acted as a whole. Boring (1950) described Broca's observation:

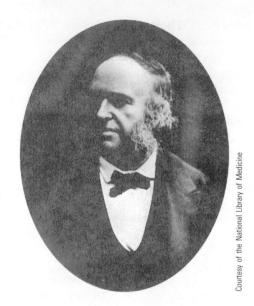

Paul Broca

Broca's famous observation was in itself very simple. There had in 1831 been admitted at the Bicêtre, an insane hospital near Paris, a man whose sole defect seemed to be that he could not talk. He communicated intelligently by signs and was otherwise mentally normal. He remained at the Bicêtre for thirty years with this defect and on April 12, 1861, was put under the care of Broca, the surgeon, because of a gangrenous infection. Broca for five days subjected him to a careful examination, in which he satisfied himself that the musculature of the larvnx and articulatory organs was not hindered in normal movements, that there was no other paralysis that could interfere with speech. and that the man was intelligent enough to speak. On April 17 the patient fortunately, it must have seemed, for science—died; and within a day Broca had performed an autopsy, discovering a lesion in the third frontal convolution of the left cerebral hemisphere, and had presented the brain in alcohol to the Société d'Anthropologie. (p. 71)

Broca was not the first to suggest that clinical observations be made and then to use autopsv examinations to locate a brain area responsible for a disorder. For example, the French scientist Jean-Baptiste Bouillaud (1796-1881) had done so as early as 1825. Using the clinical method on a large number of cases, Bouillaud reached essentially the same conclusion concerning the localization of a speech area on the cortex that Broca was to reach later using the same technique. Why, then, do we credit Broca with providing the first credible evidence for cortical localization and not Bouillaud? It is primarily because Bouillaud had been closely associated with phrenology and, by the time that Broca made his observations, "The scientific community [was] overly cautious about anything or anyone associated in any way with Gall or phrenology" (Finger, 1994, p. 37). In any case, subsequent research confirmed Broca's observation that a portion of the left cortical hemisphere is implicated in speech articulation or production, and this area has been named Broca's area. In 1874, just over a decade after Broca's discovery, the German neurologist Carl Wernicke (1848-1905) discovered a cortical area, near Broca's area, responsible for speech comprehension. This area on the left temporal lobe of the cortex has been named Wernicke's area

Broca's localizing of a function on the cortex supported the phrenologists and damaged Flourens's contention that the cortex acted as a unit. Unfortunately for the phrenologists, however, Broca did not find the speech area to be where the phrenologists had said it would be.

Other aspects of Broca's work were less impressive. Reflecting the Zeitgeist, he engaged in craniometry (the measurement of the skull and its characteristics) in order to determine the relationship between brain size and intelligence. He began his research with a strong conviction that there was such a relationship, and (not surprisingly, because of his conviction) he found evidence for it. In 1861 Broca summarized his findings:

In general, the brain is larger in mature adults than in the elderly, in men than in

women, in eminent men than in men of mediocre talent, in superior races than in inferior races.... Other things equal, there is a remarkable relationship between the development of intelligence and the volume of the brain. (Gould, 1981, p. 83)

Broca was aware of several facts that contradicted his theory: There existed an abundance of large-brained criminals, highly intelligent women, and small-brained people of eminence; and Asians, despite their smaller average brain size, were generally more intelligent than ethnic groups with larger brains. In spite of these contradictions, and in the absence of reliable, supportive evidence, Broca continued to believe in the relationship between brain size and intelligence until his death. Then it was discovered that his brain weighed 1,424 grams: "A bit above average to be sure, but nothing to crow about" (Gould, 1981, p. 92).

Broca and other craniometricians were not purposefully deceitful. As so often happens, however, they found what they were looking for:

The leaders of craniometry were not conscious political ideologues. They regarded themselves as servants of their numbers, apostles of objectivity. And they confirmed all the common prejudices of comfortable white males—that blacks, women, and poor people occupy their subordinate roles by the harsh dictates of nature. (Gould, 1981, p. 74)

So what is the relationship between brain size and intelligence? Dealy (2001) first reviews the contemporary research on the topic and then concludes, "There is a modest association between brain size and ... intelligence. People with bigger brains tend to have higher mental test scores. We do not know yet why this association occurs" (p. 45). Thus, it appears that Broca and other craniometricians were not totally wrong and that Gould's criticism of them was too harsh. However, their claims far exceeded their evidence. As we will see in Chapter 10, the tendency to "scientifically" confirm personal beliefs concerning

intelligence continued even when measures of intelligence became more sophisticated.

Gustav Fritsch, Eduard Hitzig, and David Ferrier

Electrically stimulating the exposed cortex of a dog, Gustav Fritsch (1838-1927) and Eduard Hitzig (1838-1907) made two important discoveries. First, the cortex is not insensitive, as had been previously assumed. Second, they found that when a certain area of the cortex is stimulated, muscular movements are elicited from the opposite side of the body. Stimulating different points in this motor area of the brain stimulated movements from different parts of the body. Thus, another function was localized on the cortex. David Ferrier (1843-1928) refined the cortical research performed by Fritsch and Hitzig. Using monkeys as subjects and finer electrical stimulation, he was able to produce a more articulated map of the motor cortex. He was able to elicit behaviors "as intricate as the twitch of an eyelid, the flick of an ear, and the movement of one digit" (Finger, 1994, p. 40). Ferrier then mapped cortical regions corresponding to the cutaneous senses, audition, olfaction, and, eventually, vision. He summarized his findings in Functions of the Brain (1876) which had a substantial impact on the scientific community: "One outcome was that it opened the 'modern' era of neurosurgery. Neurosurgeons now turned to 'functional maps' of the brain for guidance" (Finger, 1994, p. 41).

The evidence seemed clear; there is a great deal of localization of function on the cortex, just as the phrenologists had maintained. These findings, however, did not support traditional phrenology. Seldom was a function (faculty) found where the phrenologists had said it was. Furthermore, the phrenologists had spoken of faculties such as vitality, firmness, love, and kindness, but the researchers instead found sensory and motor areas. These findings extended the Bell–Magendie law to the brain. That is, the sensation experienced seemed to be more a matter of the cortical area stimulated than

a matter of the sensory nerve stimulated. It looked very much as if the brain is a complex switchboard where sensory information is projected and where it in turn stimulates appropriate motor responses. The localization studies seemed to favor the empirical-materialistic view rather than the rationalist view.

The brain research that was stimulated in an effort to evaluate the claims of the phrenologists made it clear that physical stimulation gives rise to various types of subjective experiences and that they are directly related to brain activity. The next step in psychology's development toward becoming an experimental science was to examine *scientifically* how sensory stimulation is systematically related to conscious experience.

THE RISE OF EXPERIMENTAL PSYCHOLOGY

The very important difference between what is physically present and what is experienced psychologically had been recognized and agonized over for centuries. This was the distinction that had caused Galileo to conclude that a science of psychology was impossible and Hume to conclude that we could know nothing about the physical world with certainty. Kant amplified this distinction when he claimed that the mind embellished sensory experience, and Helmholtz reached the same conclusion with his concept of unconscious inference.

With advances in science, much had been learned about the physical world—that is, about physical stimulation. Also, as we have seen, much had been learned about the sense receptors, which convert physical stimulation into nerve impulses, and about the brain structures where those impulses terminate. There was never much doubt about the existence of consciousness; the problem was in determining what we were conscious of and what caused that consciousness. By now it was widely believed that conscious sensations were triggered by brain processes, which themselves were initiated by sense reception. But the question remained:

How are the two domains (mental sensations and the sensory processes) related?

Without measurement, science is impossible. Therefore, it was assumed that a science of psychology was impossible unless consciousness could be measured as objectively as the physical world. Furthermore, once measured, mental events would have to be shown to vary in some systematic way with physical events. Ernst Heinrich Weber and Gustav Theodor Fechner were the first to measure how sensations vary systematically as a function of physical stimulation.

Ernst Heinrich Weber

Ernst Heinrich Weber (1795–1878), a contemporary of Johannes Müller, was born on June 24 in Wittenberg and was the son of a theology professor. He was the third of 13 children. Weber obtained his doctorate from the University of Leipzig in 1815 and taught there until his retirement in 1871. Weber was a physiologist who was interested in the senses of touch and kinesthesis (muscle sense). Most of the research on sense perception before Weber had been confined to vision and audition. Weber's research consisted largely in exploring new fields, most notably skin and muscle sensations. Weber was among the first to demonstrate that the sense of touch is not one but several senses. For

Ernst Heinrich Weber

example, what is ordinarily called the sense of touch includes the senses of pressure, temperature, and pain. Weber also provided convincing evidence that there is a muscle sense. It was in regard to the muscle sense that Weber performed his work on just noticeable differences, which we consider shortly.

Weber's Work on Touch. For the sensation of touch, Weber attempted to determine the least spatial separation at which two points of touch on the body could be discriminated. Using a compasslike device consisting of two points, he simultaneously applied two points of pressure to a subject's skin. The smallest distance between the two points at which the subject reported sensing two points instead of one was called the **two-point threshold**. In his famous book One Touch: Anatomical and Physiological Notes (1834), Weber provided charts of the entire body with regard to the two-point threshold. He found the smallest two-point threshold on the tongue (about 1 millimeter) and the largest in the middle of the back (about 60 millimeters). He assumed that the differences in thresholds at different places on the body resulted from the anatomical arrangement of the sense receptors for touch—the more receptors, the finer the discrimination.

Weber's Work on Kinesthesis. Within the history of psychology, Weber's research on the muscle sense, or kinesthesis, is even more important than his research on touch. It was while investigating kinesthesis that Weber ran his important weightdiscrimination experiments. In general, he sought to determine the smallest difference between two weights that could be discriminated. To do this, he had his subjects lift one weight (the standard), which remained the same during a series of comparisons, and then lift other weights. The subject was to report whether the varying weights were heavier, lighter, or the same as the standard weight. He found that when the variable weights were only slightly different from the standard, they were judged to be the same as the standard. Through a series of such comparisons, Weber was able to

determine the just noticeable difference (jnd) between the standard and the variable weight. It is important to note that, although Weber did not label them as such, jnds were psychological experiences (sensations) that may or may not occur depending on the relationships between standard and variable weights.

Weber ran the basic weight-discrimination experiment under two conditions. In one condition, the weights were placed on the subject's hands while the hands were resting on a table. In this condition, the subject's judgments were made primarily on the basis of tactile sensations. In the second condition, the subject lifted the hands with the weights on them. In this condition, the subject's judgments were made on the basis of both tactile and kinesthetic sensations. It was found that subjects could detect much smaller weight differences when they lifted the weights than they could when the weights were simply placed on their hands. Weber thought that it was the involvement of kinesthesis in the lifted-weight condition that provided the greater sensitivity to weight differences.

Judgments Are Relative, Not Absolute. During his research on kinesthesis, Weber made the startling observation that the jnd is a constant fraction of the standard weight. For lifted weights, that fraction is 1/40; for nonlifted weights, it is 1/30. Using lifted weights as an example, if the standard weight is 40 grams, the variable weight would have to be 41 grams to be judged heavier or 39 grams to be judged lighter than the standard. If the standard weight is 160 grams, the variable weight would have to be 164 grams or 156 grams to be judged heavier or lighter, respectively, than the standard. Weber then aligned himself with the large number of scientists and philosophers who found that there was not a simple one-to-one correspondence between what is present physically and what is experienced psychologically. Weber observed that discrimination does not depend on the absolute difference between two weights but on the relative difference between the two, or the ratio of one to the other. Weber extended his research to other sense modalities and found evidence that suggested that there is a constant fraction corresponding to inds for each sense modality.

The finding that jnds corresponded to a constant fraction of a standard stimulus was later called Weber's law, and it can be considered the first quantitative law in psychology's history. This was the first statement of a systematic relationship between physical stimulation and a psychological experience. But because Weber was a physiologist, psychology was not his primary concern. It was Fechner who realized the implications of Weber's work for psychology and who saw in it the possible resolution of the mind-body problem.

Gustav Theodor Fechner

Born on April 19, Gustav Theodor Fechner (1801-1887) was a brilliant, complex, and unusual individual. Fechner's father had succeeded his grandfather as village pastor. After his father died, Fechner, his brother, and his mother spent the next nine years with Fechner's uncle, who was also a pastor. At the age of 16, Fechner began his studies in medicine at the University of Leipzig (where Weber was studying) and obtained his medical degree in 1822 at the age of 21. Upon receiving his medical degree, Fechner's interest shifted from biological science to physics and mathematics. At this time, he made a meager living by translating into

Gustav Theodor Fechner

German certain French handbooks of physics and chemistry, by tutoring, and by lecturing occasionally. Fechner was interested in the properties of electric currents and in 1831 published a significant article on the topic, which established his reputation as a physicist. In 1834, when he was 33 years old, Fechner was appointed professor of physics at Leipzig. Soon his interests began to turn to the problems of sensation, and by 1840 he had published articles on color vision and afterimages.

In about 1840, Fechner had a "nervous breakdown," resigned his position at Leipzig, and became a recluse. Aside from the philosophical conflicts Fechner experienced (we discuss those conflicts next), he had been almost blinded, presumably while looking at the sun through colored glasses while performing his research on afterimages. At this time, Fechner entered a state of depression that was to last several years and that resulted in his interests turning from physics to philosophy. The shift was in emphasis only, however, because throughout his adult life he was uncomfortable with materialism, which he called the "nightview"; it contrasted with the "dayview," which emphasized mind, spirit, and consciousness. He accepted Spinoza's double-aspect view of mind and matter and therefore believed that consciousness is as prevalent in the universe as is matter. Because he believed that consciousness cannot be separated from physical things, his position represents panpsychism; that is, all things that are physical are also conscious. It was Fechner's interest in the mind-body relationship that led to the development of psychophysics, which we will consider shortly.

In his lifetime, Fechner wrote 183 articles and 81 books and edited many others (Bringmann, Bringmann, and Balance, 1992). He died in his sleep on November 18, 1887, at the age of 86, a few days after suffering a stroke. He was eulogized by his friend and colleague Wilhelm Wundt.

The Adventures of Dr. Mises. Although Fechner was an outstanding scientist, there was a side of him that science could not satisfy. In addition to Fechner the materialistic scientist, there was Fechner the satirist, philosopher, and spiritualist and

Fechner the mystic. For a young scientist to express so many viewpoints, especially because so many of them were incompatible with science, would have been professional suicide. So, Fechner invented a person to speak for his other half, and thus was born "Dr. Mises." The pseudonym Dr. Mises first appeared while Fechner was still a medical student. Under this pseudonym, Fechner wrote *Proof That the Moon Is Made of Iodine* (1821), a satire on the medical profession's tendency to view iodine as a panacea. In 1825 Dr. Mises published *The Comparative Anatomy of Angels*, in which it is reasoned, tongue firmly in cheek, that angels cannot have legs. Marshall (1969) summarizes the argument:

Centipedes have God-knows-how-many legs; butterflies and beetles have six, mammals only four; birds, who of all earthly creatures rise closest to the angels, have just two. With each developmental step another pair of legs is lost, and "Since the final observable category of creatures possesses only two legs, it is impossible that angels should have any at all." (p. 51)

Dr. Mises also argued that because the sphere is the most perfect shape and angels are perfect, angels must be spherical; but planets are also spherical, so angels must be planets.

There followed The Little Book of Life After Death (1836), Nanna, or Concerning the Mental Life of Plants (1848), and Zend-Avesta, or Concerning Matters of Heaven and the Hereafter (1851). In all, Dr. Mises was heard from 14 times from 1821 to 1879. Fechner always used Dr. Mises to express the dayview, the view that the universe is alive and conscious. Always behind Fechner's satire or humor was the message that the dayview must be taken seriously. Marshall (1969) makes this point concerning Zend-Avesta:

Indeed, in Zoroastrian dogma, Zend-Avesta meant the "living word," and Fechner was to intend that his own Zend-Avesta should be the word which would reveal all nature to be alive. In this work Fechner argues

that the earth is ensouled, just as the human being is; but the earth possesses a spirituality which surpasses that of her creatures. (p. 54)

In fact, it was in *Zend-Avesta* that Fechner first described what would later become psychophysics:

[Fechner] laid down the general outlines of his program [psychophysics] in Zend-Avesta, the book about heaven and the future life. Imagine sending a graduate student of psychology nowadays to the Divinity School for a course in immortality as preparation for advanced experimental work in psychophysics! How narrow we have become! (Boring, 1963, p. 128)

In The Little Book of Life After Death (Fechner, 1836/1992), written to console a friend who had just lost a loved one, Dr. Mises described human existence as occurring in three stages. The first stage is spent alone in continuous sleep in the darkness of the mother's womb. The second stage, after birth, is spent alternating between sleeping and waking and in the company of other people. During this second stage, people often have glimpses into the third stage. These glimpses include moments of intense faith or of intuitions that cannot be explained by one's life experiences. Dr. Mises tells us that we enter the third stage by dying: "The passing from the first to the second stage is called birth; the transition from the second to the third is called death" (Fechner, 1836/1992, p. 7). Just as unborn children cannot foresee their forthcoming experiences in stage two, people cannot foresee their forthcoming experiences in stage three. In the third stage, one's soul merges with other souls and becomes part of the "Supreme Spirit." It is only during this stage that the ultimate nature of reality can be discerned.

Whether as Dr. Mises or not, Fechner was always interested in spiritual phenomena. He was also interested in parapsychology and even attended several séances in which he experienced the anomalous movements of a bed, a table, and even himself. His belief and involvement in parapsychology is clearly seen in the last book he wrote as Dr. Mises, *The Dayview as Compared to the Nightview* (1879).

Psychophysics. From Fechner's philosophical interest in the relationship between the mind and the body sprang his interest in psychophysics. He wanted desperately to solve the mind-body problem in a way that would satisfy the materialistic scientists of his day. Fechner's mystical philosophy taught him that the physical and mental were simply two aspects of the same fundamental reality. Thus, as we have seen, he accepted the double aspectism that Spinoza had postulated. But to say that there is a demonstrable relationship between the mind and the body is one thing; proving it is another matter. According to Fechner, the solution to the problem occurred to him the morning of October 22, 1850, as he was lying in bed (Adler, 1996, p. 6). His insight was that a systematic relationship between bodily and mental experience could be demonstrated if a person were asked to report changes in sensations as a physical stimulus was systematically varied. Fechner speculated that for mental sensations to change arithmetically, the physical stimulus would have to change geometrically. In testing these ideas, Fechner created the area of psychology that he called psychophysics.

As was mentioned, Fechner's insight concerning the relationship between stimuli and sensations was first reported in *Zend-Avesta* (1851). Fechner spent the next few years experimentally verifying his insight and published two short papers on psychophysics in 1858 and 1859. Then in 1860 he published his famous *Elements of Psychophysics*, a book that went a long way in launching psychology as an experimental science.

As the name suggests, psychophysics is the study of the relationship between physical and psychological events. Fechner's first step in studying this relationship was to state mathematically what Weber had found and to label the expression Weber's law:

$$\frac{\Delta R}{R} = k$$
,

where

- R = Reiz (the German word for "stimulus"). In Weber's research, this was the standard stimulus.
- ΔR = The minimum change in R that could be detected; that is, the minimum change in physical stimulation necessary to cause a person to experience a jnd.
- k = A constant. As we have seen, Weber found this constant to be 1/40 of R for lifted weights.

Weber's law concerns the amount that a physical stimulus must change before it results in the awareness of a difference or in a change of sensation (S). Through a series of mathematical calculations, Fechner arrived at his famous formula, which he believed showed the relationship between the mental and the physical (the mind and the body):

$S = k \log R$

This formula mathematically states Fechner's earlier insight. That is, for sensations to rise arithmetically (the left side of the equation), the magnitude of the physical stimulus must rise geometrically (the right side of the equation). This means that as a stimulus gets larger, the magnitude of the change must become greater and greater if the change is to be detected. For example, if the stimulus (R) is 40 grams, a difference of only 1 gram can be detected; whereas if the stimulus is 200 grams, it takes a difference of 5 grams to cause a ind. In everyday terms, this means that sensations are always relative to the level of background stimulation. If a room is dark, for example, turning on a dim light will be immediately noticed, as would a whisper in a quiet room. If a room is fully lighted, however, the addition of a dim light would go unnoticed, as would a whisper in a noisy room. However, Fechner did not believe his formula applied only to the evaluation of simple stimuli. He believed it applied to the more complex realm of human values as well:

Our physical possessions ... have no value or meaning for us as inert material, but

constitute only a means for arousing within us a sum of psychic values. In this respect they take the place of stimuli. A dollar has, in this connection, much less value to a rich man than to a poor man. It can make a beggar happy for a whole day, but it is not even noticed when added to the fortune of a millionaire. (1860/1966, p. 197)

The Ind as the Unit of Sensation. Fechner assumed that as the magnitude of a stimulus increased from zero, a point would be reached where the stimulus could be consciously detected. The lowest intensity at which a stimulus can be detected is called the absolute threshold. That is, the absolute threshold is the intensity of a stimulus at or above which a sensation results and below which no detectable sensation occurs. According to Fechner, intensity levels below the absolute threshold do cause reactions, but those reactions are unconscious. In that it allowed for these negative sensations, Fechner's position was very much like those of Leibniz (petites perceptions) and Herbart (threshold of consciousness). For all three, the effects of stimulation cumulated and, at some point (the absolute threshold), was capable of causing a conscious sensation.

Fechner's analysis of sensation started with the absolute threshold, but because that threshold provided only one measure, it was of limited usefulness. What Fechner needed was a continuous scale that showed how sensations above the absolute threshold varied as a function of level of stimulation. This was provided by the differential threshold, which is defined by how much a stimulus magnitude needs to be increased or decreased before a person can detect a difference. It was in regard to the differential threshold that Fechner found that stimulus intensities must change geometrically in order for sensation to change arithmetically. Given a geometric increase in the intensity of a stimulus, Fechner assumed that sensations increased in equal increments (jnds). With this assumption it was possible, using Fechner's equation, to deduce how many jnds above absolute threshold a particular sensation was at any given level of stimulus intensity. In other words, Fechner's law assumed that sensations increased in equal units (jnds) as the stimulus intensity increased geometrically beyond the absolute threshold.

With his equation, Fechner believed that he had found the bridge between the physical and the psychical that he sought—a bridge that was scientifically respectable. Subsequent research demonstrated that the predictions generated by Fechner's equation were accurate primarily for the middle ranges of sensory intensities. Predictions were found to be less accurate for extremely high or low levels of physical intensity.

Psychophysical Methods. After establishing that mental and physical events varied systematically, and thus showing that a science of the mind is indeed possible (contrary to the beliefs of such individuals as Galileo, Comte, and Kant), Fechner employed several methods to further explore the mind-body relationship:

- The **method of limits** (also called the method of just noticeable differences): With this method, one stimulus is varied and is compared to a standard. To begin with, the variable stimulus can be equal to the standard and then varied, or it can be much stronger or weaker than the standard. The goal here is to determine the range of stimuli that the subject considers to be equal to the standard.
- The method of constant stimuli (also called the method of right and wrong cases): Here, pairs of stimuli are presented to the subject. One member of the pair is the standard and remains the same, and the other varies in magnitude from one presentation to another. The subject reports whether the variable stimulus appears greater than, less than, or equal to the standard.
- The method of adjustment (also called the method of average error): Here, the subject has

control over the variable stimulus and is instructed to adjust its magnitude so that the stimulus appears equal to the standard stimulus. After the adjustment, the average difference between the variable stimulus and the standard stimulus is measured.

These methods were another of Fechner's legacies to psychology, and they are still widely used today.

Fechner's Contributions. In addition to creating psychophysics, Fechner also created the field of experimental esthetics. Between 1865 and 1876, Fechner wrote several articles attempting to quantify reactions to works of art. For example, in an effort to discover the variables that made some works of art more pleasing than others, Fechner analyzed 20,000 paintings from 22 museums (Fechner, 1871). After publishing his major work on esthetics (1876), Fechner spent the remainder of his professional life responding to criticisms of psychophysics. For an interesting discussion of Fechner's experimental esthetics and its relationship to his philosophical beliefs, see Arnheim, 1985.

Fechner did not solve the mind-body problem; it is still alive and well in modern psychology. Like Weber, however, he did show that it was possible to measure mental events and relate them to physical ones. A number of historians have suggested that the beginning of experimental psychology be marked by the 1860 publication of Fechner's Elements. Although a case can be made for marking the beginning of experimental psychology with the publication of that book, most agree that another important step had to be taken before psychology could emerge as a full-fledged science: Psychology needed to be founded as a separate discipline. As we will see in Chapter 9, it was Wilhelm Wundt who took that step.

SUMMARY

The discovery of individual differences among astronomers in the recording of astronomical events demonstrated the need, even within the physical sciences, for understanding how the physical world was sensed and mentally represented. An intense investigation of the human sensory apparatus and nervous system followed. Bell and Magendie discovered that some nerves are specialized to carry sensory information to the brain, whereas others are specialized to carry sensory information from the brain to the muscles of the body. This distinction between sensory and motor nerves is called the Bell-Magendie law. Müller found that each sensory nerve was specialized to produce a certain type of energy, which in turn produced a certain type of sensation. For example, no matter how the optic nerve is stimulated, it will produce the sensation of light. The same is true for all other sensory nerves of the body. Müller's finding is called the doctrine of specific nerve energies.

Helmholtz is a monumental figure in the history of science. He opposed the belief in vitalism that his teacher Müller and others held. The vitalists maintained that life could not be reduced to physical processes and therefore could not be investigated scientifically. For Helmholtz nothing was beyond scientific investigation. He showed that the amount of energy an organism expended was directly proportional to the amount of food and oxygen it consumed, thereby showing that the principle of conservation of energy applied to living organisms as well as to physical systems. Ignoring the contention that nerve impulses are too fast to be measured, he measured their speed and found them to be remarkably slow.

Helmholtz differentiated between sensations and perceptions, the former being the raw images provided by the sense receptors and the latter reflecting the meaning that past experiences give to those raw sensations. Through the process of unconscious inference, the wealth of prior experience we have had with objects and events is brought to bear on current sensations, converting them into perceptions. With his notion of unconscious

inference, Helmholtz offered an empirical explanation of perception instead of the nativistic explanation, which Kant and others had offered. And he extended the doctrine of specific nerve energies to color vision by saying that specific receptors on the retina corresponded to each of the three additive primary colors: red, green, and blue-violet. If one of the three receptors is missing or inoperative, the person would be blind to the color to which the receptor is sensitive. For Helmholtz all experiences of color could be explained as the stimulation of one or a pattern of the three types of color receptors. Because Young had earlier proposed a similar theory of color vision, the theory became known as the Young-Helmholtz (or trichromatic) theory of color vision.

Helmholtz also explained auditory perception by applying the doctrine of specific nerve energies. He believed that tiny fibers on the basilar membrane each respond to a different frequency and that our auditory perception results from the combination of the various fibers that are being stimulated at any given time. This is called the resonance place theory of auditory perception. Helmholtz's work clearly indicated that there is a difference between what is present physically and what is experienced psychologically. The reason for this difference is that the sensory equipment of the body is not capable of responding to everything that is physically present. Although Helmholtz found substantial mismatches between what is present physically and what is experienced psychologically, he did postulate an active mind that takes whatever sensory information is available and creates the best possible interpretation of external reality. Helmholtz's work moved physiology closer to psychology and thus paved the way for experimental psychology.

In his explanation of perceptual phenomena, Helmholtz sided with the empiricists, but Hering sided with the nativists. In his explanation of color vision, Hering postulated red-green, yellow-blue, and black-white receptors on the retina that could either be torn down (causing the color experiences of red, yellow, and white, respectively), or built up (causing the experiences of green, blue, and black, respectively). Hering's theory could explain a number of color experiences that Helmholtz's theory could not. Ladd-Franklin proposed a theory of color vision based on evolutionary principles.

Gall and Spurzheim expanded faculty psychology into phrenology, according to which individuals differ in the extent to which they possess various faculties. The faculties are housed in specific areas of the brain, and an evaluation of a person's faculties could be made by examining the bumps and depressions of his or her skull. Phrenology became very popular because it seemed to provide an objective method of studying the mind and because it seemed to provide practical information. Many phrenologists believed that various faculties could be strengthened by practicing the activities associated with them. This belief resulted in the formal discipline, or the "mental muscle" approach to education. Flourens experimentally tested many of the conclusions the phrenologists had reached concerning the localization of brain function, and although he found some evidence for localization of function in the lower parts of the brain, he concluded that the cortex itself acts as a whole. Because of Flourens's prestige as a scientist, the claims of the phrenologists concerning cortical localization were seriously questioned within the scientific community. Using the clinical method, however, Broca did find evidence for an area of the cortex responsible for the ability to articulate speech. Later, Wernicke discovered a cortical area responsible for speech comprehension. Furthermore, Fritsch and Hitzig found a motor area on the cortex, and Ferrier further articulated the motor cortex and then mapped cortical areas associated with the cutaneous senses, audition, olfaction, and vision. Thus, there did seem to be localization of function on the cortex, but the functions were not the same as those the phrenologists had proposed, nor were they in the locations the phrenologists had suggested.

Weber was the first to attempt to quantify the relationship between a physical stimulus and the

sensation it caused. He determined the two-point threshold for various parts of the body by observing the smallest distance between two points of stimulation that would be reported as two points. Working with weights, Weber determined how much heavier or lighter than a standard a weight must be before it was reported as being lighter or heavier than the standard. This sensation of difference was called a just noticeable difference (jnd). Weber found that for lifted weights, if a weight was 1/40 lighter than the standard, the subject would report that it was lighter; if it was 1/40 heavier than the standard, it would be reported as heavier. A difference in weight of less than 1/40 of the standard went undetected. For weights not lifted but simply placed in a subject's hand, the jnd was 1/30 of the standard weight. Weber's work provided the first statement of a systematic relationship between physical and mental events.

Fechner expanded Weber's work by showing that inds are related to stimulation in a geometric way. That is, as the magnitude of the standard stimulus increases, so did the amounts that needed to be added to or subtracted from a comparison stimulus before those differences could be noticed. In his work on psychophysics, Fechner used three methods: the method of limits, by which one stimulus is held constant and another varied in order to determine which values of the variable stimulus are perceived as the same as the standard; the method of constant stimuli, by which pairs of stimuli are presented and the subject reports which stimulus appears to be greater than, less than, or equal to the standard stimulus; and the method of adjustment, by which the subject adjusts the magnitude of one stimulus until it appears to be the same as the standard stimulus. In addition to psychophysics, Fechner also created the field of experimental esthetics. Now that it had been demonstrated that mental events could be studied experimentally, the ground was laid for the founding of psychology as an experimental science.

DISCUSSION QUESTIONS

- 1. What significance did the observation that astronomers differ in their reaction times have for the history of psychology?
- 2. What is the Bell–Magendie law? What was the significance of this law in the history of psychology?
- 3. Summarize Müller's doctrine of specific nerve energies.
- 4. Define *vitalism*. Was Müller a vitalist? Was Helmholtz?
- 5. How did Helmholtz apply the principle of conservation of energy to living organisms?
- 6. Describe the procedure Helmholtz used to measure the rate of nerve conduction.
- How did Helmholtz explain perception? Include in your answer a discussion of unconscious inference.
- 8. Summarize the Young–Helmholtz theory of color vision.
- 9. Summarize the resonance place theory of auditory perception.
- 10. Discuss the importance of Helmholtz's work for the development of psychology as a science.
- 11. Explain in what way Helmholtz was a rationalist.
- 12. How did Hering explain space perception?
- 13. Summarize Hering's theory of color vision.
- 14. Discuss the theory of color vision proposed by Ladd-Franklin.

- 15. Discuss the basic tenets of phrenology. Also discuss the reasons for phrenology's popularity and its influence on psychology.
- 16. Describe Flourens's approach to brain research. Did his conclusions support or refute phrenology? Explain.
- 17. Describe Broca's approach to brain research. What conclusions did he reach concerning the functioning of the brain? Concerning intelligence?
- 18. Describe the functions associated with Broca's and Wernicke's cortical areas.
- 19. What approach to brain research did Fritsch, Hitzig, and Ferrier take? Did their results support Gall or Flourens? Explain.
- 20. What significance did Weber's work have for the development of experimental psychology? In your answer, describe Weber's research techniques and his findings.
- 21. Why did Fechner feel it necessary to invent Dr. Mises?
- 22. What was Fechner's proposed solution to the mind-body problem? What evidence did he offer in support of his solution?
- 23. What did Fechner mean by a negative sensation?
- 24. Distinguish between the absolute threshold and the differential threshold.
- 25. Summarize Fechner's psychophysical methods.
- 26. What were Fechner's contributions to the development of psychology as a science?

SUGGESTIONS FOR FURTHER READING

- Adler, H. E. (1966). Gustav Theodor Fechner: A German Gelehrter. In G. A. Kimble, C. A. Boneau, & M. Wertheimer (Eds.), Portraits of pioneers in psychology (Vol. 2, pp. 1–13). Washington, DC: American Psychological Association.
- Adler, H. E. (2000). Hermann Ludwig Ferdinand von Helmholtz: Physicist as psychologist. In G. A. Kimble & M. Wertheimer (Eds.) Portraits of pioneers in psychology (Vol. 4, pp. 15–31). Washington, DC: American Psychological Association.

- Bakan, D. (1966). The influence of phrenology on American psychology. *Journal of the History of the Behavioral Sciences* 2, 200–220.
- Cahan, D. (Ed.). (1994). Hermann von Helmholtz and the foundation of nineteenth-century science. Berkeley: University of California Press.
- Cahan, D. (Ed.). (1995). Hermann von Helmholtz: Science and culture. Chicago: University of Chicago Press.
- Fechner, G. (1992). The little book of life after death. Journal of Pastoral Counseling: An Annual, 27, 7–31. (Original work published 1836)
- Marshall, M. E. (1969). Gustav Fechner, Dr. Mises, and the comparative anatomy of angels. *Journal of the History of the Behavioral Sciences*, 5, 39–58.
- Turner, R. S. (1977). Hermann von Helmholtz and the empiricist vision. *Journal of the History of the Behavioral Sciences*, 13, 48–58.

GLOSSARY

Absolute threshold The smallest amount of stimulation that can be detected by an organism.

Adequate stimulation Stimulation to which a sense modality is maximally sensitive.

Bell, Charles (1774–1842) Discovered, in modern times, the distinction between sensory and motor nerves.

Bell–Magendie law There are two types of nerves: sensory nerves carrying impulses from the sense receptors to the brain and motor nerves carrying impulses from the brain to the muscles and glands of the body.

Broca, Paul (1824–1880) Found evidence that part of the left frontal lobe of the cortex is specialized for speech production or articulation.

Broca's area The speech area on the left frontal lobe side of the cortex (the inferior frontal gyrus).

Clinical method The technique that Broca used. It involves first determining a behavior disorder in a living patient and then, after the patient had died, locating the part of the brain responsible for the behavior disorder.

Differential threshold The amount that stimulation needs to change before a difference in that stimulation can be detected.

Doctrine of specific nerve energies Each sensory nerve, no matter how it is stimulated, releases an energy specific to that nerve.

Fechner, Gustav Theodor (1801–1887) Expanded Weber's law by showing that, for just noticeable differences to vary arithmetically, the magnitude of a stimulus must vary geometrically.

Ferrier, David (1843–1928) Created a more detailed map of the motor cortex than Fritsch and Hitzig had. He

also mapped cortical areas corresponding to the cutaneous senses, audition, olfaction, and vision.

Flourens, Pierre (1794–1867) Concluded that the cortical region of the brain acts as a whole and is not divided into a number of faculties, as the phrenologists had maintained.

Formal discipline The belief that the faculties of the mind can be strengthened by practicing the functions associated with them. Thus, one supposedly can become better at reasoning by studying mathematics or logic.

Fritsch, Gustav (1838–1927) Along with Hitzig, discovered motor areas on the cortex by directly stimulating the exposed cortex of a dog.

Gall, Franz Joseph (1758–1828) Believed that the strengths of mental faculties varied from person to person and that they could be determined by examining the bumps and depressions on a person's skull. Such an examination came to be called phrenology. (*See also* **Phrenology**.)

Helmholtz, Hermann von (1821–1894) A monumental figure in the history of science who did pioneer work in the areas of nerve conduction, sensation, perception, color vision, and audition.

Hering, Ewald (1834–1918) Offered a nativistic explanation of space perception and a theory of color vision based on the existence of three color receptors, each capable of a catabolic process and an anabolic process. Hering's theory of color vision could explain a number of color experiences that Helmholtz's theory could not.

Hitzig, Eduard (1838–1907) Along with Fritsch, discovered motor areas on the cortex by directly stimulating the exposed cortex of a dog.

Just noticeable difference (jnd) The sensation that results if a change in stimulus intensity exceeds the differential threshold. (*See also* **Differential threshold**.)

Kinesthesis The sensations caused by muscular activity.

Ladd-Franklin, Christine (1847–1930) Proposed a theory of color vision based on evolutionary principles.

Magendie, François (1783–1855) Discovered, in modern times, the distinction between sensory and motor nerves.

Method of adjustment An observer adjusts a variable stimulus until it appears to be equal to a standard stimulus.

Method of constant stimuli A stimulus is presented at different intensities along with a standard stimulus, and the observer reports if it appears to be greater than, less than, or equal to the standard.

Method of limits A stimulus is presented at varying intensities along with a standard (constant) stimulus to determine the range of intensities judged to be the same as the standard.

Müller, Johannes (1801–1858) Expanded the Bell–Magendie law by demonstrating that each sense receptor, when stimulated, releases an energy specific to that particular receptor. This finding is called the doctrine of specific nerve energies.

Negative sensations According to Fechner, sensations that occur below the absolute threshold and are therefore below the level of awareness.

Panpsychism The belief that everything in the universe experiences consciousness.

Perception According to Helmholtz, the mental experience arising when sensations are embellished by the recollection of past experiences.

Personal equations Mathematical formulae used to correct for differences in reaction time among observers.

Phrenology The examination of the bumps and depressions on the skull in order to determine the strengths and weaknesses of various mental faculties.

Physiognomy The attempt to determine a person's character by analyzing his or her facial features, bodily structure, and habitual patterns of posture and movement.

Principle of conservation of energy The energy within a system is constant; therefore, it cannot be added to or subtracted from but only transformed from one form to another.

Psychophysics The systematic study of the relationship between physical and psychological events.

Reaction time The period of time between presentation of and response to a stimulus.

Resonance place theory of auditory perception The tiny fibers on the basilar membrane of the inner ear are stimulated by different frequencies of sound. The shorter the fiber, the higher the frequency to which it responds.

Sensation The rudimentary mental experience caused when sense receptors are stimulated by an environmental stimulus.

Spurzheim, Johann Kaspar (1776–1832) A student and colleague of Gall, who did much to expand and promote phrenology.

Two-point threshold The smallest distance between two points of stimulation at which the two points are experienced as two points rather than one.

Unconscious inference According to Helmholtz, the process by which the remnants of past experience are added to sensations, thereby converting them into perceptions.

Weber, Ernst Heinrich (1795–1878) Using the twopoint threshold and the just noticeable difference, was the first to demonstrate systematic relationships between stimulation and sensation.

Weber's law Just noticeable differences correspond to a constant proportion of a standard stimulus.

Wernicke, Carl (1848–1905) Discovered an area on the left temporal lobe of the cortex associated with speech comprehension.

Wernicke's area The area on the left temporal lobe of the cortex associated with speech comprehension.

Young-Helmholtz theory of color vision Separate receptor systems on the retina are responsive to each of the three primary colors: red, green, and blue-violet. Also called the trichromatic theory.

Voluntarism, Structuralism, and Other Early Approaches to Psychology

e saw in the last chapter that Helmholtz, Weber, and Fechner were pioneers in experimental psychology. It was Wilhelm Wundt, however, who took the diverse achievements of these and other individuals and synthesized them into a unified program of research that was organized around certain beliefs, procedures, and methods. As early as 1862, Wundt performed an experiment that led him to believe that a full-fledged discipline of experimental psychology was possible. Using the apparatus shown in Figure 9.1, Wundt showed that it took about 1/10 of a second to shift one's attention from the sound of the bell to the position of the pendulum or vice versa. Wundt believed that, with his "thought meter," he had demonstrated that humans could attend to only one thought at a time and that it takes about 1/10 of a second to shift from one thought to another.

From this early experiment, Wundt concluded not only that experimental psychology was feasible but also that such a psychology must stress selective attention, or volition:

Wundt suddenly realized that he was measuring the speed of a central mental process, that for the first time, he thought, a self-conscious experimental psychology was taking place. The time it takes to switch attention voluntarily from one stimulus to another had been measured—it varied around a tenth of a second.

FIGURE 9.1

Wundt's "thought meter." The clock was arranged so that the pendulum (B) swung along a calibrated scale (M). The apparatus was arranged so that a bell (g) was struck by the metal pole(s) at the extremes of the pendulum's swing (d, b), Wundt discovered that if he looked at the scale as the bell sounded, it was never in position d or b but some distance away from either. Thus, determining the exact position of the pendulum as the bell sounded was impossible. Readings were always about 1/10 of a second off. Wundt concluded that one could either attend to the position of the pendulum or to the bell, but not both at the same time.

SOURCE: Wundt (1862b, p. 264).

At this moment, the unfolding of Wundt's theoretical system began. For it was not the simple fact of the measured speed of selective attention that impressed him as much as it was the demonstration of a central voluntary control process. From

then on, a prominent theme in Wundtian psychology was the distinction between voluntary and involuntary actions. (Blumenthal, 1980, pp. 121–122)

In the introduction to his book Contributions to the Theory of Sense Perception (1862a), Wundt enunciated the need for a new field of experimental psychology that would uncover the facts of human consciousness. In his epoch-making book Principles of Physiological Psychology (1874/1904), Wundt clearly stated that his goal was to create such a field. It should be noted that in Wundt's time the term physiological meant more or less the same as experimental. Thus, reading "physiological psychology" in the title of Wundt's book as "experimental psychology" is more accurate than viewing it as emphasizing a search for the biological correlates of thought and behavior, as is the case with much physiological psychology today.

Wundt reached his goal by 1890, and psychology's first school had been formed. A **school** can be defined as a group of individuals who share common assumptions, work on common problems, and use common methods. This definition of *school* is very similar to Kuhn's definition of *paradigm*. In both a school of thought and a paradigm, individuals work to explore the problems articulated by a particular viewpoint. That is, they engage in what Kuhn (1996) called normal science.

By 1890 students the world over were traveling to Leipzig to be trained in experimental psychology at Wundt's laboratory. There now appeared to be little doubt that a productive discipline of scientific psychology was possible. A staggering amount of research poured out of Wundt's laboratory, and laboratories similar to his were being established throughout the world, including in the United States.

VOLUNTARISM

Wundt's stated goal was to understand consciousness, and his pursuit of this goal was very much within the German rationalistic tradition:

Wundt said that Herbart was second only to Kant in terms of the debt owed for the development of his own thoughts.... But beyond Herbart and Kant, there looms the influence of Leibniz, in whose shadow Wundt clearly felt himself to be working from the beginning.... Numerous ... references to Leibniz at key points in Wundt's more theoretical works make it clear that he felt a special affinity with this philosopher. (Danziger, 1980a, pp. 75–76)

Wundt opposed materialism, about which he said, "Materialistic psychology ... is contradicted by ... the fact of consciousness itself, which cannot possibly be derived from any physical qualities of material molecules or atoms" (1912/1973, p. 155). He also opposed the empiricism of the British and French philosophers, in which a person is viewed as the passive recipient of sensations that are then passively "organized" by the laws of association. Lacking in empiricism, according to Wundt, were central volitional processes that act on the elements of thought giving them forms, qualities, or values not found in either external stimulation or the elemental events themselves.

Wundt's goal was not only to understand consciousness as it is experienced but also to understand the mental laws that govern the dynamics of consciousness. Of utmost importance to Wundt was the concept of will as it was reflected in attention and volition. Wundt said that will was the central concept in terms of which all of the major problems in psychology must be understood (Danziger, 1980b, p. 108). Wundt believed that humans can decide what is attended to and thus what is perceived clearly. Furthermore, he believed that much behavior and selective attention are undertaken for a purpose; that is, such activities are motivated. The name that Wundt gave to his approach

to psychology was **voluntarism** because of its emphasis on will, choice, and purpose.

Voluntarism, then, was psychology's first school—not structuralism, as is often claimed. Structuralism is the name of a rival school started by Edward Titchener, one of Wundt's students (discussed later). As we will see, the schools of voluntarism and structuralism had very little in common.

WILHELM MAXIMILIAN WUNDT

Wilhelm Maximilian Wundt (1832-1920) was born at Neckarau, a suburb of the important commercial center of Mannheim, on August 16 of the same year that Goethe died. When he was 4 years old, he and his family moved to the small town of Heidelsheim. He was the fourth, and last, child of a Lutheran minister. His father's side of the family included historians, theologians, economists, and two presidents of the University of Heidelberg. On his mother's side were physicians, scientists, and government officials. Despite the intellectually stimulating atmosphere in which Wundt grew up (or perhaps because of it), he remained a shy, reserved person who was fearful of new situations. Wundt's only sibling to survive infancy was a brother, eight years his elder, who went away to school. Wundt's only friend his own age was a mentally retarded boy who could barely speak. When Wundt was about eight years old, his education was turned over to a young vicar who worked in his father's church. The vicar was Wundt's closest friend until Wundt entered high school. Wundt's first year in high school was a disaster: he made no friends, daydreamed incessantly, was physically punished by his teachers, and finally failed. At this time, one of his teachers suggested that a reasonable aspiration for Wundt would be a career in the postal service (Diamond, 1980, pp. 12-13). The following year, he started high school over, this time in the city of Heidelberg, where his brother

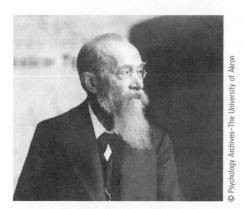

Wilhelm Maximilian Wundt

and a cousin were students. Although he was not an outstanding student, he did much better there.

After graduation from high school, Wundt enrolled in the premedical program at the University of Tübingen. He stayed for a year and then transferred to the University of Heidelberg, where he became one of the top medical students in his class, graduated summa cum laude, and placed first in the state medical board examination. After receiving his medical degree in 1855 at the age of 23, he went to Berlin and studied with Johannes Müller, who so influenced Wundt that he decided to pursue a career in experimental physiology instead of medicine. After a year of working and studying at Müller's institute, Wundt returned to the University of Heidelberg, where he became Helmholtz's laboratory assistant. While he was working for Helmholtz, Wundt gave his first course in psychology as a natural science and wrote his first book, Contributions to the Theory of Sense Perception (1862a). In this book, Wundt formed the plan for psychology that he was to follow for the rest of his life. The following year, he published Lectures on Human and Animal Psychology (1863), which clearly indicated the dual interests in psychology that Wundt entertained throughout his career. Wundt believed that experimental psychology could be used in an effort to understand immediate consciousness (discussed later) but that it was useless in attempting to understand the higher mental processes and their products. For the study of the latter, only naturalistic observation or historical analysis

could be used. Both of these concerns were clearly present in Lectures, the first part of which included a history of psychology, a review of research on sensation and perception, and research related to the personal equation. The second part of *Lectures* included discussions of aesthetic and religious feelings, moral judgments, the development of societies, comparative religion, language, and the will. In fact, most of the topics that later appeared in Völkerpsychologie (1900-1920), the monumental 10-volume work that Wundt worked on for the last 20 years of his life, first appeared in Lectures in 1863. Wundt remained a teacher at Heidelberg until 1874, when he accepted a professorship in inductive philosophy at the University of Zürich in Switzerland. The following year he was offered an appointment to teach scientific philosophy at the University of Leipzig. Wundt accepted the appointment and remained at Leipzig for 45 years.

Wundt wanted to teach experimental psychology at Leipzig in 1875, but the university could not provide space for his equipment; he ended up teaching courses in anthropology, logic, and language instead. He obtained the space he needed the following year and began teaching experimental psychology. By 1879 his laboratory was in full production, and he was supervising the research of several students. The year 1879 is usually given as the date of the founding of the first laboratory dedicated exclusively to psychological research. Wundt called his laboratory the Institute for Experimental Psychology. At first, the university administration was not supportive of Wundt's institute, and it was not listed in the university catalog until 1883. The institute became extremely popular, however, and Wundt's lecture classes became the most popular at the university, sometimes exceeding 250 students (Bringmann, Bringmann, and Ungerer, 1980, p. 147). In 1881, Wundt began the journal Philosophical Studies, the first journal devoted to experimental psychology. He wanted to call his journal Psychological Studies, but a journal with that title already existed, and it dealt with spiritualism and parapsychological phenomena. Several years later, Wundt did change the name of his journal to the more appropriate Psychological Studies.

In response to the increasing popularity of Wundt's institute, it was physically enlarged several times. In 1882 he moved from his small one-room laboratory to one with nine rooms, and in 1897 he was given an entire building, which he helped design. By this time Wundt dominated experimental psychology, something he continued to do for three decades. During his years at Leipzig, Wundt supervised 186 doctoral dissertations (70 in philosophy and 116 in psychology). His psychology students became pioneers of experimental psychology throughout the world; we will encounter several of them.

Wundt was one of the most productive individuals in the history of psychology. Boring (1950) estimated that from 1853 to 1920, Wundt wrote a total of 53,735 pages:

If there are 24,836 days in sixty-eight years, then Wundt wrote or revised at the average rate of 2.2 pages a day from 1853 to 1920, which comes to about one word every two minutes, day and night, for the entire sixty-eight years. (p. 345)Obviously, Wundt's primary interest was his work:

He never was much excited about anything other than his work. Even his wife and family receive no more than one paragraph in his entire autobiography. His dedication went so far that he analyzed his psychological experiences when he was very seriously ill and near death; at one point in his life he was rather intrigued with the idea of experiencing the process of dying. (Wertheimer, 1987, p. 62)

Appropriately, the last thing Wundt worked on was his autobiography, which he finished a few days before he died at the age of 88.

Psychology's Goals

Wundt disagreed with individuals like Galileo, Comte, and Kant who claimed that psychology could never be a science; and he disagreed with Herbart, who said that psychology could be a mathematical science but not an experimental one. Wundt believed strongly that psychology had, in fact, become an experimental science. As we have seen, however, in his comprehensive view of psychology, experimentation played only a limited role. He believed that experimentation could be used to study the basic processes of the mind but could not be used to study the higher mental processes. For the latter, only various forms of naturalistic observation could be used. We will see how Wundt proposed to study the higher mental thought processes when we discuss his Völkerpsychologie. Still, the role of experimental psychology was vital to Wundt. Learning about the simpler conscious processes may shed some light on those that are more complex: "Let us remember the rule, valid for psychology as well as for any other science, that we cannot understand the complex phenomena, before we have become familiar with the simple ones which presuppose the former" (Wundt, 1912/1973, p. 151). To summarize, according to Wundt, psychology's goal was to understand both simple and complex conscious phenomena. For the former, experimentation could be used; for the latter, it could not.

Mediate and Immediate Experience. Wundt believed that all sciences are based on experience and that scientific psychology is no exception. But the type of experience psychology would use would be different. Whereas other sciences were based on mediate experience, psychology was to be based on immediate experience. The data the physicist uses, for example, are provided by various measuring devices such as spectrometers (to measure wavelengths of light) or sound spectrographs (to measure the frequencies and intensities of sound waves). The physicist records the data these devices provide and then uses the data to analyze the characteristics of the physical world. Thus the experience of the natural scientist is mediated by recording devices and is not direct. For Wundt the subject matter of psychology was to be human consciousness as it occurred. Wundt was not interested in the nature of the physical world but wanted to understand the psychological processes by which we experience the physical world.

Once the mental elements were isolated, the laws governing their combination into more complex experiences could be determined. Thus, Wundt set two major goals for his experimental psychology: (1) to discover the basic **elements of thought**, and (2) to discover the laws by which mental elements combine into more complex mental experiences.

Wundt's Use of Introspection

To study the basic mental processes involved in immediate experience, Wundt used a variety of methods, including **introspection**. Wundt's use of introspection bore little resemblance, however, to how the technique was used by St. Augustine to explore the mind to find the essence of God or by Descartes to find certain truth. Wundt's use of introspection was also different from how the empiricists and sensationalists used it to study ideas and association. Wundt distinguished between *pure introspection*, the relatively unstructured self-observation used by earlier philosophers, and *experimental introspection*, which he believed to be scientifically respectable:

Experimental introspection made use of laboratory instruments to vary the conditions and hence make the results of internal perception more precise, as in the psychophysical experiments initiated by Fechner or in the sense-perception experiments of Helmholtz. In most instances saying "yes" or "no" to an event was all that was needed, without any description of inner events. Sometimes the subject responded by pressing a telegraph key. The ideal was to make introspection, in the form of internal perception, as precise as external perception. (Hilgard, 1987, p. 44)

Wundt had little patience with colleagues who used introspection in the more philosophical and less objective way. Danziger (1980c) examined

180 studies performed in Wundt's laboratory between 1883 and 1903 and found that all but four used experimental introspection, and Wundt himself criticized two of the four studies that did not. Wundt, then, used introspection more or less as the physiologists (such as Helmholtz) and the psychophysicists had used it—that is, as a technique to determine whether a person is experiencing a specific sensation or not. In fact, Wundt replicated much of the work on audition and vision that the physiologists had done and much of the work on absolute and differential thresholds that the psychophysicists had done.

In the restrictive way that Wundt used it, introspection could be used to study immediate experience, but under no circumstances could it be used to study the higher mental processes.

Elements of Thought

According to Wundt, there are two basic types of mental experience: sensations and feelings. A **sensation** occurs whenever a sense organ is stimulated and the resulting impulse reaches the brain. Sensations can be described in terms of *modality* (visual, auditory, taste, and so on) and *intensity* (such as how loud an auditory stimulus is). Within a modality, a sensation can be further analyzed to determine its *qualities*. For example, a visual sensation can be described in terms of hue (color) and saturation ("richness" of color). An auditory sensation can be described in terms of pitch and timbre ("fullness" of tone). A taste sensation can be described in terms of its degree of saltiness, sourness, bitterness, or sweetness.

All sensations are accompanied by **feelings**. Wundt reached this conclusion while listening to the beat of a metronome and noting that some rates of beating were more pleasant than others. From his own introspections, he formulated his **tridimensional theory of feeling**, according to which any feelings can be described in terms of the degree to which they possess three attributes: pleasantness-unpleasantness, excitement-calm, and strain-relaxation.

Perception, Apperception, and Creative Synthesis

Often a discussion of Wundt's system stops with his concern with mental elements and his use of introspection as the means of isolating them. Such a discussion omits some of Wundt's most important ideas. Indeed, sensations and feelings are the elements of consciousness, but in everyday life they are rarely, if ever, experienced in isolation. Most often, many elements are experienced simultaneously, and then perception occurs. According to Wundt, perception is a passive process governed by the physical stimulation present, the anatomical makeup of the individual, and the individual's past experiences. These three influences interact and determine an individual's perceptual field at any given time. The part of the perceptual field the individual attends to is apperceived (Wundt borrowed the term apperception from Herbart). Attention and apperception go hand in hand; what is attended to is apperceived. Unlike perception, which is passive and automatic, apperception is active and voluntary. In other words, apperception is under the individual's control. It was primarily because Wundt believed so strongly that individuals could direct their attention by exercising their will that he referred to his approach to psychology as voluntarism. Wundt even criticized John Stuart Mill's concept of "mental chemistry," according to which two or more ideas could synthesize and give rise to an idea unlike any of those it comprises. Wundt rejected this process because it is passive, just as the blending of chemical elements is passive. For Wundt the vital difference between his position and that of the empiricists was his emphasis on the active role of attention. When elements are attended to, they can be arranged and rearranged according to the individual's will, and thus arrangements never actually experienced before can result. Wundt called this phenomenon creative synthesis and thought that it was involved in all acts of apperception. It was, according to Wundt, the phenomenon of creative synthesis that made psychology a discipline that was qualitatively different from the physical sciences. Blumenthal (1998) summarizes Wundt's position as follows:

There are no psychological qualities in physics. For example, there is no red, or green, or blue in that world. Redness, greeness, and blueness are phenomena that are created by the cortex of the experiencing individual. A musical quality, the flavor of the wine, or the familiarity of a face is a rapid creative synthesis that cannot, in principle, be explained as a mere sum of elemental physical features. (p. 45)

So, contrary to the popular view that Wundt busied himself searching for the cognitive and emotional elements of a static mind, he viewed the mind as active, creative, dynamic, and volitional. In fact, he believed that the apperceptive process was vital for normal mental functioning, and he speculated that schizophrenia could be the result of a breakdown of the attentional processes. If a person lost the ability to apperceive, his or her thoughts would be disorganized and would appear meaningless, as in the case of schizophrenia. The theory that schizophrenia could be understood as a breakdown of the attentional processes was expanded by Wundt's student and friend Emil Kraepelin (1856-1926). According to Kraepelin, a defect in the "central control process" can result in reduced ability to pay attention, an erratic ability to pay attention, or in extremes in focusing one's attention—any one of which would result in severe mental illness.

As we have seen, Wundt was interested in sensations; and in explaining how sensations combined into perceptions, he remained close to traditional associationism. With apperception, however, he emphasized attention, thinking, and creative synthesis. All these processes are much more closely aligned with the rationalist tradition than with the empiricist tradition.

Mental Chronometry

In his book *Principles of Physiological Psychology* (1874/1904), Wundt expressed his belief that reaction time could supplement introspection as a

Franciscus Cornelius Donders

technique for studying the elemental contents and activities of the mind. We saw in Chapter 8 that Friedrich Bessel performed the first reaction-time experiment to collect data that could be used to correct for individual differences in reaction times among those observing and reporting astronomical events. Helmholtz used reaction time to determine the rate of nerve conduction but then abandoned it because he found it to be an unreliable measure.

Franciscus Cornelius Donders. About 15 years after Helmholtz gave up the technique, Franciscus Cornelius Donders (1818–1889), a famous Dutch physiologist, began an ingenious series of experiments involving reaction time. First, Donders measured simple reaction time by noting how long it took a subject to respond to a predetermined stimulus (such as a light) with a predetermined response (such as pressing a button). Next, Donders reasoned that by making the situation more complicated, he could measure the time required to perform various mental acts.

In one experiment, for example, Donders presented several different stimuli to his subjects but instructed them to respond to only one, which he designated ahead of time. This required the subjects to discriminate among the stimuli before responding. The arrangement can be diagrammed as follows:

Stimuli:	Α	В	С	D	Е
					\downarrow
Response:				С	

The time it took to perform the mental act of discrimination was determined by subtracting simple reaction time from the reaction time that involved discrimination. Donders then made the situation more complicated by presenting several different stimuli and instructing his subjects to respond to each of them differently. This experimental arrangement can be diagrammed as follows:

Stimuli:	Α	В	C	D	Е
	1	\downarrow	1	\downarrow	\downarrow
Response:	a	В	С	d	е

Donders called reactions under these circumstances choice reaction time, and the time required to make a choice was determined by subtracting both simple and discrimination reaction times from choice reaction time.

Wundt's Use of Donders's Methods. Wundt enthusiastically seized upon Donders's methods, believing that they could provide a mental chronometry, or an accurate cataloging of the time it took to perform various mental acts. Almost 20% of the early work done in Wundt's laboratory involved repeating or expanding on Donders's research on reaction time. Wundt believed strongly that such research provided another way (along with experimental introspection) of doing what so many had thought to be impossible—experimentally investigating the mind. According to Danziger (1980b), reaction-time studies conducted during the early years of Wundt's laboratory constitute the first example of a research program explicitly concerned with psychological issues.

Wundt repeated and expanded many of Donders's experiments and was originally optimistic

about being able to measure precisely the time required to perform various mental operations. However, he eventually abandoned his reaction-time studies. One reason was that he, like Helmholtz, found that reaction times varied too much from study to study, from subject to subject, and often for the same subject at different times. Reaction time also varied with the sense modality stimulated, the intensity of the stimulus, the number of items to be discriminated and the degree of difference among them, how much practice a subject received, and several other variables. The situation was much too complicated to obtain measurable psychological "constants."

After Wundt rejected them, Donders's methods were subsequently ignored. However, when cognitive psychology was resurrected in the 1960s, Donders's reaction-time procedures were rediscovered and found to be effective in studying cognitive processes (Boynton and Smith, 2006).

Psychological Versus Physical Causation

Wundt believed that psychological and physical causality were "polar opposites" because physical events could be predicted on the basis of antecedent conditions and psychological events could not. It is the will that makes psychological causation qualitatively different from physical causation. We have already seen that Wundt believed humans can will-fully arrange the elements of thought into any number of configurations (creative synthesis). Wundt also believed that because intentions are willfully created, they cannot be predicted or understood in terms of physical causation:

[Wundt argued that the] physical sciences would ... describe the act of greeting a friend, eating an apple, or writing a poem in terms of the laws of mechanics or in terms of physiology. And no matter how finegrained and complicated we make such descriptions, they are not useful as descriptions of psychological events. Those events need be described in terms of intentions and

goals, according to Wundt, because the actions, or physical forces, for a given psychological event may take an infinite variety of physical forms. In one notable example, he argued that human language cannot be described adequately in terms of its physical shape or of the segmentation of utterances, but rather must be described as well in terms of the rules and intentions underlying speech. For the ways of expressing a thought in language are infinitely variable. (Blumenthal, 1975, p. 1083)

Another factor that makes the prediction of psychological events impossible is what Wundt called the **principle of the heterogony of ends**. According to this principle, a goal-directed activity seldom attains its goal and nothing else. Something unexpected almost always happens that, in turn, changes one's entire motivational pattern:

An action arising from a given motive produces not only the ends latent in the motive, but also other, not directly purposed, influences. When these latter enter into consciousness and stir up feelings and impulses, they themselves become new motives, which either make the original act of volition more complicated, or they change it or substitute some other act for it. (Wundt, 1912/1973, pp. 168–169)

Wundt also employed the **principle of contrasts** to explain the complexity of psychological experience. He maintained that opposite experiences intensify one another. For example, after eating something sour, something sweet tastes even sweeter, and after a painful experience, pleasure is more pleasurable (Blumenthal, 1980). The related principle, the **principle toward the development of opposites**, states that after a prolonged experience of one type, there is an increased tendency to seek the opposite type of experience. This latter principle not only applies to the life of an individual but also to human history in general (Blumenthal, 1980). For example, a prolonged period during which rationalism is emphasized (for

example, the Enlightenment) would tend to be followed by a period during which the human emotions would be emphasized, such as in romanticism.

Volitional Acts Are Creative but Not Free. Wundt was a determinist. That is, he did not believe in free will. Behind all volitional acts were mental laws that acted on the contents of consciousness. These laws were unconscious, complex, and not knowable through either introspection or other forms of experimentation; but laws they were, and their products were lawful. According to Wundt, the laws of mental activity can be deduced only after the fact, and in that sense the psychologist studying them is like a historian:

Future resultants can never be determined in advance; but ... on the other hand it is possible, starting with the given resultants, to achieve, under favourable conditions, an exact deduction into the components. The psychologist, like the psychological historian, is a prophet with his eyes turned towards the past. He ought not only to be able to tell what has happened, but also what necessarily must have happened, according to the position of events. (Wundt, 1912/1973, p. 167)

The historical approach must be used to investigate the higher mental processes, and it is that approach that Wundt used in his *Völkerpsychologie*, to which we turn next.

VÖLKERPSYCHOLOGIE

Although Wundt went to great lengths to found experimental psychology as a separate branch of science and spent years performing and analyzing experiments, he believed, as we have seen, that the higher mental processes, which are reflected in human culture, could be studied only through historical analysis and naturalistic observation. According to Wundt, the nature of the higher mental processes could be deduced from the study of such cultural products as

religion, social customs, myths, history, language, morals, art, and the law. Wundt studied these topics for the last 20 years of his life, with his research culminating in his 10-volume **Völkerpsychologie** ("group" or "cultural" psychology). In this work, Wundt emphasized the study of language, and his long-overlooked conclusions have a strikingly modern ring to them.

According to Wundt, verbal communication begins with a general impression, or unified idea, that one wishes to convey. The speaker apperceives this general impression and then chooses words and sentences to express it. The linguistic structures and words the speaker chooses for expressing the general impression may or may not do so accurately; and upon hearing his or her own words, the speaker may say, No, that's not what I had in mind, and make another attempt at expression. Once the speaker has chosen sentences appropriate for expressing the general idea, the next step is that the listener must apperceive the speaker's words. That is, the listener must understand the general impression the speaker is attempting to convey. If this occurs, the listener can replicate the speaker's general impression by using any number of different words or sentence structures. Verbal communication, then, is a three-stage process.

- 1. The speaker must apperceive his or her own general impression.
- 2. The speaker chooses words and sentence structures to express the general impression.
- 3. The listener, after hearing the words and sentences, must apperceive the speaker's general impression.

As evidence for this process, Wundt points out that we often retain the *meaning* of a person's words long after we have forgotten the specific words the person used to convey that meaning.

The Historical Misunderstanding of Wundt

Bringmann and Tweney (1980) observe, "Our modern conceptions of psychology—its problems, its

methods, its relation to other sciences, and its limits—all derive in large part from [Wundt's] inquiries" (p. 5). And yet Blumenthal (1975) comments, "To put it simply, the few current Wundt-scholars (and some do exist) are in fair agreement that Wundt as portrayed today in many texts and courses is largely fictional and often bears little resemblance to the actual historical figure" (p. 1081). Blumenthal (1979) speculates that, to a large extent, Wundt's early use of the word *element* was responsible for his being misinterpreted by so many:

Today I cannot help but wonder whether Wundt had any notion of what might happen the day he chose the word "Elemente" as part of a chapter title. Later generations seized upon the word with such passion that they were eventually led to transform Wundt into something nearly opposite to the original. (p. 549)

Earlier in this chapter, we discussed a major source of the distortion of Wundt's ideas: Wundt's psychology reflected the rationalist tradition, and U.S. psychology embraced the empiricistic-positivistic tradition. The distortion of Wundt's ideas started early: "For all the American students who went abroad to attend Wundt's lectures, very little of Wundt's psychological system survived the return passage" (Blumenthal, 1980, p. 130). Edward Titchener (whom we consider next) was an Englishman who came to the United States and came to be viewed as the U.S. representative of Wundtian ideas. That was a mistake:

While the stimulus of some of Wundt's ideas is detectable in Titchener's psychology, an enormous cultural and intellectual gulf separated the general approach of these two psychologists.... It seems that [Titchener] genuinely could not think in terms of categories that differed fundamentally from the English positivist tradition. (Danziger, 1980a, pp. 84–85)

By misrepresenting Wundt, psychology has overlooked a rich source of ideas. Fortunately,

Wundt's true psychology is in the process of being rediscovered, and one reason for this may be psychology's return to an interest in cognition.

Strange as it may seem, Wundt may be more easily understood today than he could have been just a few years ago. This is because of the current milieu of modern cognitive psychology and of the recent research on human information processing. (Blumenthal, 1975, p. 1087)

EDWARD BRADFORD TITCHENER

Born on January 11 in Chichester, England, **Edward Bradford Titchener** (1867–1927) attended Malvern College, a prestigious secondary school. He then went to Oxford from 1885 to 1890, where his academic record was outstanding. While at Oxford, he developed an interest in experimental psychology and translated the third edition of Wundt's *Principles of Physiological Psychology* into English. Following graduation from Oxford, Titchener went to Leipzig and studied for two years with Wundt.

During his first year at Leipzig, Titchener struck up a friendship with Frank Angell, a fellow student who was to play an important role in bringing Titchener to the United States. After completing his studies with Wundt, Angell went to Cornell University in Ithaca, New York, to establish a psychological laboratory. After only one year, however, Angell decided to accept a position at Stanford University. When Titchener earned his doctorate in 1892, he was offered the job as Angell's replacement. Titchener was also offered a job at Oxford, but there he would have no laboratory facilities. In 1892 he accepted the offer from Cornell and soon developed the largest doctoral program in psychology in the United States. When Titchener arrived at Cornell, he was 25 years old, and he remained there for the rest of his life.

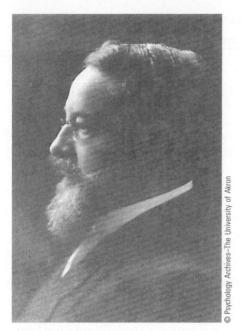

Edward Bradford Titchener

However, Titchener remained a loyal British subject and never became a U.S. citizen.

Titchener ruled his domain with an iron fist. He determined what the research projects would be and which students would work on them. For him, psychology was experimental psychology (as he defined it); and everything that preceded his version of psychology was not psychology at all: "To Titchener, the American psychologies prior to the 1880s—and much since then—were little more than watered-down Cartesianisms, codified phrenologies, or worst of all, thinly disguised theology" (Evans, 1984, p. 18). When the school of behaviorism was introduced by John B. Watson in the early 1900s (see Chapter 12), Titchener (1914) claimed that it was a technology of behavior but not part of psychology. Titchener was also opposed to seeking psychological information for its applied value; science seeks pure knowledge, and psychology (his psychology) was a science: "Science deals, not with values, but with facts. There is no good or bad, sick or well, useful or useless, in science" (Titchener, 1915, p. 1). Titchener was well aware

of developments in abnormal, clinical, developmental, animal-comparative, social psychology, and psychological testing, and he even supported investigations in these areas. In spite of their usefulness, however, he believed that they did not represent pure, experimental psychology—psychology as he defined it.

Anecdotes about Titchener's authoritarian style abound. It is said that he refused a dinner invitation from Cornell's president because the president had not called in person to invite him. When the president protested that he did not have time to make such personal calls, Titchener said that he at least could have sent his coachman with the invitation. The coachman came, and Titchener went to dinner (Hilgard, 1987, p. 76). Needless to say, Titchener's students were in awe of him. Hilgard (1987) describes a lasting experience that Edwin Boring, then a graduate student at Cornell, had with Titchener:

Once Boring was invited to dinner at Titchener's to celebrate Titchener's birthday. After dinner the cigars were passed and Boring could not refuse under the circumstances, though he had never smoked a cigar. The consequence was that he had to excuse himself presently because of his nausea and go outside to throw up. Still, the honor of having been invited once was so great that every year thereafter Titchener's birthday would be celebrated by dinner at the Boring home, followed by the smoking of a cigar, with the inevitable consequence. (p. 106)

Although Titchener was domineering concerning psychology, it would be a mistake to conclude that he was narrow-minded. He was an accomplished musician and provided instruction in music at Cornell until a music department was established. He conducted a small orchestra in his home on Sunday nights, and students with musical ability were encouraged to participate. Casual, nonpsychological conversation followed the concerts. He was a dedicated and knowledgeable collector of ancient coins, and his home was described as a "veritable museum." In addition, he was well versed in several

languages. In his autobiography, Boring (1961) provided a sample of Titchener the generalist:

He always seemed to me the nearest approach to genius of anyone with whom I have been closely associated.... He was competent with languages, and could ad lib in Latin when the occasion required it. If you had mushrooms, he would tell you at once how they should be cooked. If you were buying oak for a new floor, he would at once come forward with all the advantages of ash. If you were engaged to be married, he would have his certain and insistent advice about the most unexpected aspects of your problems, and if you were honeymooning, he would write to remind you, as he did me, on what day you ought to be back at work. (pp. 22-23)

Incidentally, Boring (1886–1968) dedicated his classic *History of Experimental Psychology* (1950) to Titchener. This book did much to perpetuate the myth that Wundt's and Titchener's versions of psychology were similar.

Titchener was a charter member of the American Psychological Association (APA) but never attended a meeting, even when the national meeting was held in Ithaca. Instead, in 1904 founded his own organization, Experimentalists, and until his death in 1927, he ran it according to his own ideas of what psychology should be. Membership was by Titchener's invitation only. Titchener apparently felt the need to create an organization separate from the APA for two reasons. First, he was upset because the APA failed to expel one of its members whom he believed to be guilty of plagiarism. Second, and probably most important, he believed that the APA was too friendly toward a variety of applied topics and therefore was drifting away from pure experimental psychology. (For a description of the goals and characteristics of Titchener's Experimentalists, see Furumoto, 1988; for a discussion of how the Experimentalists were reorganized following Titchener's death, see Goodwin, 2005.)

Titchener's Paradoxical Relationship with Female Psychologists

Although the APA had admitted women as members almost from its inception, when Titchener created the Experimentalists, women were excluded. The ban on women lasted from the organization's inception until its reorganization two years after Titchener's death, in 1929. Although membership included many of the most illustrious psychologists in the United States, few criticized the ban and several supported it.

Of the female psychologists excluded from Titchener's organization, Christine Ladd-Franklin (see Chapter 8) was the most outraged. In an exchange of letters with Titchener, she expressed extreme indignation with his "old-fashioned" policy. To Titchener's claim that he believed women might be offended by the excessive cigar smoke at the meetings, she replied, "Have your smokers separated if you like (tho I for one always smoke when I am in fashionable society), but a scientific meeting (however personal) is a public affair, and it is not open to you to leave out a class of fellow workers without extreme discourtesy" (Scarborough and Furumoto, 1987, p. 125). Ladd-Franklin's comments did not cause Titchener to change his exclusionary policy.

However, Titchener's first doctoral candidate was Margaret Floy Washburn who, in June 1894, became the first woman ever to receive a doctorate in psychology. Titchener was so impressed by Washburn's dissertation, which explored the influence of visual imagery on judgments of tactile distance and direction, that he took the unusual step of submitting it to Wundt for publication in his journal *Philosophical Studies*. Washburn went on to make significant contributions to comparative psychology (see Chapter 11) and to be elected president of the APA in 1921.

Other women to whom Titchener taught his version of experimental psychology included Celestia Susannah Parrish (1855–1918). In 1893 Titchener, then a newly appointed professor at Cornell, accepted Parrish as a summer school stu-

dent. During that summer, Parrish persuaded Titchener to furnish her with a tailor-made correspondence course that she could take while teaching at Randolph-Macon Woman's College (R-MWC) the following fall. Parrish, who took additional summer school classes from Titchener in 1894 and 1895, went on to establish the first psychology laboratory in the southern United States at R-MWC in Lynchburg, Virginia, and to chair the Department of Psychology and Pedagogy at the State Normal School in Georgia, which later became part of the University of Georgia (Rowe and Murray, 1979).

Including Washburn and Parrish, half of Titchener's first 12 doctorates were awarded to women, and of the 56 doctoral students he directed between 1894 and 1927, 19 were women. Titchener took women into his graduate program at a time when universities such as Harvard and Columbia would not. "More women completed their PhD degrees with him than with any other male psychologist of his generation.... Titchener also favored hiring women for academic positions when they were the best candidates for a job. In one case he did so, even over the objection of the dean" (Evans, 1991, p. 90).

So what was Titchener's attitude toward female psychologists? It has been suggested that during Titchener's tenure, Cornell had unusually liberal and advanced ideas about women to which Titchener was obliged to conform. However, given what we know about his domineering personality, it is difficult to imagine him conforming to anything he was not sympathetic toward.

As long as Titchener was healthy, structuralism flourished; but when he died on August 3, 1927, of a brain tumor at the age of 60, structuralism essentially died with him. The reasons or the demise of structuralism will be discussed later.

Psychology's Goals

Titchener agreed with Wundt that psychology should study immediate experience—that is, consciousness. He defined *consciousness* as the sum total of mental experience at any given moment and *mind* as the accumulated experiences of a lifetime.

Titchener set as goals for psychology the determination of the what, how, and why of mental life. The *what* was to be learned through careful introspection. The goal here was a cataloging of the basic mental elements that account for all conscious experience. The *how* was to be an answer to the question of how the elements combine, and the *why* was to involve a search for the neurological correlates of mental events.

Unlike Wundt, who sought to explain conscious experience in terms of unobservable cognitive processes, Titchener sought only to describe mental experience. Titchener, accepting the positivism of Ernst Mach, believed that speculation concerning unobservable events has no place in science. It is interesting to note that Titchener took the same position toward the use of theory as B. F. Skinner (see Chapter 13) was to take many years later. For both, theorizing meant entering the world of metaphysical speculation; and for both, science meant carefully describing what could be observed. However, whereas Skinner focused on observable behavior, Titchener focused on observable (via introspection) conscious events. It was the structure of the mind that Titchener wanted to describe, and thus he named his version of psychology structuralism (Titchener, 1898, 1899).

What Titchener sought was a type of periodic table for mental elements, like that which chemists had developed for the physical elements. Once the basic elements were isolated, the laws governing their combination into more complex experiences could be determined. Finally, the neurophysiological events correlated with mental phenomena could be determined. In 1899 Titchener defined the goal of structuralism as describing the *is* of mental life; he was willing to leave the *is* for for others to ponder.

Titchener's Use of Introspection

Titchener's use of introspection was more complicated than Wundt's. Typically, Wundt's subjects would simply report whether an experience was triggered by an external object or event. Titchener's subjects, however, had to search for the elemental ingredients of their experiences. Their job was to

describe the basic, raw, elemental experiences from which complex cognitive experience was built. Titchener's subjects therefore had to be carefully trained to avoid reporting the *meaning* of a stimulus. The worst thing introspectionists could do would be to name the object of their introspective analysis. If the subjects (more accurately, observers) were shown an apple, for example, the task would be to describe hues and spatial characteristics. Calling the object an apple would be committing what Titchener called the **stimulus error**. In this case, Titchener wanted his subjects to report sensations, not perceptions. Titchener said, "Introspecting through the glass of meaning ... is the besetting sin of the descriptive psychologist" (1899, p. 291).

Toward the end of his career, Titchener became more liberal in his use of introspection (Evans, 1984). He found that allowing untrained introspectionists to simply describe their phenomenological experience could be an important source of information. That is, taking a report of everyday experience at face value from a nonscientific "observer" could lead to important scientific discoveries. Unfortunately, Titchener died before he and his students could explore this possibility.

Mental Elements

From his introspective studies, Titchener concluded that the elemental processes of consciousness consist of sensations (elements of perceptions), images (elements of ideas), and affections (elements of emotions). According to Titchener, an element could be known only by listing its attributes. The attributes of sensations and images (remnants of sensations) are quality, intensity, duration, clearness, and extensity. Extensity is the impression that a sensation or image is more or less spread out in space. Affections could have the attributes of quality, intensity, and duration but neither clearness nor extensity.

In practice, Titchener and his students concentrated most on the study of sensations, then on affections, and least of all on images. Titchener (1896) concluded that there are over 40,000 identifiable sensations, most of which are related to the sense

of vision (about 30,000), with audition next (about 12,000), and then all the other senses (about 20). In his later years, Titchener changed the object of his introspective analysis from the elements themselves to their attributes (such as quality, intensity, and clearness) because it is only through its attributes that an element could be known (Evans, 1972).

Titchener did not accept Wundt's tridimensional theory of feeling. Titchener argued that feelings occur along only one dimension, not three, as Wundt had maintained. According to Titchener, feelings (affections) can be described only in terms of Wundt's pleasantness-unpleasantness dimension. He argued that the other two dimensions Wundt had suggested (tension-relaxation and excitement-calm) were really combinations of sensations and true feelings (pleasantness-unpleasantness). The what of psychology, then, included the sensations and images that were described in terms of quality, intensity, duration, clearness, and extensity, as well as the feelings that varied in terms of pleasantness.

Law of Combination

After Titchener had isolated the elements of thought, the next step was to determine *how* they combine to form more complex mental processes. In explaining how elements of thought combine, Titchener rejected Wundt's notions of apperception and creative synthesis in favor of traditional associationism. Titchener (1910) made the law of contiguity his basic law of association:

Let us try ... to get a descriptive formula for the facts which the doctrine of association aims to explain. We then find this: that, whenever a sensory or imaginal process occurs in consciousness, there are likely to appear with it (of course, in imaginal terms) all those sensory and imaginal processes which occurred together with it in any earlier conscious present.... Now the law of contiguity can, with a little forcing, be translated into our own general law of association. (pp. 378–379)

What about attention, the process that was so important to Wundt? For Titchener attention was simply an attribute of a sensation (clearness). We do not make sensations clear by attending to them as Wundt had maintained. Rather, we say we have attended to them because they were clearer than other sensations in our consciousness. Titchener there is no underlying process of apperception that causes clarity; it is just that some sensations are more vivid and clear than others, and it is those that we say we attend to. The vague feelings of concentration and effort that accompany "attention" are nothing more than the muscle contractions that accompany vivid sensations. Consistent with his positivism, Titchener saw no need to postulate faculties, functions, or powers of the mind to explain the apparently rational process of attention. For him attention was clearness of sensation period.

For the *how* of mental processes, then, Titchener accepted traditional associationism, thus aligning himself with the British empiricists.

Neurological Correlates of Mental Events

Titchener referred to himself as a psychophysical parallelist concerning the mind-body relationship, and indeed much of his writing reflects that position. Occasionally, however, he appeared to embrace Spinozian double aspectism and at other times epiphenomenalism. Titchener's uncharacteristic equivocation in his position on the mind-body relationship reflected disinterest rather than shoddiness in his thinking. For him attempting to explain the mind-body relationship came dangerously close to metaphysical speculation, and that was foreign to his positivism. Essentially, Titchener believed that physiological processes provide a continuous substratum that give psychological processes a continuity they otherwise would not have. Thus, for Titchener, although the nervous system does not cause mental events, it can be used to explain some of their characteristics.

Ultimately then, neurophysiological processes are the why of mental life, if why is understood to

mean a description of the circumstances under which mental processes occur.

Context Theory of Meaning

What do we mean by the word meaning? Titchener's answer again involved associationism. Sensations are never isolated. In accordance with the law of contiguity, every sensation tends to elicit images of sensations that were previously experienced along with the sensation. A vivid sensation or group of sensations forms a core, and the elicited images form a *context* that gives the core meaning. A rattle may elicit images of the baby who used it, thus giving the rattle meaning to the observer. A picture of a loved one tends to elicit a wide variety of images related to the loved one's words and activities, thus giving the picture meaning. Even with such a rationalist concept as meaning, Titchener's context theory of meaning maintains his empiricist and associationist philosophy.

The Decline of Structuralism

A case can be made that Wundt's voluntarism is still with us, but Titchener's structuralism is not. Indeed, ample evidence shows that many of Wundt's ideas are alive and well in contemporary psychology, whereas nothing of substance from Titchener's system has survived. The question is, What caused the virtual extinction of structuralism?

In many ways, the decline of the school of structuralism was inevitable. We have seen that interest in the mind is as old as history itself, and the question of how the mind is related to bodily processes goes back at least as far as the early Greeks. Focusing mainly on the physical world, early science was extremely successful, and its success stimulated interest in directing scientific methodology to a study of the mind. Because both empiricists and rationalists alike had long believed that the senses were the gateways to the mind, it is no surprise that sensory processes were among the first things on which science focused when it was applied to humans. From there it was but a short,

logical step to looking at neural transmission, brain mechanisms, and finally conscious sensations.

Structuralism was essentially an attempt to study scientifically what had been the philosophical concerns of the past. How does sensory information give rise to simple sensations, and how are these sensations then combined into more complex mental events? The major tool of the structuralists, and even their opponents, was introspection. This, too, had been inherited from the past. Although it was now used scientifically (that is, in a controlled situation), introspection was yielding different results depending on who was using it and what they were seeking. Also, there was lack of agreement among highly trained introspectionists concerning the correct description of a given stimulus display.

Other arguments against the use of introspection began to appear. Some pointed out that what was called introspection was really retrospection because the event being reported had already occurred. Therefore what was being reported was a memory of a sensation rather than the sensation itself. Also, it was suggested that one could not introspect on something without changing it—that is, that observation changed what was being observed. It was beginning to appear that those who claimed that a science of the mind was impossible were correct.

Aside from the apparent unreliability of introspection, structuralism came under attack for several other reasons. Structuralism excluded several developments that researchers outside the school of structuralism were showing to be important. The study of animal behavior had little meaning for those hoping to find the basic elements of human consciousness, yet others were finding that much could be learned about humans by studying nonhuman animals. The structuralists were not interested in the study of abnormal behavior even though Freud and others were making significant advances in understanding and treating individuals who were mentally ill. Similarly, the structuralists essentially ignored the study of personality, learning, psychological development, and individual differences while others were making major breakthroughs in these areas. Also damaging was the structuralists' refusal to seek *practical* knowledge. Titchener insisted that he was seeking pure knowledge and was not concerned with applying the principles of psychology to the solution of practical problems. Most important to structuralism's demise, however, was its inability to assimilate one of the most important developments in human history—the doctrine of evolution. For all these reasons, the school of structuralism was short-lived and essentially died with Titchener.

It was now time for a psychological school of thought that would deal with the important areas structuralism neglected, do so within the context of evolutionary theory, and use research techniques that were more reliable and valid than introspection. Titchener himself named this new school functionalism, a school that was concerned with the *what for* of the mind instead of the *what is* (1898, 1899). The development and characteristics of the school of functionalism will be the topics of the next two chapters.

OTHER EARLY APPROACHES TO PSYCHOLOGY

Although Wundt's voluntarism and Titchener's structuralism dominated psychology for many years, they were not without their critics. The assumptions of both schools were effectively challenged, and these challenges influenced the development of other schools of psychology.

Franz Clemens Brentano

Franz Clemens Brentano (1838–1917), born on January 16, was the grandson of an Italian merchant who had immigrated to Marienburg, the town in Germany where Brentano was born. Like Wundt, Brentano had many prominent relatives: some of his aunts and uncles wrote in the German romantic tradition, and his brother won a Nobel Prize for his work on intellectual history. When Brentano was 17, he began studying for the priesthood, but before being ordained he obtained his doctorate in

Franz Clemens Brentano

philosophy from the University of Tübingen in 1862. His dissertation was titled "On the Manifold Meaning of Being According to Aristotle." Two years later, he was ordained a priest and in 1866 became a teacher at the University of Würzburg. Brentano eventually left the church because of his disagreement with the doctrine of the pope's infallibility, his favorable attitude toward Comte's positivism, his criticisms of Scholasticism, and his desire to marry (which he eventually did, twice). In 1874 he was appointed professor of philosophy at the University of Vienna, where he enjoyed his most productive years. In the same year, Brentano published his most influential work, Psychology from an Empirical Standpoint (1874/1973). (This was the same year that Wundt published his Principles of Physiological Psychology.) In 1894 pressure from the church forced Brentano to leave Vienna and move to Florence. Italy's entrance into World War I ran contrary to Brentano's pacifism, and he protested by moving to Zürich, where he died in 1917.

Brentano agreed with Wundt about the limitations of experimental psychology. Like Wundt, Brentano believed that overemphasizing experimentation (systematic manipulation of one variable and noting its effects on another) diverted the researcher's attention from the important issues.

Brentano disagreed, however, with Titchener over the importance of knowing the physiological mechanisms behind mental events. Finally, he agreed with Wundt that the search for mental elements implied a static view of the mind that was not supported by the facts. According to Brentano, the important thing about the mind was not what was in it but what it did. In other words, Brentano felt that the proper study of the mind should emphasize the mind's *processes* rather than its contents.

Brentano's views came to be called act psy**chology** because of his belief that mental processes are aimed at performing some function. Among the mental acts, he included judging, recalling, expecting, inferring, doubting, loving, hating, and hoping. Furthermore, each mental act refers to an object outside itself. For example, something is judged, recalled, expected, loved, hated, and so forth. Brentano used the term intentionality to describe the fact that every mental act incorporates something outside itself. Thus, Brentano clearly distinguished between seeing the color red and the color red that is seen. Seeing is a mental act, which in this case has as its object the color red. Acts and contents (objects) are inseparable; every mental act intends (refers to, encompasses) an object or event that is the content of the act. Brentano did not mean "intention" or "purpose" by the term intentionality; he simply meant that every mental act intends (refers to) something outside itself.

To study mental acts and intentionality, Brentano had to use a form of introspection that Wundt and Titchener (until his later years) found to be abhorrent. The careful, controlled analytic introspection designed to report the presence or absence of a sensation or to report the elements of experience was of no use to Brentano. Rather, he used the very type of phenomenological introspection—introspective analysis directed toward intact, meaningful experiences—that Titchener allowed into his program only toward the end of his life. Clearly, Brentano, like Wundt, followed in the tradition of rationalism. For him the mind is active, not passive as the British empiricists, the French sensationalists, and the structuralists had believed.

Brentano wrote very little, believing that oral communication was most effective, and his major influence on psychology has come through those whom he influenced personally; as we will see, there were many. One of Brentano's many students who later became famous was Sigmund Freud, who took his only nonmedical courses from Brentano. Much of what became Gestalt psychology and modern existential psychology can be traced to Brentano. Smith (1994) makes the case that Brentano's influence on philosophy and psychology was so pervasive that it is appropriate to refer to a Brentanian school of thought. Smith says, "A table of Brentano's students ... would ... come close to embracing all of the most important philosophical movements of the twentieth century on the continent of Europe" (p. 21).

Carl Stumpf

Carl Stumpf (1848-1936) (pronounced "shtoomph") was born on April 21 in Wiesentheid, Bavaria (now part of Germany). He was the third of seven children born to prominent parents. By the age of seven, Carl was playing the violin, and later he mastered five additional musical instruments and composed music. A sickly child, Carl was first tutored at home by his grandfather but then went on to nearby schools, where he was an excellent student. He eventually enrolled at the University of Würzburg, where he was greatly influenced by Brentano. From the University of Würzburg, Stumpf went on to the University of Göttingen, where he earned his doctorate in 1868. He then returned to Würzburg and again attended Brentano's lectures. Deciding to become a priest, Stumpf entered the Catholic seminary at Würzburg in 1869. However, like Brentano, he couldn't accept the newly announced dogma of papal infallibility, so he returned to Göttingen for postdoctoral study. Following this, Stumpf held several academic positions, but in 1893 he accepted the chair of psychology at the University of Berlin. This appointment established psychology as an independent discipline within the university. At Berlin, Stumpf created a psychological laboratory (later to become a "psychological institute") that was a serious competitor to Wundt's at Leipzig.

As an experimental psychologist, Stumpf was primarily interested in acoustical perception. He had published his influential two-volume Psychology of Tone (1883, 1890) before his appointment at Berlin, and he continued to pursue the topic in his new laboratory. However, he had many other interests as well: "As a theoretical psychologist, he was concerned with questions of emotional and perceptional psychology, scientific theory, research methodology, and the theory of evolution" (Sprung and Sprung, 2000, p. 57). In addition, Stumpf believed that there is an intimate relationship between psychology and philosophy, and he spent considerable time attempting to make the scholarly community accept that idea (Sprung and Sprung, 2000, p. 57).

Like Brentano, Stumpf argued that mental events should be studied as meaningful units, just as they occur to the individual, and should not be broken down for further analysis. In other words, for Stumpf the proper object of study for psychology was mental *phenomena*, not conscious elements. This stance led to the phenomenology that was to become the cornerstone of the later school of Gestalt psychology (see Chapter 14). In fact, the chair that Stumpf occupied at the University of Berlin for 26 years was passed on to the great Gestalt psychologist Wolfgang Köhler. The other two founders of Gestalt psychology, Max Wertheimer and Kurt Koffka, also studied with Stumpf.

It is interesting to note that Stumpf played a prominent role in the famous case of Clever Hans, a horse owned and trained by Wilhelm von Osten of Berlin. Hans could correctly solve arithmetic problems by tapping his hoof or shaking his head the appropriate number of times, and as a result the horse became a celebrity. Thousands of people came to see it perform. There were allegations of fraud, and Von Osten appealed to the Berlin Board of Education to resolve the matter. The board appointed a committee under the direction of Stumpf, but it initially was unable to determine how Hans was able to correctly answer the

Carl Stumpf

questions. In a second investigation, Stumpf assigned Oskar Pfungst, a graduate student, to investigate Hans's performance. Pfungst found that when Von Osten was out of Hans's sight, the horse's performance fell to chance level. It became clear that Clever Hans was responding to very subtle cues unintentionally furnished by Von Osten, such as nodding his head when Hans had made the appropriate number of responses. Pfungst was able to replicate Hans's original level of performance by himself supplying subtle cues to the horse. Several other cases of apparent high-level intellectual feats by animals have also been explained as responses to cues provided consciously or unconsciously by their trainers. Such communication is now referred to as the Clever Hans phenomenon (Zusne and Jones, 1989). For an interesting account of the details surrounding the case of Clever Hans, including Pfungst's replication of the Clever Hans phenomenon with humans, see Candland, 1993.

It was Robert Rosenthal (for example, 1966, 1967) who explored the implications of the Clever Hans phenomenon for psychological experimentation in general. Rosenthal found that an experimenter may provide subtle cues that unwittingly convey his or her expectations of the experimental outcome to the experimental participants, thus

influencing the outcome of the experiment. Such an influence on an experiment's outcome is called experimenter bias or the Rosenthal Effect. One way to minimize this effect is to use a double blind procedure where neither the experimenter nor the participant know into which experimental condition the participant has been placed.

Edmund Husserl

Edmund Husserl (1859-1938) studied with Brentano from 1884 to 1886 and then worked with Stumpf, to whom he dedicated his book Logical Investigations (1900-1901). Husserl accepted Brentano's concept of intentionality, according to which mental acts are functional in the sense that they are directed at something outside themselves. For Brentano, mental acts are the means by which we make contact with the physical world. For Husserl, however, studying intentionality results in only one type of knowledge—that of the person turned outward to the environment. Equally important is the knowledge gained through studying the person turned inward. The former study uses introspection to examine the mental acts with which we embrace the physical world. The latter study uses introspection to examine all subjective experience as it occurs, without the need to relate it to anything else. For Husserl then, there are at least two types of introspection: one that focuses on intentionality and one that focuses on whatever processes a person experiences subjectively. For example, the former type would ask what external object the act of seeing intended, whereas the latter would concentrate on a description of the pure experience of seeing. Both types of introspection focus on phenomenological experience, but because the latter focuses on the essences of mental processes, Husserl referred to it as pure phenomenology. When the term phenomenon is used to describe a mental event, it refers to a whole, intact, meaningful experience and not to fragments of conscious experiences such as isolated sensations. In this sense, Wundt (as an experimentalist) and the earlier Titchener were not phenomenologists, whereas

Edmund Husserl

Brentano, Stumpf, and Husserl were. The point is that it is incorrect to use the terms *subjective*, *cognitive*, and *mental* as synonyms for *phenomenological*.

The Methods of the Natural Sciences Are Inappropriate to the Study of Mental Phenomena. Husserl thought that those who believe that psychology should be an experimental science made a mistake by taking the natural sciences as their model. Jennings (1986) explains Husserl's reasoning:

Historically, psychology adopted the experimental methods used by the physical sciences (despite the fact that mental events lack the physical tangibility of "natural" events) because it hoped to claim the same authoritative knowledge enjoyed by the physical sciences.... However, psychology could not simply adopt the experimental method without also adopting its implicit naturalistic perspective and the philosophical problems inherent in that belief system. First, the new scientific psychology actively disallowed any study of con-

sciousness by direct "seeing" of what consciousness is like because such a procedure was regarded as unscientific "introspection." Second, and more important, psychologists were forced to ground the nonnatural phenomena of consciousness in physical events that could be studied experimentally. This problem is analogous to a fool who tries putting 12 oranges into an egg carton because the egg carton did such a great job of neatly ordering eggs. Instead of finding a new container suitable for holding oranges (the phenomenological study of consciousness), the fool cuts and tapes the egg carton until the oranges will fit. Or, worse yet, the fool mangles the oranges themselves in a misguided effort to force them into the egg carton (the experimental study of consciousness). (p. 1234)

Husserl did not deny that an experimental psychology was possible; he simply said that it must be preceded by a careful, rigorous, phenomenological analysis. Husserl believed that it was premature to perform experiments on perception, memory, and feelings without first knowing the essence (the ultimate nature) of these processes. Without such knowledge, the experimenter does not know how the very nature of what he or she is studying may bias what is found or how the experiences are initially organized.

Husserl's Goal. Husserl's goal was to create a taxonomy of the mind. He wanted to describe the mental essences by which humans experience themselves, other humans, and the world. Husserl believed strongly that a description of such essences must *precede* any attempt to understand the interactions between humans and their environment and any science of psychology. Indeed, he believed that such an understanding was basic to *any* science because all sciences ultimately depend on human mental attributes.

Husserl's position differed radically from that of the structuralists in that Husserl sought to examine meanings and essences, not mental elements, via introspection. He and his subjects would thus commit the dreaded stimulus error. Husserl also differed from his teacher Brentano and his colleague Stumpf by insisting on a pure phenomenology with little or no concern for determining the relationship between subjective experience and the physical world.

Brentano, Stumpf, and Husserl all insisted that the proper subject matter for psychology was intact, meaningful, psychological experiences. This phenomenological approach was to appear soon in Gestalt psychology and existential psychology. Martin Heidegger, one of the most famous modern existential thinkers, dedicated his book *Being and Time* (1927) to Husserl. We will have more to say about Husserl when we discuss third-force psychology in Chapter 18.

Oswald Külpe

Oswald Külpe (1862–1915) was interested in many things, including music, history, philosophy, and psychology. During the time he was primarily interested in philosophy, he wrote five books on

Oswald Külpe

philosophy for the lay reader, including one on Kant's philosophy. He was majoring in history at the University of Leipzig when he attended Wundt's lectures and became interested in psychology. Under Wundt's supervision, Külpe received his doctorate in 1887, and he remained Wundt's assistant for the next eight years. Külpe dedicated his book Outlines of Psychology (1893/1909) to Wundt. During his time as Wundt's assistant, Külpe met and roomed with Titchener, and although the two often disagreed, they maintained the highest regard for one another. In fact, Titchener later translated several of Külpe's works into English. In 1894 Külpe moved to the University of Würzburg, where for the following 15 years he did his most influential work in psychology. In 1909 he left Würzburg and went to the University of Bonn and then to the University of Munich. After Külpe left Würzburg, his interest turned more and more to philosophy. He was working on epistemological questions when he died of influenza on December 30, 1915. He was only 53 years old.

Imageless Thought. Although starting out very much in the Wundtian camp, Külpe became one of Wundt's most worthy opponents. Külpe disagreed with Wundt that all thought had to have a specific referent—that is, a sensation, image, or feeling. Külpe believed that some thoughts were imageless. Furthermore, he disagreed with Wundt's contention that the higher mental processes (like thinking) could not be studied experimentally, and he set out to do so using what he called systematic experimental introspection. This technique involved giving subjects problems to solve and then asking them to report on the mental operations they engaged in to solve them. In addition, subjects were asked to describe the types of thinking involved at different stages of problem solving. They were asked to report their mental experiences while waiting for the problem to be presented, during actual problem solving, and after the problem had been solved.

Külpe's more elaborate introspective technique indicated that there were indeed **imageless thoughts** such as searching, doubting, confidence,

and hesitation. In 1901 Karl Marbe, one of Külpe's colleagues, published a study describing what happened when subjects were asked to judge weights as heavier or lighter than a standard weight. Marbe was interested not in the accuracy of the judgments but in how the judgments were made. Subjects reported prejudgment periods of doubt, searching, and hesitation, after which they simply made the judgments. Marbe concluded that Wundt's elements of sensations, images, and feelings were not enough to account for the act of judging. There appeared to be a mental act of judging that was independent of what was being judged. Marbe concluded that such an act was imageless. Incidentally, these pure (imageless) processes, such as judging, were the very things that Husserl was seeking to describe with his pure phenomenology.

Mental Set. The most influential work to come out of the Würzburg school was that on Einstellung, or mental set. It was found that focusing subjects on a particular problem created a determining tendency that persisted until the problem was solved. Furthermore, although this tendency or set was operative, subjects were unaware of it; that is, it operated on the unconscious level. For example, a bookkeeper can balance the books without being aware of the fact that he or she is adding or subtracting. Mental sets could similarly be induced experimentally by instructing subjects to perform different tasks or solve different problems. Mental sets could also result from a person's past experiences. William Bryan, one of the American students working in Külpe's laboratory, provided an example of an experimentally induced set. Bryan showed cards containing various nonsense syllables written in different colors and in different arrangements. Subjects who were instructed to attend to the colors were afterward able to report the colors present but could not report the other stimuli. Conversely, subjects instructed to attend to the syllables could report them with relative accuracy but could not accurately report the colors. It appeared that instructions had directed the subjects' attention to certain stimuli and away from others. This demonstrated that environmental stimuli do not automatically create sensations that become images. Rather, the process of attention determines which sensations will and will not be experienced. This finding was in accordance with Wundt's view of attention but not with Titchener's.

Narziss Ach, who was also working in Külpe's laboratory, demonstrated the type of mental set derived from experience. Ach found that when the numbers 7 and 3 were flashed rapidly and subjects had not been instructed to respond in any particular way, the most common response was to say "ten." Ach's explanation was that the mental set to add was more common than the mental sets to subtract, multiply, or divide, which would have resulted, respectively, in the responses "four," "twenty-one," and "two point three."

Titchener and his students responded to the challenge to his version of psychology by the Würzburg school in a series of studies published between 1907 and 1915. In these studies it was claimed that the apparent existence of imageless thought was due to shoddy introspective methods. More careful introspection, said Titchener and his students, revealed that "imageless thoughts" were simply vague sensory experiences and, therefore, they indeed had referents.

Other findings of the Würzburg School. In addition to showing the importance of mental sets in problem solving, members of the Würzburg school showed that problems have motivational properties. Somehow, problems caused subjects to continue to apply relevant mental operations until a solution was attained. The motivational aspect of problem solving was to be emphasized later by the Gestalt psychologists. (Wertheimer, one of the founders of the school of Gestalt psychology, wrote his doctoral dissertation under Külpe's supervision.)

The Würzburg school showed that the higher mental processes could be studied experimentally and that certain mental processes occur independently of content (that is, they are imageless). The school also claimed that associationism was inadequate for explaining the operations of the mind and challenged the voluntarists' and the structuralists' narrow use of the introspective method. Members

of the Würzburg school made the important distinction between thoughts and thinking, between mental contents and mental acts. In elaborating these distinctions, members of the school moved closer to Brentano and away from aspects of Wundt and especially Titchener. Brentano and members of the Würzburg school were both interested in how the mind worked instead of what static elements it contains.

The controversies the Würzburg school caused did much to promote the collapse of both voluntarism and structuralism. Was there imageless thought or not? Was it possible, as some maintained, that some individuals had imageless thought and others did not? If so, how would this affect the search for universal truths about the mind? How could introspection be properly used? Could it be directed only at static contents of the mind, or could it be used to study the dynamics of the mind? Most devastating was the fact that different individuals were using the same research technique (introspection) and reaching very different conclusions. More and more, any form of introspection became looked upon as unreliable. This questioning of the validity of introspection as a research tool did much to launch the school of behaviorism (see Chapter 12).

Hans Vaihinger

In 1911 Hans Vaihinger (1852-1933) published his influential book The Philosophy of "As If": A System of the Theoretical, Practical and Religious Fictions of Mankind. In his book, Vaihinger sided with the Machian positivists, saying that all we ever experience directly are sensations and the relationships among sensations; therefore, all we can be certain of are sensations. It was Vaihinger's next step, however, that made his position unusual. According to Vaihinger, societal living requires that we give meaning to our sensations, and we do that by inventing terms, concepts, and theories and then acting "as if" they were true. That is, although we can never know if our fictions correspond to reality, we act as if they do. This tendency to invent meaning, according to Vaihinger, is part of human nature:

Just as [the clam] when a grain of sand gets beneath its shining surface, covers it over with a self-produced mass of mother-of-pearl, in order to change the insignificant grain into a brilliant pearl, so, only still more delicately, the psyche, when stimulated, transforms the material of sensation which it absorbs into shining pearls of thought. (Vaihinger, 1911/1952, p. 7)

For Vaihinger the term *fiction* was not derogatory. Because a concept is false, in the sense that it does not refer to anything in physical reality, does not mean that it is useless:

The principle of fictionalism is as follows: An idea whose theoretical untruth or incorrectness, and therefore its falsity, is admitted, is not for that reason practically valueless and useless; for such an idea, in spite of its theoretical nullity may have great practical importance. (Vaihinger, 1911/1952, p. viii)

Everyday communication would be impossible without fictional words and phrases, according to Vaihinger. Science would be impossible without such fictions as matter and causality. Many believe that science is actually describing physical reality but, said Vaihinger, that is forever impossible: "We must ... regard it as a pardonable weakness on the part of science if it believes that its ideas are concerned with reality itself' (1911/1952, p. 67). Mathematics would be impossible without such fictions as zero, imaginary numbers, infinity, and the infinitesimal. Religion would be impossible without such fictions as gods or God, immortality, and reincarnation. Concepts of morality and jurisprudence would be impossible without such fictions as freedom and responsibility. The fiction of freedom is especially vital to societal living:

We encounter at the very threshold of these fictions one of the most important concepts ever formed by man, the idea of *freedom;* human actions are regarded as free, and therefore as "responsible" and

Hans Vaihinger

contrasted with the "necessary" course of natural events. We need not here recapitulate the familiar antinomies found in this contradictory concept; it not only contradicts observation which shows that everyone obeys unalterable laws, but is also selfcontradictory, for an absolutely free, chance act, resulting from nothing, is ethically just as valueless as an absolutely necessary one. In spite of all these contradictions, however, we not only make use of this concept in ordinary life in judging moral actions, but it is also the foundation of criminal law. Without this assumption punishment inflicted for any act would, from an ethical standpoint, be unthinkable, for it would simply be a precautionary measure for protecting others against crime. Our judgment of our fellowmen is likewise so completely bound up with this ideational construct that we can no longer do without it. In the course of their development, men have formed this important construct from immanent necessity, because only on this basis is a high degree

of culture and morality possible.... There is nothing in the real world corresponding to the idea of liberty, though in practice it is an exceedingly necessary fiction. (1911/1952, p. 43)

There is a similarity between Vaihinger's fictionalism and the philosophy of pragmatism (see, for example, William James in Chapter 11). Both fictionalism and pragmatism evaluate ideas in terms of their usefulness. However, Vaihinger believed that there was an important difference between his position and pragmatism. For the pragmatist, he said, truth and usefulness were inseparable. If an idea was useful, it was considered true: "An idea which is found to be useful in practice proves thereby that it is also true in theory" (Vaihinger, 1911/1952, p. viii). Vaihinger rejected this notion. For him a concept could be demonstrably false and still be useful. For example, although the concept of free will is demonstrably false, there may be benefits from acting as if it were true.

We will see in Chapter 17 that Alfred Adler made Vaihinger's fictionalism an integral part of his theory of personality. Also, George Kelly (see Chapter 18) noted a similarity between his thinking and Vaihinger's.

Hermann Ebbinghaus

Hermann Ebbinghaus (1850–1909) was born on January 24 in the industrial city of Barmen, near Bonn. His father was a wealthy paper and textile merchant. He studied classical languages, history, and philosophy at the Universities of Bonn, Halle, and Berlin before receiving his doctorate from the University of Bonn in 1873. He wrote his dissertation on Hartmann's philosophy of the unconscious. He spent the next 3 1/2 years traveling through England and France. In London, he bought and read a copy of Fechner's Elements of Psychophysics, which deeply impressed him. Ebbinghaus later dedicated his book Outline of Psychology (1902) to Fechner, of whom he said, "I owe everything to you." Unaware of Wundt's belief that the higher

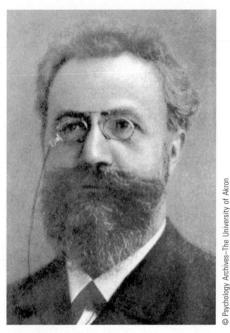

Hermann Ebbinghaus

mental processes could not be studied experimentally, Ebbinghaus proceeded to systematically study learning and memory.

Ebbinghaus began his research in his home in Berlin in 1878, and his early studies were written and offered as support of his successful application to be a lecturer in philosophy at the University of Berlin. Ebbinghaus's research culminated in a monograph titled On Memory: An Investigation in Experimental Psychology (1885/1964), which marked a turning point of psychology. It was the first time that the processes of learning and memory had been studied as they occurred rather than after they had occurred. Furthermore, they were investigated experimentally. As testimony to Ebbinghaus's thoroughness, many of his findings are still cited in modern psychology textbooks. Hoffman, Bringmann, Bamberg, and Klein (1986) list eight major conclusions that Ebbinghaus reached about learning and memory; most are still valid today and are being expanded by current researchers. Ebbinghaus's Principles of Psychology (1897) was widely used as an introductory psychology text, as was his Outline of Psychology (1902). It was the Outline that began with Ebbinghaus's famous statement, "Psychology has a long past, but only a short history."

Along with Hering, Stumpf, Helmholtz, and others, Ebbinghaus established psychology's second experimental journal, *Journal of Psychology and Physiology of the Sense Organs*, which broke Wundt's monopoly on the publishing of results from psychological experiments. Ebbinghaus was also the first to publish an article on the testing of schoolchildren's intelligence. He devised a sentence-completion task for the purpose, and it later became part of the Binet-Simon scale of intelligence (Hoffman et al., 1986).

In 1909 Ebbinghaus developed pneumonia; he died on February 26 at the age of 59.

Nonsense Material. To study learning as it occurred, Ebbinghaus needed material that had not been previously experienced. For this, he created a pool of 2,300 "nonsense syllables." Hoffman et al. (1986) point out that the standard discussion of Ebbinghaus's syllables is incorrect. It was not his syllables that had little or no meaning; it was a series of syllables that was essentially meaningless. That is, referring to Ebbinghaus's syllables as nonsense syllables is a misnomer. Many of Ebbinghaus's syllables were actual words, and many others closely resembled words. From the pool of 2,300 syllables, Ebbinghaus chose a series to be learned. The series usually consisted of 12 syllables, although he varied the size of the group in order to study rate of learning as a function of the amount of material to be learned. Keeping the syllables in the same order and using himself as a subject, he looked at each syllable for a fraction of a second. After going through the list in this fashion, he paused for 15 seconds and went through the list again. He continued in this manner until he could recite each syllable without making a mistake, at which point mastery was said to have occurred.

At various time intervals following mastery, Ebbinghaus relearned the group of syllables. He recorded the number of exposures it took to relearn the material and subtracted that from the number of exposures it took to initially learn the material. He called the difference between the two **savings**. By plotting savings as a function of time, Ebbinghaus created psychology's first retention curve. He found that forgetting was most rapid during the first few hours following a learning experience and relatively slow thereafter. And he found that if he *overlearned* the original material (if he continued to expose himself to material after he had attained mastery), the rate of forgetting was considerably reduced. Ebbinghaus also studied the effect of *meaningfulness* on learning and memory. For example, he found that it took about 10 times as many exposures to learn 80 random syllables as it did to learn 80 successive syllables from Byron's *Don Juan*.

Finally, Ebbinghaus found that "with any considerable number of repetitions a suitable distribution of them over a space of time is decidedly more advantageous than the massing them at a single time" (1885/1964, p. 89). In other words, in learning lists of syllables, distributed practice is more efficient than massed practice.

Another common misconception concerning Ebbinghaus is that he followed in the empiricist tradition. Hoffman et al. (1986) indicate that this simply is not true. He most often quoted Herbart, and the topics that were of most interest to him—such as meaning, imagery, and individual differences in cognitive styles—followed in the tradition of rationalism, not empiricism.

SUMMARY

Wundt was the founder of both experimental psychology as a separate discipline and the school of voluntarism. One of Wundt's goals was to discover the elements of thought using experimental introspection. A second goal was to discover how these elements combine to form complex mental experiences. Wundt found that there are two types of basic mental experiences: sensations, which could be described in terms of modality and intensity, and feelings, which could be described in terms of attributes of pleasantness-unpleasantness, excitement-calm, and strain-relaxation. Wundt distinguished among sensations, which are basic mental elements; perceptions, which are mental experiences given meaning by past experience; and apperceptions, which are mental experiences that are the focus of attention. Because humans can focus their attention on whatever they wish. Wundt's theory was referred to as voluntarism. By focusing one's attention on various aspects of conscious experience, that experience can be arranged and rearranged in any number of ways, and thus a creative synthesis results from apperception. Wundt believed that if the ability to apperceive broke down, mental illness such as schizophrenia might result. With his concept of apperception, Wundt

was closer to the rationalist than to the empiricist tradition.

Wundt initially believed that reaction time could supplement introspection as a means of studying the mind. Following techniques developed by Donders, Wundt presented tasks of increasing complexity to his subjects and noted that more complex tasks resulted in longer reaction times. Wundt believed that the time required to perform a complex mental operation could be determined by subtracting the times it took to perform the simpler operations of which the complex act consists. Wundt eventually gave up his reactiontime studies because he found reaction time to be an unreliable measure. Although Donders's techniques remained dormant for many years following Wundt's rejection of them, they were rediscovered in the 1960s and since have been used effectively to study cognitive processes.

In keeping with the major thrust of voluntarism, Wundt claimed that physical events could be explained in terms of antecedent events but psychological events could not be. Unlike the behavior of physical objects, psychological events can be understood only in terms of their purpose. The techniques used by the physical sciences are therefore

inappropriate for psychology. Wundt believed that volitional acts are lawful but that the laws governing such acts could not be investigated experimentally. Volitional acts can be studied only after the fact by studying their outcomes. Wundt believed, then, that the higher mental functions could not be studied through experiments but only through historical analysis and naturalistic observation. In his 10-volume Völkerpsychologie, Wundt showed how the latter techniques could be used to study such topics as social customs, religion, myths, morals, art, law, and language. In his analysis of language, Wundt assumed that communication begins when one person forms a general impression. Next, the person chooses words to express the general impression. Finally, if the words adequately convey the general impression and if the listener apperceives it, communication is successful.

Titchener created the school of structuralism at Cornell University. He set as his goal the learning of the what, how, and why of mental life. The what consisted of determining the basic mental elements, the how was determining how the elements combined, and the why consisted of determining the neurological correlates of mental events. His introspectionists had to be carefully trained so that they would not commit the stimulus error. According to Titchener, sensations and images could vary in terms of quality, intensity, duration, clearness, and extensity. He found evidence for over 40,000 separate mental elements. Titchener thought that all feelings vary only along the pleasantness-unpleasantness dimension, thus disagreeing with Wundt's tridimensional theory. Following in the empirical-associationistic tradition, Titchener said that attention is only a clear sensation. According to Titchener's context theory of meaning, sensations always stimulate the memories of events that were previously experienced along with those sensations, and these memories give the sensations meaning. There were a number of fundamental differences between Wundt's voluntarism and Titchener's structuralism. Many factors led to the downfall of structuralism: examples are the unreliability of introspection; the observation that introspection was really retrospection; and the ignoring of psychological development, abnormal behavior, personality, learning, individual differences, evolutionary theory, and practicality.

Those offering alternative views to voluntarism and structuralism included Brentano, Stumpf, Husserl, Külpe, Vaihinger, and Ebbinghaus. Brentano believed that mental acts should be studied rather than mental elements, and therefore his position is referred to as act psychology. Brentano used the term *intentionality* to describe the fact that a mental act always encompasses (intends) something external to itself. Like Brentano, Stumpf believed that introspective analysis should be directed at intact, meaningful psychological experience instead of the elements of thought. Stumpf had a major influence on those individuals who later created the school of Gestalt psychology.

Husserl believed that before scientific psychology would be possible, a taxonomy of the mind was required. To create such a taxonomy, pure phenomenology would be used to explore the essence of subjective experience. According to Husserl, it did not make sense to perform experiments involving such processes as perception, memory, or judgment without first knowing the essences of those processes. The mind itself, he said, must be understood before we can study how the mind responds to objects external to it.

Through his technique of systematic experimental introspection, Külpe found that the mind possesses processes—not just sensations, images, and feelings—and that these processes are imageless. Examples of imageless thoughts include searching, doubting, and hesitating. Külpe and his colleagues found that a mental set, which could be created either through instructions or through personal experience, provided a determining tendency in problem solving. They also found that once a mental set had been established, humans could solve problems unconsciously.

Vaihinger contended that because sensations are all that we can be certain of, all references to so-called physical reality must be fictional. All societal living is based on fictions that can be evaluated only in terms of their usefulness. Vaihinger's fictionalism was distinguished from pragmatism

because, for the pragmatist, the extent to which an idea is useful it is also considered true. For Vaihinger, however, ideas are often demonstrably false but still useful.

Ebbinghaus, like members of the Würzburg school, demonstrated that Wundt had been wrong

in saying that the higher mental processes could not be studied experimentally. Using "nonsense" material, Ebbinghaus systematically studied both learning and memory so thoroughly that his conclusions are still cited in psychology texts.

DISCUSSION QUESTIONS

- 1. What is meant by a school of psychology?
- 2. Why was the school of psychology created by Wundt called voluntarism?
- 3. Why did Wundt believe that experimentation in psychology was of limited uselessness?
- 4. How did Wundt differentiate between mediate and immediate experience?
- 5. Discuss Wundt's use of introspection.
- For Wundt, what were the elements of thought, and what were their attributes? Include in your answer a discussion of Wundt's tridimensional theory of feeling.
- 7. How did Wundt distinguish between psychological and physical causation?
- 8. What did Wundt mean when he said that volitional acts are creative but not free?
- 9. Define the terms *sensation*, *perception*, *apperception*, and *creative synthesis* as they were used in Wundt's theory.
- 10. Summarize how Wundt used reaction time in an effort to determine how long it took to perform various mental operations. Why did Wundt abandon his reaction-time research?
- 11. Why did Wundt think it necessary to write his *Völkerpsychologie*? What approach to the study of humans did it exemplify?
- 12. Summarize Wundt's explanation of language.
- 13. For Titchener, what were the goals of psychology?

- 14. What did Titchener believe would be the ultimate "why" of psychology?
- 15. How did Titchener's explanation of how mental elements combine differ from Wundt's?
- 16. What was Titchener's context theory of meaning?
- 17. Compare and contrast Wundt's view of psychology with Titchener's.
- 18. List the reasons for the decline of structuralism. Include in your answer the various criticisms of introspection.
- 19. Summarize Brentano's act psychology.
- 20. What did Brentano mean by intentionality?
- 21. What did Husserl mean by *pure phenomenology*? Why did he believe that an understanding of the essence of subjective experience must precede scientific psychology?
- 22. What did Külpe mean by imageless thought? Mental set?
- 23. What did Vaihinger mean by his contention that without fictions, societal life would be impossible? Describe the difference between pragmatism and fictionalism.
- 24. Why is it incorrect to refer to the material that Ebbinghaus used for his research as "nonsense syllables"?
- 25. Discuss the significance of Ebbinghaus's work to the history of psychology.

SUGGESTIONS FOR FURTHER READING

- Blumenthal, A. L. (1975). A reappraisal of Wilhelm Wundt. *American Psychologist*, 30, 1081–1088.
- Blumenthal, A. L. (1998). Leipzig, Wilhelm Wundt, and psychology's gilded age. In G. A. Kimble & M. Wertheimer (Eds.), Portraits of pioneers in psychology (Vol. 3, pp. 31–48). Washington, DC: American Psychological Association.
- Bringmann, W. G., & Tweney, R. D. (Eds.). (1980). Wundt studies: A centennial collection. Toronto: Hogrefe.
- Danziger, K. (1980c). The history of introspection reconsidered. Journal of the History of the Behavioral Sciences, 16, 241–262.
- Henle, M. (1971a). Did Titchener commit the stimulus error? The problem of meaning in structural psy-

- chology. Journal of the History of the Behavioral Sciences, 7, 279–282.
- Leahey, T. H. (1981). The mistaken mirror: On Wundt's and Titchener's psychologies. *Journal of the History of the Behavioral Sciences*, 17, 273–282.
- Smith, B. (1994). Austrian philosophy: The legacy of Franz Brentano. Chicago: Open Court.
- Sprung, H., & Sprung, L. (2000). Carl Stumpf:
 Experimenter, theoretician, musicologist, and promoter. In G. A. Kimble & M. Wertheimer (Eds.),
 Portraits of pioneers in psychology (Vol. 4, pp. 51–69).
 Washington DC: American Psychological
 Association.

GLOSSARY

Act psychology The name given to Brentano's brand of psychology because it focused on mental operations or functions. Act psychology dealt with the interaction between mental processes and physical events.

Brentano, Franz Clemens (1838–1917) Believed that introspection should be used to understand the functions of the mind rather than its elements. Brentano's position came to be called act psychology. (*See also* **Act psychology**.)

Clever Hans phenomenon The creation of apparently high-level intelligent feats by nonhuman animals by consciously or unconsciously furnishing them with subtle cues that guide their behavior.

Context theory of meaning Titchener's contention that a sensation is given meaning by the images it elicits. That is, for Titchener, meaning is determined by the law of contiguity.

Creative synthesis The arrangement and rearrangement of mental elements that can result from apperception.

Donders, Franciscus Cornelius (1818–1889) Used reaction time to measure the time it took to perform various mental acts.

Ebbinghaus, Hermann (1850–1909) The first to study learning and memory experimentally.

Elements of thought According to Wundt and Titchener, the basic sensations from which more complex thoughts are derived.

Feelings The basic elements of emotion that accompany each sensation. Wundt believed that emotions consist of various combinations of elemental feelings. (*See also* **Tridimensional theory of feeling**.)

General impression The thought a person has in mind before he or she chooses the words to express it.

Husserl, Edmund (1859–1938) Called for a pure phenomenology that sought to discover the essence of subjective experience. (See also Pure phenomenology.)

Imageless thoughts According to Külpe, the pure mental acts of, for example, judging and doubting, without those acts having any particular referents or images.

Immediate experience Direct subjective experience as it occurs.

Intentionality Concept proposed by Brentano, according to which mental acts always intend something. That is, mental acts embrace either some object in the physical world or some mental image (idea).

Introspection Reflection on one's subjective experience, whether such reflection is directed toward the detection of the presence or absence of a sensation (as in the

case of Wundt and Titchener) or toward the detection of complex thought processes (as in the cases of Brentano, Stumpf, Külpe, Husserl, and others).

Külpe, Oswald (1862–1915) Applied systematic, experimental introspection to the study of problem solving and found that some mental operations are imageless.

Mediate experience Experience that is provided by various measuring devices and is therefore not immediate, direct experience.

Mental chronometry The measurement of the time required to perform various mental acts.

Mental essences According to Husserl, those universal, unchanging mental processes that characterize the mind and in terms of which we do commerce with the physical environment.

Mental set A problem-solving strategy that can be induced by instructions or by experience and that is used without a person's awareness.

Perception Mental experience that occurs when sensations are given meaning by the memory of past experiences.

Phenomenological introspection The type of introspection that focuses on mental phenomena rather than on isolated mental elements.

Principle of contrasts According to Wundt, the fact that experiences of one type often intensify opposite types of experiences, such as when eating something sour will make the subsequent eating of something sweet taste sweeter than it would otherwise.

Principle of the heterogony of ends According to Wundt, the fact that goal-directed activity often causes experiences that modify the original motivational pattern.

Principle toward the development of

opposites According to Wundt, the tendency for prolonged experience of one type to create a mental desire for the opposite type of experience.

Pure phenomenology The type of phenomenology proposed by Husserl, the purpose of which was to create a taxonomy of the mind. Husserl believed that before a science of psychology would be possible, we would first need to understand the essences of those mental processes in terms of which we understand and respond to the world.

Savings The difference between the time it originally takes to learn something and the time it takes to relearn it.

School A group of scientists who share common assumptions, goals, problems, and methods.

Sensation A basic mental experience that is triggered by an environmental stimulus.

Stimulus error Letting past experience influence an introspective report.

Structuralism The school of psychology founded by Titchener, the goal of which was to describe the structure of the mind.

Stumpf, Carl (1848–1936) Psychologist who was primarily interested in musical perception and who insisted that psychology study intact, meaningful mental experiences instead of searching for meaningless mental elements.

Titchener, Edward Bradford (1867–1927) Created the school of structuralism. Unlike Wundt's voluntarism, structuralism was much more in the tradition of empiricism-associationism.

Tridimensional theory of feeling Wundt's contention that feelings vary along three dimensions: pleasantness-unpleasantness, excitement-calm, and strain-relaxation.

Vaihinger, Hans (1852–1933) Contended that because sensations are all that we can be certain of, all conclusions reached about so-called physical reality must be fictitious. Although fictions are false, they are nonetheless essential for societal living.

Völkerpsychologie Wundt's 10-volume work, in which he investigated higher mental processes through historical analysis and naturalistic observation.

Voluntarism The name given to Wundt's school of psychology because of his belief that, through the process of apperception, individuals could direct their attention toward whatever they wished.

Will According to Wundt, that aspect of humans that allows them to direct their attention anywhere they wish. Because of his emphasis on will, Wundt's version of psychology was called voluntarism.

Wundt, Wilhelm Maximilian (1832–1920) The founder of experimental psychology as a separate discipline and of the school of voluntarism.

Würzburg school A group of psychologists under the influence of Oswald Külpe at the University of Würzburg. Among other things, this group found that some thoughts occur without a specific referent (that is, they are imageless), the higher mental processes could be studied experimentally, and problems have motivational properties that persist until the problem is solved.

The Darwinian Influence and the Rise of Mental Testing

he experimental psychology of consciousness was a product of Germany. Because it did not fit the U.S. temperament, Titchener's attempt to transplant his version of that psychology to the United States was ultimately unsuccessful. When Titchener arrived at Cornell in 1892, there was a spirit of independence, practicality, and adventure that was incompatible with the authoritarian, dry, and static views of structuralism. That structuralism survived as long as it did in the United States was testimony to the forceful personality of Titchener himself. The pioneering U.S. spirit was prepared to accept only a viewpoint that was new, practical, and unconcerned with the abstract analysis of the mind. Evolutionary theory provided such a view, and the United States embraced it as no other country did. Not even in England, the birthplace of modern evolutionary theory, did it meet with the enthusiasm it received across the Atlantic. In the United States, evolutionary theory became the dominant theme running through most, if not all, aspects of psychology. The translation of evolutionary theory into psychology created a psychology that was uniquely American, and it caused the center of psychological research to shift from Europe to the United States, where it has been ever since.

EVOLUTIONARY THEORY BEFORE DARWIN

The idea that both the earth and living organisms change in some systematic way over time goes back at least as far as the early Greeks. Because Greece was a maritime country, a wide variety of life forms could be observed there. Such

observations, along with the growing tendency toward objectivity, caused some early Greeks to develop at least rudimentary theories of evolution. But evolutionary theory did not develop more fully because, to a large extent, Plato and Aristotle did not believe in evolution. For Plato the number of pure forms was fixed forever, and the forms themselves did not change. For Aristotle the number of species was fixed, and transmutation from one species to another was impossible. To the beliefs of Plato and Aristotle, the early Christians added the notion of divine creation as described in Genesis. God in his wisdom had created a certain fixed number of species, including humans, and this number could be modified only by another act of God, not by natural forces. This religious account of the origin of species put the matter to rest until modern times.

By the 18th century, several prominent individuals were postulating a theory of evolution, including Charles Darwin's grandfather, Erasmus Darwin (1731–1802), who believed that one species could be gradually transformed into another. What was missing from these early theories was the mechanism by which the transformation took place. The first to postulate such a mechanism was Jean Lamarck.

Jean Lamarck

In his Philosophie Zoologique (1809/1914), the French naturalist Jean Lamarck (1744-1829) noted that fossils of various species showed that earlier forms were different from current forms; therefore, species changed over time. Lamarck concluded that environmental changes were responsible for structural changes in plants and animals. If, for example, because of a scarcity of prey, members of a species had to run faster to catch what few prey were available, the muscles involved in running would become more fully developed as a result of the frequent exercise they received. If the muscles involved in running were fully developed in an adult of a species, Lamarck believed, the offspring of this adult would be born with highly developed muscles, which also enhanced their chances for survival. This theory was called the inheritance of acquired characteristics. Obviously, those adult

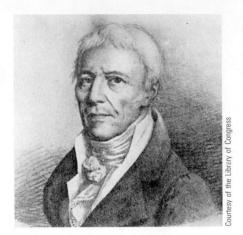

Jean Lamarck

members of species who did not adjust adequately to their environment would not survive and therefore would produce no offspring. In this way, according to Lamarck, the characteristics of a species would change as the traits necessary for survival changed, thus, transmuting the species.

Herbert Spencer

Herbert Spencer (1820-1903) was born in the industrial town of Derby, England, and was tutored first by his father, who was a schoolmaster, and later by his uncle. He never received a formal education. At age 17, Spencer went to work for the railroad and for the next 10 years worked at jobs ranging from surveyor to engineer. In 1848 he gained employment in London as a journalist—first as a junior editor of the journal The Economist and then as a freelance writer. Spencer's interest in psychology and in evolutionary theory came entirely from what he read during this time. One especially influential book was John Stuart Mill's System of Logic (1843/1874). Spencer's "education" was also enhanced by a small group of intellectuals he befriended. The group included Thomas Huxley (shortly to become the public defender of Darwin's theory of evolution), George Henry Lewes (a fellow journalist whose broad interests included acting, writing biographies, and science), and Mary Ann Evans (also a fellow journalist, better

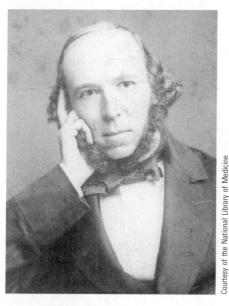

Herbert Spencer

known as George Eliot). Clearly, Spencer was not inhibited by a lack of formal education:

From his voracious reading and the exchanges with his group of friends during the early 1850s Spencer acquired a general vision of the world that was to have a more pervasive effect on nineteenth century thinking than that of any other philosopher of his era. (Boakes, 1984, p. 10)

Spencer's View of Evolution. An early follower of Lamarck (and later Darwin), Spencer took the notion of evolution and applied it not only to animals but also to the human mind and human societies. In fact, he applied the notion of evolution to everything in the universe. Everything, according to Spencer, begins as an undifferentiated whole. Through evolution, differentiation occurs so that systems become increasingly complex. This notion applies to the human nervous system, which was simple and homogenous eons ago but through evolution has become highly differentiated and complex.

The fact that we now have complex nervous systems allows us to make a greater number

of associations; the greater the number of associations an organism can make, the more intelligent it is. Although the term *intelligence* goes back at least as far as Cicero's use of the term *intelligentia*, Spencer is credited with the introduction of the term into psychology (Guilford, 1967). Our highly complex nervous system allows us to make an accurate neurophysiological (and thus mental) recording of events in our environment, and this ability is conducive to survival.

In his explanation of how associations are formed, Spencer relied heavily on the principle of contiguity. Environmental events that occur either simultaneously or in close succession are recorded in the brain and give rise to ideas of those events. Through the process of contiguity, our ideas come to map environmental events. However, for Spencer, the principle of contiguity alone was not adequate to explain why some behaviors persist whereas others do not. To explain the differential persistence of various behaviors, Spencer accepted Bain's explanation of voluntary behavior. Spencer said, "On the recurrence of the circumstances, these muscular movements that were followed by success are likely to be repeated; what was at first an accidental combination of motions will now be a combination having considerable probability" (1870, p. 545). Spencer placed Bain's observation within the context of evolutionary theory by asserting that a person persists in behaviors that are conducive to survival (those that cause pleasant feelings) and abstain from those that are not (those that cause painful feelings). Spencer's synthesis of the principle of contiguity and evolutionary theory has been called "evolutionary associationism." The contention that the frequency or probability of some behavior increases if it is followed by a pleasurable event and decreases if it is followed by a painful event came to be known as the Spencer-Bain principle. This principle was to become the cornerstone of Thorndike's connectionism (see Chapter 11) and Skinner's operant behavior (see Chapter 13).

The next step that Spencer took tied his theory directly to Lamarck's. Spencer claimed that an off-spring inherited the cumulative associations its ancestors had learned. Those associations that

preceding generations had found to be conducive to survival were passed on to the next generation that is, there is an inheritance of acquired associations. Spencer's theory was a blending of empiricism, associationism, and nativism because he believed that the associations gained from experience are passed on to offspring. Spencer was therefore an associationist, but to associationism he added Lamarck's evolutionary theory. He maintained that frequently used associations are passed on to offspring as instincts or reflexes. For Spencer, then, instincts are nothing more than habits that had been conducive to survival for preceding generations. Instincts had been formed in past generations just as habits are formed in an organism's lifetime—through association.

When Darwin's work appeared, Spencer merely shifted his emphasis from acquired characteristics to natural selection. The concept of the **survival of the fittest** (a term Spencer introduced in 1852 that was later adopted by Darwin) applied in either case.

Social Darwinism. There was a basic difference between Spencer and Darwin in how they viewed evolution. To Spencer evolution meant progress. That is, evolution has a purpose; it is the mechanism by which perfection is approximated. Darwin believed no such thing:

For Darwin, evolution did not manifest any prestructured, preestablished or predetermined design or order throughout natural history; there is no overall direction in evolution, i.e., no ultimate purpose or final end-goal to organic evolution in general, or human evolution in particular. (Birx, 1998, p. xxii)

On the other hand, for Spencer, the attainment of human perfection was just a matter of time. Spencer went further, saying that evolutionary principles apply to societies as well as individuals. Spencer's application of his notion of the survival of the fittest to society came to be called **social Darwinism**. As Spencer saw it, humans in society,

like other animals in their natural environment, struggle for survival, and only the most fit survive. According to Spencer, if the principles of evolution are allowed to operate freely, all living organisms will approximate perfection, including humans. The best policy for a government to follow, then, is a laissez-faire policy that provides for free competition among its citizens. Government programs designed to help the weak and poor would only interfere with evolutionary principles and inhibit a society on its course toward increased perfection.

The following statement demonstrates how far Spencer believed governments should follow a laissez-faire policy: "If [individuals] are sufficiently complete [both physically and mentally] to live, they do live, and it is well they should live. If they are not sufficiently complete to live, they die, and it is best they should die" (1864, p. 415). Interestingly, Spencer opposed only government programs to help the weak and poor. He supported private charity because he believed it strengthened the character of the donors (Hofstadter, 1955, p. 41).

Clearly, Spencer's ideas were compatible with U.S. capitalism and individualism. In the United States, Spencer's ideas were taught in most universities, and his books sold hundreds of thousands of copies. Indeed, when Spencer visited the United States in 1882, he was treated like a hero. As might be expected, social Darwinism was especially appreciated by U.S. industrialists. In a Sunday school address, John D. Rockefeller said,

The growth of a large business is merely a survival of the fittest.... The American Beauty rose can be produced in the splendor and fragrance which bring cheer to its beholder only by sacrificing the early buds which grow up around it. This is not an evil tendency in business. It is merely the working-out of a law of nature and a law of God. (Hofstadter, 1955, p. 45)

Andrew Carnegie went even further, saying that for him evolutionary theory (social Darwinism) replaced traditional religion:

I remember that light came as in a flood and all was clear. Not only had I got rid of theology and the supernatural, but I had found the truth of evolution. "All is well since all grows better," became my motto, my true source of comfort. Man was not created with an instinct for his own degradation, but from the lower he had risen to the higher forms. Nor is there any conceivable end to his march to perfection. His face is turned to the light; he stands in the sun and looks upward. (Hofstadter, 1955, p. 45)

It should not be concluded that Darwin was entirely unsympathetic toward applying evolutionary principles to societies in the way Spencer had. In *The Descent of Man* (1874/1998a), Darwin said,

With savages, the weak in body or mind are soon eliminated; and those that survive commonly exhibit a vigorous state of health. We civilized men, on the other hand, do our utmost to check the process of elimination; we build asylums for the imbecile, the maimed, and the sick; we institute poor-laws; and our medical men exert their utmost skill to save the life of every one to the last moment. There is reason to believe that vaccination has preserved thousands, who from a weak constitution would formerly have succumbed to smallpox. Thus the weak members of civilized societies propagate their kind. No one who has attended to the breeding of domestic animals will doubt that this must be highly injurious to the race of man.... [E]xcepting in the case of man himself, hardly any one is so ignorant as to allow his worst animals to breed. (pp. 138-139)

It was Spencer, however, who featured such thinking and emphasized the belief that societies, like individuals, would approximate perfection if natural forces were allowed to operate freely.

CHARLES DARWIN

Charles Darwin (1809-1882) was born on February 12 in Shrewsbury, England, in the same year that Lamarck published his book describing the inheritance of acquired characteristics. Incidentally, it is one of those interesting quirks of history that Darwin and Abraham Lincoln were born within hours of each other. As previously noted, Darwin's grandfather Erasmus Darwin was a famous physician who dabbled in, among many other things, evolutionary theory. Darwin's father, Robert, was also a prominent physician, and his mother, Susannah Wedgwood, came from a family famous for their manufacture of chinaware. Robert and Susannah had six children, of whom Charles was fifth. His mother died in 1817, when he was eight years old. His care thereafter was primarily the responsibility of two of his older sisters. After receiving his early education at home, Charles was eventually sent to school, where he did so poorly that his father predicted that some day he would disgrace himself and his family. Outside of school, however, he spent most of his time collecting and classifying plants, shells, and minerals. Academically, matters did not improve much when, at 16 years of age, Darwin entered medical school at the University of Edinburgh. He found the lectures boring and could not stand watching operations performed without benefit of anesthesia (which had not yet been invented). Following his father's advice, Darwin transferred to Cambridge University to train to become an Anglican clergyman. At Cambridge, he drank, sang, and ate (he was a member of the gourmet club) his way to an 1831 graduation with a mediocre academic record. Darwin remembered collecting beetles as the activity that brought him the most pleasure while at Cambridge.

It was Darwin's passion for entomology (the study of insects) that brought him into contact with professors of botany and geology at Cambridge, with whom he studied and did field research. For example, immediately upon graduation from Cambridge, Darwin went on a geological expedition to Wales headed by Adam Sedgwick, a

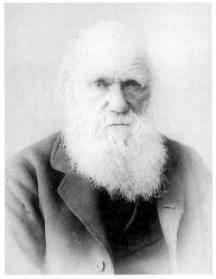

Charles Darwin

Cambridge professor of geology. Although Darwin was certainly interested in the expedition, he also saw it as a way of temporarily escaping the taking of his religious vows. A more permanent escape on the high seas was soon to be available to him. While at Cambridge, Darwin had befriended the botanist John Henslow, and it was Henslow who was first offered the position of naturalist aboard the Beagle. Because of family commitments, Henslow had to decline the offer and suggested that Darwin go in his place. At first, Darwin's father refused his permission because he would need to pay Charles's expenses on the trip and because he felt the journey would interfere with his son's clerical career. After discussing the matter with other members of the family, however, Darwin's father changed his mind and endorsed the adventure.

Courtesy of the National Library of Medicine

The Journey of the Beagle

Thus, it was at the instigation of one of his instructors that Darwin signed on as an unpaid naturalist aboard the *Beagle*, which the British government was sending on a five-year scientific expedition (1831–1836). There are several unusual facts about this trip. First, the captain of the *Beagle*, Robert

Fitzroy, who was a firm believer in the biblical account of creation, wanted a naturalist aboard so that evidence could be gathered that would *refute* the notion of evolution. Furthermore, Darwin himself began the trip as a believer in the Bible's explanation of creation (Monte, 1975). It was only after reading Sir Charles Lyell's *Principles of Geology* aboard ship that he began to doubt the biblical account. A third fact almost changed the course of history: Because Captain Fitzroy believed in physiognomy (see Chapter 8), he almost rejected Darwin as the *Beagle*'s naturalist:

On becoming very intimate with Fitz-Roy, I heard that I had run a very narrow risk of being rejected on account of the shape of my nose! He was ... convinced that he could judge a man's character by the outline of his features; and doubted whether anyone with my nose could possess sufficient energy and determination for the voyage. But I think he was afterwards well satisfied that my nose had spoken falsely. (F. Darwin, 1892/1958, p. 27)

The journey of the Beagle began on December 27, 1831, from Plymouth, England. Darwin was 23 years old at the time. The Beagle went first to South America, where Darwin studied marine organisms, fossils, and tribes of Indians. Then, in the fall of 1835, the Beagle stopped at the Galápagos Islands, where Darwin studied huge tortoises, lizards, sea lions, and 13 species of finch. Of special interest was his observation that tortoises, plants, insects, and other organisms differed somewhat from island to island, even when the islands were separated by a relatively short distance. The Beagle went on to Tahiti, New Zealand, and Australia; and in October 1836, Darwin arrived back in England, where he went to work classifying his enormous specimen collection.

Back in England

Even after Darwin returned to England, his observations remained disjointed; he needed a principle to tie them together. Reading **Thomas Malthus**'s

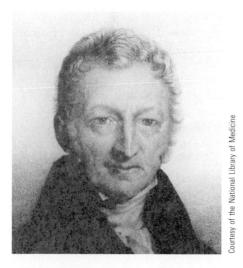

Thomas Malthus

An Essay on the Principle of Population (1798/1914) furnished Darwin with that principle. An economist, Malthus (1766–1834) observed that the world's food supply increased arithmetically, whereas the human population tended to increase geometrically. He concluded that food supply and population size were kept in balance by such events as war, starvation, and disease. Darwin embellished Malthus's concept and applied it to animals and plants as well as to humans.

In January 1839 Darwin married his cousin Emma Wedgwood, with whom he eventually had 10 children. Emma was 48 years old when she gave birth to her last child, Charles Waring, who was born retarded. It was about the time that he married Emma that Darwin began to have the serious health problems that were to plague him for the next 30 years. At one time or another, he experienced severe gastric pain, heart palpitations, acute anxiety, depression, hysterical crying, and a variety of skin disorders. Most scholars agree that Darwin's ailments were psychosomatic: "During the course of his life Darwin consulted most of the leading physicians and surgeons of his day, but none of them ever found anything organically wrong" (Bowlby, 1991, p. 7). In part because of his health problems and in part because he realized that what he was working on was revolutionary (perhaps the two

were related), Darwin delayed publication of his theory of evolution for more than 20 years. In fact, there is reason to believe that Darwin's theory would have been published only after his death if it had not been for a forceful demonstration that the time was right for such a theory. In June 1858 Darwin received a letter from Alfred Russell Wallace (1823-1913) describing a theory of evolution almost identical to his own. Wallace, too, had been influenced by Malthus's essay, as well as by his own observations in the Amazon and in the Malay Archipelago. Charles Lyell, the evolutionary geologist, reviewed both Wallace's and Darwin's ideas and suggested that both Wallace's paper and one hastily prepared by Darwin be read at the Linnaean Society on the same day and with both authors absent. This was done, and neither paper roused much interest (Boakes, 1984). Darwin's epoch-making book On the Origin of Species by Means of Natural Selection (1859) was published two months later. By then there was so much interest in evolutionary theory that all 1,500 copies of the book sold on the first day it was available.

Following the publication of *Origin* were several public debates over the validity of Darwin's theory, but Darwin didn't participate. Instead it was his friend Thomas Huxley (1825–1895) who effectively defended the theory. For this he was dubbed "Darwin's bulldog." (For the colorful details of Huxley's life, including his relationship with Darwin, see Desmond, 1997).

Six years after the publication of Darwin's theory, Captain Fitzroy committed suicide, perhaps because he felt that he was at least partially responsible for Darwin's theory of evolution (Gould, 1976; White and Gribbon, 1995). Because of the abundance of data Darwin amassed and the thoroughness of his work, we attribute the theory to him and not to Wallace, but what follows may someday be referred to as the Darwin–Wallace theory of evolution. Darwin died on April 19, 1882, at the age of 73. He was buried in Westminster Abbey, near the grave of Isaac Newton.

Incidentally, Wallace was one of the most outspoken opponents of social Darwinism. Rather than accepting a laissez-faire philosophy concerning human competition, Wallace believed that humans could, and should, guide their own evolution. For Wallace, this meant creating government programs that help those individuals less equipped to compete in a complex society. At the time, Wallace's view was very much in the minority (Larson, 2001, lecture 8).

Darwin's Theory of Evolution

The reproductive capacity of all living organisms allows for many more offspring than can survive in a given environment; therefore, there is a struggle for survival. Among the offspring of any species, there are vast individual differences, some of which are more conducive to survival than others. This results in the survival of the fittest (a term Darwin borrowed from Spencer). For example, if there is a shortage of food in the environment of giraffes, only those giraffes with necks long enough to reach the few remaining leaves on tall trees will survive and reproduce. In this way, as long as food remains scarce, giraffes with shorter necks will tend to become extinct. Thus, a natural selection occurs among the offspring of a species. This natural selection of adaptive characteristics from the individual differences occurring among offspring accounts for the slow transmutation of a species over the eons. Evolution, then, results from the natural selection of those accidental variations among members of a species that prove to have survival value.

Darwin defined **fitness** as an organism's ability to survive and reproduce. Fitness, then, is determined by an organism's features and its environment. Features that allow adequate adjustment to an organism's environment are called adaptive. Those organisms possessing **adaptive features** are fit; those that do not are not. Notice that nothing is said about strength, aggression, and competitiveness. None of these features are *necessarily* conducive to fitness. Adaptive features are those features that are conducive to survival in a given environment, *whatever* those features may be. Also notice that Darwin said nothing about progress or perfection. Unlike Spencer, Darwin believed that evolution just happens; there is no direction or purpose

involved. The direction that evolution takes is completely determined by the features possessed by members of various species of organisms and the environments in which those organisms exist. As environments change, what features are adaptive also change, and on it goes forever.

Evolution and the Earth's Age. One of the earliest conflicts that Darwin had with the church was over the age of the earth. As Darwin saw it, the process of evolution occurred over millions of years. Within the church at the time, it was generally believed that the earth was not nearly as old as was required by Darwin's theory and, therefore, the theory must be false. For their arguments against Darwin, church officials drew upon estimates of the earth's age based on biblical study. For example, Archbishop James Ussher (1581-1656), Vice Chancellor of Trinity College in Dublin, after carefully studying various biblical events, concluded that the creation had occurred in 4004 B.C. John Lightfoot (1602-1675), Vice Chancellor of Cambridge University, was even more specific. After exhaustive study of the scriptures, he concluded that the creation occurred at precisely 9 a.m. on Sunday, October 23, 4004 B.C. (White and Gribbin, 1995, p. 83). Even in Darwin's time, there was considerable geological and fossil evidence indicating that the earth was significantly older than was suggested by church authorities. Currently, many scientists estimate the earth to be approximately 4.5 billion years old, and this, of course, is more than what is required by Darwin's theory. However, the debate between evolutionary theory and creationism continues (see, for example, Larson, 2001).

Human Evolution. In *On the Origin of Species*, Darwin said very little about humans, but later, in *The Descent of Man* (1871, revised in 1874/1998a), he made his case that humans are also the product of evolution. Both humans and the great apes, he said, descended from a common, distant primate ancestor.

Of Darwin's books, the one most directly related to psychology is *The Expression of the Emotions*

in Man and Animals (1872/1998b), in which he argued that human emotions are remnants of animal emotions that had once been necessary for survival. In the distant past, only those organisms capable of such things as biting and clawing survived and reproduced. Somewhat later, perhaps, simply baring of teeth or snarling were enough to discourage an aggressor and therefore facilitated survival. Although no longer as functional in modern society, the emotions that were originally associated with attack or defense are still part of our biological makeup, as can be seen in human reactions under extreme conditions. Darwin also noted that the expression of human emotions is culturally universal. By observing the facial characteristics of a person anywhere on earth, one could determine if that person were experiencing joy, grief, anger, sadness, or some other emotion. It would be almost 100 vears before Darwin's research on emotions would be improved upon. For an excellent summary of Darwin's theory of emotions and a discussion of its current relevance, see Ekman (1998).

Darwin's direct comparison of humans with other animals in *The Expression of the Emotions*, along with his forceful assertion that humans differ from other animals only in degree, launched modern comparative and animal psychology. It became clear that much could be learned about humans by studying nonhuman animals.

Darwin also influenced subsequent psychology when he carefully observed the development of his first son, William (born 1839). He noted when various reflexes and motor abilities first appeared, as well as various learning abilities. Although he delayed publication of his observations until William was 37, Darwin's report (1877) was among the first examples of what was later called child psychology.

Darwin's Influence

To say the least, Darwin's theory was revolutionary. Its impact has been compared to that of the theories of Copernicus and Newton. He changed the traditional view of human nature and with it changed the history of philosophy and psychology. Many of the topics dismissed by Titchener because they did

not represent pure experimental psychology were encouraged by Darwin's theory. Popular topics in contemporary psychology clearly reveal a strong Darwinian influence: developmental psychology, animal psychology, comparative psychology, psychobiology, learning, tests and measurements, emotions, behavioral genetics, abnormal psychology, and a variety of other topics under the heading of applied psychology. In general, Darwin stimulated interest in the study of individual differences and showed that studying behavior is at least as important as studying the mind. As we will see, Darwin's theory of evolution played a significant role in the development of the schools of functionalism (Chapter 11) and behaviorism (Chapter 12).

Darwin's influence, however, was not entirely positive. He entertained a number of beliefs now considered highly questionable or mistaken, such as the following:

- Contemporary primitive people are the link between primates and modern humans (that is Europeans) and are therefore, inferior.
- Women are intellectually inferior to men. Alland (1985) says, "Darwin at his worst is Darwin on women" (p. 24). For examples of Darwin's beliefs concerning the intellectual inferiority of women, see Darwin (1874/1998a, pp. 576–577, 584).
- Long practiced habits become heritable instincts; in the other words, in explaining cultural differences among humans, Darwin accepted Larmarkian theory. For a discussion of Darwin's highly questionable or mistaken beliefs, see Alland, 1985.

In addition to its general impact on psychology, evolutionary theory is currently having a more direct impact. In 1975 Edward Wilson published *Sociobiology: The New Synthesis*, which attempts to explain the social behavior of organisms, including that of humans, in terms of evolutionary theory. By modifying Darwin's definition of fitness from the survival and reproductive success of the individual (Darwin's definition) to the perpetuation of one's genes, **sociobiology** can account for a wide array

of human social behaviors. That is, according to sociobiologists, fitness is determined by how successful one is at perpetuating one's genes but not necessarily how successful one is at producing offspring. By emphasizing the importance of perpetuating one's genes, the sociobiologists place great emphasis on kin, or genetic, relationships. Because one's kin carries one's genes, helping them survive and reproduce becomes an effective way of perpetuating one's genes. Armed with this conception of inclusive fitness, sociobiologists attempt to explain such things as love, altruism, warfare, religion, morality, mating systems, mate-selection strategies, child-rearing strategies, xenophobia, aggressive behavior, nepotism, and indoctrinatability. What Wilson called sociobiology is now called evolutionary psychology and is extremely popular in contemporary psychology. We will say more about evolutionary psychology in Chapter 19.

As we will see in the remainder of this chapter, Darwin's ideas ultimately gave birth to a uniquely U.S. type of psychology—a psychology that emphasized individual differences and their measurement, the adaptive value of thoughts and behavior, and the study of animal behavior. Before discussing U.S. psychology, however, we must first review the works of a man who was an important link between Darwinian theory and U.S. psychology.

SIR FRANCIS GALTON

Erasmus Darwin, the physician, philosopher, poet, and early evolutionary theorist, was the grandfather of both Charles Darwin and Francis Galton (1822–1911). Darwin's cousin Galton was born near Birmingham, England, on February 16, the youngest of seven children. His father was a wealthy banker, and his mother was a half-sister of Charles Darwin's father. Receiving his early education at home, Galton could read and write by the age of 2 1/2. At age 5, he could read any book written in English, and by age 7, he was reading such authors as Shakespeare for pleasure. But things changed when Galton was sent to a boarding

Psychology Archives-The University of

Francis Galton

school, where his experiences included being flogged, hell-raising, enduring sermons from the teachers, and fighting with his fellow students. At age 16, he was taken out of boarding school and sent to Birmingham General Hospital to study medicine; after this practical experience, he transferred to King's College in London. He then moved to Cambridge University, where he obtained his degree in 1843. Galton planned to return to King's College to obtain his medical degree; but when his father died, he decided not to, so his formal education ended.

Because Galton was independently wealthy, he could work on what he wanted, when he wanted. After graduation he traveled in Egypt, the Sudan, and the Middle East. Then he came home and socialized with his rich friends for a few years—riding, shooting, ballooning, and experimenting with electricity. After consulting with a phrenologist who recommended an active life, Galton decided to join the Royal Geographical Society on a trip to southwest Africa. The trip lasted two years, and for Galton's creation of a map of previously unexplored territories in Africa (now called Namibia), the Royal Geographical Society honored him in 1853 with its highest medal. Galton was 32 at the time. We can see in Galton's map-making ability a passion that he had all his adult life: the passion to measure things.

In 1853 Galton published his first book, Narrative of an Explorer in Tropical South Africa. He became a recognized expert on travel in the wild, and the British government commissioned him to teach camping procedures to soldiers. In 1855 he published his second book, The Art of Travel, which included information on how to deal with wild animals and savages. For his inventiveness, Galton was elected president of the Royal Geographical Society in 1856.

To further illustrate Galton's passion for measurement, here are a few of his other endeavors:

- In his effort to measure and predict the weather, he invented the weather map and was the first to use the terms highs, lows, and fronts.
- He was the first to suggest that fingerprints could be used for personal identification—a procedure later adopted by Scotland Yard.
- He attempted to determine the effectiveness of prayer (he found it ineffective).
- He tried to determine which country had the most beautiful women.
- He measured the degree of boredom at scientific lectures.

One can imagine Galton's delight when he became aware of his cousin's evolutionary theory with its emphasis on individual differences. Galton believed that if there were important individual differences among people, clearly they should be measured and cataloged. This became Galton's mission in life.

The Measurement of Intelligence

Galton assumed that intelligence is a matter of sensory acuity because humans can know the world only through the senses. Thus, the more acute the senses, the more intelligent a person was presumed to be. Furthermore, because sensory acuity is mainly a function of natural endowment, intelligence is inherited. And if intelligence is inherited, as Galton assumed, one would expect to see extremes in intelligence run in families. Assuming

that high reputation or eminence is an accurate indicator of high intellectual ability, Galton set out to measure the frequency of eminence among the offspring of illustrious parents as compared to the frequency of eminence among the offspring of the general population. For comparison with the general population, Galton studied the offspring of judges, statesmen, commanders, literary men, scientists, poets, musicians, painters, and divines. The results, published in Hereditary Genius: An Inquiry into Its Laws and Consequences (1869), were clear: the offspring of illustrious individuals were far more likely to be illustrious than were the offspring of nonillustrious individuals. Galton also observed, however, that zeal and vigor must be coupled with inherited capacity before eminence can be attained.

Eugenics. Galton's conclusion raised a fascinating possibility: *selective breeding*. If intelligence is inherited, could not the general intelligence of a people be improved by encouraging the mating of bright people and discouraging the mating of people who were less bright? Galton's answer was yes. He called the improvement of living organisms through selective breeding **eugenics** and advocated its practice:

I propose to show in this book that a man's natural abilities are derived by inheritance, under exactly the same limitations as are the form and physical features of the whole organic world. Consequently, as it is easy, notwithstanding those limitations, to obtain by careful selection a permanent breed of dogs or horses gifted with peculiar powers of running, or of doing anything else, so it would be quite practicable to produce a highly-gifted race of men by judicious marriages during several consecutive generations. I shall show that social agencies of an ordinary character, whose influences are little suspected, are at this moment working towards the degradation of human nature, and that others are working towards its improvement. I conclude that each generation has enormous power over the natural gifts of those that

follow, and maintain that it is a duty we owe to humanity to investigate the range of that power, and to exercise it in a way that, without being unwise towards ourselves, shall be most advantageous to future inhabitants of the earth. (Galton, 1869, p. 45)

In 1865 Galton proposed that couples be scientifically paired and that the government pay those possessing desirable characteristics to marry. The government was also to take care of the educational expenses of any offspring. After reading Hereditary Genius, Darwin wrote to his cousin: "You have made a convert of an opponent in one sense, for I have always maintained that excepting fools, men did not differ much in intellect only in zeal and hard work" (Pearson, 1914, p. 6). Darwin gave credit to Galton for calling to his attention the fact that allowing weak members of a society to breed weakens the human stock. Thus, as we have noted, Darwin was not entirely adverse to what was called social Darwinism nor, as we have seen, was he entirely opposed to the idea of eugenics.

The Nature–Nurture Controversy. Galton's extreme nativism did not go unchallenged. Alphonse de Candolle (1806–1893), for example, wrote a book stressing the importance of environment in producing scientists. Candolle suggested that climate, religious tolerance, democratic government, and a thriving economy were at least as important as inherited capacity in producing scientists.

Such criticism prompted Galton's next book, English Men of Science: Their Nature and Nurture (1874). To gather information for this book, Galton sent a questionnaire to 200 of his fellow scientists at the Royal Society. This was the first use of the questionnaire in psychology. The participants were asked many factual questions, ranging from their political and religious backgrounds to their hat sizes. In addition, they were asked to explain why they had become interested in science in general as well as in their particular branches of

science. Finally, the scientists were asked whether they thought that their interest in science was innate.

Although the questionnaire was very long, most of the scientists finished and returned it, and most believed that their interest in science was inherited. Galton noticed, however, that a disproportionate number of the scientists were Scottish and that these scientists praised the broad and liberal Scottish educational system. Conversely, the English scientists had very unkind things to say about the English educational system. On the basis of these findings, Galton urged that English schools be reformed to make them more like Scottish schools; here Galton was acknowledging the importance of the environment. His revised position was that the potential for high intelligence was inherited but that it must be nurtured by a proper environment. Galton (1874) clearly stated the nature-nurture controversy, which is still the focus of much attention in modern psychology:

The phrase "nature and nurture" is a convenient jingle of words, for it separates under two distinct heads the innumerable elements of which personality is composed. Nature is all that a man brings with himself into the world; nurture is every influence that affects him after his birth. The distinction is clear: the one produces the infant such as it actually is, including its latent faculties of growth and mind; the other affords the environment amid which the growth takes place, by which natural tendencies may be strengthened or thwarted, or wholly new ones implanted. (p. 12)

In his next book, *Inquiries into Human Faculty* and *Its Development* (1883), Galton further supported his basic nativistic position by studying twins. He found monozygotic (one-egged) twins to be very similar to each other even when they were reared apart, and he found dizygotic (two-egged) twins to be dissimilar even when they were reared together. Following Galton's lead, it became very popular to study twins to determine

the relative influence of nature and nurture on various attributes, such as intelligence. Twin research remains popular today (see, for example, the work of Thomas Bouchard and his colleagues, reviewed in Chapter 19).

The Word-Association Test

In *Inquiries*, Galton devised psychology's first word-association test. He wrote 75 words, each on a separate piece of paper. Then he glanced at each word and noted his response to it on another piece of paper. He went through the 75 words on four different occasions, randomizing the words each time. Three things struck Galton about this study. First, responses to stimulus words tended to be constant; he very often gave the same response to a word all four times he experienced it. Second, his responses were often drawn from his childhood experience. Third, he felt that such a procedure revealed aspects of the mind never revealed before:

Perhaps the strongest of the impressions left by these experiments regards the multifariousness of the work done by the mind in a state of half-consciousness, and the valid reason they afford for believing in the existence of still deeper strata of mental operations, sunk wholly below the level of consciousness, which may account for such mental phenomena as cannot otherwise be explained. (Galton, 1883, p. 145)

Whether Galton influenced Freud is not known, but Galton's work with word association anticipated two aspects of psychoanalysis: the use of free association and the recognition of unconscious motivation.

Mental Imagery

Galton was also among the first, if not the first, to study imagery. In *Inquiries* he reported the results of asking people to imagine the scene as they had sat down to breakfast. He found that the ability to imagine was essentially normally distributed, with

some individuals almost totally incapable of imagery and others having the ability to imagine the breakfast scene flawlessly. Galton was amazed to find that many of his scientist friends had virtually no ability to form images. If sensations and their remnants (images) were the stuff of all thinking, as the empiricists had assumed, why was it that many scientists seemed unable to form and use images? Galton also found, not so surprisingly, that whatever a person's imagery ability was, he or she assumed that everyone else had the same ability.

Anthropometry

Galton's desire to measure individual differences among humans inspired him to create what he called an "anthropometric laboratory" at London's International Health Exhibition in 1884. Here, in about one year, Galton measured 9,337 humans in just about every way he could imagine. For example, he measured head size, arm span, standing height, sitting height, length of the middle finger, weight, strength of hand squeeze (measured by a dynamometer), breathing capacity, visual acuity, auditory acuity, reaction time to visual and auditory stimuli, the highest detectable auditory tone, and speed of blow (the time it takes for a person to punch a pad). Some of these measures were included because Galton believed sensory acuity to be related to intelligence, and for that reason, Galton's anthropometric laboratory can be viewed as an effort to measure intelligence. Incidentally, Gall measured head size because he believed it to be an indirect measure of brain size: "He assumed that the brightest people had to have the biggest brains and, hence, the biggest skulls" (Finger, 1994, p. 312). In 1888 Galton set up a similar laboratory in the science galleries of the South Kensington Museum, and it operated for several years. A handout described the purpose of the laboratory to potential participants:

 For the use of those who desire to be accurately measured in many ways, either to obtain timely warning of remediable faults in development, or to learn their powers.

- 2. For keeping a methodological register of the principal measurements of each person, of which he may at any future time obtain a copy under reasonable restrictions. His initials and date of birth will be entered in the register, but not his name. The names are indexed in a separate book.
- 3. For supplying information on the methods, practice, and uses of human measurement.
- 4. For anthropometric experiment and research, and for obtaining data for statistical discussion. (Pearson, 1924, p. 358)

For a small fee (threepence), a person would be measured in all ways described above; and for a smaller fee (twopence), a person could be measured again at another time. Each participant was given a copy of his or her results, and Galton kept a copy for his files. Among the many things that Galton was interested in examining were test-retest relationships, gender differences on various measurements, intercorrelations among various measurements, relationships of various measurements to socioeconomic status, and family resemblances among various measurements. Because Galton's incredible amount of data existed long before there were computers or even calculators, much of it went unanalyzed at the time. Since then, however, other researchers have analyzed portions of the previously unanalyzed data. Johnson, McClearn, Yuen, Nagoshi, Ahern, and Cole (1985) reported the results of Galton's own analyses, the results of analyses of Galton's data done by researchers after him, and their own analyses of Galton's data that had not been previously analyzed.

Although intelligence is no longer believed to be related to sensory acuity, Galton's early efforts can be seen as the beginning of the mental testing movement in psychology. Following our review of Galton, we will have more to say about how intelligence testing changed after Galton's efforts.

The Concept of Correlation

The last of Galton's many contributions to psychology we will consider is his notion of correlation,

which has become one of psychology's most widely used statistical methods. In 1888 Galton published an article titled "Co-Relations and Their Measurement, Chiefly from Anthropometric Data," and in 1889 he published a book titled *Natural Inheritance*. Both works describe the concepts of correlation and regression. Galton (1888) defined **correlation**, or co-relation, as follows:

Two variable organs are said to be corelated when the variation on one is accompanied on the average by more or less variation of the other, and in the same direction. Thus the length of the arm is said to be co-related with that of the leg, because a person with a long arm has usually a long leg, and conversely. (p. 135)

In a definition of correlation, the word *tend* is very important. Even in the above quotation, Galton said that those with long arms *usually* have long legs. After planting peas of varying sizes and measuring the size of their offspring, Galton observed that very large peas tended to have offspring not quite as large as they were and that very small peas tended to have offspring not quite as small as themselves. He called this phenomenon **regression toward the mean**, something he also found when he correlated heights of children with heights of their parents. In fact, Galton found regression whenever he correlated inherited characteristics. Earlier, Galton had observed that eminent individuals only *tended* to have eminent offspring.

By visually displaying his correlational data in the form of scatterplots, Galton found that he could visually determine the strength of a relationship. It was **Karl Pearson** (1857–1936) who devised a formula that produced a mathematical expression of the strength of a relationship. Pearson's formula produces the now familiar **coefficient of correlation** (r).

In addition to introducing the concept of correlation, Galton also introduced the *median* as a measure of central tendency. He found the *mean* to be overly influenced by extreme scores in a distribution and preferred to use the middle-most score (the median) in a distribution instead.

Galton's Contributions to Psychology

Few individuals in psychology have more firsts attributed to them than does Galton. Galton's firsts include study of the nature–nurture question, the use of questionnaires, the use of a word-association test, twin studies, the study of imagery, intelligence testing, and the development of the correlational technique. Everywhere in his work, we see a concern with individual differences and their measurements, a concern that was a direct reflection of the influence of Darwin's theory of evolution.

INTELLIGENCE TESTING AFTER GALTON

James McKeen Cattell

The transfer of Galton's testing procedures to the United States was accomplished mainly through the efforts of James McKeen Cattell (1860-1944). who had studied with both Wundt and Galton in Europe but had been much more influenced by Galton. Cattell, born on May 25 in Easton, Pennsylvania, was the son of a Presbyterian clergyman who was also a professor of Latin and Greek at Lafayette College and later its president. Cattell entered Lafayette College before his 16th birthday and stood first in his class without much effort. Among his favorite subjects were mathematics and physics. After graduation from Lafayette in 1880, he traveled to Germany to study with the Kantian physiologist R. H. Lotze (1817-1881). Cattell was very impressed by Lotze, and it came as quite a blow when Lotze died a year after Cattell's arrival. The following year, Cattell returned home and wrote a paper on philosophy that won him a fellowship at Johns Hopkins University. While at Johns Hopkins (1882-1883), he did research in G. Stanley Hall's new psychology laboratory (see Chapter 11) and decided to become a psychologist. In 1883 Cattell returned to Germany, this time to study with Wundt. Cattell was not only Wundt's first experimental assistant but was also the first student from the United States to earn a doctorate under Wundt's supervision. Cattell received his degree in 1886. While with Wundt, Cattell and a fellow student did numerous reaction-time studies. Among other things, Cattell noticed that his own reaction times differed systematically from those of his fellow researcher and proposed to Wundt that individual differences in reaction time be explored. The proposal was rejected because Wundt was more interested in the nature of the mind in general than with individual differences.

After attaining his doctorate, Cattell returned to the United States, where he taught at Bryn Mawr College and the University of Pennsylvania. About this time. Cattell became aware of Galton's anthropometric laboratory in London and began a correspondence with Galton, mainly concerning the measurement of reaction time. Soon Cattell applied for and received a two-year research fellowship at Cambridge University, where he worked with Galton. In Galton, Cattell finally found someone who shared his intense interest in individual differences. Galton confirmed Cattell's conviction that individual differences were important and that they could be objectively measured. Under Galton's influence, Cattell came to believe that intelligence was related to sensory acuity and was therefore largely inherited:

As a self-proclaimed disciple of Francis Galton, Cattell's interest in eugenics is clear.... He proposed that incentives be given "the best elements of all the people" to intermarry and have large families [Cattell and his wife had seven children] and in fact offered each of his children \$1,000 if they would marry the child of a college professor. (Sokal, 1971, p. 630)

On his return to the United States in 1888, Cattell was first affiliated with the University of Pennsylvania, where in 1889 he founded the first psychology laboratory designed for undergraduate students. It was also at the University of Pennsylvania that Cattell administered Galtonian-type measures to his students.

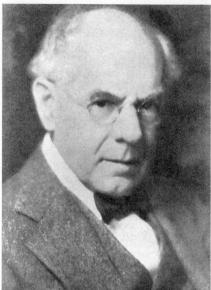

Psychology Archives—The University of Akror

James McKeen Cattell

In 1890 Cattell published his techniques and results in an article that used the term *mental test* for the first time:

Psychology cannot attain the certainty and exactness of the physical sciences, unless it rests on a foundation of experiment and measurement. A step in this direction could be made by applying a series of mental tests and measurements to a large number of individuals. The results would be of considerable scientific value in discovering the constancy of mental processes, their interdependence, and their variation under different circumstances. (p. 373)

It was also in this article that Cattell described 10 mental tests that he believed could be administered to the general public and a total of 50 tests that he believed should be administered to university students. The 10 mental tests were mainly Galtonian, but Cattell also added a few measurements he learned in Wundt's laboratory. Among the 10 tests were hand strength, two-point threshold, amount of pressure required to

cause pain, ability to discriminate between weights, reaction time, accuracy of bisecting a 50-centimeter line, accuracy in judging a 10-second interval, and ability to remember a series of letters. The more comprehensive series of 50 tests was essentially more of the same; the vast majority of them measured some form of sensory acuity or reaction time.

In 1891 Cattell moved to Columbia University, where he began administering his tests to entering freshmen. Implicit in Cattell's testing program was the assumption that if a number of his tests were measuring the same thing (intelligence), performance on those tests should be highly correlated. Also implicit was the assumption that if tests were measuring intelligence, they should correlate highly with academic success in college. That is, for a test of intelligence to be valid, it must make differential predictions about how individuals will perform on tasks requiring intelligence.

In 1901 Clark Wissler, one of Cattell's graduate students, tested Cattell's assumptions. Armed with Pearson's newly perfected correlation coefficient, Wissler measured the relationships among Cattell's tests and between performance on various tests and academic performance. Wissler's results were disastrous for Cattell's testing program. He found that intercorrelations among the tests were very low and that the correlation between various tests and success in college was nearly zero (Guilford, 1967). Thus, the tests were not measuring the same thing because if they were, they would be highly correlated; and they were not valid because if they were, scores would correlate highly with academic achievement.

With such unambiguous, negative findings, the interest in mental testing quickly faded. Wissler switched his field to anthropology and became an outspoken environmentalist, and Cattell turned to other aspects of applied psychology. Because Cattell was a key figure in the school of functionalism, we will consider him further in the next chapter. The emphasis in U.S. psychology was turning toward practicality, and it appeared that Galtonian measures were not very useful, at least as far as intelligence was concerned. This moratorium on mental testing was not to last long, however.

Alfred Binet

In France, a different approach to measuring intelligence was being tried, one that appeared to be more successful than Galton's. It involved *directly* measuring the complex mental operations thought to be involved in intelligence. **Alfred Binet** (1857–1911) championed this method of testing, which was more in the rationalist tradition than in the empiricist tradition.

Binet was born on July 11 in Nice, France. His father was a physician, as were both of his grand-fathers. Binet's parents separated when he was a young child, and he, an only child, was reared mainly by his mother, a successful artist. Although he initially followed the family tradition by studying medicine, Binet terminated his medical studies and turned to psychology instead. Being independently wealthy allowed Binet to take the time to educate himself, and he read the works of Darwin, Galton, and the British empiricists (especially John Stuart Mill), among others. He received no formal education in psychology.

Binet began his career in psychology by working with Jean-Martin Charcot (1825-1893), the world famous psychiatrist, at La Salpêtrière. Like Charcot, Binet conducted research on hypnotism, and he claimed that in one study he had been able to manipulate the symptoms and sensations of a hypnotized subject by moving a magnet to various places around the subject's body. He also claimed that application of the magnet could convert fear of an object, such as a snake, into affection. Binet thought that such findings would have important implications for the practice of medicine in general and for psychiatry in particular, but other researchers could not reproduce Binet's findings and concluded that Binet's results were due to poor experimental control. For example, it was found that Binet's subjects always knew what was expected of them and acted accordingly. When subjects were unaware of the researcher's expectations, they did not exhibit the phenomena Binet had observed. Thus, suggestion had caused Binet's results, not the magnet. After a long attempt to defend his beliefs, Binet finally admitted that his results had been

O Psychology Archives-The University of Akrol

Alfred Binet

due to suggestion and not to the magnet's power, and he resigned his position at La Salpêtrière in 1890. The humiliation resulting from his public admission of shoddy research procedures haunted Binet all his life. His statement "Tell me what you are looking for, and I will tell you what you will find" (Wolf, 1973, p. 347) was directed at metaphysicians, but Binet knew from personal experience that it could apply to researchers as well.

Fortunately, Binet's second career in psychology was more successful. Without a professional position, Binet directed his attention to the study of the intellectual growth of his two daughters (Alice and Madeleine), who were 2 1/2 and 4 1/2 years old at the time. The tests he created to investigate his children's mental operations were very similar to those Jean Piaget later devised. He asked, for example, which of two piles contained more objects and found that the answer was not determined by the number of objects in the piles but by the amount of space the piles took up on the table. Binet also investigated how well his daughters could remember objects that he first showed them and then removed from sight. Binet also employed a number of tests used by Galton and Cattell to

measure visual acuity and reaction time. In 1890 he published three papers describing his research on his daughters, and in 1903 he published *The Experimental Study of Intelligence*, which summarized his longitudinal study of the intellectual growth of his daughters.

In 1891 Binet joined the laboratory for physiological psychology at the Sorbonne, where he performed research in such areas as memory, the nature of childhood fears, the reliability of eyewitness testimony, creativity, imageless thought, psychophysics, abnormal psychology, craniometry, and graphology. During his years at the Sorbonne, Binet also investigated individual differences in the perception of inkblots-before the famous work of Rorschach. In her outstanding biography of Binet, Theta Wolf (1973) said that Binet was the father of experimental psychology in France and that he had more of an impact on U.S. psychology than Wundt did. (The reader is directed to Wolf's book for more details concerning Binet's many pioneering research endeavors and for the interesting details of his life.)

Individual Psychology. Rather than being interested in what people have in common, Binet was primarily interested in what made them different. In 1896 he and his assistant Victor Henri (1872-1940) wrote an article titled "Individual Psychology," which proposed a list of variables on which individuals differ, especially intellectually. What they sought was a list of important variables and a way of determining the extent to which each variable exists in a given individual. With the variables isolated and a way of measuring them available, they hoped that it would be possible to "evaluate" any individual in a relatively short period of time. The work of Galton and Cattell was rejected because it placed too much emphasis on sensory processes and not enough on higher mental processes. In other words, Binet and Henri proposed to study cognitive abilities directly instead of indirectly via sensory acuity. Another reason the work of Galton and Cattell was rejected is that it minimized important differences between a child's mind and an adult's. According to Binet and Henri,

the important variables on which humans differ are complex, higher-order processes that vary according to age. The list of such variables proposed in 1896 included memory, imagery, imagination, attention, comprehension, suggestibility, aesthetic judgment, moral judgment, force of will, and judgment of visual space.

Unfortunately, Binet and Henri's goal of accessing a person's higher mental processes in a relatively short period of time failed. Administering the tests took many hours, and interpreting the results required even more hours of subjective, clinical judgment. Even more devastating, however, was the study on their tests performed by Stella Sharp, a graduate student at Cornell University. Sharp (1899) found very low intercorrelations among the Binet-Henri tests and concluded (as Wissler had concluded about Cattell's tests) that they could not be measuring the same attribute (presumably intelligence). Such findings, along with their own disappointing results, caused Binet and Henri to abandon their "individual psychology" project. The experience gained, however, would serve Binet well on his next project.

Assessing Intellectual Deficiency. In 1899 Theodore Simon (1873-1961), who worked as an intern at a large institution for children with mental retardation, asked Binet to supervise his doctoral research. Binet agreed and viewed this as an opportunity to have access to a large subject pool. Also in 1899, Binet joined the Free Society for the Psychological Study of the Child, an organization that sought scientifically valid information about children, especially about their educational problems. Binet soon became leader of the society. In 1903 Binet and Simon were appointed to the group that the French government commissioned to study the problems of children with retardation in the French schools. It was immediately clear that if children with retardation were to receive special education, it was necessary to have an adequate method of distinguishing them from normal children. At the time, variations of Galton's tests were being used to detect mental retardation, and Binet noted that because of these tests, children who were

blind or deaf were erroneously being classified as having mental deficiencies.

In 1904 Binet and Simon set out to create tests that would differentiate between intellectually normal and intellectually subnormal children. Their first step was to isolate one group of children clearly diagnosed as normal and another group diagnosed as subnormal. The second step was to test both groups in a number of different ways, hoping to discover measurements that would clearly distinguish members of one group from the other. From his previous research, Binet was convinced that the best way to examine individual differences was in terms of complex, mental processes, so many of the tests given to the normal and subnormal children were of that type. After much trial and error, Binet and Simon arrived at the first test of intelligence that measured intelligence directly instead of indirectly through measures of sensory acuity.

The 1905 Binet-Simon Scale of Intelligence and Its Revisions. Binet and Simon offered the Binet-Simon scale of intelligence as a valid way of distinguishing between normal children and children with mental deficiencies—a way that was to replace the less reliable physical, social, and educational signs being used at the time to identify children with mental retardation. The 1905 scale consisted of 30 tests ranging in difficulty from simple eye movements to abstract definitions. Three of the tests measured motor development, and the other 27 were designed to measure cognitive abilities. The tests were arranged in order of difficulty so that the more tests a child passed, the more fully developed his or her intelligence was assumed to be. The scale was given to normal children and to children thought to have retardation, all of them between the ages of 2 and 12.

Binet and Simon found that almost all normal children aged 2 years or older could easily pass tests 1 through 6. Also, children with slight or moderate retardation could pass some or all of these tests. Children with severe retardation could pass only a few or none of them. Most of tests 7 through 15 could be passed by normal children between the ages of 2 and 5. Children with slight retardation

could pass several of these tests, children with moderate retardation had great difficulty, and children with severe retardation could rarely pass any of them. Tests 16 through 30 could be routinely passed by normal children between the ages of 5 and 12, but children with even slight retardation had great difficulty with them, and children with moderate and severe retardation usually could pass none.

We see in the Binet–Simon scale a reflection of Binet's belief that intelligence is not a single ability but several. With this belief, Binet reflects the faculty psychology of several rationalistic philosophers. He did not, however, accept the nativism that often accompanies rationalistic viewpoints. He did believe that inheritance may place an upper limit on one's intellectual ability, but he also believed that almost everyone functions below their potential. Therefore, he believed strongly that *everyone* could grow intellectually, and that fact should be of prime importance to educators.

In 1908 Binet and Simon revised their scale. Their goal at that time was to go beyond simply distinguishing normal children from children with retardation to distinguishing among levels of intelligence for normal children. The tests were administered to a large number of normal children from ages 3 to 13. If 75% or more of the children of a certain age passed a particular test, the test was assigned to that age level. For example, most 4year-old children could copy a square but not a diamond. More specifically, it was found that only a minority of 3-year-olds could copy a square, a majority of 4-year-olds (75% or more) could copy a square, and essentially all 5-year-olds could do so. In this way, it could be determined whether a given child was performing at, above, or below average. A 5-year-old passing the tests that most other 5year-olds also passed was considered to have normal intelligence. But if that child passed only the tests typically passed by 4-year-olds, he or she was thought to have below-average intelligence. And if the 5-year-old passed tests normally passed by 6-year-olds, he or she was thought to have above-average intelligence. In other words, a child's intelligence level was determined by how much higher or lower than the norm the child performed. The 1908 revision of the Binet–Simon scale consisted of 58 tests, each showing the age at which 75% or more of the children taking it perform correctly.

The 1911 revision of the scale included normative data on adults (15-year-olds) and provided exactly five tests for each age level. The latter allowed for a more refined measure of intelligence. For example, if an 8-year-old child passed all the tests corresponding to his or her age, he or she would be considered normal. It is possible, however, that an 8-year-old will also pass some tests typically passed only by 9-year-olds. The new procedure allowed one-fifth of a year to be added to a child's score for each test the child passed beyond those that were the norm for his or her age. Thus, a child's "intellectual level" could be expressed in terms of "intellectual age"—that is, the age corresponding to the most difficult tests the child could pass.

Binet warned that extreme caution should be taken in interpreting a child's intellectual age. For one thing, he observed that it was quite common for children to have an intellectual age that was only one year behind their chronological age and that these children probably would have little trouble in school. Children whose intellectual age was two or more years behind their chronological age would probably have trouble in a standard school program and would need special attention. But even in the latter case, poor test performance did not necessarily mean the child had mental deficiencies. Before such a label was applied, the test administrator had to ensure that the child was healthy and motivated when he or she took the test and that he or she was knowledgeable enough about French culture to understand the reflections of that culture on the test.

Intelligence Quotient. In 1911 William Stern (1871–1938), a German psychologist, introduced the term mental age. For Stern, a child's mental age was determined by his or her performance on the Binet–Simon tests. Stern also suggested that mental age be divided by chronological age, yielding an intelligence quotient (IQ). For example, if

a particular 7-year-old passed all tests typically passed by 7-year-olds, his or her intelligence quotient would be 7/7, or 1.00. If another 7-year-old passed only those tests typically passed by 5-year-olds, his or her intelligence quotient would be 5/7, or about .71. In 1916 Lewis Terman suggested that the intelligence quotient be multiplied by 100 to remove the decimal point. It was also Terman who abbreviated *intelligence quotient* as IQ. Thus, combining the suggestions made by Stern and Terman, we have the familiar formula for IQ:

$$IQ = \frac{Mental Age (MA)}{Chronological Age (CA)} \times 100$$

Binet was opposed to the use of the intelligence quotient. He believed that intelligence is too complex to be represented by a simple term or number. History shows, however, that Stern's simplifications won out over Binet's opposition. In any case, Binet and Simon had developed a relatively brief, easy-to-administer measure of intelligence, and it became extremely popular. By the beginning of World War I, the Binet–Simon test was being used throughout most of the world.

Binet's View of His Intelligence Scale. Before reviewing what happened to the Binet-Simon scale in the United States, it is important to review how Binet viewed his scale. First and foremost, Binet saw the scale as a device for identifying children who needed some sort of special education. Binet strongly believed that children with low test scores could benefit considerably if given special attention. Although Binet believed that inheritance may set an upper limit on intellectual potential, he also believed that everyone could grow a great deal intellectually if properly stimulated. He worried very much about students in classrooms where teachers believed that students' intellectual performance was innately determined. This, of course, was especially regretful for students believed to have low intelligence:

I have often observed, to my regret, that a widespread prejudice exists with regard to the educability of intelligence. The familiar proverb, "When one is stupid, it is for a long time," seems to be accepted indiscriminately by teachers with a stunted critical judgment. These teachers lose interest in students with low intelligence. Their lack of sympathy and respect is illustrated by their unrestrained comments in the presence of the children: "This child will never achieve anything.... He is poorly endowed.... He is not intelligent at all." I have heard such rash statements too often. They are repeated daily in primary schools, nor are secondary schools exempt from the charge. (Binet, 1909/1975, p. 105)

In Binet's (1909/1975) reaction to those who maintained that some children would *never* accomplish certain things, he indicates clearly that he did not accept an extreme nativist view of intelligence:

"Never!" What a strong word! A few modern philosophers seem to lend their moral support to these deplorable verdicts when they assert that an individual's intelligence is a fixed quantity, a quantity which cannot be increased. We must protest and react against this brutal pessimism. We shall attempt to prove that it is without foundation. (pp. 105–106)

Mental Orthopedics. Binet believed that mental orthopedics could prepare disadvantaged children for school. Mental orthopedics consisted of exercises that would improve a child's will, attention, and discipline—all abilities that Binet thought were necessary for effective classroom education. Binet (1909/1975) believed that by engaging in mental orthopedics, children learned how to learn:

If we consider that intelligence is not a single function, indivisible and of a particular essence, but rather that it is formed by the chorus of all the little functions of discrimination, observation, retention, etc., the plasticity and extensibility of which have been determined, it will appear undeniable that the same law governs the

whole and its parts, and that consequently anyone's intelligence is susceptible to being developed. With practice, training, and above all, method, we manage to increase our attention, our memory, our judgment and literally to become more intelligent than we were before. Improvement goes on in this way until the time when we reach our limit. (p. 107)

Both Binet and Galton died in 1911. Galton was an old man of 89 who had a long, highly productive life; Binet was 54 and at the height of his career.

Charles Spearman and the Concept of General Intelligence

After a military career in the English army that lasted until he was 34, Charles Spearman (1863-1945) turned to a career in psychology, studying with both Wundt and Külpe in Germany. During a break in his studies with Wundt, during which he returned to England to serve in the army during the Boer War (1899-1902), Spearman began reading the works of Galton. Thoroughly impressed, he performed a number of experiments on village schoolchildren, and the results tended to confirm Galton's belief concerning the relationship between sensory acuity and intelligence. He found that not only did measures of sensory acuity correlate highly among themselves but, more important, they also correlated highly (+.38) with "cleverness in school." In 1904 he published his results in an article titled "'General Intelligence,' Objectively Determined and Measured." In part because of this controversial article, Spearman was offered a position at the University of London, where he began a career that included attacks on empiricism, sensationalism, associationism, hedonism, and most other accepted philosophical and psychological beliefs.

In order to more thoroughly investigate the nature of intelligence, Spearman laid the groundwork for what became **factor analysis**. Factor analysis is a complex statistical technique based on

correlation. The technique begins by measuring either an individual or a group of individuals in a variety of ways. Next, all the measures are intercorrelated to determine which of them vary together in some systematic way. It is assumed that measures (for example, tests) that vary together (that is, are correlated) are measuring the same thing. The final step is to examine the matrix of correlations to determine which measures vary together and how many factors (influences) need to be postulated to account for the intercorrelations observed.

Spearman found that intelligence could be explained by two postulated factors. Individuals differ in their competence in such things as mathematics, language, and music. Such abilities are called *specific factors* (s). Because measures of s tended to be intercorrelated, Spearman postulated an overriding kind of intelligence that he called a general factor or **general intelligence** (g). According to Spearman, g is determined almost exclusively by inheritance. Spearman, then, had a two-factor theory of intelligence; one factor (s) described specific abilities, and the other (g) described general intelligence.

Armed with factor analysis and his two-factor theory of intelligence, Spearman attacked the results of studies, such as Wissler's, that showed little intercorrelation among Galton's and Cattell's measures of sensory acuity and almost no correlation between measures of sensory acuity and academic performance. Because his own results were almost the opposite, he concluded that the results contrary to his were statistical artifacts. He also concluded that because he found measures of sensory acuity were intercorrelated, it must be g that was being measured.

Spearman's conclusions about the nature of intelligence are important for three reasons:

- He emphasized the unitary nature of intelligence, whereas Binet emphasized its diversity.
- He viewed intelligence as largely inherited, whereas Binet viewed it as modifiable by experience.
- It was largely Spearman's conception of intelligence that was embraced by the new testing movement in the United States, not Binet's.
 That is, IQ was viewed as measuring something

like Spearman's *g* rather than Binet's multifarious "intellectual level."

Cyril Burt

Cyril Burt (1883–1971) was Spearman's colleague at the University of London. Burt accepted Spearman's concept of *g* and believed education should be stratified according to a student's native intelligence. Students of high native intellectual ability should be provided with more challenging educational opportunities than students with low native intellectual ability. Furthermore, Burt believed it is fruitless to try to raise a student's intellectual ability through remedial educational programs.

Burt retired from the University of London in 1950 but continued to publish papers providing data supporting the idea that g was largely inherited. For example, he studied identical (monozygotic) twins reared together and reared apart. He reported that whether reared together or apart the correlation of measures of intelligence for the identical twins was .70 or higher. On the other hand, the correlations between identical twins and their younger or older siblings were only about .40 or .50. These data reinforced the ideas that intelligence was largely innate and that a change of environment would not affect it significantly. In a paper published posthumously, in 1972, Burt summarized the results of his lifelong research on intelligence, including those just described.

The Scandal. Leon Kamin (1974, 1977) reviewed Burt's data as presented in 1972 and found a number of discrepancies suggesting that Burt's data were invented. Oliver Gillie, a British journalist, attempted to contact people whom Burt had listed as having gathered data for him and found that they either did not exist or had never gathered data. Gillie (1977) called for the establishment of a committee to help expose fraud in science. Finally, in his biography of Burt, Leslie Hearnshaw (1979) charged that Burt had published fraudulent data, supporting his case under a pseudonym and published with a co-author who did not exist.

It appeared that the case against Burt was clearly established. However, some argued that the case was either exaggerated or not proven (for example, Fletcher, 1991; Joynson, 1989). After reviewing the case against Burt, Green (1992) concluded, "The charge of deliberately falsifying data can neither be established nor disproved with certitude" (p. 331). For an overview of the Burt scandal, see Samelson, 1992, 1993.

It is interesting to note that Burt's conclusions, whether real or fabricated, have been essentially confirmed by other researchers who, like Burt, studied identical twins. For example, Raymond B. Cattell (1905–1998), who also studied with Spearman, concluded that intelligence was about 65% genetically determined (Cattell, 1982). Thomas Bouchard (see Chapter 19) also concluded that the heritability of intelligence is about 70%.

In the end, perhaps, the Burt episode taught us more about the politics of science than about the nature of intelligence. Among Burt's supporters were those who believed that the high heritability of intelligence had been proven scientifically and this fact has, or ought to have, implications of social and educational policy. On the other hand, Burt's critics believed "not just that the evidence for IQ heritability is unpersuasive but that, in any event, increased educational assistance for some students is based on moral, not scientific principles" (Tucker, 1997, p. 156). This controversy between "conservatives" (nativists) and "liberals" (nurturists) was rekindled by the publication of Herrnstein and Murray's The Bell Curve: Intelligence and Class Structure in American Life (1994). We will discuss The Bell Curve later in this chapter.

THE BINET-SIMON SCALE IN THE UNITED STATES

Henry Herbert Goddard

Henry Herbert Goddard (1866–1957) was born into a New England Quaker family and obtained his bachelor's and master's degrees from Haverford

College. After being a high school teacher and then principal for several years, he enrolled in the doctoral program in psychology at Clark University to pursue his interests in education and psychology. Goddard did his doctoral dissertation, which investigated the psychological factors involved in faith healing, under the supervision of G. Stanley Hall (see Chapter 11). After completing his degree in 1899, Goddard first accepted a teaching position at Pennsylvania's State Normal School, and then in 1906 he became director of research at the New Jersey Training School in Vineland, which was established for the education and care of "feeble-minded" (Goddard's term) children.

It was Goddard who translated the Binet–Simon scale into English. Although initially skeptical of the scale, he found it to be very effective in classifying children in terms of their degree of retardation. Goddard then translated all of Binet and Simon's works into English and, following Binet's death in 1911, became the world's leading proponent of Binet's approach to measuring intelligence. However, although accepting Binet's testing procedures, Goddard accepted the Galton–Cattell–Spearman view of the nature of intelligence rather than Binet's.

In addition to administering the translated Binet–Simon scale to the children at the Training School, Goddard also administered it to 2,000 public school students in New Jersey. He was shocked to find that many of the public school students performed below the norms for their ages. This especially disturbed Goddard because of his belief that intelligence was largely inherited—a belief he thought was supported by the observation that the children at Vineland often had brothers and sisters who were "feeble–minded."

Study of the "Kallikak" Family. Goddard decided to investigate the relationship between family background and intelligence more carefully. In 1911 he administered the Binet–Simon scale to a young woman he called Deborah Kallikak, who had been living at the Training School since 1897. "Kallikak" was a fictitious name that Goddard created out of the Greek words *kalos*

Henry Herbert Goddard

(good) and kakos (bad). Although Deborah's chronological age was 22, her test performance yielded a mental age of 9, producing an IQ of about 41. Goddard coined the term moron to denote Deborah's intellectual level. He then traced Deborah's ancestry back to the American Revolution, when Martin Kallikak, Sr., had had a relationship with a "feeble-minded" barmaid that resulted in the birth of Martin Kallikak, Jr. After leaving the army, the elder Martin married a "worthy girl," and they had seven children. The younger Martin eventually married and had 10 children. In Goddard's analysis, the descendants of the elder Martin and the "worthy girl" represented the "good" side of Deborah's ancestry, and the descendants of the younger Martin represented the "bad" side.

Goddard found that of the elder Martin's children, none were feeble-minded, whereas five of the younger Martin's children were. In subsequent generations on the younger Martin's side, Goddard found an abundance of individuals with mental deficiencies. In Goddard's time, people believed that feeble-mindedness was the cause of most criminal, immoral, and antisocial behavior; and Goddard supported this belief by showing that

many descendants of the younger Martin had been horse thieves, prostitutes, convicts, alcoholics, parents of illegitimate children, or sexual deviates. Of the hundreds of descendants from the elder Martin's marriage, only three had had mental deficiencies, and one had been considered "sexually loose." Among the elder Martin's descendants had been doctors, lawyers, educators, and other prestigious individuals.

Goddard reported his findings in *The Kallikak Family: A Study in the Heredity of Feeble-Mindedness* (1912). His research was taken as support for the Galtonian belief that intelligence was genetically determined. Along with Goddard, several leading scientists of the day urged that those with mental deficiencies be sterilized or segregated from the rest of society. They contended that because the feebleminded could not be expected to control their own reproduction, the intelligent members of society must control it for them:

If both parents are feeble-minded all the children will be feeble-minded. It is obvious that such matings should not be allowed. It is perfectly clear that no feeble-minded person should ever be allowed to marry or to become a parent. It is obvious that if this rule is to be carried out, the intelligent part of society must enforce it. (Goddard, 1914, p. 561)

No fewer than 20 states passed sterilization laws, and thousands of "undesirables" were sterilized. In some states, the sterilization law was enforced until the 1970s. Galton would have been pleased.

Mental Testing and Immigration. In the years from 1905 to 1913, millions of individuals emigrated from Europe to the United States, and there was growing concern that many of these immigrants might have mental deficiencies. The question was how to know for certain. In 1912 the commissioner of immigration invited Goddard to Ellis Island to observe the immigrants. Goddard claimed he could tell that many of the immigrants had mental deficiencies simply by observing their physical

characteristics, but to be sure he administered the Binet–Simon scale. On the basis of the test results, many immigrants were labeled "mentally defective," and thousands were deported. Goddard even went so far as to specify the European countries for which the percentage of immigrants with mental deficiencies was the highest. In general, Goddard concluded that between 40% and 50% of the immigrants were "morons."

As with his earlier work, Goddard assumed that the immigrants' test performance was due mainly to inherited intelligence and not to educational, cultural, or personal experience—all factors that were later found to influence test performance. But the immigrants were also taking the test under special circumstances:

For the evident reason, consider a group of frightened men and women who speak no English and who have just endured an oceanic voyage in steerage. Most are poor and have never gone to school; many have never held a pencil or pen in their hand. They march off the boat: one of Goddard's [assistants] takes them aside shortly thereafter, sits them down, hands them a pencil, and asks them to reproduce on paper a figure shown to them a moment ago, but now withdrawn from their sight. Could their failure be a result of testing conditions, of weakness, fear, or confusion. rather than of innate stupidity? Goddard considered the possibility, but rejected it. (Gould, 1981, p. 166)

Furthermore, the tests were administered by a translator whose accuracy in translating the test into the immigrant's native tongue was taken on faith.

Because of Goddard's efforts, the rate of deportation increased 350% in 1913 and 570% in 1914. Although he regretted the loss to the United States of inexpensive labor, Goddard was pleased. In his later years, however, Goddard radically changed his beliefs, embracing many of Binet's views. For example, he finally agreed that the proper treatment for individuals who scored low on intelligence tests

was special education, not segregation or sterilization. But he had already done much damage.

Lewis Madison Terman

Lewis Madison Terman (1877-1956) was born on January 15, the 12th of 14 children of a farm family from central Indiana. He went to a oneroom school and completed the eighth grade when he was 12 years old. At age 9, a phrenology book salesman gave each member of the Terman family a phrenological analysis. Terman's analysis indicated great promise, thus stimulating him to aspire for a life beyond the farm. At age 15, Terman left to attend Central Normal College in Danville, Indiana. At age 17, he began teaching in a rural school. Within six years after leaving home, Terman had taught school and earned three undergraduate degrees: one in arts, one in sciences, and one in pedagogy. The next three years were busy ones for Terman; he became a high school principal, a husband, and a father. In 1901, he enrolled at Indiana University, where he pursued a master's degree in pedagogy. Upon completing his master's degree, he was about to seek a teaching position when he received the offer of a fellowship for doctoral study at Clark University. With financial support from his family, Terman was able to accept the offer, and soon he was off to study with G. Stanley Hall, as Goddard had done. Terman did not write his dissertation under Hall's supervision, however. Terman became increasingly interested in mental testing, and Hall had little enthusiasm for the topic. Under the supervision of Edmund C. Sanford, Terman isolated a group of "bright" students and a group of "dull" students and then attempted to determine what types of tests could be used to differentiate between members of the two groups. (Terman was unaware that Binet and Simon had done essentially the same thing earlier.) Terman's dissertation was titled "Genius and Stupidity: A Study of the Intellectual Processes of Seven 'Bright' and Seven 'Stupid' Boys." Terman was to say later in his life that all of his career interests were shaped during his years at Clark.

Lewis Madison Terman

Before obtaining his doctorate from Clark University in 1905, Terman had become seriously ill with tuberculosis, and although he recovered, he thought it best that he choose a warm climate in which to work. For that reason, he accepted the position of high school principal in San Bernardino, California. A year later, he accepted a position teaching child study and pedagogy at Los Angeles State Normal School (later to become the University of California, Los Angeles). In 1910 Terman accepted an appointment to the education department at Stanford University, where he spent the rest of his career. He became chair of the psychology department in 1922, a position he held until his retirement in 1942.

It was coincidental with his arrival at Stanford that Terman became aware of the Binet–Simon intelligence scale (through Goddard's translation). Terman began immediately to work with the scale and found that it could not be used accurately on U.S. children without modifications.

The Stanford-Binet Tests. Terman found that when the Binet-Simon scale was administered to U.S. children, the results were uneven. That is, the average scores of children of various ages were either higher or lower than the chronological age of the age group being tested. For example, Terman observed that items from the Binet-Simon scale were too easy for 5-year-olds and too difficult for

12-year-olds. This caused the mental age of average 5-year-olds to be artificially high and that of average 12-year-olds to be artificially low. Working with his graduate student, H. G. Childs, Terman deleted existing items from the Binet-Simon scale and added new items until the average score of a sample of children was 100, no matter what their age. This meant that for each age group tested, the average mental age would equal the group's chronological age. Terman and Childs published their first revision of the Binet-Simon tests in 1912, and in 1916 Terman alone published a further revision. The 1916 revision became known simply as the Stanford-Binet. It was in 1916 that Terman adopted Stern's "intelligence ratio" and suggested that the ratio be multiplied by 100 to remove the decimal and to call the ratio IQ. The Stanford-Binet, which made Terman both rich and famous, was revised in 1937 and again in 1960 (after Terman's death). Incidentally, Wolf (1973, p. 35) noted that Terman bought the rights to translate the Binet-Simon scale into English for one dollar.

Terman's Position on the Inheritance of Intelligence. Throughout his career, Terman believed that intelligence was largely inherited. Furthermore, Terman, like Goddard, believed that low intelligence was the cause of most criminal and other forms of antisocial behavior. For Terman (1916), a stupid person could not be a moral person:

Not all criminals are feeble-minded, but all feeble-minded persons are at least potential criminals. That every feeble-minded woman is a potential prostitute would hardly be disputed by anyone. Moral judgment, like business judgment, social judgment, or any other kind of higher thought process, is a function of intelligence. Morality cannot flower and fruit if intelligence remains infantile. (p. 11)

And in 1922 Terman said,

There is nothing about an individual as important as his IQ, except possibly his

morals.... [T]he great test problem of democracy is how to adjust itself to the large IQ differences which can be demonstrated to exist among the members of any race or nationality group.... All the available facts that science has to offer support the Galtonian theory that mental abilities are chiefly a matter of original endowment.... It is to the highest 25 per cent. of our population, and more especially to the top 5 per cent., that we must look for the production of leaders who will advance science, art, government, education, and social welfare generally.... The least intelligent 15 or 20 per cent. of our population ... are democracy's ballast, not always useless but always a potential liability. How to make the most of their limited abilities. both for their own welfare and that of society; how to lead them without making them helpless victims of oppression; are perennial questions in any democracy. (Minton, 1988, p. 99)

Although Terman was impressed by and borrowed much from Binet, his view of intelligence was much more like that of Galton. Terman was so impressed by Galton that he published an intellectual portrait of him in which he estimated Galton's IQ to be nearly 200 (Terman, 1917).

Terman's contention that IQ is a valid measure of native intelligence did not go unchallenged. Among Terman's harshest critics was the journalist Walter Lippmann. Lippmann and Terman debated in a series of articles appearing in the *New Republic* between 1922 and 1923. In one of these articles Lippmann (1923) wrote,

I hate the impudence of a claim that in fifty minutes you [Terman] can judge and classify a human being's predestined fitness in life. I hate the pretentiousness of that claim. I hate the abuse of scientific method which it involves. I hate the sense of superiority which it creates and the sense of inferiority which it imposes. (p. 46)

Terman validated the Stanford–Binet by correlating test performance with teacher ratings of academic performance, teacher estimations of intelligence, and school grades. He found fairly high correlations in each case, but this was not surprising because the traits and abilities that schools and teachers valued highly in students were the same traits and abilities that yielded high scores on the Stanford–Binet. Nonetheless, the correlations meant that academic performance could be predicted with some success from test performance. Whether the tests were truly measuring native intelligence, however, Terman never determined.

Terman's Study of Genius. In Terman's day, it was widely believed that very bright children were abnormal in more than a statistical sense. One common expression describing such children was "early ripe, early rot," suggesting that if mental ability developed too fast at an early age, not enough would remain for the later years. To objectively study the experience of bright children through the years, Terman ran one of the most famous studies in psychology's history. By identifying highly intelligent children and observing them over a long period of time, Terman could evaluate his belief that children with high IQs are more successful in life than children with lower IQs.

As his first step, Terman defined genius as a score of 135 or higher on his test. Next, he and his colleagues administered the test to thousands of California schoolchildren, and he isolated 1,528 gifted children (856 boys and 672 girls). The average chronological age of the group was 11, and the average IQ of the group was 151. Learning everything he could about his subjects-including their interests, family history, health, physical characteristics, and personality—Terman wanted to study the experiences of group members as they matured through the years. He began his study in 1921 and reported the first results in Genetic Studies of Genius (1926). The term genetic can have two meanings. First, it can mean "developmental." When the term is being used in this sense, a genetic study is one that traces how something varies as a function of maturation, or time. Second, genetic can refer to

the genes or chromosomes responsible for various traits. Terman used the term in the developmental sense.

Terman found that the children in his study (who referred to themselves as "Termites") had parents with above-average educational backgrounds, had learned to read at an early age, participated in a wide range of activities, and produced schoolwork that was usually excellent. All of this might have been expected; the major question was how these children would fare as they became older. Terman did follow-up studies in 1927-1928, when the average age of the group was about 16, and again in 1939-1940, when the average age was about 29. These studies indicated that test scores were still in the upper 1% of the general population, that members of the group still participated in a wide variety of activities and excelled in most of them, and that they were still outstanding academically. Seventy percent of the men and 67% of the women had finished college, and 56% of the men and 33% of the women had gone on for at least one advanced degree. All these percentages were far higher than for the general population at the time.

In 1947 Terman appeared on the radio show *Quiz Kids*. On the show, bright, healthy children were asked extremely difficult questions to which they typically knew the answers. Terman appeared on the program because he felt that it was responsible for correcting many of the misconceptions about gifted children. In fact, Terman thought the program did more in that regard than his own work had done:

I have devoted a good part of my life to research on children of high I.Q.... But despite all my investigations, and those of others, many people continued to think of the brainy child as a freak—physically stunted, mentally lop-sided, nonsocial, and neurotic. Then came the *Quiz Kids* program, featuring living specimens of highly gifted youngsters who were obviously healthy, wholesome, well-adjusted, socially minded, full of fun, and versatile beyond belief.... Result: the program has

done more to correct popular misconceptions about bright children than all the books ever written. (Minton, 1988, pp. 222–223)

It is probably best that it was not until after Terman's death that it was discovered that the "quiz kids" were often given their questions in advance of the show (Minton, 1988, p. 223).

The final follow-up in which Terman participated took place in 1950-1952, and it showed that members of the group continued to excel in most of the categories studied. By that time, many members of the group had attained prominence as doctors, lawyers, teachers, judges, engineers, authors, actors, scientists, and businesspeople. Upon Terman's death in 1956, the directorship of the investigation was taken over by Robert R. Sears, a Stanford professor who was one of Terman's Termites. In the 1970s, two other Stanford professors were added to the investigation team, Lee J. Cronbach (another Termite) and Pauline S. Sears, Robert's wife. The most recent data collection phase of the study was completed in 1986 under the supervision of Robert Sears and Albert Hastorf.

The group of gifted individuals identified by Terman in 1921 has been studied intensely for more than 80 years, and the study continues. For example, Tomlinson-Keasey and Little (1990) examined 1,069 of the original 1,528 Termites and found that, although generally successful and well-adjusted, some were more successful and well-adjusted than others. The authors isolated the variables related to differential achievement and personal adjustment levels so that they may be used to predict and enhance the achievement and adjustment of other gifted individuals. Friedman, Tucker, Schwartz, Tomlinson-Keasey, Martin, Wingard, and Criqui (1995) examined the backgrounds of a sample of Terman's Termites who were deceased as of 1991. They found that certain psychosocial and behavioral variables were significant predictors of premature mortality, such as parental divorce during childhood, unstable marriage patterns during adulthood, certain childhood

personality characteristics (such as being unconscientious), psychological instability in adulthood, and unhealthy habits (such as excessive smoking and drinking).

For the researchers involved in Terman's longitudinal study, the primary results were clear: The gifted child becomes a gifted adult. Terman's study put to rest many mistaken beliefs about gifted children, but it left unanswered the question of whether "giftedness" was inherited or the result of experience. Terman believed strongly that it was inherited, but subsequent researchers have shown that many of Terman's results can be explained by taking into account the group members' experiences. How much of intelligence is genetically determined and how much is environmentally determined are still hotly contested questions in psychology. Most modern researchers, however, concede that both factors are important. In any case, Terman's longitudinal study of gifted individuals clearly showed that individuals who score high on so-called measures of intelligence early in life do not deteriorate later in life. In fact, his results showed that those who fare best in youth also tend to fare best as mature adults

Leta Stetter Hollingworth

For Terman, the primary purpose of mental testing was the identification of gifted individuals so that they could be encouraged to reach their full potential and become societal leaders. He believed that a tracking system whereby gifted students are provided educational experiences different from those provided for nongifted children is essential for the survival of democracy. Mainly through the efforts of Terman and his colleagues, intelligence testing and ability grouping were common practices in U.S. elementary schools by 1930. However, although strongly recommending a differentiated school curriculum, Terman had no specific recommendations concerning the educational methods that should be adopted in meeting the needs of intellectually superior children. It was Leta Stetter Hollingworth (1886-1939) who was primarily concerned with developing educational

Leta Stetter Hollingworth

strategies that would ensure the developmental well-being of gifted students.

Born Leta A. Stetter, Hollingworth attained her bachelor's degree from the University of Nebraska. In 1908 Hollingworth, who had been teaching school in Nebraska, accompanied her husband, Harry, to New York where he had been hired as a psychology instructor at Barnard College, Columbia University. Harry L. Hollingworth himself went on to gain considerable prominence as a psychologist. Earning his PhD under Cattell at Columbia, he wrote 25 books on psychological topics and served as president of the American Psychological Association (APA) in 1927. Leta Hollingworth intended to continue teaching in New York but discovered that the city had a policy of not employing married women as teachers. She decided to enroll as a graduate student at Columbia University, where she took courses from Edward L. Thorndike (see Chapter 11), who became her advisor. It was through Thorndike that she developed an interest in psychological testing. However, Hollingworth was also interested in the many misconceptions about women that were prevalent at the time. To her surprise, Thorndike agreed to supervise her dissertation on "Functional Periodicity," which investigated the notion that women are psychologically

impaired during menstruation. She found no evidence for such impairment (Hollingworth, 1914).

Hollingworth also challenged the widely accepted beliefs that intelligence is largely inherited and that women are intellectually inferior to males. At the time, Thorndike was among those who shared these beliefs. Hollingworth (1940) believed that women reach positions of prominence less often than males not because of intellectual inferiority but because of the social roles assigned to them:

Why do we not consider first the established, obvious inescapable fact that women bear and rear the race, and that this has always meant, and still means that nearly 100% of their energy is consumed in the performance and supervision of domestic and allied tasks, a field where eminence is impossible. No one knows who is the best housekeeper in America. Eminent housekeepers do not and cannot exist. If we discuss at all the matter of sex differences in achievement, we should consider first the most obvious conditioning factors. Otherwise our discussion is futile scientifically. (p. 16)

Thorndike later modified his views on intelligence to stress nurture more than nature. Hollingworth believed that she was at least partially responsible for his revised beliefs. She also discussed with Terman her belief that more men than women are classified as gifted not because of differential intellectual abilities but because of social factors. Terman did eventually modify his nativistic position concerning gender differences in intelligence, allowing for social influences, but he maintained his belief that intelligence was primarily genetically determined.

After receiving her master's degree in 1913, Hollingworth worked for a while as a clinical psychologist at the New York City Clearing-House for Mental Defectives, where she administered Binet tests. She then worked at Bellevue Hospital as a clinical psychologist until attaining her doctorate from Columbia University in 1916. Soon thereafter she

became a professor of education at Teachers College, Columbia University. Her work at the Clearing-House made her realize that there were as many myths about so-called mentally defective individuals as there were about women. For example, she found that many individuals classified as "defective" were in reality manifesting social and personal adjustment problems. In a series of books, Hollingworth attempted to correct this and related problems: *The Psychology of Subnormal Children* (1920); *Special Talents and Defects: Their Significance for Education* (1923); and *The Psychology of the Adolescent* (1928). The last replaced G. Stanley Hall's text (see Chapter 11) as the standard in the field.

Hollingworth next concentrated her attention on the education of gifted children. She observed that simply classifying a child as gifted is not enough. Emphasizing abstract test scores or group characteristics causes the needs of individual students to often be overlooked. As an example, she described the experience of a gifted 8-year-old girl named Jean who typically finished her assignments more quickly than her classmates. The teacher's reaction to this problem was to have Jean write digits in a book over and over until her classmates could finish their assignments:

Jean had with her the copy books in which she had been writing for the past year, one digit after another by the hour. Jean's mother said, "She can't stand the numbers any longer. Her hand gets stiff." I wish you could see the thousands of rows of digits obediently inscribed by this intelligent child, till finally she burst out crying, "I can't stand the numbers anymore." (Hollingworth, 1940, p. 127)

Correcting such mistreatment of gifted children occupied Hollingworth for the rest of her career. In 1926 she published *Gifted Children*, which became the standard text in schools of education for many years, and *Children Above 180 I.Q.* was published posthumously in 1942. (For interesting biographical sketches of Hollingworth, see Benjamin, 1975; and Shields, 1975, 1991).

INTELLIGENCE TESTING IN THE ARMY

Robert M. Yerkes

Robert M. Yerkes (1876–1956) was the firstborn son of a rural Pennsylvania farm family. He was disillusioned by farm life, however, and dreamed of becoming a medical doctor. During his college years, Yerkes lived with an uncle for whom he did chores in return for tuition to Ursinus College. After Ursinus, Yerkes went to Harvard, where he became interested in animal behavior. Obtaining his doctorate in 1902, he remained at Harvard as a faculty member. With his friend John B. Watson (see Chapter 12), who was then at Johns Hopkins University, Yerkes established comparative psychology in the United States. In recognition of his ultimate success, Yerkes was elected president of the APA in 1917.

As a student, Yerkes had had to borrow considerable amounts of money, and his faculty post at Harvard did not pay very much. This meant that he had to take part-time jobs in order to survive financially. Hence, in 1912 he took the job as the director of psychological research at the Boston Psychopathic Hospital; it was here that Yerkes had his first experience with intelligence testing. At the hospital, the Binet-Simon scale was being explored as an instrument to aid clinical diagnoses. One of Yerkes's Harvard professors, and now his friend and colleague, was the biologist Charles Davenport, who corresponded with Galton and was a leader in the U.S. eugenics movement. Yerkes, too, became a strong advocate of eugenics. He became increasingly involved in testing at the Boston Psychopathic Hospital, at the expense of his work in comparative psychology.

Yerkes's contribution to intelligence testing was his suggestion that all individuals be given all items on the Binet–Simon test and be given points for the items passed. Thus, a person's score would be in terms of total points earned instead of an IQ. This removes age as a factor in scoring. The traditional procedure followed in administering the Binet–Simon scale was to locate the range of tests

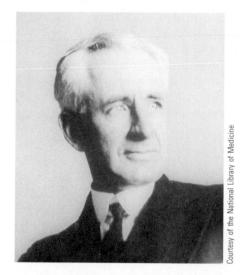

Robert M. Yerkes

appropriate for a given individual. For example, if a 7-year-old was being tested, the tests appropriate for that age would be given. If the child missed any of those tests, the tests appropriate for the next lowest age (6) would be administered. If, in this case, the child initially passed all tests appropriate for the 7year-old level, tests from the 8-year-old level would be administered, and so forth until the child began to fail tests. In other words, using age as a frame of reference, the testing procedure was customized for each child. Yerkes's "point-scale" procedure rendered all of this unnecessary. Yerkes did point out, however, that point norms could be established for various ages or for any group one wanted to compare. Yerkes believed that, besides being easier to administer, point scores were more amenable to statistical analyses than IQ scores. Also, because with point scores all individuals take the same tests without regard to their age or level, Yerkes's method is conducive to group testing, whereas the Binet-Simon test has to be given to one person at a time. Soon Yerkes would see his method tried on a level he never dreamed possible.

The Army Testing Program. When the United States entered World War I in 1917, Yerkes was president of the APA. He called a special meeting

of the association to determine how psychologists could help in the war effort. It was decided that psychologists could contribute by devising ways of selecting and evaluating recruits into the armed forces. Upon Goddard's invitation, a small group of psychologists, including Yerkes and Terman, went to the Vineland Training School to develop psychological tests that were then tried at various army and navy bases. The results were encouraging, and Yerkes was made an army major and given the job of organizing a testing program for the entire army (the navy rejected the idea). The goals of the program were to identify those with mental deficiencies, to classify men in terms of their intelligence level, and to select individuals for special training—for example, to become officers. Yerkes believed that, to be effective, the test used had to be a group test rather than an individual test, had to measure "native" intelligence, and had to be easy to administer and score. Using Yerkes's point-score method of scoring, the group created a test that met these criteria; however, they found that 40% of the recruits could not read well enough to take the test. The group solved the problem by creating two forms of the test: the Army Alpha for literate individuals and the Army Beta for illiterate individuals or for those who spoke and read a language other than English.

The war ended in 1918, and the testing program was terminated in 1919, by which time more than 1.75 million individuals had been tested. Many people claimed that the army testing program had demonstrated psychology's practicality, but the evidence does not support such a contention. Samelson (1977) reports that only .005% of those tested were recommended for discharge as mentally unfit, and in many cases the army ignored the recommendations. Also, if the army had perceived the testing program as effective, it would not have terminated the program so soon after the war ended. In his evaluation of the army testing program under Yerkes's leadership, Reed (1987) reached the following conclusion:

In retrospect, Yerkes's greatest coup as a scientific bureaucrat and promoter was not

in getting the Surgeon General to find a place for psychologists in the army, although that was a notable accomplishment, nor in writing tests, recruiting several hundred officers and technicians, and administering examinations to over 1.7 million individuals, despite fierce competition for resources and status from army officers and psychiatrists, although that too was a notable accomplishment. His most remarkable achievement was the myth that the army testing program had been a great practical success and that it provided a "goldmine" of data on the heritability of intelligence. (p. 84)

THE DETERIORATION OF NATIONAL INTELLIGENCE

The use of the Army Alpha and Beta tests rekindled concern about the deterioration of the nation's intelligence level. About half of the white males tested in the army had native intelligence equal to that of a 13-year-old or lower, and the situation was even worse for black soldiers. Goddard's response was that people with low mental ability should not be allowed to vote. Along with Goddard, Terman and Yerkes were very concerned about the deterioration of the nation's intelligence, which they believed was caused by immigration and the fact that "intellectually inferior" individuals were reproducing faster than normal or abovenormal individuals.

As was common at the time, Yerkes (1923) believed that many of the nation's ills were being caused by people of low intelligence and that immigration policies were only aggravating the problem:

By some people meagre intelligence in immigrants has been considered an industrial necessity and blessing; but when all the available facts are faced squarely, it looks more like a burden. Certainly the results of psychological examining in the United States Army establish the relation of inferior intelligence to delinquency and crime, and justify the belief that a country which encourages, or even permits, the immigration of simple-minded, uneducated, defective, diseased, or criminalistic persons, because it needs cheap labor, seeks trouble in the shape of public expense.

It might almost be said that whoever desires high taxes, full almshouses, a constantly increasing number of schools for defectives, of correctional institutions, penitentiaries, hospitals, and special classes in our public schools, should by all means work for unrestricted and non-selective immigration. (p. 365)

However, as we have seen, this extremely nativistic position that Goddard, Terman, and Yerkes represented did not go unchallenged. More and more, people realized that performance on socalled intelligence tests could be at least partially explained by such factors as early experience and education. Rather than simply measuring native intelligence, the tests were apparently also measuring personal achievement and the influence of life's circumstances. It followed that the more privileged a person was in terms of enriching experiences and education, the higher his or her scores would be on so-called intelligence tests. For example, African American scholar Horace Mann Bond observed that blacks living in the north typically scored higher on intelligence tests than those living in the south (Urban, 1989). This fact could not be easily explained by the extreme nativists.

The book *The Bell Curve: Intelligence and Class Structure in American Life* (1994), by Richard J. Herrnstein and Charles Murray, reflects many of the earlier beliefs about intelligence accepted by Galton, Cattell, Spearman, Burt, Goddard, Terman, and Yerkes. Herrnstein and Murray organize their book around six conclusions, or points, about intelligence that are "beyond dispute." By "beyond dispute," they mean the following:

That if you gathered the top experts on testing and cognitive ability, drawn from all points of view, to argue over these points, away from television cameras and reporters, it would quickly become apparent that a consensus already exists on all of the points, in some cases amounting to near unanimity. (p. 23)

Here are the six points:

- 1. There is such a thing as a general factor of cognitive ability on which human beings differ.
- 2. All standardized tests of academic aptitude or achievement measure this general factor to some degree, but IQ tests expressly designed for that purpose measure it most accurately.
- 3. IQ scores match, to a first degree, whatever it is that people mean when they use the word *intelligent* or *smart* in ordinary language.
- 4. IQ scores are stable, although not perfectly so, over much of a person's life.
- Properly administered IQ tests are not demonstrably biased against social, economic, ethnic, or racial groups.
- 6. Cognitive ability is substantially heritable, apparently no less than 40 percent and no more than 80 percent. (pp. 22–23)

Not on the list, but featured in the book, is the contention that in the United States the best jobs and the highest income tend to go to the most intelligent individuals, the "cognitive elite." The less intellectually endowed are doomed to menial labor in our information-based economy, if they can find work at all. Couple this with the fact that (according to Herrnstein and Murray) intelligence is largely inherited, and we have a major problem—that is, an economic class structure based on inherited intelligence. The authors do not offer a solution to the problem, but others have. Galton, Cattell, Goddard, Terman, and Yerkes all described a similar problem, and all suggested that the solution was to somehow discourage less intelligent individuals from reproducing. There is nothing new, and much that is quite old, in Herrnstein and

Murray's list. In fact, each of their "indisputable points" about intelligence has been and continues to be hotly disputed (see, for example, Azar, 1994, 1995a, 1995b; DeAngelis, 1995; Jacoby and Glauberman, 1995; *The New Republic*, 1994).

The controversy caused by *The Bell Curve* contained many of the same elements of the "Burt scandal." According to Zenderland (1997), it touched "an ever-sensitive national nerve—a nerve exposed by the questions it raised concerning race, class, and social equality" (p. 135). Weidman (1997) describes the controversy as a culture war that

pits the academic left—the believers in the importance of nurture, or environment—against the conservatives—the believers in nature, hereditary endowment, innate capacity. The conservatives accuse the leftists of being in "biodenial," of misunderstanding and greatly underestimating the role that biology plays in determining behavior. The leftists reply that behavior is malleable, that no one is congenitally unteachable, that anyone can become anything, given the right environment. In this nature/nurture skirmish, *The Bell Curve* has come down solidly on the conservative side. (p. 143)

Such a controversy reflects widely different worldviews and cannot be resolved by science; both sides claim to be supported by the scientific facts. In the recent history of the nature–nurture debate, there has been an emotional upheaval when any idea suggesting biological determinism

has been proposed. Perhaps greater understanding of these debates will come when it is realized that they are essentially moral, philosophical, or political but not scientific.

Currently there is little agreement even on an adequate definition of intelligence. When 24 prominent researchers in the field of intelligence were asked to define intelligence, they provided 24 different definitions (Sternberg and Detterman, 1986). After reviewing which of the many notions concerning intelligence have scientific support and which do not, Neisser et al. (1996) concluded the following:

In a field where so many issues are unresolved and so many questions unanswered, the confident tone that has characterized most of the debate on these topics is clearly out of place. The study of intelligence does not need politicized assertions and recriminations; it needs self-restraint, reflection, and a great deal more research. The questions that remain are socially as well as scientifically important. There is no reason to think them unanswerable, but finding the answers will require a shared and sustained effort as well as the commitment of substantial scientific resources. Just such a commitment is what we strongly recommend. (p. 97)

Sternberg, Lautrey, and Lubart (2003) provide an international perspective on the many complex issues involved in the current study of intelligence.

SUMMARY

Evolutionary theory has existed in one form or another since the time of the early Greeks. The biblical account of the origin of species silenced evolutionary theory for many centuries, but by the 18th century there was again speculation about the evolutionary process. Lamarck claimed that traits acquired during an individual's lifetime

that are conducive to survival are passed on to the individual's offspring. Spencer originally followed Lamarck by saying that frequently used associations are passed on to offspring in the form of reflexes and instincts. Later, Spencer accepted Darwin's version of evolutionary theory and applied it to society, saying that society should allow enough freedom so that those most fit for survival could differentiate themselves from those least fit for survival. This was called social Darwinism.

After his five-year journey aboard the Beagle. Darwin realized that in different locations members of a species possessed different characteristics and that the characteristics of a species change over time, but he could not explain why. Darwin found the explanation he needed in Malthus's essay (1798/1914), in which Malthus observed that a species always produces many more offspring than the food supply could support and that population size is kept in check by events such as starvation and disease. Darwin expanded Malthus's notion into the notion of a general struggle for survival in which only the fittest survive. According to Darwin, many more offspring of a species are born than can survive. There are individual differences among those offspring; some offspring possess traits that are conducive to survival, whereas others do not. Only the fittest offspring would survive. Thus, there was a natural selection of those offspring whose traits are most conducive to survival under the existing circumstances. In his books (1871, 1872, 1874), Darwin demonstrated that the evolutionary process applies to humans as well as to other living organisms. Darwin defined fitness by the reproductive success of an individual. By changing the definition of fitness to mean an individual's ability to perpetuate copies of his or her genes into future generations, sociobiologists have been able to explain a vast array of human social behavior in terms of evolutionary theory. What was originally called sociobiology is now called evolutionary psychology.

Darwin's cousin Francis Galton had a passion for measurement. He equated intelligence with sensory acuity and therefore measured intelligence mainly by measuring the acuity of the senses. Because he believed that intelligence is inherited, he urged the practice of eugenics, or selective breeding, to improve human intelligence. Using psychology's first word-association test, Galton found that responses to stimulus words tend to remain constant, tend to be drawn from childhood experience, and suggest the existence of an unconscious mind. In his research

on mental imagery, Galton found great individual differences in the ability to experience mental images. Galton also observed that although there is a tendency for children to inherit the traits of their parents, there is also a regression toward the mean. For example, extremely tall parents tend to have tall children, but the children tend to be not as tall as the parents. By demonstrating how two things tended to vary together, Galton invented the method of correlation. It was Pearson who created the formula that quantified the magnitude of a correlation by generating a coefficient of correlation (*r*). Galton was also the first to use the median as a measure of central tendency.

Cattell brought Galton's notion of intelligence testing to the United States and was the first to employ the term *mental test*. Wissler's research indicated that Galton's sensory and motor tests were not all measuring the same thing (intelligence) because the correlations among the tests were low. When Wissler found practically no relationship between performance on the tests and performance in college, it was concluded that the tests had little practical value.

In France, Binet took another approach to measuring intelligence. The earlier research of Binet and others had indicated that intelligence consists of several different mental abilities such as memory, imagery, attention, comprehension, and judgment. Binet's goal was to devise tests that would directly measure these mental abilities. In response to the French government's request for an instrument that could be used to reliably distinguish between normal children and children with mental deficiencies, Binet and Simon offered their 1905 scale of intelligence. The scale consisted of 30 tests arranged from the simplest to the most difficult. The more tests a child passed, the higher was his or her score. It was assumed that scores varied with intelligence. In 1908 Binet and Simon revised their scale so that it not only would distinguish between normal and subnormal children but also would distinguish levels of intelligence among normal children. They gave the scale to children between the ages of 3 and 13, and all tests that 75% or more of the children of a certain age passed were

assigned to that age. In this way, it became possible to determine whether any particular child was performing at, above, or below the average performance of other children of his or her age. In 1911 Binet and Simon again revised the scale so that five tests corresponded to each age level. This allowed one-fifth of a year to be added to a child's score for each test he or she passed beyond the average for his or her age group. Stern offered the term mental age and also the notion of intelligence quotient. Intelligence quotient was calculated by dividing a child's mental age (score on the Binet-Simon scale) by the child's chronological age. It was Terman who later suggested that the quotient be multiplied by 100 to remove the decimal point and that "intelligence quotient" be abbreviated as IO. Binet believed that intelligence was not one mental faculty but many; he therefore opposed describing people's intelligence in terms of IQs. He also believed that, although intellectual potential may be inherited, most people function below their potential and could therefore benefit from education. Even individuals with mental deficiencies, he believed, could benefit greatly from special education.

Contrary to what Wissler found when evaluating Cattell's test, Spearman found high correlations among measures of sensory acuity and between measures of acuity and academic performance. Using a technique that came to be called factor analysis, Spearman concluded that intelligence consists of two factors. One factor (s) consists of specific abilities, and the other (g) consists of general intellectual ability. Furthermore, Spearman concluded that g is almost entirely inherited. Burt, a colleague of Spearman's, accepted Spearman's beliefs concerning g and suggested that education be stratified according to students' native intellectual ability. Burt was accused of falsifying his data, and a major scandal ensued. It appears that the combatants in the debate that followed were divided more by moral, political, and philosophical issues than by scientific facts.

Goddard translated the Binet-Simon scale into English and administered it to both children with mental retardation at the New Jersey Training School, where he worked, and to children in the New Jersey public schools. Appalled to find that many public school students performed at a level below their age norm, Goddard believed this poor performance reflected a deterioration in the nation's native intelligence. To investigate the relationship between inheritance and intelligence, Goddard studied the family history of a girl with mental retardation at the Training School. He found that one of the girl's distant relatives had had a child by a "feeble-minded" barmaid and that the line of descendants from that child forward was characterized by mental deficiency and criminal and antisocial behavior. The man who had fathered the barmaid's child subsequently married a "normal" woman, and their descendants showed a very low incidence of mental deficiency. Also, many individuals from that side of the family attained positions of prominence. Goddard and many others took these findings as support for the contention that intelligence is inherited. Many states instituted laws allowing for the sterilization of individuals with mental deficiencies as well as others who were socially undesirable, whereas the influence of personal experience on intelligence level was essentially ignored. Fear of the "menace of the feeble-minded" directed attention to the immigrants entering the United States. Administration of the Binet-Simon test led to the conclusion that many immigrants had mental deficiencies, and they were deported back to Europe. The fact that poor test performance could have been due to educational, cultural, and personal experiences were initially considered by Goddard and rejected; late in his life, however, Goddard accepted all these factors as possible contributors to test performance.

Terman revised the Binet–Simon scale, making it more compatible with U.S. culture and statistically easier to analyze. Terman's revision, called the Stanford–Binet, was used to isolate 1,528 intellectually gifted children who were then intensely studied throughout their lives. Through the years, it was found that members of this group of gifted individuals continued to score in the top 1% of the population in intelligence, participated in and excelled at a wide range of activities, and

were outstanding academically. Because the study showed that the gifted children became welladjusted, successful, healthy adults, it laid to rest the belief that gifted children were physically or psychologically handicapped as adults. Although Terman urged the use of mental tests to identify gifted children so that they could be groomed to be the future leaders of society, it was Leta Stetter Hollingworth who attempted to specify optimal educational experiences for the gifted. She also did much to improve the education of "subnormal" individuals. In addition, Hollingworth challenged many of the beliefs about women that were prevalent at the time—for example, the beliefs that the performance of women suffers during menstruation and that women are intellectually inferior to men.

When the United States entered World War I, Yerkes and others concluded that psychology could help in the war effort by devising tests that could be used to classify recruits into the armed forces in terms of their intellectual level. These psychologists developed an Army Alpha test for literate recruits and an Army Beta test for illiterate or non–English-speaking recruits. Although more than 1.75 million recruits were tested, only a very few were recommended for rejection because of low test performance. The army ignored most of those

recommendations and terminated the testing program shortly after the war ended.

According to the results of the army's testing program, about half of the white males tested had a mental age of 13 or lower, and the situation was even worse for black males. Once again, proposals arose for restricting marriage and for widespread sterilization of individuals with mental deficiencies. At the time, however, a growing number of prominent individuals were wondering whether so-called intelligence tests actually measure genetically determined intelligence. They argued that test performance is determined more by education and personal experience than by inheritance, and there was a growing feeling that as more people received equal experiential opportunities, test performance would also equalize.

When *The Bell Curve* was published in 1994, it reignited more or less the same controversy that surrounded the Burt "scandal." Once again, the issues seemed to be moral, political, or philosophical rather than scientific.

Efforts to define intelligence and to determine how best to measure it continue in contemporary psychology. Today, most psychologists believe that both inheritance and experience are factors in intelligence. The argument now mainly concerns the relative contributions of each of the two factors.

DISCUSSION QUESTIONS

- Given the fact that rudimentary theories of evolution go back at least as far as the early Greeks, why did it take until the 19th century for adequate theories of evolution to develop?
- 2. Summarize Lamarck's theory of evolution.
- Describe Spencer's social Darwinism and explain why it was so popular in the United States.
- 4. What is the Spencer-Bain principle?
- 5. What were the ironies concerning Darwin's voyage aboard the *Beagle*?

- 6. Why did Darwin delay publication of his theory for so long? What finally prompted him to publish it?
- 7. Summarize Darwin's theory of evolution.
- 8. Compare Darwin's concept of fitness with the sociobiologists' concept of inclusive fitness. What are the implications of the difference between the two concepts for the explanation of human social behavior?
- 9. How did Galton support his argument that eugenics should be practiced?

- Explain why Galton's measures of "intelligence" were mainly sensory in nature.
- 11. Summarize Galton's contributions to psychology.
- Describe Cattell's approach to intelligence testing and explain why that approach was eventually abandoned.
- 13. In what ways did Binet's approach to intelligence testing differ from Galton's and Cattell's?
- 14. Describe the 1905 Binet–Simon scale of intelligence. How was the scale revised in 1908? In 1911?
- 15. What procedure did Stern suggest for reporting a person's intelligence? Why did Binet oppose this procedure?
- 16. What did Binet mean by *mental orthopedics*? Why did Binet believe that such exercises were valuable?
- 17. Summarize Spearman's views of intelligence.
- 18. What was the Burt "scandal"? In what way did it reflect the age-old controversy concerning nature versus nurture? Were the issues involved scientific or political?
- 19. What conclusions did Goddard reach when he administered the Binet–Simon scale to schoolchildren in the United States?
- 20. What procedures did Goddard suggest for stopping the deterioration of intelligence in the

- United States? In suggesting these procedures, what assumption did he make?
- 21. Summarize the conclusions Goddard reached when he traced the ancestry of Deborah Kallikak.
- 22. Did Goddard cause many immigrants to be unjustifiably deported? Justify your answer.
- 23. In what important way did Terman modify the Binet–Simon scale?
- 24. What prompted Terman's longitudinal study of gifted individuals? Summarize the results of that study.
- 25. Summarize Leta Stetter Hollingworth's contributions to psychology.
- 26. How did Yerkes suggest that psychologists help in the war effort? Was the effort that resulted from this suggestion a success or a failure?
- 27. What arguments were offered in opposition to the contention that intelligence tests were measuring innate intelligence?
- 28. In what way was the controversy surrounding the publication of *The Bell Curve* the same as that surrounding the Burt "scandal"?
- 29. Where do most psychologists today stand on the nature–nurture question as it applies to intelligence?

SUGGESTIONS FOR FURTHER READING

- Boakes, R. (1984). From Darwin to behaviourism: Psychology and the minds of animals. New York: Cambridge University Press.
- Crosby, J. R., & Hastorf, A. H. (2000). Lewis Terman: Scientist of mental measurement and product of his time. In G. A. Kimble & M. Wertheimer (Eds.), *Portraits of pioneers in psychology* (Vol. 4, pp. 131–147). Washington DC: American Psychological Association.
- Deary, I. J. (2001). *Intelligence: A very short introduction*. New York: Oxford University Press.

- Desmond, A. (1997). Huxley: From devil's disciple to evolution's high priest. Reading, MA: Perseus Books.
- Fancher, R. E. (1985). The intelligence men: Makers of the IQ controversy. New York: Norton.
- Fancher, R. E. (1998). Alfred Binet, general psychologist. In G. A. Kimble & M. Wertheimer (Eds.), Portraits of pioneers in psychology (Vol. 3, pp. 67–83). Washington DC: American Psychological Association.
- Gould, S. J. (1981). The mismeasure of man. New York: Norton.

- Jacoby, R., & Glauberman, N. (Eds.). (1995). The Bell Curve debate: History, documents, opinions. New York: Random House.
- Jensen, A. R. (2000). Charles E. Spearman: The discovery of g. In G. A. Kimble & M. Wertheimer (Eds.). Portraits of pioneers in psychology (Vol. 4, pp. 93–111). Washington DC: American Psychological Association.
- Masterton, R. R. (1998) Charles Darwin: Father of evolutionary psychology. In G. A. Kimble & M. Wertheimer (Eds.), Portraits of pioneers in psychology (Vol. 3, pp. 17–29). Washington DC: American Psychological Association.
- Minton, H. L. (1988). Lewis M. Terman: Pioneer in psychological testing. New York: New York University Press.

- Samelson, F. (1977). World War I intelligence testing and the development of psychology. *Journal of the History of the Behavioral Sciences*, 13, 274–282.
- Snyderman, M., & Rothman, S. (1990). The IQ controversy, the media and public policy. New Brunswick, NJ: Transaction Publishers.
- Sokal, M. M. (Ed.). (1987). Psychological testing and American society: 1890–1930. New Brunswick, NJ: Rutgers University Press.
- White, M., & Gribbin, J. (1995). Darwin: A life in science. New York: Dutton.
- Zenderland, L. (2001). Measuring minds: Henry Herbert Goddard and the origins of American intelligence testing. New York: Cambridge University Press.

GLOSSARY

Adaptive features Those features that an organism possesses that allow it to survive and reproduce.

Binet, Alfred (1857–1911) Found that following Galton's methods of measuring intelligence often resulted in falsely concluding that deaf and blind children had low intelligence. Binet attempted to measure directly the cognitive abilities he thought constituted intelligence.

Binet-Simon scale of intelligence The scale Binet and Simon devised to directly measure the various cognitive abilities they believed intelligence comprised. The scale first appeared in 1905 and was revised in 1908 and in 1911.

Burt, Cyril (1883–1971) Claimed that his studies of identical twins reared together and apart showed intelligence to be largely innate. Evidence suggested that Burt invented his data, and a major scandal ensued.

Cattell, James McKeen (1860–1944) Worked with Galton and developed a strong interest in measuring individual differences. Cattell brought Galton's methods of intelligence testing to the United States.

Coefficient of correlation (r) A mathematical expression indicating the magnitude of correlation between two variables.

Correlation Systematic variation between two variables.

Darwin, Charles (1809–1882) Devised a theory of evolution that emphasized a struggle for survival that results in the natural selection of the most fit organisms. By showing the continuity between human and non-human animals, the importance of individual differences, and the importance of adaptive behavior, Darwin strongly influenced subsequent psychology.

Eugenics The use of selective breeding to increase the general intelligence of the population.

Evolutionary psychology A modern extension of Darwin's theory to the explanation of human and non-human social behavior (also called sociobiology).

Factor analysis A complex statistical technique that involves analyzing correlations among measurements and attempting to explain the observed correlations by postulating various influences (factors).

Fitness According to Darwin, an organism's ability to survive and reproduce.

Galton, Francis (1822–1911) Influenced by his cousin, Charles Darwin, was keenly interested in the measurement of individual differences. Galton was convinced that intellectual ability is inherited and therefore recommended eugenics, or the selective breeding of humans. He was the first to attempt to systematically measure intelligence, to use a questionnaire to gather data, to use a word-association test, to study mental imagery, to

define and use the concepts of correlation and median, and to systematically study twins.

General intelligence (g) The aspect of intelligence that, according to Spearman, is largely inherited and coordinates specific intellectual abilities.

Goddard, Henry Herbert (1866–1957) Translated Binet's intelligence test into English and used it to test and classify students with mental retardation. Goddard was an extreme nativist who recommended that those with mental deficiencies be sterilized or institutionalized. As a result of Goddard's efforts, the number of immigrants allowed into the United States was greatly reduced.

Hollingworth, Leta Stetter (1886–1939) Rejected the belief, popular at the time, that women achieve less than males do because they are intellectually inferior to males; instead her explanation emphasized differences in social opportunity. Her career focused on improving the education of both subnormal and gifted students.

Inclusive fitness The type of fitness that involves the survival and perpetuation of copies of one's genes into subsequent generations. With this expanded definition of fitness, one can be fit by helping his or her kin survive and reproduce as well as by producing one's own offspring.

Inheritance of acquired characteristics Lamarck's contention that adaptive abilities developed during an organism's lifetime are passed on to the organism's offspring.

Intelligence quotient (IQ) Stern's suggested procedure for quantifying intelligence. The intelligence quotient is calculated by dividing mental age by chronological age.

Lamarck, Jean (1744–1829) Proposed that adaptive characteristics acquired during an organism's lifetime were inherited by that organism's offspring. This was the mechanism by which species were transformed. (See also Inheritance of acquired characteristics.)

Malthus, Thomas (1766–1834) Economist who wrote *Essay on the Principle of Population* (1798), which provided Darwin with the principle he needed to explain the observations that he had made while aboard the *Beagle*. The principle stated that because more individuals are born than environmental resources can support, there is a struggle for survival and only the fittest survive.

Mental age According to Stern, a composite score reflecting all the levels of the Binet–Simon test that a child could successfully pass.

Mental orthopedics The exercises that Binet suggested for enhancing determination, attention, and discipline. These procedures would prepare a child for formal education.

Natural selection A key concept in Darwin's theory of evolution. Because more members of a species are born than environmental resources can support, nature selects those with characteristics most conducive to survival under the circumstances, which allows them to reproduce.

Nature–nurture controversy The debate over the extent to which important attributes are inherited or learned.

Pearson, Karl (1857–1936) Devised the formula for calculating the coefficient of correlation.

Regression toward the mean The tendency for extremes to become less extreme in one's offspring. For example, the offspring of extremely tall parents tend not to be as tall as the parents.

Simon, Theodore (1873–1961) Collaborated with Binet to develop the first test designed to directly measure intelligence.

Social Darwinism Spencer's contention that, if given freedom to compete in society, the ablest individuals will succeed and the weaker ones will fail, and this is as it should be.

Sociobiology See Evolutionary psychology.

Spearman, Charles (1863–1945) Using an early form of factor analysis, found that intelligence comprised specific factors (s) and general intelligence (g). He believed the latter to be largely inherited. (See also **General intelligence**.)

Spencer, Herbert (1820–1903) First a follower of Lamarck and then of Darwin. Spencer applied Darwinian principles to society by saying that society should maintain a laissez-faire policy so that the ablest individuals could prevail. Spencer's position is called social Darwinism. (*See also* **Social Darwinism**.)

Spencer–Bain principle The observation first made by Bain and later by Spencer that behavior resulting in pleasurable consequences tends to be repeated and behavior resulting in painful consequences tends not to be.

Stern, William (1871–1938) Coined the term *mental age* and suggested the intelligence quotient as a way of quantifying intelligence. (*See also* **Intelligence quotient**.)

Struggle for survival The situation that arises when there are more offspring of a species than environmental resources can support.

Survival of the fittest The notion that, in a struggle for limited resources, those organisms with traits conducive to survival under the circumstances will live and reproduce.

Terman, Lewis Madison (1877–1956) Revised Binet's test of intelligence, making it more compatible with U.S. culture. Terman, along with Goddard and Yerkes, was instrumental in creating the Army Alpha and Army Beta tests. He also conducted a longitudinal study

of gifted children and found that, contrary to the belief at the time, gifted children tended to become healthy, gifted adults.

Wallace, Alfred Russell (1823–1913) Developed a theory of evolution almost identical to Darwin's, at almost the same time that Darwin developed his theory.

Yerkes, Robert M. (1876–1956) Suggested that psychology could help in the war effort (World War I) by creating tests that could be used to place recruits according to their abilities and to screen the mentally unfit from military service. The testing program was largely ineffective and was discontinued soon after the war.

Functionalism

n Chapter 9, we saw that Titchener's brand of psychology, which he called structuralism, was essentially a psychology of pure consciousness with little concern for practical applications. In this chapter, we will look first at what psychology was like before Titchener and then at what psychology became after Titchener, when the doctrine of evolution combined with the U.S. Zeitgeist to create what became the U.S. brand of psychology—functionalism.

EARLY U.S. PSYCHOLOGY

It is often assumed that U.S. psychology did not exist before Titchener and William James. In his presidential address to the Ninth International Congress of Psychology at Yale University in 1929, James McKeen Cattell said that a history of U.S. psychology before the 1880s "would be as short as a book on snakes in Ireland since the time of St. Patrick. Insofar as psychologists are concerned, America was then like heaven, for there was not a damned soul there" (1929, p. 12).

In making such a statement, Cattell assumed that only experimental psychology was *real* psychology and that everything else was mental or moral philosophy. Titchener agreed and argued forcibly that experimental psychology should be completely separated from philosophy and especially from theology. The problem with Cattell and Titchener's argument is that it ignored the fact that experimental psychology grew out of nonexperimental psychology; and therefore to understand the former, one must understand the latter.

In an attempt to set the record straight, J. W. Fay wrote American Psychology Before William James (1939), and A. A. Roback wrote History of American Psychology (1952), which traces U.S. psychology back to the colonial days. Also, Josef Brožek edited a book titled Explorations in the History of Psychology in the

United States (1984). For our purposes, however, we will follow Sahakian's (1975) description of the four stages of early U.S. psychology.

Stage One: Moral and Mental Philosophy (1640–1776)

Early in the 136-year period of moral and mental philosophy, psychology included such topics as ethics, divinity, and philosophy. During this time, psychology concerned matters of the soul, and what was taught was not questioned. Thus, to learn psychology was to learn the accepted theology of the day. Like all other subjects taught at the time, psychology was combined with religious indoctrination. The earliest U.S. universities, such as Harvard (founded in 1636), were modeled after the British universities whose main purpose was to perpetuate religious beliefs.

A period of "American Enlightenment" began in 1714, when John Locke's An Essay Concerning Human Understanding (1690) arrived in the colonies and had a widespread influence. Samuel Johnson (1696-1772), the first president of Columbia University (founded in 1754), embraced Locke enthusiastically and wrote a book containing many of his ideas. This book also contained a number of topics clearly psychological in nature—for example, child psychology, the nature of consciousness, the nature of knowledge, introspection, and perception. Lockean philosophy provided the basis for a logic and a psychology that could be used to support one's religious beliefs. Roback says of this period, "Psychology existed for the sake of logic, and logic for the sake of God" (1952, p. 23).

Stage Two: Intellectual Philosophy (1776–1886)

During the stage of intellectual philosophy, psychology became a separate discipline in the United States, largely under the influence of Scottish commonsense philosophy. As we saw in Chapter 6, the Scottish philosophy of common sense was a reaction against philosophers such as

Hume, who maintained that nothing could be known with certainty and that moral and scientific laws were nothing more than mental habits. Scottish philosophers such as Thomas Reid (1710–1796) disagreed, saying that sensory information could be accepted at face value (naive realism). The Scottish philosophers also maintained that self-examination, or introspection, yields valid information and that morality is based on self-evident intuitions. The commonsense philosophy had clear implications for theology: The existence and nature of God need not be proved logically because one's personal feelings could be trusted on these matters.

With the respectability of the senses and feelings established, textbooks written by the Scottish philosophers began to include such topics as perception, memory, imagination, association, attention, language, and thinking. Such a textbook was written by Dugald Stewart (1753–1828), titled *Elements of the Philosophy of the Human Mind* (1792), and was used at Yale University in 1824.

Soon U.S. textbooks bearing a close resemblance to those of the Scottish philosophers began to appear, such as Noah Porter's The Human Intellect: With an Introduction Upon Psychology and the Soul (1868). Porter's text represented a transitional period when psychology was leaving the realm of philosophy and theology and becoming a separate discipline. Porter's book defined psychology as the science of the human soul and covered such topics as psychology as a branch of physics, psychology as a science, consciousness, sense perception, development of the intellect, association of ideas, memory, and reason. We can see in Porter's text, and in many other texts of the time, the strong influence of the Scottish commonsense philosophy, as well as the emphasis on the individual that was later to characterize modern U.S. psychology.

Stage Three: The U.S. Renaissance (1886–1896)

During the U.S. renaissance, psychology was completely emancipated from religion and

philosophy and became an empirical science. In 1886 John Dewey (discussed later) published Psychology, which described the new empirical science. Also in 1887 came the first issue of the American Journal of Psychology, the first psychology journal in the United States, and in 1890 William James's The Principles of Psychology was published. All these events marked the beginning of a psychology that was to emphasize individual differences, adaptation to the environment, and practicality—in other words, a psychology that was perfectly compatible with evolutionary theory. Since the days of the pioneers, people in the United States had emphasized individuality and practicality, and adaptation to the environment had to be a major concern. This explains why the United States was such fertile ground for physiognomy, phrenology, mesmerism, and spiritualism—practices that purported to help individuals live more effective lives.

It was also during this stage that Titchener began his highly influential structuralist program at Cornell University (1892), which successfully competed with functionalism for several years.

Stage Four: U.S. Functionalism (1896 to Present)

During the stage of U.S. functionalism, science, concern for practicality, emphasis on the individual, and evolutionary theory combined into the school of **functionalism**. Sahakian (1975) marks the beginning of functionalism at 1896, with the publication of John Dewey's article "The Reflex Arc in Psychology." This date is somewhat arbitrary. Others mark the formal beginning of functionalism with the 1890 publication of James's book *The Principles of Psychology*.

If functionalism began with the publication of *The Principles of Psychology* (1890), then it predated the school of structuralism and ran parallel to it. Titchener was at Cornell from 1892 to 1927. Members of the two schools were largely adversaries, and there was little meaningful dialog between them. The schools nicely illustrate Kuhn's concept of paradigm because their assumptions, goals, and

methodologies were distinctly different. For the structuralist, the assumptions concerning the mind were derived from British and French empiricism. the goal of psychology was to understand the structure of the mind, and the primary research tool was introspection. For the functionalist, the assumptions concerning the mind were derived from evolutionary theory, the goal was to understand how the mind and behavior work in aiding an organism's adjustment to the environment, and research tools included anything that was informative—including the use of introspection, the study of animal behavior, and the study of the mentally ill. In other words, the schools of structuralism and functionalism, having little in common, were incommensurable.

CHARACTERISTICS OF FUNCTIONALISTIC PSYCHOLOGY

Functionalism was never a well-defined school of thought with one recognized leader or an agreed-on methodology. Amid all of functionalism's diversity, however, common themes ran through the work of all those calling themselves functionalists. We follow Keller (1973) in delineating those themes.

- The functionalists opposed what they considered the sterile search for the elements of consciousness in which the structuralists engaged.
- The functionalists wanted to understand the function of the mind rather than provide a static description of its contents. They believed that mental processes had a function—to aid the organism in adapting to the environment. That is, they were interested in the "is for" of the mind rather than the "is," its function rather than its structure.
- The functionalists wanted psychology to be a practical science, not a pure science, and they

sought to apply their findings to the improvement of personal life, education, industry, and so on. The structuralists actively avoided practicality.

- The functionalists urged the broadening of psychology to include research on animals, children, and abnormal humans. They also urged a broadening of methodology to include anything that was useful, such as puzzle boxes, mazes, and mental tests.
- The functionalists' interest in the "why" of mental processes and behavior led directly to a concern with motivation. Because an organism will act differently in the same environment as its needs change, these needs must be understood before the organism's behavior can be understood.
- The functionalists accepted both mental processes and behavior as legitimate subject matter for psychology, and most of them viewed introspection as one of many valid research tools.
- The functionalists were more interested in what made organisms different from one another than what made them similar.
- All functionalists were directly or indirectly influenced by William James, who had been strongly influenced by Darwin's theory of evolution.

Next, we review the thoughts of some members of the school of functionalism, starting with William James, the most influential functionalist of all, and ending with Edward L. Thorndike, a transitional figure who could almost as easily be labeled an early behaviorist.

WILLIAM JAMES

William James (1842–1910) represents the transition between European psychology and U.S. psychology. His ideas were not fully developed enough to suggest a school of thought, but they contained the seeds that were to grow into the school

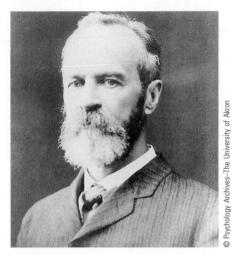

William James

of functionalism. As mentioned, James had already brought prominence to U.S. psychology through the publication of Principles two years before Titchener arrived at Cornell. James was 25 years older than Titchener, and James died in 1910 when Titchener's influence was at its peak. James's psychology, however, became far more influential than Titchener's. In fact, soon after the publication of Principles, James began to compete with Wundt for the unofficial title of worldwide leader of psychology. In 1896 the Third International Congress of Psychology met in Munich. Wundt's laboratory was 17 years old, and he was 64. James's Principles was 6 years old, and he was 54. At the time, a Berlin newspaper referred to Wundt as "the psychological Pope of the Old World" and to James as "the psychological Pope of the New World" (Hilgard, 1987, p. 37). Although neither Wundt nor James attended the conference, the designation of "pope" indicated their status as spiritual leaders of the psychological world.

William James was born on January 11 in New York City. His brother Henry, who would become a famous novelist, was born 15 months later. Their father, Henry James Sr., who had lost a leg in an adolescent accident, embraced Swedenborgianism, a mystic religion named after Emanuel Swedenborg (1688–1772). So enchanted with Swedenborgianism

was the elder James that he wrote a book titled The Secret of Swedenborg. Henry James Sr. was independently wealthy and believed his children should receive the best possible education. After enrolling William in several private schools in the United States, the father decided that European schools would be better; so William attended schools in Switzerland, France, Germany, and England. His early life was highly stimulating, involving a great deal of travel and exposure to intense intellectual discussions at home. In 1860, at 18 years of age and after showing considerable talent for painting, William decided on a career as an artist. However, his father was so distressed by this career choice that he moved the family away from William's art teacher and even threatened suicide if William persisted in his choice (Fancher, 1990). Unfortunately for William, no career choice satisfied his father:

Mr. James was not only critical of William's desire to paint, but when he followed his father's wishes and chose science, the elder James belittled that choice. Finally when William embraced metaphysics because his father praised philosophy as the most elevated intellectual pursuit, Henry maligned William for not adopting the proper kind. (Bjork, 1983, pp. 22–23)

Not surprisingly, William James displayed career uncertainty and ambivalence all his life.

In 1861 James enrolled as a chemistry student at Harvard University. He soon switched to physiology to prepare himself for a career in medicine, and in 1864 (at the age of 22) he enrolled in Harvard's medical school. James's medical studies were interrupted when he accepted an invitation from Louis Agassiz, a famous Harvard biologist and an opponent of Darwinian theory, to go on an expedition to Brazil. Seasick most of the time, James also came down with smallpox. Once he recovered, he decided to return to continue his medical studies, but after arriving back home, his health deteriorated, his eyesight became weak, and he experienced severe back pains. In 1867

James decided to go to Germany and bathe in mineral springs in hopes of improving his back problems. While in Germany, he began to read German psychology and philosophy. In his diary, James shared a letter written to a friend in 1867, which shows that this was the time when James discovered Wundt and agreed with Wundt that it was time for psychology to become a science (James, 1920, Vol. 1, pp. 118–119).

James's Crisis

James returned to the United States and finally obtained his medical degree from Harvard in 1869 at the age of 27. After graduation, however, James's health deteriorated further, and he became deeply depressed. Apparently, one reason for his depression was the implications of the German materialistic physiology and psychology that had so impressed him. It was clear to James that if the materialistic philosophy was correct, it applied to him as well. This meant that anything that happened to him was predetermined and thus beyond his control. His depression, for example, was a matter of fate, and it made no sense to attempt to do anything about it. James's acceptance of Darwin's theory of evolution exacerbated the problem. In Darwin's view, there is variation, natural selection, and survival of the fittest; there is no freedom, hope, or choice.

A major turning point in James's life came when he read an essay on free will by Charles-Bernard Renouvier (1815–1903). After reading this essay, James (1920) wrote in his diary:

I think that yesterday was a crisis in my life. I finished the first part of Renouvier's second "Essais" and see no reason why his definition of free will—"The sustaining of a thought because I choose to when I might have other thoughts"—need be the definition of an illusion. At any rate, I will assume for the present—until next year—that it is no illusion. My first act of free will shall be to believe in free will.... Hitherto, when I have felt like taking a free

initiative, like daring to act originally, without carefully waiting for contemplation of the external world to determine all for me, suicide seemed the most manly form to put my daring into; now I will go a step further with my will, not only act with it, but believe as well; believe in my individual reality and creative power. (Vol. 1, pp. 147–148)

This change in beliefs cured James's depression, and he became highly productive. Here we have the beginnings of James's pragmatism—the belief that if an idea works, it is valid. That is, the ultimate criterion for judging an idea should be the idea's usefulness or "cash-value." At this point, we also see the conflict James perceived between the objective, scientific viewpoint based on determinism and personal, subjective feelings, such as the feeling that one's will is free. James used pragmatism to solve the problem. While using the scientific method in psychology, he said, it was necessary to assume that human behavior is determined. As useful as this assumption was, however, it had limits. Certain metaphysical questions lay beyond the reach of science, and a subjective approach was more useful in dealing with them. Therefore, according to James, both a scientific and a philosophical approach must be used in the study of human behavior and thought. To assume that all aspects of humans could be known through scientific research, he said, was akin to a physician giving all his patients tics because it was the only thing he could cure. If something about humans—for example, free will—could not be studied effectively using a certain method, James said, one did not throw out that aspect of human existence. Rather, one sought alternative methods of investigation. In other words, for James, it was not proper for science to determine which aspects of human experience are worthy of investigation and which are not. James proposed a radical empiricism by which all consistently reported aspects of human experience are worthy of study. About James, Heidbreder (1933) said, "It was his opinion that nothing that presented itself as a possibility should be dismissed without a hearing" (p. 157).

Following his own advice, as he often did, James explored the phenomenon of religious experience and summarized his findings in *The Varieties of Religious Experience* (1902). James's willingness to accept methods ranging from anecdotes to rigorous experimentation was further testimony to his belief in pragmatism and radical empiricism.

In 1872 James was given the opportunity to teach physiology at Harvard, which he did for one year. He then toured Europe for a year and again returned to Harvard to teach, but this time his course concerned the relations between physiology and psychology. In 1875 James created a small demonstration laboratory, which he used in teaching his course. This has raised a controversy concerning who should be given credit for establishing psychology's first laboratory, Wundt in 1879 or James in 1875. Usually the credit is given to Wundt because his laboratory was more elaborate and was designed for research instead of merely for teaching demonstrations.

In 1878 publisher Henry Holt offered James a contract to write a textbook on psychology. The textbook was finally published 12 years later, in 1890, when James was 48 years old. Although James's *The Principles of Psychology* was to revolutionize psychology, James (1920) did not think much of it, as he indicated in a letter he sent to the publisher along with the manuscript:

No one could be more disgusted than I at the sight of the book. No subject is worth being treated of in 1000 pages. Had I ten years more, I could rewrite it in 500; but as it stands it is this or nothing—a loathsome, distended, tumefied, bloated, dropsical mass, testifying to nothing but two facts: 1st, that there is no such thing as a science of psychology, and 2nd, that W. J. is an incapable. (Vol. 1, p. 294)

James's highly influential *Principles* appeared in two volumes, 28 chapters, and a total of 1,393 pages. Two years later, James published a condensed version of his *Principles* titled *Psychology: The Briefer Course* (1892/1985). *The Briefer Course*

came to be called Jimmy, as the larger *Principles* was called James.

James retired from Harvard in 1907 and died of a heart condition at his country home near Mount Chocorua, New Hampshire, on August 26, 1910.

In neither James's writings nor in James the man do we find an organized theory. Rather, we find treatment of a wide variety of topics, many of which later researchers pursued. As we will see, however, the themes of practicality (pragmatism) and individuality permeate most of his writings. Following his radical empiricism, James was always willing to entertain a wide variety of ideas ranging from religion, mysticism, faith healing, and psychic phenomena to the most rigorous scientific facts and methods available in psychology at the time.

The Spanish-born U.S. philosopher and poet, and James's colleague at Harvard, George Santayana (1920) said of James,

I think it would have depressed him if he had to confess that any important question was finally settled. He would still have hoped that something might turn up on the other side, and that, just as the scientific hangman was about to dispatch the poor convicted prisoner, an unexpected witness would ride up in hot haste, and prove him innocent. (p. 82)

We now sample a few of James's more famous concepts.

Opposition to Wundt's Approach to Psychology

Almost everything in *Principles* can be seen as a criticism of what James perceived Wundt's approach to psychology to be. That approach, James thought, consisted of a search for the elements of consciousness. James (1890/1950) was especially harsh in his criticism in the following passage:

Within a few years what one may call a microscopic psychology has arisen in Germany, carried on by experimental methods, asking of course every moment

for introspective data, but eliminating their uncertainty by operating on a large scale and taking statistical means. This method taxes patience to the utmost, and hardly could have arisen in a country whose natives could be bored. Such Germans as Weber, Fechner ... and Wundt obviously cannot; and their success has brought into the field an array of younger experimental psychologists, bent on studying the elements of the mental life, dissecting them from the gross results in which they are embedded, and as far as possible reducing them to quantitative scales. The simple and open method of attack having done what it can, the method of patience, starving out, and harassing to death is tried; the Mind must submit to a regular siege, in which minute advantages gained night and day by the forces that hem her in must sum themselves up at last into her overthrow. There is little left of the grand style about these new prism, pendulum, and chronographyphilosophers. They mean business, not chivalry. What generous divination, and that superiority in virtue which was thought by Cicero to give a man the best insight into nature, have failed to do, their spying and scraping, their deadly tenacity and almost diabolic cunning, will doubtless some day bring about. (Vol. 1, pp. 192-193)

James, of course, was responding to Wundt the experimentalist. If James had probed deeper into Wundt's voluntarism and into his *Völkerpsychologie*, he would have seen a remarkable similarity between himself and Wundt. In any case, it was Wundt the experimentalist who, after reading James's *Principles*, commented, "It is literature, it is beautiful, but it is not psychology" (Blumenthal, 1970, p. 238).

Although James appreciated Fechner's excursions into the supernatural (James wrote a sympathetic introduction to the English translation of Fechner's *The Little Book of Life After Death*), he

did not think much of Fechner's scientific endeavors, which had so impressed Wundt (James, 1890/1950, Vol. 1, pp. 534, 549).

Stream of Consciousness

With his concept of **stream of consciousness**, James opposed those who were busy searching for the *elements* of thought. In the first place, said James, *consciousness is personal*. It reflects the experiences of an individual, and therefore it is foolhardy to search for elements common to all minds. Second, *consciousness is continuous and cannot be divided up for analysis:*

Let anyone try to cut a thought across in the middle and get a look at its section.... The rush of the thought is so headlong that it almost always brings us up at the conclusion before we can arrest it. Or if our purpose is nimble enough and we do arrest it, it ceases forthwith to be itself. As a snowflake crystal caught in the warm hand is no longer a crystal but a drop, so, instead of catching the feeling of relation moving to its term, we find we have caught some substantive thing, usually the last word we were pronouncing, statically taken, and with its function, tendency, and particular meaning in the sentence quite evaporated. The attempt at introspective analysis in these cases is in fact like seizing a spinning top to catch its motion, or trying to turn up the gas quickly enough to see how the darkness looks. (James, 1890/1950, Vol. 1, p. 244)

Third, consciousness is constantly changing. Even though consciousness is continuous and can be characterized as a steady stream from birth to death, it is also constantly changing. James quoted Heraclitus's aphorism about the impossibility of stepping into the same river twice. For James, the same is true for conscious experience. One can never have exactly the same idea twice because

the stream of consciousness that provides the context for the idea is ever-changing.

Fourth, consciousness is selective. Some of the many events entering consciousness are selected for further consideration and others are inhibited. Here James (1890/1950) flirted again with free will:

We see that the mind is at every stage a theatre of simultaneous possibilities. Consciousness consists in the comparison of these with each other, the selection of some, and the suppression of the rest by the reinforcing and inhibiting agency of attention. (Vol. 1, p. 288)

Finally, and perhaps most important, consciousness is functional. This idea permeates all of James's writing, and it is the point from which the school of functionalism developed. According to James, the most important thing about consciousness—and the thing the elementists overlooked—is that its purpose is to aid the individual in adapting to the environment. Here we see the powerful influence of Darwin on early U.S. scientific psychology.

Consciousness, then, is personal, continuous, constantly changing, selective, and purposive. Very little in this view is compatible with the view held by Wundt the experimentalist (although it is very much in accordance with the view held by Wundt the voluntarist) or later by the structuralists. James (1890/1950) reached the following famous conclusion concerning consciousness:

Consciousness, then, does not appear to itself chopped up in bits. Such words as "chain" or "train" do not describe it fitly as it presents itself in the first instance. It is nothing jointed; it flows. A "river" or a "stream" are the metaphors by which it is most naturally described. In talking of it hereafter, let us call it the stream of thought, of consciousness, or of subjective life. (Vol. 1, p. 239)

Although James first mentioned "stream of consciousness" in his 1884 article "On Some Omissions of Introspective Psychology," J. Gill

Holland (1986) indicates that George Henry Lewes used the term four years earlier in his *Problems of Life and Mind* (1880).

Habits and Instincts

James (1890/1950) believed that much animal and human behavior is governed by instinct:

Why do the various animals do what seem to us such strange things, in the presence of such outlandish stimuli? Why does the hen, for example, submit herself to the tedium of incubating such a fearfully uninteresting set of objects as a nestful of eggs, unless she has some sort of a prophetic inkling of the result? The only answer is ad hominem. We can only interpret the instincts of brutes by what we know of instincts in ourselves. Why do men always lie down, when they can, on soft beds rather than on hard floors? Why do they sit around the stove on a cold day? Why, in a room, do they place themselves, ninety-nine times out of a hundred, with their faces towards the middle rather than to the wall? Why do they prefer saddle of mutton and champagne to hard-tack and ditch-water? Why does the maiden interest the youth so that everything about her seems more important and significant than anything else in the world? Nothing more can be said than that these are human ways, and that every creature likes its own ways, and takes to following them as a matter of course. (Vol. 2, pp. 386–387)

James did not believe that instinctive behavior is "blind and invariable." Rather, he believed that such behavior is modifiable by experience. Furthermore, he believed that new instinctlike patterns of behavior develop within the lifetime of the organism. James called these learned patterns of behavior **habits**.

According to James, habits are formed as an activity is repeated. Repetition causes the same

neural pathways to, from, and within the brain to become more entrenched, making it easier for energy to pass through those pathways (see 1890/1950, Vol. 1, p. 566). Thus, James had a neurophysiological explanation of habit formation, and his neurophysiological account of learning was very close to Pavlov's. Habits are functional because they simplify the movements required to achieve a result, increase the accuracy of behavior, reduce fatigue, and diminish the need to consciously attend to performed actions.

For James (1890/1950), then, it is habit that makes society possible:

Habit is ... the enormous fly-wheel of society, its most precious conservative agent. It alone is what keeps us all within the bounds of ordinance, and saves the children of fortune from the envious uprisings of the poor. It alone prevents the hardest and most repulsive walks of life from being deserted by those brought up to tread therein.... It dooms us all to fight out the battle of life upon the lines of our nurture or our early choice, and to make the best of a pursuit that disagrees, because there is no other for which we are fitted, and it is too late to begin again. It keeps different social strata from mixing. Already at the age of twenty-five you see the professional mannerism settling down on the young commercial traveller, on the young doctor, on the young minister, on the young counsellor-at-law. You see the little lines of cleavage running through the character, the tricks of thought, the prejudices, the ways of the "shop," in a word, from which the man can by-and-by no more escape than his coat-sleeve can suddenly fall into a new set of folds. On the whole, it is best he should not escape. It is well for the world that in most of us, by the age of thirty, the character has set like plaster, and will never soften again. (Vol. 1, p. 121)

Through habit formation, we can make our nervous system our ally instead of our enemy:

For this we must make automatic and habitual, as early as possible, as many useful actions as we can, and guard against the growing into ways that are likely to be disadvantageous to us, as we should guard against the plague. (James, 1892/1985, p. 11)

James (1892/1985) offered five maxims to follow in order to develop good habits and eliminate bad ones.

- Place yourself in circumstances that encourage good habits and discourage bad ones.
- Do not allow yourself to act contrary to a new habit that you are attempting to develop: "Each lapse is like the letting fall of a ball of string which one is carefully winding up; a single slip undoes more than a great many turns will wind again" (p. 12).
- Do not attempt to slowly develop a good habit or eliminate a bad one. Engage in positive habits completely to begin with and abstain completely from bad ones.
- It is not the *intention* to engage in good habits and avoid bad ones that is important; it is the actual doing so: "There is no more contemptible type of human character than that of the nerveless sentimentalist and dreamer, who spends his life in a weltering sea of sensibility and emotion, but who never does a manly concrete deed" (p. 15).
- Force yourself to act in ways that are beneficial to you, even if doing so at first is distasteful and requires considerable effort.

All of James's maxims converge on a fundamental principle: Act in ways that are compatible with the type of person you would like to become.

The Self

James (1892/1985) discussed what he called the **empirical self**, or the "me" of personality, which

consists of everything that a person could call his or her own:

In its widest possible sense ... a man's Me [empirical self] is the sum total of all that he CAN call his, not only his body and his psychic powers, but his clothes, and his house, his wife and children, his ancestors and friends, his reputation and works, his lands and horses, and yacht, and bankaccount. (p. 44)

James divided the empirical self into three components: the material self, the social self, and the spiritual self. The *material self* consists of everything material that a person could call his or her own, such as his or her own body, family, and property. The *social self* is the self as known by others. "A man has as many social selves as there are individuals who recognize him and carry an image of him in their mind" (1892/1985, p. 46). The spiritual self consists of a person's states of consciousness. It is everything we think as we think of ourselves as thinkers. Also included in the spiritual self are all emotions associated with various states of consciousness. The spiritual self, then, has to do with the experience of one's subjective reality.

Self as Knower. The empirical self (the me) is the person as known by himself or herself, but there is also an aspect of self that does the knowing (the I). Thus, for James, the self is "partly known and partly knower, partly object and partly subject" (1892/1985, p. 43). James admitted that dealing with the "me" was much easier than dealing with the "I," or what he called "pure ego." James struggled with his concept of self as knower and admitted that it was similar to older philosophical and theological notions such as "soul," "spirit," and "transcendental ego."

Self-esteem. James was among the first to examine the circumstances under which people feel good or bad about themselves. He concluded that a person's **self-esteem** is determined by the ratio of things attempted to things achieved:

With no attempt there can be no failure; with no failure, no humiliation. So our self-feeling in this world depends entirely on what we *back* ourselves to be and do. It is determined by the ratio of our actualities to our supposed potentialities; a fraction of which our pretensions are the denominator and the numerator our success: thus,

 $Self-esteem = \frac{Success}{Pretensions}$

(James 1892/1985, p. 54)

It should be noted that, according to James, one could increase self-esteem either by succeeding more *or* attempting less: "To give up pretensions is as blessed a relief as to get them gratified" (1892/1985, p. 54).

There is the strangest lightness about the heart when one's nothingness in a particular line is once accepted in good faith. All is not bitterness in the lot of the lover sent away by the final inexorable "No." Many Bostonians ... (and inhabitants of other cities, too, I fear), would be happier women and men today, if they could once for all abandon the notion of keeping up a Musical Self, and without shame let people hear them call a symphony a nuisance. How pleasant is the day when we give up striving to be young,—or slender! Thank God! we say, those illusions are gone. Everything added to the Self is a burden as well as a pride. A certain man who lost every penny during our civil war went and actually rolled in the dust, saying he had not felt so free and happy since he was born. (James, 1892/1985, p. 54)

Emotions

James reversed the traditional belief that emotion results from the perception of an event. For example, it was traditionally believed that if we see a bear, we are frightened and we run. According to James, if we see a bear, we run and *then* we are

frightened. Perception, according to James, causes bodily reactions that are then experienced as emotions. In other words, the emotions we feel depend on what we *do*. James (1890/1950) put his theory as follows:

Our natural way of thinking about ... emotions is that the mental perception of some fact excites the mental affection called the emotion, and that this latter state of mind gives rise to the bodily expression. My theory, on the contrary, is that the bodily changes follow directly the perception of the exciting fact, and that our feeling of the same changes as they occur IS the emotion. Common-sense says, we lose our fortune, are sorry and weep; we meet a bear, are frightened and run; we are insulted by a rival, are angry and strike. The hypothesis here to be defended says that this order of sequence is incorrect, that the one mental state is not immediately induced by the other, that the bodily manifestations must first be interposed between, and that the more rational statement is that we feel sorry because we cry, angry because we strike, afraid because we tremble, and not that we cry, strike, or tremble, because we are sorry, angry, or fearful, as the case may be. Without the bodily states following on the perception, the latter would be purely cognitive in form, pale, colorless, destitute of emotional warmth. We might then see a bear, and judge it best to run, receive the insult and deem it right to strike, but we should not actually feel afraid or angry. (Vol. 2, pp. 449-450)

Coupled with James's belief in free will, his theory of emotion yields practical advice: *Act the way you want to feel*. If we believe James, there is a great deal of truth in Oscar Hammerstein's lines, "Whenever I feel afraid, I ... whistle a happy tune and ... the happiness in the tune convinces me that I'm not afraid."

Whistling to keep up courage is no mere figure of speech. On the other hand, sit all

day in a moping posture, sigh, and reply to everything with a dismal voice, and your melancholy lingers. There is no more valuable precept in moral education than this, as all who have experience know: if we wish to conquer undesirable emotional tendencies in ourselves we must assiduously, and in the first instance coldbloodedly, go through the outward movements of those contrary dispositions which we prefer to cultivate. The reward of persistency will infallibly come, in the fading out of the sullenness or depression, and the advent of real cheerfulness and kindliness in their stead. (James, 1890/1950, Vol. 2, p. 463)

James's theory of emotion provides still another example of the importance of the Zeitgeist; the Danish physician Carl George Lange (1834–1900) published virtually the same theory at about the same time. In recognition of the contributions of both men, the theory is now known as the James–Lange theory of emotion. Almost immediately after this theory was presented, it was harshly criticized by such individuals as Wilhelm Wundt and Walter B. Cannon (1871–1945). For a review of these and other criticisms, see Finger, 1994, pp. 276–277.

Free Will

Although James did not solve the free will-determinism controversy, he did arrive at a position with which he was comfortable. He noted that without the assumption of determinism, science would be impossible, and insofar as psychology was to be a science, it too must assume determinism. Science, however, is not everything, and for certain approaches to the study of humans, the assumption of free will might be very fruitful:

Science ... must constantly be reminded that her purposes are not the only purposes, and that the order of uniform causation which she has use for, and is therefore right in postulating, may be enveloped in a wider order, on which she has no claims at all. (James, 1890/1950, Vol. 2, p. 576)

James's Analysis of Voluntary Behavior. According to James's ideo-motor theory of behavior, an idea of a certain action causes that action to occur. He believed that in the vast majority of cases, ideas of actions flowed immediately and automatically (habitually or reflexively) into behavior. This automatic process continues unless mental effort is expended to purposively select and hold an idea of interest in consciousness. For James, voluntary action and mental effort were inseparable. The ideas of various behavioral possibilities are retained from previous experience, and their recollection is a prerequisite to voluntary behavior: "A supply of the various movements that are possible, left in the memory by experiences of their involuntary performance, is thus the prerequisite of the voluntary life" (James, 1892/1985, p. 283). From the ideas of various possible actions, one is selected for attention, and that is the one that causes behavior and continues to do so as long as the idea is attended to. Therefore, "what holds attention determines action" (James, 1892/1985, p. 315). The will functions, then, by selecting one from among many ideas of action we are interested in doing. By fiat (consent, or literally "let it be"), the will expends energy to hold the idea of interest in consciousness, thus inhibiting other ideas: "Effort of attention is thus the essential phenomenon of will" (James, 1892/1985, p. 317). It is by controlling our ideas of behavior that we control our actual behavior. Because ideas cause behavior, it is important to attend to those ideas that result in behavior deemed desirable under the circumstances: "The terminus of the psychological process in volition, the point to which the will is directly applied, is always an idea" (James, 1892/1985, p. 322). So if we combine James's theories of volition and emotion, what we think determines what we do, and what we do determines how we feel.

James believed that bodily events cause thoughts and that thoughts cause behavior. Thus,

on the mind-body question, he was an interactionist. Exactly how the mind and body interacted was not known to James and, to him, the nature of the interaction may never be known. He said, "Nature in her unfathomable designs has mixed us of clay and flame, of brain and mind, that the two things hang indubitably together and determine each other's being, but how or why, no mortal may ever know" (1890/1950, Vol. 1, p. 182).

Pragmatism

Everywhere in James's writing is his belief in pragmatism. According to pragmatism, which is the cornerstone of functionalism, any belief, thought, or behavior must be judged by its consequences. Any belief that helps create a more effective and satisfying life is worth holding, whether such a belief is scientific or religious. Believing in free will was emotionally satisfying to James, so he believed in it. According to the pragmatic viewpoint, truth is not something "out there" in a static form waiting to be discovered, as many of the rationalists maintained. Instead, truth is something that must be gauged by effectiveness under changing circumstances. What works is true, and because circumstances change, truth must be forever dynamic.

There is a kinship between Vaihinger's philosophy of "as if" (see Chapter 9) and James's pragmatism. Both insisted that words and concepts be judged by their practical consequences. For both, arriving at concepts such as God, free will, matter, reason, the Absolute, and energy was not the end of a search for knowledge but a beginning. The practical consequences of such concepts must be determined:

If you follow the pragmatic method, you cannot look on any such word as closing your quest. You must bring out of each word its practical cash-value, set it at work within the stream of your experience. It appears less as a solution, then, than as a program for more work. (James, 1907/1981, p. 28)

James's pragmatic philosophy appears in his description of the methods that psychology should employ. He urged the use of both introspection and experimentation, as well as the study of animals, children, preliterate humans, and abnormal humans. In short, he encouraged the use of any method that would shed light on the complexities of human existence; he believed that nothing useful should be omitted.

In 1907 James published *Pragmatism* (dedicated to the memory of John Stuart Mill), in which he delineated two types of personality: the *tender-minded* and the *tough-minded*. Tender-minded people are rationalistic (principle-oriented), intellectual, idealistic, optimistic, religious, and dogmatic, and they believe in free will. Conversely, tough-minded people are empiricistic (fact-oriented), sensationalistic, materialistic, pessimistic, irreligious, skeptical, and fatalistic. James viewed pragmatism as a way of compromising between the two world-views. The pragmatist simply takes from each list whatever works best in the circumstances at hand.

Again, the criterion of the validity of an idea, according to the pragmatist, is its usefulness. No idea, no method, no philosophy, no religion should be accepted or rejected except on the basis of usefulness:

Rationalism sticks to logic and the empyrean [lofty, abstract]. Empiricism sticks to the external senses. Pragmatism is willing to take anything, to follow either logic or the senses and to count the humblest and most personal experiences. She will count mystical experiences if they have practical consequences. She will take a God who lives in the very dirt of private fact—if that should seem a likely place to find him.

Her only test of probable truth is what works best in the way of leading us, what fits every part of life best and combines with the collectivity of experience's demands, nothing being omitted. If theological ideas should do this, if the notion of God, in particular, should prove to do it,

how could pragmatism possibly deny God's existence? She could see no meaning in treating as "not true" a notion that was pragmatically so successful. (James, 1907/1981, pp. 38–39)

Following his belief that any idea has potential pragmatic value, James enthusiastically embraced parapsychology and in 1884 was a founder of the American Society for Psychical Research. For an interesting survey of James's thoughts on parapsychology, religion, and faith healing, see Murphy and Ballon, 1960/1973.

James's Contributions to Psychology

James helped incorporate evolutionary theory into psychology. By stressing what is useful, he represented a major departure from the pure psychology of both voluntarism and structuralism. In fact, the pragmatic spirit in James's psychology quite naturally led to the development of applied psychology. For James, as well as for the functionalists who followed him, usefulness defined both truth and value. James expanded research techniques in psychology by not only accepting introspection but also encouraging any technique that promised to yield useful information about people. By studying all aspects of human existence-including behavior, cognition, emotions, volition, and even religious experience—James also expanded the subject matter of psychology. As we will see in Chapter 21, James's eclectism is very much in accordance with postmodernism, which is becoming increasingly influential in contemporary psychology.

In 1892, when James was 50, he decided that he had said everything he could say about psychology. He decided to devote his full attention to philosophical matters, something that necessitated relinquishing the directorship of the Harvard Psychology Laboratory. To maintain the laboratory's reputation as the best in the country, James sought an outstanding, creative, experimentally oriented psychologist, and certainly one who did not embrace Wundtian psychology (at least as James

understood it). He found such a person in Hugo Münsterberg.

HUGO MÜNSTERBERG

Born on June 1 in the east Prussian port city of Danzig (now Gdansk, Poland), Münsterberg (1863-1916) was one of four sons of prominent parents. His father was a successful businessman, his mother a recognized artist and musician. Both his mother and father died before he was 20 years old. Throughout his life, Münsterberg had wide-ranging interests. In his early years, he displayed interest and talent in art, literature, poetry, foreign languages, music, and acting. Then, while studying at the University of Leipzig, he heard a lecture by Wundt and became interested in psychology. Münsterberg eventually became Wundt's research assistant and received his doctorate under Wundt's supervision in 1885, at the age of 22. Perhaps on Wundt's advice, Münsterberg next studied medicine at the University of Heidelberg; he received his medical degree in 1887. In that same year, he began teaching as a Privatdocent (unpaid instructor) at the University of Freiburg, where he started a psychology laboratory and began publishing papers on time perception, attentional processes, learning, and memory.

During the time when he was Wundt's assistant, one of Münsterberg's jobs was to study voluntary activities through introspection. The two men disagreed, however, over whether the will could be experienced as a conscious element of the mind during introspection. Wundt believed that it could, whereas Münsterberg believed that it could not. In fact, Münsterberg did not believe that will was involved in voluntary behavior at all. For him, as we prepare to act one way or another, we consciously experience this bodily preparedness and confuse it with the will to act. For Münsterberg then, what we experience consciously as will is an epiphenomenon, a by-product of bodily activity. This idea, of course, was diametrically opposed to Wundt's

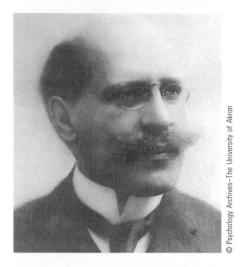

Hugo Münsterberg

interpretation of voluntary behavior. For Wundt volitional behavior is always preceded by a conscious will to act. Although James would never have removed consciousness as a causal element in his analysis of voluntary (willful) behavior, he did see in Münsterberg's position some support for his ideo-motor theory of behavior. If nothing else, both analyses noted a close, direct relationship between thoughts and behavior. However, the relationships postulated were converse. For James ideas cause behavior; for Münsterberg behavior causes ideas. In fact, there was a closer correspondence between James's theory of emotion Münsterberg's analysis of voluntary behavior. As we have seen, the James-Lange theory of emotion states that consciously experienced emotions are by-products (epiphenomena) of bodily reactions elicited by a situation. For Münsterberg the feeling of willful action results from an awareness of covert behavior, or a readiness to act overtly, elicited by a situation. In both cases (emotion for James, the feeling of volition for Münsterberg), conscious experience is a by-product (epiphenomenon) of behavior. In the case of volition, James's analysis was much closer to Wundt's than it was to Münsterberg's. In any case, in 1888 Münsterberg elaborated his theory in Voluntary Action, a book that James called a masterpiece and Wundt criticized harshly. James was impressed by many of Münsterberg's publications and cited them often in his *Principles*. He arranged to meet Münsterberg in Paris at the first International Congress of Psychology in 1889, and their relationship strengthened further.

After completing Principles, James wanted very much to leave psychology, especially experimental psychology, so that he could more actively pursue his interests in philosophy and psychic phenomena. To make the change, James needed someone to replace him as director of the Harvard Psychology Laboratory. In 1892 (the same year that Titchener arrived at Cornell), James offered Münsterberg the job despite the fact that Münsterberg could read but not speak English. Münsterberg accepted and learned to speak English so well and so quickly that his classes were soon attracting as many students as those of James. Although he adjusted well, Münsterberg could not decide whether he wanted to give up his homeland (Germany) in favor of a lifelong commitment in the United States. In 1895 he asked for and received a leave of absence so that he could return to the University of Freiburg. After two years, he was unable to obtain the type of academic appointment that he sought. He wrote to James in 1897, once again accepting the position at Harvard. However, Münsterberg never severed his emotional ties with his homeland.

For several years, Münsterberg did extremely well at Harvard. In 1898 he was elected president of the American Psychological Association (APA) and became chair of the Division of Philosophy at Harvard, which at the time still included psychology. When in 1900 he published Basics of Psychology, he dedicated it to James. As time went on, however, James's liberal attitude toward philosophy and psychology began to irritate Münsterberg, who had a more positivistic approach to science. He was especially appalled by James's acceptance of psychoanalysis, psychic phenomena, and religious mysticism into the realm of psychology. For Münsterberg, "Mysticism and mediums were psychology thing, was quite another. Experimental psychology and psychic hocus-pocus did not mix" (Bjork, 1983, pp. 63-64). Despite his difference with James, Münsterberg remained

highly productive. More and more, however, Münsterberg's interests turned to the practical applications of psychological principles. Münsterberg felt *very* strongly that psychologists should attempt to uncover information that could be used in the real world. With his efforts, Münsterberg did much to create what is now referred to as **applied psychology**.

Münsterberg's Applied Psychology

Clinical Psychology. In an attempt to underthe causes of abnormal behavior. Münsterberg saw many mentally ill people. Because he was seeing them for scientific reasons, he never charged them a fee. He applied his "treatment," which consisted mainly of causing his patients to expect to improve, to cases of alcoholism, drug addiction, phobia, and sexual dysfunction, but not to psychosis. He felt that psychosis was caused by deterioration of the nervous system and could not be treated. Along with the suggestion that individuals would improve as the result of his efforts, Münsterberg also employed reciprocal antagonism, which involved strengthening the thoughts opposite to those causing problems. Although Münsterberg was aware of Freud's work, he chose to treat symptoms directly and did not search for the underlying causes of those symptoms. Münsterberg said of Freud's theory of unconscious motivation, "The story of the subconscious mind can be told in three words: there is none" (1909, p. 125).

Forensic Psychology. Münsterberg was the first to apply psychological principles to legal matters, thus creating forensic psychology. Among other things, he pointed out that eyewitness testimony could be unreliable because sensory impressions could be illusory, suggestion and stress could affect perception, and memory is not always accurate. Münsterberg would often stage traumatic events in his classroom to show that even when witnesses were attempting to be accurate, there were wide differences in the individual accounts of what had

actually happened. Münsterberg urged that psychological methods replace the brutal interrogation of criminals. He believed that harsh interrogation could result in false confessions because some people want to please the interrogators, some need to give in to authority figures, and some very depressed people need to be punished. Münsterberg published his thoughts on forensic psychology in his best-selling book *On the Witness Stand* (1908). In this book, he described an apparatus that could detect lying by observing changes such as those in pulse rate and respiration. Others would follow Münsterberg's lead and later create the controversial lie detector.

Industrial Psychology. Münsterberg's Vocation and Learning (1912) and Psychology and Industrial Efficiency (1913) are usually considered the beginning of what later came to be called industrial psychology. In these books, Münsterberg dealt with such topics as methods of personnel selection, methods of increasing work efficiency, and marketing and advertising techniques. To aid in personnel selection, for example, he recommended defining the skills necessary for performing a task and then determining the person's ability to perform that task. In this way, one could learn whether a person had the skills necessary for doing a certain job adequately. Münsterberg also found that whether a task is boring could not be determined by observing the work of others. Often, work that some people consider boring is interesting to those doing it. It is necessary, then, to take individual differences into account when selecting personnel and when making job assignments.

Münsterberg's Fate

Because of his work in applied psychology, Münsterberg was well known to the public, the academic world, and the scientific community. William James had made psychology popular within the academic world, but Münsterberg helped make it popular with the general population by showing its practical uses. In addition, Münsterberg had among his personal friends some

of the most influential people in the world, including Presidents Theodore Roosevelt and William Howard Taft and the philosopher Bertrand Russell. He was invited to dine at the White House, and in his home in Cambridge, Massachusetts, he and his wife often hosted European scholars and German royalty. In addition, he was awarded several medals by the German government. By the time Münsterberg died in 1916, however, the general attitude toward him had turned negative, and his death went essentially unnoticed. The main reason for his unpopularity was his desire to create a favorable relationship between the United States and his native Germany. Never obtaining U.S. citizenship, Münsterberg maintained a nationalistic loyalty toward Germany. He believed that both Germans and Americans had inaccurate stereotypes of each other, and he wrote books attempting to correct them—for example, The Americans (1904). In another book, American Problems (1910), Münsterberg was highly critical of Americans, saying that they had a general inability to concentrate their attention on any one thing for very long. He explained this national inability to attend by the fact that, in the United States, women were influential in forming intellectual and cultural development. The intellectual vulnerability of women also explained the popularity of psychological fads such as séances. While James was attempting to discover if any of the claims of "mediums" were valid, Münsterberg was busy exposing them as dangerous frauds.

As World War I approached, Münsterberg found himself caught up in the U.S. outrage over German military aggression. He was suspected of being a spy, many of his colleagues at Harvard disassociated themselves from him, and there were threats against his life. Perhaps because of all the stress, Münsterberg died on December 16, 1916, from a cerebral hemorrhage just as he began a Saturday lecture; he was only 53 years old. (For an interesting account of Münsterberg's rise to fame and his decline into disfavor, see Spillmann and Spillmann, 1993.)

Harvard sought Titchener as a replacement for Münsterberg, but Titchener refused the offer. James McKeen Cattell applied for the position, but his application was denied. The position was finally filled by William McDougall, whom we discuss in the next chapter.

Mary Whiton Calkins

When Münsterberg took over James's psychology laboratory, he also became supervisor of the psychology graduate students, and it was he who directed their dissertation research. One of those graduate students was Mary Whiton Calkins (1863-1930). Calkins was the oldest of five children. She grew up in Buffalo, New York, where her father, Wolcott Calkins, was a Protestant minister. In 1881 the family moved to Newton, Massachusetts, where the reverend accepted a pastorate. After completing high school in Newton, Calkins attended Smith College and graduated in 1885. Shortly after her graduation, Calkins accompanied her family on a yearlong vacation in Europe. Upon their return, Calkins was offered a position at Wellesley College teaching Greek. This began Calkins's more than 40-year affiliation with Wellesley.

After Calkins had taught for about a year at Wellesley, college officials sought a woman to teach experimental psychology. Because no woman was available for the job, Wellesley officials decided to arrange for the training of one. Calkins was designated as that person because of her success as a teacher and her interest in philosophy. The appointment was made with the understanding that Calkins would study experimental psychology for a year. This posed a problem because none of the nearby institutions accepted female graduate students at the time. In 1890 Calkins contacted philosopher Josiah Royce and William James at Harvard, seeking permission to attend their seminars. Both Royce and James said yes, but Charles W. Eliot, Harvard's president, said no. After intense lobbying by Royce, James, and Calkins's father, Eliot reversed his position and allowed Calkins to attend graduate seminars at Harvard. He stipulated, however, that she attend without being officially enrolled as a Harvard student. Eliot was concerned

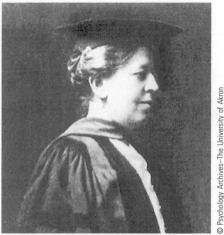

Mary Whiton Calkins

that Calkins's official enrollment would open the door to coeducation at Harvard, which he strongly opposed. When it became known that Calkins would be attending James's seminar, the male students promptly withdrew, presumably in protest. This left Calkins alone in the seminar with James to discuss his just-published Principles. Calkins (1930) described her experience:

I began the serious study of psychology with William James. Most unhappily for them and most fortunately for me the other members of his seminary in psychology dropped away in the early weeks of the fall of 1890; and James and I were left ... at either side of a library fire. The Principles of Psychology was warm from the press; and my absorbed study of those brilliant, erudite, and provocative volumes, as interpreted by their writer, was my introduction to psychology. (p. 31)

While Calkins was attending seminars at Harvard, she was also doing laboratory work at Clark University under the supervision of Edmund C. Sanford, who later became a president of the APA. This too was by special arrangement. Her research on dreams, under Sanford's supervision, was presented at the first annual APA meeting in December 1892 and published in 1893. Calkins also published a paper on the association of ideas, stimulated by James's seminar, in 1892.

In the fall of 1891, Calkins returned to Wellesley, where she established a psychology laboratory (the first in a women's college) and introduced experimental psychology into the curriculum. After about a year, Calkins felt the need to continue her formal education, so she returned to Harvard, again as a nonregistered student. By now James had moved on to philosophy on a full-time basis, and Münsterberg had taken over the psychology laboratory. For the first year and a half, while working with Münsterberg, Calkins continued to teach at Wellesley. Then, in the academic year of 1894-1895, she took an academic leave to devote herself full-time to laboratory work with Münsterberg. Calkins, who was two months older than Münsterberg, got along very well with him; the fact that Calkins was fluent in German probably helped. Münsterberg remained Calkins's mentor and advocate for many years. Strangely, Calkins and Münsterberg shared the same view of professional women. Both believed that the primary female roles were mother and wife. Calkins "pitied" and "condemned" women who declined marriage to pursue a career, although Calkins never married. She also disavowed feminism, believing that it was incompatible with family values: "Wherein feminism makes encroachments into the institution of the family, I cannot follow it" (Scarborough and Furumoto, 1987, p. 43). Münsterberg agreed, except for the cases of a few exceptional women who should pursue careers instead of motherhood. Clearly, Calkins was seen as such an exception.

While working in Münsterberg's laboratory, Calkins did original research on the factors influencing memory. During this research, Calkins invented the still widely used paired-associate technique to study the influence of frequency, recency, and vividness on memory. For example, Calkins showed her subjects a series of colors paired with numbers. Later, after several paired presentations, the colors alone were presented and the

subjects were asked to recall the corresponding numbers. Among other things, Calkins found that frequency of occurrence facilitated memory more than recency or vividness did. In addition to her work on paired-associate learning, Calkins did pioneering research on short-term memory (Madigan and O'Hara, 1992).

So impressed was Münsterberg that he described Calkins as the most qualified student he had supervised at Harvard, and he urged Harvard officials to accept her as a doctoral candidate. His request was considered and rejected. In April 1895, Calkins requested and was given an unofficial PhD examination, which she passed with high honors. James, who was a member of her examining committee, described her performance as the best he had ever seen at Harvard. In James's opinion, Calkins's performance exceeded even that of George Santayana, who until then had the reputation of having had the most outstanding performance on a Harvard PhD examination. Still, Harvard refused to grant Calkins a doctorate because she was a woman.

In 1894 Harvard created Radcliffe College as a degree-granting women's college. Radcliffe offered no graduate courses or seminars, and it had no laboratories. Those students officially enrolled at Radcliffe actually did all of their graduate work and research at Harvard. In April 1902, the governing board at Radcliffe voted to grant Calkins a PhD even though she had never been enrolled there. Münsterberg encouraged her to accept, but she refused.

After her unofficial PhD examination at Harvard, Calkins returned to Wellesley in the fall of 1895 as an associate professor. In 1898 she was promoted to full professor. Although trained in mainstream experimental psychology at Harvard and Clark, Calkins soon came to dislike the cold, impersonal nature of such psychology. Her attention shifted to self-psychology, showing the influence of James. According to Heidbreder (1972), Calkins came to see "the classical experimental psychologists as out of touch ... with important portions of ... [the] subject matter [of psychology] as it presents itself in ordinary experience as she herself observed it and as

she believed, by checking with others, that they too observed it" (p. 63). Calkins (1930) lamented that psychology, in its effort to rid itself of metaphysical speculation, had essentially dismissed the concept of self as unnecessary:

Modern psychology has quite correctly rid itself of the metaphysicians' self—the self often inferred to be free, responsible, and [immortal]—and has thereupon naively supposed that it has thus cut itself off from the self. But the self of psychology has no one of these inferred characters: it is the self, immediately experienced, directly realized, in recognition, in sympathy, in vanity, in assertiveness, and indeed in all experiencing. (p. 54)

Furumoto (1991) speculates that it was Calkins's life circumstances that created her intense interest in self-psychology:

It should come as no great surprise ... that the alternative to the classical experimental view espoused by Calkins concerned itself with something of the utmost significance to her and to the other women with whom she shared her Wellesley world, namely the reality and importance of selves in everyday experience. (p. 70)

Wentworth (1999) argues that Calkins's interest in self-psychology reflected her deep religious convictions:

Her personal and intellectual lives seem to have been bonded together by what I have come to think of as a distinctly moral paste composed of an interest not in the study of selves in isolation but in the study of selves living in knowledge of their interconnectedness to other human beings, to a divine being, or to both. (p. 128)

Calkins continued to promote self-psychology even in the heyday of behaviorism, when the topic of self-psychology was essentially taboo. Her tenacity finally resulted in the creation of a U.S. brand of personality theory featuring the concept of self. According to Woodward (1984), there were two pioneers of personality theory in the U.S.—Calkins and Gordon Allport—and Calkins was first.

Calkins remained at Wellesley until her retirement in 1929. During her academic career, she published four books and over a hundred journal articles. Also, it was Calkins, again demonstrating her facility with foreign languages, who translated La Mettrie's L'Homme Machine (Man a Machine) into English. Her major contribution to psychology was her version of self-psychology, which she developed over a period of 30 years. So significant were her contributions that even without an advanced degree, she was elected the first female president of the APA (1905). She was also the first female president of the American Philosophical Association (1918). She was granted honorary degrees by Columbia (1909) and by her alma mater, Smith (1910). In 1928 she was given honorary membership in the British Psychological Association. Calkins died in 1930 at the age of 67. (For interesting biographical sketches of Calkins, see Furumoto, 1991; Scarborough and Furumoto, 1987.)

GRANVILLE STANLEY HALL

In his influence on U.S. psychology, **Granville Stanley Hall (1844–1924)** was second only to William James. As we will see, Hall was a theorist in the Lamarckian and Darwinian traditions, but above all he was an organizer. The number of firsts associated with Hall is unequaled by any other U.S. psychologist.

Hall was born on February 1 in the small farming town of Ashfield, Massachusetts. In 1863 he enrolled in Williams College, where he learned associationism, Scottish commonsense philosophy, and evolutionary theory as he prepared for the ministry. Upon graduation in 1867, at the age of 23, he enrolled in the Union Theological Seminary in

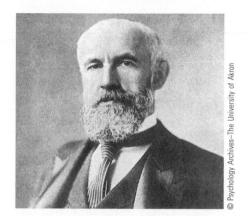

Granville Stanley Hall

New York City. There, Hall gave indications that perhaps he was not cut out for the clergy:

During his year in New York, he explored the city with zest, roaming the streets, visiting police courts, and attending churches of all denominations. He joined a discussion club interested in the study of positivism, visited the theater for plays and musicals, tutored young ladies from the elite of New York, visited a phrenologist, and generally had an exciting year. He was not noted for his religious orthodoxy. After preaching his trial sermon before the faculty and students, he went to the office of the president for criticism. Instead of discussing his sermon, the president knelt and prayed that Hall would be shown the errors of his ways. (R. I. Watson, 1978, p. 398)

In 1868 a small grant made it possible for Hall to travel to Germany, where he studied theology and philosophy. He also spent much time in beer gardens and theaters and engaged in considerable romance.

In 1871 Hall accepted a position at Antioch College in Ohio, where he not only taught English literature, French, German, and philosophy but also served as the librarian, led the choir, and did a little preaching. While at Antioch, Hall read Wundt's Principles of Physiological Psychology. In 1876 he was offered an instructorship of English at Harvard. During his stay at Harvard, Hall became friends with William James, who was only two years his elder. Hall did research in Harvard's medical school, writing up his results as "The Muscular Perception of Space," which he offered as his doctoral thesis in 1878. Harvard was the first institution to offer a doctorate in psychology, and in 1878 Hall was the first to obtain that degree (Ross, 1972, p. 79). After receiving his doctorate, Hall returned to Germany, where he studied first with Wundt and then with Helmholtz. Hall was Wundt's first student from the United States. In a letter to James, Hall confessed that he had learned more from Helmholtz than from Wundt.

In 1880 at the age of 36, Hall returned to the United States, where after giving a series of lectures, he accepted a position at Johns Hopkins University. In 1883 Hall set up a working psychology laboratory. It is generally agreed that Wundt founded the world's first psychology laboratory, in Leipzig in 1879, and that Hall's laboratory at Johns Hopkins was the first psychology laboratory in the United States (Boring, 1965). (As previously mentioned, the laboratory James established in 1875 is generally discounted because it was designed for teaching demonstrations rather than for research.) In 1884, at age 40, Hall became the first professor and departmental chair in the new field of psychology in the United States (Ross, 1972, p. 143). While at Johns Hopkins, besides founding a psychology laboratory, Hall founded the first U.S. journal dedicated to psychological issues, the American Journal of Psychology, which first appeared in 1887. Also while at Johns Hopkins, Hall taught James McKeen Cattell and John Dewey, who were later to become key figures in functionalism, and Arnold Gesell, who became a highly influential pediatrician. Also among Hall's students at Hopkins was Thomas Woodrow Wilson (1856-1924), who went on to become the 28th president of the United States. Under Hall's influence, Wilson actually pondered giving up his study of politics and history and majoring in psychology instead (Pruette, 1926, p. 91).

President of Clark University

In 1888 Hall left Johns Hopkins to become the first president of Clark University in Worcester, Massachusetts, but he also remained a professor of psychology. At Clark, Hall maintained a strong hand in directing and shaping U.S. psychology: "Hall was the Great Graduate Teacher of American psychology. By 1893 eleven of the fourteen PhD degrees from American universities had been given by him; by 1898 this had increased to thirty awarded out of fifty-four" (R. I. Watson, 1978, p. 403).

While at Clark University, Hall invited 26 of the most prominent psychologists in the United States and Canada to meet in Worcester to form an association of psychologists. The meeting took place on July 8, 1892, and represents the founding of the APA. Some of those who were invited did not attend (such as William James and John Dewey), but they were considered charter members because they were invited to join and they supported the association. The group also decided to extend membership in the new organization to five others, including two that Hall had neglected to invite and three recent Leipzig PhDs (including Münsterberg and Titchener). This brought the charter membership in the APA up to 31 (Sokal, 1992, p. 111). Hall was elected the first president of the APA, and in subsequent years William James and John Dewey would also serve as presidents. Besides being the first president, Hall was one of only two individuals to be elected to the presidency twice; James was the other. However, Hall died in 1924 before he could serve his second elected term. From an original membership of 31, the APA now has more than 148,000 members and affiliates. Michael Wertheimer has jokingly pointed out that "if [the] APA continues to grow at the rate it did during the first three-quarters of a century of its existence, there should be more psychologists than people in the world" (1987, p. 92).

In 1891 Hall founded the second U.S. psychological journal, *Pedagogical Seminary*, now the *Journal of Genetic Psychology*. In 1904 he founded the *Journal of Religious Psychology*, and in 1917 the *Journal of Applied Psychology*. Hall maintained an interest in religion, and in 1917 published *Jesus, the Christ, in the Light of Psychology*, which described Jesus as a mythical creation who symbolized all of the best human tendencies. For Hall the implications of the Jesus myth for humane living were more important than its theological implications:

The story of his death and resurrection embodied the fundamental rhythm of psychic life, from pain to joy; to experience and understand this rhythm in conversion was the supreme lesson of life. The message Jesus left was not to be projected "upon the clouds" or to be made into a cult for assuring immortality, but was to be realized within each individual, in this world, in service to his fellow man. (Ross, 1972, p. 418)

One critic of the book said, "If it is probable that president Hall has not carefully enough studied the Gospels, it is quite certain that he has not reverently enough studied the person of Jesus Christ". (Kemp, 1992, p. 294). In general, Hall's book was not well received by organized religion.

Hall's many other interests included the histories of philosophy and psychology, to which he made significant contributions (see Bringmann, Bringmann, and Early, 1992).

Recapitulation Theory

Hall was enamored with evolutionary theory. He said in his autobiography, "As soon as I first heard it in my youth I think I must have been almost hypnotized by the word 'evolution,' which was music to my ear and seemed to fit my mouth better than any other" (1923, p. 357). So strongly did Hall feel about evolutionary theory that he believed that it, instead of physics, should act as a model for science. He believed that evolution explained not only the phylogenetic development of the human species

but also the development of each individual. That is, he believed that each individual in his or her lifetime reenacted all evolutionary stages of the human species. This idea is called the **recapitulation theory** of development: "Every child, from the moment of conception to maturity, recapitulates, very rapidly at first, and then more slowly every stage of development through which the human race from its lowest beginnings has passed" (Hall, 1923, p. 380).

During prenatal development, a single-celled organism develops into a newborn child whose capabilities are equal to a number of mammals lower than humans on the phylogenetic scale. In child-hood, there is still evidence of the impulsiveness, cruelty, and immorality that characterized earlier, less civilized stages of human development. Hall's view was that if these primitive impulses were not given expression in childhood, they would be carried into adulthood. Hall therefore encouraged parents and teachers to create situations in which these primitive impulses could be given expression.

Hall's Magnum Opus

In 1904, when he was 60 and after 10 years of work, Hall published a two-volume, over 1300page book titled Adolescence: Its Psychology and Its Relations to Physiology, Anthropology, Sociology, Sex, Crime, Religion and Education, which focused on a wide variety of topics, including growth norms, language development, diseases of childhood, hygiene. juvenile crime, lying, showing off and bashfulness, fear, curiosity, and friendship. For Hall adolescence occurred between ages 14 and 24, and masturbation during that period was discussed in considerable detail. Hall rejected the claim that masturbation caused psychosis, or even death, but he did believe it had a number of less severe consequences: "Neurasthenia ... optical cramps ... weak sluggishness of heart action ... purple and dry skin ... anemic complexion, dry cough, and many digestive perversions can be attributed to this scourge of the human race" (1904, Vol.1, p. 443). In addition, "Growth, especially in the moral and intellectual regions, is dwarfed or stunted" (1904, Vol. 1,

p. 444). However, of all the effects of masturbation, Hall believed the most serious to be on the biological quality of the offender's offspring. Revealing his acceptance of Lamarckian theory, he said, "[W]orse and earlier than any of these psychic effects are those that appear in the offspring.... Its effects are manifest, nearer, perhaps, in the incomplete maturity of mind and body in the next generation; in persistent infantilism or overripeness of children" (1904, Vol. 1, p. 444). Masturbation, he said, is "destructive of that perhaps most important thing in the world, the potency of good heredity" (1904, Vol., 1, p. 453).

To discourage this "evil habit," Hall gave the following advice: "Work reduces temptation and so does early rising.... Good music is a moral tonic.... [Clold is one of the best of all checks.... Cold washing without wiping has special advantages.... Pockets should be placed well to the side and not too deep ... while habitually keeping hands in the pockets should be discouraged.... Rooms ... should not be kept too warm.... Beds should be rather hard and covering should be light" (1904, Vol. 1, pp. 465-469). Hall focused exclusively on masturbation among boys: "Evidently, masturbation among girls was something Hall either did not believe occurred or shied away from as too sensitive and potentially inflammatory to mention" (Arnett, 2006, p. 192).

Religious Conversion

Hall believed that religious conversion during adolescence was "a natural, normal, universal, and necessary process" (1904, Vol. 2, p. 301). Although he used Christian terminology to describe this "conversion," Hall was clear that he was not referring to the acceptance of any religious dogma. Sin, for him, was not a state of evil but a sense of limitation and imperfection that should be understood psychologically rather than in terms of religious dogma (1904, Vol. 2, p. 314). He took issue with those who viewed the Bible with "bibliolatry and parasitic literalism" (1904, Vol. 2, p. 330), and he declared "eternal warfare upon orthodoxies and all dogmatic finalities" (1904, Vol. 2, p. 330). So what was the

religious conversion that Hall referred to? Rather than embracing a set of religious beliefs, it was the psychological process of subordinating the self to the needs of others. "Self-love merges in resignation and renunciation into love of man: Religion has no other function than to make this change complete ... for the love of God and the love of man are one and inseparable" (1904, Vol. 2, p. 304). For Hall, then, the conversion he referred to was "the great conversion from love of self to love of others" (1904, Vol. 2, p. 345).

Many psychologists today, although perhaps sympathetic to Hall's urging adolescents to become less selfish, would not describe that process in religious or spiritual terms. Fewer still would agree the process is normative or universal among adolescents (Arnett, 2006, p. 194).

Sublimation

Hall believed that "any sexual act not designed to produce offspring was sinful, and the temptation to engage in sinful sex was great if not overwhelming" (Graebner, 2006, p. 239). Hall's proposed solution to the problem was the inhibition of the adolescent sex drive. Such inhibition, he claimed, converts sexual desire into social progress. "Powerful feelings, checked and redirected, erotic energy converted to mental energy: Hall's prescription for adolescence ... his recipe for social progress; and an explanation for his own success" (Graebner, 2006, p. 240). Although Hall didn't use the term sublimation in 1904, he certainly employed the concept, and he did so a year before it appeared it Freud's published works. In later publications, Hall did use the term sublimation after he became aware of Freud's definition and use of the term.

Hall's Opposition to Coeducation

One of Hall's main arguments for sex-segregated schools was that it enhanced sublimation and, thus, facilitated social progress:

Sex-segregated schools would hold the sexes apart, not only or simply to allow them to prosper along their natural,

different gender trajectories, but also as poles on a battery, separated to avoid the inevitable short circuit, but also because the "hot", passionate, tingling, erotic sensibilities of adolescence, heightened by separation, created an intense field of force, a kind of adolescent social electricity that was Hall's designated path to progress. (Graebner, 2006, pp. 243–244)

Hall viewed females as vital for the future evolution of the human species, and adolescence should be a period when females are trained for motherhood. As females are preparing for motherhood, males still have the need to satisfy primitive impulses, and therefore it makes no sense to include both sexes together in the same educational system:

The premises of Hall's argument against coeducation were derived from three concerns of recapitulation: (a) that adolescence was a critical period in the development of the reproductive organs in women, (b) that the adolescent male needed freedom to engage in cathartic expression of his savage impulses, and (c) that natural sexual differentiation during adolescence was the basis for later attraction between the sexes. (Diehl, 1986, p. 871)

As part of his concern for the normal development of the female reproductive capacity, Hall (1906) was worried about what association with males might do to the "normalization" of the menstrual period:

At a time when her whole future life depends upon normalizing the lunar month, is there not something not only unnatural and unhygienic, but a little monstrous, in daily school associations with boys, where she must suppress and conceal her instincts and feelings, at those times when her own promptings suggest withdrawal or stepping a little aside to let Lord Nature do his magnificent work of efflorescence. (p. 590)

In an address before the American Academy of Medicine in 1906, Hall elaborated his opposition to coeducation:

It [coeducation] violates a custom so universal that it seems to express a fundamental human instinct.... Girls ... are attracted to common knowledge which all share, to the conventional, are more influenced by fashions, more imitative and lack the boy's intense desire to know, be, do something distinctive that develops and emphasizes his individuality. To be thrown on their own personal resources in sports, in the classroom, in nature study and elementary laboratory brings out the best in a boy, but either confuses or strains a girl. (Denmark, 1983, p. 38)

Hall's views on women, although widely accepted at the time, did not go unchallenged. For example, Martha Carey Thomas, a feminist and the president of Bryn Mawr College said, "I had never chanced again upon a book that seemed to me to degrade me in my womanhood as the seventh and seventeenth chapters on women and women's education of President G. Stanley Hall's *Adolescence*" (Denmark, 1983, p. 38).

Diehl (1986) indicates that Hall's views of women were paradoxical (as were Titchener's and Münsterberg's). On one hand, Hall was unambiguously against coeducation, and he believed that the primary role for women was motherhood. On the other hand, at the beginning of the 20th century, Clark University, under Hall's leadership, was considered one of the institutions most open to female graduate students (Cornell was another). In addition, Hall seems to have been highly supportive of female graduate students in psychology as well as many other fields.

In general, Hall urged the study of adolescence because he believed that at this stage of development, habits learned during childhood were discarded but new adult habits had not yet been learned. During this transitional period, the individual was forced to rely on instincts, and therefore adolescence was a very good time to study human instinctual makeup.

Hall's Adolescence went through several printings for 20 years after its initial publication. It remained the standard text in the field until it was displaced by Leta Stetter Hollingworth's text *The Psychology of the Adolescent* (1928). What do contemporary psychologists think of Hall's *Adolescence*? Arnett's overall evaluation is positive:

Many of the findings we view today as new discoveries were already discussed by Hall a hundred years ago. I cannot discuss all of them here, so I will focus on some of the similarities I believe are most notable. Areas of similarity ... are the prevalence of depressed mood in adolescence; adolescence as a time when crime rates peak; adolescence as a time of high sensation seeking; susceptibility to media influences in adolescence; characteristics of peer relations in adolescence; and biological development during puberty. (2006, p. 187)

Several of Hall's beliefs are now considered incorrect—for example, his views of sexuality, especially masturbation, and his claim that religious conversion is normative or even universal in adolescence. He embraced the negative racial stereotypes that characterized the Victorian era in which he lived (Youniss, 2006, pp. 228-230), as well as Lamarckian theory (Arnett, 2006, pp. 190-194). Also, like Spencer but unlike Darwin, Hall believed that evolution meant progress: "Nothing so reinforces optimism as evolution. It is the best, or at any rate not the worst, that survive. Development is upward, creative, and not decreative. From cosmic gas onward there is progress, advancement, and improvement" (1904, Vol. 2, p. 546). Still, Hall is generally considered a pioneer in educational, child, and adolescent psychology and in parent education and child welfare programs (Brooks-Gunn and Johnson, 2006, p. 249). As Arnett (2006) concludes, "Who among us can hope to fare as well?" (p. 196). The entire August 2006 issue of History of the content of Psychology examines Adolescence and its historical influence.

Hall's interests in developmental psychology lasted throughout his life. His Senescence: The Last Half of Life (1922) can be seen as a forerunner of life-span psychology as well as an extension of what he started in Adolescence. Hall's Senescence is generally considered a classic in the study of aging. Among the topics covered were a cross-cultural analysis of the treatment of the elderly, sources of pleasure, belief in an afterlife, anxiety concerning death, beliefs about longevity, and recognition of the signs of aging. He also reviewed the pension plans available to the elderly in various countries, and he found the United States to be inferior to many countries in this regard. This, of course, was before the Social Security Act of 1935.

Hall's autobiography, *Life and Confessions of a Psychologist*, appeared in 1923, and a year later he died, on April 24, of pneumonia. Ross (1972) comments on an event that occurred at Hall's funeral: "The local minister caused a brief scandal by criticizing Hall for not having appreciated the importance of the institutional church, a scandal which Hall surely would have relished" (p. 436).

Francis Cecil Sumner

The fact that Hall's last graduate student was Francis Cecil Sumner (1895-1954), an African American, further testifies to his willingness to accept students who would have been, or were, rejected elsewhere at the time. Sumner was born in Pine Bluff, Arkansas, on December 7, just over 30 years after the abolishment of slavery in the United States (1863). Because most African Americans who had been slaves had no last names, Sumner's parents took their name out of respect for the one-time Massachusetts senator Charles Sumner (Guthrie, 2000, p. 182). Francis attended elementary schools in Virginia, New Jersey, and the District of Columbia. Little was available in the way of secondary education for African Americans at the time, and that little was poor quality, so Francis obtained his secondary education through extensive reading under the guidance of his parents. After passing a qualifying examination, Sumner was written admission to Lincoln University, an granted

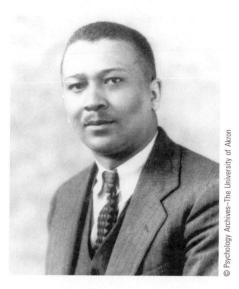

Francis Sumner

African American institution in Pennsylvania, at the age of 15. In 1915, at age 20, he received a BA, magna cum laude, with special honors in English, modern language, Greek, Latin, and philosophy (Guthrie, 2000, p. 182). He was then accepted into the undergraduate program at Clark, where he obtained a second BA in 1916. He then returned to Lincoln University as a graduate student, taught several courses in psychology and German, and obtained an MA in 1917.

Sumner applied for admission into doctorate programs at the University of Illinois and American University but was rejected. He then applied directly to G. Stanley Hall, then president of Clark University, who accepted him into the PhD program in psychology. Sumner began his PhD program, but his work was interrupted when he was drafted into the army in 1918. He eventually saw combat in France as a 22-year-old sergeant. During his military service, Sumner and Hall corresponded frequently, and when he was discharged in 1919, Sumner resumed his doctoral studies at Clark. On June 11, 1920, Sumner defended his doctoral dissertation, "Psychoanalysis of Freud and Adler." and on June 14, he, a 24-year-old World War I veteran, became the first African American to obtain a PhD in psychology. In 1920 Sumner

accepted a teaching position at Wilberforce University in Ohio and taught at Southern University during the summer of 1921. In the fall of 1921, Sumner accepted the position of chair of the departments of psychology and philosophy at West Virginia Collegiate Institute (WVCI; now West Virginia State College).

While at WVCI, Sumner published two articles (1926, 1927) that argued for segregated higher education for African Americans and whites based on the contention that African Americans were "on a lower cultural level than the White race" (1926, p. 43). Sumner supported the contention of Booker T. Washington, founder of the Tuskegee Institute in Alabama, that higher education for African Americans should emphasize training in agriculture and in various trades such as carpentry, plumbing. and masonry. Sumner's 1927 article reiterated the claim of "the cultural inferiority of the Negro" and the need for limiting the higher education of African Americans to "industrial and moral training" (p. 168). However, Sawyer (2000) provides considerable evidence that Sumner's public statements concerning segregated education did not correspond to his private beliefs and activities. Rather, Sawyer argues, Sumner was saying publicly what needed to be said given the social circumstances at the time in order to gain support for African American education. Exemplifying these social circumstances was the statement made in October 1921 by President Warren Harding that social equality between African Americans and whites would never be possible because of "fundamental, inescapable, and eternal differences of race" (Eisenberg, 1960, p. 194). According to Sawyer. Sumner had a "hidden agenda," and his public statements were fully pragmatic under the circumstances.

In 1928 Sumner resigned from WVCI and accepted a position at Howard University in Washington, DC, where he was charged with improving the quality of the psychology department. Although during Sumner's time there the highest degree that could be earned was the MA, Howard became a major center for the training of African American psychologists.

Sumner was described by his former students as "a low-keved and very dedicated psychologist; as a very quiet and unassuming individual who was brilliant with a tremendous capacity to make an analysis of an individual's personality; and as Howard's most stimulating scholar" (Guthrie, 2000, p. 192). Sumner became a fellow of the APA and held memberships in the American Association for the Advancement of Science, American Educational Psychological Research Association. Eastern Association, Southern Society for Philosophy Psychology, and District of Columbia Psychological Association.

On January 12, 1954, Sumner suffered a fatal heart attack while shoveling snow at his home in Washington, DC. As a World War I veteran, he received a military funeral, with honor guard, at Arlington Cemetery in Virginia. He was eulogized by, among others, Mordecai Johnson, the president of Howard University (Guthrie, 2000, p. 193).

By 1972, when Howard first offered the PhD, 300 African Americans had earned PhDs from U.S. colleges and universities. Of these 300, 60 had received a BA or MA from Howard University. Howard was so influential in the training of African American psychologists that it came to be known as the "Black Harvard" (Phillips, 2000, p. 150).

One of the best known products of the Howard psychology program was Kenneth Clark. **Kenneth Bancroft Clark (1914–2005)** arrived at Howard in the fall of 1931 with the goal of eventually studying medicine. After experiencing Sumner's introductory psychology class, Clark declared, "To hell with medical school.... [Psychology] is the discipline for me" (Hentoff, 1982, p. 45). Clark obtained a BA and MA from Howard and remained there as an instructor while his wife, Mamie Phipps Clark (1917–1983), completed her undergraduate work at Howard. Concerning Sumner's influence on him, Clark said,

Professor Sumner had rigorous standards for his students. And he didn't just teach psychology. He taught integrity. And although he led the way for other Blacks in psychology, Sumner would permit no nonsense about there being anything like "Black psychology"—any more than he would have allowed any nonsense about "Black astronomy." In this and in many other ways, Sumner was a model for me. In fact, he has always been my standard when I evaluate myself. (Hentoff, 1982, p. 45)

Sawyer (2000) offers Clark's experience with Sumner as evidence that Sumner did not really believe his own public statements concerning the need for segregated higher education.

Clark and his wife went on to obtain their PhDs from Columbia University and subsequently did pioneer work on the developmental effects of prejudice, discrimination, and segregation on children (for example, Clark and Clark, 1939, 1940, 1947, 1950). (For a review of Mamie Phipps Clark's life and accomplishments, see Lal, 2001). It was a portion of this research that was featured in a court brief (1952) presented in the 1954 Supreme Court case Brown v. Board of Education. The court's decision ended the legal basis for segregated education in the United States and "served as a precursor for legislation barring separate public accommodations based on race" (Guthrie, 2000, p. 181). Perhaps the most famous study considered in the Brown case is Clark and Clark, 1947, in which 2- to 7-year-old black children were shown two sets of dolls that were identical except for skin and hair color. A majority of the black children judged the white dolls to have the "nice color" and indicated that they would be their preferred playmates. Also, when the black children were instructed to "give me the doll that looks like you," 39% of them chose the white doll. Another study considered by the Supreme Court was Deutscher and Chein (1948), in which the opinions of social scientists concerning the effects of enforced segregation were surveyed. The results were a practically unanimous opinion that enforced segregation had detrimental effects on black children, and slightly fewer (83%) believed it also had detrimental effects on white children. Presumably, it was the information

Kenneth Clark and Mamie Phipps Clark

provided by such studies as Clark and Clark (1947) and Deutscher and Chein (1948) that led the Supreme Court to conclude that "segregation was psychologically damaging both to minority and majority children" (Jackson, 1998, p. 152).

Although there were several psychologists, sociologists, and other social scientists involved in the efforts to desegregate schools, it is generally agreed that no one was more instrumental than Clark (Benjamin and Crouse, 2002, p. 40). Perhaps it is ironic that 30 years earlier, Clark's mentor, Sumner, had advocated segregated education. However, Sawyer (2000) concludes, "It is reasonable to believe that Sumner's efforts were in some way responsible both for Clark's contributions and for the change in social climate that enabled the Supreme Court's 1954 decision" (p. 137). Sumner died four months before the Brown decision, but he was aware of the impending collapse of the legal basis for segregated education and was proud of the fact that one of his students had played such a significant role in that collapse (Sawyer, 2000, p. 137).

How important was the Brown decision? Michael Klarman, a legal scholar, says, "Constitutional lawyers and historians generally deem Brown v. Board of Education to be the most important United States Supreme Court decision of the twentieth century, and possibly of all time" (1994, p. 81). Perhaps because psychologists were so instrumental in the Brown decision, one might have expected that the APA would have embraced that decision and its implications enthusiastically, but that was not the case. Following Brown, the APA was slow to confront racial issues both within its own organization and in U.S. culture in general. Eventually, however, due largely to Clark's efforts, both issues were given considerable attention (Benjamin and Crouse, 2002; Pickren and Tomes, 2002). In fact, Clark went on to become the first, and to date the only, African American president of the APA (1970). One legacy of Clark's presidency was the establishment in 1971 of the Board of Social and Ethical Responsibility in Psychology (BSERP), which provided the APA with a powerful platform from which to deal with social and ethical concerns (Pickren and Tomes, 2002). In 1978 the APA presented Clark with its first Award for Distinguished Contributions to the Public Interest. In 1994, 40 years after the Brown decision, the APA presented Clark with its Award for Outstanding Lifetime Contribution Psychology; he was only the sixth psychologist to receive this prestigious award.

Clark's research, his views, and the extent of his influence have not gone unchallenged. The scientific rigor of the research that he and his colleagues submitted to the Supreme Court was criticized almost immediately (see, for example, Cahn, 1955; Van den Haag, 1960). Kendler (2002) says, "A reexamination of the evidence [provided to the Supreme Court by Clark and his colleagues] has led to the conclusion ... that the data offer a flimsy edifice to support the broad conclusions drawn" (p. 79). Some have argued that the desegregation of the 1950s and 1960s was already well underway before *Brown* and would have progressed better without the bitterness and backlash caused by the court's decision (for example, Klarman, 1994).

Similarly, Kendler (2002) speculates that it was more the Zeitgeist in the United States following World War II that influenced the *Brown* decision than the information provided to the court by Clark and his colleagues.

Clark has been criticized for abandoning the neutral objectivity of a scientist and, instead, becoming a political advocate. Phillips (2000) observes that Clark did conduct his investigations within an Afrocentric perspective and made no apologies for doing so (for example, Clark, 1965/1989, pp. xxxv, 78-80). Of course, this stance alienates more objectively oriented psychologists who argue that scientific observations should always be detached—that is, free of value judgments (see, for example, Kendler, 2002). Jackson (2003) argues against Kendler's (2002) contention that Clark and his colleagues violated scientific objectivity. Kendler (2003) rebuts Jackson's arguments and elaborates his reasons for believing that Clark and his colleagues did, in fact, violate scientific objectivity.

For whatever reason, Clark looked back upon his lifelong effort to bring about racial equality as essentially a failure (for example, Clark, 1965/1989, p. 18; 1986, p. 21). Phillips (2000) disagrees with Clark's assessment of his own life's work and after reviewing his accomplishments says, "The weight of the historical evidence argues otherwise" (p. 164). On the other hand, Keppel (2002) generally agrees with Clark's assessment of his efforts and concludes that today race relations are "moving further and further away from the vision and values expressed in Brown and in the public work of Kenneth B. Clark" (p. 36). For example, Daryl Michael Scott, an African American historian, has recently argued that enforced segregation can be harmful to the black community but that selfimposed segregation need not be. Black schools, he says, can "provide Black students a more affirming psychological environment and produce equal educational results" (1997, p. 129).

Kenneth Clark died at his home in Hastingson-Hudson, New York, on May 1, 2005, at the age of 90. He was survived his daughter Kate Clark Harris, his son Hilton B. Clark, three grandchildren, and five great-grandchildren.

Psychology at Clark University

Hall's 31 years as president of Clark University were colorful, to say the least. Under his leadership, psychology dominated Clark, and Clark was a strong competitor with Harvard for top students and faculty. In 1908 Hall decided to invite prominent European psychologists to Clark University to celebrate its 20th anniversary. Hall sent invitations to both Wundt and Freud, and both invitations were rejected. Wundt rejected the "enticing" invitation because he had already agreed to be the primary speaker at the 500th anniversary of Leipzig University on the date in question. Freud declined because the date conflicted with another commitment and because the honorarium was too small. Hall sent a revised invitation to Freud with a date more compatible with Freud's schedule and with a larger honorarium, and Freud accepted (Rosenzweig, 1985). It is interesting to note that Hall would have been as pleased with Wundt as he was with Freud; he had a deep respect for both. Hall had long been interested in Freud's ideas and was among the first to urge sex education in the United States. Earlier, as part of his recapitulation theory, Hall had suggested that memories of ancestral experiences often unconsciously influence the fantasies of adolescents. There was, therefore, a theoretical kinship between him and Freud and also with Carl Jung, who was also invited to Clark along with Freud. Freud and Jung arrived on September 5, 1909, and, according to Freud, this visit to Clark did much to further the acceptance of his theory throughout the world. (For the interesting details of Freud and Jung's visit to the United States, see Rosenzweig, 1992.)

FUNCTIONALISM AT THE UNIVERSITY OF CHICAGO

John Dewey

Despite the fact that functionalism was never a well-defined school of thought, as structuralism was, its founding is commonly attributed to **John**

Dewey (1859-1952) (1859-1952), even though James, Münsterberg, and Hall certainly laid important groundwork. Although, as we shall see, Dewey was strongly influenced by James, Shook (1995) indicates that several of Dewey's functionalistic ideas came originally from Wundt's voluntarism (see Chapter 9) and James's influence was primarily to confirm and expand those ideas. Dewey was born in Burlington, Vermont, on October 20. His father, Archibald Sprague Dewey, was a grocer. While attending the University of Vermont as an undergraduate, John Dewey became interested in philosophy. Following graduation, he taught secondary school for three years before entering Johns Hopkins University in 1882 to pursue his interests in philosophy. Dewey had Hall as a teacher but was also strongly influenced by philosopher George S. Morris (1840–1889). Besides psychology, Dewey also developed a strong interest in the philosophies of Hegel and Kant; he wrote his dissertation on Kant's philosophy. Dewey's first academic appointment was at the University of Michigan, where he taught both philosophy and psychology. While at Michigan, Dewey wrote Psychology (1886), which was a strange mixture of Hegelian philosophy and functionalistic psychology. It preceded James's Principles by four years. Dewey was at Michigan for 10 years (1884-1894), except for one year spent at the University of Minnesota.

In 1894 Dewey accepted an appointment as chair of the philosophy department at the newly established University of Chicago (at that time, philosophy included psychology and pedagogy). It was at Chicago that Dewey wrote "The Reflex Arc Concept in Psychology" (1896), which many think marks the formal beginning of the school of functionalism. Boring (1953) referred to Dewey's 1896 article as "a declaration of independence for American functional psychology" (p. 146).

Dewey's Criticism of the Analysis of Behavior in Terms of Reflexes. Dewey's argument was that dividing the elements of a reflex into sensory processes, brain processes, and motor responses for analysis was artificial and misleading. According to

Psychology Archives-T

John Dewey

Dewey, dividing behavior into elements was no more justifiable than dividing consciousness into elements. Showing the influence of James's Principles, Dewey claimed that there is a stream of behavior just as there is a stream of consciousness. The three elements of a reflex, said Dewey, must be viewed as a coordinated system directed toward a goal, and this goal is usually related to the survival of the organism. Dewey took a child touching a candle flame as an example. The analysis of such behavior in terms of reflexes claims that the child sees the flame of a candle (S) and grasps it (R). The resulting pain (S) then elicits withdrawal (R). According to this analysis, nothing changes, nothing is learned. In reality, however, the experience of being burned changes the child's perception of the flame, and he or she will avoid it next time. This, according to Dewey, could happen only if the child was still observing the flame while being burned and withdrew. Thus, the so-called stimuli and responses are not separate but form an interrelated sequence of functional events. Indeed, for the child, the candle flame is no longer the same stimulus; it now elicits avoidance. Dewey urged that all behavior be viewed in terms of its function—to adapt the organism to its environment. To study elements of the adaptive act in isolation causes one to miss the most important aspect of the act: its purposiveness. "There is simply a continuously ordered sequence of acts, all adapted in themselves

and in the order of their sequence, to reach a certain objective end, the reproduction of the species, the preservation of life, locomotion to a certain place" (Dewey, 1896, p. 366).

As an evolutionist, Dewey thought that social change was inevitable, but he also believed that it could be influenced positively by proper plans of action. Dewey was very influential in creating what came to be called "progressive" education in the United States. He believed that education should be student-oriented rather than subjectoriented and that the best way to learn something was to do it-thus his famous statement that students learn by doing. Dewey was very much opposed to rote memorization, drills, and the view that the purpose of education is to transmit traditional knowledge. Material should never be presented as something final or complete. It should be presented in such a way that stimulates personal interest in learning and the development of problem-solving skills:

Material should be supplied by way of stimulus, not with dogmatic finality and rigidity. When pupils get the notion that any field of study has been definitely surveyed, that knowledge about it is exhaustive and final, they may continue docile pupils, but they cease to be students. (Dewey, 1910/1997, p. 198)

Clearly, Dewey believed that education should facilitate creative intelligence and prepare children to live effectively in a complex society.

As James had, Dewey embraced pragmatism. For both, abstract philosophical concepts were meaningful only insofar as they had practical value. Dewey believed that the concept of democracy has to be made a living truth in the lives of individuals—in their educational experiences, for example. In several influential books, Dewey described how democratic ideals could be, and should be, translated into social action (*The School and Society*, 1899; *Interest and Effort in Education*, 1913; *Democracy and Education*, 1916; *Individualism: Old and New*, 1929; *Liberalism and Social Action*, 1935; *Experience and Education*, 1938; *Freedom and Culture*, 1939).

Dewey was always deeply involved in liberal causes, such as the New York Teacher's Union, the American Association of University Professors, and the American Civil Liberties Union. He was also supportive of his wife's promotion of women's suffrage:

An anecdote was widely circulated at the time that Dewey was marching in a parade supporting women's suffrage carrying a placard that was handed to him. He had not read its message: "Men can vote! Why can't I?" and was puzzled by the amused smiles of the onlookers. (Hilgard, 1987, p. 673)

In 1904 friction with the education department caused Dewey to resign from the University of Chicago and to accept an appointment at Teachers College at Columbia University, where he pursued his interests in education and pragmatic philosophy. He died in New York City on June 1, 1952, at the age of 93.

James Rowland Angell

James Rowland Angell (1869-1949) was born on May 8 in Burlington, Vermont (the same place as Dewey). He was the son of the long-term president of the University of Michigan. Angell was Dewey's student while Dewey was at Michigan, and after graduating in 1890, Angell remained for a year of graduate training. It was during that year that he attended a seminar conducted by Dewey on James's newly published Principles. The seminar switched Angell's primary interest from philosophy to psychology. The following year, Angell went to Harvard and became acquainted with James. The years 1892-1893 were spent traveling and studying in Germany. He attended lectures by Ebbinghaus and started to prepare a doctoral dissertation on Kant's philosophy under the supervision of the famous philosopher Hans Vaihinger but never finished. Two master's degrees, one from Michigan in 1891 and one from Harvard in 1892, were to remain his highest earned degrees.

James Rowland Angell

In 1893 Angell accepted an instructorship at the University of Minnesota (instead of finishing his doctoral dissertation) but stayed for only one year. In 1894 he accepted a position at the University of Chicago, offered to him by his former teacher, Dewey. Angell was 25 years old at the time, and Dewey was 10 years his senior. Angell, Dewey, and their colleagues were highly productive and influential at Chicago. In 1896 Dewey published his famous article on the reflex arc, and in 1904 Angell published the very popular Psychology: An Introductory Study of the Structure and Functions of Human Consciousness. Both Dewey and Angell eventually served as presidents of the APA (Dewey in 1899, Angell in 1906). Angell's presidential address, "The Province of Functional Psychology," distinguished between functional and structural psychology (a distinction that Titchener had originally made in 1898). In his address, Angell made three major points:

Functional psychology is interested in mental operations rather than in conscious elements, but even mental operations in isolation are of little interest:

The functional psychologist ... is interested not alone in the operations of mental process considered merely of and by and for itself, but also and more vigorously in mental activity as part of a larger stream of biological forces which are daily and hourly at work before our eyes and which are constitutive of the most important and most absorbing part of our world. The psychologist of this stripe is wont to take his cue from the basal conception of the evolutionary movement, i.e., that for the most part organic structures and functions possess their present characteristics by virtue of the efficiency with which they fit into the extant conditions of life broadly designated the environment. (Angell, 1907, p. 68)

- Mental processes mediate between the needs of the organism and the environment. That is, mental functions help the organism survive. Behavioral habits allow an organism to adjust to familiar situations; but when an organism is confronted with the unfamiliar, mental processes aid in the adaptive process.
- Mind and body cannot be separated; they act as a unit in an organism's struggle for survival.

At the time of Angell's address, functionalism was an established and growing school and a strong competitor to structuralism. By further demonstrating its kinship with evolutionary theory, functionalism encouraged the study of not only consciousness but also animal behavior, child psychology, habit formation, and individual differences. In addition, with its strong pragmatic orientation, it encouraged the application of psychological principles to education, business, and clinical psychology.

Angell was chairman of the psychology department at Chicago for 25 years. Under his leadership, the University of Chicago became a center of functionalism. Among Angell's famous students were Harvey Carr, who we consider next, and John B. Watson, who will be featured in the next chapter.

In 1921 Angell left Chicago to become president of Yale University, a post he held until his retirement in 1937. He died on March 4, 1949, in New Haven, Connecticut. For an interesting discussion of Angell's life and accomplishments, see Dewsbury, 2003.

Harvey Carr

Harvey Carr (1873–1954), born in Indiana on April 30, obtained his bachelor's and master's degrees from the University of Colorado and then went to the University of Chicago, where he obtained his doctorate in 1905 under the supervision of Angell. Carr stayed at Chicago throughout his professional life, and in 1927 he was elected president of the APA.

In 1925 Carr wrote *Psychology: A Study of Mental Activity*. Mental activity was "concerned with the acquisition, fixation, retention, organization, and evaluation of experiences, and their subsequent utilization in the guidance of conduct" (Carr, 1925, p. 1). We see in Carr's definition the functionalist's concern with the learning process.

Psychology Archives—The University of Akron

Harvey Carr

Because learning is a major tool used in adjusting to the environment, it was a major concern of the functionalists. Central to Carr's psychology is what he called the adaptive act, which has three components: (1) a motive that acts as a stimulus for behavior (such as hunger or thirst), (2) an environmental setting or the situation the organism is in, and (3) a response that satisfies the motive (such as eating or drinking). Here again, we see the influence of evolutionary theory on functionalism: Needs must be met for organisms to survive. Needs motivate behavior until an act satisfies the need, at which point learning occurs; and the next time the organism is in the same situation and experiences the same need, the organism will tend to repeat the behavior that was effective previously. For Carr both perception and behavior were necessary in adapting to the environment because how the environment is perceived determines how an organism responds to it. Seeing a wild animal in a zoo and seeing one while walking through the forest would elicit two different reactions.

Besides the adaptive act, Carr (1925) included sections on the human nervous system and sense organs, learning, perceiving, reasoning, affection, volition, individual differences, and the measurement of intelligence. Carr had a special interest in space perception and wrote an entire book on the topic (Carr, 1935). Although Carr, like the other functionalists, accepted both introspection and experimentation as legitimate methods, the latter became the favored research technique. One reason for this preference was the growing success of animal research in which introspection was, of course, impossible. Showing both the pragmatism that characterized functionalism and a remarkable similarity to Wundt, Carr believed that literature, art, language, and social and political institutions should be studied in order to learn something about the nature of the mind that produced them.

Heidbreder divided the functionalistic movement into three phases: "its initiation by Dewey, its development under Angell's leadership, and its preservation as a definite influence by Carr" (1933, pp. 208–209).

FUNCTIONALISM AT COLUMBIA UNIVERSITY

James McKeen Cattell

Functionalism took on a slightly different appearance under the leadership of **James McKeen Cattell (1860–1944)**, who, as noted in Chapter 10, was strongly influenced by Galton.

In 1891 Cattell accepted a professorship at Columbia University, where he stayed for 26 years. Cattell did basic research in such areas as reaction time, psychophysics, and mental testing. As we have seen, Cattell followed Galton in assuming that intelligence could be measured by studying sensory and motor abilities. In fact, he used many of the same tests Galton had used—for example, dynamometer pressure, least noticeable difference in weight, and reaction time. We also saw in Chapter 10 that Cattell's testing program was ill-fated.

Cattell and Applied Psychology. Cattell said that "sciences are not immutable species, but developing organisms" (1904, p. 176). This being so, why not experiment with ideas and methods? Who knows what may prove to be valuable? "Let us take a broad outlook and be liberal in our appreciation; let us welcome variations and sports; if birth is given to monstrosities on occasion, we may be sure that they will not survive" (Cattell, 1904, p. 180). But, true to the pragmatic spirit, Cattell (1904) believed that ideas and methods should always be evaluated in terms of their usefulness:

If I did not believe that psychology affected conduct and could be applied in useful ways, I should regard my occupation as nearer to that of the professional chessplayer or sword swallower than to that of the engineer or scientific physician. (p. 185)

According to Cattell, almost everyone attempts to apply psychological principles in what they do: "All our systems of education, our churches, our legal systems, our governments and the rest are applied psychology" (1904, p. 186). It is not, then, a

matter of whether behavior should be controlled or not. It is a matter of using the most valid knowledge of psychological principles in exercising that control. Here psychology can be extremely helpful:

It certainly is not essential and perhaps is not desirable for every mother, for every teacher, for every statesman, to study psychology, especially the kind of psychology at present available. It is not necessary for a man to be either a psychologist or a fool at forty; he may, for example, be both. But surely it is possible to discover whether or not it is desirable to feed a baby every time it cries, to whip a boy when he disobeys or to put a man in prison when he breaks a law. If each man were given the work he is most competent to do and were prepared for this work in the best way, the work of the world all the way from the highest manifestations of genius to the humblest daily labor would be more than doubled. I see no reason why the application of systematized knowledge to the control of human nature may not in the course of the present century accomplish results commensurate with the nineteenth century applications of physical science to the material world. (Cattell, 1904, p. 186)

In 1895, when he was only 35 years old, Cattell was elected as the fourth president of the APA, following William James. Also in 1895, Cattell purchased the financially troubled journal Science. Under Cattell's leadership, Science overcome its difficulties and in 1900 became the official publication of the American Association for the Advancement of Science (AAAS). In 1894, along with James Mark Baldwin, Cattell founded the third U.S. psychology journal, Psychological Review. Cattell was part owner and editor of Psychological Review from 1894 to 1904. Editing and entrepreneurship took more and more of Cattell's time, and eventually he established his own publishing firm, Science Press. Soon he became sole owner, publisher, and editor of a number of journals, including *Psychological Review, Science, Popular Science Monthly, The American Naturalist*, and *School and Society*. In 1921 Cattell (along with Thorndike and Woodworth) founded the Psychological Corporation, designed to provide a variety of services to education and industry. The Psychological Corporation continues to thrive.

By 1917 Cattell had a rather negative relationship with the president of Columbia. Cattell had been instrumental in the founding of the American Association of University Professors (AAUP), which favored complete academic freedom and tenure. He was elected president of AAUP in 1925. It was Cattell's pacifism, however, that led to his dismissal from Columbia:

[The president of Columbia University] fired him from his position on the Columbia faculty because of a letter he had written on Columbia University stationery urging that draftees not be sent overseas against their will. It was believed that the charge of pacifism was behind the firing, and other members of the faculty ... resigned from Columbia in protest. (Hilgard, 1987, p. 748)

Nonetheless, under Cattell's influence, Columbia became a stronghold of functionalism, even surpassing the University of Chicago:

Cattell was very active at Columbia between 1891 and 1917, during which time Columbia became the leading producer of PhDs in psychology. In 1929, of the 704 APA members possessing the doctorate, 155 had their degrees from Columbia, with Chicago second with 91.... If we count both Chicago and Columbia as essentially centers of functional psychology, they together accounted for 35% of the PhDs in the APA. There is little doubt that functionalism was the typical American psychology, for the Columbia and Chicago products were scattering their influence on colleges and universities throughout the country. (Hilgard, 1987, p. 84)

Cattell died on January 20, 1944.

Soon after Cattell arrived at Columbia in 1891, Robert Woodworth and Edward Thorndike joined him as his students. They, too, were destined to become leading representatives of functionalism.

Robert Sessions Woodworth

Born on October 17 in Belchertown, Massachusetts, Robert Sessions Woodworth (1869-**1962)** graduated from Amherst College in Massachusetts. Following graduation, he taught mathematics and science in high school for two years and then mathematics at Washburn College for two more years. After reading James's Principles, he decided to go to Harvard to study with James. He received his master's degree in 1897 and remained to work in Harvard's physiological laboratory. Woodworth then moved to Columbia and obtained his doctorate in 1899 under the supervision of Cattell. Following graduation, he taught physiology at New York Hospital and then spent a year in England studying with the famous physiologist Sir Charles Sherrington. In 1903 he returned to Columbia where he stayed for the remainder of his career.

As were all functionalistic psychologists, Woodworth was interested in what people do and why they do it—especially why. He was primarily interested in motivation, so he called his brand of psychology dynamic psychology. Like Dewey, Woodworth disagreed with those who talked about adjustments to the environment as a matter of stimuli, brain processes, and responses. Some psychologists even left out the brain mechanisms and spoke only of S-R (stimulus-response) relationships. Woodworth chose the symbols S-O-R (stimulusorganism-response) to designate his theory in order to emphasize the importance of the organism. He used the term mechanism much as Carr had used the term adaptive act—to refer to the way an organism interacts with the environment in order to satisfy a need. These mechanisms, or adaptive behavior patterns, remain dormant unless activated by a need (drive) of some type. Thus, in the same physical environment, an organism acts differently depending

Robert Sessions Woodworth

on what need, or *drive*, is present. According to Woodworth, the internal condition of the organism activates the organism's behavior.

Although we have included Woodworth among the functionalists, he was always willing to entertain a wide variety of ideas and believed none of them religiously. He lectured on such topics as abnormal psychology, social psychology, and tests and statistics, and he gave seminars on movement, vision, memory, thinking, and motivation. His books included Elements of Physiological Psychology (along with Edward Trumbull Ladd, 1911); Contemporary Schools of Psychology (1931); Experimental Psychology (1938); and his final book, Dynamics of Behavior (1958), written when he was 89. Woodworth's text Experimental Psychology (revised in 1954 with Harold Schlosberg) remained the standard text in experimental psychology for over two decades.

Woodworth believed that psychologists should accept valid information about humans no matter from where it comes, and he believed that, like himself, most psychologists maintain a middle-of-the-road, or eclectic, attitude:

Suppose we should organize a world's tournament or olympic contest of

psychologists, and should assemble the two or three thousand of them on some large field, with banners raised here and there as rallying points for the adherents of the several schools—a banner here for Freud, a banner there for Adler, one for Jung, one for McDougall, one for the Gestalt school, one for the behaviorists, and one for the existentialists, with perhaps two or three other banners waving for schools which I have not mentioned. After all the loval adherents of each school had flocked to their respective banners, there would remain a large body in the middle of the field, or in the grandstand ready to watch the jousting. How many would thus remain unattached? A majority? I am convinced it would be a large majority. (Woodworth, 1931, p. 205)

Though often criticized for his eclecticism, Woodworth did not care much. In response to being chided for sitting on the fence instead of getting down and becoming involved in the prevailing controversy, Woodworth (1931) said, "Well, in support of this position it may be said that it is cooler up here and one has a better view of all that is going on" (p. 216).

Woodworth was the first recipient of the Gold Medal presented by the American Psychological Foundation (1956). The inscription indicated that the award was for "unequaled contributions in shaping the destiny of scientific psychology."

Woodworth's six-decade affiliation with Columbia University ended when he died on July 4, 1962, at the age of 92.

Edward Lee Thorndike

Edward Lee Thorndike (1874–1949) was born in Williamsburg, Massachusetts, the son of a Methodist minister. He entered Wesleyan University in Connecticut in 1891 and earned his bachelor's degree in 1895. At Wesleyan, Thorndike's psychology courses did not interest him much, and it was through the reading of James's *Principles* that he

Edward Lee Thorndike

became interested in the topic. He claims never to have heard the word *psychology* until his junior year at Wesleyan, After Wesleyan, Thorndike went to Harvard, where he earned a master's degree in 1897. While at Harvard, he took a course from James, and the two became good friends. When he first moved to Cambridge, Thorndike was raising chicks in his bedroom to be used as experimental subjects. When his landlady forbade him from continuing this practice, James tried to get laboratory space for him at Harvard. When the effort failed, James allowed Thorndike to continue his research in the basement of his home.

After receiving his master's degree from Harvard, Thorndike accepted a fellowship at Columbia where, like Woodworth, he worked under Cattell's supervision. (Woodworth Thorndike were lifelong friends.) His doctoral dissertation, titled "Animal Intelligence: An Experimental Study of the Associative Processes in Animals," was published in 1898 and was republished in 1911 as Animal Intelligence. Thorndike's dissertation was the first in psychology in which nonhumans served as subjects (Galef, 1998, p. 1128).

After obtaining his doctorate in 1898, Thorndike began teaching at the College for Women at Case Western Reserve University, but after a year, he returned to Columbia, where he remained until his retirement in 1940. After retirement, he continued to write until his death in 1949 at the age of 74. During his career, Thorndike was extremely productive, and at his death his bibliography comprised 507 books, monographs, and journal articles. He did pioneer work not only in learning theory (for which he is most famous) but also in the areas of educational practices, verbal behavior, comparative psychology, intelligence testing, transfer of training, and the measurement of sociological phenomena. As an example of the last, he wrote Your City (1939), in which he attempted to quantify the "goodness of life" in various cities. Like Galton, Thorndike had a penchant to measure everything. Also like Galton, Thorndike believed intelligence to be highly heritable. Thorndike believed that educational experiences should be stratified according to a student's native intellectual ability. About the attempt to provide equal education to all children, he said, "It is wasteful to attempt to create and folly to pretend to create capacities and interests which are assumed or denied to an individual at birth" (1903, p. 44). However, Thorndike did not believe gender differences in intellectual ability were substantial enough to support arguments against coeducation. After reviewing the data, he concluded, "Differences in ability [are] not of sufficient amount to be important in arguments concerning differentiation of the curriculum or of methods of teaching in conformity of sex differences" (1903, p. 118).

Thorndike's work was to have a significant influence on psychology, and it can be seen as representing the transition from the school of functionalism to the school of behaviorism. We will review the reasons for this shortly, but first we look at the nature of animal research prior to Thorndike's work.

Animal Research before Thorndike. Modern comparative psychology clearly started with the works of Darwin, specifically with his book The Expression of Emotions in Man and Animals (1872). Darwin's work was taken a step further by his friend George John Romanes (1848–1894), who wrote

George John Romanes

a book also titled Animal Intelligence in 1882 and Mental Evolution in Animals in 1884. In a third book, Mental Evolution in Man (1888), Romanes attempted to trace the evolution of the human mind. All of Romanes's evidence was anecdotal, however, and he was often guilty of anthropomorphizing, or attributing human thought processes to nonhuman animals. For example, Romanes attributed such emotions as anger, fear, and jealousy to fish; affection, sympathy, and pride to birds; and slyness and keen reasoning power to dogs. The following is an example of how Romanes attributed human motives and intelligence to nonhuman animals:

One day the cat and the parrot had a quarrel. I think the cat had upset Polly's food, or something of that kind; however, they seemed all right again. An hour or so after, Polly was standing on the edge of the table; she called out in a tone of extreme affection, "Puss, puss, come then—come then, pussy." Pussy went and looked up innocently enough. Polly with her beak seized a basin of milk standing by, and tipped the basin and all its contents over the cat; then chuckled diabolically, of course broke the

basin, and half drowned the cat. (Sargent and Stafford, 1965, p. 149)

Romanes died on May 23, 1894, at the age of 46.

Conwy Lloyd Morgan (1852-1936) sought to correct Romanes's excesses by applying the principle that has come to be known as Morgan's canon: "In no case may we interpret an action as the outcome of the exercise of a higher psychical faculty, if it can be interpreted as the outcome of the exercise of one which stands lower in the psychological scale" (Morgan, 1894, p. 53). Morgan's canon is often mistakenly interpreted as an argument against speculation about the existence of private thoughts and feelings in nonhuman animals. Morgan, however, believed that both human and nonhuman behavior is purposive and that purposes or intentions are experienced mentally. Rather than avoiding mentalism, he argued that comparative psychology would be impossible unless both humans and nonhumans possessed mental processes. Following Darwin, Morgan believed that mental events facilitate survival and that there is a gradation of those events across species. Morgan's canon was also mistakenly believed to be an argument against anthropomorphizing. On the contrary, Morgan believed that the cognitive processes of nonhuman animals could be understood only relative to our own:

Our interpretation of animal intelligence is necessarily based on a double or two-fold process of observation: 1st, the activities of animals have to be carefully observed as objective phenomena; 2nd, our own mental processes have to be carefully observed and cautious inductions drawn from them. Finally the objective phenomena reached by the first process have to be interpreted in terms of conclusions obtained through the second. (Costall, 1993, p. 120)

So what was the purpose of Morgan's canon? Primarily its purpose was to avoid *anthropocentrism*, the belief that nonhuman cognitive processes are the same as those of humans. The problem with

Psychology Archives—The University of Akron

Conwy Lloyd Morgan

the anecdotal evidence provided by Romanes and others was that it equated human and nonhuman intelligence. With his canon, Morgan urged researchers not to attribute nonhuman behavior to reflective, rational thoughts when it could be explained in terms of simpler cognitive processes. In a sense, Morgan was attempting "to put anthropomorphizing on a sound scientific basis" (Costall, 1993, p. 120).

Morgan (1894) believed that nonhuman animals could not possibly possess many of the human attributes that Romanes and others had attributed to them: "A sense of beauty, a sense of the ludicrous, a sense of justice, and a sense of right and wrong—these abstract emotions or sentiments, as such, are certainly impossible to the brute" (p. 403).

In the following excerpt, Morgan (1894) offered what he considered a proper account of how his dog developed the ability to open a garden gate:

The way in which my dog learnt to lift the latch of the garden gate and thus let himself out affords a good example of intelligent behaviour. The iron gate is held to by a latch, but swings open by its own weight if the latch be lifted. Whenever he wanted

to go out the fox terrier raised the latch with the back of his head, and thus released the gate, which swung open. Now the question in any such case is: How did he learn the trick? In this particular case the question can be answered, because he was carefully watched. When he was put outside the door, he naturally wanted to get out into the road, where there was much to tempt him—the chance of a run, other dogs to sniff at, possible cats to be worried. He gazed eagerly out through the railings on the low parapet wall ... and in due time chanced to gaze out under the latch, lifting it with his head. He withdrew his head and looked out elsewhere but the gate had swung open. Here was a fortunate occurrence arising out of the natural tendencies of a dog. But the association between looking out just there and the open gate with a free passage into the road is somewhat indirect. The coalescence of the presentative and representative elements into a conscious situation effective for the guidance of behaviour was not effected at once. After some ten or twelve experiences, in each of which the exit was more rapidly effected, with less gazing out at wrong places, the fox terrier learnt to go straight and without hesitation to the right spot. In this case the lifting of the latch was unquestionably hit upon by accident, and the trick was only rendered habitual by repeated association in the same situation of the chance act and happy escape. Once firmly established, however, the behaviour remained constant throughout the remainder of the dog's life, some five or six years. (p. 144)

Although there is obviously still great subjectivity in Morgan's report of his dog's behavior, he did describe the trial-and-error learning that was to become so important in Thorndike's research. Incidentally, Bain had described essentially the same kind of trial-and-error learning as Morgan described above in 1855 (see Chapter 5).

In 1908 Margaret Floy Washburn (1871-1939) published The Animal Mind, which went through four editions, the last appearing in 1936. Washburn's second book, Movement and Mental Imagery: Outline of a Motor Theory of Consciousness (1916), did not receive widespread attention (Carpenter, 1997, p. 188). As mentioned in Chapter 9, Washburn was Titchener's first doctoral candidate and became the first woman to receive a doctorate in psychology in 1894. Upon receipt of her degree, Washburn became a member of the APA, joining two other women, Christine Ladd-Franklin and Mary Calkins. After brief affiliations with Wells College, Sage College, and the University of Cincinnati, Washburn accepted an appointment at her alma mater, Vassar College, in 1903. During her more than three decades at Vassar, she published more than 70 articles—mainly on animal psychology—and was active in the administrative activities of the APA and other psychological organizations. In 1921, in recognition of her many accomplishments, Washburn was elected the second female president of the APA (Calkins was the first). In her presidential address (1922), Washburn criticized Watson's behaviorism and praised Gestalt psychology for its willingness to study consciousness. In 1931 she was awarded membership in the National Academy of Sciences, only the second woman to be granted membership in that distinguished organization (Florence Sabin, MD, was the first).

In *The Animal Mind*, Washburn, like Morgan, was primarily interested in inferring consciousness in animals at all phylogenetic levels. To index consciousness in animals, she summarized hundreds of experiments in such areas as sensory discrimination, space perception, and learning ability. Although her primary concern was with animal consciousness, her use of controlled behavior to index mental events was similar to the approach taken by many contemporary cognitive psychologists. For an overview of Washburn's life and accomplishments, see Viney and Burlingame-Lee, 2003.

Morgan and Washburn made comparative psychology more objective than it had been under Romanes, but problems remained. With Morgan's

© Psychology Archives-The University of Akron

Margaret Floy Washburn

naturalistic observations, so many variables occurred simultaneously that it was impossible to observe them all, let alone to determine which was responsible for the behavior being observed. Washburn did investigate animal learning under controlled conditions, but she did so in an effort to understand animal consciousness. It remained for animal learning to be studied experimentally for its own sake rather than as an indirect means of studying animal consciousness. It was Thorndike who took this important next step.

Thorndike's Puzzle Box. To investigate systematically the trial-and-error learning that Morgan had described, Thorndike used a **puzzle box** like the one shown in Figure 11.1.

Although during his career Thorndike used chicks, rats, dogs, fish, monkeys, and humans as research subjects, his work with the puzzle box involved cats. The box was arranged so that if the animal performed a certain response, the door opened, and the animal was allowed to escape; in addition, the animal received a reward such as a piece of fish.

From his numerous puzzle-box experiments, Thorndike reached the following conclusions:

- Learning is incremental. That is, it occurs a little bit at a time rather than all at once. With each successful escape, subsequent escapes were made more quickly.
- Learning occurs automatically. That is, it is not mediated by thinking.
- The same principles of learning apply to all mammals. That is, humans learn in the same manner as all other mammals.

With these observations, Thorndike was very close to being a behaviorist. If thinking was not involved in learning, what good was introspection in studying the learning process? And if animals and humans learn in the same way, why not simplify the situation by studying only nonhuman animals?

Connectionism. Thorndike believed that sense impressions and responses are connected by neural bonds. He also believed that the probability of a response being made in the presence of a particular sensory event (stimulus) is determined by the strength of the neural connection between the stimulus and the response. Thorndike's concern was not with how *ideas* become associated but with how neural connections or bonds between sensory impressions and responses change their strength as a

FIGURE 11.1

The puzzle box Thorndike used in his experiment with cats. SOURCE: Thorndike (1898)

function of experience. Because of this concern, Thorndike's theory is often referred to as **connectionism**.

The Laws of Exercise and Effect. To account for his research findings, Thorndike developed psychology's first major theory of learning. The theory basically combined associationism and hedonism, which had been prevalent for centuries, but Thorndike stated his principles with precision and supported them with ingenious experimentation. His own research findings actually forced him to make major revisions in his own theory. The early version of his theory consisted mainly of the laws of exercise and effect. The law of exercise had two parts: the law of use and the law of disuse. According to the law of use, the more often an association (neural connection) is practiced, the stronger it becomes. This was essentially a restatement of Aristotle's law of frequency. According to the law of disuse, the longer an association remains unused, the weaker it becomes. Taken together, the laws of use and disuse stated that we learn by doing and forget by not doing.

Thorndike's early **law of effect** was that if an association is followed by a "satisfying state of affairs" it will be strengthened, and if it is followed by an "annoying state of affairs," it will be weakened. In modern terminology, Thorndike's earlier law of effect was that reinforcement strengthens behavior whereas punishment weakens it.

The Renouncement of the Law of Exercise and the Revised Law of Effect. In September 1929, Thorndike began his address to the International Congress of Psychology with the dramatic statement "I was wrong." He was referring to his early theory of learning. Research had forced him to abandon his law of exercise completely, for he had found that practice alone did not strengthen an association and that the passage of time alone (disuse) did nothing to weaken it. Besides discarding the law of exercise, Thorndike discarded half of the law of effect, concluding that a satisfying state of affairs strengthens an association but that an annoying state of affairs does not weaken one. In modern

terminology, Thorndike found that reinforcement is effective in modifying behavior, but punishment is not.

Under the influence of evolutionary theory, Thorndike added a behavioral component to associationism. Rather than focusing on the association of one *idea* to another, he studied the association between the environment and behavioral responses. Although Thorndike's brand of psychology is generally viewed as being within the framework of functionalism (because Thorndike believed that only useful associations are selected and maintained), his insistence that learning occurs without ideation brought him very close to being a behaviorist.

The Transfer of Training. In 1901 Thorndike and Woodworth combined their skills to examine the contention of some early faculty psychologists that the faculties of the mind could be strengthened by practicing the attributes associated with them. For example, it was believed that studying a difficult topic, such as Latin, could enhance general intelligence. Such a belief was sometimes called the "mental muscle" approach to education and sometimes formal discipline. Thorndike Woodworth's study, which involved 8,564 high school students, found no support for this contention. Then why did it seem that more difficult courses produced brighter students? Thorndike (1924) summarized his earlier research with Woodworth as follows:

By any reasonable interpretation of the results, the intellectual values of studies should be determined largely by the special information, habits, interests, attitudes, and ideals which they demonstrably produce. The expectation of any large differences in general improvement of the mind from one study rather than another seems doomed to disappointment. The chief reason why good thinkers seem superficially to have been made such by having taken certain school studies, is that good thinkers have taken such studies, becoming

better by the inherent tendency of the good to gain more than the poor from any study. When the good thinkers studied Greek and Latin, these studies *seemed* to make good thinking. Now that the good thinkers study physics and trigonometry, these seem to make good thinkers. If abler pupils should all study physical education and dramatic art, these subjects would seem to make good thinkers.... After positive correlation of gain with initial ability is allowed for, the balance in favor of any study is certainly not large. (p. 98)

Thorndike answered the mental muscle approach to education with his identical elements theory of transfer, which states that the extent to which information learned in one situation will transfer to another situation is determined by the similarity between the two situations. If two situations are exactly the same, information learned in one will transfer completely to the other. If there is no similarity between two situations, information learned in one will be of no value in the other. The implication for education is obvious: Schools should teach skills that are similar to those that will be useful when students leave school. Rather than attempting to strengthen the faculties of the mind by requiring difficult subjects, schools should emphasize the teaching of practical knowledge. Thorndike's research did not silence the debate between those who saw the goal of education as the strengthening of the faculties of the mind and those (like Thorndike) who claimed that the goal should be the teaching of specific transferable skills. Even today, some researchers claim that Thorndike was premature in his rejection of formal discipline (for example, Lehman, Lempert, and Nisbett, 1988).

Among Thorndike's many honors were honorary doctorates from Columbia University (1929), the University of Chicago (1932), the University of Athens (1937), the University of Iowa (1923), and the University of Edinburgh (1936); he was elected president of the New York Academy of Sciences (1919–1920), of the American Association for the Advancement of Science (1934), of the APA

(1912), and of the Psychometric Society (1936–1937); and he was an honorary member of the British Psychological Society and the Leningrad Scientific-Medical Pedagogical Society.

Many consider Thorndike the greatest learning theorist of all time, and many of his ideas can be seen in current psychology in the work of B. F. Skinner, whom we consider in the next chapter. Thorndike is usually considered a functionalist, Skinner a behaviorist. Thorndike cannot be labeled a behaviorist for two reasons, although he had strong leanings in that direction. First, he employed a few mentalistic terms such as "satisfying state of affairs." Second, he was not willing to completely abandon introspective analysis. He believed that introspective analysis could play a useful role in the study of human consciousness (Samelson, 1981).

THE FATE OF FUNCTIONALISM

What happened to functionalism? It did not die as a school as structuralism had but was absorbed. According to Chaplin and Krawiec (1979),

As a systematic point of view, functionalism was an overwhelming success, but largely because of this success it is no longer a distinct school of psychology. It was absorbed into the mainstream psychology. No happier fate could await any psychological point of view. (p. 53)

Similarly, Hilgard (1987) said, "[Functionalism] declined as a recognized school, destroyed by its success, and, in part, by the success of its intellectual progeny, behaviorism" (p. 88). It is to behaviorism that we turn in the next chapter.

SUMMARY

Before functionalism, psychology in the United States passed through three stages. During the first stage (1640-1776), psychology was the same as religion and moral philosophy, although some of John Locke's philosophy was taught. During the second stage (1776-1886), the Scottish commonsense philosophy was taught, but its relationship to religion was still emphasized. During this second stage, textbooks began to appear that contained chapters on topics constituting much of today's psychology—for example, perception, memory, language, and thinking. In the third stage (1886-1896), psychology became completely separated from religion, and the groundwork for an objective, practical psychology was laid. It was during this third stage that James published Principles (1890), thus laying the foundation for what was to become the school of functionalism, and that Titchener created the school of structuralism at Cornell (1892). U.S. psychology's fourth stage (1896 to present) was characterized by the

emergence of the school of functionalism, the beginning of which is often marked by the 1896 publication of Dewey's paper on the reflex arc. Many believe, however, that James's Principles could as easily mark the beginning of the school of functionalism. Although functionalism was never a clearly defined school, it did have the following characteristics: it opposed elementism; it was concerned with the function of mental and behavioral processes; it was interested in the practical applications of its principles; it accepted a Darwinian model of humans rather than a Newtonian model; it embraced a wide range of topics and methodologies; it was extremely interested in motivation; and it was more interested in the differences among individuals than in their similarities.

Following Darwin, James believed that mental events and overt behavior always have a function. Rather than studying consciousness as a group of elements that combined in some lawful way, as

physical elements do, James viewed consciousness as a stream of ever-changing mental events whose purpose is to allow the person to adjust to the environment. For James the major criterion for judging an idea is the idea's usefulness, and he applied this pragmatism to the idea of free will. James believed that while working as a scientist, a person has to accept determinism; while not playing the role of scientist, however, a person can accept free will and feel responsible for his or her activities, instead of feeling as if one is a victim of circumstance. James believed that much of behavior is instinctive and much of it learned. James discussed the empirical self, which consists of the material self (all the material things that a person can call his or her own), the social self (the self as known by other people), and the spiritual self (all of which a person is conscious). There was, for James, also a self as knower, or an "I" of the personality. The self as knower, or "pure ego," transcends the empirical self. Selfesteem is determined by the ratio of things attempted to things achieved. One can increase one's self-esteem by either accomplishing more or attempting less. According to the James-Lange theory of emotion, an individual first reacts behaviorally and then has an emotional reaction. Because people feel according to how they act, they can determine their feelings by choosing their actions. James believed that thoughts determined behavior and that we can determine our thoughts. Behind all acts of volition is selective attention because it is what we select to attend to that determines our behavior. Everywhere in James's writings, one sees his pragmatism: Ideas are to be evaluated only in terms of their usefulness or "cash-value." In many ways, psychology today is the type of psychology James outlined—a psychology willing to embrace all aspects of human existence and to employ those techniques found to be effective.

James chose Münsterberg to replace him as director of the Harvard Psychology Laboratory. At first, Münsterberg concentrated on performing controlled laboratory experiments, but his interests turned more and more to the application of psychological principles to problems outside of the laboratory. In developing his applied psychology,

Münsterberg did pioneer work in clinical, forensic, and industrial psychology. Although at one time he was one of the most famous psychologists in the world, he died in obscurity because his efforts to improve relations between the United States and Germany came at a time when the U.S. populace was disgusted with German military and political aggression. Mary Whiton Calkins invented the paired-associate technique while studying verbal learning under Münsterberg's supervision. She also did pioneering work on short-term memory. Although meeting all of Harvard's requirements for the PhD, she was denied the degree because she was a woman. Nonetheless, she went on to become the first female president of the APA (1905), and through her self-psychology, she influenced the development of a U.S. brand of personality theory.

Like James and Münsterberg, Hall was very influential in the development of functionalism. The first person to obtain a doctorate specifically in psychology, Hall was Wundt's first U.S. student; he created the first working psychology laboratory in the United States in 1883, and he created the first U.S. journal dedicated exclusively to psychological issues. As president of Clark University, he invited Freud to deliver a series of lectures, which helped psychoanalysis gain international recognition and respect. Hall also founded the APA and was its first president. According to his recapitulation theory, human development reflects all evolutionary stages that humans passed through before becoming human. Several of Hall's beliefs are now considered incorrect. Nonetheless, he is still remembered as an important pioneer in educational, child, and adolescent psychology and in parent education and child welfare programs. Also, combining his studies of children, adolescents, and the elderly, Hall anticipated what was later called life-span psychology. Along with James and Münsterberg, Hall incorporated Darwinian theory into psychology and, in so doing, helped pave the way for the school of functionalism. It was under Hall's supervision that Francis Cecil Sumner became the first African American to obtain a PhD in psychology (1920). At Howard University, Sumner created a highly

influential training center for African American psychologists. His students included Kenneth B. Clark, whose research influenced the *Brown v. Board of Education* decision (1954), which ended the legal basis for segregated education. Clark went on to become the first African American president of the APA (1970).

Once launched, functionalism was centered at University of Chicago and Columbia University. At Chicago, Dewey wrote "The Reflex Arc Concept in Psychology," an article thought by many to mark the formal beginning of the school of functionalism. Dewey's text Psychology (1886) was the first functionalist textbook ever written. Also at Chicago was Angell, who had studied with James. During his 25 years as department chairman at Chicago, Angell encouraged the growth of functional psychology. Carr was another who furthered the development of functional psychology at Chicago. A key figure in Columbia University's brand of functionalism, it was Cattell who encouraged psychologists to study a wide variety of topics using a wide variety of methodologies and to emphasize the practical value of psychological principles. Another leading figure at Columbia was Woodworth, whose dynamic psychology focused on motivation. Woodworth took an eclectic approach to explaining behavior.

Perhaps the most influential Columbia functionalist was Thorndike. Thorndike's goal was to animal behavior objectively because Darwin's theory had shown that there were only quantitative differences between humans and other animals. Romanes did rudimentary animal research, but his observations were riddled with anecdotes attributing higher, human thought processes to nonhuman animals. Morgan's animal work was better because he applied the principle that came to be called Morgan's canon: No animal action should be explained on a higher level (reflective, rational thought) if it can be explained on a lower level (a simple intention or purpose). Morgan's canon was used to discount the anecdotal evidence that Romanes and others had offered. Although Morgan's work was an improvement over

Romanes's, it consisted mainly of uncontrolled naturalistic observations. Washburn used animal behavior generated under controlled conditions to infer the mental processes utilized by nonhuman animals. Although overcoming the restrictions of naturalistic observation, her primary goal was to understand animal consciousness. Thorndike, too, studied animal behavior under controlled conditions, but his research vastly reduced the importance of consciousness, both human and nonhuman. From his research using the puzzle box, Thorndike concluded that learning occurs gradually rather than all at once, that learning occurs without the involvement of mental processes, and that the same principles of learning apply to all mammals, including humans. Because Thorndike was interested in how the strength of the neural bonds or connections between stimuli and responses varies with experience, his theory is often referred to as connectionism.

Thorndike summarized many of his observations with his famous laws of exercise and effect. According to his law of exercise, the strength of an association varies with the frequency of its occurrence. His original law of effect stated that if an association is followed by a positive experience, it is strengthened, whereas if an association is followed by a negative experience, it is weakened. In 1929 Thorndike revised his theory by discarding the law of exercise and salvaging only the half of the law of effect that said positive consequences strengthen an association. Negative consequences, he found, have no effect on an association. Thorndike opposed the old "mental muscle" explanation of the transfer of training, which was an outgrowth of faculty psychology. Thorndike contended that learning would transfer from one situation to another to the degree that the two situations were similar or had common elements. Many of Thorndike's ideas are found in the contemporary work of Skinnerians.

Unlike structuralism, which faded away as a school because most of its findings and methodologies were rejected, functionalism lost its distinctiveness as a school because most of its major tenets were assimilated into all forms of psychology.

DISCUSSION QUESTIONS

- 1. Briefly describe the four stages of U.S. psychology.
- 2. What are the major themes that characterized functionalistic psychology?
- 3. What was the personal crisis that James experienced, and how did he resolve it?
- 4. Why was James's approach to psychology called radical empiricism?
- 5. Define pragmatism.
- 6. For James, what are the major characteristics of consciousness?
- 7. Make the case that James's criticisms of elementism were more applicable to Titchener's version of psychology than to Wundt's.
- 8. How, according to James, did habits develop? What did he mean when he referred to habits as "the enormous fly-wheel of society"? What advice did he give for developing good habits?
- 9. How did James distinguish between the empirical self and the self as knower? Include in your answer a definition of the material self, the social self, and the spiritual self.
- 10. What did James mean by self-esteem? What, according to James, could be done to enhance one's self-esteem?
- 11. Summarize the James–Lange theory of emotion. How, according to James, could one escape or avoid negative emotions such as depression?
- 12. What did James mean by *voluntary behavior*? How did he account for such behavior?
- 13. What, according to James, are the important differences between tender-minded and tough-minded individuals? How did he suggest pragmatism could be used to resolve the differences between the two types of individuals?
- 14. Compare James's analysis of voluntary behavior with that of Münsterberg.
- 15. Summarize Münsterberg's work in clinical, forensic, and industrial psychology.
- 16. What was Münsterberg's fate?

- 17. Describe the difficulties that Calkins had in attaining her graduate school education.

 Summarize her accomplishments in spite of these difficulties.
- 18. Describe Hall's recapitulation theory.
- 19. Why was Hall opposed to coeducation at the secondary and college levels?
- 20. Why were the views of women held by Titchener, Münsterberg, and Hall considered paradoxical?
- 21. Discuss the beliefs held by Hall that are now considered to be incorrect.
- 22. In what areas is Hall currently thought to be an important pioneer?
- 23. Summarize Kenneth B. Clark's efforts to bring about racial equality in the United States and indicate why his efforts were controversial.
- 24. What was Dewey's criticism of the analysis of behavior in terms of reflexes? What did he propose instead? What part did Dewey's work play in the development of functionalism?
- 25. In his address "The Province of Functional Psychology," what important distinctions did Angell make between structuralism and functionalism?
- 26. What did Carr mean by an adaptive act? How did Carr contribute to the development of functionalism?
- 27. In what way(s) was Cattell's approach to psychology different from that of other functionalists?
- 28. Why was Woodworth's approach to psychology called dynamic psychology? Why did he prefer an S–O–R explanation of behavior over an S–R explanation?
- 29. What was Morgan's canon, and why did he propose it?
- 30. What was Washburn's primary goal in studying animal behavior? In what way was her

- approach an improvement over those of Romanes and Morgan?
- 31. Why did Thorndike's research represent a major shift in emphasis among comparative psychologists?
- 32. What major conclusions did Thorndike reach concerning the nature of the learning process?
- 33. Why was Thorndike's theory referred to as connectionism?

- 34. Describe Thorndike's laws of exercise and effect before and after 1929.
- 35. How did Thorndike's theory of the transfer of training differ from the earlier theory based on faculty psychology?
- 36. Explain why Thorndike is viewed as a transitional figure between the schools of functionalism and behaviorism.
- 37. What was functionalism's fate?

SUGGESTIONS FOR FURTHER READING

- Backe, A. (2001). John Dewey and early Chicago functionalism. *History of psychology*, 4, 323–340.
- Benjamin, L. T., Jr. (2000). Hugo Münsterberg: Portrait of an applied psychologist. In G. A. Kimble & M. Wertheimer (Eds.), *Portraits of pioneers in psychology* (Vol. 4, pp. 113–129). Washington, DC: American Psychological Association.
- Campbell, J. (1995). Understanding John Dewey: Nature and cooperative intelligence. La Salle, IL: Open Court.
- Dewsbury, D. A. (2003). James Rowland Angell: Born administrator. In G. A. Kimble & M. Wertheimer (Eds.), *Portraits of pioneers in psychology* (Vol. 5, pp. 57–71). Washington, DC: American Psychological Association.
- Diehl, L. A. (1986). The paradox of G. Stanley Hall: Foe of coeducation and educator of women. *American Psychologist*, 41, 868–878.
- Donnelly, M. E. (Ed.). (1992). Reinterpreting the legacy of William James. Washington, DC: American Psychological Association.
- Guthrie, R. V. (2000). Francis Cecil Sumner: The first African American pioneer in psychology. In G. A. Kimble & M. Wertheimer (Eds.), Portraits of pioneers in psychology (Vol. 4, pp. 181–193). Washington, DC: American Psychological Association.
- Hogan, J. D. (2003). G. Stanley Hall: Educator, organizer and pioneer developmental psychologist. In G. A. Kimble & M. Wertheimer (Eds.), Portraits of pioneers in psychology (Vol. 5, pp. 19–36).
 Washington, DC: American Psychological Association.

- Jackson, J. P., Jr. (2006). Kenneth B. Clark: The complexities of activist psychology. In D. A. Dewsbury, L. T. Benjamin Jr., & M. Wertheimer (Eds.), Portraits of pioneers in psychology (Vol. 6, pp. 273–286). Washington, DC: American Psychological Association.
- James, W. (1962). Talks to teachers on psychology and to students on some of life's ideals. Mineola, NY: Dover. (Original work published 1899)
- James, W. (1981). Pragmatism: A new name for some old ways of thinking. Indianapolis: Hackett. (Original work published 1907)
- Johnson, M. G., & Henley, T. B. (Eds.). (1990). Reflections on the principles of psychology: William James's after a century. Hillsdale, NJ: Erlbaum.
- Joncich, G. (1968). The sane positivist: A biography of Edward L. Thorndike. Middletown, CT: Wesleyan University Press.
- Myers, G. E. (1986). William James: His life and thought. New Haven, CT: Yale University Press.
- Simon, L. (1998). Genuine reality: A life of William James. New York: Harcourt Brace.
- Sokal, M. M. (2006). James McKeen Cattell:
 Achievement and alienation. In D. A. Dewsbury,
 L. T. Benjamin Jr., & M. Wertheimer (Eds.),
 Portraits of pioneers in psychology (Vol. 6, pp. 19–35).
 Washington, DC: American Psychological
 Association.
- Viney, W. (2001). The racial empiricism of William James and philosophy of history. *History of Psychology*, 4, 211–227.

Viney, W., & Burlingame-Lee, L. (2003). Margaret Floy Washburn: A quest for the harmonies in the context of a rigorous scientific framework. In G. A. Kimble & M. Wertheimer (Eds.), *Portraits of pioneers in psychology*. (Vol. 5, pp. 73–88). Washington, DC: American Psychological Association.

Winston, A. S. (2006). Robert S. Woodworth and the creation of an eclectic psychology. In D. A. Dewsbury, L. T. Benjamin Jr., & M. Wertheimer (Eds.), *Portraits of pioneers in psychology* (Vol. 6, pp. 51–66). Washington, DC: American Psychological Association.

Woodward, W. R. (1984). William James's psychology of will: Its revolutionary impact on American psychology. In J. Brožek (Ed.), *Explorations in the history of psychology in the United States* (pp. 148–195). Cranbury, NJ: Associated University Presses.

GLOSSARY

Adaptive act Carr's term for a unit of behavior with three characteristics: a need, an environmental setting, and a response that satisfies the need.

Angell, James Rowland (1869–1949) As president of the American Psychological Association and as chairman of the psychology department at the University of Chicago for 25 years, did much to promote functionalism.

Applied psychology Psychology that is useful in solving practical problems. The structuralists opposed such practicality, but Münsterberg and, later, the functionalists emphasized it.

Calkins, Mary Whiton (1863–1930) Although satisfying all the requirements for a PhD at Harvard, she was denied the degree because she was a woman. In spite of such restrictions, Calkins made significant contributions to the study of verbal learning and memory and to self-psychology. Her many honors included being elected the first female president of the American Psychological Association in 1905.

Carr, Harvey (1873–1954) An early functionalistic psychologist at the University of Chicago.

Cattell, James McKeen (1860–1944) Represented functionalistic psychology at Columbia University. He did much to promote applied psychology.

Clark, Kenneth Bancroft (1914–2005) Along with his colleagues, conducted research that demonstrated the negative effects of segregation of children. A portion of this research was cited in the 1954 Supreme Court decision that ended the legal basis for segregated education in the United States. Clark went on to become the first African American president of the APA in 1970.

Connectionism The term often used to describe Thorndike's theory of learning because of its concern

with the neural bonds or connections that associate sense impressions and impulses to action.

Dewey, John (1859–1952) A key person in the development of functionalism. Some mark the formal beginning of the school of functionalism with the 1896 publication of Dewey's article "The Reflex Arc Concept in Psychology."

Dynamic psychology The brand of psychology suggested by Woodworth that stressed the internal variables that motivate organisms to act.

Empirical self According to James, the self that consists of everything a person can call his or her own. The empirical self consists of the material self (all of one's material possessions), the social self (one's self as known by others), and the spiritual self (all of which a person is conscious).

Forensic psychology The application of psychological principles to legal matters. Münsterberg is considered the first forensic psychologist.

Functionalism Under the influence of Darwin, the school of functionalism stressed the role of consciousness and behavior in adapting to the environment.

Habits Those learned patterns of behavior that James and others believed were vital for the functioning of society.

Hall, Granville Stanley (1844–1924) Created the first U.S. experimental psychology laboratory, founded and became the first president of the American Psychological Association, and invited Freud to Clark University to give a series of lectures. Hall thus helped psychoanalysis receive international recognition. Many of the beliefs contained in his two-volume book on adolescence are now considered incorrect. Nonetheless, that work is currently seen as an important pioneering effort in

educational, child, and adolescent psychology and in parent education and child welfare programs.

Identical elements theory of transfer Thorndike's contention that the extent to which learning transfers from one situation to another is determined by the similarity between the two situations.

Ideo-motor theory of behavior According to James, ideas cause behavior, and thus we can control our behavior by controlling our ideas.

Industrial psychology The application of psychological principles to such matters as personnel selection; increasing employee productivity; equipment design; and marketing, advertising, and packaging of products. Münsterberg is usually considered the first industrial psychologist.

James, William (1842–1910) Was instrumental in the founding of functionalistic psychology. James emphasized the function of both consciousness and behavior. For him the only valid criterion for evaluating a theory, thought, or act is whether it works. In keeping with his pragmatism, he claimed that psychology needs to employ both scientific and nonscientific procedures. Similarly, on the individual level, sometimes one must believe in free will and at other times in determinism.

James–Lange theory of emotion The theory that people first respond and then have an emotional experience. For example, we run first, and then we are frightened. An implication of the theory is that we should act according to the way we want to feel.

Lange, Carl George (1834–1900) Along with James, proposed the theory that a person's emotional experience follows his or her behavior.

Law of disuse Thorndike's contention that infrequently used associations become weak. Thorndike discarded this law in 1929.

Law of effect Thorndike's contention that reward strengthens associations, whereas punishment weakens them. Later, Thorndike revised the law to state that reward strengthens associations, but punishment has no effect on them.

Law of exercise Thorndike's contention that the strength of an association varied with the frequency of the association's use. Thorndike discarded this law in 1929.

Law of use Thorndike's contention that the more often an association is made, the stronger it becomes. Thorndike discarded this law in 1929.

Morgan, Conwy Lloyd (1852–1936) An early comparative psychologist who believed that there is a gradation of consciousness among animal species. To infer the cognitive processes used by various animals, he observed their naturally occurring behavior.

Morgan's canon The insistence that explanations of animal behavior be kept as simple as possible. One should never attribute higher mental activities to an animal if lower mental activities are adequate to explain its behavior.

Münsterberg, Hugo (1863–1916) Stressed the application of psychological principles in such areas as clinical, forensic, and industrial psychology. In so doing, Münsterberg created applied psychology.

Paired-associate technique The still widely used method of investigating verbal learning invented by Calkins. Pairs of stimulus material are first presented to subjects and then, after several exposures, only one member of the pair is presented and the subject is asked to recall the second.

Pragmatism The belief that usefulness is the best criterion for determining the validity of an idea.

Puzzle box The experimental chamber Thorndike used for systematically studying animal behavior.

Recapitulation theory Hall's contention that all stages of human evolution are reflected in the life of an individual.

Reciprocal antagonism Münsterberg's method of treating mentally disturbed individuals, whereby he would strengthen thoughts antagonistic to those causing a problem.

Radical empiricism James's contention that all consistent categories of human experience are worthy of study, whether or not they are amenable to the methods of science.

Romanes, George John (1848–1894) One of the first to follow Darwin's lead and study animal behavior. Romanes's research was very subjective, however, and relied heavily on anecdotal evidence.

Self as knower According to James, the pure ego that accounts for a person's awareness of his or her empirical self.

Self-esteem According to James, how a person feels about himself or herself based on the ratio of successes to attempts. One can increase self-esteem either by accomplishing more or attempting less.

Stream of consciousness Term for the way James thought the mind worked. James described the mind as consisting of an ever-changing stream of interrelated, purposive thoughts rather than static elements that could be isolated from one another, as the structuralists had suggested.

Sumner, Francis Cecil (1895–1954) In 1920, under the supervision of Hall, became the first African American to obtain a PhD in psychology. Later, under Sumner's, leadership, Howard University became a highly influential training center for African American psychologists.

Thorndike, Edward Lee (1874–1949) Marks the transition between the schools of functionalism and behaviorism. Thorndike concluded from his objective animal research that learning occurs gradually, occurs inde-

pendent of consciousness, and is the same for all mammals. His final theory of learning was that practice alone has no effect on an association (neural bond) and that positive consequences strengthen an association but negative consequences do not weaken it.

Washburn, Margaret Floy (1871–1939) First woman to attain a doctorate in psychology and second female president of the APA (1921). She made significant contributions to comparative psychology by studying animal behavior under controlled conditions before inferring the mental attributes necessary to explain the observed behavior

Woodworth, Robert Sessions (1869–1962) An influential functionalist at Columbia University who emphasized the role of motivation in behavior.

Behaviorism

THE BACKGROUND OF BEHAVIORISM

Seldom, if ever, has a major development in psychology resulted from the work of one person. This is not to say that single individuals have not been important, but their importance lies in their ability to culminate or synthesize previous work rather than to create a unique idea. The founding of the school of **behaviorism** is a clear example. Although John B. Watson is usually given credit for founding behaviorism, we will see that so much of his thinking was "in the air" that the term *founding* should not be taken to indicate innovation as much as an extension of existing trends. Objective psychology (psychology that insists on studying only those things that are directly measurable) was already well developed in Russia before the onset of behaviorism, and several functionalists were making statements very close to those Watson later made.

As we have seen in preceding chapters, the school of structuralism relied heavily on introspection as a means for studying the content and processes of the mind; functionalism accepted both introspection and the direct study of behavior. Whereas the structuralist sought a pure science unconcerned with practical applications, the functionalist was more concerned with practical applications than with pure science. Some functionalists were impressed by how much could be learned about humans without the use of introspection, and they began to drift toward what was later called the behavioristic position. One such functionalist was James McKeen Cattell, whom we encountered in the last two chapters. A full nine years before Watson's official founding of behaviorism, Cattell (1904) said this about psychology:

I am not convinced that psychology should be limited to the study of consciousness.... The rather wide-spread notion that there is no psychology apart from introspection is refuted by the brute argument of accomplished fact.

It seems to me that most of the research work that has been done by me or in my laboratory is nearly as independent of introspection as work in physics or in zoology. The time of mental processes, the accuracy of perception and movement, the range of consciousness, fatigue and practise, the motor accompaniments of thought, memory, the association of ideas. the perception of space, color-vision, preferences, judgments, individual differences, the behavior of animals and children, these and other topics I have investigated without requiring the slightest introspection on the part of the subject or undertaking such on my own part during the course of the experiments.... It is certainly difficult to penetrate by analogy into the consciousness of the lower animals, of savages and of children, but the study of their behavior has already yielded much and promises much more. (pp. 179-184)

Cattell's statement is clearly within the functionalistic framework because it stresses the study of both consciousness and behavior and emphasizes the practicality of knowledge; but it also stresses that *much* important information can be attained without the use of introspection.

Walter Pillsbury (1911) provided another example of the Zeitgeist:

Psychology has been defined as the "science of consciousness" or as the "science of experience subjectively regarded." Each of these definitions has advantages, but none is free from objection... Mind is known from man's activities. Psychology may be most satisfactorily defined as the science of human behavior [italics added].

Man may be treated as objectively as any physical phenomenon. He may be regarded only with reference to what he does. Viewed in this way the end of our science is to understand human action. (pp. 1–2)

The success of research on nonhuman animals, in addition to the tendency toward the objective study of behavior in psychology, had much do to with the development of behaviorism. Thorndike, for example, who was technically a functionalist because he did not completely deny the usefulness of the introspective analysis of consciousness and because he used some mentalistic terminology in his work, was discovering how the laws of learning that were derived from work on nonhumans applied to humans. The success of animal researchers such as Thorndike created a strain between them and the prominent psychologists who insisted that psychology concentrate on introspective data. This strain between the animal researchers and the introspectionists created the atmosphere in which behaviorism took on revolutionary characteristics.

As we will see, John B. Watson was one of these animal researchers. Before we consider Watson's proposed solution to the problem, however, we must review the work of the Russians, work that preceded and was similar in spirit to Watson's behaviorism.

RUSSIAN OBJECTIVE PSYCHOLOGY

Ivan M. Sechenov

The founder of Russian objective psychology, **Ivan M. Sechenov (1829–1905)**, started out studying engineering but switched to medicine at the University of Moscow, where he received his MD in 1856. As part of his postgraduate training, he studied with Johannes Müller, Emil Du Bois-Reymond, and Hermann von Helmholtz in Berlin. During this time he was also influenced by the evolutionary thought of Spencer and Darwin. Sechenov's academic career began with an appointment at the Military Medical Academy at St. Petersburg and ended at the University of Moscow.

Courtesy of the National Library of Medicine

Ivan M. Sechenov

Sechenov sought to explain all psychic phenomena on the basis of associationism and materialism, thus showing the influence of the Berlin physiologists' positivism. Sechenov strongly denied that thoughts cause behavior. Rather, he insisted that external stimulation causes *all* behavior:

Since the succession of two acts is usually regarded as an indication of their causal relationship ... thought is generally regarded as the cause of action. When the external influence, i.e., the sensory stimulus, remains unnoticed—which occurs very often thought is even accepted as the initial cause of action. Add to this the strongly pronounced subjective nature of thought, and you will realize how firmly man must believe in the voice of self-consciousness when it tells him such things. But actually this is the greatest of falsehoods: the initial cause of any action always lies in external sensory stimulation, because without this thought is inconceivable. (Sechenov, 1863/1965, pp. 88-89)

Sechenov did not deny consciousness or its importance, but he insisted that there was nothing

mysterious about it and sought to explain it in terms of physiological processes triggered by external events. For Sechenov both overt behavior and covert behavior (mental processes) are reflexive in the sense that they are both triggered by external stimulation. Furthermore, both result from physiological processes in the brain.

The Importance of Inhibition. The most important concept that Sechenov introduced in Reflexes of the Brain (1863/1965) was that of inhibition. It was Sechenov's discovery of inhibitory mechanisms in the brain that caused him to conclude that psychology could be studied in terms of physiology. In fact, before the title was changed by a St. Petersburg censor, Reflexes of the Brain was originally called An Attempt to Bring Physiological Bases into Mental Processes (Boakes, 1984). In 1845 Eduard Weber (brother of Ernst Weber of Weber's law fame) discovered that if he stimulated a frog's vagus nerve (a major nerve linking the brain to various internal organs), the frog's heart would beat slower. This was the first observation that increased activity (stimulation) of one part of the neuromuscular system caused decreased activity in another. Weber found that stimulating the vagus nerve inhibited heart rate. He also observed that spinal reflexes are often more sluggish in animals whose cerebral cortices are intact than for animals whose cortices had been ablated. Weber speculated that one cortical function may be to inhibit reflexive behavior.

Weber's observations and insights went essentially unnoticed except for Sechenov, who saw in them a possible explanation for why we often have voluntary control over what is ordinarily involuntary behavior. For example, we can sometimes suppress or delay an impulse to sneeze or to cough. Sechenov also saw in inhibition an explanation for smooth, coordinated movement without the need to employ subjective, metaphysical concepts such as mind or soul. In other words, he could explain so-called volition and purposive behavior and still remain objective.

Using frogs as subjects, Sechenov found that he could inhibit the reflexive withdrawal of a leg from an acid solution by placing salt crystals in certain

areas of the brain. When the salt was washed away with water, the reflex returned at full force. Although Sechenov found that the frog's inhibitory centers were in places other than where Weber speculated they were, he still confirmed that certain brain centers, when stimulated, would inhibit reflexive behavior. Sechenov's observation solved a problem that had restricted attempts to explain behavior in terms of reflexes: Why is there often a discrepancy between the intensity of a stimulus and the intensity of the response it elicits? It had been observed, for example, that a stimulus of very low intensity could produce a very intense response, and a very intense stimulus could produce only a slight response. Sechenov's answer was that sometimes a response to a stimulus is partially or even completely inhibited, and sometimes it is not. With this major obstacle out of the way, it was now possible, according to Sechenov, to explain all behavior, including human behavior, as reflexive. Sechenov saw human development as the slow establishment of inhibitory control over reflexive behavior. Such control allows contemplative action or inaction and the quiet endurance of aversive experience. In other words, Sechenov postulated a mechanism by which prior experience could influence present experience and behavior:

Hence a new and extremely important addition was made to the theory of reflexes. They were now regarded as directly related, not only to present stimuli, but also to the sum total of previous influences leaving their impression on the nervous system. (Yaroshevski, 1968, p. 91)

In *Reflexes*, Sechenov attempted to explain all behavior in terms of the excitation or inhibition of reflexes. It should be noted, however, that by *reflex* Sechenov meant only that every muscle movement is caused by an event that preceded it. Thus, he rejected the idea of spontaneous or unelicited behavior.

Psychology Must Be Studied Using the Methods of Physiology. Sechenov strongly believed

that the traditional approach to understanding psychological phenomena using introspective analysis had led nowhere. For Sechenov (1935/1973) the only valid approach to the study of psychology involves the objective methods of physiology:

Physiology will begin by separating psychological reality from the mass of psychological fiction which even now fills the human mind. Strictly adhering to the principle of induction, physiology will begin with a detailed study of the more simple aspects of psychical life and will not rush at once into the sphere of the highest psychological phenomena. Its progress will therefore lose in rapidity, but it will gain in reliability. As an experimental science, physiology will not raise to the rank of incontrovertible truth anything that cannot be confirmed by exact experiments; this will draw a sharp boundary-line between hypothesis and positive knowledge. Psychology will thereby lose its brilliant universal theories; there will appear tremendous gaps in its supply of scientific data; many explanations will give place to a laconic "we do not know." ... And yet, psychology will gain enormously, for it will be based in scientifically verifiable facts instead of the deceptive suggestions of the voice of our consciousness. Its generalizations and conclusions will be limited to actually existing analogies, they will not be subject to the influence of the personal preferences of the investigator which have so often led psychology to absurd transcendentalism, and they shall thereby become really objective scientific hypotheses. The subjective, the arbitrary and the fantastic will give way to a nearer or more remote approach to truth. In a word, psychology will become a positive science. Only physiology can do this, for only physiology holds the key to the scientific analysis of psychical phenomena. (pp. 350-351)

Although Sechenov never enjoyed much support from his country's government or from his colleagues during his lifetime, he did influence the next generation of neurophysiologists. After him, the study of inhibition became central, it was widely accepted that the best way to study psychological phenomena was by using the objective methods of physiology, and it was generally believed that behavior is best understood as reflexive.

Ivan Petrovich Pavlov

Ivan Petrovich Pavlov (1849-1936) was born on September 14 in the town of Ryazan, about 250 miles from Moscow. His father was first a teacher of classical languages (Greek and Latin) and later a priest. Pavlov's two paternal uncles were also priests, but they were rather unruly: "Both were often disciplined by the Church authorities for their disorderly behavior and their penchant for the bottle" (Windholz, 1991, p. 52). The older uncle died of a lung disorder at a relatively young age. The younger uncle, although once popular with the clergy, was eventually defrocked because "as a priest, he had mocked family, death, God, and was a practical joker" (Windholz, 1991, p. 52). For his practical jokes, he often received beatings from angry villagers. One such joke was binding a calf to a village alarm bell in the middle of the night, using a long rope. He gloated as the villagers ran in panic in response to the frantic tolling of the bell. Pavlov felt sorry for his uncle because of the beatings he received and because he was "forced to stand outside in the cold and the rain when he was drunk" (Windholz, 1991, p. 56). Pavlov's mother was the daughter of a priest, and Pavlov remembered her as being loving but "thought that she mistook overprotectiveness for love" (Windholz, 1991, p. 55).

At the age of 10, Pavlov suffered a severe fall, which delayed his entering high school for a year. During his convalescence, he spent considerable time with his godfather, an abbot of a monastery near Ryazan. His godfather's lack of concern for worldly matters and his attention to detail were to

have a lifelong influence on Pavlov. Eventually, Pavlov enrolled in the local ecclesiastical high school and then in the Ryazan Theological Seminary where he, like his father, studied for the priesthood. However, in 1870, at the age of 21, he changed his mind and enrolled in the Military Medical Academy at St. Petersburg, where he studied natural science. Pavlov walked the several hundred miles from Ryazan to St. Petersburg, and his arrival there was coincidental with Sechenov's departure. It was under Sechenov's successor, Elias Cyon, that Pavlov first studied physiology.

Pavlov obtained a degree in natural science in 1879 and then remained at the academy to pursue a degree in medicine. Pavlov was so impressive as a medical student that he was appointed director of a small laboratory, where he helped several students obtain their doctorates even before he obtained his own in 1883. After receiving his medical degree, Pavlov studied physiology in Germany for two years. During this time, he studied with Carl Ludwig at the University of Leipzig. We saw in Chapter 8 that Ludwig, along with Helmholtz, Du Bois-Reymond, and Brücke, had signed an oath committing himself to a materialistic science devoid of metaphysical speculation. This positivism was to have a lasting effect on Pavlov: "Pavlov believed that facts were more important than theories because facts could stand on their own merit, whereas theories were constructs that could be easily proposed and just as well rejected" (Windholz, 1990, p. 69). Upon returning to Russia, Pavlov held a variety of ill-paying jobs until 1890, when he was finally appointed professor of physiology at St. Petersburg's Military Medical Academy. Pavlov was 41 at the time, and he would spend most of the remainder of his career at the academy.

Sechenov, like Hartley and Bain before him, had suggested that psychology should be studied using physiological concepts and techniques. Pavlov agreed with him completely and went a step further. Unlike Sechenov, Pavlov actually demonstrated in detail how such study could take place. Also unlike Sechenov, Pavlov was highly regarded both by the government and by most of his colleagues. In 1921 Lenin bestowed many special

privileges on Pavlov and proclaimed him a Hero of the Revolution. All this came rather late in Pavlov's life, however. Before he developed his interest in psychology, he first spent many years studying the digestive system.

Research on Digestion. During his first 10 years at St. Petersburg, Pavlov pursued his interests in the digestive system. At this time, most of what was known about digestion came from studies in which animals had been operated on to expose the organs of interest. Often the experimental animals were already dead as their organs were investigated; and if not dead, they were at least traumatized by the operation. Noting that little could be learned about normal digestive functioning by studying dead or traumatized animals, Pavlov sought a more effective experimental procedure. He knew of someone who had suffered a severe gunshot wound to the stomach and recovered. The victim's treatment, however, had left an open hole in his body through which his internal organs could be observed. The grateful patient allowed his physician to observe his internal processes, including those of the digestive system. Although this particular case lacked scientific control, it gave Pavlov the information he

Pavlov operating on an experimental animal.

needed to perfect his technique for studying digestion. Using the latest antiseptic surgical techniques and his outstanding surgical skills, Pavlov prepared a gastric fistula—a channel—leading from a dog's digestive organs to outside the dog's body. Such a procedure allowed the animal to recover fully from surgical trauma before its digestive processes were investigated. Pavlov performed hundreds of experiments to determine how the amount of secretion through the fistula varied as a function of different types of stimulation to the digestive system, and his pioneering research won him the 1904 Nobel Prize in physiology.

Discovery of the Conditioned Reflex. During his work on digestion, Pavlov discovered the conditioned reflex. As mentioned, Pavlov's method of studying digestion involved a surgical arrangement that allowed the dog's gastric juices to flow out of the body and be collected. While studying the secretion of gastric juices in response to such substances as meat powder, Pavlov noticed that objects or events associated with meat powder also caused stomach secretions—for example, the mere sight of the experimenter or the sound of his or her footsteps. Pavlov referred to these latter responses as conditional because they depended on something else—for example, meat powder. In an early translation of Pavlov's work, conditional was translated as conditioned, and the latter term has been used ever since. In light of subsequent history, it is interesting to note that the initial announcement of the discoverv of the conditioned reflex received little attention:

Pavlov's initial reference to conditional reflexes was made in an 1899 address before the Society of Russian Doctors of St. Petersburg. The address, delivered to a local group, failed to receive wide attention. His work, however, became internationally known when on 12 December 1904, in his Nobel Prize address, Pavlov mentioned the phenomenon of conditioning while describing his research on digestive processes. (Windholz, 1983, p. 394)

Paylov realized that conditioned reflexes could be explained by the associative principles of contiguity and frequency. He also realized that by studying conditioned reflexes, which he had originally called "psychic reflexes," he would be entering the realm of psychology. Like Sechenov before him, Pavlov had a low opinion of psychology with its prevailing use of introspection. He resisted the study of conditioned reflexes for a long time because of their apparently subjective nature. After pondering Sechenov's work, however, he concluded that conditioned reflexes, like natural reflexes, could be explained in terms of the neural circuitry and the physiology of the brain. At the age of 50. Pavlov began studying the conditioned reflex. His work would continue for 30 years.

Pavlov's Personality. Like Sechenov, Pavlov was a positivist and was totally dedicated to his laboratory work. He edited no journals, engaged in no committee work, and actually wrote very little. The only two books he wrote were edited versions of lectures he had given. The first, Work of the Principal Digestive Glands (1897), contained only a brief reference to "psychic secretions," and the second, Conditioned Reflexes (English translation, 1927/1960), dealt exclusively with the topic. Most of the information concerning Pavlov's work is found in the dissertations of doctoral students whose work he supervised. In fact, the first formal research on the conditioned reflex was performed by Pavlov's student Stefan Wolfsohn in 1897. His students viewed Pavlov as hard but fair, and they were very fond of him. Pavlov encouraged both women and Jewish students to study in his laboratory, a practice very uncommon at the time. One thing for which Pavlov had no tolerance, however, was mentalism. If researchers in his laboratory used mentalistic terminology to describe their findings, he fined them. Fancher (1990) describes how Pavlov ran his laboratory:

In pursuing his research he overlooked no detail. While he uncomplainingly lived frugally at home, he fought ferociously to ensure his laboratory was well equipped and his experimental animals well fed. Punctual in his arrival at the lab and perfectionistic in his experimental technique, he expected the same from his workers. Once during the Russian Revolution he disciplined a worker who showed up late from having to dodge bullets and street skirmishes on the way to the laboratory. (p. 279)

In private life, however, Pavlov was a completely different person. Fancher (1990) gives the following account of Pavlov outside the laboratory:

Outside, he was sentimental, impractical, and absent-minded—often arousing the wonder and amusement of his friends. He became engaged while still a student, and lavished much of his meager income on extravagant luxuries such as candy, flowers, and theater tickets for his fiancée. Only once did he buy her a practical gift, a new pair of shoes to take on a trip. When she arrived at her destination she found only one shoe in her trunk, accompanied by a letter from Pavlov: "Don't look for your other shoe. I took it as a remembrance of you and have put it on my desk." Following marriage, Pavlov often forgot to pick up his pay, and once when he did remember he immediately loaned it all to an irresponsible acquaintance who could not pay it back. On a trip to New York he carried all of his money in a conspicuous wad protruding from his pocket; when he entered the subway at rush hour, the predictable felony ensued and his American hosts had to take up a collection to replace his funds. (p. 279)

(For other versions of Pavlov's mugging in New York, see Thomas, 1994.)

During the early years of their marriage, Pavlov and his wife lived in extreme poverty. Once some relief appeared forthcoming when a few of Pavlov's colleagues managed to raise a small amount of money to pay him for giving a few lectures.

However, Pavlov used the money to purchase additional laboratory animals (Boakes, 1984). Pavlov's wife tolerated the situation, and she continued to give Pavlov her complete support during their long marriage:

What sustained Sara was belief in her husband's genius and in the supreme value of his work. In the early years of marriage they agreed upon a pact which both were to keep for the rest of their long life together. If she was to devote herself entirely to his welfare so that there would be nothing to distract him from his scientific work, then he was to regulate his life accordingly; she made him promise to abstain from all forms of alcohol to avoid card games and to restrict social events to visits from friends on Saturday evenings and entertainment, in the form of concerts or the theatre, to Sunday evenings. (Boakes, 1984, p. 116)

On rare occasions, Pavlov did demonstrate a concern for practical economics. For example, when his laboratory animals were producing an abundance of saliva, he sold it to the townspeople:

For some years gastric juice became very popular around St. Petersburg as a remedy for certain stomach complaints. As Pavlov was able to supply gastric juice in relatively large quantities and of a particularly pure quality by using the sham feeding preparation, the proceeds from its sale became considerable, to the extent of almost doubling the laboratory's income when this already far surpassed that of any comparable Russian laboratory. (Boakes, 1984, p. 119)

Unconditioned and Conditioned Reflexes. According to Pavlov, organisms respond to the environment in terms of unconditioned and conditioned reflexes. An **unconditioned reflex** is innate and is triggered by an **unconditioned stimulus** (US). For example, placing food powder in a hungry dog's mouth will increase the dog's saliva

flow. The food powder is the unconditioned stimulus, and the increased salivation is the unconditioned response (UR). The connection between the two is determined by the biology of the organism. A conditioned reflex is derived from experience in accordance with the laws of contiguity and frequency. Before Pavlov's experiment, stimuli such as the sight of food powder, the sight of the attendant, and the sound of the attendant's footsteps were biologically neutral in the sense that they did not automatically elicit a specific response from the dogs. Pavlov called a biologically neutral stimulus a conditioned stimulus (CS). Because of its contiguity with an unconditioned stimulus (in this case, food), this previously neutral stimulus developed the capacity to elicit some fraction of the unconditioned response (in this case, salivation). When a previously neutral stimulus (a conditioned stimulus) elicits some fraction of an unconditioned response, the reaction is called a conditioned response (CR). Thus, a dog salivating to the sound of an attendant's footsteps exemplifies a conditioned response.

Through this process of conditioning, the stimuli governing an organism's behavior are gradually increased from a few unconditioned stimuli to countless other stimuli that become associated to unconditioned stimuli through contiguity.

Excitation and Inhibition. Showing the influence of Sechenov, Pavlov believed that all central nervous system activity can be characterized as either excitation or inhibition. Like Sechenov, Pavlov believed that all behavior is reflexive. that is, caused by antecedent stimulation. If not modified by inhibition, unconditioned stimuli and conditioned stimuli will elicit unconditioned and conditioned reflexes, respectively. However, through experience, organisms learn to inhibit reflexive behavior. We will see one example of learned inhibition when we consider extinction. The important point here is that we are constantly experiencing a wide array of stimuli, some of them tending to elicit behavior and some tending to inhibit behavior. These two "fundamental processes" are always present, and how an organism behaves at

any given moment depends on their interaction. The pattern of excitation and inhibition that characterizes the brain at any given moment is what Pavlov called the **cortical mosaic**. The cortical mosaic determines how an organism will respond to its environment at any given moment.

Extinction, Spontaneous Recovery, and Disinhibition. If a conditioned stimulus is continually presented to an organism and is no longer followed by an unconditioned stimulus, the conditioned response will gradually diminish and finally disappear, at which point extinction is said to have occurred. If a period of time is allowed to elapse after extinction and the conditioned stimulus is again presented, the stimulus will elicit a conditioned response. This is called spontaneous recovery. For example, if a tone (CS) is consistently followed by the presentation of food powder (US), an organism will eventually salivate when the tone alone is presented (CR). If the tone is then presented but not followed by the food powder, the magnitude of the conditioned response will gradually diminish, and finally the tone will no longer elicit a conditioned response (extinction). After a delay, however—even without any further pairing of the tone and food powder—the tone will again elicit a conditioned response (spontaneous recovery).

Pavlov believed that spontaneous recovery demonstrated that the extinction process does not eliminate a conditioned response but merely inhibits it. That is, presenting the conditioned stimulus without the unconditioned stimulus causes the animal to inhibit the conditioned response. Further evidence that extinction is best explained as an inhibitory process is provided by **disinhibition**. This phenomenon is demonstrated when, after extinction has taken place, presenting a strong, irrelevant stimulus to the animal causes the conditioned response to return. The assumption was that the fear caused by the strong stimulus displaces the inhibitory process, thus allowing the return of the conditioned response.

Experimental Neurosis. Let us say that showing a dog a circle is always followed by food and

showing a dog an ellipse is never followed by food. According to Pavlov, the circle will come to elicit salivation, and the ellipse will inhibit salivation. Now let us make the circle increasingly more elliptical. What happens? According to Pavlov, when the circle and the ellipse become indistinguishable, the excitatory and the inhibitory tendencies will conflict, and the animal's behavior will break down. Because this deterioration of behavior was brought about in the laboratory, it was called **experimental neurosis**.

Almost as interesting as the fact that abnormal behavior could be produced in the laboratory by producing conflicting tendencies was the fact that the "neurotic" behavior took different forms in different animals. Some dogs responded to the conflict by becoming highly irritable, barking violently, and tearing at the apparatus with their teeth. Other animals responded to the conflict by becoming depressed and timid. Observations such as these caused Pavlov to classify animals in terms of different types of nervous systems. He thought that there are four types of animals: those for whom the excitatory tendency is very strong, those for whom the excitatory tendency is moderately strong, those for whom the inhibitory tendency is very strong, and those for whom the inhibitory tendency is moderately strong. Thus, how animals, including humans, respond to conflict is to a large extent determined by the type of nervous system they possess. In his later years, Pavlov speculated that much human abnormal behavior was caused by a breakdown of inhibitory processes in the brain.

Pavlov's work on conflict and his typology of nervous systems were to strongly influence subsequent work on abnormal behavior, conflict, frustration, and aggression.

The First- and Second-Signal Systems. According to Pavlov, all tendencies that animals acquire during their lifetimes are based on innate, biological processes—that is, on unconditioned stimuli and unconditioned responses that have been acquired during their phylogenetic history. These innate processes are expanded by conditioning. As biologically neutral stimuli (CSs) are consistently associ-

ated with biologically significant stimuli (USs), the former come to *signal* the biologically significant events. The adaptive significance of such signals should be obvious; if an animal is warned that something either conducive or threatening to survival is about to happen, it will have time to engage in appropriate behavior.

Pavlov ... rated very highly the ability of the conditioned reaction to act as a "signal" reaction or, as he expressed it many times, a reaction of "warning character." It is this "warning" character which accounts for the profound historical significance of the conditioned reflex. It enables the animal to adapt itself to events which are not taking place at that particular moment but which will follow in the future. (Anokhin, 1968, p. 140)

Pavlov called the stimuli (CSs) that come to signal biologically significant events the **first-signal system**, or "the first signals of reality." However, humans also learn to respond to *symbols* of physical events. For example, we learn to respond to the word *fire* just as we would to the sight of a fire. Pavlov referred to the words that come to symbolize reality "signals of signals," or the **second-signal system**. Language, then, consists of symbols of environmental and bodily experiences. Once established, these symbols can be organized into abstract concepts that guide our behavior because even these abstract symbols represent events in the physical world:

Obviously for man speech provides conditioned stimuli which are just as real as any other stimuli. At the same time speech provides stimuli which exceed in richness and many-sidedness any of the others, allowing comparison neither qualitatively nor quantitatively with any conditioned stimuli which are possible in animals. Speech, on account of the whole preceding life of the adult, is connected up with all the internal and external stimuli which can reach the cortex, signalling all of them

and replacing all of them, and therefore it can call forth all those reactions of the organism which are normally determined by the actual stimuli themselves. (Pavlov, 1927/1960, p. 407)

Pavlov's Attitude toward Psychology. As we have seen, Pavlov, like Sechenov, had a low opinion of psychology. Also like Sechenov, Pavlov was not opposed to psychology because it studied consciousness but because it used introspection to do so. According to Pavlov,

It would be stupid to reject the subjective world. Of course it exists. It is on this basis that we act, mix with other people, and direct all our life.

Formerly I was a little carried away when I rejected psychology. Of course it has the right to exist, for our subjective world is a definite reality for us. The important thing, therefore, is not to reject the subjective world, but to study it by means of scientifically based methods. (Anokhin, 1968, p. 132)

Although Pavlov had a low opinion of most psychologists, he did have a high opinion of Thorndike. In the following passage, Pavlov (1928) even acknowledges Thorndike as the first to do systematic, objective research on the learning process in animals:

Some years after the beginning of the work with our new method I learned that somewhat similar experiments on animals had been performed in America, and indeed not by physiologists but by psychologists. Thereupon I studied in more detail the American publications, and now I must acknowledge that the honour of having made the first steps along this path belongs to E. L. Thorndike. By two or three years his experiments preceded ours, and his book must be considered as a classic, both for its bold outlook on an immense task and for the accuracy of its results. (pp. 38–40)

Payloy and Associationism. Payloy believed that he had discovered the physiological mechanism for explaining the associationism that philosophers and psychologists had been discussing for centuries. He believed that by showing the physiological underpinnings of association, he had put associationism on an objective footing and that speculation about how ideas become associated with each other could finally end. For Pavlov (1955) the temporary connections formed by conditioning were precisely the associations that had been the focus of philosophical and psychological speculation:

Are there any grounds ... for distinguishing between that which the physiologist calls the temporary connection and that which the psychologist terms association? They are fully identical; they merge and absorb each other. Psychologists themselves seem to recognize this, since they (at least, some of them) have stated that the experiments with conditioned reflexes provide a solid foundation for associative psychology, i.e., psychology which regards association as the base of psychical activity. (p. 251)

Pavlov died of pneumonia on February 27, 1936, at the age of 87. The entire September 1997 issue of American Psychologist explores the life, works, and influence of Payloy.

Vladimir M. Bechterev

Vladimir M. Bechterev (1857-1927) was born on January 20, and at 16 years of age he entered the Military Medical Academy at St. Petersburg, where Sechenov had studied and Pavlov was studying. He graduated in 1878 (one year before Pavlov) but continued to study in the Department of Mental and Nervous Diseases until he obtained his doctorate in 1881 at the age of 24. He then studied with Wundt in Leipzig, Du Bois-Reymond in Berlin, and Charcot (the famous French psychiatrist) in Paris. In 1885 he returned to Russia to a position at the University of Kazan, where he created the first Russian experimental

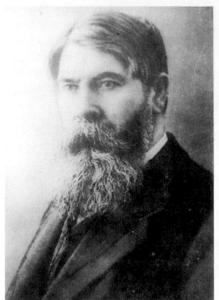

of the National Library of Medicine

Vladimir M. Bechterey

psychology laboratory. In 1893 he returned to St. Petersburg's Military Medical Academy, where he held a chair of the psychic and nervous diseases department. In 1904 he published an important paper titled "Objective Psychology," which evolved into a three-volume book by the same name (1907-1912; French translation, 1913). Like Sechenov and Pavlov, Bechterev argued for a completely objective psychology, but, unlike them, Bechterev concentrated almost exclusively on the relationship between environmental stimulation and behavior.

In 1907 Bechterev and his collaborators left the Military Medical Academy to found Psychoneurological Institute, which was later named the V. M. Bechterev Institute for Brain Research in his honor.

When Bechterev died in 1927, his bibliography totaled about 600 articles and books written on a wide variety of topics in biology, psychology, and philosophy.

Reflexology. Late in his life, Bechterev summarized his views about psychology in General Principles of Human Reflexology: An Introduction to the Objective Study of Personality, which first appeared in 1917 and reached its fourth edition in 1928. By reflexology, Bechterev meant a strictly objective study of human behavior that seeks to understand the relationship between environmental influences and overt behavior. He took the position that if so-called psychic activity exists, it must manifest itself in overt behavior; therefore, "the spiritual sphere" can be bypassed by simply studying behavior. His reflexology studied the relationship between behavior (such as facial expressions, gestures, and speech) and physical, biological, and, above all, so-cial conditions.

Many of Bechterev's ideas were also found in U.S. behaviorism at about the same time. It should be remembered, however, that Bechterev was writing about objective psychology as early as 1885 (Bechterev, 1928/1973). A few passages from Bechterev's General Principles of Human Reflexology (1928/1973) exemplify his thinking:

In order to assume ... a strictly objective standpoint in regard to man, imagine yourself in a position of being from a different world and of a different nature, and having come to us, say, from another planet.... Observing human life in all its complex expressions, would this visitor from another planet, of a different nature, ignorant of human language, turn to subjective analysis in order to study the various forms of human activity and those impulses which evoke and direct it? Would he try to force on man the unfamiliar experiences of another planetary world, or would this being study human life and all its various manifestations from the strictly objective point of view and try to explain to himself the different correlations between man and his environment, as we study, for example, the life of microbes and lowly animals in general? I think there can be no doubt of the answer.

In following this method, obviously we must proceed in the manner in which

natural science studies an object: in its particular environment, and explicate the correlation of the actions, conduct, and all other expressions of a human individual with the external stimuli, present and past, that evoke them; so that we may discover the laws to which these phenomena conform, and determine the correlations between man and his environment, both physical, biological, and, above all, social.

It is regrettable that human thought usually pursues a different course—the subjective direction—in all questions concerning the study of man and his higher activities, and so extends the subjective standpoint to every department of human activity. But this standpoint is absolutely untenable, since each person develops along different lines on the basis of unequal conditions of heredity, education, and life experience, for these conditions establish a number of correlations between man and his environment, especially the social, and so each person is really a separate phenomenon, completely unique and irreproducible, while the subjective view presupposes an analogy with oneself—an analogy not existing in actual fact, at least not in the highest, and consequently more valuable, expressions of a human being.

You will say that we use analogy everywhere, that in everyday life we cannot approach another man without it. All that is, perhaps, true to a certain extent, but science cannot content itself with this, because taking the line of subjective interpretation, we inevitably commit some fallacy. It is true that, in estimating another person, we turn to subjective terminology, and constantly say that such and such a man thinks this or that, reasons in this or that manner, etc. But we must not forget that everyday language and the scientific approach to natural phenomena cannot be identical. For instance, we always say of the

sun that it rises and sets, that it reaches its zenith, travels across the sky, etc., while science tells us that the sun does not move, but that the earth revolves round it. And so, from the point of view of present-day science, there must be only one way of studying another human being expressing himself in an integration of various outward phenomena in the form of speech, facial and other expressions, activities, and conduct. This way is the method usually employed in natural science, and consists in the strictly objective study of the object, without any subjective interpretation and without introducing consciousness. (pp. 33–36)

By 1928 Bechterev was aware of the growing tendency toward objective psychology in the United States and claimed that he was the originator of that tendency:

The literature on the objective study of animal behavior has grown considerably and in America an approach is being made to the study of human behavior, a study which has first been set on a scientific basis on Russian soil in my laboratories at the Military Medical Academy and at the Psychoneurological Institute. (Bechterev, 1928/1973, p. 214)

Bechterev versus Pavlov. Who discovered the conditioned reflex? It was neither Bechterev nor Pavlov. Bechterev spent considerable time showing that such reflexes were known for a very long time: "These 'psychic' secretions, by the way, attracted attention as early as the 18th century. Even then it was known that when oats is given to a horse, he secretes saliva before the oats enters his mouth" (1928/1973, p. 403).

Both Bechterev and Pavlov studied conditioned reflexes at about the same time. What Pavlov called a conditioned reflex, Bechterev called an **association reflex**. Bechterev was well aware of Pavlov's research and thought that it had major flaws. In fact, almost every time Bechterev mentioned Pavlov in his 1928 book, he had something

negative to say. Bechterev criticized Pavlov's "saliva method" for the following reasons:

- An operation is necessary for collecting gastric juices from the stomach.
- Pavlov's procedure cannot be easily used on humans.
- The use of acid to elicit an unconditioned response causes reactions in the animal that may contaminate the experiment.
- If food is used as an unconditioned stimulus, the animal will eventually become satiated and therefore no longer respond in the desired fashion.
- The secretory reflex is a relatively unimportant part of an organism's behavior.
- The secretory reflex is unreliable and therefore difficult to measure accurately.

Instead of studying secretion, Bechterev (1928/1973) studied motor reflexes, and stated his reasons as follows:

Luckily, in all animals, and especially in man, who particularly interests us in regard to the study of correlative activity, the secretory activities play a much smaller part than do motor activities, and, as a result of this, and for other reasons also (the absence of an operation, the possibility of exact recording, the possibility of frequent repetition of the stimuli ... and the absence of any complications as a result of frequent stimulation in experiment) we give unconditional preference, in view of the above-mentioned defects of the saliva method, to the method of investigation of association-motor reflexes of the extremities and of respiration—a method developed in my laboratory. This method, which is equally applicable to animals and to man, and consists in the electrical stimulation on the front paw of the animal, and in man, of the palm or fingers of the hand, or the ball of the foot, with simultaneous visual, auditory, cutaneo-muscular and

other stimulations, has as far as I know, not met with any opposition in scientific literature from the time of its publication. (p. 203)

Bechterev's concentration on the overt behavior of organisms was more relevant to U.S. behaviorism than was Pavlov's research on secretion. But Pavlov was the one whom Watson discovered, and therefore the name Pavlov became widely known in U.S. psychology. It is another one of those quirks of history that but for the sake of fortuitous circumstances, the name Bechterev could have been a household name instead of Pavlov. And as we will see, in his application of conditioning procedures, Watson actually followed Bechterev more closely than he did Pavlov.

JOHN B. WATSON AND BEHAVIORISM

John Broadus Watson (1878–1958) was born on January 9 in the village of Travelers Rest near Greenville, South Carolina. Religion was a major theme in Watson's early life:

Watson's mother was "insufferably religious." She took an active role in the Reedy River Baptist Church and became one of the "principal lay organizers for the

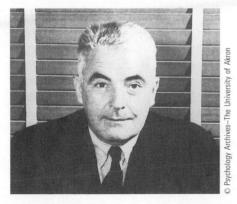

John B. Watson

Baptists in the whole of South Carolina." In keeping with her proselytizing zeal, Emma named her youngest son John Broadus Watson, after John Albert Broadus, "one of the founding ministers of the Southern Baptist Theological Seminary which had been located in Greenville up until a few months before Watson's birth in January, 1878." John was made to vow to his mother that he would become a minister—"slated," as he put it, at an early age. Emma tied her family closely to the church, strictly adhering to the fundamentalist prohibition against drinking, smoking, or dancing. Cleanliness was always next to godliness, and Emma never ceased to keep her family next to God. (Karier, 1986, p. 111)

Although his mother (Emma Kesiah Roe Watson) was extremely religious, his father (Pickens Butler Watson) was not. His father drank, swore, and chased women. This incompatibility finally resulted in Watson's father leaving home in 1891, when Watson was 13 years old. Watson and his father had been close, and his father's departure disturbed him deeply. He immediately became a troublemaker and was arrested twice, once for fighting and once for firing a gun in the middle of Greenville. Later, when Watson was famous, his father sought out his son, but Watson refused to see him.

One can only speculate on the effects of the mother's intense religious convictions in Watson's life, but the origin of Watson's lifelong fear of the dark seems clear:

The nurse [that Emma, Watson's mother, had employed] told him [Watson] that the devil lurked in the dark and that if ever Watson went a-walking during the night, the Evil One might well snatch him out of the gloom and off to Hell. Emma seems to have done nothing to stop the nurse instilling such terrors in her young son. Most likely, she approved. To be terrified of the

Devil was only right and prudent. As a fundamentalist Baptist, she believed that Satan was always prowling. All this left Watson with a lifelong fear of the dark. He freely admitted that he studied whether children were born with an instinctual fear of the dark because he had never managed to rid himself of the phobia. He tried a number of times to use his behaviourist principles to cure himself but he never really managed to do it. As an adult Watson was often depressed, and when he got depressed he sometimes had to sleep with his light on. (Cohen, 1979, p. 7)

Watson's Adult Life

Undergraduate Years. Despite his history of laziness and violence in school, Watson somehow managed to get himself accepted to Furman University at the age of 15. Although it is not known why Watson was accepted, Cohen (1979) suggests Watson's persuasive ability as the reason. All his life, Watson demonstrated an ability to get what he wanted. While at college, Watson continued to live at home and worked at a chemical laboratory in order to pay his fees. His most influential teacher at Furman was Gordon B. Moore, who taught philosophy and psychology. The psychology Watson learned involved mainly the works of Wundt and James. All during college, Watson had problems with his brother Edward, who considered Watson a sinner like his father and therefore a disgrace to the family.

At Furman, Watson did well but not exceptionally well. He should have graduated in 1898, but an unusual event set him back a year. Moore, his favorite teacher, warned that he would flunk any student who handed his or her examination in backward. Absentmindedly, Watson handed in his examination backward and was flunked:

Watson then made what he later called "an adolescent resolve [to] make [Moore] seek me out for research some day." Years later,

as a professor at Johns Hopkins University, Watson had his revenge. To his "surprise and real sorrow," Watson recalled, he received a request from his former teacher to be accepted as a research student. Before it could be arranged, Moore's eyesight failed; within a few years, he died. (Buckley, 1989, p. 12)

The episode ended up benefiting Watson, however, because during the extra year at Furman that failing Moore's course necessitated, he earned a master's degree at the age of 21.

Following graduation, Watson taught in a one-room school in Greenville, for which he earned \$25 a month. When his mother died, he decided to continue his education outside the Greenville area, and he applied to both Princeton and the University of Chicago. When he learned that Princeton required a reading knowledge of Greek and Latin, he decided to go to the University of Chicago. Another reason for his decision was that his favorite teacher—Moore, the one who had flunked him—had studied at the University of Chicago, and his reminiscences intrigued Watson. So in September 1900, Watson left Greenville for Chicago.

Watson arrived in Chicago with \$50 and no other financial resources. To survive, he took a room in a boardinghouse and worked as a waiter there to pay for his room and board. He also earned \$1 a week as a janitor in the psychology laboratory and another \$2 a week for taking care of the white rats.

The Chicago Years. At Chicago, Watson studied the British empiricists with A. W. Moore (not the Gordon B. Moore of Furman). Watson especially liked Hume because Hume taught that nothing was necessarily fixed or sacred. Watson took philosophy from John Dewey but confessed that he could not understand Dewey. Although the faculty member who had the greatest influence on Watson was the functionalist James Angell, the radical physiologist, Jacques Loeb also influenced him. Loeb (1859–1924) was famous for his work

on **tropism**, having shown that the behavior of simple organisms could be explained as being automatically elicited by stimuli. Just as plants orient toward the sun because of the way they are constructed, so do animals respond in certain ways to certain stimuli because of their biological makeup. According to Loeb, no mental events are involved in such tropistic behavior; it is simply a matter of the stimulation and the structure of the organism. This viewpoint, which Loeb applied to plants, insects, and lower animals, Watson would later apply to humans as well.

Under the influence of Angell and Henry Donaldson, a neurologist, Watson began to investigate the learning process in the white rat. In 1901 very little was known about animal learning, even though Thorndike had done some objective research by that time. Also in 1901 Willard Small had published an article on the maze-learning ability of the white rat, but the article was as anthropomorphic as the work of Romanes. Thus, Watson had little information on which to draw. By the end of 1902, however, he knew more about the white rat than anyone else in the United States. Also about this time, Watson first began to develop a feeling for behaviorism: "If you could understand rats without the convolutions of introspection, could you not understand people the same way?" (Cohen, 1979, p. 33).

Even though Watson had begun thinking about behaviorism as early as 1902, he resisted mentioning it to his mentor and friend Angell because he knew that Angell believed psychology should include the study of consciousness. When he finally did tell Angell of his ideas in 1904, Angell responded negatively and told him that he should stick to animals, thus silencing Watson on the subject for four years.

Although Watson suffered a nervous breakdown in 1902, he managed to submit his doctoral thesis in 1903. The title, "Animal Education: The Psychical Development of the White Rat," shows that there was still a hint of mentalistic thinking in Watson at this time. The thesis was accepted, and Watson attained his doctorate (magna cum laude) at age 25, making him the youngest person ever to

attain a doctorate at the University of Chicago. Donaldson lent Watson the \$350 that was needed to publish the thesis, and it took Watson 20 years to repay the loan.

The University of Chicago hired Watson as an assistant professor for a salary of \$600 a year, and he taught courses in both animal and human psychology. For the latter, he used Titchener's laboratory manuals. During this time, Watson married one of his students, Mary Ickes. Buckley (1989) describes the origin of Watson's relationship with Mary:

As family legend has it, Mary was a student in Watson's introductory psychology class. She developed a crush on her professor and during one long exam wrote a love poem in her copybook instead of answers to the test questions. When Watson insisted on taking the paper at the end of the quiz, Mary blushed, handed him the paper, and ran from the room. The literary effort must have had its desired effect. (p. 49)

Watson actually married Mary twice—once in 1903, in private, because of her family's strong opposition to her relationship with Watson, and a second time, publicly, in 1904. The marriage produced two children, Mary (nicknamed Polly) and John. Polly was the mother of television and film actress Mariette Hartley.

Also about this time, Watson began his correspondence with Robert Yerkes. Yerkes (1876-1956) was another young animal researcher, who, while a student at Harvard, had been encouraged to pursue his interest in comparative psychology. After receiving his doctorate from Harvard in 1902, Yerkes had been offered an appointment at Harvard as instructor of comparative psychology. In his career, Yerkes studied the instincts and learning abilities of many different species, including mice, crabs, turtles, rats, worms, birds, frogs, monkeys, pigs, and apes; but he is probably best remembered for the work on anthropoid apes that he supervised at the Yerkes Laboratories of Primate Biology in Orange Park, Florida. In Chapter 10, we learned that Yerkes was also instrumental in the creation of the Army Alpha and Beta tests of intelligence. Despite Yerkes's involvement with animal research and his friendship with Watson, he never accepted Watson's behaviorist position. During the formative stages of behaviorism, Yerkes remained loyal to Titchener.

In 1906 Watson began his research designed to determine what sensory information rats used as they learned to solve a complex maze. He did his research with Harvey Carr, the prominent functionalist. Using 6-month-old rats that had previously learned the maze, Watson began systematically to remove one sensory system after another, in hopes of learning which sensory system the rats used to traverse the maze correctly. One by one, he eliminated the senses of vision, hearing, and smell. Nothing appeared to make a difference. After full recovery from each operation, the rats were able to traverse the maze accurately. Watson and Carr then took a naive group of rats and performed the same operations, finding that the naive rats learned the maze as well as the rats that had full sensory apparatus. Watson then speculated that perhaps the rats were using their whiskers, but shaving off the whiskers made no difference; even destroying the sense of taste made no difference. Watson and Carr finally found that the rats were relying on kinesthetic sensations—sensations from the muscles. If the maze was made shorter or longer, after destruction of the kinesthetic sense, the rats were confused and made many errors. This discovery of the importance of kinesthetic sensation was to play an important role in Watson's later theory. Watson published the research results in 1907 in an article titled "Kinesthetic and Organic Sensations: Their Role in the Reactions of the White Rat to the Maze."

In 1907 the Carnegie Institution offered Watson an opportunity to study the migratory instinct of terns, and Watson made several visits to an island near Key West, Florida, to do so. Much of his research on instinctive behavior was done in collaboration with Karl Lashley, who was later to make significant contributions to neurophysiological psychology (see Chapter 19). One summer, Watson brought Lashley with him to see whether terns, in fact, had the ability to home. To find out, Lashley

took a number of terns to Mobile. Alabama, and some to Galveston, Texas, and turned them loose. The results were exciting. Without any training, the terns found their way back to the small island. which was about a thousand miles from where Lashley had released them. Watson and Lashley tried in vain to explain how the terns did it; in the end, both men turned to other matters. Because Watson has become known for other accomplishments, it is often overlooked that he was one of the first U.S. ethologists. (Ethologists study the behavior of animals in their natural habitats and usually attempt to explain that behavior in terms of evolutionary theory.) Watson's early publication (with Lashley), "Homing and Related Activities of Birds" (1915), provides an interesting contrast to Watson's later work.

Interestingly, Watson and Lashley also cooperated in research on what is now called "sports psychology." Under the supervision of Watson, Lashley attempted to improve the performance of archers. Among other things, Lashley found that distributed practice enhanced performance more than massed practice (Lashley, 1915).

The Move to Johns Hopkins. By 1907 Watson had a national reputation in animal psychology, and he was offered a position at Johns Hopkins University. He really did not want to leave the University of Chicago, but the offer of \$3,000 a year from Johns Hopkins was irresistible. Watson arrived in Baltimore in August 1908. At Johns Hopkins, psychology was part of the Department of Philosophy, Psychology, and Education, and James Mark Baldwin was chairman of the department. Baldwin, who had been a founding member of the APA and its sixth president in 1897, was also the editor of Psychological Review, one of psychology's leading journals. Among Watson's duties was teaching human psychology, for which he still used Titchener's manuals. Watson wrote to Titchener about the problems he was having setting up a laboratory at Johns Hopkins, and Watson and Titchener exchanged many letters from that point on. The two men always showed great respect for each other. In Watson's time of great trouble (discussed shortly), Titchener was the only person who stuck with him.

In December 1908, an event occurred that significantly changed the lives of Baldwin and Watson: Baldwin was caught in a brothel and was forced to resign from Johns Hopkins immediately. (For details concerning this "Baltimore affair" and its effect on Baldwin's life and work, see Horley, 2001.) Upon Baldwin's resignation, Watson became the editor of the Psychological Review, and ultimately he used the journal to publish his views on behaviorism. For many years, Watson had been pondering a purely behavioristic position, but when he tried his ideas on those closest to him-for example, Angell and Yerkes—they discouraged him because they both believed that the study of consciousness had an important place in psychology. Watson first publicly announced his behavioristic views in 1908 at a colloquium at Yale University. Watson was again severely criticized, and again he fell silent. At the time, Watson did not have enough confidence to "go to war" against established psychology on his own. He also remained silent to avoid offending his friend Titchener.

Watson gained courage, however, and in 1913 he decided to take another plunge. When asked to give a series of lectures at Columbia University in New York, he used the opportunity to state publicly his views on psychology again. He began his now famous lecture "Psychology as the Behaviorist Views It" (1913) with the following statement:

Psychology as the Behaviorist views it is a purely objective experimental branch of natural science. Its theoretical goal is the prediction and control of behavior. Introspection forms no essential part of its methods, nor is the scientific value of its data dependent upon the readiness with which they lend themselves to interpretation in terms of consciousness. The Behaviorist, in his efforts to get a unitary scheme of animal response, recognizes no dividing line between man and brute. The behavior of man, with all of its refinement and complexity, forms only a part of the

Behaviorist's total scheme of investigation. (p. 158)

Published in 1913 in the *Psychological Review*, which Watson edited, this lecture is usually taken as the formal founding of behaviorism.

The responses immediately began rolling in. Titchener was not upset because he felt Watson had outlined a technology of behavior that did not conflict with psychology proper; but Angell, Cattell, and Woodworth criticized Watson for being too extreme. Thorndike too, although sympathetic toward much of Watson's program, expressed concern that it might become "a restrictive orthodoxy" (Joncich, 1968, p. 418). After his Columbia lectures, Watson was publicly committed to behaviorism and had no tolerance for any other brand of psychology. As we will see, Watson's position gradually expanded to the point where it attempted to explain all human behavior. Perhaps because Watson's ideas were so radical, they did not gain immediate popularity. Instead, their acceptance grew steadily over a period of several years (Samelson, 1981). Still, Watson was elected president of the Southern Society for Philosophy and Psychology in 1914. The same year, he was elected the 24th president of the APA-all this at the age of 36 and only 11 years after receiving his doctorate from the University of Chicago.

Watson's accomplishments at Johns Hopkins are even more impressive when one realizes that his professional activities were interrupted by induction into military service between 1917 and 1919. He was as iconoclastic in the military as he was in psychology. He was almost court-martialed for insubordination, and in his autobiography, he summarized his military experience in these words: "Never have I seen such incompetence, such extravagance, such a group of overbearing, inferior men" (1936, p. 278). Nonetheless he attained the rank of major and was honorably discharged.

Scandal. As rapidly as Watson's influence rose, it fell even more rapidly. In 1920 Watson's wife discovered that he was having an affair with Rosalie

Rayner, with whom he was doing research on infant behavior, and sued him for divorce. The scandal was too much for Johns Hopkins: Watson was asked to resign, and he did. For all practical purposes, this marked the end of Watson's professional career in psychology. He wrote about and lectured on psychology for many years and revised many of his earlier works, but more and more he directed his ideas toward the general public rather than toward psychologists. For many years, he tried to gain another academic position in psychology, but the "scandal" had taken its toll and no college or university would have him. His thoughts appeared in popular magazines such as Harper's, the New Republic, McCall's, and Cosmopolitan instead of in professional journals. Watson also appeared on many radio talk shows. The following is a sample of titles of his articles and radio talks: "How We Think" (1926), "The Myth of the Unconscious" (1927), "On Reconditioning People" (1928), "Feed Me on Facts" (1928), "Why 50 Years from Now Men Won't Marry" (1929), "After the Family-What?" (1929), "Women and Business" (1930), "On Children" (1935).

The last article Watson wrote was titled "Why I Don't Commit Suicide." He submitted it to Cosmopolitan, but it was rejected as too depressing.

Advertising Work. In 1921 Watson's divorce was final, and he married Rosalie Rayner; he was 42 and she was 21. They eventually had two children, William ("Billy"), born in 1921, and James, born in 1924. Brewer (1991) speculates that the combination of first names, William and James, reflected Watson's admiration for William James. When Watson married Rosalie, he was out of work and broke. An opportunity arose for him to work for the advertising company J. Walter Thompson. The job offered to Watson contrasted sharply with what Watson had grown accustomed to. Cohen (1979) describes the job interview and the job itself:

If Watson had been able to laugh at that point, he must have done so. Resor [the person who interviewed Watson] was a man who had graduated from Yale with no great

distinction in 1901. He had sold stoves for his father and had gone on to run a twelveman office in Cincinnati. In 1916 he had clubbed together with some friends from Yale to buy out the original J. Walter Thompson who had made the agency a small success. Now John B. Watson, who was recognized as being one of the greatest psychologists in the world, who was in the same intellectual league as Freud and Russell and Bergson, was asking Resor for a job. And Resor gave Watson only a temporary job. And what a job! Resor had to address the annual convention of the Boot Sellers League of America. In order to have the most impressive paper at the convention, he wanted some quick research to be done on the boot market. John B. Watson was given the job of studying the rubber boot market on each side of the Mississippi River from Cairo to New Orleans. It is a measure of Watson that he took to this job without feeling humiliated. He set out to learn it. He did not feel bitter that he had come to this. He always believed in being adaptable, in coping with what he called "life's little difficulties." Most psychologists would have felt this little difficulty as a crushing blow. And, in many ways, it was crushing. Watson wanted to pursue his work on children; he enjoyed his status as a leading professor. But one had to deal with life and, for him, the best way of doing so was to plunge whole-heartedly into it adversity and all. He threw himself into the study of the rubber boot market on the Mississippi. To be immersed even in that was some relief. (p. 161)

Resor asked for letters of recommendation for Watson, and a very supportive one came from none other than Titchener:

Watson was always deeply grateful to Titchener for consenting to write a reference and wrote to him in 1922 that "I know, in my heart, that I owe you more than almost all my other colleagues put together." Watson's instinct was just. (Cohen, 1979, p. 172)

Resor hired Watson in 1921 at a salary of \$10,000 a year. By 1924 Watson was considered one of the leading people in advertising and was made a vice president of the J. Walter Thompson Company. Titchener wrote and congratulated him but worried that the promotion would give Watson less time to work on psychology. By 1928 Watson was earning over \$50,000 a year and, by 1930, over \$70,000. Remember that this was in 1930 imagine what the equivalent salary would be today! One thing that made Watson so successful was his use of the then almost-unknown concept of market research. He found, for example, that blindfolded smokers could not differentiate among different brands of cigarettes. Because preference must be based on the images associated with various brand names. Watson concluded that sales could be influenced by manipulating the images associated with brand names. Following this strategy, Watson increased the sales of such products as Johnson's baby powder, Pebeco toothpaste, Ponds cold cream, Maxwell House coffee, and Odorono, one of the early deodorants. In 1935 Watson left the J. Walter Thompson Company to become vice president of William Esty Advertising, where he remained until his retirement in 1945 at the age of 67. For an overview of Watson's contributions to the field of advertising, see Larson, 1979.

Even though Watson's accomplishments in advertising were vast, his first love was always psychology, and he regretted for the rest of his life that he was unable to pursue his professional goals, especially his research on children. How psychology would be different today if Watson had not been dismissed from Johns Hopkins in 1920 cannot be known, but surely it would be different.

Watson's Objective Psychology

When Watson discovered Russian objective psychology, he found support in it, but he had arrived

at his position independently of the Russians. What Watson and the Russian psychologists had in common was a complete rejection of introspection and of any explanation of behavior based on mentalism. That is, both thought that consciousness could not cause behavior; it was merely a phenomenon that accompanied certain physiological reactions caused by stimuli—an epiphenomenon. Most of the Russian physiologists, such as Sechenov and Pavlov, were more interested than Watson in explaining the physiology underlying behavior, especially brain physiology. As time went by, Watson became even less interested in physiology and more interested in correlating stimuli and responses. He called the brain a "mystery box" that was used to account for behavior when the real cause was unknown. In other words, Watson's approach to studying organisms (including humans) was closer to Bechterev's than it was to Sechenov's or Pavlov's. In fact, the approaches of Bechterev and Watson were very close, both methodologically and philosophically.

In his 1913 statement on behaviorism, Watson did not mention the work of the Russians and said very little about human behavior. And though Watson's first book (1914) dealt mainly with animal behavior, there was still no mention of the Russian physiologists. Finally, in his presidential address to the APA in 1915 (published as "The Place of the Conditioned Reflex in Psychology" in 1916), Watson suggested that Pavlov's work on the conditioned reflex could be used to explain human as well as animal behavior. But Watson never fully accepted or used Pavlovian concepts in his work. As we will see, he had his own notions concerning the terms *stimulus* and *response* and concerning the learning process.

The Goal of Psychology. In his major work (*Psychology from the Standpoint of a Behaviorist*, 1919), Watson fully elaborated a stimulus–response psychology. In his 1913 article, he had stated the goal of psychology as the prediction and control of behavior, and in 1919 he explained further what he meant:

If its facts were all at hand the behaviorist would be able to tell after watching an individual perform an act what the situation is that caused his action (prediction), whereas if organized society decreed that the individual or group should act in a definite, specific way the behaviorist could arrange the situation or stimulus which would bring about such action (control). In other words, *Psychology from the Standpoint of the Behaviorists* is concerned with the prediction and control of human action and not with an analysis of "consciousness." (pp. vii–ix)

He went on to say,

The goal of psychological study is the ascertaining of such data and laws that, given the stimulus, psychology can predict what the response will be; or, on the other hand, given the response, it can specify the nature of the effective stimulus. (1919, p. 10)

Watson, however, did not use the terms stimulus and response in as narrow a sense as the Russian physiologists. For him, a stimulus could be a general environmental situation or some internal condition of the organism. A response was anything the organism did—and that included a great deal:

The rule, or measuring rod, which the behaviorist puts in front of him always is: Can I describe this bit of behavior I see in terms of "stimulus and response"? By stimulus we mean any object in the general environment or any change in the tissues themselves due to the physiological condition of the animal, such as the change we get when we keep an animal from sex activity, when we keep it from feeding, when we keep it from building a nest. By response we mean anything the animal does-such as turning toward or away from a light, jumping at a sound, and more highly organized activities such as building a skyscraper, drawing plans, having babies, writing books, and the like. (J. B. Watson, 1924/1930, pp. 6-7)

Thus, Watson's position has been unjustly called "the psychology of twitchism," implying that it is concerned with specific reflexes elicited by specific stimuli.

Types of Behavior and How They Are Studied. For Watson, there were four types of behavior: explicit (overt) learned behavior such as talking, writing, and playing baseball; implicit (covert) learned behavior such as the increased heart rate caused by the sight of a dentist's drill; explicit unlearned behavior such as grasping, blinking, and sneezing; and implicit unlearned behavior such as glandular secretions and circulatory changes. According to Watson, everything that a person did, including thinking, falls into one of these four categories.

For studying behavior, Watson proposed four methods: observation, either naturalistic or experimentally controlled; the conditioned-reflex method, which Pavlov and Bechterev had proposed; testing, by which Watson meant the taking of behavior samples and not the measurement of "capacity" or "personality"; and verbal reports, which Watson treated as any other type of overt behavior. By now it should be clear that Watson did not use verbal behavior as a means of studying consciousness.

Language and Thinking. The most controversial aspect of Watson's theory concerned language and thinking. To be consistent in his behavioristic view, Watson had to reduce language and thinking to some form of behavior and nothing more: "Saying is doing—that is, behaving. Speaking overtly or to ourselves (thinking) is just as objective a type of behavior as baseball" (1924/1930, p. 6).

For Watson then, speech presented no special problem; it was simply a type of overt behavior. Watson solved the problem of thinking by claiming that thinking is implicit or subvocal speech. Because overt speech is produced by substantial movement of the tongue and larynx, Watson assumed that minute movements of the tongue and larynx accompany thought. Watson (1924/1930) described the evolution from overt speech to implicit speech (thinking) as follows:

The child talks incessantly when alone. At three he even plans the day aloud, as my own ear placed outside the keyhole of the nursery door has very often confirmed. Soon society in the form of nurse and parents steps in. "Don't talk aloud-Daddy and Mother are not always talking to themselves." Soon the overt speech dies down to whispered speech and a good lip reader can still read what the child thinks of the world and of himself. Some individuals never make this concession to society. When alone they talk aloud to themselves. A still larger number never go beyond even the whispering stage when alone. Watch people reading on the street car; peep through the keyhole sometime when individuals not too highly socialized are just sitting and thinking. But the great majority of people pass on to the third stage under the influence of social pressure constantly exerted. "Quit whispering to yourself," and "Can't you even read without moving your lips?" and the like are constant mandates. Soon the process is forced to take place behind the lips. Behind these walls you can call the biggest bully the worst name you can think of without even smiling. You can tell the female bore how terrible she really is and the next moment smile and overtly pay her a verbal compliment. (pp. 240-241)

Although there was some experimental support for Watson's contention that thought consisted entirely of subvocal speech (see, for example, Jacobson, 1932), the contention was widely opposed. Woodworth's (1931) reaction was typical:

I may as well tell you in a few words some reasons why I personally do not accept the equation, thought = speech. One is that I often have difficulty in finding a word required to express a meaning which I certainly have "in mind." I get stuck not infrequently, for even a familiar word.

Another reason is that you certainly cannot turn the equation around and say that speech = thought. You can recite a familiar passage with no sense of its meaning, and while thinking something entirely different. Finally, thinking certainly seems as much akin to seeing as to manipulating. It seems to consist in seeing the point, in observing relations. Watson's speech habits substituted for actual manipulation fail to show how thinking carries you beyond your previous habits. Why should the combination of words, "Suppose I moved the piano over there," lead to the continuation, "But it would jut out over the window," just as a matter of language habit? Something more than the words must certainly be in the game, and that something consists somehow in seeing the point. (p. 72)

The problem of determining the nature of thought and determining thought's relationship to behavior is as old as psychology and is just as much an issue today as it ever was. Watson did not solve the problem, but neither has anyone else.

The Role of Instincts in Behavior. Watson's attitude toward instincts changed radically over the years. In 1914 instincts played a prominent role in his theory. By 1919 Watson had taken the position that instincts are present in infants but that learned habits quickly displace them. In 1925 he completely rejected the idea of instincts in humans, contending that there are a few simple reflexes such as sneezing, crying, eliminating, crawling, sucking, and breathing but no complex, innate behavior patterns called instincts. In 1926 Watson said,

In this relatively simple list of human responses there is none corresponding to what is called an "instinct" by present-day psychologists and biologists. There are then for us no instincts—we no longer need the term in psychology. Everything we have been in the habit of calling an

"instinct" today is a result largely of training—belonging to man's *learned behavior*. (p. 1)

For Watson *experience* and not inheritance makes people what they are. Change experience, and you change personality. Thus, Watson's (1926) position ended up as a **radical environmentalism**.

I would feel perfectly confident in the ultimate favorable outcome of careful upbringing of a healthy, well-formed baby born of a long line of crooks, murderers, thieves and prostitutes. Who has any evidence to the contrary? Many, many thousands of children yearly, born from moral households and steadfast parents, become wayward, steal or become prostitutes, through one mishap or another of nurture. Many more thousands of sons and daughters of the wicked grow up to be wicked because they couldn't grow up any other way in such surroundings. But let one adopted child who had a bad ancestry go wrong and it is used as incontestible [sic] evidence for the inheritance of moral turpitude and criminal tendencies. (p. 9)

Finally, Watson (1926) made one of the most famous (or infamous) statements in the history of psychology:

I should like to go one step further tonight and say, "Give me a dozen healthy infants, well-formed, and my own specified world to bring them up in and I'll guarantee to take any one at random and train him to become any type of specialist I might select —a doctor, lawyer, artist, merchant-chief and, yes, even into beggarman and thief, regardless of his talents, penchants, tendencies, abilities, vocations and race of his ancestors." I am going beyond my facts and I admit it, but so have the advocates of the contrary and they have been doing it for thousands of years. Please note that

when this experiment is made I am to be allowed to specify the way they are to be brought up and the type of world they have to live in. (p. 10)

Watson (1926) did, however, allow for heritable differences in *structure* that could influence personality characteristics:

So let us hasten to admit—yes, there are heritable differences in form, in structure. Some people are born with long, slender fingers, with delicate throat structure; some are born tall, large, of prize-fighter build; others with delicate skin and eye coloring. These differences are in the germ plasm and are handed down from parent to child.... But do not let these undoubted facts of inheritance lead you astray as they have some of the biologists. The mere presence of these structures tell us not one thing about function.... Our hereditary structure lies ready to be shaped in a thousand different ways—the same structure mind you-depending on the way in which the child is brought up. (p. 4)

Watson (1926) gave the following example of how structure interacts with experience to produce specific behavior patterns:

The behaviorist would *not* say: "He inherits his father's capacity or talent for being a fine swordsman." He would say: "This child certainly has his father's slender build of body, the same type of eyes. His build is wonderfully like his father's. He, too, has the build of a swordsman." And he would go on to say: "And his father is very fond of him. He put a tiny sword into his hand when he was a year of age, and in all their walks he talks sword play, attack and defense, the code of duelling and the like." A certain type of structure, plus early training—slanting—accounts for adult performance. (p. 2)

Emotions. Watson believed that, along with structure and the basic reflexes, humans inherit the emotions of fear, rage, and love. In infants, fear is elicited by loud noises and loss of support (such as falling), rage by restricting the infant's freedom of movement, and love by stroking or patting the infant. Through learning, these emotions come to be elicited by stimuli other than those that originally elicited them. Furthermore, all adult emotions such as hate, pride, jealousy, and shame are derived from fear, rage, and love.

Watson believed that each basic emotion has a characteristic pattern of visceral and glandular responses that is triggered by an appropriate stimulus. Also, each basic emotion has a pattern of overt responses associated with it. With fear, there is a catching of the breath, clutching with the hands, closing of the eyes, and crying. With rage, there is a stiffening of the body and slashing and striking movements. With love, there is smiling, gurgling, cooing, and an extension of the arms. For Watson, the three important aspects of emotions are the stimuli that elicit the emotions, the internal reactions, and the external reactions. Feelings and sensations are not important.

Watson's Experiment with Albert. To demonstrate how emotions could be displaced to stimuli other than those that had originally elicited the emotions, Watson and Rosalie Rayner performed an experiment in 1920 on an 11-month-old infant named Albert. They showed Albert a white rat, and he expressed no fear of it. In fact, he reached out and tried to touch it. As Albert reached for the rat, a steel bar behind him was struck with a hammer. The loud, unexpected noise caused Albert to jump and fall forward. Again Albert was offered the rat, and just as he touched it, the steel bar behind him was again struck. Again Albert jumped, and this time he began to cry. So as not to disturb Albert too much, further testing was postponed for a week. A week later, when the rat was again presented to Albert, Albert was less enthusiastic and attempted to keep his distance from it. Five more times Watson and Rayner placed the rat near Albert and struck the steel bar; and Albert, who had at first been attracted to the rat, was now frightened of it:

The instant the rat was shown the baby began to cry. Almost instantly he turned sharply to the left, fell over on his left side, raised himself on all fours and began to crawl away so rapidly that he was caught with difficulty before reaching the edge of the table. (Watson and Rayner, 1920, p. 5)

Five days later, Watson and Rayner found that Albert's fear of the rat was just as strong as it had been at the end of testing and that the fear had generalized to other furry objects such as a rabbit, a dog, a fur coat, and a Santa Claus mask. Watson and Rayner had clearly demonstrated how experience rearranged the stimuli that caused emotional responses. They believed that all adult emotional reactions develop by the same mechanism that had operated in the experiment with Albert—that is, contiguity.

Although they knew the origin of Albert's fears, Watson and Rayner (1920) speculated about how the Freudians might interpret Albert's fears later in his life:

The Freudians twenty years from now, unless their hypotheses change, when they come to analyze Albert's fear of a seal skin coat—assuming that he comes to analysis at that age-will probably tease from him the recital of a dream which upon their analysis will show that Albert at three years of age attempted to play with the pubic hair of the mother and was scolded violently for it.... If the analyst has sufficiently prepared Albert to accept such a dream when found as an explanation of his avoiding tendencies, and if the analyst has the authority and personality to put it over, Albert may be fully convinced that the dream was a true revealer of the factors which brought about the fear. (p. 14)

Although Watson was generally critical of psychoanalysis, his criticism did much to popularize

J. B. Watson, Rosalie Rayner, and Albert (with the rat).

psychoanalytical ideas, and he was a pioneer in the effort to scientifically evaluate psychoanalytic concepts (Rilling, 2000). Also, Watson, as we will see, appreciated the fact that Freud helped to lift the veil of secrecy concerning sexual matters.

Watson and Rayner found that Albert's fear of the rat was still present a month after Albert's training. They intended to eliminate Albert's fear, but before they could do so he was removed from the hospital in which he was living. It was left to Mary Cover Jones (1896–1987), under Watson's supervision, to show how a child's fear could be systematically eliminated. Watson believed that his earlier research on Albert had shown how fear was produced in a child, and he felt strongly that no further research of that type was necessary. Instead, he would find children who had already developed a fear and would try to eliminate it. The researchers found such a child—a three-year-old boy named Peter who was intensely frightened of white rats, rabbits, fur coats, frogs, fish, and mechanical toys.

Peter and the Rabbit. Watson and Jones first tried showing Peter other children playing fearlessly with objects of which he was frightened, and there was some improvement. (This is a technique called modeling, which Bandura and his colleagues employ today.) At this point, Peter came down with scarlet fever and had to go to the hospital. Following recovery, he and his nurse were attacked by a dog on

Mary Cover Jones

their way home from the hospital, and all of Peter's fears returned in magnified form. Watson and Jones decided to try counterconditioning on Peter. Peter ate lunch in a room 40 feet long. One day as Peter was eating lunch, a rabbit in a wire cage was displayed far enough away from him so that Peter was not disturbed. The researchers made a mark on the floor at that point. Each day they moved the rabbit a bit closer to Peter until one day it was sitting beside Peter as he ate. Finally, Peter was able to eat with one hand and play with the rabbit with the other. The results generalized and most of Peter's other fears were also eliminated or reduced. This is one of the first examples of what we now call behavior therapy. In 1924 Jones published the results of the research with Peter, and in 1974 she published more of the details surrounding the research. Alexandra Rutherford (2006) regrets that reports of Jones's professional accomplishments typically include only her involvement in the "little Albert study." She reviews Jones's less known, but impressive, research on development across the life span, in which she consistently emphasized the importance of individual differences.

Child Rearing. Watson, an extremely popular writer and speaker, dealt with many topics, but

his favorite topic, and the one that he considered to be most important, was children. Unable to continue his laboratory studies after being forced out of the profession of psychology, he decided to share his thoughts about children with the public by writing, with the assistance of his wife Rosalie, *The Psychological Care of the Infant and Child* (1928), which was dedicated to "The first mother who brings up a happy child." The book was extremely popular (it sold 100,000 copies in a few months), and in many ways Watson was the Dr. Spock of the 1920s and 1930s. Watson and Watson's (1928) advice was to treat children as small adults:

Never hug and kiss them, never let them sit on your lap. If you must, kiss them once on the forehead when they say good night. Shake hands with them in the morning. Give them a pat on the head if they have made an extraordinary good job of a difficult task. Try it out. In a week's time you will find how easy it is to be perfectly objective with your child and at the same time kindly. You will be utterly ashamed at the mawkish, sentimental way you have been handling it. (pp. 81–82)

Watson and Watson went on to say, "When I hear a mother say, 'Bless its little heart' when it falls down, or stubs its toe, or suffers some other ill, I usually have to walk a block or two to let off steam" (1928, p. 82). And finally, Watson and Watson (1928) gave the following warning:

In conclusion won't you then remember when you are tempted to pet your child that mother love is a dangerous instrument? An instrument which may inflict a never healing wound, a wound which may make infancy unhappy, adolescence a nightmare, an instrument which may wreck your adult son or daughter's vocational future and their chances for marital happiness. (p. 87)

One suspects that their book on child rearing reflected John's ideas more than Rosalie's. In a 1930

article titled "I am the Mother of a Behaviorist's Sons," Rosalie wrote:

In some respects I bow to the great wisdom in the science of behaviourism, and in others I am rebellious.... I secretly wish that on the score of (the children's) affections they will be a little weak when they grow up, that they will have a tear in their eyes for the poetry and drama of life and a throb for romance.... I like being merry and gay and having the giggles. The behaviorists think giggling is a sign of maladjustment. (Boakes, 1984, p. 227)

In 1935 Rosalie Watson died suddenly of pneumonia at the age of 35. Watson was devastated and "the social aspects of his life all but disappeared" (Buckley, 1989, p. 180).

The period following Rosalie's death was also hard on the children. The emotional support Rosalie provided the family was now missing. James remembered his father as bright, charming, and reflective but devoid of emotional responsiveness. James said his father was "unable to express and cope with any feelings of emotion of his own, and determined unwittingly to deprive, I think, my brother and me of any emotional foundation" (Hannush, 1987, p. 138).

In spite of bouts with depression, James went on to receive a degree in industrial psychology and become a successful corporate executive. The situation was severe for the eldest child, Billy. During adolescence, Billy had a contemptuous relationship with his father. The estrangement deepened when, following graduation from college, Billy decided to become a psychiatrist, which Watson took as "a slap in the face." Eventually, Watson and Billy reached an uneasy peace, but the conflict between them was never completely resolved. Billy eventually took his own life (Buckley, 1989, p. 181). One must be cautious about drawing causal inferences, however. Even Billy's brother James noted that many people not reared by behaviorists experience depression (Hannush, 1987, p. 139).

Sex Education. Watson also had a great deal to say about sex education, urging that children be given frank, objective information about sex; and he often expressed his gratitude to Freud for breaking down the myth and secrecy surrounding sex. None other than Bertrand Russell reviewed Watson's book on child rearing. Although Russell felt that Watson's emphasis on the environment was extreme and that Watson had gone a bit too far in banning hugging and kissing, he heaped praise on the book. Watson's liberal views, however, did not impress most psychologists:

The honesty in sex education which Watson demanded seemed wholly admirable to Russell. Watson had also revived Plato's argument that perhaps it would be best for parents and children not to know each other. While this was bound to shock the American public, Russell believed this was an issue that was worth discussing. He ended by saying that no one since Aristotle had actually made as substantial a contribution to our knowledge of ourselves as Watson had-high praise indeed, from a man who was then regarded as one of the greatest minds in the world! None of this impressed most psychologists who complained that Watson had demeaned himself, which was only to be expected, and demeaned their science, which was only to be deplored. (Cohen, 1979, p. 218)

As one may suspect from the above quotation, Russell admired Watson for more than his thoughts on child rearing. For example, in *The Analysis of Mind* (1921/2005), Russell comments favorably on Watson's proposed solutions to a number of philosophical problems, such as those related to "consciousness."

Behaviorism and the Good Life. Along with the functionalists and most other subsequent behaviorists, Watson firmly believed that psychology should be useful in everyday life, and he often applied his behaviorism to himself and his children. Though behaviorism might have shortcomings, Watson (1924/1930) believed that it could make for a better life than traditional beliefs could:

I think behaviorism does lay a foundation for saner living. It ought to be a science that prepares men and women for understanding the first principles of their own behavior. It ought to make men and women eager to rearrange their own lives, and especially eager to prepare themselves to bring up their own children in a healthy way. I wish I had time more fully to describe this, to picture to you the kind of rich and wonderful individual we should make of every healthy child; if only we could let it shape itself properly and then provide for it a universe unshackled by legendary folk lore of happenings thousands of years ago; unhampered by disgraceful political history; free of foolish customs and conventions which have no significance in themselves, yet which hem the individual in like taut steel bands. (p. 248)

Learning. Although Watson was very impressed by Thorndike's early animal research, he believed that Thorndike's law of effect was unnecessarily mentalistic. After all, what was a "satisfying state of affairs" but a feeling or a state of consciousness? For Watson the important thing about conditioning is that it causes events to be associated in time; that is, it causes contiguity. Employing the concept of reinforcement is unnecessary. Instead of relying on Thorndike's law of effect, Watson explained learning in terms of the ancient principles of contiguity and frequency. In other words, Watson's explanation of learning was more similar to that of Pavlov's and Bechterev's than it was to Thorndike's.

Watson pointed out that in a learning situation, a trial always ends with the animal making the correct response. This means that the correct response tends to occur more frequently than incorrect responses and that the more often a response is made, the higher the probability that it will be made again

(the law of frequency). It also means that the final response an organism makes in a learning situation will be the response it will tend to make when it is next in that situation; Watson called this the **law of recency**. In the classical conditioning situation, the conditioned stimulus (CS) and the unconditioned stimulus (US) become associated (elicit the same type of response) simply because they occur at about the same time (the law of contiguity). According to Watson, learning results from the mechanical arrangement of stimuli and responses; no "effects" of any type entered into his explanation.

The Mind-Body Problem. By the time Watson had begun to formulate his theory, there were four views on the mind-body relationship. One was an interactionist view of the type Descartes, and sometimes William James, had accepted. According to this position, the mind can influence the body, and the body influences the mind. That is, the mind and the body interact. A second position was psychophysical parallelism, according to which mental and bodily events are parallel with no interaction between them. In a third view, epiphenomenalism, mental events are the by-products of bodily events but do not cause behavior. That is, bodily events cause mental events, but mental events cannot cause bodily events. During Watson's time, epiphenomenalism was probably the most commonly held view concerning the mind-body relationship. A fourth position, called physical monism (materialism), involved rejecting the existence of mental events (consciousness) altogether. In his early writings, Watson (1913) accepted consciousness as an epiphenomenon:

Will there be left over in psychology a world of pure psychics, to use Yerkes' term? I confess I do not know. The plans that I most favor for psychology lead practically to the ignoring of consciousness in the sense that the term is used by psychologists today. I have virtually denied that this realm of psychics is open to experimental investigation. I don't wish to go further into the problem at present because

it leads inevitably over into metaphysics. If you will grant the behaviorist the right to use consciousness in the same way as other natural scientists employ it—that is, without making consciousness a special object of observation—you have granted all that my thesis requires. (p. 174)

Later, in his debate with McDougall (discussed shortly), Watson switched to a physical monist position. Consciousness, he said, "has never been seen, touched, smelled, tasted, or moved. It is a plain assumption just as unprovable as the old concept of the soul" (Watson and McDougall, 1929, p. 14). Watson "solved" the mind-body problem by simply denying the existence of the mind. Watson believed that functionalism represented a timid, half-hearted attempt to be scientific. Any approach to psychology that accepts the study of consciousness in any form cannot be a science: "It is important to realize the vehemence and thoroughness with which the concept of consciousness is rejected [by Watson]. Mental processes, consciousness, souls, and ghosts are all of a piece, and are altogether unfit for scientific use" (Heidbreder, 1933, p. 235).

Watson's Influence

Although, as Samelson (1981) has shown, it took several years before Watson's behaviorism gained widespread acceptance, it eventually did just that. Watson's view of psychology was to have two long-lasting effects. First, he changed psychology's major goal from the description and explanation of states of consciousness to the prediction and control of behavior. Second, he made overt behavior the almost-exclusive subject matter of psychology. On these issues, Watson's influence has been so pervasive that today most psychologists can be considered behaviorists:

Some of the central tenets of behaviorism are at this point so taken for granted that they have simply become part of standard experimental psychology. All modern psychologists restrict their *evidence* to

observable behavior, attempt to specify stimuli and responses with the greatest possible precision, are skeptical of theories that resist empirical testing, and refuse to consider unsupported subjective reports as scientific evidence. In these ways, we are all behaviorists. (Baars, 1986, pp. viii–ix)

There are different types of behaviorists, however. Those psychologists who, like Watson, either deny the existence of mental events or claim that if such events exist they could be and should be ignored represent radical behaviorism. More generally, radical behaviorism is the belief that an explanation of behavior cannot be in terms of unobserved internal events. All that can be directly observed are environmental events and overt behavior, and therefore only they should constitute the subject matter of a scientific analysis of behavior. After Watson, however, few psychologists took such an extreme position. Rather, many psychologists—although they agree that the primary subject matter of psychology should be overt behavior—do not deny the importance of unobserved cognitive or physiological events in their analyses of behavior. For them behavior is used to index the cognitive or physiological events thought to be taking place within the organism. Such psychologists represent methodological behaviorism, the second type of behaviorism. The methodological behaviorist sees nothing wrong with postulating cognitive or physiological events but insists that such events be validated by studying their manifestations in overt behavior. Although methodological behaviorism is much more popular in contemporary psychology than is radical behaviorism, the latter is still very much alive.

Although Watson would probably be pleased to see how much he has influenced contemporary psychology, he would be disappointed to observe that his attempt to rid psychology of the notion of consciousness clearly failed. Today there are more psychologists than ever studying the very cognitive processes that Watson ignored, deplored, or denied.

In 1957 the APA awarded Watson one of its prestigious gold medals in recognition of his sig-

nificant contributions to psychology. Watson was very pleased with the award, but because of poor health he was unable to receive it in person; his son Billy accepted it for him. Watson died in New York City on September 25, 1958, at the age of 80. In reviewing Watson's accomplishments, the influential philosopher of science Gustav Bergmann said that next to Freud, Watson was "the most important figure in the history of psychological thought during the first half of the century" (1956, p. 265).

Although Watson's position eventually became extremely popular, there were always prominent psychologists who opposed him. One of his most persistent adversaries was William McDougall.

WILLIAM MCDOUGALL: ANOTHER TYPE OF BEHAVIORISM

William McDougall (1871–1938) was born June 22 in Lancashire, England, where his father owned a chemical factory. Educated in private schools in England and Germany, McDougall entered the University of Manchester when he was only 15 years old. Four years later, he started his medical training at Cambridge and finally obtained his medical degree from St. Thomas's Hospital in London in 1897, at the age of 26. After a trip to the Far East, McDougall went to the University of Göttingen in Germany to study experimental psychology with the famous Georg Elias Müller (1850–1934). However, it was the reading of William James's work that got McDougall interested in psychology, and he always considered himself a disciple of James. Upon his return from Germany, he accepted a position at University College in London to teach experimental psychology. While there, McDougall instrumental in founding the Psychological Society and the British Journal of Psychology. He moved to Oxford University in 1904 and remained there until World War I. During the war, he served as a major in the medical corps and was in charge of treating soldiers with

William McDougall

mental problems. After the war, he was psychoanalyzed by Carl Jung.

In 1920 McDougall accepted an invitation from Harvard to become chair of the psychology department, a position once held by William James and then by Hugo Münsterberg. Although McDougall was actually replacing Münsterberg, he perceived himself as replacing James, to whom he dedicated his book *An Outline of Psychology* (1923). McDougall stayed at Harvard until 1926, when he resigned his position. The following year, he moved to Duke University in North Carolina, where he remained until his death in 1938. In his lifetime, McDougall wrote 24 books and more than 160 articles.

Eight years after his arrival in the United States, McDougall still felt out of place and misunderstood. He tended to be disliked by his students, his colleagues, and the media. Part of the reason for his problems was his effort to promote a psychology that emphasized instinct in the increasingly anti-instinct climate of U.S. psychology. Other factors offered to explain McDougall's plight include a generally anti-British sentiment in the United States in the 1920s; the fact that he attempted to test Lamarck's theory of acquired characteristics when that theory had been largely discarded; his willingness to entertain

the vitalistic belief that behavior is ultimately caused by a nonphysical force or energy; his willingness to explore paranormal phenomena such as mental telepathy and clairvoyance; and the fact that he had a pugnacious personality. R. A. Jones (1987) discusses McDougall's problems in the United States, especially those with the press. Innis (2003) discusses McDougall's research projects, purposive psychology, and personality and the then prevailing U.S. psychology in order to explain why McDougall's life was characterized as "a major tragedy."

McDougall's Definition of Psychology

Although McDougall spent a great deal of time arguing with Watson, he was among the first to redefine psychology as the *science of behavior*. For example, in 1905, he said, "Psychology may be best and most comprehensively defined as the positive science of the conduct of living creatures" (p. 1). In his highly successful *An Introduction to Social Psychology* (1908), he elaborated the point:

Psychologists must cease to be content with the sterile and narrow conception of their science as the science of consciousness, and must boldly assert its claim to be the positive science of the mind in all its aspects and modes of functioning, or, as I would prefer to say, the positive science of conduct or behaviour. Psychology must not regard the introspective description of the stream of consciousness as its whole task, but only as a preliminary part of its work. Such introspective description, such "pure psychology," can never constitute a science, or at least can never rise to the level of an explanatory science; and it can never in itself be of any great value to the social sciences. The basis required by all of them is a comparative and physiological psychology relying largely on objective methods, the observation of the behaviour of men and of animals of all varieties under all possible conditions of health and disease.... Happily this more generous

conception of psychology is beginning to prevail. (p. 15)

Thus, at about the same time that Watson was making his first public statement of his behaviorism, McDougall was also questioning the value of introspection and calling for the objective study of the behavior of both humans and nonhuman animals. Unlike Watson, however, McDougall did not deny the importance of mental events. McDougall thought that one could study such events objectively by observing their influence on behavior. According to our previous distinction between radical and methodological behaviorism, McDougall was a methodological behaviorist.

Purposive Behavior

The type of behavior McDougall studied was quite different from the reflexive behavior that the Russians and, in a more general way, Watson studied. McDougall (1923) studied purposive behavior, which differed from reflexive behavior in the following ways:

- Purposive behavior is spontaneous. That is, unlike reflexive behavior, it need not be elicited by a known stimulus.
- In the absence of environmental stimulation, it persists for a relatively long time.
- It varies. Although the goal of purposive behavior remains constant, the behavior used to attain that goal may vary. If an obstacle is encountered, an alternative route is taken to reach the goal.
- Purposive behavior terminates when the goal is attained.
- Purposive behavior becomes more effective with practice. That is, the useless aspects of behavior are gradually eliminated. Trialand-error behavior is purposive, not reflexive.

McDougall saw behavior as goal-directed and stimulated by some instinctual motive rather than by environmental events. He believed that any behaviorist who ignores the purposive nature of behavior is missing its most important aspect. McDougall referred to his position as **hormic psychology** (from the Greek word *horme*, meaning "urge").

The Importance of Instincts

As we have seen, McDougall did not believe that purposive behavior is stimulated by the environment. Rather, it is stimulated by instinctual energy. A belief in instincts formed the core of McDougall's theory, and McDougall (1908) defined an instinct as

an inherited or innate psycho-physical disposition which determines its possessor to perceive and to pay attention to objects of a certain class, to experience an emotional excitement of a particular quality upon perceiving such an object, and to act in regard to it in a particular manner, or, at least, to experience an impulse to such action. (p. 29)

According to McDougall, all organisms, including humans, are born with a number of instincts that provide the motivation to act in certain ways. Each instinct has three components:

- Perception. When an instinct is active, the person will attend to stimuli related to its satisfaction. For example, a hungry person will attend to food-related events in the environment.
- Behavior. When an instinct is active, the person will tend to do those things that will lead to its satisfaction. That is, the person will engage in goal-directed or purposive behavior until satisfaction is attained.
- Emotion. When an instinct is active, the person will respond with an appropriate emotion to those environmental events that are related to the satisfaction of or the failure to satisfy the instinct. For example, while hungry, a person will respond to food or food-related events (such as the odor of food) with positive emotions (like the feeling of happiness) and to those events that prevent satisfaction (not having any money) with negative emotions (sadness).

Although McDougall viewed instincts as ultimate motives, he believed they seldom, if ever, operate as singular tendencies. Rather, a single environmental event or a single thought tends to elicit several instinctual tendencies. For example, one's spouse may simultaneously elicit the parental, mating, and assertion instincts. Other configurations of instincts may be elicited by the ideas of one's country, one's self, or one's job. When two or more instincts become associated with a single object or thought, a sentiment is said to exist. According to McDougall, most human social behavior is governed by sentiments, or configurations of instinctual tendencies. McDougall, then, was in agreement with Freud's contention that most human behavior, no matter how complex, is ultimately instinctive.

McDougall (1908) was well aware of one major danger of explaining behavior in terms of instincts—the tendency to postulate an instinct for every type of behavior and then claim that the behavior has been explained:

Lightly to postulate an indefinite number and variety of human instincts is a cheap and easy way to solve psychological problems and is an error hardly less serious and less common than the opposite error of ignoring all the instincts. (p. 88)

Similarly, "Attribution of the actions of animals to instincts ... was a striking example of the power of a word to cloak our ignorance and to hide it even from ourselves" (1912, p. 138). Although McDougall's list of instincts varied through the years, the following is the list he proposed in *Outline of Psychology* (1923, p. 324).

Instinct	Emotion
	Accompanying the
	Instinct
Escape	Fear
Combat	Anger
Repulsion	Disgust
Parental (protective)	Love and tenderness
Appeal (for help)	Distress, feeling of
	helplessness

Mating	Lust
Curiosity	Feeling of mystery, of
	strangeness, of the
	unknown
Submission	Feeling of subjection,
	inferiority, devotion,
	humility; negative self-
	feeling
Assertion	Feeling of elation, su-
	periority, masterful-
	ness, pride; positive
	self-feeling
Gregariousness	Feeling of loneliness,
	isolation, nostalgia
Food-seeking	Appetite or craving
Hoarding	Feeling of ownership
Construction	Feeling of creativeness,
	of making, or
	productivity
Laughter	Amusement, care-
	lessness, relaxation

N / - + : - -

The Battle of Behaviorism

At this point, we find two of the world's most famous psychologists taking opposite stands. On one hand, McDougall said that the instincts are the motivators of all animal behavior, including that of humans. Conversely, Watson said that instincts do not exist on the human level and that psychology should rid itself of the term instinct. Another major difference between Watson and McDougall concerned their views of the learning process. As we have seen, Watson rejected the importance of reinforcement in learning, saying that learning could be explained in terms of the associative principles of contiguity, frequency, and recency. For McDougall, habits of thought and behavior served the instincts; that is, they were formed because they satisfied some instinct. McDougall believed that reinforcement in the form of need reduction was an important aspect of the learning process.

The time was right for a debate between McDougall and Watson, and debate they did. On February 5, 1924, they confronted one another

before the Psychological Club in Washington, DC, and more than 300 people attended. In 1929 Watson and McDougall published the proceedings under the title *The Battle of Behaviorism*. Space permits presenting only a small sample from their lengthy debate. Watson said,

He then who would introduce consciousness, either as an epiphenomenon or as an active force interjecting itself into the physical and chemical happenings of the body, does so because of spiritualistic and vitalistic leanings. The Behaviorist cannot find consciousness in the test tube of his science. He finds no evidence anywhere for a stream of consciousness, not even for one so convincing as that described by William James. He does, however, find convincing proof of an ever-widening stream of behavior. (Watson and McDougall, 1929, p. 26)

McDougall's argumentative style is seen in his opening remarks in the debate:

I would begin by confessing that in this discussion I have an initial advantage over Dr. Watson, an advantage which I feel to be so great as to be unfair; namely that all persons of common sense will of necessity be on my side from the outset, or at least as soon as they understand the issue.

On the other hand, Dr. Watson also can claim certain initial advantages.... First, there is a considerable number of persons so constituted that they are attracted by whatever is bizarre, paradoxical, preposterous, and outrageous ... whatever is unorthodox and opposed to accepted principles. All these will inevitably be on Dr. Watson's side.

Secondly, Dr. Watson's views are attractive to many persons ... by reason of the fact that these views simplify so greatly the problems that lie before the student of psychology: they abolish at one stroke many tough problems with which the

greatest intellects have struggled with only very partial success for more than two thousand years; and they do this by the bold and simple expedient of inviting the student to shut his eyes to them, to turn resolutely away from them, and to forget that they exist.

Now, though I am sorry for Dr. Watson, I mean to be entirely frank about his position. If he were an ordinary human being, I should feel obliged to exercise a certain reserve, for fear of hurting his feelings. We all know that Dr. Watson has feelings, like the rest of us. But I am at liberty to trample on his feelings in the most ruthless manner; for Dr. Watson has assured us (and it is the very essence of his peculiar doctrine) that he does not care a cent about feelings, whether his own or those of any other person. (Watson and McDougall, 1929, pp. 40–44)

McDougall then responded to Watson's inability to account for the most satisfying human experiences, for example, the enjoyment of music:

I come into this hall and see a man on this platform scraping the guts of a cat with hairs from the tail of a horse; and, sitting silently in attitudes of rapt attention, are a thousand persons who presently break out into wild applause. How will the Behaviorist explain these strange incidents: How explain the fact that the vibrations emitted by the cat-gut stimulate all the thousand into absolute silence and quiescence; and the further fact that the cessation of the stimulus seems to be a stimulus to the most frantic activity? Common sense and psychology agree in accepting the explanation that the audience heard the music with keen pleasure, and vented their gratitude and admiration for the artist in shouts and hand clappings. But the Behaviorist knows nothing of pleasure and pain, of admiration and gratitude. He has

relegated all such "metaphysical entities" to the dust heap, and must seek some other explanation. Let us leave him seeking it. The search will keep him harmlessly occupied for some centuries to come. (Watson and McDougall, 1929, pp. 62–63)

McDougall also resented the fact that Watson was using the same techniques to sell his brand of behaviorism as he used to sell products such as cigarettes and deodorants:

Dr. Watson knows that if you wish to sell your wares, you must assert very loudly, plainly, and frequently that they are the best on the market, ignore all criticism, and avoid all argument and all appeal to reason.... The susceptibility of the public to attack by these methods in the purely commercial sphere is a matter of no serious consequence. When the same methods make a victorious invasion of the intellectual realm, it is difficult to regard the phenomenon with the same complacency. (Watson and McDougall, 1929, p. 95)

Watson, of course, claimed that to accept McDougall's brand of psychology was to reject all advances that had occurred in psychology in about the last 25 years.

A vote taken after the debate showed McDougall to be the narrow victor. He believed that if the women in the audience had not voted almost unanimously for Watson, his margin of victory would have been much greater:

The vote of the audience taken by sections after the Washington debate showed a small majority against Dr. Watson. But when account is taken of the amusing fact that the considerable number of women students from the University voted almost

unanimously for Dr. Watson and his Behaviorism, the vote may be regarded as an overwhelming verdict of sober good sense against him from a representative American gathering. (Watson and McDougall, 1929, p. 87)

Of course, McDougall was not the only one believing it to be folly to remove subjective experience from psychology's domain. Nelson (1996) notes that although radical behaviorism was the subject of many jokes, it persisted nonetheless:

For example, the first behaviorist says to the second behaviorist just after making love, "It was great for you, but how was it for me?" Although something important seems to be missing, this approach of ignoring participants' introspections about their own cognitions permeated the field of human learning for nearly 50 years! (p. 103)

McDougall concluded the preface to the 23rd edition of his *An Introduction to Social Psychology* (1936/2003) as follows:

For myself I am more than ever convinced that these principles are valid, and that, after the lapse of some few years, when my name shall have been entirely forgotten, these principles will be generally accepted as main pillars of a psychology which will serve the indispensable basis of all the social sciences—provided our civilization shall contrive to endure so long a period. (p. xxii)

Neither Watson's nor McDougall's position has survived intact. For the moment, however, the student of psychology is more likely to know about Watson than about McDougall. Whether this remains the case, only time will tell.

SUMMARY

Several years before Watson's formal founding of the school of behaviorism, many U.S. psychologists with strong leanings toward behaviorism insisted that psychology be defined as the science of behavior. Also, several Russians whom Sechenov had influenced were calling for a completely objective psychology devoid of metaphysical speculation. It was Sechenov's discovery of inhibitory processes in the brain that allowed him to believe that all behavior, including that of humans, could be explained in terms of reflexes. During his research on digestion, Pavlov discovered "psychic reflexes" (conditioned reflexes), but he resisted studying them because of their apparent subjective nature. Under the influence of Sechenov, however, he was finally convinced that conditioned reflexes could be studied using the objective techniques of physiology. Pavlov saw all behavior, whether learned or innate, as reflexive. Innate associations between unconditioned stimuli (USs) and unconditioned responses (URs) were soon supplemented by learned associations between conditioned stimuli (CSs) and conditioned responses (CRs). Pavlov believed that some stimuli elicit excitation in the brain and other stimuli elicit inhibition. The pattern of the points of excitation and inhibition on the cortex at any given moment was called the cortical mosaic, and it was this mosaic that determined an organism's behavior. If a conditioned stimulus that was previously associated with an unconditioned stimulus is now presented without the unconditioned stimulus, extinction occurs. The facts that spontaneous recovery and disinhibition occur indicate that extinction is due to inhibition. If stimuli that elicit excitation on one hand and inhibition on the other are made increasingly similar, experimental neurosis results. An organism's susceptibility to experimental neurosis is determined by the type of nervous system it possesses. According to Pavlov, conditioned stimuli act as signals announcing the occurrence of biologically significant events; he called such stimuli the first-signal system. An example is when the sight of a flame announces the possibility of a painful experience unless appropriate behavior is taken. Language allows symbols (words) to provide the same function as conditioned stimuli, such as when the word *fire* elicits defensive behavior. Pavlov called the words that symbolize physical events the second-signal system. Pavlov believed that his work on conditioned and unconditioned reflexes furnished an objective explanation for the associationism that philosophers had been discussing for centuries.

Bechterev was a reflexologist who also sought a completely objective psychology. Unlike Pavlov, who studied internal reflexes such as salivation, Bechterev studied overt behavior. Bechterev believed that his technique was superior to Pavlov's because it required no operation, it could be used easily on humans, it minimized unwanted reactions from the subject, overt behavior could be easily measured, and satiation was not a problem. The type of reflexive behavior later studied by U.S. behaviorists was more like Bechterev's than Pavlov's.

Several factors molded Watson's behavioristic outlook. First, many of the functionalists at Chicago and elsewhere were studying behavior directly, without the use of introspection. Second, Loeb had shown that some of the behavior of simple organisms and plants was tropistic (an automatic reaction to environmental conditions). Third, animal research that related behavior to various experimental manipulations was becoming very popular. In fact, before his founding of the school of behaviorism, Watson was a nationally recognized expert on the white rat. Watson began to formulate his behavioristic ideas as early as 1902, and in 1904 he shared them with Angell, whose reaction was negative. Watson first publicly stated his behavioristic views at a colloquium at Yale in 1908, and the response was again negative. In 1913 Watson gave a lecture titled "Psychology as the Behaviorist Views It" at Columbia University. The publication of this lecture in the Psychological Review in 1913 marks the formal beginning of the school of behaviorism. In 1920 scandal essentially ended Watson's career as a

professional psychologist, although afterward he published articles in popular magazines, spoke on radio, and revised some of his earlier works.

Watson found support for his position in Russian objective psychology and eventually made conditioning the cornerstone of his stimulus-response psychology. For Watson the goal of psychology is to predict and control behavior by determining how behavior is related to environmental events. Watson even viewed thinking as a form of behavior, consisting of minute movements of the tongue and larynx. Early in Watson's theorizing, instincts played a prominent role in explaining human behavior. Later, Watson said that humans possess instincts but that learned behavior soon replaces instinctive behavior. Watson's final position on instincts was that they have no influence on human behavior. He did say, however, that a person's physical structure is inherited and that the interaction between structure and environmental experience determines many personality characteristics. Also, the emotions of fear, rage, and love are inherited, and experience greatly expands the stimuli that elicit these emotions. The experiment with Albert showed the process by which previously neutral stimuli could come to elicit fear. Later, along with Mary Cover Jones, Watson showed how fear could become disassociated from a stimulus.

John and Rosalie Watson advised parents not to pamper children but to treat them as small adults, and he urged that open, honest, and objective sex education be given to children. Watson accepted only two principles of learning: contiguity and frequency. That is, the more often two or more events are experienced together, the stronger the association between those events becomes. On the mind-body problem, Watson's final position was that of a physical monist. The two major influences Watson had on psychology were (1) to change its goals from the description and understanding of consciousness to the prediction and control of behavior and (2) to

change its subject matter from consciousness to overt behavior. Those psychologists who, like Watson, rejected internal events such as consciousness as causes of behavior were called radical behaviorists. Those who accepted internal events such as consciousness as possible causes of behavior but insisted that any theories about unobservable causes of behavior be verified by studying overt behavior were called methodological behaviorists.

Even in Watson's time, his was not the only type of behaviorism. One of Watson's most formidable adversaries was McDougall, who agreed with Watson that psychology should be the science of behavior but thought that purposive behavior should be emphasized. Because of its emphasis on goal-directed behavior, McDougall's position was referred to as hormic psychology. Although McDougall defined psychology as the science of behavior, he did not deny the importance of mental events, and he believed they could be studied through their influence on behavior. In other words, McDougall was a methodological behaviorist. Whereas Watson had concluded that instincts played no role in human behavior, McDougall made instincts the cornerstone of his theory. For McDougall an instinct is an innate disposition that, when active, causes a person to attend to a certain class of events, to feel emotional excitement when perceiving those events, and to act relative to those events in such a way as to satisfy the instinctual need. When the instinctual need is satisfied, the whole chain of events terminates. Thus, for McDougall, instincts and purposive behavior go hand in hand. McDougall believed that the reason humans learn habits is that they satisfy instinctual needs. Also, McDougall believed that instincts seldom, if ever, motivate behavior in isolation. Rather objects, events, and ideas tend to elicit two or more instincts simultaneously, in which case a sentiment is experienced. In the famous debate between Watson and McDougall, McDougall was narrowly declared the winner.

DISCUSSION QUESTIONS

- Make the case that prior to Watson's formulations, behaviorism was very much "in the air" in the United States.
- 2. Summarize Sechenov's argument that thoughts cannot cause behavior.
- 3. What was the significance of the concept of inhibition in Sechenov's explanation of behavior?
- 4. How, according to Sechenov, should psychological phenomena be studied?
- 5. What were the circumstances under which Pavlov discovered the conditioned reflex, and why did he initially resist studying it?
- 6. What did Pavlov mean by a cortical mosaic, and how was that mosaic thought to be causally related to behaviour?
- 7. What observations led Pavlov to conclude that extinction is caused by inhibition?
- 8. How did Pavlov create experimental neurosis in his research animals, and how did he explain differential susceptibility to experimental neurosis?
- Distinguish between the first- and secondsignal systems, and then explain how those systems facilitate adaptation to the environment.
- 10. How did Pavlov view the relationship between his work and philosophical associationism?
- 11. Summarize Bechterev's reflexology. Why did Bechterev believe that he was the first behaviorist?
- 12. How did Bechterev's method of studying conditioned reflexes differ from Pavlov's? According to Bechterev, what advantages did his method have over Pavlov's?
- 13. Describe the major experiences that steered Watson toward behaviorism.

- 14. According to Watson, what was the goal of psychology? How did this differ from psychology's traditional goal?
- 15. Summarize Watson's explanation of thinking.
- 16. What was Watson's final position on the role of instinct in human behavior?
- 17. Employing the notion of structure, explain why Watson believed that inheritance could influence personality.
- 18. Summarize Watson's views on emotion. What emotions did Watson think were innate? How do emotions become associated with various stimuli or events? What research did Watson perform to validate his views?
- 19. Describe the procedure that Watson and Mary Cover Jones used to extinguish Peter's fear of rabbits.
- Summarize the advice that Watson and Watson gave on child rearing.
- 21. How did Watson explain learning?
- 22. What was Watson's final position on the mind-body problem?
- 23. Distinguish between radical and methodological behaviorism.
- 24. Summarize McDougall's hormic psychology. Why can his approach to psychology be called behavioristic? What type of behavior did he study, and what did he assume to be the cause of that behavior?
- 25. For McDougall, what were the characteristics of purposive behavior?
- 26. For McDougall, what were the three components of an instinct?
- 27. What, according to McDougall, is a sentiment?
- 28. In their famous debate, what were the important points of disagreement between Watson and McDougall? If the debate were held today, for whom would you vote? Why?

SUGGESTIONS FOR FURTHER READING

- Buckley, K. W. (1989). Mechanical man: John Broadus Watson and the beginnings of behaviorism. New York: Guilford Press.
- Harris, B. (1979). Whatever happened to little Albert? *American Psychologist*, 34, 151–160.
- Innis, N. K. (2003). William McDougall: "A major tragedy"? In G. A. Kimble, & M. Wertheimer (Eds.), Portraits of pioneers in psychology (Vol. 5, pp. 91–108). Washington, DC: American Psychological Association.
- Jones, R. A. (1987). Psychology, history, and the press: The case of William McDougall and the *New York Times. American Psychologist*, 42, 931–940.
- Kimble, G. A. (1996a). Ivan Mikhailovich Sechenov: Pioneer in Russian Reflexology. In G. A. Kimble, C. A. Boneau, & M. Wertheimer (Eds.), *Portraits of*

- pioneers in psychology (Vol. 2, pp. 33–45). Washington DC: American Psychological Association.
- O'Donnell, J. M. (1985). *The origins of behaviorism:*American psychology, 1870–1920. New York: New York University Press.
- Rutherford, A. (2006). Mother of behavior therapy and beyond: Mary Cover Jones and the study of the "whole child." In D. A. Dewsbury, L. T. Benjamin Jr., & M. Wertheimer (Eds.), *Portraits of pioneers in psychology* (Vol. 6, pp. 189–204). Washington, DC: American Psychological Association.
- Samelson, F. (1981). Struggle for scientific authority: The reception of Watson's behaviorism, 1913–1920. Journal of the History of the Behavioral Sciences, 17, 399–425.

GLOSSARY

Association reflex Bechterev's term for what Pavlov called a conditioned reflex.

Bechterev, Vladimir M. (1857–1927) Like Pavlov, looked upon all human behavior as reflexive. However, Bechterev studied skeletal reflexes rather than the glandular reflexes that Pavlov studied.

Behavior therapy The use of learning principles in treating behavioral or emotional problems.

Behaviorism The school of psychology, founded by Watson, that insisted that behavior be psychology's subject matter and that psychology's goal be the prediction and control of behavior.

Conditioned reflex A learned reflex.

Conditioned response (CR) A response elicited by a conditioned stimulus (CS).

Conditioned stimulus (CS) A previously biologically neutral stimulus that, through experience, comes to elicit a certain response (CR).

Cortical mosaic According to Pavlov, the pattern of points of excitation and inhibition that characterizes the cortex at any given moment.

Disinhibition The inhibition of an inhibitory process. Disinhibition is demonstrated when, after extinction, a loud noise causes the conditioned response to reappear.

Excitation According to Pavlov, brain activity that leads to overt behavior of some type.

Experimental neurosis The neurotic behavior that Pavlov created in some of his laboratory animals by bringing excitatory and inhibitory tendencies into conflict.

Extinction The elimination or reduction of a conditioned response (CR) that results when a conditioned stimulus (CS) is presented but is not followed by the unconditioned stimulus (US).

First-signal system Those objects or events that become signals (CSs) for the occurrence of biologically significant events, such as when a tone signals the eventuality of food.

Hormic psychology The name given to McDougall's version of psychology because of its emphasis on purposive or goal-directed behavior.

Inhibition The reduction or cessation of activity caused by stimulation, such as when extinction causes a conditioned stimulus to inhibit a conditioned response. It was Sechenov's discovery of inhibitory mechanisms in the brain that led him to believe that all human behavior could be explained in terms of brain physiology.

Law of recency Watson's observation that typically it is the "correct" response that terminates a learning trial and it is this final or most recent response that will be repeated when the organism is next placed in that learning situation.

McDougall, William (1871–1938) Pursued a type of behaviorism very different from Watson's. McDougall's behaviorism emphasized purposive and instinctive behavior. (*See also* **Hormic psychology**.)

Methodological behaviorism The version of behaviorism that accepts the contention that overt behavior should be psychology's subject matter but is willing to speculate about internal causes of behavior, such as various mental and physiological states.

Pavlov, Ivan Petrovich (1849–1936) Shared Sechenov's goal of creating a totally objective psychology. Pavlov focused his study on the conditioned and unconditioned stimuli that control behavior and on the physiological processes that they initiate. For Pavlov all human behavior is reflexive.

Radical behaviorism The version of behaviorism that claims only directly observable events, such as stimuli and responses, should constitute the subject matter of psychology. Explanations of behavior in terms of unobserved mental events can be, and should be, avoided.

Radical environmentalism The belief that most, if not all, human behavior is caused by environmental experience.

Reflexology The term Bechterev used to describe his approach to studying humans. Because he emphasized the study of the relationship between environmental events and overt behavior, he can be considered one of the earliest behaviorists, if not the earliest.

Sechenov, Ivan M. (1829–1905) The father of Russian objective psychology. Sechenov sought to explain all human behavior in terms of stimuli and physiological mechanisms without recourse to metaphysical speculation of any type.

Second-signal system The symbols of objects or events that signal the occurrence of biologically significant events. Seeing fire and withdrawing from it would exemplify the first signal system, but escaping in response to hearing the word *fire* exemplifies the second-signal system.

Sentiment According to McDougall, the elicitation of two or more instinctual tendencies by the same object, event, or thought.

Spontaneous recovery The reappearance of a conditioned response after a delay following extinction.

Tropism The automatic orienting response that Loeb studied in plants and animals.

Unconditioned reflex An unlearned reflex.

Unconditioned response (UR) An innate response elicited by the unconditioned stimulus (US) that is naturally associated with it.

Unconditioned stimulus (US) A stimulus that elicits an unconditioned response (UR).

Watson, John Broadus (1878–1958) The founder of behaviorism who established psychology's goal as the prediction and control of behavior. In his final position, he denied the existence of mental events and concluded that instincts play no role in human behavior. On the mind-body problem, Watson finally became a physical monist, believing that thought is nothing but implicit muscle movement.

Neobehaviorism

POSITIVISM

As we saw in Chapter 5, Auguste Comte insisted that one could obtain valid information about the world only by adopting a form of radical empiricism (not to be confused with the form suggested by William James). Metaphysical speculation was to be avoided because it employed unobservable entities. Within psychology, all that can be known with certainty about people is how they behave, and therefore any attempt to understand how the "mind" functions using introspection was, according to Comte, silly. Although the mind cannot be investigated objectively, the *products* of the mind can be because they manifest themselves in behavior. According to Comte, individual and group behavior can and should be studied scientifically; he coined the term *sociology* to describe such a study.

Several years after Comte, the distinguished German physicist Ernst Mach argued for another type of **positivism**. In his Contributions to the Analysis of Sensations (1886/1914), Mach, agreeing with such British empiricists as Berkeley and Hume, argued that all we can be certain of is our sensations. Sensations, then, form the ultimate subject matter for all sciences, including physics and psychology. For Mach introspection was essential for all sciences because it was the only method by which sensations can be analyzed. However, one must not speculate about what exists beyond sensations nor attempt to determine their ultimate meaning. To do so is to enter the forbidden realm of metaphysical speculation. What a careful analysis of sensations can do is determine how they are correlated. Knowing which sensations tend to go together allows prediction, which in turn allows better adaptation to the environment. For Mach, then, a strong, pragmatic reason exists for the systematic study of sensations. For both Comte and Mach, scientific laws are statements that summarize experiences. Both sought, above all, to avoid metaphysical speculation, and both were, in

that sense, radical empiricists. Remember that an empiricist believes that all knowledge comes from experience; Comte emphasized experiences that can be shared publicly, and Mach emphasized private experience. Both argued for a close-to-the-data approach that avoids theorizing about what is observed. Echoing Francis Bacon, both believed that theorizing most likely introduces error into science. Thus, the best way to avoid error is to avoid theorizing.

John Watson and the Russian physiologists were positivists (although Pavlov did engage in considerable speculation concerning brain physiology). All emphasized objective data and avoided or minimized theoretical speculation. Watson's goals for psychology of predicting and controlling behavior were very much in accordance with positivistic philosophy. However, in being positivistic, his system lacked the predictive ability that Watson himself believed was so important. His research often generated facts that appeared to have no relationship among themselves.

LOGICAL POSITIVISM

By the early 20th century, the Comtean and Machian goal of having sciences deal only with that which is directly observable was recognized as unrealistic. Physicists and chemists were finding such theoretical concepts as gravity, magnetism, atom, force, electron, and mass indispensable, although none of these entities could be observed directly. The problem was to find a way for science to use theory without encountering the dangers inherent in metaphysical speculation. The solution was provided by logical positivism. Logical positivism divided science into two major parts: the empirical and the theoretical. In other words, it wedded empiricism and rationalism. The observational terms of science refer to empirical events, and the theoretical terms attempt to explain that which is observed. By accepting theory as part of science, the logical positivists in no way reduced the importance of empirical observation. In fact, the ultimate authority for the logical positivist was empirical observation, and theories were considered useful only if they helped explain what was observed.

Logical positivism was the name given to the view of science developed by a small group of philosophers in Vienna (the Vienna Circle) around 1924. These philosophers took the older positivism of Comte and Mach and combined it with the rigors of formal logic. For them, abstract theoretical terms were allowed only if such terms could be logically tied to empirical observations. In his influential book *Language*, *Truth and Logic* (1936/1952), Alfred Ayer (1910–1989) summarized the position of the logical positivist as follows:

The criterion which we use to test the genuineness of apparent statements of fact is the criterion of verifiability. We say that a sentence is factually significant to any given person, if, and only if, he knows how to verify the proposition which it purports to express—that is, if he knows what observations would lead him, under certain conditions, to accept the proposition as being true, or reject it as being false.... We enquire in every case what observations would lead us to answer the question, one way or the other; and, if none can be discovered, we must conclude that the sentence under consideration does not, as far as we are concerned, express a genuine question, however strongly its grammatical appearance may suggest that it does. (p. 35)

As we will see, logical positivism had a powerful influence on psychology. It allowed much more complex forms of behaviorism to emerge because it allowed theorizing without sacrificing objectivity. The result was that psychology entered into what Koch (1959) called the "age of theory" (from about 1930 to about 1950). Herbert Feigl, a member of the Vienna Circle, both named logical positivism and did the most to bring it to the attention of U.S. psychologists,

S. S. Stevens (1935a, b) was among the first to believe that if psychology followed the dictates of logical positivism, which he called "the science of science," it could at last be a science on par with physics. For this to happen, psychology would need to adhere to the principles of operationism, to which we turn next.

OPERATIONISM

In 1927 Harvard physicist Percy W. Bridgman (1892–1961) published The Logic of Modern Physics, in which he elaborated Mach's proposal (see Chapter 5) that every abstract concept in physics be defined in terms of the procedures used to measure the concept. He called such a definition an operational definition. Thus, concepts such as force and energy would be defined in terms of the operations or procedures followed in determining the quantity of force or energy present. In other words, operational definitions tie theoretical terms to observable phenomena. In this way, there can be no ambiguity about the definition of the theoretical term. The insistence that all abstract scientific terms be operationally defined was called operationism. Bridgman's ideas were very much in accord with what the logical positivists were saying at about the same time.

Along with logical positivism, operationism took hold in psychology almost immediately. Operational definitions could be used to convert theoretical terms like drive, learning, anxiety, and intelligence into empirical events and thus strip them of their metaphysical connotations. Such an approach was clearly in accordance with psychology's new emphasis on behavior. For example, learning could be operationally defined as making x number of successive correct turns in a T-maze, and anxiety and intelligence could be operationally defined as scores on appropriate tests. Such definitions were entirely in terms of publicly observable behavior; they had no excess "mentalistic" meaning. Most psychologists soon agreed with the logical positivists that unless a concept can be operationally defined, it is scientifically meaningless.

Unlike positivism, logical positivism had no aversion to theory. In fact, one primary goal of logical positivism was to show how science could be theoretical without sacrificing objectivity. Once operationally defined, concepts could be related to one another in complex ways, such as the statements F =MA (force equals mass times acceleration) and E =mc² (energy equals mass times a constant, the speed of light, squared). No matter how complex, however, it is the job of a scientific theory to make statements about empirical events. Because a scientific theory is evaluated in terms of the accuracy of its predictions, it is seen as self-correcting. If the deductions from a theory were experimentally confirmed, the theory gained strength; if its deductions were found to be incorrect, the theory diminished in strength. In the latter case, the theory had to be revised or abandoned. No matter how complex a theory becomes, its ultimate function is to make accurate predictions about empirical events.

By the late 1930s, logical positivism dominated U.S. experimental psychology.

PHYSICALISM

One outcome of the logical positivism movement was that all sciences were viewed as essentially the same. Because they all followed the same principles, made the same assumptions, and attempted to explain empirical observations, why should they not use the same terminology? It was suggested that a database language be created in which all terms would be defined in reference to publicly observable, physical objects and events. The push for unification of and a common vocabulary among the sciences (including psychology) was called **physicalism**. The proposal that all scientific propositions refer to physical things had profound implications for psychology:

Innocent as this assertion about language may appear, it is charged with far-reaching implications for psychology. In fact, the examples used to illustrate Physicalism make it appear that the doctrine was aimed directly against psychology—at least against the kind peddled by philosophers.... All sentences purporting to deal with psychical states are translatable into sentences in the physical language. Two distinctly separate languages to describe physics and psychology are therefore not necessary.... It is the Logical Positivist's way of saying that psychology must be operational and behavioristic. (Stevens, 1951, pp. 39–40)

The "unity of science" movement and physicalism went hand in hand:

How we get from Physicalism to the thesis of the *Unity of science* is obvious indeed. If every sentence can be translated into the physical language, then this language is an all-inclusive language—a universal language of science. And if the esoteric jargons of all the separate sciences can, upon demand, be reduced to a single coherent language, then all science possesses a fundamental logical unity. (Stevens, 1951, p. 40)

The science that was proposed as the model for this "unified science" was physics.

NEOBEHAVIORISM

Neobehaviorism resulted when behaviorism was combined with logical positivism: "It is only a slight caricature to represent neobehaviorism as the product of the remarriage of psychology, in the guise of behaviorism, and philosophy, in the guise of logical positivism" (Toulmin and Leary, 1985, p. 603). Logical positivism made many forms of behaviorism possible: "Objectivism in data collection was one thing; agreement about specific modes of objectivism, and about the theoretical implications of 'objective' data, was something else" (Toulmin and Leary, 1985, p. 603). Thus, as we will see, a number of versions of behaviorism emerged, all following,

more or less, the tenets of logical positivism and all claiming scientific respectability.

Although there were major differences among the neobehaviorists, they all tended to believe the following:

- If theory is used, it must be used in ways demanded by logical positivism.
- All theoretical terms must be operationally defined.
- Nonhuman animals should be used as research subjects for two reasons: (1) Relevant variables are easier to control than they are for human subjects. (2) Perceptual and learning processes occurring in nonhuman animals differ only in degree from those processes in humans; therefore, the information gained from nonhuman animals can be generalized to humans.
- The learning process is of prime importance because it is the primary mechanism by which organisms adjust to changing environments.

Not all psychologists followed the new approach. During the period from about 1930 to about 1950, psychoanalysis (see Chapter 16) was becoming increasingly important in U.S. psychology, as was Gestalt psychology (see Chapter 14), and psychologists embracing these viewpoints saw little need to follow the dictates of logical positivism. With these exceptions and a few others, however, neobehaviorism dominated the period.

Edward Tolman was among the first to expand behaviorism by employing the tenets of logical positivism, and it is to his version of neobehaviorism that we turn next.

EDWARD CHACE TOLMAN

Edward Chace Tolman (1886–1959) was born on April 14 in West Newton, Massachusetts, the son of a businessman who was a member of the first graduating class of the Massachusetts Institute of Technology (MIT) and a member of its board of trustees. Tolman's father, encouraged by his wife

Edward Chace Tolman

who was raised in the Quaker religion, had a strong interest in social reform. Both sons, Edward and his older brother Richard, earned their undergraduate degrees in experimental and theoretical chemistry at MIT. Richard went on to become a prominent physicist after earning his doctorate at MIT. Edward's interests began to turn toward philosophy and psychology after taking summer school courses from Harvard philosopher Ralph Barton Perry (1876–1957) and Harvard psychologist Robert Yerkes; most influential, however, was his reading of James's *Principles*. At this time, psychology was dominated by Titchener and James, and psychology was still defined as the study of conscious experience, a fact that bothered Tolman (1922):

The definition of psychology as the examination and analysis of private conscious contents has been something of a logical sticker. For how *can* one build up a science upon elements which, by very definition, are said to be private and noncommunicable? (p. 44)

Tolman's concern was put to rest in the course he took from Yerkes, in which J. B. Watson's

Behavior: An Introduction to Comparative Psychology (1914) was used as the text:

This worry about introspection is perhaps one reason why my introduction in Yerkes' courses to Watson behaviorism came as a tremendous stimulus and relief. If objective measurement of behavior and not introspection was the true method of psychology I didn't have to worry any longer. (Tolman, 1952, p. 326)

In 1911 Tolman decided to pursue graduate work in philosophy and psychology at Harvard; once enrolled, his interest turned increasingly to psychology. After a year of study, Tolman decided to improve his German by spending a summer in Germany. While in Germany, Tolman studied with the young Gestalt psychologist Kurt Koffka (whom we will meet in the next chapter). Although Gestalt psychology did not impress Tolman at the time, it greatly influenced his later theorizing. Upon returning to Harvard, Tolman studied the learning of nonsense material under the supervision of Hugo Münsterberg, and his doctoral dissertation was on retroactive inhibition (Tolman, 1917).

After attaining his doctorate from Harvard in 1915, Tolman accepted an appointment at Northwestern University. Although he became a compulsive researcher, he confessed to being "self-conscious and inarticulate" as a teacher and frightened of his classes. Also, at about the time that the United States entered World War I, he wrote an essay expressing his pacifism. In 1918 Tolman was dismissed for "lack of teaching success," but more than likely his pacifism contributed to his dismissal. From Northwestern he went to the University of California at Berkeley, where he remained almost without interruption for the rest of his career. As we have seen, Tolman was raised in a Quaker home, and pacifism was a constant theme throughout his life. He wrote a short book titled Drives Toward War (1942) to explain, from a psychoanalytic viewpoint, the human motives responsible for warfare. In the preface of that book, he stated his reasons for writing it:

As an American, a college professor, and one brought up in the pacifist tradition, I am intensely biased against war. It is for me stupid, interrupting, unnecessary, and unimaginably horrible. I write this essay within that frame of reference. In short, I am driven to discuss the psychology of war and its possible abolition because I want intensely to get rid of it. (p. xi)

By the time the book came out, however, the United States was already involved in World War II. The brutality of the war overcame even Tolman's strong pacifism, and after receiving the approval of his brother Richard, he served for two years in the Office of Strategic Services (1944–1945).

After the war, Tolman's social conscience was tested once again. In the early 1950s, under the influence of McCarthyism, the University of California began to require its faculty members to sign a loyalty oath, and Tolman led a group of faculty members who would rather resign than sign it. They saw the requirement as an infringement of their civil liberties and academic freedom. Tolman was suspended from his duties at California and taught for a while at the University of Chicago and Harvard University. Finally, the courts agreed with Tolman, and he was reinstated at the University of California. In 1959, upon his retirement and shortly before his death, the regents of the university symbolically admitted that Tolman's position had been morally correct by awarding him an honorary doctorate.

Tolman was a kind, shy, honest person who inspired affection and admiration from his students and colleagues. Although he was always willing to engage in intellectual dispute, he never took himself or his work too seriously. In the final year of his life, Tolman (1959) reflected on his theoretical contributions:

[My theory] may well not stand up to any final canons of scientific procedure. But I do not much care. I have liked to think about psychology in ways that have proved congenial to me. Since all the sciences, and especially psychology, are still immersed in such tremendous realms of the uncertain and the unknown, the best that any individual scientist, especially any psychologist, can do seems to be to follow his own gleam and his own bent, however inadequate they may be. In fact, I suppose that actually this is what we all do. In the end, the only sure criterion is to have fun. And I have had fun. (p. 159)

Tolman died in Berkeley, California, on November 19, 1959.

Purposive Behaviorism

In the early 1920s, there were two dominant explanations of learning: Watson's explanation in terms of the associative principles of contiguity and frequency, and Thorndike's, which emphasized the law of effect. Tolman (1952) explained why he could accept neither:

It was Watson's denial of the law of effect and his emphasis on frequency and recency as the prime determiners of animal learning which first attracted our attention. In this we were on Watson's side. But we got ourselves-or at least I got myself-into a sort of in-between position. On the one hand I sided with Watson in not liking the law of effect. But, on the other hand, I also did not like Watson's over-simplified notions of stimulus and response.... According to Thorndike an animal learned, not because it achieved a wanted goal by a certain series of responses, but merely because a quite irrelevant "pleasantness" or "unpleasantness" was, so to speak, shot at it, as from a squirt gun, after it had reached the given goal box. (p. 329)

Tolman (perhaps incorrectly) referred to Watson's psychology as "twitchism" because he felt it concentrated on isolated responses to specific stimuli. Watson contended that even the most complex human behavior could be explained in

terms of S–R reflexes. Tolman referred to such reflexes as **molecular behavior**. Instead of taking as his subject matter these "twitches," Tolman decided to study **purposive behavior**. Although Tolman's approach differed from Watson's in several important ways, Tolman was still a behaviorist and was completely opposed to introspection and metaphysical explanations. In other words, Tolman agreed with Watson that behavior should be psychology's subject matter, but Tolman believed that Watson was focusing on the wrong type of behavior. The question was how Tolman could employ a mentalistic term like *purpose* and still remain a behaviorist.

While at Harvard, Tolman learned from two of his professors, Edwin B. Holt and Ralph Barton Perry, that the purposive aspects of behavior could be studied without sacrificing scientific objectivity. This was done by seeing purpose in the behavior itself and not inferring purpose from the behavior. Tolman accepted this contention and believed that it pointed to a major distinction between his view of purpose and that of McDougall: "The fundamental difference between [McDougall] and us arises in that he, being a 'mentalist,' merely infers purpose from these aspects of behavior; whereas we, being behaviorists, identify purpose with such aspects" (1925, p. 288). Tolman would later change his position and use the terms purpose and cognition more in accordance with the mentalistic tradition as actual determinants of behavior. Tolman never believed, however, that using concepts like purpose and cognition violated the tenets of behaviorism. (For a discussion of Tolman's use of mentalistic terms and how that use changed during his career, see L. D. Smith, 1982.)

Tolman called purposive behavior **molar behavior** to contrast it with molecular behavior. Because Tolman chose to study molar behavior, his position is often referred to as **purposive behaviorism**. In his major work, *Purposive Behavior in Animals and Men* (1932), Tolman gave examples of what he called purposive (molar) behavior:

A rat running a maze; a cat getting out of a puzzle box; a man driving home to dinner; a

child hiding from a stranger; a woman doing her washing or gossiping over the telephone; a pupil marking a mental-test sheet; a psychologist reciting a list of nonsense syllables; my friend and I telling one another our thoughts and feelings—these are behaviors (Qua Molar). And it must be noted that in mentioning no one of them have we referred to, or, we blush to confess it, for the most part even known, what were the exact muscles and glands, sensory nerves, and motor nerves involved. For these responses somehow had other sufficiently identifying properties of their own. (p. 8)

Tolman's Use of Rats

Tolman did not engage in any animal research as a graduate student at Harvard or as an instructor at Northwestern University. When he arrived at the University of California, he was asked to suggest a new course to teach and, remembering fondly his course with Yerkes, chose to teach comparative psychology. It was teaching this course that stimulated Tolman's interest in the rat as an experimental subject. He saw the use of rats as a way of guarding against even the possibility of indirect introspection that could occur if humans were used as experimental subjects. Tolman developed such a fondness for rats that he dedicated his *Purposive Behavior* to the white rat, and in 1945 he said,

Let it be noted that rats live in cages; they do not go on binges the night before one has planned an experiment; they do not kill each other off in wars; they do not invent engines of destruction, and if they did, they would not be so inept about controlling such engines; they do not go in for either class conflicts or race conflicts; they avoid politics, economics, and papers on psychology. They are marvelous, pure, and delightful. (p. 166)

About what could be learned by studying rats, Tolman (1938) said,

I believe that everything important in psychology (except perhaps such matters as the building up of a super-ego, that is, everything save such matters as involve society and words) can be investigated in essence through the continued experimental and theoretical analysis of the determiners of rat behavior at a choice-point in a maze. Herein I believe I agree with Professor Hull and also with Professor Thorndike. (p. 34)

The Use of Intervening Variables

Tolman was not consistent in using mentalistic concepts as only descriptions of behavior. By 1925 he was referring to purpose and cognition both as descriptions and determinants of behavior. L. D. Smith (1982) noted Tolman's vacillation:

Within a single paragraph of *Purposive Behavior*, Tolman described purposes and cognitions on the one hand as "immanent" in behavior, "in-lying," "immediate," and "discovered" by observers, and on the other hand as "determinants" and "causes" of behavior which are "invented" or "inferred" by observers. (p. 162)

In the following quotation, Tolman (1928) appeared to believe that purposes were in the organism and were causally related to its behavior:

Our doctrine ... is that behavior (except in the case of the simplest reflexes) is not governed by simple one to one stimulus-response connections. It is governed by more or less complicated sets of patterns of adjustment which get set up within the organism. And in so far as these sets of adjustments cause only those acts to persist and to get learned which end in getting the organism to (or from) specific ends, these sets or adjustments constitute purposes. (p. 526)

Increasingly, Tolman came to believe that cognitive processes really exist and are influential in

determining behavior (as McDougall believed). In 1938 he decided how he would proceed: "I, in my future work, intend to go ahead imagining how, if I were a rat, I would behave" (p. 24). Clearly, Tolman was now embracing mentalism, and yet he still felt strongly about remaining a behaviorist. For Tolman the solution to the dilemma was to treat cognitive events as intervening variables—that is, variables that intervene between environmental events and behavior. Following logical positivism, Tolman painstakingly tied all his intervening variables to observable behavior. In other words, he operationally defined all his theoretical terms. Tolman's final position was to regard purpose and cognition as theoretical constructs that could be used to describe, predict, and explain behavior.

By introducing the use of intervening variables, Tolman brought abstract scientific theory into psychology. It was clear that environmental events influenced behavior; the problem was to understand *why* they did. One could remain entirely descriptive and simply note what organisms do in certain situations, but for Tolman this was unsatisfactory. Here is a simplified diagram of Tolman's approach:

Independent Variables
(Environmental Events)

↓
Intervening Variables
(Theoretical Concepts)

↓
Dependent Variables
(Behavior)

Thus, for Tolman, environmental experience gives rise to internal, unobservable events, which, in turn, cause behavior. To account fully for the behavior, one has to know both the environmental events and the internal (or intervening) events that they initiate. The most important intervening variables Tolman postulated are cognitive or mental in nature. Tolman, then, was a methodological rather than a radical behaviorist. What made Tolman a different type of mentalist was his insistence that his intervening variables, even those that were

presumed to be mental, be operationally defined—that is, systematically tied to observable events.

Hypotheses, Expectancies, Beliefs, and Cognitive Maps. Although Tolman used several intervening variables, we will discuss only those related to the development of a cognitive map. Everyone knows that a rat learns to solve a maze; the question is, How does it do so? Tolman's explanation was mentalistic. As an example, when an animal is first placed in the start box of a T-maze, the experience is entirely new, and therefore the animal can use no information from prior experience. As the animal runs the maze, it sometimes turns right at the choice point and sometimes left. Let us say that the experimenter has arranged the situation so that turning left is reinforced with food. At some point, the animal formulates a weak hypothesis that turning one way leads to food and turning another way does not. In the early stages of hypothesis formation, the animal may pause at the choice point as if to "ponder" the alternatives. Tolman referred to this apparent pondering as vicarious trial and error because, instead of behaving overtly in a trialand-error fashion, the animal appears to be engaged in mental trial and error. If the early hypothesis "If I turn left, I will find food" is confirmed, the animal will develop the expectancy "When I turn left, I will find food." If the expectancy is consistently confirmed, the animal will develop the belief "Every time I turn left in this situation, I will find food." Through this process, a cognitive map of this situation develops—an awareness of all possibilities in a situation—for example: If I leave the start box, I will find the choice point; if I turn left at the choice point, I will find food; if I turn right, I will not; and so on.

For Tolman, hypotheses, expectations, beliefs, and finally a cognitive map intervene between experience and behavior. Rather than just describing an organism's behavior, these intervening variables were thought to explain it. Tolman was careful, however, to test his theoretical assumptions through experimentation. Tolman's research program was one of the most creative any psychologist

has ever devised (for details, see Hergenhahn and Olson, 2005).

Tolman's Position on Reinforcement

Tolman rejected Watson's and Thorndike's explanations of learning. In other words, he did not believe that learning is an automatic process based on contiguity and frequency nor that it results from reinforcement (a pleasurable state of affairs). He believed that learning occurs constantly, with or without reinforcement and with or without motivation. About as close as Tolman came to a concept of reinforcement was confirmation. Through the confirmation of a hypothesis, expectancy, or belief, a cognitive map develops or is maintained. The animal learns what leads to what in the environment-that if it does such and such, such and such will follow; or that if it sees one stimulus (S₁), a second stimulus (S₂) will follow. Because Tolman emphasized the learning of relationships among stimuli, his position is often called an S-S theory rather than an S-R theory.

Learning versus Performance

According to Tolman's theory, an organism learns constantly as it observes its environment. But whether the organism uses what it learned—and if so, how—is determined by the organism's motivational state. For example, a food-satiated rat might not leave the start box of a maze or might wander casually through the maze even though it had previously learned what had to be done to obtain food. Thus, for Tolman, motivation influences performance but not learning. Tolman defined **performance** as the translation of learning into behavior. The importance of motivation in Tolman's theory was due to the influence of Woodworth's dynamic psychology.

Latent Learning. In one of his famous **latent learning** experiments, Tolman dramatically demonstrated the distinction between learning and performance. Tolman and Honzik (1930) ran an experiment using three groups of rats as subjects.

Subjects in group 1 were reinforced with food each time they correctly traversed a maze. Subjects in group 2 wandered through the maze but were not reinforced if they reached the goal box. Subjects in group 3 were treated like subjects in group 2 until the 11th day, when they began receiving reinforcement in the goal box. Subjects in all three groups were deprived of food before being placed in the maze. Tolman's hypothesis was that subjects in all groups were learning the maze as they wandered through it. If his hypothesis was correct, subjects in group 3 should perform as well as subjects in group 1 from the 12th day on. This was because, before the 11th day, subjects in group 3 had already learned how to arrive at the goal box, and finding food there on the 11th day had given them an incentive for acting on this information. As Figure 13-1 shows, the experiment supported Tolman's hypothesis. Learning appeared to remain latent until the organism had a reason to use it.

Latent Extinction. Tolman explained both the acquisition of a response tendency and its extinction in terms of changing expectations. In extinction, reinforcement no longer follows a goal response, and an animal's expectation is modified accordingly. Tolman's explanation of extinction has been supported by a number of latent extinction experiments (for example, Moltz, 1957; Seward and Levy, 1949). In the typical latent extinction experiment, one group of animals undergoes normal extinction, whereby a series of nonreinforced responses gradually leads to extinction. A second group of animals is passively placed in the empty goal box a number of times before extinction trials begin. These experiments consistently found that the second group of animals extinguished the behavior much more rapidly than the first. Tolman's explanation was that animals in the second group "come to see" the absence of reinforcement, and this influences both their expectations and their performance.

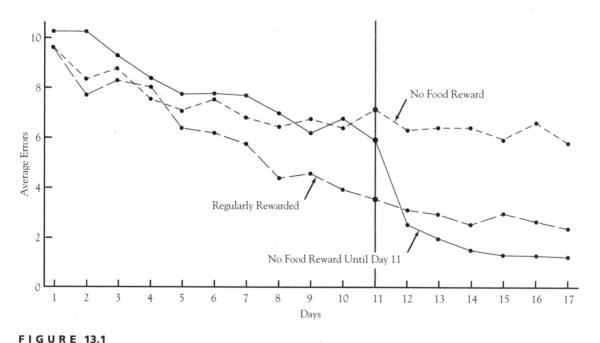

The results of the Tolman and Honzik (1930) experiment on latent learning. (Used by permission.)

Tolman's Influence

L. D. Smith (1982) summarizes Tolman's importance as follows:

In adopting and adapting the concepts of purpose and cognition ... Tolman helped preserve and shape the tradition of cognitive psychology during a time when it was nearly eclipsed by the ascendancy of classical behaviorism. He was able to do so by demonstrating that such concepts were compatible with a behaviorism of a more sophisticated—clearly non—Watsonian—variety. (p. 160)

With regard to Tolman's use of mentalistic concepts, Innis (1999) says:

Rather than get rid of them, he wanted to give them objective, operational definitions. In place of the sterile mathematics and empty organisms of his competitors, Tolman proposed a rich theoretical structure in which purpose and cognition played well-defined parts as potentially measurable intervening variables. For him, actions were infused with meaning; behavior was goal-directed—that is, motivated and purposive. However, adopting this view did not mean that it was impossible to develop mechanistic rules to account for the behavior observed. (p. 115)

Once Tolman began postulating intervening variables, his theory became extremely complex. He postulated several independent variables and several intervening variables, and the possible interactions between the two types of variables were enormous. Tolman expressed regret over this practical difficulty. L. D. Smith (1982) believes that Tolman's theory was proposed before a technology was developed to evaluate it:

Tolman expressed despair over the immense practical difficulty of determining intervening variables and their interactions.... I would suggest that it was just this sort of difficulty that became tractable with the realization by psychologists in the 1960s that computer programs are highly suited for expressing complex interactions in models of cognitive processing. If Tolman's theoretical innovations suffered from the limitations of the technology available in his time, they would seem to suffer no longer. (p. 464)

Clearly, Tolman viewed organisms as active processors of information, and such a view is very much in accordance with contemporary cognitive psychology. In Chapter 20, we will see much in common between Tolman's theory and both information-processing psychology and Bandura's social cognitive theory. Also (although space does not permit discussion of it), Tolman was a pioneer in the currently popular field of behavior genetics (Innis, 1992). Tolman was the first to publish a study on selective breeding for maze-learning ability in rats (1924). And it was Tolman's student, Robert C. Tryon, whose name became most associated with selective breeding because of his longitudinal study of maze-bright and maze-dull rats.

In 1937 Tolman served as the 45th president of the American Psychological Association (APA), and in 1957 he received the APA's Distinguished Scientific Contribution Award with the following citation:

For the creative and sustained pursuit of a theoretical integration of the multifaceted data of psychology, not just its more circumscribed and amenable aspects; for forcing theorizing out of the mechanical and peripheral into the center of psychology without the loss of objectivity and discipline; for returning [the human being] to psychology by insisting upon molar behavior purposely organized as the unit of analysis, most explicitly illustrated in his purposive-cognitive theory of learning. (*American Psychologist*, 1958, p. 155)

CLARK LEONARD HULL

Clark Leonard Hull (1884-1952) was born on May 24 near Akron, New York, the son of an uneducated father and quiet mother who wed at the age of 15. It was Hull's mother who taught his father to read. Hull's education in a rural oneroom school was often interrupted by necessary chores on the family farm. After passing a teacher's examination at the age of 17, Hull taught in a oneroom school, but after a year of teaching returned to school, where he excelled in science and mathematics. While at school, Hull contracted typhoid fever from contaminated food. Although several of Hull's fellow students died from the outbreak, he survived but, in Hull's opinion, with his memory impaired. After his recuperation, he went to Alma College in Michigan to study mining engineering. Following his training, he obtained a job at a mining company in Minnesota, where his job was to evaluate the manganese content in iron ore. After only two months on the job, at the age of 24, he contracted poliomyelitis, which left him partially paralyzed. At first he could walk only with crutches; for the rest of his life he used a cane. He needed to ponder a career that was less strenuous than mining. Hull first considered becoming a Unitarian minister. He was attracted to Unitarianism because it was "a free, Godless religion," but the idea of "attending an endless succession of ladies' teas" caused him to abandon the idea. What he really wanted was to work in a field where success could come relatively quickly and that would permit him to tinker with apparatus:

[I wanted] an occupation in a field allied to philosophy in the sense of involving theory: one which was new enough to permit rapid growth so that a young man would not need to wait for his predecessors to die before his work could find recognition, and one which would provide an opportunity to design and work with automatic apparatus. Psychology seemed to satisfy this unique set of requirements. (Hull, 1952a, p. 145)

© Deane Keller, "Dr. Clark Leonard Hull (1884–1952), M.A. (Hon.) 1929" Yale University Art Gallery, Gift of Colleagues, friends and students of the sitter.

Clark Leonard Hull

Although Hull set a career in psychology as his goal, he was not financially able to pursue it. Instead, he became principal of the school he had attended as a child (which had expanded to two rooms). In his spare time, he read James's Principles to prepare himself for his chosen profession. After two years, he had saved enough money to enter the University of Michigan as a junior. Among the courses that Hull took at Michigan was one in experimental psychology, which he loved, and one in logic, for which he constructed a machine that could simulate syllogistic reasoning. After graduation from the University of Michigan, Hull's funds were again exhausted, and he accepted a position in a school of education in Kentucky. During this time, although not yet in graduate school, he began planning what would become his doctoral dissertation on concept formation. Hull applied for graduate study at Cornell and Yale (where he ultimately would spend most of his professional career) and was rejected by both. He was, however, accepted at the University of Wisconsin. It took four years for Hull to complete his dissertation on concept learning (1920). Although Hull believed that his research represented a breakthrough in experimental psychology, it was essentially ignored. Hilgard (1987) reminisced on Hull's experiences with his dissertation:

Hull had struggled hard to complete his dissertation, undergoing the trials of a baby daughter smearing the ink on charts he had so carefully laid out to dry, so that he had to do them all over again. He felt proud of his dissertation because it moved experimental psychology into the area of thought processes by investigating the learning of concepts.... He told me how downcast he had become when year after year no one paid attention to it or cited it. He was finally prepared to accept the fact that it had been "still-born" (his words). (p. 200)

Hull received his doctorate from the University of Wisconsin in 1918 and remained there as an instructor until 1929.

Perhaps disappointed over the reception of his dissertation research on concept learning, Hull moved into other research areas. For example, he accepted a research grant to study the influence of pipe smoking on mental and motor performance. Next, Hull was asked to teach a course in psychological tests and measurements. He observed that the existing bases for vocational guidance were not objective, and his efforts to improve the situation ultimately resulted in his book Aptitude Testing (1928). As part of his work in this area, Hull invented a machine that could automatically compute intercorrelations among test scores. This machine, which was programmed by punching holes in a tape, is now housed in the Smithsonian Institution in Washington, DC (Hilgard, 1987). In addition to his contributions to concept learning and aptitude testing, Hull also pursued his interests in suggestibility and hypnosis while at the University of Wisconsin. Over about a 10-year period, Hull and his students published 32 papers on these topics. This work culminated in Hull's Hypnosis and Suggestibility: An Experimental Approach (1933).

In 1929 Hull accepted a professorship at Yale University (one of the institutions that rejected his graduate school application). At Yale, Hull pursued two interests: the creation of machines that could learn and think (like his correlation machine) and the study of the learning process. The two interests were entirely compatible because Hull viewed humans as machines that learn and think. Not surprisingly, one of Hull's heroes was Newton, who

viewed the universe as a huge machine that could be described in precise mathematical terms. Hull simply applied the Newtonian model to living organisms. Another of Hull's heroes was Pavlov. Hull was deeply impressed by the English translation of Pavlov's work that appeared in 1927. He began studying conditioned responses in humans while he was still at Wisconsin and continued his studies when he moved to Yale. At Yale, however, his experimental subjects were rats instead of humans.

Hull's many contributions were finally recognized when, in 1936, he served as 44th president of the APA. In his presidential address, he outlined his goal of creating a theoretical psychology that would explain "purposive" behavior in terms of mechanistic, lawful principles. In creating his theoretical psychology, Hull would employ the tenets of logical positivism (and euclidean geometry) in that new knowledge is deduced from what is already known. In his autobiography, Hull said, "The study of geometry proved to be the most important event of my intellectual life; it opened to me an entirely new world—the fact that thought itself could generate and really prove new relationships from previously possessed elements" (1952a, p. 144). It is important to note that neither Hull nor Tolman developed the theories they did because of logical positivism. Both reached their conclusions about theoretical psychology independently of logical positivism; when they discovered that philosophy of science in the 1930s, they simply assimilated its terminology into their systems. In other words, Tolman and Hull used the language of logical positivism to express their own ideas. They could do so because of the compatibility between the two.

Unlike Tolman, Hull found no need for mentalistic concepts, whether they were considered real entities or simply theoretical conveniences. Like Watson, Hull believed that psychology's preoccupation with consciousness was derived from medieval metaphysics and theology. Although Hull's interest in "psychic machines" was now secondary, he did demonstrate such a machine to his APA audience, and he expressed the belief that if a machine could be built that performed adaptive

behaviors, it would support his contention that the adaptive behaviors of living organisms could be explained in terms of mechanistic principles.

Because of their willingness to speculate about internal causes of behavior, both Hull and Tolman were methodological behaviorists, and both eventually employed logical positivism in their theorizing. Philosophically, however, Hull was a mechanist and a materialist, and Tolman was, insofar as he believed mental events determined behavior, a dualist. Supporters of Hull's mechanistic behaviorism and those of Tolman's purposive behaviorism battled with each other throughout the 1930s and 1940s. This running debate resulted in one of the most productive periods in psychology's history.

Between 1929 and 1950. Hull wrote 21 theoretical articles in the Psychological Review, and in 1940 he (with co-authors Hovland, Ross, Hall, Perkins, and Fitch) published Mathematico-Deductive Theory of Rote Learning. This book was an effort to show how rote learning could be explained in terms of conditioning principles. In 1943 Hull published Principles of Behavior, one of the most influential books in psychology's history; and A Behavior System (1952b) extended the ideas found in Principles to more complex phenomena. In 1948, while preparing the manuscript for A Behavior System, Hull suffered a massive heart attack that exacerbated his already frail physical condition. It took all the strength he could muster, but he finished the book four months before he died, on May 10, 1952, of a second heart attack. Near his death, Hull expressed profound regret that a third book he had been planning would never be written. He believed that his third book would have been his most important because it would have extended his system to human social behavior.

Hull's Hypothetico-Deductive Theory

Hull borrowed the technique of using intervening variables from Tolman, but he used them even more extensively than Tolman did. Hull was the first (and last) psychologist to attempt to apply a comprehensive, scientific theory to the study of learning, creating a highly complex **hypothetico-**

deductive theory, which he hoped would be self-correcting. Hull first reviewed the research that had been done on learning; then he summarized that research in the form of general statements, or postulates. From these postulates, he inferred theorems that yielded testable propositions. Hull (1943) explained why his system should be self-correcting:

Empirical observation, supplemented by shrewd conjecture, is the main source of the primary principles or postulates of a science. Such formulations, when taken in various combinations together with relevant antecedent conditions, yield inferences or theorems, of which some may agree with the empirical outcome of the conditions in question, and some may not. Primary propositions yielding logical deductions which consistently agree with the observed empirical outcome are retained, whereas those which disagree are rejected or modified. As the sifting of this trial-and-error process continues, there gradually emerges a limited series of primary principles whose joint implications are progressively more likely to agree with relevant observations. Deductions made from these surviving postulates, while never absolutely certain, do at length become highly trustworthy. This is in fact the present status of the primary principles of the major physical sciences. (p. 382)

Whereas Watson believed that all behavior could be explained in terms of the associations between stimuli and responses, Hull concluded that a number of intervening internal conditions had to be taken into consideration. Tolman had reached the same conclusion. However, for Tolman, cognitive events intervened between environmental experience and behavior; for Hull, the intervening events were primarily physiological.

In Hull's final statement of his theory (1952b), he listed 17 postulates and 133 theorems, but we review only a few of his more important concepts here.

Reinforcement

Unlike Watson and Tolman, Hull was a reinforcement theorist. For Hull a biological need creates a *drive* in the organism, and the diminution of this drive constitutes **reinforcement**. Thus, Hull had a **drive-reduction** theory of reinforcement. For Hull drive is one of the important events that intervenes between a stimulus and a response.

Habit Strength. If a response made in a certain situation leads to drive reduction, **habit strength** $(_{S}H_{R})$ is said to increase. Hull operationally defined habit strength, an intervening variable, as the number of reinforced pairings between an environmental situation (S) and a response (R). For Hull an increase in habit strength constitutes learning.

Reaction Potential

Drive is not only a necessary condition for reinforcement but also an important energizer of behavior. Hull called the probability of a learned response **reaction potential (SER)**, which is a function of both the amount of drive (D) present and the number of times the response had been previously reinforced in the situation. Hull expressed this relationship as follows:

$$_{S}E_{R} = _{S}H_{R} \times D$$

If either ${}_{S}H_{R}$ or D is zero, the probability of a learned response being made is also zero.

Hull postulated several other intervening variables, some of which contributed to ${}_{S}E_{R}$ and some of which diminished it. The probability of a learned response is the net effect of all these positive and negative influences, each intervening variable being carefully operationally defined. (For a more detailed account of Hull's theory, see Bower and Hilgard, 1981; Hergenhahn and Olson, 2005.)

Hull's Theory in General

Hull's theory can be seen as an elaboration of Woodworth's S-O-R concept. Using operational

definitions, Hull attempted to show how a number of internal events interact to cause overt behavior. Hull's theory is in the Darwinian tradition because it associates reinforcement with those events that are conducive to an organism's survival. His theory reflected the influence of Darwin, Woodworth, Watson, and logical positivism.

Hull's Influence

Within 10 years of the publication of *Principles of Behavior* (1943), 40% of all experimental studies in the highly regarded *Journal of Experimental Psychology* and *Journal of Comparative and Physiological Psychology* referred to some aspect of Hull's theory. The figure increases to 70% when only the fields of learning and motivation are considered (Spence, 1952). Hull's influence went beyond these areas, however; during the period between 1949 and 1952, there were 105 references to Hull's *Principles of Behavior* in the *Journal of Abnormal and Social Psychology*, compared to only 25 for the next most commonly cited work (Ruja, 1956).

In 1945 Hull was awarded the prestigious Warren Medal by the Society of Experimental Psychologists. It carried this inscription:

To Clark L. Hull: For his careful development of a systematic theory of behavior. This theory has stimulated much research and it has been developed in a precise and quantitative form so as to permit predictions which can be tested empirically. The theory thus contains within itself the seeds of its own ultimate verification and of its own possible final disproof. A truly unique achievement in the history of psychology to date. (Kendler, 1987, p. 305)

After Hull's death in 1952, one of his former students, Kenneth W. Spence (1907–1967), became the major spokesman for his theory (see Spence, 1956, 1960). The extensions and modifications Spence made in Hull's theory were so substantial that the theory became known as the Hull–Spence theory. So successful was Spence in perpetuating Hullian theory

that a study showed that as late as the 1960s, Spence was the most cited psychologist in experimental psychology journals, with Hull himself in eighth place (Myers, 1970).

Although Hull's theory eventually won its battle with Tolman's and was extremely popular in the 1940s and 1950s—and under Spence's influence, even into the 1960s—it is now generally thought of as having mainly historical value. Hull attempted to create a general behavior theory that all social sciences could use to explain human behavior, and his program fit all the requirements of logical positivism (for example, all his theoretical concepts were operationally defined). However, although Hull's theory was scientifically respectable, it was relatively sterile. More and more, the testable deductions from his theory were criticized for being of little value in explaining behavior beyond the laboratory. Psychologists began to feel hampered by the need to define their concepts operationally and to relate the outcomes of their experiments to a theory such as Hull's. They realized that objective inquiry could take many forms and that the form suggested by logical positivism had led to a dead end. In many ways, Hull's approach was ultimately as unproductive as Titchener's had been.

EDWIN RAY GUTHRIE

Edwin Ray Guthrie (1886-1959) was born on January 9 in Lincoln, Nebraska, the first of five children. His father owned a piano shop in Lincoln, where he also sold bicycles and furniture. His mother had been a school teacher before her marriage. According to Guthrie's son Peter, his father showed early academic promise:

He and a friend read Darwin's Origin of Species and The Expression of the Emotions in Man and Animals while they were in the 8th grade. Edwin studied Greek and Latin along with his other subjects and read Xenophon in Greek. (Prenzel-Guthrie, 1996, p. 138)

Edwin Ray Guthrie

Guthrie graduated from the University of Nebraska in 1907 with a BA in mathematics and a Phi Beta Kappa key. After graduation he taught mathematics at a Lincoln high school while working toward an MA in philosophy at the University of Nebraska. He obtained his MA in 1910. That same year, Guthrie began work on his PhD at the University of Pennsylvania and, after obtaining it, returned in 1912 to teaching high school mathematics. In 1914 he accepted a position as instructor of philosophy at the University of Washington. In 1919 he became a member of the psychology department at the University of Washington, where he remained until accepting the position of dean of the graduate school in 1943. In 1951 Guthrie attained emeritus status but continued to teach and involve himself in university affairs until his retirement in 1956.

Guthrie's basic work, The Psychology of Learning, was published in 1935 and revised in 1952. His writing was nontechnical, humorous, and filled with numerous homespun anecdotes. He believed strongly that any scientific theory, including his own, should be presented in such a way that it could be understood by college undergraduates. He also placed great emphasis on the practical application of his ideas. Although he had an experimental outlook

and orientation, he, along with George P. Horton, performed only one experiment related to his theory (discussed shortly). Guthrie was clearly a behaviorist, but he argued with other behaviorists (such as Watson, Tolman, Hull, and Skinner), saying their theories were unparsimonious and too subjective. As we will see, Guthrie believed all learning phenomena could be explained by using only one of Aristotle's laws of association—the law of contiguity.

The One Law of Learning

Guthrie's one law of learning was the **law of contiguity**, which he stated as follows: "A combination of stimuli which has accompanied a movement will on its recurrence tend to be followed by that movement. Note that nothing is here said about 'confirmatory waves' or reinforcement or pleasant effects" (1952, p. 23). In other words, according to Guthrie, what you do last in a situation is what you will tend to do if the situation recurs. Thus, Guthrie accepted Watson's recency principle.

In his last publication before his death, Guthrie (1959) revised his law of contiguity to read, "What is being noticed becomes a signal for what is being done" (p. 186). This was Guthrie's way of recognizing that an organism is confronted with so many stimuli at any given time that it cannot possibly form associations with all of them. Rather, the organism responds selectively to only a small proportion of the stimuli present, and it is that proportion that becomes associated with whatever response is made.

One-Trial Learning

Learning theorists prior to Guthrie accepted Aristotle's law of contiguity and his law of frequency. For example, Pavlov, Watson, Tolman, Hull, and (as we will see later in this chapter) Skinner theorized that associative strength increases as a function of increased exposure to the learning environment. Of course, they disagreed in their explanation as to why an increase in associative strength took place, but they all agreed that

frequency of exposure was necessary. What made Guthrie's theory of learning unique was his rejection of the law of frequency, saying instead that "a stimulus pattern gains its full associative strength on the occasion of its first paring with a response" (1942, p. 30). In other words, unlike any learning theorist before him, Guthrie postulated **one-trial learning**. As Guthrie was aware, Aristotle had observed that learning can result from one experience. Aristotle said,

It is a fact that there are some movements, by a single experience of which persons take the impress of custom more deeply than they do by experiencing others many times; hence upon seeing some things but once we remember them better than others which we may have seen frequently. (Barnes, 1984, Vol. 1, p. 717)

However, Aristotle believed such learning to be the exception and learning governed by the law of frequency to be the rule.

Why Practice Improves Performance

If learning occurs in one trial, why does practice appear to improve performance? To answer this question. Guthrie distinguished between acts and movements. A movement is a specific response made to a specific configuration of stimuli. It is this association that is learned at full strength after one exposure. An act is a response made to varying stimulus configurations. For example, typing the letter "a" on a specific typewriter under specific stimulus conditions (such as under certain lighting and temperature conditions, and in a specific bodily position) is a movement. However, typing "a" under varying conditions is an act. It is because learning an act involves learning a specific response under varying conditions that practice improves performance.

Just as an act consists of many movements, a *skill* consists of many acts. Thus, a skill such as typing, playing golf, or driving a car consists of many acts that, in turn, consist of thousands of movements. For example, the skill of playing golf consists

of the acts of driving, putting, playing out of sand traps, and the like. Again, it is the fact that acts and skills require the learning of so many S–R associations that their performance improves with practice.

pre-escape conditions and the animal's characteristic response to those conditions. Guthrie's claim that reinforcement is merely a mechanical arrangement that prevents unlearning was confirmed.

The Nature of Reinforcement

According to Thorndike, cats gradually became more proficient at escaping from a puzzle box because each time they did so they experienced a "satisfying state of affairs" (reinforcement). Guthrie rejected this idea. Guthrie explained the effects of "reinforcement" in terms of the recency principle. He noted that when a cat in a puzzle box made a response that allowed it to escape (moving a pole, for example), the entire stimulus configuration in the puzzle box changed. Thus we have one set of stimuli existing before the pole is moved and another after it is moved. According to Guthrie, because moving the pole is the last thing the cat does under the prereinforcement conditions, it is that response the cat will make when next placed in the puzzle box. For Guthrie "reinforcement" changes the stimulating conditions thereby preventing unlearning. In other words, "reinforcement" preserves the association that preceded it.

The only systematic research ever performed by Guthrie was done with Horton and was summarized in a small book titled Cats in a Puzzle Box (Guthrie and Horton, 1946). Guthrie and Horton observed approximately 800 escape responses by cats in an apparatus similar to that used by Thorndike. Like Thorndike, Guthrie and Horton observed that cats learned to move a pole to escape the apparatus. However, it was observed that each cat learned to move the pole in its own unique way. For example, one cat would hit the pole by backing into it, another would push it with its head, and another would move it with its paws. This stereotyped behavior would be repeated by each cat when it was replaced into the apparatus. This, of course, supported Guthrie's claim that whatever an animal does last in a situation will be repeated when the situation recurs (the recency principle). Moving the pole changes the stimulating conditions, thus preserving the association between the

Forgetting

According to Guthrie, not only does learning occur in one trial but so does forgetting. Forgetting occurs when an old S–R association is displaced by a new one. Thus, for Guthrie, all forgetting involves new learning. Forgetting occurs only if an existing S–R association is interfered with in some way. Guthrie explained,

The child who has left school at the end of the seventh grade will recall many of the details of his last year for the rest of his life. The child who has continued on in school has these associations of the schoolroom and school life overlaid by others, and by the time he is in college may be vary vague about the names and events of his seventhgrade experience.

When we are somehow protected from established cues we are well aware that these may retain their connection with a response indefinitely. A university faculty member's wife recently visited Norway, the original home of her parents. She had not spoken Norwegian since the death of her grandmother when she was five and believed that she had forgotten the language. But during her stay in Norway, she astonished herself by joining in the conversation. The language and atmosphere of her childhood revived words and phrases she could not remember in her American home. But her conversation caused much amusement among her relatives because she was speaking with a facile Norwegian "baby talk." If her family in America had continued to use Norwegian, this "baby talk" would have been forgotten, its association with the language destroyed by other phrases.

Forgetting is not a passive fading of stimulus-response associations contingent upon the lapse of time, but requires active unlearning, which consists in learning to do something else under the circumstances. (1942, pp. 29–30)

Breaking Habits

A habit is an act that has become associated with a large number of stimuli. The more stimuli that elicit the act, the stronger is the habit. Smoking, for example, can be a strong habit because the act of smoking has become associated with so many stimuli. According to Guthrie, there is one general rule for breaking undesirable habits: Observe the stimuli that elicit the undesirable act and perform another act in the presence of those stimuli. Once this is done, the new, desirable act will be elicited by those stimuli instead of the old, undesirable act.

Punishment

For Guthrie the effectiveness of punishment is determined not by the pain it causes but by what it causes the organism to do it the presence of stimuli that elicit undesirable behavior. If punishment elicits behavior incompatible with the undesirable behavior in the presence of these stimuli, it will be effective. If not, it will be ineffective. For example, in attempting to discourage a dog from chasing cars, hitting it on the nose while it is chasing is likely to be effective. On the other hand, hitting it on its rear is likely to be ineffective, or perhaps even strengthen the tendency to chase. In both cases, it can be assumed the amount of pain involved is the same.

Drives and Intentions

For Guthrie, drives provide **maintaining stimuli** that keep an organism active until a goal is reached. Maintaining stimuli can be internal (for example, hunger) or external (for example, a loud noise). When an organism performs an act that terminates

the maintaining stimuli, that act becomes associated with the maintaining stimuli. That is, because of the recency principle, the last act performed in the presence of the maintaining stimuli will tend to be performed when those stimuli recur. Such acts are referred to as intentions because they appear to have as their goal the removal of maintaining stimuli (drives). In fact, however, "intentional" behavior is explained by Guthrie as any other kind of behavior—that is, by the law of contiguity.

In 1945 Guthrie was elected president of the APA, and in the same year, his alma mater the University of Nebraska awarded him an honorary doctorate. In 1958 the American Psychological Foundation (APF) awarded Guthrie its gold medal for distinguished contributions to the science of psychology. Shortly thereafter, the University of Washington named its new psychology building Edwin Ray Guthrie Hall. Guthrie died of a heart attack in April 1959.

The Formalization of Guthrie's Theory

Guthrie often presented his theory in terms too general to be tested experimentally. An effort to make Guthrie's theory more scientifically rigorous was made by Virginia W. Voeks (1921–1989), who studied at the University of Washington when Guthrie was influential there. After receiving her BA from the University of Washington in 1943, Voeks went to Yale, where she was influenced by Hull. She obtained her PhD from Yale in 1947. In 1949 Voeks moved to San Diego State College, where she remained until her retirement in 1971.

Voeks's formalization of Guthrie's theory (1950) consisted of four basic postulates, eight definitions, and eight theorems (testable deductions). Voeks tested a number of her deductions and found considerable support for Guthrie's theory (see, for example, Voeks, 1954).

Another attempt to formalize Guthrie's theory was made by William Kaye Estes (b. 1919). Early in his career, Estes performed significant research on the effects of punishment (1944). However, it is for his development of *stimulus sampling theory* (SST) that Estes is best known (1950, 1960, 1964). The

cornerstone of SST was Guthrie's law of contiguity with its assumption of one-trial learning. Estes's SST showed that Guthrie's theory, while appearing to be simple, was actually very complex. The model that Estes created (SST) effectively dealt with that complexity and launched a highly heuristic research program. Estes modified his theory, making it more compatible with cognitive psychology (see, for example, Estes, 1994). Even through its various revisions, however, Guthrie's law of contiguity has remained at the core of Estes's theorizing. For an overview of Estes's SST and its revisions through the years, see Hergenhahn and Olson, 2005

B. F. SKINNER

As the complex theoretical systems of Tolman and Hull began to lose their popularity and Guthrie's theory survived primarily through Estes's relatively esoteric effort to create a mathematical model of learning, another form of behaviorism was in its ascendancy. The version of behaviorism promoted by B. F. Skinner was contrary to logical positivism because it was antitheoretical, and yet it was in accordance with logical positivism because it insisted that all its basic terms be operationally defined. As we will see, Skinner's version of behaviorism was more in accordance with positivism than with logical positivism. After World War II, Skinner's version of behaviorism essentially displaced all other versions.

Burrhus Frederic Skinner (1904–1990) was born on March 20 in Susquehanna, Pennsylvania, into a warm, stable, middle-class family. Skinner had a younger brother who was a better athlete and more socially popular than he was but who died suddenly at the age of 16. Skinner was raised according to strict moral standards but was physically punished only once:

I was never physically punished by my father and only once by my mother. She washed my mouth out with soap and

B. F. Skinner

water because I had used a bad word. My father never missed an opportunity, however, to inform me of the punishments which were waiting if I turned out to have a criminal mind. He once took me through the county jail, and on a summer vacation I was taken to a lecture with colored slides describing life in Sing Sing. As a result I am afraid of the police and buy too many tickets to their annual dance. (Skinner, 1967, pp. 390–391)

In high school, Skinner did well in literature but poorly in science, and he earned money by playing in a jazz band and with an orchestra. He went to Hamilton College, a small liberal arts school in Clinton, New York, where he majored in English. Skinner did not fit well into college life, was terrible at sports, and felt "pushed around" by requirements such as daily chapel. By his senior year, Skinner viewed himself as "in open revolt" against the school. He, along with a friend, decided to play a trick on their English composition professor, whom they disliked because he was "a great

name-dropper." Skinner and his friend had posters printed that read: "Charles Chaplin, the famous cinema comedian, will deliver his lecture 'Moving Pictures as a Career' in the Hamilton College chapel on Friday, October 9" (Skinner, 1967, p. 393). The Chaplin visit was said to be under the auspices of the disliked English professor. The posters were displayed all over town, and Skinner's friend called the newspaper in Utica with the news. By noon the prank was completely out of hand. Police roadblocks were necessary to control the crowds. The next day, the English professor to whom the hoax was directed wrote an editorial lambasting the entire episode. Skinner said that it was the best thing the professor ever wrote. The Chaplin prank was only the beginning of a mischievous senior year for Skinner:

As a nihilistic gesture, the hoax was only the beginning. Through the student publications we began to attack the faculty and various local sacred cows. I published a parody of the bumbling manner in which the professor of public speaking would review student performances at the end of the class. I wrote an editorial attacking Phi Beta Kappa. At commencement ... I covered the walls with bitter caricatures of the faculty ... and we [Skinner and his friends] made a shambles of the commencement ceremonies, and at intermission the President warned us sternly that we would not get our degrees if we did not settle down. (Skinner, 1967, p. 393)

Skinner graduated from Hamilton College with a bachelor's degree in English literature and a Phi Beta Kappa key and without having had a course in psychology. He left college with a passion to become a writer. This passion was encouraged in part by the fact that the famous poet Robert Frost favorably reviewed three of his short stories. Skinner's first attempt at writing was in the attic of his parents' home: "The results were disastrous. I frittered away my time. I read aimlessly ... listened to the newly invented radio, contributed to the

humorous column of a local paper but wrote almost nothing else, and thought about seeing a psychiatrist" (Skinner, 1967, p. 394). Next, Skinner tried writing in New York City's Greenwich Village and then in Paris for a summer; these attempts also failed. By this time, Skinner (1967) had developed a distaste for most literary pursuits: "I had failed as a writer because I had had nothing important to say, but I could not accept that explanation. It was literature which must be at fault" (p. 395).

Having failed to describe human behavior through literature, Skinner decided to describe it scientifically. While in Greenwich Village, Skinner had read the works of Pavlov and Watson and was greatly impressed. On his return from Europe in 1928, he enrolled in the graduate program in psychology at Harvard. Feeling that he at last found his niche, Skinner threw himself completely into his studies:

I would rise at six, study until breakfast, go to classes, laboratories, and libraries with no more than fifteen minutes unscheduled during the day, study until exactly nine o'clock at night and go to bed. I saw no movies or plays, seldom went to concerts, had scarcely any dates and read nothing but psychology and physiology. (Skinner, 1967, p. 398)

This high degree of self-discipline typified Skinner's work habits throughout his long life.

Skinner earned his master's degree in two years (1930) and his doctorate in three (1931) and then remained at Harvard for the next five years as a post-doctoral fellow. Skinner began his teaching career at the University of Minnesota in 1937 and remained there until 1945. While he was at Minnesota, Skinner published *The Behavior of Organisms* (1938), which established him as a nationally prominent experimental psychologist. In 1945 Skinner moved to Indiana University as chairman of the psychology department, where he remained until 1948 when he returned to Harvard. He remained affiliated with Harvard until his death in 1990. In 1974 he became professor emeritus

but continued for years to walk the two miles between his home and his office in William James Hall to answer correspondence, to meet with scholars who paid him visits from around the world, and on occasion to conduct research and supervise graduate students. (Fowler, 1990, p. 1203)

In addition to the short autobiography Skinner wrote in 1967, he described the details of his life in three more extensive volumes: *Particulars of My Life* (1976), *The Shaping of a Behaviorist* (1979), and *A Matter of Consequences* (1983).

Skinner's Positivism

In Chapter 4, we discussed the great Renaissance thinker Francis Bacon. Bacon was intensely interested in overcoming the mistakes of the past and thus arriving at knowledge that was free of superstition and prejudice. His solution to the problem was to stay very close to what was empirically observable and to avoid theorizing about it. Bacon proposed that science be descriptive and inductive rather than theoretical and deductive. Following Bacon's suggestion, scientists would first gather empirical facts and then infer knowledge from those facts (instead of first developing abstract theories from which facts are deduced). Bacon's main point was that in the formulation of theories, a scientist's biases, misconceptions, traditions, and beliefs (perhaps false beliefs) could manifest themselves and that these very things inhibited a search for objective knowledge. Skinner was deeply impressed by Bacon and often referred to his influence on his life and work (L. D. Smith, 1992). Bacon can be seen as starting the positivistic tradition that was later followed by Comte and Mach. As he did with Bacon, Skinner often acknowledged a debt to Mach (see, for example, Skinner, 1931/1972, 1979). For Mach, as we have previously noted, it was important that science rid itself of metaphysical concepts, which, for him, were any concepts that refer to events that cannot be directly observed (causation is such a concept). Mach and the other positivists were interested only in facts and how facts

are related to each other. According to Mach, the scientist determines how facts are related by doing a functional analysis. That is, by noting that if X occurs, Y also tends to occur. To ponder why such relationships exist is to enter the dangerous and unnecessary realm of metaphysics. The job of science is to describe empirical relationships, not explain them. Skinner followed Mach's positivism explicitly. By adopting Mach's functional approach to science, Skinner (1931/1972) avoided the complex problem of establishing causation in human behavior:

We may now take the more humble view of explanation and causation which seems to have been first suggested by Mach and is now a common characteristic of scientific thought, wherein ... the notion of function [is] substituted for that of causation. (pp. 448–449)

As far as theory is concerned, Skinner was a positivist, not a logical positivist. We examine Skinner's positivism again when we review his attitude toward theory.

Functional Analysis of Behavior

Like Watson, Skinner denied the existence of a separate realm of conscious events. He believed that what we call mental events are simply verbal labels given to certain bodily processes: "[My] position can be stated as follows: What is felt or introspectively observed is not some nonphysical world of consciousness, mind or mental life but the observer's own body" (Skinner, 1974, p. 17). But, said Skinner, even if there were mental events, nothing would be gained by studying them. He reasoned that if environmental events give rise to conscious events, which, in turn, cause behavior, nothing is lost and a great deal is gained by simply doing a functional analysis of the environmental and the behavioral events. Such an analysis avoids the many problems associated with the study of mental These so-called mental events. Skinner, will someday be explained when we learn which internal physiological events people are responding to when they use such terms as thinking, choosing, and willing to explain their own behavior. Skinner, then, was a physical monist (materialist) because he believed that consciousness as a nonphysical entity does not exist. Because we do not at present know to which internal events people are responding when they use mentalistic terminology, we must be content simply to ignore such terms. Skinner (1974) said,

There is nothing in a science of behavior or its philosophy which need alter feelings or introspective observations. The bodily states which are felt or observed are acknowledged, but there is an emphasis on the environmental conditions with which they are associated and an insistence that it is the conditions rather than the feelings which enable us to explain behavior. (p. 245)

Skinner (1974) also said, "A completely independent science of subjective experience would have no more bearing on a science of behavior than a science of what people feel about fire would have on the science of combustion" (pp. 220–221), and "There is no place in the scientific position for a self as a true originator or initiator of action" (p. 225). Like Watson then, Skinner was a radical behaviorist in that he refused to acknowledge any causal role of mental events in human conduct. For Skinner, so-called mental events were nothing but neurophysiological events to which we have assigned mentalistic labels.

Skinner continued to attack cognitive psychology throughout his professional life, and toward the end of his life he deeply regretted the increased popularity of cognitive psychology.

Operant Behavior

Whereas Watson modeled his psychology after the Russian physiologists, Skinner modeled his after Thorndike. Watson and Pavlov attempted to correlate behavior with environmental stimuli. That is, they were interested in reflexive behavior. Skinner

called such behavior respondent behavior because it was elicited by a known stimulus. Because both Pavlov and Watson studied the relationship between environmental stimuli (S) and responses (R), their endeavors represent S-R psychology. Thorndike, however, studied behavior that is controlled by its consequences. For example, behavior that had been instrumental in allowing an animal to escape from a puzzle box tends to be repeated when the animal is next placed in the puzzle box. Using Thorndike's experimental arrangement, a response was instrumental in producing certain consequences, and therefore the type of learning that he studied was called instrumental conditioning. Thorndike neither knew nor cared about the origins of the behavior that is controlled by its consequences. What Thorndike called instrumental behavior, Skinner called operant behavior because it operates on the environment in such a way as to produce consequences. Unlike respondent behavior, which is elicited by known stimulation, operant behavior is simply emitted by the organism. It is not that operant behavior is not caused but that its causes are not known—nor is it important to know them. The most important aspect of operant behavior is that it is controlled by its consequences and not elicited by known stimulation. Skinner's concentration on operant behavior is one major reason that his brand of behaviorism was much different from Watson's.

Although both Skinner and Thorndike studied behavior controlled by its consequences, how they studied that behavior was different. Thorndike measured how long it took an animal to make an escape response as a function of successive, reinforced trials. He found that as the number of reinforced escapes increases, the time it takes for the animal to escape decreases. His dependent variable was the latency of the escape response. Skinner's procedure was to allow an animal to respond freely in an experimental chamber (called a Skinner box) and to note the effect of reinforcement on response rate. For example, a lever-press response may occur only 2 or 3 times a minute before it is reinforced and 30 or 40 times a minute when it results in

reinforcement. Rate of responding, then, was Skinner's dependent variable.

Despite the differences between them, however, both Watson and Skinner exemplified radical behaviorism because they believed that behavior could be completely explained in terms of events external to the organism. For Watson, environmental events elicit either learned or unlearned responses; for Skinner, the environment selects behavior via reinforcement contingencies. For both, what goes on within the organism is relatively unimportant. As we have seen, the theories of Tolman and Hull exemplified methodological behaviorism because they postulated a wealth of events that were supposed to intervene between experience and behavior.

The Nature of Reinforcement

If an operant response leads to reinforcement, the rate of that response increases. Thus, those responses an organism makes that result in reinforcement are most likely to occur when the organism is next in that situation. This is what is meant by the statement that operant behavior is controlled by its consequences. According to Skinner, reinforcement can be identified only through its effects on behavior. Just because something acts as a reinforcer for one organism under one set of circumstances does not mean that it will be a reinforcer for another organism or for the same organism under different circumstances:

In dealing with our fellow men in every-day life and in the clinic and laboratory, we may need to know just how reinforcing a specific event is. We often begin by noting the extent to which our own behavior is reinforced by the same event. This practice frequently miscarries; yet it is still commonly believed that reinforcers can be identified apart from their effects upon a particular organism. As the term is used here, however, the only defining characteristic of a reinforcing stimulus is that it reinforces. (Skinner, 1953, p. 71)

Thus, for Skinner, there is no talk of drive reduction, satisfying states of affairs, or any other mechanisms of reinforcement. A reinforcer is *anything* that, when made contingent on a response, changes the rate with which that response is made. For Skinner nothing additional needs to be said. He accepted Thorndike's law of effect but not the mentalism that the phrase "satisfying state of affairs" implies.

The Importance of the Environment

Whereas the environment was important for Watson and the Russian physiologists because it elicited behavior, it was important for Skinner because it *selected* behavior. The reinforcement contingencies the environment provides determine which behaviors are strengthened and which are not. Change reinforcement contingencies, and you change behavior:

The environment is obviously important, but its role has remained obscure. It does not push or pull, it selects, and this function is difficult to discover and analyze. The role of natural selection in evolution was formulated only a little more than a hundred years ago, and the selective role of the environment in shaping and maintaining the behavior of the individual is only beginning to be recognized and studied. As the interaction between organism and environment has come to be understood. however, effects once assigned to states of mind, feeling, and traits are beginning to be traced to accessible conditions, and a technology of behavior may therefore become available. It will not solve our problems, however, until it replaces traditional prescientific views, and these views are strongly entrenched. (Skinner, 1971, p. 25)

Thus, Skinner applied Darwinian notions to his analysis of behavior. In any given situation, an organism initially makes a wide variety of responses. Of those responses, only a few will be functional

(reinforcing). These effective responses survive and become part of the organism's response repertoire to be used when that situation next occurs.

According to Skinner, the fact that behavior is governed by reinforcement contingencies provides hope for the solution of a number of societal problems. If it was the "mind" or the "self" that needed to be understood instead of how the environment selects behavior, we would be in real trouble:

Fortunately, the point of attack is more readily accessible. It is the environment which must be changed. A way of life which furthers the study of human behavior in its relation to that environment should be in the best possible position to solve its major problems. This is not jingoism, because the great problems are now global. In the behavioristic view, man can now control his own destiny because he knows what must be done and how to do it. (Skinner, 1974, p. 251)

The Positive Control of Behavior

Like Thorndike, Skinner (1971) found that the effects of reinforcement and punishment are not symmetrical; reinforcement strengthens behavior, but punishment does not weaken behavior:

A child who has been severely punished for sex play is not necessarily less inclined to continue; and a man who has been imprisoned for violent assault is not necessarily less inclined toward violence. Punished behavior is likely to reappear after the punitive contingencies are withdrawn. (p. 62)

Why, if punishment is ineffective as a modifier of behavior, is it so widely used? Because, said Skinner (1953), it is reinforcing to the punisher:

Severe punishment unquestionably has an immediate effect in reducing a tendency to

act in a given way. This result is no doubt responsible for its widespread use. We "instinctively" attack anyone whose behavior displeases us—perhaps not in physical assault, but with criticism, disapproval, blame, or ridicule. Whether or not there is an inherited tendency to do this, the immediate effect of the practice is reinforcing enough to explain its currency. In the long run, however, punishment does not actually eliminate behavior from a repertoire, and its temporary achievement is obtained at tremendous cost in reducing the over-all efficiency and happiness of the group. (p. 190)

The "tremendous cost" involved in the use of punishment comes from the many negative by-products associated with it, including the fact that it induces fear, it often elicits aggression, it justifies inflicting pain on others, and it often replaces one undesirable response with another, such as when a child spanked for a wrongdoing cries instead.

How then is undesirable behavior to be dealt with? Skinner (1953) said to ignore it:

The most effective alternative process [to punishment] is probably *extinction*. This takes time but is much more rapid than allowing the response to be forgotten. The technique seems to be relatively free of objectional by-products. We recommend it, for example, when we suggest that a parent "pay no attention" to objectionable behavior on the part of his child. If the child's behavior is strong only because it has been reinforced by "getting a rise out of" the parent, it will disappear when this consequence is no longer forthcoming. (p. 192)

Because of the relative ineffectiveness of punishment and the many negative by-products associated with its use, Skinner consistently urged that behavior be modified positively through reinforcement contingencies, not negatively through punishment.

Skinner's Attitude toward Theory

Because Skinner's position was nontheoretical, it contrasted with the behavioristic positions of Tolman and Hull and, to a lesser extent, of Guthrie. Skinner accepted operationism but rejected the theoretical aspects of logical positivism. He was content to manipulate environmental events (such as reinforcement contingencies) and note the effects of these manipulations on behavior, believing that this functional analysis is all that is necessary. For this reason, Skinner's approach is sometimes referred to as a descriptive behaviorism. There is, Skinner felt, no reason for looking "under the skin" for explanations of relationships between the environment and behavior. Looking for physiological explanations of behavior is a waste of time because overt behavior occurs whether or not we know its neurophysiological underpinnings. We have already reviewed Skinner's attitude toward mentalistic explanations of behavior. Because Skinner did not care what was going on "under the skin" either physiologically or mentally, his approach is often referred to as the empty-organism approach. Skinner knew, of course, that the organism is not empty, but he thought that nothing is lost by ignoring events that intervene between the environment and the behavior it selects.

Besides opposing physiological and mentalistic explanations of behavior, Skinner (1950) opposed abstract theorizing like that of Tolman and Hull:

Research designed with respect to theory is also likely to be wasteful. That a theory generates research does not prove its value unless the research is valuable. Much useless experimentation results from theories, and much energy and skill are absorbed by them. Most theories are eventually overthrown, and the greater part of the associated research is discarded. This could be justified if it were true that productive research requires a theory—as is, of course, often claimed. It is argued that research would be aimless and disorganized without a theory to guide it. The view is supported by psychological texts which take their cue

from the logicians rather than empirical science, and describe thinking as necessarily involving stages of hypothesis, deduction, experimental test, and confirmation. But this is not the way most scientists actually work. It is possible to design significant experiments for other reasons, and the possibility to be examined is that such research will lead more directly to the kind of information which a science usually accumulates. (pp. 194–195)

In describing his nontheoretical approach, Skinner (1956) said that if he tried something and if it seemed to be leading to something useful, he persisted. If what he was doing seemed to be leading to a dead end, he abandoned it and tried something else.

Some believe that Skinner's article "Are Theories of Learning Necessary?" (1950) marked the end of what Koch (1959) called the "age of theory" in psychology.

Applications of Skinnerian Principles

Like Watson, Skinner and his followers sought to apply their principles to the solution of practical problems. In all applications of Skinnerian principles, the general rule is always the same: Change reinforcement contingencies, and you change behavior. This principle has been used to teach pigeons to play games like table tennis and basketball, and many animals trained through the use of Skinnerian principles have performed at tourist attractions throughout the United States. In a defense effort, pigeons were even trained to guide missiles as the missiles sped toward enemy targets (Skinner, 1960). In 1948 Skinner wrote a utopian novel entitled Walden Two, in which he demonstrated how his principles could be used in designing a model society. In Beyond Freedom and Dignity (1971), Skinner reviewed the reasons that cultural engineering, although possible, has been largely rejected.

In the realm of education, Skinner developed a teaching technique called *programmed learning* (1954, 1958). With programmed learning, material

is presented to students in small steps; students are then tested on the material, given immediate feedback on the accuracy of their answers, and allowed to proceed through the material at their own pace. Skinner had criticized U.S. education ever since 1953, when he visited his daughter's classroom and concluded that the teacher was violating everything that was known about learning. Skinner (1984) maintained that many of the problems in our educational system could be solved through the use of operant principles. Skinner's main criticism of U.S. educational practices was that the threat of punishment is used to force students to learn and to behave instead of the careful manipulation of reinforcement contingencies. This aversive control, Skinner said, creates a negative attitude toward education.

In 1983 Skinner, along with Margaret Vaughan, wrote *Enjoy Old Age: Living Fully Your Later Years*, in which they addressed such topics as diet, retirement, exercise, forgetfulness, sensory deficiencies, and fear of death. Interestingly, although Skinner counseled the elderly to avoid fatigue, he and Vaughan wrote the book in three months.

Skinner and his followers have applied behavior modification principles to helping individuals with problems ranging from psychosis to smoking, alcoholism, drug addiction, mental retardation, juvenile delinquency, speech disorders, shyness, phobias, obesity, and sexual disorders. The Skinnerian version of **behavior therapy** assumes that people learn abnormal behavior in the same way that they learn normal behavior. Therefore, "treatment" is a matter of removing the reinforcers that are maintaining the undesirable behavior and arranging the reinforcement contingencies so that they strengthen desirable behavior.

Skinnerian principles have also been used to create **token economies** in a number of institutions, such as psychiatric hospitals. When participants in such economies behave in desirable ways, they are reinforced with tokens that can be exchanged for such items as candy, cigarettes, coffee, or the exclusive use of a radio or television set. Token economies have been criticized as contrived or unnatural but, according to Masters, Burish,

Hollon, and Rimm (1987), it is institutions without token economies that are unnatural and relatively ineffective:

Token economies are not really unnatural. Indeed, any national economy with a currency system is in every sense a token economy: any currency consists by definition of token or symbolic "reinforcers" that may be exchanged for items that constitute a more direct form of reinforcement. Whereas the individual in society works to earn tokens (money) with which he purchases his dwelling place, food, recreation, and so on, most institutions provide such comforts noncontingently and hence cease to encourage many adaptive behaviors that are appropriate and effective in the natural environment. (p. 222)

In general, the use of Skinnerian principles in treating behavior problems has been very effective (for example, see Ayllon and Azrin, 1968; Craighead, Kazdin, and Mahoney, 1976; Kazdin, 1989; Kazdin and Wilson, 1978; Leitenberg, 1976; Masters et al., 1987; Rimm and Masters, 1974; Ulrich, Stachnik, and Mabry, 1966). For his role in developing behavior modification procedures used to improve the quality of life of the mentally retarded, Skinner was presented a Kennedy International Award in 1971. In 1972 he was named "Humanist of the Year" by the American Humanist Association. On August 10, 1990, the APA presented Skinner with an unprecedented Lifetime Contribution to Psychology Award. Eight days later. he died of leukemia at the age of 86. As a further tribute to Skinner, the entire November 1992 issue of the American Psychologist was dedicated to his ideas and their influence.

BEHAVIORISM TODAY

The work of all the neobehaviorists covered in this chapter remains influential in contemporary psychology. Tolman's brand of behaviorism, with its

emphasis on purposive behavior and mental constructs, can be viewed as a major reason for the current popularity of cognitive psychology. Although Hull did much to promote an objective behavioristic approach, his current influence is due mainly to some of the esoteric features of his theory. His goal of developing a comprehensive behavior theory, however, has given way to the goal of developing theories designed to explain specific phenomena (see, for example, Amsel, 1992; Rashotte and Amsel, 1999). Guthrie's theory has survived mainly through Estes's efforts to create mathematical models of learning and memory.

Skinner's influence remains strong. In 1974 Skinner wrote About Behaviorism, which attempted to correct 20 misconceptions about behaviorism. In this book. Skinner traced a number of these misconceptions to Watson's early writings-for example, Watson's dependence on reflexive behavior and his denial of the importance of genetic endowment. Skinner's position rectified both "mistakes." Skinner also pointed out that he did not deny socalled mental processes but believed that ultimately they will be explained as verbal labels that we attach to certain bodily processes. As evidence of the recent popularity of Skinnerian behaviorism, followers of Skinner have formed their own division of the APA (Division 25, the division of the Experimental Analysis of Behavior) and have two of their own journals in which to publish their research, the Journal of Applied Behavior Analysis and the Journal for Experimental Analysis of Behavior.

Korn, Davis, and Davis (1991) provide further evidence for the popularity of Skinner in contemporary psychology. Historians of psychology and chairpersons of graduate programs in psychology were asked to rank the 10 most important psychologists of all time and the 10 most important contemporary psychologists. On the "all time" list, historians ranked Wundt first and Skinner eighth. Chairpersons ranked Skinner first and Wundt sixth. On the "contemporary" list, both historians and chairpersons ranked Skinner first. In another survey 1,725 members of the American Psychological Society were asked to rank the most eminent psychologists of the 20th century. In this

survey Skinner ranked first, Piaget second, and Freud third (Dittman, 2002, p. 28). As far as recognition by the general public is concerned, Skinner is perhaps second only to Freud. For an interesting account of how the popular press reacted to Skinner's ideas, see Rutherford (2000).

Despite the current manifestations of behaviorism and neobehaviorism in contemporary psychology, the influence of both has diminished. The overwhelming interest in cognitive psychology today runs counter to all brands of behaviorism except Tolman's (see Chapter 20). Contrary to what the behaviorists believed, evolutionary psychologists, and others, are providing evidence that much animal behavior, including human social behavior, is genetically influenced (see Chapter 19). Also, the neobehaviorist's insistence that all theoretical terms be operationally defined became a problem. Even the logical positivists abandoned a strict operationism because it was too restrictive; it excluded from science concepts that were too nebulous to be defined operationally but were still useful in suggesting new avenues of research and methods of inquiry:

If one were to criticize behaviorism, it would not be for what it tried to accomplish, but rather for the things it found necessary to *deny*. Fundamentally, it denied the need for free theorizing, because all theory had to be limited to observable stimuli and responses. It denied all of the commonsense constructs without which none of us can get along in the world: Conscious experience, thinking, knowledge, images, feelings, and so on. In fact, it rejected commonsense knowledge by fiat, rather than testing it and transcending it, as the other sciences had done. (Baars, 1986, pp. 82–83)

Even the suggestions that logical positivism made concerning theory construction eventually fell into disrepute. Perhaps the most important reason that logical positivism ultimately failed was the discovery that it did not accurately describe how science was practiced even by its most effective practitioners. Individuals such as Thomas Kuhn (see Chapter 1) have shown that the behavior of scientists is determined as much by beliefs, biases, and emotions as by axioms, postulates, theories, or logic.

One major legacy of behaviorism and neobehaviorism still characterizes psychology, however. Psychologists generally agree now that the subject matter of psychology is overt behavior. Today, cognitive psychology is very popular, but even the psychologists studying cognitive events use behavior to index those events. In that sense, most experimental psychologists today are behaviorists.

SUMMARY

The positivism of Bacon, Comte, and Mach insisted that only that which is directly observable be the object of scientific investigation. For the positivists, all speculation about abstract entities should be actively avoided. Watson and the Russian physiologists were positivists. The logical positivists had a more liberal view of scientific activity. For them, theorizing about unobservable entities was allowed. provided those entities were directly linked to observable events via operational definitions. Operational definitions define abstract concepts in terms of the procedures used to measure those concepts. The belief that all scientific concepts be operationally defined was called operationism. Physicalism was the belief that all sciences should share common assumptions, principles, and methodologies should model themselves after physics. Neobehaviorism resulted when behaviorism, with its insistence that the subject matter of psychology be overt behavior, merged with logical positivism, with its acceptance of theory and its insistence on operational definitions. By following the tenets of logical positivism, many neobehaviorists believed they could be theoretical and still remain objective.

Independently of logical positivism but in accordance with it, Tolman introduced intervening variables into psychology. Instead of studying reflexive, or molecular, behavior, Tolman studied purposive, or molar, behavior; thus, his version of psychology was called purposive behaviorism. To avoid even the possibility of introspection in his research, Tolman used only rats as his experimental subjects. According to Tolman, the learning process progresses from the formation of hypotheses

concerning what leads to what in an environment, to an expectancy, and, finally, to a belief. A set of beliefs constitutes a cognitive map, which was Tolman's most important intervening variable. In Tolman's theory, confirmation replaced the notion of reinforcement, and an important distinction was made between learning and performance. Tolman's general influence on contemporary psychology can be seen in the widespread popularity of cognitive psychology. Contemporary information-processing approaches to psychology also have much in common with Tolman's theory.

Using intervening variables even more extensively than did Tolman, Hull developed an open-ended, self-correcting, hypothetico-deductive theory of learning. If experimentation supports the deductions from this theory, the theory gains strength; if not, the part of the theory on which the deductions were based is revised or rejected. Equating reinforcement with drive reduction, Hull defined habit strength as the number of reinforced pairings between a stimulus and a response. He saw reaction potential as a function of the amount of habit strength and drive present. Hull's theory was extremely influential in the 1940s and 1950s, and because of the efforts of Hull's disciples such as Kenneth Spence, the influence of his theory extended well into the 1960s. Some particular aspects of Hull's theory are still found in contemporary psychology, but not his comprehensive approach to theory building; psychologists now seek theories of more limited domain.

Guthrie created an extremely parsimonious theory of learning. All learning was explained by

the law of contiguity, which stated that when a pattern of stimuli and a response occur together they become associated. Furthermore, the association between the two occurs at full strength after just one exposure. By postulating one-trial learning, Guthrie rejected the law of frequency. To explain why practice improves performance, Guthrie differentiated among movements, acts, and skills. A movement is a specific response made to a specific pattern of stimuli. It is the association between a movement and a pattern of stimuli that is learned in one trial. An act is a movement that has become associated with a number of stimuli patterns. A skill, in turn, consists of many acts. It is because acts are made up of many movements and skills are made up of many acts that practice improves performance. According to Guthrie, "reinforcement" is a mechanical arrangement that prevents unlearning. Forgetting occurs when one S-R relationship is displaced by another. Like learning, forgetting occurs in one trial. Bad habits can be broken by causing a response, other than the undesirable one, to be made in the presence of the stimuli that previously elicited the undesirable response. Like the other procedures used to break bad habits, punishment, to be effective, must cause behavior incompatible with the undesirable behavior in the presence of the stimuli that previously elicited the undesirable behavior. What others called drives, Guthrie called maintaining stimuli. Maintaining stimuli, either internal or external, keep an organism active until the maintaining stimuli are terminated. It is behavior associated with maintaining stimuli that appears to be intentional. Attempts to formalize Guthrie's theory, thereby making it more testable, were made by Virginia Voeks and William Kaye Estes.

In his approach to psychology, Skinner accepted positivism instead of logical positivism. He can still be classified as a neobehaviorist, however, because although he avoided theory he did accept

operationism. Skinner distinguished between respondent behavior, which a known stimulus elicits, operant behavior, which an organism emits. Skinner was concerned almost exclusively with operant behavior. For Skinner reinforcement is anything that changes the rate or probability of a response. Nothing more needs to be known about reinforcement, nor is an understanding of physiology necessary for an understanding of behavior. Under the influence of Mach's positivistic philosophy of science, Skinner urged a study of the functional relationship between behavior and the environment. Because such an analysis is correlational, it avoided the complexities of determining causation in human behavior and eliminated the need to postulate unobserved cognitive or physiological determinants of behavior. Watson and Skinner were radical behaviorists because they stressed environmental influences on behavior to the exclusion of so-called mental events and physiological states. Tolman, Hull, and Guthrie were methodological behaviorists because they were willing to theorize about internal causes of behavior (such as cognitive maps and physiological drives). Many contemporary psychologists label themselves Skinnerians and are active in both research and the applied aspects of psychology. According to Skinnerian psychology, behavior that is reinforced is strengthened (more probable), but behavior that is punished is not necessarily weakened. It is best then to arrange reinforcement contingencies so that desirable behavior is reinforced and undesirable behavior is not. No matter what type of behavior is under consideration, the rule is always the same: Change reinforcement contingencies and you change behavior.

Although the influence of behaviorism and neobehaviorism has diminished in contemporary psychology, some of their basic tenets have been incorporated into all current brands of experimental psychology.

DISCUSSION QUESTIONS

- 1. Compare positivism to logical positivism.
- 2. What is an operational definition? Give an example. What is operationism?
- 3. What is physicalism?
- 4. What is neobehaviorism?
- 5. What convinced Tolman that he could study purposive behavior and still be an objective behaviorist?
- Explain how Tolman used intervening variables in a way that was consistent with logical positivism.
- 7. How, according to Tolman, do early hypotheses concerning what leads to what in a situation evolve into a cognitive map?
- 8. What did Tolman mean by *vicarious trial and error*?
- 9. In Tolman's theory, was reinforcement necessary for learning to occur? What term in Tolman's theory had some similarity to what others called reinforcement?
- 10. What evidence did Tolman provide for his contention that reinforcement influences performance but not learning? Also, how did he explain extinction?
- 11. What influence did Tolman's theory have on contemporary psychology?
- 12. Why was Hull's theory called a hypotheticodeductive theory? Why did Hull consider his theory to be self-correcting?
- 13. With reference to Hull's theory, define the following terms: reinforcement, habit strength, and reaction potential.
- 14. What was Guthrie's one law of learning?
- 15. Did Guthrie accept or reject the law of frequency? Explain.
- 16. If learning occurs at full strength in one trial, how did Guthrie explain improvement in performance as a function of practice?
- 17. According to Guthrie, what is the function of "reinforcement"? What did Guthrie and

- Horton observe that confirmed their view of "reinforcement"?
- 18. Summarize Guthrie's explanation of forgetting.
- 19. According to Guthrie, under what circumstances is punishment effective? Ineffective?
- 20. In Guthrie's theory, what is the function of maintaining stimuli? For example, how were these stimuli used to explain what other theorists called drives and intentions?
- 21. Was Skinner's proposed functional analysis of the relationship between environmental and behavioral events more in accordance with positivistic or with logical positivistic philosophy?
- 22. Summarize Skinner's arguments against cognitive psychology.
- 23. How did Skinner distinguish between respondent and operant behavior?
- 24. What is meant by the statement that operant behavior is controlled by its consequences?
- 25. Distinguish between radical and methodological behaviorism.
- 26. For Skinner, what constitutes a reinforcer?
- 27. How did Skinner apply Darwinian concepts to his analysis of behavior?
- 28. Why did Skinner argue that behavior should be controlled by reinforcement contingencies rather than by punishment?
- 29. Summarize Skinner's argument against the use of theory in psychology.
- 30. State the general rule that Skinnerians follow in modifying behavior. Give an example of how this rule could be applied in treating a behavior disorder.
- 31. Explain why the influence of behaviorism and neobehaviorism has diminished in contemporary psychology.
- 32. In what ways do the tenets of behaviorism remain influential in contemporary psychology?

SUGGESTIONS FOR FURTHER READING

- Bjork, D. W. (1997). B. F. Skinner: A life. Washington, DC: American Psychological Association.
- Hull, C. L. (1952a). Clark L. Hull. In E. G. Boring, H. S. Langfeld, H. Werner, & R. M. Yerkes (Eds.), A history of psychology in autobiography (Vol. 4, pp. 143– 162). Worcester, MA: Clark University Press.
- Nye, R. D. (1992). The legacy of B. F. Skinner: Concepts and perspectives, controversies and misunderstandings. Pacific Grove, CA: Brooks/Cole.
- Prenzel-Guthrie, P. (1996). Edwin Ray Guthrie: Pioneer learning theorist. In G. A. Kimble, C. A. Boneau, & M. Wertheimer (Eds.), Portraits of pioneers in psychology (Vol. 2, pp. 137–149). Washington, DC: American Psychological Association.
- Skinner, B. F. (1953). Science and human behavior. New York: Macmillan.

- Skinner, B. F. (1971). Beyond freedom and dignity. New York: Knopf.
- Skinner, B. F. (1974). *About behaviorism*. New York: Knopf.
- Skinner, B. F. (1990). Can psychology be a science of mind? American Psychologist, 45, 1206–1210.
- Tolman, E. C. (1952). Edward C. Tolman. In E. G. Boring, H. S. Langfeld, H. Werner, & R. M. Yerkes (Eds.), *A history of psychology in autobiography* (Vol. 4, pp. 323–339). Worcester, MA: Clark University Press.
- Wiener, D. N. (1996). B. F. Skinner: Benign anarchist. Needham Heights, MA: Allyn & Bacon.

GLOSSARY

Behavior therapy The use of learning principles to treat emotional or behavioral disorders.

Belief According to Tolman, an expectation that experience has consistently confirmed.

Cognitive map According to Tolman, the mental representation of the environment.

Confirmation According to Tolman, the verification of a hypothesis, expectancy, or belief.

Descriptive behaviorism Behaviorism that is positivistic in that it describes relationships between environmental events and behavior rather than attempting to explain those relationships. Skinner's approach to psychology exemplified descriptive behaviorism.

Drive reduction Hull's proposed mechanism of reinforcement. For Hull anything that reduces a drive is reinforcing.

Expectancy According to Tolman, a hypothesis that has been tentatively confirmed.

Functional analysis Skinner's approach to research that involves studying the systematic relationship between behavioral and environmental events. Such study focuses on the relationship between reinforcement contingencies and response rate or response probability.

Guthrie, Edwin Ray (1886–1959) Accepted the law of contiguity but not the law of frequency. For him, learning occurs at full strength after just one association between a pattern of stimuli and a response. (*See also* **Law of contiguity.**)

Habit strength (sH_R) For Hull, the strength of an association between a stimulus and response. This strength depends on the number of reinforced pairings between the two.

Hull, Clark Leonard (1884–1952) Formulated a complex hypothetico-deductive theory in an attempt to explain all learning phenomena.

Hypothesis According to Tolman, an expectancy that occurs during the early stages of learning.

Hypothetico-deductive theory A set of postulates from which empirical relationships are deduced (predicted). If the empirical relationships are as predicted, the theory gains strength; if not, the theory loses strength and must be revised or abandoned.

Instrumental conditioning The type of conditioning studied by Thorndike, wherein an organism learns to make a response that is instrumental in producing reinforcement.

Intervening variables Events believed to occur between environmental and behavioral events. Although intervening variables cannot be observed directly, they are thought to be causally related to behavior. Hull's habit strength and Tolman's cognitive map are examples of intervening variables.

Latent extinction The finding that animals who passively experience a goal box no longer containing reinforcement extinguish a previously learned response to that goal box significantly faster than animals without such experience.

Latent learning According to Tolman, learning that has occurred but is not translated into behavior.

Law of contiguity Guthrie's one law of learning, which states that when a pattern of stimuli is experienced along with a response, the two become associated. In 1959 Guthrie revised the law of contiguity to read, "What is being noticed becomes a signal for what is being done."

Logical positivism The philosophy of science according to which theoretical concepts are admissible if they are tied to the observable world through operational definitions.

Maintaining stimuli According to Guthrie, the internal or external stimuli that keep an organism active until a goal is reached.

Molar behavior (See Purposive behavior.)

Molecular behavior A small segment of behavior such as a reflex or a habit that is isolated for study.

Neobehaviorism Agreed with older forms of behaviorism that overt behavior should be psychology's subject matter but disagreed that theoretical speculation concerning abstract entities must be avoided. Such speculation was accepted provided that the theoretical terms employed are operationally defined and lead to testable predictions about overt behavior.

Observational terms According to logical positivism, terms that refer to empirical events.

One-trial learning Guthrie's contention that the association between a pattern of stimuli and a response develops at full strength after just one pairing of the two.

Operant behavior Behavior that is emitted by an organism rather than elicited by a known stimulus.

Operational definition A definition that relates an abstract concept to the procedures used to measure it.

Operationism The belief that all abstract scientific concepts should be operationally defined.

Performance The translation of learning into behavior.

Physicalism A belief growing out of logical positivism that all sciences should share common assumptions, principles, and methodologies and should model themselves after physics.

Positivism The belief that science should study only those objects or events that can be experienced directly. That is, all speculation about abstract entities should be avoided.

Purposive behavior Behavior that is directed toward some goal and that terminates when the goal is attained.

Purposive behaviorism The type of behaviorism Tolman pursued, which emphasizes molar rather than molecular behavior.

Reaction potential (${}_{S}E_{R}$) For Hull, the probability of a learned response being elicited in a given situation. This probability is a function of the amount of drive and habit strength present.

Reinforcement For Hull, drive reduction; for Skinner, anything that increases the rate or the probability of a response; for Tolman, the confirmation of a hypothesis, expectation, or belief; for Guthrie, a mechanical arrangement that prevents unlearning.

Respondent behavior Behavior that is elicited by a known stimulus.

Skinner, Burrhus Frederic (1904–1990) A behaviorist who believed that psychology should study the functional relationship between environmental events, such as reinforcement contingencies, and behavior. Skinner's work exemplified positivism. (*See also* **Positivism**.)

S–R psychology The type of psychology insisting that environmental stimuli elicit most, if not all, behavior. The Russian physiologists and Watson were S–R psychologists.

Theoretical terms According to logical positivism, those terms that are employed to explain empirical observations.

Token economies An arrangement within institutions whereby desirable behavior is strengthened using valuable tokens as reinforcers.

Tolman, Edward Chace (1886–1959) Created a brand of behaviorism that used mental constructs and emphasized purposive behavior. Although Tolman employed many intervening variables, his most important was the cognitive map.

Vicarious trial and error According to Tolman, the apparent pondering of behavioral choices in a learning situation.

Gestalt Psychology

bout the same time that the behaviorists were rebelling against structuralism and functionalism in the United States, a group of young German psychologists was rebelling against Wundt's experimental program that featured a search for the elements of consciousness. Whereas the focus of the behaviorists' attack was the study of consciousness and the associated method of introspection, the German protesters focused their attack on Wundt's elementism. Consciousness, said the German rebels, could not be reduced to elements without distorting the true meaning of the conscious experience. For them, the investigation of conscious experience through the introspective method was an essential part of psychology, but the type of conscious experience Wundt and the U.S. structuralists investigated was artificial. These young psychologists believed that we do not experience things in isolated pieces but in meaningful, intact configurations. We do not see patches of green, blue, and red; we see people, cars, trees, and clouds. These meaningful, intact, conscious experiences are what the introspective method should concentrate on. Because the German word for "configuration," "form," or "whole" is Gestalt, this new type of psychology was called Gestalt psychology.

The Gestaltists were opposed to any type of elementism in psychology, whether it be the type Wundt and the structuralists practiced or the type the behaviorists practiced in their search for S–R associations. The attempt to reduce either consciousness or behavior to the basic elements is called the **molecular approach** to psychology, and psychologists such as Wundt (as experimentalist), Titchener, Pavlov, and Watson used this type of approach. The Gestaltists argued that a molar approach should be taken. Taking the **molar approach** in studying consciousness would mean concentrating on *phenomenological* experience (mental experience as it occurred to the naive observer, without further analysis). The

term phenomenon means "that which appears" or "that which is given," and so phenomenology, the technique used by the Gestaltists, is the study of that which naturally appears in consciousness. Taking the molar, or phenomenological, approach while studying behavior means concentrating on goal-directed (purposive) behavior. We saw in the last chapter that, under the influence of Gestalt psychology, Tolman chose to study this type of behavior. As we will see, the Gestaltists attempted to show that in every aspect of psychology, it is more beneficial to concentrate on wholes (Gestalten, plural of Gestalt) than on parts (atoms, elements). Those taking a molar approach to the study of behavior or psychological phenomena are called holists, in contrast to the elementists or atomists, who study complex phenomena by seeking simpler components that compose those phenomena. The Gestaltists were clearly holists.

ANTECEDENTS OF GESTALT PSYCHOLOGY

Immanuel Kant

Immanuel Kant (1724–1804) believed that conscious experience is the result of the interaction between sensory stimulation and the actions of the faculties of the mind. In other words, the mind adds something to our conscious experience that sensory stimulation does not contain. If the phrase faculties of the mind is replaced by characteristics of the brain, there is considerable agreement between Kant and the Gestaltists. Both believed that conscious experience cannot be reduced to sensory stimulation, and for both conscious experience is different from the elements that compose it. Therefore, looking for a one-to-one correspondence between sensory events and conscious experience is doomed

to failure. For Kant and the Gestaltists, an important difference exists between perception and sensation. This difference arises because our minds (Kant) or our brains (the Gestaltists) change sensory experience, making it more structured and organized and thus more meaningful than it otherwise would be. Accordingly, the world we perceive is never the same as the world we sense. Because this embellishment of sensory information results from the nature of the mind (Kant) or the brain (Gestaltists), it is independent of experience.

Ernst Mach

Ernst Mach (1838-1916), a physicist, postulated (1886/1914) two perceptions that appeared to be independent of the particular elements that compose them: space form and time form. For example, one experiences the form of a circle whether the actual circle presented is large, small, red, blue, bright, or dull. The experience of "circleness" is therefore an example of space form. The same would be true of any geometric form. Similarly, a melody is recognizable as the same no matter what key or tempo it is played in. Thus, a melody is an example of time form. Mach was making the important point that a wide variety of sensory elements can give rise to the same perception; therefore, at least some perceptions are independent of any particular cluster of sensory elements.

Christian von Ehrenfels

Christian von Ehrenfels (1859–1932) studied in Vienna with Brentano and in 1890 wrote a paper titled "Uber 'Gestaltqualitäten'" (On Gestalt Qualities). About this paper Barry Smith (1994) says, "Almost all of the theoretical and conceptual issues which subsequently came to be associated with the Gestalt idea are treated at some point ... at least in passing" (pp. 246–247). Max Wertheimer, the founder of Gestalt psychology, took several courses from Ehrenfels between 1898 and 1901 and no doubt was influenced by him. Elaborating on Mach's notions of space and time forms, Ehrenfels

said that our perceptions contain Gestaltqualitäten (form qualities) that are not contained in isolated sensations. No matter what pattern dots are arranged in, one recognizes the pattern, not the individual dots. Similarly, one cannot experience a melody by attending to individual notes; only when one experiences several notes together does one experience the melody. For both Mach and Ehrenfels, form is something that emerges from the elements of sensation. Their position was similar to the one John Stuart Mill had taken many years earlier. With his idea of "mental chemistry," Mill had suggested that when sensations fuse, a new sensation totally unlike those of which it was composed could emerge.

Like Mill, Mach and Ehrenfels believed that elements of sensation often combine and give rise to the experience of form. However, for Mach, Ehrenfels, and Mill, the elements are still necessary in determining the perception of the whole or the form. As we will see, the Gestaltists turned this relationship completely around by saying that the whole dominates the parts, not the other way around.

William James

Because of his distaste for elementism in psychology, William James (1842-1910) can also be viewed as a precursor to Gestalt psychology. He said that Wundt's search for the elements of consciousness depended on an artificial and distorted view of mental life. Instead of viewing the mind as consisting of isolated mental elements, James proposed a stream of consciousness. He believed that this stream should be the object of psychological inquiry, and any attempt to break it up for more detailed analysis must be avoided. The Gestaltists agreed with James's antielementistic stand but thought that he had gone too far. The mind, they believed, could indeed be divided for study; it was just that in choosing the mental element for their object of study, Wundt and the structuralists had made a bad choice. For the Gestaltists, the correct choice was the study of mental Gestalten.

Act Psychology

We saw in Chapter 9 that Franz Brentano and Carl Stumpf favored the type of introspection that focuses on the *acts* of perceiving, sensing, or problem solving. They were against using introspection to search for mental elements, and they directed their more liberal brand of introspection toward mental phenomena. Thus, both the act psychologists and the Gestaltists were phenomenologists. It should come as no surprise that **act psychology** influenced Gestalt psychology because all three founders of Gestalt psychology (Wertheimer, Koffka, and Köhler), at one time or another, studied under Carl Stumpf. In 1920 Köhler even dedicated one of his books to Stumpf.

Developments in Physics

Because properties of magnetic fields were difficult to understand in terms of the mechanistic-elementistic view of Galilean—Newtonian physics, some physicists turned to a study of force fields, in which all events are interrelated. (Anything that happened in a force field in some way influences everything else in the field.) Köhler was well versed in physics and had even studied for a while with Max Planck, the father of quantum mechanics. In fact, it is accurate to say that Gestalt psychology represented an effort to model psychology after **field theory** instead of Newtonian physics. We will say more about this effort shortly.

THE FOUNDING OF GESTALT PSYCHOLOGY

In 1910 Max Wertheimer was on a train, on his way from Vienna to a vacation on the Rhineland, when he had an idea that was to launch Gestalt psychology. The idea was that our perceptions are structured in ways that sensory stimulation is not. That is, our perceptions are different from the sensations that comprise them. To further explore this notion, Wertheimer got off the train at Frankfurt,

bought a toy stroboscope (a device that allows still pictures to be flashed in such a way that makes them appear to move), and began to experiment in a hotel room. Clearly, Wertheimer was perceiving motion where none actually existed. To examine this phenomenon in more detail, he went to the University of Frankfurt, where a tachistoscope was made available to him. (A tachistoscope can flash lights on and off for measured fractions of a successively, second.) Flashing two lights Wertheimer found that if the time between the flashes was long (200 milliseconds or longer), the observer perceived two lights flashing on and off successively—which was, in fact, the case. If the interval between flashes was very short (30 milliseconds or less), both lights appeared to be on simultaneously. But if the interval between the flashes was about 60 milliseconds, it appeared that one light was moving from one position to the other. Wertheimer called this apparent movement the phi phenomenon, and his 1912 article "Experimental Studies of the Perception of Movement" describing this phenomenon is usually taken as the formal beginning of the school of Gestalt psychology.

It should be noted that Wertheimer was not the first to observe apparent motion. As early as 1824, Peter Roget presented a paper on the topic to the Royal Society of London (Boorstein, 1991). The Prague physiologist Sigmund Exner, with whom Wertheimer did postdoctoral research, published a paper on the phenomenon in 1875. The American psychologist George Stratton's article on the topic in 1911 preceded Wertheimer's landmark article of 1912. Finally, by the time Wertheimer published his article, motion pictures were commonplace. However, although he did not discover apparent motion, "It was Wertheimer who saw the deeper significance of the phenomenon, relating it to a coherent system of explanatory principles that gave it a central place in psychology" (Boynton and Smith, 2006, p. 131).

Wertheimer's research assistants at the University of Frankfurt were two recent Berlin doctoral graduates—Kurt Koffka and Wolfgang Köhler—both of whom acted as Wertheimer's sub-

jects in his perception experiments. So closely are Koffka and Köhler linked with the development of Gestalt psychology that they, along with Wertheimer, are usually considered cofounders of the school.

Max Wertheimer

Max Wertheimer (1880-1943) was born on April 15 in Prague and attended a Gymnasium (roughly equivalent to a high school) until he was 18, at which time he went to the University of Prague to study law. While Wertheimer was attending the University of Prague, his interest shifted from law to philosophy, and during this time he attended lectures by Ehrenfels. After spending some time at the University of Berlin (1901-1903), where he attended Stumps's classes, Wertheimer moved to the University of Würzburg, where in 1904 he received his doctorate, summa cum laude, under Külpe's supervision. His dissertation was on lie detection. Being at Würzburg at the time when Külpe and others were locked in debate with Wundt over the existence of "imageless thought" and over what introspection should focus on no doubt affected Wertheimer's thinking.

Between 1904 and 1910, Wertheimer held academic positions at the Universities of Prague, Vienna, and Berlin. He was at the University of Frankfurt from 1910 to 1916, the University of Berlin from 1916 to 1929, and again at the University of Frankfurt from 1929 to 1933. Because of the chaos caused by the Nazi movement in Germany, Wertheimer, who was 53 years old at the time, decided to pursue his career elsewhere. Positions were offered to him at Cambridge University, Oxford University, and the University of Jerusalem; but in 1933 he accepted a position at the New School for Social Research, and he, his wife Anne, and their three children (Valentin, Michael, and Lise) sailed for New York. Wertheimer knew only German, and his first classes were taught in that language. After only five months, however, he began teaching and publishing in English. His second language posed a problem for Wertheimer because it sometimes interfered

Courtesy of the National Library of Medic

Max Wertheimer

with his desire to express himself precisely. Michael Wertheimer and King (1994) give an example: "He ... had some problems with mathematical terms; his students were occasionally baffled before they realized that his references to obtuse and acute 'angels' had nothing to do with heavenly beings but with trigonometric angles" (pp. 5-6).

Wertheimer had wide interests and, after arriving in the United States, wrote (in English) articles on truth (1934), ethics (1935), democracy (1937), and freedom (1940). Wertheimer intended to publish these articles as a collection, and Albert Einstein wrote a forward. Although the collection was never published in English, it was eventually published in German under the editorship of Hans-Jürgen Walter (1991). Wertheimer wrote only one book, Productive Thinking, but he died suddenly on October 12, 1943, of a coronary embolism at his home in New Rochelle, New York, before it was published. Productive Thinking was published posthumously in 1945. In October 1988, the German Society for Psychology bestowed upon Wertheimer its highest honor, the Wilhelm Wundt Plaque.

Courtesy of the National Library of Medicine

Kurt Koffka

Kurt Koffka

Born on March 18 in Berlin, Kurt Koffka (1886-**1941)** received his doctorate from the University of Berlin in 1908, under the supervision of Stumpf. Koffka served as an assistant at Würzburg and at Frankfurt before accepting a position at the University of Giessen in central Germany, where he remained until 1924. During his stay at the University of Frankfurt, Koffka began his long association with Wertheimer and Köhler. In 1924 he came to the United States, and after holding visiting professorships at Cornell and the University of Wisconsin, he accepted a position at Smith College in Northampton, Massachusetts, where he remained until his death.

In 1922 Koffka wrote an article, in English, on Gestalt psychology. Published in the Psychological Bulletin, the article was titled "Perception: An Introduction to Gestalt-Theorie." This article is believed to have been responsible for most U.S. psychologists erroneously assuming that the Gestaltists were interested only in perception. The truth was that, besides perception, the Gestaltists were interested in many philosophical issues as well as in learning and thinking. The reason for their early concentration on perception was that Wundt had been concentrating on perception, and he was the primary focus of their attack.

Wolfgang Köhler

In 1921 Koffka published an important book on child psychology, later translated into English as *The Growth of the Mind: An Introduction to Child Psychology* (1924). In 1935, Koffka published *Principles of Gestalt Psychology*, which was intended to be a complete, systematic presentation of Gestalt theory. The latter book was dedicated to Köhler and Wertheimer in gratitude for their friendship and inspiration.

Wolfgang Köhler

Wolfgang Köhler (1887-1967) was born on January 21 in Reval (now Tallinn), Estonia, and received his doctorate in 1909 from the University of Berlin. Like Koffka, Köhler worked under the supervision of Stumpf. In 1909 Köhler went to the University of Frankfurt, where a year later he would participate with Wertheimer and Koffka in the research that was to launch the Gestalt movement. Köhler's collaboration with Koffka and Wertheimer was temporarily interrupted when, in 1913, the Prussian Academy of Sciences invited him to go to its anthropoid station on Tenerife, one of the Canary Islands, to study chimpanzees. Shortly after his arrival, World War I began, and his stay on Tenerife was prolonged for seven years. While at the anthropoid station, Köhler concentrated his study on the nature of learning in chimpanzees. He summarized his observations in the Mentality of Apes (1917/1925).

Psychologist Ronald Ley (1990) suggests that Köhler did more than observe chimpanzees on Tenerife. The Canary Islands are an unlikely place to establish an anthropoid research station because chimpanzees are not native to the region. The German Cameroons (a German colony in Africa) or a large zoo in Germany would have been more logical locations. Ley speculates that Köhler's reason for being in such a remote place was to observe British shipping activity for the German military. With a carefully concealed radio, Köhler informed German military officials whether or not British vessels were in the vicinity. If they were not, German ships could safely be refueled by nearby fuel ships. These activities were confirmed by Manuel, the 87-year-old keeper, handler, and trainer of Köhler's animals, and by two of Köhler's children. Ley also provides documents from both German and British naval archives that confirm an active espionage organization in the Canary Islands during World War I. Furthermore, the British documents indicate that Köhler was strongly suspected of being part of that organization. Several times Köhler's home was searched by Spanish authorities on the orders of the British government. If these charges are true, it indicates that, at the time, Köhler was a loyal citizen of Germany. As we shall see, this loyalty was to change dramatically when the Nazis came to power.

Upon his return to Germany, Köhler accepted a professorship at the University of Göttingen (1921–1922), and in 1922 he succeeded Stumpf as director of the Psychological Institute at the University of Berlin. This was a prestigious appointment, and it gave Gestalt psychology international recognition. Köhler's directorship was interrupted twice by trips to the United States: He was a visiting professor at Clark University (1925–1926), a William James lecturer at Harvard (1934–1935), and a visiting professor at the University of Chicago (1935). His Gestalt Psychology (1929/1970) was written in English and was especially intended for U.S. psychologists.

Like James, Köhler was highly critical of Fechner and offered psychophysics as an example of what could happen if measurement precedes an understanding of what is being measured:

Apparently [Fechner] was convinced that measuring as such would make a science out of psychology.... Today we can no longer doubt that thousands of quantitative psychophysical experiments were made almost in vain. No one knew precisely what he was measuring. Nobody had studied the mental processes upon which the whole procedure was built. (Köhler, 1929/1970, p. 44)

Köhler believed that U.S. psychologists were making a similar mistake in their widespread acceptance of operationism (see Chapter 13). He gave as an example the operational definition of intelligence in terms of performance on intelligence tests. Here, he said, the measurements are precise (as they were in Fechner's work), but it is not clear exactly what is being measured. In the quotation that follows, note the similarity between Köhler's (1929/1970) criticisms of the use of IQ tests and those of Binet (see Chapter 10):

It seems that a crude total ability for certain performances is actually measured by such tests. For, on the whole, the test scores show a satisfactory correlation with achievements both in school and in subsequent life. This very success, however, contains a grave danger. The tests do not show what specific processes actually participate in the test achievements. The scores are mere numbers which allow many different interpretations. Figuratively speaking, a given score may mean: degree 3 of "intelligence," together with degree 1 of "accuracy," with degree 4 of "ambition" and degree 3 of "quickness of fatigue." But it may also mean "intelligence" 6, "accuracy" 2, "ambition" 1 and "quickness of fatigue" 4—and so forth. Thus combinations of certain components in varying proportions may give precisely the same IQ. Obviously, this matters, even for practical purposes. For instance, a child ought to be treated according to the nature and strength of the specific factors which co-operate in establishing his total IQ. This is not a new criticism, of course, but in view of the influence which the tests have gained in our schools it must be repeated. We are still much too easily satisfied by our tests because, as quantitative procedures, they look so pleasantly scientific. (p. 45)

Back in Germany, the Nazis were harassing institutions of higher learning and professors, and Köhler's attitude toward the fatherland changed dramatically. Köhler complained bitterly and, on April 28, 1933, published the last article that publicly criticized the Nazis. In the following excerpt from that article, Köhler, who was not Jewish, commented on the Nazis' wholesale dismissal of Jews from universities and other positions:

During our conversation, one of my friends reached for the Psalms and read: "The Lord is my shepherd, I shall not want." He read the 90th Psalm and said, "It is hard to think of a German who has been able to move human hearts more deeply and so to console those who suffer. And these words we have received from the Jews."

Another reminded me that never had a man struggled more nobly for a clarification of his vision of the world than the Jew Spinoza, whose wisdom Goethe admired. My friend did not hesitate to show respect, as Goethe did. Lessing, too, would not have written his *Nathan the Wise* unless human nobility existed among the Jews.... It seems that nobody can think of the great work of Heinrich Hertz without an almost affectionate admiration for him. And Hertz had Jewish blood.

One of my friends told me: "The greatest German experimental physicist of the present time is Franck; many believe that he is the greatest experimental physicist of our age. Franck is a Jew, an unusually kind human being. Until a few days ago, he was professor at Göttingen, an honor to Germany and the envy of the international scientific community." [Perhaps the dismissal of Franck] shows the deepest reason why all these people are not joining [the Party]: they feel a moral imposition. They believe that only the quality of a human being should determine his worth, that intellectual achievement, character, and obvious contributions to German culture retain their significance whether a person is Jewish or not. (Henle, 1978, p. 940)

Eventually, the Nazi menace became too unbearable, and in 1935 Köhler immigrated to the United States. After lecturing at Harvard for a year, he accepted an appointment at Swarthmore College, in Pennsylvania, where he remained until his retirement in 1958. While at Swarthmore, he published his William James lectures as The Place of Value in a World of Facts (1938) and Dynamics in Psychology (1940), in which he discussed the relationship between field theory in physics and Gestalt psychology. After retiring, Köhler moved to New Hampshire, where he continued his writing and research at Dartmouth College. He also spent considerable time lecturing at European universities. Köhler died in Enfield, New Hampshire, on June 11, 1967. His last book, The Task of Gestalt Psychology (1969), was published posthumously.

Gestalt psychology became highly influential in the United States. When it is realized that Koffka was at Smith College (an undergraduate institution), Köhler was at Swarthmore (an undergraduate institution), and Wertheimer was affiliated with the New School for Social Research (which was not yet granting advanced degrees), the success of Gestalt psychology in the United States is especially impressive. Also, behaviorism was the dominant theme in U.S. psychology as the Gestaltists were attempting to make inroads. Köhler described an experience he had shortly after arriving in the United States:

In 1925, soon after my first arrival in this country, I had a curious experience. When once talking with a graduate student of psychology who was, of course, a behaviorist, I remarked that McDougall's psychology of striving seemed to me to be associated with certain philosophical theses which I found it hard to accept; but that he might nevertheless be right in insisting that, as a matter of simple observation, people do this or that in order to reach certain goals. Did not the student himself sometimes go to a post office in order to buy stamps? And did he not just now prepare himself for certain examinations to be held next Thursday? The answer was prompt: "I never do such things," said the student. There is nothing like a solid scientific conviction. (Henle, 1986, p. 120)

Köhler's many honors included membership in the American Philosophical Society, National Academy of Sciences, and the American Academy of Arts and Sciences; numerous honorary degrees; being declared an *Ehrenbürger* (honorary citizen) of the University of Berlin (an honor previously given to only two Americans—John F. Kennedy and Paul Hindesmith); the American Psychological Association's Distinguished Scientific Contributions Award (1956); and the presidency of the American Psychological Association (APA) (1959).

ISOMORPHISM AND THE LAW OF PRÄGNANZ

A basic question Wertheimer had to answer was how only two stimuli could cause the perception of motion. As previously noted, Wertheimer did not discover apparent motion; however, his *explanation* of the phenomenon was unique. As we have seen, Mach, Ehrenfels, and J. S. Mill all recognized that the whole was sometimes different from the sum of its parts, but they all assumed that somehow

the whole (Gestalt) emerged from the characteristics of the parts. That is, after the parts (elements) are attended to, they somehow fuse and give rise to the whole experience. For example, attending to the primary colors causes the sensation of white to emerge, and attending to several musical notes causes the sensation of melody to emerge. This viewpoint still depends on a form of elementism and its related assumption of association. For example, Wundt's explanation of apparent movement was that the fixation of the eyes changed with each successive presentation of the visual stimulus. and this causes the muscles controlling the eyes to give off sensations identical to those given off when real movement is experienced. Thus, because of past experience with such sensations (association), one experiences what appears to be movement. Because with apparent movement the sensation of movement is not contained in the sensations that cause it, Wundt believed that the experience exemplifies creative synthesis. Similarly, Helmholtz explained the phenomenon as an unconscious inference. Both Wundt and Helmholtz emphasized the role of learning in experiences like the phi phenomenon.

Through an ingenious demonstration, however, Wertheimer showed that explanations based on learning were not plausible. Again using a tachistoscope, he showed that the phi phenomenon could occur in two directions at the same time. Three lights were arranged as shown in the diagram below:

The center light was flashed on, and shortly thereafter the two other lights were flashed on, both at the same time. Wertheimer repeated this sequence several times. The center slit of light appeared to fall to the left and right simultaneously, and because the eyes could not move in two directions at the same time, an explanation based on sensations from the eye muscles was untenable.

Application of Field Theory

If the experience of psychological phenomena could not be explained by sensory processes, inferences, or fusions, how could it be explained? The Gestaltists' answer was that the brain contains structured fields of electrochemical forces that exist prior to sensory stimulation. Upon entering such a field. sensory data both modify the structure of the field and are modified by it. What we experience consciously results from the interaction of the sensory data and the force fields in the brain. The situation is similar to one in which metal particles are placed into a magnetic field. The nature of the field will have a strong influence on how the particles are distributed, but the characteristics of the particles will also influence the distribution. For example, larger, more numerous particles will be distributed differently within the field than smaller, less numerous particles. In the case of cognitive experience, the important point is that fields of brain activity transform sensory data and give that data characteristics it otherwise would not possess. According to this analysis, the whole (electrochemical force fields in the brain) exists prior to the parts (individual sensations), and it is the whole that gives the parts their identity or meaning.

Psychophysical Isomorphism

To describe more fully the relationship between the field activity of the brain and conscious experience, the Gestaltists introduced the notion of **psychophysical isomorphism**, which Köhler described as follows: "Experienced order in space is always structurally identical with a functional order in the distribution of underlying brain processes" (1929/1970, p. 61). Elsewhere, Köhler said, "Psychological facts and the underlying events in the brain resemble each other in all their structural characteristics" (1969, p. 66).

The Gestalt notion of isomorphism stresses that the force fields in the brain transform incoming sensory data and that it is the transformed data that we experience consciously. The word isomorphism comes from the Greek iso ("similar") and morphic ("shape"). The patterns of brain activity and the patterns of conscious experience are structurally equivalent. The Gestaltists did not say that patterns of electrochemical brain activity are the same as patterns of perceptual activity. Rather, they said that perceptual fields are always caused by underlying patterns of brain activity. It was believed that, although the patterns of perceptual and brain activity might have some similarity, the two represent two totally different domains and certainly cannot be identical. The relationship is like that between a map of the United States and the actual United States; although the two are related in important ways, they are hardly identical.

Opposition to the Constancy Hypothesis

With their notion of isomorphism, the Gestaltists opposed the constancy hypothesis, according to which there is a one-to-one correspondence between certain environmental stimuli and certain sensations. This one-to-one correspondence did not mean that sensations necessarily reflect accurately what is present physically. The psychophysicists, Helmholtz, Wundt, and the structuralists all accepted the constancy hypothesis while recognizing that large discrepancies could exist between psychological experiences and the physical events that cause them. Rather, the constancy hypothesis contended that individual physical events cause individual sensations and that these sensations remain isolated unless acted on by one or more of the laws of association or, in Wundt's case, are intentionally rearranged. This hypothesis was accepted by most British and French empiricists and was the cornerstone of Titchener's structuralism. The structuralists. following in the tradition of empiricism, viewed mental events as the passive reflections of specific environmental events.

The Gestaltists totally disagreed with the conception of brain functioning implied by the constancy hypothesis. By rejecting the constancy hypothesis, the Gestaltists rejected the empirical philosophy on which the schools of structuralism, functionalism, and behaviorism were based. Instead, as we have seen, the Gestaltists employed field theory in their analysis of brain functioning. In any physical system, energy is distributed in a lawful way, and the brain is a physical system. Köhler said, "According to several physicists the distribution of materials and processes in physical systems tends to become regular, simple, and often symmetrical when the systems approach a state of equilibrium or a steady state" (1969, pp. 64–65). Michael Wertheimer (1987) elaborates this point:

The Gestaltists argue that physical forces, when released, do not produce chaos, but their own internally determined organization. The nervous system, similarly, is not characterized by machinelike connections of tubes, grooves, wires, or switchboards, but the brain too, like almost all other physical systems, exhibits the dynamic self-distribution of physical forces. (p. 137)

Thus, instead of viewing the brain as a passive receiver and recorder of sensory information, the Gestaltists viewed the brain as a dynamic configuration of forces that transforms sensory information. They believed that incoming sensory data interacts with force fields within the brain to cause fields of mental activity; and like the underlying physical fields in the brain, these mental fields are organized configurations. The nature of the mental configurations depends on the totality of the incoming stimulation and the nature of the force fields within the brain, and any configurations that occur in the fields of brain activity would be experienced as perceptions (psychophysical isomorphism).

Analysis: Top Down, Not Bottom Up

According to the Gestaltists, organized brain activity dominates our perceptions, *not* the stimuli that

enter into that activity. For this reason, the whole is more important than the parts, thus reversing one of psychology's oldest traditions. The Gestaltists said that their analysis proceeded *from the top to the bottom* instead of *from the bottom to the top*, as had been the tradition. In other words, they proceeded from the wholes to the parts instead of from the parts to the wholes. As Michael Wertheimer (1987) explains,

This formulation involved a radical reorientation: the nature of the parts is determined by the whole rather than vice versa; therefore analysis should go "from above down" rather than "from below up." One should not begin with elements and try to synthesize the whole from them, but study the whole to see what its natural parts are. The parts of a whole are not neutral and inert, but structurally intimately related to one another. That parts of a whole are not indifferent to one another was illustrated. for example, by a soap bubble: change of one part results in a dramatic change in the entire configuration. This approach was applied to the understanding of a wide variety of phenomena in thinking, learning, problem solving, perception, and philosophy, and the movement developed and spread rapidly, with violent criticisms against it from outside, as well as equally vehement attacks on the outsiders from inside. (p. 136)

The Law of Prägnanz

The Gestaltists believed that the same forces that create configurations such as soap bubbles and magnetic fields also create configurations in the brain. The configurations of energy occurring in all physical systems always result from the total field of interacting forces, and these physical forces always distribute themselves in the most simple, symmetrical way possible under the circumstances. Therefore, according to the principle of

psychophysical isomorphism, mental experiences, too, must be simple and symmetrical. The Gestaltists summarized this relationship between force fields in the brain and cognitive experience with their law of Prägnanz, which was central to Gestalt psychology. The German word Prägnanz has no exact English counterpart, but an approximation is "essence." Pragnanz refers to the essence or ultimate meaning of an experience. Sensory information may be fragmented and incomplete, but when that information interacts with the force fields in the brain, the resultant cognitive experience is complete and organized. The law of Prägnanz states that psychological organization will always be as good as conditions allow because fields of brain activity will always distribute themselves in the simplest way possible under the prevailing conditions, just as other physical force fields do. The law of Prägnanz asserts that all cognitive experiences will tend to be as organized, symmetrical, simple, and regular as they can be, given the pattern of brain activity at any given moment. This is what "as good as conditions allow" means.

It is tempting to categorize Gestalt psychology as nativistic, but the Gestaltists themselves disagreed with that. Köhler said, "Such concepts as genes, inherited, and innate should never be mentioned when we refer to the basic ... dynamic ... processes in the nervous system" (1969, p. 89). According to Köhler, what governs brain activity are not genetically controlled programs but the *invariant dynamics* that govern *all* physical systems.

According to Henle (1986), it is time for psychology to follow the lead of the Gestaltists and stop attempting to explain everything in terms of the nativism-empiricism dichotomy:

I do not know why we find it so difficult to break out of the nativism–empiricism dichotomy. Are we unable to think in terms of trichotomies? If we are, we will continue to misinterpret Gestalt psychology and—more serious—our explanations will not do justice to our subject matter. (p. 123)

PERCEPTUAL CONSTANCIES

Perceptual constancy (*not* to be confused with the constancy hypothesis) refers to the way we respond to objects as if they are the same, even though the actual stimulation our senses receive may vary greatly:

The man who approaches us on the street does not seem to grow larger as for simple optical reasons he should. The circle which lies in an oblique plane does not appear as an ellipse; it seems to remain a circle even though its retinal image may be a very flat ellipse. The white object with the shadow across it remains white, the black paper in full light remains black, although the former may reflect much less light than the latter. Obviously, these three phenomena have something in common. The physical object as such always remains the same, while the stimulation of our eyes varies, as the distance, the orientation or the illumination of that constant object are changed. Now, what we seem to experience agrees with the actual invariance of the physical object much better than it does with the varying stimulations. Hence the terms constancy of size, constancy of shape and constancy of brightness. (Köhler, 1929/1970, pp. 78-79)

The empiricists explained perceptual constancies as the result of learning. The sensations provided by objects seen at different angles, positions, and levels of illumination are different, but through experience we learn to correct for these differences and to respond to the objects as the same. Woodworth (1931) described what our perceptions would be like, according to the empiricists, if the influence of learning could be removed:

If we could for a moment lay aside all that we had learned and see the field of view just as the eyes present it, we should see a mere mosaic of variegated spots, free of meaning, of objects, of shapes or patterns. Such is the traditional associationist view of the matter. (pp. 105–106)

The Gestaltists disagreed. Köhler, for example, asserted that the constancies are a direct reflection of ongoing brain activity and *not* a result of sensation plus learning. The reason we experience an object as the same under varied conditions is that the *relationship* between that object and other objects remains the same. Because this relationship is the same, the field of brain activity is also the same, and therefore the mental experience (perception) is the same. The Gestaltists' explanation, then, is simply an extension of the notion of psychophysical isomorphism. Using brightness constancy as an example, Bruno (1972) nicely summarizes this point:

[Köhler] said that brightness constancy is due to the existence of a real constancy that is an existing Gestalt in the environment. This Gestalt is physical—really there as a pattern. It is the ratio of brightness of the figure to the brightness of the ground. This ratio remains constant for sunlight and shade. Let us say that a light meter gives a reading of 10 (arbitrary units) for a bikini in the sun. A reading from the grass in the sun is 5. The ratio of figure to ground is 10/5; or 2. Assume now that the girl in the bikini is in the shade, and the light meter gives a reading of 4 for the bikini. The grass in the shade gives a reading of 2. The ratio of figure to ground is 4/2; or 2—the same ratio as before. The ratio is a constant. The human nervous system responds directly to this constant ratio. The constant ratio in the environment gives rise to a pattern of excitation in the nervous system. As long as the ratio does not change, the characteristics of the pattern of excitation do not change. Thus Köhler explained brightness constancy as a directly perceived Gestalt not derived from learning or the association of sensations.

Köhler explained other perceptual constancies involving color, shape, and size in a similar manner. (p. 151)

PERCEPTUAL GESTALTEN

Through the years, the Gestaltists have isolated over 100 configurations (Gestalten) into which visual information is arranged. We will sample only a few of them here.

The Figure-Ground Relationship

According to Danish psychologist Edgar Rubin (1886–1951), the most basic type of perception is the division of the perceptual field into two parts: the *figure*, which is clear and unified and is the object of attention, and the *ground*, which is diffuse and consists of everything that is not being attended to. Such a division creates what is called a **figure-ground relationship**. Thus, what is the figure and what is the ground can be changed by shifting one's attention. Figure 14.1 demonstrates this phenomenon. When one focuses attention on the two profiles, one cannot see the vase, and vice versa. Similarly, when one focuses attention on the black cross, one cannot see the white cross, and vice versa.

The Gestaltists made the figure–ground relationship a major component of their theoretical system.

Gestalt Principles of Perceptual Organization

In addition to describing figure—ground perception, the Gestaltists described the principles by which the elements of perception are organized into configurations. For example, stimuli that have continuity with one another will be experienced as a perceptual unit. To describe this principle, Wertheimer used the terms *intrinsic togetherness, imminent necessity*, and *good continuation*. Figure 14.2a provides an example of this **principle of continuity**. Note that the pattern that emerges cannot be found in any particular dot (element). Rather, because some dots seem to be tending in the same direction, one responds to them as a configuration (Gestalt). Most people would describe this figure as consisting of two curved lines.

When stimuli are close together, they tend to be grouped together as a perceptual unit. This is known as the **principle of proximity**. In Figure 14.2b, the Xs tend to be seen in groups of two, instead of as individual Xs. The same is true of the lines.

According to the **principle of inclusiveness**, when there is more than one figure, we are most

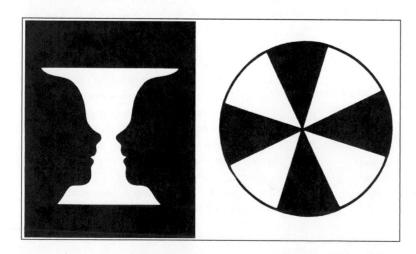

FIGURE 14.1

In each illustration, which is the figure and which is the ground?

SOURCE: Adapted from Rubin, 1915/1921.

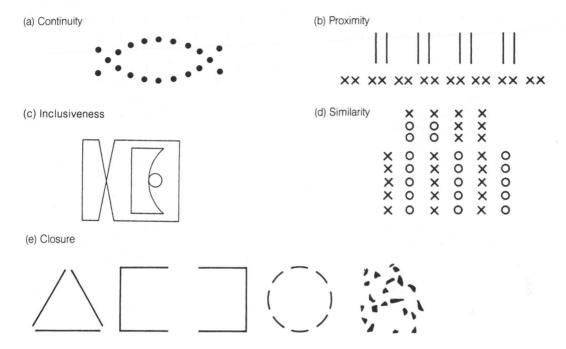

FIGURE 14.2

Examples of (a) principle of continuity, (b) principle of proximity, (c) principle of inclusiveness (Köhler, 1969), (d) principle of similarity, and (e) principle of closure.

SOURCE: Sartain et al., 1973; used by permission of Prentice-Hall, Inc.

likely to see the figure that contains the greatest number of stimuli. If, for example, a small figure is embedded in a larger one, we are most likely to see the larger figure and not the smaller. The use of camouflage is an application of this principle. For example, ships painted the color of water and tanks painted the color of the terrain in which they operate blend into the background and are thus less susceptible to detection. In Figure 14.2c, the symbol $\sqrt{16}$ is difficult to see because so many of its components are part of a larger stimulus complex. Köhler believed that the principle of inclusiveness provided evidence against the empiricalistic explanation of perception. He said most people would clearly have much more experience with the symbol $\sqrt{16}$ than with the figure shown in Figure 14.2c. Yet, the stronger tendency is to perceive the more inclusive figure. Köhler (1969) made the same point with the following figure:

Köhler observed that if perception is determined by past experience (learning), then most people would perceive the familiar word "men" along with its mirror image in the figure. Instead, however, most people perceive a less familiar figure, which somewhat resembles a horizontal row of heart-shaped forms.

Objects that are similar in some way tend to form perceptual units. This is known as the **principle of similarity**. Twins, for example, stand out in a crowd, and teams wearing different uniforms stand out as two groups on the field. In Figure 14.2d, the stimuli that have something in common stand out as perceptual units.

MKM<

As we have seen, the Gestaltists believed in psychophysical isomorphism, according to which our conscious experience is directly related to patterns of brain activity, and the brain activity organizes itself into patterns according to the law of Prägnanz. Thus, it is quite likely that the patterns of brain activity are often better organized than the stimuli that enter them. This is clearly demonstrated in the principle of closure, according to which incomplete figures in the physical world are perceived as complete ones. As Figure 14.2e shows, even if figures have gaps in them-and thus are not truly circles, triangles, or rectangles—they are nonetheless experienced as circles, triangles, or rectangles. This is because the brain transforms the stimuli into organized configurations that are then experienced cognitively. For the same reason, in Figure 14.2e we see a person on horseback.

SUBJECTIVE AND OBJECTIVE REALITY

Because the brain acts on sensory information and arranges it into configurations, what we are conscious of, and therefore what we act in accordance with at any given moment, is more a product of the brain than of the physical world. Koffka used this fact to distinguish between the geographical and the behavioral environments. For him, the **geographical environment** is the physical environment, whereas the **behavioral environment** is our subjective interpretation of the geographical environment. Koffka (1935/1963) used an old German legend to illustrate the important difference between the two environments:

On a winter evening amidst a driving snowstorm a man on horseback arrived at an inn, happy to have reached a shelter after hours of riding over the wind-swept plain on which the blanket of snow had covered all paths and landmarks. The landlord who came to the door viewed the

stranger with surprise and asked him whence he came. The man pointed in the direction straight away from the inn, whereupon the landlord, in a tone of awe and wonder, said: "Do you know that you have ridden across the Lake of Constance?" at which the rider dropped stone dead at his feet.

In what environment, then, did the behavior of the stranger take place? The Lake of Constance? Certainly, because it is a true proposition that he rode across it. And yet, this is not the whole truth, for the fact that there was a frozen lake and not ordinary solid ground did not affect his behavior in the slightest. It is interesting for the geographer that this behavior took place in this particular locality, but not for the psychologist as the student of behavior; because the behavior would have been just the same had the man ridden across a barren plain. But the psychologist knows something more: since the man died from sheer fright after having learned what he had "really" done, the psychologist must conclude that had the stranger known before, his riding behavior would have been very different from what it actually was. Therefore the psychologist will have to say: there is a second sense to the word environment according to which our horseman did not ride across the lake at all. but across an ordinary snow-swept plain. His behavior was a riding-over-a-plain, but not a riding-over-a-lake.

What is true of the man who rode across the Lake of Constance is true of every behavior. Does the rat run in the maze the experimenter has set up? According to the meaning of the word "in," yes and no. Let us therefore distinguish between a geographical and a behavioral environment. Do we all live in the same town? Yes, when we mean the geographical, no, when we mean the behavioral. (pp. 27–28)

a. An ape named Chica using a pole to obtain food (p. 72a). SOURCE: All photos from *The Mentality of Apes by* W. Köhler (1917/1925), London: Routledge and Kegan Paul Ltd. Reproduced by permission of Taylor & Francis Book UK.

In other words, our own subjective reality governs our actions more than the physical environment does.

THE GESTALT EXPLANATION OF LEARNING

Cognitive Trial and Error

As we have seen, the Gestaltists believed that brain activity tends toward a balance, or equilibrium, in accordance with the law of Prägnanz. This tendency toward equilibrium continues naturally unless it is somehow disrupted. According to the Gestaltists, the existence of a problem is one such disruptive influence. If a problem is confronted, a state of disequilibrium exists until the problem is solved. Because a state of disequilibrium is unnatural, it creates a tension with motivational properties

that keeps the organism active until it solves the problem. Typically, an organism solves its problems perceptually by scanning the environment and cognitively trying one possible solution and then another until it reaches a solution. Thus, the Gestaltists emphasized *cognitive* trial and error as opposed to *behavioral* trial and error. They believed that organisms come to *see* solutions to problems.

Insightful Learning

Köhler did much of his work on learning between 1913 and 1917 when he was on the island of Tenerife during World War I. In a typical experiment, using apes as subjects, Köhler suspended a desired object—for example, a banana—in the air just out of the animal's reach. Then he placed objects such as boxes and sticks, which the animal could use to obtain the banana, in the animal's environment. By stacking one or more boxes under the banana or by using a stick, the animal could obtain the banana. In one case, the animal needed to join two sticks together in order to reach a banana. The photographs on the next page depict the problem-solving activities of some of Köhler's apes.

In studying learning, Köhler also employed socalled detour problems, problems in which the animal could see its goal but could not reach it directly. To solve the problem, the animal had to

FIGURE 14.3

A typical detour problem that Köhler used to study the learning process.

SOURCE: Köhler (1917/1925).

UNIVERSITY OF WINCHESTER

b. Sultan putting two sticks together to obtain food (p. 128a).

c. An ape named Grande using a stack of boxes to obtain food as Sultan watches (p. 138a).

d. Chica beating down her objective with a pole (p. 146a).

learn to take an indirect route to the goal. Figure 14.3 shows a typical detour problem. Köhler found that although chickens had great difficulty with such problems, apes solved them with ease.

Köhler noted that during a problem's presolution period, the animals appeared to weigh the situation—that is, to test various hypotheses. (This is what we referred to earlier as cognitive, or vicarious, trial and error.) Then, at some point, the animal achieved insight into the solution and behaved according to that insight. For the Gestaltists, a problem can exist in only two stages: It is either unsolved or solved—there is no in-between. According to the Gestaltists, the reason that Thorndike and others had found what appeared to be incremental learning (learning that occurs gradually) was that all ingredients necessary for the attainment of insight had not been available to the animal. But if a problem is presented to an organism along with those things necessary for the problem's solution, insightful learning typically occurs.

According to the Gestaltists, insightful learning is much more desirable than learning achieved through either rote memorization or behavioral trial and error. Hergenhahn and Olson (2005) summarize the conclusions that the Gestaltists reached about insightful learning:

Insightful learning is usually regarded as having four characteristics: (1) the transition from presolution to solution is sudden and complete; (2) performance based on a solution gained by insight is usually smooth and free of errors; (3) a solution to a problem gained by insight is retained for a considerable length of time; (4) a principle gained by insight is easily applied to other problems. (p. 276)

Transposition

To explore further the nature of learning, Köhler used chickens as subjects. In one experiment, he placed a white sheet and a gray sheet of paper on the ground and covered both with grain. If a chicken pecked at the grain on the white sheet, it was shooed away; but if it pecked at the grain on the gray sheet, it was allowed to eat. After many trials, the chickens learned to peck at the grain on only the gray sheet. The question is, What did the animals learn? Thorndike, Hull, and Skinner would say that reinforcement strengthened the response of eating off the gray paper. To answer the question, Köhler proceeded with phase two of the experiment: He replaced the white paper with a sheet of black paper. Now the choice was between a grav sheet of paper, the one for which the chickens had received reinforcement, and a black sheet. Given this choice, most reinforcement theorists would have predicted that the chickens would continue to approach the gray paper. The vast majority of the chickens, however, approached the black paper. Köhler's explanation was that the chickens had not learned a stimulus-response association or a specific response but a relationship. In this case, the animals had learned to approach the darker of the two sheets of paper. If, in the second phase of the experiment, Köhler had presented a sheet of paper of a lighter gray than the one on which the chickens had been reinforced, the chickens would have continued to approach the sheet on which they had previously been fed because it would have been the darker of the two.

Thus, for the Gestaltist, an organism learns principles or relationships, not specific responses to specific situations. Once it learns a principle, the organism applies it to similar situations. This was called **transposition**, Gestalt psychology's explanation of transfer of training. The notion of transposition is contrary to Thorndike's identical-elements theory of transfer, according to which the similarity (common elements) between two situations determines the amount of transfer between them.

The Behaviorists' Explanation of Transposition. The Gestalt theory explanation of transposition did not go unchallenged. Kenneth Spence, the major spokesman for Hullian psychology, came up with an ingenious alternative explanation.

major spokesman for Hullian psychology, came up with an ingenious alternative explanation. Hergenhahn and Olson (2005) summarize Spence's

explanation:

Suppose, said Spence, that an animal is reinforced for approaching a box whose lid measures 160 sq. cm., and not reinforced for approaching a box whose lid measures 100 sq. cm. Soon the animal will learn to approach the larger box exclusively. In phase two of this experiment, the animal chooses between the 160 sq. cm. box and the box whose lid is 256 sq. cm. The animal will usually choose the larger box (256 sq. cm.) even though the animal had been reinforced specifically for choosing the other one (160 sq. cm.) during phase one. This finding seems to support the relational learning point of view.

Spence's behavioristic explanation of transposition is based on generalization.... Spence assumed that the tendency to approach the positive stimulus (160 sq. cm.) generalizes to other related stimuli. Second, he assumed that the tendency to

approach the positive stimulus (and the generalization of this tendency) is stronger than the tendency to avoid the negative stimulus (and the generalization of this tendency). What behavior occurs will be determined by the algebraic summation of the positive and negative tendencies.

Whenever there is a choice between two stimuli, the one eliciting the greatest net approach tendency will be chosen. In the first phase of Spence's experiment, the animal chose the 160 sq. cm. box over the 100 sq. cm. box because the net positive tendency was 51.7 for the former and 29.7 for the latter. In phase two, the 256 sq. cm. box was chosen over the 160 sq. cm. box because the net positive tendency was 72.1 for the former and still 51.7 for the latter. (pp. 279–280; see Figure 14.4)

Spence's explanation had the advantage of predicting the circumstances under which transposition would not occur. As the matter stands today, neither the Gestalt nor the behaviorist explanations can account for all transpositional phenomena; therefore, a comprehensive explanation is still being sought.

PRODUCTIVE THINKING

Wertheimer was concerned with the application of Gestalt theory to education. As mentioned, his book *Productive Thinking* was published posthumously in 1945. Under the editorship of Wertheimer's son Michael, this book was later revised and expanded, and it was republished in 1959. The conclusions Wertheimer reached about **productive thinking** were based on personal experience, experimentation, and interviews with individuals considered excellent problem solvers, such as Einstein.

Those were wonderful days, beginning in 1916, when for hours and hours I was fortunate enough to sit with Einstein, alone in his study, and hear from him the story of the dramatic developments which culminated in the theory of relativity. (Max Wertheimer, 1945/1959, p. 213)

Wertheimer contrasted learning according to Gestalt principles with rote memorization governed by external reinforcement and the laws of association. The former is based on an understanding of the nature of the problem. As we have seen, the existence of a problem creates a cognitive disequilibrium that lasts until the problem is solved. The solution restores a cognitive harmony, and this restoration is all the reinforcement the learner needs.

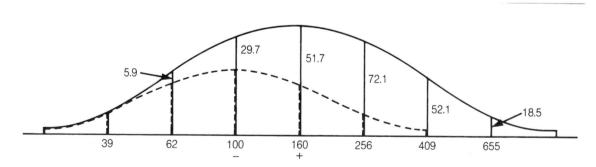

FIGURE 14.4

According to Spence, the algebraic sum of the positive and negative influences determines which of two stimuli in a discrimination problem will be approached.

SOURCE: Spence (1942).

Because learning and problem solving are personally satisfying, they are governed by **intrinsic** (internal) **reinforcement** rather than **extrinsic** (external) **reinforcement**. Wertheimer thought that we are motivated to learn and to solve problems because it is personally satisfying to do so, not because someone or something else reinforces us for doing so. Because learning governed by Gestalt principles is based on an understanding of the structure of the problem, it is easily remembered and generalized to other relevant situations.

Wertheimer believed that some learning did occur when mental associations, memorization, drill, and external reinforcement are employed but that such learning is usually trivial. He gave as examples of such learning associating a friend's name with his or her telephone number, learning to anticipate correctly a list of nonsense syllables, and a dog learning to salivate to a certain sound. Unfortunately, according to Wertheimer, this is the type of learning that most schools emphasize.

In Wertheimer's analysis, teaching that emphasizes logic does not fare much better than rote memorization. Supposedly, logic guarantees that one will reach correct conclusions. Teaching based on such a notion, said Wertheimer, assumes that there is a correct way to think and that everyone should think that way. But like rote memorization, learning and applying the rules of logic stifle productive thinking because neither activity is based on the realization that problem solving involves the total person and is unique to that person:

According to Wertheimer, reaching an understanding involves many aspects of learners, such as their emotions, attitudes, and perceptions, as well as their intellects. In gaining insight into the solution to a problem, a student need not—in fact, should not—be logical. Rather, the student should cognitively arrange and rearrange the components of the problem until a solution based on understanding is reached. Exactly how this process is done will vary from student to student. (Hergenhahn and Olson, 2005, p. 281)

Wertheimer's *Productive Thinking* is filled with delightful examples of productive problem solving. One involves a childhood experience of Carl Friedrich Gauss, who went on to become a famous mathematician. Gauss's teacher asked the class to add the numbers from 1 through 10 and report the sum as soon as it was attained. While the other students were just beginning to solve the problem, Gauss raised his hand and correctly reported the sum as 55. When the teacher asked Gauss how he arrived at the answer so quickly, he said,

[H]ad I done it by adding 1 and 2, then 3 to the sum, then 4 to the new result, and so on, it would have taken very long; and, trying to do it quickly, I would very likely have made mistakes. But you see, 1 and 10 make eleven, 2 and 9 are again—must be —11! And so on! There are 5 such pairs; 5 times 11 makes 55. (Wertheimer, 1945/1959, p. 109)

Gauss's solution was based on a flexible, creative approach to the problem rather than on standard, mechanical rules. Similarly, Michael Wertheimer (1980) describes an experiment that Katona originally performed in 1940. Katona showed subjects the following 15 digits and told them to study them for 15 seconds:

149162536496481

With only these instructions, most people attempt to memorize as many digits as possible in the allotted time. Indeed, Katona found that most subjects could reproduce only a few of the numbers correctly; and when tested a week later, most subjects remembered none.

Katona asked another group of subjects to look for a pattern or theme running through the numbers. Some individuals in this group realized that the 15 digits represented the squares of the digits from 1 to 9. These subjects saw a principle that they could apply to the problem and were able to reproduce all numbers correctly, not only during the experiment but also for weeks after. In fact, those individuals could no doubt reproduce the

series correctly for the rest of their lives. Gauss's experience and Katona's experiment thus supported Wertheimer's belief that learning and problem solving based on Gestalt principles has many advantages over rote memorization or problem solving based on formal logic.

MEMORY

Although the Gestaltists emphasized the tendency for the energy in the brain to organize itself into simple and symmetrical patterns in their accounts of learning and perception, they did not deny the importance of experience. They maintained that the tendency toward perceptual organization and cognitive equilibrium is derived from the fact that the brain is a physical system and, as such, distributes its activity in the simplest, most concise configuration possible under any circumstances. What the brain organizes, however, is provided by sensory experience, and this provides an experiential component to Gestalt theory. Another experiential component is apparent in the Gestaltists' treatment of memory. Of the three founders of Gestalt theory, Koffka wrote the most about memory.

Memory Processes, Traces, and Systems

Koffka assumed that each physical event we experience gives rise to specific activity in the brain. He called the brain activity caused by a specific environmental event a **memory process**. When the environmental event terminates, so does the brain activity it caused. However, a remnant of the memory process—a **memory trace**—remains in the brain. Once the memory trace is formed, all subsequent related experience involves an interaction between the memory process and the memory trace. For example, when we experience a cat for the first time, the experience creates a characteristic pattern of brain activity; this is the memory process. After the experience is terminated, the brain registers its

effects; this is the memory trace. The next time we experience a cat, the memory process elicited interacts with the already existing trace from the first experience. The conscious experience will be the result of both the present memory process and the trace of previously related experiences. Furthermore, a trace "exerts an influence on the process in the direction of making it similar to the process which originally produced the trace" (Koffka, 1935/1963, p. 553).

According to this analysis, we are aware of and remember things in general terms rather than by specific characteristics. Instead of seeing and remembering such things as cats, clowns, or elephants, we see and remember "catness," "clownness," and "elephantness." This is because the trace of classes of experience records what those experiences have in common—for example, those things that make a cat a cat. With more experience, the trace becomes more firmly established and more influential in our perceptions and memories. The individual trace gives way to a trace system, which is the consolidation of a number of interrelated experiences. In other words, a trace system records all our experiences with, say, cats. The interaction of traces and trace systems with ongoing brain activity (memory processes) results in our perceptions and memories being smoother and better organized than they otherwise would be. For example, we remember irregular experiences as regular, incomplete experiences as complete, and unfamiliar experiences as familiar. Trace systems govern our memories of particular things as well as of general categories. For example, the memory of one's own dog, cat, or mother will tend to be a composite of memories of experiences that occurred over a long period of time and under a wide variety of circumstances.

Like everything else addressed by Gestalt theory, memory is governed by the law of Prägnanz. That is, we tend to remember the essences of our experiences. The brain operates in such a way as to make memories as simple and symmetrical as is possible under the circumstances.

LEWIN'S FIELD THEORY

Born on September 9 in Mogilno, Germany, Kurt Lewin (1890-1947) received his doctorate in 1914 from the University of Berlin, under the supervision of Stumpf. After several years of military service, for which he earned Germany's Iron Cross, Lewin returned to the University of Berlin where he held various positions until 1932 and where he worked with Wertheimer, Koffka, and Köhler. Although Lewin is usually not considered a founder of Gestalt psychology, he was an early disciple, and most of his work can be seen as an extension or application of Gestalt principles to the topics of motivation, personality, and group dynamics.

Lewin was a visiting lecturer at Stanford University in 1932 and from 1933 to 1935 at Cornell. In 1935 he became affiliated with the Child Welfare Station at the University of Iowa as a professor of child psychology. In 1944 he created and directed the Research Center for Group Dynamics at the Massachusetts Institute of Technology. Although Lewin died only three years after starting his work on group dynamics, the influence of this work was profound and is still evi-

Kurt Lewin

dent in psychology today. (See Patnoe, 1988, for a number of interviews with prominent experimental social psychologists who were either directly or indirectly influenced by Lewin.)

Aristotelian versus Galilean Conception of Science

Lewin (1935) distinguished between Aristotle's view of nature, which emphasizes inner essences and categories, and Galileo's view, which emphasizes outer causation and the dynamics of forces. For Aristotle various natural objects fall into categories according to their essence, and everything that members of a certain category have in common defines the essence of members of that category. Unless external forces interfere, all members of a category have an innate tendency to manifest their essence. For example, all elephants would, unless interfered with by accidental circumstances, manifest the essence of elephantness. In this world of distinct classes, internal forces drive the members of the classes to become what their essence dictates they must become. Aristotle saw individual differences as distortions caused by external forces interfering with an object's or organism's natural growth tendencies. He emphasized the common attributes that members of a certain class possess, not their differences.

According to Lewin, Galileo revolutionized science when he changed its focus from inner causation to a more comprehensive notion of causation. For Galileo the behavior of an object or organism is determined by the total forces acting on the object or organism at the moment. For example, whether a body falls or not-and if it falls, how fast—is determined by its total circumstances and not by the innate tendency for heavy bodies to fall and light ones to rise. For Galileo causation springs not from inner essences but from physical forces; thus, he eliminated the idea of distinct categories characterized by their own essences and their own associated inward drives. The interaction of natural forces causes everything that happens; there are no accidents. Even so-called unique events are

totally comprehensible if the dynamic forces acting on them are known.

For Lewin (1935) too much of psychology was still Aristotelian. Psychologists were still seeking inner determinants of behavior, such as instincts, and still attempting to place people in distinct categories, such as normal and abnormal. Lewin also saw stage theories as extensions of Aristotelian thinking -for example, a theory that says average twoyear-olds act in certain ways and average threeyear-olds in other ways. Any theory attempting to classify people into types was also seen as exemplifying Aristotelian thinking—for example, a theory that characterizes people as introverts or extroverts. According to Lewin, when Galileo's conception of causation is employed, all these distinct categories vanish and are replaced with a conception of universal causation (the view that everything that occurs is a function of the total influences occurring at the moment).

In psychology, switching from an Aristotelian to a Galilean perspective would mean deemphasizing such notions as instincts, types, and even averages (which imply the existence of distinct categories) and emphasizing the complex, dynamic forces acting on an individual at any given moment. For Lewin, these dynamic forces—and not any type of inner essences—explain human behavior.

Life Space

Probably Lewin's most important theoretical concept was that of life space. A person's **life space** consists of all influences acting on him or her at a given time. These influences, called **psychological facts**, consist of an awareness of internal events (such as hunger, pain, and fatigue), external events (restaurants, restrooms, other people, stop signs, and angry dogs), and recollections of prior experiences (knowing that a particular person is pleasant or unpleasant or knowing that one's mother tends to say yes to certain requests and no to others). The only requirement for something to be a psychological fact is that it exist in a person's awareness at the moment. A previous experience is a psychological fact only if one recalls it in the present. Lewin sum-

marized his belief concerning psychological facts in his **principle of contemporaneity**, which states that only those facts that are currently present in the life space can influence a person's thinking and behavior. Unlike Freud and others, Lewin believed that experiences from infancy or childhood can influence adult behavior only if those experiences are reflected in a person's current awareness.

Not only does a person's life space reflect real personal, physical, and social events, but it also reflects imaginary events. If a person believes he or she is disliked by someone, that belief, whether it is true or not, will influence his or her interactions with that person. If we believe we are incapable of doing something, we will not attempt to do it, regardless of what our true capabilities are. For Lewin subjective reality governs behavior, not physical reality. One could be physically in a classroom but mentally pondering a forthcoming social engagement. If so, one would be oblivious to what was going on in the classroom. Again, Lewin believed that a person's thinking and behavior at any given moment are governed by the totality of psychological facts (real or imagined) present, and that totality constitutes a person's life space.

According to Lewin, if a need arises, the life space is articulated with facts that are relevant to the satisfaction of that need. For example, if one is hungry, psychological facts related to obtaining and ingesting food dominate one's life space. Some facts facilitate the satisfaction of the need (such as having money, the availability of food) and some facts inhibit its satisfaction (having other urgent commitments, being on a very restrictive diet). Often two or more needs can exist simultaneously, and the articulation of the life space can become quite complex. The life space, then, is dynamic, reflecting not only changing needs but also dominant environmental experiences such as hearing a doorbell ring or a person cry for help.

Motivation

Like the other Gestaltists, Lewin believed that people seek a cognitive balance. We saw how Köhler used this assumption in his explanation of learning. Lewin used the same assumption in his explanation of motivation. According to Lewin, both biological and psychological needs cause tension in the life space, and the only way to reduce the tension is through satisfaction of the need. Psychological needs, which Lewin called **quasi needs**, include such intentions as wanting a car, wanting to go to a concert, or wanting to go to medical school.

Doing her doctoral work under Lewin's supervision, Bluma Zeigarnik (1927) tested Lewin's tension-system hypothesis concerning motivation. According to this hypothesis, needs cause tensions that persist until the needs are satisfied. It was Lewin's custom to have long discussions with his students in a café while drinking coffee and snacking. Apparently, the tension-system hypothesis occurred to him as a result of an experience he had during one of these informal discussions. As Marrow (1969) reports,

On one such occasion, somebody called for the bill and the waiter knew just what everyone had ordered. Although he hadn't kept a written reckoning, he presented an exact tally to everyone when the bill was called for. About a half hour later Lewin called the waiter over and asked him to write the check again. The waiter was indignant. "I don't know any longer what you people ordered," he said. "You paid your bill." In psychological terms, this indicated that a tension system had been building up in the waiter as we were ordering and upon payment of the bill the tension system was discharged. (p. 27)

In her formal testing of Lewin's hypothesis, Zeigarnik (1927) assumed that giving a subject a task to perform would create a tension system and that completion of the task would relieve the tension. In all, Zeigarnik gave 22 tasks to 138 subjects. The subjects were allowed to finish some tasks but not others. Zeigarnik later tested the subjects on their recall of the tasks, and she found that the subjects remembered many more of the *uncompleted*

tasks than the completed ones. Her explanation was that for the uncompleted tasks the associated tension is never reduced; therefore, these tasks remain as intentions, and as such they remain part of the person's life space. The tendency to remember uncompleted tasks better than completed ones has come to be called the **Zeigarnik effect**. According to Leonard Zusne (1995), it is unfortunate that Zeigarnik's name has become associated only with the Zeigarnik effect. More important is the little known fact that she was essentially the "mother" of clinical psychology in the Soviet Union.

A year after Zeigarnik did her research, Maria Ovsiankina (1928), who was also working with Lewin, found that individuals would rather resume interrupted tasks than completed ones. Her explanation for this was the same as the one for the Zeigarnik effect.

Conflict

Although the fact that human tendencies often conflict was discussed by Plato (see Chapter 2), St. Paul (see Chapter 3), and Spinoza (see Chapter 6) and was made the cornerstone of psychoanalysis by Freud (see Chapter 16), it was Lewin who first investigated conflict experimentally (see, for example, Lewin, 1935). Lewin concentrated his study on three types of conflict. An approach-approach **conflict** occurs when a person is attracted to two goals at the same time, such as needing to choose from two attractive items on a menu or between two equally attractive colleges after being accepted by both. An avoidance-avoidance conflict occurs when a person is repelled by two unattractive goals at the same time, such as when one must get a job or not have enough money or study for an examination or get a bad grade. An approachavoidance conflict is often the most difficult to resolve because it involves only one goal about which one has mixed feelings, such as when having a T-bone steak is an appealing idea but it is one of the most expensive items on the menu or when marriage is appealing but it means giving up a great

deal of independence. The types of conflict Lewin studied can be diagrammed as follows (where p symbolizes a person):

Goal 1	Goal 2	
$+\leftarrow oldsymbol{ ho} ightarrow +$		Approach–Approach
		Conflict
$oldsymbol{-} ightarrow oldsymbol{p} \leftarrow oldsymbol{-}$		Avoidance-Avoidance
		Conflict
$f \pm \leftrightarrow m p$		Approach–Avoidance
		Conflict

After Lewin, the next significant research on conflict was performed by Neal Miller (1909–2002) as part of his highly regarded effort to precisely define and evaluate a number of psychoanalytic concepts within the context of learning theory (see, for example, Dollard and Miller, 1950; N. E. Miller, 1944, 1959, 1964).

Group Dynamics

In his later years, Lewin extended Gestalt principles to the behavior of groups. According to Lewin, a group can be viewed as a physical system just as the brain can be. In both cases, the behavior of individual elements is determined by the configuration of the existing field of energy. Therefore, the nature or configuration of a group will strongly influence the behavior of its members. Among the members of each group, there exists what Lewin called a dynamic interdependence. Lewin's studies of **group dynamics** led to what are now called encounter groups, sensitivity training, and leadership institutes.

Lundin (1991) describes one of Lewin's studies of group dynamics:

The concept of group dynamics has led to several avenues of research. During World War II, Lewin conducted a number of experiments that attempted to alter group decision-making. At the time, certain food products, such as meat, were rationed.

Consequently, housewives were encouraged to buy more accessible products, such as brains, liver, kidneys, and heart and other animal organs not generally considered to be food items. He used two methods—the first was lecturing on the merits of the food, their nutritional values, how they could be tastily prepared, and so on. The second method involved group discussion. The same materials were presented in both cases. In the group discussion, there was participation by the members on the pros and cons of trying and eating and preparing such substances. In a follow-up study only 3 percent of the lecture group took up the suggestions, while 32 percent of the discussion group changed their food habits by trying the formerly unpopular products. Lewin concluded that in the discussion group more forces were made available for a change in behavior. (pp. 261–262)

In another study, Lewin, Lippitt, and White (1939) investigated the influence of various types of leadership on group performance. Boys were matched and then placed in (1) a democratic group, in which the leader encouraged group discussion and participated with the boys in making decisions; (2) an authoritarian group, in which the leader made all decisions and told the boys what to do; or (3) a laissez-faire group, in which no group decisions were made and the boys could do whatever they wanted. The researchers found that the democratic group was highly productive and friendly, the authoritarian group was highly aggressive, and the laissez-faire group was unproductive. Lewin et al. concluded that group leadership influenced the Gestalt characterizing the group and, in turn, the attitude and productivity of the group's members.

When Lewin died suddenly on February 11, 1947, of a heart attack, he was at the height of his career and influence. He was only 57 years old at the time of his death and had been in the United States for only 12 years.

THE IMPACT OF GESTALT PSYCHOLOGY

Like any school in psychology, Gestalt psychology has had its share of criticism. Critics have said that many of its central terms and concepts are vague and therefore hard to pin down experimentally. Even the term Gestalt, the critics say, has never been defined precisely. The same is true for the law of Prägnanz for insight and for cognitive equilibrium and disequilibrium. As might be expected, the behaviorists attacked the Gestaltists' concern with consciousness, claiming that such a concern was a regression to the old metaphysical position that had caused psychology so many problems. Following a discussion with Köhler on Gestalt psychology, the illustrious neuropsychologist Karl Lashley said, "Excellent work—but don't you have religion up your sleeve?" (Henle, 1971b, p. 117). Despite these and other criticisms, however, Gestalt theory has clearly influenced almost every aspect of modern psychology. Sokal (1984) said the following about the influence of Gestalt psychology:

[Gestalt psychology] enriched American psychology greatly and did much to counter the attractions of extreme behaviorism. If Gestalt psychology has today lost its identity as a school of thought—and very few of Koffka's, Köhler's, Wertheimer's, or Lewin's students call themselves Gestalt psychologists—it is not because the mainstream of American psychology has swamped their ideas. Rather, their work has done much to redirect this mainstream, which adopted many of their points of view. Few other migrating scientific schools have been as successful. (p. 1263)

In a thoughtful chapter titled "Rediscovering Gestalt Psychology," Henle (1985) discusses several important relationships that exist between Gestalt psychology and contemporary cognitive psychology. Murray (1995) also discusses those relationships. We will have more to say about the influence of Gestalt psychology on contemporary cognitive psychology in Chapter 20.

SUMMARY

Attacking both the structuralists and the behaviorists for their elementism, the Gestaltists emphasized cognitive and behavioral configurations that could not be divided without destroying the meaning of those configurations. Gestalt is the German word for "whole," "totality," or "configuration." Antecedents of Gestalt psychology include Kant's contention that sensory experience is structured by the faculties of the mind; Mach's contention that the perception of space form and time form are independent of any specific sensory elements; Ehrenfels's observation that although form qualities emerge from sensory experience, they are different from that experience; J. S. Mill's notion of mental chemistry; James's contention that consciousness is like an ever-moving stream that cannot be divided into elements without losing its meaning; act psy-

chology, which emphasizes the conscious acts of perceiving, sensing, and problem solving instead of the elements of thought; and the emergence of field theory in physics.

The 1912 publication of Wertheimer's article on the phi phenomenon usually marks the founding of the Gestalt school of psychology. The phi phenomenon indicates that conscious experience cannot be reduced to sensory experience. Koffka and Köhler worked with Wertheimer on his early perception experiments and are usually considered cofounders of Gestalt psychology. Wertheimer assumed that forces in the brain distribute themselves as they do in any physical system (symmetrically and evenly) and that these force fields interact with sensory information to determine conscious experience. The contention that force fields in the brain

determine consciousness was called psychophysical isomorphism, and the contention that brain activity is always distributed in the most simple, symmetrical, and organized way was called the law of Prägnanz. The term *perceptual constancy* refers to the way we respond to objects or events as the same even when we experience them under a wide variety of circumstances.

According to the Gestaltists, the most basic perception is that of a figure-ground relationship. Perceptual principles that cause the elements of perception to be organized into configurations include continuity, by which stimuli following some pattern are seen as a perceptual unit; proximity, by which stimuli that are close together form a perceptual unit; similarity, by which similar stimuli form a perceptual unit; inclusiveness, by which a larger perceptual configuration masks smaller ones; and closure, by which incomplete physical objects are experienced psychologically as complete. The Gestaltists distinguished the geographical (physical) environment from the behavioral (subjective) environment. They believed that the behavioral environment governs behavior.

The Gestaltists viewed learning as a perceptual phenomenon. For them, the existence of a problem creates a psychological disequilibrium, or tension, that persists until the problem is solved. As long as there is tension, the person engages in cognitive trial and error in an effort to find the solution to the problem. Problems remain in an unsolved state until insight into the solution is gained. Insightful learning is sudden and complete; it allows performance that is smooth and free of errors. Also, the person retains the information gained by insight for a long time and can easily transfer that information to similar problems. The application of a principle learned in one problem-solving situation to other similar situations is called transposition.

Productive thinking involves the understanding of principles rather than the memorization of facts or the utilization of formal logic. The Gestaltists believed that reinforcement for productive thinking comes from personal satisfaction, not from events outside oneself. They thought that memory, like other psychological phenomena, is governed by the law of Prägnanz. Experience activates a brain activity called a memory process, which lasts as long as an experience lasts. After the memory process terminates, a trace of it remains, and that memory trace influences subsequent memories of similar objects or events. Eventually, a trace system develops that records the features that memories of a certain type have in common. After a memory trace—and to a larger extent, a trace system—is established, the memory of a specific event is determined by the memory trace and by the trace system of similar experiences, as well as by one's immediate experience.

Lewin was an early Gestaltist who believed that psychology should not categorize people into types or emphasize inner essences. Rather, he believed psychology should attempt to understand the dynamic force fields that motivate human behavior. He believed that such a shift in emphasis would switch psychology from an Aristotelian to a Galilean model of science. According to Lewin, anything influencing a person at a given moment is a psychological fact, and the totality of psychological facts that exists at the moment constitutes a person's life space. Lewin believed that both biological and psychological needs create a tension that persists until the needs are satisfied. The Zeigarnik effect, or the tendency to remember uncompleted tasks longer than completed ones, supported Lewin's theory of motivation. Lewin observed that intentions often conflict, as when one wants two desirable things at the same time, wants to avoid two undesirable things at the same time, or wants and does not want the same thing at the same time. With his work on group dynamics, Lewin showed that different types of group structures create different Gestalten that influence the performance of group members.

Gestalt psychology played a major role in directing the attention of psychologists away from insignificant bits of behavior and consciousness and toward the holistic aspects of behavior and consciousness. As with functionalism, many of the basic features of Gestalt psychology have been assimilated into modern psychology, and therefore Gestalt psychology has lost its distinctiveness as a school.

DISCUSSION QUESTIONS

- Summarize the disagreements that the Gestaltists had with Wundt's experimental program, the structuralists, and the behaviorists.
- 2. Differentiate the molecular approach to psychology from the molar approach.
- 3. Describe similarities and differences that existed between the positions of Kant, Mach, Ehrenfels, James, and the act psychologists, on one hand, and the Gestaltists, on the other.
- Explain what is meant by the contention that Gestalt theory used field theory as its model and that empirical-associationistic psychology used Newtonian physics as its model.
- 5. What is the phi phenomenon? What was its importance in the formation of the Gestalt school of psychology?
- 6. What is meant by the contention that Gestalt analysis proceeds from the top down rather than from the bottom up?
- 7. Contrast the Gestalt notion of psychophysical isomorphism with the constancy hypothesis.
- 8. What is the law of Prägnanz? Describe the importance of this law to Gestalt psychology.
- 9. What is perceptual constancy? Give an example. How did the Gestaltists explain the perceptual constancies?
- 10. Briefly define each of the following: figure—ground relationship, principle of continuity, principle of proximity, principle of similarity, principle of inclusiveness, and principle of closure.
- 11. Distinguish between subjective and objective reality. According to the Gestaltists, which is

- more important in determining behavior? Give an example.
- 12. How did the Gestaltists explain learning? In your answer, summarize the characteristics of insightful learning.
- 13. What is transposition? Summarize the Gestalt and the behavioristic explanations of this phenomenon.
- 14. For Wertheimer, what represents the best type of problem solving? Contrast this type of problem solving with rote memorization and logical problem solving.
- 15. Summarize the Gestalt explanation of memory. Include in your answer definitions of memory process, memory trace, and trace system. What does it mean to say that memory is governed by the law of Prägnanz?
- 16. For Lewin, how does psychology based on Aristotle's view of nature differ from psychology based on Galileo's view of nature? Give an example of each.
- 17. What did Lewin mean by life space? Include in your answer the definition of *psychological fact*.
- 18. Summarize Lewin's theory of motivation. In your answer, distinguish between needs and quasi needs.
- 19. What is the Zeigarnik effect? Describe the research used to demonstrate the effect.
- 20. Describe the three types of conflict studied by Lewin and give an example of each.
- 21. Summarize Lewin's work on group dynamics.
- 22. Summarize the impact that Gestalt psychology has had on contemporary psychology.

SUGGESTIONS FOR FURTHER READING

Gold, M. (Ed.). (1999). *The complete social scientist: A Kurt Lewin reader*. Washington, DC: American Psychological Association.

Henle, M. (Ed.). (1971). The selected papers of Wolfgang Köhler. New York: Liveright.

- Henle, M. (1978). One man against the Nazis— Wolfgang Köhler. American Psychologist, 33, 939– 944.
- Henle, M. (1986). 1879 and all that: Essays in the theory and history of psychology. New York: Columbia University Press.
- Köhler, W. (1966). The place of value in a world of facts. New York: Liveright. (Original work published 1938)
- Lewin, K. (1997). Resolving social conflicts and Field theory in social science. Washington, DC: American

- Psychological Association. (Original works published in 1948 and 1951, respectively)
- Ley, R, (1990). A whisper of espionage: Wolfgang Köhler and the apes of Tenerife. Garden City, NY: Avery.
- Murray, D. J. (1995). Gestalt psychology and the cognitive revolution. New York: Harvester Wheatsheaf.
- Sokal, M. M. (1984). The Gestalt psychologists in behaviorist America. American Historical Review, 89, 1240–1263.

GLOSSARY

Act psychology Type of psychology that emphasizes the study of intact mental acts, such as perceiving and judging, instead of the division of consciousness into elements.

Approach-approach conflict According to Lewin, the type of conflict that occurs when a person is attracted to two goals at the same time.

Approach-avoidance conflict According to Lewin, the type of conflict that occurs when a person is attracted to and repelled by the same goal at the same time.

Avoidance-avoidance conflict According to Lewin, the type of conflict that occurs when a person is repelled by two goals at the same time.

Behavioral environment According to Koffka, subjective reality.

Constancy hypothesis The contention that there is a strict one-to-one correspondence between physical stimuli and sensations, in the sense that the same stimulation will always result in the same sensation regardless of circumstances. The Gestaltists argued against this contention, saying instead that what sensation a stimulus elicits is relative to existing patterns of activity in the brain and to the totality of stimulating conditions.

Ehrenfels, Christian von (1859–1932) Said that mental forms emerge from various sensory experiences and that these forms are different from the sensory elements they comprise.

Elementism The belief that complex mental or behavioral processes are composed of or derived from simple elements and that the best way to understand these processes is first to find the elements of which they are composed.

Extrinsic reinforcement Reinforcement that comes from a source other than one's self.

Field theory That branch of physics that studies how energy distributes itself within physical systems. In some systems (such as the solar system), energy can distribute itself freely. In other systems (such as an electric circuit), energy must pass through wires, condensers, resistors, and so forth. In either type of system, however, energy will always distribute itself in the simplest, most symmetrical way possible *under the circumstances*. According to the Gestaltists, the brain is a physical system whose activity could be understood in terms of field theory.

Figure–ground relationship The most basic type of perception, consisting of the division of the perceptual field into a figure (that which is attended to) and a ground, which provides the background for the figure.

Geographical environment According to Koffka, physical reality.

Gestalt The German word meaning "configuration," "pattern," or "whole".

Gestalt psychology The type of psychology that studies whole, intact segments of behavior and cognitive experience.

Group dynamics Lewin's extension of Gestalt principles to the study of group behavior.

Holists Those who believe that complex mental or behavioral processes should be studied as such and not divided into their elemental components for analysis. (*See also* **Phenomenology**.)

Insightful learning Learning that involves perceiving the solution to a problem after a period of cognitive trial and error.

Intrinsic reinforcement The self-satisfaction that comes from problem solving or learning something. According to the Gestaltists, this feeling of satisfaction occurs because solving a problem or learning something restores one's cognitive equilibrium.

Kant, Immanuel (1724–1804) Said that what we experience consciously is determined by the interaction of sensory information with the categories of thought.

Koffka, Kurt (1886–1941) Worked with Wertheimer on his early perception experiments. Koffka is considered a cofounder of the school of Gestalt psychology.

Köhler, Wolfgang (1887–1967) Worked with Wertheimer on his early perception experiments. Köhler is considered a cofounder of the school of Gestalt psychology.

Law of Prägnanz Because of the tendencies of the force fields that occur in the brain, mental events will always tend to be organized, simple, and regular. According to the law of Prägnanz, cognitive experience will always reflect the essence of one's experience instead of its disorganized, fragmented aspects.

Lewin, Kurt (1890–1947) An early Gestaltist who sought to explain human behavior in terms of the totality of influences acting on people rather than in terms of the manifestation of inner essences. Lewin was mainly responsible for applying Gestalt principles to the topics of motivation and group dynamics.

Life space According to Lewin, the totality of the psychological facts that exist in one's awareness at any given moment. (*See also* **Psychological fact**.)

Mach, Ernst (1838–1916) Observed that some mental experiences are the same even though they are stimulated by a wide range of sensory events. The experiencing of geometric forms (space forms) and melodies (time forms) are examples.

Memory process The brain activity caused by the experiencing of an environmental event.

Memory trace The remnant of an experience that remains in the brain after an experience has ended.

Molar approach The attempt to focus on intact mental and behavioral phenomena without dividing those phenomena in any way.

Molecular approach The attempt to reduce complex phenomena into small units for detailed study. Such an approach is elementistic.

Perceptual constancy The tendency to respond to objects as being the same, even when we experience those objects under a wide variety of circumstances.

Phenomenology The study of intact, meaningful, mental phenomena.

Phi phenomenon The illusion that a light is moving from one location to another. The phi phenomenon is caused by flashing two lights on and off at a certain rate.

Principle of closure The tendency to perceive incomplete objects as complete.

Principle of contemporaneity Lewin's contention that only present facts can influence present thinking and behavior. Past experiences can be influential only if a person is presently aware of them.

Principle of continuity The tendency to experience stimuli that follow some predictable pattern as a perceptual unit.

Principle of inclusiveness The tendency to perceive only the larger figure when a smaller figure is embedded in a larger figure.

Principle of proximity The tendency to perceptually group together stimuli that are physically close.

Principle of similarity The tendency to perceive as units stimuli that are physically similar to one another.

Productive thinking According to Wertheimer, the type of thinking that ponders principles rather than isolated facts and that aims at understanding the solutions to problems rather than memorizing a certain problemsolving strategy or logical rules.

Psychological facts According to Lewin, those things of which a person is aware at any given moment.

Psychophysical isomorphism The Gestaltists' contention that the patterns of activity produced by the brain—rather than sensory experience as such—causes mental experience.

Quasi needs According to Lewin, psychological rather than biological needs.

Trace system The consolidation of the enduring or essential features of memories of individual objects or of classes of objects.

Transposition The application of a principle learned in one learning or problem-solving situation to other similar situations.

Wertheimer, Max (1880–1943) Founded the school of Gestalt psychology with his 1912 paper on the phi phenomenon.

Zeigarnik effect The tendency to remember uncompleted tasks longer than completed ones.

Early Diagnosis, Explanation, and Treatment of Mental Illness

WHAT IS MENTAL ILLNESS?

Although the condition we now refer to as **mental illness** has existed from at least the beginning of recorded history, the terms used to describe that condition have varied. Today, besides the term *mental illness*, we use such terms as *psychopathology* and *abnormal behavior*. At earlier times, terms such as *mad, lunatic, maniac*, and *insane* have been used. Although the terms have changed, all refer to more or less the same type of behavior. As W. B. Maher and B. A. Maher (1985) explain,

The old terms meant pretty much the same thing as the new terms replacing them. "Mad," for example, was an old English word meaning emotionally deranged and came in turn from an ancient root word meaning crippled, hurt; "insanity" comes from the root word "sanus" or free from hurt or disease, and thus "insane" means hurt or unhealthy; "lunacy" refers to the periodic nature of many psychopathological conditions and perhaps was originally intended to differentiate periodic madnesses from those in which the state was chronic and unremitting; "mania" refers to excess of passion or behavior out of control of the reason. (p. 251)

When the behavior and thought processes thought to characterize mental illness are examined, several recurring themes become evident. In describing these themes, we follow W. B. Maher and B. A. Maher (1985).

Harmful Behavior

Normal individuals possess a powerful motive to survive, and therefore behavior contrary to that motive, such as self-mutilation or suicide, is considered abnormal. There have been cultural settings. however, in which harming oneself was considered desirable, such as when in Japan committing harakiri was viewed as a way of restoring lost personal or family honor. Also, there have been cultural settings in which injuring another person or persons was sanctioned, such as in 17th- and 18th-century Italy, when castrating a child with musical talent to prepare him for an operatic career as a castrato was an acceptable practice; or during warfare, when killing the enemy was encouraged. But generally, behavior that is harmful to oneself or others has been and is viewed as abnormal.

Unrealistic Thoughts and Perceptions

If a person's beliefs or perceptions differ markedly from those considered normal at a certain time and place in history, those beliefs and perceptions are taken as signs of mental illness. Using today's terminology, we say that people are having delusions if their beliefs are not shared by other members of the community. For example, it is considered delusional if a person believes that he or she can be transformed into some type of animal, such as a wolf or a cat. Similarly, people are considered abnormal if their perceptions do not correspond to those of other members of the community. Today we call such perceptions hallucinations. An example would be a person seeing a bountiful crop where others see only dust or dirt. Both false beliefs (delusions) and false perceptions (hallucinations) have traditionally been taken as representing unrealistic contact with reality and therefore as abnormal.

Inappropriate Emotions

When an individual consistently laughs when the mores of a community dictate that he or she should cry or cries when he or she should laugh, that person is often branded as mentally ill. Likewise, if a person's emotional reactions are considered ex-

treme, as when extreme fear, sadness, or joy are displayed in situations where much more moderate levels of these emotions are considered appropriate, the person is often suspected of being mentally disturbed. Inappropriate or exaggerated emotional responses have been and are standard criteria used in labeling a person as mentally ill.

Unpredictable Behavior

Sudden shifts in one's beliefs or emotions have also traditionally been taken as signs of psychopathology. For example, the person who is happy one moment and sad the next or who embraces one conviction only to have it displaced by another in a short period of time has been and is considered to be at least emotionally unstable. If such rapid shifts in moods or beliefs persist, the person is often characterized as mentally ill.

What these criteria of mental illness all have in common is that they define abnormality in terms of the behavior and thought processes of the average person in a community. Of course, the characteristics of this average person will vary according to the mores of his or her culture, but it is always the average person's beliefs and behavior that have been used as a frame of reference in determining mental illness.

Right or wrong, using the experiences of the average members of a community as a frame of reference in defining mental illness is as operative today as it has been throughout human history. This means that two categories of people are susceptible to being labeled mentally ill: those who for one reason or another cannot abide by cultural norms and those who choose not to. (For more on the tendency to brand extreme nonconformists as mentally ill, see Szasz, 1974; Vatz and Weinberg, 1983.)

EARLY EXPLANATIONS OF MENTAL ILLNESS

The proposed explanations of mental illness that have been offered throughout history fall into three general categories: biological, psychological, and supernatural.

Biological Explanations

Generally, biological explanations of abnormal behavior constitute the **medical model of mental illness**. This model assumes that *all* disease is caused by the malfunctioning of some aspect of the body, mainly the brain. The bodily abnormalities causing mental illness can be inherited directly, as was supposed to be the case with "natural fools," or a predisposition toward mental illness could be inherited, which could be activated by certain experiences. In one way or another, constitutional factors have almost always been suggested as possible causes of mental illness.

Also, included among the biological explanations of mental illness are the many events that can interfere with the normal functioning of the body. Such events include injuries; tumors and obstructions; ingestion of toxins; polluted air, water, or food; disease; excessive physical stress; and physiological imbalances such as those caused by improper diet.

Psychological Explanations

A psychological model of mental illness proposes that psychological events are the causes of abnormal behavior. Here, psychological experiences such as grief, anxiety, fear, disappointment, frustration, guilt, or conflict are emphasized. The mental stress that results from living in an organized society has always been recognized as a possible explanation of mental illness; how much psychological explanations were stressed varied with time and place. As is the case today, biological and psychological explanations of mental illness most often existed simultaneously. More often than not, it was believed that psychological events influenced biological events, and vice versa. In more recent times, however, tension has arisen between those accepting the medical model of mental illness and those accepting the psychological model. We will say more about that tension later in this chapter.

Supernatural Explanations

In primitive times, people attributed most ailments not caused by obvious things—such as falling down, being attacked by an animal or an enemy, or overeating or drunkenness—to mysterious forces entering the body. People did not distinguish between mental and physical disorders but believed both to be inflicted on a person by some mortal or immortal being. Supernatural explanations of all illness (including mental) prevailed until the time of the early Greek physicians, such as Alcmaeon and Hippocrates. The Greek naturalistic approach to medicine was highly influential until the collapse of the Roman Empire in A.D. 476. From that time until about the 18th century, supernatural explanations of diseases of all types prevailed.

Although the **supernatural model of mental illness** was popular during the Middle Ages, it would be a mistake to conclude that it was the only model:

Although notions of demonology flourished in medieval religious, lay, and even medical speculation, rational and naturalistic theories and observations continued to be influential. This is evident in the historical, biographical, medical, legal, and creative literature of the times. Explanations of psychopathological behavior were not confined to demon possession; they embraced a diversity of ideas derived from common sense, classical medicine and philosophy, folklore and religion. In medieval descriptions of mental illness there is most typically an interweaving of statements variously implying natural (biological and psychological) and supernatural causation. It is difficult to assess which was considered most important; it is also difficult to discern what was intended to be taken literally and what metaphorically. (W. B. Maher and B. A. Maher, 1985, p. 283)

Biological, psychological, and supernatural explanations of mental illness have almost always existed in one form or another; what has changed through history is how one type of explanation has been emphasized over the others.

TREATMENT OF MENTAL ILLNESS

Psychotherapy is any attempt to help a person with a mental disturbance. As mentioned earlier, common themes characterize behavior that is considered abnormal. Common themes also run through all forms of psychotherapy:

No matter what its form, cost or setting, all that is meant by psychotherapy is the service that one human being, a helper, renders another, a sufferer, toward the end of promoting the latter's well being. The common elements in both ancient and modern forms of psychotherapy are a sufferer, a helper, and a systematized ritual through which help is proffered. Although the specific purposes in consulting a psychotherapist are as numerous and unique as the individuals who seek such help, the basic reasons have always been to obtain assistance in (1) removing, modifying or controlling anxiety, depression, alienation, and other distressing psychological states, (2) changing undesirable patterns of behavior such as timidity, overaggressiveness, alcoholism, disturbed sexual relationships, and the like, or (3) promoting more positive personal growth and the development of greater meaning in one's life through more effective personal functioning, or through the pursuit of new educational, occupational, recreational, or other goals which will better allow expression of the individual's potential. (Matarazzo, 1985, p. 219)

Although it may be true that ideally all versions of psychotherapy address the needs of the "sufferer," it is also true that not all versions of psychotherapy have been successful in doing so. In addition, individuals with mental illness have often been treated or confined, not so much for their own benefit as for the benefit of the community:

Throughout the course of history there is a constantly recurring list of therapies for mental illness, each related in one way or another to the symptoms of and/or the supposed causes of the pathology. Although ideally therapies are devised to effect cures, they are often merely palliative, intended to relieve symptoms whilst the disease process does or does not run its course. And although therapies have often been derived from theories of causation, at times the theories of causation have been contrived to rationalize the treatments used. Therapies have been developed by physicians, priests, psychiatric and psychological specialists, interested laymen, charlatans, and quacks; the therapies vary accordingly. Treatments in general have been undertaken to meet the patient's need, to meet the needs of the patient's family or friends or community to do something for or about the patient, to solve social problems presented by the patient's condition. Treatment therefore may not be primarily intended to be therapeutic. The patient may be placed under custodial care in order to protect the patient from his or her own self neglect or abuse or the consequences of poor judgment; to allow time for rest, freedom from responsibility, proper diet to effect improvement; to protect others from the violence, problems, embarrassment, or inconvenience caused by the patient—or all of the above. (W. B. Maher and B. A. Maher, 1985, p. 266)

In any case, if an honest effort was made to treat mental illness, the treatment used was determined largely by beliefs concerning its cause. If it was believed that mental illness was caused by psychological factors, those factors were addressed during the therapeutic process. If it was believed that supernatural or biological factors caused mental illness, the therapeutic process was conducted accordingly.

The Psychological Approach

When psychological factors such as fear, anxiety, frustration, guilt, or conflict were viewed as the causes of mental illness, treatment was aimed at those factors. Methods used throughout history to address psychological factors thought to be responsible for mental illness include having the individual observe (such as by watching a drama) or personally reenact the traumatic experience in order to create a catharsis (purging the mind of disturbing emotions); having the person listen to relaxing music; offering support, reassurance, and love from authority figures or relevant others; analyzing dreams, thoughts, and motives; and attempting to teach the "sufferer" new and more effective skills to enable better coping with personal or interpersonal problems. Today the last method would exemplify behavior therapy.

Somewhere between the psychological and supernatural explanations of mental illness was the 18th-century belief in natural law. Generally, **natural law** is the belief that you get what you deserve in life:

Philosophical ideas about human society were, in the eighteenth century, affected by the concept of "natural law." According to this view there were certain natural consequences to behavior such that actions long regarded as sinful, such as drinking, gambling, or whoring, naturally led to madness, disease, and poverty. The alcoholic with delirium tremens or the patient in the terminal stages of syphilis-induced paresis could thus be seen as suffering an inevitable and natural outcome of their own behavior. On the other hand, wealth, health, and prosperity came from habits of industry, sobriety, and the like; the rewards were not to be seen as "prizes" given for good behavior, but as natural effects of this behavior. (B. A. Maher and W. B. Maher, 1985, p. 303)

The implications for psychotherapy are clear. To alleviate suffering, the patient must change his

or her ways, and it is the therapist's job to help him or her to do so.

The Supernatural Approach

If it was believed that evil forces entering the body caused illness, then a cure would involve removing those forces. In attempting to coax the invading forces from an inflicted person's body, the primitive medicine man would use appeal, bribery, reverence, and intimidation—and sometimes exorcism, magical rituals, and incantations.

In his famous book The Golden Bough (1890/ 1963), Sir James Frazer (1854-1941) discussed sympathetic magic, which, for primitive humans, was extremely important in the explanation and treatment of ailments. Frazer distinguished between two types of sympathetic magic: homeopathic and contagious. Homeopathic magic was based on the principle of similarity. An example of homeopathic magic is the belief that what one did to a model or image of a person would affect that person. Contagious magic, which was based on the principle of contiguity, involved the belief that what was once close to or part of someone would continue to exert an influence on that person. For example, having an article of clothing that belonged to a person whose actions one was trying to control would increase the likelihood of success. Thus, if two things were similar or were at one time connected, they were thought to influence one another through sympathy. Using these principles, a medicine man would sometimes mimic a patient's symptoms and then model a recovery from them. Frazer (1890/1963) indicated that, to the individuals using them, these magical techniques must have appeared to be very effective:

A ceremony intended to make the wind blow or the rain fall, or to work the death of an enemy, will always be followed, sooner or later, by the occurrence it is meant to bring to pass; and primitive man may be excused for regarding the occurrence as a direct result of the ceremony, and the best possible proof of its efficacy. Similarly, rites observed in the morning to help the sun to rise, and in the spring to wake the dreaming earth from her winter sleep, will invariably appear to be crowned with success, at least in the temperate zones; for in these regions the sun lights his golden lamp in the east every morning, and year by year the vernal earth decks herself afresh with a rich mantle of green. (p. 68)

Primitive humans, then, saw most illness as caused by evil forces or spirits entering the body. This view of illness was simply an extension of how primitive people viewed everything:

Wind was destructive; hence he [the primitive human] assumed an angry being who blew it to attack him. Rain was sent by spirits to reward or punish him. Disease was an affliction sent by invisible superhuman beings or was the result of magic manipulations by his enemies. He animated the world around him by attributing to natural events the human motivations that he knew so well from his own subjective experiences. Thus it was logical to him to try to influence natural events by the same methods he used to influence human beings; incantation, prayer, threats, submission, bribery, punishment and atonement. (Alexander and Selesnick, 1966, p. 9)

Bleeding a patient or removing a section of his or her skull were apparently also widely used to allow evil spirits to escape from the body. Thousands of prehistoric human skulls have been found throughout the world with man-made openings in them. These skulls display an opening made by chipping away at it with a sharp stone, a procedure known as **trepanation**. The photograph on the next page shows two trepanned skulls. Concerning trepanation, Finger (1994) says, "The fact the holes often exhibit smooth margins and clear signs of healing provides convincing evidence that this sort of surgery was conducted on living subjects and was not just a sacrificial or funeral rite" (p. 4). Just why trepanation

was performed on living people thousands of years ago is a matter of considerable speculation. One idea is that it was performed to treat skull fractures or to relieve pressure from brain tumors. There is evidence that, in some cases, trepanned skulls had first been fractured. However, perhaps the most widely accepted belief concerning trepanation is that it was used to treat headaches, convulsions, and mental disorders. Finger (1994) says, "These disorders were likely to have been attributed to demons, and it is conceivable that the holes were made to provide the evil spirits with an easy way out" (p. 5).

The Biological Approach

As early as 3000 B.C., the Egyptians showed great proficiency in treating superficial wounds and setting fractures (Sigerist, 1951). Even for ailments with unknown causes, the Egyptians used "natural" treatments such as vapor baths, massage, and herbal remedies. They believed, however, that even the influence of these natural treatments, if there was one, was due to the treatments' effect on evil spirits. The emphasis was clearly on mysterious forces and magic. Even the early Greeks, prior to physicians like Hippocrates, believed that a god inflicted mental illness upon a person for impiety. The Bible perpetuated this belief, which had much to do with how patients with mental illness were treated until modern times.

Hippocrates (ca. 460–377 B.C.) was among the first to liberate medicine and psychiatry from their magico-religious background. As we saw in Chapter 2, the Greeks, starting with Thales, had a tendency to replace mystical explanations with naturalistic explanations. Hippocrates applied the naturalistic outlook to the workings of the human body. In addition to believing that physical health was associated with a balance among the four humors of the body (see Chapter 2), the Hippocratics implicated the brain as a source of mental health or illness:

Men ought to know that from the brain, and from the brain only arise our pleasures, joys, laughter and jests, as well as our

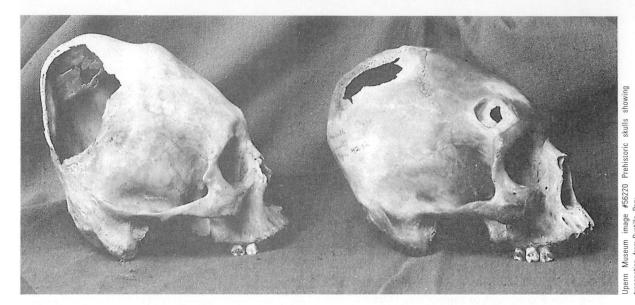

Prehistoric skulls showing trepanation

sorrows, pains, griefs and tears. Through it, in particular, we think, see, hear, and distinguish the ugly from the beautiful, the bad from the good, the pleasant from the unpleasant. ... It is the same thing which makes us mad or delirious, inspires us with dread and fear, whether by night or by day, brings sleeplessness, inopportune mistakes, aimless anxieties, absentmindedness, and acts that are contrary to habit. These things that we suffer all come from the brain, when it is not healthy, but becomes abnormally hot, cold, moist, or dry, or suffers any other unnatural affection to which it is not accustomed. (W. H. S. Jones, 1923, Vol. 2, p. 175)

It was the condition of the brain, then, that determined whether a person was mentally normal or abnormal. Because abnormalities developed when the brain was too hot, cold, dry, or moist, therapy involved providing those experiences that returned the brain to its normal limits.

Besides arguing that all ailments had natural causes, claiming that nature healed and not physi-

cians, and prescribing treatments such as baths, fresh air, and proper diet, the Hippocratics identified several mental illnesses—for example, hysteria, the mental illness that was to become so important in Freud's work. Hysteria is a term used to describe a wide variety of disturbances such as paralysis, loss of sensation, and disturbances of sight and hearing. The Hippocratics accepted the earlier Greek and Egyptian contention that hysteria is a uniquely female affliction. Hystera is the Greek word for "uterus," and it was believed that the symptoms of hysteria are caused by the uterus wandering to various parts of the body. Although later proven false, this view of hysteria represents the biological approach to explaining mental illness.

The naturalistic and humane treatment of patients lasted through the time of Galen (ca. A.D. 129–199), who perpetuated and extended the Hippocratic approach to medicine. Also, as we saw in Chapter 2, Galen expanded the Hippocratic theory of humors into one of the first theories of personality. When the Roman Empire fell in A.D. 476, however, the humane and rational treatment of physical and mental disorders essentially fell with it.

The Return of the Supernatural Approach

When the Romans came to power, they adopted much of the Greek emphasis on knowledge and reason even though they were more concerned with law, technology, and the military than were the Greeks. With the collapse of the Roman Empire came an almost complete regression to the nonrational thinking that had characterized the time before the Greek naturalists:

The collapse of the Roman security system produced a general regression to belief in the magic, mysticism, and demonology from which, seven centuries before, men had been liberated through Greek genius. ... The psychiatry of the Middle Ages can be scarcely distinguished from prescientific demonology, and mental treatment was synonymous with exorcism. ... In medieval exorcism Christian mythology and prehistoric demonology found a quaint union. (Alexander and Selesnick, 1966, pp. 50, 52)

Although W. B. Maher and B. A. Maher (1985) refer to the therapeutic practices that occurred during the Middle Ages as eclectic, the emphasis was on exorcising demons. Even with this emphasis, however, several hospitals scattered throughout Europe treated the old, the sick, and the poor. Evidence also suggests that in many cases, individuals who had mental illness were treated alongside those who were physically ill (Allderidge, 1979). Still, the preferred explanation of mental illness during the Middle Ages was a supernatural one, and the preferred treatment was some form of exorcism. Even with the preoccupation with demons and exorcism, however, witch hunts were not typical during the Middle Ages. Witch hunts occurred primarily during the Renaissance and the Reformation (Kirsch, 1978).

Witch Hunts. Magic, sorcery, and witchcraft have been practiced since the dawn of human history. In Christian Europe, prior to about the middle

of the 14th century, such activities were typically viewed as remnants of paganism and were discouraged with relatively mild sanctions and punishments. During this period, the existence of witches (those in consort with the devil) and witchcraft (the evil work performed by witches) were taken for granted by almost everyone in Europe, especially eastern Europe. Eventually, however, the church became so concerned with witches and their evil deeds that a wholesale, institutionalized persecution of them was begun. The result was a reign of terror that gripped Europe for about three centuries. According to Zusne and Jones (1989), the European persecution of witches occurred mostly between 1450 and 1750, with its peak around 1600.

On December 9, 1484, Pope Innocent VIII issued a papal bull (an official document) that authorized the systematic persecution of witches. In his bull, the Pope authorized Heinrich Kramer and James Sprenger, both Dominican priests and professors of theology, to act as inquisitors in northern Germany. To guide their work, Kramer and Sprenger wrote Malleus Maleficarum (The Witches' Hammer, 1487/1971). The papal bull of 1484 appeared as the preface, giving the book great authority. Also included was a letter of endorsement signed by members of the theology faculty from the University of Cologne; this too added to the book's authority. Indeed, the Malleus became the official manual of the Inquisition. In his introduction to the Malleus, Montague Summers said, "The Malleus lay on the bench of every judge, on the desk of every magistrate. It was the ultimate, unarguable authority. It was implicitly accepted not only by Catholic but by Protestant legislature" (1971, p. viii). Translated into several languages, the Malleus went through 30 editions by 1669and this at a time when bookmaking was very difficult and literacy was very low. Clearly, the Malleus was one of the most popular and influential books of the time.

The *Malleus* begins by attempting to prove the existence of devils and their hosts, witches. The *Malleus* also indicates that if the authors' arguments do not convince the reader, he or she must be the

victim of witchcraft or a heretic. The second part of the book describes how pacts with the devil are made and consummated, the various forms witchcraft can take, and how those suffering from witchcraft can be cured. In general, all disorders, both physical and mental, whose origins were not known (and that was most) were believed to have a supernatural origin; that is, they were assumed to be caused by witchcraft. The list of such disorders included loss of sensory or motor functions, sexual dysfunction (including impotence, sterility, lust, prostitution), hallucinations, visions, mutism, apparitions, drunkenness, melancholy (depression), and somnambulism. Suggested treatments of the bewitched included exorcism, confession, prayer, repetition of holy scripture, visits to holy shrines, and participation in church ceremonies.

Much of the Malleus is concerned with sexual matters. It describes in detail how female witches (who were the vast majority) copulate with incubi (male demons) and how male witches copulate with succubi (female demons). Considerable attention is paid to how witches interfere with human procreation. Of special interest was how witches could deprive men of their penises or make them nonfunctional. It was generally believed that sinful individuals were much more susceptible to witchcraft than were individuals without sin, and abnormal behavior was generally taken as a sign of sinfulness. One of the most grievous sins was sexual lust, which invited possession by a devil or the influence of a witch. Because, according to the authors, women have stronger carnal desires than men, they are much more likely to be witches or to be bewitched. Not surprisingly, the Malleus was consistently harsh on women. According to Ruiz (2002, lecture 17), there was also a political aspect to the witch craze because most accused of being witches in Protestant villages were Catholic and most accused in Catholic villages were Protestant. There may also have been an economic aspect because the property of those convicted of being witches was confiscated and sold.

The final section of the *Malleus* describes how witches are to be forced to confess, tried, and punished. If interrogation and mild punishment were

unsuccessful in eliciting a confession, more extreme measures could be employed, such as the application of a red-hot iron or boiling water (Kramer and Sprenger, p. 233). Eventually, most of the individuals convicted of being witches confessed to swearing allegiance to the devil, eating the flesh of infants, attending witches' sabbaths, or having sexual intercourse with the devil. After confessing, some of the convicted committed suicide, which was taken as further confirmation of their guilt (Kramer and Sprenger, p. 224). The confessions, of course, reinforced the beliefs upon which the witch hunts were based. J. B. Russell (1980) concludes that "only 10% [of those convicted] persisted in denying their guilt to the moment of death" (pp. 79-80). Most convicted of being witches were burned, but others were hanged or beheaded.

Clark (1997) estimates that in Europe between 1450 and 1750 over 200,000 people were accused of witchcraft and 100,000 of them were executed. Of those executed, approximated 80% to 85% were women. It should be noted, however, that arriving at an accurate count of individuals executed because of their presumed involvement in witchcraft is extremely difficult, if not impossible. In fact, evidence suggests that the numbers often given are greatly exaggerated (Trevor-Roper, 1967). For example, Harris (1974) places the number of executions at about 500,000. In any case, as recently as 1692, twenty people were condemned as witches and sentenced to death in Salem, Massachusetts, and the last legal execution of a condemned witch occurred in Glarus, Switzerland, in 1782 (Trevor-Roper, 1967). The preoccupation with witches and witchcraft during the Renaissance and Reformation clearly illustrates how conceptions of mental illness vary with the Zeitgeist. In most places today, witch hunting itself would be perceived as reflecting mental illness.

During the Renaissance, when advances were being made on so many other fronts, witch hunting was widespread, and astrology, palmistry, and magic were extremely popular. Also, conditions were bad for those with mental illness. As we have seen, individuals with mental illness were generally assumed to be bewitched individuals, and they either

roamed the streets or were locked up in "lunatic asylums." One such asylum was the St. Mary of Bethlehem Hospital in London. Established in 1247 as a priory, it was converted to a mental asylum in 1547 by order of Henry VIII. Coming to be known as Bedlam because of the Cockney pronunciation of *Bethlehem*, this institution was typical of such places at the time. Inmates were chained, beaten, fed only enough to remain alive, subjected to bloodletting, and put on public display for visitors.

GRADUAL IMPROVEMENT IN THE TREATMENT OF MENTAL ILLNESS

Even during the 16th century, when witch hunts and trials were very popular, a few courageous people argued that "witches" were not possessed by demons, spirits, or the devil. They argued that the type of behavior "witches" displayed was caused by emotional or physical disorders. One such individual was the ill-tempered, flamboyant Swiss physician Philippus Paracelsus (1493-1541). Paracelsus argued that an understanding of nature should come from experience and not from the blind allegiance to ancient philosophy as was often exemplified by the Scholastics. He noted that herbal remedies employed by common people were often effective in curing disorders. Being an alchemist, he speculated that it was the chemical composition of such remedies that explained their effectiveness, and he performed empirical studies to determine which chemicals could cure specific ailments. Incidentally, in one of his many chemical experiments Paracelsus mixed sulfuric acid and alcohol, thus creating an early harmless anesthetic (Finger, 1994, pp. 160-161). Although Paracelsus rejected demonology, he did believe in a "universal spirit" that permeated nature. When people were in harmony with this spirit, they were healthy; when they were not, they were unhealthy. Paracelsus believed that things such as chemicals, magnets, and the alignments of heavenly bodies could influence one's harmony with nature and therefore one's health. As bizarre as these suggestions were, they tended toward naturalistic explanations of mental disorders and away from supernatural explanations. One of Paracelsus's maxims was, "Keep sorcery out of medicine" (Webster, 1982, p. 80). Paracelsus denounced the cruel treatment of women brought before the Inquisition as witches, saying, "There are more superstitions in the Roman church than in all these women" (Ehrenwald, 1991, p. 195). If the term spiritual is replaced by psychological, the following statement by Paracelsus has a modern ring to it: "There are two kinds of diseases in all men: One of them material and one spiritual. ... Against material diseases material remedies should be applied. Against spiritual diseases spiritual remedies" (Ehrenwald, 1991, pp. 195-196).

According to Alexander and Selesnick (1966), Paracelsus was the second physician to argue against labeling individuals as witches; Agrippa had been the first. Not only did Cornelius Agrippa (1486-1535) argue against witch hunts, but he also saved many individuals from the ordeal of a witch trial. In 1563 Agrippa's student Johann Weyer (1515–1588) published The Deception of Demons, in which he claimed that those labeled as witches or as bewitched were actually mentally disturbed people. Wever's Deception was a carefully written, welldocumented, step-by-step rebuttal of the Malleus Maleficarum. He referred to witch burning as "Godlessness" and condemned theologians, judges, and physicians for tolerating it. Weyer became known to his contemporaries as a crusader against witch hunting, and this was enough for him to be considered weird, insane, or even a witch.

The view that "witches" were actually people with mental illness also found support from Reginald Scot (1538–1599), who wrote *Discovery of Witchcraft* (1584/1964), and from the Swiss psychiatrist Felix Plater (1536–1614). In his book *Practice of Medicine*, Plater outlined several different types of mental disorders, including consternation, foolishness, mania, delirium, hallucinations, convulsions, drunkenness, hypochondria, disturbance of sleep, and unusual dreams. The arguments of such

people were eventually effective. In 1682, for example, Louis XIV of France abolished the death penalty for witches. Although mental illness increasingly came to be viewed as having natural rather than supernatural causes, it was still poorly understood, and people with mental illness were treated very poorly—if they were treated at all. Bloodletting was still the most popular way of treating all ailments, including mental disorders, and methods were devised for inducing shock in patients. One such method was to spin patients very rapidly in a chair; another was to throw several buckets of cold water on chained patients. Physicians would often report dramatic improvement in the condition of a patient following such treatments. These dismal conditions for people with mental illness lasted until the end of the 18th century.

Philippe Pinel

Philippe Pinel (1745-1826) came from a family of physicians and received his medical degree in 1773 from the University of Toulouse. Upon beginning his practice, Pinel was so upset by the greed and insensitivity of his fellow physicians that he moved to Paris, where he concentrated on treating that city's poor people. Pinel became interested in mental illness when a close friend became afflicted with a mental disorder and Pinel could not treat him. He read the existing literature on mental illness and consulted with the so-called experts, finding the information on mental illness essentially worthless except for the work of Joseph Daquin (1733-1815). Daquin believed that mental illness was a natural phenomenon that should be studied and treated by means of the methods of natural science. Pinel and Daquin became close friends, and Daquin dedicated the second edition of his book Philosophy of Madness (1793) to Pinel.

Pinel began writing influential articles in which he argued for the humane treatment of people with mental disturbances. In 1793 he was appointed director of the Bicêtre Asylum, which had been an institution for the insane since 1660. Upon touring the facility, Pinel found that most inmates were chained and guards patrolled the walls to prevent escape. Pinel asked for permission to release the prisoners from their chains, and although the authorities thought Pinel himself was insane for having such a wish, they reluctantly gave him permission. Pinel proceeded cautiously. Starting in 1793, he removed the chains from a small number of inmates and carefully observed the consequences.

The first inmate to be unchained was an English soldier who had once crushed a guard's skull with his chains and was considered to be a violent person. Once released from his chains, the man proved to be nonviolent, and he helped Pinel care for the other inmates. Two years later, the soldier was released from Bicêtre. Pinel gradually removed more inmates from their constraints, improved rations, stopped bloodletting, and forbade all harsh treatment such as whirling an inmate in a chair. In his book A Treatise on Insanity, Pinel said of bloodletting, "The blood of maniacs is sometimes so lavishly spilled, and with so little discernment, as to render it doubtful whether the patient or his physician has the best claim to the appellation madman" (1801/1962, p. 251).

In addition to unchaining inmates and terminating bloodletting and harsh treatment, Pinel was responsible for many innovations in the treatment of mental illness. He segregated different types of patients, encouraged occupational therapy, favored bathing and mild purgatives as physical treatments, and argued effectively against the use of any form of punishment or exorcism. In addition, Pinel was the first to maintain precise case histories and statistics on his patients, including a careful record of cure rates.

Under Pinel's leadership, the number of inmate deaths decreased greatly, and the number of inmates cured and released increased greatly. His success at Bicêtre led to his 1795 appointment as director of La Salpêtrière, the largest asylum in Europe, housing 8,000 insane women. Following the same procedures he had followed at Bicêtre, Pinel had equally dramatic success. When he died of pneumonia in 1826, he was given a hero's funeral attended by not only the most influential people in Europe but also hundreds of ordinary citizens,

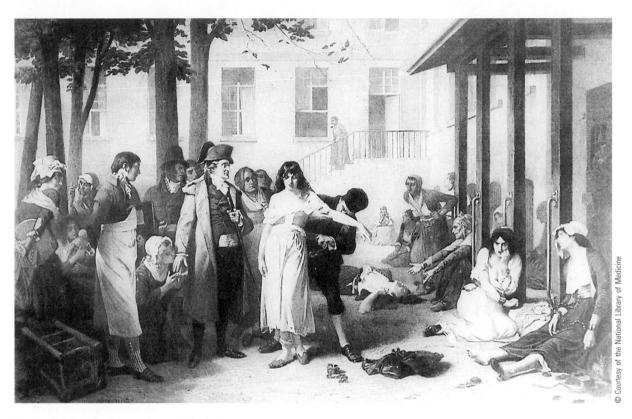

Pinel releasing the insane from their chains

including many former patients at the Bicêtre and La Salpêtrière asylums.

Partially because of Pinel's success and partially because of the Zeitgeist, people throughout Europe and the United States began to argue for the humane treatment of the mentally disturbed. In Britain, William Tuke (1732-1822), a Quaker and a prosperous retired tea and coffee merchant with no medical training, visited a lunatic asylum and was horrified by what he saw. He dedicated the remaining 30 years of his life to improving the plight of those with mental illness, and in 1792 he founded the York Retreat. At the retreat, designed more like a farm than a prison, inmates were given good food, freedom, respect, medical treatment, recreation, and religious instruction. Tuke lived long enough to see his retreat become a model for institutions for people with mental illness throughout the world. After his death, his son and

then his grandson ran the retreat. His great grandson, Daniel Hack Tuke (1827–1895), was the first in the family to receive medical training, and he became a prominent psychiatrist during the Victorian period.

In 1788 Italian physician Vincenzo Chiarugi (1759–1820) was appointed superintendent of Ospidale di Bonifazio, a newly opened hospital for mental illness in Florence. Even before Pinel, Chiarugi had argued that those with mental illness should be spared physical restraint and harsh treatment. He also provided work and recreational activities for his patients and recorded detailed case histories. Chiarugi's advice for dealing with mental illness has a particularly modern ring to it:

It is a supreme moral duty and medical obligation to respect the insane individual as a person. It is especially necessary for the person who treats the mental patient to gain his confidence and trust. It is best, therefore, to be tactful and understanding and try to lead the patient to the truth and to instill reason into him little by little in a kindly way. ... The attitude of doctors and nurses must be authoritative and impressive, but at the same time pleasant and adapted to the impaired mind of the patient. ... Generally it is better to follow the patient's inclinations and give him as many comforts as is advisable from a medical and practical standpoint. (Mora, 1959, p. 431)

It is interesting to note that although both Pinel and Chiarugi argued forcefully for the humane treatment of the mentally ill, their work was guided by different conceptions of mental illness. Pinel's work was guided primarily by the psychological model of mental illness, and Chiarugi's work was guided primarily by the medical model (Gerald, 1997).

Benjamin Rush

Benjamin Rush (1745–1813) had among his friends Thomas Jefferson and John Adams, and he served as surgeon general of the army under George Washington. As a member of the Continental Congress, he was one of the original signers of the Declaration of Independence. Rush had many strong convictions: he argued for the abolition of slavery; he opposed capital punishment, public punishment, and the inhumane treatment of prisoners; he advocated the education of women; and he argued for a greater emphasis on practical information in school curricula.

In 1812 Rush, who is often referred to as the first U.S. psychiatrist, wrote *Medical Inquiries and Observations Upon the Diseases of the Mind*, in which he lamented that people with mental illness were often treated like criminals or "beasts of prey." Instead, he urged that patients be unchained and no longer punished. They should experience fresh air and sunlight and be allowed to go for pleasant walks within their institution. Furthermore, Rush

contended, they should never be on display to the public for the purposes of inhumane curiosity and amusement. Despite his many enlightened views, Rush still advocated bloodletting and the use of rotating and tranquilizing chairs. He believed that bloodletting relieved vascular congestion, that rotating relieved the patient's congested brain, and that strapping a patient's arms and legs in a so-called tranquilizing chair calmed the patient.

Dorothea Lynde Dix

Also in the United States, Dorothea Lynde Dix (1802-1887) in 1841 began a campaign to improve the conditions of the mentally ill. Unhappy home circumstances had forced Dix to leave her home when she was only 10 years old, and when she was 14, she began her career as a schoolteacher. Later, illness caused her to give up her full-time teaching position and take a position teaching female inmates in a Boston prison. It became clear to Dix that many of the women labeled and confined as criminals actually had mental illnesses, and so Dix began her 40-year campaign to improve the plight of those with mental illness, traveling from state to state and pointing out their inhumane treatment. Within a 3-year period, Dix visited 18 states and brought about institutional reforms in most of them. In 1841, when Dix had begun her campaigning, mental hospitals housed only about 15% of those needing care; by 1890, that figure had risen to about 70%. To a large extent, the improvement was due to Dix's efforts.

During the Civil War, Dix served as the Union's superintendent of female nurses; after the war, she toured Europe seeking better treatment of people with mental illness. While in Europe, Dix visited with Queen Victoria and Pope Pius IX, convincing both that these patients were in dire need of better facilities and treatment. For more details concerning the life and work of Dix, see Viney (1996).

As a result of the efforts of such individuals as Pinel, Tuke, Chiarugi, Rush, and Dix, patients with mental illness began to receive better treatment than they had during the Middle Ages and

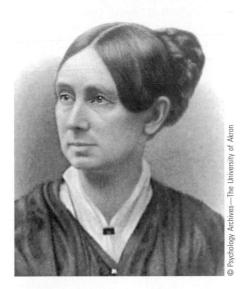

Dorothea Lynde Dix

the Renaissance. However, this treatment involved only the patients' physical surroundings and maintenance. Effective treatment for mental illness itself was still lacking. Alexander and Selesnick (1966) speculate that there were three reasons for the patients' poor treatment, even after it was no longer believed that they were possessed by demons. The reasons were ignorance of the nature of mental illness, fear of those with mental illness, and the widespread belief that mental illness was incurable. The work of such individuals as Kraepelin, Witmer, and the early hypnotists dramatically improved the understanding and treatment of mental illness, and it is to that work that we turn next.

Emil Kraepelin

Emil Kraepelin (1856–1926), a German psychiatrist who did postdoctoral research with Wundt, attempted to do for mental disorders what Wundt and his colleagues attempted to do for sensations—classify them. In 1883 Kraepelin published a list of mental disorders that was so thorough it was adopted the world over and has lasted until recent times. He based his classification of mental diseases on what caused them, how much they involved the

brain and nervous system, their symptoms, and their treatment. Some categories of mental disorders that Kraepelin listed, such as mania and depression, had been first mentioned by Hippocrates 2,300 years earlier. Some other categories of mental illness Kraepelin listed were dementia praecox, characterized by withdrawal from reality, excessive daydreaming, and inappropriate emotional responses; paranoia, characterized by delusions of grandeur or of persecution; manic depression, characterized by cycles of intense emotional outbursts and passive states of depression; and neurosis, characterized by relatively mild mental and emotional disorders. Kraepelin's friend, neurologist Alois Alzheimer (1864-1915), observed that a general loss of memory, reasoning ability, and comprehension sometimes accompanies old age. It was Kraepelin who this condition Alzheimer's disease. dubbed Kraepelin believed that most major mental illnesses, such as dementia praecox, are incurable because they are caused by constitutional factors. When the Swiss psychiatrist Eugen Bleuler (1857-1939) found that dementia praecox could be successfully treated, he changed the name of the disease to schizophrenia, which literally means "a splitting of the personality."

The list of categories of mental illness that many clinicians, psychoanalysts, and psychiatrists currently use as a guide is found in The Diagnostic and Statistical Manual of Mental Disorders, published by the American Psychiatric Association (2000). This manual, referred to simply as DSM, is a direct descendant of Kraepelin's earlier work. Although Kraepelin's classifications brought order to an otherwise chaotic mass of clinical observations, his work is now seen by many as standing in the way of therapeutic progress. People do not fall nicely into the categories that he created, nor are the causes for their disorders always physical in nature, as Kraepelin assumed they were. Still, Kraepelin went a long way toward standardizing the categories of mental illness and thus making communication about them more precise.

For an overview of the many problems associated with attempting to categorize mental illnesses, see Sadler, Wiggins, and Schwartz, 1994. For

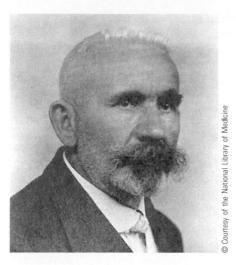

Emil Kraepelin

evidence of the growing dissatisfaction with DSM and suggested alternatives to it, see Beutler and Malik, 2002.

Kraepelin and Psychopharmacology. The use of psychoactive drugs has been reported in the earliest historical records. For example, the benefits of using such drugs as alcohol, opium, and hemp have been recorded by ancient Egyptian, Greek, Roman, Babylonian, Chinese, Hindu, and Arabic physicians. Although most such reports are concerned with the medicinal properties of drugs, there are also reports of using drugs to gain access to spiritual entities or as part of religious rituals (Schmied, Steinberg, and Sykes, 2006, p. 145). Perhaps less known is that Kraepelin was among the first, if not the first, to systematically study the effects of drugs on various cognitive and behavioral functions. In the early 1880s, while studying in Wundt's laboratory, he studied the effects of "poisons," such as alcohol, on various mental functions. Upon leaving Leipzig to take his academic post at Dorpat, he and his assistants continued to study what, in 1892, Kraepelin called pharmacopsychology (Schmied, Steinberg, and Sykes, 2006, p. 146). The effects of alcohol, morphine, caffeine, and other drugs on such intellectual tasks as comprehension, association, and memory were quantified as were

their effects on such behavioral tasks as writing and speech. According to Schmied, Steinberg, and Sykes (2006), Kraepelin was an important pioneer in the field now known as psychopharmacology.

Lightner Witmer

Lightner Witmer (1867–1956) earned his doctorate under Wundt. He was born on June 28 into a prominent Philadelphia family. Witmer earned his bachelor's degree from the University of Pennsylvania in 1888 and then took a position teaching history and English at Rugby Academy, a secondary school in Philadelphia. He remained there for two years while taking classes in law and political science at the University of Pennsylvania. After taking a class from James McKeen Cattell, Witmer resigned his position at Rugby and entered graduate school. Cattell put Witmer to work studying individual differences in reaction times. He intended to earn his doctorate under Cattell, but when Cattell moved to Columbia. Witmer went to Leipzig for his advanced degree. Witmer's training at Leipzig coincided with Titchener's.

In the fall of 1892, Witmer returned from Europe to a faculty position at the University of Pennsylvania, where he taught courses and conducted research as an experimental psychologist in the Wundtian tradition. He remained at Pennsylvania for 45 years. The APA was also founded in 1892, and Witmer became a charter member, along with such individuals as William James, G. Stanley Hall, and James McKeen Cattell. (Incidentally, Witmer was the last charter member to die.) In 1894 the university created special courses for public school teachers, and Witmer became involved in those courses. One teacher's description of the problem a student was having learning to spell strengthened Witmer's developing belief that psychology should provide practical information. The student was a 14-year-old boy who had what would probably be diagnosed today as dyslexia. Witmer decided to work with the student, and this marked the beginning of his career as a clinical psychologist. Soon he offered a special course on how to work with students who were

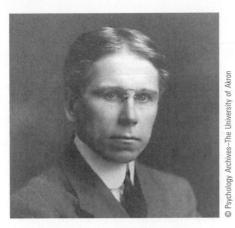

Lightner Witmer

"mentally defective, blind, or criminally disturbed" (McReynolds, 1987, p. 851).

In 1896 Witmer published an article titled "Practical Work in Psychology," and in 1897 he delivered a paper at an APA convention in Boston on the same topic in which he first employed the term psychological clinic. In 1896 Witmer founded the world's first psychological clinic at the University of Pennsylvania, only 17 years after the establishment of Wundt's experimental laboratory. In 1907 Witmer founded the Psychological Clinic journal, which was instrumental in promoting and defining the profession of clinical psychology. The journal continued publication until 1935. To Witmer and others, a new profession was clearly emerging, and it needed to have a name. In the opening article of the first issue of his journal, Witmer named the profession clinical psychology and described the new profession as follows:

Although clinical psychology is clearly related to medicine, it is quite as closely related to sociology and to pedagogy. ... An abundance of material for scientific study fails to be utilized, because the interest of psychologists is elsewhere engaged, and those in constant touch with the actual phenomena do not possess the training necessary to make the experience and observation of scientific value. ... While the

field of clinical psychology is to some extent occupied by the physician, especially by the psychiatrist, and while I expect to rely in a great measure upon the educator and social worker for the more important contributions to this branch of psychology, it is nevertheless true that none of these has quite the training necessary for this kind of work. For that matter, neither has the psychologist, unless he had acquired this training from sources other than the usual course of instruction in psychology. ... The phraseology of "clinical psychology" and "psychological clinic" will doubtless strike many as an odd juxtaposition of terms relating to quite disparate subjects. ... I have borrowed the word "clinical" from medicine, because it is the best term I can find to indicate the character of the method which I deem necessary for this work. ... The methods of clinical psychology are necessarily involved wherever the status of an individual mind is determined by observation and experiment, and pedagogical treatment applied to effect a change, i.e., the development of such individual mind. Whether the subject be a child or an adult, the examination and treatment may be conducted and their results expressed in the terms of the clinical method. (McReynolds, 1987, p. 852)

In 1908 Witmer established a residential school for the care and treatment of retarded and troubled children. This was the first of several such schools that he established. In this same year, Witmer began publishing articles that were highly critical of what he viewed as unscientific, or even fraudulent, ways of treating mental illness. He was especially critical of William James because of James's interest in supernatural phenomena.

McReynolds argues that Witmer should be considered the founder or "father" of clinical psychology, but he recognizes that others may argue that Freud, Binet, or Rogers should be given that honor. McReynolds (1987) makes his case for Witmer as follows:

Witmer's role in the formation of clinical psychology is somewhat analogous to that of Wundt in experimental psychology, in that in each case the individual deliberately and self-consciously defined the existence of a new area and nurtured its early development, but other, later workers were responsible for giving the area greater depth and new directions. In Witmer's case the designation of founder is based primarily on the following six pioneering achievements:

- 1. He was the first to enunciate the idea that the emerging scientific psychology could be the basis of a new helping profession.
- He established and developed the first facility to implement this idea a "psychological clinic," headed by a psychologist and primarily staffed by psychologists.
- 3. He proposed the term *clinical psychology* for the new profession and outlined its original agenda.
- 4. He conceptualized, organized, and carried out the first program to train clinical psychologists in the sense he defined.
- 5. Through his founding and long-time editorship of a journal (*The Psychological Clinic*) specifically intended to be the organ of the new profession, he further defined the area, publicized it, and attracted young persons to it.
- 6. Through his own activities in performing the kinds of professional activities that he envisaged for clinical psychologists, he served as a role model for early members. (pp. 855–856)

Although we have concentrated on Witmer's contributions to clinical psychology, he also made significant contributions to school psychology and special education (see, for example, Fagen, 1992,

1996; McReynolds, 1996, 1997). As far as clinical psychology is concerned, however, Witmer made three lasting impressions:

(a) the idea that scientific psychology, in its rigorous experimental sense, can, if appropriately utilized, be useful in helping people; (b) the conception that this help can best be provided through the instrument of a special profession (clinical psychology) that is independent of both medicine and education; and (c) a commitment to the view that clinical psychology should itself be highly research oriented and should be closely allied with basic psychology. (McReynolds, 1987, p. 857)

It is important to note that Witmer was trained as an experimental psychologist and never wavered in his belief that clinicians should receive rigorous training in scientific methodology, the type of training leading to the Doctor of Philosophy degree (PhD). This tradition of the clinician as a scientistpractitioner has only recently been challenged. In 1973 the APA agreed that the intense scientific training characteristic of the PhD program is not necessary for clinical psychologists and established the Doctor of Psychology degree (PsyD) for those seeking training that emphasizes professional applications rather than research methodology. In Chapter 21, we discuss the current debate over whether clinicians should be PhDs or PsyDs, but as far as Witmer was concerned, clinicians should be scientists—scientists who apply their knowledge to helping troubled individuals.

THE TENSION BETWEEN THE PSYCHOLOGICAL AND MEDICAL MODELS OF MENTAL ILLNESS

As natural science succeeded, people applied its principles to everything, including humans. When applied to humans, mechanism, determinism, and positivism involved the search for a natural cause for all human behavior, including abnormal behavior. After 2,000 years, conditions had returned to almost the point where they had been about the time of Hippocrates; once again people were emphasizing the brain as the seat of the intellect and the emotions.

This return to naturalism was both good and bad for psychology. It was good because it discouraged mysticism and superstition. No longer did people use evil demons, spirits, or forces to explain mental illness. On the negative side, it discouraged a search for the psychological factors underlying mental illness, for it suggested that a search for such factors was a return to demonology. By the mid-19th century, the dominant belief was that the cause of all illness, including mental illness, was disordered physiology or brain chemistry. This belief retarded psychology's search for psychological causes of mental illness, such as conflict, frustration, emotional disturbance, or other cognitive factors. Under the organic, or medical, model of mental illness, psychological explanations of mental illness were suspect. Because it was generally believed that all disorders had an organic origin, classifying "mental" diseases just as organic diseases had been classified made sense, and this is what Kraepelin attempted to do.

The debate still exists between those who seek to explain all human behavior in terms of physiology or chemistry (those following a medical model) and those who stress the importance of mental variables such as conflict, frustration, anxiety, fear, and unconscious motivation (those following a psychological model). This debate is illustrated in the explanations currently offered for alcoholism. Those individuals accepting the medical model claim that alcoholism is a disease that either is inherited (perhaps only as a predisposition) or results from a biochemical imbalance, a metabolic abnormality, or some other biological condition. Those individuals accepting the psychological model are more likely to emphasize the alcoholic's life circumstances in their explanation—circumstances that cause the stress, frustration, conflict, or anxiety from which the alcoholic is presumably attempting to escape.

Some believe that unless an illness has a neurophysiological basis, it is not an illness at all. That is, it is possible for a brain to be diseased and cause various behavior disorders, but in such a case there is no "mental" illness, only an actual physical disease or dysfunction. For example, in his influential book The Myth of Mental Illness (1974), Thomas Szasz, himself a psychiatrist, contends that what has been and is labeled mental illness reflects problems in living or nonconformity but not true illness. Therefore, according to Szasz, the diagnosis of mental illness reflects a social, political, or moral judgment, not a medical one. Of course, problems in living are very real and can be devastating enough to require professional help. According to Szasz, psychiatry and clinical psychology are worthy professions if they view those whom they help as clients rather than patients and have as their goal helping people to learn about themselves, others, and life. They are invalid, or "pseudosciences," if they view their goal as helping patients recover from mental illness.

Szasz argues that the belief that mental illness is a real illness has hurt many more people than it has helped. For one thing, he says, to label problems in living as an illness or as a disease implies that a person is not responsible for solving those problems, that they are circumstances beyond his or her control. Furthermore, Szasz, and others, observed that diagnosing a person as having a particular mental illness may encourage him or her to think and act in ways dictated by the diagnosis:

Such labels, conferred by mental health professionals, are as influential on the patient as they are on his relatives and friends, and it should not surprise anyone that the diagnosis acts on all of them as a self-fulfilling prophesy. Eventually, the patient himself accepts the diagnosis, with all of its surplus meanings and expectations, and behaves accordingly. (Rosenhan, 1973, p. 254)

Kutchins and Kirk (1997) support many of the points made by Rosenhan, 1973.

Although most accepting the psychological model are willing to employ the term *mental illness*,

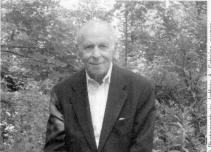

Photograp www.szasz.c

Thomas Szasz

Szasz is not; he prefers to refer to such abnormalities as "problems in life" or "adjustment problems." Farber (1993) describes the ordeal of seven individuals who were diagnosed mentally ill instead of having, as Szasz would say, problems in life.

As we will see in the next chapter, Freud received his medical training within the positivistic tradition of Helmholtz, and he first attempted to explain personality in terms of the medical model. Frustrated, however, he soon was forced to switch to the psychological model. It was, to a large extent, the work of the early hypnotists that caused Freud to change his mind, and it is to that work that we turn next.

THE USE OF HYPNOTISM

Franz Anton Mesmer

It is ironic that the road away from demonology and toward better understanding of mental illness included the work of **Franz Anton Mesmer** (1734–1815). Mesmer's work was eventually judged unscientific, but at one time his theory of animal magnetism was an improvement over the prevailing superstitions. Mesmer obtained his medical degree in 1766 from the University of Vienna. In his dissertation, which was titled "On the Influence of the Planets," he maintained that the planets influence humans through a force called *an*-

imal gravitation. Considering Newton's theory of universal gravitation, this contention did not seem far-fetched.

In the early 1770s, Mesmer met a Jesuit priest named Maximilian Hell, who told Mesmer of cures he had accomplished using a magnet. This was not the first time magnets had been used to treat disorders. Paracelsus and others had used the same technique many years before. Mesmer himself then used a magnet to "cure" one of his patients when all conventional forms of treatment had failed. Next, Mesmer tried the magnetic treatment on other patients with equal success. It should be pointed out that the magnetic treatment always involved telling the patient exactly what was expected to occur.

With the success of his magnetic treatment, Mesmer had the information he needed to challenge one of the most famous exorcists of the late 18th century, an Austrian priest named Johann Gassner (1727–1779), who claimed great success in curing patients by "driving out demons." Mesmer claimed that Gassner's "cures" resulted from the rearrangement of "animal gravitation," not the removal of demons. In the heated debate that ensued, Mesmer won, and exorcism as a form of "psychotherapy" suffered a major setback. As mentioned, this was generally regarded as an improvement in the treatment of mental illness because Mesmer's "cure" was natural (although fallacious) and Gassner's was supernatural.

At first, Mesmer assumed that each person's body contains a magnetic force field. In the healthy individual, this force field is distributed evenly throughout the body, but in the unhealthy individual it is unevenly distributed, causing physical symptoms. By using magnets, it was possible to redistribute the force field and restore the patient's health.

Soon Mesmer concluded that it was not necessary to use iron magnets because anything he touched became magnetized:

Steel is not the only object which can absorb and emanate the magnetic force. On the contrary, paper, bread, wool, silk, leather, stone, glass, water, various metals, wood, dogs, human beings, everything

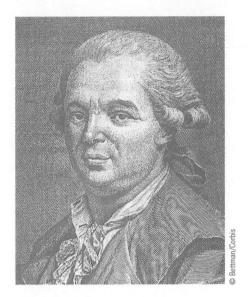

Franz Anton Mesmer

that I touched became so magnetic that these objects exerted as great an influence on the sick as does a magnet itself. I filled bottles with magnetic materials just as one does with electricity. (Goldsmith, 1934, p. 64)

Finally, Mesmer found that he did not need to use any object at all; simply holding his hand next to a patient's body was enough for the patient to be influenced by Mesmer's magnetic force. Mesmer concluded that although all humans contain a magnetic force field, in some people the field is much stronger than in others. These people are natural healers, and he, of course, was one of them.

When magnetic therapy became popular, Father Hell claimed to be the first to have used it. A great dispute followed, which was covered by the newspapers. During this controversy, which Mesmer (probably unjustly) won, the term **animal magnetism** was first used.

In 1777 Mesmer agreed to treat Maria Theresa Paradies, a 17-year-old pianist who had been blind since the age of three. Mesmer claimed that his treatment returned her sight but that she could see only while alone in his presence. The medical

community accused Mesmer of being a charlatan, and he was forced to leave Vienna. He fled to Paris where, almost immediately, he attracted an enthusiastic following. He was so popular that he decided to treat patients in groups rather than individually, and still he was effective. Patients would enter a thickly carpeted, dimly lit, fully mirrored room. Soft music played, and the air was filled with the fragrance of orange blossoms. The patients held iron rods that projected from a baquet, a tub filled with "magnetized" water. Into this scene stepped Mesmer, wearing a lilac cloak and waving a yellow wand. This entire ritual was designed to produce a "crisis" in his patients. During a crisis, a patient would typically scream, break into a cold sweat, and convulse. He noted that when one patient experienced a crisis, others would soon do so also. Thus, treating groups increased not only Mesmer's profits (although poor patients were not charged) but his effectiveness as well. Because of what was later called the contagion effect, many patients who would not respond to suggestion when alone with a physician would do so readily after seeing others respond. As was undoubtedly the case with exorcism and with faith healing, many of Mesmer's patients reported being cured of their ailments. In all these cases, the symptoms removed were probably hysterical—that is, of psychological origin. As we have seen, hysteria refers to a number of symptoms such as blindness, paralysis, and convulsive disorders. Exorcists, faith healers, and Mesmer all probably benefited from the fact that after experiencing a violent emotional episode, a patient's symptoms (especially if these symptoms are hysterical) will subside. By this time Mesmer's treatment was filled with ritual.

As Mesmer's fame grew and thousands came to his clinic, his critics became more severe. The French clergy accused Mesmer of being in consort with the devil, and the medical profession accused him of being a charlatan. In response to the medical profession's criticisms, Mesmer proposed that 20 patients be chosen at random, 10 sent to him for treatment, and 10 sent to members of the French Academy of Medicine; the results would then be compared. Mesmer's interesting proposal was rejected. In 1781

Queen Marie Antoinette, one of Mesmer's many influential friends, offered Mesmer a chateau and a lifetime pension if he would disclose the secrets of his success. Mesmer turned down the offer.

Popularity alone did not satisfy Mesmer. What he desperately wanted was the acceptance of the medical profession, which saw him as a quack. In 1784 the Society of Harmony (a group dedicated to the promotion of animal magnetism) persuaded the king of France to establish a commission to objectively study the effects of animal magnetism. This truly high-level commission consisted of Benjamin Franklin (the commission's presiding officer); Antoine Lavoisier, the famous chemist; and Joseph Guillotin, the creator of a way to put condemned people to death in a "humane" manner. The commission conducted several experiments to test Mesmer's claims. In one experiment, a woman was told that she was being mesmerized by a mesmerist behind a door, and she went into a crisis although there was actually no one behind the door. In another experiment, a patient was offered five cups of water, one of which was mesmerized. She chose and drank a cup with plain water but experienced a crisis anyway.

Much to Mesmer's dismay, in its report of August 1784, the commission concluded that there was no such thing as animal magnetism and that any positive results from treatment supposedly employing it were due to the imagination. The commission branded Mesmer a mystic and a fanatic. Although many people, some of them prominent, urged Mesmer to continue his work and his writing, the commission's findings had essentially destroyed him, and he sank into obscurity.

Although Mesmer became obscure, mesmerism did not, especially in the United States. In January of 1836, Charles Poyen, a Parisian, strode upon the stage of Boston's Chauncey Hall to give the first of a series of lectures on animal magnetism. These lectures piqued the interest of members of the local intelligentsia, including Ralph Waldo Emerson, who embraced the topic enthusiastically (Schmitt, 2005, pp. 403–404). However, Emerson was not alone: "A cohort of Americans took to the practice enthusiastically, publishing materials, presenting

lectures attended by thousands, conducting empirical investigations, and treating untold numbers of ill people" (Schmitt, 2005, pp. 403). The widespread popularity of mesmerism continued for about 20 years. Among the factors leading to its demise were Helmholtz's persuasive experiments that questioned the existence of vital substances, such as magnetism (see Chapter 8), and the discovery that trance could be induced without recourse to magnetism (see below). Nonetheless, "[The mesmerists] helped define the character of psychology for their generation, showing how it was applicable to people's lives and that it was a 'mental science' based on obtaining 'facts' from demonstrable 'experiments'" (Schmitt, 2005, p. 422).

Marquis de Puységur

Although the commission's report silenced Mesmer himself, other members of the Society of Harmony continued to use and modify Mesmer's techniques. One such member, the Marquis de Puységur (1751-1825), discovered that magnetizing did not need to involve the violent crisis that Mesmer's approach necessitated. Simply by placing a person in a peaceful, sleeplike trance, Puységur could demonstrate a number of phenomena. Although the person appeared to be asleep, he or she would still respond to Puységur's voice and follow his commands. When Puységur instructed the magnetized patient to talk about a certain topic, perform various motor activities, or even dance to imagined music, he or she would do so and have no recollection of the events upon waking. Because a sleeplike trance replaced the crisis, Puységur renamed the condition artificial somnambulism. He found that the therapeutic results of using this artificial sleep were as good as they had been with Mesmer's crisis approach.

With his new approach, Puységur made many discoveries. In fact, he discovered most of the hypnotic phenomena known today. He learned that while in the somnambulistic state, individuals are highly suggestible. If they were told something was true, they acted as if it were true. Paralyses

and various sensations, such as pain, could be moved around the body solely by suggestion. When individuals were told that a part of their body was anaesthetized, they could tolerate normally painful stimuli such as burns and pin pricks without any sign of distress. Also, a wide variety of emotional expressions, such as laughing and crying, could be produced on command. It was observed that individuals could not remember what had occurred while in a trance, a phenomenon later called posthypnotic amnesia. What is now called posthypnotic suggestion was also observed. That is, while in a trance, an individual is told to perform some act such as scratching his or her nose when they hear their name. After being aroused from the trance, the individual will typically perform the act as instructed without any apparent knowledge of why he or she is doing so.

John Elliotson, James Esdaile, and James Braid

Because magnetizing a patient could, by suggestion, make him or her oblivious to pain, a few physicians began to look upon magnetism as a possible surgical anesthetic. John Elliotson (1791–1868) suggested that mesmerism be used during surgery, but the medical establishment forbade it even when other anesthetics were not available. In 1842 W. S. Ward performed a leg amputation in which the patient was magnetized, but some physicians accused the patient of being an impostor. Other physicians said that patients should suffer pain during an operation because it helps them recover better (Fancher, 1990). In India, James Esdaile (1808-1859), a surgeon with the British Army in Calcutta, performed more than 250 painless operations on Hindu convicts, but his results were dismissed because his operations had been performed on natives and therefore had no relevance to England. About this time, anesthetic gases were discovered, and interest in magnetism as an anesthetic faded almost completely. The use of gases was much more compatible with the training of the physicians of the day than were the mysterious forces involved in magnetism or somnambulism.

James Braid (1795–1860), a prominent Scottish surgeon, was skeptical of magnetism, but after carefully examining a magnetized subject, he was convinced that many of the effects were real. Braid proceeded to examine the phenomenon systematically, and in 1843 he wrote The Rationale of Nervous Sleep. Braid explained magnetism in terms of prolonged concentration and the physical exhaustion that followed, stressing that the results are explained by the subject's suggestibility rather than by any power that the magnetizer possessed. He renamed the study of the phenomenon neurohypnology, which was then shortened to hypnosis (hypnos is the Greek word for "sleep"). Braid did as much as anyone to make the phenomenon previously known as magnetism, mesmerism, or somnambulism respectable within the medical community.

The Nancy School

Convinced of the value of hypnosis, Auguste Ambroise Liébeault (1823–1904) wanted to use it in his practice but could find no patient willing to be subjected to it. Eventually, he agreed to provide free treatment to any patient willing to undergo hypnotism. A few patients agreed, and Liébeault was so successful that his practice was quickly threatened by an excess of nonpaying patients. Soon Liébeault was treating all his patients with hypnotism and accepting whatever fee they could afford. A "school" grew up around his work, and because he practiced in a French village just outside of the city of Nancy, it was called the Nancy school.

The school attracted a number of physicians; among them **Hippolyte Bernheim** (1840–1919), who became the major spokesperson of the Nancy school. Bernheim contended that *all* humans are suggestible but that some are more suggestible than others, and highly suggestible people are easier to hypnotize than those less suggestible. Furthermore, Bernheim found that whatever a highly suggestible patient believed would improve his or her symptoms usually did so.

Charcot's Proposed Explanation of Hypnosis and Hysteria

When Jean-Martin Charcot (1825–1893) became the director of La Salpêtrière (the institution where Pinel had released the patients from their chains) in 1862, he immediately converted it into a research center. Though flamboyant, Charcot was considered one of the most brilliant physicians in all of Europe. Space does not permit presenting a complete list of Charcot's impressive accomplishments as a neurologist, but a sample includes the following: He carefully observed his patients' symptoms, and upon their death he correlated those symptoms with specific

abnormalities in the brain and spinal cord. He and his colleagues identified features of the spinal cord associated with poliomyelitis and multiple sclerosis. He described a disease of the motor neurons still referred to as Charcot's disease. He helped identify brain structures associated with a number of behavioral and physiological functions. And he instituted temperature taking as a daily hospital routine. Because of these and other accomplishments, Charcot's La Salpêtrière became a place of pilgrimage for physicians from throughout the world; it became "the mecca of neurologists" (E. Jones, 1953, p. 207). Among those attending Charcot's lectures and demonstrations were Alfred Binet, William James, and Sigmund Freud, who

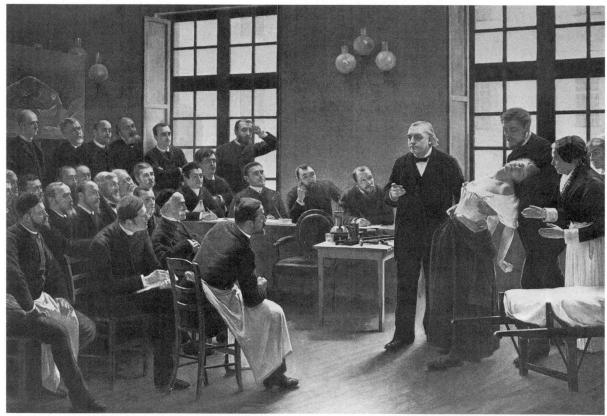

Charcot demonstrating various hypnotic phenomena

Rettmann/CORR

studied with Charcot from October 13, 1885, to February 28, 1886.

Charcot's interests increasingly turned to hysteria, an ailment most physicians dismissed as malingering because they could find no organic cause for its symptoms. Charcot rejected the popular malingering theory and concluded that hysteric patients are suffering from a real disease. Staying within the medical model, however, he concluded that hysteria is caused by a hereditary neurological degeneration that is progressive and irreversible. Because both hysteria and hypnosis produce the same symptoms (such as paralyses and anesthesia), Charcot concluded that hypnotizability indicated the presence of hysteria. Charcot's belief that only those people suffering from hysteria could be hypnotized brought him into sharp conflict with members of the Nancy school—the former believing that hypnotizability is a sign of mental pathology, the latter believing that it is perfectly normal. The debate was heated and lasted for years. Toward the end of his life, Charcot admitted that his theory of suggestibility was wrong and that of the Nancy school was correct.

In his effort to explain hysteria and hypnotic phenomena, the otherwise positivistic Charcot became highly speculative. He noted that several of his hysteric patients had suffered a traumatic experience (such as an accident) prior to the onset of their symptoms. Often the accidents were not severe enough to cause neurological damage, but Charcot speculated that the accidents may have caused ideas that, in turn, caused the symptoms associated with hysteria. Among the more dramatic symptoms associated with hysteria are paralysis of various parts of the body and insensitivity to pain. Specifically, Charcot assumed that trauma had caused certain ideas to become dissociated from consciousness and, thus, isolated from the restrictions of rational thought. In this way an idea caused by trauma "would be removed from every influence, be strengthened, and finally become powerful enough to realize itself objectively through paralysis" (Webster, 1995, p. 67). Contrary to the positivistic medicine that Charcot had previously accepted, he now speculated that hysterical symptoms (such as paralysis) had a psychological rather

than an organic origin. Charcot referred to the paralyses he observed in his hysteric patients as "those remarkable paralyses depending on an idea, paralyses by imagination" (Webster, 1995, p. 68).

According to Charcot, the sequence of events from trauma to pathogenic ideas (ideas that produce physical symptoms) to the symptoms themselves could occur only in individuals who were inherently predisposed to hysteria. Also, as we have seen, Charcot believed for many years that only individuals predisposed to hysteria could be hypnotized. With hypnosis, the hypnotist's suggestions created the same "annihilation of the ego" as did traumatic experience. Thus, Charcot's explanation of hysteria and hypnotic phenomena combined biology (the inherited potential for hysteria) and psychology (the pathogenic ideas caused by trauma or suggestion). Uncharacteristically, Charcot accepted his speculations as fact: "No sooner had Charcot formulated this completely speculative solution to his two major scientific problems [hysteria and hypnosis] than he began to treat it as if it were an established scientific fact" (Webster, 1995, p. 67).

By coincidence, Freud was studying with Charcot as Charcot was formulating the preceding theory. Freud accepted the theory uncritically and returned to Vienna believing that ideas could lodge in the unconscious portion of the mind where they could produce bodily symptoms:

[Freud's] experience in Paris had ... a profound effect on him and he returned not so much as a student reporting on a study-trip as a zealot who had undergone a religious conversion. The new gospel which he brought with him ... was ... the idea that physical illnesses could have a purely psychological origin. (Webster, 1995, p. 100)

(Libbrecht and Quackelbeen, 1995; and Webster, 1995, provide more detailed discussions of Charcot's theory of hysteria and its impact on Freudian thought.)

Pierre Janet (1859–1947) was Charcot's student, and he agreed with his mentor that for some

individuals, aspects of the personality could become dissociated, or "split off," and these dissociated aspects of the personality could manifest themselves in hysteric symptoms or in hypnotic phenomena. Janet, like Charcot, speculated that both might result from the "subconscious" influence of dissociated aspects of personality. He noticed that the dissociated aspects of a patient's personality quite often consist of traumatic or unpleasant memories, and it was therefore the therapist's task to discover these memories and make the patient aware of them. Hypnosis was used to discover these dissociated memories, and when they were brought to the attention of a patient, his or her hysterical symptoms often abated. (For a more detailed account of Janet's work, see Ellenberger, 1970.)

As was the case with Charcot, we see much in Janet's work that anticipated Freud's. Even the names used to describe their methods were similar; Janet called his method psychological analysis, and Freud called his psychoanalysis. The ideas of Janet and Freud were so similar that there was a dispute between the two over priority (R. I. Watson, 1978).

It is important to note that the discussion of hypnosis featured in this chapter is not only of historical interest. The nature of hypnosis continues to be debated within contemporary psychology. For a review of current questions and controversies concerning hypnosis see, for example, Kirsch and Lynn, 1995.

SUMMARY

Although mental illness has been referred to by different names throughout history, all those names appear to refer to the same types of behavior or thought processes—namely, behavior that is harmful to oneself or others, unrealistic thoughts and perceptions, inappropriate emotions, and unpredictable behavior. Early explanations of mental illness fall into three categories: biological explanations (the medical model), psychological explanations (the psychological model), and supernatural or magical explanations (the supernatural model). How mental illness was treated was largely determined by what its causes were assumed to be. All forms of psychotherapy, however, involved a sufferer, a helper, and some form of ritual. If the psychological model of mental illness was assumed, then treatment involved such things as the analysis of dreams, encouragement and support, or the teaching of more effective coping skills. If the supernatural model was assumed, then treatment consisted of such things as exorcism, incantation, or magical ritual. If the biological model was assumed, then treatment consisted of such things as proper exercise, proper diet, massage, bloodletting, purgatives, or drugs. Hippocrates was among the first to accept the biological model of illness (both physi-

cal and mental). He saw physical health resulting from a balance among the four humors of the body and illness resulting from an imbalance among them. He saw mental illness resulting primarily from abnormal conditions in the brain. To regain health, either physical or mental, the Hippocratics prescribed such naturalistic remedies as mineral baths, fresh air, and proper diets. The Hippocratics also identified a number of mental illnesses, including hysteria.

Naturalistic medicine and psychiatry characterized treatment of physical and mental problems until the collapse of the Roman Empire, when there was a regression to demonology and magic. During the Middle Ages, and especially during the Renaissance, those with mental illness were believed to be possessed by evil spirits and were harshly treated. But even during this dark time in history for those with mental illness, some people refused to believe that abnormal behavior resulted from possession of the person by demons, spirits, or the devil. Paracelsus, Agrippa, Weyer, Scot, and Plater argued effectively that abnormal behavior had natural causes and that people with mental illness should be treated humanely. Even when the supernatural explanation of mental illness subsided,

however, patients were still treated harshly in "lunatic asylums" such as Bedlam. Not until the end of the 18th century did Pinel, Tuke, Chiarugi, Rush, Dix, and others help bring about dramatically better living conditions for people with mental illness. Through the efforts of these pioneers, many patients were unchained; given better food; provided recreation, fresh air, sunlight, and medical treatment; and treated with respect.

In 1883 Kraepelin summarized all categories of mental illness known at that time; he attempted to show the origins of the various disorders and how the disorders should be treated. Kraepelin also performed pioneering research in the field that came to be called psychopharmacology. One of the charter members of the APA, Lightner Witmer, was trained as a Wundtian experimental psychologist but became increasingly interested in using psychological principles to help people. He coined the term clinical psychology, established the world's first psychological clinic in 1896 (and subsequently several others), developed the first curriculum designed to train clinical psychologists, and founded the first journal devoted to the diagnosis and treatment of mental illness. By the mid-19th century, the medical model of illness (both physical and mental) prevailed just as it had before the collapse of the Roman Empire. The prevalence of the medical model discouraged a search for the psychological causes of mental illness because it was believed that such a search exemplified a return to a form of demonology. Although psychological explanations of mental illness became more respectable, there was and is a tension between those accepting the medical model and those accepting the psychological model. Szasz contends that mental illness is a myth because it has no organic basis. To him, what is called mental illness is more accurately described as problems in living, and individuals should have the responsibility for solving those problems rather than attributing them to some illness or disease.

The work of Mesmer played a crucial role in the transition toward objective psychological explanations of mental illness. Mesmer believed that physical and mental disorders are caused by the uneven distribution of animal magnetism in the patient's body. He also believed that some people have stronger magnetic force fields than others and that they, like himself, are natural healers. Mesmer contended that his extraordinary powers could redistribute the magnetic fields in clients and thereby cure them. Because of something later to be called the contagion effect, some of Mesmer's clients were more easily "cured" in a group than individually. Even after Mesmer fell into professional disrepute, mesmerism remained influential, especially in the United States.

Puységur discovered that placing clients in a sleeplike trance, which he called artificial somnambulism, was as effective as Mesmer's crisis-oriented approach for treating disorders. Puységur explained this sleeplike state as the result of suggestibility. He also discovered the phenomena of posthypnotic suggestion and posthypnotic amnesia. Because "magnetizing" patients made them insensitive to pain, several physicians used it as an anesthetic. This technique was controversial, however, and physicians dropped it when anesthetic gases such as ether were discovered. By systematically studying hypnosis and attempting to explain it as a biological phenomenon, Braid gave it greater respectability in the medical community. Members of the Nancy school, such as Liébeault and Bernheim, believed that all humans are more or less suggestible and therefore hypnotizable; Charcot, in contrast, believed that only hysterics are hypnotizable. Unlike most other physicians of his day, Charcot treated hysteria as a real rather than an imagined illness. Charcot theorized that traumatic experiences cause ideas to become dissociated from consciousness and thus from rational consideration. In such isolation, the dissociated ideas became powerful enough to cause the bodily symptoms associated with hysteria. In hysteric patients, hypnotism also causes dissociation and thus, according to Charcot, hypnotic phenomena and the symptoms of hysteria have much in common. Charcot's speculation that unconscious ideas could cause bodily symptoms played a significant role in Freud's subsequent work. Like Charcot, Janet believed that aspects of the personality, such as traumatic memories, could become dissociated from the rest of the personality and that such

dissociation explains both hysterical symptoms and hypnotic phenomena. Janet found that often when a patient became aware of and dealt with a dissociated memory, his or her hysterical symptoms would improve.

DISCUSSION QUESTIONS

- 1. What is mental illness? In your answer, include the criteria that have been used throughout history to define mental illness.
- Summarize the medical, psychological, and supernatural models of mental illness and give an example of each.
- 3. What, if anything, do all versions of psychotherapy have in common?
- 4. Describe what therapy would be like if it were based on the psychological model of mental illness, on the supernatural model, and on the biological model.
- 5. Define and give an example of homeopathic and contagious magic.
- 6. How did Hippocrates define *health* and *illness*? What treatments did he prescribe for helping his patients regain health?
- 7. When did witch hunting reach its peak in Europe? How did the publishing of the *Malleus Maleficarum* facilitate witch hunting? What were some of the signs taken as proof that a person was a witch or was bewitched? Why was it assumed that women were more likely to be witches or bewitched than men?
- 8. In what ways did individuals such as Paracelsus, Agrippa, Weyer, Scot, and Plater improve the plight of the mentally ill?
- 9. What significance did Pinel have in the history of the treatment of the mentally ill? Rush? Dix?

- 10. Why was Kraepelin's listing of the various mental disorders seen as something both positive and negative?
- 11. Summarize the reasons Witmer is considered the founder of clinical psychology.
- 12. Describe and give an example exemplifying the tension between explanations of mental illness based on the medical model and those based on the psychological model.
- 13. Why does Szasz refer to mental illness as a myth? Why does he feel that labeling someone as mentally ill may be doing him or her a disservice?
- 14. According to Mesmer, what causes mental and physical illness? What procedures did Mesmer use to cure such illnesses? What was Mesmer's fate?
- 15. In what way could Mesmer's techniques be considered an improvement over other techniques of treating mental illness that existed at the time?
- 16. What major phenomena did Puységur observe during his research on artificial somnambulism?
- 17. Describe the debate that occurred between members of the Nancy school and Charcot and his colleagues over hypnotizability. Who finally won the debate?
- 18. Summarize the theory that Charcot proposed to explain hysteria and hypnotic phenomena.

SUGGESTIONS FOR FURTHER READING

Ehrenwald, J. (Ed.). (1991). *The history of psychotherapy*. Northvale, NJ: Jason Aronson.

Farber, S. (1993). Madness, heresy, and the rumor of angels: The revolt against the mental health system. Chicago: Open Court.

- Kramer, H., & Sprenger, J. (1971). The malleus maleficarum (M. Summers, Trans.). New York: Dover. (Original work published 1487)
- Maher, B. A., & Maher, W. B. (1985). Psychopathology: II. From the eighteenth century to modern times. In G. A. Kimble, & K. Schlesinger (Eds.), *Topics in the history of psychology* (Vol. 2, pp. 295–329). Hillsdale, NJ: Erlbaum.
- Maher, W. B., & Maher, B. A. (1985). Psychopathology:
 I. From ancient times to the eighteenth century. In G. A. Kimble, & K. Schlesinger (Eds.), Topics in the history of psychology (Vol. 2, pp. 251–294). Hillsdale, NJ: Erlbaum.
- McReynolds, P. (1987). Lightner Witmer: Little-known founder of clinical psychology. *American Psychologist*, 42, 849–858.

- McReynolds, P. (1997). Lightner Witmer: His life and times. Washington, DC: American Psychological Association.
- Porter, R. (2002). *Madness: A brief history*. New York: Oxford University Press.
- Roccatagliata, G. (1986). *A history of ancient psychiatry*. New York: Greenwood Press.
- Szasz, T. S. (1974). The myth of mental illness: Foundations of a theory of personal conduct (rev. ed.). New York: Harper & Row.
- Viney, W. (1996). Dorothea Dix: An intellectual conscience for psychology. In G. A. Kimble, C. A. Boneau, & M. Wertheimer (Eds.), *Portraits of pioneers in psychology* (Vol. 2, pp. 15–31). Washington, DC: American Psychological Association.

GLOSSARY

Animal magnetism A force that Mesmer and others believed is evenly distributed throughout the bodies of healthy people and unevenly distributed in the bodies of unhealthy people.

Artificial somnambulism The sleeplike trance that Puységur created in his patients. It was later called a hypnotic trance.

Bernheim, Hippolyte (1840–1919) A member of the Nancy school of hypnotism who believed that anything a highly suggestible patient believed would improve his or her condition would do so.

Charcot, Jean-Martin (1825–1893) Unlike most of the physicians of his day, concluded that hysteria was a real disorder. He theorized the inherited predisposition toward hysteria could become actualized when traumatic experience or hypnotic suggestion causes an idea or a complex of ideas to become dissociated from consciousness. Isolated from rational control, such dissociated ideas become powerful enough to cause the symptoms associated with hysteria, for example, paralysis.

Clinical psychology The profession founded by Witmer, the purpose of which was to apply the principles derived from psychological research to the diagnosis and treatment of disturbed individuals.

Contagion effect The tendency for people to be more susceptible to suggestion when in a group than when alone.

Contagious magic A type of sympathetic magic. It involves the belief that what one does to something that a person once owned or that was close to a person will influence that person.

Dix, Dorothea Lynde (1802–1887) Caused several states (and foreign countries) to reform their facilities for treating mental illness by making them more available to those needing them and more humane in their treatment.

Hippocrates (ca. 460–377 B.C.) Argued that all mental and physical disorders had natural causes and that treatment of such disorders should consist of such things as rest, proper diet, and exercise.

Homeopathic magic The type of sympathetic magic involving the belief that doing something to a likeness of a person will influence that person.

Janet, Pierre (1859–1947) Like Charcot, theorized that components of the personality, such as traumatic memories, could become dissociated from the rest of the personality and that these dissociated components are responsible for the symptoms of hysteria and for hypnotic phenomena.

Kraepelin, Emil (1856–1926) Published a list of categories of mental illness in 1883. Until recent times, many clinicians used this list to diagnose mental illness. Today the *Diagnostic and Statistical Manual of Mental Disorders*

(2000) serves the same purpose. Kraepelin was also a pioneer in the field known today as psychopharmacology.

Liébeault, Auguste Ambroise (1823–1904) Founder of the Nancy school of hypnotism.

Medical model of mental illness The assumption that mental illness results from such biological causes as brain damage, impaired neural transmissions, or biochemical abnormalities.

Mental illness The condition that is said to exist when a person's emotions, thoughts, or behavior deviate substantially from what is considered to be normal at a certain time and place in history.

Mesmer, Franz Anton (1734–1815) Used what he thought were his strong magnetic powers to redistribute the magnetic fields of his patients, thus curing them of their ailments.

Nancy school A group of physicians who believed that because all humans are suggestible, all humans can be hypnotized.

Natural law The belief prevalent in the 18th century that undesirable or sinful behavior has negative consequences such as mental or physical disease or poverty, and virtuous behavior has positive consequences such as good health or prosperity.

Pinel, Philippe (1745–1826) Among the first, in modern times, to view people with mental illness as sick people rather than criminals, beasts, or possessed individuals. In the asylums of which he was in charge, Pinel ordered that patients be unchained and treated with kindness in a peaceful atmosphere. Pinel was also responsible for many innovations in the treatment and understanding of mental illness.

Posthypnotic amnesia The tendency for a person to forget what happens to him or her while under hypnosis.

Posthypnotic suggestion A suggestion that a person receives while under hypnosis and acts on when he or she is again in the waking state.

Psychological model of mental illness The assumption that mental illness results from such psychological causes as conflict, anxiety, faulty beliefs, frustration, or traumatic experience.

Psychotherapy Any attempt to help a person with a mental disturbance. What all versions of psychotherapy have had in common throughout history are a sufferer, a helper, and some form of ritualistic activity.

Puységur, Marquis de (1751–1825) Found that placing patients in a sleeplike trance was as effective in alleviating ailments as was Mesmer's approach, which necessitated a crisis. He also discovered a number of basic hypnotic phenomena.

Rush, Benjamin (1745–1813) Often called the first U.S. psychiatrist. Rush advocated the humane treatment of people with mental illness but still clung to some earlier treatments, such as bloodletting and the use of rotating chairs.

Supernatural model of mental illness The assumption that mental illness is caused by malicious, spiritual entities entering the body or by the will of God.

Sympathetic magic The belief that by influencing things that are similar to a person or that were once close to that person, one can influence the person. (*See also* **Homeopathic magic** and **Contagious magic**.)

Trepanation The technique of chipping or drilling holes in a person's skull, presumably used by primitive humans to allow evil spirits to escape.

Witmer, Lightner (1867–1956) Considered to be the founder of clinical psychology.

Psychoanalysis

hen psychology became a science, it became first a science of conscious experience and later a science of behavior. Representatives of psychology's early schools—for example, Wundt, Titchener, and James—were aware of unconscious processes but dismissed them as unimportant. The methodological behaviorists, such as Tolman and McDougall, postulated conscious but not unconscious cognitive constructs. The radical behaviorists, such as Watson and Skinner, refused even to admit consciousness into their psychology; thus, the study of the unconscious would have been unthinkable. And although Gestalt psychology was mentalistic, it concentrated entirely on phenomenological conscious experience.

How then could a psychology that emphasized the unconscious mind emerge? The answer is that it did not come from academic or experimental psychology. Indeed, it did not come from the tradition of empiricism and associationism at all, as so much of psychology had. Rather, it came from clinical practice. Those who developed the psychology of the unconscious were not concerned with experimental design or the philosophy of science; nor were they concerned with substantiating the claims of the associationists. They were concerned with understanding the causes of mental illness and using that understanding to help mentally ill patients.

By emphasizing the importance of unconscious processes as causes of mental illness (and later of most human behavior), this band of individuals set themselves apart not only from the psychologists of the time but also from the medical profession. The medical profession had been strongly influenced by the mechanistic-positivistic philosophy, according to which physical events caused all illness. For example, physicians explained abnormal behavior in terms of brain damage or

biochemical imbalance. If they used the term *mental illness* at all, it was as a descriptive term because they believed that all illnesses have physical origins.

The stressing of *psychological* causes of mental illness separated this small group of physicians from both their own profession and academic psychology. Theirs was not an easy struggle, but they persisted; in the end, they had convinced the medical profession, academic psychology, and the public that unconscious processes must be taken into consideration in understanding why people act as they do. Sigmund Freud was the leader of this group of rebels, but before we examine his work, we consider some of the antecedents of his work.

DEVELOPMENT OF PSYCHOANALYSIS

As we saw in the last chapter, both hypnotic phenomena and Charcot's proposed explanation of hysteria had a strong influence on the development of Freud's theory, but there were several other influences as well. In fact, a case can be made that all components of what was to become psychoanalysis existed before Freud began to formulate that doctrine. Some of those components were very much a part of the German culture in which Freud was raised, and others he learned as a medical student trained in the Helmholtzian tradition. We briefly review the philosophy, science, and literature of which Freud was aware and that later emerged in one form or another in Freud's formulation of psychoanalysis.

Leibniz (1646–1716), with his monadology, showed that depending on the number of monads involved, levels of awareness could range from clear perception (apperception) to experiences of which we are unaware (petites perceptions). Goethe (1749–1832) was one of Freud's favorite authors, and the major thrust of psychoanalysis was certainly

compatible with Goethe's description of human existence as consisting of a constant struggle between conflicting emotions and tendencies. Herbart (1776-1841) suggested that there is a threshold above which an idea is conscious and below which an idea is unconscious. He also postulated a conflict model of the mind because only ideas compatible with each other could occur in consciousness. If two incompatible ideas occur in consciousness, one of them is forced below the threshold into the unconscious. Herbart used the term repression to denote the inhibiting force that keeps an incompatible idea in the unconscious. As far as the notion of the unconscious is concerned, Boring said, "Leibniz foreshadowed the entire doctrine of the unconscious, but Herbart actually began it" (1950, p. 257).

Schopenhauer (1788-1860) believed that humans are governed more by irrational desires than by reason. Because the instincts determine behavior, humans continually vacillate between being in a state of need and being satisfied. Schopenhauer anticipated Freud's concept of sublimation when he said that we could attain some relief or escape from the irrational forces within us by immersing ourselves in music, poetry, or art. One could also attempt to counteract these irrational forces, especially the sex drive, by living a life of asceticism. Schopenhauer also spoke of repressing undesirable thoughts into the unconscious and of the resistance one encounters when attempting to recognize repressed ideas. Although Freud credited Schopenhauer as being the first to discover the processes of sublimation, repression, and resistance, Freud also claimed that he had discovered the same processes independently.

Nietzsche (1844–1900)—and later, Freud—saw humans as engaged in a perpetual battle between their irrational (Dionysian) and rational (Apollonian) tendencies. According to Nietzsche, it is up to each person to create a unique blend of these tendencies within his or her own personality, even if doing so violates conventional morality. Like Herbart, Fechner (1801–1887) employed the concept of threshold in his work. More important to Freud, however, was that Fechner likened the

mind to an iceberg, consciousness being the smallest part (about 1/10), or the tip, and the unconscious mind making up the rest (about 9/10). Besides borrowing the iceberg analogy of the mind from Fechner, Freud also followed Fechner in attempting to apply the recently discovered principle of the conservation of energy to living organisms. Freud said, "I was always open to the ideas of G. T. Fechner and have followed that thinker upon many important points" (E. Jones, 1953, p. 374). By showing the continuity between humans and other animals, Darwin (1809-1882) strengthened Freud's contention that humans, like nonhuman animals, are motivated by instincts rather than by reason. According to Freud, it is our powerful animal instincts, such as our instincts for sexual activity and for aggression, that are the driving forces of personality, and it is these instincts that must be at least partially inhibited for civilization to exist. As was the case with most scientists of his day, Freud's view of evolution combined Darwinian and Lamarckian principles.

Representing the positivistic approach to medicine and psychology, Helmholtz (1821-1894) tolerated no metaphysical speculation while studying living organisms, including humans. His approach, which permeated most of medicine and physiology at the time, initially had a profound effect on Freud. However, Freud soon abandoned Helmholtz's materialism and switched from a medical (biological) to a highly speculative psychological model in his effort to explain human behavior. Also important for Freud was Helmholtz's concept of the conservation of energy. Helmholtz demonstrated that an organism is an energy system that could be explained entirely on the basis of physical principles. Helmholtz demonstrated that the energy that comes out of an organism depends on the energy that goes into it; no life force is left over. Taking Helmholtz's idea of the conservation of energy and applying it to the mind, Freud assumed that only so much psychic energy is available at any given time and that it could be distributed in various ways. How this finite amount of energy is distributed in the mind accounts for all human behavior and thought. Brentano (1838-1917) was one of

Freud's teachers at the University of Vienna when Freud was in his early twenties. Brentano taught that motivational factors are extremely important in determining the flow of thought and that there are major differences between objective reality and subjective reality. This distinction was to play a vital role in Freud's theory. Under the influence of Brentano, Freud almost decided to give up medicine and pursue philosophy (which was Brentano's main interest); but Ernst Brücke (1819–1892), the positivistic physiologist, influenced Freud even more than Brentano, and Freud stayed in medicine.

Karl Eduard von Hartmann (1842-1906) wrote a book titled Philosophy of the Unconscious (1869), which went through 11 editions in his lifetime. During the time that Freud was studying medicine and later when he was developing his theory, the idea of the unconscious was quite common in Europe, and no doubt every reasonably educated person was familiar with the concept. Hartmann was strongly influenced by both Schopenhauer's philosophy and Jewish mysticism. For him, there were three types of unconsciousness: processes that govern all natural phenomena in the universe; the physiological unconscious, which directs the bodily processes; and the psychological unconscious, which is the source of all behavior. Although Hartmann's position was primarily mystical, it had some elements in common with Freud's theory, especially the notion of the psychological unconscious. (For an account of how Hartmann influenced Freud, see Capps, 1970.)

Clearly then, the notions of an active, dynamic mind with a powerful unconscious component were very much part of Freud's philosophical heritage. As we will see, other aspects of Freud's theory—such as infantile sexuality, the emphasis on the psychological causes of mental illness, psychosexual stages of development, and even dream analysis—were not original with Freud. Freud's accomplishment was synthesizing all these elements into a comprehensive theory of personality: "Much of what is credited to Freud was diffuse current lore, and his role was to crystallize these ideas and give them an original shape" (Ellenberger, 1970, p. 548).

SIGMUND FREUD

Sigmund Freud (1856–1939) was born on either March 6 or May 6 in Freiberg, Moravia (now Pribor, Czech Republic). His father, Jakob, was a wool merchant who had 10 children. Both his grandfather and his great-grandfather were rabbis. Freud considered himself a Jew all his life but had a basically negative attitude toward Judaism as well as Christianity. Jakob's first wife (Sally Kanner), whom he married when he was 17 years old, bore him two children (Emanuel and Philipp); his second wife apparently bore him none; and his third wife Amalie Nathansohn bore him eight children, of whom Sigmund was the first. In 1968 examination of the town records of Freiberg revealed that Jakob Freud's second wife was a woman named Rebecca, about whom practically nothing is known. Earlier the town records indicated that Freud's birth date was March 6, not May 6 as was claimed by the family and as has been traditionally reported as Freud's birth date. Ernest Jones, Freud's official biographer, believed that the discrepancy reflected only a clerical error, but others see it as having greater significance. Balmary (1979) speculates that Freud's parents reported the birth date of May 6 instead of March 6 to conceal the fact that Freud's mother was pregnant with Sigmund when she married Jakob. Balmary believes that both "family secrets" (the facts that Freud's mother was Jakob's third wife and not his second, as the family had reported, and that Amalie was pregnant when she married) had a significant influence on Freud's early views and therefore on his later theorizing. In any case, when Sigmund was born, his father was 40 years old and already a grandfather, and his mother was a youthful 20. Among the paradoxes that young Freud had to grapple with were the facts that he had half-brothers as old as his mother and a nephew older than he was. Sigmund was the oldest child in the immediate family, however, and clearly Amalie's favorite. Freud and his mother had a close, strong, and positive relationship, and he always felt that being the indisputable favorite child of his young mother had much to do with his success. Because his mother believed that he was special,

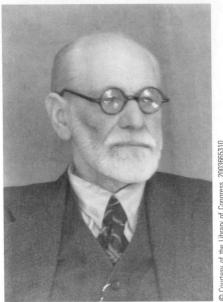

Congress, the Library of Courtesy

Sigmund Freud

he came to believe it too; therefore, much of what he accomplished later was due, he thought, to a type of self-fulfilling prophecy. Freud's father lived 81 years, and his mother lived until 1930, when she died at the age of 95, only eight years before her son Sigmund.

When Jakob's business failed, the Freuds moved first to Leipzig and then, when Sigmund was age 4, to Vienna. From early on, Sigmund showed great intellectual ability; to aid his studies, he was given an oil lamp and a room of his own—the only one in the large household to have those things. His mother would often serve him his meals in his room, and a piano was taken away from one of his sisters because the music bothered him. Sigmund began reading Shakespeare when he was eight years old, and he deeply admired that author's power of expression and understanding of human nature all his life. Freud also had an amazing gift for languages. As a boy, he taught himself Latin, Greek, French, Spanish, Italian, and English, and later in life he became an acknowledged master of German prose. He entered high school at age 9 (a year earlier than normal) and was always at the head of his class; at age 17, he graduated summa cum laude.

Until his final year of high school, Freud was attracted to a career in law or politics, or even in the military; but hearing a lecture on Goethe's essay on nature and reading Darwin's theory of evolution aroused his interest in science, and he decided to enroll in the medical school at the University of Vienna in the fall of 1873, at the age of 17. He also made this decision partly because, in anti-Semitic Vienna, medicine and law were the only professions open to Jews. Although Freud enrolled in medical school in 1873, it took him eight years to complete the program; because he had such wide interests, he was often diverted from his medical studies. For example, Brentano caused him to become interested in philosophy, and Freud even translated one of John Stuart Mill's books into German.

According to Freud's own account, the person who influenced him most during his medical studies was Ernst Brücke, who, along with some of his friends such as Helmholtz and Du Bois-Reymond, founded the materialistic-positivistic movement in physiology (see Chapter 8). In Brücke's laboratory, Freud studied the reproductive system of male eels and wrote a number of influential articles on anatomy and neurology. Freud obtained his medical degree in 1881 and continued to work in Brücke's laboratory. Even though doing physiological research was Freud's main interest, he realized that jobs in that area were scarce, low-paying, and generally not available to Jews. Freud's financial concerns became acute in 1882, when he became engaged to Martha Bernays. Circumstances and advice from Brücke caused Freud to change his career plans and seek a career in medical practice. To help prepare himself, Freud went to the Vienna General Hospital to study with Theodor Meynert (1833-1893), one of the best-known brain anatomists at the time, and Freud soon became a recognized expert at diagnosing various types of brain damage. Freud considered Meynert the most brilliant person he had ever known.

Many important events happened in Freud's life about this time. In addition to making the decision to practice medicine, Freud was making a name for himself as a neuroanatomist, he had just befriended Joseph Breuer (who, as we will see, introduced Freud to many of the phenomena that would occupy Freud's attention for the next 50 years), and he had been given the opportunity to study with Charcot in Paris. All these events were to have a significant influence on the development of Freud's career. There was, however, a major setback: Freud's involvement with the "magical substance" cocaine.

The Cocaine Episode

In the spring of 1884, Freud experimented with cocaine after learning that it had been used successfully in the military to increase the energy and endurance of soldiers. Freud almost decided not to pursue his interest when he learned from the pharmaceutical company, Merck, that the price of 1 gram of cocaine was \$1.27 instead of 13 cents as he had believed (E. Jones, 1953, p. 80). Freud persisted, however, and after taking the drug himself, he found that it relieved his feelings of depression and cured his indigestion, helped him work, and appeared to have no negative side effects. Besides taking cocaine regularly himself, Freud gave it to his sisters, friends, colleagues, and patients and sent some to his fiancée Martha Bernays "to make her strong and give her cheeks a red color" (E. Jones, 1953, p. 81). The apparent improvement caused by cocaine in Freud's patients made him feel, for the first time, that he was a real physician. He became an enthusiastic advocate of cocaine and published six articles in the next two years describing its benefits. Carl Koller (1857-1944), one of Freud's younger colleagues, learned from Freud that cocaine could be used as an anesthetic. Koller was interested in ophthalmology and pursued Freud's observation as it related to eve operations. Within a few months, Koller delivered a paper describing how eye operations previously impossible could now, using cocaine as an anesthetic, be done with ease. The paper caused a sensation and brought Koller worldwide fame almost overnight. Freud deeply regretted having just missed gaining this professional recognition himself.

With the exception of the anesthetizing effects of cocaine, all of Freud's other beliefs about the substance soon proved to be false. In 1884 he administered cocaine to his colleague and friend Ernst von

Fleischl-Marxow (1846–1891), who was addicted to morphine. Freud's intention was to switch Fleischl-Marxow, who was a prominent physicist and physiologist, from morphine to cocaine, believing the latter was harmless. Instead, he died a cocaine addict. Soon reports of cocaine addiction began coming in from throughout the world, and the drug came under heavy attack from the medical community. Freud was severely criticized for his indiscriminate advocacy of cocaine, which was now being referred to as the "third scourge of humanity" (the other two being morphine and alcohol). Freud's close association with cocaine considerably harmed his medical reputation. It was the cocaine episode that, to a large extent, made the medical community skeptical of Freud's later ideas.

Freud's Addiction to Nicotine. Although Freud avoided addiction to cocaine, he was addicted to nicotine most of his adult life, smoking an average of 20 cigars a day. At the age of 38, it was discovered that he had heart arrhythmia; his physician advised him to stop smoking, but he continued to do so. Being a physician himself, Freud was well aware of the health risks associated with smoking, and he tried several times to quit but without success. In 1923, when Freud was 67 years old, he developed cancer of the palate and jaw. A series of 33 operations eventually necessitated his wearing of an awkward prosthetic device (which he called "the monster") to replace the surgically removed sections of his jaw. He was in almost constant pain during the last 16 years of his life, yet he continued to smoke his cigars.

DEVELOPMENT OF PSYCHOANALYSIS

Josef Breuer and the Case of Anna O.

Shortly before Freud obtained his medical degree, he developed a friendship with **Josef Breuer** (1842–1925), another one of Brücke's former

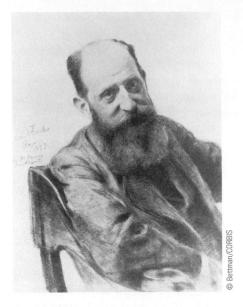

Josef Breuer

students. Breuer was 14 years older than Freud and had a considerable reputation as a physician and researcher. Breuer had made an important discovery concerning the reflexes involved in breathing, and he was one of the first to show how the semicircular canals influenced balance. Breuer loaned Freud money, and when Freud married in April 1886, the Breuer and Freud families socialized frequently. (It is also interesting to note that Breuer was the Brentano family's physician.)

It is what Freud learned from Breuer concerning the treatment of a woman, anonymously referred to as Fräulein Anna O., that essentially launched psychoanalysis. Because Breuer started treating Anna O. in 1880, while Freud was still a medical student, Freud (1910/1949) gave Breuer the credit for creating psychoanalysis:

Granted that it is a merit to have created psychoanalysis, it is not my merit. I was a student, busy with the passing of my last examinations, when another physician of Vienna, Dr. [Josef] Breuer, made the first application of this method to the case of an hysterical girl (1880–82). (p. 1)

Anna O. was a bright, attractive, 21-year-old woman who had a variety of symptoms associated with hysteria. At one time or another, she had experienced paralysis of the arms or legs, disturbances of sight and speech, nausea, memory loss, and general mental disorientation. Breuer hypnotized the young woman and then asked her to recall the circumstances under which she had first experienced a particular symptom. For example, one symptom was the perpetual squinting of her eyes. Through hypnosis, Breuer discovered that she had been required to keep a vigil by the bedside of her dying father. The woman's deep concern for her father had brought tears to her eyes so that when the weak man asked her what time it was she had to squint to see the hands of the clock.

Breuer discovered that each time he traced a symptom to its origin, which was usually some traumatic experience, the symptom disappeared either temporarily or permanently. One by one, Anna O.'s symptoms were relieved in this way. It was as if certain emotionally laden ideas could not be expressed directly but instead manifested themselves in physical symptoms. When such pathogenic ideas were given conscious expression, their energy dissipated, and the symptoms they initiated disappeared. Because relief followed the emotional release, which in turn followed the expression of a pathogenic idea, Breuer called the treatment the **cathartic method**. Aristotle had used the term catharsis (from the Greek katharsis, which means "to purify") to describe the emotional release and the feeling of purification that an audience experienced as they viewed a drama. Anna O. called the method the "talking cure" or "chimney sweeping." Breuer found that the catharsis occurred either during a hypnotic trance or when Anna O. was very relaxed.

Breuer's treatment of Anna O. started in December 1880 and continued until June 1882. During that time, Breuer typically saw her several hours each day. Soon after treatment had started, Anna O. began responding to Breuer as if he were her father, a process later called **transference**. All emotions Anna had once expressed toward her father, both positive and negative, she now expressed toward Breuer. Breuer also began develop-

ing emotional feelings toward Anna, a process later called countertransference. Because of the excessive amount of time involved and because his emotional involvement in the case began to negatively impact his marriage and his other professional obligations, Breuer decided to terminate his treatment of Anna O. Freud gave various accounts of how Anna O. responded to Breuer's termination of her treatment, and eventually these accounts evolved into a story that was widely accepted as fact. According to Freud, Breuer visited Anna O. the day after his announced termination of her treatment and found that she had developed a hysterical (phantom) pregnancy and was in the throes of hysterical childbirth. Upon questioning, Breuer learned that it was his imaginary child that was being delivered. Ernest Jones (1953), Freud's biographer, described Freud's account of what happened next:

Though profoundly shocked, he [Breuer] managed to calm her down by hypnotizing her, and then fled the house in a cold sweat. The next day he and his wife left for Venice to spend a second honeymoon, which resulted in the conception of a daughter. (p. 225)

According to Freud, Breuer was so upset by the case of Anna O. that he never again treated another case of hysteria. As entertaining as Freud's account may be, Hirschmüller (1989) corrects the historical record: Breuer did not end his treatment of Anna O. abruptly but carefully planned it in consultation with her mother; there was no hysterical pregnancy and therefore no need to hypnotize Anna O. and leave the house in a "cold sweat"; the Breuers went to Gmunden on a family vacation, not to Venice; their daughter was born on March 11, 1882, well before the Breuers went on their "second honeymoon"; and finally, Breuer continued treating cases of hysteria, although he did probably abandon the cathartic method.

The Fate of Anna O. The story of Anna O. usually ends with the revelation that Anna's real name was Bertha Pappenheim (1859–1936) and that

Breuer's treatment must have been effective because the woman went on to become a prominent social worker in Germany. Ellenberger (1972), however, discovered that Anna O. was institutionalized after Breuer terminated her treatment. Documents indicate that she was admitted into a sanatorium in 1882, still suffering many of the ailments that Breuer had treated. The records show that she was treated with substantial amounts of morphine while at the sanatorium and that she continued to receive morphine injections even after her release. Little is known about her life between the time of her release from the sanatorium and her emergence as a social worker in the late 1880s. However, Pappenheim eventually went on to become a leader in the European feminist movement; a playwright: an author of children's stories: a founder of several schools and clubs for the poor, the illegitimate, or wayward young women; and an effective spokesperson against white slavery and abortion. Her feminism is evident in the following statement she made in 1922: "If there is any justice in the next life women will make the laws there and men will bear the children" (E. Jones, 1953, p. 224). It is interesting to note that throughout her professional life she maintained a negative attitude toward psychoanalysis and would not allow any of the girls in her care to be psychoanalyzed (Edinger, 1968, p. 15).

When Pappenheim died in 1936, tributes came in from throughout Europe, including one from Martin Buber, the famous philosopher and educator. In 1954 the German government issued a stamp in her honor, part of a series paying tribute to "helpers of humanity." The effectiveness of Breuer's treatment of Pappenheim and, if effective, how much of her ultimate success can be attributed to that treatment are still being debated (see, for example, Borch–Jacobsen, 1996; Kimble, 2000; Rosenbaum and Muroff, 1984). Breuer and Freud published *Studies on Hysteria* (1895/1955), in which the case of Anna O. was the first presented, in 1895, and that date is usually taken as the date of the official founding of the school of psychoanalysis.

Freud's Visit with Charcot

As we saw in the last chapter, Freud studied with the illustrious Charcot from October 1885 to February 1886. Until this visit, although Freud was aware of Breuer's work with Anna O., he remained a materialistic-positivistic physiologist; he sought to explain all disorders, including hysteria, only in terms of neurophysiology. As did most physicians at the time. Freud viewed psychological explanations of illness as nonscientific. As we have seen, Charcot assumed hysteria to be a real disease that could be triggered by dissociated ideas. Taking hysteria seriously and proposing a partially psychological explanation of the disease set Charcot apart from most of his colleagues. Furthermore, Charcot insisted that hysteria occurred in males as well as females. This contention caused a stir because from the time of the Greeks it had been assumed that hysteria was caused by a disturbance of the uterus.

It is significant for the subsequent development of psychoanalysis that Freud claimed to have overheard Charcot say about hysteria, "But in this kind of case it is always something genital—always, always, always" (Boring, 1950, p. 709). Although Charcot denied making the statement, Freud nonetheless claimed that Charcot had suggested to him the relationship between sexual factors and hysteria. The final lesson that Freud learned from Charcot was that one could go against the established medical community if one had enough prestige. Freud, as we will see, went contrary to the medical community, but because he did not have the prestige that Charcot had, he paid the price. So impressed was Freud by Charcot that he later named his first son Jean-Martin after him (E. Jones, 1953).

Freud returned to Vienna and, on October 15, 1886, presented a paper entitled "On Male Hysteria" to the Viennese Society of Physicians, in which he presented and endorsed Charcot's views on hysteria. The presentation was poorly received because, according to Freud, it was too radical. Sulloway (1979), however, indicates that the paper was poorly received not because it was shocking but because Charcot's views on hysteria,

including the fact that hysteria was not a disorder confined to women, were already widely known within the medical community. Furthermore, the physicians believed that Charcot's ideas were presented too positively and uncritically; there was still too much uncertainty about Charcot's views and techniques to justify such certitude. According to Sulloway, Freud's account of the reaction to his paper on hysteria was perpetuated by his followers to enhance the image of Freud as a bold innovator fighting against the medical establishment.

On April 25, 1886, Freud established a private practice as a neurologist in Vienna, and on September 13, 1886, he finally married Martha Bernays after a four-year engagement. The Freuds eventually had six children—three boys and three girls. The youngest, Anna (1895-1982), as we will see in the next chapter, went on to become a world-renowned child psychoanalyst and assumed leadership of the Freudian movement after her father's death. Freud soon learned that he could not make an adequate living treating only neurological disorders, and he made the fateful decision to treat hysterics, becoming one of the few Viennese physicians to do so. At first, he tried the traditional methods of treating neurological disorders-including baths, massage, electrotherapy, and rest cures—but found them ineffective. It was at this point that everything that he had learned from Breuer about the cathartic method and from Charcot about hypnosis became relevant. When Freud used hypnosis while treating hysteria, he encountered several problems: He could not hypnotize some patients; often when a symptom was removed during a hypnotic trance, it, or some other symptom, would recur later; and some patients refused to believe what they had revealed under hypnosis, thus preventing a rational discussion and understanding of the recovered memories. In 1889 Freud visited Liébeault and Bernheim at the Nancy school in hopes of improving his hypnotic skills. From Liébeault and Bernheim, Freud learned about posthypnotic suggestion, observing that an idea planted during hypnosis could influence a person's behavior even when the person was unaware of it. This observation—that intact ideas of which a person was unaware could play an important role in that person's behavior—confirmed what Freud had learned from Charcot and was to become an extremely important part of psychoanalysis. He also learned from Liébeault and Bernheim that although patients tend to forget what they had experienced during hypnosis (a phenomenon called *posthypnotic amnesia*), such memories could return if the patient is strongly encouraged to remember them. This observation, too, was important to the development of psychoanalysis.

The Birth of Free Association

Upon returning to his practice, Freud still found hypnosis to be ineffective and was seeking an alternative. Then he remembered that, while at the Nancy school, he had observed that the hypnotist would bring back the memory of what had happened during hypnosis by putting his hand on the patient's forehead and saying, "Now you can remember." With this in mind, Freud tried having his patients lie on a couch, with their eyes closed, but not hypnotized. He asked the patients to recall the first time they had experienced a particular symptom, and the patients began to recollect various experiences but usually stopped short of the goal. In other words, as they approached the recollection of a traumatic experience, they displayed resistance. At this point, Freud placed his hand on the patient's forehead and declared that additional information was forthcoming, and in many cases it was. Freud found that this pressure technique was as effective as hypnosis, and soon he learned that he did not even need to touch his patients; simply encouraging them to speak freely about whatever came to their mind worked just as well. Thus, the method of free association was born.

With free association, the important phenomena of resistance, transference, and countertransference still occur but with the major advantage that the patient is conscious of what is going on. Also, although when using free association it is often more difficult to arrive at the original traumatic experience, once attained it is available for the patient to deal with in a rational manner. For Freud the

goals of psychotherapy are to help the patient overcome resistance and rationally ponder early traumatic experience. This is why he said that true psychoanalysis started only when hypnosis had been discarded (Heidbreder, 1933). Freud likened the use of free association to an archeologist's excavation of a buried city. It is from only a few fragmented artifacts that the structure and nature of the city must be ascertained. Similarly, free association provides only fragmented glimpses of the unconscious, and from those glimpses the psychoanalyst must determine the structure and nature of a person's unconscious mind.

During a therapeutic session Freud had his patients lie on a couch while he sat out of sight behind them. Freud gave two reasons for this arrangement: (1) It enhanced free association, for example, by preventing his facial expressions and mannerisms from influencing the flow of his patients' thoughts; and (2) he could not tolerate being stared at for eight, or more, hours a day (Storr, 1989, p. 96).

It is interesting to note that, at times, Freud demonstrated a rather cavalier attitude during his therapeutic sessions. Early in his career he wrote a letter to his friend Wilhelm Fliess (1858–1928) while his (Freud's) patient was hypnotized (Masson, 1985, p. 21). Later, he confessed to taking naps as his patients free associated (Masson, 1985, p. 303).

Studies on Hysteria

In *Studies on Hysteria* (1895/1955), Breuer and Freud put forth a number of the basic tenets of psychoanalysis. They noted that hysteria is caused by a traumatic experience that is not allowed adequate expression and therefore manifests itself in physical symptoms. Therefore, symptoms could be taken as *symbolic representations* of an underlying traumatic experience that is no longer consciously available to the patient. Because such experience is traumatic, it is *repressed*—that is, actively held in the unconscious because to ponder it would provoke anxiety. Resistance, then, is a sign that the therapist is on the right track. **Repression** also often results from **conflict**, the tendency both to approach and to avoid something considered wrong.

The fundamental point is that repressed experiences or conflicts do not go away. Rather, they go on exerting a powerful influence on a person's personality. The only way to deal with repressed material properly is to make it conscious and thereby deal with it rationally. For Freud the most effective way of making repressed material conscious is through free association. By carefully analyzing the content of free associations, gestures, and transference, the analyst could determine the nature of the repressed experience and help the patient become aware of it and deal with it. Thus, in Studies on Hysteria, Freud clearly outlined his belief in the importance of unconscious motivation. Freud and Breuer wrote separate conclusions to the book, and Freud emphasized the role of sex in unconscious motivation. At the time, Freud contended that a person with a normal sex life could not become neurotic. Breuer disagreed, saying instead that any traumatic memory (not just those that were sexual) could be repressed and cause neurotic symptoms. The two men eventually parted company.

PROJECT FOR A SCIENTIFIC PSYCHOLOGY

In 1895, the same year that Breuer and Freud published Studies on Hysteria, Freud completed Project for a Scientific Psychology. The purpose of Project was to explain psychological phenomena in purely neurophysical terms. In other words, he intended to apply the principles of Helmholtzian physiology, in which he was trained, to the study of the mind. Freud was not satisfied with his effort, and Project was not published in his lifetime (it was published in German in 1950 and in English in 1954). Frustrated in his attempt to create a neurophysical (medical) model of the mind, Freud turned to a psychological model, and the development of psychoanalysis was begun. However, Sirkin and Fleming (1982) point out that, although Freud's Project failed, it contained many of the concepts that were to appear in his psychoanalytic works. (For an interesting analysis of why Freud's Project failed, see Parisi, 1987.)

The Seduction Theory

On April 21, 1896, Freud delivered a paper to the Psychiatric and Neurological Society in Vienna titled "The Aetiology of Hysteria." The paper stated that, without exception, Freud's hysteric patients related to him a childhood incident in which they had been sexually attacked. Freud concluded that such an attack was the basis of all hysteria. He stated his conclusion forcefully as follows:

Whatever case and whatever symptom we take as our point of departure, in the end we infallibly come to the field of sexual experience. So here for the first time we seem to have discovered an aetiological precondition for hysterical symptoms. (Masson, 1984, p. 259)

Freud went on to say, "In all eighteen cases (cases of pure hysteria and of hysteria combined with obsessions, and comprising six men and twelve women) I have ... come to learn of sexual experiences in childhood" (Masson, 1984, p. 268).

Richard von Krafft-Ebing (1840–1902), the illustrious physician and head of the department of psychiatry at the University of Vienna, chaired the meeting at which Freud's paper was presented. In a letter to his close friend Wilhelm Fliess, Freud described how his paper was received:

A lecture on the aetiology of hysteria at the Psychiatric Society met with an icy reception from the asses, and from Krafft-Ebing the strange comment: It sounds like a scientific fairy tale. And this after one has demonstrated to them a solution to a more than thousand-year-old problem, a "source of the Nile"! They can all go to hell. (Masson, 1984, p. 9)

Masson (1984) suggests that the hostile reception by the medical community of Freud's paper was at least partially responsible for his subsequent abandonment of the **seduction theory**. Esterson (2002a), however, reviewed the historical record and found that the so-called hostile reception of Freud's paper was greatly exaggerated. In any case,

for reasons that are still not clear, Freud abandoned his seduction theory on September 21, 1897. In most cases, he concluded, the seduction had not really taken place. Rather, the patients had *imagined* the encounter. Freud decided that the imagined incidents were very real to his patients and therefore just as traumatic as if they had actually occurred. His original belief remained intact: The basis of neuroses was the repression of sexual thoughts, whether the thoughts were based on real or imagined experience.

Although Freud later claimed that his change from real to imagined seductions marked the real beginning of psychoanalysis, Masson (1984) believes that the profession of psychoanalysis would be better off today if Freud had not revised his theory:

By shifting the emphasis from an actual world of sadness, misery, and cruelty to an internal stage on which actors performed invented dramas for an invisible audience of their own creation, Freud began a trend away from the real world that, it seems to me, is at the root of the present day sterility of psychoanalysis and psychiatry throughout the world. (p. 144)

Masson concluded that Freud's major mistake was changing his belief that seductions were real to the belief that they were fantasies. We will see later in this chapter that several Freudian scholars and researchers believe that Freud's mistake was more basic. They believe that Freud invented the memories of seduction that he attributed to his patients and, therefore, whether it is assumed that these memories were of real or imagined events is irrelevant.

FREUD'S SELF-ANALYSIS

Because of the many complexities involved in the therapeutic process, Freud soon realized that to be an effective analyst, he had to be psychoanalyzed himself. Freud (1927) insisted later that to be a

qualified psychoanalyst one need not be a physician, but one does need to be psychoanalyzed. And, in addition to being psychoanalyzed, one needs at least two years of supervised practice as a psychoanalyst. Because no one was available to psychoanalyze Freud, he took on the job himself. Along with a variety of insecurities, such as an intense fear of train travel, a major motivation for Freud's self-analysis was his reaction to the death of his father in the fall of 1896. Although his father had been very ill and his death was no surprise, Freud found that his father's death affected him very deeply. For months following the death, Freud experienced severe depression and could not work. His reaction was so acute that he decided he had to regard himself as a patient.

Analysis of Dreams

Clearly, Freud could not use free association on himself, so he needed another vehicle for his selfanalysis. Freud assumed that the content of dreams could be viewed in much the same way as hysterical symptoms. That is, both dreams and hysterical symptoms could be seen as symbolic manifestations of repressed traumatic thoughts. If one properly analyzed the symbols of either dreams or hysterical symptoms, one could get at the roots of the problem. Dream analysis, then, became a second way of tapping the unconscious mind (the first way being free association) and one that was suitable for Freud's self-analysis. About the interpretation of dreams, Freud said, "The interpretation of dreams is the royal road to knowledge of the unconscious activities of the mind" (1900/1953, p. 608). Freud's self-analysis culminated in what he, and others, considered to be his most important work, The Interpretation of Dreams (1900/1953).

Like the physical symptoms of hysteria, dreams require a knowledgeable interpretation. During sleep, a person's defenses are down but not eliminated, so a repressed experience reaches consciousness only in *disguised* form. Therefore, there is a major difference between what a dream appears to be about and what it really is about. What a dream appears to be about is its **manifest content**, and

what it really is about is its **latent content**. Freud concluded that every dream is a **wish fulfillment**. That is, it is a symbolic expression of a wish that the dreamer could not express or satisfy directly without experiencing anxiety. Wishes expressed in symbolic form during sleep are disguised enough to allow the dreamer to continue sleeping because a direct expression of the wish involved would produce too much anxiety and disrupt sleep.

According to Freud, dream interpretation is complex business, and only someone well versed in psychoanalytic theory can accomplish the task. One has to understand the **dream work** that disguises the wish actually being expressed in the dream. Dream work includes **condensation**, in which one element of a dream symbolizes several things in waking life, such as when a family dog symbolizes an entire family. Dream work also involves **displacement**, in which, instead of dreaming about an anxiety-provoking object or event, the dreamer dreams of something symbolically similar to it, such as when one dreams of a cave instead of a vagina.

Freud believed that although the most important dream symbols come from a person's own experience, there also are universal dream symbols, which have the same meaning in everyone's dreams. For example, travel symbolizes death; falling symbolizes giving in to sexual temptation; boxes, gardens, doors, or balconies symbolize the vagina; and cannons, snakes, trees, swords, church spires, and candles symbolize the penis.

After Freud used dream interpretation to analyze himself, the procedure became an integral part of psychoanalysis.

Freud, Dreams, and Originality. In 1914 Freud said about dreams, "I do not know of any outside influence which drew my interest to them or inspired me with any helpful expectations" (1914/1966c, p. 18). He also said that, prior to his work, for a physician to suggest there was scientific value in the interpretation of dreams would have been "positively disgraceful," and such a physician would have been "excommunicated" from the medical community. All of this is Freudian myth.

The use of dream interpretation for diagnosing physical and mental disorders goes back at least to the early Greeks. In fact, as we saw in Chapter 2, Plato described dreams in a way reminiscent of Freud's later description. Rosemarie Sand (1992) indicates that, before Freud, some of the most prominent physicians in Europe were convinced of the scientific significance of dream interpretation. Among them were Charcot, Janet, and Krafft-Ebing. These individuals suggested that often important information about a patient could be ascertained only through the interpretation of dreams. For example, Krafft-Ebing observed that some homosexuals dream of heterosexual relations and concluded that, for them, homosexuality was acquired and not congenital. Krafft-Ebing believed that, for such individuals, heterosexual tendencies are unconscious and disclosed only by dream analysis. In his personal library Freud had four editions of the book by Krafft-Ebing describing how dreams could be used to explore the unconscious mind. Sand (1992) discusses the use of dream interpretation by Charcot, Janet, and Krafft-Ebing, all of whom anticipated Freud's contributions.

The Oedipus Complex

Freud's self-analysis did not result in any major theoretical breakthroughs, but it served to confirm many of the theoretical notions that Freud entertained before his self-analysis began:

Freud's self-analysis [did not] serve, as Freud scholars commonly claim, as the "heroic" vehicle for his discovery of the hidden world of spontaneous infantile sexuality. It is clear that he was already looking for evidence of sexual activity in his own childhood ... when he finally undertook this self-analysis.

What, then, was the real scientific value of Freud's self-analysis? Self-analysis finally allowed him to confirm from his own experience just how remarkably widespread the opportunities were in every *normal* childhood for both traumatic and sponta-

neous sexual activity. At the same time, self-analysis enabled Freud to extend significantly his understanding of the various psychological correlates of such early sexual experiences. He was able to recall feelings of jealousy and hatred at the birth of a younger male sibling, one year his junior (and who died after only eight months of life). He also recognized love for the mother and jealousy of the father in the early years of his childhood and therefore concluded that such feelings must be a universal concomitant of this period of life. ... He even recalled that "libido towards matrem was aroused" when, at the age of two, he had seen his mother in the nude. (Sulloway, 1979, p. 209)

Thus, by analyzing his own dreams, Freud confirmed his belief that young males tend to love their mothers and hate their fathers. He called this tendency the **Oedipus complex** after the Greek play *Oedipus Rex* by Sophocles, in which Oedipus unknowingly killed his father and married his mother.

Because male children have a close physical relationship with their mothers (the mother bathes, strokes, nurses, and hugs them), Freud thought that it was natural for them to have a sexual desire for their mothers. It is important to note, however, that Freud used the term *sexual* in a very general way. A better translation might be "pleasurable" rather than "sexual." For Freud, anything pleasurable was roughly what he meant by *sexual*. Heidbreder (1933) summarized the Freudian use of the word *sex*:

Freud used the word "sex" in a very general sense. He includes in it not only the specifically sexual interests and activities, but the whole love life—it might almost be said, the whole pleasure life—of human beings. The list of activities that he and his followers have seen as having a sexual significance is almost inexhaustible; but its range and variety may be indicated by the fact that it includes such simple practices as walking, smoking, and bathing, and such

complex activities as artistic creation, religious ceremonial, social and political institutions, and even the development of civilization itself. (p. 389)

In the case of the Oedipus complex, however, it appears that when Freud said *sexual*, he meant sexual. When the male child manipulates his sex organs, he thinks about his mother and thus becomes her lover:

He wishes to possess her physically in such ways as he has divined from his observations and intuitions about sexual life, and he tries to seduce her by showing her the male organ which he is proud to own. In a word, his early awakened masculinity seeks to take his father's place with her; his father has hitherto in any case been an envied model to the boy, owing to the physical strength he perceives in him and the authority with which he finds him clothed. His father now becomes a rival who stands in his way and whom he would like to get rid of. (Freud, 1940/1969, p. 46)

Now the male child is in competition with the father who also desires the mother, but the reality of the situation (that the father is much more powerful than the child) causes the child to repress his amorous desires for the mother and his hostility toward the father. According to Freud, however, repressed ideas do not go away; they continue to manifest themselves in dreams, symptoms, or unusual behavior. For example, it became clear to Freud that his overreaction to his father's death had been at least partially motivated by the guilt he felt from wishing his father would die.

Freud believed that the Oedipus conflict is universal among male children and that its remnants in adult life explain much normal and abnormal behavior. One bit of "normal" behavior it explains is that males often marry women who are very similar to their mothers. (We will discuss what happens to female children at this time of life when we discuss the psychosexual stages of development later in this chapter.)

At this point, Freud had the vehicle he needed for explaining the seduction fantasies he had presumably observed in so many of his patients. He now saw such fantasies as representing repressed desires to possess the parent of the opposite sex and to eliminate the same-sex parent. Such desires, Freud concluded, are as natural and universal as the need to repress them, and so *infantile sexuality* became an important ingredient in his general theory of unconscious motivation.

According to the history of psychoanalysis offered by Freud and his followers, attributing sexual desires to children and claiming that such desires are natural ran contrary to the Victorian morality of Freud's time, and therefore he was further alienated from the medical establishment. This contention appears to be another myth. Views of infantile sexuality very similar to those proposed by Freud had already been offered by individuals such as Krafft-Ebing, Albert Moll (1862–1939), and Havelock Ellis (1859–1939), and sexology was very much in vogue when Freud was developing his theory. (For details, see Sulloway, 1979.)

THE PSYCHOPATHOLOGY OF EVERYDAY LIFE

Freud's next major work following *The Interpretation of Dreams* was *Psychopathology of Everyday Life* (1901/1960b) in which he discussed **parapraxes** (singular, *parapraxis*). Parapraxes are relatively minor errors in everyday living, such as slips of the tongue (Freudian slips), forgetting things, losing things, small accidents, and mistakes in writing. According to Freud, all behavior is motivated; so for him, it was legitimate to seek the causes of all behavior, "normal" or "abnormal." Furthermore, he believed that because the causes of behavior are usually unconscious, people seldom know why they act as they do. Freud pointed out that parapraxes are often unconsciously motivated.

Freud is never at a loss to find evidence for his theories in the commonplace incidents

we dismiss as insignificant or attribute to chance. Slips of the tongue and slips of the pen, forgotten names and forgotten appointments, lost gifts and mislaid possessions, all point to the role of wish and motive. Such happenings, Freud insists, are by no means accidental. The woman who loses her wedding ring wishes that she had never had it. The physician who forgets the name of his rival wishes that name blotted out of existence. The newspaper that prints "Clown Prince" for "Crown Prince" and corrects its error by announcing that of course it meant "Clown Prince," really means what it says. Even untutored common sense had a shrewd suspicion that forgetting is significant; one rarely admits without embarrassment that he failed to keep an appointment because he forgot it. Events of this sort are always determined. They are even overdetermined. Several lines of causation may converge on the same mishap, and physical as well as psychical determinants may be involved. Errors in speech, for example, may be due in part to difficulties of muscular coordination, to transposition of letters, to similarities in words, and the like. But such conditions do not constitute the whole explanation. They do not explain why one particular slip and not another was made—why just that combination of sounds and no other was uttered. A young business man, for example, striving to be generous to a rival, and intending to say "Yes, he is very efficient," actually said, "Yes, he is very officious." Obviously he was slipping into an easy confusion of words, but he was also expressing his real opinion. Desire and indirect fulfillment are at the basis of normal as well as abnormal conduct, and motive determines even those happenings we attribute to chance. (Heidbreder, 1933, pp. 391-392)

In the preceding quotation, Heidbreder used the term *overdetermined* in regard to acts of forgetting and errors in speech. The concept of **overdetermination** is very important in Freudian theory. In general, it means that behavioral and psychological acts often have more than one cause. A dream, for example, may partially satisfy several needs at the same time, as may a hysterical symptom. Also, as we have just seen, an error in speech may be caused (determined) by difficulties in muscle coordination, the tendency to transpose letters, or by some unconscious motive. If a phenomenon is determined by two or more causes, it is said to be overdetermined.

Humor

Freud (1905/1960a) indicated that people often use jokes to express unacceptable sexual and aggressive tendencies. Like dreams, jokes exemplify wish fulfillments; so, according to Freud, jokes offer a socially approved vehicle for being obscene, aggressive or hostile, cynical, critical, skeptical, or blasphemous. Viewed in this way, jokes offer a way of venting repressed, anxiety-provoking thoughts, and so it is no wonder that people find most humorous those things that bother them the most. Freud said that we laugh most at those things that cause us the most anxiety. However, to be effective, jokes, like dreams, must disguise the true sexual or aggressive motives behind them, or they would cause too much anxiety. Freud believed that a joke often fails because the motive it expresses is too blatant, in the same way that a nightmare is a failed dream from which one awakes because the motive expressed is too powerful for dream work to disguise.

Thus, in his search for the contents of the unconscious mind, Freud made use of free association, dream analysis, slips of the tongue, memory lapses, "accidents," gestures and mannerisms, what the person finds humorous, and literally everything else the person does or says.

FREUD'S TRIP TO THE UNITED STATES

As Freud's fame gradually grew, he began to attract disciples. In 1902 Freud began meeting on Wednesday evenings with a small group of his followers in the waiting room outside his office. This group, called the Wednesday Psychological Society, became the Vienna Psychoanalytic Society in 1908. By Freud's own account, psychoanalysis remained rather obscure until he and two of his disciples, Carl Jung (discussed in the next chapter) and Sandor Ferenczi, were invited to Clark University in 1909 by G. Stanley Hall. Aboard ship, Freud saw a cabin steward reading *Psychopathology of Everyday Life* and thought for the first time that he might be famous (E. Jones, 1955). Freud was 53 years old at the time.

After a few days of sightseeing, Freud began his series of five lectures. Each lecture was prepared only a half-hour before it was given, and preparation consisted of a walk and discussion with Ferenczi. Freud delivered the lectures in German without any notes. Upon completion of his lectures, he was given an honorary doctorate, and in his acceptance speech, he said, "This is the first official recognition of my endeavors" (E. Jones, 1955, p. 57). Although his lectures were met with some criticism, reactions were generally favorable. Supposedly, none other than William James, who was fatally ill at the time, said to Ernest Jones, Freud's friend, colleague, and, later, his biographer, "The future of psychology belongs to your work" (E. Jones, 1955, p. 57). However, Jones's recollection may be another historical distortion. Simon (1998, pp. 362-364) indicates that James believed that psychoanalysis had little value and was perhaps even dangerous. In a letter to a friend, James expressed ambivalence toward Freud and his ideas:

I hope that Freud and his pupils will push their ideas to their utmost limits, so that we may learn what they are. They can't fail to throw light on human nature, but I confess that he made on me personally the impression of a man obsessed with fixed ideas. I can make nothing in my own case with his dream theories, and obviously 'symbolism' is a most dangerous method. (Hale, 1971, p. 19)

Freud's series of five lectures was later expanded into his influential *Introductory Lectures of Psychoanalysis* (1915–1917/1966a).

Freud was deeply grateful that his visit to Clark University had given psychoanalysis international recognition, but still he returned to Germany with a negative impression of the United States. He said to Ernest Jones, "America is a mistake; a gigantic mistake it is true, but none the less a mistake" (E. Jones, 1955, p. 66). Hale (1971) summarized what Freud liked and did not like about the United States:

At the time, the trip aroused Freud's hope that there might be a future for psychoanalysis in the United States. He made lasting friendships with a few Americans. Yet he was puzzled and somewhat distrustful, amused but not pleased, by what he had seen—Worcester, the Adirondacks, Coney Island, his first movie, full of wild chasing. He admired Niagara Falls-it was grander and larger than he had expected. He was charmed by a porcupine and by the Greek antiquities at the Metropolitan Museum. Yet the American cooking irritated his stomach; the free and easy informality irked his sense of dignity. He learned of a popular mania for religious mind cures, and he detected a distressing potential lay enthusiasm for his hard-won discoveries. (p. 4)

(For the details of Freud's trip to the United States, along with copies of his correspondence with Hall concerning the trip and a number of interesting photographs, see Rosenzweig, 1992.)

After his trip to the United States, Freud's fame and that of psychoanalysis grew very rapidly. In 1910 the International Training Commission was organized to standardize the training of psychoanalysts. However, not everything went well for

Freud. In 1911 Alfred Adler, an early disciple of Freud's, broke away to develop his own theory; this was closely followed by the defection of Carl Jung. Freud worried that such defections would contaminate psychoanalytic doctrine; thus, in 1912 he established a committee of loyal disciples to ensure the purity of psychoanalytic theory. This inner circle consisted of Karl Abraham, Sandor Ferenczi, Ernest Jones, Otto Rank, and Hans Sachs. In time, even members of this group would disagree with Freud.

A REVIEW OF THE BASIC COMPONENTS OF FREUD'S THEORY OF PERSONALITY

The components of Freud's theory of personality are widely known, so we will simply review them here.

The Id, Ego, and Superego

Early in his theorizing, Freud differentiated among the conscious, the preconscious, and the unconscious. Consciousness consists of those things of which we are aware at any given moment. The preconscious consists of the things of which we are not aware but of which we could easily become aware. The unconscious consists of those memories that are being actively repressed from consciousness and are therefore made conscious only with great effort. Later, Freud summarized and expanded these views with his concepts of the id, ego, and superego.

The Id. The **id** (from the German *das es*, meaning "the it") is the driving force of the personality. It contains all **instincts** (although better translations of the word Freud used might be "drives" or "forces") such as hunger, thirst, and sex. The id is entirely unconscious and is governed by the *pleasure principle*. When a need arises, the id wants immediate gratification of that need. The collective energy

associated with the instincts is called **libido** (the Latin word for "lust"), and libidinal energy accounts for most human behavior. Associated with every instinct are a *source*, which is a bodily need of some kind; an *aim* of satisfying the need; an *object*, which is anything capable of satisfying the need; and an *impetus*, a driving force whose strength is determined by the magnitude of the need.

The id has only two means of satisfying a need. One is *reflex action*, which is automatically triggered when certain discomforts arise. Sneezing and recoiling from a painful stimulus are examples of reflex actions. The second means of satisfaction is wish fulfillment, in which the id conjures up an image of an object that will satisfy an existing need. But because the id never comes directly into contact with the environment, where do these images come from?

Freud speaks of the id as being the true psychic reality. By this he means the id is the primary subjective reality, the inner world that exists before the individual has had experience of the external world. Not only are the instincts and reflexes inborn, but the images that are produced by tension states may also be innate. This means that a hungry baby can have an image of food without having to learn to associate food with hunger. Freud believed that experiences that are repeated with great frequency and intensity in many individuals of successive generations become permanent deposits in the id. (C. S. Hall, 1954, pp. 26-27)

Freud, then, accepted Lamarck's theory of acquired characteristics when explaining how the id is capable of conjuring up images of things in the external world that are capable of satisfying needs.

Because the activities in the id occur independently of personal experience and because they provide the foundation of the entire personality, Freud referred to them as *primary processes*. The primary processes are irrational because they are directly determined by a person's need state, they

tolerate *no* time lapse between the onset of a need and its satisfaction, and they exist entirely on the unconscious level. Furthermore, the primary processes can, at best, furnish only temporary satisfaction of a need; therefore, another aspect of the personality is necessary if the person is to survive.

The Ego. The ego (from the German das ich, meaning "the I") is aware of the needs of both the id and the physical world, and its major job is to coordinate the two. In other words, the ego's job is to match the wishes (images) of the id with their counterparts in the physical environment. For this reason, the ego is said to operate in the service of the id. The ego is also said to be governed by the reality principle, because the objects it provides must result in real rather than imaginary satisfaction of a need.

When the ego finds an environmental object that will satisfy a need, it invests libidinal energy into the thought of that object, thus creating a cathexis (from the Greek *kathexo*, meaning "to occupy") between the need and the object. A **cathexis** is an investment of psychic energy in thoughts of objects or processes that will satisfy a need. The realistic activities of the ego are called *secondary processes*, and they contrast with the unrealistic primary processes of the id.

If the id and the ego were the only two components of the personality, humans could hardly be distinguished from other animals. There is, however, a third component of the personality that vastly complicates matters.

The Superego. Although the newborn child is completely dominated by the id, the child must soon learn that need gratification usually cannot be immediate. More important, he or she must learn that some things are "right" and some things are "wrong." For example, the male child must inhibit his sexual desires for his mother and his aggressive tendencies toward his father. Teaching these do's and don'ts is usually what is meant by socializing the child.

As the child internalizes these do's and don'ts, he or she develops a **superego** (from the German *das überich*, meaning "the over I"), which is the

moral arm of the personality. The fully developed superego has two divisions. The conscience consists of the internalized experiences for which the child has been consistently punished. Engaging in or even thinking about engaging in such activities now makes the child feel guilty. The ego-ideal consists of the internalized experiences for which the child has been rewarded. Engaging in or even thinking about engaging in such activities makes the child feel good about himself or herself. Although Freud believed that the superego, like the id, has archaic rudiments, he stressed the role of personal experience with reward and punishment in its development. Once the superego is developed, the child's behavior and thoughts are governed by internalized values, usually those of the parents, and the child is said to be socialized.

At this point, the job of the ego becomes much more complex. The ego not only must find objects or events that satisfy the needs of the id, but these objects or events must also be sanctioned by the superego. In some cases, a cathexis that is acceptable to the id and ego causes guilt, and therefore libidinal energy is diverted to inhibit the cathexis. The diversion of libidinal energy in an effort to inhibit an association between a need and an object or event is called an anticathexis. In such cases, the superego inhibits the association to avoid the feelings of guilt, and the ego inhibits it to postpone need satisfaction until an acceptable object or event can be found. Anticathexis causes a displacement from a guilt- or anxiety-provoking object or event to one that does not cause anxiety or guilt.

Life and Death Instincts. Freud (1920/1955b) differentiated between life and death instincts. The life instincts were collectively referred to as eros (named after the Greek god of love), and the energy associated with them was called libido. Earlier, Freud equated libido with sexual energy, but because of increased evidence to the contrary and because of severe criticism from even his closest colleagues, he expanded the notion of libido to include the energy associated with all life instincts including sex, hunger, and thirst. Freud's final position was that when a need arises, libidinal energy is

expended to satisfy it, thereby prolonging life. When all needs are satisfied, the person is in a state of minimal tension. One of life's major goals is to seek this state of needlessness that corresponds to complete satisfaction.

What happens if the above discussion is carried an additional step? There is a condition of the body that represents the ultimate steady state or state of nontension; it is called death. Life, Freud said, started from inorganic matter, and part of us longs to return to that state because only in that state is there no longer the constant struggle to satisfy biological needs. Here we see the influence of Schopenhauer, who said every meal we eat and every breath we take simply postpone death, which is the ultimate victor. Quoting Schopenhauer, Freud said that "the aim of all life is death" (1920/1955b, p. 38). Thus, besides the life instincts, there is a death instinct called thanatos (named after the Greek god of death). The life instincts seek to perpetuate life, and the death instinct seeks to terminate it. So, to all the other conflicts that occur among the id, ego, and superego, Freud added a life-and-death struggle. When directed toward one's self, the death instinct manifests itself as suicide or masochism; when directed outwardly, it manifests itself in hatred, murder, cruelty, and general aggression. For Freud then, aggression is a natural component of human nature.

No wonder the ego was referred to as the executive of the personality. Not only does it need to deal with real environmental problems, but it also needs to satisfy the needs of the id in ways that do not alienate the superego. Another of its jobs is to minimize the anxiety that arises when one does act contrary to one's internalized values. To combat such anxiety, the ego could employ the ego defense mechanisms to which we turn next.

Anxiety and the Ego Defense Mechanisms

Anxiety. Anxiety is a warning of impending danger, and Freud distinguished three types. *Objective anxiety* arises when there is an objective threat to

the person's well-being. For example, being physically attacked by another person or an animal would cause objective anxiety. *Neurotic anxiety* arises when the ego feels that it is going to be overwhelmed by the id—in other words, when the needs of the id become so powerful that the ego feels that it will be unable to control them and that the irrationality of the id will manifest itself in the person's thought and behavior. *Moral anxiety* arises when an internalized value is or is about to be violated. Moral anxiety is about the same as shame or guilt. It is the self-punishment we experience when we act contrary to the values internalized in the superego.

Any form of anxiety is uncomfortable, and the individual experiencing it seeks its reduction or elimination just as one would seek to reduce hunger, thirst, or pain. It is the ego's job to deal with anxiety. To reduce objective anxiety, the ego must deal effectively with the physical environment. To deal with neurotic and moral anxiety, the ego must use processes that Freud called the **ego defense mechanisms**. Freud believed that all ego defense mechanisms have two things in common: They distort reality, and they operate on the unconscious level—that is, a person is unaware of the fact that he or she is using one.

The Ego Defense Mechanisms. Repression is the fundamental defense mechanism because it is involved in all others. Repressed ideas enter consciousness only when they are disguised enough that they do not cause anxiety. Modified repressed ideas show up in dreams, in humor, in physical symptoms, during free association, and in parapraxes. Because it is found almost everywhere in psychoanalytic theory, displacement is another very important defense mechanism. In general, displacement involves replacing an object or goal that provokes anxiety with one that does not. When a displacement involves substituting a nonsexual goal for a sexual one, the process is called sublimation. Freud considered sublimation to be the basis of civilization. Because we often cannot express our sexual urges directly, we are forced to express them indirectly in the form of poetry, art, religion, football, baseball, politics, education, and everything else

that characterizes civilization. Thus, Freud viewed civilization as a compromise. For civilization to exist, humans must inhibit direct satisfaction of their basic urges. Freud believed that humans are animals frustrated by the very civilization they create to protect themselves from themselves. Freud said, "Sublimation of instinct is an especially conspicuous feature of cultural development; it is what makes it possible for higher psychical activities, scientific, artistic or ideological, to play such an important part in civilized life" (1930/1961b, p. 49).

Another way to deal with an anxietyprovoking thought is to attribute it to someone or something other than one's self. Such a process is called projection. One sees the causes of failure, undesirable urges, and secret desires as "out there" instead of in the self because seeing them as part of one's self would cause anxiety. Also, when one feels frustrated and anxious because one has not lived up to some internalized value, one can symbolically borrow someone else's success through the process of identification. Thus, if one dresses, behaves, or talks the way a person considered successful does, some of that person's success becomes one's own. Rationalization involves giving a rational and logical, but false, reason for a failure or shortcoming rather than the true reason for it. Sometimes, when people have a desire to do something but doing it would cause anxiety, they do the opposite of what they really want to do. This is called reaction formation. Thus, the male with strong homosexual tendencies becomes a Don Juan type, the mother who hates her child becomes overindulgent, the person with strong antigovernment leanings becomes a superpatriot, or the person with strong sexual urges becomes a preacher concerned with pornography, promiscuity, and the sinfulness of today's youth.

For a discussion of the status of the ego defense mechanisms in contemporary psychology, see, for example, Cramer, 2000.

Psychosexual Stages of Development

Although Freud considered the entire body to be a source of sexual pleasure, he believed that this

pleasure was concentrated on different parts of the body at different stages of development. At any stage, the area of the body on which sexual pleasure is concentrated is called the *erogenous zone*. The erogenous zones give the stages of development their respective names. According to Freud, the experiences a child has during each stage determine, to a large extent, his or her adult personality. For this reason, Freud believed that the foundations for one's adult personality are formed by the time a child is about five years old.

The Oral Stage. The oral stage lasts through about the first year of life, and the erogenous zone is the mouth. Pleasure comes mainly through the lips, tongue, and such activities as sucking, chewing, and swallowing. If either overgratification or undergratification (frustration) of the oral needs causes a fixation to occur at this level of development, as an adult the child will be an oral character. Fixation during the early part of the oral stage results in an oral-incorporative character. Such a person tends to be a good listener and an excessive eater. drinker, kisser, or smoker; he or she also tends to be dependent and gullible. A fixation during the latter part of the oral stage, when teeth begin to appear, results in an oral-sadistic character. Such a person is sarcastic, cynical, and generally aggressive.

The Anal Stage. The anal stage lasts through about the second year of life, and the erogenous zone is the anus-buttocks region of the body. Fixation during this stage results in an anal character. During the first part of the anal stage, pleasure comes mainly from activities such as feces expulsion, and a fixation here results in the adult being an anal-expulsive character. Such a person tends to be generous, messy, or wasteful. In the latter part of the anal stage, after toilet training has occurred, pleasure comes from being able to withhold feces. A fixation here results in the person becoming an anal-retentive character. Such an adult tends to be a collector and to be stingy, orderly, and perhaps perfectionistic.

The Phallic Stage. The phallic stage lasts from about the beginning of the third year to the end

of the fifth year, and the erogenous zone is the genital region of the body. Because Freud believed the clitoris to be a small penis, the phallic stage describes the development of both male and female children. The most significant events that occur during this stage are the male and female Oedipal complexes. According to Freud, both male and female children develop strong, positive, even erotic feelings toward their mother because she satisfies their needs. These feelings persist in the boy but typically change in the girl. The male child now has an intense desire for his mother and great hostility toward his father, who is perceived as a rival for his mother's love. Because the source of his pleasurable feelings toward his mother is his penis and because he sees his father as much more powerful than he, the male child begins to experience castration anxiety, which causes him to repress his sexual and aggressive tendencies. According to Freud, a male child need not be overtly threatened with castration to develop castration anxiety. Boys may have had the opportunity to observe that girls do not have penises and assume they once did. Also, castration anxiety can result from the phylogenetic memory of actual castrations that occurred in the distant past:

It is not a question of whether castration is really carried out; what is decisive is that the danger is one that threatens from outside and that the child believes in it. He has some ground for this, for people threaten him often enough with cutting off his penis during the phallic phase, at the time of his early masturbation, and hints at the punishment must regularly find a phylogenetic reinforcement in him. (Freud, 1933/1964a, p. 86)

In any case, the male child solves the problem by identifying with the father. This identification accomplishes two things: Symbolically becoming his father (through identification) allows the child at least to share the mother; and it removes his father as a threat, thus reducing the child's castration anxiety.

The female child's situation is much different from the male's. Like the male child, the female starts out with a strong attraction and attachment to the mother. She soon learns, however, that she lacks a penis and she blames the mother for its absence. She now has both positive and negative feelings toward her mother. At about the same time, she learns that her father possesses the valued organ, which she wants to share with him. This causes a sexual attraction toward the father, but the fact that her father possesses something valuable that she does not possess causes her to experience penis envy. Thus, the female child also has ambivalent feelings toward her father. To resolve the female Oedipal complex in a healthy way, the female child must repress her hostility toward her mother and her sexual attraction to her father. Thereafter, she "becomes" the mother and shares the father.

The repression and strong identification necessary during this stage result in the full development of the superego. When a child identifies with his or her parent of the same sex, the child introjects that parent's moral standards and values. Once these standards have been introjected, they control the child for the rest of his or her life. For this reason, the final and complete formation of the superego is said to go hand in hand with the resolution of the Oedipal complexes.

One of the major reasons Freud believed that the male's and female's experiences during the phallic stage are not symmetrical is the fact that a key ingredient in the male experience is castration anxiety. Because the female is already castrated (symbolically), she never has the intense motivation to defensively identify with the potential castrator. Because such identification results in the development of the superego, Freud reached the controversial conclusion that the male superego (morality) is stronger than that of the female.

Clearly, Freud viewed women as more enigmatic than men. He once commented to his close friend Princess Marie Bonaparte that "the great question that has never been answered and which I have not yet been able to answer, despite my thirty years of research into the feminine soul, is

'What does a woman want?'" (Jones, 1955, p. 421). After trying several approaches to understanding feminine psychology, Freud essentially admitted defeat. His last words on the subject were:

That is all I [have] to say to you about femininity. It is certainly incomplete and fragmentary and does not always sound friendly. ... If you want to know more about femininity, enquire from your own experiences of life, or turn to the poets, or wait until science can give you deeper and more coherent information. (1933/1966b, p. 599)

Freud's views on women have been appropriately criticized. However, he is often also criticized for things he never said. To provide a more objective appraisal of Freud's views on feminine psychology, Young-Bruehl (1990) collected all Freud's writings on the topic and arranged them in chronological order so that one can observe how Freud's views on the topic changed throughout his career.

The Latency Stage. The latency stage lasts from about the beginning of the sixth year until puberty. Because of the intense repression required during the phallic stage, sexual activity is all but eliminated from consciousness during the latency stage. This stage is characterized by numerous substitute activities, such as schoolwork and peer activities, and by extensive curiosity about the world.

The Genital Stage. The *genital stage* lasts from puberty through the remainder of one's life. With the onset of puberty, sexual desires become too intense to repress completely, and they begin to manifest themselves. The focus of attention is now on members of the opposite sex. If everything has gone correctly during the preceding stages, this stage will culminate in dating and eventually marriage.

The undergratifications or overgratifications and fixations that a person experiences (or does not experience) during the psychosexual stages

will determine the person's adult personality. If the person has adjustment problems later in life, the psychoanalyst looks into these early experiences for solution to the problems. For the psychoanalyst, childhood experience is the stuff of which neuroses or normality are made. Indeed, psychoanalysts believe that "the child is father to the man" (Freud, 1940/1969, p. 64).

FREUD'S VIEW OF HUMAN NATURE

It should be clear by now that Freud was largely pessimistic about human nature. Freud (1930/1961b) reacted to the biblical commandment "Thou shalt love thy neighbor as thyself" as follows:

What is the point of a precept enunciated with so much solemnity if its fulfillment cannot be recommended as reasonable? ... Not merely is this stranger in general unworthy of my love; I must honestly confess that he had more claim to my hostility and even my hatred. He seems not to have the least trace of love for me and shows me not the slightest consideration. If it will do him any good he has no hesitation in injuring me, nor does he ask himself whether the amount of advantage he gains bears any proportion to the extent of the harm he does to me. Indeed, he need not even obtain an advantage; if he can satisfy any sort of desire by it, he thinks nothing of jeering at me, insulting me, slandering me and showing his superior power; and, the more secure he feels and the more helpless I am, the more certainly I can expect him to behave like this to me. ... Indeed, if this grandiose commandment had run "Love thy neighbour as thy neighbour loves thee," I should not take exception to it....

The element of truth behind all this, which people are so ready to disavow, is

that men are not gentle creatures who want to be loved, and who at the most can defend themselves if they are attacked; they are, on the contrary, creatures among whose instinctual endowments is to be reckoned a powerful share of aggressiveness. As a result, their neighbour is for them not only a potential helper or sexual object, but also someone who tempts them to satisfy their aggressiveness on him, to exploit his capacity for work without compensation, to use him sexually without his consent, to seize his possessions, to humiliate him, to cause him pain, to torture and to kill him. Homo homini lupus [man is a wolf to man]. (pp. 65–69)

Although pessimistic, Freud (1917/1955a) believed that people could, and should, live more rational lives, but to do so they must first understand the workings of their own minds:

The news that reaches your consciousness is incomplete and often not to be relied on. ... Even if you are not ill, who can tell all that is stirring in your mind of which you know nothing or are falsely informed? You behave like an absolute ruler who is content with the information supplied him by his highest officials and never goes among the people to hear their voice. Turn your eyes inward, look into your own depths, learn first to know yourself! (p. 143)

Religion

Freud also showed his pessimism in *The Future of an Illusion* (1927/1961a), which was his major statement on religion. In this book, Freud contended that the basis of religion is the human feeling of helplessness and insecurity. To overcome these feelings, we create a powerful father figure who will supposedly protect us, a father figure symbolized in the concept of God. The problem with this practice, according to Freud, is that it keeps humans

operating at a childlike, irrational level. The dogmatic teachings of religion inhibit a more rational, realistic approach to life. In *Civilization and Its Discontents* (1930/1961b), he said,

The whole thing [religion] is so patently infantile, so foreign to reality, that to anyone with a friendly attitude to humanity it is painful to think that the great majority of mortals will never be able to rise above this view of life. (p. 22)

For Freud our only hope is to come to grips with the repressed forces that motivate us; only then can we live rational lives. Freud said, "Those who do not suffer from the neurosis will need no intoxicant to deaden it" (1927/1961a, p. 49). For him, religion is the intoxicant. Just as Freud refused to take pain-killing drugs during his 16-year bout with cancer, he believed that humans could and should confront reality without religious or any other type of illusions.

It was Freud's hope that religious illusions would eventually be replaced by scientific principles as guides for living. Scientific principles are not always flattering or comforting, but they are rational:

No belittlement of science can in any way alter the fact that it is attempting to take account of our dependence on the real external world, while religion is an illusion and it derives its strength from its readiness to fit in with our instinctual wishful impulses. (Freud, 1933/1966b, pp. 638–639)

And elsewhere Freud said, "Our science is no illusion. But an illusion it would be to suppose that what science cannot give us we can get elsewhere" (1927/1961a, p. 71).

FREUD'S FATE

Even while suffering from cancer in the later years of his life, Freud continued to be highly productive. However, when the Nazis occupied Austria in 1936, his life became increasingly precarious.

Psychoanalysis had already been labeled as "Jewish science" in Germany, and his books were banned there. In Vienna, the Nazis destroyed Freud's personal library and publicly burned all his books found in the Vienna public library. About this Freud said, "What progress we are making. In the Middle Ages they would have burnt me; nowadays they are content with burning my books" (E. Jones, 1957, p. 182). Freud resisted as long as he could but eventually decided it was time to leave Vienna. To do so, however, he was required to sign a document attesting to the respectful and considerate treatment he had received from the Nazis: to this document. Freud added the comment (sarcastically, of course), "I can heartily recommend the Gestapo to anyone" (Clark, 1980, p. 511). When Freud left Vienna, he had to leave four of his sisters behind, and he died without knowing that they were all soon to perish in Nazi concentration camps (E. Iones, 1957).

With his daughter Anna, Freud first journeved to Paris, where they were received by their close friend Princess Marie Bonaparte and one of Freud's sons. Shortly afterward, they traveled to London. where they took up residence at 20 Maresfield Gardens in Hampstead, North London. Freud was well received in England and, although in great pain, he continued to write, see patients, and occasionally attend meetings of the London Psychoanalytic Society. On June 28, 1938, three secretaries from the London Royal Society brought to Freud's home the "sacred book of the Society" for his signature; among the other signatures in the book were those of Newton and Darwin. Freud was very pleased. It was in London that Freud completed his last book, Moses and Monotheism, 1939/1964b, and he died the same year at the age of 83. Freud's wife Martha died 12 years later on November 2, 1951, at the age of 90.

Freud had reached an agreement with his physician, Max Schur, that when Freud's condition became hopeless, Schur would assist him in dying. Gay (1988) describes Freud's final days:

Schur was on the point of tears as he witnessed Freud facing death with dignity and without self-pity. He had never seen

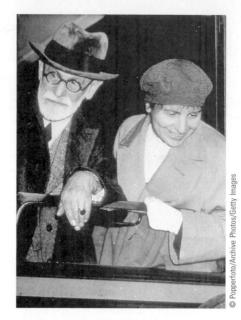

Sigmund and Anna Freud

anyone die like that. On September 21, Schur injected Freud with three centigrams of morphine—the normal dose for sedation was two centigrams—and Freud sank into a peaceful sleep. Schur repeated the injection, when he became restless, and administered a final one the next day, September 22. Freud lapsed into a coma from which he did not awake. He died at three in the morning, September 23, 1939. (p. 651)

Freud's body was cremated and his ashes placed in a Grecian urn that had been given to him by Marie Bonaparte. He left an estate of 20,000 English pounds (Roazen, 1992, p. 543).

REVISIONS OF THE FREUDIAN LEGEND

We have already examined two recent modifications of the Freudian legend: the dubious circumstances under which Freud revised his seduction theory and that many of his ideas were not as courageous and innovative as he and his followers claimed (such as his ideas concerning infantile sexuality, dream analysis, and male hysteria). According to Ellenberger (1970), Freud and his followers purposefully attempted to create an image of Freud as a lonely, heroic figure who was discriminated against because he was a Jew and because his ideas were so revolutionary that the established medical community could not accept them. According to Ellenberger (1970), the Freudian legend had two main components:

The first is the theme of the solitary hero struggling against a host of enemies, suffering "the slings and arrows of outrageous fortune" but triumphing in the end. The legend considerably exaggerates the extent and role of anti-Semitism, of the hostility of the academic world, and of alleged Victorian prejudices. The second feature of the Freudian legend is the blotting out of the greatest part of the scientific and cultural context in which psychoanalysis developed, hence the theme of the absolute originality of the achievements, in which the hero is credited with the achievements of his predecessors, associates, disciples, rivals, and contemporaries. (p. 547)

According to Ellenberger, the facts contradict both components of the legend. First, Freud experienced only slight anti-Semitism, and he did not experience nearly the amount of hostility that several more prominent physicians experienced. Second, most of Freud's ideas were not as original as he and his followers claimed. Concerning the tendency for psychoanalysts to distort their history, Sulloway (1992) noted, "Insofar as psychoanalysts have repeatedly censored and distorted the history of their own discipline, they may well be doing the same thing in reconstructing the case histories of their patients" (p. 159). We will see in the next section that a growing number of Freudian scholars support Sulloway's conclusion.

Freud and his followers had a very low tolerance for criticism and usually accused critics of resistance, lack of understanding, or even bigotry. However, Sulloway (1979) points out that most of the criticisms of psychoanalysis were valid:

In addition to the criticisms that had already been raised before Freud acquired a substantial following, common objections against psychoanalysis now began to include: (1) that psychoanalysts were continually introducing their assertions with the statement, "We know from psychoanalytic experience that ...," and then leaving the burden of proof to others; (2) that Freud's disciples refused to listen to opinions that did not coincide with their own; (3) that they never published statistics on the success of their method; (4) that they persisted in claiming that only those who had used the psychoanalytic method had the right to challenge Freud; (5) that they saw all criticism as a form of "neurotic resistance"; (6) that psychoanalysts tended to ignore all work that had been done before them and then proceeded to make unwarranted claims about their own originality; (7) that they frequently addressed themselves to the wider lay audience as if their theories were already a proven fact, thus making their opponents seem narrow-minded and ignorant; (8) that socalled wild analysts, or individuals without proper training, were analyzing patients in irresponsible ways; and (9) that Freud's followers were becoming a sect, with all of the prominent features of one, including a fanatical degree of faith, a special jargon, a sense of moral superiority, and a predilection for marked intolerance of opponents. In their contemporary context, such criticisms were considerably more rational and had far more merit than traditional psychoanalytic historians have been willing to admit. (p. 460)

The Reality of Repressed Memories

Concerning his seduction theory, Freud believed the mistake he made was accepting the stories of seduction his patients told as true. As we have seen, Jeffrey Masson believed the opposite. For Masson, Freud's mistake was rejecting the seduction stories as true and accepting them as fantasies instead. But what if Freud's patients did not report seduction stories at all? What if the seduction stories were created by Freud instead of by his patients? A careful reading of Freud's "The Aetiology of Hysteria" (1896), and two other articles he wrote on his seduction theory in the same year, reveals that none of Freud's patients reported a seduction of any kind. There is now convincing evidence that Freud entered the therapeutic process with a strong conviction that hysteria had a sexual origin and that he manipulated events during therapy so that his conviction was confirmed: "A consideration of all the evidence ... points to the conclusion that Freud's early patients, in general, did not recount stories of infantile seductions, these stories were actually analytic reconstructions which he foisted on them" (Esterson, 1993, pp. 28-29; see also, Esterson, 1998, 2001).

Freud noted that a physician does not require that a patient know the nature of his or her ailment before it can be effectively treated. Similarly, psychoanalysts assume that patients are ignorant of the origins of their symptoms. It is the analyst who must define the ailment, determine its cause and cure, and then *inform* the patient of these matters. Freud assumed seduction was present in a hysteric's history whether the patient realized it or not; the disease required it! *In Studies on Hysteria* (1895), Freud said,

It is of use if we can guess the ways in which things are connected up and tell the patient before we have uncovered it. ... We need not be afraid ... of telling the patient what we think his next connection of thought is going to be. It will do no harm. (Webster, 1995, p. 163)

In "The Aetiology of Hysteria" (1896, reprinted in Masson, 1984), Freud pondered the idea

that analysts could encourage patients to have certain ideas through suggestion or that patients may invent stories of seduction:

Is it not very possible ... that the physician forces such scenes upon his docile patients, alleging that they are memories, or else that the patients tell the physician things which they have deliberately invented or have imagined and that he accepts those things as true? (Masson, 1984, p. 264)

Freud (1896) rejected these ideas, saying,

In the first place, the behaviour of patients while they are reproducing these infantile experiences is in every respect incompatible with the assumption that the scenes are anything else than a reality which is being felt with distress and reproduced with the greatest reluctance. Before they come for analysis the patients know nothing about these scenes. They are indignant as a rule if we warn them that such scenes are going to emerge. Only the strongest compulsion of the treatment can induce them to embark on a reproduction of them. While they are recalling these infantile experiences to consciousness, they suffer under the most violent sensations, of which they are ashamed and which they try to conceal; and, even after they have gone through them once more in such a convincing manner, they still attempt to withhold belief from them, by emphasizing the fact that, unlike what happens in the case of other forgotten material, they have no feeling of remembering the scenes.

This latter piece of behaviour seems to provide conclusive proof. Why should patients assure me so emphatically of their unbelief, if what they want to discredit is something which—from whatever motive—they themselves have invented? [emphasis added]

It is less easy to refute the idea that the doctor forces reminiscences of this sort on the patient, that he influences him by suggestion to imagine and reproduce them. Nevertheless it appears to me

equally untenable. I have never yet succeeded in forcing on a patient a scene I was expecting to find, in such a way that he seemed to be living through it with all the appropriate feelings. Perhaps others may be more successful in this. (Masson, 1984, pp. 264–265)

Thus, even when Freud suggested stories of seduction to his patients, the stories were met with great resistance and denial, which Freud took as signs of confirmation. The suggestive nature of Freud's technique was well known to a number of Freud's contemporaries. French psychologist and psychotherapist Pierre Janet (1925) said, "The psychoanalysts invariably set to work in order to discover a traumatic memory, with the *a priori* conviction that it is there to be discovered. ... Owing to the nature of their methods, they can invariably find what they seek" (p. 65). In 1899, the German psychiatrist Leopold Lowenfeld reported what happened when one of Freud's previous patients came under Lowenfeld's care:

By chance, one of the patients with whom Freud used the analytic method came under my observation. The patient told me with certainty that the infantile sexual scene which analysis had apparently uncovered was pure fantasy and had never really happened to him. It is difficult to understand how a researcher like Freud, who normally is very critical, despite such remarks, still could maintain toward his patients that the pictures that arose in their minds were memories of real events. However, it is even still more difficult to understand that Freud thought that he could consider this assumption to be completely proven in each single case of hysteria. (Israëls and Schatzman, 1993, p. 44)

It is also important to note that even while Freud was embracing his seduction theory, in no case did he implicate parents in the seductions. Rather, he implicated nursemaids, governesses, domestic servants, adult strangers, teachers, tutors, and in most cases brothers who were slightly older than the sisters they supposedly seduced. Immediately after abandoning his seduction theory, Freud claimed that seduction stories were created by patients to mask memories of real infantile sexual experiences, such as masturbation. It was only later, when Freud developed his concept of the Oedipal complex, that he began to attribute seduction fantasies to infantile incestuous desires directed at the parent of the opposite sex. In his *An Autobiographical Study* (1925/1952), Freud remembered the events surrounding first his acceptance and then his rejection of the seduction theory much differently than his account of them in 1896:

Under the pressure of the technical procedure which I used at that time, the majority of my patients reproduced from their childhood scenes in which they were sexually seduced by some grown-up person. With female patients the part of seducer was almost always assigned to their father. ... I do not believe even now that I forced the seduction-phantasies upon my patients, that I 'suggested' them. I had in fact stumbled for the first time upon the *Oedipus complex*, which was later to assume such an overwhelming importance. (pp. 36–37)

Esterson (1993) notes that Freud's clinical method allowed him to corroborate whatever theoretical notions he was entertaining at the time. Concerning Freud's seduction theory and its subsequent abandonment, Esterson says, "It is difficult to escape the conclusion that both self-deception and dishonesty play a role in this story though at times it is scarcely possible to distinguish one from the other" (p. 31). The philosopher Ludwig Wittgenstein (1889–1951) made the following observations about Freud in a letter to a friend:

He is full of fishy thinking & his charm & the charm of [his] subject is so great that you may be easily fooled. ... Unless you think *very* clearly psycho-analysis is a

dangerous & a foul practice & it's done no end of harm &, comparatively, very little good. ... So hold on to your brains. (Malcolm, 2001, p. 39).

Elsewhere Wittgenstein said, "Freud's fanciful pseudo-explanations, precisely because they are so brilliant, perform a disservice. Now any ass has these pictures available for use in 'explaining' symptoms of illness' (Cioffi, 1998, p. 79).

It should be clear that the questions raised about Freud's clinical method are valid whether repressed memories are assumed to be of real or imagined events. The basic question is whether psychoanalysts, when uncovering repressed memories, are discovering something real about the patient or embracing figments of their own imagination. For Webster (1995) the answer to the question is unambiguous: "There is no evidence that any of the patients who came to Freud without memories of sexual abuse had ever suffered from such abuse" (p. 517).

Not all of the recent accounts of Freud's development of his seduction theory and its subsequent rejection are negative. For a more positive account and a rebuttal to most of the criticisms just described, see Gleaves and Hernandez (1999). For a rebuttal of the claims made by Gleaves and Hernandez (1999), see Esterson (2002b); and for a rebuttal of Esterson's rebuttal, see Gleaves and Hernandez (2002).

Space does not permit a discussion of additional problems associated with Freud's account of repressed memories and several of his other theoretical concepts. For a more comprehensive discussion of these problems, see, for example, Cioffi, 1974, 1998; Crews, 1995; Esterson, 1993, 1998, 2001; Gelfand and Kerr, 1992; Israëls and Schatzman, 1993; Powell and Boer, 1994; Schatzman, 1992; Webster, 1995; Wilcocks, 1994.

Current Concern about Repressed Memories. Recently there has been a dramatic increase in the number of reported memories of childhood abuse that had allegedly been repressed for many years. Although many researchers accept the concept of repressed memories as valid (for example,

Erdelyi, 1985; Frawley, 1990; Rieker and Carmen, 1986; Schuker, 1979; and M. Williams, 1987), many do not. Elizabeth Loftus, in her article "The Reality of Repressed Memories" (1993), recognizes that childhood sexual abuse is tragically common and constitutes a major social problem. She does, however, question the repression and subsequent recovery of the memory of such experiences. From her own research, and after reviewing the literature on the topic, Loftus concludes that most, if not all, reports of *repressed* memories are false. If her conclusion is accurate, why do so many individuals claim to have such memories? One possible reason is that the creation of such memories satisfies a personal need:

The internal drive to manufacture an abuse memory may come about as a way to provide a screen for perhaps more prosaic but, ironically, less tolerable, painful experiences of childhood. Creating a fantasy of abuse with its relatively clear-cut distinction between good and evil may provide the needed logical explanation for confusing experiences and feelings. The core material for the false memories can be borrowed from the accounts of others who are either known personally or encountered in literature, movies, and television. (Loftus, 1993, p. 525)

According to Loftus, the popular literature is filled with material that suggests or even encourages a belief in repressed memories. The "bible" of such books is The Courage to Heal (Bass and Davis, 1988). As of 1995, Courage had sold over 750,000 copies in the United States alone (Webster, 1995, p. 523). This book suggests that people with low selfesteem, suicidal or self-destructive thoughts, depression, or sexual dysfunction were probably victims of childhood sexual abuse, even if they have no recollection of it. About this book, Loftus (1993) says. "Readers without any abuse memories of their own cannot escape the message that there is a strong likelihood that abuse occurred even in the absence of such memories" (p. 525). Other "checklists" suggest people were probably victims of childhood

Elizabeth Loftus

abuse if they have trouble knowing what they want, are afraid of having new experiences, cannot remember parts of their childhood, have a feeling that something bad happened to them, or are intimidated by authority figures (Loftus and Ketcham, 1994). School performance such as failing grades, decreased interest, and difficulty in concentrating have also been suggested as signs of abuse (Davies and Frawley, 1994). With these criteria, almost anyone can suspect that they were the victim of childhood abuse. As Loftus (1994) says, "If everything is a sign of past childhood sexual abuse, then nothing is" (p. 444).

According to Loftus, the fact that so many individuals enter therapy without memories of abuse, but leave with them, should make one wonder about what is going on in therapy. Loftus (1993) cites numerous examples of how therapists suggest memories of abuse to their clients and reaches the following conclusion:

If therapists ask questions that tend to elicit behaviors and experiences thought to be characteristic of someone who had been a victim of childhood trauma, might they too be creating this social reality?

Whatever the good intentions of therapists, the documented examples of rampant suggestion should force us to at least ponder whether some therapists might be suggesting illusory memories to their clients rather than unlocking authentic distant memories. ... What is considered to be present in the client's unconscious mind might actually be present solely in the therapist's conscious mind. (p. 530)

Researchers, such as Loftus, do not deny that many individuals have had traumatic experiences as children or that therapy can help them cope with or overcome the memories of such experiences. It is the supposed repression and the procedures employed to recover "repressed memories" that are being questioned:

Many tortured individuals live for years with the dark secret of their abusive past and only find the courage to discuss their childhood traumas in the supportive and empathic environment of therapy. We are not disputing those memories. We are only questioning the memories commonly referred to as "repressed"—memories that did not exist until someone went looking for them. (Loftus and Ketcham, 1994, p. 141)

Loftus (1993) believes that many questions surrounding the area of repression remain essentially unanswered, and they must be addressed in an objective manner:

Is it possible that the therapist's interpretation is the cause of the patient's disorder rather than the effect of the disorder? ... Is it necessarily true that people who cannot remember an abusive childhood are repressing the memory? Is it necessarily true that people who dream about or visualize abuse are actually getting in touch with true memories? (p. 534)

Loftus (1993) warns that until answers to questions like those above are provided, "zealous conviction is a dangerous substitute for an open mind" (p. 534). Elsewhere Loftus says,

My efforts to write about the power of suggestion to create false memories have been with the hope of encouraging changes in procedures and practices Aggressive efforts to unearth presumably recalcitrant memories can lead to falsememory reports. Uncritical acceptance of every trauma memory report can harm the false victims and, also sadly, trivialize the experiences of the true victims. (2003, p. 871)

Similarly, Powell and Boer (1994) advise that until additional information is obtained on the reliability, risks, and therapeutic effectiveness of memory retrieval, it should be used very conservatively. A primary reason for caution is that the lives of those falsely accused of abuse on the basis of "recovered memories" are often all but destroyed (see, for example, Pendergrast, 1995).

In 2003 the American Psychological Association (APA) presented Loftus its Award for Distinguished Scientific Applications of Psychology for her over 30 years of research on memory, both real and false. See Loftus (2007) for an interesting and informative autobiographical sketch.

EVALUATION OF FREUD'S THEORY

Criticisms

It should come as no surprise that a theory as broad as Freud's, and one that touched so many aspects of human existence, would receive severe criticism. The common criticisms of Freud and his theory include the following:

- Method of data collection. Freud used his own observations of his own patients as his source of data. There was no controlled experimentation. Not only did his patients not represent the general population, but his own needs and expectations probably influenced his observations.
- Definition of terms. Freud's theory became popular at a time when psychology was preoccupied with operational definitions, and many, if not most, of Freud's concepts were too nebulous to be measured. For example, how does one quantify psychic energy, castration anxiety, penis envy, or the Oedipal complex? How does one determine whether the interpretation of the latent symbols of a dream is valid? Science demands measurement, and many of Freud's concepts were not and are not measurable.
- Dogmatism. As we have seen, Freud saw himself as the founder and leader of the psychoanalytic movement, and he would tolerate no ideas that conflicted with his own. If a member of his group insisted on disagreeing with him, Freud expelled that member from the group.
- Overemphasis on sex. The main reason many of Freud's early colleagues eventually went their own way was that they believed Freud overemphasized sex as a motive for human behavior. Some thought that to see sexual motivation everywhere, as Freud did, was extreme and unnecessary. The personality theories that other psychoanalytically oriented theorists developed show that human behavior can be explained just as well, if not better, employing motives other than sexual ones.
- The self-fulfilling prophecy. Any theorist, not just Freud, can be criticized for being susceptible to self-fulfilling prophecy. The point is that Freud may have found what he was looking for simply because he was looking for it. For example, free association is not really free. Rather, it is guided, at least in part, by the analyst's comments and gestures. Furthermore, once a

patient is "trained," he or she may begin to tell the analyst exactly what the analyst wants to hear. This criticism also applies to dream interpretation.

- Length, cost, and limited effectiveness of psychoanalysis. Because psychoanalysis usually takes years to complete, it is not available to most troubled people. Only the most affluent can participate. Furthermore, only reasonably intelligent and mildly neurotic people can benefit from psychoanalysis because patients must be able to articulate their inner experiences and understand the analyst's interpretation of those experiences. Psychoanalysis is not effective with psychotic patients.
- Lack of falsifiability. In Chapter 1, we saw that Karl Popper said Freud's theory was unscientific because it violated the principle of falsification. According to Popper, for a theory to be scientific, it must specify observations that, if made, would refute the theory. Unless such observations can be specified, the theory is unscientific. Popper claimed that because Freudian theory could account for anything a person did, nothing that a person could do would be contrary to what the theory predicted. Let us say, for example, that according to Freudian theory a certain cluster of childhood experiences will make an adult leery of heterosexual relationships. Instead, we find an adult who has had those experiences seeking and apparently enjoying such relationships. The Freudian can simply say that the person is demonstrating a reaction formation. Thus, no matter what happens, the theory is supported. A related criticism is that psychoanalysts engage in postdiction rather than prediction. That is, they attempt to explain events after they have occurred rather than predict what events will occur. The former is clearly easier than the latter. Stanovich (2004) says,

Adherents of psychoanalytic theory spend much time and effort in getting the theory to explain every known event, from individual quirks of behavior to large-scale social phenomena, but their success in making the theory a rich source of after-the-fact explanation robs it of any scientific utility. (p. 26)

Contributions

Despite the criticisms, many believe that Freud made truly exceptional contributions to psychology. The following are usually listed among them:

- Expansion of psychology's domain. Like no one before him, Freud pointed to the importance of studying the relationships among unconscious motivation, infantile sexuality, dreams, and anxiety. Freud's was the first comprehensive theory of personality, and every personality theory since his can be seen as a reaction to his theory or to some aspect of it.
- Psychoanalysis. Freud created a new way of dealing with age-old mental disorders. Many still believe that psychoanalysis is the best way to understand and treat neuroses.
- Understanding of normal behavior. Freud not only provided a means of better understanding much abnormal behavior but also made much normal behavior comprehensible. Dreams, forgetfulness, mistakes, choice of mates, humor, and use of the ego defense mechanisms characterize everyone's life, and Freud's analysis of them makes them less mysterious for everyone.
- Generalization of psychology to other fields. By showing psychology's usefulness in explaining phenomena in everyday life—religion, sports, politics, art, literature, and philosophy—Freud expanded psychology's relevance to almost every sector of human existence.

As influential as Freud's theory has been, much of it has not withstood the rigors of scientific examination; in fact, much of it, as we have seen, is untestable. Why then is Freud's theory so often referred to as a milestone in human history? The

answer seems to be that scientific methodology is not the only criterion by which to judge a theory. Structuralism, for example, was highly scientific, requiring controlled, systematic experiments to test its hypotheses. Yet structuralism has faded away while psychoanalysis has remained.

It is enlightening to compare psychoanalytic psychology with structuralism, in this respect its antithesis. Structuralism, equipped with a highly developed scientific method, and refusing to deal with materials not amenable to that method, admirably illustrates the demand for exactness and correctness by which science disciplines untutored curiosity. Psychoanalysis, with its seemingly inexhaustible curiosity, at present lacks the means, and apparently at times the inclination, to check its exuberant speculation by severely critical tests. But what it lacks in correctness, it gains in vitality, in the comprehensiveness of its view, and in the

closeness of its problems to the concerns of everyday life. (Heidbreder, 1933, pp. 410–411)

Similarly, Robinson (1985) says,

The psychoanalytic account is a story, a narrative, but not a scientific one. It is rather a historical narrative—something of a saga—which is "good" or less than good depending upon the contact it makes with the reader's own experiences and thoughts. We ask of such accounts only whether they make sense, recognizing that they are but one of an indefinite number of possible accounts all of which may make as much (or as little) sense. (p. 123)

To the means by which we evaluate theories, we must add intuition. A theory that, among other things, makes sense personally may survive longer than one that develops and is tested within the realm of science.

SUMMARY

Although most, if not all, of the conceptions that would later characterize psychoanalysis were part of Freud's philosophical and scientific heritage, his historically significant accomplishment was to take those disparate conceptions and synthesize them into a comprehensive theory of personality. Although Freud was trained in the tradition of positivistic physiology and originally tried to explain hysteria as a physiological problem, events led him to attempt a psychological explanation of hysteria instead. Freud learned from Breuer that when Breuer's patient Anna O. was totally relaxed or hypnotized and then asked to remember the circumstances under which one of her many symptoms had first occurred, the symptom would at least temporarily disappear. This type of treatment was called the cathartic method. Freud also learned from Breuer's work with Anna O. that the therapist was sometimes responded to as if he were a relevant person in the patient's life, a process called transference. Sometimes the therapist also became emotionally involved with a patient, a process called countertransference. Studies on Hysteria (1895/1955), the book that Freud coauthored with Breuer, is usually taken as the formal beginning of the school of psychoanalysis. From his visit with Charcot, Freud learned that hysteria is a real disorder that occurs in both males and females, that ideas dissociated from consciousness by trauma could trigger bodily symptoms in those inherently predisposed to hysteria, and that the symptoms of hysteria may have a sexual origin.

The year before his visit with Charcot, Freud began experimenting with cocaine. At first, he viewed it as a "magical substance" that could be used to cure a wide variety of ailments. It was soon realized, however, that cocaine was highly addictive and had a number of negative side effects.

Freud's medical career suffered considerably because of close association with and strong endorsement of the drug. Although Freud escaped personal addiction to cocaine, he was addicted to nicotine, and it is widely believed that his lifelong habit of smoking about 20 cigars a day caused the cancer of the mouth and jaw that he developed late in life.

Soon after Freud began treating hysterical patients, he used hypnosis but found that he could not hypnotize some patients and that the ones he could hypnotize received only temporary relief from their symptoms. He also found that patients often refused to believe what they had revealed under hypnosis and therefore could not benefit from a rational discussion of previously repressed material. After experimenting with various other techniques, Freud finally settled on free association, whereby he encouraged his patients to say whatever came to their minds without inhibiting any thoughts. By analyzing a patient's symptoms and by carefully scrutinizing a patient's free associations, Freud hoped to discover the repressed memories responsible for a patient's disorder. Because these pathogenic thoughts provoked anxiety, patients resisted allowing them to enter consciousness. Freud originally believed that hysteria results from a childhood sexual seduction but later concluded that the seductions he had discovered were usually patient fantasies.

During his self-analysis, Freud found that dreams contain the same clues concerning the origins of a psychological problem as did physical symptoms or free associations. He distinguished between the manifest content of a dream, or what the dream appears to be about, and the latent content, or what the dream is actually about. Freud believed that the latent content represents wish fulfillments that a person could not entertain consciously without experiencing anxiety. Dream work disguises the true meaning of a dream. Examples of dream work include condensation, in which several things from a person's life are condensed into one symbol, and displacement, in which a person dreams about something symbolically related to an anxietyprovoking object, person, or event instead of dreaming about whatever it is that actually provokes the anxiety. During his self-analysis, Freud confirmed several of his theoretical notions such as the Oedipus complex.

According to Freud, the adult mind consists of an id, an ego, and a superego. The id is entirely unconscious and demands immediate gratification; it is therefore said to be governed by the pleasure principle. The id also contains all instincts and the energy associated with instincts. To satisfy needs, the id has at its disposal only the primary processes of reflex action and wish fulfillment. The ego's job is to find real objects in the environment that can satisfy needs; it is therefore said to be governed by the reality principle. The realistic processes of the ego are referred to as secondary in order to distinguish them from the irrational primary processes of the id. The third component of the mind is the superego, which consists of the conscience, or the internalization of the experiences for which a child had been punished, and the ego-ideal, or the internalization of the experiences for which a child had been rewarded.

The ego's job is to find ways of effectively satisfying needs without violating the values of the superego. When such a way is found, the ego invests energy in it, a process called cathexis. If an available way to satisfy a need violates a person's values, energy is expended to inhibit its utilization, in which case an anticathexis occurs. When an anticathexis occurs, the person displaces the anxiety-provoking object or event to one that does not cause anxiety. Freud distinguished between life instincts called eros and a death instinct called thanatos. Freud used the concept of the death instinct to explain such things as suicide, masochism, murder, and general aggression.

Freud distinguished among objective anxiety, the fear of environmental events; neurotic anxiety, the feeling that one is about to be overwhelmed by one's id; and moral anxiety, the feeling caused by violating one or more internalized values. One of the major jobs of the ego is to reduce or eliminate anxiety; to accomplish this, the ego employs the ego defense mechanisms, which operate on the unconscious level and distort reality. All defense mechanisms depend on repression, which is the

holding of disturbing thoughts in the unconscious. Other ego defense mechanisms are displacement, sublimation, projection, identification, rationalization, and reaction formation.

During the psychosexual stages of development, the erogenous zone, or the area of the body associated with the greatest amount of pleasure, changes. Freud named the stages of development in terms of their erogenous zones. During the oral stage, either overgratification or undergratification of the oral needs results in a fixation, which in turn causes the individual to become either an oralincorporative or an oral-sadistic character. Fixation during the anal stage results in the adult being either an anal-expulsive or an anal-retentive character. During the phallic stage, the male and female Oedipal complexes occur. Freud believed the psychology of males and females to be qualitatively different, primarily because of differential Oedipal experiences. After encountering difficulties in his various attempts to understand women, he finally gave up trying. The latency stage is characterized by repression of sexual desires and much sublimation. During the genital stage, the person emerges possessing the personality traits that experiences during the preceding stages have molded.

Freud found considerable evidence for his theory in everyday life. He felt that forgetting, losing things, accidents, and slips of the tongue were often unconsciously motivated. He also thought jokes provide information about repressed experience because people tend to find only anxiety-provoking material humorous. Freud believed that although we share the instinctual makeup of other animals, humans have the capacity to understand and harness instinctual impulses by exercising rational thought. To come to grips with the unconscious mind through rationality, however, is an extremely difficult process, and for that reason, Freud was not optimistic that rationalism would prevail over our

animal nature. Freud was especially critical of religion, believing that it is an illusion that keeps people functioning on an infantile level. His hope was that people would embrace the principles of science, thereby becoming more objective about themselves and the world.

In recent years, there have been efforts to correct several misconceptions about Freud and psychoanalysis. Historians such as Ellenberger and Sulloway have shown that Freud was not the courageous, innovative hero that he and his followers portrayed him to be. The facts seem to be that he did not suffer nearly the amount of anti-Semitism that he claimed, he was not overly discriminated against by the medical establishment, and his ideas were not as original as he and his followers claimed. Several current scholars and researchers suggest that Freud entered the therapeutic situation assuming that childhood sexual trauma is the cause of a patient's disorder. He then manipulated events so that his expectations were confirmed. Evidence indicates that none of Freud's early patients volunteered seduction stories (either real or imagined) and that in each case such stories were suggested to them by Freud. Others, such as Loftus, question the very existence of repressed memories and suggest that a search for them may do more harm than good. Freud has also been criticized for using data from his patients to develop and validate his theory, using nebulous terms that make measurement difficult or impossible, being intolerant of criticism, overemphasizing sexual motivation, and creating a method of psychotherapy that is too long and costly to be useful to most troubled people. Also, Freud's theory violates Popper's principle of falsifiability. Among Freud's contributions are the vast expansion of psychology's domain, a new method of psychotherapy, and a theory that explains much normal as well as abnormal behavior and is relevant to almost every aspect of human existence.

DISCUSSION QUESTIONS

- Provide evidence that many components of what was to become psychoanalysis were part of Freud's philosophical or scientific heritage.
- 2. Describe the cocaine episode in Freud's career.
- 3. Briefly define the terms *pathogenic idea*, *catharsis*, *transference*, and *countertransference*.
- 4. What was the significance of Freud's visit with Charcot for the development of psychoanalysis?
- 5. What did Freud learn from Liébeault and Bernheim at the Nancy school of hypnosis that influenced the development of psychoanalysis?
- 6. Discuss the importance of resistance in psychoanalysis.
- 7. What did Freud mean when he said that *true* psychoanalysis began only after hypnosis had been discarded?
- 8. What was Freud's seduction theory? What did Freud conclude his mistake regarding the seduction theory had been?
- 9. Explain the significance of dream analysis for Freud. Why did he originally use it? What is the difference between the manifest and the latent content of a dream? What is meant by dream work?
- 10. What is the Oedipus complex, and what is its significance in Freud's theory?
- 11. Define the term *parapraxes* and show its importance to Freud's contention that much everyday behavior is unconsciously motivated.
- 12. What is meant by saying that a behavioral or psychological act is overdetermined?
- 13. Give an example showing the interactions among the id, the ego, and the superego.
- 14. Make the case that Freud's theory accepted Lamarck's theory of evolution, that is, the inheritance of acquired characteristics.

- 15. Why did Freud feel the need to postulate the existence of a death instinct? What types of behavior did this instinct explain?
- 16. Define and give examples of objective, neurotic, and moral anxiety.
- 17. What, according to Freud, is the function of the ego defense mechanisms? Why is repression considered the most basic ego defense mechanism? Explain what Freud meant when he said that civilization is built on sublimation.
- 18. Why did Freud refer to the experiences of both male and female children during the phallic stage as Oedipal complexes? In what important ways do the two complexes differ? How did Freud's effort to understand women end?
- 19. What was Freud's view of human nature? Religion? What was his hope for humankind?
- 20. What major Freudian myths are currently being revealed and corrected by such individuals as Ellenberger, Esterson, and Sulloway?
- 21. Summarize the evidence suggesting that Freud instilled in his patients the repressed memories that he claimed to discover.
- 22. Explain why Esterson and others argue that psychoanalysts often discover repressed memories of childhood seduction in their patients because the analysts' beliefs require that they be found. Also explain why, according to this argument, it is irrelevant whether such memories are assumed to be of real or imagined events.
- 23. Why do researchers, such as Loftus, question the existence of repressed memories? Explain why these researchers believe that a search for repressed memories may do more harm than good.
- 24. Summarize the major criticisms and contributions of Freud's theory.

SUGGESTIONS FOR FURTHER READING

- Borch-Jacobsen, M. (1996). Remembering Anna O.: A century of mystification (K. Olson, Trans.). New York: Routledge.
- Cioffi, F. (1998). Freud and the question of pseudoscience. La Salle, IL: Open Court.
- Crews, F. (1995). The memory wars: Freud's legacy in dispute. New York: The New York Review of Books.
- Esterson, A. (1993). Seductive mirage: An exploration of the work of Sigmund Freud. La Salle, IL: Open Court.
- Gay, P. (1988). Freud: A life for our time. New York: Norton.

- Loftus, E. (1993). The reality of repressed memories. *American Psychologist*, 48, 518–537.
- Loftus, E. (2007). Elizabeth F. Loftus. In G. Lindzey & W. M. Runyan (Eds.), A history of psychology in autobiography (Vol. 9, pp. 199–224). Washington, DC: American Psychological Association.
- Roazen, P. (1992). Freud and his followers. New York: Da Capo Press.
- Sulloway, F. J. (1979). Freud, biologist of the mind: Beyond the psychoanalytic legend. New York: Basic Books.
- Webster, R. (1995). Why Freud was wrong: Sin, science, and psychoanalysis. New York: Basic Books.

GLOSSARY

Anticathexis The expenditure of psychic energy to prevent the association between needs and the ideas of anxiety-provoking objects or events.

Anxiety The feeling of impending danger. Freud distinguished three types of anxiety: objective anxiety, which is caused by a physical danger; neurotic anxiety, which is caused by the feeling that one is going to be overwhelmed by his or her id; and moral anxiety, which is caused by violating one or more values internalized in the superego.

Breuer, Josef (1842–1925) The person Freud credited with the founding of psychoanalysis. Breuer discovered that when the memory of a traumatic event is recalled under deep relaxation or hypnosis, there is a release of emotional energy (catharsis) and the symptoms caused by the repressed memory are relieved.

Cathartic method The alleviation of hysterical symptoms by allowing pathogenic ideas to be expressed consciously.

Cathexis The investment of psychic energy in thoughts of things that can satisfy a person's needs.

Condensation The type of dream work that causes several people, objects, or events to be condensed into one dream symbol.

Conflict According to Freud, the simultaneous tendency both to approach and avoid the same object, event, or person.

Countertransference The process by which a therapist becomes emotionally involved with a patient.

Death instinct The instinct that has death as its goal (sometimes called the death wish).

Displacement The ego defense mechanism by which a goal that does not provoke anxiety is substituted for one that does. Also, the type of dream work that causes the dreamer to dream of something symbolically related to anxiety-provoking events rather than dreaming about the anxiety-provoking events themselves.

Dream analysis A major tool that Freud used in studying the contents of the unconscious mind. Freud thought that the symbols dreams contain could yield information about repressed memories, just as hysterical symptoms could.

Dream work The mechanism that distorts the meaning of a dream, thereby making it more tolerable to the dreamer. (*See also* **Condensation** and **Displacement**.)

Ego According to Freud, the component of the personality that is responsible for locating events in the environment that will satisfy the needs of the id without violating the values of the superego.

Ego defense mechanisms The strategies available to the ego for distorting the anxiety-provoking aspects of reality, thus making them more tolerable.

Free association Freud's major tool for studying the contents of the unconscious mind. With free association,

a patient is encouraged to express freely everything that comes to his or her mind.

Freud, Sigmund (1856–1939) The founder of psychoanalysis, a school of psychology that stresses the conflict between the animalistic impulses possessed by humans and the human desire to live in a civilized society.

Id According to Freud, the powerful, entirely unconscious portion of the personality that contains all instincts and is therefore the driving force for the entire personality.

Instincts According to Freud, the motivational forces behind personality. Each instinct has a source, which is a bodily deficiency of some type; an aim of removing the deficiency; an object, which is anything capable of removing the deficiency; and an impetus, which is a driving force whose strength is determined by the magnitude of the deficiency. (*See also* **Life instincts** and **Death instinct**.)

Latent content What a dream is *actually* about.

Libido For Freud, the collective energy associated with the life instincts.

Life instincts The instincts that have as their goal the sustaining of life.

Manifest content What a dream *appears* to be about **Oedipus complex** The situation that, according to Freud, typically manifests itself during the phallic stage of psychosexual development, whereby children sexually desire the parent of the opposite sex and are hostile toward the parent of the same sex.

Overdetermination Freud's observation that behavioral and psychological phenomena often have two or more causes.

Parapraxes Relatively minor errors in everyday living such as losing and forgetting things, slips of the tongue, mistakes in writing, and small accidents. Freud believed that such errors are often unconsciously motivated.

Pathogenic ideas Ideas that cause physical disorders.

Repression The holding of traumatic memories in the unconscious mind because pondering them consciously would cause too much anxiety.

Resistance The tendency for patients to inhibit the recollection of traumatic experiences.

Seduction theory Freud's contention that hysteria is caused by a sexual attack: Someone familiar to or related to the hysteric patient had attacked him or her when the patient was a young child. Freud later concluded that in most cases such attacks are imagined rather than real.

Studies on Hysteria The book Breuer and Freud published in 1895 that is usually viewed as marking the formal beginning of the school of psychoanalysis.

Superego According to Freud, the internalized values that act as a guide for a person's conduct.

Transference The process by which a patient responds to the therapist as if the therapist were a relevant person in the patient's life.

Unconscious motivation The causes of our behavior of which we are unaware.

Wish fulfillment In an effort to satisfy bodily needs, the id conjures up images of objects or events that will satisfy those needs.

Early Alternatives to Psychoanalysis

A lthough much of Anna Freud's work in psychoanalysis reflected her father's views, some of her contributions represent important extensions of, or alternatives to, psychoanalytic orthodoxy. Thus, we begin our sample of early alternatives to psychoanalysis with a discussion of those contributions.

ANNA FREUD

Anna Freud (1895–1982), the youngest of Freud's six children, was born on December 3 in the same year that Breuer and Freud published *Studies on Hysteria*, marking the founding of psychoanalysis. According to Young-Bruehl, "To Anna Freud's reckoning, she and psychoanalysis were twins who started out life competing for their father's attention" (1988, p. 15). As a young child, Anna began describing her dreams to her father, and several of them were included in Freud's *The Interpretation of Dreams* (1900/1953). At the age of 13 or 14, Anna was allowed to attend the Wednesday meetings of the Vienna Psychoanalytic Society by sitting on a library ladder in the corner of the room. By the time she was 17, Anna had read some of her father's books and often discussed with him the meaning of psychoanalytic terms.

Although Anna became a successful primary school teacher, her interest in psychoanalysis intensified and, contrary to his own sanction against analysts analyzing their own friends or family members, Freud began to psychoanalyze Anna in 1918. The analysis continued until 1922 and was resumed for another year in 1925. In 1922 Anna presented a paper to the Vienna Psychoanalytic Society on childhood fantasies (presumably her own), and two weeks later she was certified as a psychoanalyst.

Anna Freud

The discovery of Freud's cancer in 1923 (Anna was 27 years old at the time) brought him and Anna even closer together. Anna's mother (Martha) was never as important to Anna as her father was, and as her father's physical condition worsened, Anna successfully competed with her mother to become his primary caregiver. The relationship was reciprocal. With Anna, Freud could have meaningful discussions about psychoanalysis, something he could never do with his wife, who considered psychoanalytic ideas a form of pornography (Gay, 1988, p. 61). By the early 1920s, Freud and Anna were inseparable. Anna became her father's emissary to psychoanalytic societies throughout the world, delivered his papers, typed his daily correspondence, and, along with his friend and physician Max Schur, attended to his personal and medical needs. When her father died, Anna inherited his library, his cherished antiques, and his ideas. Anna Freud not only preserved and perpetuated her father's ideas, but she extended them into new areas such as child analysis (1928) and education and child rearing (1935). As we shall see, she also made several original contributions to the psychoanalytic literature.

Anna Freud's and Melanie Klein's Conflicting Views on Child Analysis

As Anna Freud began developing her views on child analysis, they soon came into conflict with

the views being developed by Melanie Klein (1882-1960). Klein attended the University of Vienna and was analyzed by two members of the Freudian inner circle, Sandor Ferenczi and Karl Abraham. Soon after becoming an analyst, Klein began extending psychoanalytic concepts to children. She summarized her ideas in The Psycho-Analysis of Children (1932). Klein departed from traditional psychoanalysis by emphasizing pre-Oedipal development. She also deemphasized biological drives (such as sexual pleasure) and emphasized the importance of interpersonal relationships. The mother-child relationship was especially important to Klein. The earliest stage of this relationship focused on the mother's breast, which the infant viewed as either good (satisfying) or bad (frustrating). The good breast satisfies the life instincts and stimulates feelings of love and creativity. The bad breast satisfies the death instinct and stimulates feelings of hate and destruction. According to Klein, the emotions caused by the interaction of the infant's experiences with the mother's breast and with life and death instincts provide the prototype used to evaluate all subsequent experiences. For Klein notions of good and bad and right and wrong develop during the oral stage, not the phallic stage as the Freudians (including Anna) had assumed. According to Klein's theory, the superego develops very early in life, and its development is largely determined by the interaction between life and death instincts. About the importance of the death instinct in Klein's theory, Gay (1988) said, "If anyone took Freud's death drive with all its implications seriously, it was Melanie Klein" (p. 468). Klein also believed that child analysis could begin much earlier than the traditional psychoanalysts believed by analyzing a child's playful activities instead of the child's free associations. Klein's belief that a child's free, undirected play reveals unconscious conflicts allows children as young as two years old to be analyzed. For an overview of Klein's version of psychoanalysis, see Segal, 1974.

Anna Freud disagreed with most of Klein's conceptions of child analysis, continuing to emphasize the importance of the phallic and genital stages of development and to analyze children's fantasies

and dreams instead of their play activities during therapy. Although Klein's views had a substantial impact on child analysis, it was the views of Anna Freud that generally prevailed. (For the details of the controversies between Klein and Anna Freud, see Donaldson, 1996; King and Steiner, 1991; Viner, 1996.)

Ego Psychology

There are significant differences between analyzing children and adults, and these differences caused Anna to emphasize the ego more in child analysis than when treating adults. The major difference is that children do not recall early traumatic experiences as adults do. Rather, children display developmental experiences as they occur. The problems that children have reflect obstacles to their normal growth. Rather than viewing the problems of childhood as reflecting conflicts among the id, ego, and superego, as with adults, children were viewed as reflecting the many vulnerabilities encountered during the transition between childhood and adolescence and young adulthood. Anna Freud (1965) used the term developmental lines to describe a child's gradual transition from dependence on external controls to mastery of internal and external reality. Developmental lines are attempts by the child to adapt to life's demands, whether those demands are situational, interpersonal, or personal. They describe normal development and therefore can be used as a frame of reference for defining maladjustment. Although, according to Anna Freud (1965), each developmental line consists of several components, the following list consists only of the major characteristics of each line:

- From dependency to emotional self-reliance
- From sucking to rational eating
- From wetting and soiling to bowel-bladder control
- From irresponsibility to responsibility in body management
- From egocentricity to companionship
- From play to work

Although Anna Freud believed that her developmental lines complemented her father's psychosexual stages, we see in them ego functions that are relatively independent of conflicts between the id and superego.

In her influential book The Ego and the Mechanisms of Defense (published in German in 1936; in English in 1937), Anna Freud also emphasized autonomous ego functions. In this book, she described in detail the ego defenses described by her father and others, and she correlated each mechanism with a specific type of anxiety (objective, neurotic, moral). Whereas traditional analysts—including her father—had viewed the ego defenses as obstacles to the understanding of the unconscious, Anna viewed them as having independent importance. She showed how the mechanisms are normally used in adjusting to social and biological needs. When normal use is understood, abnormal use is easier to determine. To the traditional list of defense mechanisms, Anna Freud added two of her own. Altruistic surrender occurs when a person gives up his or her own ambitions and lives vicariously by identifying with another person's satisfactions and frustrations. Identification with the aggressor occurs when a person adopts the values and mannerisms of a feared person as his or her own. According to Anna Freud, it was the latter mechanism that explains the development of the superego: "What else is the superego than identification with the aggressor?" (Young-Bruehl, 1988, p. 212). Identification with the aggressor also explains why some hostages develop affection toward their captors. In contemporary psychology, the latter tendency is referred to as the Stockholm syndrome. The name derives from the case of a woman who was taken hostage during a 1973 bank robbery in Stockholm, Sweden. During the ordeal the woman became so emotionally attached to one of the robbers that she subsequently broke off her engagement to another man and remained faithful to her former captor as he served his prison term.

Clearly, Anna Freud overcame her conflict with her "twin," psychoanalysis:

By the time Anna Freud was thirty and a practicing psychoanalyst as well as a

lecturer at the Vienna Psychoanalytic Institute on her specialty, child analysis, she and her twin were no longer rivals. They were merged. In 1936, for his eightieth birthday, she gave her father a book she had written, The Ego and the Mechanisms of Defense, which marked a reconfiguration of their lives: she was then the inheritor of her twin, the mother of psychoanalysis; the one to whom primary responsibility for its spirit, its future, was passed. Sigmund Freud, old, weak, faced with the imminent occupation of his homeland by the Nazis, the prospect of exile, called his daughter "Anna Antigone." (Young-Bruehl, 1988, p. 15)

Why Antigone? Because in Sophocles' play Oedipus at Colonus, it is the dutiful and courageous Antigone who leads her blind and ill father (Oedipus) by the hand. She, like Anna, was a gallant and loyal companion to her father: "It was Anna Freud who was firmly installed as her wounded father's secretary, confidante, representative, colleague, and nurse. She became his most precious claim on life, his ally against death" (Gay, 1988, p. 442).

In 1950 Anna Freud received an honorary degree from Clark University, as her father had done in 1909. This was her first university degree of any kind. She subsequently received honorary degrees from several other universities, including Harvard, Yale, and Vienna. After devoting nearly 60 years to the analysis of children and adolescents, Anna Freud suffered a stroke on March 1, 1982, and died on October 9.

The analysis of the ego for its own sake, started by Anna Freud, was continued by others and became known as ego psychology. For example, Heinz Hartmann (1894–1970) wrote Psychology and the Problem of Adaptation (1939/ 1958), in which he introduced the concept of the "conflict-free ego sphere." Problems, he said, are often solved in an open and adaptive manner, without regard to the remnants of infantile experiences. Erik Erikson (1902–1994), in his influential book Childhood and Society (1950/1985), described how the ego gains strength as it progresses through eight stages of psychosocial (not psychosexual) development that occur over a person's lifetime. Incidentally, it was Anna Freud who analyzed Erikson, qualifying him to become an analyst himself. (For the details of Erikson's influential theory of personality, see Hergenhahn and Olson, 2007.)

CARL JUNG

Born on July 26 in the Swiss village of Kesswil, Carl Jung (1875–1961) studied medicine at Basel from 1895 to 1901 and then worked as a resident under Eugen Bleuler (who coined the term schizophrenia). Jung spent the winter of 1902-1903 studying with Janet. On Bleuler's recommendation, Jung administered Galton's word association test to psychotics in hopes of discovering the nature of their unconscious thought processes. This research was fairly successful and brought Jung some early fame. Jung first became acquainted with Freud's theory when he read The Interpretation of Dreams. When Jung tried Freud's ideas in his own practice, he found them effective. He and Freud began to correspond, and eventually they met in Freud's

Carl Jung

home in Vienna. Their initial meeting lasted 13 hours, and the two became close friends.

When G. Stanley Hall invited Freud to give a series of lectures at Clark University in 1909, Jung traveled to the United States with Freud and gave a few lectures of his own (on his word-association research). About this time, Jung began to express doubts about Freud's emphasis on sexual motivation. These doubts became so intense that in 1912 the two stopped corresponding, and in 1914 they completely terminated their relationship—despite the fact that Freud had earlier nominated Jung to be the first president of the International Psychoanalytic Association. The break in the relationship was especially disturbing to Jung, who entered what he called his "dark years," a period of three years during which he was so depressed he could not even read a scientific book. During this time, he analyzed his innermost thoughts and developed his own distinct theory of personality, which differed markedly from Freud's. Jung continued to develop his theory until his death on June 6, 1961.

Libido

The major source of difficulty between Freud and Jung was the nature of the libido. At the time of his association with Jung, Freud defined libido as "sexual energy," which he saw as the main driving force of personality. Thus, for Freud, most human behavior is sexually motivated. Jung disagreed, saying that libidinal energy is a creative life force that could be applied to the individual's continuous psychological growth. According to Jung, libidinal energy is used in a wide range of human endeavors beyond those of a sexual nature, and it can be applied to the satisfaction of both biological and philosophical or spiritual needs. In fact, as one becomes more proficient at satisfying the former needs, one can use more libidinal energy in dealing with the latter needs. In short, sexual motivation was much less important to Jung than it was to Freud.

The Ego

Jung's conception of the **ego** was similar to Freud's. The ego is the mechanism by which we interact with the physical environment. It is everything of which we are conscious and is concerned with thinking, problem solving, remembering, and perceiving.

The Personal Unconscious

Combining the Freudian notions of the preconscious and the unconscious, Jung's **personal unconscious** consists of experiences that had either been repressed or simply forgotten—material from one's lifetime that for one reason or another is not in consciousness. Some of this material is easily retrievable, and some of it is not.

The Collective Unconscious and the Archetypes

The collective unconscious was Jung's most mystical and controversial concept, and his most important. Jung believed the collective unconscious to be the deepest and most powerful component of the personality, reflecting the cumulative experiences of humans throughout their entire evolutionary past. According to Jung, it is the "deposit of ancestral experience from untold millions of years, the echo of prehistoric world events to which each century adds an infinitesimally small amount of variation and differentiation" (1928, p. 162). The collective unconscious registers common experiences that humans have had through the eons. These common experiences are recorded and are inherited as predispositions to respond emotionally to certain categories of experience. Jung referred to each inherited predisposition contained in the collective unconscious as an archetype.

Thus, for Jung, the mind is not a "blank tablet" at birth but contains a structure that had developed in a Lamarckian fashion. That is, experiences of preceding generations are passed on to new generations. Archetypes can be thought of as generic images with which events in one's lifetime interact. They record not only perceptual experiences but also the emotions typically associated with those perceptual experiences. In fact, Jung thought that the emotional component of archetypes is their most important feature. When an experience "communicates with" or "identifies with" an

archetype, the emotion elicited is typical of the emotional response people have had to that type of experience through the eons. For example, each child is born with a generic conception of mother that is the result of the cumulative experiences of preceding generations, and the child will tend to project onto its real mother the attributes of the generic mother-image. This archetype will influence not only how the child views his or her mother but also how the child responds to her emotionally. For Jung then, archetypes provide each person with a framework for perceptual and emotional experience. They predispose people to see things in certain ways, to have certain emotional experiences, and to engage in certain categories of behavior. One such category is myth making:

Primitive humans responded to all of their emotional experiences in terms of myths, and it is this tendency toward myth making that is registered in the collective unconscious and passed on to future generations. What we inherit, then, is the tendency to reexperience some manifestation of these primordial myths as we encounter events that have been associated with those myths for eons. Each archetype can be viewed as an inherited tendency to respond emotionally and mythologically to certain kinds of experience—for example, when a child, a mother, a lover, a nightmare, a death, a birth, an earthquake, or a stranger is encountered. (Hergenhahn and Olson, 2007, p. 75)

Although Jung recognized a large number of archetypes, he elaborated the following ones most fully. The *persona* causes people to present only part of their personality to the public. It is a mask in the sense that the most important aspects of personality are hidden behind it. The *anima* provides the female component of the male personality and a framework within which males can interact with females. The *animus* provides the masculine component of the female personality and a framework within which females can interact with males. The *shadow*,

the archetype that we inherit from our prehuman ancestors, provides us with a tendency to be immoral and aggressive. We project this aspect of our personalities onto the world symbolically as devils, demons, monsters, and evil spirits. The *self* causes people to try to synthesize all components of their personalities. It represents the human need for unity and wholeness of the total personality. The goal of life is first to discover and understand the various parts of the personality and then to synthesize them into a harmonious unity. Jung called this unity *self-actualization*.

The Attitudes

Jung described two major orientations, or attitudes, that people take in relating to the world. One attitude he labeled introversion, the other extroversion. Jung believed that although every individual possesses both attitudes, he or she usually assumes one of the two attitudes more than the other. The introverted person tends to be quiet, imaginative, and more interested in ideas than in interacting with people. The extroverted person is outgoing and sociable. Although most people tend toward either introversion or extroversion, Jung believed that the mature, healthy adult personality reflects both attitudes about equally.

Causality, Teleology, and Synchronicity

Like Freud, Jung was a determinist. Both believed that important causes of a person's personality are found in his or her past experiences. However, Jung believed that to truly understand a person, one must understand the person's prior experiences—including those registered in the collective unconscious—and the person's goals for the future. Thus, unlike Freud's theory, Jung's embraced teleology (purpose). For Jung people are both pushed by the past and pulled by the future.

For Jung another important determinant of personality is **synchronicity**, or meaningful coincidence. Synchronicity occurs when two or more

events, each with their own independent causality, come together in a meaningful way. Progoff (1973) gives the following examples:

A person ... has a dream or a series of dreams, and these turn out to coincide with an outer event. An individual prays for some special favor, or wishes, or hopes for it strongly, and in some inexplicable way it comes to pass. One person believes in another person, or in some special symbol, and while he is praying or meditating by the light of faith, a physical healing or some other "miracle" comes to pass. (p. 122)

Progoff (1973, pp. 170-171) describes a synchronistic experience in the life of Abraham Lincoln. In his early life, Lincoln had dreams of doing meaningful work in the world. In conflict with these dreams was Lincoln's realization that in his frontier environment there were few tools available for his intellectual development. Lincoln despaired of his dreams ever being fulfilled. Then a stranger appeared wishing to sell a barrel full of odds and ends for a dollar. The stranger told Lincoln that the contents of the barrel were essentially worthless, but that he needed a dollar very badly. With characteristic kindness, Lincoln gave the stranger a dollar for the barrel. Some time later, Lincoln discovered that the barrel contained an almost complete edition of Blackstone's Commentaries. These books furnished Lincoln with the information and the intellectual stimulation he needed to eventually become a lawyer and enter into a career in politics.

Dreams

Dreams were important to Jung, but he interpreted them very differently than Freud. Freud believed that repressed, traumatic experiences reveal themselves in dreams because one's defenses are reduced during sleep. During the waking state, these experiences are actively held in the unconscious mind because to entertain them consciously would provoke extreme anxiety. Jung believed that everyone has the same collective unconscious but that

individuals differ in their ability to recognize and give expression to the various archetypes. As we have seen, Jung also believed that everyone has an innate tendency to recognize, express, and synthesize the various components of his or her personality and, in so doing, to become self-actualized. Even with this tendency, however, most people are not self-actualized. For most individuals, certain components of the personality remain unrecognized and underdeveloped. For Jung, dreams are a means of giving expression to aspects of the psyche that are underdeveloped. If a person did not give adequate expression to the shadow, for example, he or she would tend to have nightmares involving various monsters. Dream analysis, then, can be used to determine which aspects of the psyche are being given adequate expression and which are not.

The Importance of Middle Age

According to Jung, the goal of life is to reach selfactualization, which involves the harmonious blending of all aspects of the personality. How the various aspects of personality manifest themselves within the context of a particular person's life is called individuation. The job of recognizing and expressing all forces within us is monumental because these forces usually conflict with one another. The rational conflicts with the irrational, feeling with thinking, masculine tendencies with feminine tendencies, introversion with extroversion, and conscious processes with unconscious processes. The process of attempting to understand these conflicting forces occupies most of childhood, adolescence, and early adulthood. It is usually not until the late thirties or early forties that a major transformation occurs. Once a person has recognized the many conflicting forces in his or her personality, the person is in a position to synthesize and harmonize them. Self-actualization occurs when all discordant elements of personality are given equal expression. In a healthy, integrated individual, each system of the personality is differentiated, developed, and expressed. Although Jung believed that everyone has an innate tendency toward self-actualization, he also believed that people rarely attain that state.

Criticisms and Contributions

Jung's theory has been criticized for embracing occultism, spiritualism, mysticism, and religion. Many saw Jung as unscientific or even antiscientific because he used such things as the symbols found in art, religion, and human fantasy to develop and verify his theory. The concept of the archetype, which is central to Jung's theory, has been criticized for being metaphysical and unverifiable. Some have referred to Jung's theory in general as unclear, incomprehensible, inconsistent, and, in places, contradictory. Finally, Jung has been criticized for employing the Lamarckian notion of the inheritance of acquired characteristics.

Despite these criticisms, Jungian theory remains popular in psychology. Jung has influential followers throughout the world, and several major cities have Jungian institutes that elaborate and disseminate his ideas (DeAngelis, 1994; Kirsch, 2000). Jung's notions of introversion and extroversion have stimulated much research and are part of several popular personality tests—for example, the Minnesota Multiphasic Personality Inventory and the Myers-Briggs Type Indicator. Also, Jung's concepts of introversion and extroversion were major components of Hans J. Eysenck's (1916-1997) influential theory of personality (see, for example, Eysenck and Eysenck, 1985). Finally, it was Jung who introduced the Aristotelian notion of selfactualization into modern psychology.

ALFRED ADLER

Born on February 17 in a suburb of Vienna, **Alfred Adler (1870–1937)** remembered his childhood as being miserable. He was a sickly child who thought of himself as small and ugly. He also had a severe rivalry with his older brother. All these recollections may have influenced the type of personality theory Adler developed.

Like Jung, Adler became acquainted with Freudian psychology by reading *The Interpretation of Dreams*. Adler wrote a paper defending Freud's theory and was invited to join the Vienna

Alfred Adler

Psychoanalytic Society, of which he became president in 1910. Differences between Adler and Freud began to emerge, however, and by 1911 they became so pronounced that Adler resigned as president of the society. After a nine-year association with Freud, the friendship crumbled, and the two men never saw each other again. Freud accused Adler of becoming famous by reducing psychoanalysis to the commonsense level of the layperson. About Adler, Freud said, "I have made a pygmy great" (Wittels, 1924, p. 225). History shows that Freud and Adler never had much in common, and it was probably a mistake for Adler to join the Freudians. Ernest Jones (1955) summarized Adler's major disagreements with Freud:

Sexual factors, particularly those of childhood, were reduced to a minimum: a boy's incestuous desire for intimacy with his mother was interpreted as the male wish to conquer a female masquerading as sexual desire. The concepts of repression, infantile sexuality, and even that of the unconscious itself were discarded. (p. 131)

In 1926 Adler visited the United States and was warmly received. Adler made the United States his permanent home in 1935, partially because of the Nazi menace in Europe. He died on May 28, 1937,

while on a lecture tour in Aberdeen, Scotland. The animosity that Freud felt toward Adler can be seen in the following comment Freud made to a person who was moved by the news of Adler's death:

I don't understand your sympathy for Adler. For a Jew boy out of a Viennese suburb a death in Aberdeen is an unheard-of career in itself and a proof of how far he had got on. The world really rewarded him richly for his service in having contradicted psychoanalysis. (E. Jones, 1957, p. 208)

Fiebert (1997) provides details concerning Adler's initial professional involvement with Freud, the sources of dissension between Adler and Freud, and the relationship between the two following Adler's "excommunication."

Organ Inferiority and Compensation

Like Freud, Adler was trained in the materialistic-positivistic medical tradition; that is, every disorder, whether physical or mental, was assumed to have a physiological origin. Adler (1907/1917) presented the view that people are particularly sensitive to disease in organs that are "inferior" to other organs. For example, some people are born with weak eyes, others with weak hearts, still others with weak limbs, and so on. Because of the strain the environment puts on these weak parts of the body, the person develops weaknesses that inhibit normal functioning.

One way to adjust to a weakness is through **compensation**. That is, a person can adjust to a weakness in one part of his or her body by developing strengths in other parts. For example, a blind person can develop especially sensitive auditory skills. Another way to adjust to a weakness is through **overcompensation**, which is the conversion of a weakness into a strength. The usual examples include Teddy Roosevelt, who was a frail child but became a rugged outdoorsman, and Demosthenes, who had a speech impediment but became a great orator. At the time when Adler

presented this view, he was a physician, and his observations were clearly in accord with the materialistic-positivistic medicine of the time.

Feelings of Inferiority

In 1910 Adler entered the realm of psychology when he noted that compensation and overcompensation can be directed toward *psychological* inferiorities as well as toward physical ones. Adler noted that *all* humans begin life completely dependent on others for their survival and therefore with **feelings of inferiority**, or weakness. Such feelings motivate people first as children and later as adults to gain power to overcome these feelings. In his early theorizing, Adler emphasized the attainment of power as a means of overcoming feelings of inferiority; later, he suggested that people strive for perfection or superiority to overcome these feelings.

Although feelings of inferiority motivate all personal growth and are therefore good, they can also disable rather than motivate some people. These people are so overwhelmed by such feelings that they accomplish little or nothing, and they are said to have an **inferiority complex**. Thus, feelings of inferiority can act as a stimulus for positive growth or as a disabling force, depending on one's attitude toward them.

Worldviews, Fictional Goals, and Lifestyles

Hans Vaihinger's philosophy of "as if" influenced Adler's theory. We saw in Chapter 9 that Vaihinger was primarily concerned with showing how fictions in science, mathematics, religion, philosophy, and jurisprudence make complex societal life possible. Adler, however, applied Vaihinger's concept of fiction to the lives of individuals. Like Vaihinger, Adler believed that life is inherently meaningless, and therefore whatever meaning life has must be assigned to it by the individual.

A person's worldview develops from early experiences as a child. Depending on the nature of these experiences, a child could come, for example,

to view the world as a dangerous, evil place or as a safe and loving place. The first invention of meaning in a person's life, then, is the creation of a worldview. Once a worldview develops, the child ponders how to live in the world as he or she perceives it. The child begins to plan his or her future by creating what Adler at various times called "fictional finalisms," "guiding self-ideals," or "guiding fictions." These are future goals that are reasonable given the child's worldview. If the worldview is positive, the child might attempt to embrace the world by planning to become a physician, teacher, artist, or scientist, for example. If the worldview is negative, the child might aggress toward the world by planning a life of crime and destruction.

From the worldview come guiding fictions (future goals), and from guiding fictions comes a **lifestyle**. Primarily, a lifestyle encompasses the everyday activities performed while pursuing one's goals. However, a person's lifestyle also determines which aspects of life are focused on and how, what is perceived and what is ignored, and how problems are solved.

According to Adler, for a lifestyle to be truly effective it must contain considerable **social interest**. That is, part of its goal must involve working toward a society that would provide a better life for everyone. Adler called any lifestyle without adequate social interest a **mistaken lifestyle**. Because the neurotic typically has a mistaken lifestyle, the job of the psychotherapist is to replace that lifestyle with one that contains a healthy amount of social interest.

The Creative Self

Adler departed radically from the theories of Freud and Jung by saying that humans are not victims of their environment or of biological inheritance. Although environment and heredity provide the raw materials of personality, the person is free to arrange those materials in any number of ways. For example, whether feelings of inferiority facilitate growth or disable a person is a matter of personal choice. And, although life is inherently meaningless, one is free to invent meaning and

then act "as if" it were true. His concept of the **creative self** aligned Adler with the existential belief that humans are free to choose their own destiny.

With his concept of the creative self, Adler rejected the very foundation of Freud's psychoanalysis —repressed memories of traumatic experiences. Adler said, "We do not suffer the shock of [traumatic experiences] we make out of them just what suits our purposes" (1931/1958, p. 14). Once a worldview, final goals, and a lifestyle are created by an individual, all experiences are interpreted relative to them. These creations, which provide the basic components of one's personality, allow some experiences to be understood but not others. For Adler, experiences that can be assimilated into one's personality are understood; those experiences that cannot be assimilated are not understood. For him, what Freud and others called unconscious simply meant not understood.

Thus, although Adler was an early member of Freud's inner circle, the theory he developed had little, if anything, in common with Freud's. Unlike Freud's theory, Adler's theory emphasized the conscious mind, social rather than sexual motives, and free will. Much of Adler's thinking was to emerge later in such theories as those of Rollo May, George Kelly, Carl Rogers, and Abraham Maslow. All these theories have in common the existential theme, which is a focus of the next chapter.

For a discussion of the influence of Adlerian theory and therapeutic techniques in contemporary psychology, see Carlson, Watts, and Maniacci, 2006.

KAREN HORNEY

Karen Horney (pronounced "horn-eye"; 1885–1952) was born Karen Danielson on September 16 in a small village near Hamburg, Germany. Her father was a Norwegian sea captain, and her mother, who was 18 years younger than the captain, was a member of a prominent Dutch-German family. Karen's father was a God-fearing fundamentalist who believed that women are inferior to men

and are the primary source of evil in the world. Karen had conflicting feelings about her father. She disliked him because of the frequent derogatory statements he made about her appearance and intelligence. She liked him because he added adventure to her life by taking her with him on at least three lengthy sea voyages. Karen's family also consisted of four children from the captain's previous marriage and her older brother Berndt. The family called the father the "Bible thrower" (Rubins, 1978, p. 11) because often, after reading the Bible at length, he would explode in a fit of anger and throw the Bible at his wife. Such experiences caused Karen to develop a negative attitude toward religion and toward authority figures in general. After being treated by a physician when she was age 12, Karen decided she wanted to become a medical doctor. Her decision was supported by her mother and opposed by her father.

In 1906, at the age of 21, Karen entered the medical school at Freiberg, Germany. In October 1909, she married Oskar Horney, a lawyer with whom she eventually had three children (two of whom were psychoanalyzed by Melanie Klein). Horney completed her medical degree at the University of Berlin in 1913, where she was an outstanding student. She then received psychoanalytic training at the Berlin Psychoanalytic Institute,

Karen Horney

where she was psychoanalyzed first by Karl Abraham and then by Hans Sachs, two of the most prominent Freudian analysts at the time (and both members of Freud's inner circle). In 1918, at the age of 33, she became a practicing analyst; from that time until 1932, she taught at the Berlin Psychoanalytic Institute and also maintained a private practice.

In 1923 the Horney marriage started to disintegrate, and at about the same time, Horney's brother died of pneumonia. These and other events triggered one of many bouts of depression that Horney experienced during her life, and on a family vacation she came close to committing suicide. Her marriage was becoming increasingly difficult, and in 1926 Horney and her three daughters moved into an apartment. It was not until 1936, however, that Horney officially filed for a divorce, and the divorce did not become final until 1939 (the year that Freud died).

In 1932 Horney accepted an invitation from the prominent analyst Franz Alexander to come to the United States to become an associate director of the newly founded Chicago Institute of Psychoanalysis. Two years later, she moved to New York, where she trained analysts at the New York Psychoanalytic Institute and established a private practice. It was during this time that major differences between her views and those of the traditional Freudians became apparent. Because of these differences, the theses submitted by her students were routinely rejected, and eventually her teaching duties were restricted. In 1941 she resigned from the New York Psychoanalytic Institute; shortly afterward, she founded her own organization called the American Institute for Psychoanalysis, where she continued to develop her own ideas until her death in 1952.

General Disagreement with Freudian Theory

Horney believed that Freudian notions such as unconscious sexual motivation, the Oedipal complex, and the division of the mind into an id, ego, and superego may have been appropriate in Freud's cultural setting and at his time in history but that they had little relevance for problems experienced by people during the Depression years in the United States. She found that the problems that her clients were having had to do with losing their jobs and not having enough money to pay the rent, buy food, or provide their families with adequate medical care. She rarely found unconscious sexual conflicts to be the cause of a client's problem. Horney reached the conclusion that what a person experiences socially determines whether he or she will have psychological problems, and not the intrapsyche conflict (among the id, ego, and superego) that Freud had described. For Horney, the causes of mental illness are to be found in society and in social interactions, and it is therefore those factors that need to be addressed in the therapeutic process.

Basic Hostility and Basic Anxiety

Horney (1937) elaborated her view that psychological problems are caused by disturbed human relationships, and of these relationships, those between the parents and the child are most important. She believed that every child has two basic needs: to be safe from pain, danger, and fear and to have biological needs satisfied. Two possibilities exist: the parents can consistently and lovingly satisfy the child's needs, or the parents can demonstrate indifference, inconsistency, or even hatred toward the child. If the former occurs, the child is well on the way to becoming a normal, healthy adult. If the latter occurs, the child is said to have experienced the **basic** evil and is well on the way to becoming a neurotic.

A child experiencing some form of the basic evil develops **basic hostility** toward the parents. Because the parent-child relationship is so basic to a child, the hostility he or she feels develops into a worldview. That is, the world is viewed as a dangerous, unpredictable place. However, because the child is in no position to aggress toward the parents or the world, the basic hostility felt toward them must be repressed. When basic hostility is repressed, it becomes **basic anxiety**. Basic anxiety is the "allpervading feeling of being lonely and helpless in a

hostile world" (Horney, 1937, p. 77), and it is the prerequisite for the development of neurosis.

Adjustments to Basic Anxiety

Feeling alone and helpless in a hostile world, the person experiencing basic anxiety must find a way to cope with such feelings and such a world. Horney (1945) described three major adjustment patterns available to neurotic individuals, that is, those with basic anxiety.

One adjustment is **moving toward people**, thus becoming the *compliant type*. The compliant type seems to be saying, "If I give in, I shall not be hurt" (Horney, 1937, p. 83).

In sum, this type needs to be liked, wanted, desired, loved; to feel accepted, welcomed, approved of, appreciated; to be needed, to be of importance to others, especially to one particular person; to be helped, protected, taken care of, guided. (Horney, 1945, p. 51)

A second major adjustment pattern is **moving against people**, thus becoming the *hostile type*. The hostile type seems to be saying, "If I have power, no one can hurt me" (Horney, 1937, p. 84).

Any situation or relationship is looked at from the standpoint of "What can I get out of it?"—whether it has to do with money, prestige, contacts, or ideas. The person himself is consciously or semiconsciously convinced that everyone acts this way, and so what counts is to do it more efficiently than the rest. (Horney, 1945, p. 65)

The third major adjustment pattern is **moving** away from people, thus becoming the *detached* type. The detached type seems to be saying, "If I withdraw, nothing can hurt me" (Horney, 1937, p. 85).

What is crucial is their inner need to put emotional distance between themselves and others. More accurately, it is their conscious and unconscious determination not to get emotionally involved with others in any way, whether in love, fight, co-operation, or competition. They draw around themselves a kind of magic circle which no one may penetrate. (Horney, 1945, p. 75)

Horney believed that psychologically healthy individuals use all three adjustment patterns as circumstances warrant. Neurotics, however, use only one pattern and attempt to use it to deal with all of life's eventualities.

Feminine Psychology

Horney initially agreed with Freud's contention that **anatomy is destiny**—that is, that one's major personality traits are determined by gender. However, in her version of this contention, it is males who envy female anatomy rather than the other way around:

From the biological point of view woman has in motherhood, or in the capacity for motherhood, a quite indisputable and by no means negligible physiological superiority. This is most clearly reflected in the unconscious of the male psyche in the boy's intense envy of motherhood....

When one begins, as I did, to analyze men only after a fairly long experience of analyzing women, one receives a most surprising impression of the intensity of this envy of pregnancy, childbirth, and motherhood, as well as of the breasts and of the act of suckling. (Horney and Kelman, 1967, pp. 60–61)

(For a discussion of how Horney's views concerning the contention that anatomy is destiny changed over time, see Hergenhahn and Olson, 2007, pp. 141–143; Paris, 2000, pp. 166–168.)

In the end, Horney's position was that personality traits are determined more by cultural than by biological factors. As early as 1923, Horney began writing articles on how culture influences female personality development, and she continued to

write such articles until 1937. These articles have been compiled in *Feminine Psychology* (Horney and Kelman, 1967).

Horney agreed with Freud that women often feel inferior to men, but, to her, this feeling has nothing to do with penis envy. According to Horney, women are indeed inferior to men, but they are culturally, not biologically, inferior. Horney described how cultural stereotypes hold women back:

Woman's efforts to achieve independence and an enlargement of her field of interests and activities are continually met with skepticism which insists that such efforts should be made only in the face of economic necessity, and that they run counter to her inherent character and her natural tendencies. Accordingly, all efforts of this sort are said to be without any vital significance for woman, whose every thought, in point of fact, should center exclusively upon the male or upon motherhood. (Horney and Kelman, 1967, p. 182)

When women appear to wish to be masculine, what they are really seeking is cultural equality. Because culture is a masculine product, one way to gain power in culture is to become masculine: "Our whole civilization is a masculine civilization. The State, the laws, morality, religion, and the sciences are the creation of men" (Horney and Kelman, 1967, p. 55):

The wish to be a man ... may be the expression of a wish for all those qualities or privileges which in our culture are regarded as masculine, such as strength, courage, independence, success, sexual freedom, right to choose a partner. (1939, p. 108)

As we have seen, Freud was essentially mystified by women and finally gave up trying to understand them. Perhaps for this reason, psychoanalysis has always seemed to understand men better than women and to view men more positively than women. According to Horney, this should not be surprising:

The reason for this is obvious. Psychoanalysis is the creation of a male genius, and almost all those who have developed his ideas have been men. It is only right and reasonable that they should evolve more easily a masculine psychology and understand more of the development of men than of women. (Horney and Kelman, 1967, p. 54)

Horney agreed with Freud on the importance of early childhood experiences and unconscious motivation but disagreed with his emphasis on biological motivation, stressing cultural motivation instead. As far as the therapeutic process is concerned, Horney used free association and dream analysis and believed transference and resistance provided important information. She was much more optimistic about people's ability to change their personalities than Freud was, and, unlike Freud, she believed people could solve many of their own problems. Horney's book Self-Analysis (1942/1968) was one of the first self-help books in psychology, and it was controversial. One reason for the controversy was Freud's contention that all analysts had to be psychoanalyzed before being qualified to treat patients.

In conclusion, we can say that Horney was strongly influenced by Freudian theory and accepted much of it. However, she ended up disagreeing with almost every conclusion that Freud had reached about women. At the time, disagreeing with Freud took considerable courage:

It must be realized that departing from Freudian dogma at the time was no easy matter. In fact, those who did so were excommunicated just as if they had violated religious dogma. Horney was excommunicated because she dared to contradict the master.... Horney learned from observing her father as a child how devastating blind belief in religious dogma could be; perhaps that was one reason she decided not to let Freud go unchallenged. (Hergenhahn and Olson, 2007, p. 149)

Chodorow (1989) recognizes Horney as the first psychoanalytic feminist.

Because Freud's was the first comprehensive effort to explain personality and his was the first comprehensive attempt to understand and treat individuals with mental illness, all subsequent theories of personality and therapeutic techniques owe a debt to him. One of the greatest tributes to Freud is the number of prominent individuals he influenced, and we have discussed only a small sample. (For a more extensive sample, see Roazen, 1992.)

SUMMARY

Anna Freud became the spokesperson for psychoanalysis after her father died. She also applied psychoanalysis to children, which brought her into conflict with Melanie Klein, who had distinctly different ideas about child analysis. In her analysis of children, Anna Freud concentrated on developmental lines, which describe a child's attempts to deal with situational, personal, and interpersonal problems. Her approach to understanding children emphasized ego functions and minimized libidinal functions. Her interest in ego psychology was further demonstrated by her analysis of the ego defense mechanisms, to which she added two: altruistic surrender and identification with the aggressor.

Jung, an early follower of Freud, eventually broke with him because of Freud's emphasis on sexual motivation. Jung saw the libido as a pool of energy that could be used for positive growth throughout one's lifetime rather than as purely sexual energy, as Freud had seen it. Jung distinguished between the personal unconscious, which consists of experiences from one's lifetime of which a

person is not conscious, and the collective unconscious, which represents the recording of universal human experience through the eons of human history. According to Jung, the collective unconscious contains archetypes, or predispositions, to respond emotionally to certain experiences in one's life and to create myths about them. Among the more fully developed archetypes are the persona, the anima, the animus, the shadow, and the self. Jung distinguished between the attitudes of introversion and extroversion. He stressed the importance of middle age in personality development because before selfactualization can occur, the many conflicting forces within the psyche must be understood. Reaching such an understanding is a long, complicated process that usually takes place during childhood, adolescence, and early adulthood. Jung believed that human behavior is both pushed by the past and the present (causality) and pulled by the future (teleology). He also believed that synchronicity, or meaningful coincidence, plays a major role in determining one's course of life. Jung assumed that dreams give expression to the parts of the personality that are not given adequate expression in one's life. Dream analysis, then, can be used to determine which aspects of the personality are adequately developed and which are not.

Like Jung, Adler was an early follower of Freud who eventually went his own way. The theory Adler developed was distinctly different from the theories of both Freud and Jung. Early in his career, Adler noted that a person suffering from some physical disability could either compensate for the disability by strengthening other abilities or, by overcompensating, turn the disability into a strength. Later, he discovered that all humans begin life feeling inferior because of infant helplessness. Adler believed that most people develop a lifestyle that allows them to gain power or approach perfection and thereby overcome their feelings of inferiority. Some people, however, are overwhelmed by their feelings of inferiority and develop an inferiority complex. Influenced by Vaihinger's philosophy of "as if," Adler believed that the only meaning in life is the meaning created by the individual. Out of its earliest experiences, a child creates a worldview.

From the worldview, guiding fictions or future goals are derived, and a lifestyle is created to achieve those goals. According to Adler, healthy lifestyles involve a significant amount of social interest, whereas mistaken lifestyles do not. The creative self gives people control over their personal destinies.

Horney was trained as a Freudian analyst but eventually developed her own theory. She believed that psychological problems result more from societal conditions and interpersonal relationships than from sexual conflicts, as the Freudians maintained. Among interpersonal relationships, that between parent and child is most important. Horney believed that there were two types of parent-child relationships: one that consistently and lovingly satisfies the child's biological and safety needs and one that frustrates those needs. Horney referred to the latter relationship as the basic evil, and for her, it was the seed from which neurosis grows. The basic evil causes the child to feel basic hostility toward the parents and the world, but this hostility must be repressed because of the child's helplessness. When basic hostility is repressed, it becomes basic anxiety, which is the feeling of being alone and helpless in a hostile world. A child experiencing basic anxiety typically uses one of three major adjustment patterns with which to embrace reality: Moving toward people emphasizes love, moving against people emphasizes hostility, and moving away from people emphasizes withdrawal. Normal people use all three adjustment techniques as they are required, whereas neurotics attempt to cope with all of life's experiences using just one.

Horney disagreed with Freud's contention that anatomy is destiny, saying instead that gender differences in personality are culturally determined. She said that women often feel inferior to men because they are often culturally inferior. In her practice, Horney found that it was males who were envious of female biology rather than the reverse. Horney contended that psychoanalysis seemed more appropriate and complimentary to males because it was created by males. Although in her practice of psychoanalysis Horney used a number of Freudian concepts and techniques, she

was more optimistic in her prognosis for personality change than was Freud. Also, unlike Freud, she believed that many individuals could solve their own psychological problems and wrote a book designed to help them in that effort.

DISCUSSION QUESTIONS

- What were Anna Freud's contributions to psychoanalysis? Why is she considered a pioneer of ego psychology?
- 2. Define the following terms from Jung's theory: collective unconscious, archetype,persona, anima, animus, shadow, and self.
- 3. Define the following terms from Adler's theory: compensation, overcompensation, feelings of inferiority, inferiority complex, worldview, guiding fiction, lifestyle, social interest, mistaken lifestyle, and creative self.
- 4. Summarize the main differences between Freud's and Adler's theories of personality.
- 5. In what way(s) did Vaihinger's philosophy of "as if" influence Adler's theory of personality?

- 6. Define the following terms from Horney's theory: basic evil, basic hostility, and basic anxiety.
- 7. According to Horney, what are the three major adjustment patterns that neurotics can use while interacting with people? How does the way normal people use these patterns differ from the way neurotics use them?
- 8. Why, according to Horney, do women sometimes feel inferior to men?
- 9. Did Horney agree with Freud's contention that anatomy is destiny? Explain.
- 10. How did Horney and Freud differ in their explanations of the origins of psychological problems? On the prognosis for personality change? On the belief in peoples' ability to solve their own psychological problems?

SUGGESTIONS FOR FURTHER READING

- Alexander, I. E. (1991). C. G. Jung: The man and his work, then, and now. In G. A. Kimble,
 M. Wertheimer, & C. L. White (Eds.), *Portraits of pioneers in psychology*, (pp. 153–196). Washington,
 DC: American Psychological Association.
- Hannah, B. (1976). Jung, his life and work: A biographical memoir. New York: Putnam.
- Horney, K., & Kelman, H., (Ed.). (1967). Feminine psychology. New York: Norton.
- Paris, B. J. (1994). Karen Horney: A psychoanalyst's search for self-understanding. New Haven, CT: Yale University Press.
- Paris, B. J. (2000). Karen Horney: The three phases of her thought. In G. A. Kimble, & M. Wertheimer

- (Eds.), Portraits of pioneers in psychology (Vol. 4, pp. 163–179). Washington, DC: American Psychological Association.
- Quinn, S. (1988). A mind of her own: The life of Karen Horney. Reading, MA: Addison-Wesley.
- Rubins, J. L. (1978). Karen Horney: Gentle rebel of psychoanalysis. New York: Dial.
- Segal, H. (1974). Introduction to the work of Melanie Klein (2nd ed.). New York: Basic Books.
- Stern, P. J. (1976). C. G. Jung: The haunted prophet. New York: Dell.
- Young-Bruehl, E. (1988). Anna Freud: A biography. New York: Norton.

GLOSSARY

Adler, Alfred (1870–1937) An early follower of Freud who left the Freudian camp and created his own theory of personality, which emphasized the conscious mind and the individual creation of a worldview, guiding fictions, and a lifestyle in order to overcome feelings of inferiority and to seek perfection.

Altruistic surrender An ego defense mechanism, postulated by Anna Freud, whereby a person avoids personal anxiety by vicariously living the life of another person.

Anatomy is destiny The Freudian contention that a number of major personality characteristics are determined by one's gender.

Archetype According to Jung, an inherited predisposition to respond emotionally to certain categories of experience.

Basic anxiety According to Horney, the feeling of being alone and helpless in a hostile world that a child experiences when he or she represses basic hostility. (*See also* **Basic hostility**.)

Basic evil According to Horney, anything that parents do to frustrate the basic needs of their child and thus undermine the child's feeling of security.

Basic hostility According to Horney, the feeling of anger that a child experiences when he or she experiences the basic evil. (*See also* **Basic evil**.)

Collective unconscious Jung's term for the part of the unconscious mind that reflects universal human experience through the ages. For Jung the collective unconscious is the most powerful component of the personality.

Compensation According to Adler, the making up for a weakness by developing strengths in other areas.

Creative self According to Adler, the component of the personality that provides humans with the freedom to choose their own destinies.

Developmental lines A concept introduced by Anna Freud describing the major adjustments that typify the transition between childhood and adolescence and young adulthood.

Dream analysis For Jung dreams provided a mechanism by which inhibited parts of the psyche might be given expression. Therefore, for Jung, dream analysis indicated which aspects of the psyche are underdeveloped.

Ego According to Jung, that aspect of the psyche responsible for problem solving, remembering, and perceiving.

Ego psychology Psychology that emphasizes the autonomous functions of the ego and minimizes the conflicts among the ego, id, and superego.

Extroversion According to Jung, the attitude toward life that is characterized by gregariousness and a willingness to take risks.

Feelings of inferiority According to Adler, those feelings that all humans try to escape by becoming powerful or superior.

Freud, Anna (1895–1982) Became the official spokesperson for psychoanalysis after her father's death. In addition to perpetuating traditional psychoanalytic concepts, she extended them into new areas such as child psychology, education, and child rearing. By elaborating on autonomous ego functions, she encouraged the development of ego psychology. (See also Ego psychology.)

Horney, Karen (1885–1952) Trained in the Freudian tradition, she later broke away from the Freudians and created her own theory of mental disorders that emphasized cultural rather than biological (such as sexual) causes.

Identification with the aggressor An ego defense mechanism, postulated by Anna Freud, whereby the fear caused by a person is reduced by adopting the feared person's values.

Inferiority complex According to Adler, the condition one experiences when overwhelmed by feelings of inferiority instead of being motivated toward success by those feelings.

Introversion According to Jung, the attitude toward life that is characterized by social isolation and an introspective nature.

Jung, Carl (1875–1961) An early follower of Freud who eventually broke with him because of Freud's emphasis on sexual motivation. Jung developed his own theory, which emphasized the collective unconscious and self-actualization.

Klein, Melanie (1882–1960) An early child analyst whose theory emphasized the importance of the mother-child relationship and the development of the superego

during the oral stage of development. By using play therapy, Klein believed that child analysis could begin as early as two years of age. Klein's ideas concerning the psychology of children were often in conflict with those of Anna Freud.

Libido For Jung, the creative life force that provides the energy for personal growth.

Lifestyle According to Adler, the way of life that a person chooses to implement the life's goals derived from his or her worldview.

Mistaken lifestyle According to Adler, any lifestyle lacking sufficient social interest.

Moving against people The neurotic adjustment pattern suggested by Horney by which people adjust to a world perceived as hostile by gaining power over people and events.

Moving away from people The neurotic adjustment pattern suggested by Horney by which people adjust to a world perceived as hostile by creating a distance between themselves and the people and events in that world.

Moving toward people The neurotic adjustment pattern suggested by Horney by which people adjust to a world perceived as hostile by being compliant.

Overcompensation According to Adler, the conversion of a weakness into a strength.

Personal unconscious Jung's term for the place that stores material from one's lifetime of which one is currently not conscious.

Social interest The concern for other humans and for society that Adler believed characterizes a healthy lifestyle.

Synchronicity According to Jung, what occurs when unrelated events converge in a person's life in a meaningful way.

Teleology The doctrine that states that at least some human behavior is purposive, that is, directed to the attainment of future goals.

Humanistic (Third-Force) Psychology

THE MIND, THE BODY, AND THE SPIRIT

Generally speaking, human nature can be divided into three major components: the mind (our intellect), the body (our biological makeup), and the spirit (our emotional makeup). Different philosophies and, more recently, schools of psychology have tended to emphasize one of these aspects at the expense of the others. Which philosophy or school of psychology prevailed seemed to be determined largely by the Zeitgeist. The decade of the 1960s was a troubled time in the United States. There was increased involvement in the unpopular Vietnam War and its corresponding antiwar movement; Martin Luther King Jr., John Fitzgerald Kennedy, and Robert Kennedy were assassinated; and violent, racial protests occurred in a number of major cities. "Hippies" were in open rebellion against the values of their parents and their nation. Like the ancient Skeptics, they found little worth believing in, and like the ancient Cynics, they dropped out of society and returned to a simple, natural life. This Age of Aquarius was clearly not a time when rational philosophy (with emphasis on the mind) or empirical philosophy (with emphasis on the body) were appealing.

During the 1920s and 1930s, the schools of structuralism, functionalism, behaviorism, Gestalt psychology, and psychoanalysis coexisted and pursued their respective goals. By the mid-20th century, however, structuralism had disappeared as a school, and functionalism and Gestalt psychology had lost their distinctiveness as schools by being assimilated into other viewpoints. In the 1950s and early 1960s, only behaviorism and psychoanalysis remained as influential, intact schools of thought. In the troubled times described above, the knowledge of humans provided by behaviorism and psychoanalysis was seen by many as

incomplete, distorted, or both. Needed was a new view of psychology, one that emphasized neither the mind nor the body but the human spirit.

In the early 1960s, a group of psychologists headed by Abraham Maslow started a movement referred to as third-force psychology. These psychologists claimed that the other two forces in psychology, behaviorism and psychoanalysis, neglected a number of important human attributes. They said that by applying the techniques used by the natural sciences to the study of humans, behaviorism likened humans to robots, lower animals, or computers. For the behaviorist, there was nothing unique about humans. The major argument against psychoanalysis was that it concentrated mainly on emotionally disturbed people and on developing techniques for making abnormal people normal. What was missing, according to third-force psychologists, was information that would help already healthy individuals become healthier—that is, to reach their full potential. What was needed was a model of humans that emphasized their uniqueness and their positive aspects rather than their negative aspects, and it was this type of model that thirdforce psychologists attempted to provide.

Although third-force psychology became very popular during the 1960s and 1970s, its popularity began to wane in the 1980s. Like behaviorism and psychoanalysis, however, third-force psychology remains influential in contemporary psychology (see, for example, Clay, 2002). Third-force psychology contrasts vividly with most other types because it does not assume determinism in explaining human behavior. Rather, it assumes that humans are free to choose their own type of existence. Instead of attributing the causes of behavior to stimuli, drive states, genetics, or early experience, third-force psychologists claim that the most important cause of behavior is subjective reality. Because these psychologists do not assume determinism, they are not scientists in the traditional sense, and they make no apology for that. Science in its present form, they say, is not equipped to study, explain, or understand human nature. A new science is needed, a human science. A human science would not study humans as the physical

sciences study physical objects. Rather, it would study humans as aware, choosing, valuing, emotional, and unique beings in the universe. Traditional science does not do this and must therefore be rejected.

ANTECEDENTS OF THIRD-FORCE PSYCHOLOGY

Like almost everything else in modern psychology, third-force psychology is not new. It can be traced to the philosophies of romanticism and existentialism, which in turn can be traced to the early Greeks. In Chapter 7, we saw that the romantics (such as Rousseau) insisted that humans are more than machines, which was how the empiricists and sensationalists were describing them, and more than the logical, rational beings, which was how rationalists were describing them. Like the ancient Cynics, the romantics distrusted reason, religious dogma, science, and societal laws as guides for human conduct. For them, the only valid guide for a person's behavior was that person's honest feelings. The romantics (especially Rousseau) believed that humans are naturally good and gregarious, and if given freedom they would become happy, fulfilled, and social-minded. That is, given freedom, people would do what was best for themselves and for other people. If people acted in self-destructive or antisocial ways, it was because their natural impulses had been interfered with by societal forces. People can never be bad, but social systems can be and often are. Also in Chapter 7, we saw that the existentialists (such as Kierkegaard and Nietzsche) emphasized the importance of meaning in human existence and the human ability to choose that meaning; this, too, was contrary to the philosophies of empiricism and rationalism. For Kierkegaard subjectivity is truth. That is, it is a person's beliefs that guide his or her life and determine the nature of his or her existence. Truth is not something external to the person waiting to be discovered by logical, rational thought processes; it is inside each person and is, in fact, created by each person. According to

Nietzsche, God is dead, and therefore humans are on their own. People can take two approaches to life: they can accept conventional morality as a guide for living, thus participating in herd conformity; or they can experiment with beliefs, values, and life and arrive at their own truths and morality and thus become supermen. Nietzsche clearly encouraged people to do the latter.

Third-force psychology combines the philosophies of romanticism and existentialism, and this combination is called humanistic psychology. Third-force and humanistic psychology, then, are the same, but humanistic psychology has become the preferred label. In applying this label, however, it is important not to confuse the term *humanistic* with the terms *human*, *humane*, or *humanitarian*.

The frequent confusion of the terms human, humane, and humanistic indicates that many do not clearly understand the meaning of the humanistic stance. To qualify as humanistic, it is not enough to concern human beings. Playing, working, building, traveling, organizing, are all human activities. This, however, does not make them humanistic. Similarly, when these activities are performed, for instance, for charitable or philanthropic purposes, they are then raised to a humane or humanitarian status, which may be of vital importance but still does not make them humanistic. For an endeavor or a viewpoint to qualify properly as humanistic, it must imply and focus upon a certain concept of man—a concept that recognizes his status as a person, irreducible to more elementary levels, and his unique worth as a being potentially capable of autonomous judgment and action. A pertinent example of the difference between the humane and the humanistic outlook is found in the case of behavior control that relies entirely upon positive reinforcement. Such an approach is humane (or humanitarian), since it implements generous and compassionate attitudes. But it is not humanistic, because the

rationale behind systematic behavior modification by purely external forces is incompatible with a concept of man as a self-purposive and proactive, rather than merely reactive, being.

The focus of humanistic psychology is upon the specificity of man, upon that which sets him apart from all other species. It differs from other psychologies because it views man not solely as a biological organism modified by experience and culture but as a person, a symbolic entity capable of pondering his existence, of lending it meaning and direction. (Kinget, 1975, p. v)

Although it is true that existentialism is a major component of humanistic psychology, important differences exist between existential and humanistic psychology. After discussing phenomenology, a technique used by both existential and humanistic psychologists, we will review existential psychology and then humanistic psychology, and we will conclude the chapter with a comparison of the two.

PHENOMENOLOGY

Throughout this text, we have referred to a variety of methodologies as phenomenological. In its most general form, phenomenology refers to any methodology that focuses on cognitive experience as it occurs, without attempting to reduce that experience to its component parts. Thus, one can study consciousness without being a phenomenologist, as was the case when Wundt and Titchener attempted to reduce conscious experience to its basic elements. After making this distinction, however, phenomenology can take many forms. The phenomenology of Johann Goethe and Ernst Mach focused on complex sensations including afterimages and illusions. The phenomenology of Franz Brentano (1838-1917) and his colleagues focused on psychological acts such as judging, recollecting, expecting, doubting, fearing, hoping, or loving. As we saw in Chapter 9, in Brentano's brand of phenomenology, the concept of **intentionality** was extremely important. Brentano believed that every mental act refers to (intends) something outside itself—for example, "I see a tree," "I like my mother," or "That was a good piece of pie." The contents of a mental act could be real or imagined, but the act, according to Brentano, always refers to (intends) something. In Chapter 14, we saw how Brentano's phenomenology influenced the Gestalt psychologists. Next, we see how Brentano's phenomenology was instrumental in the development of modern existentialism, mainly through its influence on Edmund Husserl.

The goal of Edmund Husserl (1859–1938) was to take the type of phenomenology Brentano described and use it to create an objective, rigorous basis for philosophical and scientific inquiry. Like Brentano, Husserl believed that phenomenology could be used to create an objective bridge between the outer, physical world and the inner, subjective world. Of prime importance to Husserl was that phenomenology be free of any preconceptions. That is, Husserl believed in reporting exactly what appears in consciousness, not what *should* be there according to some belief, theory, or model.

As we saw in Chapter 9, however, Husserl believed that phenomenology could go beyond an analysis of intentionality. A study of intentionality determined how the mind and the physical world interact, and such a study was essential for the physical sciences. But, in addition to an analysis of intentionality, Husserl proposed a type of phenomenology that concentrates on the workings of the mind that are independent of the physical world. Husserl called this second type of phenomenology pure phenomenology, and its purpose was to discover the essence of conscious experience. Whereas the type of phenomenology that focuses on intentionality involves the person turned outward, pure phenomenology involves the person turned inward. The goal of the latter is to accurately catalog all mental acts and processes by which we interact with environmental objects or events. Husserl believed that an inventory of such acts and processes had to precede any adequate philosophy, science, or psychology because it is those mental acts and processes on which all human knowledge is based.

Husserl's pure phenomenology soon expanded into modern existentialism. Whereas Husserl was mainly interested in epistemology and in the essence of mental phenomena, the existentialists were interested in the nature of human existence. In philosophy, **ontology** is the study of existence, or what it means to be. The existentialists are concerned with two ontological questions: (1) What is the nature of human nature? and (2) What does it mean to be a particular individual? Thus, the existentialists use phenomenology to study either the important experiences that humans have in common or those experiences that individuals have as they live their lives—experiences such as fear, dread, freedom, love, hate, responsibility, guilt, wonder, hope, and despair.

Husserl's phenomenology was converted into existential psychology mainly by his student Martin Heidegger, to whom we turn next.

EXISTENTIAL PSYCHOLOGY

Although it is possible to trace existential philosophy to such early Greek philosophers as Socrates, who urged people to understand themselves and said that "an unexamined life is not worth living," it has become traditional to mark the beginning of existential philosophy with the writings of Kierkegaard and Nietzsche. The great Russian novelist Fyodor Dostoevsky is also mentioned as among the first existential thinkers. All these individuals probed the meaning of human existence and tried to restore the importance of human feeling, choice, and individuality that had been minimized in rationalistic philosophies, such as those of Kant and Hegel, and in conceptions of people based on Newtonian concepts, such as those proposed by the British empiricists and French sensationalists.

Martin Heidegger

Born on September 26, **Martin Heidegger** (1889–1976) was Husserl's student and then his assistant, and he dedicated his famous book *Being and*

Time (1927) to Husserl. Heidegger's work is generally considered the bridge between existential philosophy and existential psychology. Many, if not most, of the terms and concepts that appear in the writings of current existential psychologists can be traced to the writings of Heidegger. Like Husserl, Heidegger was a phenomenologist; but unlike Husserl, Heidegger used phenomenology to examine the totality of human existence. In 1933 Heidegger became rector at the University of Freiburg. In his inaugural speech titled "The Role of the University in the New Reich," he was highly supportive of the Nazi party. Although Heidegger resigned his rectorship a few months after the Nazis took office, he never took a strong stand against them (Langan, 1961, p. 4). In fact, Farias (1989) leaves little doubt that Heidegger was committed to Nazism and was involved in the activities of the Nazi regime. It is ironic that someone with such unfortunate political leanings had such a significant influence on humanistic psychology.

Dasein. Heidegger used the term **Dasein** to indicate that a person and the world are inseparable. Literally, *Dasein* means "to be" (*sein*) "there" (*Da*),

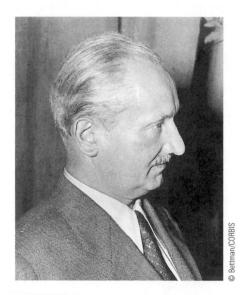

Martin Heidegger

and Heidegger usually described the relationship between a person and the world as "being-in-theworld." A more dramatic way of stating this relationship is to say that without the world humans would not exist, and without humans the world would not exist. The human mind illuminates the physical world and thereby brings it into existence.

But Heidegger's concept of Dasein is even more complicated. To be means "to exist," and to exist is a dynamic process. To exist as a human is to exist unlike anything else. In the process of existing, humans choose, evaluate, accept, reject, and expand. Humans are not static; they are always becoming something other than what they were. To exist is to become different; to exist is to change. How a particular person chooses to exist is an individual matter, but for all people existence is an active process. The Da, or there, in Dasein refers to that place in space and time where existence takes place; but no matter where and when it takes place, existence (to be) is a complex, dynamic, and uniquely human phenomenon. Unlike anything else in the universe, humans choose the nature of their own existence

Authenticity and Inauthenticity. It was very important to Heidegger that humans can ponder the finiteness of their existence. For Heidegger a prerequisite for living an authentic life is coming to grips with the fact that "I must someday die." With that realization dealt with, the person can get busy and exercise his or her freedom to create a meaningful existence, an existence that allows for almost constant personal growth, or becoming.

Because realizing that one is mortal causes anxiety, however, people often refuse to recognize that fact and thereby inhibit a full understanding of themselves and their possibilities. According to Heidegger, this results in an **inauthentic life**. An authentic life is lived with a sense of excitement or even urgency because one realizes one's existence is finite. With the time that one has available, one must explore life's possibilities and become all that one can become. An inauthentic life does not have the same urgency because the inevitability of death is not accepted. One pretends, and pretending is

inauthentic. Other inauthentic modes of existence include living a traditional, conventional life according to the dictates of society and emphasizing present activities without concern for the future. The inauthentic person gives up his or her freedom and lets others make the choices involved in his or her life. In general, the speech and behavior of authentic individuals accurately reflect their inner feelings, whereas with inauthentic individuals this is not the case.

Guilt and Anxiety. Heidegger believed that if we do not exercise our personal freedom, we experience guilt. Because most people do not fully exercise their freedom to choose, they experience at least some guilt. All humans can do to minimize guilt is try to live an authentic life—that is, to recognize and live in accordance with their ability to choose their own existence.

Because acceptance of the fact that at some time in the future we will be nothing causes **anxiety**, such acceptance takes **courage**. Heidegger believed that choosing one's existence rather than conforming to the dictates of society, culture, or someone else also takes courage. And in general, living an authentic life by accepting all conditions of existence and making personal choices means that one must experience anxiety. For Heidegger anxiety is a necessary part of living an authentic life. One reason for this anxiety is that authentic people are always experimenting with life, always taking chances, and always becoming. Entering the unknown causes part of the anxiety associated with an authentic life.

Another reason that exercising one's freedom in life causes anxiety is that it makes one responsible for the consequences of those choices. The free individual cannot blame God, parents, circumstances, genes, or anything else for what he or she becomes. One is responsible for one's own life. Freedom and **responsibility** go hand in hand.

Thrownness. Heidegger did, however, place limits on personal freedom. He said that we are thrown into the Da, or there, aspect of our particular life by circumstances beyond our control. This

thrownness determines, for example, whether we are male or female, short or tall, attractive or unattractive, rich or poor, American or Russian, the time in human history that we are born, and so on. Thrownness determines the conditions under which we exercise our freedom. According to Heidegger, all humans are free, but the conditions under which that freedom is exercised varies. Thrownness provides the context for one's existence. What Heidegger called thrownness has also been called facticity, referring to the facts that characterize a human existence.

Ludwig Binswanger

Ludwig Binswanger (1881–1966) obtained his medical degree from the University of Zürich in 1907 and then studied psychiatry under Eugen Bleuler and psychoanalysis under Carl Jung. Binswanger was one of the first Freudian psychoanalysts in Switzerland, and he and Freud remained friends throughout their lives. Under the influence of Heidegger, Binswanger applied phenomenology to psychiatry, and later he became an existential analyst. Binswanger's goal was to integrate the writings of Husserl and Heidegger with psychoanalytic theory. Adopting Heidegger's notion of Dasein, Binswanger called his approach to psychotherapy Daseinanalysis (existential analysis).

Like most existential psychologists, Binswanger emphasized the here-and-now, considering the past or future important only insofar as they manifested themselves in the *present*. To understand and help a person, according to Binswanger, one must learn how that person views his or her life at the moment. Furthermore, the therapist must try to understand the *particular person's* anxieties, fears, values, thought processes, social relations, and personal meanings instead of those notions in general. Each person lives in his or her own private, subjective world, which is not generalizable.

Modes of Existence. Binswanger discussed three different modes of existence to which individuals give meaning through their consciousness. They are the **Umwelt** (the "around world"), the world

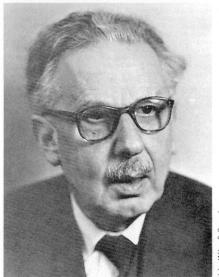

John Wiley & Sons,

Ludwig Binswanger

of things and events; the Mitwelt (the "with world"), interactions with other humans; and the Eigenwel (the "own world"), a person's private, inner, subjective experience. To understand a person fully, one must understand all three of his or her modes of existence.

One of Binswanger's most important concepts was that of Weltanschauung, or world-design (worldview). In general, world-design is how an individual views and embraces the world. Worlddesigns can be open or closed, expansive or constructive, positive or negative, or simple or complex, or it could have any number of other characteristics. In any case, it is through the world-design that one lives one's life, and therefore the world-design touches everything that one does. If a world-design is ineffective, in the sense that it results in too much anxiety, fear, or guilt, it is the therapist's job to help the client see that there are other ways of embracing the world, other people, and oneself.

Ground of Existence. Binswanger agreed with Heidegger that thrownness places limits on personal freedom. For Binswanger the circumstances into which one is thrown determines one's ground of existence, defined as the conditions under which

one exercises one's personal freedom. No matter what a human's circumstances are, however, he or she aspires to transcend them—that is, not to be victimized or controlled by them. Everyone seeks being-beyond-the-world. By "being-beyondthe-world," Binswanger was not referring to a life after death, or anything else supernatural, but to the way in which people try to transform their circumstances by exercising their free will.

The Importance of Meaning in One's Life. People may be thrown into negative circumstances such as poverty, incest, rape, or war, but they need not be devastated by those experiences. Most existentialists accept Nietzsche's proclamation: "What does not kill me, makes me stronger" (Nietzsche, 1889/1998). This strength comes from finding meaning even in a negative experience and growing from that meaning. In his famous book Man's Search for Meaning (1946/1984), Viktor E. Frankl (1905-1997) described his experiences in a Nazi concentration camp. One of his major observations was that prisoners who, even under those dire circumstances, found meaning in their lives and something to live for continued to live:

We who lived in concentration camps can remember the men who walked through the huts comforting others, giving away their last piece of bread. They may have been few in number, but they offer sufficient proof that everything can be taken from a man but one thing: the last of the human freedoms—to choose one's attitude in any given set of circumstances, to choose one's own way. (p. 86)

According to Frankl (1964/1984), "Suffering ceases to be suffering at the moment it finds a meaning" (p. 135).

By choosing, we change the meanings and values of what we experience. Although physical circumstances may be the same for different people, how those circumstances are embraced, interpreted, valued, symbolized, and responded to is a matter of personal choice. By exercising our freedom, we grow as human beings; and because exercising

freedom is an unending process, the developmental process is never completed. Becoming characterizes the authentic life, which, in turn, is characterized by anxiety. Not becoming, or remaining stagnant, characterizes the inauthentic life—as does guilt—because the person does not attempt to fully manifest his or her human potential.

Rollo May

Rollo May (1909–1994) introduced Heideggerian existentialism to U.S. psychology through books he edited, *Existence: A New Dimension in Psychiatry and Psychology* (with Angel and Ellenberger, 1958) and *Existential Psychology* (1961). Because Binswanger's work has only recently been translated into English, May was primarily responsible for incorporating European existential philosophy (mainly Heidegger's) into U.S. psychology.

May was born on April 21 in Ada, Ohio. Neither of his parents was well educated, and there was little intellectual stimulation in the home. When his older sister became psychotic, his father blamed it on too much education. May was not close to either of his parents, but he especially disliked his mother (Rabinowitz, Good, and Cozad, 1989). May received his Bachelor of Arts degree from Oberlin College in 1930 and a Bachelor of Divinity degree from Union Theological Seminary in 1938. While at the Union Seminary, May met the existential philosopher Paul Tillich, and the two became lifelong friends. In 1973 May wrote Paulus: Reminiscences of a Friendship as a tribute to Tillich, who died in 1965. After receiving his BD from Union Seminary, May served as a minister for two years in Montclair, New Jersey. In the 1940s, he studied psychoanalysis at the William Alanson White Institute of Psychiatry, Psychoanalysis, and Psychology, and he became a practicing psychoanalyst in 1946. May enrolled in the doctorate program at Columbia University, but before he obtained his degree, he contracted tuberculosis and nearly died. During this depressing time, May studied Kierkegaard's and Freud's views on anxiety; upon returning to Columbia, he submitted "The Meaning of Anxiety" as his doctoral dissertation. In 1949 May re-

Rollo May

ceived the first PhD in clinical psychology ever awarded by Columbia University. In modified form, this dissertation became his book The Meaning of Anxiety (1950). May's other books include The Art of Counseling: How to Give and Gain Mental Health (1939), The Springs of Creative Living: A Study of Human Nature and God (1940), Man's Search for Himself (1953), Psychology and the Human Dilemma (1967), Love and Will (1969), Power and Innocence: A Search for the Sources of Violence (1972), The Courage to Create (1975), Freedom and Destiny (1981), The Discovery of Being: Writings in Existential Psychology (1983), and The Cry for Myth (1991). May died on October 22, 1994, of multiple causes.

Like many other existential thinkers, May was strongly influenced by Kierkegaard, who had rejected Hegel's belief that an individual's life had meaning only insofar as it related to the totality of things, which Hegel called the Absolute. Kierkegaard proposed that each person's life is a separate entity with its own self-determined meaning. Again, for Kierkegaard, subjectivity is truth; that is, a person's beliefs define that person's reality.

The Human Dilemma. May (1967) pointed out that humans are both objects and subjects of experience. We are objects in the sense that we exist physically, and therefore things happen to us. As objects, we are not distinguished from the other physical objects that are studied by the natural sciences. It is as objects that humans are studied by the traditional methods of science—the assumption being that human behavior is caused in much the same way that the behavior of any physical object is caused. Besides being objects, however, we are also subjects. That is, we do not simply have experience; we interpret, value, and make choices regarding our experience. We give our experience meaning. This dual aspect of human nature, which May called the human dilemma, makes humans unique in the universe. By dilemma, May did not mean an insoluble problem; rather, he meant a paradox of human existence.

Normal and Neurotic Anxiety. May believed, along with the other existentialists, that the most important fact about humans is that they are free. As we have seen, however, freedom does not produce a tranquil life. Freedom carries with it responsibility, uncertainty, and therefore anxiety. The healthy (authentic) person exercises freedom to embrace life fully and to approach his or her full potential. Exercising one's freedom means going beyond what one previously was, ignoring the expectations (roles) for one's behavior that others impose, and therefore often acting contrary to traditions, mores, or conventions. All this causes anxiety, but it is normal, healthy anxiety because it is conducive to personal growth (becoming). Neurotic anxiety is not conducive to personal growth because it results from the fear of freedom. The person experiencing neurotic anxiety lives his or her life in such a way that reduces or eliminates personal freedom. Such a person conforms to tradition, religious dogma, the expectations of others, or anything else that reduces his or her need to make personal choices. Kierkegaard called the neurotic's situation shut-upness. The neurotic is shut off from himself or herself as well as from other people; he or she has become alienated from his or her true

self. **Self-alienation** occurs whenever people accept, as their own, values dictated by society rather than those personally attained. Self-alienation results not only in guilt but also in apathy and despair. The frightening aspects of human freedom and the many ways people attempt to escape from their freedom are discussed in Erich Fromm's classic book *Escape from Freedom* (1941).

According to Kierkegaard, May, and most other existentialists, we can either exercise our free will and experience **normal anxiety** or not exercise it and feel guilty. Obviously, it is not easy being human, for this conflict between anxiety and guilt is a constant theme in human existence: "The conflict is between every human being's need to struggle toward enlarged self-awareness, maturity, freedom and responsibility, and his tendency to remain a child and cling to the protection of parents or parental substitutes" (May, 1953, p. 193).

The Importance of Myth. According to May, myths provide the major vehicle for providing meaning in life: "Myth is a way of making sense in a senseless world. Myths are narrative patterns that give significance to our existence" (1991, p. 15). After a long, illustrious career as a psychoanalyst, May reached the following conclusion about people seeking professional help: "As a practicing psychoanalyst I find that contemporary therapy is almost entirely concerned, when all is surveyed, with the problems of the individual's search for myth" (1991, p. 9). In sympathy with May's conclusion, McAdams and Pals (2006) say, "The process of putting life experience into a meaningful narrative form influences development, coping, and well-being" (p. 210). Because myth is a type of narrative (story), May's observation that effective living depends on effective myths is supported by recently developed "narrative therapy." Narrative therapy examines the stories by which people live and understand their lives and the effectiveness of those stories (see, for example, Lieblich, McAdams, and Josselson, 2004; McAdams, 2006; McLeod, 1997; Pennebaker and Seagal, 1999; Singer, 2004; White and Epston, 1990).

In his analysis of myth, May (1991) shows close argument with Jung: "Individual myths will generally be a variation on some central theme of classical myths. ... Myths are archetypal patterns in human consciousness [and therefore] where there is consciousness, there will be myth" (pp. 33, 37).

Like Nietzsche, Freud, and Jung, May believed that positive and negative tendencies coexist in all humans and that the tension between them is the primary source of creativity. For May, it is the daimonic that is responsible for great literature, drama, and art, and it is the daimonic that is at the heart of many myths; for example, myths portraying conflicts between good and evil or between God and Satan. May (1969) defined the daimonic as

any natural function which has the power to take over the whole person. Sex and eros, anger and rage, and the craving for power are examples. The daimonic can be either creative or destructive and is normally both. ... The daimonic is the urge in every being to affirm itself, assert itself, perpetuate and increase itself. The daimonic becomes evil when it usurps the total personality without regard to the integration of that self, or to the unique forms and desires of others and their need for integration. It then appears as excessive aggression, hostility, cruelty—the things about ourselves which horrify us most, and which we repress whenever we can, or more likely, project on others. But these are the reverse side of the same assertion which empowers our creativity. All life is a flux between these two aspects of the daimonic. (p. 123)

May had little patience with those who portray humans as only good or bad. For him, we are potentially both, and therein lies the drama of human existence.

According to May, myths serve four primary functions: They provide a sense of identity, provide a sense of community, support our moral values,

and provide a means of dealing with the mysteries of creation. Most important, however, "hunger for myth is a hunger for community. ... To be a member of one's community is to share in its myths" (1991, p. 45). For May, then, the best myths are those that encourage a sense of kinship among humans. The myth of the rugged individual, popular for so long in the United States, encourages people to live in isolation and leads to loneliness and violence. Survival itself depends on replacing myths that isolate people with those that bind them together. For example,

We awake after a sleep of many centuries to find ourselves in a new and irrefutable sense in the myth of humankind. We find ourselves in a new world community; we cannot destroy the parts without destroying the whole. In this bright loveliness we know now that we are truly sisters and brothers, at last in the same family. (May, 1991, p. 302)

Human Science. Unlike many existential thinkers, May was not opposed to studying humans scientifically. He was opposed, however, to employing the methods of the physical sciences to study humans. Such methods, he said, overlook attributes that are uniquely human. Instead, May (1967) suggested the creation of a new science specifically designed to study humans:

The outlines of a science of man we suggest will deal with man as the symbol-maker, the reasoner, the historical mammal, who can participate in his community and who possesses the potentiality of freedom and ethical action. The pursuit of this science will take no less rigorous thought and wholehearted discipline than the pursuit of experimental and natural science at their best, but it will place the scientific enterprise in a broader context. Perhaps it will again be possible to study man scientifically and still see him whole. (p. 199)

Schneider (1998) elaborates the human science envisioned by May and discusses its relevance for contemporary psychology. Also, the emerging field of positive psychology (discussed later in this chapter) is moving in the direction suggested by May.

George Kelly

George Kelly (1905-1967) was born on April 28 on a farm near Perth, Kansas. An only child, his father was an ordained Presbyterian minister, and his mother was a former schoolteacher. By the time Kelly was born, his father had given up the ministry and turned to farming. In 1909, when Kelly was 4 years old, his father converted a lumber wagon into a covered wagon and with it moved his family to Colorado, where he staked a claim to a plot of land offered free to settlers. Unable to find an adequate amount of water on their claim, the family moved back to Kansas. There, Kelly's education consisted of attending a one-room school and being tutored by his parents. From the pioneering efforts of his family, Kelly developed a pragmatic spirit that remained with him throughout his life: the major criterion he used to judge an idea or a device was whether it worked.

When Kelly was 13, he was sent to Wichita, where he attended four different high schools in four years. Upon graduation from high school, he attended Friends University in Wichita for three years and then Park College in Parkville, Missouri, where he earned his bachelor's degree in 1926 with majors in physics and mathematics. Kelly was totally unimpressed by his first psychology class. For several class meetings, he waited in vain for something interesting to be said. Finally, one day the instructor wrote "S \rightarrow R" on the blackboard, and Kelly (1969) believed that finally he was going to hear something interesting. He recalled his disappointment:

Although I listened intently for several sessions, after that the most I could make of it was that the "S" was what you had to have in order to account for the "R" and

George Kelly

the "R" was put there so the "S" would have something to account for. I never did find out what that arrow stood for—not to this day—and I have pretty well given up trying to figure it out. (p. 47)

Next, Kelly went to the University of Kansas, where he earned his master's degree in 1928 with a major in educational psychology and a minor in labor relations. While at the University of Kansas, Kelly decided that it was time for him to become acquainted with Freud's writings. Freud did not impress him any more than S→R psychology did: "I don't remember which one of Freud's books I was trying to read, but I do remember the mounting feeling of incredulity that anyone could write such nonsense, much less publish it" (1969, p. 47).

The next year was a busy one for Kelly; he taught part-time in a labor college in Minneapolis and gave speech classes for the American Bankers Association and an Americanization class to immigrants wishing to become U.S. citizens. In the winter of 1928, he moved to Sheldon, Iowa, where he

taught at a junior college. Among his other duties, Kelly coached dramatics, and this experience may have influenced his later theorizing. It was here that Kelly met his future wife, Gladys Thompson, an English teacher at the same school. After a year and a half, Kelly returned to Minnesota, where he taught for a brief time at the University of Minnesota. He then returned to Wichita to work for a while as an aeronautical engineer. In 1929 he received an exchange scholarship, which allowed him to study for a year at the University of Edinburgh in Scotland. It was while earning his advanced degree in education at Edinburgh under the supervision of the illustrious statistician and psychologist Sir Godfrey Thomson that Kelly became interested in psychology. His thesis was on predicting teaching success.

In 1930, on his return from Scotland, Kelly enrolled in the graduate program in psychology at the State University of Iowa, where he obtained his doctorate in 1931. His dissertation was on the common factors in speech and reading disabilities. Kelly began his academic career at Fort Hays Kansas State College during the Great Depression. This was a time when there were many troubled people; Kelly desperately wanted to help them, but his training in physiological psychology did not equip him to do so. He decided to become a psychotherapist. His lack of training in clinical psychology, along with his pragmatic attitude, gave Kelly great latitude in dealing with emotional problems, and his observations eventually resulted in his unique theory of personality.

Soon after arriving at Fort Hays, Kelly developed traveling clinics that serviced the public school system. The clinics brought Kelly into contact with a wide range of emotional problems that both students and teachers experienced. Kelly soon made a remarkable observation. Because he was not trained in any particular therapeutic approach, he began to experiment with a variety of approaches, and he discovered that anything that caused his clients to view themselves or their problems differently improved the situation. Whether a proposed explanation was "logical" or "correct" seemed to have little to do with its effectiveness:

I began fabricating "insights." I deliberately offered "preposterous interpretations" to my clients. Some of them were about as un-Freudian as I could make them—first proposed somewhat cautiously, of course, and then, as I began to see what was happening, more boldly. My only criteria were that the explanation account for the crucial facts as the client saw them, and that it carry implications for approaching the future in a different way. (Kelly, 1969, p. 52)

In this statement lies the cornerstone of Kelly's position: Whether or not a person has a psychological problem is mainly a matter of how that person views things.

At the beginning of World War II, Kelly joined the Navy and was placed in charge of a local civilian pilot-training program. After the war, he taught at the University of Maryland for a year and in 1946 moved to Ohio State University as professor of psychology and director of clinical psychology. It was during his 19 years at Ohio State that Kelly refined his theory of personality and his approach to psychotherapy. In 1955, he published his most important work, *The Psychology of Personal Constructs*, in two volumes.

In 1960 Kelly and his wife received a grant from the human ecology fund, allowing them to travel around the world discussing the relationship between Kelly's theory and international problems. In 1965 Kelly accepted a position at Brandeis University, where for a short time he was a colleague of Maslow. Kelly died on March 6, 1967, at the age of 62. His honors included presidencies of both the clinical and counseling divisions of the APA. He also headed the American Board of Examiners in Professional Psychology, an organization whose purpose was to upgrade the quality of professional psychology.

Constructive Alternativism. Kelly observed that the major goal of scientists is to reduce uncertainty; and because he believed that this is also the goal of all humans, he said all humans are like

scientists. But whereas scientists create theories with which they attempt to predict future events, non-scientists create **construct systems** to predict future events. If either a scientific theory or a personal construct system is effective, it adequately predicts the future and thereby reduces uncertainty. And both scientific theories and construct systems are tested empirically. That is, they are checked against reality and are revised until their ability to predict future events or experiences is satisfactory. For Kelly a construct was a verbal label. For example,

On meeting a person for the first time, one might construe that person with the construct "friendly." If the person's subsequent behavior is in accordance with the construct of friendly, then the construct will be useful in anticipating that person's behavior. If the new acquaintance acts in an unfriendly manner, he or she will need to be construed either with different constructs or by using the other pole ... of the friendly-unfriendly construct. The major point is that constructs are used to anticipate the future, so they must fit reality. Arriving at a construct system that corresponds fairly closely to reality is largely a matter of trial and error. (Hergenhahn and Olson, 2007, p. 409)

For Kelly, whether or not an experience is physically pleasant is relatively unimportant. Of greater importance is whether or not it validates the predictions generated by one's construct system. Kelly (1970) said, "Confirmation and disconfirmation of one's predictions [have] greater psychological significance than rewards, punishments, or... drive reduction" (p. 11).

With his concept of **constructive alternativism**, Kelly aligned himself squarely with the existentialists. Kelly maintained that people are free to choose the constructs they use in interacting with the world. This means that people can view and interpret events in an almost infinite number of ways because construing them is an individual matter. No one needs to be a victim of circumstances

nor a victim of the past; all are free to view things as they wish:

We take the stand that there are always some alternative constructions available to choose among in dealing with the world. No one needs to paint himself into a corner; no one needs to be completely hemmed in by circumstances; no one needs to be the victim of his biography. (Kelly, 1955, Vol. 1, p. 15)

According to Kelly, it is not common experience that makes people similar; rather, it is how they construe reality. If two people employ more or less the same personal constructs in dealing with the world, then they are similar no matter how similar or dissimilar their physical experiences had been. Kelly also said that to truly understand another person, we have to know how that person construes things. In other words, we have to know what that person's expectations are, and then we can choose to act in accordance with those expectations. The deepest type of social interaction occurs when this process is mutual.

Kelly and Vaihinger. Although Kelly's thinking was existential in nature, there is no evidence that he was directly influenced by any existential philosophers or psychologists. However, he was aware of Vaihinger's philosophy of "as if." Although there are important differences between Vaihinger's philosophy and Kelly's theory (see Hermans, Kempen, and Van Loon, 1992), both emphasized **propositional thinking**, or the experimentation with ideas to see where they lead. About Vaihinger, Kelly (1964) said,

Toward the end of the last century a German philosopher, Hans Vaihinger, began to develop a system of philosophy he called the "philosophy of 'as if." In it he offered a system of thought in which God and reality might best be represented as [propositions]. This was not to say that either God or reality was any less certain than anything else in the realm of man's

awareness, but only that all matters confronting man might best be regarded in hypothetical ways. In some measure, I suppose, I am suggesting that Vaihinger's position has particular value for psychology. At least, let us pursue the topic—which is probably just the way Vaihinger would have proposed that we go at it. (p. 139)

The following statement nicely summarizes Kelly's belief in the importance of propositional thinking and exemplifies his kinship with existential philosophy: "Whatever nature may be, or however the quest for truth will turn out in the end, the events we face today are subject to as great a variety of constructions as our wits will enable us to contrive" (1970, p. 1).

Fixed-Role Therapy. Kelly's approach to therapy reflected his belief that psychological problems are perceptual problems and that the job of the therapist is therefore to help the client view things differently. Kelly often began the therapeutic process by having a client write a self-characterization. which provided Kelly with information about how the client viewed himself or herself, the world. and other people. Next, Kelly created a role for the client to play for about two weeks. The character in the role was markedly different from the client's self-characterization. The client became an actor, and the therapist became a supporting actor. Kelly called this approach to treating clients fixed-role therapy. He hoped that this procedure would help the client discover other possible ways of viewing his or her life:

What I am saying is that it is not so much what man is that counts as it is what he ventures out to make himself. To make the leap he must do more than disclose himself; he must risk a certain amount of confusion. Then, as soon as he does catch a glimpse of a different kind of life, he needs to find some way of overcoming the paralyzing moment of threat, for this is the instant when he wonders what he really is—whether he is

what he just was or is what he is about to be. (Kelly, 1964, p. 147)

In the role of supporting actor, the therapist helps the client deal with this threatening moment and then provides experiences that validate the client's new construct system. According to Kelly, people with psychological problems have lost their ability to make-believe, an ability that the therapist must help the client regain. Kelly's fixed-role therapy can be seen as an early version of narrative therapy that was discussed earlier.

In the 1960s, there was much talk about people being "themselves"; Kelly's advice was the opposite:

A good deal is said these days about being oneself. It is supposed to be healthy to be oneself. While it is a little hard for me to understand how one could be anything else, I suppose what is meant is that one should not strive to become anything other than what he is. This strikes me as a very dull way of living; in fact, I would be inclined to argue that all of us would be better off if we set out to be something other than what we are. Well, I'm not so sure we would all be better off—perhaps it would be more accurate to say life would be a lot more interesting. (Kelly, 1964, p. 147)

Kelly became a major force within clinical psychology in the postwar years, but the popularity of his ideas in the United States diminished. In England, however, Kelly's ideas became extremely popular even after his death—primarily because of the efforts of his disciple Donald Bannister. Exposure to Kelly's theory remains a requirement in most clinical programs approved by the British Psychological Association (Jankowicz, 1987, p. 483). The popularity of Kelly's theory is again growing in the United States, especially in the area of industrialorganizational psychology (Jankowicz, 1987). Other areas to which Kelly's theory is being applied include friendship formation, developmental psychology, perception, political science, and environmental psychology (Adams-Webber, 1979; Mancuso and

UNIVERSITY OF

Adams-Webber, 1982); depression and suicide (Neimeyer, 1984; Parker, 1981); obsessive-compulsive disorders (Rigdon and Epting, 1983); drug and alcohol abuse (Dawes, 1985; Rivers and Landfield, 1985); childhood disorders (Agnew, 1985); fear of death and physical illness (Robinson and Wood, 1984; Viney, 1983, 1984); couples in conflict (Neimeyer and Hudson, 1984); and other relationship disorders (Leitner, 1984; Neimeyer and Neimeyer, 1985).

Neimeyer and Jackson (1997) provide a brief, but informative, overview of Kelly's life, the development of his ideas, and the relevance of his ideas in contemporary psychology.

HUMANISTIC PSYCHOLOGY

Abraham Maslow

Some argue that Alfred Adler should be considered the first humanistic psychologist because he defined a healthy lifestyle as one reflecting a considerable amount of social interest and his concept of the creative self stressed that what a person becomes is largely a matter of personal choice. Certainly, Adler's theory had much in common with those theories later called humanistic. Usually, however, **Abraham Maslow (1908–1970)** is recognized as the one most responsible for making **humanistic psychology** a formal branch of psychology.

Maslow was born on April 1 in Brooklyn, New York. He was the oldest of seven children born to parents who were Jewish immigrants from Russia. Maslow recalled his father Samuel as loving whiskey, women, and fighting (Wilson, 1972, p. 131). Maslow disliked his father but eventually made peace with him. Not so with his mother, however; Maslow hated his mother all his life:

[Maslow] grew to maturity with an unrelieved hatred for her and never achieved the slightest reconciliation. He even refused to attend her funeral. He characterized Rose Maslow as a cruel, ignorant, and

Psychology Archives—The University of Akron

Abraham Maslow

hostile figure, one so unloving as to nearly induce madness in her children. In all of Maslow's references to his mother—some uttered publicly while she was still alive—there is not one that expresses any warmth or affection. (Hoffman, 1988, p. 7)

It is interesting that Maslow saw the motivation for his work in humanistic psychology in his hatred of his mother. Shortly before he died, Maslow entered the following comment in his personal journal:

I've always wondered where my Utopianism, ethical stress, humanism, stress on kindness, love, friendship, and all the rest came from. I knew certainly of the direct consequences of having no mother-love. But the whole thrust of my life-philosophy and all my research and theorizing also has its roots in a hatred for and revulsion against everything she stood for. (Lowry, 1979, p. 958)

Not being close to his parents and being the only Jewish boy in his neighborhood, Maslow was intensely lonely and shy and took refuge in books and scholarly pursuits. He was an excellent student at Boys High School in Brooklyn and went

on to attend City College of New York. While attending City College, he made an effort to satisfy his father's desire for him to become a lawyer by also attending law school. Unhappy with law school, however, he walked out of class one night, leaving his books behind. Being a mediocre student at City College, he transferred to Cornell University, where he took introductory psychology from Edward Titchener. Titchener's approach to psychology did not impress Maslow, and after only one semester at Cornell he transferred back to City College, partly to be near his first cousin Bertha Goodman, whom he loved very much. He and Bertha were married in 1928 when he was 20 and she was 19, and they eventually had two children. Prior to their marriage, Maslow had enrolled at the University of Wisconsin, and Bertha joined him there. By Maslow's own account, his life did not really begin until he and Bertha moved to Wisconsin

As ironic as it now seems, Maslow was first infatuated with the behaviorism of John Watson, in which he saw a way of solving human problems and changing the world for the better. His infatuation ended when he and Bertha had their first child:

Our first baby changed me as a psychologist. It made the behaviorism I had been so enthusiastic about look so foolish I could not stomach it anymore. That was the thunderclap that settled things. ... I was stunned by the mystery and by the sense of not really being in control. I felt small and weak and feeble before all this. I'd say anyone who had a baby couldn't be a behaviorist. (M. H. Hall, 1968, p. 55)

At the University of Wisconsin, Maslow earned his bachelor's degree in 1930, his master's degree in 1931, and his doctorate in 1934. As a graduate student at Wisconsin, Maslow became the first doctoral student of the famous experimental psychologist Harry Harlow. Maslow's dissertation was on the establishment of dominance in a colony of monkeys. He observed that dominance has more to do with a type of "inner confidence" than with physical strength, an observation that may have influ-

enced his later theorizing. During this time, Maslow also observed that sexual behavior within the colony was related to dominance and subservience, and he wondered whether the same was true for human sexual activity, a possibility he would explore shortly. After receiving his doctorate, Maslow taught at Wisconsin for a while before moving to Columbia University, where he became Edward Thorndike's research assistant. He also began his research on human sexuality by interviewing both male and female college students about their sexual behavior but soon abandoned males because they tended to lie too much about their sexual activities (Hoffman, 1988). Maslow made important contributions to our knowledge of human sexuality several years before Kinsey's famous research. Furthermore, the interviewing skills he developed during this research served him well when he later studied the characteristics of psychologically healthy individuals.

After a year and a half at Columbia, Maslow moved to Brooklyn College, where he stayed until 1951. Living in New York in the 1930s and 1940s gave Maslow an opportunity to come into contact with many prominent European psychologists who came to the United States to escape the Nazi terror. Among them were Erich Fromm, Max Wertheimer, Karen Horney, and Alfred Adler. Adler began giving seminars in his home on Friday evenings, and Maslow attended frequently. Maslow also befriended the famous anthropologist Ruth Benedict about this same time. Maslow became obsessed with trying to understand Ruth Benedict and Max Wertheimer, whom he considered truly exceptional people, and it was this obsession that evolved into Maslow's version of humanistic psychology.

In 1951 Maslow accepted the position of chairman of the psychology department at Brandeis University in Waltham, Massachusetts, and it was here that Maslow became the leading figure in third-force psychology. In 1968, because of increased disenchantment with academic life and failing health, Maslow accepted a fellowship offered to him by the Saga Administrative Corporation. Hoffman (1988) described the offer that was made to Maslow:

Laughlin [the president and chairman of the Saga Corporation] cheerfully informed Maslow, the fellowship was ready. He was prepared to offer Maslow a two-to-four-year commitment with the following conditions: a handsome salary, a new car, and a personally decorated private office with full secretarial services at Saga's attractive campuslike headquarters on Stanford University's suburban outskirts. What would Maslow have to do in return? Nothing. (p. 316)

Maslow accepted and, as advertised, was free to think and write as he pleased, and he enjoyed his freedom very much. On June 8, 1970, however, Maslow suffered a heart attack while jogging and died at the age of 62.

Due primarily to Maslow's efforts, the *Journal of Humanistic Psychology* was founded in 1961; also in 1961, the American Association of Humanistic Psychologists was established, with James F. T. Bugental as its first president; and a division of the American Psychological Association (APA), Humanistic Psychology, was created in 1971.

The Basic Tenets of Humanistic Psychology. The beliefs shared by psychologists working within the humanistic paradigm include the following:

- Little of value can be learned about humans by studying nonhuman animals.
- Subjective reality is the primary guide for human behavior.
- Studying individuals is more informative than studying what groups of individuals have in common.
- A major effort should be made to discover those things that expand and enrich human experience.
- Research should seek information that will help solve human problems.
- The goal of psychology should be to formulate a complete description of what it means to be a

human being. Such a description would include the importance of language, the valuing process, the full range of human emotions, and the ways humans seek and attain meaning in their lives.

Charlotte R. Bühler (1893–1974) was a founding member of the Association of Humanistic Psychologists and served as its president in 1965–1966. Her influential position paper on humanistic psychology (1971) elaborated several of the tenets listed above and showed their relevance to such topics as creativity, education, and psychotherapy.

Humanistic psychology, which rejects the notion that psychology should be entirely scientific, sees humans as indivisible wholes. Any attempt to reduce them to habits, cognitive structures, or S–R connections results in a distortion of human nature. According to Maslow (1966), psychologists often use scientific method to cut themselves off from the poetic, romantic, and spiritual aspects of human nature:

Briefly put, it appears to me that science and everything scientific can be and often is used as a tool in the service of a distorted, narrowed, humorless, de-eroticized, de-emotionalized, desacralized, and desanctified *Weltanschauung* [world-view]. This desacralization can be used as a defense against being flooded by emotion, especially the emotions of humility, reverence, mastery, wonder and awe. (p. 139)

Humanistic psychologists flatly reject the goal of predicting and controlling human behavior, which so many scientifically inclined psychologists accept:

If humanistic science may be said to have any goals beyond sheer fascination with the human mystery and enjoyment of it, these would be to release the person from external controls and to make him less predictable to the observer (to make him freer, more creative, more inner determined) even though perhaps more predictable to himself. (Maslow, 1966, p. 40)

Humans, then, are much more than physical objects, and therefore the methods employed by the physical sciences have no relevance to the study of humans. Similarly, psychoanalysis, by concentrating on the study of psychologically disturbed individuals, has created a "crippled" psychology: "It becomes more and more clear that the study of crippled, stunted, immature, and unhealthy specimens can yield only a crippled psychology and a crippled philosophy" (Maslow, 1954/1970, p. 180). For Maslow, there are exceptional people whose lives cannot be understood simply as the absence of mental disorders. To be understood, exceptional people must be studied directly:

Health is not simply the absence of disease or even the opposite of it. Any theory of motivation that is worthy of attention must deal with the highest capacities of the healthy and strong person as well as with the defensive maneuvers of crippled spirits. (Maslow, 1954/1987, p. 14)

Maslow's point was not that psychology should stop attempting to be scientific or stop studying and attempting to help those with psychological problems, but that such endeavors tell only part of the story. Beyond this, psychology needs to attempt to understand humans who are in the process of reaching their full potential. We need to know how such people think and what motivates them. Thus, Maslow invested most of his energies in trying to understand exceptional humans.

The Hierarchy of Needs. According to Maslow, human needs are arranged in a hierarchy. The lower the needs in the hierarchy, the more basic they are and the more similar they are to the needs of other animals. The higher the needs in the hierarchy, the more distinctly human they are.

The needs are arranged so that as one satisfies a lower need, one can deal with the next higher need. When one's physiological needs (such as hunger, thirst, and sex) are predictably satisfied, one can deal with the safety needs (protection from the elements, pain, and unexpected dangers);

when the safety needs are reasonably satisfied, one is free to deal with the belonging and love needs (the need to love and be loved, to share one's life with a relevant other); when the belonging and love needs are adequately satisfied, one is released to ponder the esteem needs (to make a recognizable contribution to the well-being of one's fellow humans); if the esteem needs are met satisfactorily, one is in a position to become self-actualized. Maslow's proposed **hierarchy of needs** can be diagrammed as follows:

Self-Actualization

Esteem Needs

Belonging and Love Needs

Safety Needs

Physiological Needs

Self-Actualization. By **self-actualization**, Maslow meant reaching one's full, human potential:

So far as motivational status is concerned, healthy people have sufficiently gratified their basic needs for safety, belongingness, love, respect, and self-esteem so that they are motivated primarily by trends to self-actualization defined as ongoing actualization of potentials, capacities and talents, as fulfillment of mission (or call, fate, destiny, or vocation), as a fuller knowledge of, and acceptance of, the person's own intrinsic nature, as an unceasing trend toward unity, integration or synergy within the person. (Maslow, 1968, p. 25)

Musicians must make music, artists must paint, poets must write if they are to be ultimately at peace with themselves. What humans can be, they must be. They must be true to their own nature. This need we may call self-actualization. (Maslow, 1954/1987, p. 22)

The concept of self-actualization goes back at least as far as Aristotle, but what Aristotle meant by self-actualization was the innate tendency to manifest the characteristics or the essence of one's species. For example, an acorn has an innate tendency to become an oak tree and to exhibit the characteristics of oak treeness. Jung reintroduced the concept of self-actualization into modern psychology, and what he meant by the term and what Maslow later meant by it was distinctly different from the Aristotelian meaning. By self-actualization, Jung, Maslow, and Rogers (whom we consider next) meant the realization of an *individual's* potential, not that of the species' potential, as was Aristotle's meaning.

Because it is impossible for any person to completely reach his or her full potential, Maslow referred to those who have satisfied hierarchical needs as self-actualizing. (A list of characteristics of self-actualizing people is given shortly.)

As one climbs the hierarchy, the needs become more fragile. That is, the physiological and safety needs have a long evolutionary history and are therefore very powerful; the higher needs for love, esteem, and self-actualization are "newer" and distinctly human and therefore do not have as firm a biological foundation. This means that their satisfaction is easily interfered with. The higher up the hierarchy one goes, the truer this is; and therefore the satisfaction of the need for selfactualization—although the need is innate—is easily interfered with. Of self-actualization, Maslow said, "This inner nature is not strong and overpowering and unmistakable like the instincts of animals. It is weak and delicate and subtle and easily overcome by habit, cultural pressure, and wrong attitudes toward it" (1968, p. 4).

Thus, although all humans have an innate drive to be self-actualized (to reach their full potential as humans), self-actualized people are rare. Another major reason that self-actualization occurs so infrequently is that it requires a great deal of honest knowledge of oneself, and most humans are fearful of such knowledge:

More than any other kind of knowledge we fear knowledge of ourselves, knowledge that might transform our self-esteem and our self-image. ... While human beings love knowledge and seek it—they are curious—they also fear it. The closer to the personal it is, the more they fear it. (p. 16)

Related to the fear of self-knowledge is the **Jonah complex**, which Maslow (1971) defined as "fear of one's own greatness, ... evasion of one's destiny, ... running away from one's best talents" (p. 34). According to Maslow, humans often fear success as much as they do failure and this fear, like the fear of self-knowledge, militates against self-actualization.

The Characteristics of Self-Actualizing People. As we have seen, Maslow believed that for too long psychology had emphasized the study of lower animals and psychologically disturbed individuals. To begin to remedy the situation, he studied a number of people he thought were self-actualizing. Among them were Albert Einstein, Albert Schweitzer, Sigmund Freud, Jane Addams, William James, and Abraham Lincoln. Maslow concluded that self-actualizing people have the following characteristics:

- They perceive reality accurately and fully.
- They demonstrate a great acceptance of themselves and of others.
- They exhibit spontaneity and naturalness.
- They have a need for privacy.
- They tend to be independent of their environment and culture.
- They demonstrate a continuous freshness of appreciation.
- They tend to have periodic mystic or peak experiences. Maslow (1954/1987) described peak experiences as

feelings of limitless horizons opening up to the vision, the feeling of being simultaneously more powerful and also more helpless than one ever was before, the feeling of great ecstasy and wonder and awe, the loss of placing in time and space with, finally, the conviction that something extremely important and valuable had happened, so that the subject is to some extent transformed and strengthened even in his daily life by such experiences. (p. 137)

- They are concerned with all humans instead of with only their friends, relatives, and acquaintances.
- They tend to have only a few friends.
- They have a strong ethical sense but do not necessarily accept conventional ethics.
- They have a well-developed but not hostile sense of humor.
- They are creative.

Although Maslow (1954/1987) concluded that his group of self-actualizing people was made up of outstanding humans, he also indicated that they were not without faults:

Our subjects show many of the lesser human failings. They too are equipped with silly, wasteful or thoughtless habits. They can be boring, stubborn, irritating. They are by no means free from a rather superficial vanity, pride, partiality to their own productions, family, friends, and children. Temper outbursts are not rare.

Our subjects are occasionally capable of an extraordinary and unexpected ruthlessness. It must be remembered that they are very strong people. This makes it possible for them to display a surgical coldness when this is called for, beyond the power of the average man. The man who found that a long-trusted acquaintance was dishonest cut himself off from this friendship sharply and abruptly and without any observable pangs whatsoever. Another woman who was married to someone she did not love, when she decided on divorce, did it with a decisiveness that looked almost like ruthlessness. Some of them recover so quickly from the death of people close to them as to seem heartless. (p. 146)

Deficiency and Being Motivation and Perception. If a person is functioning at any level other than self-actualization, he or she is said to be deficiency-motivated. That is, the person is seeking specific things to satisfy specific needs, and his or her perceptions are need-directed. Journard describes need-directed perception (also called deficiency or D-perception) as follows: "Need-directed perception is a highly focused searchlight darting here and there, seeking the objects which will satisfy needs, ignoring everything irrelevant to the need" (1974, p. 68). Deficiency motivation (D-motivation) leads to need-directed perception.

Unlike most psychologists, Maslow was mainly interested in what happens to people after their basic needs are satisfied. His answer was that people who satisfy their basic needs and become self-actualizing enter into a different mode of existence. Instead of being deficiency-motivated, they are beingmotivated (B-motivated). Being motivation involves embracing the higher values of life such as beauty, truth, and justice. Being-motivated people are also capable of B-love, which unlike D-love is nonpossessive and insatiable. Unlike D-perception, being perception (B-perception) does not involve seeking specific things in the environment. Therefore, the person interacting with the world through B-perception is open to a wider range of experience than the person who interacts through D-perception.

Transpersonal Psychology. Toward the end of his life, Maslow began to ponder a new kind of psychology that went beyond personal experience. This **transpersonal psychology** would constitute a fourth force and would focus on the mystical,

ecstatic, or spiritual aspects of human nature. In the preface of his book *Toward a Psychology of Being* (1968), Maslow described his vision of fourthforce psychology:

I ... consider Humanistic, Third Force Psychology to be transitional, a preparation for a still "higher" Fourth Psychology, transpersonal, transhuman, centered in the cosmos rather than in human needs and interest, going beyond humanness, identity, self-actualization, and the like. ... These new developments may very well offer a tangible, usable, effective satisfaction of the "frustrated idealism" of many quietly desperate people, especially young people. These psychologies give promise of developing into the life-philosophy, the religion-surrogate, the value-system, the life-program that these people have been missing. Without the transcendent and the transpersonal, we get sick, violent, and nihilistic, or else hopeless and apathetic. We need something "bigger than we are" to be awed by and to commit ourselves to in a new, naturalistic, empirical, nonchurchly sense. (pp. iii-iv)

Maslow lived to see Anthony J. Sutich (1907-1976), who was also a founding editor of the Journal of Humanistic Psychology, found the Journal of Transpersonal Psychology in 1969. Maslow's "The Farther Reaches of Human Nature" appeared as the lead article in the new journal. (This article should not be confused with the book of readings published posthumously [1971] with the same title.) Transpersonal psychology has much in common with non-Western psychologies, philosophies, and religions. For example, all recognize meditation as a way of getting in touch with the higher states of consciousness. Many interested in the occult and in parapsychology have been attracted to humanistic psychology and especially to transpersonal psychology. Perhaps because these topics are generally viewed as outside the realm of science, the APA has thus far denied petitions to create a division of transpersonal psychology.

Maslow's many honors include election to the presidency of the APA for the year 1967–1968. At the time of his death in 1970, Maslow's ideas were influential not only within psychology but also in fields such as medicine, marketing, theology, education, and nursing. Although Maslow's influence has diminished, it is not uncommon for his theory of motivation to be taught in psychology, education, and business courses. Coon (2006) speculates as to the reasons for Maslow's lasting appeal:

Perhaps it is that his theory of motivation embodies deeply felt democratic ideals expressed in psychological terms. It is hopeful and optimistic, even utopian in its dream of an eventual Eupsychia [good mind country]. Given the right set of psychological and social conditions, every person among us has the potential to become happy, fulfilled, creative, emotionally whole—in Maslow's terms, selfactualized. It is the American ethos of self-improvement taken to its ultimate psychological conclusion, and it unabashedly embraces our right to life, liberty, and the pursuit of happiness. (pp. 270–271)

Carl Rogers

Carl Rogers (1902–1987) was born on January 8 in the Chicago suburb of Oak Park, Illinois, and was the fourth of six children. He was closer to his mother than to his father, who was a successful civil engineer and was often away from home. In the affluent suburb of Oak Park, Rogers attended school with Ernest Hemingway and the children of the famous architect Frank Lloyd Wright. Rogers described his family as closely knit and highly religious. Friendships outside the family were discouraged:

I think the attitudes toward persons outside our large family can be summed up schematically in this way: Other persons behave in dubious ways which we do not approve in our family. Many of them play

Carl Rogers

cards, go to movies, smoke, drink, and engage in other activities—some unmentionable. So the best thing to do is to be tolerant of them, since they may not know better, and to keep away from any close communication with them and live your life within the family. (Rogers, 1973, p. 3)

Not surprisingly, Rogers was a loner in school and, like Maslow, took refuge in books, reading everything that he could get his hands on, including encyclopedias and dictionaries. When Rogers was 12 years old, he and his family moved to a farm 25 miles west of Chicago. The purpose of the move was to provide a more wholesome and religious atmosphere for the family. Because his father insisted that the farm be run scientifically, Rogers developed an intense interest in science, reading everything he could about agricultural experiments. Rogers maintained this interest in science throughout his career, although he worked in one of psychology's more subjective areas. When Rogers graduated from high school, he intended to become a farmer; and when he entered the University of Wisconsin in 1919, he chose to study agriculture. In his early years in college, Rogers was very active in church activities, and in 1922 he was selected to attend the World Student Christian Federation Conference in Peking (Beijing), China. During this six-month trip, Rogers, for the first time, experienced people of different cultures with different religions. Rogers wrote to his parents declaring his independence from their conservative religion, and almost immediately he developed an ulcer that caused him to be hospitalized for several weeks.

Upon returning to the University of Wisconsin, Rogers changed his major from agriculture to history. He received his bachelor's degree in 1924. Shortly after graduation, he married his childhood sweetheart, Helen Elliott, with whom he eventually had two children. Soon after their marriage, Carl and Helen moved to New York, where he enrolled in the liberal Union Theological Seminary while also taking courses in psychology and education at neighboring Columbia University. After two years at the seminary, Rogers's doubts about whether the religious approach was the most effective way of helping people caused him to transfer to Columbia University on a full-time basis; there he earned his master's degree in clinical psychology in 1928 and his doctorate in 1931. His dissertation concerned the measurement of personality adjustment in children.

After obtaining his doctorate, Rogers went to work for the Child Study Department of the Society for the Prevention of Cruelty to Children in Rochester, New York, where he had served as a fellow while working toward his doctorate. Rogers had several experiences there that caused him to develop his own brand of psychotherapy. For example, the society was dominated by therapists trained in the psychoanalytic tradition, people who saw their job as gaining an "insight" into the cause of a problem and then sharing that insight with the client. At first, Rogers followed this procedure. In one case, he concluded that a mother's rejection of her son was the cause of the son's delinquent behavior, but his attempts to share this insight with the mother failed completely. Rogers (1961) described what happened next:

Finally I gave up. I told her that it seemed we had both tried, but we had failed. ... She agreed. So we concluded the interview, shook hands, and she walked to the door of the office. Then she turned and asked, "Do you take adults for counseling here?" When I replied in the affirmative, she said, "Well then, I would like some help." She came to the chair she had left, and began to pour out her despair about her marriage, her troubled relationship with her husband, her sense of failure and confusion, all very different from the sterile "Case History" she had given before. Real therapy began then.

This incident was one of a number which helped me to experience that fact—only fully realized later—that it is the client who knows what hurts, what directions to go, what problems are crucial, what experiences have been deeply buried. It began to occur to me that unless I had a need to demonstrate my own cleverness and learning, I would do better to rely upon the client for the direction of movement in the process. (pp. 11–12)

It was while Rogers was employed by the Child Study Department that he wrote his first book, The Clinical Treatment of the Problem Child (1939), and its publication led to an offer of an academic position at Ohio State University. Rogers was reluctant to leave the clinical setting, but when Ohio State agreed to start him at the rank of full professor, he decided, at the age of 38, to begin a new career in the academic world. At Ohio, Rogers communicated his own ideas concerning the therapeutic process in his now famous Counseling and Psychotherapy: Newer Concepts in Practice (1942). It is widely believed that this book described the first major alternative to psychoanalysis. Rogers's approach to psychotherapy was considered revolutionary because it eliminated the needs for diagnosis, a search for the causes of disturbances, and any type of labeling of disorders. He also refused to call disturbed individuals "patients,"

as had been the case with the psychoanalysts; for Rogers, people seeking help were "clients." Gendlin (1988) said that Rogers's proposed alternative to psychoanalysis was nothing less than a "war against monolithic authority" (p. 127).

As part of the war effort, in 1944 Rogers took a leave from Ohio State to become director of counseling services for the United Services Organization in New York. After one year, Rogers moved to the University of Chicago as professor of psychology and director of counseling. It was during his 12-year stay at Chicago that Rogers wrote what many consider to be his most important work, Client-Centered Therapy: Its Current Practice, Implications, and Theory (1951). This book marked a change in Rogers's approach to psychology. Originally, his approach was called nondirective, believing that in a positive therapeutic atmosphere clients would solve their problems automatically. Therapy became client-centered when Rogers realized that the therapist had to make an active attempt to understand and accept a client's subjective reality before progress could be made. It was also at Chicago that Rogers and his colleagues engaged in the first attempt to objectively measure the effectiveness of psychotherapy.

To measure therapy's effectiveness, Rogers used a method called the Q-technique (also called the Q-sort technique) created by the British-trained researcher William Stephenson (1953). Rogers's version of the technique involved having clients describe themselves as they were at the moment (real self) and then as they would like to become (ideal self). The two selves were measured in such a way as to allow the correlation between them to be determined. Typically, when therapy begins, the correlation between the two selves is very low, but if therapy is effective it becomes higher. That is, the real self becomes more similar to the ideal self. Using this technique, a therapist can determine the effectiveness of his or her procedures at any point during, or after, therapy (see, for example, Rogers, 1954; Rogers and Dymond, 1955).

In 1957 Rogers returned to the University of Wisconsin, where he held the dual position of professor of psychology and professor of psychiatry, and

he did much to resolve differences between the two disciplines. In 1963 Rogers joined the Western Behavioral Sciences Institute (WBSI) in La Jolla, California. At WBSI Rogers became increasingly interested in encounter groups and sensitivity training and less interested in individual therapy. Toward the end of his life, he also became interested in promoting world peace. In 1968 Rogers and 75 of his colleagues resigned from WBSI and formed the Center for the Studies of the Person, also in La Jolla. There, Rogers continued to work with encounter groups, but he expanded his interests in education and international politics. In 1985 he organized the Vienna Peace Project, which brought leaders from 13 countries together, and in 1986 he conducted peace workshops in Moscow. Rogers continued to work on these and other projects until his death on February 4, 1987, from cardiac arrest following surgery for a broken hip.

Rogers received many honors. He served as president of the APA in 1946–1947, and in 1956 he was a corecipient, along with Kenneth Spence and Wolfgang Köhler, of the first Distinguished Scientific Contribution Award from the APA. The latter award moved Rogers to tears because he believed that his fellow psychologists had viewed his work as unscientific: "My voice choked and the tears flowed when I was called forth ... to receive [the award]" (Rogers, 1974, p. 117). In 1972 Rogers received the Distinguished Professional Contribution Award from the APA, making him the first person in the history of the APA to receive both the Distinguished Scientific and Professional Contribution Awards.

Rogers's Theory of Personality. At the urging of others, Rogers developed a theory of personality to account for the phenomena he had observed during the therapeutic process. The rudiments of his theory were first presented in his APA presidential address (Rogers, 1947) and then expanded in his Client-Centered Therapy (1951). The most complete statement of his theory was in a chapter titled "A Theory of Therapy, Personality, and Interpersonal Relationships, as Developed in the Client-Centered Framework" (Rogers, 1959).

Like Maslow, Rogers postulated an innate human drive toward self-actualization, and if people use this actualizing tendency as a frame of reference in living their lives, there is a strong likelihood that they will live fulfilling lives and ultimately reach their full potential. Such people are said to be living according to the organismic valuing process. Using this process, a person approaches and maintains experiences that are in accord with the actualizing tendency but terminates and avoids those that are not. Such a person is motivated by his or her own true feelings and is living what the existentialists call an authentic life—that is, a life motivated by a person's true inner feelings rather than mores, beliefs, traditions, values, or conventions imposed by others. Here we see Rogers restating the belief of the ancient Cynics and of Rousseau in the primacy of personal feelings as guides for action. In the following quotation (Rogers, 1961), we see a among ancient Cynicism, strong similarity Rousseau's romantic philosophy, and Rogers's humanistic psychology:

One of the basic things which I was a long time in realizing, and which I am still learning, is that when an activity *feels* as though it is valuable or worth doing, it *is* worth doing. Put another way, I have learned that my total organismic sensing of a situation is more trustworthy than my intellect.

All of my professional life I have been going in directions which others thought were foolish, and about which I have had many doubts myself. But I have never regretted moving in directions which "felt right," even though I have often felt lonely or foolish at the time. ... Experience is for me, the highest authority. ... Neither the Bible nor the prophets—neither Freud nor research—neither the revelations of God nor man—can take precedence over my own experience. (pp. 22–24)

Unfortunately, according to Rogers, most people do not live according to their innermost feelings (the organismic valuing process). A problem arises

because of our childhood need for positive regard. Positive regard involves receiving such things as love, warmth, sympathy, and acceptance from the relevant people in a child's life. If positive regard is given freely to a child, no problem will arise, but usually it is not freely given. Instead parents (or other relevant people) give children positive regard only if they act or think in certain ways. This sets up conditions of worth. The children soon learn that in order to receive love, they must act and think in accordance with the values of the relevant people in their lives. Gradually, as the children internalize those values, the values replace the organismic valuing process as a guide for living life. As long as people live their lives according to someone else's values instead of their own true feelings, experience will be edited, and certain experiences that would have been in accord with the organismic valuing process will be denied:

In order to hold the love of a parent, the child introjects as his own values and perceptions which he does not actually experience. He then denies to awareness the organismic experiencings that contradict these introjections. Thus, his self-concept contains false elements that are not based on what he is, in his experiencing. (Rogers, 1966, p. 192)

According to Rogers, there is only one way to avoid imposing conditions of worth on people, and that is to give them unconditional positive regard. With **unconditional positive regard**, people are loved and respected for what they truly are; therefore, there is no need for certain experiences to be denied or distorted. Only someone who experiences unconditional positive regard can become a **fully functioning person**:

If an individual should experience only unconditional positive regard, then no conditions of worth would develop, self-regard would be unconditional, the needs for positive regard and self-regard would never be at variance with organismic evaluation, and the individual would continue to be

psychologically adjusted, and would be fully functioning. (Rogers, 1959, p. 224)

When conditions of worth replace the organismic valuing process as a guide for living, the person becomes incongruent. What Rogers called an **incongruent person** is essentially the same as what the existentialists call an inauthentic person. In both cases, the person is no longer true to his or her own feelings. Rogers viewed incongruency as the cause of mental disorders, and he believed therefore that the goal of psychotherapy is to help people overcome conditions of worth and again live in accordance with their organismic valuing processes. Rogers (1959) described this goal as follows:

This, as we see it, is the basic estrangement in man. He has not been true to himself, to his own natural organismic valuing of experience, but for the sake of preserving the positive regard of others has now come to falsify some of the values he experiences and to perceive them only in terms based upon their value to others. Yet this has not been a conscious choice, but a natural—and tragic development in infancy. The path of development toward psychological maturity, the path of therapy, is the undoing of this estrangement in man's functioning, the dissolving of conditions of worth, the achievement of a self which is congruent with experience, and the restoration of a unified organismic valuing process as the regulator of behavior. (pp. 226-227)

When people are living in accordance with their organismic valuing process, they are fully functioning. The fully functioning person embraces life in much the same way as Maslow's selfactualizing person does.

Rogers fully appreciated the fact that human growth can be facilitated by relationships other than that between therapist and client. Rogers (1980) described the conditions that must characterize *any* relationship if that relationship is going to facilitate personal growth:

There are three conditions that must be present in order for a climate to be growth promoting. These conditions apply whether we are speaking of the relationship between therapist and client, parent and child, leader and group, teacher and student, or administrator and staff. The conditions apply, in fact, in any situation in which the development of the person is a goal. ... The first element could be called genuineness, realness, or congruence. ... The second attitude of importance in creating a climate for change is acceptance, or caring, or prizing—what I have called "unconditional positive regard."... The third facilitative aspect of the relationship is empathic understanding. ... This kind of sensitive, active listening is exceedingly rare in our lives. We think we listen, but very rarely do we listen with real understanding, true empathy. Yet listening, of this very special kind, is one of the most potent forces for change that I know. [italics added] (pp. 115-116)

Rogers's person-centered psychology has been applied to such diverse areas as religion, medicine, law enforcement, ethnic and cultural relations, politics, and international conflict, as well as organizational development (Levant and Schlien, 1984); education (Rogers, 1969, 1983); marriage (Rogers, 1972); personal power (Rogers, 1977); and the future (Rogers, 1980).

We will have more to say about Rogers's contributions to professional psychology in Chapter 21.

COMPARISON OF EXISTENTIAL AND HUMANISTIC PSYCHOLOGY

Existential and humanistic psychology have enough in common to cause them often to be lumped together as "existential-humanistic psychology" or simply as humanistic psychology. The following is a list of beliefs shared by existential and humanistic psychology:

- Humans have a free will and are therefore responsible for their actions.
- The most appropriate method by which to study humans is phenomenology, the study of intact subjective experience.
- To be understood, the human must be studied as a whole. Elementism of any type gives a distorted view of human nature.
- Humans are unique, and therefore anything learned about other animals is irrelevant to the understanding of humans.
- Each human is unique, therefore, anything learned about one human is irrelevant to the understanding of others.
- Hedonism is not a major motive in human behavior. Instead of seeking pleasure and avoiding pain, humans seek meaningful lives characterized by personal growth.
- Living an authentic life is better than living an inauthentic one.
- Because they possess unique attributes such as free will, humans cannot be effectively studied using traditional scientific methodology.
 Perhaps humans can be studied objectively, but to do so would require the creation of a new, uniquely human science.

The major difference between existential and humanistic psychology lies in their assumptions about human nature. The humanists assume that humans are basically good, and therefore, if placed in a healthy environment, they will naturally live a life in harmony with other humans. For humanists the major motivation in life is the actualizing tendency, which is innate and which continually drives a person toward those activities and events conducive to self-actualization. The existentialists, on the other hand, view human nature as essentially neutral. For them, the only thing we are born with is the freedom to choose the nature of our existence.

This is what Jean-Paul Sartre (1905-1980) meant by his famous statement "Existence precedes essence." For Sartre and most existential philosophers, there is no human essence at birth. We are free to choose our own essence as a unique human being. We become our choices: "Man is nothing else but what he makes of himself. Such is the first principle of existentialism" (Sartre, 1957, p. 15). We can exercise our freedom to create any type of life we wish, either good or bad. The major motive in life, according to the existentialist, is to create meaning by effectively making choices. Many existential thinkers have reached the conclusion that without meaning, life is not worth living, but that with meaning, humans can tolerate almost any conditions. Frankl quoted Nietzsche as saying, "He who has a why to live can bear with almost any how" (1946/1984, p. 12). Frankl maintained that there is only one motivational force for humans, and that is what he called the "will to meaning" (1946/1984, p. 121).

Generally, the view of human nature the humanists hold causes them to be optimistic about humans and their future. If societies could be made compatible with our nature, they say, humans could live together in peace and harmony. The existentialists are more pessimistic. For them, humans have no built-in guidance system but only the freedom to choose. Because we are free, we cannot blame God, our parents, genetics, or circumstances for our misfortune—only ourselves. This responsibility often makes freedom more of a curse than a blessing, and people often choose not to exercise their freedom by conforming to values that others have formulated. In his famous book Escape from Freedom (1941), Erich Fromm (1900-1980) said that often the first thing people do when they recognize their freedom is attempt to escape from it by affiliating themselves with someone or something that will reduce or eliminate their choices.

Another important difference between existential and humanistic psychologists is that for the existentialist, the realization that one's death is inevitable is extremely important. Before a rich, full life is possible, one must come to grips with the fact that one's life is finite. The humanistic psychologist

does not dwell as much on the meaning of death in human existence. For additional discussion of the differences between existential philosophy and humanistic psychology, see DeCarvalho (1990).

In Chapter 21 we will note the similarities between third-force psychology and contemporary postmodernism.

Evaluation

Modern humanistic psychology began as a protest movement against behaviorism and psychoanalysis. Behaviorism saw too much similarity between humans and other animals. The protesters contended that behaviorism concentrated on trivial types of behavior and ignored or minimized the mental and emotional processes that make humans unique. Psychoanalysis focused on abnormal individuals and emphasized unconscious or sexual motivation while ignoring healthy individuals whose primary motives included personal growth and the improvement of society. Humanistic psychologists criticized scientific psychology in general because it modeled itself after the physical sciences by assuming determinism and seeking lawfulness among classes of events. Scientific psychology also viewed individual uniqueness, something that was very important to humanistic psychology, as a nuisance; only general laws were of interest. Also, because science and reliable measurement went hand in hand, scientific psychology excluded many important human attributes from study simply because of the difficulty of measuring them. Processes such as willing, valuing, and seeking meaning are examples of such attributes, as are such emotions as love, guilt, despair, happiness, and hope.

Criticisms

It should come as no surprise that humanistic psychology itself has been criticized. Each of the following has been offered as one of its weaknesses:

 Humanistic psychology equates behaviorism with the work of Watson and Skinner. Both men stressed environmental events as the causes of human behavior and denied the importance of mental events. Other behaviorists, however, stress both mental events and purpose in their analysis of behavior—for example, McDougall and Tolman.

- Humanistic psychology overlooks the cumulative nature of science by insisting that scientific psychology does not care about the loftier human attributes. The problem is that we are not yet prepared to study such attributes. One must first learn a language before one can compose poetry. The type of scientific psychology that humanistic psychologists criticize provides the basis for the future study of more complex human characteristics.
- The description of humans that humanistic psychologists offer is like the more favorable ones found through the centuries in poetry, literature, or religion. It represents a type of wishful thinking that is not supported by the facts that more objective psychology has accumulated. We should not ignore facts just because they are not to our liking.
- Humanistic psychology criticizes behaviorism, psychoanalysis, and scientific psychology in general, but all three have made significant contributions to the betterment of the human condition. In other words, all three have done the very thing that humanistic psychology sets as one of its major goals.
- If humanistic psychology rejects traditional scientific methodology as a means of evaluating propositions about humans, what is to be used in its place? If intuition or reasoning alone is to be used, this enterprise should not be referred to as psychology but would be more accurately labeled philosophy or even religion. The humanistic approach to studying humans is often characterized as a throwback to psychology's prescientific past.
- By rejecting animal research, humanistic psychologists are turning their backs on an extremely valuable source of knowledge about humans. Not to use the insights of evolutionary

- theory in studying human behavior is, at best, regressive.
- Many of the terms and concepts that humanistic psychologists use are so nebulous that they defy clear definition and verification. There is even confusion over the definition of humanistic psychology. After searching for a definition of humanistic psychology in the *Journal of Humanistic Psychology*, in various books on humanistic psychology, and in the programs of the Division of Humanistic Psychology of the APA, Michael Wertheimer (1978) reached the following conclusion:

It is hard to quarrel with such goals as authenticity, actualizing the potential inherent in every human being, creating truly meaningful human relationships, being fully in touch with our innermost feelings, and expanding our awareness. But what, really, is humanistic psychology? To paraphrase an old Jewish joke, if you ask two humanists what humanistic psychology is, you are likely to get at least three mutually incompatible definitions.... It is highly unlikely that an explicit definition of [humanistic psychology] could be written that would satisfy even a small fraction of the people who call themselves "humanistic psychologists." (pp. 739, 743)

Contributions

To be fair to humanistic psychologists, it must be pointed out that they usually do not complain that behaviorism, psychoanalysis, and scientific psychology have made *no* contributions to the understanding of humans. Rather, their claim has been that behaviorism and psychoanalysis tell only part of the story and that perhaps some important human attributes cannot be studied using the traditional methods and assumptions of science. As William James said, if existing methods are ineffective for studying certain aspects of human nature, it is not those aspects of human nature that are to be

discarded but the methods. Humanistic psychologists do not want to discard scientific inquiry; they want to expand our conception of science so that scientific inquiry can be used to study the higher human attributes.

The expansion of psychology's domain is humanistic psychology's major contribution to the discipline. In psychology, there is now an increased tendency to study the whole person. We are concerned with not only how people learn, think, and mature biologically and intellectually but also how people formulate plans to attain future goals and why people laugh, cry, and create meaning in their lives. In the opinion of many, the humanistic paradigm has breathed new life into psychology. Recently, a field called positive psychology has developed that, like traditional humanistic psychology, explores positive human attributes. However, according to Seligman and Csikszentmihalyi (2000), although the aspirations of humanistic psychology were admirable, its accomplishments typically were not:

Unfortunately, humanistic psychology did not attract much of a cumulative empirical base, and it spawned myriad therapeutic self-help movements. In some of its incarnations, it emphasized the self and encouraged a self-centeredness that played down concerns for collective well-being. Future debate will determine whether this came about because Maslow and Rogers were ahead of their times, because these flaws were inherent in their original vision, or because of overly enthusiastic followers. However, one legacy of the humanism of the 1960s is prominently displayed in any large bookstore: The "psychology" section contains at least 10 shelves on crystal healing, aromatherapy, and reaching the inner child for every shelf of books that tries to uphold some scholarly standard. (p. 7)

Seligman and Csikszentmihalyi (2000) describe what positive psychology has in common with traditional humanistic psychology and what makes it different:

[The purpose of positive psychology] is to remind our field that psychology is not just the study of pathology, weakness, and damage; it is also the study of strength and virtue. Treatment is not just fixing what is broken; it is nurturing what is best. Psychology is not just a branch of medicine concerned with illness or health; it is much larger. It is about work, education, insight, love, growth, and play. And in this quest for what is best, positive psychology does not rely on wishful thinking, faith, self-deception, fads, or hand waving; it tries to adapt what is best in the scientific method to the unique problems that human behavior presents to those who wish to understand it in all its complexity. (p. 7)

Both positive psychologists and the earlier humanistic psychologists agree that mental health is more than the absence of mental illness. Currently, the term **flourishing** is used to describe people who are not only free from mental illness but, more importantly, are filled with vitality and are functioning optimally in their personal and social lives. Keyes (2007, p. 95) estimates that only one fifth of the U.S. adult population is flourishing. A major goal of positive psychology is to increase that number, and the earlier humanistic psychologists would no doubt support that goal. In fact, the characteristics of flourishing individuals are essentially the same as those thought by Maslow to characterize selfactualizing individuals or those thought by Rogers to characterize fully functioning individuals.

For additional information on positive psychology, see Aspinwall and Staudinger, 2003; Firestone, Firestone, and Catlett, 2003; Fowers, 2005; Keyes, 2007; Keyes and Haidt, 2003; Lopez and Snyder, 2003; Seligman, Steen, Park, and Peterson, 2005.

SUMMARY

The 1960s were troubled times in the United States, and a group of psychologists emerged who believed that behaviorism and psychoanalysis, the two major forces in psychology at the time, were neglecting important aspects of human existence. What was needed was a third force that emphasized the positive, creative, and emotional side of humans. This third-force psychology is a combination of existential philosophy and romantic notions of humans; the combination is called humanistic psychology, as well as third-force psychology. Humanistic psychologists are phenomenologists. In modern times, Brentano and Husserl developed phenomenology, which is the study of intact, conscious experiences as they occur and without any preconceived notions about the nature of those experiences. According to Brentano, all conscious acts intend (refer to) something outside themselves. An example is the statement "I see that girl." Husserl thought that a careful, objective study of mental phenomena could provide a bridge between philosophy and science. Besides the type of phenomenology that focuses on intentionality, Husserl proposed a second type, a pure phenomenology that studies the essence of subjective experience. Thus, for Husserl, phenomenology could study the mind turned outward or turned inward.

As used by existentialists, phenomenology became a study of the totality of human existence. Such a study focuses on the full range of human cognitive and emotional experience, including anxiety, dread, fear, joy, guilt, and anguish. Husserl's student Heidegger expanded phenomenology into existential inquiry. Heidegger studied Dasein, or being-in-the-world. Dasein means "to be there"; but for humans "to be there" means "to exist there," and existence is a complex process involving the interpretation and the evaluation of one's experiences and making choices regarding those experiences. Heidegger believed that although humans have a free will, they are thrown by events beyond their control into their life circumstances. Thrownness determines such things as whether a person is male or female, rich or poor, attractive or unattractive, and so on. It is up to each person to make the most of his or her life no matter what the circumstances. Positive growth occurs when a person explores possibilities for living through his or her choices. Choosing, however, requires entering the unknown, and this causes anxiety. For Heidegger then, exercising one's freedom requires courage, but only by exercising one's freedom can one live an authentic life—a life that the person chooses and therefore a life for which the person is completely responsible. If a person lives his or her life in accordance with other people's values, he or she is living an inauthentic life. For Heidegger the first step toward living an authentic life is to come to grips with the inevitability of death (nonbeing). Once a person comprehends and deals with finitude, he or she can proceed to live a rich, full. authentic life.

Binswanger applied Heidegger's philosophical ideas to psychiatry and psychology. Binswanger called his approach to psychotherapy Daseinanalysis, or the study of a person's approach to being-in-the-world. Binswanger divided Dasein into the Umwelt (the physical world), the Mitwelt (the social world), and the Eigenwelt (the person's self-perceptions). According to Binswanger, each person embraces life's experiences through a Weltanschauung, or worlddesign, which is a general orientation toward life. Binswanger attempted to understand his patients' world-designs; if a patient's world-design was proving to be ineffective, he would suggest alternative, potentially more effective ones. Like Heidegger, Binswanger believed that the circumstances into which one was thrown place limits on personal freedom. Thrownness creates what Binswanger called the ground of existence from which one has to begin the process of becoming by exercising one's freedom. According to Binswanger, each person attempts to rise above his or her ground of existence and to attain being-beyond-the-world—that is, to rise above current circumstances by transforming them through free choice.

May was primarily responsible for bringing existential psychology to the United States. Like the

other existential psychologists, May believed that normal, healthy living involves the experience of anxiety because living an authentic life necessitates venturing into the unknown. If a person cannot cope with normal anxiety, he or she will develop neurotic anxiety and will be driven from an authentic life to a life of conformity or to a life that is overly restrictive. Furthermore, because the person with neurotic anxiety is not exercising his or her human capacity to choose, he or she experiences guilt. Thus, an authentic life is characterized by normal anxiety and guilt and an inauthentic life by neurotic anxiety and guilt. May believed that healthy people embrace myths that provide a sense of identity and community, support moral values, and provide a way of dealing with the mysteries of life. People without such myths feel isolated and fearful and often seek professional help. By analyzing the effectiveness of the stories by which people live, narrative therapy reflects May's belief in the pragmatic value of myths. According to May, myths often reflect the daimonic, which is the potential of any human attribute or function to become negative if it is expressed excessively. May believed the most unique aspects of humans elude traditional scientific methodology and, therefore, if humans are to be studied scientifically, a new human science will need to be created.

Kelly, who was not trained as a clinical psychologist, tried a number of approaches to helping emotionally disturbed individuals. He found that anything that caused his clients to view themselves and their problems differently resulted in improvement. Because of this observation, Kelly concluded that mental problems are really perceptual problems, and he maintained that humans are free to construe themselves and the world in any way they choose. They do this by creating a construct system that is, or should be, tested empirically. Any number of constructs can be used to construe any situation. That is, one can always view the world in a variety of ways, so how one views it is a matter of personal choice. Like Vaihinger, Kelly encouraged propositional thinking—experimentation with ideas to see where they lead. In fixed-role therapy, Kelly had his clients write a self-characterization; then, he

would create a role for his client to play that was distinctly different from the client's personality. By offering the client support and help in playing his or her role, Kelly became a supporting actor and helped the client to view himself or herself differently. Once the client saw that there were alternative ways of viewing one's self, one's life, and one's problems, improvement often resulted. According to Kelly, neurotics have lost their ability to "make-believe," and it is the therapist's task to restore it. Kelley's fixed-role therapy can be seen as an early version of narrative therapy.

According to Maslow, usually considered the founder of third-force psychology, human needs are arranged in a hierarchy. If one satisfactorily meets the physiological, safety, belonging and love, and esteem needs, then one is in position to become self-actualized. Leading a life characterized by fullness, spontaneity, and creativity, the selfactualizing person is being-motivated rather than deficiency-motivated. That is, because this person has met the basic needs, he or she does not need to seek specific things in the environment. Rather, he or she can embrace the world fully and openly and ponder the higher values of life. Toward the end of his life, Maslow proposed fourth-force or transpersonal psychology, which explores a person's relationship to the universe and emphasized the mystical and spiritual aspects of human nature.

Rogers concluded that the only way to understand a person is to determine how that person views things—that is, to determine that person's subjective reality. This view resulted in Rogers's famous client-centered therapy, which was the first major therapeutic alternative to psychoanalysis. Rogers was also the first clinician to attempt to quantify the effectiveness of therapy. He did this by employing the Q-technique (or Q-sort technique), which allows the comparison between a person's real self and his or her ideal self at various points during the therapeutic process. Like Maslow, Rogers postulated an innate actualizing tendency. For this actualizing tendency to be realized, one has to use the organismic valuing process as a frame of reference in living one's life; that is, one has to use one's own inner feelings in determining the

value of various experiences. If one lives according to one's organismic valuing process, one is a fully functioning person and is living an authentic life. Unfortunately, because humans have a need for positive regard, they often allow the relevant people in their lives to place conditions of worth on them. When conditions of worth replace the organismic valuing process as a frame of reference for living one's life, the person becomes incongruent and lives an inauthentic life. According to Rogers, the only way to prevent incongruency is for the person to receive unconditional positive regard from the relevant people in his or her life.

Existential and humanistic psychology share the following beliefs: humans possess a free will and are therefore responsible for their actions; phenomenology is the most appropriate method for studying humans; humans must be studied as whole beings and not divided up in any way; because humans are unique as a species, animal research is irrelevant to an understanding of humans; no two humans are alike; the search for meaning is the most important human motive; all humans should aspire to live authentic lives; and, because humans are unique, traditional scientific methodology cannot be used effectively to study them. The major difference between existential and humanistic psychology is that the former views human nature as neutral whereas the latter views it as basically good. According to existential psychologists, because we do not have an innate nature or guidance system, we must choose our existence. Existential psychologists see freedom as a curse as well as a blessing and something from which most humans attempt to escape.

Humanistic psychology has been criticized for equating behaviorism with the formulations of

Watson and Skinner and thereby ignoring the work of other behaviorists who stressed the importance of mental events and goal-directed behavior, for failing to understand that psychology's scientific efforts must first concentrate on the simpler aspects of humans before it can study the more complex aspects, for offering a description of humans more positive than the facts warrant, for minimizing or ignoring the positive contributions of behaviorism and psychoanalysis, for suggesting methods of inquiry that go back to psychology's prescientific history, for having more in common with philosophy and religion than with psychology, for overlooking a valuable source of information by rejecting the validity of animal research, and for using terms and concepts so nebulous as to defy clear definition or verification. Humanistic psychology's major contribution has been to expand psychology's domain by urging that all aspects of humans be investigated and that psychology's conception of science be changed to allow objective study of uniquely human attributes. Recently the field of positive psychology has emerged, studying positive human attributes but doing so in a manner more scientifically rigorous and less self-centered than was often the case with traditional humanistic psychology. However, both traditional humanistic psychology and positive psychology insist that mental health is more than the absence of mental illness. Both describe the truly healthy person as living an exciting, meaningful life. Whereas positive psychologists refer to such a person as flourishing, traditional humanistic psychologists had referred to him or her as self-actualizing (Maslow) or as fully functioning (Rogers).

DISCUSSION QUESTIONS

- 1. What is third-force psychology? What did the third-force psychologists see as the limitations of the other two forces?
- 2. Describe Brentano's phenomenology. What did he mean by *intentionality*? What did Husserl mean by *pure phenomenology*?

- 3. How did Heidegger expand phenomenology? Discuss the following terms and concepts from Heidegger's theory: Dasein, authenticity, becoming, responsibility, and thrownness.
- Describe Binswanger's method of Daseinanalysis. Discuss the following terms and concepts from Binswanger's theory: *Umwelt*, *Mitwelt*, *Eigenwelt*, *world-design*, *ground of existence*, and *being-beyond-the-world*.
- 5. In May's theory, what is the relationship between anxiety and guilt? What is the difference between normal anxiety and neurotic anxiety?
- 6. What, according to May, is the human dilemma?
- 7. For May, what functions do myths provide in human existence? What determines the content of classical myths? Are some myths better than others?
- Describe the relationship between May's belief in the importance of myth in living one's life and contemporary narrative therapy.
- Describe the kind of science that May believed needs to be created in order to effectively study humans.
- 10. Why did Kelly maintain that all humans are like scientists?
- 11. Describe Kelly's concepts of constructive alternativism and prepositional thinking.
- 12. Describe Kelly's approach to psychotherapy. What did Kelly mean when he said that psychological problems are perceptual problems? What techniques did Kelly use to help his clients regain their ability to make-believe?

- 13. What are the main tenets of humanistic psychology?
- 14. Summarize Maslow's hierarchy of needs.
- 15. Why, according to Maslow, are self-actualizing people so rare?
- 16. List what Maslow found to be the characteristics of self-actualizing people.
- 17. What is the difference between deficiency motivation and being motivation? Give an example of each.
- 18. Describe what Maslow meant by *transpersonal* or *fourth-force psychology*.
- 19. How did Rogers attempt to measure the effectiveness of psychotherapy?
- 20. For Rogers, what constitutes an incongruent person? In your answer, include a discussion of the organismic valuing process, the need for positive regard, and conditions of worth.
- 21. According to Rogers, what is the only way to avoid incongruency?
- 22. According to Rogers, what are the three major components of any relationship that facilitate personal growth?
- 23. What are the similarities and differences between humanistic and existential psychology?
- 24. Summarize the criticisms and contributions of humanistic psychology.
- 25. Compare the contemporary field of positive psychology with traditional humanistic psychology.

SUGGESTIONS FOR FURTHER READING

Coon, D. J. (2006). Abraham H. Maslow:
Reconnaissance for Eupsychia. In D. A. Dewsbury,
L. T. Benjamin Jr., & M. Wertheimer (Eds.),
Portraits of pioneers in psychology (Vol. 6, pp. 255–271). Washington, DC: American Psychological Association.

Hoffman, E. (1988). The right to be human: A biography of Abraham Maslow. Los Angeles: Tarcher.

Inwood, M. (2000). Heidegger: A very short introduction. New York: Oxford University Press.

- Jankowicz, A. D. (1987). Whatever happened to George Kelly? Applications and implications. American Psychologist, 42, 481–487.
- Kelly, G. A. (1964). The language of hypotheses: Man's psychological instrument. *Journal of Individual Psychology*, 20, 137–152.
- Kirschenbaum, H. (1979). On becoming Carl Rogers. New York: Dell.
- Maslow, A. H. (1968). *Toward a psychology of being* (2nd ed.). New York: Van Nostrand Reinhold.
- Maslow, A. H. (1971). The farther reaches of human nature. New York: Penguin Books.
- Maslow, A. H. (1987). *Motivation and personality* (3rd ed.). New York: Harper & Row. (Original work published 1954)

- May, R. (1991). The cry for myth. New York: Norton.
- Rogers, C. R. (1980). A way of being. Boston: Houghton Mifflin.
- Royce, J. R., & Mos, L. P. (Eds.). (1981). *Humanistic* psychology: Concepts and criticisms. New York: Plenum.
- Schneider, K. J. (1998). Toward a science of the heart: Romanticism and the revival of psychology. *American Psychologist*, 53, 277–289.
- Seligman, M. E. P., & Csikszentmihalyi, M. (2000). Positive psychology: An introduction. *American Psychologist*, 55, 5–14.

GLOSSARY

Anxiety The feeling that results when one confronts the unknown, as when one contemplates death or when one's choices carry one into new life circumstances. According to existentialists, one cannot live an authentic life without experiencing anxiety.

Authentic life According to existentialists, the type of life that is freely chosen and not dictated by the values of others. In such a life, one's own feelings, values, and interpretations act as a guide for conduct.

Becoming A characteristic of the authentic life because the authentic person is always becoming something other than what he or she was. Becoming is the normal, healthy psychological growth of a human being.

Being motivation For Maslow, the type of motivation that characterizes the self-actualizing person. Because being motivation is not need-directed, it embraces the higher values of human existence, such as beauty, truth, and justice. (Also called B-motivation.)

Being perception Perception that embraces fully "what is there" because it is not an attempt to locate specific items that will satisfy needs. (Also called B-perception.)

Being-beyond-the-world Binswanger's term for becoming. The healthy individual always attempts to transcend what he or she is.

Binswanger, Ludwig (1881–1966) Applied Heidegger's existential philosophy to psychiatry and psychology. For Binswanger a prerequisite for helping an emotionally disturbed person is to determine how that person views himself or herself and the world. (*See also* **Daseinanalysis** and **World-design**.)

Conditions of worth According to Rogers, the conditions that the relevant people in our lives place on us and that we must meet before these people will give us positive regard.

Construct systems According to Kelly, the collection of personal constructs with which people make predictions about future events.

Constructive alternativism Kelly's notion that it is always possible to view ourselves and the world in a variety of ways.

Courage According to existentialists, that attribute necessary for living an authentic life because such a life is characterized by uncertainty.

Daimonic According to May, any human attribute or function that in moderation is positive but in excess is negative.

Dasein Heidegger's term for "being-in-the-world." The world does not exist without humans, and humans do not exist without the world. Because humans exist in the world, it is there that they must exercise their free will. Being-in-the-world means existing in the world, and existing means interpreting and valuing one's experiences and making choices regarding those experiences.

Daseinanalysis Binswanger's method of psychotherapy that requires that the therapist understand the client's worldview. Daseinanalysis examines a person's mode of being-in-the-world.

Deficiency motivation According to Maslow, motivation that is directed toward the satisfaction of some specific need. (Also called D-motivation.)

Eigenwelt Binswanger's term for a person's private, inner experiences.

Existential psychology The brand of contemporary psychology that was influenced by existential philosophy. The key concepts in existential psychology include freedom, individuality, responsibility, anxiety, guilt, thrownness, and authenticity.

Fixed-role therapy Kelly's brand of therapy whereby he would assign a role for his clients to play that was distinctly different from the client's self-characterization. With this type of therapy, the therapist acts much like a supporting actor. (*See also* **Self-characterization**.)

Flourishing According to positive psychologists, the state of being free from mental illness and also living an enthusiastic, meaningful, and effective life.

Ground of existence Binswanger's term for the circumstances into which a person is thrown and according to which he or she must make choices. (Also called facticity.) (*See also* **Thrownness**.)

Guilt The feeling that results most intensely from living an inauthentic life.

Heidegger, Martin (1889–1976) Expanded Husserl's phenomenology to include an examination of the totality of human existence.

Hierarchy of needs Maslow's contention that human needs are arranged in a hierarchy and that lower needs in the hierarchy must be adequately satisfied before attention can be focused on higher needs. The most basic and powerful needs in the hierarchy are physiological needs, and then come safety needs, needs for belonging and love, and the need for self-esteem. When all lower needs in the hierarchy are adequately satisfied, a person becomes self-actualizing.

Human dilemma According to May, the paradox that results from the dual nature of humans as objects to which things happen and as subjects who assign meaning to their experiences.

Humanistic psychology The branch of psychology that is closely aligned with existential psychology. Unlike existential psychology, however, humanistic psychology

assumes that humans are basically good. That is, if negative environmental factors do not stifle human development, humans will live humane lives. Humanistic psychology is concerned with examining the more positive aspects of human nature that behaviorism and psychoanalysis had neglected. (Also called third-force psychology.)

Inauthentic life A life lived in accordance with values other than those freely and personally chosen. Such a life is characterized by guilt.

Incongruent person Rogers's term for the person whose organismic valuing process is replaced by conditions of worth as a guide for living.

Intentionality Brentano's contention that every mental act refers to something external to the act.

Jonah complex According to Maslow, the fear of one's own potential greatness.

Kelly, George (1905–1967) Emphasized that it is always possible to construe one's self and the world in a variety of ways. For Kelly, psychological problems are essentially perceptual problems.

Maslow, Abraham (1908–1970) A humanistic psychologist who emphasized the innate human tendency toward self-actualization. Maslow contended that behaviorism and psychoanalysis provided only a partial understanding of human existence and that humanistic, or third-force, psychology needed to be added to complete our understanding.

May, Rollo (1909–1994) Psychologist who was instrumental in bringing European existential philosophy and psychology to the United States.

Mitwelt Binswanger's term for the realm of social interactions.

Narrative therapy Examines the stories by which people live and understand their lives and, where necessary, encourages the replacement of ineffective stories with effective ones.

Need for positive regard According to Rogers, the need for positive responses from the relevant people in one's life.

Need-directed perception Perception whose purpose is to locate things in the environment that will satisfy a need. (Also called deficiency perception or D-perception.)

Neurotic anxiety The abnormal fear of freedom that results in a person living a life that minimizes personal choice.

Normal anxiety Results from living an authentic life. (See also Authentic life.)

Ontology The study of the nature of existence.

Organismic valuing process According to Rogers, the innate, internal guidance system that a person can use to "stay on the track" toward self-actualization.

Phenomenology The introspective study of intact, mental experiences.

Positive psychology Field in contemporary psychology that explores the positive attributes of humans but does so in a more scientifically rigorous and less selfcentered way than was often the case with traditional humanistic psychology.

Propositional thinking According to Kelly, the experimentation with ideas to see where they lead.

Pure phenomenology The methodology proposed by Husserl to discover the essence of those mental acts and processes by which we gain all knowledge.

Responsibility A necessary by-product of freedom. If we are free to choose our own existence, then we are completely responsible for that existence.

Rogers, Carl (1902–1987) A humanist psychologist whose nondirective and then client-centered psychotherapy was seen by many as the first viable alternative to psychoanalysis as a method for treating troubled individuals. Like Maslow's, Rogers's theory of personality emphasized the innate tendency toward self-actualization. According to Rogers, a person continues toward self-actualization unless his or her organismic valuing process is displaced by conditions of worth as a guide for living. The only way to avoid creating conditions of worth is to give a person unconditional positive regard. (See also Conditions of worth, Organismic

valuing process, Self-actualization, and Unconditional positive regard.)

Self-actualization According to Rogers and Maslow, the innate human tendency toward wholeness. The self-actualizing person is open to experience and embraces the higher values of human existence.

Self-alienation According to existentialists, the condition that results when people accept values other than those that they attained freely and personally as guides for living.

Self-characterization The self-description that Kelly required of many of his clients before beginning their therapeutic program.

Shut-upness Kierkegaard's term for the type of life lived by a defensive, inauthentic person.

Subjective reality A person's consciousness.

Third-force psychology See Humanistic psychology.

Thrownness According to Heidegger and Binswanger, the circumstances that characterize a person's existence that are beyond the person's control. (*See also* **Ground of existence**.)

Transpersonal psychology Maslow's proposed fourth force in psychology that stresses the relationship between the individual and the cosmos (universe) and in so doing focuses on the mystical and spiritual aspects of human nature.

Umwelt Binswanger's term for the physical world.

Unconditional positive regard According to Rogers, the giving of positive regard without any preconditions.

World-design (*Weltanschauung*) Binswanger's term for a person's basic orientation toward the world and life.

Psychobiology

Psychobiology attempts to explain psychological phenomena in terms of their biological foundations. The search for the biological foundations of mental events has been a recurring theme in the history of psychology and has been represented by such individuals as Hippocrates, Aristotle, Galen, Hartley, Bain, Weber, Fechner, Helmholtz, Pavlov, and Freud. Because radical behaviorism discouraged a search for any internal causes of behavior, as its influence diminished there arose a resurgence of interest not only in cognitive psychology (see Chapter 20) but in psychobiology as well. Our small sample of psychobiological research includes the pioneering work of Karl Lashley and two illustrious psychobiologists he influenced—Donald Hebb and Roger Sperry.

KARL S. LASHLEY

Karl Spencer Lashley (1890–1958) was born on June 7 in Davis, West Virginia, an only child. His father was a businessman and politician, his mother a schoolteacher. Lashley received his undergraduate education at the University of West Virginia and his graduate education first at the University of Pittsburgh and then at Johns Hopkins University, from which he received his PhD in 1914. While at Johns Hopkins, Lashley came under the influence of J. B. Watson, and much of Lashley's early work reflected Watson's influence. As we saw in Chapter 12, it was Lashley with whom Watson did his pioneering ethological research. In 1916 Lashley's collaboration with Watson ended because Lashley was interested in seeking the neurophysiological bases of conditioned reflexes and Watson was not. Although the two went their separate ways professionally, they remained close friends. In 1917 Lashley went to the University of Minnesota and then, in 1926, to the University of Chicago. In 1935 Lashley moved to Harvard, and in 1942 he became director of the Yerkes Laboratories

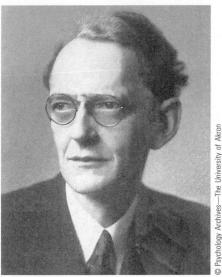

Karl S. Lashley

of Primate Biology in Orange Park, Florida (because Yerkes Laboratories was supervised by Harvard, Lashley remained affiliated with that university). Although Lashley retired as director of Yerkes Laboratories in 1955, he remained on the board of directors until his sudden death on August 7, 1958, while vacationing in France.

As mentioned, Lashley was initially a supporter of Watsonian behaviorism, and he sought to support the associationism on which it was based with neurophysiological evidence. But time after time, Lashley was frustrated in his efforts to show that the brain worked like a complex switchboard linking sensory impulses to motor reactions. Contrary to his original intention, Lashley gradually showed that brain activity was more like the Gestaltists' description than like the behaviorists'. He found no evidence that stimulation of specific areas of the brain is associated with the elicitation of specific responses.

Mass Action and Equipotentiality

Lashley made two major observations that were contrary to the switchboard conception of the brain. One was that loss of ability following destruction of parts of the cortex is related more to the amount of destruction than to the location of destruction. This finding, called mass action, indicated that the cortex works as a unified whole, as the Gestaltists had maintained. It is important to note, however, that Lashley found the principle of mass action to be true only for the ablation of cortical tissue following complex learning (such as maze learning). Presumably, localized cortical lesions following such learning has little effect on task retention because it involves many different sensory cues and because motor responses are involved, corresponding to many different cortical areas. For a simpler learning task, such as a brightness discrimination, lesions in the posterior cortex disrupt retention.

The second observation was that any part of a functional area of the brain can perform the function associated with that area. For example, within the visual area of the cortex, any of the cells within that area allow vision to occur. To destroy a brain function, then, the entire brain area associated with that function would need to be destroyed. If any part of the area were spared, the function would still be maintained. Lashley called this second observation equipotentiality, and it too supported the contention that the brain acted as an integrated whole and not as a mechanistic switchboard. The research from which the principles of mass action and equipotentiality were derived, and much of Lashley's additional creative research, was summarized by Beach, Hebb, Morgan, and Nissen (1960).

In Search of the Engram

The **engram** is the neurophysiological locus of memory and learning. Lashley spent decades searching for the engram and in the end expressed his frustration as follows:

This series of experiments has yielded a good bit of information about what and where the memory trace is not. It has discovered nothing directly of the real nature of the engram. I sometimes feel, in reviewing the evidence on the localization of

the memory trace, that the necessary conclusion is that learning is just not possible. (1950, pp. 477–478)

This frustration was not new. Compare Lashley's conclusion with that of Cicero (106–43 B.C.):

But for my part I wonder at memory in a still greater degree. For what is it that enables us to remember, what character has it, or what is its origin? ... Do we think there is ... a sort of roominess into which the things we remember can be poured as if into a kind of vessel? ... Or do we think that ... memory consists of the traces of things registered in the mind? What can be the traces of words, of actual objects, what further could be the enormous space adequate to the representation of such a mass of material? (King, 1927, p. 80)

Has the search for the engram been more successful since Lashley's efforts? Not according to Finger (1994):

In spite of the best efforts of some of the brightest scientists, the nature and locus of the engram have remained as elusive and mysterious to twentieth-century investigators as they were to Cicero and other philosophers and naturalists who pondered the characteristics of the memory trace long ago. (p. 346)

Concerning Lashley's place in the history of psychology, D. N. Robinson says, "If we were to summarize [Lashley's] role in twentieth-century developments in physiological psychology, we might say that he bore the same relationship to the Pavlovians that Flourens bore to the phrenologists" (1986, p. 421). In Chapter 8, we saw that Flourens's research demonstrated that the cortex is not characterized by localization of function, as the phrenologists had assumed, but functions as a unit. The Pavlovians (and Watson) assumed a different type of localization—an association between certain sensory centers and certain motor centers in the

brain—and Lashley's work showed that this type of localization does not exist either.

In 1929 Lashley, then president of the APA, gave an address to the International Congress of Psychology meeting in New Haven describing his research on brain functioning. Also in 1929, Lashley published his influential book *Brain Mechanisms and Intelligence*. Because of Lashley's prestige and because his findings were generally supportive of Gestalt theory, his address did much to promote the acceptance of Gestalt psychology—despite the fact that Lashley could not find evidence for the electrical fields of brain activity so important to Gestalt theory (Lashley, Chow, and Semmes, 1951).

DONALD O. HEBB

Donald Olding Hebb (1904-1985) was born on July 22 in Chester, Nova Scotia. Both of his parents were medical doctors. He received his BA from Dalhousie University with the lowest grade average a person could have and still graduate. After teaching for a while, he entered McGill University as a graduate student in psychology in spite of his poor undergraduate performance (presumably because the chair of the psychology department at McGill was a friend of Hebb's mother). Hebb studied Pavlovian psychology at McGill and was convinced of its value. After receiving his master's degree from McGill in 1932, he continued his education at the University of Chicago, where he worked with Lashley and took a seminar from Köhler. Hebb's initial concurrence with Pavlovian psychology was converted into outright opposition: "I had all the fervor of the reformed drunk at a temperance meeting; having been a fully convinced Pavlovian, I was now a fully convinced Gestalter-cum-Lashleyan" (Hebb, 1959, p. 625). In 1935 Lashley accepted a professorship at Harvard and invited Hebb to go with him. In 1936 Hebb obtained his PhD from Harvard and remained there for an additional year as a teacher and research assistant.

In 1937 Hebb went to the Montreal Neurological Institute to work with the illustrious

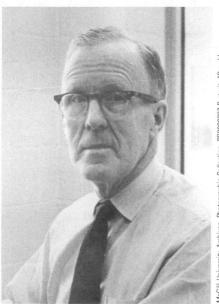

McGill University Archives. Photographic Collection. PR0000387-Portrait. "Donald D. Hebb, Professor of Psychology".

Donald O. Hebb

brain surgeon Wilder Penfield. Hebb's job was to evaluate Penfield's patients after brain surgery. Hebb consistently found little or no loss of intelligence, even after substantial loss of tissue from the frontal lobes of the brain. After five years of such observations (1937–1942), Hebb reached a conclusion about intelligence that was to guide much of his later work: "Experience in childhood normally develops concepts, modes of thought, and ways of perceiving that constitute intelligence. Injury to the infant brain interferes with that process, but the same injury at maturity does not reverse it" (1980, p. 292).

In 1942, when Lashley accepted an appointment as director of the Yerkes Laboratories, Hebb joined him there and remained for five years. In 1948 Hebb accepted an appointment as professor of psychology at McGill University, where he remained until his retirement. After retiring, Hebb moved back to a small farm near Chester, Nova Scotia, where he was born. He remained physically and psychologically active until he died on August 20, 1985, following what was thought to be routine hip surgery (Beach, 1987, p. 187).

Among Hebb's many honors were eight honorary doctorates, the presidency of the Canadian

Psychological Association (1952), the presidency of the APA (1959), and recipient of the Distinguished Scientific Contribution Award of the APA (1961).

Cell Assemblies and Phase Sequences

According to Hebb, the neural interconnections in a newborn's brain are essentially random. It is experience that causes this network of neurons to become organized and provide a means of effectively interacting with the environment. Hebb speculated that every environmental object we experience fires a complex package of neurons, called a cell assembly. When we look at a pencil, for example, our attention shifts from the point, to the shaft, to the eraser. Each shift of attention causes different neurons to fire, and, at first, these neurons fire independently of the others. Eventually, however, because the neurons stimulated by the presence of a pencil fire either simultaneously or in close succession, they become a neurological package corresponding to the experience of a pencil. According to Hebb, it is reverberating neural activity that allows neurons that were temporarily separated to become associated. For example, the neurons activated by observing a pencil's point become associated with the neurons activated by observing a pencil's eraser, although the observations do not occur at exactly the same time. Hebb believed that neural activity caused by stimulation continued for a short time after the stimulation ceases (reverberating neural activity), thus allowing the development of successive neural associations. Once a cell assembly exists, it can be fired by internal or external stimulation or by a combination of the two. When a cell assembly fires, we experience the thought of the environmental object or event to which the assembly corresponds. For Hebb the cell assembly was the neurological basis of a thought or an idea. In this way, Hebb explained why environmental objects do not need to be present for us to think about them.

Just as the various neurons stimulated by an object become neurologically interrelated to form a cell assembly, so do cell assemblies become neurologically interrelated to form **phase sequences**. Hebb (1959) defined a phase sequence as "a

temporally integrated series of assembly activities; it amounts to one current in the stream of thought" (p. 629). Like a cell assembly, a phase sequence can be fired by internal or external stimulation or by a combination of the two; when one or more assemblies in a phase sequence fire, the entire phase sequence tends to fire. When the entire phase sequence fires, a stream of thought—a series of ideas arranged in some logical order—is experienced. Hebb (1972) gave the following example:

Cell-assemblies that are active at the same time become interconnected. Common events in the child's environment establish assemblies, and then when these events occur together the assemblies become connected (because they are active together). When the baby hears footsteps, let us say, an assembly is excited; while this is still active he sees a face and feels hands picking him up, which excites other assemblies—so the "footsteps assembly" becomes connected with the "face assembly" and the "being-picked-up assembly." After this has happened, when the baby hears footsteps only, all three assemblies are excited; the baby then has something like a perception of the mother's face and the contact of her hands before she has come in sight—but since the sensory stimulations have not yet taken place, this is ideation or imagery, not perception. (p. 67)

According to Hebb, childhood learning involves the slow buildup of cell assemblies and phase sequences, and this kind of learning can be explained using associationistic terminology. Adult learning, however, is characterized by insight and creativity and involves the rearrangement of already existing cell assemblies and phase sequences. Although childhood learning can be explained in terms of associationistic principles, adult learning is better explained in terms of Gestalt principles. As we will see in the next chapter, Hebb's contention that neurons that are active together become associated came to be called Hebb's rule and was instrumental in the development of the newest and

most influential form of artificial intelligence (AI), new connectionism.

Space permits mention of only a few of Hebb's other pioneering efforts in psychobiology. In 1946 he published an article summarizing his research on the nature of fear. In 1949 he described the results of a study in which animals were reared in either an enriched or an impoverished sensory environment. He found that animals reared in an enriched sensory environment were relatively better learners as adults. In a series of experiments run under his supervision, the effects of sensory deprivation on cognitive processes were examined (for example, see Heron, 1957). In 1955 Hebb reported research showing the relationship between level of activity in the small brain structure, called the reticular activating system (RAS), and cognitive and behavioral performance. The examination of this relationship was called arousal theory. It was while they were doing research on arousal theory in Hebb's laboratory that James Olds and Peter Milner discovered reinforcement centers in the brain (Olds and Milner, 1954). Henry Buchtel (1982) provides an excellent sample of Hebb's influential articles on topics in psychobiology, and a complete list of Hebb's more than 80 publications is provided in the appendix of Buchtel's book.

ROGER W. SPERRY

Roger Wolcott Sperry (1913–1994) was born on August 20, in Hartford, Connecticut. He received his BA in English from Oberlin College in 1935 and his PhD in zoology from the University of Chicago in 1941, where he learned neurosurgical techniques from the eminent neuroembryologist Paul Weiss. After receiving his doctorate, Sperry studied with Lashley at the Yerkes Laboratories in Florida (1942–1946). In 1946 he returned to the University of Chicago first as an assistant professor of anatomy and then, in 1952, as assistant professor of psychology. In 1954 Sperry moved to the California Institute of Technology in Pasadena (Caltech) as the prestigious Hixon Professor of Psychobiology.

Ron Myer/Courtesy Caltech Archives by

Roger W. Sperry

The Split-Brain Preparation

At Caltech, Sperry pursued his interest in the routes by which information is transferred from one side of the cerebral cortex to the other. In a nowfamous series of experiments, Sperry and his colleagues discovered two possible routes for such interhemispheric transfer—the corpus callosum (a large mass of fibers that connects the two halves of the cortex) and the optic chiasm. The optic chiasm is the point in the optic nerve where information coming from one eye is projected to the side of the cortex opposite to that eye. Sperry taught cats and monkeys to learn a visual discrimination with a patch over one eve. He then tested for transfer by switching the patch to the other eye and found complete interocular transfer. Sperry then began his search for the mechanism by which information is transferred from one side of the cortex to the other. He found that ablating either the corpus callosum or the optic chiasm alone or together after training did not interfere with transfer. He also found that ablating either the corpus callosum or the optic chiasm before training did not interfere with transfer. However, he found that ablating

both the corpus callosum and the optic chiasm before training eliminated interhemispheric transfer. Thus, ablating the corpus callosum and the optic chiasm had in essence created two separate brains with no exchange of information between them. For example, when an animal's brain was split in the manner just described and it was taught to make a visual discrimination with a patch over one eye, it had no recollection of that learning when tested with the other eye (Sperry, 1961, 1964). A brain that has had its corpus callosum and its optic chiasm ablated is referred to as a split-brain preparation.

Sperry and his colleagues, Joseph Bogen and Philip Vogel, discovered that humans suffering from severe drug-resistant, intractable epilepsy could benefit from having their brains split in the manner described above. Presumably, with splitbrain preparation, a seizure begun in one hemisphere would not have a mechanism available to spread its influence to the other hemisphere and thus increase its intensity. In many cases, patients treated in this way improved enough to leave the hospital. In everyday living, these "split-brain" patients showed almost no abnormality in spite of their radical surgery. However, Sperry and his colleagues developed a number of tests that made it possible to study the function of each cerebral hemisphere independently of the other. Although Paul Broca and others had provided information indicating hemispheric specificity as early as 1831 (see Chapter 8) and speculation concerning hemispheric specificity was quite popular toward the end of the 19th century (see, for example, Brown-Séquard, 1874a, 1874b, 1890), information concerning hemispheric specificity remained extremely limited. The additional knowledge provided by Sperry and his colleagues was dramatic. They found that each hemisphere had its own characteristic range of cognition, memory, emotion, and consciousness (see, for example, Gazzaniga, 1970). Under Sperry's leadership, research on the "left brain" and the "right brain" became very popular (for a sample of such research see, for example, Springer and Deutsch, 1985). The fact that such research remains popular in contemporary psychology is demonstrated by the statement with which

Dahlia Zaidel (a one-time colleague of Sperry) begins the edited book *Neuropsychology* (1994): "Hemispheric specialization is at the heart of neuropsychology, and every topic discussed in this volume assumes its presence in the brain" (p. xviii).

Unfortunately, some speculations concerning hemispheric specificity began to exceed the facts. For example, it was speculated that some people are right-brain dominated and others left-brain dominated and that tests could be devised that reveal this domination. It was also speculated that educational practices could be employed to specifically enhance either right- or left-brain functions. The belief that the two cortical hemisphere can be educated independently goes back at least as far as Brown-Séguard (1874a, 1874b) and in one form or another, has been entertained ever since. Jerre Levy, another one-time colleague of Sperry, attempted to set the record straight in her article "Right Brain, Left Brain: Fact and Fiction" (1985). In this article, Levy emphasizes the point that in people with normal brains, the contributions of the two hemispheres to thought and behavior are inseparable. Levy concludes, "The popular myths are misinterpretations and wishes, not the observations of scientists. Normal people have not half a brain nor two brains but one gloriously differentiated brain, with each hemisphere contributing its specialized abilities. . . . We have a single brain that generates a single mental life" (1985, p. 44).

Sperry had a lifelong interest in the mind-body (brain) problem and how that problem relates to human values, and many of his publications, especially his later ones, reflected those interests (see, for example, Sperry, 1970, 1972, 1980, 1982, 1988, 1991, 1992, 1993). Sperry believed that consciousness emerges from brain processes and, once emerged, has a causal relationship to behavior. Thus, Sperry was an interactionist concerning the mind-body relationship. He believed (some say, as we will see in Chapter 20, incorrectly) that by correlating mental events directly to brain processes, he avoided dualism. In his Nobel address, Sperry (1982) said,

[Ilt remains to mention briefly that one of the more important indirect results of the split-brain work is a revised concept of the nature of consciousness and its fundamental relation to brain processing. ... The key development is a switch from prior noncausal, parallelist views to a new causal, or "interactionist" interpretation that ascribes to inner experience an integral causal control role in brain function and behavior. In effect, and without resorting to dualism, the mental forces of the conscious mind are restored to the brain of objective science from which they had long been excluded on materialist-behaviorist principles. (p. 1226)

In his lifetime, Sperry published almost 300 articles in the most prestigious journals, and many of those articles were translated into several languages (Puente, 1995, p. 941). Among the many honors received by Sperry were the Karl Lashley Award of the American Philosophical Society (1976); the Wolf Prize in Medicine (1979); the Ralph Gerard Award from the Society of Neuroscience (1979); the Nobel Prize in medicine/physiology (shared with Harvard neuroscientists David H. Hubel and Torsten N. Wiesel) (1981); and the Lifetime Achievement Award from the APA (1993).

Sperry died on April 17, 1994, in Pasadena, California, at the age of 80 from a degenerative neuromuscular disorder (Puente, 1995).

BEHAVIORAL GENETICS

Behavioral genetics is a branch of psychobiology that studies the genetic influence on cognition and behavior. Within the ancient nativism-empiricism controversy, behavioral geneticists tend toward nativism because they believe that at least some thought processes or behavior patterns are strongly influenced by heredity. Following is only a small sample of the research on behavioral genetics.

Ethology

Under the influence of radical behaviorism, reference to all internal events as explanations of behavior was actively discouraged. This positivistic philosophy discouraged the study not only of cognitive and physiological processes but also of instinctive behavior. As with cognitive and physiological explanations of behavior, however, instinctive explanations were discouraged but not eliminated. Even during behaviorism's heyday, a group of ethologists were studying instinctive animal behavior. Ethology (ethos = habit, custom, character; ology = the study of) is a branch of zoology developed primarily by Karl von Frisch (1886–1982) and Konrad Lorenz (1903–1989) in Germany and Niko Tinbergen (1907-1988) in England. For their efforts, Tinbergen, Frisch, and Lorenz shared the 1973 Nobel Prize in physiology and medicine. (For details concerning Tinbergen's colorful life and his accomplishments, Dewsbury, 2006.)

Ethologists typically study a specific category of behavior (such as aggression, migration, communication, territoriality) in an animal's natural environment and attempt to explain that behavior in terms of evolutionary theory. Of major importance to the ethologists is **species-specific behavior**, or how members of various species typically behave under certain environmental conditions. The nativistic position of the ethologists placed them in direct conflict with the behaviorists, especially the radical behaviorists:

In those early days, the 1950s, the argument was basically European vs. American, biologists vs. psychologist, instinct theorists vs. learning theorists, birdwatchers vs. ratrunners. The lines were clearly drawn. The Europeans, calling themselves ethologists, rallied behind the flamboyant Lorenz, who dismissed the Americans as "ratrunners, unprepared to ask important questions." The ethologists stated flatly that the most important question was: How much is behavior due to instinct (genetics) and how much to learning? They suspected that instinct was far more

important than anyone had previously imagined. (Wallace, 1979, p. 2)

The ethologists effectively battled the behaviorists, and their success had much to do with the decline in the popularity of radical behaviorism.

Ethology remains an active field of study, but its main influence on contemporary psychology has come through sociobiology. Edward Wilson, the founder of sociobiology, took a course from Lorenz while Wilson was a student at Harvard in 1953, and the influence of ethology on sociobiology is considerable. A major difference is that ethologists tend to concentrate on rather stereotyped, automatic responses that characterize various animal species, and sociobiologists tend to concentrate on the social behavior that results from the complex interactions between an organism's biology and its environment. Rather than studying stereotyped behavior, sociobiologists employ terms such as strategy and cost-benefit analysis, indicating that organisms weigh various alternatives before deciding on a course of action. Sociobiologists believe that an organism will choose that course of action that will increase the probability that copies of its genes will be perpetuated into future generations.

Sociobiology

Although in Chapter 10 we briefly reviewed sociobiology as an example of neo-Darwinism, we expand that coverage here because sociobiology nicely exemplifies the field of behavioral genetics in contemporary psychology. According to David Barash (1979, p. 10), humans possess a biogrammar that structures our social behavior, just as the innate rules of grammar structure our verbal behavior. We learn a language, create culture, protect our territory, and learn some things (such as phobias, societal rules and regulations, language) more readily than others because we are genetically disposed to do so. Similarly, the male strategy for perpetuating copies of his genes is promiscuity, and the female strategy is the careful selection of an adequate mate. This sex difference in strategy, according to the sociobiologists, is because the male investment

in reproduction is minimal and the female investment is substantial. Wallace (1979) wryly describes copulation from the male perspective: "A male can make up the energy expended in a sexual episode by eating a grape. His cost is low, and—who knows?—perhaps it will result in a child for him" (p. 74). However, if pregnancy results from copulation, the cost to the female is much greater. As Barash (1979) explains,

Eggs are fertilized by sperm, not vice versa. And women become pregnant, not men. It is the woman who must produce a placenta and nourish her unborn child; who must undergo the metabolic and hormonal stresses of pregnancy; who must carry around an embryo that grows in bulk and weight, making her more and more ungainly as her pregnancy advances; and who, when the child is born, must nurse it. (p. 47)

As a result, females are genetically predisposed to seek males with good (fitness enhancing) genes (those that will produce an offspring with survival and reproductive potential), good resources (for example, food, territory, shelter, and protection), and good behavior (a willingness to invest some of their resources in the female and her offspring).

Some have accused the sociobiologists of being rigid biological determinists, but this is not an accurate assessment. For example, in the case of mate selection just described, the sociobiologists describe only general genetic dispositions. They say that males have a genetic predisposition to be promiscuous, but they say more. In cultures where polygyny is practiced (where males are allowed to mate with more than one female), males have no need to inhibit their tendency toward promiscuity. In monogamous cultures, however, such promiscuity is considered adulterous and is discouraged. The social behavior of any individual, then, always results from the combined influences of biology and culture. In explaining human behavior, the sociobiologists avoid "nothing-butism"—that is, claiming that behavior is caused only by biological factors or that it is caused only by environmental (cultural) factors. For them it is always both. Barash (1979) says, "For too long social science and biological science have pursued 'nothing but' approaches. Sociobiology may just help redress that imbalance" (p. 45).

The interactive approach just described is nicely illustrated by Wilson's leash principle. According to Wilson, humans have a biological (genetic) predisposition to create culture because to do so facilitates survival. Therefore, there is, or should be, a close relationship between culture and the satisfaction of biological needs. If culture strays too far from biology, the leash holding the two together would become too taut and "personalities would quickly dissolve, relationships disintegrate, and reproduction cease" (Wilson, 1978, p. 22). Obviously, if this continued, the culture would become extinct. Before this happens, however, cultures usually adjust in the direction of biology.

According to sociobiology, then, our biogrammar furnishes us with *tendencies* to engage in certain social activities. For the title of his book *The Whisperings Within* (1979), Barash chose the term *whisperings* because a whisper is a whisper; it is not a shout or a yell. We may be biologically predisposed to act in certain ways, but we are not "hard wired" to do so. Barash (1986) makes this point:

Fortunately, there is some good news. Human beings, intelligent primates that we are, can exercise choice. We can overcome our primitive limitations and short-sightedness. We can learn all sorts of difficult things, once we become convinced that they are important, or unavoidable. We can even learn to do things that go against our nature. A primate that can be toilet trained could possibly even be planet trained someday. (p. 254)

Sociobiology versus Evolutionary Psychology. We have been using the terms sociobiology and evolutionary psychology interchangeably, but not everyone agrees that they are the same. Edward Wilson says, "Evolutionary psychology is best regarded as identical to human sociobiology" (1998, p. 150). David Buss, a prominent evolutionary

psychologist, disagrees. He notes that, according to the sociobiologists, the primary goal in life is to perpetuate copies of our genes into the next generation (see Chapter 10). Those activities of our ancestors that were conducive to that goal were selected and eventually became part of human nature. Buss refers to the contention that we live to pass copies of our genes into the next generation, the *sociobiological fallacy* (1995, p. 10). According to Buss, behaviors were selected in our evolutionary past because they solved problems, not because they perpetuated genes.

Humans are collections of mechanisms, each one was forged over evolutionary time by the process of selection. The products of this process tend to be problem specific—keep warm, avoid predators, get food, find a mate, have sex, socialize children, help kin in need, and so on. The product of the evolutionary process is not, and cannot be, the goal of maximal gene propagation. (Buss, 1999, p. 22)

Workman and Reader (2004) define evolutionary psychology as follows:

Evolutionary psychology is a relatively new discipline that applies the principles of Darwinian natural selection to the study of the human mind. A central claim is that the brain (and therefore the mind) evolved to solve problems encountered by our hunter-gatherer ancestors during the upper Pleistocene period over 10,000 years ago, a time know as the Environment of Evolutionary Adaptation (EEA). The mind, therefore, is seen as equipped with species-specific "instincts" that enabled our ancestors to survive and reproduce and which give rise to a universal human nature. This idea is in sharp contrast to that adhered to by many other social scientists who see the mind as originally a "blank slate" that is moulded into shape by a process of learning and socialization. (p. 1)

There appears to be little in this definition with which sociobiologists would disagree. In fact, Workman and Reader conclude, "There are some differences between sociobiology and what is now known as evolutionary psychology, although whether these differences are so great as to warrant a name change is up for question" (2004, p. 17). For our general purpose, we will continue to use the two terms interchangeably. In any case, evolutionary psychology has become one of the most popular topics in contemporary psychology (see, for example, Buss, 2004; Workman and Reader, 2004). However, evolutionary psychology is not without its critics. It has been criticized, for example, for accepting adaptationism. According to the adaptationists, if a bodily structure or a behavioral tendency now exists, it must have contributed to the survival of the ancestors of a species. Gould and Lewontin (1979) found three faults with adaptationism: (1) factors other than adaptation cause evolutionary change (genetic drift and genetic mutations are two examples); (2) a trait is not necessarily adaptive in a present environment because it was adaptive in the past environments; and (3) a trait may have evolved for a specific purpose in the past but may function in totally different ways in the present. Buss, Haselton, Shackeford, Bleske, and Wakefield (1998) and Gould (1991) elaborate the last point made by Gould and Lewontin (1979). That is, the way a characteristic is presently used by a species does not necessarily mean it evolved for that purpose. For example, a bird's feathers evolved as a mechanism for regulating body temperature and were later co-opted for flying. Therefore, to say feathers evolved because they allowed birds to fly is incorrect. The co-option of an original adaptation for a useful but unrelated function is called an exaptation. Also, an original adaptation may have several unforeseen side effects. For example, the increased capacity of the human brain provided our ancestors with many adaptive benefits such as improved problem-solving skills, superior tool making, and increased memory for the location of food, water, and predators. However, the side effects of a larger brain may have included the

development of language, music, and a variety of complex societal rules and regulations. Unforeseen side effects of original adaptations are called spandrels. To view spandrels as adaptations that increased the fitness of our ancestors is incorrect.

It should be noted that because sociobiology explains human social behavior in terms of innate influences, it was met with the same opposition as was seen in the Burt scandal and in the publication of *The Bell Curve* in 1994 (see Chapter 10). In his autobiography, Wilson (1995) describes a number of negative reactions to the publication of his book *Sociobiology: A New Synthesis* (1975). Clearly, many of these reactions were motivated more by political or moral than by scientific concerns.

Noam Chomsky's Influence

It is often suggested that Noam Chomsky's review of Skinner's 1957 book Verbal Behavior was a crucial event in diminishing the influence of radical behaviorism. In his review, Chomsky (1959) forcefully argues that language is too complex to be explained by operant principles, maintaining that the human brain is genetically programmed to generate language. Each child, says Chomsky, is born with brain structures that make it relatively easy for the child to learn the rules of language. Chomsky argues that children cannot learn these rules if they have to rely solely on principles of association (such as frequency or contiguity) and on reinforcement. This successful nativistic attack on empirically based behaviorism did much to weaken its influence. Although Chomsky is a linguist and not a psychologist, his views on language acquisition soon displaced the view based on operant principles. Leahey describes Chomsky's impact on contemporary psychology: "Chomsky's assault on radical behaviorism began with his lengthy review of Verbal Review in 1959, perhaps the single most influential psychological paper published since Watson's 'Behaviorist Manifesto of 1913' " (2000, p. 497). (For more on Chomsky's life and accomplishments, see Barsky, 1997.)

Noam Chomsky

The Misbehavior of Organisms

Another blow to the behaviorist's antinativistic position came from the work of Keller and Marian Breland (later Marian Breland Bailey), two of Skinner's former associates. The Brelands started a business called Animal Behavior Enterprises, which involved using operant principles to teach a variety of animals to do a variety of tricks. The trained animals were then put on display at fairs, conventions, and amusement parks and on television. At first, the Brelands found their animals to be highly conditionable, but as time passed, instinctive behavior began to interfere with or replace learned behavior. For example, pigs that had learned to place large wooden coins into a "piggy bank" began to perform more slowly, and eventually they would root the coin instead of placing it in the bank, even when doing so delayed or prevented reinforcement. The interference with or displacement of learned behavior by instinctive behavior was called instinctual drift. The Brelands summarized their findings: "It seems obvious that these animals are trapped by strong instinctive behaviors, and clearly we have here a demonstration of the prepotency of such behavior patterns over those which have been conditioned" (1961, p. 684).

The Brelands believed that their observations contradicted three assumptions the behaviorists made: (1) An animal comes to the learning situation as a *tabula rasa*—that is, with no genetic predispositions; (2) differences among various species of animals are unimportant; and (3) any response an animal can make can be conditioned to any stimulus the animal can detect. All these behavioristic assumptions either deny or minimize the importance of instinctive behavior. Although beginning their careers as Skinnerian behaviorists, the Brelands (1961) reached the following conclusion:

After 14 years of continuous conditioning and observation of thousands of animals, it is our reluctant conclusion that the behavior of any species cannot be adequately understood, predicted, or controlled without knowledge of its instinctive patterns, evolutionary history, and ecological niche. (p. 684)

In addition to calling attention to the innate aspects of behavior, the Brelands work at Animal Behavior Enterprises did much to call public attention to operant conditioning procedures (Bailey and Gillaspy, 2005).

Since the Brelands' article on the misbehavior of organisms, many other researchers have found support for their conclusions. For example, Seligman (1970) has found that within any given species of animal, some associations are easier to establish than others and that one species may be able to form associations with ease, whereas for another species this may be extremely difficult or impossible. According to Seligman, the reason for this discrepancy is that within a species, animals are biologically (genetically) prepared to form certain associations and contraprepared to form others, and the same thing is true among various species. Where an association falls on the preparedness continuum determines how easily an animal will learn it. (Many examples of how an organism's genetic makeup influences what and how easily it can

learn can be found in Hergenhahn and Olson, 2005; Seligman and Hager, 1972.)

Genetic Influences on Intelligence and Personality

At least partially because of the work of the ethologists Wilson, Chomsky, the Brelands, and Seligman, nativistic explanations of behavior are again respectable in contemporary psychology. This is exemplified by the current popularity of evolutionary psychology. As a final example, we will briefly review the work of **Thomas Bouchard** and his colleagues. As we saw in Chapter 10, it was Francis Galton who defined the nature-nurture problem and was the first to use twins in studying that problem. Galton (1875) reached the following conclusions about the relative contributions of nature and nurture from his study of twins:

There is no escape from the conclusion that nature prevails enormously over nurture when the differences of nurture do not exceed what is commonly found among persons of the same rank of society and in the same country. My only fear is that my evidence seems to prove too much and may be discredited on that account, as it seems contrary to all experience that nurture should go for so little. (p. 576)

Recent research by Bouchard and others suggests that Galton was correct on both accounts: nurture counts very little when compared to nature, and people will find that fact difficult to believe. Bouchard studied the influence of genetics on physical characteristics, intelligence, and personality characteristics using four primary comparison groups:

- Dizygotic, or fraternal, twins reared together (DZT)
- Dizygotic, or fraternal, twins reared apart (DZA)

Thomas Bouchard

- Monozygotic, or identical, twins reared together (MZT)
- Monozygotic, or identical, twins reared apart (MZA)

Dizygotic twins are genetically the same as brothers and sisters who are not twins, and monozygotic twins have all their genes in common. If experience (nurture) determines intelligence and personality, then both DZTs and MZTs would tend to correlate highly on these traits, but not DZAs and MZAs. If intelligence and personality are largely determined by genetics (nature), then DZTs and DZAs should show modest correlations on these traits, and MZTs and MZAs should show high correlations on these traits. Because all monozygotic twins in Bouchard's study were separated at birth, any similarities between them must be due to genetic influences.

Bouchard (1984) first confirmed the long-known fact that monozygotic twins are almost identical on a wide variety of physical characteristics, such as fingerprints and height. Bouchard then turned his attention to the matter of intelligence and concluded, "There is compelling evidence that the heritability of IQ is well above zero and probably between .50 and .80" (1984, p. 170). Heritability indicates the extent to which variation

on a trait or attribute is attributable to genetics. In one study, Bouchard (1984) reported correlations between IQ scores for DZTs of .14, for MZTs of .78, and MZAs of .71, yielding a heritability measure for intelligence of about .70; that is, genetics contributes about 70% to IQ scores. It should be noted that, although heritability is typically a complex measure derived from correlation coefficients, in the case of MZA twins, correlations are a direct estimate of heritability. This is because MZA twins are genetically identical but share essentially no environmental influences. Thus, the correlation of .71 on measures of intelligence for MZA twins indicates that the heritability of intelligence is about 70%.

Next, Bouchard turned to personality characteristics, about which he said, "The domain of personality is the one in which most psychologists believe that common family environmental factors and social learning are of great importance in the determination of individual differences" (1984, p. 170). It was here that Bouchard obtained perhaps his most surprising result: Shared family environment has practically no impact on personality. That is, people have similar personality traits to the extent that they are genetically related, not to the extent that they have shared experiences. It was found that parents show practically no similarity to their adoptive children, nor do adoptive children show similarity to siblings with whom they are not biologically related. Parents show some similarity to their biological children, as do biologically related siblings. Dizygotic twins show about the same degree of similarity as biological siblings, and monozygotic twins show the greatest amount of similarity, whether they are reared together or apart. Bouchard asked, "Can it be true that common family environment has at best only a minor effect on personality?" (1984, p. 172) and his answer was yes. Bouchard went on to say, "The correlations [of personality characteristics] between genetically unrelated individuals reflect only environmental influences and suggest a common family environmental effect of about 5 percent" (1984, p. 173).

Tellegen, Lykken, Bouchard, Wilcox, Segal, and Rich (1988) used the Multidimensional

Personality Questionnaire to measure the heritability of 11 personality traits, such as well-being, social potency, achievement, aggression, and traditionalism. They found that the heritability of the personality traits studied was between .50 and .60, making genetics the greatest single contributor to those traits. Perhaps even more surprising is that the researchers found that religious interests, attitudes, and values are also strongly influenced by genetics. Waller, Kojetin, Bouchard, Lykken, and Tellegen (1990) found the heritability of religiosity to be about the same as for personality traits (about .50). Again, as with personality traits, shared family experience had little impact on religious interests. attitudes, and values. Waller and his co-authors concluded, "Social scientists will have to discard the a priori assumption that individual differences in religious and other social attitudes are solely influenced by environmental factors" (1990, p. 141).

One should not conclude that environmental influences on personality are unimportant. Most genetic studies of personality suggest that genetic factors account for about 50% of the variance on personality inventories, and the other 50% is accounted for by environmental factors, such as

shared family experiences (about 5%), and idiosyncratic (nonshared) environmental experiences, such as accidental occurrences and experiences with peer groups (about 45%). Thus, according to the research cited here, genetics is a major contributor to intelligence and personality, but it is not the only contributor.

We saw in Chapter 10 that studies showing intelligence to be highly heritable have been and are very controversial. Studies like Bouchard's, which show that personality traits are highly heritable, are equally controversial, if not more so. The use of identical twins reared apart from birth, however, is a powerful method for studying the relative contributions of nature and nurture, and it is currently receiving considerable attention.

Thus, we see that despite the attempt of radical behaviorism to solve the nature-nurture controversy in favor of nurture, the ancient controversy is still alive and well in contemporary psychology. (For additional examples of research on behavioral genetics in contemporary psychology, see, for example, Buss, 1988, 1999, 2004; Geary, 2005; Plomin, 1990; Plomin, DeFries, Craig, and McGuffin, 2003; and Zuckerman, 1991.)

SUMMARY

Psychobiology explores the biological bases of psychological phenomena, and such exploration goes back at least to Hippocrates. Karl Lashley was a modern pioneer in psychobiology. Lashley was an early supporter of Watsonian behaviorism but was unable to find neurophysiological support for Watson's (and Pavlov's) switchboard conception of the brain. Instead, he found that memory for a complex learning task (like maze learning) is distributed throughout the entire cortex. If brain tissue is destroyed following such learning, disruption of performance is related more to the amount of tissue destroyed than to its location. Lashley called this observation mass action. Lashley also found that within a functional area of the brain, any of the tissues within that area are capable of performing

its function. Lashley called this equipotentiality. Lashley sought the neurophysiological locus of memory and learning in vain, as have subsequent researchers. Lashley's conclusions about brain functioning were more in accordance with Gestalt theory than with the switchboard conception of the brain, but not all of Lashley's observations supported Gestalt theory.

One of the many illustrious psychologists influenced by Lashley was Donald Hebb. Hebb was willing to speculate about psychobiology even when radical behaviorism was most influential. According to Hebb, neurons in the brain that are consistently active together or in close succession become a cell assembly. Cell assemblies that are consistently active together or in close succession

become phase sequences. In this way, consistently occurring environmental events gain neurological representation. Thereafter, when a cell assembly or phase sequence is stimulated, individuals have thoughts, or streams of thoughts, of the environmental objects or events that caused their development. Hebb's other innovative research topics included fear, enriched environments, sensory deprivation, and arousal theory.

Another illustrious psychologist influenced by Lashley was Roger Sperry. Sperry and his colleagues created split brains in animals by ablating their corpus callosums and optic chiasms. With such a preparation, the two hemispheres of the brain learn independently. It was discovered that splitting the brains of humans suffering from severe epilepsy often dramatically improved their condition. Humans with split brains made it possible to study the function of the left and right hemispheres of the cortex in ways never before possible. Sperry and his colleagues discovered considerable hemispheric specificity concerning a number of cognitive and emotional phenomena. The study of hemispheric specificity remains popular within contemporary psychobiology.

Behavioral genetics is a branch of psychobiology that studies genetic influences on cognition or behavior. Even during behaviorism's heyday, a group of ethologists were explaining a variety of species-specific behaviors in terms of evolutionary theory. The success of this research program contributed to the decline in the popularity of behaviorism. The sociobiologists extended ethology to the study of complex social behavior. Humans in-

herit a biogrammar that predisposes them to engage in a wide variety of cultural activities. However, culture is created because it enhances survival, and if it does not do so, the culture will deteriorate and perhaps become extinct. Thus, biology is said to hold culture on a leash. Although humans inherit behavioral dispositions, behavior must always be explained in terms of both biology and culture. Biological tendencies can be, and often are, inhibited by cultural influences.

What was originally called sociobiology is now generally referred to as evolutionary psychology. However, there is controversy as to whether the two fields are different enough to justify giving them separate names. Evolutionary psychologists have been criticized for assuming that because a characteristic is presently adaptative for a species it must have been so for its distant ancestors. Noam Chomsky offered a highly influential nativistic explanation of language in opposition to Skinner's empirical explanation based on operant principles. The works of Marian and Keller Breland showed that learned behavior often drifts toward instinctive behavior, and this instinctual drift violates several assumptions made by the radical behaviorists. Similarly, Seligman has found that where an association falls on the genetically determined preparedness continuum determines the ease with which it will be learned. Finally, Thomas Bouchard and his colleagues, using twin studies that included identical twins reared apart, have demonstrated a strong genetic influence on both intelligence and personality traits.

DISCUSSION QUESTIONS

- Provide evidence that psychobiology has been a persistent theme throughout psychology's history.
- 2. Discuss Lashley's principles of mass action and equipotentiality. In what way(s) did these principles conflict with the behavioristic view
- of brain functioning? How did they support the Gestalt view of brain functioning?
- 3. What is the engram? Was Lashley's search for it successful? Was that of subsequent researchers?
- 4. According to Hebb, what are cell assemblies and phase sequences, and how do they

- develop? Give an example of how Hebb employed the concepts of cell assembly and phase sequence in explaining cognitive experience.
- 5. Describe Sperry's split-brain preparation. What discoveries about the learning process did Sperry make using this preparation? Why was the preparation used on humans? What was learned about hemispheric specificity by studying humans with split brains?
- 6. Explain how the ethologists were instrumental in reducing the influence of radical behaviorism.
- 7. Within sociobiology, what is the meaning of the term *biogrammar*? *Nothing-butism*? What is the leash principle?
- 8. Why have evolutionary psychologists been criticized for emphasizing adaptationism?

- Include in your answer the definitions of *exaptations* and *spandrels*.
- What was the significance of Chomsky's review of Skinner's book *Verbal Behavior* for the development of contemporary cognitive psychology?
- 10. In what ways did the Brelands' observation of instinctual drift contradict assumptions made by the behaviorists? How did Seligman's preparedness continuum also contradict those assumptions?
- 11. What was Bouchard's rationale for using identical twins reared apart from birth in his study of the relative contributions of nature and nurture to intelligence and personality? What conclusions were supported by his research?

SUGGESTIONS FOR FURTHER READING

- Bruce, D. (1991). Integrations of Lashley. In G. A.
 Kimble, M. Wertheimer, & C. L. White (Eds.),
 Portraits of pioneers of psychology (pp. 307–323).
 Washington, DC: American Psychological
 Association.
- Buss, D. M. (2004). Evolutionary psychology: The new science of the mind (2nd ed.). Boston: Allyn & Bacon.
- Churchland, P. S. (1986). Neurophilosophy: Toward a unified science of the mind-brain. Cambridge, MA: MIT Press.
- Crawford, C., & Krebs, D. L. (Eds.). (1998). Handbook of evolutionary psychology: Ideas, issues, and applications. Mahwah, NJ: Lawrence Erlbaum Associates.
- Finger, S. (1994). Origins of neuroscience: A history of explorations into brain functions. New York: Oxford University Press.
- Hardcastle, V. G. (Eds.). (1999). Where biology meets psychology: Philosophical essays. Cambridge, MA: MIT Press.
- Kalat, J. W. (1998). *Biological psychology* (6th ed.). Pacific Grove, CA: Brooks/Cole.

- McCarthy, R. A., & Warrington, E. K. (1990). Cognitive neuropsychology: A clinical introduction. San Diego, CA: Academic Press.
- Plomin, R., DeFries, J. C., Craig, I. W., & McGuffin, P. (Eds.). (2003). Behavioral genetics in the postgenomic era. Washington, DC: American Psychological Association.
- Puente, A. E. (2000). Roger W. Sperry: Nobel laureate, neuroscientist, and psychologist. In G. A. Kimble, & M. Wertheimer (Eds.), *Portraits of pioneers in psychology* (Vol. 4, pp. 321–336). Washington, DC: American Psychological Association.
- Wilson, E. O. (1978). On human nature. Cambridge, MA: Harvard University Press.
- Workman, L., & Reader, W. (2004). Evolutionary psychology: An introduction. New York: Cambridge University Press.
- Zaidel, D. W. (Ed.). (1994). Neuropsychology. San Diego, CA: Academic Press.

GLOSSARY

Behavioral genetics A branch of psychobiology that studies the genetic influence on cognition or behavior.

Biogrammar According to the sociobiologists, the inherited structure that predisposes organisms toward certain kinds of social activities.

Bouchard, Thomas (b. 1937) Headed a research program that featured the study of identical and fraternal twins reared together and apart. Results indicated that intelligence and several personality traits are highly heritable.

Cell assembly According to Hebb, a system of interrelated neurons that reflects recurring environmental events. When stimulated, cell assemblies cause ideas of those events.

Chomsky, Noam (b. 1928) A linguist whose nativistic explanation of language was instrumental in diminishing the influence of radical behaviorism.

Engram The supposed neurophysiological locus of memory and learning. Lashley sought the engram in vain, as have subsequent researchers.

Equipotentiality Lashley's observation that within a functional area of the brain, any tissue within that area can perform its associated function. Therefore, to destroy a function, all the tissue within a functional area must be destroyed.

Ethology The study of species-specific behavior in an animal's natural habitat. The ethologist typically attempts to explain such behavior in terms of evolutionary theory. (*See also* **Species-specific behavior**.)

Hebb, Donald Olding (1904–1985) Under the influence of Lashley, did pioneering research in psychobiology. (*See also* Cell assembly and Phase sequence.)

Heritability A measure of how much of the variation in a trait or attribute is determined by genetics.

Instinctual drift The tendency for learned behavior to be interfered with or displaced by instinctive behavior.

Lashley, Karl Spencer (1890–1958) An early supporter of Watsonian behaviorism who eventually left the behavioristic camp when his neurological research failed to support the switchboard conception of the brain upon

which behaviorism was based. (See also **Equipotentiality** and **Mass action**.)

Leash principle Wilson's contention that humans create culture because doing so enhances survival. Therefore, there is, or should be, a close relationship between culture and the satisfaction of biological needs. In this sense, it can be said that biology holds culture on a leash.

Mass action Lashley's observation that if cortical tissue is destroyed following the learning of a complex task, deterioration of performance on the task is determined more by the amount of tissue destroyed than by its location.

Phase sequences According to Hebb, systems of interrelated cell assemblies that form because of the simultaneous or sequential activation of cell assemblies. When a phase sequence is activated, it causes a stream of interrelated ideas.

Preparedness continuum Seligman's observation that degree of biological preparedness determines how easily an association can be learned.

Psychobiology The attempt to explain psychological phenomena in terms of their biological foundations.

Sociobiology The discipline founded by Edward Wilson that attempts to explain complex social behavior in terms of evolutionary theory. (Also called evolutionary psychology.)

Species-specific behavior Behavior that is typically engaged in by all members of a species under certain environmental circumstances. Very close to what others call instinctive behavior.

Sperry, Roger W. (1913–1994) The psychobiologist who used the split-brain preparation to study hemispheric specificity in humans and nonhuman animals. Using this technique, Sperry and his colleagues discovered that a number of cognitive and emotional phenomena are specific to either the right or left hemispheres of the cortex. (*See also* **Split-brain preparation**.)

Split-brain preparation A brain that has had its corpus callosum and optic chiasm ablated.

Cognitive Psychology

ognitive psychology includes such topics as memory, concept formation, attention, reasoning, problem solving, mental imagery, judgment, and language. Clearly, cognitive psychology is very popular within contemporary psychology. However, in psychology's long history, some form of cognition has almost always been emphasized. The few exceptions included the materialistic philosophies or psychologies of Democritus, Hobbes, Gassendi, La Mettrie, Watson, and Skinner, which denied the existence of mental events. The philosophers who most influenced the development of psychology as a science (for example, John Stuart Mill) all sought to explain human cognition (Wilson, 1990, p. 295). Clearly, the schools of voluntarism and structuralism concentrated on the experimental study of cognition, and the school of functionalism studied both cognition and behavior. It was the supposed sterility of the research on cognition performed by members of these schools that prompted Watson to create the school of behaviorism. Thus, to say, as is common, that psychology is becoming more cognitively oriented is inaccurate because with only a few exceptions psychology has always been cognitively oriented. But there was a period from about 1930 to about 1950 when radical behaviorism was highly influential and it was widely believed that cognitive events either did not exist or, if they did, were simply by-products (epiphenomena) of brain activity and could be ignored. As long as these beliefs were dominant, the study of cognitive processes was inhibited.

Space permits only a partial listing of the people and events that helped loosen the grip of radical behaviorism, thus allowing cognitive psychology to gain its current popularity. (For a more complete list of these antecedents see, for example, Mahoney, 1991, pp. 69–75.)

DEVELOPMENTS BEFORE 1950

Throughout most of psychology's history, human attributes were studied philosophically. It was J. S. Mill (1843/1988) who set the stage for psychology as an experimental science and who encouraged the development of such a science. Fechner (1860/1966) took Mill's lead and studied cognitive events (sensations) experimentally. Ebbinghaus (1885/1964), under the influence of Fechner, studied learning and memory experimentally. William James's book The Principles of Psychology (1890/1950) cited considerable research on cognition and suggested many additional research possibilities. Sir Frederic Charles Bartlett (1886–1969), in his book Remembering: A Study in Experimental and Social Psychology (1932), demonstrated how memory is influenced more by personal, cognitive themes or schema than by the mechanical laws of association. In other words, he found that information is always encoded, stored, and recalled in terms of an individual's preconceptions and attitudes. As cognitive psychology developed, it was common to acknowledge a debt to some aspect of Bartlett's earlier work (Johnston, 2001).

As early as 1926, Jean Piaget (1896-1980) began publishing research on intellectual development. During his long life, Piaget published more than 50 books and monographs on genetic epistemology, or developmental intelligence. In general, Piaget demonstrated that a child's interactions with the environment become more complex and adaptive as its cognitive structure becomes more articuthrough maturation and experience. According to Piaget, the cognitive structure comprises schemata that determine the quality of one's interactions with the environment. For the young child, these schemata are sensory motor reflexes that allow only the most rudimentary interactions with the environment. With maturation and experience, however, the schemata become more cognitive and allow increasingly complex (intelligent) interactions with the environment. For Piaget it is always the schemata contained within the cognitive structure that determine what kinds of interactions with the environment are possible. Piaget's theory followed the rationalistic rather than the empiricistic tradition. More particularly, because it stressed the importance of schemata for determining a person's reality, it followed the Kantian tradition. Piaget wrote books about the child's conceptions of causality, reality, time, morality, and space, all showing the influence of Kant's proposed categories of thought. (For a discussion of how Piaget's influential methods for studying the cognitive abilities of children developed over time, see Mayer, 2005.)

It is interesting to note that Piaget was an even more prolific writer than Wundt was. In Chapter 9 we noted that Wundt published 53,735 pages in his lifetime, or 2.2 pages a day (Boring, 1950); Zusne and Blakely (1985) report that Piaget published 62,935 pages in his lifetime, or 2.46 pages a day. In Chapter 13 we noted that when 1,725 members of the American Psychological Society were asked to rank the most eminent psychologists of the 20th century, Skinner was ranked first, Piaget second, and Freud third (Dittman, 2002).

As we have seen, Gestalt psychology and radical behaviorism were created about the same time (1912 and 1913, respectively), and the cognitively oriented Gestaltists were a constant thorn in the side of the behaviorists. Also, during the 1930s and 1940s, methodological behaviorists such as Hull and Tolman were willing to postulate events that intervened between stimuli (S) and responses (R). For Hull these intervening variables were mainly physiological, but for Tolman they were mainly cognitive.

In 1942 Carl Rogers (1902–1987) published Counseling and Psychotherapy: Newer Concepts in Practice that challenged both radical behaviorism and psychoanalysis by emphasizing the importance of conscious experience in the therapeutic situation. In 1943 Abraham Maslow (1908–1970) first proposed his theory of human motivation based on the hierarchy of needs. In spite of the efforts of individuals such as Rogers and the popularity of behaviorism during the 1920s, 1930s, and 1940s, psychoanalysis remained very influential, especially among clinical psychologists and psychiatrists.

Donald Hebb (1904–1985) was an early critic of radical behaviorism and did much to reduce its influence. In his book *The Organization of Behavior* (1949), Hebb not only sought biological explanations of behavior but also urged the study of cognitive processes. As we saw in Chapter 19, Hebb continued to encourage the development of both physiological and cognitive psychology in the 1950s and 1960s. In 1949 Harry Harlow (1905–1981) published "The Formation of Learning Sets," which provided evidence that monkeys employ mental strategies in their solving of discrimination problems. This finding was clearly in conflict with the behavioristic psychology of the time.

In 1948 Norbert Wiener (1894-1964) defined cybernetics as the study of the structure and function of information-processing systems. Of particular interest to Wiener was how mechanical or biological systems can achieve a goal or maintain a balance by automatically utilizing feedback from their activities. The automatic pilots on airplanes and thermostats are examples of such systems. Soon it was realized that purposive human behavior could also be explained in such mechanistic terms, thus overcoming the argument that the study of purposive (goal-directed) behavior must necessarily be subjective. In 1949 Claude E. Shannon, working for the Bell Telephone Laboratories, and Warren Weaver, working for the Rockefeller Foundation, were seeking ways of improving the purity of messages between the time they are sent to the time they are received. The work of Shannon and Weaver began what came to be called information theory. Information theory notes the various transformations that information undergoes as it enters a communication system, as it operates within the system, and as it leaves the system. As we will see later in this chapter, information-processing psychology, like information theory, attempts to understand those structures, processes, and mechanisms that determine what happens to information from the time it is received to the time it is acted on. (For a discussion of the influential role the concept of "information" has played in psychology's history, see Collins, 2007.)

DEVELOPMENTS DURING THE 1950S

According to Bernard Baars (1986), "There is little doubt that George A. Miller ... has been the single most effective leader in the emergence of cognitive psychology" (p. 198). Miller remembers that during the 1950s, "'cognition' was a dirty word because cognitive psychologists were seen as fuzzy, hand-waving, imprecise people who really never did anything that was testable" (p. 254). Miller argues that modern cognitive psychology began during a symposium on information theory sponsored by the Massachusetts Institute of Technology on September 10-12, 1956. During the symposium, Allen Newell (1927-1992) and Herbert Simon (1916-2001) presented papers on computer logic; Noam Chomsky presented his views on language as an inherited, rule-governed system; and Miller described his research demonstrating that people can discriminate only seven different aspects of something—for example, hues of color or pitches of sound. Also, people can only retain about seven meaningful units of experience (chunks) such as numbers, words, or short sentences. Miller summarized his research in his influential article "The Magical Number Seven, Plus or Minus Two: Some Limits on our Capacity for Processing Information" (1956). Participants in the MIT symposium did much to bring the terminology and concepts of information theory and cybernetics into psychology. At about the same time, the English psychologist Donald Broadbent (1957, 1958) was doing the same thing. Crowther-Heyck (1999) discusses the importance of Miller's work in the early development of cognitive psychology.

In 1951 Karl Lashley (1890–1958) argued that the explanation of serial or chained behavior, offered by the behaviorists, that stressed the importance of external stimulation was insufficient. Rather, he said, such organized behavior could emanate only from within the organism. In an influential publication, "Drives and the C.N.S. (Conceptual Nervous System)" (1955), Hebb continued to show his willingness to "physiologize"

George A. Miller

about cognitive processes and thus to engage in battle with the behaviorists. Leon Festinger (1919-1989) noted that the ideas that one entertains may be compatible with or incompatible with one another. Incompatibility exists, for example, if one is engaged in an obviously boring task but is encouraged to describe it as exciting, or if one smokes cigarettes and yet believes that smoking causes cancer. When ideas are incompatible, a state of dissonance exists that motivates a person to change beliefs or behavior. In the cases above, for example, a person could reduce cognitive dissonance by telling the truth about the task being boring or become convinced that the task is actually exciting. With the smoker, cognitive dissonance could be reduced by quitting the habit or by believing there really is no proven relationship between smoking and cancer. Festinger's influential book A Theory of Cognitive Dissonance (1957) made no reference to behavioristic ideas.

In the early 1950s Jerome Bruner became interested in thinking and concept formation, and in 1955 he assisted Sir Frederic Bartlett in arranging, at Cambridge, one of the first conferences on cognitive psychology (Bruner, 1980). In 1956 Bruner (along with Jacqueline Goodnow and George Austin) published *A Study of Thinking*, which emphasized concept learning. Although concept learning had been studied earlier by Hull and Thorndike, their explanations of such learning was couched in terms of passive, associationistic principles. The explanation offered by Bruner and his

colleagues stressed the active utilization of cognitive strategies in such learning. In 1959 Tracy and Howard Kendler analyzed children's discrimination learning in terms of concept utilization rather than in terms of behavioristic principles. In 1959 Chomsky published his influential review of Skinner's book *Verbal Learning* (1957). As we saw in Chapter 19, Chomsky's nativistic explanation of language was highly influential in reducing the dominance of radical behaviorism.

Also during the 1950s, humanistic theorists such as Maslow, Kelly, Rogers, and May continued developing their ideas, as did the Gestalt psychologists and the psychoanalysts.

DEVELOPMENTS AFTER THE 1950S

In 1960 Miller and his colleagues Eugene Galanter and Karl Pribram published Plans and the Structure of Behavior, in which it was argued that cybernetic concepts (such as information feedback) explain human goal-directed behavior better than S-R concepts do, and at least as objectively. Also in 1960, Miller and Jerome Bruner founded the Center for Cognitive Studies at Harvard. In addition to promoting research on cognitive processes, the center did much to popularize the ideas of Piaget among U.S. psychologists. In 1962 Miller published an article titled "Some Psychological Studies of Grammar" (1962a), which introduced Chomsky's nativistic analysis of language into psychology. In 1890 William James had defined psychology as "the science of mental life"; in 1962 Miller purposefully used James's definition as the title of his text Psychology: The Science of Mental Life (1962b).

In 1963 as evidence of how far cognitive psychology had progressed and in recognition of Miller's role in that progress, Miller was presented a Distinguished Scientific Contribution Award by the APA. Miller served as president of the APA in 1969, received the Gold Medal for Life Achievement in Psychological Science from the American Psychological Foundation (APF) in 1990, and was

awarded a National Medal of Science by President George Bush in 1991; in 2000 the Association of Neuroscience Departments and Programs presented him with its Millennial Award. In 2003 Miller was presented the APA's Outstanding Lifetime Contribution to Psychology Award. He is currently professor emeritus in psychology at Princeton University.

In 1959 Donald Hebb served as president of the APA, and his presidential address "The American Revolution" was published in 1960. In this address, Hebb was referring not to a U.S. political revolution but to the country's psychological revolution. According to Hebb, only one phase of the American revolution in psychology had taken place. This was the behavioristic phase, and it produced precise, factual knowledge and scientific rigor that had not previously existed in psychology. However, in their effort to be entirely objective, the behaviorists had minimized or banished such topics as thought, imagery, volition, and attention. Hebb urged that the second phase of psychology's revolution use the scientific rigor promoted by the behaviorists to study the long-neglected cognitive processes. Concerning the second phase of the revolution, Hebb (1960) said, "The camel already has his nose inside the tent" (p. 741). He noted the works of Festinger, Broadbent, the Kendlers, Miller, Galanter, and Pribram as good starts toward a rigorous cognitive psychology. He was especially impressed by the possibility of the computer acting as a model for studying cognitive processes. He prophesized that such a model will become "a powerful contender for the center of the stage" (1960, p. 741). Hebb's preferred approach to studying cognitive processes was to speculate about their biological foundations. We reviewed some of Hebb's speculations in Chapter 19.

In 1962 and 1963, M. D. Egger and Neal Miller demonstrated that, contrary to tradition, classical conditioning phenomena cannot be explained in terms of associative principles alone. Rather, the information conveyed by the stimuli involved has to be taken into consideration. In 1967 Ulric Neisser, who studied with George Miller, published his influential book *Cognitive Psychology*, in which Neisser defined

the term *cognition* as "all the processes by which ... sensory input is transformed, reduced, elaborated, stored, recovered and used" (p. 4). Also in this book, Neisser attempted to integrate research on such topics as perception, concept formation, meaning, language, and thinking, using a few concepts adopted primarily from information theory. According to Roediger (2000), many of the ideas put forth in Neisser's *cognitive psychology* were derived from Bartlett's earlier work, and Neisser acknowledged this debt to him.

Once the grip of behaviorism—especially radical behaviorism—had been loosened, many earlier efforts in experimental cognitive psychology were appreciated. About the influence of Ebbinghaus, Michael Wertheimer (1987) says, "His seminal experiments can ... be viewed as the start of what was to become the currently popular field of cognitive psychology" (p. 78). Concerning the influence of Gestalt psychology, Hearst (1979) said, "Presentday cognitive psychology—with its emphasis on organization, structure, relationships, the active role of the subject, and the important part played by perception in learning and memory—reflects the influence of its Gestalt antecedents" (p. 32). In an interview, Neisser describes how Gestalt psychology influenced him:

I ... became particularly interested in Gestalt psychology. It had an idealistic quality that appealed to me. To the Gestalt psychologists human nature was something wonderful, worth exploring, worth knowing about. They were constantly doing battle with the behaviorists, who seemed to see human nature as a mere collection of conditioned responses or blind associations. From the Gestalt viewpoint, the mind is something beautiful, well-structured, in harmony with the universe. (Baars, 1986, p. 274)

And, regarding Piaget's influence, Jerome Kagan (1980) said, "With Freud, Piaget has been a seminal figure in the sciences of human development" (p. 246).

One of the most popular cognitive theories in contemporary psychology is Albert Bandura's social cognitive theory. In several ways, Bandura's theory can be understood as a direct descendent of Tolman's theory:

If one had to choose a theory of learning that is closest to Bandura's, it would be Tolman's theory. Although Tolman was a behaviorist, he used mentalistic concepts to explain behavioral phenomena ... and Bandura does the same thing. Also, Tolman believed learning to be a constant process that does not require reinforcement, and Bandura believes the same thing. Both Tolman's theory and Bandura's theory are cognitive in nature, and neither are reinforcement theories. A final point of agreement between Tolman and Bandura concerns the concept of motivation. Although Tolman believed that learning was constant, he believed further that the information gained through learning was only acted on when there was reason for doing so, such as when a need arose. For example, one may know full well where a drinking fountain is but will act on that information only when one is thirsty. For Tolman, this distinction between learning and performance was extremely important, and it is also important in Bandura's theory. (Hergenhahn and Olson, 2005, p. 341)

(See Bandura, 1986, for an excellent summary of his extensive research in social cognitive theory.)

The journal Cognitive Psychology was founded in 1969, and within the next two decades, 15 additional journals were established, featuring research articles on such topics as attention, problem solving, memory, perception, language, and concept formation. Interest in experimental cognitive psychology had become so extensive that many believed a revolution, or paradigm shift, had occurred in psychology (for example Baars, 1986; Gardner, 1985; Sperry, 1993). Others, however, suggest that con-

temporary cognitive psychology represents a return to a kind of psychology that existed before the domination of behaviorism. If anything, then, there occurred a counterrevolution, rather than a revolution (see Hergenhahn, 1994). Even George Miller, who, as we have seen, was as responsible as anyone for the current popularity of cognitive psychology, rejects the idea that a revolution took place:

What seems to have happened is that many experimental psychologists who were studying human learning, perception, or thinking began to call themselves cognitive psychologists without changing in any obvious way what they had always been thinking and doing—as if they suddenly discovered they had been speaking cognitive psychology all their lives. So our victory may have been more modest than the written record would have led you to believe. (Bruner, 1983, p. 126)

Robins, Gosling, and Craik (1999) note that the popularity of cognitive psychology has increased dramatically over the last three decades. They agree with Miller, however, that it is incorrect to refer to this increased popularity as a cognitive revolution.

In any case, from the many forms of cognitive psychology that existed prior to the 1970s, information-processing psychology emerged as the dominant form. Information-processing psychology is the kind of cognitive psychology that took the computer program as a metaphor for the workings of the mind. Before discussing information-processing psychology, however, we will first review the field of artificial intelligence that influenced its development.

ARTIFICIAL INTELLIGENCE

Developments in cybernetics, information theory, and computer technology combined to form the field of artificial intelligence. Fetzer (1991) defines artificial intelligence (AI) as a "special branch of

computer science that investigates the extent to which the mental powers of human beings can be captured by means of machines" (p. xvi). In 1950 the brilliant mathematician Alan M. Turing (1912–1954) founded the field of artificial intelligence in an article titled "Computing Machinery and Intelligence," in which he raised the question, Can machines think? Because the term *think* is so ambiguous, Turing proposed an objective way of answering his own question.

The Turing Test

Turing proposed that we play the "imitation game" to answer the question, Can machines (like computers) think? He asked that we imagine an interrogator asking probing questions to a human and to a computer, both hidden from the interrogator's view. The questions and answers are typed on a keyboard and displayed on a screen. The only information the interrogator is allowed is that which is furnished during the question-and-answer session. The human is instructed to answer the questions truthfully and to attempt to convince the interrogator that he or she really is the human. The computer is programmed to respond as if it were human. If after a series of such tests the interrogator is unable to consistently identify the human responder, the computer passes the Turing test and can be said to think.

Weak versus Strong Artificial Intelligence

What does it mean when a computer passes the Turing test for some human cognitive function? For example, if an interrogator cannot distinguish between a human and a computer with regard to thinking, reasoning, and problem solving, does that mean that the computer possesses those mental attributes just as humans do? No, say the proponents of **weak artificial intelligence**, who claim that, at best, a computer can only simulate human mental attributes. Yes, say the proponents of **strong artificial intelligence**, who claim that the computer is not merely a tool used to study the mind (as the

proponents of weak AI claim). Rather, an appropriately programmed computer really *is* a mind capable of understanding and having mental states. According to strong AI, human minds are computer programs, and therefore there is no reason they cannot be duplicated by other, nonbiological, computer programs. For the proponents of strong AI, computers do not *simulate* human cognitive processes; they *duplicate* them.

Searle's Argument against Strong Artificial Intelligence

John Searle (1980, 1990) describes his now famous "Chinese Room" rebuttal to proponents of strong AI. Thinking, according to strong AI, is the manipulation of symbols according to rules, and because computer programs manipulate symbols according to rules, they think. According to strong AI, "The mind is to brain as the program is to the hardware" (Searle, 1990, p. 26). To refute this claim, Searle asks you to consider a language you do not understand—say, Chinese. Now suppose you are placed in a room containing baskets full of Chinese symbols, along with a rule book written in English telling how to match certain Chinese symbols with other Chinese symbols. The rules instruct you how to match symbols entirely by their shapes and do not require any understanding of the meaning of the symbols. "The rules might say such things as, 'take a squiggle-squiggle sign from basket number one and put it next to a squoggle-squoggle sign from basket number two" (Searle, 1990, p. 26). Imagine further that there are people outside the room who understand Chinese and who slip batches of symbols into your room, which you then manipulate according to your rule book. You then slip the results back out of the room. Searle likens the rule book to the computer program. The people who wrote the rule book are the "programmers," and you are the "computer." The baskets full of symbols are the "database," the small batches of symbols slipped into the room are "questions," and the small batches of transformed symbols you slip out of the room are "answers."

John Searle

Finally, imagine that your rule book is written in such a way that the "answers" you generate are indistinguishable from those of a native Chinese speaker. In other words, unknown to you, the symbols slipped into your room may constitute the question, What is the capital of France? and your answer, again unknown to you, was Paris. After several such questions and answers, you pass the Turing test for understanding Chinese although you are totally ignorant of Chinese. Furthermore, in your situation there is no way that you could ever come to understand Chinese because you could not learn the meaning of any symbols. Like a computer, you manipulate symbols but attach no meaning to them. Searle (1990) concludes,

The point of the thought experiment is this: If I do not understand Chinese solely on the basis of running a computer program for understanding Chinese, then neither does any other digital computer solely on that basis. Digital computers merely manipulate formal symbols according to rules in the program.

What goes for Chinese goes for other forms of cognition as well. Just manipu-

lating the symbols is not by itself enough to guarantee cognition, perception, understanding, thinking and so forth. And since computers, qua computers, are symbol-manipulating devices, merely running the computer program is not enough to guarantee cognition. (p. 26)

Any problem that can be stated in terms of formal symbols and solved according to specified rules can be solved by a computer, such as balancing a checking account or playing chess and checkers. The manipulation of symbols according to specified rules is called syntax. Semantics, on the other hand, involves the assignment of meaning to symbols. According to Searle, computer programs have syntax but not semantics. Human thoughts, perceptions, and understandings have a mental content, and they can refer to objects or events in the world; they have a meaning or, to use Brentano's term, they have intentionality. A computer program (or you enclosed in the Chinese Room) simply manipulates symbols without any awareness of what they mean. Again, although a computer may pass the Turing test, it is not really thinking as humans think, and therefore strong AI is false. "You can't get semantically loaded thought contents from formal computations alone" (Searle, 1990, p. 28). Our brains are constructed so that they cause mental events: "Brains are specific biological organs, and their specific biochemical properties enable them to cause consciousness and other sorts of mental phenomena" (Searle, 1990, p. 29). Computer programs can provide useful simulations of the formal aspects of brain processes, but simulation should not be confused with duplication. "No one expects to get wet in a pool filled with Ping-Pong-ball models of water molecules. So why would anyone think a computer model of thought processes would actually think?" (Searle, 1990, p. 31).

Are Humans Machines?

The argument about whether machines (in this case, computers) can think reintroduces into modern psychology a number of questions that have persisted

throughout psychology's history. One such question is. What is the nature of human nature? As we have seen, one answer has been that humans are machines. Most of the English and French Newtonians of the mind took Newton's conception of the universe as a machine and applied it to humans. For anyone who believes that humans are nothing but complex machines—and there have been many philosophers and psychologists with such a belief—there would be no reason that a nonhuman machine could not be built that would duplicate every human function. This might require placing a computer into a sophisticated robot, but in principle, there is no reason a nonhuman machine could not duplicate every human function because humans too are nothing but machines. For example, materialists have no trouble with the contention that machines like robots could be built that duplicate all human functions. Humans, say the materialists, are nothing but physical systems. However, for the materialists, there is no "ghost in the machine" (that is, a mind); thus, there is no reason to wonder whether a nonhuman machine can think or not. Neither nonhuman machines nor humans can think. Thoughts, ideas, concepts, perceptions, and understandings cannot exist if they are thought to be nonphysical in nature; only physical things exist. To suggest otherwise, say the materialists, is to embrace dualism. Being materialists, radical behaviorists do not deny that machines could be made that duplicate human behavior. However, such a machine could not think any more than humans can think and, therefore, talk of duplicating human thought processes is plain nonsense. For materialists, such as the radical behaviorists, both weak and strong AI are useless concepts.

Psychologists and philosophers who accept dualism may or may not find AI useful. Postulating a cognitive component to human nature does not require that such a component be unlawful. Most of the British empiricists and French sensationalists embraced mentalism, but the mental events they postulated were governed by the laws of association. Even being a rationalist does not preclude being a determinist concerning mental events. For example, Spinoza believed thought to be lawful, and therefore a machine analogy of the mind would

not have been far-fetched for him. Similarly, the philosophers, like Kant, who divided the mind into various faculties were dualists. However, these faculties were often viewed as transforming sensory information in automatic, mechanistic, lawful ways, and therefore both the physical and mental aspects of humans were machinelike. In more recent times, the methodological behaviorists, like Tolman, who postulated cognitive events that mediated between stimuli and responses, followed in the tradition of the faculty psychologists. Thus, being a dualist does not preclude one from viewing humans as machines and thus embracing some form of AI. As we will see, information-processing psychology is a form of cognitive psychology that followed in the traditions of faculty psychology and methodological behaviorism and so found much that was useful in AI.

Standing in firm opposition to using any form of AI as a model for understanding the human mind would be all rationalistic philosophers or psychologists who postulated a free will (like Descartes). Also in opposition would be the romantic and existential philosophers and the modern humanistic psychologists. Aside from postulating human free will, humanistic psychologists claim that there are so many important unique human attributes (such as creativity and the innate tendency toward selfactualization) that the very idea of machine simulation of human attributes is ridiculous and perhaps even dangerous. It may be dangerous because if we view humans as machines, we may treat them as machines; and if we treat them as machines, they may act like machines. According to the humanistic psychologists, this is what tends to happen when the methods and assumptions of the natural sciences are applied to the study of humans. With such methods, humans are treated like physical objects (machines) and are thus desacralized. Most humanistic psychologists find the very idea of AI repulsive.

INFORMATION-PROCESSING PSYCHOLOGY

There is no better example of how developments outside psychology can influence psychology than

the emergence of information-processing psychology. Although individuals such as George Miller (1956) and Donald Broadbent (1957, 1958) had already used the computer metaphor to study human cognition, it is generally agreed that the 1958 article by Allen Newell, J. C. Shaw, and Herbert Simon marked the transition between artificial intelligence and information-processing psychology. In their article, the authors claimed that the computer programs they developed solved problems the same way humans do. That is, they claimed that both the human mind and computer programs are general problem-solving devices. This claim was highly influential, and an increasing number of psychologists began to note the similarities between humans and computers: both receive input, process that input, have a memory, and produce output. For information-processing psychologists, the term input replaces the term stimulus, the term output replaces the terms response and behavior, and terms such as storage, encoding, processing, capacity, retrieval, conditional decisions, and programs describe the information-processing events that occur between the input and the output. Most of these terms have been borrowed from computer technology. The information-processing psychologist usually concentrates his or her research on normal. rational thinking and behavior and views the human as an active seeker and user of information.

As we have seen throughout this book, assumptions made about human nature strongly influence how humans are studied. The assumption that the mind or brain either is or acts like a computer demonstrates this point:

Computers take symbolic input, recode it, make decisions about the recorded input, make new expressions from it, store some or all of the input, and give back symbolic output. By analogy, that is most of what cognitive psychology is about. It is about how people take in information, how they recode and remember it, how they make decisions, how they transform their internal knowledge states, and how they transform these states into behavioral outputs.

The analogy is important. It makes a difference whether a scientist thinks of humans as if they were laboratory animals or as if they were computers. Analogies influence an experimenter's choice of research questions, and they guide his or her theory construction. They color the scientist's language, and a scientist's choice of terminology is significant. The terms are pointers to a conceptual infrastructure that defines an approach to a subject matter. Calling a behavior a response implies something very different from calling it an output. It implies different beliefs about the behavior's origin, its history, and its explanation. Similarly, the terms stimulus and input carry very different implications about how people process them. (Lachman, Lachman, and Butterfield. 1979, p. 99)

Information-processing follows in the rationalistic tradition, and, like most rationalist theories, information-processing theory has a strong nativistic component:

We do not believe in postulating mysterious instincts to account for otherwise unexplainable behavior, but we do feel that everything the human does is the result of inborn capacities, as well as learning. We give innate capacities more significance than behaviorists did. We think part of the job of explaining human cognition is to identify how innate capacities and the results of experience combine to produce cognitive performance. This leads us, especially in the area of language, to suppose that some aspects of cognition have evolved primarily or exclusively in humans. (Lachman, Lachman, and Butterfield, 1979, p. 118)

Note the similarity between the Gestalt position and the following statement of Lachman, Lachman, and Butterfield: "The human mind has parts, and they interrelate as a *natural system*" (1979,

p. 128). Also note the similarity between Kant's philosophy and another statement made by Lachman, Lachman, and Butterfield: "Man's cognitive system is constantly active; it adds to its environmental input and literally constructs its reality" (1979, p. 128). In fact, considerable similarity exists between Kant's rationalistic philosophy information-processing psychology. Many consider Kant to be the founding father of informationprocessing psychology: "When cognitive scientists discuss their philosophical forebears one hears the name of Immanuel Kant more than any other" (Flanagan, 1991, p. 181). As we saw in Chapter 6, Kant postulated a number of categories of thought (faculties of the mind) that act on sensory information, thereby giving it structure and meaning that it otherwise would not have. In other words, according to Kant, the faculties of the mind process information. It is Kant's philosophy that creates a kinship among Piaget's theory of intellectual development, Gestalt psychology, and information-processing psychology.

The Return of Faculty Psychology

Largely because of its relationship with phrenology, faculty psychology came into disfavor among scientists and was essentially discarded by them along with phrenology. To some, discarding faculty psychology with phrenology was like throwing out the baby with the bath water. We just saw that information-processing psychology marks a return to faculty psychology. The recent discovery that the brain is organized into many "modules" (groups of cells), each associated with some specific function such as face recognition, also marks a return to faculty psychology. As Jerry Fodor (1983) notes,

Faculty psychology is getting to be respectable again after centuries of hanging around with phrenologists and other dubious types. By faculty psychology I mean, roughly, the view that many fundamentally different types of psychological mechanisms must be postulated in order to explain the facts of mental life. Faculty

psychology takes seriously the apparent heterogeneity of the mental and is impressed by such prima facie differences as between, say, sensation and perception, volition and cognition, learning and remembering, or language and thought. Since, according to faculty psychologists, the mental causation of behavior typically involves the simultaneous activity of a variety of distinct psychological mechanisms, the best research strategy would seem to be divide and conquer: first study the intrinsic characteristics of each of the presumed faculties, then study the ways in which they interact. Viewed from the faculty psychologist's perspective, overt, observable behavior is an interaction effect par excellence. (p. 1)

In his influential book *How the Mind Works* (1997), Steven Pinker also embraces faculty psychology: "The mind, I claim, is not a single organ but a system of organs, which we can think of as psychological faculties or mental modules" (p. 27).

The Return of the Mind-Body Problem

The current popularity of all varieties of cognitive psychology, including information-processing psychology, brings the mind-body problem back into psychology—not that it ever completely disappeared. The radical behaviorists "solved" the problem by denying the existence of a mind. For them, so-called mental events are nothing but physiological experiences to which we assign cognitive labels. That is, the radical behaviorists "solved" the mindbody problem by assuming materialism or physical monism. Cognitive psychology, however, assumes the existence of cognitive events. These events are viewed sometimes as the by-products of brain activity (epiphenomenalism); sometimes as automatic, passive processors of sensory information (mechanism); and sometimes as important causes of behavior (interactionism). In each case, bodily events and cognitive events are assumed, and therefore the relationship between the two must be explained. A number of contemporary cognitive psychologists believe they have avoided dualism by noting the close relationship between certain brain activities and certain cognitive events (for example, Sperry, 1993). The fact that it appears likely that such a relationship will soon be discovered for all mental events is sometimes offered in support of materialism. D. N. Robinson (1986) explains why such reasoning is fallacious:

This is hardly a justification for materialistic monism, since *dualism* does not require that there be no brain! Indeed, dualism does not even necessarily require that mental events not be the effects of neural causes. A modest dualism only asserts that there *are* mental events. To show, then, that such events are somehow caused by material events, far from establishing the validity of a monist position, virtually guarantees the validity of a dualist position. (pp. 435–436)

Replacing the term *mind-body* with the term *mind-brain* does little to solve the problem of how something material (the brain) can cause something mental (ideas, thinking). For an excellent historical review of the controversies concerning the nature of consciousness and the current status of those controversies, see D. N. Robinson, 2007.

In the 1970s, an interdisciplinary field called **cognitive science** was created to study cognitive processes. Paul Thagard (2005) describes cognitive science and its current status:

Cognitive science is the interdisciplinary study of mind and intelligence, embracing philosophy, psychology, artificial intelligence, neuroscience, linguistics, and anthropology. Its intellectual origins are in the mid-1950s when researchers in several fields began to develop theories of mind based on complex representations and computational procedures. Its organizational origins are in the mid-1970s when the Cognitive Science Society was formed

and the journal *Cognitive Science* began. Since then, more than sixty universities in North America have established cognitive science programs and many others have instituted courses in cognitive science. (p. ix)

Why an interdisciplinary approach? "How the mind works is the biggest puzzle that humans have ever tried to put together, and the pieces require contributions from many fields" (Thagard. 2005, p. 217). Thagard reviews the considerable success of cognitive science (pp. 133-141) but also notes some of its shortcomings. First, it lacks "A unified theory that explains the full range of psychological phenomena, in the way that evolutionary and genetic theory unify biological phenomena, and relativity and quantum theory unify physical theory" (p. 133). Second, an understanding of consciousness itself remains elusive: "No consensus has emerged, but some of the neurological and computational elements of a theory of consciousness are starting to appear" (p. 175). And last, the computer metaphor on which it is based fails to provide for the important role emotions play in everyday life:

In humans, the evaluation of different states is usually provided by emotions, which direct us to what matters for our learning and problem solving. Computers currently lack such intrinsic, biologically provided motivation, and so can be expected to have difficulty directing their problem solving in nonroutine directions. (p. 221)

Perhaps partially because of the more comprehensive approach of cognitive science, there was a growing realization that information-processing psychology and the AI from which it developed had become sterile. Even Ulric Neisser, whose 1967 book *Cognitive Psychology* did so much to promote information-processing psychology, eventually became disenchanted with it. In 1976 Neisser published *Cognition and Reality*, in which he argued that information-processing psychology should be replaced by *ecological psychology*. Ecological

psychology moves away from computer models of human cognition and the narrow confines of laboratory experimentation and toward a study of cognition as it occurs naturally in real-life situations. Neisser (1982) provides a collection of ecologically relevant studies on memory. Included are such topics as flashbulb memories (vivid memories of such important events as the assassination of John F. Kennedy), mnemonics (strategies that enhance effective memory retrieval), memorists (people with exceptional memory), and the accuracy of eyewitness testimony. For the details of his life, including the experiences that influenced him to dramatically revise his early version of cognitive psychology, see Neisser, 2007.

Neisser's new approach to cognitive psychology was influential, but the influence of AI in the study of cognitive processes was far from over. Enthusiasm for AI was rekindled by a dramatic new development that used the brain as a model for cognitive functioning instead of the computer—new connectionism.

NEW CONNECTIONISM

Hebb's speculations concerning how cell assemblies and phase sequences develop (see Chapter 19) have reemerged in one of contemporary psychology's most popular research areas—new connectionism. New connectionism is a form of AI that is contrasted with Thorndike's connectionism (see Chapter 11). Thorndike's connectionism and new connectionism have in common the postulating of neural connections between stimuli (input) and responses (output). However, as we will see next, the neural connections postulated by new connectionism are much more complex than those postulated by Thorndike.

Antecedents

The cornerstone of one popular type of new connectionist model is **Hebb's rule**, which states the following: If neurons are successively or simulta-

neously active, the strength of the connections among them increases. Although this rule strongly influenced new connectionism, it was not original with Hebb. It is based on the associative laws of contiguity and frequency that go back at least to Aristotle; and, as we saw in Chapter 5, David Hartley anticipated Hebb in applying these associative principles to neural activity by 200 years. William James (1890/1950, Vol. 1, p. 566) also anticipated Hebb's rule, and Pavlov's neurophysiological explanation of the development of conditioned reflexes followed Hartley and James very closely.

Warren McCulloch and Walter Pitts (1943) also preceded Hebb in attempting to demonstrate the relationship between patterns of neural activity and cognitive processes. In some ways, their approach was more closely related to new connectionism than Hebb's was. McCullock and Pitts were primarily interested in showing how neurons, and networks of neurons, engage in logical operations that could be expressed mathematically. McCullock and Pitts used the term *neuro-logical networks* to reflect their interest in expressing neuronal activity mathematically. This effort to describe neural activity mathematically and, in turn, to relate that activity to human intellectual functioning, is essentially what new connectionism attempts to do.

Hebb was well aware of the fact that the idea expressed in what became known as Hebb's rule was not original with him. In *The Organization of Behavior* (1949), he said,

The general idea is an old one, that any two cells or systems of cells that are repeatedly active at the same time will tend to become "associated," so that activity in one facilitates activity in the other. The details of speculation that follow are intended to show how this old idea might be put to work again. (p. 70)

Although the idea that neurons that are active together or in close temporal proximity become associated was not original with him, it was Hebb's version of that idea that most influenced new connectionism:

It remains true that many ideas fundamental to connectionism were set out by Hebb. At a very general level, his commitment to trying to account for psychological processes given certain neurophysiological constraints has endured. At a very specific level, Hebbian learning, as conveyed by the Hebb rule, continues to be applied even in the most recent systems. (Quinlan, 1991, p. 6)

Neural Networks

New connectionism utilizes as its model a complex system of artificial neurons called a neural network. There are typically three kinds of "neurons" (sometimes called units or processors) in a neural network: input, hidden, and output. As with the brain, the associations among neurons within a neural network change as a function of experience. For Hebb neurons become associated when the anatomy or biochemistry of the synapses among them changes. In neural networks, synaptical changes are simulated by modifiable mathematical weights, or loadings, among the units in the network. After each presentation of input, neural networks are designed to detect which units within the network are active and to reorganize themselves according to Hebb's rule. That is, the strengths of the connections among units that are active together are increased by mathematically increasing their weights. After each presentation, the network reorganizes itself in a similar fashion. This accomplishes mathematically what is supposed to happen biochemically among neurons. That is, units within a neural network that are consistently active together become associated and, when they have become associated, consistent input produces consistent output.

The influences within a neural network are arranged in a hierarchy. Hidden units mathematically convert the patterns of incoming activity they receive from the input units into single output patterns, which they (the hidden units) then broadcast to the output units. At first, input into the network

produces general activity with no predictable output. With experience, however, the weights among the connections within the network are modified according to Hebb's rule, and eventually, as was mentioned, output becomes correlated with input. Figure 20.1 shows a highly simplified neural network.

New connectionism represents a radical departure from what John Haugeland (1985) calls good old-fashioned AI (GOFAI). GOFAI processes one sequence of information at a time in an if-then fashion; neural networks process several sequences simultaneously. The latter is called parallel distributed processing. GOFAI processes symbolic information according to rules; neural networks process only patterns of excitation and inhibition expressed as mathematical weights within the system. In contrast to GOFAI, learning and memory is no longer a matter of storing and retrieving symbolic representations. "Using knowledge in processing is no longer a matter of finding the relevant information in memory and bringing it to bear; it is part and parcel of the processing itself' (McClelland, Rumelhart, and Hinton, 1992, p. 281). A shortcoming of GOFAI, and its sequential processing of information, is that any disruption in the flow of information causes the entire system to fail. Within neural networks, information processing occurs

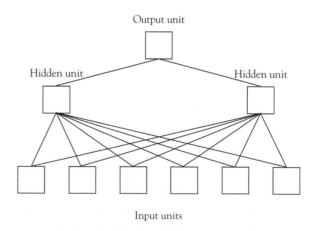

FIGURE 20.1
A highly simplified neural network.

throughout the system and, therefore, substantial portions of the system would need to be destroyed for disruption to occur. For this reason, Lashley's principle of mass action (see Chapter 19) applies to neural networks as well as to real brains. The most important distinction between GOFAI and new connectionism is that new connectionism can simulate or duplicate a number of human capabilities that GOFAI cannot—for example, learning.

Within new connectionism, learning is explained in terms of changing patterns of excitation and inhibition (represented by mathematical weights) within the neural network. For example, let us say we want a neural network to learn to recognize a particular object. Presenting that object (say, the number 3) provides input into the system, but the output will not initially resemble the number 3. However, after each presentation, the system is programmed to reorganize itself according to Hebb's rule—that is, by increasing the associative strengths of the units that were active together when the number 3 was presented. In this way, the output from the neural network gradually "learns" to match the input. Like the infant's brain, neural networks learn to represent recurring environmental events. Quinlan (1991) describes how learning occurs both in brains and in neural networks:

It is straightforward to see how whole chains of associations and hierarchies of associations could be built up over time by the recursive application of the general principles of Hebbian learning. Two simultaneously active cells map onto a third, causing it to become co-active with a fourth. In turn the third and fourth cells map onto a fifth whose behaviour eventually comes to represent a whole pattern of associations. (p. 5)

Connectionist models existed in the 1950s and 1960s (for example, Rosenblatt, 1958), and they competed with GOFAI. However, after the publication of Marvin Minsky and Seymour Papert's (1969) careful criticism of one type of connectionist model (Rosenblatt's), interest in neural networks

diminished considerably. In the 1980s, new developments in cognitive and computer science revived interest in parallel processing computers. Interest in GOFAI had declined substantially when, in 1986, David Rumelhart, James McClelland, and other members of the parallel distributed processing (PDP) group published their two-volume book Parallel Distributed Processing: Explorations in the Microstructure of Cognition. Dreyfus (1992) describes the enthusiasm with which this text was received:

Rumelhart, McClelland, and the PDP Research Group's two-volume work, *Parallel Distributed Processing*, had 6000 backorders the day it went on the market in 1986, and over 45,000 sets are now in print. Like the dissolution of the Soviet Union, the speed of collapse of the GOFAI research program has taken everyone, even those of us who expected it to happen sooner or later, by surprise. (p. xiv)

Soon new connectionism began solving problems that GOFAI either could not solve or could solve only with great difficulty. Neural networks showed their ability to recognize patterns, objects, phonemes, and words; to process sentences; to learn concepts; to generalize; and even to speak (we will see an example of the latter below). Rumelhart (1992) even believes that it is just a matter of time before new connectionism will explain the loftiest of all human cognitive abilities—reasoning: "I have become increasingly convinced that much of what we call reasoning can ... be accounted for by processes ... which are well carried out by PDP models" (p. 70).

Note that many of the neurophysiological speculations upon which neural networks are based (such as Hebb's rule) have been confirmed by observing the functioning of actual neurons (see, for example, Cleary, Hammer, and Byrne, 1989; Glanzman, 1995).

Back-Propagation Systems

Neural networks programmed in accordance with Hebb's rule are self-correcting; that is, patterns of output gradually match patterns of input, based on experience alone. But not all connectionist systems are programmed in that way. Some are backpropagation systems that require a "teacher" to provide feedback concerning the program's performance. Perhaps the most famous example of a back-propagation system is NETtalk (see, for example, Sejnowski and Rosenberg, 1987). Words are fed into the system, and their influence travels through the hidden units until they are coded into phonemes. A phoneme is the smallest unit of discernible sound within a language. This output (coded phonemes) is then fed into a voice synthesizer that produces actual speech sounds (phonemes). At first, the weights within the system are arbitrarily assigned and the output is phonemic gibberish. Training consists of adjusting the weights within the network so that the discrepancy between the input and the desired output (correct pronunciation) is systematically reduced. It is this corrective feedback that makes NETtalk a backpropagation system and not a system that learns automatically according to Hebb's rule. Andy Clark (1990) summarized how NETtalk learned how to speak coherently:

The network began with a random distribution of hidden unit weights and connections (within chosen parameters), i.e. it had no 'idea' of any rules of textto-phoneme conversion. Its task was to learn, by repeated exposure to training instances, to negotiate its way around this particularly tricky cognitive domain (tricky because of irregularities, subregularities, and context-sensitivity of text→phoneme conversion). And learning proceeded in the standard way, i.e. by a backpropagation learning rule. This works by giving the system an input, checking (this is done automatically by a computerized 'supervisor') its output, and telling it what output (i.e. what phonemic code) it should have produced. The learning rule then causes the system to minutely adjust the weights on the hidden units in a way

which would tend towards the correct output. This procedure is repeated many thousands of times. Uncannily, the system slowly and audibly learns to pronounce English text, moving from babble to half-recognizable words and on to a highly creditable final performance. (p. 299)

New connectionism is a diverse and complex field, and our discussion of it represents a vast over-simplification. For a more comprehensive overview of the field, especially as it applies to psychology, see Quinlan, 1991.

Although new connectionism is quite popular, it is not without its critics. For example, Hubert Dreyfus (1992), who because of his consistent criticism has been called the "black knight of AI," is not impressed by a neural network's supposed ability to learn:

Neural networks are almost as dependent upon human intelligence as are GOFAI systems, and their vaunted learning ability is almost illusory. What we really need is a system that learns on its own how to cope with the environment and modifies its own responses as the environment changes. (p. xxxix)

Nor is Searle (1992) impressed by any computer models of human intelligence:

Like the drunk who loses his car keys in the dark bushes but looks for them under the streetlight, "because the light is better here," we try to find out how humans might resemble our computational models rather than trying to figure out how the conscious human mind actually works. (p. 247)

Searle (1998, lecture 5) argues that new connectionism, although much more powerful than earlier linear versions of AI, still employs only syntax (the manipulation of symbols). Therefore, he says, the problem of semantics (the meaning of symbols) posed by his Chinese Room thought experiment is not solved by new connectionism.

Even Jerry Fodor, who has been largely supportive of what he calls the Computational Theory of Mind (CTM), sees that theory as severely limited in explaining human cognition:

So ... when I wrote books about what a fine thing CTM is, I generally made it a point to include a section saying that I don't suppose that it could comprise more than a fragment of a full and satisfactory cognitive psychology; and that the most interesting—certainly the hardest—problems about thinking are unlikely to be much illuminated by any kind of computational theory we are now able to imagine. I guess I sort of took it for granted that even us ardent admirers of computational psychology were more or less agreed on that. (2001, p. 1)

Finally, Jerome Bruner (1990), who we recall was among those responsible for the resurgence of interest in cognitive psychology in the late 1950s and early 1960s, asserts that cognitive science has failed in its effort to explain human cognition be-

cause it has neglected the most important aspect of mental life—its meaning:

There is no question that cognitive science has made a contribution to our understanding of how information is moved about and processed. Nor can there be much doubt on reflection that it has left largely unexplained and even somewhat obscured the very large issues that inspired the cognitive revolution in the first place. So let us return to the question of how to construct a mental science around the concept of meaning and the processes by which meanings are created and negotiated within a community. (pp. 10–11)

Despite the criticisms such as those just described, some believe that neural network theory (new connectionism) will synthesize contemporary psychology's many schisms, allowing psychology to become a mature, unified science (see, for example, Tryon, 1995). For arguments for and against various aspects of cognitive science, including new connectionism, see Johnson and Erneling, 1997.

SUMMARY

Throughout most of psychology's history, human cognition was studied philosophically. It was J. S. Mill who provided the framework within which human cognition could be studied scientifically. Fechner, Ebbinghaus, James, Bartlett, and Piaget were among the first psychologists to demonstrate that human cognition could be studied experimentally. Also included among the pioneers of experimental cognitive psychology were the Gestalt psychologists, Rogers, Hebb, Wiener, Shannon, and Weaver. During the 1950s, interest in experimental cognitive psychology increased mainly because of the efforts of such individuals as George Miller, Broadbent, Lashley, Festinger, Bruner, Tracy and Howard Kendler, Chomsky, the humanistic psychologists, and the psychoanalysts. In 1960 Hebb urged that the rigorous scientific methods

utilized by the behaviorists to study behavior be applied to the study of human cognition. Also in 1960, Miller and Bruner founded the Center for Cognitive Studies at Harvard. In 1962 and 1963, Egger and Miller demonstrated that classical conditioning could not be understood in terms of associative principles alone. Rather, the information conveyed by the stimuli involved had to be considered. In 1967 Neisser synthesized the diverse findings within experimental cognitive psychology, using a few basic principles primarily from information theory. In 1969 Miller served as president of the APA, illustrating how far experimental cognitive psychology based on information theory had come.

In 1950 Alan Turing created the field of AI. AI attempts to simulate or duplicate the intelligence

exhibited by humans, using nonhuman machines such as computers. Turing proposed the "imitation game" as a means of determining whether a machine can think as a human does. If the answers to questions given by a machine (like a computer) are indistinguishable from those given by a human, the machine can be said to think. Those adhering to strong AI believe that nonhuman machines can duplicate human intelligence, and those adhering to weak AI believe that nonhuman machines can only simulate human intelligence. Searle argues that his thought experiment of the Chinese Room showed that computers manipulate symbols without assigning meaning to them, and therefore strong AI must be rejected. Whether or not AI is seen as a useful model for studying humans depends on one's view of human nature. According to materialists, such as the radical behaviorists, there is no reason machines cannot duplicate human behavior. However, efforts to construct machines that simulate or duplicate human thought processes must fail because such processes do not exist. However, accepting a dualist position does not necessarily preclude the usefulness of AI, because many dualists are also mechanists. It is only those dualist positions that postulate unique features of the human mind (such as free will) that see AI as having little or no usefulness.

Information-processing cognitive psychology developed from AI. As the computer does, humans receive input; process that input by using various programs, strategies, schemata, memories, and

plans; and then produce output. The major goal of the information-processing psychologist was to determine the mechanisms humans employ in processing information. Information-processing psychologists followed in the rationalistic tradition, and their work and assumptions showed similarities to Kantian philosophy, Gestalt psychology, Piaget's theory of intellectual development, and methodological behaviorism. Both faculty psychology and the mind-body problem reemerged as cognitive psychology became popular. In the late 1970s, information-processing psychologists joined with researchers from other disciplines to form cognitive science. Hebb's speculations concerning the neurological basis of learning influenced the most recent version of artificial intelligence—new connectionism. New connectionism employs artificial neural networks consisting of input, hidden, and output units. One type of neural network "learns" according to Hebb's rule. That is, the mathematical weights among units that are active together are increased. The result is that consistent patterns of input into the network gradually produce consistent patterns of output. Back-propagation networks do not apply Hebb's rule but utilize a teacher or model instead. A famous example of a backpropagation system is NETtalk. Although neural networks function more like brains than GOFAI does and are capable of learning, many remain skeptical that any form of AI can reasonably duplicate or even simulate human intelligence.

DISCUSSION QUESTIONS

- Justify the contention that psychology has almost always been concerned with studying human cognition. Throughout most of psychology's history, how was cognition studied? What philosopher provided the framework within which cognition could be studied experimentally?
- 2. Give examples of early efforts (before 1950) to study human cognition experimentally.
- 3. Give examples of events that occurred in the 1950s that contributed to the development of experimental cognitive psychology.
- 4. Describe the pivotal events that occurred in the 1960s that contributed to the current popularity of experimental cognitive psychology.
- 5. Define each of the following: artificial intelligence (AI), strong AI, and weak AI.

- 6. What is the Turing test, and for what was it used?
- 7. Describe Searle's thought experiment involving the Chinese Room. What, according to Searle, does this experiment prove?
- 8. Which philosophies would tend to support the position of strong AI? Weak AI? Which would deny the usefulness of either type of AI?
- 9. What are the major tenets of informationprocessing psychology? How is informationprocessing psychology related to AI?
- 10. Why can information-processing psychology be seen as following in the tradition of Kantian philosophy? Why can information-processing psychology be seen as marking a return to

- faculty psychology? A return to the mind-body problem?
- 11. What is cognitive science?
- 12. What is new connectionism, and how does it compare to GOFAI?
- Describe an artificial neural network and then discuss how such a network learns by applying Hebb's rule.
- 14. Within new connectionism, what is a back-propagation model? Give an example.
- 15. Which of the criticisms of GOFAI remain valid when directed against new connectionism? Which are not?

SUGGESTIONS FOR FURTHER READING

- Baars, B. J. (1986). The cognitive revolution in psychology. New York: Guilford Press.
- Beakley, B., & Ludlow, P. (Eds.). (1992). The philosophy of mind: Classical problems/contemporary issues. Cambridge, MA: MIT Press.
- Block, N., Flanagen, O., & Güzeldere, G. (Eds.). (1997). The nature of consciousness. Cambridge, MA: MIT Press.
- Boden, M. A. (Ed.). (1990). The philosophy of artificial intelligence. New York: Oxford University Press.
- Churchland, P. S., & Sejnowski, T. J. (1994). *The computational brain*. Cambridge, MA: MIT Press.
- Dennett, D. C. (1991). Consciousness explained. Boston, MA: Little, Brown.
- Dreyfus, H. L. (1994). What computers still can't do: A critique of artificial reason. Cambridge, MA: MIT Press.
- Fodor, J. (2000). The mind doesn't work that way: The scope and limits of computational psychology. Cambridge, MA: MIT Press.
- Franklin, S. (1995). *Artificial minds*. Cambridge, MA: MIT Press.
- Johnson, D. M., & Erneling, C. E. (Eds.) (1997). The future of the cognitive revolution. New York: Oxford University Press.

- Pinker, S. (1997). How the mind works. New York: Norton.
- Quinlan, P. (1991). Connectionism and psychology: A psychological perspective on new connectionist research.

 Chicago: University of Chicago Press.
- Roediger, H. L. (2000). Sir Frederic Charles Bartlett: Experimental and applied psychologist. In G. A. Kimble & M. Wertheimer (Eds.), *Portraits of pioneers in psychology* (Vol. 4, pp. 149–161). Washington, DC: American Psychological Association.
- Rychlak, J. F. (1997). *In defence of human consciousness*. Washington, DC: American Psychological Association.
- Simon, H. A. (1996). *The sciences of the artificial* (3rd ed.). Cambridge, MA: MIT Press.
- Thagard, P. (2005). *Mind: Introduction to cognitive science* (2nd ed.). Cambridge, MA: MIT Press.
- Von Eckart, B. (1993). What is cognitive science? Cambridge, MA: MIT Press.
- Von Neumann, J. (2000). The computer and the brain (2nd ed.). New Haven, CT: Yale University Press. (Original work published 1958)

GLOSSARY

Artificial intelligence (AI) A branch of computer science that investigates the extent to which machines can simulate or duplicate the intelligent behavior of living organisms. (See also Strong artificial intelligence and Weak artificial intelligence.)

Back-propagation systems Neural networks that are programmed to learn by systematically reducing the discrepancy between their output and some desired output represented by a model or "teacher." Such systems learn by corrective feedback instead of by applying Hebb's rule.

Cognitive science An interdisciplinary approach to studying the mind and mental processes that combines aspects of cognitive psychology, philosophy, artificial intelligence, neuroscience, linguistics, and computer science.

Hebb's rule Hebb's contention that neurons within the brain that are simultaneously or successively active become associated. One type of neural network applies this rule by adjusting the mathematical weights of units that are simultaneously or successively active. The result is that consistent input gradually produces consistent output. (*See also* **Neural network**.)

Information-processing psychology The approach to studying cognition that follows in the tradition of faculty psychology and methodological (mediational) behaviorism and typically employs the computer as a model for human information processing.

Miller, George, A. (b. 1920) Did pioneering research on information processing in the 1950s and 1960s that significantly enhanced the popularity of cognitive psychology.

Neural network A system of input, hidden, and output units that is capable of learning if the mathematical weights

among the units are systematically modified either according to Hebb's rule or by back-propagation. (*See also* **Hebb's rule** and **Back-propagation systems**.)

New connectionism The most recent type of AI that utilizes artificial systems of neurons called neural networks. As contrasted with GOFAI, which employed the sequential processing of information according to specified rules, new connectionism employs the brain as a model. That is, the processing of information within a neural network is distributed throughout the entire network. Like the brain, neural networks are capable of learning; this was not true of GOFAI. (See also Hebb's rule and Neural network.)

Searle, John (b. 1932) With his famous "Chinese Room" thought experiment, sought to demonstrate that computer programs can simulate human thought processes but not duplicate them. Computer programs, he says, can only manipulate symbols according to rules (syntax), whereas humans assign meaning to symbols (semantics). Therefore, he accepts weak artificial intelligence and rejects strong artificial intelligence. (See also Strong artificial intelligence and Weak artificial intelligence.)

Strong artificial intelligence The contention that machines (such as computers) can duplicate human cognitive processes.

Turing test A test devised by Turing (1950) to determine whether a machine can think. Questions are submitted to both a human and a machine. If the machine's answers are indistinguishable from those of the human, it is concluded that the machine can think.

Weak artificial intelligence The contention that machines (such as computers) can simulate human cognitive processes but not duplicate them.

Contemporary Psychology

ontemporary psychology reflects its long, diverse history. In this text, we have seen that at various times the philosophies of empiricism, sensationalism, positivism, rationalism, romanticism, and existentialism have been employed in efforts to understand humans. We have also seen that one or more of these philosophies became the basis for psychology's schools of thought: voluntarism, structuralism, functionalism, behaviorism, Gestalt psychology, psychoanalysis, and humanistic psychology. The methodologies most often used to study humans throughout psychology's history have been introspection, naturalistic observation, and experimentation. Remnants of all these philosophies, schools, and methodologies are found in contemporary psychology.

THE DIVERSITY OF CONTEMPORARY PSYCHOLOGY

Psychology today is diverse, but psychology has almost always been diverse. In psychology's long history, there has never been a time when all psychologists accepted a single paradigm. Perhaps the closest psychology ever came to being a single-paradigm discipline was during the Middle Ages, when departures from the view of humans contained in church dogma were simply not tolerated. Some might suggest that behaviorism dominated psychology during the period from about 1930 through the 1950s, but this was not quite the case. Although behaviorism was extremely popular, there were always influential critics of behaviorism and an abundance of alternative views from which to choose.

What distinguishes modern psychology from psychology during the period when schools existed is the current relatively peaceful coexistence of psychologists holding dissimilar views. During the 1920s and 1930s, when several psychological schools existed simultaneously, open hostility often arose between

members of rival schools. Today, the schools are gone, and a spirit of **eclecticism** prevails, reminiscent of the functional approach to psychology that William James suggested. The eclectic chooses from diverse sources those ideas and techniques that are most effective in dealing with a problem. It is this eclecticism toward solving psychology's problems that Sternberg and Grigorenko (2001) believe may unify psychology as a discipline. It is also the approach suggested by postmodernism. We will have more to say about both Sternberg and Grigorenko (2001) and postmodernism later in this chapter.

Divisions of the American Psychological Association

Table 21.1 lists the 53 divisions of the APA, which give a clear indication of the diversity of psychology today (although the divisions go up to 55, there is no division 4 or 11, making a total of 53). Note, for example, that divisions include Experimental Psychology (3), Society for the Psychology of Aesthetics, Creativity and the Arts (10), Society for Military Psychology (19), Psychopharmacology and Substance Abuse (28), Humanistic Psychology (32), Society for the Psychology of Women (35), and Psychoanalysis (39). The number of members in each division is also listed to show which areas of psychology are currently the most popular. There is no specific APA division of cognitive psychology, but if there were, it undoubtedly would have been among the fastest growing from the 1960s to the present (see, for example, Robins, Gosling, and Craik, 1999). Note that although a large number of APA members have no divisional affiliation (49,216), total division memberships (71,054), approximates the total membership in the APA (76,538). This occurs because it is common for an APA member to belong to more than one APA division. When affiliates (foreign psychologists, high school psychology teachers, and undergraduate and graduate psychology students) are added to the APA membership, the number exceeds 148,000. Incidentally, psychology continues to be one of the science and engineering fields with the highest number of new PhDs obtained by women. In 1990, 58% of new PhDs in psychology were obtained by women. In 1999, the figure grew to 66% (Kohout, 2001) and in 2005, it had grown to 72% (Cynkar, 2007).

From the handful of individuals who founded the APA in 1892 in Worcester, Massachusetts, under the leadership of G. Stanley Hall, the membership has now grown to over 88,000 members. There are now more divisions of the APA (54) than there were charter members (31) in 1892. Clearly, psychology's popularity and diversity have been increasing, and they continue to do so.

THE TENSION BETWEEN PURE, SCIENTIFIC PSYCHOLOGY AND APPLIED PSYCHOLOGY

As we saw in Chapter 8, interest in sensory physiology was stimulated by the discovery of individual differences in the observations made by astronomers. The scientific investigation that followed, however, was concerned with sensation and perception in general, not with individual differences. Such was the case with the work of Johannes Müller, Helmholtz, Weber, Fechner, and Donders, all of whom significantly influenced Wundt. When Wundt founded psychology as an independent discipline in 1879, he saw its purpose as explaining the human mind in general; he had little or no interest in individual differences or in applied psychology. This was not true of Wundt's students from the United States, however. Typically, after receiving their PhDs under Wundt's supervision, students from the United States returned home and pursued their interests in individual differences and applied psychology (for example, G. S. Hall and Witmer). Cattell managed to pursue his interest in individual differences while studying with Wundt, but he was an exception. Of course, Cattell also pursued his interests in individual differences and applied psychology upon returning to the United States. Although

TABLE 21.1 Divisions of the American Psychological Association and Their Memberships

_						
	Division	Total	Men	Women	% Men	% Women
1.	Society for General Psychology	2,104	1,447	657	68.8%	31.2%
2.	Society for the Teaching of Psychology	2,007	1,124	883	56.0%	44.0%
3.	Experimental Psychology	1,087	833	254	76.6%	23.4%
5.	Evaluation, Measurement, and Statistics	1,341	958	383	71.4%	28.6%
6.	Behavioral Neuroscience and Comparative Psychology	606	466	140	76.9%	23.1%
7.	Developmental Psychology	1,328	554	774	41.7%	58.3%
8.	Society for Personality and Social Psychology	3,104	1,964	1,140	63.3%	36.7%
9.	Society for the Psychological Study of Social Issues	2,271	1,285	986	56.6%	43.4%
10.	Psychology and the Arts	524	277	247	52.9%	47.1%
12.	Society of Clinical Psychology	5,277	3,432	1,845	65.0%	35.0%
13.	Society of Consulting Psychology	1,079	741	338	68.7%	31.3%
14.	Society for Industrial and Organizational Psychology	3,026	1,954	1,072	64.6%	35.4%
15.	Educational Psychology	1,657	995	662	60.0%	40.0%
16.	School Psychology	1,905	936	969	49.1%	50.9%
17.	Society of Counseling Psychology	2,560	1,465	1,095	57.2%	42.8%
18.	Psychologists in Public Service	1,031	720	311	69.8%	30.2%
19.	Military Psychology	386	308	78	79.8%	20.2%
20.	Adult Development and Aging	1,530	799	731	52.2%	47.8%
21.	Applied Experimental and Engineering Psychology	320	257	63	80.3%	19.7%
22.	Rehabilitation Psychology	1,364	841	523	61.7%	38.3%
23.	Society for Consumer Psychology	241	204	37	84.6%	15.4%
24.	Theoretical and Philosophical Psychology	554	450	104	81.2%	18.8%
25.	Division of Behavior Analysis	620	477	143	76.9%	23.1%
26.	History of Psychology	694	553	141	79.7%	20.3%
27.	The Society for Community Research and Action: Division of Community Psychology	717	445	272	62.1%	37.9%
28.	Psychopharmacology and Substance Abuse	792	591	201	74.6%	25.4%
29.	Psychotherapy	3,866	2,439	1,427	63.1%	36.9%
30.	Society of Psychological Hypnosis	1,092	803	289	73.5%	26.5%
31.	State Psychological Association Affairs	453	286	167	63.1%	36.9%
32.	Humanistic Psychology	603	411	192	68.2%	31.8%

TABLE 21.1 (Continued)

					7 9 9	
	Division	Total	Men	Women	% Men	% Women
33.	Mental Retardation and Developmental disabilities	692	440	252	63.6%	36.4%
34.	Population and Environmental Psychology	345	213	132	61.7%	38.3%
35.	Society for the Psychology of Women	2,675	85	2,590	3.2%	96.8%
36.	Psychology of Religion	1,108	774	334	69.9%	30.1%
37.	Child, Youth, and Family Services	973	472	501	48.5%	51.5%
38.	Health Psychology	2,709	1,473	1,236	54.4%	45.6%
39.	Psychoanalysis	3,295	1,375	1,920	41.7%	58.3%
40.	Clinical Neuropsychology	4,132	2,485	1,647	60.1%	39.9%
41.	American Psychology—Law Society	2,220	1,469	751	66.2%	33.8%
42.	Division of Independent Practice	5,637	3,440	2,197	61.0%	39.0%
43.	Family Psychology	1,548	952	596	61.5%	38.5%
44.	Society for the Psychological Study of Lesbian, Gay, and Bisexual Issues	924	492	432	53.2%	46.8%
45.	Society for the Psychological Study of Ethnic Minority Issues	1,033	448	585	43.4%	56.6%
46.	Media Psychology	492	236	256	48.0%	52.0%
47.	Exercise and Sport Psychology	903	642	261	71.1%	28.9%
48.	Society for the Study of Peace, Conflict, and Violence: Peace Psychology Division	510	281	229	55.1%	44.9%
49.	Group Psychology and Group Psychotherapy	729	462	267	63.4%	36.6%
50.	Division of Addictions	1,114	732	382	65.7%	34.3%
51.	Society for the Psychological Study of Men and Masculinity	531	426	105	80.2%	19.8%
52.	International Psychology	750	408	342	54.4%	45.6%
53.	Society of Clinical Child and Adolescent Psychology	1,734	743	991	42.8%	57.2%
54.	Society of Pediatric Psychology	976	396	580	40.6%	59.4%
55.	American Society for the Advancement of Pharmacotherapy	706	449	257	63.6%	36.4%
	Total Division Memberships	79,875	46,908	32,967	58.7%	41.3%
	No Divisional Affiliations	48,493	20,934	27,559	43.2%	56.8%

SOURCE: APA Membership Directory, 2003, pp. 1–2. Reprinted by permission.

Münsterberg was German, he eventually went to the United States and did as much as anyone to develop applied psychology. He too received his doctorate under Wundt's supervision. We see that from psychology's very inception, there was tension between those wanting psychology to be a pure science detached from practical concerns (such as Wundt) and those wanting psychological principles to be applied to practical matters (such as G. S. Hall, Cattell, Witmer, and Münsterberg). It should be noted that one could be interested in individual differences from a purely scientific perspective without concern for their practical implications (as Darwin was); but within psychology in the United States, interests in individual differences and applied psychology have always been closely related.

The fact that James, Münsterberg, Cattell, Witmer, and Dewey were among the original members of the APA makes it clear that there was considerable interest in applied psychology. This observation is supported by the fact that the two individuals most often mentioned as the founders of the school of functionalism—James and Dewey—were part of this group. Functionalism, under the influence of evolutionary theory, was very concerned with individual differences, and most functionalists had an active interest in applied psychology.

However, Titchener, also an original member of the APA, was even more disdainful of applied psychology than was his mentor, Wundt. So upset was Titchener by the APA's embracing of applied psychology that he refused to participate in any of its activities. Instead, he created his own organization, The Experimentalists, which allowed its members to pursue their interests in pure, scientific psychology—as he defined it. So the tension between pure and applied psychology continued when the APA was created.

Note that no early psychologist argued for applied psychology *instead of* pure, scientific psychology. These psychologists knew the struggle that psychology had had in differentiating itself from philosophy and religion, and they believed that anything in psychology worth applying came from its scientific base. For them, and for scientifi-

cally oriented psychologists ever since, science came first and applications came second. It was for this reason that the stated goal of the original APA was "to promote psychology as a science." So when the APA was founded in 1892, pure, scientific psychology was valued more than applied psychology, but both were valued.

In 1896, only four years after the founding of the APA, Witmer created the first psychology clinic and shortly thereafter coined the term clinical psychology. However, Witmer's clinical psychology and modern clinical psychology have little in common. Witmer worked primarily with children with speech, motor, or learning disorders. He used whatever rudimentary tests and experimental principles were available to help diagnose, and then to solve, those problems; he "[groped] for adequate techniques as he went along" (McReynolds, 1987, p. 854). Typically, Witmer created special educational conditions to "treat" the problems he diagnosed. As we noted in Chapter 15, in addition to his contributions to early clinical psychology, Witmer also made significant contributions to school psychology and special education. In any case, neither Witmer nor any other psychologist at the time engaged in psychotherapy; everyone agreed that the treatment of disease, both physical and mental, was the province of the medical profession. As we shall see shortly, psychotherapy was rarely performed by clinical psychologists until after World War II. Witmer nicely exemplifies the attitude of early psychologists in the United States toward applied psychology. First came rigorous, scientific training, and second came the attempt to apply scientific knowledge to the solution of practical problems in Witmer's case, attempting to help troubled individuals.

World War I greatly enhanced the growth and popularity of psychology. In December 1916, shortly before the United States entered the war, G. Stanley Hall addressed a joint session of the APA and the American Association for the Advancement of Science (AAAS). He argued that the utilization of applied psychology could increase military efficiency. Even psychoanalytic theory, he said, could be used to predict which soldiers would break

down under fire. His address was well received by both scientists and the popular media (Ross, 1972, p. 420). In March 1917, Hall launched the *Journal of Applied Psychology*, the first journal in the United States devoted to the problems of business and the measurement of vocational aptitudes. A variation of the latter was to represent psychology's major contribution to the war effort. We saw in Chapter 10 how, under the leadership of Yerkes, psychology became deeply involved in the evaluation of soldiers using the Army Alpha and Army Beta intelligence tests.

During the 1930s, applied psychologists continued as they had in the 1920s, serving primarily as testers and evaluating juvenile offenders, troubled children, and people seeking guidance about their intelligence, personality, or vocational aptitude. Obviously, psychological testing developed far bevond the few intelligence tests created by Binet, Terman, and others. Testing became a major industry, and this did not please many scientifically oriented psychologists, who generally viewed testing as inferior to laboratory research. Scientific psychology had always been associated with colleges and universities (thus the terms academician and experimental psychologist are often used synonymously). Tests allowed applied psychologists to work outside of the university setting in industry, schools, and clinics or to be self-employed. The tension was increasing.

As the number of applied psychologists, including clinicians, grew, they demanded greater recognition and status within the APA. When this recognition was not forthcoming, applied psychologists began to create their own organizations. The first, the American Association of Clinical Psychologists (AACP), was established in 1917 but disbanded in 1919 when the APA formed its first division, the clinical division. The resulting peace lasted until 1930, when a group of applied psychologists from New York formed the Association of Consulting Psychologists (ACP). The ACP sought to establish professional and ethical standards for practitioners of psychology and began publication of the Journal of Consulting Psychology in 1937. Members of the clinical division of the APA were

frustrated in their efforts to have that organization define and set standards for practitioners of psychology; so in 1937 they left the APA and joined with the ACP to create the American Association of Applied Psychology (AAAP), organized into four sections corresponding to consulting, clinical, educational, and business and industrial psychology. In 1938 the AAAP took over the publication of the *Journal of Consulting Psychology*.

In 1925 the APA had created the category of associate member for psychologists with a doctorate but with no scientific publications beyond the dissertation. Associates had no voting privileges within the APA. Most applied psychologists were associates because they tended not to do research, and they were resentful of their second-class status. In 1941, in an effort to reunify psychology, the APA removed the requirement for full membership that an applicant had to publish research beyond the PhD dissertation. Instead, one became eligible for full membership either through publication of scientific research or by having a doctorate plus five years' "contribution" to psychology as an associate member. The availability of full membership in the APA based on practical experience was generally viewed as a significant step toward accepting applied psychologists and pure, scientific psychologists as equals.

In 1944, in a further attempt to unify the disparate interests of psychologists, the APA organized itself into 18 divisions, each with its own president and officers. Further, the stated purpose of the APA was changed to what it is today—"To advance psychology as a science, as a profession, and a means of promoting human welfare." Finally, a new journal, *American Psychologist*, first published in January 1946, was created as the voice of the new, unified psychology. The reorganization of the APA into relatively independent divisions satisfied the applied psychologists, and in 1944 the AAAP disbanded by merging with the APA. Once again there was peace within psychology, but the peace was short-lived.

After World War II, the need for psychotherapy among returning veterans far exceeded the capacity of psychiatrists and psychoanalysts to deal with it. Rogers (1944) estimated that as many as

80% of returning veterans requested counseling of some kind. He noted that veterans needed help in readjusting to civilian life; were often bitter because few people at home realized the horrors of combat; and expressed restlessness, disturbed sleep, excessive emotionality, and marital and family disturbances. Also, veterans who had suffered disabling injuries often needed psychological as well as physical therapy. In 1946 the Veterans Administration (VA) responded to the emergency by funding training programs at leading universities to train clinical psychologists whose jobs would include psychotherapy as well as diagnosis. Now the APA was confronted with a task it had avoided for decades—defining the professional psychologist and setting standards for his or her training and practice. We will see shortly that the question concerning clinical psychologists' training has still not been answered to everyone's satisfaction.

When clinical psychologists became involved in psychotherapy, they had little experience to draw upon. Most clinicians knew something about Freud, and his ideas were commonly utilized. Garfield (1981) commented on the domination of psychoanalysis following World War II:

The most important and influential orientation in the 1940s was that of psychoanalysis. Psychoanalytic theory was the dominant force in psychiatry in the postwar period and was embraced by a large number of clinical psychologists. To a large extent, and for all practical purposes, there was no rival orientation. (p. 176)

As late as 1960, a survey indicated that 41% of clinical psychologists still adhered to a psychoanalytic orientation (E. L. Kelly, 1961). Despite rather serious controversies (see Chapter 16), psychoanalysis continues to be a formidable influence in both contemporary psychiatry and clinical psychology.

In 1942 Rogers developed his client-centered therapy, and it soon began competing successfully with psychoanalysis as a therapeutic technique. Other psychologists, such as George Kelly, simply invented their own techniques as they went along. Currently, the therapeutic techniques clinical psy-

chologists use reflect at least the following perspectives, each with several subcategories: psychoanalytic, behavioristic, cognitive, humanistic, and existential.

Before the end of World War II, clinical psychologists were subservient to psychiatrists, who dominated the mental health profession. When clinical psychologists began to engage in psychotherapy, they entered into competition with psychiatrists and therefore with the medical profession. There followed a number of emotional battles (often in the courts) concerning the kinds of services that psychologists could provide. For example, Could psychologists admit and release patients into and out of mental institutions? Could psychologists act as expert witnesses in court on matters of mental health? Were clinical psychologists entitled to third-party payment for their services (for example, from insurance companies and government agencies)? Could clinical psychologists be certified by states as legal providers of mental health services? Could clinical psychologists legally administer medication? Until recently, clinical psychologists had won all their battles with psychiatrists except the last one: psychiatrists could prescribe medication, but clinical psychologists could not. However, in 2002 New Mexico became the first state in which psychologists were granted prescription privileges, and in 2004 Louisiana became the second. In addition, 31 state psychological associations have prescription-privilege task forces working toward such legislation. One of the newest APA divisions, the American Society for the Advancement of Pharmacotherapy, facilitates and anticipates the inevitability of widespread prescription privileges among clinical psychologists. As matters now stand, then, psychologists either have, or will soon have, all of the privileges that psychiatrists have. The elimination of the prescription restriction is considered especially important because of the present concern with health care costs. Research has shown that medication is often at least as effective as psychotherapy in treating mental disorders. For example, some forms of depression, perhaps the most common mental disorder of our time, have been effectively treated by antidepressant drugs (for

example, Klein, Gittelman, Quitkin, and Rifkin, 1980; Morris and Beck, 1974). Similarly, Baxter and his co-authors (1992) demonstrated that medication is as effective as behavior therapy in treating obsessive-compulsive patients with Finally, Reisman (1991) states, "It is no exaggeration to say that the treatment of schizophrenia was remarkably altered by the use of drugs. Return of the patient to the community and maintaining the patient within the community were feasible goals" (p. 318). The important point is that if it can be demonstrated that certain mental disorders can be effectively and economically treated by drugs, clinical psychologists are at a disadvantage by not being able to prescribe them.

However, there is currently intense debate among those advocating medication as treatment for mental disorders (such as depression), those advocating psychotherapy, and those advocating a combination of the two. (For the flavor of this debate, see Antonuccio, 1995; Antonuccio, Danton, and DeNelsky, 1994; DeNelsky, 1996; Hayes and Heiby, 1997; Karon and Teixeria, 1995; Lorion, 1996; Muñoz, Hollon, McGrath, Rehm, and Vander Bos, 1994.) We have in this debate a modern manifestation of the old tension between the medical and psychological models of mental illness. Physicians tend to view mental disorders such as depression as illnesses or diseases, and they advocate treating disorders with medication (medical model). Psychologists tend to view mental disorders as resulting from life's circumstances (such as economic frustration, marital conflict, and personal loss), and they advocate treating disorders with psychotherapy (psychological model). Of course, some accept both models and thus advocate that patients be offered a choice between, or a combination of, the two kinds of treatment (for example, Muñoz et al., 1994). For discussions of the history of psychologists' efforts to gain prescriptive privileges, the training necessary for such privileges, and the debate concerning its usefulness, see Sammons, Paige, and Levant, 2003.

Antonuccio, Danton, and McClanahan (2003) are concerned that as psychologists gain prescription privileges, the pharmaceutical industry will seek the same pervasive influence in psychology as it has in

the medical profession. Believing that such influence would demean the integrity of psychological science, the authors suggest ways of preventing its occurrence.

Controversy Concerning the Training of Clinical Psychologists

The controversy between pure versus applied psychology is currently manifested in the question of how best to train clinical psychologists. As we have seen, Witmer established a tradition in which clinical psychology would be closely aligned with scientific or experimental psychology. Then the person performing the research and the person applying the knowledge gained from the research was often the same person, as was true for Witmer. This tradition of scientist-practitioner was reconfirmed in 1949 at the Boulder Conference on Training in Clinical Psychology sponsored by the APA. The Boulder model upheld the tradition that clinicians obtain the Doctor of Philosophy (PhD) in psychology, which meant that they were trained in research methodology as any other psychologist was.

Increasingly, however, clinicians and students of clinical psychology questioned the need to be trained in scientific methodology in order to become effective clinicians. As early as 1925, Loyal Crane argued for the establishment of a special degree to be earned by applied psychologists as opposed to scientifically oriented psychologists, but "the response to Crane's plea was imperceptible" (Reisman, 1991, p. 161). The professional degree that Crane suggested was later called the **Doctor of** Psychology (PsyD). In 1968 the University of Illinois offered the first PsyD degree, and in 1969 the California School of Professional Psychology (CSPP) was founded. The CSPP was significant not only because it offered the PsyD degree but because it existed independently of any college or university. Problems associated with the creation of the PsyD degree and with free-standing professional schools needed to be addressed, and a second conference on the training of clinical psychologists was held in Vail, Colorado, in 1973. At this conference, two decisions were made that broke radically from

the tradition of clinicians as scientists-practitioners: (1) professional schools (like CSPP) that could offer advanced degrees in clinical psychology were sanctioned, and they would be administratively autonomous from university psychology departments; and (2) the PsyD degree was recognized. The PsyD degree provides professional training for clinical psychologists but without the intense exposure to research methodology typical of training for the PhD. Proponents of the PsyD indicated that the degree was equivalent to the Doctor of Medicine degree (MD), where practitioners of medicine apply the principles of biology, chemistry, pharmacology, and other scientific fields to the treatment of physically ill persons. The PsyD would have a similar relationship to scientific psychology: that is, the PsyD would apply principles discovered by experimental psychologists to the treatment of disturbed individuals. After the Vail decision, professional schools of psychology became very popular, and as early as 1979, there were 24 such schools in California alone (Perry, 1979). As of 2000, the number of institutions granting the PsvD degree had grown to more than 50 and the number of PsyDs that have been awarded is approximately 9,000 (Murray, 2000, p. 52). Although the PsyD degree is becoming increasingly popular, the training of clinicians as scientist-practitioners continues to dominate clinical programs (Baker and Benjamin, 2000; O'Sullivan and Quevillon, 1992). In 1990 a conference was held in Gainesville, Florida, to clarify aspects of the scientistpractitioner model that the Boulder conference had left unclear. Participants at the Gainesville conference reaffirmed the Boulder model as the one most appropriate for the training of professional psychologists (Belar and Perry, 1992).

The decisions to establish the PsyD and professional schools of psychology independent of university psychology departments remain highly controversial. (For supporting arguments see, for example, Fox 1980, 1994; Meehl, 1971; Peterson, 1976; and Shapiro and Wiggins, 1994.) Shapiro and Wiggins (1994) argue that the current degree situation in psychology is confusing to both professionals and the public. For example, some PhDs are scien-

tists and some are practitioners, but almost all PsyDs are practitioners. They propose that "all practitioners of psychology be clearly identified as doctors of psychology and hold the appropriate PsyD degree. ... The PhD degree in psychology ... should be reserved for individuals who are qualified to enter a career in research and scholarship" (p. 209). (For arguments opposing the PsyD, see, for example, Belar and Perry, 1991; Perry, 1979. For efforts to reconcile the differences between scientific psychologists and practitioners, see, for example, Beutler, Williams, Wakefield, and Entwistle, 1995; Peterson, 1995; Stricker, 1997; Stricker and Trierweiler, 1995.) For concerns about the quality of training in PsyD programs, see Peterson, 2003; Kenkel, DeLeon, Albino, and Porter, 2003.

No matter how the question of clinical training is ultimately resolved, it is clear that practitioners of psychology now dominate the membership of the APA. In 1940 about 70% of APA members worked in academia and were therefore associated with scientific psychology; by 1985 only about 33% did. Currently, the vast majority of APA divisions reflect applied (mainly clinical) psychology, whereas only a minority reflect academic, research-oriented psychology. Shapiro and Wiggins (1994) indicate that nearly 70% of APA members identify themselves as health care providers. It is only natural, therefore, that the APA expend considerable resources addressing the needs of psychology's practitioners. The historic shoe is now on the other foot. Instead of practitioners believing they are second-class members of the APA, many scientifically oriented psychologists believe they are. As early as 1959, a group of scientific psychologists, believing that the APA no longer adequately represented their interests, formed their own organization—the Psychonomic Society, under the leadership of Clifford T. Morgan. The society held its first conference in 1960 and soon began publishing its own journal, Psychonomic Science. In 1988 a group of scientific psychologists founded the American Psychological Society (APS) with Janet Taylor Spence as its first president (J. T. Spence had been president of the APA in 1984). This national organization, dedicated to scientific psychology, held its

first convention in 1989 in Alexandria, Virginia, and began publication of its journal *Psychological Science* in 1990. Recently, the name of the organization was changed from American Psychological Society to Association for Psychological Science (still APS). Membership in APS rose from an initial 500 to approximately 18,000 in 2007.

We see that the tension between pure, scientific psychology and applied psychology that characterized psychology in its earliest days is still very much alive. It may be unduly optimistic to hope this tension will ever be completely resolved. Perhaps the discord is inevitable because psychology embraces at least two basically incompatible cultures.

Psychology's Two Cultures

Given contemporary psychology's great diversity, what is it that inclines a particular psychologist toward one brand of psychology as opposed to other brands? A case can be made that it is a psychologist's personality or biography that, to a large extent, determines the choice. James once said that the single most informative thing you could know about a person is his or her Weltanschauung, or worldview. According to James, it is a philosopher's temperament that determines what type of Weltanschauung he or she has and thus the type of philosophy he or she will be inclined toward. As we saw in Chapter 11, James (1907/1981) argued that philosophers can be divided into two general groups according to their temperaments: the tender-minded and the tough-minded. James believed that tension between tender-minded and tough-minded philosophers has existed throughout history: "The tough think of the tender as sentimentalists and soft-heads. The tender feel the tough to be unrefined, callous, or brutal" (1907/1981, p. 11). In 1923 Karl Lashley discussed the reason some psychologists accept a mechanistic brand of psychology (such as Watson's) and others accept a purposive brand (such as McDougall's). Lashley reached much the same conclusion about psychologists that James had reached about philosophers: "It is wholly a matter of temperament; the choice

is made upon an emotional and not a rational basis" (1923, p. 344).

The British scientist-novelist C. P. Snow (1964) was so impressed by the different ways scientists and literary intellectuals (such as novelists) embraced the world that he concluded they actually represented two distinct cultures—like the two conflicting temperaments James noted among philosophers. Snow observed that one of these temperaments (tender-minded) characterizes members of the humanities and the other (tough-minded) characterizes scientists, making meaningful communication between the two groups all but impossible. Thomas Kuhn (1996) said of scientists, "The proponents of competing paradigms practice their trades in different worlds" (p. 150). Gregory Kimble (1917–2006) provided evidence that James's two temperaments, Snow's two cultures, and Kuhn's incommensurability among competing scientific paradigms also characterize contemporary psychology.

Kimble (1984) administered a scale that measured the extent to which various psychologists and students of psychology accepted rigorous scientific values as opposed to humanistic values. The scale was administered to undergraduate students enrolled in an introductory psychology course; officers of all divisions of the APA; and members of Division 3 (Experimental Psychology), Division 9 (Society for the Study of Social Issues), Division 29 (Psychotherapy), and Division 32 (Humanistic Psychology). The students showed a slight inclination toward humanistic values, and APA officers (from all APA divisions collectively) showed an even more slight inclination toward scientific values. When data from members of individual APA divisions were analyzed, however, the results were more dramatic. Scores for members of Division 3 (Experimental Psychology) were strongly biased in the direction of scientific values. Almost the opposite was true for the members of the other divisions tested. Scores for members of Division 9 (Society for the Study of Social Issues) were moderately biased in the direction of humanistic values. Scores for members of Division 29 (Psychotherapy) were strongly biased in the direction of humanistic values, as were scores for members of Division 32

(Humanistic Psychology). To use James's terminology, experimental psychologists tend to be toughminded, and humanistic psychologists and psychotherapists tend to be tender-minded. Kimble (1984) concluded that two essentially incommensurable cultures exist in psychology. If Kimble's conclusion is correct, it would explain the historic tension between pure, scientific and applied psychologists. If these two groups embrace basically incompatible values, then perhaps the tension between them can be resolved only by the groups going their separate ways.

However, dividing philosophers, psychologists, or educated people into just two categories is a gross oversimplification. Snow realized this problem, saying that "the number 2 is a very dangerous number. ... Attempts to divide anything into two ought to be regarded with much suspicion" (1964, p. 9). Kimble agreed, saying that the appearance of just two cultures in psychology was created by the careful selection of the APA divisions he evaluated. Although some psychologists fall at either end of the scientific-humanistic continuum, most psychologists would fall at various points in between. Instead of describing psychology in terms of two cultures, a description in terms of several cultures would be more accurate. In fact, there are probably as many "cultures" in psychology as there are conceptions of human nature.

Apparently, psychology's history and the Zeitgeist have combined to create a psychological smorgasbord, and it is the psychologist's personality that determines which items in that smorgasbord are appealing. Of course, the same is true for students of psychology.

PSYCHOLOGY'S STATUS AS A SCIENCE

This is James's (1892/1985) description of psychology as it appeared to him:

A string of raw facts; a little gossip and a wrangle about opinions; a little classification and generalization on the mere descriptive level; a strong prejudice that we have states of mind, and that our brain conditions them: but not a single law in the same sense in which physics shows us laws, not a single proposition from which any consequence can causally be deduced. ... This is no science, it is only the hope for a science. (p. 335)

More than 40 years later, Heidbreder (1933) offered her description of psychology:

Psychology is, in fact, interesting, if for no other reason, because it affords a spectacle of a science still in the making. Scientific curiosity, which has penetrated so many of the ways of nature, is here discovered in the very act of feeling its way through a region it has only begun to explore, battering at barriers, groping through confusions, and working sometimes fumblingly, sometimes craftily, sometimes excitedly, sometimes wearily, at a problem that is still largely unsolved. For psychology is a science that has not yet made its great discovery. It has found nothing that does for it what atomic theory has done for chemistry, the principle of organic evolution for biology, the laws of motion for physics. Nothing that gives it a unifying principle has yet been discovered or recognized. As a rule, a science is presented, from the standpoint of both subjectmatter and development, in the light of its great successes. Its verified hypotheses form the established lines about which it sets its facts in order, and about which it organizes its research. But psychology has not yet won its great unifying victory. It has had flashes of perception, it holds a handful of clues, but it has not yet achieved a synthesis or an insight that is compelling as well as plausible. (pp. 425-426)

Although the views of James and Heidbreder are separated by more than four decades, they are remarkably similar. Have things improved in the more than 70 years since Heidbreder recorded her thoughts? As we saw in Chapter 1, after addressing the question of whether psychology is a science, Koch (1981, 1993) concluded that rather than psychology being a single discipline, it is several—some of which are scientific, but most of which are not. Koch believed that it would be more realistic to refer to our discipline as psychological studies rather than as the science of psychology. The designation psychological studies recognizes the diversity of psychology and shows a willingness to use a wide variety of methods while studying humans.

Finally, Staats (1989) offered his assessment of contemporary psychology:

Fields of psychology have developed as separate entities, with little or no planning with respect to their relationships. Research areas grow in isolation without ever being called on to relate themselves to the rest of psychology. There are various oppositional positions—nature versus nurture, situationism versus personality, scientific versus humanistic psychologythat separate works throughout the many problem areas of psychology. Different methods of study are employed and psychologists are divided by the methodology that they know and use and will accept. There are innumerable theories, large and small—it is said that there are 100-400 separate psychotherapy theories alone and everyone is free to construct a personal theory without relating its elements to those in other theories. Many theoretical structures, which serve as the basis for empirical efforts, are taken from the common language as opposed to systematically developed theories. The practice of constructing small common sense conceptual structures as the basis for one's specialized work in psychology provides an infinity of different and unrelated

knowledge elements and associated methodological-theoretical structures. (p. 149)

Only rarely can a psychologist be found who believes that psychology is a unified discipline. For example, Matarazzo (1987) argues that a body of knowledge and basic processes and principles form the core of psychology, and they have remained essentially the same for the last 100 years. Furthermore, Matarazzo maintains that various types of psychology (such as clinical, industrial, social, experimental, and developmental) simply apply the same core content, processes, and principles to different types of problems. Although in 1984 Kimble described psychology as consisting of two basically incompatible cultures, he recently expressed hope that psychology might become a unified discipline. His version of unification, however, sides with psychology's scientific culture: "Psychology's best hope for unity derives from the simple truth that the sundry versions of the discipline are all kin to natural science" (Kimble, 1994, p. 510). Kimble (1996b) elaborated his vision of psychology as a unified science:

It portrays psychology as a natural science and offers a set of axioms, fashioned after Newton's laws of motion, as the fundamental principles that hold the field together.

The argument begins with a reminder that a science of psychology must obey the rules of science: it must be deterministic, empirical, and analytic. To honor those criteria, it must be some form of behaviorism, based on stimuli and response, because the sciences are about observable reality. (p. ix)

Kimble (1999) extended his argument that psychology's diverse elements could be reconciled using a natural science model. Edward Wilson (1998) argues that differences within psychology can be reconciled within the framework of evolutionary theory. It is unlikely, however, that

psychology's other culture, or cultures, would accept either Kimble's or Wilson's premise for unification. Perhaps the approach toward unification suggested by Sternberg and Grigorenko (2001) is more promising:

We believe that a more sensible and psychologically justifiable way of organizing psychology as a discipline and in departments and graduate study is in terms of psychological phenomena —which are not arbitrary—rather than so-called fields of psychology—which largely are arbitrary. Under this approach, an individual might choose to specialize in a set of related phenomena, such as learning and memory, stereotyping and prejudice, or motivation and emotion, and then study the phenomena of interest from multiple points of view. The individual thus would reach a fuller understanding of the phenomena being studied because he or she would not be limited by a set of assumptions or methods drawn from only one field of psychology. (p. 1075)

According to Sternberg and Grigorenko, it is the tendency of psychologists to identify with a specific perspective or methodology that creates unnecessary and unproductive diversity within psychology. This can be avoided by realizing that psychological phenomena are most effectively studied from a variety of perspectives. They offer the study of learning as an example:

If one considers a basic psychological phenomenon, such as learning, one realizes that it can be studied in terms of an evolutionary paradigm, a brain-based biological paradigm, a cognitive paradigm, a behaviorist paradigm, a psychoanalytic paradigm, a genetic-epistemological paradigm, and so forth. There is no one correct perspective. Each perspective presents a different way of understanding the problem of learning. (p. 1075)

Sternberg (2005) presents several strategies that could be used to accomplish the difficult task of unifying psychology.

We see that in the more than 100 years since James made his assessment of psychology, and in the more than seven decades since Heidbreder's assessment, the situation has not significantly changed. Most would agree that psychology is still a collection of different facts, theories, assumptions, methodologies, and goals. It is still not clear how much of psychology is scientific or even can be scientific, and even those who believe psychology can be a science debate over what type of a science it should be.

Some psychologists see psychology's diversity as necessary because of the complexity of humans. Others see it as a sign that psychology has failed to carefully employ scientific method. Still others say that psychology is diverse because it is still in the preparadigmatic stage that characterizes the early development of a science. Thus, psychology is characterized by diversity even regarding opinions as to what its ultimate status can be. The answers to the question, Is psychology a science? include the following: no, it is a preparadigmatic discipline; no, its subject matter is too subjective to be investigated scientifically; no, but it could and should be a science; yes and no, some of psychology is scientific, and some is not; yes, psychology is a scientific discipline with a core content and a shared scientific methodology. The answer then depends on who is asked and which aspect of psychology is considered.

Psychology's status as a science features prominently in the current debate between modernism and postmodernism, to which we turn next.

POSTMODERNISM

Premodernism refers to the belief, prevalent during the Middle Ages, that all things, including human behavior, could be explained in terms of church dogma. The questioning of church authority began in the Renaissance and eventually led to

more objective modes of inquiry. Individuals such as Newton. Bacon, and Descartes demonstrated the explanatory power of reason that was unencumbered by authority and bias. The Enlightenment ensued, and experience and reason were emphasized in the quest for knowledge (see Chapter 7). The terms modernism and Enlightenment have come to be used synonymously (Norris, 1995, p. 583). The ideals of the Enlightenment began to be challenged by such philosophers as Hume and Kant (see Chapters 5 and 6), who demonstrated the limitations of human rationality. Also, romanticism and existentialism (see Chapter 7) can be viewed as a reaction against the Enlightenment belief that human behavior can be explained in terms of abstract universal laws or principles. Kierkegaard's claim that "truth is subjectivity" and Nietzsche's "perspectivism" are two clear examples of this opposition. Later, William James's concepts of radical empiricism and pragmatism (see Chapter 11) showed a similar disdain for universalism. In fact, James referred to absolutism as "the great disease of philosophical thought" (1890/1950, Vol. 1, p. 353).

Since about the mid-1960s, postmodernism (also called social constructionism and deconstructionism) has renewed the attack on Enlightenment ideals. In essence, the postmodernist believes that "reality" is created by individuals and groups within various personal, historical, or cultural contexts. This, of course, contrasts with the modernist (Enlightenment) belief that reality is some immutable truth waiting to be discovered by experience. unbiased reason, or the methods of science. Postmodernism has much in common not only with romanticism, existentialism, and aspects of James's psychology but also with the ancient philosophies of the Sophists and Skeptics. In Chapter 2 we noted that the Sophists believed that there was not one truth but many truths, and these truths varied with individual experience. It was Protagoras who said, "Man is the measure of all things," thus anticipating much of postmodernism. In fact, Roochnik (2000, lecture 7) says, "The contemporary Sophist is called a postmodernist." In Chapter 3 we noted that the Skeptics questioned all dogmatism; that is, all claims of indisputable truth. This

theme of questioning the existence of universal truth, which began in ancient philosophy, was reborn in romantic and existential philosophy and has been perpetuated into contemporary psychology by "third-force" or humanistic psychology (see Chapter 18). What postmodernism shares with the Sophists, Skeptics, romantics, existentialists, and humanistic psychologists is the belief that "truth" is always relative to cultural, group, or personal perspectives. In fact, postmodernism has been referred to as "radical relativism" (Smith, 1994, p. 408). (1999)provides Fishman an overview postmodernism:

A core idea in postmodernism is that we are always interpreting our experienced reality through a pair of conceptual glasses—glasses based on such factors as our present personal goals in this particular situation, our past experiences, our values and attitudes, our body of knowledge, the nature of language, present trends in contemporary culture, and so forth. It is never possible to take the glasses off altogether and view the world as it "really is," with pure objectivity. All we can do is change glasses and realize that different pairs provide different pictures and perspectives of the world. (p. 5)

Ludwig Wittgenstein

Language Games. Postmodernists find support for their relativism in the concept of language games proposed by the influential Austrian philosopher Ludwig Wittgenstein (1889–1951). In his *Philosophical Investigations* (1953/1997), published posthumously, Wittgenstein argued that the only meaning that terms and concepts have is that which is assigned to them within a community. According to Wittgenstein, language is a tool used by members of a community to communicate with one another. Each community determines the meaning of its own language and determines the rules according to which language is used. That is, each

community creates its own language games, which, in turn, create its own "form of life." Clearly, Wittgenstein did not employ the term game in a frivolous or unimportant sense. To understand a community is to understand its language games. Wittgenstein (1953/1997, pp. 11-12) provided a partial list of language games that may characterize a community; they include the accepted ways of giving and obeying orders, describing and measuring objects, reporting and speculating about events, forming and testing hypotheses, making up and reading stories, acting, singing, telling jokes, solving arithmetic problems, asking questions, cursing, greeting, and praying.

For Wittgenstein, then, it is wrong to view language as reflecting a mind-independent reality. Instead, he said, language creates reality. Thus he, like the postmodernists, rejected the "correspondence theory of truth" (see Chapter 1). Communication problems occur when language games from different communities are mixed or when language games within a community are misused. Wittgenstein didn't deny the existence of a physical world nor that our senses bring us into contact with

Ludwig Wittgenstein

that world. Rather, he argued that people can, and do, give their experiences a wide variety of meanings. Sluga and Stern (1996) give an example: "A coin is currency, but that doesn't destroy its reality as a metal disc existing independently of our belief in it" (p. 359). Furthermore, there must be regularity to our experience of the physical world for some language games to have meaning, Wittgenstein gives, as an example, the weighing of a commodity to determine its buying and selling price: "The procedure of putting a lump of cheese on a balance and fixing the price by the turn of the scale would lose its point if it frequently happened for such lumps to suddenly grow or shrink for no obvious reason" (1953/1997, p. 56).

According to Wittgenstein, most, if not all, disputes among philosophers and psychologists could be resolved by understanding that different philosophical and psychological paradigms reflect their own language games. In other words, paradigms must be understood within the context of their own meanings and their own agendas. For Wittgenstein the great philosophical debates that occurred over the centuries were not over conflicting realities but over conflicting language games. For example, "Wittgenstein calls our attention to the fact that the explanation [of behavior] by causes and the explanation by reasons correspond to two different language games" (Bouversse, 1995, p. 73). Likewise, the traditional debates over materialism versus idealism, free will versus determinism, rationalism versus empiricism, nominalism versus realism, science versus nonscience, and those concerning mind-body relationships are, according to Wittgenstein, debates over linguistic practices. What then is the role of philosophy? According to Wittgenstein, "Philosophy is a battle against the bewitchment of our intelligence by means of language" (1953/1997, p. 47). In agreement with Wittgenstein, Gergen (2001) says, "Theoretical accounts of the world are not mirror reflections of the world but discursive actions within a community" (p. 811). It should be clear that Kuhn's philosophy of science (see Chapter 1) has much in common with Wittgenstein's philosophy. In fact, Kuhn concluded his highly influential The Structure of Scientific Revolutions (1996) with this very Wittgensteinian statement: "Scientific knowledge, like language, is intrinsically the common property of a group or else nothing at all. To understand it we shall need to know the special characteristics of the groups that create it" (p. 20).

Family Resemblance. Beginning with Socrates, Plato, and Aristotle and continuing through Scholasticism to the present, there have been philosophers who believed that to be a member of a category required the possession of some defining characteristic. That is, to be a member of a category, an instance must manifest the essence of that category. For example, for something to be considered beautiful or just, it must possess the essence of beauty or justice. Wittgenstein rejected this argument. Once again, he beckons us to observe how words are actually used within a community. As an example, he describes the numerous activities we refer to as "games" (1953/1997, pp. 31-32). He notes that there are board games, card games, ball games, and Olympic games, among others. Some require considerable intellectual or physical skill, others less. Some can be played alone; others cannot. Some involve winning and losing; others do not. What is the common element among these activities that make them all games? According to Wittgenstein, there is none. Instead, they are related in the same way that family members are related. Family members may share many characteristics. For example, they may tend to have similar eyes, noses, chins, heights, hair colors, temperaments, gaits, and so forth. However, not all family members share the same characteristics. A child may have its father's eyes and its mother's hair. Another child may have its grandmother's sense of humor and its grandfather's chin, and so forth. In other words, there is a cluster of traits that "overlap and crisscross" within a family, but there is no essence or universal characteristic shared by all family members. So it is with games and all other concepts. For Wittgenstein, then, the search for essences or universals is doomed to failure. Thus, Wittgenstein replaced the traditional concept of essence or universal with that of family resemblance. Games are

games, horses are horses, and beautiful things are beautiful things not because each instance of such things reflects a universal essence but because there is a family resemblance among them. Eleanor Rosch and Carolyn Mervis (1975) found empirical support for Wittgenstein's contention that family resemblances, not defining features (essences), are utilized in human categorization.

According to Wittgenstein, there is nothing to be discovered by rational analysis. When one describes how words are actually used, one discovers that general categories are formed on the basis of family resemblance, not on the basis of essence. Again, Wittgenstein argued that most, if not all, philosophical debates can be resolved by noting how language is actually used within a verbal community. He believed philosophy should be descriptive rather than theoretical, saying, "We must do away with all explanation and description alone must take its place" (1953/1997, p. 47) and "Philosophy simply puts everything before us, and neither explains nor deduces anything. Since everything lies open to view there is nothing to explain. For what is hidden, for example, is of no interest to us"(1953/1997, p. 50). Stroll (2002) summarizes Wittgenstein's position as follows:

Wittgenstein is urging that one compare and contrast cases in order to see how words like "number," "game," and "tool" are used in ordinary life. The method is applicable to all concepts traditional philosophers have explored. It replaces the search for the essence of things and the need to "penetrate phenomena" by an example-oriented, case by case description of the uses of words. (p. 116)

Both Wittgenstein and the postmodernists agree that what is considered "true" within one community may not have validity beyond the community that defined it as such. Gergen (1994) gives an example:

We are urged to consider, for example, the effects on the culture of such terms as *depression*, defined as a psychological

disorder, reified in our measures, and treated chemically. How is it that peoples in other cultures and preceding centuries manage(d) without such a concept, yet contemporary psychologists detect depression in all corners of society (now even in infants), and over six million Americans now "require" Prozac? What professions stand to profit by this particular set of constructions and practices? Is it possible that the public has served as an unwitting victim? (p. 414)

In other words, according to Gergen, and others (for example, Szasz, 1974), it is possible that a psychological community has created the concept of depression, and other forms of "mental illness" because doing so has meaning, and benefits, for members of that community. This, however, should not be taken as evidence that such illnesses actually exist in some more objective sense. They represent language games created and utilized by a specific psychological community for its own purposes.

The tension between modernism and postmodernism continues in contemporary psychology. When psychology became a science in the late 19th century, it sought the laws that govern the human mind. The goal was to understand the human mind in general, not in particular. Techniques and theories have changed through the years, but the search for the general laws governing human conduct has never wancd. This belief that science can unveil the truth about human nature has been, and is, a major theme in the history of psychology. For the scientifically inclined psychologist, the methods used to understand human behavior are the same as those used by the natural scientists to understand the physical world. Postmodernism rejects this natural science model.

Perhaps another way of understanding the cultural differences within psychology discussed earlier in this chapter is in terms of modernism and post-modernism. Psychologists embracing modernism value the methods of natural science in their search for the general laws governing human behavior. Psychologists embracing postmodernism see science

as only one approach, among many, to understanding humans. In any case, a sometimes heated debate between modernism and postmodernism exists in contemporary psychology. For arguments in favor of postmodernism, see, for example, Gergen, 1991, 1994, 2001. For arguments against postmodernism, see, for example, M. B. Smith, 1994.

As has been the case with most dichotomies in psychology's history, compromises have been suggested between modernism and postmodernism. For proposals that contain elements of both modernism and postmodernism, see, for example, Fishman (1999), who features pragmatism in his compromise, and Schneider (1998), who features romanticism. Also, the approach to unifying psychology suggested by Sternberg and Grigorenko (2001; discussed earlier) is similar to the approach to studying psychology suggested by the postmodernist. Both argue that psychology's problems would be best solved by approaching them from multiple perspectives.

IS THERE ANYTHING NEW IN PSYCHOLOGY?

No doubt, some aspects of psychology are newer and better than they have ever been. A number of techniques have been developed that have vastly increased our ability to study brain functioning. These techniques include electroencephalography (EEG), magnetic resonance imaging (MRI), computerized tomography (CT), and positron emission tomography (PET). Also, a variety of new drugs have provided psychobiologists with powerful research tools. In addition to their involvement in biological research and their use as a model for understanding cognitive processes, computers allow for complex data analysis that only a few years ago would have been impossible. So the answer to the question, Is there anything new in psychology? must be yes. But note that our examples were all technological rather than conceptual. When we look at the larger issues, the answer to our question seems to be negative. Throughout psychology's history, emphases have changed and research tools have improved, but it seems that psychology is still addressing the same questions it has addressed since its inception. Because we elaborated on psychology's persistent questions and issues in Chapter 1, we will simply list them here:

- What is the nature of human nature?
- How are the mind and body related?
- To what extent are the causes of human behavior innate as opposed to experiential?
- To what extent, if any, is human behavior freely chosen as opposed to completely determined?
- Is there some vital (nonmaterial) force in human nature that prevents a completely mechanistic explanation of human behavior?
- To what extent do the irrational aspects of human nature (for example, emotions, intuitions, and instincts) contribute to human behavior as opposed to the rational aspects?
- How are humans related to nonhuman animals?
- What is the origin of human knowledge?
- To what extent does objective (physical) reality determine human behavior as opposed to subjective (mental) reality?
- What accounts for the unity and continuity of experience?
- Are there knowable universal truths about the world in general or people in particular, or must truth always be relative to an individual or group perspective?

Psychology's persistent questions are essentially philosophical questions, and so proposed answers to them will always be tentative and uncertain. The following point made by Bertrand Russell (1945) pertains to the major questions addressed by both philosophy and psychology:

Science tells us what we can know, but what we can know is little, and if we forget how much we cannot know we become insensitive to many things of very great importance. Theology, on the other hand, induces a dogmatic belief that we have knowledge where in fact we have ignorance, and by doing so generates a kind of impertinent insolence towards the universe. Uncertainty, in the presence of vivid hopes and fears, is painful, but must be endured if we wish to live without the support of comforting fairy tales. It is not good either to forget the questions that philosophy asks, or to persuade ourselves that we have found indubitable answers to them. (p. xiv)

In his book *The Limits of Science* (1985), Peter Medawar agrees with Russell that science's ability to answer certain questions is unequaled, but there are crucial questions that science cannot answer. Medawar argues that such questions are more appropriately addressed by philosophy, or even—contrary to Russell—by theology.

However, it is not necessary to label psychology's persistent questions as philosophical to demonstrate that they cannot be answered with certitude. As seen in Chapter 1, Popper said that there are no final truths even in science. The highest status that a scientific explanation can have is "not yet disconfirmed." Although Popper and Kuhn differed in their basic conceptions of science, both believed in the dynamic nature of "scientific truth." Kuhn said, "All past beliefs about nature have sooner or later turned out to be false. On the record, therefore, the probability that any currently proposed belief will fare better must be close to zero" (Kuhn, 2000b, p. 115). All explanations, even scientific explanations, will eventually be found to be false; the search for truth is unending. Thus, important questions, whether approached philosophically or scientifically, must be persistent questions.

It also appears that through the centuries, philosophers, theologians, and psychologists have discovered partial truths about humans and have confused them with the whole truth. When these individuals were convincing and the time was right,

their ideas became popular enough to grow into schools. Perhaps to ask whether the voluntarists, structuralists, functionalists, behaviorists, Gestaltists, psychoanalysts, and the humanistic psychologists were right or wrong is to ask the wrong question. A better question might be, How much of the truth about humans was captured by each of these viewpoints? Perhaps they are all partially correct, and perhaps there are many other truths about humans not yet revealed by any viewpoint. As Jung (1921/1971) said,

The assumption that only *one* psychology exists or only *one* fundamental psychological principle is an intolerable tyranny, a pseudo-scientific prejudice Even when this is done in a scientific spirit, it should not be forgotten that science is not the *summa* of life, that it is actually only . . .

one of the forms of human thought. (p. 41)

Where does this leave the student of psychology? Psychology is not a place for people with a low tolerance for ambiguity. The diverse and sometimes conflicting viewpoints that characterize contemporary psychology will undoubtedly continue to characterize psychology in the future. There is growing recognition that psychology must be as diverse as the humans whose behavior it attempts to explain. For those looking for the "one truth," this state of affairs is distressing. For those willing to ponder several truths, psychology is and will continue to be an exciting field. If Heraclitus was correct in believing that "all things are born in flux," contemporary psychology is in a perfect position to have multiple births.

SUMMARY

Contemporary psychology is a diverse discipline that reflects a wide variety of historical influences. In contemporary psychology, there is a spirit of eclecticism, a willingness to employ whatever methods are effective in studying various aspects of humans. Psychology's great diversity is shown in the 54 divisions of the APA. From its inception, there was tension within psychology between those wanting it to be purely scientific and those seeking to apply psychological principles to the solution of practical problems. When the APA was founded in 1892, its goal was to promote psychology as a science; however, most of the charter members were also sympathetic toward applied psychology. An exception was Titchener who, like his mentor Wundt, had disdain for applied psychology.

The clinical psychology founded by Witmer in 1896 had little in common with modern clinical psychology. Until World War II, the primary function of clinical psychologists was to administer psychological tests and evaluate test performance. As the emphasis on testing grew, so did the tension between pure, scientific and applied psychologists.

Because large numbers of World War II veterans needed psychotherapy, the Veterans Administration funded programs to train psychologists as psychotherapists. Gradually, psychotherapy became the primary function of clinical psychologists. As the number of applied psychologists (such as clinicians) increased, they began creating their own organizations independent of the APA through which to pursue their professional interests. Eventually, the APA reacted by creating divisions that reflected both scientific and applied interests. The resulting peace was only temporary because applied psychology came to dominate the APA. As the applied psychologists had done earlier, scientific psychologists began to perceive themselves as second-class members of the APA, and they reacted by creating their own organizations. The tension between pure, scientific psychologists and applied psychologists also manifests itself in the current controversy concerning the training of clinical psychologists. One view is that clinical psychologists should receive the same rigorous training as does any other PhD in psychology. That is, clinicians should be scientist-practitioners. The other view is that clinical psychologists should be trained in the professional application of scientific principles but not trained in scientific methodology. That is, clinicians should earn PsyDs. As clinical psychologists entered the realm of psychotherapy, they were brought into conflict with psychiatrists, and numerous court battles ensued concerning the rights of clinical psychologists. With the recent granting of prescriptive privileges to clinical psychologists in New Mexico and Louisiana, the services legally provided by psychiatrists and psychologists in those states are essentially the same. There is little doubt that other states will also grant prescriptive privileges in the near future.

James noted that a philosopher's temperament inclines him or her toward tender-minded (subjective) philosophy or tough-minded (objective) philosophy. The scientist-novelist C. P. Snow observed that the values accepted by scientists and those accepted by individuals in the humanities are so distinct as to reflect two separate cultures. Kimble provided evidence that something like James's two temperaments and Snow's two cultures also exist in contemporary psychology. Perhaps the tension between pure, scientific and applied psychologists might be explained by the existence of two incommensurable cultures within psychology.

In 1892 James concluded that psychology was still hoping to become a science. In 1933 Heidbreder reached more or less the same conclusion. More recently, Koch argued that although some aspects of psychology are scientific, most are not. Also, Staats observes that psychology is a disunified discipline, but he suggests that with considerable effort it could become a unified science. Only rarely does someone claim, as Matarazzo does, that psychology is a unified science. Several suggestions have been offered as to how psychology might become a unified discipline, but contemporary psychology remains highly diversified. Now, as throughout history, psychology's status as a science is difficult to determine.

Premodernism refers to the belief held during the Middle Ages that religious dogma explains everything. Starting with the Renaissance humanists, religious authority was questioned and modernism,

or the Enlightenment, ensued. Stimulated by the work of such individuals as Newton, Bacon, and Descartes, a search for the universal laws or principles governing human behavior began. This search was stimulated by Newton's success in explaining most physical phenomena in terms of only a few scientific principles. Modernism embraced objective rationality and empirical observation in its search for truth and came into full fruition in British and French empiricism and positivism. Philosophers such as Hume and Kant demonstrated limitations in the ability of humans to understand physical reality, and the ideals of modernism began to be questioned. For example, the romantic and existential philosophers questioned whether human behavior could be explained in terms of universal, abstract principles. Instead they embraced perspectivism, saying that "truth" is determined by individual or group circumstances. The third-force orhumanistic psychologists also rejected universalism. This belief in the relativity of truth ushered in postmodernism. The relativistic position of postmodernism found support in Wittgenstein's concept of language games. According to Wittgenstein, each community creates the meaning of its own language and, therefore, to understand a language one must understand how it is used within the community that created it. For Wittgenstein, philosophical disputes reflect conflicting language games, and it is the job of philosophy to clarify this fact. Wittgenstein sought to replace the ancient philosophical concept of essence with that of family resemblance. For him, membership in a category can be attained by the possession of one or more features from a set, or family, of features that characterize a category; not just by possessing one feature considered essential. Within contemporary psychology, there is much in common among the ancient philosophies of the Sophists and Skeptics, humanistic (third-force) psychology, and postmodernism.

Psychology has provided considerable information about such things as learning, memory, brain functioning, and childhood and adult thinking and has refined many of its research tools because of technological advances. In a broader sense, however, psychology continues to respond to questions

that the early Greek philosophers posed. Although the emphases have changed—as well as research tools and terminology—psychology continues to address the same issues and questions that it has always addressed. It may be that psychology's persistent issues and questions are philosophical in nature and therefore have no final answers. According to Popper, even if psychology's persistent questions are scientific rather than philosophical, they still

have no final answers and, on this point, Popper and Kuhn were in agreement. It is also possible that various philosophies and psychological schools have provided only partial truths about human nature and that many more truths will be forthcoming. For those with a high tolerance for ambiguity, psychology is and will continue to be an exciting discipline.

DISCUSSION QUESTIONS

- 1. What evidence supports the claim that contemporary psychology is highly diverse? What accounts for this diversity?
- Summarize the history of the controversy concerning psychology as a pure, scientific discipline as opposed to an applied discipline.
- What was the primary function of clinical psychologists before World War II? After World War II?
- 4. Discuss the steps taken by the APA through the years to reduce the tension between pure, scientific psychology and applied psychology.
- 5. How were conflicts between clinical psychologists and psychiatrists resolved? What conflict remains?
- 6. Summarize the arguments for and against the PsyD degree.
- 7. Support or refute Kimble's contention that contemporary psychology consists of at least two incommensurable cultures.
- 8. Is psychology a science? Summarize the various answers to this question reviewed in this chapter.

- 9. What characterized premodern philosophy and psychology?
- 10. What is modernism? Who were its champions and what were its ideals?
- 11. Define postmodernism and give examples of how postmodernist thinking manifested itself throughout the history of psychology.
- 12. Describe the relevance of Wittgenstein's concept of language games to postmodernism.
- 13. How, according to Wittgenstein, are traditional philosophical debates best understood and resolved?
- 14. Discuss Wittgenstein's concept of family resemblance. What older philosophical concept was he attempting to displace with this concept?
- 15. Make a case that the answer to the question, Is there anything new in psychology? is both yes and no.
- 16. Why are psychology's persistent questions so persistent?

SUGGESTIONS FOR FURTHER READING

Fishman, D. B. (1999). *The case for pragmatic psychology*. New York: New York University Press.

Gergen, K. J. (2001). Psychological science in a post-modern context. *American Psychologist*, 56, 803–813.

- Grayling, A. C. (2001). Wittgenstein: A very short introduction. New York: Oxford University Press.
- Hacker, P. M. S. (1999). Wittgenstein on human nature. New York: Routledge.
- Powell, J. (1998). *Postmodernism for beginners*. New York: Writers and Readers Publishing.
- Schulte, J. (1993). Experience and expression: Wittgenstein's philosophy of psychology. New York: Oxford University Press.
- Sternberg, R. J. (Ed.). (2005). *Unity in psychology:*Possibility or pipedream? Washington, DC: American Psychological Association.
- Sternberg, R. J., & Grigorenko, E. L. (2001). Unified psychology. *American Psychologist*, 56, 1069–1079.
- Viney, W. (1989). The cyclops and the twelve-eyed toad: William James and the unity-disunity problem in psychology. *American Psychologist*, 44, 1261–1265.

GLOSSARY

Doctor of Psychology (PsyD) The doctoral degree in clinical psychology that emphasizes training in the professional application of psychological principles rather than in scientific methodology.

Eclecticism The willingness to employ the most effective methods available in solving a problem.

Family resemblance Wittgenstein's contention that a category does not have a defining feature (essence) that must be shared by all members of the category. Rather, there is a set of features distributed among members of a category, with no single feature essential for inclusion in the category.

Language games According to Wittgenstein, the linguistic conventions that guide activities within a community. Taken collectively, language games describe a community's "form of life."

Modernism The belief that improvement in the human condition can come about only by understanding and applying the abstract, universal principles that govern the universe (including human behavior). In the search for these principles, unbiased rationality and empirical

observation were emphasized. The period during which this belief prevailed is called the Enlightenment.

Postmodernism Opposes the search for abstract, universal laws or principles thought to govern human behavior. Instead of being governed by abstract, universal laws or principles, human behavior, say the postmodernists, can be understood only within the cultural, group, or personal contexts within which it occurs.

Premodernism The belief that prevailed during the Middle Ages that all things, including human behavior, can be explained in terms of religious dogma.

Weltanschauung Worldview or world-design.

Wittgenstein, Ludwig (1889–1951) Argued that philosophical debates are over the meaning of words rather than over some truth or truths that exist independently of linguistic conventions. In other words, he argued that philosophical debates are over language games. He also argued that the ancient concept of essence should be replaced by the concept of family resemblance. (See also Family resemblance and Language games.)

Appendix

Significant Individuals and Events in the History of Psychology

Thales (ca. 625–547 B.C.) Begins to replace supernatural explanations of the universe with naturalistic ones; encourages criticism and improvement of his teachings.

Heraclitus (ca. 540–480 B.C.) Observes that everything in the empirical world is in a constant state of flux and therefore can never be known with certainty.

Anaxagoras (ca. 500–428 B.C.) Proposes a universe consisting of an infinite number of elements or "seeds." Each seed contains all the others, but objects become differentiated depending on which seed dominates. Mind is an exception because it contains no other seeds and is responsible for life.

Protagoras (ca. 485–410 B.C.) Argues that "truth" can be understood only in terms of an individual's perceptions and beliefs.

Hippocrates (ca. 460–377 B.C.) Argues that both mental and physical disorders have natural causes; a physician's primary task is to facilitate the body's natural healing ability.

Democritus (ca. 460–370 B.C.) Proposes a completely materialistic universe wherein everything consists of atoms.

Antisthenes (ca. 445–365 B.C.) Preaches Cynicism or a back-to-nature philosophy whereby life is lived free from wants, passions, and the conventions of society.

Plato (ca. 427–347 B.C.) Postulates a dualistic universe consisting of abstract forms and matter. Because only the forms are changeless, they alone can be known with certainty.

Aristotle (384–322 B.C.) Argues that an understanding of nature must begin with its direct examination. Everything in nature has an inherent purpose that seeks to manifest itself.

Pyrrho of Elis (ca. 360–270 B.C.) Observes that because the arguments for or against any belief are equally valid, the only reasonable position is Skepticism or the withholding of belief in anything.

Epicurus of Samos (ca. 341–270 B.C.) Encourages living a simple life of moderation and one that is free of superstition. Such a philosophy came to be called Epicureanism.

Zeno of Citium (ca. 335–263 B.C.) Founds the philosophy of Stoicism with his beliefs that nature is governed by a divine plan and that living in accordance with that plan with courage and dignity is the ultimate good.

Philo (ca. 25 B.C.–A.D. 50) A Neoplatonist, preaches that God will reveal knowledge to souls properly prepared to receive it.

Galen (ca. 129–199) Perpetuates the naturalistic medicine of such Greeks as Hippocrates into the Roman

empire and extends the theory of four humors into a rudimentary theory of personality.

Constantine (ca. 272–337) Signs the Edict of Milan in 313, making Christianity a tolerated religion in the Roman empire.

Augustine (ca. 354–430) Combines Stoicism, Neoplatonism, and Judaism into a powerful Christian teleology, according to which evil exists because people choose it and God can be experienced personally through introspection.

■ 400–1000 The Dark Ages. Europe is generally dominated by mysticism and superstition.

Avicenna (980–1037) A Muslim philosopher/physician, applies Aristotelian philosophy to a wide range of topics and attempts to make it compatible with Islamic theology.

Anselm (ca. 1033–1109) Adds reason to the ways of knowing God with his ontological argument for the existence of God.

Peter Lombard (ca. 1095–1160) Argues that God can be known through the scriptures, through reason, or by studying nature.

Maimonides (1135–1204) A Jewish scholar and physician, attempts to reconcile Judaism and Aristotelian philosophy.

Thomas Aquinas (1225–1274) Succeeds in making Aristotelian philosophy the basis of Christian theology.

William of Occam (ca. 1285–1349) Argues that explanations should always be as parsimonious as possible (Occam's razor). In the realist-nominalist debate, he sides with the nominalists, thereby encouraging Empiricism.

Francesco Petrarch (1304–1374) Sometimes considered the father of the Renaissance, argues for the full exploration and manifestation of human potential.

Desiderius Erasmus (1466–1536) Opposes fanaticism, religious ritual, and superstition. Argues that fools are better off than "wise" persons because fools live in accordance with their true feelings.

Nicolaus Copernicus (1473–1543) Writes *De Revolutionibus Orbium Coelestium* (*The Revolutions of the Heavenly Spheres*; published in 1543), in which he proposes the heliocentric theory of the solar system.

Cornelius Agrippa (1486–1535) The first physician to urge that witch hunts be stopped because those accused of being witches, or of being bewitched, are actually mentally disturbed.

■ 1487 Heinrich Kramer and James

Sprenger Publish *Malleus Maleficarum (The Witches' Hammer)*.

Philippus Paracelsus (1493–1541) Among the first physicians to suggest that the unusual behavior displayed by "witches" and those bewitched have natural rather than supernatural origins.

■ 1517 Martin Luther (1483–1546) Nails his Ninety-Five Theses on the door of Wittenberg Castle Church, thereby beginning the Reformation.

Michel de Montaigne (1533–1592) Reintroduces radical Skepticism into the late Renaissance.

Francis Bacon (1561–1626) Argues for an inductive science based on the direct examination of nature and the careful generalization of those observations. Theory must be avoided because it biases observations. Believes science should provide practical information.

Galileo (1564–1642) Through experimentation, finds many previously held beliefs about nature to be false. This brings Galileo into conflict with the church because many of these fallacies were part of church dogma. Denies that cognitive experience can be studied scientifically, thereby inhibiting the development of experimental psychology.

Thomas Hobbes (1588–1679) Views humans as matter in motion and argues that all knowledge is derived from sensory experience and that all human motivation and emotions are reducible to hedonism. Governments are formed to protect people from one another.

Pierre Gassendi (1592–1655) Like Hobbes, says humans consist of nothing but matter, thus rejecting dualism in favor of physical monism.

René Descartes (1596–1650) Uses the method of doubt to confirm the validity of his subjective experiences. Concludes that several important ideas are innate and that humans consist of a physical body and a non-physical mind. The human mind provides consciousness, free choice, and rationality.

■ 1600 Giordano Bruno (1548–1600) Burned at the stake for heresy.r

John Locke (1632–1704) Forcefully argues against the existence of innate ideas, saying instead that all ideas are derived from experience. Once they exist, however, ideas can be rearranged in countless ways by reflection. Also distinguishes between primary and secondary qualities.

Baruch Spinoza (1632–1677) Equates God and nature, and claims mind and matter are inseparable. All things in nature, including humans, are governed by natural law and thus free will does not exist.

Isaac Newton (1642–1727) Describes the universe as a complex, lawful machine governed by the law of gravitation and precisely describable in mathematical terms. Explanations of nature must be parsimonious and devoid of theological considerations.

Gottfried Wilhelm von Leibniz (1646–1716) Argues that experience can only actualize ideas that already exist within us. Everything in nature consists of monads, which vary in their ability to think clearly. For an experience to be conscious, aggregates of monads must exceed a threshold; otherwise the experience remains unconscious.

George Berkeley (1685–1753) Denies the existence of a material world, saying instead that only perceptions (ideas) exist. Thus, "To be is to be perceived."

David Hartley (1705–1757) Supplements associationism with speculations about neurophysiology.

Julien de La Mettrie (1709–1751) Publishes *L'Homme Machine* (*Man a Machine*) in 1748; in it he embraces physical monism and argues that the differences between human and nonhuman animals is quantitative, not qualitative.

Thomas Reid (1710–1796) Argues that we can assume physical reality is as we perceive it because it makes common sense to do so. Innate faculties of the mind facilitate the accurate perception of the physical world.

David Hume (1711–1776) Argues that humans can never know the physical world with certainty because all we ever experience are the ideas created by that world (for example, causation is a mental habit and may or may not correspond to anything in the physical world).

Jean-Jacques Rousseau (1712–1778) Initiates the modern romantic movement by claiming that human feelings are better guides for living than rational deliberations.

Étienne Bonnot de Condillac (1715–1780) Demonstrates that a statue capable of only sensation, memory, and the feelings of pleasure and pain can display all human faculties and abilities.

Immanuel Kant (1724–1804) Argues that external reality can never be known because conscious experience always results from the interaction between sensory experience and the innate categories of thought. Believes

psychology cannot be scientific because introspection is an unreliable method of studying the mind.

Franz Anton Mesmer (1734–1815) Claims to cure disorders by redistributing animal magnetism in his patients.

Jean Lamarck (1744–1829) Publishes his *Philosophie Zoologique* in 1809, in which he elaborates his theory of the inheritance of acquired characteristics.

Benjamin Rush (1746–1813) Sometimes referred to as the first psychiatrist in the United States, argues against slavery, capital and public punishment, and the inhumane treatment of prisoners and the mentally ill.

Philippe Pinel (1745–1826) Appointed director of the Bicêtre Asylum in 1793 and begins releasing inmates from their chains. In addition, he segregates different types of patients, encourages occupational therapy, bans punishment and exorcism, and maintains precise case histories and statistics on patient cure rates.

Franz Joseph Gall (1758–1828) Claims that the extent to which one possesses various faculties can be determined by examining the bumps and depressions on the skull. Gall's colleague **Johann Gasper Spurzheim** (1776–1832) called such an examination *phrenology*.

Georg Wilhelm Friedrich Hegel (1770–1831) Views the universe as an interrelated whole, which he called the Absolute, and argues that nothing can be understood except in its relationship to the Absolute. Understanding of the Absolute is approached via the dialectic process.

James Mill (1773–1836) Argues that any idea, no matter how complex, can be understood in terms of the simple ideas it comprises.

Johann Friedrich Herbart (1776–1841) Argues that ideas compete for conscious expression; successful ideas become part of the apperceptive mass, but unsuccessful ideas remain unconscious.

Arthur Schopenhauer (1788–1860) Argues that the only relief from the unending cycle of needs and need-satisfaction comes from the sublimation, denial, or repression of those needs. Only a strong will to survive prevents most people from committing suicide.

Pierre Flourens (1794–1867) Performs experiments that demonstrate the cerebral cortex functions as an interrelated whole, not divided into discrete faculties as the phrenologists had claimed.

Ernst Heinrich Weber (1795–1878) Observes that just noticeable differences (jnds) in variable stimuli

correspond to a constant fraction of a standard stimulus (Weber's law).

Auguste Comte (1798–1857) Promotes positivistic philosophy according to which only publicly observed phenomena can be known with certainty; metaphysical speculation is to be actively avoided.

Johannes Müller (1801–1858) Formulates the doctrines of specific nerve energies and adequate stimulation.

Gustav Theodor Fechner (1801–1887) By noting that for sensations to rise arithmetically, the magnitude of the physical stimulus must rise geometrically, creates the field of psychophysics. Also creates the field of experimental esthetics.

Dorothea Lynde Dix (1802–1887) Campaigning for over 40 years, vastly improves the plight of the mentally ill in the United States and Europe.

John Stuart Mill (1806–1873) Argues that simple ideas can combine and form ideas different from the simple ideas of which they are comprised (mental chemistry). Believes that a science of psychology is possible, which would describe human nature in general, and that the discipline of ethology would explain individual differences.

Charles Darwin (1809–1882) Publishes *On the Origin of Species by Means of Natural Selection* in 1859; in it he describes how animals with adaptive features survive and reproduce and how those without such features do not.

Søren Kierkegaard (1813–1855) Urges a return to the personal, introspective religion described by Augustine. Truth must be understood in terms of what is privately and emotionally embraced by an individual; thus, "Truth is subjectivity."

Alexander Bain (1818–1903) Seeks the biological correlates of cognition and behavior. His analysis of voluntary behavior resembles the later analyses of Thorndike and Skinner. Marks the transition between philosophical and scientific psychology. Founds the journal *Mind* in 1876.

Herbert Spencer (1820–1903) Erroneously generalizes Darwinian principles to societies, thus creating social Darwinism.

Hermann von Helmholtz (1821–1894) Promotes positivist medicine, measures the rate of nerve conduction, and makes significant contributions to an understanding of color vision, hearing, and perception in general.

Francis Galton (1822–1911) Publishes Hereditary Genius: An Inquiry Into Its Laws and Consequences in 1869; in it he argues that intelligence is largely inherited and therefore eugenics should be practiced. Galton's intense interest in individual differences inspired him to create a number of methodologies that have become standard in psychology (for example, questionnaires, word association tests, twin studies, and the correlational technique).

Paul Broca (1824–1880) Conclusively demonstrates that an area on the left hemisphere of the cortex is specialized for speech (Broca's area). Also perhaps incorrectly concludes that brain size and intelligence are positively correlated.

Jean-Martin Charcot (1825–1893) Speculates that in individuals predisposed to hysteria, trauma may cause certain ideas to become dissociated from consciousness and grow strong enough to cause the symptoms associated with hysteria. Charcot's speculations significantly influenced Freud.

Ivan M. Sechenov (1829–1905) Founds Russian objective psychology with the publication of *Reflexes of the Brain* in 1863.

Wilhelm Maximilian Wundt (1832–1920) Founds voluntarism, psychology's first school. This school was very much in the rationalistic tradition with its emphasis on will and purpose. Founds the journal *Philosophische Studien (Philosophical Studies)* in 1881.

Ewald Hering (1834–1918) Offers a nativistic explanation of space perception and color vision.

Ernst Mach (1838–1916) Promotes a positivistic philosophy according to which sensations are all that humans can be certain of; therefore, scientists must determine the relationships among sensations. As with Comte's version of positivism, metaphysical speculation is to be actively avoided.

Franz Clemens Brentano (1838–1917) Observes that mental acts always refer to (intend) events outside of themselves. With his emphases on mental acts and intentionality, creates the field of act psychology.

Hippolyte Bernheim (1840–1919) Under the influence of **Auguste Ambroise Liébeault** (1823–1904), becomes the major spokesperson of the Nancy school of hypnosis, which claimed that all people can be hypnotized because all people are suggestible.

William James (1842–1910) Publishes *The Principles of Psychology* in 1890. This text is often cited as marking the beginning of the school of functionalism.

Friedrich Wilhelm Nietzsche (1844–1900) Views life as a struggle between the Apollonian (rational) and the Dionysian (irrational) aspects of human nature and an individual's personality as an artistic blending of these two aspects.

Granville S. Hall (1844–1924) Founds the APA in 1892 and serves as its first president. Makes significant contributions to developmental psychology but opposes the coeducation of adolescents and young adults. Invites Freud and Jung to Clark University in 1909. Founds the *American Journal of Psychology* in 1887.

Christine Ladd-Franklin (1847–1930) Offers a theory of color vision based on evolutionary theory.

George John Romanes (1848–1894) Does early work on comparative psychology, but his conclusions are supported only by anecdotal evidence.

Ivan Petrovich Pavlov (1849–1936) Receives the 1904 Nobel Prize for his research on digestion, during which he discovers the conditioned reflex. Believes the conditioned reflex provides an objective, physiological explanation for what psychologists and philosophers had called associationism.

Hermann Ebbinghaus (1850–1909) Publishes *On Memory: An Investigation in Experimental Psychology* in 1885, marking the first time learning and memory are studied experimentally.

Hans Vaihinger (1852–1933) Argues that acting "as if" certain fallacious concepts are true is essential for societal living (for example, the concept of free will).

Conwy Lloyd Morgan (1852–1936) Argues that in explaining animal behavior one should not postulate faculties beyond those that are required to explain the behavior in question (Morgan's canon).

Emil Kraepelin (1856–1926) Publishes a list of mental disorders in 1883 that was so thorough it was utilized worldwide until recent times.

Sigmund Freud (1856–1939) With **Joseph Breuer** (1842–1925), publishes *Studies on Hysteria* in 1895, thereby founding the school of psychoanalysis.

Alfred Binet (1857–1911) With **Theodore Simon** (1873–1961), publishes the Binet–Simon scale of intelligence in 1905. The scale was revised in 1908 and again in 1911.

Vladimir M. Bechterev (1857–1927) Argues that human behavior is reflexive and that it can and should be studied and explained without reference to conscious-

ness. Anticipates many of the features of Watsonian behaviorism.

Edmund Husserl (1859–1938) Proposes a pure phenomenology that describes all the mental processes available to humans in their efforts to understand the world.

John Dewey (1859–1952) Publishes "The Reflex Arc in Psychology" in 1896, which is often viewed as marking the beginning of the school of functionalism.

James McKeen Cattell (1860–1944) Uses the term *mental test* in 1890 and is a key figure in the school of functionalism and in the development of applied psychology.

Hugo Münsterberg (1863–1916) Replaces William James as director of the Harvard Psychology Laboratory in 1892. Makes significant contributions to such applied areas as clinical, forensic, and industrial psychology.

Mary Whiton Calkins (1863–1930) Does pioneering research on memory and creates an influential version of self psychology. In 1905 becomes the first female president of the APA.

Charles Spearman (1863–1945) Does pioneer work on the statistical technique later called factor analysis. Argues that intelligence consists of two factors—specific abilities (s) and general intelligence (g)—and that g is mostly inherited.

Henry Herbert Goddard (1866–1957) Translates the Binet–Simon scale into English, but unlike Binet concludes that intelligence is largely inherited and therefore the feeble–minded should be discouraged from reproducing.

Edward Bradford Titchener (1867–1927) Founds the school of structuralism, which seeks to describe the basic elements of thought and to explain how those elements combine in accordance with the laws of associationism.

Lightner Witmer (1867–1956) Establishes the first psychological clinic in 1896. In 1907 founds the journal *The Psychological Clinic*, and coins the term *clinical psychology* in its first issue.

Robert Sessions Woodworth (1869–1962) A key functionalist at Columbia University, promotes dynamic psychology with an emphasis on motivation.

Alfred Adler (1870–1937) Following the termination of his affiliation with Freud, goes on to develop his own theory of personality featuring such concepts as feelings

of inferiority, worldviews, fictional goals, lifestyles, and the creative self.

William Stern (1871–1938) Introduces the term *mental age* (determined by performance on the Binet–Simon test) and suggests mental age (MA) be divided by chronological age (CA), yielding the intelligence quotient (IQ).

William McDougall (1871–1938) Defines psychology as the science of behavior as early as 1905. Focuses on purposive behavior that is instinctive and has perceptual and emotional components.

Margaret Floy Washburn (1871–1939) In 1894 becomes the first woman to receive a PhD in psychology. In 1908 publishes *The Animal Mind*. In 1921 becomes the second female president of the APA (Calkins was first).

Edward Lee Thorndike (1874–1949) A transitional figure between functionalism and behaviorism. Experimentally studies trial-and-error learning and attempts to explain that learning without reference to consciousness. Along with Woodworth, tests the claims of the "mental muscle" approach to education and finds them to be incorrect.

Carl Jung (1875–1961) Following the termination of his affiliation with Freud in 1914, goes on to create his own theory of personality featuring powerful, inherited dispositions (archetypes) that have developed throughout human evolution.

Robert Yerkes (1876–1956) Is largely responsible for creating the Army testing program during World War I and for supporting the argument that many of the nation's ills are caused by people of low intelligence, thus agreeing with Goddard and Terman.

Lewis Madison Terman (1877–1956) Significantly modifies the Binet–Simon scale, thus creating the Stanford–Binet scale that was used to identify gifted children for further study. The first results of Terman's study of gifted children was published as *Genetic Studies of Genius* in 1926, and the study continues to the present.

John Broadus Watson (1878–1958) Publishes "Psychology as a Behaviorist Views It" in 1913, thereby founding the school of behaviorism.

■ 1879 Wilhelm Wundt establishes the first experimental psychology laboratory.

Max Wertheimer (1880–1943) Publishes "Experimental Studies of the Perception of Movement" in 1912, thereby founding the school of Gestalt psychology.

Ludwig Binswanger (1881–1966) Integrates psychoanalytic theory and the writings of Husserl and Heidegger.

Clark Leonard Hull (1884–1952) Creates a hypothetico-deductive theory of learning that he believes to be self-correcting. Most of the intervening variables in this theory are physiological.

Karen Horney (1885–1952) Creates a version of psychoanalysis in which dysfunctional social relationships are seen as the causes of mental disorders instead of the intrapsyche conflict proposed by Freud. In 1923, begins writing a series of articles of special relevance to women. Publishes *Self-Analysis* in 1942, which is considered one of psychology's first self-help books.

Leta Stetter Hollingworth (1886–1939) Does pioneering work in the education of exceptional children. Her *Gifted Children* (1926) becomes a standard text in schools of education.

Edward Chace Tolman (1886–1959) Publishes *Purposive Behavior in Animals and Men* in 1932; in it, learning is explained primarily in terms of cognitive processes.

Edwin Ray Guthrie (1886–1959) Creates a highly parsimonious theory of learning that embraces the law of contiguity but rejects the law of frequency.

Frederic Charles Bartlett (1886–1969) Publishes Remembering: A Study in Experimental and Social Psychology in 1932.

Martin Heidegger (1889–1976) Introduces into psychology such existential concepts as Dasein, authenticity, and thrownness.

Kurt Lewin (1890–1947) Applies Gestalt principles to such topics as personality, motivation, conflict, and group dynamics.

Karl S. Lashley (1890–1958) Summarizes his research on brain functioning in his 1929 APA presidential address. Publishes *Brain Mechanisms and Intelligence*, also in 1929.

■ 1892 The American Psychological Association (APA) is founded under the leadership of G. Stanley Hall.

Percy W. Bridgman (1892–1961) Publishes *The Logic of Modern Physics* in 1927; in it, he proposes that abstract concepts be operationally defined.

■ 1894 The journal *Psychological Review* was founded by James McKeen Cattell and James Mark Baldwin.

Norbert Wiener (1894–1964) Publishes *Cybernetics* in 1948.

Anna Freud (1895–1982) Extends psychoanalytic principles to the treatment and understanding of children, makes significant contributions to the development of ego psychology, and becomes the official spokesperson for psychoanalysis following her father's death.

Jean Piaget (1896–1980) In 1926 begins publishing an influential series of articles and books on intellectual development (genetic epistemology).

Carl Rogers (1902–1987) Publishes Counseling and Psychotherapy: Newer Concepts in Practice in 1942, creating what many consider the first viable alternative to psychoanalysis. Creates a theory of personality featuring such concepts as the organismic valuing process, need for positive regard, conditions of worth, unconditional positive regard, and incongruency.

Karl Popper (1902–1994) Publishes *The Logic of Scientific Discovery* in 1935.

■ 1904 Edward Titchener founds the Experimentalists.

Donald Hebb (1904–1985) Publishes *The Organization of Behavior* in 1949; it describes his speculations about cell assemblies and phase sequences and does much to promote cognitive and physiological psychology.

Burrhus Frederic Skinner (1904–1990) Proposes a positivistic theory of behavior that avoids theory by concentrating on how behavior is modified by its consequences.

■ 1905 Mary Whiton Calkins becomes the first female president of the American Psychological Association.

George Kelly (1905–1967) Creates a largely existential theory of personality according to which people create construct systems to facilitate the accurate anticipation of future events; so-called mental disorders are actually perceptual problems, and therefore the therapist's job is to help clients perceive life differently.

Abraham Maslow (1908–1970) Usually considered the founder of humanistic (third-force) psychology. Creates a theory of personality featuring a hierarchy of needs ranging from physiological needs to self-actualization.

Rollo May (1909–1994) Introduces existential philosophy and psychology into the United States.

Roger Wolcott Sperry (1913–1994) In the 1950s, begins an influential series of experiments on hemispheric functioning using the split-brain preparation.

- 1917 G. Stanley Hall founds the *Journal of Applied Psychology*.
- 1917 The American Association of Clinical Psychologists (AACP) is founded.

- **1919** APA creates the Division of Clinical Psychology.
- 1920 On June 14 Francis Cecil Sumner becomes the first African American to obtain a PhD in psychology.
- 1929 Edwin G. Boring (1886–1968) publishes A History of Experimental Psychology.
- 1941 APA removes the requirement that for full membership in the organization an applicant must have published research beyond the PhD dissertation.
- 1943 Warren McCulloch and Walter Pitts anticipate new connectionism by speculating about "neuro-logical networks."
- 1944 APA reorganizes itself into 18 divisions.
- 1946 APA first publishes American Psychologist.
- 1946 Veterans Administration (VA) funds training programs for clinical psychologists whose functions would include psychotherapy.
- 1949 Boulder Conference on Training in Clinical Psychology endorses the scientist-practitioner model.
- 1949 Claude Shannon and Warren Weaver publish *The Mathematical Theory of Communication*, thereby creating information theory.
- **1950** Edwin G. Boring publishes the second edition of *A History of Experimental Psychology*.
- 1950 Alan Turing (1912–1954) creates the field of artificial intelligence with his article "Computing Machinery and Intelligence."
- 1953 Ludwig Wittgenstein's *Philosophical Investigations* is published.
- 1956 Jerome Bruner, Jacqueline Goodnow, and George Austin publish *A Study in Thinking*.
- 1956 George Miller publishes "The Magical Number Seven, Plus or Minus Two: Some Limits on our Capacity for Processing Information."
- 1958 Allen Newell, J. C. Shaw, and Herbert Simon mark the transition between artificial intelligence and information-processing psychology with their article "Elements of a Theory of Problem Solving."
- 1958 Frank Rosenblatt describes an early neural network.
- **1959** The Psychonomic Society is founded.
- 1959 Noam Chomsky publishes his review of Skinner's *Verbal Learning* (1957).
- 1960 Donald Hebb publishes his 1959 APA presidential address "The American Revolution," in which

he argues that the rigorous scientific methods employed by the behaviorists be applied to the study of cognitive processes.

- 1960 George Miller and Jerome Bruner create the Center for Cognitive Studies at Harvard.
- 1960 Robert I. Watson (1909–1980) publishes "The History of Psychology: A Neglected Area."
- 1961 Marian and Keller Breland publish "The Misbehavior of Organisms."
- 1962 Thomas Kuhn publishes *The Structure of Scientific Revolutions*.
- 1967 Ulric Neisser publishes Cognitive Psychology.
- 1968 University of Illinois offers the first Doctor of Psychology (PsyD) degree.
- 1969 California School of Professional Psychology (CSPP) is founded. Offers the PsyD independently of any college or university.
- 1969 Journal of Cognitive Psychology is founded.
- 1969 Marvin Minsky and Seymour Papert criticize neural networks, thereby significantly reducing interest in them.
- 1973 Karl von Frisch, Konrad Lorenz, and Niko Tinbergen share a Nobel Prize for their work in ethology.
- 1973 Vail Conference on Training in Clinical Psychology endorses freestanding professional schools and the PsyD.
- 1975 Edward Wilson publishes *Sociobiology: The New Synthesis*, thereby creating the field of sociobiology.
- 1976 Ulric Neisser publishes Cognition and Reality.
- 1977 Albert Bandura publishes Social Learning Theory.

- 1980 John Searle presents his "Chinese Room" rebuttal to proponents of strong artificial intelligence.
- 1981 Roger Sperry shares the Nobel Prize in medicine/physiology with David Hubel and Torsten Wiesel for his work on hemispheric specialization using his splitbrain preparation.
- 1984 Gregory Kimble publishes "Psychology's Two Cultures."
- 1986 David Rumelhart, James McClelland, and other members of the Parallel Distributed Processing (PDP) group publish *Parallel Distributed Processing:* Explorations in the Microstructure of Cognition.
- 1986 Albert Bandura publishes Social Foundations of Thought and Action: A Social Cognitive Theory.
- 1988 American Psychological Society (APS) is founded. The name is later changed to the Association for Psychological Science (still APS).
- 1994 Richard J. Herrnstein and Charles Murray publish *The Bell Curve: Intelligence and Class Structure in American Life*, which rekindled many of the old scientific, moral, and political debates concerning the nature of intelligence.
- 2002 New Mexico becomes the first state in which clinical psychologists gain prescription privileges.
- 2004 Louisiana becomes the second state in which clinical psychologists gain prescription privileges.
- 2007 Membership in the Association for Psychological Science (APS) exceeds 18,000.
- 2007 The number of members and affiliates of the APA exceeds 148,000.

References

- Aarsleff, H. (2001). Introduction. In E. B. de Condillac, Essay on the origin of human knowledge (H. Aarsleff, Ed. and Trans.) (pp. xi–xxxviii). New York: Cambridge University Press.
- Adams-Webber, J. R. (1979). Personal construct theory: Concepts and applications. New York: Wiley.
- Adler, A. (1917). Study of organ inferiority and its physical compensation: A contribution to clinical medicine (S. E. Jeliffe, Trans.). New York: Nervous and Mental Diseases Publishing. (Original work published 1907)
- Adler, A. (1958). What life should mean to you. New York: Capricorn. (Original work published 1931)
- Adler, H. E. (1996). Gustav Theodor Fechner: A German Gelehrter. In G. A. Kimble, C. A. Boneau, & M. Wertheimer (Eds.), Portraits of pioneers in psychology (Vol. 2, pp. 1–13). Washington, DC: American Psychological Association.
- Adler, H. E. (2000). Hermann Ludwig Ferdinand von Helmholtz: Physicist as psychologist. In G. A. Kimble, & M. Wertheimer (Eds.), Portraits of pioneers in psychology (Vol. 4, pp. 15–31). Washington, DC: American Psychological Association.
- Agnew, J. (1985). Childhood disorders. In E. Button (Ed.), Personal construct theory and mental health: Theory, research, and practice. Beckenham, England: Croom Helm.
- Albrecht, F. M. (1970). A reappraisal of faculty psychology. *Journal of the History of the Behavioral Sciences*, 6, 36–40.
- Alexander, F. G., & Selesnick, S. T. (1966). The history of psychiatry: An evaluation of psychiatric thought and practice from prehistoric times to the present. New York: Harper & Row.
- Alexander, I. E. (1991). C. G. Jung: The man and his work, then, and now. In G. A. Kimble, M. Wertheimer, &

- C. L. White (Eds.), *Portraits of pioneers in psychology*, (pp. 153–196). Washington, DC: American Psychological Association.
- Alland, A., Jr. (1985). *Human nature: Darwin's view.* New York: Columbia University Press.
- Allderidge, P. (1979). Hospitals, madhouses and asylums: Cycles in the care of the insane. *British Journal of Psychiatry*, 134, 321–334.
- Allen, R. E. (Ed.). (1991). Greek philosophy: Thales to Aristotle (3rd ed.). New York: Free Press.
- Allport, G. W. (1964). The open system in personality theory. In H. M. Ruitenbeek (Ed.), *Varieties of personality theory* (pp. 149–166). New York: E. P. Dutton.
- American Psychiatric Association. (2000). Diagnostic and statistical manual of mental disorders (4th ed., text revision). Washington, DC.
- American Psychologist. (1958). American Psychological Association Distinguished Scientific Contribution Awards: 1957. American Psychologist, 13, 155–158.
- American Psychologist. (1990). Citation for outstanding lifetime contribution to psychology. Presented to B. F. Skinner, August 10, 1990. American Psychologist, 45, 1205.
- American Psychologist. (1992). Reflections on B. F. Skinner and psychology. *American Psychologist*, 47, entire November issue.
- American Psychologist. (1997). History of psychology: Pavlov's contributions. *American Psychologist*, 52, entire September issue.
- American Psychologist. (2001). One big idea: Koch on psychology. *American Psychologist*, 56, entire May issue.

- Amsel, A. (1992). Frustration theory: An analysis of dispositional learning and memory. New York: Cambridge University Press.
- Angell, J. R. (1904). Psychology: An introductory study of the structure and functions of human consciousness. New York: Holt.
- Angell, J. R. (1907). The province of functional psychology. Psychological Review, 14, 61–91.
- Angus, S. (1975). The mystery-religions. New York: Dover Publications.
- Annas, J. E. (1994). Hellenistic philosophy of mind. Berkeley: University of California Press.
- Annas, J. E. (2003). Plato: A very short introduction. New York: Oxford University Press.
- Anokhin, P. K. (1968). Ivan P. Pavlov and psychology. In B. B. Wolman (Ed.), Historical roots of contemporary psychology (pp. 131–159). New York: Harper & Row.
- Antonuccio, D. O. (1995). Psychotherapy for depression: No stronger medicine. *American Psychologist*, 50, 450–451.
- Antonuccio, D. O., Danton, W. G., & DeNelsky, G. Y. (1994). Psychotherapy for depression: No stronger medicine. Scientist Practitioner, 4, 2–18.
- Antonuccio, D. O., Danton, W. G., & McClanahan, T. M. (2003). Psychology in the prescription era: Building a firewall between marketing and science. *American Psychologist*, 58, 1028–1043.
- APA Membership Directory. (2007). Washington, DC: American Psychological Association.
- Armstrong, D. M. (Ed.). (1965). Berkeley's philosophical writings. New York: Macmillan.
- Arnett, J. J. (2006). G. Stanley Hall's Adolescence: Brilliance and nonsense. History of Psychology, 9, 186–197.
- Arnheim, R. (1985). The other Gustav Theodor Fechner. In S. Koch & D. E. Leary (Eds.), A century of psychology as a science (pp. 856–865). New York: McGraw-Hill.
- Aspinwall, L. G., & Staudinger, U. M. (Eds.). (2003). A psychology of human strengths: Fundamental questions and future directions for a positive psychology. Washington, DC: American Psychological Association.
- Atherton, M. (1990). Berkeley's revolution in vision. Ithaca, NY: Cornell University Press.
- Atwell, J. E. (1990). Schopenhauer: The human character. Philadelphia: Temple University Press.
- Augustijn, C. (1991). Erasmus: His life, works, and influence. (J. C. Grayson, Trans.). Toronto: University of Toronto Press.
- Ayer, A. J. (1952). Language, truth and logic. New York: Dover. (Original work published 1936)
- Ayllon, T., & Azrin, N. (1968). The token economy: A motivational system for therapy and rehabilitation. New York: Appleton-Century-Crofts.

- Azar, B. (1994, December). Psychology weighs in on "Bell Curve" debate. APA Monitor, 25, 1, 22, 23.
- Azar, B. (1995a, January). Searching for intelligence beyond "g." APA Monitor, 26, 1, 25.
- Azar, B. (1995b, January). "Gifted" label stretches, it's more than high IQ. APA Monitor, 26, 1, 25.
- Baars, B. J. (1986). The cognitive revolution in psychology. New York: Guilford Press.
- Backe, A. (2001). John Dewey and early Chicago functionalism. *History of Psychology*, 4, 323–340.
- Bacon, F. (1878). Of the proficience and advancement of learning divine and human. In *The works of Francis Bacon* (Vol. 1). Cambridge: Hurd & Houghton. (Original work published 1605)
- Bacon, F. (1994). Novum organum (P. Urbach & J. Gibson, Eds. and Trans.). La Salle, IL: Open Court. (Original work published 1620)
- Bacon, F. (2001). The advancement of learning. New York: Modern Library. (Original work published 1605)
- Bailey, R. E., & Gillaspy, J. A., Jr. (2005). Operant psychology goes to the fair: Marian and Keller Breland in the popular press, 1947–1966. The Behavior Analyst, 28, 143–159.
- Bain, A. (1875). Mind and body: The theories of their relations. New York: Appleton. (Original work published 1873)
- Bain, A. (1977a). The senses and the intellect. Washington, DC: University Publications of America. (Original work published 1855)
- Bain, A. (1977b). The emotions and the will. Washington, DC: University Publications of America. (Original work published 1859)
- Bakan, D. (1966). The influence of phrenology on American psychology. *Journal of the History of the Behavioral Sciences*, 2, 200–220.
- Baker, D. B., & Benjamin, L. T., Jr. (2000). The affirmation of the scientist-practitioner: A look back at Boulder. *American Psychologist*, 55, 241–247.
- Balmary, M. (1979). Psychoanalyzing psychoanalysis: Freud and the hidden fault of the father. Baltimore: Johns Hopkins University Press.
- Bandura, A. (1977). Social learning theory. Englewood Cliffs, NJ: Prentice-Hall.
- Bandura, A. (1982). The psychology of chance encounters and life paths. *American Psychologist*, 37, 747–755.
- Bandura, A. (1986). Social foundations of thought and action: A social cognitive theory. Englewood Cliffs, NJ: Prentice-Hall.
- Bandura, A. (1989). Human agency in social cognitive theory. *American Psychologist*, 44, 1175–1184.
- Barash, D. P. (1979). The whisperings within: Evolution and the origin of human nature. New York: Viking Press/Penguin Books.

- Barash, D. P. (1986). The hare and the tortoise: Culture, biology, and human nature. New York: Penguin.
- Barnes, J. (1982). *The presocratic philosophers*. London: Routledge & Kegan Paul.
- Barnes, J. (Ed.). (1984). The complete works of Aristotle (Vols. 1 and 2). Princeton, NJ: Princeton University Press.
- Barnes, J. (2001). Early Greek philosophy (rev. ed.). New York: Penguin Putnam.
- Barsky, R. F. (1997). Noam Chomsky: A life of dissent. Cambridge: MIT Press.
- Bartlett, F. C. (1932). Remembering: A study in experimental and social psychology. New York: Macmillan.
- Bass, E., & Davis, L. (1988). The courage to heal. New York: Harper & Row.
- Baxter, R., Jr., Schwartz, J., Bergman, K., Szuba, M., Guze, B., Mazziotta, J., Alazraki, A., Selin, C., Ferng, H., Munfort, P., & Phelps, J. (1992). Caudate glucose metabolic rate changes with both drug and behavior therapy for obsessive-compulsive disorder. Archives of General Psychiatry, 49, 681–689.
- Beach, F. A. (1987). Donald Olding Hebb (1904–1985). American Psychologist, 42, 186–187.
- Beach, F. A., Hebb, D. O., Morgan, C. T., & Nissen, H. W. (Eds.). (1960). The neuropsychology of Lashley. New York: McGraw-Hill.
- Beakley, B., & Ludlow, P. (Eds.). (1992). The philosophy of mind: Classical problems/contemporary issues. Cambridge: MIT Press.
- Beanblossom, R. E., & Lehrer, K. (Eds.). (1983). Thomas Reid's inquiry and essays. Indianapolis: Hackett.
- Bechterev, V. M. (1913). La psychologie objective. [Objective psychology]. Paris: Alcan. (Original work published 1907–1912)
- Bechterev, V. M. (1973). General principles of human reflexology: An introduction to the objective study of personality. New York: Arno Press. (Original work published 1928)
- Belar, C. D., & Perry, N. W., Jr. (Eds.). (1991). Proceedings: National conference on scientist-practitioner education. Sarasota, FL: Resource Exchange.
- Belar, C. D., & Perry, N. W., Jr. (1992). National conference on scientist-practitioner education and training for the professional practice of psychology. *American Psychologist*, 47, 71–75.
- Bencivenga, E. (1993). Logic and other nonsense: The case of Anselm and his god. Princeton, NJ: Princeton University Press.
- Benjamin, L. T., Jr. (1975). The pioneering work of Leta Hollingworth in the psychology of women. *Nebraska History*, 56, 493–505.

- Benjamin, L. T., Jr. (2000). Hugo Münsterberg: Portrait of an applied psychologist. In G. A. Kimble & M. Wertheimer (Eds.), Portraits of pioneers in psychology (Vol. 4, pp. 113–129). Washington, DC: American Psychological Association.
- Benjamin, L. T., Jr., & Crouse, E. M. (2002). The American Psychological Association's response to Brown v. Board of Education. American Psychologist, 57, 38–50.
- Benko, S. (1984). Pagan Rome and the early Christians. Bloomington: Indiana University Press.
- Bentham, J. (1988). An introduction to the principles of morals and legislation. New York: Prometheus Books. (Original work published 1781)
- Bergmann, G. (1956). The contribution of John B. Watson. *Psychological Review*, 63, 265–276.
- Berkeley, G. (1954). An essay towards a new theory of vision. In *Berkeley: A new theory of vision and other writings*. London: Dent. (Original work published 1709)
- Berman, D. (1999). Berkeley. New York: Routledge.
- Bernard, W. (1972). Spinoza's influence on the rise of scientific psychology: A neglected chapter in the history of psychology. *Journal of the History of the Behavioral Sciences*, 8, 208–215.
- Bernfeld, S. (1949). Freud's scientific beginnings. *American Imago*, 6, 163–196.
- Beutler, L. E., & Malik, M. L. (2002). Rethinking the DSM: A psychological perspective. Washington, DC: American Psychological Association.
- Beutler, L. E., Williams, R. E., Wakefield, P. J., & Entwistle, S. R. (1995). Bridging scientist and practitioner perspectives in clinical psychology. *American Psychologist*, 50, 984–994.
- Binet, A. (1903). L'Étude experimentale de l'intelligence [The experimental study of intelligence]. Paris: Schleicher.
- Binet, A. (1975). Modern ideas about children (S. Heisler, Trans.).
 Albi, France: Presses de L'Atelier Graphique. (Original work published 1909)
- Birx, H. J. (1998). Introduction to Darwin's *The descent of man*. Amherst, NY: Prometheus Books.
- Bjork, D. W. (1983). The compromised scientist: William James in the development of American psychology. New York: Columbia University Press.
- Bjork, D. W. (1997). B. F. Skinner: A life. Washington, DC: American Psychological Association.
- Blackburn, S. (1994). The Oxford dictionary of philosophy. New York: Oxford University Press.
- Block, N., Flanagen, O., & Güzeldere, G. (Eds.). (1997). *The nature of consciousness*. Cambridge: MIT Press.
- Blumenthal, A. L. (1970). Language and psychology: Historical aspects of psycholinguistics. New York: Wiley.

- Blumenthal, A. L. (1975). A reappraisal of Wilhelm Wundt. American Psychologist, 30, 1081–1088.
- Blumenthal, A. L. (1979). The founding father we never knew. *Contemporary Psychology*, 24, 547–550.
- Blumenthal, A. L. (1980). Wilhelm Wundt and early American psychology. In R. W. Rieber (Ed.), Wilhelm Wundt and the making of a scientific psychology (pp. 117–135). New York: Plenum.
- Blumenthal, A. L. (1998). Leipzig, Wilhelm Wundt, and psychology's gilded age. In G. A. Kimble, & M. Wertheimer (Eds.), *Portraits of pioneers in psychology* (Vol. 3, pp. 31–48). Washington, DC: American Psychological Association.
- Boakes, R. (1984). From Darwin to behaviourism: Psychology and the minds of animals. New York: Cambridge University Press.
- Boden, M. A. (1990). The philosophy of artificial intelligence. New York: Oxford University Press.
- Boorstin, D. J. (1991). The creators: A history of heroes of the imagination. New York: Random House.
- Borch-Jacobsen, M. (1996). Remembering Anna O.: A century of mystification (K. Olson, Trans.). New York: Routledge.
- Boring, E. G. (1950). A history of experimental psychology (2nd ed.). New York: Appleton-Century-Crofts.
- Boring, E. G. (1953). John Dewey: 1859–1952. American Journal of Psychology, 66, 145–147.
- Boring, E. G. (1961). Psychologist at large: An autobiography and selected essays. New York: Basic Books.
- Boring, E. G. (1963). History, psychology, and science: Selected papers. New York: Wiley.
- Boring, E. G. (1965). On the subjectivity of important historical dates: Leipzig, 1879. *Journal of the History of the Behavioral Sciences*, 1, 5–9.
- Bouchard, T. J., Jr. (1984). Twins reared together and apart: What they tell us about human diversity. In S. W. Fox (Ed.), *Individuality and determinism: Chemical and biological bases* (pp. 147–178). New York: Plenum.
- Boudewijnse, G-J. A., Murray, D. J., & Bandomir, C. A. (1999). Herbart's mathematical psychology. *History of Psychology*, 2, 163–193.
- Boudewijnse, G-J. A., Murray, D. J., & Bandomir, C. A. (2001). The fate of Herbart's mathematical psychology. *History of Psychology*, 4, 107–132.
- Bourke, V. J. (1993). Augustine's quest of wisdom: His life, thought, and works. Albany, NY: Magi Books.
- Bouveresse, J. (1995). Wittgenstein reads Freud: The myth of the unconscious (C. Cosman, Trans.). Princeton, NJ: Princeton University Press.
- Bowen, C. D. (1993). Francis Bacon: The temper of a man. New York: Fordham University Press.

- Bower, G. H., & Hilgard, E. R. (1981). Theories of learning (5th ed.). Englewood Cliffs, NJ: Prentice-Hall.
- Bowlby, J. (1991). Charles Darwin: A new life. New York: Norton.
- Bowra, C. M. (1957). *The Greek experience*. New York: New American Library.
- Boynton, D. M., & Smith, L. D. (2006). Bringing history to life: Simulating landmark experiments in psychology. *History of Psychology*, 9, 113–143.
- Braid, J. (1843). The rationale of nervous sleep considered in relation to animal magnetism. London: Churchill.
- Branham, R. B. (1996). Defacing the currency: Diogenes' rhetoric and the invention of Cynicism. In R. B. Branham & M.-O. Goulet-Cazé (Eds.), The Cynics: The Cynic movement in antiquity and its legacy (pp. 81–104). Berkeley: University of California Press.
- Branham, R. B., & Goulet-Cazé, M.-O. (Eds.). (1996). *The Cynics: The Cynic movement in antiquity and its legacy*. Berkeley: University of California Press.
- Breland, K., & Breland, M. (1961). The misbehavior of organisms. American Psychologist, 16, 681–684.
- Bremmer, J. N. (1993). The early Greek concept of the soul. Princeton, NJ: Princeton University Press.
- Brentano, F. (1973). Psychology from an empirical standpoint (A. C. Rancurello & D. B. Terrel, Trans.). New York: Humanities Press. (Original work published 1874)
- Bretall, R. (Ed.). (1946). A Kierkegaard anthology. Princeton, NJ: Princeton University Press.
- Brett, G. S. (1965). *A history of psychology* (2nd rev. ed.). (Edited and abridged by R. S. Peters). Cambridge: MIT Press. (Original work published 1912–1921)
- Breuer, J., & Freud, S. (1955). Studies on hysteria. In The standard edition (Vol. 2). London: Hogarth Press. (Original work published 1895)
- Brewer, C. L. (1991). Perspectives on John B. Watson. In G. A. Kimble, M. Wertheimer, & C. L. White (Eds.), Portraits of pioneers in psychology (pp. 171–186). Washington, DC: American Psychological Association.
- Bricke, J. (1974). Hume's associationist psychology. Journal of the History of the Behavioral Sciences, 10, 397–409.
- Bridgman, P. W. (1927). The logic of modern physics. New York: Macmillan.
- Bridgman, P. W. (1955). *Reflections of a physicist*. New York: Philosophical Library.
- Bringmann, W. G., Bringmann, M. W., & Balance, W. D. G. (1992). Gustav Theodor Fechner: Columbus of the new psychology. *Journal of Pastoral Counseling: An Annual*, 27, 52–62.

- Bringmann, W. G., Bringmann, M. W., & Early, C. E. (1992).
 G. Stanley Hall and the history of psychology. *American Psychologist*, 47, 281–289.
- Bringmann, W. G., Bringmann, N. J., & Ungerer, G. A. (1980). The establishment of Wundt's laboratory: An archival and documentary study. In W. G. Bringmann & R. D. Tweney (Eds.), Wundt studies: A centennial collection (pp. 123–159). Toronto: Hogrefe.
- Bringmann, W. G., Lück, H. E., Miller, R., & Early, C. E. (Eds.). (1997). A pictorial history of psychology. Carol Stream, IL: Quintessence Publishing.
- Bringmann, W. G., & Tweney, R. D. (Eds.). (1980). Wundt studies: A centennial collection. Toronto: Hogrefe.
- Bringmann, W. G., Voss, U., & Balance, W. D. G. (1997). Goethe as an early behavior therapist. In W. G. Bringmann, H. E. Lück, R. Miller, and C. E. Early (Eds.), A pictorial history of psychology (pp. 35–36). Carol Stream IL: Quintessence Publishing.
- Broadbent, D. E. (1957). A mechanical model for human attention and immediate memory. *Psychological Review*, 64, 205–215.
- Broadbent, D. E. (1958). Perception and communication. Elmsford, NY: Pergamon Press.
- Brooks, G. P. (1976). The faculty psychology of Thomas Reid. Journal of the History of the Behavioral Sciences, 12, 65–77.
- Brooks-Gunn, J., & Johnson, A. D. (2006). G. Stanley Hall's contribution to science: The child study, parent education, and child welfare movements. *History of Psychology*, 9, 247–258.
- Brown-Séquard, C.-E. (1874a). Dual character of the brain. Smithsonian Miscellaneous Collections, 15, 1–21.
- Brown-Séquard, C.-E. (1874b). The brain power of man: Has he two brains or has he only one? *Cincinnati lancet and observer*, 17, 330–333.
- Brown-Séquard, C.-E. (1890). Have we two brains or one? Forum, 9, 627–643.
- Brožek, J. (Ed.). (1984). Explorations in the history of psychology in the United States. Cranbury, NJ: Associated University Presses.
- Bruce, D. (1991). Integrations of Lashley. In G. A. Kimble, M. Wertheimer, & C. L. White (Eds.), Portraits of pioneers in psychology (pp. 307–323). Washington, DC: American Psychological Association.
- Bruner, J. S. (1980). Jerome S. Bruner. In G. Lindzey (Ed.). A history of psychology in autobiography (Vol. 7, pp. 75–151). San Francisco, CA: Freeman.
- Bruner, J. S. (1983). In search of mind: Essays in autobiography. New York: Harper & Row.
- Bruner, J. S. (1990). Acts of meaning. Cambridge, MA: Harvard University Press.

- Bruner, J. S. (2002). Making stories: Law, literature, life. Cambridge: Harvard University Press.
- Bruner, J. S., Goodnow, J. J., & Austin, G. A. (1956). A study of thinking. New York: Wiley.
- Bruno, F. J. (1972). The story of psychology. New York: Holt, Rinehart & Winston.
- Buchtel, H. A. (Ed.). (1982). The conceptual nervous system. New York: Pergamon Press.
- Buckley, K. W. (1989). Mechanical man: John Broadus Watson and the beginnings of behaviorism. New York: Guilford Press.
- Bühler, C. (1971). Basic theoretical concepts of humanistic psychology. American Psychologist, 26, 378–386.
- Burt, C. (1972). Inheritance of general intelligence. *American Psychologist*, 27, 175–190.
- Burtt, E. A. (1932). The metaphysical foundations of modern physical science. Garden City, NY: Doubleday.
- Bury, R. G. (Trans.). (1990). Sextus Empiricus: Outlines of Pyrrhonism. Buffalo, NY: Prometheus Books.
- Buss, A. H. (1988). Personality: Evolutionary heritage and human distinctiveness. Hillsdale, NJ: Lawrence Erbaum.
- Buss, D. M. (1999). Evolutionary psychology: The new science of the mind. Boston: Allyn & Bacon.
- Buss, D. M. (2004). Evolutionary psychology: The new science of the mind (2nd ed.). Boston: Allyn & Bacon.
- Buss, D. M., Haselton, M. G., Shackelford, T. K., Bleske, A. L., & Wakefield, J. C. (1998). Adaptations, exaptations, and spandels. *American Psychologist*, 53, 533–548.
- Cahan, D. (Ed.). (1994). Hermann von Helmholtz and the foundations of nineteenth-century science. Berkeley: University of California Press.
- Cahan, D. (Ed.). (1995). Hermann von Helmholtz: Science and culture. Chicago: University of Chicago Press.
- Cahn, E. (1955). Jurisprudence. New York University Law Review, 30, 150–169.
- Caldwell, C. (1824). Elements of phrenology. Lexington, KY: T. T. Skillman.
- Caldwell, C. (1827). Elements of phrenology (2nd ed.). Lexington, KY: A. G. Meriweather.
- Calkins, M. W. (1892). A suggested classification of cases of association. *Philosophical Review*, 1, 389–402.
- Calkins, M. W. (1893). Statistics of dreams. American Journal of Psychology, 5, 311–343.
- Calkins, M. W. (1930). Mary Whiton Calkins. In C. Murchison (Ed.), A history of psychology in autobiography (Vol. 1, pp. 31–62). Worchester, MA: Clark University Press.
- Campbell, J. (1995). Understanding John Dewey: Nature and cooperative intelligence. La Salle, IL: Open Court.

- Candland, D. K. (1993). Feral children and clever animals: Reflections on human nature. New York: Oxford University Press.
- Capps, D. (1970). Hartmann's relations to Freud: A reappraisal. Journal of the History of the Behavioral Sciences, 6, 162–175.
- Carlson, J., Watts, R. E., & Maniacci, M. (2006). Adlerian therapy: Theory and practice. Washington, DC: American Psychological Association.
- Carpenter, R. J. (1997). Margaret Floy Washburn. In W. G. Bringmann, H. E. Lück, R. Miller, & C. E. Early, A pictorial history of psychology (pp. 187–190). Carol Stream, IL: Quintessence Publishing.
- Carr, H. (1925). Psychology: A study of mental activity. New York: Longmans, Green.
- Carr, H. (1935). An introduction to space perception. New York: Longmans, Green.
- Cartledge, P. (1999). Democritus. New York: Routledge.
- Cary, P. (2004). Luther: Gospel, law, and reformation (24 lectures). Chantilly, VA: The Teaching Company.
- Cattell, J. M. (1890). Mental tests and measurements. *Mind*, 15, 373–381.
- Cattell, J. M. (1904). The conceptions and methods of psychology. *Popular Science Monthly*, 66, 176–186.
- Cattell, J. M. (1929). Psychology in America. In Proceedings and papers: Ninth International Congress of Psychology. Princeton, NJ: Psychological Review Company.
- Cattell, R. B. (1982). The inheritance of personality and ability. New York: Academic Press.
- Chadwick, H. (2001). Augustine: A very short introduction. New York: Oxford University Press.
- Chaplin, J. P., & Krawiec, T. S. (1979). Systems and theories of psychology (4th ed.). New York: Holt, Rinehart & Winston.
- Chodorow, N. (1989). Feminism and psychoanalytic thought. New Haven, CT: Yale University Press.
- Chomsky, N. (1957). Syntactic structures. The Hague: Mouton.
- Chomsky, N. (1959). Review of Skinner's Verbal Learning. Language, 35, 26–58.
- Chomsky, N., & Miller, G. A. (1958). Finite-state languages. *Information and Control*, 1, 91–112.
- Churchland, P. M. (1988). Matter and consciousness: A contemporary introduction to the philosophy of mind (rev. ed.). Cambridge: MIT Press.
- Churchland, P. S. (1986). Neurophilosophy: Toward a unified science of the mind-brain. Cambridge: MIT Press.
- Churchland, P. S., & Sejnowski, T. J. (1994). The computational brain. Cambridge: MIT Press.
- Cioffi, F. (1974). Was Freud a liar? *The Listener*, 91, 172–174.

- Cioffi, F. (1998). Freud and the question of pseudoscience. La Salle, IL: Open Court.
- Clark, A. (1990). Connectionism, competence, and explanation. In M. A. Boden (Ed.), The philosophy of artificial intelligence (pp. 281–308). New York: Oxford University Press.
- Clark, C. W. (1997). The witch craze in 17th century Europe. In W. G. Bringmann, H. E. Lück, R. Miller, & C. E. Early (Eds.), A pictorial history of psychology (pp. 23–29). Carol Stream, IL: Quintessence Publishing.
- Clark, K. B. (1986). A personal view of the background and development since the *Brown* decision. In L. P. Miller (Ed.), *Brown plus thirty: Perspectives on desegre*gation (pp. 18–21). New York: Metropolitan Center for Educational Research, Development, and Training, New York University.
- Clark, K. B. (1989). Dark ghetto: Dilemmas of social power. New York: Harper & Row. (Original work published 1965)
- Clark, K. B., Chein, I., & Cook, S. W. (1952). The effects of segregation and the consequences of desegregation: A social science statement. Brown v. Board of Education of Topeka, Shawnee County, Kansas: Appendix to Appellant's Briefs. Washington, DC: Supreme Court of the United States.
- Clark, K. B., & Clark, M. P. (1939). Segregation as a factor in the racial identification of Negro pre-school children: A preliminary report. *Journal of Experimental Education*, 11, 161–163.
- Clark, K. B., & Clark, M. P. (1940). Skin color as a factor in racial identification of Negro pre-school children. *Journal* of Social Education, 11, 159–169.
- Clark, K. B., & Clark, M. P. (1947). Racial identification and preference in Negro children. In T. M. Newcomb & E. L. Hartley (Eds.), *Readings in social psychology* (pp. 169– 178). New York: Holt.
- Clark, K. B., & Clark, M. P. (1950). Emotional factors in racial identification in Negro children. *Journal of Negro Education*, 19, 341–350.
- Clark, R. W. (1980). Freud: The man and the cause—A biography. New York: Random House.
- Clatterbaugh, K. (1999). The causation debate in modern philosophy: 1637–1739. New York: Routledge.
- Clay, R. A. (2002). A renaissance for humanistic psychology. Monitor on Psychology, 33, 42–43.
- Cleary, L. J., Hammer, M., & Byrne, J. H. (1989). Insights into the cellular mechanisms of short-term sensitization in *Aplysia*. In T. J. Carew &
 - D. B. Kelley (Eds.), Perspectives in neural systems and behavior. New York: Alan R. Liss.

- Cohen, D. (1979). J. B. Watson: The founder of behaviourism. London: Routledge & Kegan Paul.
- Collins, A. (2007). From $H = \log s^n$ to conceptual framework: A short history of information. *History of Psychology*, 10, 44–72.
- Comte, A. (1896). A positive philosophy (H. Martineau, Trans.). London: Bell.
- Conant, J. & Haugeland, J. (Eds.). (2000). The road since "Structure": Thomas S. Kuhn. Chicago: University Chicago Press.
- Condillac, E. B. de. (1930). Treatise on the sensations (G. Carr, Trans.). Los Angeles: University of Southern California School of Philosophy. (Original work published 1754)
- Condillac, E. B. de. (2001). Essay on the origin of human knowledge (H. Aarsleff, Ed. & Trans.). New York: Cambridge University Press. (Original work published 1746)
- Coon, D. J. (2006). Abraham H. Maslow: Reconnaissance for Eupsychia. In D. A. Dewsbury, L. T. Benjamin Jr., & M. Wertheimer (Eds.), Portraits of pioneers in psychology (Vol. 6, pp. 255–271). Washington, DC: American Psychological Association.
- Copleston, F. C. (2001). Medieval philosophy: An introduction. Mineola, NY: Dover. (Original work published 1952)
- Cornford, F. M. (1957). From religion to philosophy: A study of the origins of Western speculation. New York: Harper & Row.
- Cornford, F. M. (Trans.). (1968). *The "Republic" of Plato*. New York: Oxford University Press. (Original work published 1941)
- Costall, A. (1993). How Lloyd Morgan's canon backfired. *Journal of the History of the Behavioral Sciences*, 29, 113–122.
- Cottingham, J. (Ed.). (1992). The Cambridge companion to Descartes. New York: Cambridge University Press.
- Craighead, W. E., Kazdin, A. E., & Mahoney, M. J. (1976). Behavior modification: Principles, issues, and applications. Boston: Houghton Mifflin.
- Cramer, P. (2000). Defense mechanisms in psychology today: Further processes for adaptation. American Psychologist, 55, 637–646.
- Crane, L. (1925). A plea for the training of professional psychologists. *Journal of Abnormal and Social Psychology*, 20, 228–233.
- Cranefield, P. F. (1974). The way in and the way out: François Magendie, Charles Bell and the roots of the spinal nerves. New York: Futura.
- Crawford, C., & Krebs, D. L. (Eds.). (1998). Handbook of evolutionary psychology: Ideas, issues, and applications. Mahwah, NJ: Lawrence Erlbaum Associates.
- Crew, H., & De Salvio, A. (Trans.). (1991). Galileo Galilei: Dialogues concerning two new sciences. Buffalo, NY: Prometheus Books. (Original work published 1638).

- Crews, F. (1995). The memory wars: Freud's legacy in dispute. New York: The New York Review of Books.
- Crombie, A. C. (1961). Augustine to Galileo (2nd ed.). Cambridge: Harvard University Press.
- Crosby, J. R., & Hastorf, A. H. (2000). Lewis Terman: Scientist of mental measurement and product of his time. In G. A. Kimble & M. Wertheimer (Eds.), *Portraits of pioneers in psychology* (Vol. 4, pp. 131–147). Washington, DC: American Psychological Association.
- Crowther-Heyck, H. (1999). George A. Miller, language, and the computer metaphor of mind. *History of Psychology*, 2, 37–64.
- Cynkar, A. (2007). The changing gender composition of psychology. Monitor on Psychology, 38, 46–47.
- Dancy, J. (1987). Berkeley: An introduction. New York: Basil Blackwell.
- Danziger, K. (1980a). Wundt and the two traditions of psychology. In R. W. Rieber (Ed.), Wilhelm Wundt and the making of a scientific psychology (pp. 73–87). New York: Plenum.
- Danziger, K. (1980b). Wundt's theory of behavior and volition. In R. W. Rieber (Ed.), Wilhelm Wundt and the making of a scientific psychology (pp. 89–115). New York: Plenum.
- Danziger, K. (1980c). The history of introspection reconsidered. Journal of the History of the Behavioral Sciences, 16, 241–262.
- Daquin, J. (1793). Philosophie de la folie [Philosophy of madness].
 Paris: Alican.
- Darwin, C. (1859). On the origin of species by means of natural selection. London: Murray.
- Darwin, C. (1877). A biographical sketch of an infant. *Mind*, 2, 285–294.
- Darwin, C. (1998a). The descent of man. (2nd ed.). Amherst, NY: Prometheus Books. (Original work published 1874)
- Darwin, C. (1998b). The expression of emotions in man and animals. New York: Oxford University Press. (Original work published 1872)
- Darwin, F. (Ed.). (1958). The autobiography of Charles Darwin and selected letters. New York: Dover. (Original work published 1892)
- Davies, J. M., & Frawley, M. G. (1994). Treating the adult survivor of incest: A psychoanalytic perspective. New York: Basic Books.
- Dawes, A. (1985). Drug dependence. In E. Button (Ed.), Personal construct theory and mental health: Theory, research, and practice. Beckenham, England: Croom Helm.
- Deane, S. N. (Trans.). (1962). St. Anselm: Basic writings. (2nd ed.). La Salle, IL: Open Court.
- DeAngelis, T. (1994, July). Jung's theories keep pace and remain popular. APA Monitor, 25, 41.

LIBRARY

- DeAngelis, T. (1995). Psychologists question findings of "Bell Curve." *APA Monitor*, 10, 7.
- Deary, I. J. (2001). *Intelligence: A very short introduction*. New York: Oxford University Press.
- DeCarvalho, R. J. (1990). A history of the "third force" in psychology. Journal of Humanistic Psychology, 30, 22–44.
- Delahunty, R. J. (1985). Spinoza. Boston: Routledge & Kegan Paul.
- Denelsky, G. (1996). The case against prescription privileges. *American Psychologist*, 51, 207–212.
- Denmark, F. L. (1983). Integrating the psychology of women into introductory psychology. *The*G. Stanley Hall Lecture Series, Vol. 3, pp. 37–71.
 Washington, DC: American Psychological Association.
- Dennett, D. C. (1991). Consciousness explained. Boston, MA: Little, Brown.
- Descartes, R. (1956). *Discourse on method* (L. J. Lafleur, Ed. & Trans.). Indianapolis: Bobbs-Merrill. (Original work published 1637).
- Descartes, R. (1992). Meditations on first philosophy (2nd ed.). (G. Heffernan, Trans.). South Bend, IN: University of Notre Dame Press. (Original work published 1642).
- Desmond, A. (1997). Huxley: From devil's disciple to evolution's high priest. Reading, MA: Perseus Books.
- Deutscher, M., & Chein, I. (1948). The psychological effects of enforced segregation: A survey of social science opinion. *Journal of Psychology*, 26, 259–287.
- Dewey, J. (1886). Psychology. New York: American Book.
- Dewey, J. (1896). The reflex arc concept in psychology. *Psychological Review*, 3, 357–370.
- Dewey, J. (1899). The school and society. Chicago: University of Chicago Press.
- Dewey, J. (1913). Interest and effort in education. New York: Houghton Mifflin.
- Dewey, J. (1916). Democracy and education: An introduction to the philosophy of education. New York: Macmillan.
- Dewey, J. (1929). *Individualism: Old and new.* New York: Capricorn.
- Dewey, J. (1935). Liberalism and social action. New York: Capricorn.
- Dewey, J. (1938). Experience and education. New York: Macmillan.
- Dewey, J. (1939). Freedom and culture. New York: G. P. Putnam's Sons.
- Dewey, J. (1997). *How we think*. New York: Dover. (Original work published 1910)
- Dewsbury, D. A. (2003). James Rowland Angell: Born administrator. In G. A. Kimble & M. Wertheimer (Eds.), Portraits of pioneers in psychology (Vol. 5, pp. 57–71). Washington, DC: American Psychological Association.

- Dewsbury, D. A. (2006). Nikolaas Tinbergen: Nobelprize-winning ethologist. In D.A. Dewsbury, L. T. Benjamin Jr., & M. Wertheimer (Eds.), *Portraits of pioneers in psychology* (Vol. 6, pp. 239–252). Washington, DC: American Psychological Association.
- Diamond, S. (1980). Wundt before Leipzig. In R. W. Rieber (Ed.), Wilhelm Wundt and the making of a scientific psychology (pp. 3–70). New York: Plenum.
- Diehl, L. A. (1986). The paradox of G. Stanley Hall: Foe of coeducation and educator of women. American Psychologist, 41, 868–878.
- Dittman, M. (2002). Study ranks the top 20th century psychologists. Monitor on Psychology, 33, 28–29.
- Dollard, J., & Miller, N. E. (1950). Personality and psychotherapy: An analysis in terms of learning, thinking, and culture. New York: McGraw-Hill.
- Donaldson, G. (1996). Between practice and theory: Melanie Klein, Anna Freud and the development of child analysis. Journal of the History of the Behavioral Sciences, 32, 160–176.
- Donnelly, M. E. (Ed.). (1992). Reinterpreting the legacy of William James. Washington, DC: American Psychological Association.
- Drake, S. (1994). *Galileo: Pioneer Scientist*. Toronto: University of Toronto Press.
- Drever, J. (1968). Some early associationists. In B. B. Wolman (Ed.), *Historical roots of contemporary psychology* (pp. 11–28). New York: Harper & Row.
- Dreyfus, H. L. (1992). What computers still can't do: A critique of artificial reason. Cambridge: MIT Press.
- Driver-Linn, E. (2003). Where is psychology going? Structural fault lines revealed by psychologists' use of Kuhn. American Psychologist, 58, 269–278.
- Durant, W. (1961). The story of philosophy. New York: Washington Square Press. (Original work published 1926)
- Ebbinghaus, H. (1897). Grundzüge der Psychologie [Principles of psychology]. Leipzig, Germany: Veit.
- Ebbinghaus, H. (1902). Outline of psychology. Leipzig, Germany: Veit.
- Ebbinghaus, H. (1964). Memory: A contribution to experimental psychology (H. A. Ruger and C. E. Bussenius, Trans.). New York: Dover. (Original work published 1885)
- Edinger, D. (1968). Bertha Pappenheim: Freud's Anna O. Highland Park, IL: Congregation Solel.
- Egger, M. D., & Miller, N. E. (1962). Secondary reinforcement in rats as a function of information value and reliability of the stimulus. *Journal of Experimental Psychology*, 64, 97–104.
- Egger, M. D., & Miller, N. E. (1963). When is a reward reinforcing? An experimental study of the information hypothesis. *Journal of Comparative and Physiological Psychology*, 56, 132–137.

- Ehrenfels, C. (1890). Uber 'Gestaltqualitäten' [Concerning Gestalt qualities]. Vierteljahrsschrift für wissenschaftliche Philosophie, 14, 242–292.
- Ehrenwald, J. (Ed.). (1991). The history of psychotherapy. Northvale, NJ: Jason Aronson.
- Ehrman, B. D. (2002). Lost Christianities: Christian scriptures and battles over authentication (24 lectures). Chantilly, VA: The Teaching Company.
- Ehrman, B. D. (2003). Lost Christianities: The battles for scripture and the faiths we never knew. New York: Oxford University Press.
- Ehrman, B. D. (2005). The history of the Bible: The making of the New Testament canon (12 lectures). Chantilly, VA: The Teaching Company.
- Eisenberg, B. (1960). Kelly Miller: the Negro leader as a marginal man. *Journal of Negro History*, 45, 182–197.
- Ekman, P. (1998). Introduction. In C. Darwin, *The expression of the emotions in man and animals* (pp. xxi–xxxvi). New York: Oxford University Press.
- Ellenberger, H. F. (1970). The discovery of the unconscious: The history and evolution of dynamic psychiatry. New York: Basic Books.
- Ellenberger, H. F. (1972). The story of "Anna O.": A critical review with new data. *Journal of the History of the Behavioral Sciences*, 8, 267–279.
- Elwes, R. H. M. (Trans.). (1955). Benedict de Spinoza: On the improvement of the understanding; The ethics; and Correspondence. New York: Dover.
- Emerson, R. W. (1981) Selected writings of Emerson (D. McQuade, Ed.). New York: The Modern Library. (Original work published 1841)
- Erasmus, D. (1994). *The praise of folly* (J. Wilson, Trans.). Amherst, NY: Prometheus. (Original work published 1512)
- Erdelyi, M. H. (1985). Psychoanalysis: Freud's cognitive psychology. New York: Freeman.
- Erikson, E. H. (1977). Toys and reasons: Stages in the ritualization of experience. New York: Norton.
- Erikson, E. H. (1985). *Childhood and society*. New York: Norton. (Original work published 1950)
- Esper, E. A. (1964). A history of psychology. Philadelphia: Saunders.
- Esterson, A. (1993). Seductive mirage: An exploration of the work of Sigmund Freud. La Salle, IL: Open Court.
- Esterson, A. (1998). Jeffrey Masson and Freud's seduction theory: A new fable based on old myths. *History of the Human Science*, 11, 1–21.
- Esterson, A. (2001). The mythologizing of psychoanalytic history: Deception and self-deception in Freud's accounts of

- the seduction theory episode. *History of Psychiatry*, 12, 329–352.
- Esterson, A. (2002a). The myth of Freud's ostracism by the medical community: Jeffrey Masson's assault on truth. *History of Psychology*, 5, 115–134.
- Esterson, A. (2002b). Misconceptions about Freud's seduction theory: Comment on Gleaves and Hernandez (1999). History of Psychology, 5, 85–91.
- Estes, E. K. (1944). An experimental study of punishment. *Psychological Monographs*, 47, (Whole No. 263).
- Estes, W. K. (1950). Toward a statistical theory of learning. *Psychological Review*, 57, 94–107.
- Estes, W. K. (1960). Learning theory and the new "mental chemistry." Psychological Review, 67, 207–223.
- Estes, W. K. (1964). All-or-none processes in learning and retention. *American Psychologist*, 19, 16–25.
- Estes, W. K. (1994). Classification and cognition. New York: Oxford University Press.
- Evans, R. B. (1972). E. B. Titchener and his lost system. *Journal* of the History of the Behavioral Sciences, 8, 168–180.
- Evans, R. B. (1984). The origins of American academic psychology. In J. Brozek, (Ed.), *Explorations in the history of psychology in the United States* (pp. 17–60). Cranbury, NJ: Associated University Presses.
- Evans, R. B. (1991). E. B. Titchener on scientific psychology and technology. In G. A. Kimble, M. Wertheimer, & C. L. White (Eds.), *Portraits of pioneers in psychology* (pp. 89– 103). Washington, DC: American Psychological Association.
- Exner, S. (1875). Über das Sehen von Bewegungen und die Theorie des zusammengestzen Auges. Sitzungsberichte der Akademie der Wissenschaften in Wien, Mathematisch-Naturwissenschaftliche Klasse, 72, 156–190.
- Eysenck, H. J., & Eysenck, M. W. (1985). Personality and individual differences. New York: Plenum Press.
- Fagan, G. G. (1999). *The history of ancient Rome* (48 lectures). Springfield, VA: The Teaching Company.
- Fagan, T. K. (1992). Compulsory schooling, child study, clinical psychology, and special education: Origins of school psychology. *American Psychologist*, 47, 236–243.
- Fagan, T. K. (1996). Witmer's contributions to school psychological services. American Psychologist, 51, 241–243.
- Fancher, R. E. (1985). The intelligence men: Makers of the IQ controversy. New York: Norton.
- Fancher, R. E. (1990). Pioneers of psychology (2nd ed.). New York: Norton.

- Fancher, R. E. (1998). Alfred Binet, general psychologist. In G. A. Kimble & M. Wertheimer (Eds.), Portraits of pioneers in psychology (Vol. 3, pp. 67–83). Washington, DC: American Psychological Association.
- Fancher, R. E., & Schmidt, H. (2003). Gottfried Wilhelm Leibniz: Underappreciated pioneer of psychology. In G. A. Kimble & M. Wertheimer (Eds.), Portraits of pioneers in psychology (Vol. 5, pp. 1–17). Washington, DC: American Psychological Association.
- Farber, S. (1993). Madness, heresy, and the rumor of angels: The revolt against the mental health system. Chicago: Open Court.
- Farias, V. (1989). Heidegger and Nazism. Philadelphia: Temple University Press.
- Fay, J. W. (1939). American psychology before William James. New Brunswick, NJ: Rutgers University Press.
- Fechner, G. T. (1871). Zur experimentalen aesthetik [About experimental esthetics]. Leipzig: Hirzel.
- Fechner, G. T. (1876). Vorschule der aesthetik [Introduction to esthetics]. Leipzig: Breitkopf & Härtel.
- Fechner, G. T. (1879). Die tagesansicht gegenuber der nachtansicht [The dayview compared to the nightview]. Leipzig: Breitkopf & Härtel.
- Fechner, G. T. (1966). *Elements of psychophysics*. New York: Holt, Rinehart & Winston. (Original work published 1860)
- Fechner, G. T. (1992). The little book of life after death. Journal of Pastoral Counseling: An Annual, 27, 7–31. (Original work published 1836)
- Ferrier, D. (1876). The functions of the brain. London: Smith, Elder, and Company.
- Festinger, L. (1957). A theory of cognitive dissonance. Evanston, IL: Row, Peterson.
- Fetzer, J. H. (1991). *Philosophy and cognitive science*. New York: Paragon House.
- Feyerabend, P. K. (1975). Against method: Outline of an anarchistic theory of knowledge. London: New Left Books.
- theory of knowledge. London: New Left Books. Feyerabend, P. K. (1987). Farewell to reason. New York: Verso.
- Fideler, D. (Ed.). (1987). The Pythagorean sourcebook and library (K. S. Guthrie, Trans.). Grand Rapids, MI: Phanes Press.
- Fiebert, M. S. (1997). In and out of Freud's shadow: A chronology of Adler's relationship with Freud. *Individual Psychology*, 53, 241–269.
- Finger, S. (1994). Origins of neuroscience: A history of explorations into brain functions. New York: Oxford University Press.
- Firestone, R. W., Firestone, L. A., & Catlett, J. (2003). *Creating a life of meaning: The wisdom of psychotherapy*. Washington, DC: American Psychological Association.
- Fishman, D. B. (1999). *The case for pragmatic psychology*. New York: New York University Press.

- Fitzek, H. (1997). Johannes Müller and the principle of sensory metamorphosis. In W. G. Bringmann,
 H. E. Lück, R. Miller, & C. E. Early (Eds.), A pictorial history of psychology (pp. 46–50). Carol Stream, IL: Quintessence Publishing.
- Flanagan, O. (1991). The science of the mind (2nd ed.). Cambridge: MIT Press.
- Fletcher, R. (1991). Science, ideology, and the media: The Cyril Burt scandal. New Brunswick, NY: Transaction Publishers.
- Flew, A. (Ed.). (1962). David Hume: On human nature and the understanding. New York: Macmillan.
- Fodor, J. (1983). The modularity of mind. Cambridge: MIT Press.
- Fodor, J. (2000). The mind doesn't work that way: The scope and limits of computational psychology. Cambridge: MIT Press.
- Fowers, B. J. (2005). Virtue and psychology: Pursuing excellence in ordinary practice. Washington, DC: American Psychological Association.
- Fowler, R. D. (1990). In memoriam: Burrhus Frederic Skinner, 1904–1990. American Psychologist, 45, 1203.
- Fox, R. E. (1980). On reasoning from predicates: The PhD is not a professional degree. *Professional Psychology*, 11, 887– 891.
- Fox, R. E. (1994). Training professional psychologists for the twenty-first century. *American Psychologist*, 49, 200–206.
- Frankel, C. (Ed.). (1947). Rousseau: The social contract. New York: Macmillan.
- Frankl, V. E. (1984). Man's search for meaning (rev. ed.). New York: Washington Square Press. (Original work published as Experiences in a concentration camp, 1946)
- Franklin, S. (1995). Artificial minds. Cambridge: MIT Press.
- Frawley, M. G. (1990). From secrecy to self-disclosure: Healing the scars of incest. In G. Stricker & M. Fisher (Eds.), Selfdisclosure in the therapeutic relationship (pp. 247–259). New York: Plenum Press.
- Frazer, J. G. (1963). *The golden bough*. New York: Macmillan. (Original work published 1890)
- Freud, A. (1928). Introduction to the technique of child analysis. New York: Nervous and Mental Disease Publishing Company.
- Freud, A. (1935). *Psychoanalysis for teachers and parents*. (B. Low, Trans.). New York: Emerson Books.
- Freud, A. (1937). The ego and mechanisms of defense. New York: International Universities Press.
- Freud, A. (1965). Normality and pathology in childhood. New York: International Universities Press.
- Freud, S. (1927). *The problem of lay-analyses*. New York: Brentano.
- Freud, S. (1949). The origins and development of psychoanalysis. Chicago: Regnery. (Original work published 1910)

- Freud, S. (1952). An autobiographical study. New York: Norton. (Original work published 1925)
- Freud, S. (1953). *The interpretation of dreams*. In J. Strachey (Ed. and Trans.), *The standard edition* (Vols. 4 and 5). London: Hogarth Press. (Original work published 1900)
- Freud, S. (1954). Project for a scientific psychology. In M. Bonaparte, A. Freud, & E. Kris (Eds.) and E. Mossbacher & J. Strachey (Trans.), The origins of psychoanalysis, letters to Wilhelm Fliess, drafts, and notes: 1887–1902. New York: Basic Books. (Original work published 1950)
- Freud, S. (1955a). A difficulty in the path of psychoanalysis. In J. Strachey (Ed. and Trans.), *The standard edition* (Vol. 17, pp. 136–144). London: Hogarth Press. (Original work published 1917)
- Freud, S. (1955b). Beyond the pleasure principle. In J. Strachey (Ed. and Trans.), The standard edition (Vol. 18). London: Hogarth Press. (Original work published 1920)
- Freud, S. (1960a). *Jokes and their relation to the unconscious*. In J. Strachey (Ed. and Trans.) *The standard edition* (Vol. 8). London: Hogarth Press. (Original work published 1905)
- Freud, S. (1960b). Psychopathology of everyday life. In J. Strachey (Ed. and Trans.), The standard edition (Vol. 6). London: Hogarth Press. (Original work published 1901)
- Freud, S. (1961a). *The future of an illusion*. New York: Norton. (Original work published 1927)
- Freud, S. (1961b). Civilization and its discontents. New York: Norton. (Original work published 1930)
- Freud, S. (1963). An autobiographical study (J. Strachey, Ed. and Trans.) New York: Norton. (Original work published 1925)
- Freud, S. (1964a). New introductory lectures on psychoanalysis. In J. Strachey (Ed. and Trans.), *The standard edition* (Vol. 22, pp. 3–182). London: Hogarth Press. (Original work published 1933)
- Freud, S. (1964b). Moses and monotheism. In J. Strachey (Ed. and Trans.), The standard edition (Vol. 23, pp. 3–137). London: Hogarth Press. (Original work published 1939)
- Freud, S. (1966a). Introductory lectures on psychoanalysis (J. Strachey, Ed. and Trans.). New York: Norton. (Original work published 1915–1917)
- Freud, S. (1966b). The complete introductory lectures on psychoanalysis (J. Strachey, Ed. and Trans.). New York: Norton. (Original work published 1933)
- Freud, S. (1966c). On the history of the psycho-analytic movement. New York: Norton. (Original work published 1914)
- Freud, S. (1969). An outline of psychoanalysis (rev. ed.). New York: Norton. (Original work published 1940)
- Friedländer, M. (Trans.). (1956). Moses Maimonides: The guide for the perplexed (2nd ed.). New York: Dover.
- Friedman, H. S., Tucker, J. S., Schwartz, J. E., Tomlinson-Keasey, C., Martin, L. R.,

- Wingard, D. L., & Criqui, M. H. (1995). Psychosocial and behavioral predictors of longevity: The aging and death of the "Termites." *American Psychologist*, 50, 69–78.
- Fromm, E. (1941). Escape from freedom. New York: Holt, Rinehart & Winston.
- Furumoto, L. (1988). Shared knowledge: The Experimentalists, 1904–1929. In J. G. Morawski (Ed.), The rise of experimentation in American psychology. New Haven, CT: Yale University Press.
- Furumoto, L. (1991). From "paired associates" to a psychology of self: The intellectual odyssey of Mary Whiton Calkins. In G. A. Kimble, M. Wertheimer, & C. L. White (Eds.), Portraits of pioneers in psychology (pp. 57–72). Washington, DC: American Psychological Association.
- Furumoto, L. (1992). Joining separate spheres—Christine Ladd-Franklin, woman-scientist (1847–1930). American Psychologist, 47, 175–182.
- Galef, B. G., Jr. (1998). Edward Thorndike: Revolutionary psychologist, ambiguous biologist. *American Psychologist*, 53, 1128–1134.
- Galton, F. (1853). Narrative of an explorer in tropical South Africa. London: Murray.
- Galton, F. (1855). The art of travel. London: Murray.
- Galton, F. (1869). Hereditary genius: An inquiry into its laws and consequences. London: Macmillan.
- Galton, F. (1874). English men of science: Their nature and nurture. London: Macmillan.
- Galton, F. (1875). The history of twins as a criterion of the relative powers of nature and nurture. *Fraser's Magazine*, 92 566–576
- Galton, F. (1883). Inquiries into human faculty and its development. London: Macmillan.
- Galton, F. (1888). Co-relations and their measurement, chiefly from anthropological data. *Proceedings of the Royal Society*, 45, 135–145.
- Galton, F. (1889). Natural inheritance. London: Macmillan.
- Gardiner, P. (2002). Kierkegaard: A very short introduction. New York: Oxford University Press.
- Gardner, H. (1985). The mind's new science: A history of the cognitive revolution. New York: Basic Books.
- Garfield, S. L. (1981). Psychotherapy: A 40-year appraisal. American Psychologist, 36, 174–183.
- Gaskin, J. C. A. (1998). David Hume: Principal writings on religion. New York: Oxford University Press.
- Gay, P. (1988). Freud: A life for our time. New York: Norton.
- Gazzaniga, M. S. (1970). *The dissected brain*. New York: Appleton–Century–Crofts.
- Geary, D. C. (2005). The origin of mind: Evolution of brain, cognition, and general intelligence. Washington, DC: American Psychological Association.

- Gelfand, T., & Kerr, J. (Eds.). (1992). Freud and the history of psychoanalysis. Hillsdale, NJ: Analytic Press.
- Gendlin, E. T. (1988). Carl Rogers (1902–1987). American Psychologist, 43, 127–128.
- Gerard, D. L. (1997). Chiarugi and Pinel considered: Soul's brain/person's mind. Journal of the History of the Behavioral Sciences, 33, 381–403.
- Gergen, K. J. (1991). The saturated self: Dilemmas of identity in contemporary life. New York: Basic Books.
- Gergen, K. J. (1994). Exploring the postmodern: Perils or potentials. American Psychologist, 49, 412–416.
- Gergen, K. J. (2001). Psychological science in a postmodern context. American Psychologist, 56, 803–813.
- Gillie, O. (1977). Letter. Bulletin of the British Psychological Society, 30, 257–258.
- Glanzman, D. L. (1995). The cellular basis of classical conditioning in *Aplysia Californica*: It's less simple than you think. *Trends in Neurosciences*, 18(1), 32–35.
- Gleaves, D. H., & Hernandez, E. (1999). Recent reformulations of Freud's development and abandonment of his seduction theory: Historical/scientific clarification or a continued assault on truth? *History of Psychology*, 2, 324–354.
- Gleaves, D. H., & Hernandez, E. (2002). Wethinks the author doth protest too much: A reply to Esterson (2002). History of Psychology, 5, 92–98.
- Goddard, H. H. (1912). The Kallikak family, a study in the heredity of feeble-mindedness. New York: Macmillan.
- Goddard, H. H. (1914). Feeble-mindedness: Its causes and consequences. New York: Macmillan.
- Goddard, H. H. (1920). Human efficiency and levels of intelligence. Princeton, NJ: Princeton University Press.
- Goethe, J. W. (1952). Sorrows of young Werther. Chapel Hill: University of North Carolina Press. (Original work published 1774)
- Gold, M. (Ed.). (1999). The complete social scientist: A Kurt Lewin reader. Washington, DC: American Psychological Association.
- Goldman, S. L. (2006). Science wars: What scientists know and how they know it (24 lectures). Chantilly, VA: The Teaching Company.
- Goldsmith, M. (1934). Franz Anton Mesmer. New York: Doubleday.
- Golomb, J. (1989). Nietzsche's enticing psychology of power. Ames, IA: Iowa State University Press.
- Goodman, L. E. (1992). Avicenna. New York: Routledge.
- Goodwin, C. J. (2005). Reorganizing the Experimentalists: The origins of the Society of Experimental Psychologists. *History of Psychology*, 8, 347–361.

- Gould, S. J. (1976). Darwin and the captain. *Natural History*, 85(1), 32–34.
- Gould, S. J. (1981). The mismeasure of man. New York: Norton.
- Gould, S. J. (1991). Exaptation: A crucial tool for evolutionary psychology. *Journal of Social Issues*, 47, 43–65.
- Gould, S. J., & Lewontin, R. C. (1979). The spandrels of San Marco and the Panglossian paradigm: A critique of the adaptationist programme. Proceedings of the Royal Society of London, 205, 581–598.
- Goulet-Cazé, M.-O. (1996). Religion and the early Cynics. In R. B. Branham & M.-O. Goulet-Cazé (Eds.), The Cynics: The Cynic movement in antiquity and its legacy (pp. 47–80). Berkeley: University of California Press.
- Graebner, W. (2006). "Back-fire to lust": G. Stanley Hall, sex-segregated schooling, and the engine of sublimation. History of Psychology, 9, 236–246.
- Grane, L. (1970). Peter Abelard: Philosophy and Christianity in the Middle Ages (F. Crowley & C. Crowley, Trans). New York: Harcourt, Brace & World.
- Grayling, A. C. (1986). Berkeley: The central arguments. La Salle, IL: Open Court.
- Grayling, A. C. (2001). Wittgenstein: A very short introduction. New York: Oxford University Press.
- Green, B. F. (1992). Exposé or smear? Psychological Science, 6, 328–331.
- Greenway, A. P. (1973). The incorporation of action into associationism: The psychology of Alexander Bain. *Journal of the History of the Behavioral Sciences*, 9, 42–52.
- Gregory, J. (1991). The neoplatonists. London: Kyle Cathie.
- Gregory, R. L. (Ed.). (1987). The Oxford companion to the mind. Oxford: Oxford University Press.
- Grube, G. M. A. (Trans.). (1974). *Plato's* Republic. Indianapolis, IN: Hackett.
- Guilford, J. P. (1967). The nature of human intelligence. New York: McGraw-Hill.
- Guthrie, E. R. (1935). The psychology of learning. New York: Harper & Row.
- Guthrie, E. R. (1938). The psychology of human conflict. New York: Harper & Row.
- Guthrie, E. R. (1942). Conditioning: A theory of learning in terms of stimulus, response, and association. In N. B. Henry (Ed.), The forty-first yearbook of the National Society for the Study of Education: Pt II. The psychology of learning. Chicago: University of Chicago Press.
- Guthrie, E. R. (1952). The psychology of learning (rev. ed.). New York: Harper & Row.
- Guthrie, E. R. (1959). Association by contiguity. In S. Koch (Ed.), *Psychology: A study of a science* (Vol. 2) (pp. 158–195). New York: McGraw-Hill.

- Guthrie, E. R., & Horton, G. P. (1946). Cats in a puzzle box. New York: Rinehart.
- Guthrie, K. S. (Comp. & Trans.). (1987). The Pythagorean sourcebook and library. Grand Rapids: Phanes Press.
- Guthrie, R. V. (2000). Francis Cecil Sumner: The first African American pioneer in psychology. In G. A. Kimble & M. Wertheimer (Eds.), Portraits of pioneers in psychology (Vol. 4, pp. 181–193). Washington, DC: American Psychological Association.
- Guyer, P. (Ed.). (1992). The Cambridge companion to Kant. New York: Cambridge University Press.
- Hacker, P. M. S., (1999). Wittgenstein on human nature. New York: Routledge.
- Hadden, A. W. (Trans.). (1912). St. Augustine's "On the Trinity." In B. Rand (Ed.), The classical psychologists. Boston: Houghton Mifflin.
- Hale, N. G., Jr. (1971). Freud and the Americans: The beginnings of psychoanalysis in the United States, 1876–1917. New York: Oxford University Press.
- Hall, C. S. (1954). A primer of Freudian psychology. Cleveland: World.
- Hall, C. S., & Lindzey, G. (1978). *Theories of personality* (3rd ed.). New York: Wiley.
- Hall, G. S. (1904). Adolescence: Its psychology and its relation to physiology, anthropology, sociology, sex, crime, religion and education (Vols. 1 and 2). New York: Appleton.
- Hall, G. S. (1906). The question of coeducation. *Munsey's Magazine*, 34, 588–592.
- Hall, G. S. (1917). Jesus, the Christ, in the light of psychology. Garden City, NJ: Doubleday.
- Hall, G. S. (1922). Senescence: The last half of life. New York: Appleton.
- Hall, G. S. (1923). Life and confessions of a psychologist. New York: Appleton.
- Hall, M. B. (1994). *The scientific renaissance 1450–1630*. New York: Dover.
- Hall, M. H. (1968, July). A conversation with Abraham Maslow. *Psychology Today*, pp. 35–37, 54–57.
- Hamilton, E., & Cairns, H. (1961). Plato: The collected dialogues, including the letters. Princeton, NJ: Princeton University Press.
- Hankinson, R. J. (1995). The sceptics. New York: Routledge.
- Hannah, B. (1976). Jung, his life and work: A biographical memoir. New York: Putnam.
- Hannush, M. J. (1987). John B. Watson remembered: An interview with James B. Watson. Journal of the History of the Behavioral Sciences, 23, 137–152.
- Hardcastle, V. G. (Ed.). (1999). Where biology meets psychology: Philosophical essays. Cambridge: MIT Press.

- Harlow, H. (1949). The formation of learning sets. Psychological Review, 56, 51–65.
- Harris, B. (1979). Whatever happened to little Albert? American Psychologist, 34, 151–160.
- Harris, M. (1974). Cows, pigs, wars and witches: The riddles of culture. New York: Vintage.
- Hartley, D. (1834). Observations on man, his frame, his duty, and his expectations. London: Tegg. (Original work published 1749)
- Hartmann, H. (1958). Ego psychology and the problem of adaptation (D. Rapaport, Trans.). New York: International Universities Press. (Original work published 1939)
- Hartmann, K. E. von (1869). *Philosophie des Unbewussten* [Philosophy of the unconscious]. Berlin: Duncker.
- Hartshorne, C. (1965). Anselm's discovery: A re-examination of the ontological proof for God's existence. La Salle, IL: Open Court.
- Haugeland, J. (1985). Artificial intelligence: The very idea. Cambridge: MIT Press.
- Hayes, S. C., & Heiby, E. (1996). Psychology's drug problem: Do we need a fix or should we just say no? *American Psychologist*, 51, 198–206.
- Hayman, R. (1999). Nietzsche. New York: Routledge.
- Hearnshaw, L. S. (1979). Cyril Burt, psychologist. Ithaca, NY: Cornell University Press.
- Hearst, E. (Ed.). (1979). The first century of experimental psychology. Hillsdale, NJ: Erlbaum.
- Hebb, D. O. (1946). On the nature of fear. Psychological Review, 53, 259–276.
- Hebb, D. O. (1949). The organization of behavior: A neuropsychological theory. New York: Wiley.
- Hebb, D. O. (1955). Drives and the C.N.S. (conceptual nervous system). *Psychological Review*, 62, 243–254.
- Hebb, D. O. (1959). A neuropsychological theory. In S. Koch (Ed.), Psychology: A study of science (Vol. 1, pp. 622–643). New York: McGraw-Hill.
- Hebb, D. O. (1960). The American revolution. *American Psychologist*, 15, 735–745.
- Hebb, D. O. (1972). *Textbook of psychology* (3rd ed.). Philadelphia: Saunders.
- Hebb, D. O. (1980). [Autobiography]. In G. Lindzey (Ed.), A history of psychology in autobiography (Vol. 7). San Francisco: Freeman.
- Hegel, G. W. F. (1973). The encyclopedia of the mind (W. Wallace, Trans.). Oxford: Oxford University Press. (Original work published 1817)
- Heidbreder, E. (1933). Seven psychologies. New York: Appleton-Century.
- Heidbreder, E. (1972). Mary Whiton Calkins: A discussion. Journal of the History of the Behavioral Sciences, 8, 56–68.

- Heidegger, M. (1927). Being and time. Halle, Germany: Niemeyer.
- Henle, M. (1971a). Did Titchener commit the stimulus error? The problem of meaning in structural psychology. *Journal of the History of the Behavioral Sciences*, 7, 279–282.
- Henle, M. (Ed.). (1971b). The selected papers of Wolfgang Köhler. New York: Liveright.
- Henle, M. (1978). One man against the Nazis—Wolfgang Köhler. American Psychologist, 33, 939–944.
- Henle, M. (1985). Rediscovering Gestalt psychology. In S. Koch & D. E. Leary (Eds.), A century of psychology as science (pp. 100–120). New York: McGraw-Hill.
- Henle, M. (1986). 1879 and all that: Essays in the theory and history of psychology. New York: Columbia University Press.
- Hentoff, N. (1982, August 23). Profiles: The integrationist. *The New Yorker*, 58, 37–73.
- Herbart, J. F. (1824–1825). Psychology as a science, newly based upon experience, metaphysics, and mathematics (Vols. 1 and 2). Königsberg, Germany: Unzer.
- Herbart, J. F. (1888). Über die dunkle seite der p\u00e4dagogik (On the dark side of pedagogy). In K. Kehrback & O. Fl\u00fcgel (Eds.), Jon. Fr. Herbart's s\u00e4mtliche Werke in chronologisher reihenfolge (Vol. 3, pp. 147–154). Langensalza, Germany: Hermann Beyer und S\u00f6hne. (Original work published 1812)
- Herbert, G. B. (1989). Thomas Hobbes: The unity of scientific and moral wisdom. Vancouver: University of British Columbia Press.
- Hergenhahn, B. R. (1994). Psychology's cognitive revolution. American Psychologist, 49, 816–817.
- Hergenhahn, B. R., & Olson, M. H. (2007). An introduction to theories of personality (7th ed.). Englewood Cliffs, NJ: Prentice-Hall.
- Hergenhahn, B. R., & Olson, M. H. (2005). An introduction to theories of learning (7th ed.). Englewood Cliffs, NJ: Prentice-Hall.
- Hermans, H. J. M., Kempen, H. J. G., & Van Loon, R. J. P. (1992). The dialogical self: Beyond individualism and rationalism. *American Psychologist*, 47, 23–33.
- Heron, W. (1957, January). The pathology of boredom. Scientific American, pp. 52–56.
- Herrnstein, R. J., & Murray, C. (1994). The bell curve: Intelligence and class structure in American life. New York: Free Press.
- Hicks, R. D. (Trans.). (1991). Aristotle: De anima. Buffalo, NY: Prometheus Books.
- Hilgard, E. R. (1987). Psychology in America: A historical survey. Orlando, FL: Harcourt Brace Jovanovich.
- Hirschmüller, A. (1989). The life and work of Josef Breuer: Physiology and psychoanalysis. New York: New York University Press.

- History of Psychology (2006). G. Stanley Hall's Adolescence: A centennial reappraisal. History of Psychology, 9, entire August issue.
- Hobbes, T. (1962). Leviathan. New York: Macmillan. (Original work published 1651)
- Hoffman, E. (1988). The right to be human: A biography of Abraham Maslow. Los Angeles: Tarcher.
- Hoffman, R. R., Bringmann, W., Bamberg, M., & Klein, R. (1986). Some historical observations on Ebbinghaus. In D. Gorfein & R. Hoffman (Eds.), Memory and learning: The Ebbinghaus centennial conference. Hillsdale, NJ: Erlbaum.
- Hofstadter, R. (1955). Social Darwinism in American thought. Boston: Beacon Press.
- Hogan, J. D. (2003). G. Stanley Hall: Educator, organizer, and pioneer developmental psychologist. In G. A. Kimble & M. Wertheimer (Eds.), Portraits of pioneers in psychology (Vol. 5, pp. 19–36). Washington, DC: American Psychological Association.
- Holland, J. G. (1986). George Henry Lewes and "stream of consciousness": The first use of the term in English. South Atlantic Review, 51, 31–39.
- Hollingdale, R. J. (1969). Introduction. In F. Nietzsche, *Thus spoke Zarathustra* (R. J. Hollingdale, Trans.). (pp. 11–35). New York: Viking Press/Penguin Books.
- Hollingworth, L. S. (1914). Functional periodicity. Contributions to education, No. 69. New York: Columbia University Press.
- Hollingworth, L. S. (1920). The psychology of subnormal children. New York: Macmillan.
- Hollingworth, L. S. (1923). Special talents and defects: Their significance for education. New York: Macmillan.
- Hollingworth, L. S. (1926). Gifted children. New York: Macmillan.
- Hollingworth, L. S. (1928). The psychology of the adolescent. New York: Appleton.
- Hollingworth, L. S. (1940). Public addresses. Lancaster, PA: Science Press.
- Hollingworth, L. S. (1942). Children above 180 IQ. Yonkers, NY: World Book.
- Holloway, J. D. (2004). Louisiana grants psychologists prescriptive authority. *Monitor on Psychology*, 35, 20–21.
- Honderich, T. (1993). How free are you? The determinism problem. New York: Oxford University Press.
- Honderich, T. (Ed.). (1995). The Oxford companion to philosophy. New York: Oxford University Press.
- Hong, H. V., & Hong, E. H. (1985). Introduction. In S. Kierkegaard, *Philosophical fragments* [and] *Johannes Climacus* (H. V. Hong & E. H. Hong, Eds. and Trans.). (pp. ix–xxii). Princeton, NJ: Princeton University Press.

- Horley, J. (2001). After "The Baltimore Affair": James Mark Baldwin's life and work, 1908–1934, History of Psychology, 4, 24–33.
- Horney, K. (1937). The neurotic personality of our time. New York: Norton.
- Horney, K. (1939). New ways in psychoanalysis. New York: Norton.
- Horney, K. (1945). Our inner conflicts. New York: Norton.
- Horney, K. (1968). Self-analysis. New York: Norton. (Original work published 1942)
- Horney, K., & Kelman, H. (Ed.). (1967). Feminine psychology. New York: Norton.
- Hubben, W. (1952). Dostoevsky, Kierkegaard, Nietzsche, and Kafka. New York: Macmillan.
- Huizinga, J. (2001). Erasmus and the age of reformation. Mineola, NY: Dover. (Original work published 1924)
- Hulin, W. S. (1934). A short history of psychology. New York: Holt.
- Hull, C. L. (1920). Quantitative aspects of the evolution of concepts: An experimental study. *Psychological Monographs*, 28(123).
- Hull, C. L. (1928). Aptitude testing. Yonkers-on-Hudson, NY: World Book.
- Hull, C. L. (1933). Hypnosis and suggestibility: An experimental approach. New York: Appleton-century.
- Hull, C. L. (1943). Principles of behavior. New York: Appleton-Century.
- Hull, C. L. (1952a). Clark L. Hull. In E. G. Boring, H. S. Langfeld, H. Werner, & R. M. Yerkes (Eds.), A history of psychology in autobiography (Vol. 4, pp. 143–162). Worcester, MA: Clark University Press.
- Hull, C. L. (1952b). A behavior system. New Haven, CT: Yale University Press.
- Hull, C. L., Hovland, C. I., Ross, R. T., Hall, M., Perkins, D. T., & Fitch, F. B. (1940). Mathematicodeductive theory of rote learning. New Haven, CT: Yale University Press.
- Hulse, M. (1989). Introduction. In J. Goethe, The sorrows of young Werther (M. Hulse, Trans.) (pp. 5–19). London: Penguin Books.
- Hurvich, D. J. (1971). Christine Ladd-Franklin. In E. T. James (Ed.), Notable American women (Vol. 2). Cambridge: Harvard University Press.
- Husserl, E. (1900–1901). Logical investigations. Halle, Germany: Niemeyer.
- Innis, N. K. (1992). Tolman and Tryon: Early research on the inheritance of the ability to learn. American Psychologist, 47, 190–197.
- Innis, N. K. (1999). Edward C. Tolman's purposive behaviorism. In W. O' Donohue & R. Kitchener (Eds.). *Handbook*

- of Behaviorism (pp. 97–117). San Diego, CA: Academic Press.
- Innis, N. K. (2003). William McDougall: "A major tragedy"? In G. A. Kimble & M. Wertheimer (Eds.), Portraits of pioneers in psychology (Vol. 5, pp. 91–108). Washington, DC: American Psychological Association.
- Inwood, M. J. (1995). Enlightenment. In T. Honderich (Ed.), The Oxford companion to philosophy (pp. 236–237). New York: Oxford University Press.
- Inwood, M. J. (2000). Heidegger: A very short introduction. New York: Oxford University Press.
- Israëls, H., & Schatzman, M. (1993). The seduction theory. History of Psychiatry, 4, 23–59.
- Jackson, J. P., Jr. (1998). Creating a consensus: Psychologists, the Supreme Court, and school desegregation, 1952– 1955. Journal of Social Issues, 54, 143–177.
- Jackson, J. P., Jr. (2003). Facts, values, and policies: A comment on Howard H. Kendler (2002). History of psychology, 6, 195–202.
- Jackson, J. P., Jr. (2006). Kenneth B. Clark: The complexities of activist psychology. In D. A. Dewsbury, L. T. Benjamin Jr., & M. Wertheimer (Eds.), Portraits of pioneers in psychology (Vol. 6, pp. 273–286). Washington, DC: American Psychological Association.
- Jacobson, E. (1932). The electrophysiology of mental activities. American Journal of Psychology, 44, 677–694.
- Jacoby, R., & Glauberman, N. (Eds.). (1995). The bell curve debate: History, documents, opinions. New York: Random House.
- Jahnke, J. (1997). Physiognomy, phrenology, and non-verbal communication. In W. G. Bringmann, H. E. Lück, R. Miller, & C. E. Early (Eds.), A pictorial history of psychology (pp. 30–34). Chicago, IL: Quintessence Publishing Co.
- James, W. (1884). On some omissions of introspective psychology. Mind, 9, 1–26.
- James, W. (1902). The varieties of religious experience. New York: Longmans, Green.
- James, W. (1920). Letters. In H. James (Ed.), Letters of William James (Vols. 1 and 2). Boston: Atlantic Monthly Press.
- James, W. (1950). The principles of psychology (Vols. 1 and 2).New York: Dover. (Original work published 1890)
- James, W. (1956). The dilemma of determinism. In W. James, The will to believe and other essays in popular philosophy (pp. 145–183). New York: Dover. (Original work published 1884)
- James, W. (1962). Talks to teachers on psychology and to students on some of life's ideals. Mineola, NY: Dover. (Original work published 1899)
- James, W. (1981). Pragmatism: A new name for some old ways of thinking. Indianapolis: Hackett. (Original work published 1907)

- James, W. (1985). Psychology: The briefer course (G. Allport, Ed.). South Bend, IN: University of Notre Dame Press. (Original work published 1892)
- Janaway, C. (1994). Schopenhauer. New York: Oxford University Press.
- Janaway, C. (2002). Schopenhauer: A very short introduction. New York: Oxford University Press.
- Janet, P. (1925). Psychological healing: A historical and clinical study, Vol. 1. (E. Paul and C. Paul, Trans.). New York: Macmillan.
- Jankowicz, A. D. (1987). Whatever happened to George Kelly? Applications and implications. American Psychologist, 42, 481–487.
- Jennings, J. L. (1986). Husserl revisited: The forgotten distinction between psychology and phenomenology. American Psychologist, 41, 1231–1240.
- Jensen, A. R. (2000). Charles E. Spearman: The discoverer of g. In G. A. Kimble & M. Wertheimer (Eds.), Portraits of pioneers in psychology (Vol. 4, pp. 93–111). Washington, DC: American Psychological Association.
- Johnson, D. M., & Erneling, C. E. (Eds.). (1997). The future of the cognitive revolution. New York: Oxford University Press.
- Johnson, M. G., & Henley, T. B. (Eds.). (1990). Reflections on the principles of psychology: William James after a century. Hillsdale, NJ: Erlbaum.
- Johnson, R. C., McClearn, G. E., Yuen, S., Nagoshi, C. T., Ahern, F. M., & Cole, R. E. (1985). Galton's data a century later. American Psychologist, 40, 875–892.
- Johnston, E. B. (2001). The repeated reproduction of Barlett's Remembering. History of Psychology, 4, 341–366.
- Joncich, G. (1968). The sane positivist: A biography of Edward L. Thorndike. Middletown, CT: Wesleyan University Press.
- Jones, E. (1953, 1955, 1957). The life and work of Sigmund Freud (Vols. 1–3). New York: Basic Books.
- Jones, M. C. (1924). A laboratory study of fear: The case of Peter. Pedagogical Seminary, 31, 308–315.
- Jones, M. C. (1974). Albert, Peter and John B. Watson. American Psychologist, 29, 581–583.
- Jones, R. A. (1987). Psychology, history, and the press: The case of William McDougall and the New York Times. American Psychologist, 42, 931–940.
- Jones, W. H. S. (1923). *Hippocrates* (Vols. 1 and 2). New York: Putnam.
- Jourard, S. M. (1974). Healthy personality: An approach from the viewpoint of humanistic psychology. New York: Macmillan.
- Jowett, B. (Trans.). (1942). Plato. Rosyln, NY: Black.
- Jowett, B. (Trans.). (1986). The "Republic of Plato." Buffalo, NY: Prometheus Books.
- Jowett, B. (Trans.). (1988). Plato: Euthyphro, apology, crito, and phaedo. Amherst, NY: Prometheus Books.

- Joynson, R. B. (1989). The Burt affair. London: Routledge.
- Jung, C. G. (1928). Contributions to analytical psychology. New York: Harcourt Brace Jovanovich.
- Jung, C. G. (1933). Modern man in search of a soul. New York: Harcourt Brace Jovanovich.
- Jung, C. G. (1953). Two essays on analytic psychology. In The collected works of C. G. Jung (Vol. 7). Princeton, NJ: Princeton University Press. (Original work published 1917)
- Jung, C. G. (1963). Memories, dreams, reflections. New York: Pantheon Books.
- Jung, C. G. (1971). Psychological types. In H. Read, M. Fordham, G. Adler, & W. McGuire (Eds.), The collected works of C. G. Jung (Vol. 6). Princeton, NJ: Princeton University Press. (Original work published 1921)
- Kagan, J. (1980, December). Jean Piaget's contributions. Phi Delta Kappan, pp. 245–246.
- Kagan, J. (1994). Galen's prophecy: Temperament in human nature. New York: Basic Books.
- Kalat, J. W. (1998). Biological psychology (6th ed.). Pacific Grove, CA: Brooks/Cole.
- Kamin, L. J. (1974). The science and politics of IQ. New York: Wiley.
- Kamin, L. J. (1977). Letter. Bulletin of the British Psychological Society, 30, 259.
- Kahl, R. K. (Ed.). (1971). Selected writings of Hermann von Helmholtz. Middletown, CT: Wesleyan University Press.
- Kant, I. (1912). Anthropologie in pragmatischer hinsicht [Anthropology from a pragmatic point of view]. Berlin: Bresser Cassiner. (Original work published 1798)
- Kant, I. (1977). Prolegomena to any future metaphysics (J. W. Ellington, Trans.). Indianapolis: Hackett Publishing. (Original work published 1783)
- Kant, I. (1981). Grounding for the metaphysics of morals (J. W. Ellington, Trans.). Indianapolis, IN: Hackett Publishing Company. (Original work published 1785)
- Kant, I. (1990). Critique of pure reason (J. M. D. Meiklejon, Trans.). Buffalo, NY: Prometheus Books. (Original work published 1781)
- Kant, I. (1994). The one possible basis for a demonstration of the existence of God (G. Treash, Trans.). Lincoln, NE: University of Nebraska Press. (Original work published 1763)
- Kant, I. (1996). Critique of practical reason (T. K. Abbott, Trans.). Amherst, NY: Prometheus Books. (Original work published 1788)
- Karier, C. J. (1986). Scientists of the mind: Intellectual founders of modern psychology. Chicago: University of Illinois Press.
- Karon, B. P., & Teixeria, M. A. (1995). "Guidelines for the Treatment of Depression in Primary Care" and the APA response. American Psychologist, 50, 453–454.

- Kaufmann, W. (Trans.). (1961). Goethe's "Faust." New York: Doubleday.
- Kaufmann, W. (Ed. and Trans.). (1982). The portable Nietzsche. New York: Viking Press/Penguin Books.
- Kazdin, A. E. (1989). Behavior modification in applied settings (4th ed.). Pacific Grove, CA: Brooks/Cole.
- Kazdin, A. E., & Wilson, G. T. (1978). Evaluation of behavior therapy. Cambridge: Bollinger.
- Keller, F. S. (1973). The definition of psychology (2nd ed.). Englewood Cliffs, NJ: Prentice-Hall.
- Kelly, E. L. (1961). Clinical psychology—1960: Report of survey findings. American Psychological Association, Division of Clinical Psychology Newsletter, 14(1), 1–11.
- Kelly, G. A. (1955). The psychology of personal constructs: A theory of personality (Vols. 1 and 2). New York: Norton.
- Kelly, G. A. (1964). The language of hypotheses: Man's psychological instrument. *Journal of Individual Psychology*, 20, 137–152.
- Kelly, G. A. (1969). The autobiography of a theory. In B. Maher (Ed.), Clinical psychology and personality: Selected papers of George Kelly. New York: Wiley.
- Kelly, G. A. (1970). A brief introduction to person construct theory. In D. Bannister (Ed.), Perspectives in personal construct theory. New York: Academic Press.
- Kemp, S. (1998). Medieval theories of mental representation. History of Psychology, 1, 275–288.
- Kemp, V. H. (1992). G. Stanley Hall and the Clark School of Religious Psychology. American Psychologist, 47, 290–298.
- Kendler, H. H. (1987). Historical foundations of modern psychology. Chicago: Dorsey Press.
- Kendler, H. H. (2002). A personal encounter with psychology (1937–2002). History of Psychology, 5, 52–84.
- Kendler, H. H. (2003). Political goals versus scientific truths: A response to Jackson (2003). History of Psychology, 6, 203– 207.
- Kendler, T. W., & Kendler, H. H. (1959). Reversal and non-reversal shifts in kindergarten children. *Journal of Experimental Psychology*, 58, 56–60.
- Kenkel, M. B., DeLeon, P. H., Albino, J. E. N., & Porter, N. (2003). Challenges to professional psychology education in the 21st century: Response to Peterson. *American Psychologist*, 58 801–805.
- Kennedy, G. (Trans.). (1972). Gorgias. In R. W. Sprague (Ed.), The older Sophists (pp. 30–67). Columbia: University of South Carolina Press.
- Kenny, A. (Ed. and Trans.). (1970). Descartes's philosophical letters. Oxford: Clarendon Press.
- Keppel, B. (2002). Kenneth B. Clark in patterns of American culture. American Psychologist, 57, 29–37.

- Keyes, C. L. M., & Haidt, J. (Eds.). (2003). Flourishing: Positive psychology and the life well-lived. Washington, DC: American Psychological Association.
- Keyes, C. L. M. (2007). Promoting and protecting mental health as flourishing: A complementary strategy for improving national mental health. *American Psychologist*, 62, 95–108.
- Kierkegaard, S. (1985). Philosophical fragments [and] Johannes Climacus (H. V. Hong & E. H. Hong, Trans.). Princeton, NJ: Princeton University Press. (Original work published 1844)
- Kierkegaard, S. (1990). For self-examination [and] judge for yourselves (H. V. Hong & E. H. Hong, Trans.). Princeton, NJ: Princeton University Press. (Original work published 1851)
- Kimble, G. A. (1984). Psychology's two cultures. American Psychologist, 39, 833–839.
- Kimble, G. A. (1994). A frame of reference for psychology. *American Psychologist*, 49, 510–519.
- Kimble, G. A. (1996a). Ivan Mikhailovich Sechenov: Pioneer in Russian reflexology. In G. A. Kimble, C. A. Boneau, & M. Wertheimer (Eds.), Portraits of pioneers in psychology (Vol. 2, pp. 33–45). Washington, DC: American Psychological Association.
- Kimble, G. A. (1996b). *Psychology: The hope of a science*. Cambridge: MIT Press.
- Kimble, G. A. (1999). Functional behaviorism: A plan for unity in psychology. American Psychologist, 54, 981–988.
- Kimble, M. M. (2000). From "Anna O." to Bertha Pappenheim: Transforming private pain into public action. *History of Psychology*, 3, 20–43.
- King, J. E. (Trans). (1927). Cicero's Tusculan disputations. London: Heinemann.
- King, P., & Steiner, R. (Eds.). (1991). The Freud-Klein controversies: 1941–1945. London: Tavistock/Routledge.
- Kinget, G. M. (1975). On being human: A systematic view. New York: Harcourt Brace Jovanovich.
- Kirsch, I. (1978). Demonology and the rise of science: An example of the misperception of historical data. *Journal of the History of the Behavioral Sciences*, 14, 149–157.
- Kirsch, I., & Lynn, S. J. (1995). The altered state of hypnosis: Changes in the theoretical landscape. *American Psychologist*, 50, 846–858.
- Kirsch, T. B. (2000). The Jungians: A comparative and historical perspective. Philadelphia: Routledge.
- Kirschenbaum, H. (1979). On becoming Carl Rogers. New York: Dell.
- Klarman, M. (1994). How "Brown" changed race relations: The backlash thesis. *Journal of American History*, 81, 81–118.

- Klein, D. F., Gittelman, R., Quitkin, F., & Rifkin, A. (1980). Diagnosis and drug treatment of psychiatric disorders: Adults and children (2nd ed.). Baltimore: Williams & Wilkins.
- Klein, M. (1932). The psycho-analysis of children. New York: Norton.
- Klemke, E. D., Hollinger, R., & Kline, A. D. (Eds.). (1988). Introductory readings in the philosophy of science. Buffalo, NY: Prometheus Books.
- Koch, S. (Ed.). (1959). Psychology: A study of science (Vol. 3). New York: McGraw-Hill.
- Koch, S. (1981). The nature and limits of psychological knowledge: Lessons of a century qua "science." American Psychologist, 36, 257–269.
- Koch, S. (1993). "Psychology" or "the psychological studies"? American Psychologist, 48, 902–904.
- Koffka, K. (1922). Perception: An introduction to Gestalt-Theorie. *Psychological Bulletin*, 19, 531–585.
- Koffka, K. (1924). The growth of the mind: An introduction to child psychology (R. M. Ogden, Trans.). New York: Harcourt, Brace.
- Koffka, K. (1963). Principles of Gestalt psychology. New York: Harcourt, Brace & World. (Original work published 1935)
- Köhler, W. (1920). Die physischen Gestalten in Rule und im stationären Zustand [Static and stationary physical configurations]. Braunschweig, Germany: Vieweg.
- Köhler, W. (1925). The mentality of apes. London: Routledge & Kegan Paul. (Original work published 1917)
- Köhler, W. (1940). Dynamics in psychology. New York: Liveright.
- Köhler, W. (1966). The place of value in a world of facts. New York: Liveright. (Original work published 1938)
- Köhler, W. (1969). The task of Gestalt psychology. Princeton, NJ: Princeton University Press.
- Köhler, W. (1970). Gestalt psychology: An introduction to new concepts in modern psychology. New York: Liveright. (Original work published 1929)
- Kohout, J. (2001). Who's earning those psychology degrees? Monitor on Psychology, 31, 42.
- Korn, J. H., Davis, R., & Davis, S. F. (1991). Historians' and chairpersons' judgments on eminence among psychologists. American Psychologist, 46, 789–792.
- Kousoulas, D. G. (1997). The first Christian emperor: The life and times of Constantine the Great. Danbury, CT: Rutledge Books.
- Kramer, H., & Sprenger, J. (1971). The malleus maleficarum (M. Summers, Trans.). New York: Dover. (Original work published 1487)
- Krueger, D. (1996). The bawdy and society: The shamelessness of Diogenes in Roman imperial culture. In R. B.

- Branham & M.-O. Goulet-Cazé (Eds.), *The Cynics: The Cynic movement in antiquity and its legacy* (pp. 222–239). Berkeley, CA: University of California Press.
- Kuhn, T. S. (1957). The Copernican revolution: Planetary astronomy in the development of Western thought. New York: MJF Books.
- Kuhn, T. S. (1962). The structure of scientific revolutions. Chicago: University of Chicago Press.
- Kuhn, T. S. (1970). The structure of scientific revolutions (2nd ed.). Chicago: University of Chicago Press.
- Kuhn, T. S. (1996). The structure of scientific revolutions (3rd ed.). Chicago: University of Chicago Press.
- Kuhn, T. S. (2000a). The road since Structure. In J. Conant & J. Haugeland (Eds.). Thomas S. Kuhn: The road since Structure (pp. 105–120). Chicago: University of Chicago Press.
- Kuhn, T. S. (2000b). The trouble with the historical philosophy of science. In J. Conant & J. Haugeland (Eds.). Thomas S. Kuhn: The road since Structure (pp. 90–104). Chicago: University of Chicago Press.
- Külpe, O. (1909). Outlines of psychology: Based upon the results of experimental investigation (3rd ed.). New York: Macmillan. (Original work published 1893)
- Kurtz, P. (1992). The new skepticism: Inquiry and reliable knowledge. Buffalo, NY: Prometheus Books.
- Kutchins, H. & Kirk, S. A. (1997). Making us crazy: DSM: The psychiatric bible and the creation of mental disorders. New York: Free Press.
- Lachman, R., Lachman, J. L., & Butterfield, E. C. (1979).
 Cognitive psychology and information processing. Hillsdale, NJ:
 Erlbaum.
- Ladd, G. T., & Woodworth, R. S. (1911). Elements of physiological psychology. New York: Scribner.
- Lafleur, L. J. (1956). Introduction to Descartes's "Discourse on Method." Indianapolis: Bobbs-Merrill.
- Lal, S. (2002). Giving children security: Mamie Phipps Clark and the racialization of child psychology. *American Psychologist*, 57, 20–28.
- Lamarck, J. B. (1914). Philosophie zoologique [Zoological philosophy] (H. Elliot, Trans.). London: Macmillan. (Original work published 1809)
- La Mettrie, J. O. de. (1912). L'homme machine [Man a machine] (M. W. Calkins, Trans.). La Salle, IL: Open Court. (Original work published 1748)
- Land, E. H. (1964). The retinex. American Scientist, 52, 247-264.
- Land, E. H. (1977). The retinex theory of color vision. Scientific American, 237(6), 108–128.
- Langan, T. (1961). The meaning of Heidegger: A critical study of an existentialist phenomenology. New York: Columbia University Press.

- Larson, C. A. (1979). Highlights of Dr. John B. Watson's career in advertising. *Journal of Industrial/Organizational Psychology*, 16, 3.
- Larson, E. J. (2001). The theory of evolution: A history of controversy (12 lectures). Chantilly, VA: The Teaching Company.
- Lashley, K. S. (1915). The acquisition of skill in archery. Papers from the Department of Marine Biology of the Carnegie Institution of Washington, 7, 105–128.
- Lashley, K. S. (1923). Behavioristic interpretation of consciousness. Psychological Review, 30, 237–272, 329–353.
- Lashley, K. S. (1929). Brain mechanisms and intelligence. Chicago: University of Chicago Press.
- Lashley, K. S. (1950). In search of the engram. Symposia of the Society for Experimental Biology, 4, 454–482.
- Lashley, K. S. (1951). The problem of serial order in behavior. In L. Jeffress (Ed.), Cerebral mechanisms in behavior. New York: Wiley.
- Lashley, K. S., Chow, K. L., & Semmes, J. (1951). An examination of the electrical field theory of cerebral integration. Psychological Review, 40, 175–188.
- Leahey, T. H. (1981). The mistaken mirror: On Wundt's and Titchener's psychologies. *Journal of the History of the Behavioral Sciences*, 17, 273–282.
- Leahey, T. H. (1992). The mythical revolutions of American psychology. American Psychologist, 47, 308–318.
- Leahey, T. H. (2000). A history of psychology: Main currents in psychological thought (5th ed.). Englewood Cliffs, NJ: Prentice-Hall.
- Leary, D. E. (1982). The fate and influence of John Stuart Mill's proposed science of ethology. *Journal of the History of Ideas*, 43, 153–162.
- Lehman, D. R., Lempert, R. O., & Nisbett, R. E. (1988). The effects of graduate training on reasoning: Formal discipline and thinking about everyday-life events. *American Psychologist*, 43, 431–442.
- Leibniz, G. W. (1982). New essays on human understanding (P. Remnant & J. Bennett, Eds. and Trans.). Cambridge: Cambridge University Press. (Original work published 1765)
- Leitenberg, H. (Ed.). (1976). Handbook of behavior modification and behavior therapy. Englewood Cliffs, NJ: Prentice-Hall.
- Leitner, L. (1984). The terrors of cognition. In D. Bannister (Ed.), Further perspectives in personal construct theory. New York: Academic Press.
- Levant, R. F., & Schlien, J. M. (Eds.). (1984). Client-centered therapy and the person-centered approach: New directions in theory, research, and practice. New York: Praeger.
- Levy, J. (1985, May). Right brain, left brain: Fact and fiction. *Psychology Today*, pp. 38–39, 42–44.

- Lewes, G. H. (1880). *Problems of life and mind*. Boston: Houghton, Osgood.
- Lewin, K. (1935). A dynamic theory of personality: Selected papers. New York: McGraw-Hill.
- Lewin, K. (1997). Resolving social conflicts and Field theory in social science. Washington, DC: American Psychological Association. (Original works published 1948 and 1951, respectively)
- Lewin, K., Lippitt, R., & White, R. K. (1939). Patterns of aggressive behavior in experimentally created "social climates." *Journal of Social Psychology*, 10, 271–299.
- Ley, R. (1990). A whisper of espionage: Wolfgang Köhler and the apes of Tenerife. Garden City, NY: Avery.
- Libbrecht, K., & Quackelbeen, J. (1995). On the early history of male hysteria and psychic trauma: Charcot's influence on Freudian thought. *Journal of the History of the Behavioral Sciences*, 31, 370–384.
- Lieblich, A., McAdams, D. P., & Josselson, R. (Eds.). (2004).Healing plots: The narrative basis of psychotherapy.Washington, DC: American Psychological Association.
- Lippman, W. (1923, January 3). The great confusion. New Republic, pp. 145–146.
- Lloyd, G. E. R. (Ed.). (1978). Hippocratic writings (J. Chadwick, W. N. Mann, I. M. Lonie, and E. T. Withington, Trans.). New York: Penguin Books.
- Locke, J. (1974). An essay concerning human understanding (A. D. Woozley, Ed.). New York: New American Library. (Original work published 1706)
- Locke, J. (2000). Some thoughts concerning education. J. W. Yolton & J. S. Yolton (Eds.). New York: Oxford University Press. (Original work published 1693)
- Loftus, E. (1993). The reality of repressed memories. *American Psychologist*, 48, 518–537.
- Loftus, E. (1994). The repressed memory controversy. American Psychologist, 49, 443–445.
- Loftus, E. (2003). Make-believe memories. *American Psychologist*, 58, 867–873.
- Loftus, E. (2007). Elizabeth F. Loftus. In G. Lindzey & W. M. Runyan (Eds.), A history of psychology in autobiography (Vol. 9, pp. 199–224). Washington, DC: American Psychological Association.
- Loftus, E., & Ketcham, K. (1994). The myth of repressed memory: False memories and allegations of sexual abuse. New York: St. Martin's Press.
- Long, A. A. (1996). The Socratic tradition: Diogenes, Crates, and hellinistic ethics. In R. B. Branham & M.-O. Goulet-Cazé (Eds.), The Cynics: The Cynic movement in antiquity and its legacy (pp. 28–46). Berkeley, CA: University of California Press.

- Lopez, S. J., & Snyder, C. R. (Eds.). (2003). Positive psychological assessment: A handbook of models and measures. Washington, DC: American Psychological Association.
- Lorion, R. P. (1996). Applying our medicine to the psychopharmacology debate. American Psychologist, 51, 219–224.
- Losee, J. (2001). A historical introduction to the philosophy of science (4th ed.). New York: Oxford University Press.
- Lovett, B. J. (2006). The new history of psychology: A review and critique. History of Psychology, 9, 17–37.
- Lowry, R. J. (1979). *The journals of A. H. Maslow* (Vols. 1 and 2). Pacific Grove, CA: Brooks/Cole.
- Luddy, A. J. (1947). The case of Peter Abelard. Westminster, MD: Newman Bookshop.
- Lundin, R. W. (1991). Theories and systems of psychology (4th ed.). Lexington, MA: Heath.
- Maccoby, H. (1986). The mythmaker: Paul and the invention of Christianity. New York: Harper Collins.
- Mach, E. (1914). Contributions to the analysis of sensations. La Salle, IL: Open Court. (Original work published 1886)
- Mach, E. (1960). The science of mechanics: A critical and historical account of its development (T. J. McCormack, Trans.). La Salle, IL: Open Court. (Original work published 1883)
- MacLeod, R. B. (1975). *The persistent problems of psychology*. Pittsburgh: Duquesne University Press.
- Madigan, S., & O'Hara, R. (1992). Short-term memory at the turn of the century: Mary Whiton Calkins's memory research. American Psychologist, 47, 170–182.
- Magee, B. (1997). The philosophy of Schopenhauer (rev. ed.). New York: Oxford University Press.
- Maher, B. A., & Maher, W. B. (1985). Psychopathology: II. From the eighteenth century to modern times. In G. A. Kimble & K. Schlesinger (Eds.), Topics in the history of psychology (Vol. 2, pp. 295–329). Hillsdale, NJ: Erlbaum.
- Maher, W. B., & Maher, B. A. (1985). Psychopathology: I. From ancient times to the eighteenth century. In G. A. Kimble & K. Schlesinger (Eds.), *Topics in the history of psychology* (Vol. 2, pp. 251–294). Hillsdale, NJ: Erlbaum.
- Mahoney, M. J. (1991). Human change processes: The scientific foundations of psychotherapy. New York: Basic Books.
- Malcolm, N. (2001). Ludwig Wittgenstein: A memoir. New York: Oxford University Press.
- Malthus, T. (1914). Essay on the principle of population. New York: Dutton. (Original work published 1798)
- Mancuso, J. C., & Adams-Webber, J. R. (Eds.). (1982). The construing person. New York: Praeger.
- Marrow, A. J. (1969). The practical theorist: The life and work of Kurt Lewin. New York: Basic Books.
- Marshall, M. E. (1969). Gustav Fechner, Dr. Mises, and the comparative anatomy of angels. *Journal of the History of the Behavioral Sciences*, 5, 39–58.

- Martin, S. (1994, October). Music lessons enhance spatial reasoning skill. APA Monitor, 25, 5.
- Martineau, H. (1893). The positive philosophy of Auguste Comte (Vol. 1). London: Kegan Paul, Trench, Trubner. (Original work published 1853)
- Marty, M. (2004). Martin Luther. New York: Viking Penguin.
- Marx, M. H., & Goodson, F. E. (1976). Theories in contemporary psychology (2nd ed.). New York: Macmillan.
- Maslow, A. H. (1943). A theory of human motivation. *Psychological Review*, 50, 370–396.
- Maslow, A. H. (1966). *The psychology of science: A reconnaissance*. South Bend, IN: Gateway Editions.
- Maslow, A. H. (1968). Toward a psychology of being (2nd ed.). New York: Van Nostrand Reinhold.
- Maslow, A. H. (1969). The farther reaches of human nature. *Journal of Transpersonal Psychology*, 1, 1–9.
- Maslow, A. H. (1970). *Motivation and personality* (2nd ed.). New York: Harper & Row. (Original work published 1954)
- Maslow, A. H. (1971). The farther reaches of human nature. New York: Penguin Books.
- Maslow, A. H. (1987). *Motivation and personality* (3rd ed.). New York: Harper & Row. (Original work published 1954)
- Masson, J. M. (1984). The assault on truth: Freud's suppression of the seduction theory. New York: Farrar, Straus, and Giroux.
- Masson, J. M. (Trans. & Ed.). (1985). The complete letters of Sigmund Freud to Wilhelm Fliess. Cambridge: Harvard University Press.
- Masters, J. C., Burish, T. G., Hollon, S. D., & Rimm, D. C. (1987). Behavior therapy: Techniques and empirical findings (3rd ed.). Orlando, FL: Harcourt Brace Jovanovich.
- Masterton, R. R. (1998). Charles Darwin: Father of evolutionary psychology. In G. A. Kimble &
 M. Wertheimer (Eds.), Portraits of pioneers in psychology (Vol. 3, pp. 17–29). Washington, DC: American Psychological Association.
- Matarazzo, J. D. (1985). Psychotherapy. In G. A. Kimble & K. Schlesinger (Eds.), Topics in the history of psychology (Vol. 1, pp. 219–250). Hillsdale, NJ: Erlbaum.
- Matarazzo, J. D. (1987). There is one psychology, no specialties, but many applications. *American Psychologist*, 42, 893–903.
- May, R. (1939). The art of counseling: How to give and gain mental health. New York: Abingdon-Cokesbury.
- May, R. (1940). The springs of creative living: A study of human nature and God. New York: Abingdon-Cokesbury.
- May, R. (1950). The meaning of anxiety. New York: Ronald Press
- May, R. (1953). Man's search for himself. New York: Norton.
- May, R. (Ed.). (1961). Existential psychology. New York: Random House.

- May, R. (1967). Psychology and the human dilemma. New York: Van Nostrand.
- May, R. (1969). Love and will. New York: Norton.
- May, R. (1972). Power and innocence: A search for the sources of violence. New York: Norton.
- May, R. (1973). Paulus: Reminiscences of a friendship. New York: Harper & Row.
- May, R. (1975). The courage to create. New York: Norton.
- May, R. (1981). Freedom and destiny. New York: Norton.
- May, R. (1983). The discovery of being: Writings in existential psychology. New York: Norton.
- May, R. (1991). The cry for myth. New York: Norton.
- May, R., Angel, E., & Ellenberger, H. F. (Eds.). (1958). Existence: A new dimension in psychiatry and psychology. New York: Basic Books.
- Mayer, S. J. (2005). The early evolution of Jean Piaget's clinical method. History of Psychology, 8, 362–382.
- Mayr, E. (1994). The advance of science and scientific revolutions. *Journal of the History of the Behavioral Sciences*, 30, 328–334.
- McAdams, D. P. (2006). The redemptive self: Stories Americans live by. New York: Oxford University Press.
- McAdams, D. P., & Pals, J. F. (2006). A new big five: Fundamental principles for an integrative science of personality. *American Psychologist*, 61, 204–217.
- McCarthy, R. A., & Warrington, E. K. (1990). Cognitive neuropsychology: A clinical introduction. San Diego, CA: Academic Press.
- McClelland, J. L., Rumelhart, D. E., & Hinton, G. E. (1992). The appeal of parallel distributed processing. In B. Beakley & P. Ludlow (Eds.), *The philosophy of mind: Classical problems/contemporary issues* (pp. 269–288). Cambridge: MIT Press.
- McCulloch, W. S., & Pitts, W. (1943). A logical calculus of the ideas immanent in nervous activity. *Bulletin of Mathematical Biophysics*, 5, 115–133.
- McDougall, W. (1905). Physiological psychology. London: Dent.
- McDougall, W. (1908). An introduction to social psychology. London: Methuen.
- McDougall, W. (1912). Psychology: The study of behavior. London: Williams & Norgate.
- McDougall, W. (1923). Outline of psychology. New York: Scribner.
- McDougall, W. (2003). An introduction to social psychology (23rd ed.). Mineola, NY: Dover. (Original work published 1936)
- McInerny, R. (1990). A first glance at St. Thomas Aquinas: A handbook for peeping Thomists. South Bend, IN: University of Notre Dame Press.
- McLeish, K. (1999). Aristotle. New York: Routledge.

- McLeod, J. (1997). Narrative and psychotherapy. London: Sage.
- McReynolds, P. (1987). Lightner Witmer: Little-known founder of clinical psychology. American Psychologist, 42, 849–858.
- McReynolds, P. (1996). Lightner Witmer: A centennial tribute. American Psychologist, 51, 237–240.
- McReynolds, P. (1997). Lightner Witmer: His life and times. Washington, DC: American Psychological Association.
- Medawar, P. (1985). *The limits of science*. New York: Oxford University Press.
- Meehl, P. (1971). A scientific, scholarly, nonresearch doctorate for clinical practitioners: Arguments pro and con. In R. Holt (Ed.), New Horizons for Psychotherapy (pp. 37–81). New York: International Universities Press.
- Mill, J. S. (1874). A system of logic, ratiocinative and inductive, being a connected view of the principles of evidence, and the methods of scientific investigation (8th ed.). New York: Harper & Brothers. (Original work published 1843)
- Mill, J. S. (Ed.). (1967). Analysis of the phenomena of the human mind by James Mill (Vol. 1). New York: Augustus M. Kelly, Publishers. (Original work published 1869)
- Mill, J. S. (1969). *Autobiography*. Boston: Houghton Mifflin. (Original work published 1873)
- Mill, J. S. (1979). *Utilitarianism*. Indianapolis, IN: Hackett Publishing Company. (Original work published 1861)
- Mill, J. S. (1986). The subjection of women. Buffalo, NY: Prometheus Books. (Original work published 1861)
- Mill, J. S. (1988). The logic of the moral sciences. La Salle, IL: Open Court. (Original work published 1843)
- Miller, E. F. (1971). Hume's contribution to behavioral science. Journal of the History of the Behavioral Sciences, 7, 154–168.
- Miller, G. A. (1956). The magical number seven, plus or minus two: Some limits on our capacity for processing information. *Psychological Review*, 63, 81–97.
- Miller, G. A. (1962a). Some psychological studies of grammar. *American Psychologist*, 17, 748–762.
- Miller, G. A. (1962b). Psychology: The science of mental life. New York: Harper & Row.
- Miller, G. A. (1969). Psychology as a means of promoting human welfare. *American Psychologist*, 24, 1063–1075.
- Miller, G. A., Galanter, E., & Pribram, K. H. (1960). *Plans and the structure of behavior*. New York: Holt.
- Miller, N. E. (1944). Experimental studies of conflict. In J. M. Hunt (Ed.), Personality and Behavior Disorders (Vol. 1). New York: Ronald Press.
- Miller, N. E. (1959). Liberalization of basic S–R concepts: Extensions to conflict behavior, motivation, and social learning. In S. Koch (Ed.), *Psychology: A study of a science* (Vol. 2, pp. 196–292). New York: McGraw-Hill.

- Miller, N. E. (1964). Some implications of modern behavior theory for personality change and psychotherapy. In P. Worchel & D. Bryne (Eds.), *Personality change*. New York: Wiley.
- Minsky, M., & Papert, S. (1969). Perceptrons: An introduction to computational geometry. Cambridge, MA: MIT Press.
- Minton, H. L. (1988). Lewis M. Terman: Pioneer in psychological testing. New York: New York University Press.
- Moles, J. L. (1996). Cynic cosmopolitanism. In R. B. Branham & M.-O. Goulet-Cazé (Eds.), The Cynics: The Cynic movement in antiquity and its legacy (pp. 105–120). Berkeley: University of California Press.
- Moltz, H. (1957). Latent extinction and the fractional anticipatory response mechanism. *Psychological Review*, 64, 229–241.
- Monte, C. F. (1975). Psychology's scientific endeavor. New York: Praeger.
- Mora, G. (1959). Vincenzo Chiarugi (1759–1820) and his psychiatric reform in Florence in the late eighteenth century. *Journal of the History of Medicine*, 14.
- Morgan, C. L. (1894). An introduction to comparative psychology. London: Scott.
- Morgan, C. L. (1900). Animal life and intelligence (revised as Animal behavior). London: Edward Arnold. (Original work published 1891)
- Morris, J. B., & Beck, A. T. (1974). The efficacy of antidepressant drugs: A review of research (1958–1972). Archives of General Psychiatry, 30, 667–674.
- Mossner, E. C. (Ed.). (1969). David Hume: A treatise of human nature. New York: Viking Press/Penguin Books. (Original work published 1739–1740)
- Müller, J. (1842). Handbuch der Physiologie des Menschen [Handbook of human physiology] (Vols. 1 and 2). London: Taylor and Walton. (Original work published 1833–1840)
- Muñoz, R. F., Hollon, S. D., McGrath, E., Rehm, L. P., & Vander Bos, G. R. (1994). On the AHCPR depression in primary care guidelines: Further considerations for practitioners. *American Psychologist*, 49, 42–61.
- Münsterberg, H. (1888). Voluntary action. Freiburg, Germany: Mohr.
- Münsterberg, H. (1900). *Grundzüge der Psychologie* [Basics of psychology]. Leipzig, Germany: Barth.
- Münsterberg, H. (1904). *The Americans* (E. B. Holt, Trans.). New York: McClure, Phillips.
- Münsterberg, H. (1908). On the witness stand. New York: Clark Boardman.
- Münsterberg, H. (1909). Psychotherapy. New York: Moffat, Yard.
- Münsterberg, H. (1910). American problems. New York: Moffat, Yard.

- Münsterberg, H. (1912). Vocation and learning. St. Louis: People's University.
- Münsterberg, H. (1913). Psychology and industrial efficiency. New York: Houghton Mifflin.
- Murphy, G., & Ballou, R. O. (Eds.). (1973). William James on physical research. Clifton, NJ: Augustus M. Kelley-Publishers. (Original work published 1960)
- Murray, B. (2000, January). The degree that almost wasn't: The PsyD comes of age. APA Monitor, 31, 52–54.
- Murray, D. J. (1995). Gestalt psychology and the cognitive revolution. New York: Harvester Wheatsheaf.
- Murray, G. (1955). Five stages of Greek religion. New York: Doubleday.
- Myers, C. R. (1970). Journal citations and scientific eminence in psychology. American Psychologist, 25, 1041–1048.
- Myers, G. E. (1986). William James: His life and thoughts. New Haven, CT: Yale University Press.
- Neimeyer, G. J., & Hudson, J. E. (1984). Couples' constructs: Personal systems in marital satisfaction. In D. Bannister (Ed.), Further perspectives in personal construct theory. New York: Academic Press.
- Neimeyer, R. A. (1984). Toward a personal construct conceptualization of depression and suicide. In F. R. Epting & R. A. Neimeyer (Eds.), Personal meanings of death: Applications of personal construct theory to clinical practice (pp. 127–173). New York: McGraw-Hill.
- Neimeyer, R. A., & Jackson, T. T. (1997). George A. Kelly and the development of personal construct theory. In W. G. Bringmann, H. E. Lück, R. Miller, & C. E. Early (Eds.), A pictorial history of psychology (pp. 364–372). Carol Stream, IL: Quintessence.
- Neimeyer, R. A., & Neimeyer, G. J. (1985). Disturbed relationships: A personal construct view. In E. Button (Ed.), Personal construct theory and mental health: Theory, research, and practice. Beckenham, England: Croom Helm.
- Neisser, U. (1967). Cognitive psychology. New York: Appleton-Century-Crofts.
- Neisser, U. (1976). Cognition and reality: Principles and implications of cognitive psychology. San Francisco: Freeman.
- Neisser, U. (Ed.). (1982). Memory observed: Remembering in natural contexts. San Francisco: Freeman.
- Neisser, U. (2007). Ulric Neisser. In G. Lindzey & W. M. Runyan (Eds.), A history of psychology in autobiography (Vol. 9, pp. 269–300). Washington, DC: American Psychological Association.
- Neisser, U., Boodoo, G., Bouchard, T. J., Jr., Boykin, A. W., Brody, N., Ceci, S. J., Halpern, D. F., Loehlin, J. C., Perloff, R., Sternberg, R. J., & Urbina, S. (1996). Intelligence: Knowns and unknowns. *American Psychologist*, 51, 77–101.

- Nelson, T. D. (1996). Consciousness and metacognition. American Psychologist, 51, 102–116.
- Newell, A., Shaw, J. C., & Simon, H. A. (1958). Elements of a theory of problem solving. *Psychological Review*, 65, 151– 166.
- The New Republic (1994, October 31). Race and IQ.
- Newton, I. (1952). Opticks or a treatise of the reflections, refractions, inflections and colours of light. New York: Dover. (Original work published 1704)
- Newton, I. (1995). The mathematical principles of natural philosophy. Amherst, NY: Prometheus. (Original work published 1687)
- Niehues-Pröbsting, H. (1996). The modern reception of Cynicism: Diogenes in the Enlightenment. In R. B. Branham & M.-O. Goulet-Cazé (Eds.), *The Cynics: The Cynic movement in antiquity and its legacy* (pp. 329–365). Berkeley: University of California Press.
- Nietzsche, F. (1969). *Thus spoke Zarathustra* (R. J. Hollingdale, Trans.). New York: Viking Press/Penguin Books. (Original work published 1883–1885)
- Nietzsche, F. (1998a). Beyond good and evil (M. Faber, Trans.). New York: Oxford University Press. (Original work published 1886)
- Nietzsche, F. (1998b). Twilight of the idols, or how to philosophize with a hammer (D. Large, Trans.). New York: Oxford University Press. (Original work published 1889)
- Nietzsche, F. (2001). *The gay science* (J. Nauckhoff, Trans.). New York: Cambridge University Press. (Original work published 1882)
- Nietzsche, F. (2006). *Human, all too human* (Vols. 1 & 2). (H. Zimmern & P. V. Cohn, Trans.). Mineola, NY: Dover. (Original work published 1878)
- Norris, C. (1995). Modernism. In T. Honderich (Ed.), *The Oxford companion to philosophy* (p. 583). New York: Oxford University Press.
- Notturno, M. A. (Ed.). (1996). Karl R. Popper: Knowledge and the body-mind problem. New York: Routledge.
- Nye, R. D. (1992). The legacy of B. F. Skinner: Concepts and perspectives, controversies and misunderstandings. Pacific Grove, CA: Brooks/Cole.
- O'Brien, M. J. (Trans.). (1972). Protagoras. In R. K. Sprague (Ed.), *The older Sophists* (pp. 3–28). Columbia: University of South Carolina Press.
- O'Connor, E. (Trans.). (1993). The essential Epicurus: Letters, principal doctrines, Vatican sayings, and fragments. Buffalo, NY: Prometheus Books.
- O'Donnell, J. M. (1985). The origins of behaviorism: American psychology, 1870–1920. New York: New York University Press.
- Okasha, S. (2002). Philosophy of science: A very short introduction. New York: Oxford University Press.

- Olds, J., & Milner, P. (1954). Positive reinforcement produced by electrical stimulation of septal area and other regions of rat brain. *Journal of Comparative and Physiological Psychology*, 47, 419–427.
- O'Sullivan, J. J., & Quevillon, R. P. (1992). 40 years later: Is the Boulder model still alive? *American Psychologist*, 47, 67–70.
- Ovsiankina, M. (1928). Die Wiederaufnahme von Interbrochenen Handlungen [The resumption of interrupted activities]. *Psychologische Forschung*, 2, 302–389.
- Pappas, G. S. (2000). Berkeley's thought. Ithaca, NY: Cornell University Press.
- Paris, B. J. (1994). Karen Horney: A psychoanalyst's search for selfunderstanding. New Haven, CT: Yale University Press.
- Paris, B. J. (2000). Karen Horney: The three phases of her thought. In G. A. Kimble, & M. Wertheimer (Eds.), Portraits of pioneers in psychology (Vol. 4, pp. 163–179). Washington, DC: American Psychological Association.
- Parisi, T. (1987). Why Freud failed: Some implications for neurophysiology and sociobiology. *American Psychologist*, 42, 235–245.
- Parker, A. (1981). The meaning of attempted suicide to young parasuicides: A repertory grid study. *British Journal of Psychiatry*, 139, 306–312.
- Patnoe, S. (1988). A narrative history of experimental social psychology: The Lewin tradition. New York: Springer-Verlag.
- Pavlov, I. P. (1897). Work of the principal digestive glands. St. Petersburg, Russia: Kushneroff.
- Pavlov, I. P. (1928). Lectures on conditioned reflexes. New York: Liveright.
- Pavlov, I. P. (1955). Selected works. Moscow: Foreign Languages.
- Pavlov, I. P. (1960). Conditioned reflexes: An investigation of the activity of the cerebral cortex (G. V. Anrep, Trans.). New York: Dover. (Original work published 1927)
- Pearson, K. (1914). *The life, letters, and labours of Francis Galton* (Vol. 1). London: Cambridge University Press.
- Pearson, K. (1924). The life, letters, and labours of Francis Galton. Vol. 2: Researches of middle life. London: Cambridge University Press.
- Pendergrast, M. (1995). Victims of memory: Incest accusations and shattered lives. Hinesberg, VT: Upper Access.
- Pennebaker, J. W., & Seagal, J. D. (1999). Forming a story: The health benefits of narrative. *Journal of Clinical Psychology*, 55, 1243–1254.
- Perry, N. W., Jr. (1979). Why clinical psychology does not need alternative training models. *American Psychologist*, 34, 603–611.
- Peters, R. C. (1962). *Introduction to Hobbes's* Leviathan. New York: Macmillan.

- Peterson, D. R. (1968). The doctor of psychology program at the University of Illinois. *American Psychologist*, 23, 511–516.
- Peterson, D. R. (1976). Need for the doctor of psychology degree in professional psychology. *American Psychologist*, 31, 792–798.
- Peterson, D. R. (1992). The doctor of psychology degree. In D. K. Freedheim (Ed.), History of psychotherapy: A century of change (pp. 829–849). Washington, DC: American Psychological Association.
- Peterson, D. R. (1995). The reflective educator. *American Psychologist*, 50, 975–983.
- Peterson, D. R. (2003). Unintended consequences: Ventures and misadventures in the training of professional psychologists. American Psychologist, 58, 791–800.
- Phillips, L. (2000). Recontextualizing Kenneth B. Clark: An Afrocentric perspective on the paradoxical legacy of a model psychologist-activist. *History of Psychology*, 3, 142–167.
- Piaget, J. (1926). The language and thought of the child. London: Routledge.
- Pickren, W. E., & Tomes, H. (2002). The legacy of Kenneth B. Clark to the APA: The Board of Social and Ethical Responsibility for Psychology. *American Psychologist*, 57, 51–59.
- Pillsbury, W. B. (1911). Essentials of psychology. New York: Macmillan.
- Pinel, P. (1962). A treatise on insanity. Academy of Medicine— The History of Medicine Series. New York: Hafner. (Original work published 1801)
- Pinker, S. (1997). How the mind works. New York: Norton.
- Plomin, R. (1990). Nature and nurture: An introduction to human behavioral genetics. Pacific Grove, CA: Brooks/Cole.
- Plomin, R., DeFries, J. C., Craig, I. W., & McGuffin, P. (Eds.). (2003). Behavioral genetics in the postgenomic era. Washington, DC: American Psychological Association.
- Popkin, R. H. (1967). Michel Eyquem de Montaigne. In Paul Edwards (Ed.), *The encyclopedia of philosophy* (Vol. 5, pp. 366–368). New York: Macmillan.
- Popkin, R. H. (1979). The history of skepticism from Erasmus to Darwin. (rev. ed.). Berkeley: University of California Press.
- Popkin, R. H. (Ed.). (1980). David Hume: Dialogues concerning natural religion. Indianapolis: Hackett Publishing. (Original work published 1779)
- Popper, K. (1958). The beginnings of rationalism. In D. Miller (Ed.), Popper selections (pp. 25–32). Princeton, NJ: Princeton University Press.
- Popper, K. (1982). Unended quest: An intellectual autobiography. La Salle, IL: Open Court.

- Popper, K. (2002a). Conjectures and refutations: The growth of scientific knowledge. New York: Routledge. (Original work published 1963)
- Popper, K. (2002b). The logic of scientific discovery. New York: Routledge. (Original work published 1935)
- Porter, N. (1868). The human intellect: With an introduction upon psychology and the soul. New York: Scribner.
- Porter, R. (2002). Madness: A brief history. New York: Oxford University Press.
- Powell, J. (1998). Postmodernism for beginners. New York: Writers and Readers Publishing.
- Powell, R. A., & Boer, D. P. (1994). Did Freud mislead patients to confabulate memories of abuse? *Psychological Reports*, 74, 1283–1298.
- Prenzel-Guthrie, P. (1996). Edwin Ray Guthrie: Pioneer learning theorist. In G. A. Kimble, C. A.Boneau, & M. Wertheimer (Eds.), Portraits of pioneers in psychology (Vol. 2, pp. 137–149). Washington, DC: American Psychological Association.
- Priestley, J. (1775). Hartley's theory of the human mind, on the principle of the association of ideas. London: Johnson.
- Progoff, I. (1973). Jung, synchronicity, and human destiny. New York: Dell.
- Pruette, L. (1926). G. Stanley Hall: A biography of a mind. Freeport, NY: Books for Libraries Press.
- Puente, A. E. (1995). Roger Wolcott Sperry (1913–1994). American Psychologist, 50, 940–941.
- Puente, A. E. (2000). Roger W. Sperry: Nobel laureate, neuroscientist, and psychologist. In G. A. Kimble & M. Wertheimer (Eds.), *Portraits of pioneers in psychology* (Vol. 4, pp. 321–336). Washington, DC: American Psychological Association.
- Pusey, E. B. (Trans.). (1961). The confessions of St. Augustine. New York: Macmillan.
- Quinlan, P. (1991). Connectionism and psychology: A psychological perspective on new connectionist research. Chicago: University of Chicago Press.
- Quinn, S. (1988). A mind of her own: The life of Karen Horney. Reading, MA: Addison-Wesley.
- Rabinowitz, F. E., Good, G., & Cozad, L. (1989). Rollo May: A man of meaning and myth. *Journal of Counseling and Development*, 67, 436–441.
- Radice, B. (Trans.). (1974). The letters of Abelard and Heloise. New York: Penguin Books.
- Raphael, F. (1999). Popper. New York: Routledge.
- Rashotte, M. E., & Amsel, A. (1999). Clark L. Hull's behaviorism. In W. O'Donohue & R. Ketchener (Eds.), Handbook of behaviorism (pp. 119–158). San Diego, CA: Academic Press.

- Reed, J. (1987). Robert M. Yerkes and the mental testing movement. In M. M. Sokal (Ed.), *Psychological testing and American society* (pp. 75–94). New Brunswick, NJ: Rutgers University Press.
- Reid, T. (1969). Essays on the intellectual powers of man (Intro. by B. A. Brody). Cambridge: MIT Press. (Original work published 1785)
- Reisman, J. M. (1991). A history of clinical psychology (2nd ed.). New York: Hemisphere.
- Remnant, P., & Bennett, J. (1982). Introduction. In G. W. Leibniz, *New essays on human understanding*. (P. Remnant & J. Bennett, Eds. and Trans.) (pp. ix–xxxvi). New York: Cambridge University Press. (Original work published 1765).
- Reston, J., Jr. (1994). *Galileo: A life.* New York: Harper-Collins.
- Rieker, P. P., & Carmen, E. H. (1986). The victim-to-patient process: The disconfirmation and transformation of abuse. *American Journal of Orthopsychiatry*, 56, 360–370.
- Rigdon, M. A., & Epting, F. R. (1983). A personal construct perspective on an obsessive client. In J. Adams-Webber & J. C. Mancuso (Eds.), Applications of personal construct theory. New York: Academic Press.
- Rilling, M. (2000). John Watson's paradoxical struggle to explain Freud. American Psychologist, 55, 301–312.
- Rimm, D. C., & Masters, J. C. (1974). Behavior therapy: Techniques and empirical findings. New York: Academic Press.
- Rivers, P., & Landfield, A. W. (1985). Alcohol abuse. In E. Button (Ed.), Personal construct theory and mental health: Theory, research, and practice. Beckenham, England: Croom Helm.
- Roazen, P. (1992). Freud and his followers. New York: Da Capo Press.
- Roback, A. A. (1952). History of American psychology. New York: Library.
- Robins, R. W., Gosling, S. D., & Craik, K. H. (1999). An empirical analysis of trends in psychology. *American Psychologist*, 54, 117–128.
- Robinson, D. N. (Ed.). (1977). Alexander Bain: The senses and the intellect. Washington, DC: University Publications of America. (Original work published 1855)
- Robinson, D. N. (1982). Toward a science of human nature: Essays on the psychologies of Mill, Hegel, Wundt and James. New York: Columbia University Press.
- Robinson, D. N. (1985). *Philosophy of psychology*. New York: Columbia University Press.
- Robinson, D. N. (1986). An intellectual history of psychology (rev. ed.). Madison: University of Wisconsin Press.
- Robinson, D. N. (1989). Aristotle's psychology. New York: Columbia University Press.

- Robinson, D. N. (1997). The great ideas of philosophy (50 lectures). Springfield, VA: The Teaching Company.
- Robinson, D. N. (2000). Philosophy of psychology at the turn of the century. American Psychologist, 55, 1018–1021
- Robinson, D. N. (2007). Consciousness and its implications (12 lectures). Chantilly, VA: The Teaching Company.
- Robinson, P. J., & Wood, K. (1984). Fear of death and physical illness: A personal construct approach. In F. R. Epting & R. A. Neimeyer (Eds.), Personal meanings of death:
 Applications of personal construct
 theory to clinical practice. Washington, DC: Hemisphere.
- Robinson, T. M. (1995). *Plato's psychology* (2nd ed.). Toronto: University of Toronto Press.
- Robinson, V. (1943). The story of medicine. New York: New Home Library.
- Roccatagliata, G. (1986). A history of ancient psychiatry. New York: Greenwood Press.
- Rodis-Lewis, G. (1998). Descartes: His life and thought (J. M. Todd, Trans.). Ithaca, NY: Cornell University Press.
- Roediger, H. L. (2000). Sir Frederic Charles Bartlett:
 Experimental and applied psychologist. In G. A. Kimble & M. Wertheimer (Eds.), Portraits of pioneers in psychology (Vol. 4, pp. 149–161). Washington, DC: American Psychological Association.
- Rogers, C. R. (1939). The clinical treatment of the problem child. Boston: Houghton Mifflin.
- Rogers, C. R. (1942). Counseling and psychotherapy: Newer concepts in practice. Boston: Houghton Mifflin.
- Rogers, C. R. (1944). Psychological adjustment of discharged service personnel. *Psychological Bulletin*, 41, 689–696.
- Rogers, C. R. (1947). Some observations on the organization of personality. *American Psychologist*, 2, 358–368.
- Rogers, C. R. (1951). Client-centered therapy: Its current practice, implications, and theory. Boston: Houghton Mifflin.
- Rogers, C. R. (1954). The case of Mrs. Oak: A research analysis. In C. R. Rogers & R. F. Dymond (Eds.), Psychotherapy and personality change. Chicago: University of Chicago Press.
- Rogers, C. R. (1959). A theory of therapy, personality, and interpersonal relationships, as developed in the client-centered framework. In S. Koch (Ed.), *Psychology: A study of a science* (Vol. 3, pp. 184–256). New York: McGraw-Hill.
- Rogers, C. R. (1961). On becoming a person: A therapist's view of psychotherapy. Boston: Houghton Mifflin.
- Rogers, C. R. (1966). Client-centered therapy. In S. Arieti (Ed.), *American handbook of psychiatry*. New York: Basic Books.
- Rogers, C. R. (1969). Freedom to learn. Columbus, OH: Merrill.
- Rogers, C. R. (1972). Becoming-partners: Marriage and its alternatives. New York: Delacorte.

- Rogers, C. R. (1973). My philosophy of interpersonal relationships and how it grew. *Journal of Humanistic Psychology*, 13, 3–15.
- Rogers, C. R. (1974). In retrospect: Forty-six years. American Psychologist, 29, 115–123.
- Rogers, C. R. (1977). Carl Rogers on personal power. New York: Delacorte.
- Rogers, C. R. (1980). A way of being. Boston: Houghton Mifflin.
- Rogers, C. R. (1983). Freedom to learn for the 80s. Columbus, OH: Merrill.
- Rogers, C. R., & Dymond, R. F. (1955). Psychotherapy and personality change. Chicago: University of Chicago Press.
- Rogers, G. A. J., & Ryan, A. (Eds.). (1990). Perspectives on Thomas Hobbes. New York: Oxford University Press.
- Romanes, G. J. (1882). Animal intelligence. London: Kegan Paul, Trench.
- Romanes, G. J. (1884). *Mental evolution in animals*. New York: Appleton.
- Romanes, G. J. (1888). Mental evolution in man. London: Kegan Paul.
- Roochnik, D. (2002). An introduction to Greek philosophy (24 lectures). Chantilly, VA: The Teaching Company.
- Rosch, E., & Mervis, C. (1975). Family resemblances: Studies in the internal structures of categories. Cognitive Psychology, 7, 573–605.
- Rosenbaum, M., & Muroff, M. (Eds.). (1984). Anna O. Fourteen contemporary reinterpretations. New York: Free Press.
- Rosenblatt, F. (1958). The perceptron: A probabilistic model for information storage and organization in the brain. *Psychological Review*, 65, 386–408.
- Rosenhan, D. L. (1973). On being sane in insane places. *Science*, 179, 250–258.
- Rosenthal, R. (1966). Experimenter effects in behavioral research. New York: Appleton-Century-Crofts.
- Rosenthal, R. (1967). Covert communication in the psychology experiment. Psychological Bulletin, 67, 356–367.
- Rosenzweig, S. (1985). Freud and experimental psychology: The emergence of idiodynamics. In S. Koch & D. E. Leary (Eds.), *A century of psychology as* science (pp. 135–207). New York: McGraw-Hill.
- Rosenzweig, S. (1992). Freud, Jung and Hall the king-maker: The expedition to America (1909). Kirkland, WA: Hogrefe & Huber.
- Ross, David. (Trans.). (1990). Aristotle: The Nicomachean ethics. New York: Oxford University Press.
- Ross, Dorothy. (1972). G. Stanley Hall: The psychologist as prophet. Chicago: University of Chicago Press.
- Rousseau, J. J. (1947). *The social contract* (C. Frankel, Trans.). New York: Macmillan. (Original work published 1762)

- Rousseau, J. J. (1974). *Emile* (B. Foxley, Trans.). London: Dent. (Original work published 1762)
- Rousseau, J. J. (1996). The confessions (Trans. anon.). Hertfordshire, England: Wordsworth Editions. (Original work published 1781)
- Rowe, F. B., & Murray, F. S. (1979). A note on the Titchener influence on the first psychology laboratory in the south. *Journal of the History of the Behavioral Sciences*, 15, 282–284.
- Royce, J. R. (1975). Psychology is multi-methodological, variate, epistemic, world view, systemic, paradigmatic, theoretic, and disciplinary. In W. Arnold (Ed.), Nebraska Symposium on Motivation. Lincoln: University of Nebraska Press.
- Royce, J. R., & Mos, L. P. (Eds.). (1981). Humanistic psychology: Concepts and criticisms. New York: Plenum.
- Rubin, E. J. (1921). Visuell wahrgenommene Figuren. Studien in psychologischer Analyse [Visually perceived figures. Studies in psychological analysis]. (Pt. 1). Copenhagen: Gyldendal. (Original work published 1915)
- Rubins, J. L. (1978). Karen Horney: Gentle rebel of psychoanalysis. New York: Dial Press.
- Ruiz, T. F. (2002). The terror of history: Mystics, heretics, and witches in the Western tradition (24 lectures). Chantilly, VA: The Teaching Company.
- Ruja, H. (1956). Productive psychologists. American Psychologist, 11, 148–149.
- Rumelhart, D. E. (1992). Towards a microstructural account of human reasoning. In S. Davis (Ed.), Connectionism: Theory and practice (pp. 69–83). New York: Oxford University Press.
- Rumelhart, D. E., & McClelland, J. L., and the PDP Research Group. (1986). Parallel distributed processing: Explorations in the microstructure of cognition (2 Vols.). Cambridge: MIT Press.
- Rummel, E. (Ed.). (1996). *Erasmus on women*. Toronto: University of Toronto Press.
- Rush, B. (1812). Medical inquiries and observations upon the diseases of the mind. Philadelphia: Kimber and Richardson.
- Russell, B. (1945). A history of Western philosophy. New York: Simon & Schuster.
- Russell, B. (1959). Wisdom of the West. Garden City, NJ: Doubleday.
- Russell, B. (2005). *The analysis of mind*. Mineola, NY: Dover. (Original work published 1921)
- Russell, J. B. (1980). A history of witchcraft. London: Thames and Hudson.
- Rutherford, A. (2000). Radical behaviorism and psychology's public: B. F. Skinner in the popular press, 1934–1990. *History of Psychology*, 3, 371–395.
- Rutherford, A. (2006). Mother of behavior therapy and beyond: Mary Cover Jones and the study of the "whole

- child." In D.A. Dewsbury, L.T. Benjamin Jr., & M. Wertheimer (Eds.), *Portraits of pioneers in psychology* (Vol. 6, pp. 189–204). Washington, DC: American Psychological Association.
- Rychlak, J. (1975). Psychological science as a humanist views it. In W. Arnold (Ed.), Nebraska Symposium on Motivation. Lincoln: University of Nebraska Press.
- Rychlak, J. F. (1997). In defense of human consciousness. Washington, DC: American Psychological Association.
- Sadler, J. Z., Wiggins, O. P., & Schwartz, M. A. (Eds.). (1994). Philosophical perspectives on psychiatric diagnostic classification. Baltimore: The Johns Hopkins University Press.
- Sahakian, W. S. (1975). History and systems of psychology. New York: Wiley.
- Sahakian, W. S. (1981). History of psychology: A source book in systematic psychology (rev. ed.). Itasca, IL: Peacock.
- Samelson, F. (1977). World War I intelligence testing and the development of psychology. *Journal of the History of the Behavioral Sciences*, 13, 274–282.
- Samelson, F. (1981). Struggle for scientific authority: The reception of Watson's behaviorism, 1913–1920. Journal of the History of the Behavioral Sciences, 17, 399–425.
- Samelson, F. (1992, June). On resurrecting the reputation of Sir Cyril [Burt]. Paper presented at the meeting of Cheiron, Windsor, ON.
- Samelson, F. (1993, June). Grappling with fraud charges in science, or: Will the Burt affair ever end? Paper presented at the meeting of Cheiron, Durham, NH.
- Sammons, M. T., Paige, R. U., & Levant, R. F. (Eds.). (2003). Prescriptive authority for psychologists: A history and guide. Washington, DC: American Psychological Association.
- Sand, R. (1992). Pre-Freudian discovery of dream meaning: The achievements of Charcot, Janet, and Kraftt-Ebing. In T. Gelfand & J. Kerr (Eds.), Freud and the history of psychoanalysis (pp. 215–229). Hillsdale, NJ: Atlantic Press.
- Santayana, G. (1920). Character and opinion in the United States. New York: Scribner.
- Sargent, S. S., & Stafford, K. R. (1965). Basic teachings of the great psychologists. Garden City, NY: Doubleday.
- Sartain, J., North, J., Strange, R., & Chapman, M. (1973).
 Psychology: Understanding human behavior. New York:
 McGraw-Hill.
- Sartre, J-P. (1957). Existentialism and human emotions. New York: Wisdom Library.
- Saunders, J. L. (Ed.). (1966). Greek and Roman philosophy after Aristotle. New York: Free Press.
- Sawyer, T. E. (2000). Francis Cecil Sumner: His views and influence on African American higher education. *History* of Psychology, 3, 122–141.

- Scarborough, E., & Furumoto, L. (1987). Untold lives: The first generation of American women psychologists. New York: Columbia University Press.
- Scarre, C. (1995). Chronicle of the Roman emperors: The reignby-reign record of the rulers of imperial Rome. London: Thames and Hudson.
- Schatzman, M. (1992, March 21). Freud: Who seduced whom? New Scientist, pp. 34–37.
- Schmied, L. A., Steinberg, H., & Sykes, E. A. B. (2006).Psychopharmacology's debt to experimental psychology.History of Psychology, 9, 144–157.
- Schmit, D. (2005). Re-visioning antebellum American psychology: The dissemination of Mesmerism, 1836–1854. History of Psychology, 8, 403–434.
- Schneider, K. J. (1998). Toward a science of the heart: Romanticism and the revival of psychology. *American Psychologist*, 53, 277–289.
- Schoedinger, A. B. (Ed.). (1996). Readings in medieval philosophy. New York: Oxford University Press.
- Schopenhauer, A. (1966). The world as will and representation (Vols. 1 and 2) (E. F. J. Payne, Trans.). New York: Dover. (Original work published 1818)
- Schopenhauer, A. (1995). The wisdom of life [a] and Counsels and maxims [b] (T. B. Saunders, Trans.). Amherst, NY: Prometheus Books. (Original works published 1851)
- Schopenhauer, A. (2005). Essay on the freedom of the will. Mineola, NY: Dover. (Original work published 1841)
- Schuker, E. (1979). Psychodynamics and treatment of sexual assault victims. *Journal of the American Academy of Psychoanalysis*, 7, 553–573.
- Schulte, J. (1993). Experience and expression: Wittgenstein's philosophy of psychology. New York: Oxford University Press.
- Schwartz, B., & Lacey, H. (1982). Behaviorism, science and human nature. New York: Norton.
- Scot, R. (1964). Discovery of witchcraft. Carbondale: Southern Illinois University Press. (Original work published 1584)
- Scott, D. M. (1997). Contempt and pity: Social policy and the image of the damaged Black psyche. Chapel Hill: University of North Carolina Press.
- Scruton, R. (2001). Kant: A very short introduction. New York: Oxford University Press.
- Scruton, R. (2002). Spinoza: A very short introduction. New York: Oxford University Press.
- Searle, J. R. (1980). Minds, brains, and programs. The Behavioral and Brain Sciences, 3, 417–424.
- Searle, J. R. (1990, January). Is the brain's mind a computer program? *Scientific American*, pp. 26–31.
- Searle, J. R. (1992). The rediscovery of the mind. Cambridge: MIT Press.

- Searle, J. R. (1998). *The philosophy of mind* (12 lectures). Springfield, VA: The Teaching Company.
- Sechenov, I. M. (1965). Reflexes of the brain. Cambridge, MA: MIT Press. (Original work published 1863)
- Sechenov, I. M. (1973). I. M. Sechenov: Biographical sketch and essays. New York: Arno Press. (Reprinted from I. Sechenov, Selected works, 1935)
- Segal, H. (1974). Introduction to the work of Melanie Klein (2nd ed.). New York: Basic Books.
- Sejnowski, T. J., & Rosenberg, C. R. (1987). Parallel networks that learn how to pronounce English text. *Complex* Systems, 1, 145–168.
- Seligman, M. E. P. (1970). On the generality of the laws of learning. Psychological Review, 77, 406–418.
- Seligman, M. E. P., & Csikszentmihalyi, M. (2000). Positive psychology: An introduction. American Psychologist, 55, 5–14.
- Seligman, M. E. P., & Hager, J. L. (1972). Biological boundaries of learning. New York: Appleton–Century–Crofts.
- Seligman, M. E. P., Steen, T. A., Park, N., & Peterson, C. (2005). Positive psychology progress: Empirical validation of interventions. American Psychologist, 60, 410–421.
- Seward, J. P., & Levy, N. J. (1949). Sign learning as a factor in extinction. Journal of Experimental Psychology, 39, 660–668.
- Shannon, C. E., & Weaver, W. (1949). The mathematical theory of communication. Urbana: University of Illinois Press.
- Shapiro, A. E., & Wiggins, J. G., Jr. (1994). A PsyD degree for every practitioner: Truth in labeling. American Psychologist, 49, 207–210.
- Sharp, S. E. (1899). Individual psychology: A study in psychological method. The American Journal of Psychology, 10, 329–391.
- Shields, S. A. (1975). Ms. Pilgrim's progress: The contributions of Leta Stetter Hollingworth to the psychology of women. American Psychologist, 30, 852–857.
- Shields, S. A. (1991). Leta Stetter Hollingworth: "Literature of opinion" and the study of individual differences. In G. A. Kimble, M. Wertheimer, & C. L. White (Eds.), Portraits of pioneers in psychology (pp. 243–255). Washington, DC: American Psychological Association.
- Shook, J. R. (1995). Wilhelm Wundt's contribution to John Dewey's functional psychology. *Journal of the History of the Behavioral Sciences*, 31, 347–369.
- Sigerist, H. E. (1951). A history of medicine. New York: Oxford University Press.
- Simon, H. A. (1996). The sciences of the artificial (3rd ed.). Cambridge: MIT Press.
- Simon, L. (1998). Genuine reality: A life of William James. New York: Harcourt Brace.

- Singer, J. A. (2004). Narrative identity and meaning making across the adult lifespan: An introduction. *Journal of Personality*, 72, 437–459.
- Singer, P. (2001). Hegel: A very short introduction. New York: Oxford University Press.
- Sirkin, M., & Fleming, M. (1982). Freud's "project" and its relationship to psychoanalytic theory. Journal of the History of the Behavioral Sciences, 18, 230–241.
- Skinner, B. F. (1938). The behavior of organisms: An experimental analysis. New York: Appleton-Century.
- Skinner, B. F. (1948). Walden two. New York: Macmillan.
- Skinner, B. F. (1950). Are theories of learning necessary? *Psychological Review*, 57, 193–216.
- Skinner, B. F. (1953). Science and human behavior. New York: Macmillan.
- Skinner, B. F. (1954). The science of learning and the art of teaching. *Harvard Educational Review*, 24, 86–97.
- Skinner, B. F. (1956). A case study in scientific method. *American Psychologist*, 11, 221–233.
- Skinner, B. F. (1957). Verbal behavior. Englewood Cliffs, NJ: Prentice-Hall.
- Skinner, B. F. (1958). Teaching machines. Science, 128, 969-977.
- Skinner, B. F. (1960). Pigeons in a pelican. American Psychologist, 15, 28–37.
- Skinner, B. F. (1967). B. F. Skinner. In E. G. Boring & G. Lindzey (Eds.), A history of psychology in autobiography (Vol. 5, pp. 385–413). New York: Appleton–Century-Crofts.
- Skinner, B. F. (1968). The technology of teaching. New York: Appleton–Century–Crofts.
- Skinner, B. F. (1971). Beyond freedom and dignity. New York: Knopf.
- Skinner, B. F. (1972). The concept of reflex in the description of behavior. In B. F. Skinner, *Cumulative record: A selection* of papers (3rd ed., pp. 429–457). Des Moines: Meredith. (Original work published 1931)
- Skinner, B. F. (1974). About behaviorism. New York: Knopf.
- Skinner, B. F. (1976). Particulars of my life. New York: Knopf.
- Skinner, B. F. (1978). *Reflections on behaviorism and society*. Englewood Cliffs, NJ: Prentice-Hall.
- Skinner, B. F. (1979). *The shaping of a behaviorist*. New York: Knopf.
- Skinner, B. F. (1983). A matter of consequences. New York: Knopf.
- Skinner, B. F. (1984). The shame of American education. *American Psychologist*, 39, 947–954.
- Skinner, B. F. (1987). Upon further reflection. Englewood Cliffs, NJ: Prentice-Hall.
- Skinner, B. F. (1990). Can psychology be a science of mind? American Psychologist, 45, 1206–1210.

- Skinner, B. F., & Vaughn, M. E. (1983). Enjoy old age: Living fully in your later years. New York: Warner.
- Sluga, H., & Stern, D. G. (Eds.). (1996). The Cambridge companion to Wittgenstein. New York: Cambridge University Press.
- Small, W. S. (1901). Experimental study of the mental processes of the rat. American Journal of Psychology, 12, 218– 220.
- Smith, B. (1994). Austrian philosophy: The legacy of Franz Brentano. Chicago: Open Court.
- Smith, L. D. (1982). Purpose and cognition: The limits of neorealist influence on Tolman's psychology. *Behaviorism*, 10, 151–163.
- Smith, L. D. (1992). On prediction and control: B. F. Skinner and the technological ideal of science. *American Psychologist*, 47, 216–223.
- Smith, M. B. (1994). Selfhood at risk: Postmodern perils and the perils of postmodernism. *American Psychologist*, 49, 405–411.
- Smith, P. (1911). The life and letters of Martin Luther. New York: Houghton Mifflin.
- Smith, S. (1983). *Ideas of the great psychologists*. New York: Harper & Row.
- Snow, C. P. (1964). The two cultures and a second look. London: Cambridge University Press.
- Snyderman, M., & Rothman, S. (1990). The IQ controversy, the media and public policy. New Brunswick, NJ: Transaction.
- Sokal, M. M. (1971). The unpublished autobiography of James McKeen Cattell. American Psychologist, 26, 621–635.
- Sokal, M. M. (1984). The Gestalt psychologists in behaviorist America. American Historical Review, 89, 1240–1263.
- Sokal, M. M. (Ed.). (1987). Psychological testing and American society: 1890–1930. New Brunswick, NJ: Rutgers University Press.
- Sokal, M. M. (1992). Origins and early years of the American Psychological Association, 1890–1906. American Psychologist, 47, 111–122.
- Sokal, M. M. (2006). James McKeen Cattell: Achievement and alienation. In D. A. Dewsbury, L. T. Benjamin Jr., & M. Wertheimer (Eds.), Portraits of pioneers in psychology (Vol. 6, pp. 19–35). Washington, DC: American Psychological Association.
- Sorell, T. (2000). Descartes: A very short introduction. New York: Oxford University Press.
- Spearman, C. (1904). "General intelligence," objectively determined and measured. American Journal of Psychology, 15, 201–293.
- Spence, K. W. (1942). The basis of solution by chimpanzees of the intermediate size problem. *Journal of Experimental Psychology*, 131, 257–271.

- Spence, K. W. (1952). Clark Leonard Hull: 1884–1952. American Journal of Psychology, 65, 639–646.
- Spence, K. W. (1956). Behavior theory and conditioning (Silliman lectures). New Haven, CT: Yale University Press.
- Spence, K. W. (1960). Behavior theory and learning: Selected papers. Englewood Cliffs, NJ: Prentice-Hall.
- Spencer, H. (1864). Social statics. New York: Appleton.
- Spencer, H. (1870). Principles of psychology (2nd ed.). London: Longman.
- Sperry, R. W. (1961). Cerebral organization and behavior. Science, 133, 1749–1757.
- Sperry, R. W. (1964). The great cerebral commissure. Scientific American, 210, 42–52.
- Sperry, R. W. (1970). An objective approach to subjective experience: Further explanation of a hypothesis. *Psychological Review*, 77, 585–590.
- Sperry, R. W. (1972). Science and the problem of values. Perspectives in Biology and Medicine, 16, 115–130.
- Sperry, R. W. (1980). Mind-brain interaction: Mentalism, yes; dualism, no. Neuroscience, 5, 195–206.
- Sperry, R. W. (1982). Some effects of disconnecting the cerebral hemispheres. *Science*, 217, 1223–1226.
- Sperry, R. W. (1988). Psychology's mentalist paradigm and the religion/science tension. American Psychologist, 43, 607– 613.
- Sperry, R. W. (1991). In defense of mentalism and emergent interaction. The Journal of Mind and Behavior, 12, 221–245.
- Sperry, R. W. (1992). Turnabout on consciousness: A mentalist view. *The Journal of Mind and Behavior*, 13, 259–280.
- Sperry, R. W. (1993). The impact and promise of the cognitive revolution. American Psychologist, 48, 878–885.
- Spillmann, J., & Spillmann, L. (1993). The rise and fall of Hugo Münsterberg. Journal of the History of the Behavioral Sciences, 29, 322–338.
- Springer, S. P., & Deutsch, G. (1985). Left brain, right brain (rev. ed.). New York: Freeman.
- Sprung, H. & Sprung, L. (2000). Carl Stumpf: Experimenter, theoretician, musicologist, and promoter. In G. A. Kimble & M. Wertheimer (Eds.), Portraits of pioneers of psychology (Vol. 4, pp. 51–69). Washington, DC: American Psychological Association.
- Spurzheim, G. (1834). Phrenology, or the doctrine of mental phenomena. Boston: Marsh, Capen, & Lyon.
- Staats, A. W. (1981). Paradigmatic behaviorism, unified theory, unified theory construction methods, and the Zeitgeist of separatism. American Psychologist, 36, 239–256.
- Staats, A. W. (1989). Unificationism: Philosophy for the modern disunified science of psychology. *Philosophical Psychology*, 2, 143–164.

- Staats, A. W. (1991). Unified positivism and unification psychology: Fad or new field? *American Psychologist*, 46, 899– 912.
- Stanovich, K. E. (2004). How to think straight about psychology (7th ed.). Boston: Allyn & Bacon.
- Steinberg, E. (Ed.). (1987). David Hume: An enquiry concerning human understanding. Indianapolis: Hackett Publishing Company. (Original work published 1748)
- Stephenson, W. (1953). The study of behavior: Q-technique and its methodology. Chicago: University of Chicago Press.
- Stern, P. J. (1976). C. G. Jung: The haunted prophet. New York: Dell.
- Sternberg, R. J. (Ed.). (2005). Unity in psychology: Possibility or pipedream? Washington, DC: American Psychological Association.
- Sternberg, R. J., & Detterman, D. K. (Eds.). (1986). What is intelligence? Contemporary viewpoints on its nature and definition. Norwood, NJ: Ablex.
- Sternberg, R. J., & Grigorenko, E. L. (2001). Unified psychology. American Psychologist, 56, 1069–1079.
- Sternberg, R. J., Lautrey, J., & Lubart, I. (2003). Models of intelligence: International perspectives. Washington, DC: American Psychological Association.
- Stevens, S. S. (1935a). The operational basis of psychology. American Journal of Psychology, 43, 323–330.
- Stevens, S. S. (1935b). The operational definition of psychological concepts. *Psychological Review*, 42, 517–527.
- Stevens, S. S. (1951). Psychology and the science of science. In M. H. Marx (Ed.), Psychological theory: Contemporary readings (pp. 21–54). New York: Macmillan.
- Stevenson, L., & Haberman, D. L. (1998). Ten theories of human nature (3rd ed.). New York: Oxford University Press.
- Stewart, D. (1792). Elements of the philosophy of the human mind. London: Straham & Caddell.
- Stocking, G. S., Jr. (1965). On the limits of "presentism" and "historicism" in the historiography of the behavioral sciences. *Journal of the History of the Behavioral Sciences*, 1, 211–218
- Stricker, G. (1997). Are science and practice commensurable? American Psychologist, 52, 442–448.
- Stricker, G., & Trierweiler, S. J. (1995). The local scientist: A bridge between science and practice. *American Psychologist*, 50, 995–1002.
- Storr, A. (1989). Freud. New York: Oxford University Press.
- Stratton, G. M. (1911). The psychology of change: How is the perception of movement related to that of succession? *Psychological Review*, 18, 262–293.
- Stroll, A. (2002). Wittgenstein. Oxford, England: Oneworld Publications.

- Stumpf, C. (1883, 1890). Psychology of tone (Vols. 1 and 2). Leipzig, Germany: Hirzel.
- Sulloway, F. J. (1979). Freud, biologist of the mind: Beyond the psychoanalytic legend. New York: Basic Books.
- Sulloway, F. J. (1992). Reassessing Freud's case histories: The social construction of psychoanalysis. In T. Gelfand & J. Kerr (Eds.), Freud and the history of psydnoanalysis (pp. 153–192). Hillsdale, NJ: Analytic Press.
- Summers, M. (Trans.). (1971). The malleus maleficarum of Heinrich Kramer and James Sprenger. New York: Dover.
- Sumner, F. C. (1926). Philosophy of Negro education. *Educational Review*, 71, 42–45.
- Sumner, F. C. (1927). Morale and the Negro college. Educational Review, 73, 168–172.
- Szasz, T. S. (1974). The myth of mental illness: Foundations of a theory of personal conduct (rev. ed.). New York: Harper & Row.
- Tanner, M. (2000). Nietzsche: A very short introduction. New York: Oxford University Press.
- Taub, L. C. (1993). Ptolemy's universe: The natural philosophical and ethical foundations of Ptolemy's astronomy. La Salle, IL: Open Court.
- Taylor, C. C. W. (1998). Socrates. New York: Oxford University Press.
- Taylor, R. (1963). Metaphysics. Englewood Cliffs, NJ: Prentice-Hall.
- Taylor, R. (1967). Determinism. In P. Edwards (Ed.), The encyclopedia of philosophy. New York: Macmillan.
- Tellegen, A., Lykken, D. T., Bouchard, T. J., Jr., Wilcox, K. J., Segal, N. L., & Rich, S. (1988). Personality similarity in twins reared apart and together. *Journal of Personality and Social Psychology*, 54, 1031–1039.
- Temkin, D., & Temkin, C. L. (Eds.). (1987). Ancient medicine: Selected papers of Ludwig Edelstein (C. L. Temkin, Trans.). Baltimore: The Johns Hopkins University Press.
- Terman, L. M. (1916). The measurement of intelligence. Boston: Houghton Mifflin.
- Terman, L. M. (1917). The intelligence quotient of Francis Galton in childhood. American Journal of Psychology, 28, 209–215.
- Terman, L. M. (1926). Genetic studies of genius. Vol. 1: Mental and physical traits of a thousand gifted children. Stanford, CA: Stanford University Press.
- Thagard, P. (2005). Mind: Introduction to cognitive science (2nd ed.). Cambridge: MIT Press.
- Theissen, G. (1987). Psychological aspects of Pauline theology (J. P. Galvin, Trans.). Edinburgh: T & T Clark.
- Thomas, R. K. (1994). Pavlov was "mugged." *History of Psychology Newsletter*, 26, 86–91.

- Thorndike, E. L. (1898). Animal intelligence: An experimental study of the associative processes in animals. *Psychological Review*, Monograph Suppl., 2(8).
- Thorndike, E. L. (1903). Educational psychology. New York: Lemcke & Buechner.
- Thorndike, E. L. (1911). *Animal intelligence*. New York: Macmillan.
- Thorndike, E. L. (1924). Mental discipline in high school studies. *Journal of Educational Psychology*, 15, 1–22, 83–98.
- Thorndike, E. L. (1939). Your city. New York: Harcourt, Brace.
- Thorndike, E. L., & Woodworth, R. S. (1901, May, July, November). The influence of improvement in one mental function upon the efficiency of the other. *Psychological Review*, 8, 247–261, 381–395, 556–564.
- Tibbetts, P. (1975). An historical note on Descartes' psychophysical dualism. *Journal of the History of the Behavioral Sciences*, 9, 162–165.
- Titchener, E. B. (1896). An outline of psychology. New York: Macmillan.
- Titchener, E. B. (1898). The postulates of a structural psychology. *Philosophical Review*, 7, 449–465.
- Titchener, E. B. (1899). Structural and functional psychology. Philosophical Review, 8, 290–299.
- Titchener, E. B. (1910). A textbook of psychology. New York: Macmillan.
- Titchener, E. B. (1914). On "psychology as the behaviorist views it." *Proceedings of the American Philosophical Society*, 53, 1–17.
- Titchener, E. B. (1915). A beginner's psychology. New York: Macmillan.
- Tolman, E. C. (1917). Retroactive inhibition as affected by conditions of learning. *Psychological Monographs*, 25(107).
- Tolman, E. C. (1922). A new formula for behaviorism. *Psychological Review*, 29, 44–53.
- Tolman, E. C. (1924). The inheritance of maze-learning ability in rats. *Journal of Comparative Psychology*, 4, 1–18.
- Tolman, E. C. (1925). Purpose and cognition: The determiners of animal learning. *Psychological Review*, 32, 285–297.
- Tolman, E. C. (1928). Purposive behavior. Psychological Review, 35, 524–530.
- Tolman, E. C. (1932). Purposive behavior in animals and men. New York: Naiburg.
- Tolman, E. C. (1938). The determiners of behavior at a choice point. *Psychological Review*, 45, 1–41.
- Tolman, E. C. (1942). Drives toward war. New York: Appleton-Century-Crofts.
- Tolman, E. C. (1945). A stimulus-expectancy need-cathexis psychology. *Science*, 101, 160–166.

- Tolman, E. C. (1948). Cognitive maps in rats and men. *Psychological Review*, 55, 189–208.
- Tolman, E. C. (1952). Edward C. Tolman. In E. G. Boring, H. S. Langfeld, H. Werner, & R. M. Yerkes (Eds.), A history of psychology in autobiography (Vol. 4, pp. 323–339). Worcester, MA: Clark University Press.
- Tolman, E. C. (1959). Principles of purposive behavior. In S. Koch (Ed.), Psychology: A study of a science (Vol. 2, pp. 92– 157). New York: McGraw-Hill.
- Tolman, E. C., & Honzik, C. H. (1930). Introduction and removal of reward, and maze performance in rats. *University of California Publications in Psychology*, 4, 257–273.
- Tomlinson-Keasey, C., & Little, T. D. (1990). Predicting educational attainment, occupational achievement, intellectual skill, and personal adjustment among gifted men and women. *Journal of Educational Psychology*, 82, 442–455.
- Toulmin, S., & Leary, D. E. (1985). The cult of empiricism in psychology, and beyond. In S. Koch & D. E. Leary (Eds.), *A century of psychology as science* (pp. 594–617). New York: McGraw-Hill.
- Treash, G. (1994). Introduction. In E. Kant, *The one possible basis for a demonstration of the existence of God* (G. Treash, Trans.) (pp. 9–32). Lincoln, NE: University of Nebraska Press.
- Trevor-Roper, H. R. (1967). The European witch-craze of the 16th and 17th centuries. Harmondsworth, England: Penguin.
- Tryon, W. W. (1995). Synthesizing psychological schisms through connectionism. In F. D. Abraham & A. R. Gilgen (Eds.), *Chaos theory in psychology* (pp. 247–263). Westport, CT: Praeger.
- Tuck, R. (2002). Hobbes: A very short introduction. New York: Oxford University Press.
- Tucker, W. H. (1997). Re-reconsidering Burt: Beyond a reasonable doubt. *Journal of the History of the Behavioral Sciences*, 33, 145–162.
- Turing, A. M. (1950). Computing machinery and intelligence. Mind, 59, 433–460.
- Turner, R. S. (1977). Hermann von Helmholtz and the empiricist vision. *Journal of the History of the Behavioral Sciences*, 13, 48–58.
- Ulrich, R., Stachnik, T., & Mabry, J. (Eds.). (1966). Control of human behavior (Vols. 1 and 2). Glenview, IL: Scott, Foresman.
- Urbach, P. (1987). Francis Bacon's philosophy of science: An account and a reappraisal. La Salle, IL: Open Court.
- Urban, W. J. (1989). The black scholar and intelligence testing: The case of Horace Mann Bond. *Journal of the History of the Behavioral Sciences*, 25, 323–334.
- Vaihinger, H. (1952). The philosophy of "as if": A system of the theoretical, practical and religious fictions of mankind

- (C. K. Ogden, Trans.). London: Routledge & Kegan Paul. (Original work published 1911)
- Van den Haag, E. (1960). Social science testimony in the desegregation cases—a reply to Professor Kenneth Clark. Villanova Law Review, 6, 69–79.
- Vatz, R. E., & Weinberg, L. S. (Eds.). (1983). Thomas Szasz: Primary values and major contentions. Buffalo, NY: Prometheus.
- Viner, R. (1996). Melanie Klein and Anna Freud: The discourse of the early dispute. *Journal of the History of the Behavioral Sciences*, 32, 4–15.
- Viney, L. L. (1983). Images of illness. Miami: Krieger.
- Viney, L. L. (1984). Concerns about death among severely ill people. In F. R. Epting & R. A. Neimeyer (Eds.), Personal meanings of death. Washington, DC: Hemisphere.
- Viney, W. (1989). The cyclops and the twelve-eyed toad: William James and the unity-disunity problem in psychology. American Psychologist, 44, 1261–1265.
- Viney, W. (1996). Dorothea Dix: An intellectual conscience for psychology. In G. A. Kimble, C. A. Boneau, & M. Wertheimer (Eds.), Portraits of pioneers in psychology (Vol. 2, pp. 15–31). Washington, DC: American Psychological Association.
- Viney, W. (2001). The radical empiricism of William James and philosophy of history. History of Psychology, 4, 211–227.
- Viney, W., & Burlingame-Lee, L. (2003). Margaret Floy Washburn: A quest for the harmonies in the context of a rigorous scientific framework. In G. A. Kimble & M. Wertheimer (Eds.), Portraits of pioneers in psychology (Vol. 5, pp. 73–88). Washington, DC: American Psychological Association.
- Voeks, V. W. (1950). Formalization and clarification of a theory of learning. *Journal of Psychology*, 30, 341–363.
- Voeks, V. W. (1954). Acquisition of S–R connections: A test of Hull's and Guthrie's theories. *Journal of Experimental Psychology*, 47, 137–147.
- Von Eckart, B. (1993). What is cognitive science? Cambridge: MIT Press.
- Von Neumann, J. (2000). The computer and the brain (2nd ed.). New Haven, CT: Yale University Press. (Original work published 1958)
- Wallace, R. A. (1979). The genesis factor. New York: Morrow.
- Waller, N. G., Kojetin, B. A., Bouchard, T. J., Jr., Lykken, D. T., & Tellegen, A. (1990). Genetic and environmental influences on religious interests, attitudes, and values. Psychological Science, 1, 138–142.
- Walter, H.-J. (Ed.). (1991). Max Wertheimer: Zur Gestaltpsychologie menschlicher Werte [Max Wertheimer: Gestalt psychology of human values]. Opladen, Germany: Westdeutscher Verlag.

- Washburn, M. F. (1908). The animal mind: A text-book of comparative psychology. New York: Macmillan.
- Washburn, M. F. (1916). Movement and mental imagery: Outline of a motor theory of consciousness. Boston: Houghton Mifflin.
- Washburn, M. F. (1922). Introspection as an objective method. Psychological Review, 29, 89–112.
- Waterfield, R. (2000). The first philosophers: The presocratics and the Sophists. New York: Oxford University Press.
- Watkin, J. (1997). Kierkegaard. New York: Geoffrey Chapman.
- Watson, J. B. (1907). Kinesthetic and organic sensations: Their role in the reactions of the white rat to the maze. Psychological Review, Monograph Supplements, 8(33).
- Watson, J. B. (1913). Psychology as the behaviorist views it. Psychological Review, 20, 158–177.
- Watson, J. B. (1914). Behavior: An introduction to comparative psychology. New York: Holt, Rinehart & Winston.
- Watson, J. B. (1916). The place of the conditioned reflex in psychology. *Psychological Review*, 23, 89–116.
- Watson, J. B. (1919). Psychology from the standpoint of a behaviorist. Philadelphia: Lippincott.
- Watson, J. B. (1926). What the nursery has to say about instincts. In C. Murchison (Ed.), *Psychologies of 1925* (pp. 1–34). Worcester, MA: Clark University Press.
- Watson, J. B. (1930). *Behaviorism* (rev. ed.). New York: Norton. (Original work published 1924)
- Watson, J. B. (1936). John Broadus Watson. In C. Murchison (Ed.), A history of psychology in autobiography (Vol. 3, pp. 271–281). Worcester, MA: Clark University Press.
- Watson, J. B., & Lashley, K. S. (1915). Homing and related activities of birds (Vol. 7). Carnegie Institution, Department of Marine Biology.
- Watson, J. B., & McDougall, W. (1929). The battle of behaviorism. New York: Norton.
- Watson, J. B., & Rayner, R. (1920). Conditioned emotional reactions. *Journal of Experimental Psychology*, 3, 1–14.
- Watson, J. B., & Watson, R. R. (1928). The psychological care of the infant and child. New York: Norton.
- Watson, J. S. (Trans.). (1997). Lucretius: On the nature of things. Amherst, NY: Prometheus Books.
- Watson, R. I. (1978). *The great psychologists* (2nd ed.). Philadelphia: Lippincott.
- Watson, R. I., & Evans, R. B. (1991). The great psychologists: A history of psychological thought (5th ed.). New York: Harper Collins.
- Weber, I., & Welsch, U. (1997). Lou Andreas-Salomé: Feminist and Psychoanalyst. In W. G. Bringmann, H. E. Lück, R. Miller, & C. E. Early (Eds.), *A pictorial history of psychology* (pp. 406–412). Carol Stream, IL: Quintessence.

- Webster, C. (1982). From Paracelsus to Newton: Magic and the making of modern science. New York: Barnes & Noble.
- Webster, R. (1995). Why Freud was wrong: Sin, science, and psychoanalysis. New York: Basic Books.
- Weidman, N. (1997). Heredity, intelligence, and neuropsychology; or, why The Bell Curve is good science. Journal of the History of the Behavioral Sciences, 33, 141–144.
- Wells, G. A. (1991). Who was Jesus?: A critique of the New Testament record. La Salle, IL: Open Court.
- Wells, G. A. (1996). The Jesus legend. La Salle, IL: Open Court.
- Wentworth, P. A. (1999). The moral of her story: Exploring the philosophical and religious commitments in Mary Whiton Calkins's self-psychology. *History of Psychology*, 2, 119–131.
- Wertheimer, Max. (1912). Experimentelle Studien über das Sehen von Bewegung [Experimental studies on the perception of motion]. Zeitschrift für Psychologie, 61, 161–265.
- Wertheimer, Max. (1934). On truth. Social Research, 1, 135–146.
- Wertheimer, Max. (1935). Some problems in the theory of ethics. *Social Research*, 2, 353–367.
- Wertheimer, Max. (1937). On the concept of democracy. In M. Ascoli & F. Lehmann (Eds.), *Political and economic de-mocracy* (pp. 271–283). New York: Norton.
- Wertheimer, Max. (1940). A story of three days. In R. N. Anshen (Ed.), *Freedom: Its meaning* (pp. 555–569). New York: Harcourt, Brace.
- Wertheimer, Max. (1959). Productive thinking (enlarged ed.) (Michael Wertheimer, Ed.). New York: Harper. (Original work published 1945)
- Wertheimer, Michael. (1978). Humanistic psychology and the humane but tough-minded psychologists. *American Psychologist*, 33, 739–745.
- Wertheimer, Michael. (1980). Gestalt theory of learning. In G. M. Gazda & R. J. Corsini (Eds.), Theories of learning: A comparative approach (pp. 208–251). Itasca, IL: Peacock.
- Wertheimer, Michael. (1987). A brief history of psychology (3rd ed.). New York: Holt, Rinehart & Winston.
- Wertheimer, Michael, & King, B. D. (1994). Max Wertheimer's American sojourn: 1933–1943. History of Psychology Newsletter, 26, 3–15.
- Weyer, J. (1563). De praestigiis daemonum [The deception of demons]. Basel, Switzerland: Per Joannem Oporinum.
- White, M., & Epston, D. (1990). Narrative means to therapeutic ends. New York: Norton.
- White, M., & Gribbin, J. (1995). Darwin: A life in science. New York: Dutton.
- Wiener, D. N. (1996). B. F. Skinner: Benign anarchist. Needham Heights, MA: Allyn & Bacon.
- Wiener, N. (1948). Cybernetics. New York: Wiley.

- Wilcocks, R. (1994). Maelzel's chess player: Sigmund Freud and the rhetoric of deceit. Savage, MD: Rowman and Littlefield.
- Wilken, R. L. (2003). The Christians as the Romans saw them (2nd ed.). New Haven: Yale University Press.
- Williams, M. (1987). Reconstruction of an early seduction and its aftereffects. *Journal of the American Psychoanalytic* Association, 15, 145–163.
- Wilson, C. (1972). New pathways in psychology. New York: Taplinger.
- Wilson, E. O. (1975). Sociobiology: The new synthesis. Cambridge: Harvard University Press.
- Wilson, E. O. (1978). On human nature. Cambridge: Harvard University Press.
- Wilson, E. O. (1995). Naturalist. New York: Warner Books.
- Wilson, E. O. (1998). Consilience: The unity of knowledge. New York: Knopf.
- Wilson, F. (1990). Psychological analysis and the philosophy of John Stuart Mill. Toronto: University of Toronto Press.
- Wilson, J. (1994). Introduction. In D. Erasmus, The praise of folly (J. Wilson, Trans.) (pp. vii–viii). Amherst, NY: Prometheus. (Original work published 1512)
- Windholz, G. (1983). Pavlov's position toward American behaviorism. Journal of the History of the Behavioral Sciences, 19, 394–407.
- Windholz, G. (1990). Pavlov and the Pavlovians in the laboratory. *Journal of the History of the Behavioral Sciences*, 26, 64–74.
- Windholz, G. (1991). I. P. Pavlov as a youth. *Integrative Physiological and Behavioral Science*, 26, 51–67.
- Winston, A. S. (2006). Robert S. Woodworth and the creation of an eclectic psychology. In D. A. Dewsbury, L. T. Benjamin Jr., & M. Wertheimer (Eds.), Portraits of pioneers of psychology (Vol. 6, pp. 51–66). Washington, DC: American Psychological Association.
- Winter, E. F. (Ed. & Trans.). (2005). Erasmus & Luther: Discourse on free will. New York: Continuum.
- Witmer, L. (1896). Practical work in psychology. *Pediatrics*, 2, 462–471.
- Wittels, F. (1924). Sigmund Freud: His personality, his teaching, and his school. London: Allen and Unwin.
- Wittgenstein, L. (1997). Philosophical investigations (G. E. M. Anscombe, Trans.). Malden, MA: Blackwell. (Original work published 1953)
- Wokler, R. (1995). Rousseau. New York: Oxford University Press.
- Wolf, T. H. (1973). Alfred Binet. Chicago: University of Chicago Press.
- Wolff, C. von. (1732). Psychologia empirica [Empirical psychology]. Frankfurt: Rengeriana.

- Wolff, C. von. (1734). Psychologia rationalis [Rational psychology]. Frankfurt: Rengeriana.
- Wolman, B. B. (1968a). Immanuel Kant and his impact on psychology. In B. B. Wolman (Ed.), Historical roots of contemporary psychology (pp. 229–247). New York: Harper & Row.
- Wolman, B. B. (1968b). The historical role of Johann Friedrich Herbart. In B. B. Wolman (Ed.), Historical roots of contemporary psychology (pp. 29–46). New York: Harper & Row.
- Woodward, W. R. (1984). William James's psychology of will: Its revolutionary impact on American psychology. In J. Brozek (Ed.), Explorations in the history of psychology in the United States (pp. 148–195). Cranbury, NJ: Associated University Presses.
- Woodworth, R. S. (1931). Contemporary schools of psychology. New York: Ronald Press.
- Woodworth, R. S. (1938). Experimental psychology. New York: Holt.
- Woodworth, R. S. (1958). *Dynamics of behavior*. New York: Holt, Rinehart & Winston.
- Woozley, A. D. (Ed.). (1974). Introduction. In J. Locke, An essay concerning human understanding (pp. 9–51). New York: New American Library.
- Workman, L. & Reader, W. (2004). Evolutionary psychology: An Introduction. New York: Cambridge University Press.
- Wundt, W. (1862a). Contributions to a theory of sense perception. Leipzig, Germany: Winter.
- Wundt, W. (1862b). Die Geschwindigkeit des Gedankens [The speed of thought]. Gartenlaube, 263–265.
- Wundt, W. (1863). Vorlesungen über die Menschen-und Thierseele [Lectures on human and animal psychology]. Leipzig, Germany: Voss.
- Wundt, W. (1897). Outlines of psychology (C. H. Judd, Trans.). Leipzig, Germany: Engelmann.
- Wundt, W. (1900–1920). Völkerpsychologie [Group psychology] (Vols. 1–10). Leipzig, Germany: Engelmann.
- Wundt, W. (1904). Principles of physiological psychology (E. Titchener, Trans.). London: Swan Sonnenschein. (Original work published 1874)

- Wundt, W. (1973). An introduction to psychology. New York: Arno Press. (Original work published 1912)
- Yandell, K. E. (1990). Hume's "inexplicable mystery": His views on religion. Philadelphia: Temple University Press.
- Yaroshevski, M. G. (1968). I. M. Sechenov—The founder of objective psychology. In B. B. Wolman (Ed.), Historical roots of contemporary psychology (pp. 77–110). New York: Harper & Row.
- Yates, F. A. (1964). Giordano Bruno and the hermetic tradition. Chicago: University of Chicago Press.
- Yerkes, R. M. (1923). Testing the human mind. Atlantic Monthly, 121, 358–370.
- Yonge, C. D. (Trans.). (1997). Cicero: The nature of the gods and On divination. Amherst, NY: Prometheus Books.
- Young-Bruehl, E. (1988). Anna Freud: A biography. New York: Norton
- Young-Bruehl, E. (1990). Freud on women: A reader. New York: Norton.
- Youniss, J. (2006). G. Stanley Hall and his times: Too much so, yet not enough. *History of Psychology*, 9, 224–235.
- Zaidel, D. W. (Ed.). (1994). Neuropsychology. San Diego, CA: Academic Press.
- Zeigarnik, B. (1927). Über Behalten von erledigten und unerledigten Handlungen [On the retention of finished and unfinished tasks]. *Psychologische Forschung*, 9, 1–85.
- Zenderland, L. (1997). "The Bell Curve" and the shape of history. Journal of the History of the Behavioral Sciences, 33, 135–139.
- Zenderland, L. (2001). Measuring minds: Henry Herbert Goddard and the origins of American intelligence testing. New York: Cambridge University Press.
- Zuckerman, M. (1991). Psychobiology and personality. New York: Cambridge University Press.
- Zusne, L. (1995). Letter to author, 11 October.
- Zusne, L., & Blakely, A. S. (1985). Contributions to the history of psychology: XXXVI. The comparative prolificacy of Wundt and Piaget. Perceptual Motor Skills, 61, 50.
- Zusne, L., & Jones, W. H. (1989). Anomalistic thinking: A study of magical thinking (2nd ed.). Hillsdale, NJ: Erlbaum.

Subject Index

Albertus Magnus, Saint, 89, 97

Alcmaeon, 38, 62

Abelard, Peter, 86-89, 96 the Absolute, 199, 205 absolute threshold, 255, 260 academician, 648 acquired characteristics, inheritance of 294, 332 Jung's belief in, 556, 559 McDougall's interest in, 413 Active mind, 21, 25, 179, 205 Active reason, 53, 62 Act psychology, 279, 291, 458, 484 Adaptive act, 366, 381 Adaptive features, 300, 331 Adequate stimulation, 235, 260 Adler, Alfred, 531, 559-561, 568, 669 break with Freud, 559 creative self, 561 feelings of inferiority, 560 move to the U.S., 559 mistaken lifestyle, 561 organ inferiority and compensation, 560 worldview, fictional goals, and lifestyles, Adolescent psychology Hall, Granville S., 355, 358 Aesthetic stage, 220, 230 "Aetiology of Hysteria" (Freud), 525, 540

African Americans intelligence testing and, 325 segregated education and, 360-362

Sumner, Francis C., 358-360 Against Method: Outline of an Anarchistic

Theory of Knowledge (Feyerabend), 13

Aging Hall on, 358 Skinner on, 449 Agrippa, Cornelius, 495, 666 Alexander the Great, 50, 68 Allegory of the cave, 47, 62 Almagest (Ptolemy), 105 Altruistic surrender, 554, 568 Alzheimer, Alois, 499 Alzheimer's disease, 499 American Association of Applied Psychology (AAAP), 648 American Institute for Psychoanalysis, 562 American Journal of Psychology, 336, 354 American Philosophical Society, 353 American Psychological Association (APA), 274, 651, 670 Angell as president, 365 applied psychology and, 647 associate member category, 648 Calkins as first female president, 353 Cattell as president, 367 Clark as only African American president, 361 clinical division, 648 Dewey as president, 365 Divisions and their memberships, 644, 645-646, 648 Doctor of Psychology degree (PsyD), 502 founder and president, G. S. Hall, 354 Guthrie as president, 441 Hebb's presidency and award from, 609, Hollingworth (L. S.) as president, 321 Hull as president, 435 humanistic ideals versus rigorous science, 652

James as president, 354

Kelly, George, 581

Lashley, Karl, 608 Loftus's award for memory research, 544 Köhler's award and presidency of, 461 Maslow and humanistic psychology, 586, 590, 507 Miller, George, presidency and award, 626 Münsterberg as president, 348 pharmacotherapy division, 649 racial issues, 361 rankings of eminent psychologists, 624 Skinner's award, 449 Skinner's followers, 450 Sperry's award, 612 Thorndike as president, 375 Tolman as president and award from, 433 Washburn as President, 373 Watson as president, 401, 403 Witmer as charter member, 500 American Psychiatric Association, 499 American Psychological Foundation (APF) award to Guthrie, 441 award to Miller, George, 626 American Psychologist, 394, 449, 648 anal stage, 534 Analogy of the divided line, 46, 62 Analysis of Mind, The (Russell), 410 Analysis of the Phenomena of the Human Mind (Mill), 153 Anatomy is destiny, 564, 568 Anaxagoras, 37, 62, 665 Anaximander, 32, 62 Angell, James R., 364-366, 381, 397 Anima and animus, 557 Animal Intelligence (Thorndike), 370 Animal magnetism, 505, 513 Animal Mind, The (Washburn), 373 animal research

synthesis of philosophy with Islam, 83

synthesis of philosophy with Judaism, 84

Breland, Keller and Marian, 616 artificial intelligence (AI), 628-631, 642 genetic influences on personality, 617 Darwin and, 301, 370 limitations in brain function analogy, 634 research in contemporary psychology, 619 development of behaviorism, 385 new connectionism (neural networks), Tolman as pioneer, 433 Harlow, Harry, 625 635-639 Behaviorism, 384, 397-422, 624. See also Hebb, Donald, 610 transition to information-processing neobehaviorism; objective humanistic psychology and, 597 psychology, 632 psychology Köhler, Wolfgang, 461, 471-473 Turing test, 629 background of, 384 weak versus strong AI, 629 Morgan, Conwy L., 371 consciousness and, 515 Pavlov, Ivan, 389, 391-393 Darwin's influence, 301 artificial somnambulism, 506, 513 Romanes, George J., 370 "As if", philosophy of, 285, 582 diminished influence in current structuralism and, 278 Associationism, 55, 62, 138, 152, 176 psychology, 450 Sechenov, Ivan, 386 Analysis by James Mills, 153 defined, 421 Thorndike, 370, 373 Berkeley's principle of association, 141 denial of cognitive events, 623 Hartley's application to behavior, 151 Tolman, 429 ethologists versus, 613 Washburn, Margaret F., 371 Hartley's explanation of association, 150 humanistic psychologists' view on, 586 Watson, John B., 399 Hume on association of ideas, 146 Köhler on, 463 Yerkes, Robert, 399 Locke and, 138 methodological, 412 Animals Pavlov on physiological basis of, 394 Titchener's view of, 273 Cynics' view of, 68 Sechenov, Ivan M., 386 radical, 412 Christian view of (Aguinas), 90 Spencer's evolutionary associationism, 295 McDougall, William, 412-417 Emotional expression and evolution, 301 Titchener's use of, 276 Watson, John B., 273, 397-412 Empedocles' view of, 36 utilitarianism and, 153 Behavior of Organisms, The (Skinner), 443 relation to humans, 19, 164 Association of Consulting Psychologists Behavior System, A (Hull), 436 Renaissance humanist view of, 100 (ACP), 648 behavior therapy, 421 Animal spirits, 120, 127 Association of Humanistic Psychologists, 586 Skinner's version, 449 Animism, 29, 62 Association for Psychological Science (APS), Watson and Jones's use of, 408 Anomalies, 12, 25 651 Behavior theory, 454 Anselm, Saint, 85, 87, 96, 666 association reflex, 396, 421 environmental determinism, 15 Anthropology, 196, 205 Atoms, Democritus on, 37 Hartley's application of association to, 151 Anthropometry, 305 Attention Hume's view of emotions as determinants, Anthropomorphism, 29, 62 Hobbes on, 133 148 Anticathexis, 532, 550 James on, 345 McDougall's emphasis on instincts, 414 Antisthenes, 68, 96, 665 Behavior, unpredictable, 487 Titchener on, 277 Anxiety, 533, 550, 603 Wundt on, 268 being, 33, 62 Heidegger on, 575 Auditory perception, Helmholtz theory of, Being and Time (Heidegger), 573 Horney on, 563, 568 Being-beyond-the-world, 476, 603 May on, 577, 578 Augustine, Saint, 78-81, 96, 99, 666 Being-in-the-world, 574 Apollonian aspect of human nature, 222, 230 Authentic life, 574, 593, 603 Being motivation, 589, 603 Apperception, 188, 205 Autobiographical Study (Freud), 541 Being perception, 589, 603 Wundt on, 268 Averroës, 84, 96 beliefs, Tolman on, 431, 454 Apperceptive mass, 197, 205 Avicenna, 83, 96, 666 Bell, Charles, 234, 260 Applied psychology, 349, 381 Ayer, Alfred, 424 Bell Curve: Intelligence and Class Structure in Cattell, James M., 367 Baars, Bernard, 625, 627 American Life (Hernstein and pure, scientific psychology versus, 644-Back-propagation systems, 637-639, 642 Murray), 325, 616 Bacon, Francis, 114-117, 127, 180, 444, 666 Bell-Magendie law, 234, 260 Approach-approach conflict, 479, 484 Bain, Alexander, 158-162, 176, 668 Bentham, Jeremy, 153, 158-162, 176 Approach-avoidance conflict, 479, 484 Bandura, Albert, 628 Berkeley, George, 140-143, 176, 667 Archetypes, 556, 568 Bannister, Donald, 583 Bernheim, Hippolyte, 507, 513, 523, 668 Avoidance-avoidance conflict, 479, 484 Barash, David, 613, 614 Beyond Freedom and Dignity (Skinner), 448 Aptitude testing, 648 Bartlett, Frederic Charles, 624, 626, 627, 670 Beyond Good and Evil (Nietzsche), 222 Aptitude Testing (Hull), 435 Basic evil, Horney on, 563, 568 Binet, Alfred, 309-312, 331, 669 Aquinas. See Thomas Aquinas, Saint Basic anxiety, Horney on, 563, 568 assessing intellectual deficiency, 310 Aristarchus of Samos, 106, 127 Basic hostility, Horney on, 563, 568 Binet-Simon scale of intelligence, 311 Aristotle, 2, 49-57, 62, 665 Basics of Psychology (Münsterberg), 348 individual psychology, 310 Battle of Behaviorism, The (Watson and anti-Aristotelianism in Renaissance intelligence quotient (IQ) tests, 312 Köhler's criticism of testing, 461 humanism, 99 McDougall), 416 conception of science, 477 Bechterev, Vladimir M., 394-397, 421, 669 mental orthopedics, 313 Galileo's discrediting of, 111 reflexology, 394-396 view of his intelligence scale, 312 learning resulting from one experience, versus Pavlov, 396 Binet-Simon scale of intelligence, 311, 315-Becoming, 33, 62, 574, 603 322 Protestant challenge to Christianized Behavioral environment, 470, 484 Goddard, Henry H., 315-317 version, 103 Behavior: An Introduction to Comparative Binswanger, Ludwig, 575-577, 603, 670 synthesis of philosophy with Christianity, Psychology (Watson), 427 Daseinanalysis, 575 86-91 Behavioral genetics, 612, 622 ground of existence, 576

Bouchard's twin studies, 617-619

ethology, 613

importance of meaning in life, 576

modes of existence, 575

709

ls, 561
285
, 458, 484
n in Gestalt psychology, 464 .urt, 477–480
nd relationship, 468, 484
, 52, 63
system, 393, 421
on, 300, 331
ology, inclusive fitness, 302, 331
e therapy, 583, 604
Pierre, 247, 260, 608, 667
ng, 598, 604
psychology, 349, 381 ause, 52, 63
discipline, 247, 260
on of Learning Sets, The" (Harlow),
625
46, 63, 110
-force psychology, 590 Victor, 576, 596
Sir James, 490
ssociation, 523, 550
om
ethe on, 212
idegger on, 575
erkegaard on, 220 etzsche on, 223
ousseau on, 210, 571
chopenhauer on, 216
aihinger on, 285
ree will, 16. See also nondeterminism
Adler on, 561
rtificial intelligence and the human mind, 631
Augustine on, 79
Binswanger on, 576
Epicurean view of, 69
Hobbes on, 134 James on, 338, 345
Luther on, 102
Lutilei on, 102
Spinoza on, 182
Spinoza on, 182 third–force psychology, 571
Spinoza on, 182 third–force psychology, 571 Wundt on, 271
Spinoza on, 182 third–force psychology, 571 Wundt on, 271 we Will, The (Erasmus), 192
Spinoza on, 182 third–force psychology, 571 Wundt on, 271 we Will, The (Erasmus), 192 eud, Anna, 523, 538, 552–555,
Spinoza on, 182 third-force psychology, 571 Wundt on, 271 eee Will, The (Erasmus), 192 eud, Anna, 523, 538, 552–555, 568, 671 child analysis, conflict with Melanie Klein
Spinoza on, 182 third–force psychology, 571 Wundt on, 271 we Will, The (Erasmus), 192 eud, Anna, 523, 538, 552–555, 568, 671 child analysis, conflict with Melanie Klein ego psychology, 554
Spinoza on, 182 third–force psychology, 571 Wundt on, 271 we Will, The (Erasmus), 192 eud, Anna, 523, 538, 552–555, 568, 671 child analysis, conflict with Melanie Klein ego psychology, 554 eudian slips, 528
Spinoza on, 182 third–force psychology, 571 Wundt on, 271 we Will, The (Erasmus), 192 eud, Anna, 523, 538, 552–555, 568, 671 child analysis, conflict with Melanie Klein ego psychology, 554 eudian slips, 528 Freud, Sigmund, 3, 19, 518–546, 551,
Spinoza on, 182 third-force psychology, 571 Wundt on, 271 wee Will, The (Erasmus), 192 eud, Anna, 523, 538, 552–555, 568, 671 child analysis, conflict with Melanie Klein ego psychology, 554 eudian slips, 528 Freud, Sigmund, 3, 19, 518–546, 551, 669. See also psychoanalysis
Spinoza on, 182 third-force psychology, 571 Wundt on, 271 eee Will, The (Erasmus), 192 eud, Anna, 523, 538, 552–555, 568, 671 child analysis, conflict with Melanie Klein ego psychology, 554 eudian slips, 528 Freud, Sigmund, 3, 19, 518–546, 551, 669. See also psychoanalysis break with Adler, 559 break with Jung, 556
Spinoza on, 182 third-force psychology, 571 Wundt on, 271 wee Will, The (Erasmus), 192 eud, Anna, 523, 538, 552–555, 568, 671 child analysis, conflict with Melanie Klein ego psychology, 554 eudian slips, 528 Freud, Sigmund, 3, 19, 518–546, 551, 669. See also psychoanalysis break with Adler, 559 break with Jung, 556 cocaine use, 519
Spinoza on, 182 third-force psychology, 571 Wundt on, 271 we Will, The (Erasmus), 192 eud, Anna, 523, 538, 552–555, 568, 671 child analysis, conflict with Melanie Klein ego psychology, 554 eudian slips, 528 Freud, Sigmund, 3, 19, 518–546, 551, 669. See also psychoanalysis break with Adler, 559 break with Jung, 556 cocaine use, 519 contributions to psychology, 545
Spinoza on, 182 third-force psychology, 571 Wundt on, 271 we Will, The (Erasmus), 192 eud, Anna, 523, 538, 552–555, 568, 671 child analysis, conflict with Melanie Klein ego psychology, 554 eudian slips, 528 Freud, Sigmund, 3, 19, 518–546, 551, 669. See also psychoanalysis break with Adler, 559 break with Jung, 556 cocaine use, 519 contributions to psychology, 545 criticisms of his theories, 544
Spinoza on, 182 third-force psychology, 571 Wundt on, 271 eve Will, The (Erasmus), 192 eud, Anna, 523, 538, 552–555, 568, 671 child analysis, conflict with Melanie Klein ego psychology, 554 eudian slips, 528 Freud, Sigmund, 3, 19, 518–546, 551, 669. See also psychoanalysis break with Adler, 559 break with Jung, 556 cocaine use, 519 contributions to psychology, 545 criticisms of his theories, 544 early influences on psychoanalysis, 520–
Spinoza on, 182 third-force psychology, 571 Wundt on, 271 eee Will, The (Erasmus), 192 eud, Anna, 523, 538, 552–555, 568, 671 child analysis, conflict with Melanie Klein ego psychology, 554 eudian slips, 528 Freud, Sigmund, 3, 19, 518–546, 551, 669. See also psychoanalysis break with Adler, 559 break with Jung, 556 cocaine use, 519 contributions to psychology, 545 criticisms of his theories, 544 early influences on psychoanalysis, 520– 524 light from the Nazis, 537
Spinoza on, 182 third–force psychology, 571 Wundt on, 271 wee Will, The (Erasmus), 192 eud, Anna, 523, 538, 552–555, 568, 671 child analysis, conflict with Melanie Klein ego psychology, 554 eudian slips, 528 Freud, Sigmund, 3, 19, 518–546, 551, 669. See also psychoanalysis break with Adler, 559 break with Jung, 556 cocaine use, 519 contributions to psychology, 545 criticisms of his theories, 544 early influences on psychoanalysis, 520– 524 light from the Nazis, 537 Goethe's influence on, 213
Spinoza on, 182 third-force psychology, 571 Wundt on, 271 we Will, The (Erasmus), 192 eud, Anna, 523, 538, 552–555, 568, 671 child analysis, conflict with Melanie Klein ego psychology, 554 eudian slips, 528 Freud, Sigmund, 3, 19, 518–546, 551, 669. See also psychoanalysis break with Adler, 559 break with Jung, 556 cocaine use, 519 contributions to psychology, 545 criticisms of his theories, 544 early influences on psychoanalysis, 520– 524 light from the Nazis, 537 Goethe's influence on, 213 Horney's disagreements with, 562
Spinoza on, 182 third-force psychology, 571 Wundt on, 271 wee Will, The (Erasmus), 192 eud, Anna, 523, 538, 552–555, 568, 671 child analysis, conflict with Melanie Klein ego psychology, 554 eudian slips, 528 Freud, Sigmund, 3, 19, 518–546, 551, 669. See also psychoanalysis break with Adler, 559 break with Jung, 556 cocaine use, 519 contributions to psychology, 545 criticisms of his theories, 544 early influences on psychoanalysis, 520– 524 light from the Nazis, 537 Goethe's influence on, 213 Horney's disagreements with, 562 Kelly on, 580
Spinoza on, 182 third-force psychology, 571 Wundt on, 271 we Will, The (Erasmus), 192 eud, Anna, 523, 538, 552–555, 568, 671 child analysis, conflict with Melanie Klein ego psychology, 554 eudian slips, 528 Freud, Sigmund, 3, 19, 518–546, 551, 669. See also psychoanalysis break with Adler, 559 break with Jung, 556 cocaine use, 519 contributions to psychology, 545 criticisms of his theories, 544 early influences on psychoanalysis, 520– 524 light from the Nazis, 537 Goethe's influence on, 213 Horney's disagreements with, 562

advantas 110 de nos	
nicotine addiction, 520	
on Nietzsche, 226 self–analysis, 525	
studies with Charcot, 509, 522	
view of human nature, 536	
visit to the U. S., 362, 530	
Wittgenstein on, 541	
Frish, Karl von, 613	
Fritzsch, Gustav, 250, 260	
Fromm, Erich, 578, 596	
Fully functioning person, 594	
Functional analysis, 444, 454	
Functionalism, 334-383, 384, 623	
Angell, James R., 364–366	
applied psychology and, 647	
Calkins, Mary Whiton, 350–353	
Carr, Harvey, 366	
Cattell, James M., 367	
characteristics of, 336	
Clark, Kenneth B., 360-362	
Darwin's influence, 301	
defined, 336, 381	
Dewey, John, 362-364	
fate of, 376	
James, William, 337-347	
Münsterberg, Hugo, 347–350	
psychology at Clark University, 362	(
Sumner, Francis C., 358–360	(
Thorndike, Edward L., 369–376 Woodworth, Robert S., 368	(
Future of an Illusion, The (Freud), 537	(
Galen, 41, 63, 120, 492, 665	(
Galileo, 108–112, 127, 132, 666	
conception of science, 477	(
Gall, Franz Joseph, 244, 260, 667	
Galton, Sir Francis, 302-307, 331, 668	C
anthropometry, 305	
contributions to psychology, 307	
correlation, 306	
eugenics, 303	
measure of intelligence, 303	
mental imagery, 305	
nature-nurture controversy, 304, 617	
word–association test, 305	
Garcia effect, 139	
Gassendi, Pierre, 162, 176, 666 Gassner, Johann, 504	
Gauss, Carl Friedrich, 475	
Gender. See also women	
Aristotle on male superiority, 57	
Horney on, 564	
Mill (J.S.) on equality of sexes, 158	
Schopenhauer on inferiority of women,	
214	
Saint Paul's views on women, 76	
sociobiology on role of 613	
General impression, 271, 291	
General intelligence (g), 314, 332	,
Geographical environment, 470, 484	
General Principles of Human Refloxology	Gro
(Bechterev), 394	Gro
General will, 211, 230	Gro
Genetic Studies of Genius (Terman), 319	
General stage, 536	Gui
Geocentric theory, 106, 127 Gestalt 456, 484	e

Gestalt, 456, 484

Gestalt psychology, 456-485,	484 608 624
antecedents, 457	
application of field theory.	464
explanation of learning, 47	1-473
figure-ground relationship,	468
founding of, 458	04 44-
influence on psychology, 4 information-processing the	81, 627
Koffka, Kurt, 460	ory and, 632
Köhler, Wolfgang, 461–463	3
law of Prägnanz, 466	·
Lewin, Kurt, 477-481	
memory, 476	
opposition to constancy hyp	othesis, 465
perceptual constancies, 467	. April sa
principles of perceptual orga phi phemomenon, 464	inization, 468
productive thinking, 474–47	76
psychophysical isomorphism	464
subjective and objective real	ity. 470
success in the U.S., 463	,, , , , o
Tollman and, 427	
top-down analysis, not botto	om up, 465
Wertheimer, Max, 459	
Gestalt Psychology (Köhler), 461	
Gifted Children (Hollingworth), Gillie, Oliver, 314	322
Goddard, Henry H., 315–317,	332 660
Goethe, Johann Wolfgang von 21	2 230 516
Golden Bough, The (Frazer), 490	2, 230, 310
Golden mean, 56, 63	
Good old-fashioned AI (GOFA	I), 636
Gorgias, 42	,,
Great-person approach, 4, 26	
Greek philosophy	
Anaxagoras, 37	
Anaximander, 32	
animism and anthropomorphi Antisthenes, 68	sm, 29
Aristotle, 2, 49–57	
early Greek medicine, 38	
early Greek religion, 30	
Diogenes, 68	
Empedocles, 36	
Galen, 41	
Gorgias, 42	
Heraclitus, 32	
Hedonism, 70	
Hippocrates, 39–41	
importance of early philosophe Parmenides, 33	ers, 57
Plato, 21, 35, 45–49	
Protagoras, 41	
Pyrro of Elis, 67	
Pythagoras, 34	
relativity of truth, 41	
Socrates, 44	
Thales, 31	
Zeno of Elea, 34	
round of existence, 576, 604	
roup dynamics, 480, 484	
Frowth of the Mind: An Introduction	to Child
Psychology (Koffka), 461 uilt, 604	
existentialist thought on, 578	
Heidegger on, 575	

biogrammar, 613, 622 Biological approach to mental illness. See medical model of mental illness Biological determinism, 14, 26, 326 sociobiology, 614 Biological explanations of mental illness, 488 Bleuler, Eugen, 499 Bonaventure, Saint, 90, 96 Bond, Horace M., 325 Bouchard, Thomas, 617-619, 622 Boyle, Robert, 135 Braid, James, 507 Brain function research (early). See also psychobiology Broca, Paul, 248 Ferrier, David, 250 Flourens, Pierre, 247 Fritzsch, Gustav, 250 Hitzig, Eduard, 250 Phrenology, 244-247 Wernicke, Carl. 249 Brain Mechanisms and Intelligence (Lashley), Breland, Keller and Marian, 616 Bretano, Franz Clemens, 278, 291, 517, 572, 630, 668 Breuer, Josef, 520, 550 Bridgman, Percy W., 13, 670 British Journal of Psychology, 412 British Psychological Association, 583 Broadbent, Donald, 625, 632 Broca, Paul, 248, 260, 611, 668 Broca's area, 249, 260 Brown v. Board of Education (1954), 360-362 Brücke, Ernst, 517 Bruner, Jerome, 626, 639 Bruno, Giordano, 106-108, 127, 666 Buchtel, Henry, 610 Bühler, Charlotte R., 586 Burt, Cyril, 314, 331, 616 Caldwell, Charles, 246 Calkins, Mary Whiton, 350-353, 381, 669, Harvard's refusal to grant her a PhD, 352 Memory research, 351 self-psychology, 352 Calvin, John, 107, 108 Canadian Psychological Association, 609 Carr, Harvey, 366, 381 Carnegie, Andrew, 296 Castration anxiety, 535 Categorical imperative, 199, 205 Categories of thought, 193, 200, 205, 633 Cathartic method, 521, 550 Cathexis, 532, 550 Catholic church. See also religion Copernicus and, 106 Bruno and, 106 Erasmus' criticisms of, 101 further challenges to authority, 104 Galileo and, 109, 111 Luther's challenge to, 101-103 Reformation and, 101 witch hunts, 493-496 Cattell, James M., 307, 331, 334, 367, 381,

and applied psychology, 367, 644 drift toward behaviorism, 384 Cattell, Raymond B., 315 Cats in a Puzzle Box, (Guthrie and Horton), 440 Causal laws, 8, 26 Cause and effect Hume's law, 147 Mach on, 171 Causation analysis of, 147 Aristotle's views, 52 Kant on, 193 psychological versus physical (Wundt), 270 cell assemblies, 609, 622 Center for Cognitive Studies, 626 Charcot, Jean-Martin, 408, 513, 527, 668 Chiarugi, Vincenzo, 497 Childhood and Society (Erikson), 555 Child psychoanalysis, 553 Child psychology Darwin's influence, 301 effects of racial segregation, 360 Hall on., 358 Koffka on, 461 Rogers on, 591 Watson on, 408 Chinese Room thought experiment (Searle), 629, 638 Chodorov, N., 565, 679 Chomsky, Noam, 616, 622, 625, 626 Christianity Augustine, Saint, 78-81 Constantine, Emperor, 77 Dark Ages, 81 Jesus, 75 influences combined in, 75 mystery religions and, 74 pre-Renaissance spirit, 92 reconciliation of faith and reason, 85 neoplatonism and, 71-74 Paul, Saint 75-77 Scholasticism, 86-91 witch hunts, 493-496 Civilization and Its Discontents (Freud), 537 Clark, Andv, 638 Clark, Kenneth B., 360-362, 381 Clark, Mamie P., 360 Clark University Calkins's studies at, 351 Freud's visit, 530 Hall as president, 354 Köhler at, 461 psychology at, 362 Sumner at, 359 Clever Hans phenomenon, 281, 291 Client-centered therapy, 649 Client-Centered Therapy: Its Current Practice, Implications, and Theory (Rogers), 592 "Clients", use by Rogers, 592 Clinical method, 248, 260 Clinical psychology, 513 controversy over training, 650-652 current therapeutic techniques, 649 Münsterberg, Hugo, 349

Witmer's pioneering contributions, 501, 647 professional associations, 648 prescription privileges, 649 therapeutic techniques after World War II, Zeigarnik, Bluma, 479 Clinical Treatment of the Problem Child, The (Rogers), 592 Coeducation, Hall on, 356 Coefficient of correlation (r), 306, 313 Cognition and Reality (Neisser), 634 Cognitive dissonance, 626 cognitive maps, 431, 454 cognitive psychology, 623-642 artificial intelligence (AI), 628-631 current interest in, 450 developments after 1950s, 626 developments before 1950, 624 developments during 1950s, 625 faculty psychology, return of, 633 information-processing psychology, 631-633 mind-body problem, return of, 633-635 new connectionism, 635-639 Skinner's attacks on, 445 Tolman and, 433 Cognitive Psychology (journal), 628 Cognitive Psychology (Neisser), 627 Cognitive science, 634, 642 Cognitive science (journal), 634 Cognitive trial and error (Gestalt psychology), 471 Collective unconscious, 556, 568 Color vision. See vision Columbia University, functionalism at, 367-376 Common sense, 53, 62 Commonsense philosophy, 190, 205 Compensation, Adler on, 560, 568 Complex ideas, 176 Hartley on, 151 Hobbes on, 237 Hume on, 145 Locke on, 137 Computational Theory of Mind (CTM), 639 "Computing Machinery and Intelligence" (Turing), 629 Computer models of human intelligence, 628. See also artificial intelligence; information-processing psychology Comte, Auguste, 168-171, 176, 423, 668 Concept formation, 626 Conceptualism, 87, 96 Condensation, 526, 550 Condillac, Étienne Bonnot de, 166, 176, 667 conditioned reflex, 389, 391, 421 conditioned response (CR), 391, 421 conditioned stimulus (CS), 391, 421 Conditioned Reflexes (Pavlov), 390 Conditioned responses, Hull's study of, 435 Conditioning, rote learning explanation, 436 conditions of worth, 594, 603

Confessions (Augustine), 79, 81

Confirmable propositions, 7, 26

Confirmation, Tolman on, 431, 454

Conflict, 524, 550 Empedocles on, 36 Herbart on, 198, 516 Jung on, 558 Lewin on, 479 May on, 579 Miller on, 480 Paul, Saint, on, 76 Plato on, 48 connectionism, 374, 381 new connectionism, 635-639 Consciousness. See also mind-body relationships Experimental psychologists' view of, 250 functionalist and structuralist study of, 384 Hull on, 435 James on, 341 methodological behaviorism on, 515 mind-body relationship theories, 411 mind-brain and mind-body relationships. 634 molar approach to, 456 molecular approach to, 456 Schopenhauer on, 216 Searle on, 630 Sechenov on, 386 Skinner on, 445 Sophists' concerns with, 43 Sperry on, 612 Titchener's mental elements, 276 Watson, John, on, 411 Wundt on, 264 Conservation of energy, principle of, 237, 261, 517 Constancy hypothesis, 465, 484 Constantine, Emperor, 77, 96, 666 Constructive alternativism, 581, 603 Construct systems, 582, 603 Contagion effect, 505, 513 Contagious magic, 490, 513 Contemporary psychology, 643-664 APA divisions, 644 diversity of, 643 eclecticism, 644 new developments in psychology, 659-661 postmodernism, 655-659 psychology's status as a science, 653-655 psychology's two cultures, 652 pure, scientific versus applied psychology, 644-653 Contemporary Schools of Psychology (Woodworth), 369 Context theory of meaning, 277, 291 Contributions to the Analysis of Sensations (Mach), 423 Contributions to the Theory of Sense Perception (Wundt), 263 Convictions, Nietzsche on, 223, 230 Copernicus, Nicolaus, 106-108, 127, 666 Correlation, 306, 331 Correlational laws, 8, 26 Correspondence theory of truth, 10, 13, 26 Cortical mosaic, 392, 421 Cosmology, 31, 62 Counseling and Psychotherapy: Newer Concepts in Practice (Rogers), 592, 624

Cours de Philosophe Positive (Comte), 168 Courage, 575, 603 Countertransference, 521, 550 Crane, Loval, 650 Creationism, 298 age of the earth and evolution, 300 creative self, 561, 568 Creative synthesis, 268, 291 Critique of Pure Reason (Kant), 182 Critique of Practical Reason (Kant), 182 Cultural determinants of behavior, 564, 614 Cybernetics, 625 application to human behavior, 626 Cynicism, 68, 96, 101, 130, 226 Daimonic, 579, 603 Daquin, Joseph, 496 Dark Ages, 81, 666 Darwin, Charles, 3, 297-302, 331, 668 age of the earth and evolution, 300 human evolution 300 influence on Freud, 517 influence on psychology and other disciplines, 301 journey of the Beagle, 298 return to England, 298 social Darwinism and, 297, 304 theory of evolution, 300 Darwin, Erasmus, 294 Dasein, 574, 603 Daseinanalysis, 575, 604 Death existentialists on, 596 Fechner on, 254 Freud on death instincts, 533, 550 Nietzsche on, 223 Schopenhauer on, 215 Deception of Demons (Weyer), 495 Deduction, 115, 127, 132, 180 Defense mechanisms, 533, 550 Deficiency motivation (D-motivation), 589, Deficiency perception (D-perception), 589 Deism, 112, 127, 181 Dementia praecox, 499 Democritus, 37, 62, 665 Depression, 649, 658 Derrida, Jacques, 104 Descartes, RenÉ, 18, 21, 117-124, 127, 130, 180, 184, 234, 666 Descent of Man, The (Darwin), 297, 300 Descriptive behaviorism, 448, 454 Determinism, 8, 14-17, 26 Democritus, 37 Nietzsche's view versus Freudians, 223 responsibility and, 16 third-force psychology and, 571 Wundt, 271 Developmental lines, 554, 568 Dewey, John, 362-364, 381, 647, 669 criticism of reflexes in behavior analysis, involvement in social causes, 364 views on education, 364 Diagnostic and Statistical Manual of Mental Disorders (DSM), 499

dialectic method, 86, 96

dialectic process, 200, 205 Dialogues Concerning Natural Religion (Hume), Dialogues Concerning the Two Chief World Systems (Galileo), 123 Dialogues Concerning Two New Sciences (Galileo), 111 Differential threshold, 255, 260 Diogenes, 68, 96 Dionysiac-Orphic religion, 30, 35, 62 Dionysian aspect of human nature, 222, 230 Direct realism, 180, 205 Discovery of Witchcraft (Scot), 495 Disinhibition, 392, 421 Displacement, 526, 533, 550 Distance perception, Berkelev's theory of. Divided line analogy (Plato), 46, 62 Dix, Dorothea Lynde, 498, 513, 667 Doctor of Medicine (MD) degree, 651 Doctor of Philosophy (PhD) degree, 502, 650 Doctor of Psychology degree (PsyD), 502, 650, 664 Dogmatist, 67, 96 Donders, Franciscus Cornelius, 269, 291, 644 Dostovevsky, Fyodor, 226, 573 double aspectism, 16, 26, 182, 205 doctrine of specific nerve energies, 235, 250 dream analysis Freud on, 526, 550 Jung on, 558, 568 dream work, 526, 550 dreams, 62 Aristotle on, 55 Condillac on, 166 Descartes's explanation of, 121 Hobbes's views on, 133 Plato on, 49, 527 Dreyfus, Hubert, 638 Drive reduction, 437, 454 "Drives and the C.N.S." (Hebb), 625 Drives, Guthrie on, 441 Drives Toward War (Tolman), 427 dualism, 18, 631, 634 dualists, 18, 26, 127 Descartes, 122 Pythagoreans, 35 Dynamics of Behavior (Woodworth), 369 Dynamic psychology, 368, 381 Dynamics in Psychology (Köhler), 463 Ebbinghaus, Hermann, 286-288, 291, 624. 627, 668 Eclectic approach, 4, 26 Eclecticism, 644, 664 Ecological psychology, 634 Education Dewey on, 364 gifted children, 321 Hall's opposition to coeducation, 356 HÉlvetius on, 168 influence of phrenology, 247 La Mettrie's views on, 164 Locke on, 139 nature-nurture controversy and, 304 racial segregation in U.S. schools, 360-

Rousseau on, 211 Skinner on, 448 Sumper on, 359 Educational psychology, 198 Kelly, George, 580 Efficient cause, 52, 63 Egger, M. D., 627 Ego, 531, 532, 550 Jung on, 556, 568 Ego defense mechanisms, 533, 550 Ego and the Mechanisms of Defense (Anna Freud), 554 ego psychology, 554, 568 Ehrenfels, Christian von, 457, 484 Eigenwelt, 576, 603 Fidola, 36, 63 Either/Or (Kierkegaard), 218, 220 Electroencephalography (EEG), 659 Elementism, 37, 63, 456, 484 Elements of the Philosophy of the Human Mind (Stewart), 335 Elements of Phrenology (Caldwell), 246 Elements of Physiological Psychology (Woodworth), 369 Elements of Psychophysics (Fechner), 254, 286 Elements of thought, 267, 291, 456 Elliotson, John, 507 Emergentism, 18, 26 Emerson, Ralph Waldo, 4, 506 Emile, 210, 211 Emotions Aristotle on, 56 computer metaphor for the brain and, 634 Darwin on, 300 Democritus on, 38 Hartley on, 152 Hume on, 148 inappropriate, in mental illness, 487 James on, 344 Locke on, 137 McDougall on, 414 Plato on, 48 romanticism's emphasis on, 208 Spinoza on, 183 Titchener's affections, 276 Watson on, 407 Emotions and the Will (Bain), 159 Empedocles, 36, 63 Empirical observation, 7, 26 Empirical self, 343, 381 Empiricism, 7, 21, 26, 130. See also positivism; sensationalism Aristotle, 51 Bain, Alexander, 158-162, 176 Bacon, Francis, 114-116 Berkeley, George, 140-143, 176 British empiricism, 131-162 defined, 131, 176 Hartley, David, 150-152, 176 Hobbes, Thomas, 5, 131-134, 176 Hume, David, 143-150, 177 James on, 346 Locke, John, 134-140, 177 mental events and, 631 Mill, James, 152-154, 177 Mill, John Stuart, 5, 154-158, 177

nativism versus, 18 process of becoming, 33 rationalism versus, 179-181 English Men of Science: Their Nature and Nurture (Galton), 304 Engram, 607, 622 Enjoy Old Age: Living Fully Your Later Years (Skinner and Vaughan), 449 Enlightenment, 207, 230, 656 Enquiry Concerning Human Understanding, An (Hume), 143 entelechy, 52, 63 Environmental determinism, 14, 26 Environmentalism, 168. See also naturenurture controversy intelligence testing and, 308 nature-nurture controversy, 304 sociobiology and, 614 Environment, importance to Skinner, 446 Epicureanism, 69, 96, 163 Epicurus of Samos, 69, 96, 665 Epiphenomenalism, 16, 26, 411, 633 Epistemololgy, 20, 26 Equipotentiality, 607, 622, 622 Erasmus, Desiderius, 100, 103, 127, 666 Escape from Freedom (Fromm), 578, 596 Essay Concerning Human Understanding, An (Locke), 135 Essay on the Origin of Human Knowledge (Condillac), 166 Essay on the Principle of Population, An (Malthus), 299 Essay Towards a New Theory of Vision, An (Berkelev), 140 Essays on the Active Powers of the Human Mind (Reid), 190 Essays on the Intellectual Powers of Man (Reid), Essays on the Mind (HelvÉtius), 167 Essences, 44, 50, 63 family resemblance versus, 658 nomanilism versus realism, 86 ethical stage, 220, 230 Ethics: Demonstrated in Geometrical Order (Spinoza), 181 Ethnology, 5 Ethology, 157, 176, 613, 622 Eugenics, 303, 331 Cattell, James M., 307 Davenport, Charles, 323 Yerkes, Robert M., 323 evil, 71, 102 Horney on basic evil, 563 Evolution, 3 Anaximander on, 32 applied psychology and, 647 Empedocles on, 36 Darwin, Charles, 297-302 Dewey on, 364 Freud's theories and, 517 Galton, Sir Francis, 302-307 Goethe on, 213 Hall, Granville S., 358 Ladd-Franklin color vision theory, 243

Lamarck, Jean, 294

Nietzsche on, 223

Fictional goa Fictionalism Skir Field theory Sper application Evoluti sociol Lewin, figure-grou Excitatio Final cause Existentia First-signa emphas Fitness in huma Darwin Kierkega sociobi Nietzsch Fixed-rol truth as re Flourens, Existence: A Flourishi Psychi Forensic, Existential psy Formal Binswanger Formal comparison ("Format Heidegger, N Kelly, George May, Rollo, 5 Forms, Fourth Existential Psychol Frankl, expectancies, 431, Experimental neur Frazer. Experimental psy Free a Freed Go He also pure, sc association with a Calkins's view of. Bretano's view of, Fechner, Gustav Tl Husserl on, 282 Hull's influence on, James on, 340 Weber, Ernst Heinric Wundt's view of, 265. Experimental Psychology (V "Experimental Studies of Movement" (Wert Expression of the Emotions in (Darwin), 300 Extinction, 392, 421 latent extinction, 432 Skinner's alternative to pur Extrinsic reinforcement, 475, Extraversion, 557, 559, 568 Factor analysis, 313, 331 Faculty psychology, 191, 205, 6 return of, 633 Falsifiability, 9, 27 Family resemblance, 658, 664 Farewell to Reason (Feyerabend), 13 Fashions in psychology, 5 Faust (Goethe), 212 In Fear and Trembling (Kierkegaard), Fear, Hebb's research on, 610 Fechner, Gustav Theodor, 252-256, 340, 461, 667 experimental study of cognitive ever influence on Freud, 516 feedback, information, 625, 626 feelings of inferiority, 560, 568 Feelings. See also emotions Rogers on, 593 Wundt on, 267, 291 Feminine Psychology (Horney), 564 Ficino, Marsilio, 99, 127

Guthrie, Edwin R., 438-442, 450, 454 drives and intentions, 441 forgetting, 440 formalization of his theory, 441 learning theory, 439 one-trial learning, 439, 455 punishment research, 441 why practice improves performance, 439 nature of reinforcement, 440 habit strength (SHR), 437, 454 habits, 381 breaking, Guthrie on, 441 James on, 342 Hall, Granville S., 353-358, 381, 644, 669 applied psychology and military efficiency, founder and president of APA, 354 opposition to coeducation, 356 president of Clark University, 354 recapitulation theory, 355 religious conversion, 356 study of aging, 358 sublimation, 356 views on women, 357 work on adolescent psychology, 355, 357 Happiness. See also hedonism Aristotle on, 56 Epicurean view of, 70 Stoicism and, 71 Hard determinism, 16 Harlow, Harry, 585, 625 Hartley, David, 150-152, 176, 234, 635, 667 Hebb, Donald O., 608-610, 622, 671 cell assemblies and phase sequences, 609 criticism of radical behaviorism, 625 experimental study of cognitive processes, 627 on idea in Hebb's rule, 635 physiological and cognitive psychology, 625 Hebb's rule, 635, 642 Hedonism, 70, 96 Bain on, 161 Bentham on, 153 HÉlvetius on, 168 Hobbes on motivation, 134 Locke on motivation, 137 Spinoza on, 183 Hegel, Georg Wilhelm Friedrich, 199-201, 205, 667 Heidbreder, 527, 529, 653 Heidegger, Martin, 573-575, 604, 670 authenticity and inauthenticity, 374 Dasein, 574 guilt and anxiety, 575 Nazism, 574 thrownness, 575 Heliocentric theory, 106, 127 Helmholtz, Hermann von, 236-242, 260, 506, 644, 668 influence on Freud, 517, 524 Heloise, 88 HelvÉtius, Claude-Adrien, 167, 176 Henri, Victor, 310 Heraclitus, 32, 63, 661, 665 Herbart, Johann Friedrich, 196-199, 205, 516, 667

Hereditary Genius: An Inquiry into Its Laws and Consequences (Galton), 303 Hering, Ewald, 242, 260, 668 Heritability, 618, 622 Hernstein, Richard I., 325 hierarchy of needs (Maslow), 587, 604 Hippocrates, 39-41, 63, 665 mental disorders and treatment, 491, 513 Historical development approach, 4, 26 Historicism, 2, 26 Historiography, 2, 26 History of Experimental Psychology (Boring), History of Psychology, 358 Hobbes, Thomas, 5, 131-134, 176, 666 Holists, 457, 484 Hollingworth, Leta S., 321, 331, 670 Homeopathic magic, 490, 513 L'Homme Machine (Man a Machine), 163, 353 Homo homini lupus (Man is a wolf to man), Hormic psychology, 414, 421 Horney, Karen, 561-565, 568, 670 adjustments to basic anxiety, 563 basic hostility and basic anxiety, 563 feminine psychology, 564 hostility, Horney on, 563, 568 Hull, Clark L., 434-438, 454, 624, 670 aptitude testing, 435 concept formation, research on, 434 humans as machines, 435 hypnosis and suggestibility, 435 hypothetico-deductive theory, 436 influence on psychology, 437, 450 reinforcement theory, 437 Hull-Spence theory, 437 Human, All-Too-Human (Nietzsche), 221, 223 Human dilemma, 578, 603 Human evolution, 300 Human Intellect: With an Introduction Upon Psychology and the Soul (Porter), 335 Humanism Bruno, Giordano, 106-108 Copernicus, Nocolaus, 106 Defined, 99, 127 Erasmus, Desiderius, 100 Galileo, 108-112 humanistic ideals versus rigorous science, Kepler, Johannes, 108 Luther, Martin, 101-103 major themes, 98 Petrarch, Francesco, 99 Pico, Giovanni, 100 Montaigne, Michel de, 103 Renaissance, 104 Humanistic psychology, 570-572, 584-605, 626. See also existential psychology artificial intelligence and the mind, 631 basic tenets, 586 combination of romanticism and existentialism, 572 comparison to existential psychology, 595 contributions of, 597

criticisms of 596 evaluation of, 596 Maslow, Abraham, 584-590 mind, body, and spirit, 570 phenomenology, 572 positive psychology and, 598 truth as relative to cultural group, 656 Human nature, 17, 630 Apollonian and Dionysian aspects, 222 assumptions about, effect on study of humans, 632 existential psychology on, 597 Freud on, 536 humanistic psychology on, 596, 597 Hume on, 143 science of, I. S. Mill human science, 579 Humans, relation to other animals, 19 Hume, David, 143-150, 177, 189, 192, 667 Humor, Freud on, 529 Husserl, Edmund, 281, 291, 573, 669 Huxley, Thomas, 294, 299 Hypnosis and Suggestibility: An Experimental Approach (Hull), 435 Hypnotism, 504-506 artificial somnambulism, 506 Charcot's explanation of, 508 Freud's use in treatment of hysteria, 523 Janet's expnanation of, 510 mesmerism's popularity, 506 mesmerism used as anesthetic, 507 Nancy school, 507 origin of term "hypnosis", 507 posthypnotic amnesia, 507 posthypnotic suggestion, 507 hypotheses, 431, 454 hypothetico-deductive theory, 436, 454 hysteria, 492 case of Anna O., 520 Charcot's explanation of, 509 Freud and Brueur, Studies on Hysteria, 524, Freud on male hysteria, 522 Freud's seduction theory, 525, 540 Janet's explanation of, 510 Id, 531, 551 Idealists, 18, 26 Ideas, 177. See also associationism; complex ideas; simple ideas association of, 146 Berkeley on, 140 Condillac on, 166 Herbart on, 197 Hume on, 145 Locke on, 137 Spinoza on, 183, 186 identical elements theory of transfer, 375, 382 identification, 534, 535 identification with the aggressor, 554, 568 Ideo-motor theory of behavior, 345, 382 Idols of the cave, 116, 127 Idols of the marketplace, 116, 128 Idols of the theater, 116, 128 Idols of the tribe, 116, 128 Imageless thoughts, 283, 291 Imagination

Aristotle on, 55, 63 Interpretation of Dreams, The (Freud), 526 Journal of Transpersonal Psychology, 590 intervening variables, 430, 433, 455 Condillac on, 166 **Judaism** intrinsic reinforcement, 475, 484 Galton on mental imagery, 305 Maimonides, 84, 97, 666 Hobbes on, 133 Introduction to Social Psychology, An. Neoplatonism and, 72 Hume on, 145, 177 (McDougall), 413, 417 Jung, C. G., 18, 531, 555-559, 568, 579, 670 Immediate experience, 266, 291 Introductory Lectures of Psychoanalysis (Freud), attitudes, 557 Impressions, 145, 150, 177 530 break with Freud, 556 General impression (Wundt), 271 introspection, 48, 63. 97, 120, 291 causality, teleology, and synchronicity, 557 Inauthentic life, 574, 604 Bretano's use of, 279 collective unconscious and archetypes, 556 Inclusive fitness, 302, 332 in functionalism and structuralism, 384 dream analysis, 558 Incongruent person, 594, 604 Külpe's use of, 283 ego, 556 Mach on, 423 Goethe's influence on, 213 Indeterminism, 16, 26 Individual differences and applied Pavlov on, 393 libido, 556 questioning of validity as research tool, 285 middle age, importance of, 558 psychology, 647 Individuation, Jung on, 558 Thorndike on, 376 Nietzsche's influence on, 227 Induction, 115, 128, 132, 180 Titchener's use of, 275, 278 personal unconscious, 556 truth and differing viewpoints, 661 Inductive definition, 44, 63 Watson on, 403 Industrial psychology, 349, 382 Wundt's use of, 267, 268 visit to the U.S., 362, 555 Infantile sexuality, 528, 540 Introversion, 557, 559, 568 Just noticeable difference (ind), 252, 255, 261 Inferiority complex, 560, 568 intuition, 120, 128 Kagan, Jerome, 627 Information processing psychology, 625, 628, irrationalism, 26 Kallikak Family: A Study of the Heredity of 631-633, 642 rationalism versus, 19 Feeble-Mindedness (Goddard), 315 human mind and computer programs, 632 James-Lange theory of emotions, 345, 382 Kamin, Leon, 314 James, William, 337-347, 382, 597, 624, 647. Kant, Immanuel, 192-196, 205, 236, 485, 667 influence of Kant, 633 limitations of, 634 668 Gestalt psychology and, 457 return of faculty psychology, 633 on Calkins at her PhD exam, 352 information-processing psychology and, return of mind-body problem, 633 contributions to psychology, 347 Information processing systems, 625 definition of psychology, 626 mechanistic view of human nature, 631 Information theory, 625, 627 description of psychology, 653 Kelly, George, 580-584, 604, 671 Inheritance. See also evolution; measurement free will, 345 constructive alternativism, 581 of intelligence; nativism on Freud and psychoanalysis, 530 construct systems, 582 of acquired characteristics, 294, 332 habits and instincts, 342 fixed-role therapy, 583 experience versus, Watson's view, 406 health crisis, 338 self-characterization, 583 genetic influences on intelligence and Hebb's rule and, 635 Vaihinger and, 582 personality, 617 influence on McDougall, 412 Kendler, Tracy and Howard, 626 nativism, 18, 27 influence on Tolman, 427 Kepler, Johannes, 108, 128 inhibition, 421 Maslow on, 588 Kierkegaard, Soren, 217-220, 227, 230, 668 Pavlov on, 391 opposition to Wundt's approach, 340 exercise of free will, 578 Sechenov on, 386 philosophy's two cultures, 652 meaning in human life, 576 innate ideas, 119, 128, 180 pragmatism, 345 shut-upness, 578 Kimble, Gregory, 652, 654 Hobbes's opposition to, 133 precursor to Gestalt psychology, 458 Locke's opposition to, 136 rejection of universals or absolutism, 656 Kinesthesis, 251, 261 Insightful learning, 471, 484 the self, 343 Klein, Melanie, 553, 568 stream of consciousness, 341 Instincts Knowledge Freud on, 531, 551 Janet, Pierre, 509, 513, 527, 540 origin of human knowledge, 20 James on, 342 Jesus, 75, 97 reminiscence theory of knowledge, 48 McDougall on, 413-415 Jesus, the Christ, in the Light of Psychology Koch, age of theory, 424, 654 Watson on, 405, 415 (Hall), 355 Koffka, Kurt, 427, 460, 485 Instinctual drift, 616, 622 Jews, treatment by Nazis, 462 geographical and behavioral environments, Instrumental conditioning, 445, 454 Jokes, Freud on, 529 470 Intellectual philosophy (U. S.), 335 Jonah complex, 588, 604 on memory, 476 Intelligence, 295. See also measurement of Jones, Mary Cross, 408 Köhler, Wolfgang, 461, 485 intelligence Journal of Abnormal and Social Psychology, 437 criticism of the Nazis, 462 controversy over definition of, 326 Journal of Applied Behavior Analysis, 450 disagreement with nativism, 466 genetic influences on, 617 Journal of Applied Psychology, 355, 648 honors, 463 Piaget on developmental intelligence, 624 Journal of Comparative and Physiological immigration to the U.S., 463 Intelligence quotient (IQ), 312, 332, 462 Psychology, 437 learning research, 471-473 Intentionality, 279, 291, 573, 604, 630 Journal of Consulting Psychology, 648 perceptual constancies, 467 Intentions, Guthrie on, 441 Journal for Experimental Analysis of Behavior, principles of perceptual organization, 469 interactionism, 18, 26, 122, 128 psychophysical isomorphism, 464 Journal of Experimental Psychology, 437 Koller, Carl, 519 defined, 411 James on, 345 Journal of Genetic Psychology, 355 Kramer, Heinrich, 493, 666 Journal of Humanistic Psychology, 586, 590, 597 mind-body problem in cognitive Kraepelin, Emil, 499, 513, 669 Journal of Psychology and Physiology of the Sense psychology, 633 Krafft-Ebing, Richard von, 525, 527 Sperry on, 612 Organs, 287 Kuhn, Thomas, 10-12, 22, 26, 93, 106, 109, internal sense, 79, 97 Journal of Religious Psychology, 355 117, 263, 652, 660

Wittgenstein and, 657 Leviathan (Hobbes), 133 being motivation and perception, 589 Külpe, Oswald, 283, 292 Leibniz, Gottfried Wilhelm von, 185-189, Ladd-Franklin, Christine, 243, 261, 274, 669 206, 516, 667 588 Lamarck, Jean, 294, 332, 667 Levy, Jerre, 612 La Mettrie, Julien de, 163-166, 177, 353, 667 Lewin, Kurt, 477-481, 485, 670 Aristotelian versus Galilean science, 477 Land, Edwin, 213 Lange, Carl George, 345, 382 conflict research, 479 Language group dynamics, 480 Chomsky on, 616, 622, 625 life space, 478 motivation, 478 Condillac on, 167 NETtalk speech synthesizer, 638 principle of contemporaneity, 478 Pavlov on, 393 libido, 531, 551, 569 Watson on language and thinking, 404 Jung on, 556 Language games, 656-658, 664 LiÉbeault, Auguste Ambroise, 507, 514, 523, Language, Truth and Logic (Ayer), 424 Lashley, Karl, 400, 481, 606-608, 622, 625, Life instincts, 532, 551 Life space, 478, 485 mass action and equipotentiality, 607, 637 Lifestyles, 561, 569 psychologists' teperaments, 652 Limen (threshold), 189, 198, 206 search for the engram, 607 Limits of Science, The (Medawar), 660 Lincoln, Abraham, 558, 588 Latency stage, 536 Latent content, 526, 551 Lippman, Walter, 319 Latent extinction, 432, 455 Little Book of Life After Death, The (Fechner), Latent learning, 431, 455 253, 340 Law of cause and effect, 146, 177 Loeb, Jacques, 398 Law of compound association, 160, 177 Locke, John, 134-140, 177, 185, 666 Loftus, Elizabeth, 542-544 Law of constructive association, 160, 177 Law of contiguity, 54, 63, 142, 146, 177 Logical positivism, 424, 455. See also Guthrie on, 439, 455 neobehaviorism Law of continuity, 188, 206, 454 in current psychology, 450 Law of contrast, 54, 63 Hull and Tolman, 435, 438 Law of disuse, 374, 382 merged with behaviorism Law of effect, 374, 382 (neobehaviorism), 426 Law of exercise, 374, 382 Lombard, Peter, 85, 97, 666 Law of frequency, 54, 63, 439 Lorenz, Konrad, 613 Law of Prägnanz, 466, 476, 485 Lowenfield, Lcopold, 541 Law of recency, 411, 422, 439 Ludwig, Karl, 237, 388 Law of resemblance, 146, 177 Luther, Martin, 101-103, 108, 128, 666 Law of similarity, 54, 63 Mach, Ernst, 171, 423, 457, 485, 668 Law of use, 374, 382 Machines, humans as, 630 Laws of association, 54, 63, 146, 148 Hobbes on, 132 Hull on, 435 Bain's use of, 159 Berkeley's use of, 151 La Mettrie, Julien de, 163 Hume's use of, 146, 148 Mills, James, 154 thinking and machines, 629 learning theorists prior to Guthrie, 439 Magendie, François, 234, 261 Laws, scientific, 8 Learning. See also education; learning Magic, 30, 63, 93 theory treatment of mental illness, 490 "Magical Number Seven, Plus or Minus latent learning, 431 performance versus (Tolman), 431 Two" (Miller), 625 Learning theory magnetic resonance imaging (MRI), 659 Aristotle's laws of association, 55 magnetism Bechterev, 396 use as anesthetic, 507 Brelands on genetic determinants of, 617 use in treating mental illness, 504 Ebbinghaus, 287 Magnus. See Albertus Magnus, Saint Mean, 306 Gestalt psychology, 471-473 Maimonides, 84, 97, 666 Maintaining stimuli, Guthrie on, 441, 455 Guthrie and law of contiguity, 439 Hebb on, 610 Malebranche, Nocolas De, 18, 185, 206 McDougall versus Watson, 415 "On Male Hysteria" (Freud), 522 Pavlov, 391-393 Malleus Maleficarum (The Witches' Hammer), Skinner's questioning of, 448 493 May on, 578 Thorndike, 374-376, 428 Malthus, Thomas, 298, 332 Watson, John, 410, 428 Manifest content, 526, 551 Leash principle (Wilson), 614, 622 Man's Search for Meaning (Binswanger), 576 Maslow, Abraham, 571, 584-590, 604, 671 Lectures on Human and Animal Psychology (Wundt), 265 basic tenets of humanistic psychology, 586 Binet, Alfred, 309-313

characteristics of self-actualizing people, deficiency, 589 hierarchy of needs, 587, 624 Johan complex, 588 self-actualization, 587 transpersonal psychology, 589 mass action, 607, 622 Material cause, 52, 63 Materialism, 17, 27 Berkeley's opposition to, 140 brain activities and cognitive events, 634 Democritus, 37 denial of mental events, 623 Fechner on, 253-256 Gassendi, Pierre, 163 Hobbes, Thomas, 133 humans as machines, 631 Newton, Isaac, 111 Sechenov, Ivan M., 386 vitalism versus, 237 Wundt's opposition to, 264 Mathematico-Deductive Theory of Rote Learning (Hull et al.), 436 McDougall, William, 412-417, 422 debates with Watson on behaviorism, 415-417 definition of psychology, 413 his life as a "major tragedy", 412 influence of William James, 412 purposive behavior, 414 Mathematical Principles of Natural Philosophy, The (Newton), 112 Mathematics, 34 Bacon's views on, 115 Descartes's discoveries, 118 Herbart as a mathematical psychologist, Newton's use of mathematical deduction, Psychological phenomena and, 233 May, Rollo, 577-580, 604, 671 human dilemma, 478 human science, 579 importance of myth, 578 normal and neurotic anxiety, 578 McCulloch, Warren, 635 McDougall, William, 412-417, 669 definition of psychology, 413 his life as a "major tragedy", 412 influence of William James, 412 Köhler on, 461 purposive behavior, 414 Meaning of Anxiety, The (May), 577 Meaning in human existence Binswanger on, 576 Heidegger on, 574 Kierkegaard on, 577 Nietzsche on, 226, 571 Wittgenstein on language games, 656-658 MD (Doctor of Medicine) degree, 651 Measurement of intelligence, 648

Binet-Simon scale of intelligence, 311	defined, 486, 514	Descartes on, 121
Burt, Cyril, 314	Dix, Dorothea Lynde, 498	Gassendi, Pierre, 162
Cattell, James M., 307	early approaches to treatment, 489-495	Hobbes on, 133
deterioration of national intelligence (U.	early explanations of, 487	Liebniz on, 187
S.), 324–326	harmful behavior, 487	Malebranche on, 185
Galton, Francis, 303–305	hypnotism and magnetism as treatments,	Psychophysical methods of exploring, 256
general intelligence concept (Spearman),	504–508	
313	improvements in treatment, 495	Pythagoran view of, 35 Sperry on, 612
intelligence quotient (IQ), 312		
	inappropriate emotions, 487	Spinoza on, 182
Köhler's criticism of, 462	Janet on hypnosis and hysteria, 509	Summary of main views on, 411
Simon, Theodore, 310	Kraepelin, Emil, 499	Titchener on, 277
U. S. army intelligence testing, 323	Pinel, Philippe, 496–498	Watson, John, on, 411
use of Binet–Simon scale in the U. S.,	postmodernism and, 658	Mind-brain relationship, 634
315–323	psychological versus medical model, 502-	strong artificial intelligence, 629
Mechanism, 27, 237. See also machines,	504	Mistaken lifestyle, 561, 569
humans as; materialism	Rush, Benjamin, 498	Mitwelt, 576, 604
vitalism versus, 19	unconscious processes as cause, 515	Modernism, 656, 659, 664
nechanistic behaviorism, 436	unrealistic thoughts and perceptions, 487	Molar approach, 456, 485
Medawar, Peter, 660	unpredictable behavior, 487	Molar behavior. See purposive behavior
nedian, 306	Witmer, Lightner, 500-502	Molecular approach, 456, 485
nediate experience, 266, 292	Mental imagery, 305	Molecular behavior, 429, 455
Iedical Inquiries and Observations Upon the	Mental orthopedics, 313, 332	Monads, 186, 206
Diseases of the Mind (Rush), 498	Mental philosophy (U. S.), 335	Monists, 18, 27
nedical model of mental illness, 488, 491,	Mental physics, 154	Montaigne, Michel de, 103, 128, 666
514, 515	mental chemistry versus, 155	Moral philosophy, 144, 335
medication versus psychotherapy debate,	mental set, 284, 292	Morgan, Conwy L., 371, 382, 669
650	mental tests. See also measurement of	Morgan's canon, 371, 382
tensions with pschological model, 502-	intelligence	Motivation
504	Cattell, James M., 308	Aristotle on, 56
nedicine	immigration into the U. S. and, 316	computer metaphor for the brain and, 634
Alcmaeon on, 39	Mesmer, Franz Anton, 504–506, 514, 667	Hobbes on, 134
Descartes and, 121	Metaphysics (Aristotle), 50	Lewin on, 478
early Greek medicine, 38	Method of adjustment, 256, 261	Locke on, 137
early understanding of mental illness, 495	Method of constant stimuli, 256, 261	Maslow on, 587–590, 624
Empedocles on, 37	Method of limits, 256, 261	Spinoza on, 183
Galen, 41, 63, 665	Methodological behaviorism, 412, 414, 422	Tolman on, 431
Harvey, William, 121	Hull, 436	unconscious, 524
Hippocrates, 39–41, 63, 665	McDougall, William, 412–417, 430	moving against people, 563, 569
Maimonides, 84	Tolman, Edward C., 430	moving away from people, 563, 569
Paracelsus, Philippus, 495	View on consciousness, 515, 624	moving away from people, 563, 569
Pythogaras on, 34	Middle age, Jung on, 558	Müller, Johannes, 235, 235, 237, 261, 265,
nemory	Middle Ages, 78	644, 667
Alzheimer's disease, 499	Dark Ages, 81	Multidimensional Personality Questionnaire
Aristotle on, 54	Islamic and Jewish influences, 82–85	618
Bartlett's research on, 624		
Calkins's research on, 351	supernatural model of mental illness, 488 Mill, James, 152–154, 177, 667	Münsterberg, Hugo, 347–350, 382, 647, 669
Cicero on, 608		applied psychology, 349
	Mill, John Stuart, 5, 21, 154–158, 177, 458,	clinical psychology, 349
Condillac on, 166	624, 668	feeling of willful action, 348
Ebbinghaus's research on, 287	Miller, George A., 625–627, 628, 632, 642	forensic psychology, 349
Gestalt theories on, 476	Miller, Neal, 627	industrial psychology, 349
Guthrie on, 440	Milner, Peter, 610	rise to fame and decline into disfavor, 350
Hobbes on, 133	Mind	Murray, Charles, 325
Lashley on, 60/	Analysis of, 147	Mystery religions, 74, 97
repressed memories, 540-544	as a computer or computer program, 628,	Myth, importance of, 578
On Memory: An Investigation in Experimental	632	Myth of Mental Illness, The (Szasz), 503
Psychology (Ebbinghaus), 287	Empiricist and rationalist views on, 179	Naïve realism, 21, 27, 190
On Memory (Aristotle), 55	Helmholtz on, 241	Nancy school, 507, 514, 523
Memory processes, 476, 485	Hume on, 148	Narrative therapy, 578, 604
Memory traces, 476, 485	Mills' analysis of associationism, 153	Nativism, 21, 27. See also evolution
Mental age, 312, 332	Mind and Body (Bain), 159	Brelands on innate aspects of behavior, 616
Mental chemistry, 155, 177, 458	Mind-body relationships, 17	empiricism versus, 18
Mental chronometry, 268–270, 292	Angell on, 365	empiricist and rationalist views on, 180
Mental essences, 282, 292	British empiricists following Locke, 136	ethologists, 613
Mental illness, 486–514. See also	Chisholm's depictions of, 20	Galton on inherited intelligence, 303-305
psychoanalysis	in cognitive psychology, 633	genetic influences on intelligence and
Charcot on hypnosis and hysteria, 508	in cognitive science, 634	personality, 617-619

Gestalt psychology and, 466 information-processing theory, 632 Hering on, 242 Natural History of the Soul, The (La Mettrie), 163 Natural Inheritance (Galton), 306 Natural law, 490, 514 Natural selection, 300, 332 Nature-nurture controversy, 304, 326, 332 Adler on, 561 environmental influences on personality, 619 genetic influences on intelligence and personality, 617-619 naturalistic view of the universe, 38 natural philosophy, 144 need-directed perception, 589, 604 need for positive regard, 594, 604 needs, hierarchy of (Maslow), 587, 604 negative sensations, 255, 261 Neisser, Ulric, 627, 634 Neobehaviorism, 423-455 behaviorism today, 449 defined, 426, 455 Guthrie, Edwin R., 438-442 Hull, Clark L., 434-438 logical positivism, 424 physicalism, 425 positivism, 423 Tolman, Edward C., 426-433, 449 Spence on transposition, 473 Neoplatonism, 71-74, 97 Neurophysiology Charcot, Jean-Martin, 508, 522 Freud's interest in, 522 Nerve physiology, 234-236 Dell, Charles, 233 Helmholtz, Hermann von, 236-242 Müller, Johannes, 235 NETtalk, 638 Neural networks, 636, 642 Neurophysiology, 612 Neurotic anxiety, 578, 604 New connectionism, 635-639, 642 New Essays on the Understanding (Leibniz), 185 Newell, Allen, 625, 632 Newton, Isaac, 112-114, 128, 135, 233, 667 Nietzsche, Friedrich Wilhelm, 220-227, 230, 516, 576, 596, 669 nihilism, 42, 63 noble savage, 210, 230 nomanilism, 87, 91, 97 Nondeterminism, 16, 27 Normal anxiety, 578, 605 Normal science, 11, 27 Novum Organum, 114 Objective psychology, 384. See also behaviorism Bechterev, Vladimir M., 394-397 Sechenov, Ivan M., 385-388 Pavlov, Ivan P., 388-394 Objective reality, 21 Difference from subjective reality, 233 Galileo on, 110 Gestalt psychology, 470 Locke on, 138

Observational terms, 424, 455 Observations on Man, His Frame, His Duty, and His Expectations (Hartley), 150 Occam's razor, 91, 97, 113 Occasionalism, 18, 27, 185, 206 Oedipus complex, 527, 535, 540, 551 Olds, James, 610 Olympian religion, 30, 63 one-trial learning, 439, 455 On the Origin of Species by Means of Natural Selection (Darwin), 299 On the Trinity (Augustine), 80 Ontological argument for the existence of God, 85, 97 Ontology, 573, 605 Operant behavior, 445, 455 Operant conditioning, 617 Operational definition, 425, 455 Operationism, 425, 450, 455, 462 Opinions, Nietzsche on 224, 231 Opposites polar opposites, 33 principle toward the development of (Wundt), 270 oral stage, 534 organ inferiority, 560 organismic valuing process, 593, 605 Organization of Behavior, The (Hebb), 625, Outline of Psychology (Ebbinghaus), 286 Outlines of Psychology (Külpe), 283 Overcompensation, 560, 569 Overdetermination, 529, 551 Overt behavior as subject of psychology, 451 Paired-associate technique, 351, 382 Panpsychism, 253, 261 Pantheism, 181, 206 Paracelsus, Philippus, 495, 666 Paradigmatic stage, 12, 27 Paradigms, 10, 27 language games and, 657 Psychology and, 12 Paradox of the basins, 138, 177 Parallel distributed processing (PDP) research group, 63/ Parapraxes, 528, 551 Parapsychology humanistic psychology and, 590 James's interest in, 347 McDougall's interest in, 413 Parmenides, 33, 63 Parrish, Celestia Susannah, 274 Passions, Spinoza on, 183 Passive mind, 21, 27, 179, 206 Passive reason, 53, 63 Pathogenic ideas, 521, 551 Paul, Saint, 75-77, 97 Paulus: Reminiscences of a Friendship (May), 577 Pavlov, Ivan P., 388-394, 422, 669 attitude toward psychology, 393 Bechterev versus, 396 discovery of conditioned reflex, 389 excitation and inhibition, 391 experimental neurosis, 392 extinction, spontaneous recovery, and disinhibition, 392

first- and second-signal systems, 392 Hebb's rule and, 635 personality of, 390 physiological basis of associationism, 394 research on digestion, 389 unconditioned and conditioned reflexes, Watson's view of, 403 Pearson, Karl, 306, 332 Pedagogical Seminary (Hall), 355 Penfield, Wilder, 609 Penis envy, 535 Perception, 292 Aristotle, emotions and selective perception, 56 Berkeley's theories, 140-143 Democritus' theory, 38 Empedocles' theory, 36 Gestaltists' interest in, 460 Gestalt theories of, 465, 468-470 Helmholtz's theory, 239, 261 Hume's theory, 145 Leibniz on, 188 Maslow on, 589 McDougall on instincts and, 414 unrealistic perceptions in mental illness, Wundt on, 268 "Perception: An Introduction to Gestalt-Theorie" (Koffka), 460 perceptual constancy, 467, 485 Performance, 455 improvement from practice (Guthrie), 439 learning versus (Tolman), 431 persona, 557 Personal equations, 233, 261 Personality tests, Jung's legacy to, 559 Personality theory Bouchard on nature versus nurture, 618 Calkins, Mary W., 353 Freud, Sigmund, 531-534 genetic influences on personality, 617 James, William, 346 Watson, John B., 406 Personal unconsciouness, 556, 569 Perspectivism, 223, 231 Petites perceptions, 188, 206 Petrarch, Francesco, 99, 128, 666 Phallic stage, 534 phase sequences, 609, 622 PhD (Doctor of Philosophy) degree, 502, Phenomena, 280 Phenomenological introspection, 279, 292 Phenomenologists, 120, 128 Bretano, Franz Clemens, 278-280 Hering, Ewald, 242 Husserl, Edmund, 281-283 Stumpf, Carl, 280 Phenomenology, 485, 572, 605 Pure phenomenology (Husserl), 281, 605 use by Gestaltists, 457 phi phenomenon, 459, 463, 485 Phrenology, 171, 261 Philo, 72, 97, 665 Philosophical Essays (Hume), 143

Philosophical Fragments (Kierkegaard), 227 Renaissance humanists' interest in, 99 Philosophical Investigations (Wittgenstein), 656 Plotinus, 73, 97 Philosophical Studies, 265 Political philosophy Philosophy. See also Greek philosophers Bentham, Jeremy, 153 of Augustine, Saint, 78-81 Comte, Auguste, 168 of Constantine, Empeoro, 77 Hobbes, Thomas, 132 Descartes, RenÉ, 18, 21, 117-124 Locke, John, 140 emphasis on spirit, 74 Mill, J. S., 158 Epicureanism, 69 Rousseau, 211 Islamic and Jewish influenes, 82-85 social Darwinism, 296 neoplatonism, 71-74 Popper, Karl, 9, 22, 27, 32, 57, 117, 660, 671 Paul, Saint, 75-77 Porter, Noah, 335 pre-Renaissance times, spirit of, 92 Posthypnotic suggestion, 507, 514, 523 psychology's persistent questions, 660 Positive psychology, 598, 605 reconciliation of Christian faith and Positive regard, need for, 594 reason, 85 Positivism, 115, 128, 168-172, 177, 423 Renaissance humanism, 98-Bacon, 114-117, 444 Russell on science and philosophy, 660 Comte, 168-171, 423, 444 scholasticism, 86-91 defined, 455 stoicism. 70 logical positivism, 424 William of Occam, 91 Mach, 171, 423, 444 Wittgenstein on, 657 Pavlov, 388 Philosophy of "As If" (Vaihinger), 285, 582 Skinner, 444 Philosophy of Madness (Daquin), 496 Positron emission tomography (PET), 659 Philosophy of the Unconscious (Hartmann), 517 Postdiction, 10, 27, 128 Phrenology, 6, 261, 608 Posthypnotic amnesia, 507, 514, 523 Formal discipline, 247 postmodernism, 655-659, 664 Gall, Franz Joseph, 244 family resemblance, 658 modernism versus, 659 Popularity of, 245-247 Spurzheim, Johann Kaspar, 245 rejection of natural science model, 659 Physical determinism, 15, 27 truth, nature of, 658 Physicalism, 425, 455 Wittgenstein, Ludwig, 656-658 Physical monism, 411. See also materialism Power Skinner, B. F., 445 Adler on, 560 Physical reality Nietzsche on, 224, 231 Berkeley on, 141 Practice of Medicine, The (Plater), 495 Galileo on, 110 Practice, why it improves performance, 439 Hume on, 145 Pragmatism, 286, 339, 346, 382, 659 Kant on, 193 Pragmatism (James), 346 language and, Wittgenstein on, 657 Prägnanz, 466 Locke on, 138 Praise of Folly, The (Erasmus), 100 sensations versus, 236 Predestination, 79, 97 Physicists, 32, 64 Preestablished harmony, 18, 27, 187, 206 Physiognomy, 244, 261 Premodernism, 655, 664 Physiology, 233 Pre-paradigmatic stage, 12, 27 as basis of consciousness in objective Preparedness continuum, 617, 622 psychology, 387, 388 Prescription privileges for psychologists, 649 correlates of psychological processes, 159 Presentism, 2, 27 early developments in, 232-244 Primary laws, 156, 178 early research on brain functioning, 244-Primary qualities, 128 Berkeley and, 141 rise of experimental psychology, 250-258 Gallileo and, 110 Physis, 32, 64 Locke on, 137 field theory and Gestalt psychology, 458 Principle of closure, 470, 485 Piaget, Jean, 624, 626, 671 Principle of conservation of energy, 237, 261 influence on psychology, 627, 633 Principle of contemporaneity, 478, 485 prolific writings and standing in Principle of continuity, 468, 485 psychology, 624 Principle of contrasts, 270, 292 Pico, Giovanni, 100, 128 Principle toward the development of Pinel, Philippe, 496-498, 514, 667 opposites, 270, 292 Place of Value in a World of Facts, The (Köhler), Principle of falsifiability, 9, 27, 545 Principle of the heterogony of ends, 270, 292 Plans and the Structure of Behavior (Miller, Principle of inclusiveness, 468, 485 Galanter, and Pribram), 626 Principle of proximity, 468, 485

Principle of similarity, 469, 485

Principles of Behavior (Hull), 436, 437

Plato, 21, 35, 45-49, 64, 665

Neoplatonism, 71-74

Principles of Physiological Psychology (Wundt), 263, 268 Principles of Psychology (Ebbinghaus), 287 Principles of Psychology (James), 336, 339, 624 Problem solving, human minds and computer programs, 632 productive thinking, 474-476, 485 Productive Thinking (Wertheimer), 474, 475 Project for a Scientific Psychology (Freud), 524 Prepositional thinking, 582, 605 Protagoras, 41, 64, 656, 665 Protestantism, 103 Psychiatry, 649 Psychical determinism, 15 Psychic mechanics, 197, 206 Psychoanalysis, 515-551. See also Freud, Sigmund antecedents of, 516 Breuer, Josef, and the case of Anna O., 520-522 clinical psychology after World War II, contributions of Freud's theories to psychology, 545 criticisms of Freud's theories, 544 Dream analysis, 526 Free association, 523 Freud and Janet's claims to priority, 510 Freud, Sigmund, 518-520 Freud's self-analysis, 525 Freud's studies with Charcot, 522 Freud's view of human nature, 536 humor, 529 hypnosis, 523 hysteria, studies on, 524 Oedipus complex, 527 Rogers's challenge to, 592, 624 Project for a Scientific Psychology, 524 Psychopathology of Everyday Life, 528 seduction theory, 525 repressed memories, 540-544 revisions of the Freudian legend, 538 theory of personality, 531-534 Watson on, 408 Psychoanalysis of Children, The (Klein), 553 Psychobiology, 606-612, 622 behavioral genetics, 612 Chomsky's influence, 616 genetic influences on intelligence and personality, 617-619 Lashley, Karl, 606-608 misbehavior of organisms, 616 new research tools, 659 sociobiology, 613 sociobiology versus evolutionary psychology, 614-616 Sperry, Roger W., 610-612 Psychological Care of the Infant and Child (Watson), 409 Psychological Clinic, 501 Psychological Corporation, 368 Psychological facts, 478, 485 Psychological model of mental illness, 488, 490, 514, 515 medication versus psychotherapy debate,

philosophy of science, Karl Popper, 9 philosophy of science, Thomas Kuhn, 10sensory acuity in intelligence measurement, 305, 307 Popper versus Kuhn on, 13 sensory experience. See also sensation Psychology as, 14-17, 196, 653-655 Aristotle on, 51 as religion, 114 as basis of knowledge, 33 search for laws, 8 Democritus on, 38 third-force psychology and, 571 in empiricism and rationalism, 51 Science, 367 empiricist view of, 18, 131 zv. 595 Science of Colors (Goethe), 212 French sensationalists' view of, 169 fter World War Science Wars (Goldman), 14 Parmenides on, 33 Scientific laws, 8, 28 Philo on, 72 scientific theory, 7, 28 to psychotherapy, Plato on, 46, 47 scientism, 168, 178 Pythagoras on, 35 Scot, Reginald, 495 Sentiment, 415, 422 Searle, John B., 629, 638, 642 Servetus, Michael, 107 or. 77 Sears, Robert R., 320 Sex education, Watson on, 410 Sechenov, Ivan M., 385-388, 422, 668 culture, 74 secondary laws, 156, 178 criticism of Freud's theories, 544 59-74 secondary qualities, 129 Freud on cause of hysteria, 522 I., 370, 382, 669 Berkeley on, 141 Freud on seduction theory, 523 -217, 231, 571, 659 Gallileo and, 110 Freud on unconscious motivation, 524 gence and the mind, 631 Locke on, 137 Infantile sexuality, 528 nn Wolfgang von, 212 Second-signal system, 393, 422 libido, 531, 551 c psychology, 572 Seduction theory (Freud), 525, 541, 551 Maslow's research on, 585 ean-Jaques, 209-212 self, 22 Oedipus complex, 527 Adler on, 561 uer, Arthur, 213-216 psychosexual stages of development, 534elative to cultural group, 656 Calkins on, 352 536 Robert, 281 Condillac on, 167 shadow, Jung on, 557 ing, 436 Hume on, 147 shut-upness, Kierkegaard on, 578, 605 Jean-Jaques, 209-212, 231, 571, James on, 343 Signs, theory of (Helmholtz), 241 Jung on, 557 Simon, Herbert, 625, 632 Benjamin, 498, 514, 667 self-actualization, 605 Simon, Theodore, 310-312, 332 Aristotle on, 54, 588 , Bertrand, 410, 660 Simple ideas, 178 Jung on, 557, 558 sian objective psychology. See Hartley on, 151 Maslow on, 587-589, 590 objective psychology Hobbes on, 137 ngs, 288, 292 Rogers on, 593 Hume on, 145 a natura, 52, 64 Self-alienation, 578, 605 Locke on, 137 remata (Piaget), 624 Self-Analysis (Horney), 565 skepticism, 66-68, 97, 103, 208, 656 hizophrenia, 499, 650 Self as knower (James), 343, 382 Skinner, B. F., 117, 275, 442-449, 455, 671 Self-characterization, 583, 605 cholasticism, 86 91, 97, 100 application of his principles, 448 School, 263, 292 Self-esteem, 343, 382 attitude toward theory, 448 Self-preservation Schopenhauer, Arthur, 213-216, 516, 667 Chomsky's review of Verbal Behavior, 616 science, 7-14 Herbart on, 197 functional analysis of behavior, 444 Aristotelian versus Galilean, 477 Schopenhauer on, 214 importance of the environment, 446 assumption of determinism, 8 Spinoza on, 183 influence on psychology, 450 Bacon, Francis, 114-117 Seligman, M. E. P., 617 nature of reinforcement, 446 challenges to authority of Catholic church, Semantics, 630, 638 operant behavior, 445 105 Senescence: The Last Half of Life (Hall), 358 positive control of behavior, 447 cognitive science, 634 Sensation, 178, 261, 292 positivism, 444 combination of rationalism and Aristotle on, 53 sleep and dreams. See dreams empiricism, 7 Berkeley on, 142 Smith, L. D., 430, 433 Copernicus, Nicolaus, 106 Conversion to perception (Helmholtz), Snow, C. P., 652, 653 definition of, 7, 28 social cognitive theory, 628 Hartley on, 150 Comte's hierarchy of sciences, 171 Social Contract, The (Rousseau), 210 Descartes, RenÉ, 117-124 jnd as unit of, 255 Social Darwinism, 296, 332 empirical and theoretical, logical Locke on, 13 Darwin's attitude towards, 297, 304 Mach on, 171, 423 positivism, 424 Wallace's opposition to, 299 Physical reality versus, 236 Galileo, 108-112 Social interest, 561, 569 Wundt on, 267 humanistic psychology and, 586, 597 Sociobiological fallacy, 615 human science, May on, 579 Sensationalism, 162-168 Sociobiology, 301, 613 Condillac, Étienne Bonnot de, 166 Hume's science of man, 144 evolutionary psychology versus, 614-616 Limits of, psychology's persistent Gassendi, Pierre, 162 Sociobiology: The New Synthesis (Wilson), 301, questions, 660 La Mettrie, Julien de, 163-166 616 Mill, J. S., science of ethology, 157 mental events, 631 sociocultural determinism, 15, 28 Senses and the Intellect, The (Bain), 159 Newton, Isaac, 112-114 sociology, 170, 178

sensitive soul, 52, 64

SUBJECT INDE tensions with medical model, 502-504 pure, scientific psychology Psychological Review, 367 purposive behavior, 426 Psychological Science, 652 Purposive Behavior in ombras, 024 of 404 Wasson suse or son Spring Psychological Studies, 265 (Tolmar Output as, 632 purposive b Psychology. See also contemporary psychology PuysÉgr Tisky Predictions 1.7. definition of, 1 puzzle be Rogert Carl Descartes's contributions to, 123 puzzle solv nexy Realitrons, 7, 20 Rees, Art. 321 370, and Pyrro of Elis, Galileo and, 111 dientracentered thereby do a Hume's influence, 149 Pythagoras, 34, countributions to be the true paradigms and, 12 Q-sort technique persistent questions, 17-23, 631, 660 Q-technique (Rog problems in writing history of, 2-4 Qualities, 137, 178 revolutionary appl reasons to study history, 4-6 Quasi needs, 479, 485 Roman Empire, Empi as a science, 14-17, 196, 653-655 Radical behaviorism, 412 Psychology, 336 artificial intelligence and, Psychology of the Adolescent (Hollingworth), denial of cognitive events, Hebb's criticism of, 625 322 end of 74, influence of Gre Psychology: The Briefer Course (James), 339 refusal to admit consciousness. philosophess of Psychology from an Empirical Standpoint Chomsky's attack on, 616 (Bretano), 279 Rogers's challenge to, 592, 624 George Tomanticism, 204 Psychology: An Introductory Study of the Skinner, B. F., 445 Romanes, reaction intel Structure and Functions of Human Watson and Skinner, 446 Goethe, Joh Consciousness (Angell), 365 Radical empiricism in humanis Psychology of Learning, The (Guthrie), 438 Comte and Mach, 424 James, William, 339, 382 Psychology of Personal Constructs (Kelly), 581 Psychology: The Science of Mental Life (Miller), Radical environmentalism, 406, 422 Rationale of Nervous Sleep, The (Braid), 507 626 Psychology of Subnormal Children rationalism, 7, 21, 27, 179-296 (Hollingworth), 322 artificial intelligence and the mind, 631 La Psychology from the Standpoint of a Behaviorist Aristotle, 51 myste (Watson), 403 Bacon's view of, 115 Nietzso Psychology of Tone (Stumpf), 280 Bretano, Franz Clemens, 279 personal. Psychonomic Science, 651 defined, 206 huma Psychonomic Society, 651 Descartes, 117-124, 127, 130, 180, 185 Plato's legacy Hegel, Georg Wilhelm Friedrich, 199-201 Psychopathology of Everyday Life (Freud), 528 premodernism, Herbart, Johann Friedrich, 196-199 reason freed fron. Psychopharmacology Kraepelin as pioneer, 500 Information-processing theory, 632 replacement by soc pharmaceutical companies' influence, 650 irrationalism versus, 19 science as, 114 James on, 346 religious stage, 220, 231 prescription privileges for psychologists, Kant, Immanuel, 192-196 remembering, 54 649 medication versus psychotherapy, 649 Leibniz, Gottfried Wilhelm von, 185-189 Remembering: A Study in Expe. Malebranche, Nocolas De, 185 Social Psychology (Bartlet. Psychophysical isomorphism, 464 reminiscence theory of knowledge psychophysical parallelism, 18, 27, 187, 206 Plato, 46 Reid, Thomas, 189-192 defined, 411 Renaissance. See also humanism defined, 98, 129 Socrates, 44 Titchener, 277 Spinoza, Baruch, 181-185 spirit of the time, 104 psychophysics, 254, 261 Wundt, Wilhelm, 264, 272 United States, 335 constancy hypothesis, 465 rational soul, 53, 64 witch hunts, 493-495 ind as unit of sensation, 255 repressed memories, 540-544 methods, 256 rationalization, 534 Weber's law, 254 reaction potential (SER), 437, 455 Adler on, 561 Psychosexual stages of development, 534reaction time, 233, 261 current concerns with, 542-544 Cattell's testing of, 308 Freud on, 540-542 Psychosocial stages of development, 555 Donders's experiements with, 269 Repression, 551 Psychotherapy, 489, 514, 647 Wundt's use of Donders's methods, 269 Freud on, 524, 533, 535 Herbart on, 198, 516 need for, after World War II, 648 Reader, W., 615 realism, 86, 91, 97 Rogers on, 592, 649 Schopenhauer on, 217, 516 PsyD (Doctor of Psychology degree), 502, recall, 54, 64 Republic (Plato), 48, 49 650, 664 recapitulation theory, 355, 382 Resistance, 516, 523, 551 Ptolemaic system, 105, 128 reciprocal antagonism, 349, 382 Responsibility, 605. See also free will Ptolemy, 105, 128 reductionism, 37, 64 determinism and, 16 public observation, 8, 27 reflection, 136, 178 existentialist view of, 596 punishment Reflex Arc Concept in Psychology, The (Dewey), resonance place theory of auditory Guthrie on, 441 perception, 241, 261 Skinner on, 447 Reflexes of the Brain (Sechenov), 386 respondent behavior, 445, 455 reflexology, 394-396, 422

pure phenomenology, 281, 292, 573, 605

Rousseau

response, 391

Schopeni

truth as

Rosenthal

Socrates, 44, 64 Searle's argument against, 629 revisions in his learning theory, 374 soft determinism, 16 structuralism, 6, 275, 292, 623. See also strain between animal research and solipsism, 42, 64 Titchener, Edward B. "Some Psychological Studies of Grammar" constancy hypothesis, 465 (Miller), 626 decline of, 277 puzzle box, 373 somnambulism, artificial, 506, 513 functionalism versus, 365 Sophists, 41-44, 64, 208, 656 summary of, 384 Sorrows of Young Werther, The (Goethe), 212 Structure of Scientific Revolutions, The (Kuhn), 657 140 Aristotle's hierarchy of souls, 52 struggle for survival, 300, 333 Democritus on, 37 Studies on Hysteria (Freud force psychology, Philo on, 72 Plato on, 48 Subjection of Women, The (Mill), 158 Tillich, Paul, 577 Plotinus on, 73 Subjectivity as truth, Kierkegaard, 219, 571 Time Pythagorean view of, 35 Sublimation Space perception Freud on, 533 Hering on, 242 Gestalt psychology, 470 Kant on, 194 Hall on, 356 Spearman, Charles, 313, 332, 669 Schopenhauer on, 215, 516 Special Talents and Defects: Their Significance for Suffering, Schopenhauer on, 215 Education (Hollingworth), 322 Suicide, Schopenhauer on, 216 Species-specific behavior, 613, 622 Summers, Montague, 493 Speech. See also language Sumner, Francis C., 358-360, 383 Broca's area, 249 Superego, 531, 532, 535, 551 NETtalk speech synthesizer, 638 Supermen, 224-227, 231 Speech comprehension (Wernicke's area), Supernatural model of mental illness, 488, 490, 493, 514 Spence, Kenneth W., 437, 473 Survival of the fittest, 296, 333 Spencer-Bain principle, 295, 332 Sympathetic magic, 490, 514 Spencer, Herbert, 294-297, 668 Synchronicity, 557, 569 social Darwinism, 296 Syntax, 630, 638 view of evolution, 295 System of Logic (Mill), 155 Sperry, Roger W., 16, 18, 610-612, 622, 671 Système de Politique Positive (Comte), 168 624, 670 honors, 612 Task of Gestalt Psychology, The (Köhler), 463 split-brain preparation, 611 teleology, 52, 64 Spinoza, Baruch, 181-185, 206, 631, 667 Jung on, 557, 569 temple medicine, 38, 64 Terman, Lewis M., 312, 317-321, 333, 670 emphasis on human spirituality, 74-81 humanistic psychology, 571 position on inheritance of intelligence, 318 Plotinus on, 73 Stanford-Binet tests, 318 split-brain preparation, 611, 622 study of genius, 319-321 Spontaneous activity, 160, 178 testing, psychological, 648. See also Spontaneous recovery, 392, 422 measurement of intelligence pacifism, 427 Spurzheim, Johann Kaspar, 245-247, 261 Thagard, Paul, 634 S-R psychology, 445, 455, 456 Thales, 31, 64, 665 Kelly on, 580 Theoretical terms, 424, 455 Maslow on, 586 Theory Sprenger, James, 493, 666 Hull's attitude toward, 435 Staats, A. W., 654 Skinner's attitude toward, 448 Stanford-Binet tests, 318 Tolman's use of, 430 Sternberg, 655, 655 Theory of Cognitive Dissonance, A. (Festinger), Stephenson, Wiliam, 392 Stein, William, 312, 332, 670 Theory of forms, 46, 64 Stevens, S. S., 425 Third-force psychology. See also Stewart, Dugald, 335 humanistic psychology Stimulus, 391 antecedents of, 571-584 Guthrie on maintaining stimuli, 441, 455 Thomas Aquinas, Saint, 89-91, 96, 103, 666 input as, 632 Thomas, Martha C., 357 stimulus sampling theory (SST), 441 Thorndike, Edward L., 369-376, 383, 440, Watson's use of, 404 585, 670 Tropism, 399, 422 Stimulus error, 276, 292 animal research before, 370-373 truth Stimulus-response (S-R) psychology, 445, connectionism, 374 455, 456 Gestaltists' criticism of, 4/2 Stoicism, 70, 97 identical elements theory of transfer, 375 Stream of consciousness, 341, 383, 458 laws of exercise and effect, 374 relativity of, 41 Strong artificial intelligence, 629, 642 Pavlov's opinion of, 393

introspective data, 385 transfer of training, 375 Skinner's approach compared to, 445 thought as subvocal speech (Watson), 405 Three Dialogues Between Hylas and Philonous, thrownness, 575, 605 Thus Spake Zarathustra (Nietzsche), 221, 224-Augustine's analysis of, 81 Kant on perception of time, 194 Tinbergen, Niko, 613 Titchener, Edward B., 272-278, 292, 293, Context theory of meaning, 277 decline of structuralism, 277 goals of psychology, 275 law of combination, 276 mental elements, 276 neurological correlates of mental events, pure, scientific psychology, 647 relationship with female psychologists, 274 use of introspection, 275 view on imageless thoughts, 284 token economies, 449, 455 Tolman, Edward C., 426-433, 436, 455, animal research with rats, 429 Bandura's theory as descendent of, 628 contributions to psychology, 428 hypotheses, expectancies, beliefs and cognitive maps, 431 influence on psychology, 433, 449 intervening variables, 430 latent extinction, 432 learning versus performance, 431 position on reinforcement, 431 purposive behaviorism, 428 resistance to McCarthyism, 428 trace system, 476, 485 transference, 521, 551 transmigration of the soul, 31, 35, 65 transpersonal psychology, 589, 605 transposition, 473, 485 Treatise Concerning the Principles of Human Knowledge, A (Berkeley), 140 Treatise of Human Nature (Hume), 143 Treatise on Insanity (Pinel), 496 Treatise on Man: His Intellectual Faculties and His Education (HelvÉtius), 167 Trepanation, 491, 514 Tridimensional theory of feeling, 267, 292 correspondence theory of, 10 postmodern view of, 658 psychology and, 661 subjectivity as (Kierkegaard), 219, 571

Tuke, William, 497 Wallace, Alfred Russell, 299, 333 Woodworth, Robert S., 368, 375, 383, 669 Turing, Alan M., 629 Warfare, human motives for (Tolman), 427 Hull's reinforcement theory, 437 Turing test, 629, 630, 642 Washburn, Margaret Floy, 274, 373, 383, perception without influence of learning, twin studies on Watson's view of thinking and Bouchard, Thomas, 617-619 Watson, John B., 273, 397-412, 422, 436, 670 Burt, Cyril, 314 language, 405 Galton, Francis, 304, 307, 617 advertising work, 402 Women. See also gender heritability of intelligence, 315 behaviorism applied to everyday life, 410 Calkins on professional women, 351 two-point threshold, 251, 261 behavior therapy, 408 Darwin on, 301 "Uber Gestaltqualitäten" (Ehrenfels), 457 Chicago years, 398 Freud on, 535, 564 child psychology, 408 Umwelt, 575, 605 Horney on, 564 debates with McDougall on behaviorism, Münsterberg on, 350, 351 uncertainty principle, 16. See also indeterminism Titchener and female psychologists, unconditional positive regard, 594, 605 dismissal from Johns Hopkins, 401 unconditioned reflex, 391, 422 on emotions, 497 Hollingworth (L. S.), studies on experiment with Albert, 407 unconditioned response (UR), 391, 422 intelligence, 321 unconditioned stimulus (US), 390, 422 goal of psychology, 403 Word-association test, 305 Work of the Principal Digestive Glands (Pavlov), unconscious inference, 239, 261 influence on psychology, 411 influence on Tolman, 427 unconscious mind, Schopenhauer on, 216 World as Will and Representation, The language and thinking, 404 unconscious motivation, 3, 524, 551 Adler's rejection of, 561 learning theory, 410 (Schopenhauer), 214 Maslow on, 585 World-design, 576, 605. See also Jung on, 556, 569 mind-body problem, 411 Weltanschauung unconscious processes causing behavior, 16 United States. See also functionalism move to Johns Hopkins, 400 World, The, 123 (Descartes), 123 Worldview, 560. See also Weltanschauung army intelligence testing, 323 objective psychology, 403 World War I, 647 intelligence testing with Binet-Simon radical environmentalism, 406 role of instincts in behavior, 405 World War II, 648 scale, 315-323 sex education, 410 Wundt, Wilhelm M., 262-272, 292, 668 concerns over deterioration of intelligence, Cattell's studies under, 307 324-326 Skinner on, 450 early psychology, 334-336 undergraduate years, 398 Goals of psychology, 266 Freud's trip to, 362, 530 Watson, Rosalie, 409 elements of thought, 267 functionalism, 336 Weak artificial intelligence, 629, 642 first psychology laboratory, 339 universalism, 22, 28 Weaver, Warren, 625 Gestalt attack on elementism, 456 University of Chicago historical misunderstanding of, 271 Weber, Eduard, 386 functionalism at, 362-366 Weber, Ernst Heinrich, 251, 261, 667 James's opposition to Wundt's approach, Köhler at, 461 Weber's law, 252, 254, 261 Watson at, 398-400 Weltanschauung, 576, 586, 605, 652, 664 mediate and immediate experience, 266 unmoved mover, 52, 65 Wernicke, Carl, 249, 261 mental chronometry, 268-270 utilitarianism, 153, 158, 178 Wernicke's area, 249, 261 Münsterberg's studies under, 347 Vaihinger, Hans, 285, 292, 582, 669 Wertheimer, Max, 459, 485, 670 perception, apperception, and creative explanation of phi phenomenon, 463 Varieties of Religious Experience, The (James), synthesis, 265 field theory in analysis of brain function, prolific writings of, 624 339 Vaughan, Margaret, 449 465 pure, scientific psychology, 644 psychological versus physical causation, Vedantism, 74, 97 Maslow and, 585 vegetative soul, 52, 65 productive thinking, 474 ranking of his importance to psychology, Verbal Behavior (Skinner), 616 top-down analysis, 466 vibrantiuncules, 150, 178 Weyer, Johann, 495 use of introspection, 267 vicarious trial and error, 431, 455 Whisperings Within, The (Barash), 614 Wiener, Norbert, 625, 670 volitional acts, 271 Vienna Circle, 424 Will, Wundt on, 264, 292 V⊠lkerspsychologie, 271 vision Würzburg school, 284, 292 William of Occam, 91, 97, 666 Hering's theory of color vision, 242 Ladd-Franklin theory of color vision, 243 Will to power, 224, 231 Xenophanes, 43, 65 Young-Helmholtz theory of color vision, Will to survive, 214, 231 Yerkes Laboratories, 606, 239 Wilson, Edward. O., 301, 613 609, 610 Yerkes, Robert M., 323-325, 333, 427, 670 vitalism, 28 on evolutionary psychology, 614, 654 Young-Helmholtz theory of color vision, Helmholtz's opposition to, 237 leash principle, 614 239, 261 Wish fulfillment, 526, 551 McDugall's beliefs, 413 Witch hunts, 493-496 Zaidel, Dahlia, 612 mechanism versus, 19 Witmer, Lightner, 500-502, 514, 644, 669 Zeigarnik, Bluma, 479 volition, James on, 345 clinical psychology, 647 Zeigarnik effect, 479, 485 V\(\text{\text{Mundt}}\), 265, 271, 292, Wittgenstein, Ludwig, 664 Zeitgeist, 4, 28 Zend-Avesta (Fechner), 253 voluntarism, 264, 292, 623. See also family resemblance, 658 Zeno of Elea, 34 Wundt, Wilhelm M. language games, 656-658 on Freud, 541 Zeno of Citium, 70, 97, 665 Voluntary Action (Münsterberg), 348 voluntary behavior, 160, 178 on truth, 658 Zeno's paradox, 34, 65 Walden Two (Skinner), 448 Wolff, Christian von, 189 Zoroastrianism, 74, 97

Name Index

Aarsleff, H., 167 Abelard, Peter, 86-89, 96 Adams-Weber, J. R., 583, 584 Addams, Jane, 588 Adler, A., 531, 559-561, 568, 669 Agassiz, L., 338 Agnew, J., 584 Agrippa, C., 495, 666 Ahern, F. M., 306 Alazraki, A., 650 Albertus Magnus, Saint, 89, 97 Albino, J. E. N., 651 Albrecht, F. M., 191 Alcmaeon, 38, 62, 488 Alexander the Great, 50, 68 Alexander, F. G., 83, 84, 181, 184, 491, 493, 495, 499 Alland, A., Jr., 301 Allderidge, P., 493 Allen, R. E., 44 Allport, G. W., 5 Alzheimer, A., 499 Amsel, A., 450 Anaxagoras, 37, 62, 665 Anaximander, 32, 62 Andreas-Salomé, Lou, 221 Angel, E., 577 Angell, J. R., 364-366, 381, 397, 399 Angus, S., 74 Anokhin, P. K., 393 Annas, J. E., 71 Anselm, Saint, 85, 87, 96, 666 Antisthenes, 68, 96, 665 Antonuccio, D. O., 650 Aquinas. See Thomas Aquinas, Saint Aristarchus of Samos, 106, 127

Aristotle, 2, 49–57, 62, 83–84, 86–91, 99, 103, 111, 439, 477, 665
Armstrong, D. M., 141, 142, 143
Arnett, J. J., 356, 358
Aspinwall, L. G., 598
Atherton, M., 143
Augustijn, C., 101, 102, 103
Austin, G. A., 626
Averroës, 84, 96
Avicenna, 83, 96, 666
Ayer, A. J., 424
Ayllon, T., 449
Azar, B., 326
Azrin, N., 449

Baars, B. J., 115, 412, 450, 625, 627 Bacon, F., 114-117, 127, 180, 444, 666 Bailey, R. E., 617 Bain, Alexander, 138-162, 176, 668 Bakan, D., 245, 246, 247 Baker, D. B., 651 Balance, W., 253 Baldwin, J. M., 400 Ballou, R. O., 347 Balmary, M., 518 Bamberg, M., 287, 288 Bandura, A., 15, 16, 628 Bannister, Donald, 583 Barash, D. P., 613, 614 Barnes, J., 35, 36, 43, 53, 55, 56, 57, 67, 439 Barsky, R. F., 616 Bartlett, F. C., 624, 626, 627, 670 Bass, E., 542 Baxter, R., Jr., 650 Beach, F. A., 507, 609 Beanblossom, R. E., 190 Bechterev, V. M., 394-397, 421, 669

Beck, A. T., 650 Belar, C. D., 651 Bell, C., 234, 260 Bencivenga, E., 85 Benjamin, L. T. Jr., 322, 361, 651 Benko, S., 77, 78 Bennett, J., 185 Bentham, J., 153, 158-162, 176 Bergmen, G., 412 Bergman, K., 650 Berkeley, G., 140-143, 176, 667 Bernard, W., 184 Bernfeld, S., 237 Bernheim, H., 507, 513, 523, 668 Bessel, F., 233 Beutler, L. E., 500, 651 Binet, A., 309-312, 313, 331, 461, 669 Binswanger, L., 575-577, 603, 670 Birx, H. J., 296 Bjork, D. W., 338, 348 Blackburn, S., 112, 226 Blakeley, A. S., 624 Bleske, A. L., 615 Bleuler, E., 499 Blumenthal, A. L., 263, 268, 270, 272, 340 Boakes, R. 124, 295, 299, 386, 391, 409 Boer, D. P., 542, 544 Bonaventure, Saint, 90, 96 Bond, H. M., 325 Boodoo, G., 326 Boorstin, D. J., 459 Borch-Jacobsen, M., 522 Boring, E. G., 4, 5, 192, 198, 235, 248, 254, 266, 273, 274, 354, 363, 516, 522, Bouchard, T. J., Jr., 326, 617-619, 622

Boudewijnse, G-J., 198

Bouillaud, J.-B., 249 Bourke, V. J., 79 Bowen, C. D., 117 Bower, G. H., 437 Bowlby, J., 299 Boykin, A. W., 326 Boyle, Robert, 135 Boynton, D. M., 270, 459 Braid, J., 507 Branham, R. B., 68, 69, 77 Breland, K. and Breland, M., 616, 617 Bretall, R., 217, 218, 219 Bretano, F. C., 278, 291, 457, 517, 572, 630, 668 Brett, G. S., 10, 39, 72, 73, 75, 189 Breuer, J., 520, 550 Brewer, C. L., 402 Bridgman, P. W., 13, , 425, 670 Bringmann, W. G., 213, 253, 265, 271, 287, 288, 355 Broadbent, D. E., 625, 632 Broca, P., 248, 260, 611, 668 Brody, N., 326 Brooks, G. P., 192 Brooks-Gunn, I., 358 Brown-Séquard, C.-E., 6, 611, 612 Brücke, E., 237, 388, 517 Bruner, J. S., 626, 628, 639 Bruno, F. J., 467 Bruno, G., 106-108, 127, 666 Buchtel, H. A., 610 Buckley, K. W., 398, 409 Buckley, M. I., 399 Bühler, Charlotte R., 586 Burlingame-Lee, L., 373 Burrish, T. G., 449 Burt, C., 314, 331, 616 Burtt, E. A., 109, 110, 111 Bury, R. G., 67 Buss, D. M., 614, 615, 619 Butterfield, E. C., 632 Byrne, J. H., 637

Cahan, D., 241 Cahn, E., 361 Cairns, H., 48 Caldwell, Charles, 246 Calkins, M. W., 350-353, 381, 669, 671 Calvin, John, 107, 108 Candland, D. K., 281 Cannon, W. B., 345 Capps, D., 517 Carlson, J., 561 Carr, H., 366, 381 Carmen, E. H., 542 Carnegie, A., 296 Carpenter, R. J., 373 Cattell, J. M., 307, 325, 331, 334, 367, 381, 384, 644, 669 Catlett, J., 598 Cattell, R. B., 315 Ceci, S. J., 326 Chadwick, H., 79 Chaplin, J. P., 376 Chapman, M., 469

Charcot, J.-M., 309, 408, 513, 522, 527, 668

Chein, I., 360 Chiarugi, V., 497 Childs, H. G., 318 Chisholm, R. M., 20 Chodorov, N., 565, 679 Chomsky, N., 616, 622, 625, 626 Chow, K. L., 508 Cioffi, F., 542 Clark, A., 638 Clark, C. W., 494 Clark, K. B., 360-362, 381 Clark, M. P., 360, 361 Clatterbaugh, K., 8 Clay, R. A., 571 Cleary, L. J., 637 Cohen, D., 398, 399, 402, 403, 410 Cole, R. E., 306 Collins, A., 625 Comte, A., 168-171, 176, 423, 668 Condolle, A., 304 Condillac, E. B. de, 166, 176, 667 Coon, D. J., 590 Copernicus, N., 106-108, 127, 666 Copleston, F. C., 2-3 Costall, A., 371, 372 Cozad, L., 577 Craighead, W. E., 449 Craig, I. W., 619 Craik, K. H., 628, 644 Crane, Loyal, 650 Cranefield, P. F., 235 Crews, F., 542 Criqui, M. H., 320 Crombie, A. C., 84 Crouse, E. M., 361

Crowther-Heyck, H., 625 Csikszentmihalyi, M., 598

Cynkar, A., 644

Danton, W. G., 650 Danziger, K., 264, 269, 272 Daguin, J., 496 Darwin, C., 3, 297-302, 304, 331, 517, 668 Darwin, E., 294 Da Vinci, L., 104 Davies, J. M., 543 Davis, L., 542 Davis, R., 450 Davis, S. F., 450 Dawes, A., 584 DeAngelis, T., 326, 559 Deary, I. J., 249 Deane, S. N., 85 DeCarvalho, R. J., 596 DeFries, J. C., 619 Delahunty, R. J., 182 DeLeon, P. H., 651 Democritus, 37, 62, 665 DeNelsky, G. Y., 650 Denmark, F. L., 357 Derrida, J., 104 Descartes, R., 18, 21, 117-124, 127, 130, 180, 184, 234, 666 Desmond, A., 299 Detterman, D. K., 326 Deutscher, M., 360

Deutsch, G., 611 Dewey, J., 336, 362-364, 381, 398, 647, 669 Dewsbury, D. A., 366, 613 Diamond, S., 264 Diehl, L. A., 357 Diogenes, 68, 96 Dix, D. L., 498, 513, 667 Dollard, I., 480 Donaldson, G., 554 Donders, F. C., 269, 291, 644 Dostoyevsky, F., 226, 573 Drake, S., 110 Drever, J., 152 Dreyfus, H. L., 638 Driver-Linn, E., 13 DuBois-Reymond, E., 237, 388 Durant, W., 50 Dymond, R. F., 592

Early, C. E., 355

Ebbinghaus, H., 286-288, 291, 624, 627, 668 Edinger, D., 522 Egger, M. D., 627 Ehrenfels, C., 457, 484 Ehrenwald, J., 495 Ehrman, B. D., 77, 78, 207 Einstein, A., 172, 460, 588 Eisenberg, B., 359 Ekman, P., 301 Eliot, C. W., 350 Ellenberger, H. F., 510, 517, 522, 539, 577 Elliotson, J., 507 Elwes, R. H. M., 182, 183, 184 Emeling, C. E., 639 Emerson, R. W., 4, 506 Empedocles, 36, 63 Entwistle, S. R., 651 Epicurus of Samos, 69, 96, 665 Epston, D., 579 Epting, F. R., 584 Erasmus, Desiderius, 100, 103, 127, 666 Erdelyi, M. H., 542 Erikson, E. H., 15, 555 Esdaile, J., 507 Esper, E. A., 34, 36, 50, 68, 115, 169, 189 Esterson, A., 525, 540, 541, 542 Estes, W. K., 441, 442 Evans, R. B., 273, 275, 276 Exner, S., 459 Eysenck, H. J. 256, 260, 340, 461, 516, 624,

Feigl, H., 424
Ferrier, D., 250, 260
Festinger, L., 626
Fetzer, J. H., 628
Feyerabend, P. K., 6, 13–14
Ficino, Marsilio, 99, 127
Fiebert, M. S., 560
Finger, S., 245, 249, 250, 305, 345, 491, 608
Firestone, R. W. and Firestone, L. A., 598
Fishman, D. B., 656, 659
Fitch, F. B., 436
Fitzek, H., 236
Flanagan, O., 633

Fleming, M., 524 Grigorenko, 644, 655, 659 Hoffman, E., 584, 585 Fletcher, R., 315 Grube, G. M. A., 49 Hoffman, R. R., 287, 288 Flew, A., 144, 145, 146, 147, 148 Guilford, J. P., 295, 308 Hofstadter, R., 296, 297 Flourens, P., 247, 260, 608, 667 Guthrie, E. R., 438-442, 450, 454, 455 Holland, J. G., 341 Fodor, J., 639 Guthrie, K. S., 34, 35 Hollingworth, L. S., 321, 331, 358, 670 Fowers, B. J., 598 Guthrie, R. V., 358, 359, 360 Hollon, S. D., 449, 650 Fowler, R. D., 444 Honderich, T., 112 Fox, R. E., 651 Hadden, A. W., 80 Hong, H. V., and Hong, E. H., 227 Frankel, C., 211 Hager, J. L., 617 Honzik, C. H., 431, 432 Frankl, V. E., 215, 576, 596 Haidt, J., 598 Horley, J., 401 Frazer, J. G., 490 Hale, N. G., Jr., 530 Horney, K., 561-565, 568, 670 Frawley, M. G., 542, 543 Hall, C. S., 531 Horton, G. P., 440 Freud, A., 523, 538, 552-555, 568, 671 Hall, G. S., 322, 353-358, 359, 362, 381, Hovland, C. L., 436 Freud, S., 3, 19, 213, 226, 362, 504, 509, 644, 647, 669 Hubben, W., 218, 221 518-546, 551, 556, 559, 562, 580, Hall, M., 436 Hudson, J. E., 584 588, 669 Hall, M. B., 107, 108 Huizinga, J., 102 Friedländer, M., 84, 85 Hall, M. H., 585 Hull, C. L., 7, 434–438, 450, 454, 624, 670 Friedman, H. S., 320 Halpern, D. F., 326 Hume, David, 143-150, 177, 189, 192, 667 Frish, K., 613 Hamilton, E., 48 Humor, Freud on, 529 Fritzsch, G., 250, 260 Hammer, M., 637 Hurvich, D. J., 244 Hankinson, R. J., 67 Fromm, E., 578, 596 Husserl, E., 281, 291, 573, 669 Furumoto, L., 244, 274, 351, 352 Hannush, M. J., 409 Huxley, T., 294, 299 Harding, W. G., 359 Galef, B. G., Jr., 370 Harlow, H., 585, 625 Innis, N. K., 413, 433 Galanter, E., 626 Harris, M., 494 Inwood, M. J., 207, 298 Galen, 41, 63, 120, 492, 665 Hartley, D., 150-152, 176, 234, 635, 667 Israëls, H., 541, 542 Galileo, 108-112, 127, 132, 477, 666 Hartmann, H., 555 Hartmann, K. E., 517 Gall, F. J., 244, 260, 667 Jackson, J. P., Jr., 361, 362 Galton, F., 302-307, 325, 331, 617, 668 Hartshorne, C., 85 Jackson, T. T., 584 Gardner, H., 628 Harvey, W., 121 Jacobson, E., 405 Garfield, S. L., 649 Haselton, M. G., 615 Jacoby, R., 326 Gassendi, Pierre, 162, 176, 666 Hastorf, A., 320 Jahnke, J., 244 Gassner, J., 504 Haugeland, J., 636 James, H., Sr., 337 Gauss, C. F., 475 Hearnshaw, L. S., 314 James, W., 337-347, 352, 354, 370, 382, Hayes, S. C., 650 Gay, P., 221, 538, 553, 555 412, 427, 458, 530, 588, 597, 624, Hayman, R., 221 Gazzaniga, M. S., 611 626, 635, 647, 652, 653, 656, 668 Geary, D. C., 619 Hebb, D. O., 607, 608-610, 622, 625, 627, Janaway, C., 213, 214 Gelfand, T., 542 Jankowicz, A. D., 583 Gendlin, E. T., 592 Hegel, G. W. F., 199-201, 205, 363, 667 Janet, P., 509, 513, 527, 540 Gerard, D. L., 498 Heiby, E., 650 Jennings, J. L., 282 Heidbreder, E., 234, 339, 352, 366, 411, Gergen, K., 658, 659 Jesus, 75, 97, 355 Gillaspy, J. A., Jr., 617 524, 527, 529, 546, 653 Johnson, A. D., 358 Gillie, O., 314 Heidegger, M., 283, 374, 573-575, 604, 670 Johnson, D. M., 639 Gittelman, R., 650 Heisenberg, W. K., 16 Johnson, R. C., 306 Glauberman, N., 326 Helmholtz, H., 236-242, 260, 388, 506, 517, Johnson, S., 335 Gleaves, D. H., 542 524, 644, 668 Johnston, E. B., 624 Goddard, H. H., 315-317, 324, 325, 332, Heloise, 88 Joncich, , G., 401 669 Helvétius, Claude-Adrien, 167, 176 Jones, E., 227, 508, 518, 519, 521, 522, 530, Goethe, J. W., 212, 230, 516 Henle, M. 463, 466, 481 536, 538, 559, 560 Goldman, S. L., 14 Henri, V., 310 Jones, M. C., 408 Goldsmith, M., 505 Hentoff, N., 360 Jones, R. A., 413 Golomb, J., 222, 223, 227 Heraclitus, 32, 63, 661, 665 Jones, W. H., 281, 493 Good, G., 577 Herbart, J. F., 196-199, 205, 516, 667 Jones, W. H. S., 40, 492 Goodman, L. E., 83 Hergenhahn, B. R., 431, 437, 442, 473, 475. Josselson, R., 579 Goodnow, J. J., 626 555, 557, 564, 565, 582, 617, 628 Jowett, B., 44, 45, 47, 49 Goodson, F. E., 10 Hering, E., 242, 260, 668 Joynson, R. B., 315 Goodwin, C. J., 274 Hermans, H. J. M., 582 Jung, C. G., 18, 213, 227, 362, 531, 555-Gorgias, 42 Hernandez, E., 542 559, 568, 579, 661, 670 Gosling, S. D., 628, 644 Hernstein, R. J., 325 Gould, S. J., 249, 317, 615 Heron, W., 610 Kagan, J., 41, 627 Goulet-Cazé, M.-O., 68, 77 Hilgard, E. R., 267, 273, 337, 364, 368, 434, Kahl, R. K., 240 Graehner, W., 356, 357 435, 437 Kamin, L. J., 314 Green, B. F., 315 Hinton, G. E., 636 Kant, I., 16, 192-196, 200, 205, 236, 239, Greenway, A. P., 162 Hippocrates, 39-41, 63, 665, 488, 491, 513 363, 457, 485, 631, 633, 667 Gregory, J., 73 Hitzig, E., 250, 260 Karier, C. J., 397

Hobbes, T., 5, 131-134, 176, 666

Karon, B. P., 650

Gregory, R. L., 135, 213

Malebranche, N. De, 18, 185, 206 Langfield, A. W., 584 Katona, 475 Malik, M. L., 500 Kaufmann, W., 212, 224, 226 Lashley, K. S., 608 Malthus, T., 298, 332 Larson, C. A., 403 Kazdin, A. E., 449 Larson, E. J., 300 Keller, F. S., 336 Mancuso, I. C., 584 Lashley, K. S., 400, 481, 606-608, 622, 625, Maniacci, M., 561 Kelly, E. L., 649 Kelly, G. A., 580-584, 604, 649, 671 637, 652, 670 Marbe, K., 284 Kelman, H., 564, 565 Marrow, A. J., 479 Lautrey, J., 326 Marshall, M. E., 253, 254 Kempen, H. J. G., 582 Leahey, T. H., 12, 616 Leary, D. E., 158, 426 Martineau, H., 170, 171 Kemp, S., 91 Kemp, V. H., 355 Leher, K., 190 Martin, L. R., 320 Lehman, D. R., 375 Martin, S., 247 Kendler, H. H., 361, 362, 437, 626 Marty, M., 101, 102, 103 Leibniz, G. W., 185-189, 206, 516, 667 Kendler, T. W, 626 Leitenberg, H., 449 Marx, M. H., 10 Kenkel, M. B., 651 Maskelyne, N., 232 Leitner, L., 584 Kennedy, G., 43 Maslow, A., 571, 584-590, 604, 624, 671 Kenny, A., 123 Lempert, R. O., 375 Kepler, Johannes, 108, 128 Levant, R. F., 595, 650 Masson, J. M., 524, 525, 540, 541 Masters, J. C., 449 Keppel, B., 362 Levy, J., 612 Kerr, J., 542 Levy, N. J., 432 Matarazzo, J. D., 489, 654 May, R., 577-580, 604, 671 Lewes, G. H., 342 Ketcham, K., 543 Lewin, K., 477-481, 485, 670 Mayr, E., 12 Keyes, C. L. M., 598 Lewontin, R. C., 615 Mazziotta, J., 650 Kierkegaard, S., 217-220, 227, 230, 576, Libbrecht, K., 509 McAdams, D. P., 578, 579 578, 668 Liébeault, A. A., 507, 514, 523, 668 McClanahan, T. M., 650 Kimble, G. A., 652, 653, 654 Lieblich, A., 578 McClearn, G. E., 306 Kimble, M. M., 522 Lightfoot, J., 300 McClelland, J. L., 636, 637 Kinget, G. M., 572 McCulloch, W. S., 635 Lincoln, A., 558, 588 King, B. D., 460 McDougall, W., 411, 412-417, 422, 429, King, J. E., 698 Lippitt, R., 480 Lippman, W., 319 461, 669 King, P., 554 McGrath, E., 650 Kinnebrook, D., 232 Little, T. D., 320 McGuffin, P., 619 Lloyd, G. E. R., 39, 40 Kirk, S. A., 503 Loeb, J., 398 McLeod, I., 579 Kirsch, I., 510, 559 Locke, John, 134-140, 177, 185, 666 McReynolds, P., 501, 502, 647 Klarman, M., 361 Medawar, P., 660 Klein, D. F., 650 Loehlin, J. C., 326 Meehl, P., 651 Klein, M., 553, 568 Loftus, E., 542-544 Mervis, C., 658 Klein, R., 287, 288 Lombard, P., 85, 97, 666 Mesmer, F. A., 504-506, 514, 667 Long, A. A., 68 Koch, S., 12, 17, 424, 448, 654 Mill, J., 152-154, 177, 667 Koffka, K., 280, 427, 460, 470, 476, 485 Lopez, S. J., 598 Mill, J. S., 5, 21,154-158, 177, 294, 458, Köhler, W., 280, 458, 461, 462, 463, 464, Lorenz, K., 613 466, 467, 469, 471-473, 485 Lorion, R. P., 650 624, 668 Kohout, J., 644 Lovett, B. I., 5 Miller, E. F., 144 Miller, G. A., 625-627, 628, 632, 642 Kojetin, B. A., 619 Lowenfield, Leopold, 541 Miller, N. E., 480, 627 Koller, C., 519 Lowry, R. J., 584 Lubart, I., 326 Milner, P., 610 Korn, J. H., 450 Lucretius, 69 Minsky, M., 637 Kousoulas, D. G., 77 Minton, H. L., 319, 320 Kramer, H., 493, 494, 666 Luddy, A. J., 87, 88 Kraepelin, E., 268, 499, 513, 669 Ludwig, K., 237, 388 Moles, I. L., 69 Lundin, R. W., 480 Moltz, H. 432 Krafft-Ebing, R., 525, 527 Montaigne, M. de, 103, 128, 666 Krawiec, T. S., 376 Luther, M., 101-103, 108, 128, 666 Monte, C. F., 298 Lyell, C., 398 Krueger, D., 69 Lykken, D. T., 618, 619 Mora, G., 498 Kuhn, T. S., 10-13, 22, 26, 93, 106, 107, Morgan, C. L., 371, 382, 669 108, 109, 117, 263, 652, 657, 660 Lynn, S. J., 510 Morgan, C. T., 607 Külpe, O., 283, 292 Morris, G. S., 363 Mabry, J., 449 Kurtz, P. 67 Maccoby, H., 77 Morris, J. B., 650 Kutchins, H., 503 Mach, Ernst, 171, 423, 444, 457, 485, 668 Mossner, E. C., 145, 147, 148, 149 Machiavelli, N., 104 Müller, J., 235, 235, 237, 261, 265, 644, 667 Lacey, H., 15 Lachman, J. L., 632 MacLeod, R. B., 16, 114 Muñoz, R. F., 650 Münsterberg, H., 347-350, 354, 382, 647, Lachman, R., 632 Madigan, S., 352 Magee, B., 214, 216 Ladd-Franklin, C., 243, 261, 274, 669 669 Magendie, F., 234, 261 Muroff, M., 522 Lafleur, L. J., 123

Lamarck, J., 294, 332, 667 La Mettrie, Julien de, 163–166, 177, 353, 667 Land, E. H., 213 Langan, T., 574 Lange, C. G., 345, 382 Magnus. See Albertus Magnus, Saint
Maher, W. B. and Maher, B. A., 486, 488,
489, 490
Mahoney, M. L. 449, 623

Murphy, G., 347

Murray, B., 651

Murray, C., 325 Murray, D. J., 481

Murray, F. S., 275

Myers, C. R., 438

Mahoney, M. J., 449, 623 Maimonides, 84, 97, 666 Malcolm, N., 542 biogrammar, 613, 622 Biological approach to mental illness. See medical model of mental illness Biological determinism, 14, 26, 326 sociobiology, 614 Biological explanations of mental illness, 488 Bleuler, Eugen, 499 Bonaventure, Saint, 90, 96 Bond, Horace M., 325 Bouchard, Thomas, 617-619, 622 Boyle, Robert, 135 Braid, James, 507 Brain function research (early). See also psychobiology Broca, Paul, 248 Ferrier, David, 250 Flourens, Pierre, 247 Fritzsch, Gustav, 250 Hitzig, Eduard, 250 Phrenology, 244-247 Wernicke, Carl, 249 Brain Mechanisms and Intelligence (Lashley), Breland, Keller and Marian, 616 Bretano, Franz Clemens, 278, 291, 517, 572, 630, 668 Breuer, Josef, 520, 550 Bridgman, Percy W., 13, 670 British Journal of Psychology, 412 British Psychological Association, 583 Broadbent, Donald, 625, 632 Broca, Paul, 248, 260, 611, 668 Broca's area, 249, 260 Brown v. Board of Education (1954), 360-362 Brücke, Ernst, 517 Bruner, Jerome, 626, 639 Bruno, Giordano, 106-108, 127, 666 Buchtel, Henry, 610 Bühler, Charlotte R., 586 Burt, Cyril, 314, 331, 616 Caldwell, Charles, 246 Calkins, Mary Whiton, 350-353, 381, 669, Harvard's refusal to grant her a PhD, 352 Memory research, 351 self-psychology, 352 Calvin, John, 107, 108 Canadian Psychological Association, 609 Carr, Harvey, 366, 381 Carnegie, Andrew, 296 Castration anxiety, 535 Categorical imperative, 199, 205 Categories of thought, 193, 200, 205, 633 Cathartic method, 521, 550 Cathexis, 532, 550 Catholic church. See also religion Copernicus and, 106 Bruno and, 106 Erasmus' criticisms of, 101 further challenges to authority, 104 Galileo and, 109, 111 Luther's challenge to, 101-103 Reformation and, 101 witch hunts, 493-496

Cattell, James M., 307, 331, 334, 367, 381,

and applied psychology, 367, 644 drift toward behaviorism, 384 Cattell, Raymond B., 315 Cats in a Puzzle Box, (Guthrie and Horton), 440 Causal laws, 8, 26 Cause and effect Hume's law, 147 Mach on, 171 Causation analysis of, 147 Aristotle's views, 52 Kant on, 193 psychological versus physical (Wundt), 270 cell assemblies, 609, 622 Center for Cognitive Studies, 626 Charcot, Jean-Martin, 408, 513, 527, 668 Chiarugi, Vincenzo, 497 Childhood and Society (Erikson), 555 Child psychoanalysis, 553 Child psychology Darwin's influence, 301 effects of racial segregation, 360 Hall on., 358 Koffka on, 461 Rogers on, 591 Watson on, 408 Chinese Room thought experiment (Searle), 629, 638 Chodorov, N., 565, 679 Chomsky, Noam, 616, 622, 625, 626 Christianity Augustine, Saint, 78-81 Constantine, Emperor, 77 Dark Ages, 81 Jesus, 75 influences combined in, 75 mystery religions and, 74 pre-Renaissance spirit, 92 reconciliation of faith and reason, 85 neoplatonism and, 71-74 Paul, Saint 75-77 Scholasticism, 86-91 witch hunts, 493-496 Civilization and Its Discontents (Freud), 537 Clark, Andy, 638 Clark, Kenneth B., 360-362, 381 Clark, Mamie P., 360 Clark University Calkins's studies at, 351 Freud's visit, 530 Hall as president, 354 Köhler at, 461 psychology at, 362 Sumner at, 359 Clever Hans phenomenon, 281, 291 Client-centered therapy, 649 Client-Centered Therapy: Its Current Practice, Implications, and Theory (Rogers), 592 "Clients", use by Rogers, 592 Clinical method, 248, 260 Clinical psychology, 513 controversy over training, 650-652 current therapeutic techniques, 649 Münsterberg, Hugo, 349

Witmer's pioneering contributions, 501, 647 professional associations, 648 prescription privileges, 649 therapeutic techniques after World War II, Zeigarnik, Bluma, 479 Clinical Treatment of the Problem Child, The (Rogers), 592 Coeducation, Hall on, 356 Coefficient of correlation (r), 306, 313 Cognition and Reality (Neisser), 634 Cognitive dissonance, 626 cognitive maps, 431, 454 cognitive psychology, 623-642 artificial intelligence (AI), 628-631 current interest in, 450 developments after 1950s, 626 developments before 1950, 624 developments during 1950s, 625 faculty psychology, return of, 633 information-processing psychology, 631-633 mind-body problem, return of, 633-635 new connectionism, 635-639 Skinner's attacks on, 445 Tolman and, 433 Cognitive Psychology (journal), 628 Cognitive Psychology (Neisser), 627 Cognitive science, 634, 642 Cognitive science (journal), 634 Cognitive trial and error (Gestalt psychology), 471 Collective unconscious, 556, 568 Color vision. See vision Columbia University, functionalism at, 367-Common sense, 53, 62 Commonsense philosophy, 190, 205 Compensation, Adler on, 560, 568 Complex ideas, 176 Hartley on, 151 Hobbes on, 237 Hume on, 145 Locke on, 13/ Computational Theory of Mind (CTM), 639 "Computing Machinery and Intelligence" (Turing), 629 Computer models of human intelligence, 628. See also artificial intelligence; information-processing psychology Comte, Auguste, 168-171, 176, 423, 668 Concept formation, 626 Conceptualism, 87, 96 Condensation, 526, 550 Condillac, Étienne Bonnot de, 166, 176, 667 conditioned reflex, 389, 391, 421 conditioned response (CR), 391, 421 conditioned stimulus (CS), 391, 421 Conditioned Reflexes (Pavlov), 390 Conditioned responses, Hull's study of, 435 Conditioning, rote learning explanation, 436 conditions of worth, 594, 603 Confessions (Augustine), 79, 81 Confirmable propositions, 7, 26 Confirmation, Tolman on, 431, 454

Conflict, 524, 550 Cours de Philosophe Positive (Comte), 168 dialectic process, 200, 205 Empedocles on, 36 Courage, 575, 603 Dialogues Concerning Natural Religion (Hume), Herbart on, 198, 516 Countertransference, 521, 550 Jung on, 558 Crane, Loyal, 650 Dialogues Concerning the Two Chief World Lewin on, 479 Creationism, 298 Systems (Galileo), 123 age of the earth and evolution, 300 May on, 579 Dialogues Concerning Two New Sciences Miller on, 480 creative self, 561, 568 (Galileo), 111 Paul, Saint, on, 76 Creative synthesis, 268, 291 Differential threshold, 255, 260 Plato on, 48 Critique of Pure Reason (Kant), 182 Diogenes, 68, 96 connectionism, 374, 381 Critique of Practical Reason (Kant), 182 Dionysiac-Orphic religion, 30, 35, 62 new connectionism, 635-639 Cultural determinants of behavior, 564, 614 Dionysian aspect of human nature, 222, 230 Consciousness. See also mind-body Cybernetics, 625 Direct realism, 180, 205 relationships application to human behavior, 626 Discovery of Witchcraft (Scot), 495 Cynicism, 68, 96, 101, 130, 226 Experimental psychologists' view of, 250 Disinhibition, 392, 421 functionalist and structuralist study of, 384 Daimonic, 579, 603 Displacement, 526, 533, 550 Hull on, 435 Daquin, Joseph, 496 Distance perception, Berkelev's theory of. James on, 341 Dark Ages, 81, 666 Darwin, Charles, 3, 297-302, 331, 668 methodological behaviorism on, 515 Divided line analogy (Plato), 46, 62 mind-body relationship theories, 411 age of the earth and evolution, 300 Dix, Dorothea Lynde, 498, 513, 667 mind-brain and mind-body relationships, human evolution, 300 Doctor of Medicine (MD) degree, 651 634 influence on Freud, 517 Doctor of Philosophy (PhD) degree, 502, 650 molar approach to, 456 influence on psychology and other Doctor of Psychology degree (PsyD), 502, molecular approach to, 456 disciplines, 301 650, 664 Schopenhauer on, 216 journey of the Beagle, 298 Dogmatist, 67, 96 Searle on, 630 return to England, 298 Donders, Franciscus Cornelius, 269, 291, 644 Sechenov on, 386 social Darwinism and, 297, 304 Dostoyevsky, Fyodor, 226, 573 Skinner on, 445 theory of evolution, 300 double aspectism, 16, 26, 182, 205 Sophists' concerns with, 43 Darwin, Erasmus, 294 doctrine of specific nerve energies, 235, 250 Sperry on, 612 Dasein, 574, 603 dream analysis Titchener's mental elements, 276 Daseinanalysis, 575, 604 Freud on, 526, 550 Watson, John, on, 411 Death Jung on, 558, 568 Wundt on, 264 existentialists on, 596 dream work, 526, 550 Conservation of energy, principle of, 237, Fechner on, 254 dreams, 62 Freud on death instincts, 533, 550 261, 517 Aristotle on, 55 Constancy hypothesis, 465, 484 Nietzsche on, 223 Condillac on, 166 Constantine, Emperor, 77, 96, 666 Schopenhauer on, 215 Descartes's explanation of, 121 Constructive alternativism, 581, 603 Deception of Demons (Wever), 495 Hobbes's views on, 133 Construct systems, 582, 603 Deduction, 115, 127, 132, 180 Plato on, 49, 527 Contagion effect, 505, 513 Defense mechanisms, 533, 550 Drevfus, Hubert, 638 Contagious magic, 490, 513 Deficiency motivation (D-motivation), 589, Drive reduction, 437, 454 Contemporary psychology, 643-664 "Drives and the C.N.S." (Hebb), 625 APA divisions, 644 Deficiency perception (D-perception), 589 Drives, Guthrie on, 441 diversity of, 643 Deism, 112, 127, 181 Drives Toward War (Tolman), 427 eclecticism, 644 Dementia praecox, 499 dualism, 18, 631, 634 new developments in psychology, 659-661 Democritus, 37, 62, 665 dualists, 18, 26, 127 postmodernism, 655-659 Depression, 649, 658 Descartes, 122 psychology's status as a science, 653-655 Derrida, Jacques, 104 Pythagoreans, 35 Descartes, RenÉ, 18, 21, 117-124, 127, 130, psychology's two cultures, 652 Dynamics of Behavior (Woodworth), 369 pure, scientific versus applied psychology, 180, 184, 234, 666 Dynamic psychology, 368, 381 644-653 Descent of Man, The (Darwin), 297, 300 Dynamics in Psychology (Köhler), 463 Contemporary Schools of Psychology Descriptive behaviorism, 448, 454 Ebbinghaus, Hermann, 286-288, 291, 624, (Woodworth), 369 Determinism, 8, 14-17, 26 627, 668 Context theory of meaning, 277, 291 Democritus, 37 Eclectic approach, 4, 26 Contributions to the Analysis of Sensations Nietzsche's view versus Freudians, 223 Eclecticism, 644, 664 (Mach), 423 responsibility and, 16 Ecological psychology, 634 Contributions to the Theory of Sense Perception third-force psychology and, 571 Education (Wundt), 263 Wundt, 271 Dewey on, 364 Convictions, Nietzsche on, 223, 230 Developmental lines, 554, 568 gifted children, 321 Copernicus, Nicolaus, 106-108, 127, 666 Dewey, John, 362-364, 381, 647, 669 Hall's opposition to coeducation, 356 Correlation, 306, 331 criticism of reflexes in behavior analysis, HÉlvetius on, 168 Correlational laws, 8, 26 influence of phrenology, 247 Correspondence theory of truth, 10, 13, 26 involvement in social causes, 364 La Mettrie's views on, 164 Cortical mosaic, 392, 421 views on education, 364 Locke on, 139 Cosmology, 31, 62 Diagnostic and Statistical Manual of Mental nature-nurture controversy and, 304 Counseling and Psychotherapy: Newer Concepts Disorders (DSM), 499 racial segregation in U.S. schools, 360in Practice (Rogers), 592, 624 dialectic method, 86, 96

tensions with medical model, 502-Psychological Review, 367 Psychological Science, 652 Psychological Studies, 265 Psychology. See also contemporary psychology definition of, 1 Descartes's contributions to, 123 Galileo and, 111 Hume's influence, 149 paradigms and, 12 persistent questions, 17-23, 631, 660 problems in writing history of, 2-4 reasons to study history, 4-6 as a science, 14-17, 196, 653-655 Psychology, 336 Psychology of the Adolescent (Hollingworth Psychology: The Briefer Course (James), 33! Psychology from an Empirical Standpoint (Bretano), 279 Psychology: An Introductory Study of the Structure and Functions of Human Consciousness (Angell), 365 Psychology of Learning, The (Guthrie), 438 Psychology of Personal Constructs (Kelly), 58 Psychology: The Science of Mental Life (Mille 626 Psychology of Subnormal Children (Hollingworth), 322 Psychology from the Standpoint of a Behavioris. (Watson), 403 Psychology of Tone (Stumpf), 280 Psychonomic Science, 651 Psychonomic Society, 651 Psychopathology of Everyday Life (Freud), 528 Psychopharmacology Kraepelin as pioneer, 500 pharmaceutical companies' influence, 650 prescription privileges for psychologists, 649 medication versus psychotherapy, 649 Psychophysical isomorphism, 464 psychophysical parallelism, 18, 27, 187, 206 defined, 411 Titchener, 277 psychophysics, 254, 261 constancy hypothesis, 465 ind as unit of sensation, 255 methods, 256 Weber's law, 254 Psychosexual stages of development, 534-536 Psychosocial stages of development, 555 Psychotherapy, 489, 514, 647 need for, after World War II, 648 Rogers on, 592, 649 PsyD (Doctor of Psychology degree), 502, 650, 664 Ptolemaic system, 105, 128 Ptolemy, 105, 128 public observation, 8, 27 punishment Guthrie on, 441 Skinner on, 447 pure phenomenology, 281, 292, 573, 605

Rousseau on, 211 Skinner on, 448 Sumner on, 359 Educational psychology, 198 Kelly, George, 580 Efficient cause, 52, 63 Egger, M. D., 627 Ego, 531, 532, 550 Jung on, 556, 568 Ego defense mechanisms, 533, 550 Ego and the Mechanisms of Defense (Anna Freud), 554 ego psychology, 554, 568 Ehrenfels, Christian von, 457, 484 Eigenwelt, 576, 603 Eidola, 36, 63 Either/Or (Kierkegaard), 218, 220 Electroencephalography (EEG), 659 Elementism, 37, 63, 456, 484 Elements of the Philosophy of the Human Mind (Stewart), 335 Elements of Phrenology (Caldwell), 246 Elements of Physiological Psychology (Woodworth), 369 Elements of Psychophysics (Fechner), 254, 286 Elements of thought, 267, 291, 456 Elliotson, John, 507 Emergentism, 18, 26 Emerson, Ralph Waldo, 4, 506 Emile, 210, 211 Emotions Aristotle on, 56 computer metaphor for the brain and, 634 Darwin on, 300 Democritus on, 38 Hartley on, 152 Hume on, 148 inappropriate, in mental illness, 487 James on, 344 Locke on, 137 McDougall on, 414 Plato on, 48 romanticism's emphasis on, 208 Spinoza on, 183 Titchener's affections, 276 Watson on, 407 Emotions and the Will (Bain), 159 Empedocles, 36, 63 Empirical observation, 7, 26 Empirical self, 343, 381 Empiricism, 7, 21, 26, 130. See also positivism; sensationalism Aristotle, 51 Bain, Alexander, 158-162, 176 Bacon, Francis, 114-116 Berkeley, George, 140-143, 176 British empiricism, 131-162 defined, 131, 176 Hartley, David, 150-152, 176 Hobbes, Thomas, 5, 131-134, 176 Hume, David, 143-150, 177 James on, 346 Locke, John, 134-140, 177 mental events and, 631 Mill, James, 152-154, 177 Mill, John Stuart, 5, 154–158, 177

nativism versus, 18 process of becoming, 33 rationalism versus, 179-181 English Men of Science: Their Nature and Nurture (Galton), 304 Engram, 607, 622 Enjoy Old Age: Living Fully Your Later Years (Skinner and Vaughan), 449 Enlightenment, 207, 230, 656 Enquiry Concerning Human Understanding, An (Hume), 143 entelechy, 52, 63 Environmental determinism, 14, 26 Environmentalism, 168. See also naturenurture controversy intelligence testing and, 308 nature-nurture controversy, 304 sociobiology and, 614 Environment, importance to Skinner, 446 Epicureanism, 69, 96, 163 Epicurus of Samos, 69, 96, 665 Epiphenomenalism, 16, 26, 411, 633 Epistemololgy, 20, 26 Equipotentiality, 607, 622, 622 Erasmus, Desiderius, 100, 103, 127, 666 Escape from Freedom (Fromm), 578, 596 Essay Concerning Human Understanding, An (Locke), 135 Essay on the Origin of Human Knowledge (Condillac), 166 Essay on the Principle of Population, An (Malthus), 299 Essay Towards a New Theory of Vision, An (Berkeley), 140 Essays on the Active Powers of the Human Mind (Reid), 190 Essays on the Intellectual Powers of Man (Reid), Essays on the Mind (HelvÉtius), 167 Essences, 44, 50, 63 family resemblance versus, 658 nomanilism versus realism, 86 ethical stage, 220, 230 Ethics: Demonstrated in Geometrical Order (Spinoza), 181 Ethnology, 5 Ethology, 157, 176, 613, 622 Eugenics, 303, 331 Cattell, James M., 307 Davenport, Charles, 323 Yerkes, Robert M., 323 evil, 71, 102 Horney on basic evil, 563 Evolution, 3 Anaximander on, 32 applied psychology and, 647 Empedocles on, 36 Darwin, Charles, 297-302 Dewey on, 364 Freud's theories and, 517 Galton, Sir Francis, 302-307 Goethe on, 213 Hall, Granville S., 358 Ladd-Franklin color vision theory, 243 Lamarck, Jean, 294 Nietzsche on, 223

pre-Darwinian theories, 293 Skinner's behavior analysis and, 446 Spencer, Herbert, 294-297 Evolutionary psychology, 302, 331, 450 sociobiology versus, 614-616 Excitation, 391, 421 Existentialism, 217-227, 230, 571 emphasis on meaning in human life, 571 in humanistic psychology, 572 Kierkegaard, Soren, 217-220 Nietzsche, Friedrich Wilhelm, 220-227 truth as relative to cultural group, 656 Existence: A New Dimension in Psychiatry and Psychology (May), 577 Existential psychology, 573-584, 604 Binswanger, Ludwig, 575-577 comparison to humanistic psychology, 595 Heidegger, Martin, 573-575 Kelly, George, 580-584 May, Rollo, 577-580 Existential Psychology (May), 577 expectancies, 431, 454 Experimental neurosis, 392, 421 Experimental psychology, 250-256. See also pure, scientific psychology association with academia, 648 Calkins's view of, 352 Bretano's view of, 279 Fechner, Gustav Theodor, 252-256, 644 Husserl on, 282 Hull's influence on, 437 James on, 340 Weber, Ernst Heinrich, 251 Wundt's view of, 265, 644 Experimental Psychology (Woodworth), 369 "Experimental Studies of the Perception of Movement" (Wertheimer), 459 Expression of the Emotions in Man and Animals (Darwin), 300 Extinction, 392, 421 latent extinction, 432 Skinner's alternative to punishment, 447 Extrinsic reinforcement, 475, 484 Extraversion, 557, 559, 568 Factor analysis, 313, 331 Faculty psychology, 191, 205, 631 return of, 633 Falsifiability, 9, 27 Family resemblance, 658, 664 Farewell to Reason (Feyerabend), 13 Fashions in psychology, 5 Faust (Goethe), 212 In Fear and Trembling (Kierkegaard), 219 Fear, Hebb's research on, 610 Fechner, Gustav Theodor, 252–256, 260, 340, 461, 667 experimental study of cognitive events, influence on Freud, 516 feedback, information, 625, 626 feelings of inferiority, 560, 568 Feelings. See also emotions Rogers on, 593 Wundt on, 267, 291 Feminine Psychology (Horney), 564 Ficino, Marsilio, 99, 127

Fictional goals, 561 Fictionalism, 285 Field theory, 458, 484 application in Gestalt psychology, 464 Lewin, Kurt, 477-480 figure-ground relationship, 468, 484 Final cause, 52, 63 First-signal system, 393, 421 Fitness Darwin on, 300, 331 sociobiology, inclusive fitness, 302, 331 Fixed-role therapy, 583, 604 Flourens, Pierre, 247, 260, 608, 667 Flourishing, 598, 604 Forensic psychology, 349, 381 Formal cause, 52, 63 Formal discipline, 247, 260 "Formation of Learning Sets, The" (Harlow), Forms, 46, 63, 110 Fourth-force psychology, 590 Frankl, Victor, 576, 596 Frazer, Sir James, 490 Free association, 523, 550 Freedom Goethe on, 212 Heidegger on, 575 Kierkegaard on, 220 Nietzsche on, 223 Rousseau on, 210, 571 Schopenhauer on, 216 Vaihinger on, 285 Free will, 16. See also nondeterminism Adler on, 561 artificial intelligence and the human mind, Augustine on, 79 Binswanger on, 576 Epicurean view of, 69 Hobbes on, 134 James on, 338, 345 Luther on, 102 Spinoza on, 182 third-force psychology, 571 Wundt on, 271 Free Will, The (Erasmus), 192 Freud, Anna, 523, 538, 552-555, 568, 671 child analysis, conflict with Melanie Klein ego psychology, 554 Freudian slips, 528 Freud, Sigmund, 3, 19, 518-546, 551, 669. See also psychoanalysis break with Adler, 559 break with Jung, 556 cocaine use, 519 contributions to psychology, 545 criticisms of his theories, 544 early influences on psychoanalysis, 520-524 flight from the Nazis, 537 Goethe's influence on, 213 Horney's disagreements with, 562 G Kelly on, 580 Maslow on, 588 G models of mental illness, 504 Ge

Ge

output as, 632 Watson's use of, 404 revolutionary stage, 12, 27 De Revolutionibus Orbium Coelestium (Copernicus), 106 risky predictions, 9, 28 Rockefeller, John D., 296 Rogers, Carl, 590-598, 605, 624, 671 client-centered therapy, 592 contributions to psychology, 595 need for psychotherapy after World War revolutionary approach to psychotherapy, theory of personality, 592-Roman Empire, 74 Constantine, Emperor, 77 end of, 74, 81 influence of Greek culture, 74 philosophers of, 69-74 Romanes, George J., 370, 382, 669 romanticism, 208-217, 231, 571, 659 artificial intelligence and the mind, 631 Goethe, Johann Wolfgang von, 212 in humanistic psychology, 572 Rousseau, Jean-Jaques, 209-212 Schopenhauer, Arthur, 213-216 truth as relative to cultural group, 656 Rosenthal, Robert, 281 Rote learning, 436 Rousseau, Jean-Jaques, 209-212, 231, 571, Rush, Benjamin, 498, 514, 667 Russell, Bertrand, 410, 660 Russian objective psychology. See objective psychology Savings, 288, 292 scala natura, 52, 64 schemata (Piaget), 624 schizophrenia, 499, 650 Scholasticism, 86-91, 97, 100 School, 263, 292 Schopenhauer, Arthur, 213-216, 516, 667 science, 7-14 Aristotelian versus Galilean, 477 assumption of determinism, 8 Bacon, Francis, 114-117 challenges to authority of Catholic church, 105 cognitive science, 634 combination of rationalism and empiricism, 7 Copernicus, Nicolaus, 106 definition of, 7, 28 Comte's hierarchy of sciences, 171 Descartes, RenÉ, 117-124 empirical and theoretical, logical positivism, 424 Galileo, 108-112 humanistic psychology and, 586, 597 human science, May on, 579 Hume's science of man, 144 Limits of, psychology's persistent questions, 660 Mill, J. S., science of ethology, 157 Newton, Isaac, 112-114

philosophy of science, Karl Popper, 9 philosophy of science, Thomas Kuhn, 10-Popper versus Kuhn on, 13 Psychology as, 14-17, 196, 653-655 as religion, 114 search for laws, 8 third-force psychology and, 571 Science, 367 Science of Colors (Goethe), 212 Science Wars (Goldman), 14 Scientific laws, 8, 28 scientific theory, 7, 28 scientism, 168, 178 Scot, Reginald, 495 Searle, John B., 629, 638, 642 Sears, Robert R., 320 Sechenov, Ivan M., 385-388, 422, 668 secondary laws, 156, 178 secondary qualities, 129 Berkeley on, 141 Gallileo and, 110 Locke on, 137 Second-signal system, 393, 422 Seduction theory (Freud), 525, 541, 551 self, 22 Adler on, 561 Calkins on, 352 Condillac on, 167 Hume on, 147 James on, 343 Jung on, 557 self-actualization, 605 Aristotle on, 54, 588 Jung on, 557, 558 Maslow on, 587-589, 590 Rogers on, 593 Self-alienation, 578, 605 Self-Analysis (Horney), 565 Self as knower (James), 343, 382 Self-characterization, 583, 605 Self-esteem, 343, 382 Self-preservation Herbart on, 197 Schopenhauer on, 214 Spinoza on, 183 Seligman, M. E. P., 617 Semantics, 630, 638 Senescence: The Last Half of Life (Hall), 358 Sensation, 178, 261, 292 Aristotle on, 53 Berkeley on, 142 Conversion to perception (Helmholtz), 239 Hartley on, 150 jnd as unit of, 255 Locke on, 13 Mach on, 171, 423 Physical reality versus, 236 Wundt on, 267 Sensationalism, 162-168 Condillac, Étienne Bonnot de, 166 Gassendi, Pierre, 162 La Mettrie, Julien de, 163-166 mental events, 631 Senses and the Intellect, The (Bain), 159

sensitive soul, 52, 64 sensory acuity in intelligence measurement, 305, 307 sensory experience. See also sensation Aristotle on, 51 as basis of knowledge, 33 Democritus on, 38 in empiricism and rationalism, 51 empiricist view of, 18, 131 French sensationalists' view of, 169 Parmenides on, 33 Philo on, 72 Plato on, 46, 47 Pythagoras on, 35 Sentiment, 415, 422 Servetus, Michael, 107 Sex education, Watson on, 410 Sexuality criticism of Freud's theories, 544 Freud on cause of hysteria, 522 Freud on seduction theory, 523 Freud on unconscious motivation, 524 Infantile sexuality, 528 libido, 531, 551 Maslow's research on, 585 Oedipus complex, 527 psychosexual stages of development, 534shadow, Jung on, 557 shut-upness, Kierkegaard on, 578, 605 Signs, theory of (Helmholtz), 241 Simon, Herbert, 625, 632 Simon, Theodore, 310-312, 332 Simple ideas, 178 Hartley on, 151 Hobbes on, 137 Hume on, 145 Locke on, 137 skepticism, 66-68, 97, 103, 208, 656 Skinner, B. F., 117, 275, 442-449, 455, 671 application of his principles, 448 attitude toward theory, 448 Chomsky's review of Verbal Behavior, 616 functional analysis of behavior, 444 importance of the environment, 446 influence on psychology, 450 nature of reinforcement, 446 operant behavior, 445 positive control of behavior, 447 positivism, 444 sleep and dreams. See dreams Smith, L. D., 430, 433 Snow, C. P., 652, 653 social cognitive theory, 628 Social Contract, The (Rousseau), 210 Social Darwinism, 296, 332 Darwin's attitude towards, 297, 304 Wallace's opposition to, 299 Social interest, 561, 569 Sociobiological fallacy, 615 Sociobiology, 301, 613 evolutionary psychology versus, 614-616 Sociobiology: The New Synthesis (Wilson), 301, 616 sociocultural determinism, 15, 28 sociology, 170, 178

Nagoshi, C. T., 306 Neimeyer, G. J., 584 Neimeyer, R. A., 584 Neisser, U., 326, 627, 634, 635 Newell, A., 625, 632 Newton, I., 112–114, 128, 135, 233, 667 Niehues–Pröbsting, H., 210, 226 Nietzsche, F. W., 220–227, 230, 516, 576, 596, 669 Nisbett, R. E., 375 Nissen, H. W., 607 Norris, C., 656 North, J., 469

Occam's razor, 91, 97, 113 O'Connor, E., 69, 70 O'Donnell, J. M., 246 O'Hara, R., 352 Olds, J., 610 Olson, M. H., 431, 437, 442, 473, 475, 555, 557, 564, 565, 582, 617, 628 O'Sullivan, J. J., 651 Ovsiankina, M., 479

Paige, R. U., 650
Pals, J. F., 578
Papert, S., 637
Paracelsus, P., 495, 666
Parmenides, 33, 63
Paris, T., 564
Parker, A., 584
Park, N., 598
Parrish, C. S., 274
Patnoe, S., 477
Paul, Saint, 75–77, 97
Pavlov, I. P., 388–394, 396, 403, 422, 635, 669
Pearson, K., 394, 306, 332

Pearson, K., 394, 306, 332
Pendergrast. M., 544
Penfield, Wilder, 609
Pennebaker, J. W., 579
Perkins, D. T., 436
Perloff, R., 326
Perry, N. W., Jr., 651
Perry, R. B., 427
Peterson, C., 598
Peterson, D. R., 651
Peters, R. C., 132
Petrarch, F., 99, 128, 666
Phillips, L., 360, 362
Philo, 72, 97, 665
Piaget, J., 198, 624, 626, 627, 633, 671
Pico, G., 100, 128

Pickren, W. E., 361 Pillsbury, W., B., 385

Pinel, P., 496–498, 514, 667 Pinker, S., 633

Pitts, W., 635 Plater, F., 495

Plato, 21, 35, 45–49, 64, 71–74, 99, 665

Plomin, R., 619 Plotinus, 73, 97

Popkin, R. H., 104, 118
Popper, K., 9, 13, 22, 27, 32, 57, 58, 117,

660, 671 Porter, N., 335, 651 Powell, R. A., 542, 544 Prenzel–Guthrie, P., 438 Pribram, K. H., 626 Progoff, I., 558 Protagoras, 41, 64, 656, 665 Pruette, L., 354

Ptolemy, 105, 128 Puente, A. E., 612 Purkinje, J. E., 242 Pusey, E. B., 80, 81

Puységur, Marquis de, 506, 514 Pyrro of Elis, 67, 97, 665

Pythagoras, 34, 64

Quackelbeen, J., 509 Quevillon, R. P., 651 Quinlan, P., 636, 637, 638 Quitkin, F., 650

Rabinowitz, F. E., 577 Radice, B., 87, 88, 89 Rashotte, M. E., 450 Rayner, R., 402, 497 Reader, W., 615 Reed, J., 324 Rehm, L. P., 650 Reid, T., 189–192, 206, 667 Reisman, J. M., 650

Remnant, P., 185 Renouvier, C. B., 338 Reston, J., Jr., 111

Reston, J., Jr., 111 Rich, S., 618 Rieker, P. P., 542 Rifkin, A., 650 Rigdon, M. A., 584 Rilling, M., 408 Rimm, D. C., 449

Rimm, D. C., 449 Rivers, P., 584

Roazen, P., 538, 565 Robinson, D. N., 13, 16, 51, 84, 112, 131, 161, 169, 170, 171, 201, 213, 546,

Robinson, P. J., 584 Robinson, V., 41 Robins, R. W., 628, 644 Rockefeller, J. D., 296

Rodis-Lewis, G., 118 Roedinger, H. L., 627

Rogers, C. R., 590–598, 605, 624, 648, 671 Romanes, G. J., 370, 382, 669

Roochnik, D., 45, 656 Rosch, E., 658

Rosenbaum, M., 522 Rosenberg, C. R., 638 Rosenblatt, F., 637 Rosenhan, D. L., 503

Rosenthal, R., 281 Rosenzweig, S., 362, 530

Ross, David, 56

Ross, Dorothy, 354, 355, 358, 648 Ross, R. T., 436

Rousseau, J. J., 209–212, 231, 571, 667 Rubin, E. J., 468 Ruja, H., 437

Ruja, H., 43/ Rowe, F. B., 275 Rubins, J. L., 562 Royce, J. R., 12 Ruiz, T. F., 494 Rumelhart, D. E., 636, 637 Rummel, E., 100 Rush, B., 498, 514, 667 Russell, Bertrand, 32, 34, 37, 67, 68, 70, 71,

73, 74, 168, 199, 200, 201, 209, 210, 410, 660

Russell, J. B., 494 Rutherford, A., 408 Rychlak, J., 12

Sadler, J. Z., 499 Sahakian, W. S., 224, 335, 336 Saint–Simone, H. de, 168 Samelson, F., 315, 376, 324, 401 Sammons, M. T., 650

Sand, R., 527 Sanford, E. C., 351 Santayana, G., 6, 340, 352 Sargent, S. S., 371 Sartain, J., 469 Sartre, I.–P., 596

Sawyer, T. E., 359 Scarborough, E., 244, 274, 351, 353

Scarre, C., 78 Schatzman, M., 541, 542 Schlien, J. M., 595 Schmidt, H., 189, 338 Schmied, L. A., 500 Schmit, D., 506

Schneider, K. J., 208, 580, 659 Schopenhauer, Arthur, 213–216, 516, 667

Schuker, E., 542 Schwartz, B., 15 Schwartz, J., 650 Schwartz, J. E., 320 Schwartz, M. A., 499 Scot, R., 495 Scott, D. M., 362

Scruton, R., 181, 183, 193, 194, 195

Seagal, J. D., 479

Searle, J. B., 629, 638, 642 Sears, R. R., 320

Sechenov, I. M., 385-388, 422, 668 Segal, H., 553

Segal, H., 553 Segal, N. L., 618 Sejnowski, T. J., 638

Selesnick, S. T., 83, 84, 181, 184, 491, 493, 495, 499

Seligman, M. E. P., 596, 598, 617 Semmes, J., 608

Servetus, M., 107 Seward, J. P., 432 Shackelford, T. K., 615 Shannon, C. E., 625 Shapiro, A. E., 651 Sharp, S. E., 310 Shaw, J. C., 632 Shields, S. A., 322 Simon, H. A., 625, 632

Simon, Theodore, 310–312, 332 Singer, J. A., 579

Singer, P., 199 Sirkin, M., 524

Skinner, B. F., 117, 275, 376, 442-449, 455, 616, 671 Smith, B., 280, 457 Smith, L. D., 270, 429, 430, 433, 444, 459 Smith, M. B., 656, 659 Smith, P., 103 Smith, S., 83 Snow, C. P., 652, 653 Snyder, C. R., 598 Socrates, 44, 64 Sokal, M. M., 307, 354, 481 Spearman, C., 313, 332, 669 Spence, J. T., 651 Spence, K. W., 437, 473, 474 Spencer, H., 294-297, 332, 668 Sperry, R. W., 16, 18, 610-612, 622, 628, 671 Spillman, J., and Spillman, L., 350 Spinoza, Baruch, 181-185, 206, 631, 667 Springer, S. P., 611 Spurzheim, J. K., 245-247, 261 Sprenger, I., 493, 494, 666 Sprung, H. and Sprung, L., 280 Staats, A. W., 12, 654 Stachnik, T., 449 Stafford, K. R., 371 Stanovich, K. E., 545 Staudinger, U. M., 598 Steen, T. A., 598 Steinberg, E., 144, 145, 146, 147, 148, 149 Steinberg, H., 500 Steiner, R., 554 Sternberg, R. J., 326, 644, 655, 659 Stephenson, W., 592

Steiner, R., 554
Sternberg, R. J., 326, 644, 655, 65'
Stephenson, W., 592
Stern, William, 312, 332, 670
Stevens, S. S., 425, 426
Stewart, D., 335
Stocking, G. S., Jr., 2
Storr, A., 524
Strange, R., 469
Stratton, G. M., 459
Stricker, G., 651
Stroll, A., 658

Stumpf, C., 280, 292, 458 Sulloway, F. J., 522, 527, 528, 539 Summers, M., 493

Sumner, F. C., 358–360, 383

Sutich, A. J., 590 Sykes, E. A. B., 500 Szasz, T. S., 487, 503, 659

Szuba, M., 650

Tanner, M., 221
Taub, L. C., 106
Taylor, C. C. W., 45
Taylor, R., 8, 20
Teixeria, M. A., 650
Tellengen, A., 618, 619
Temkin, D. 321, 324, 325, 333, 670
Thagard, P., 634
Thales, 31, 64, 665
Thomas Aquinas, Saint, 89–91, 96, 103, 666
Thomas, M. C., 357
Thomas, R. K., 390
Thorndike, E. L., 369–376, 383, 385, 393,

Tibbets, P., 122 Tillich, Paul, 577 Tinbergen, N., 613 Titchener, E. B., 272-278, 284, 292, 293, 337, 354, 400, 401, 402, 647, 669 Tolman, E. C., 426-433, 436, 449, 455, 624, 628, 670 Tomes, H., 361 Tomlinson-Keasey, C., 320 Toulmin, S., 426 Treash, G., 85, 195 Trevor-Roper, H. R., 494 Trierweiler, S. J., 651 Tryon, R. C., 433 Tryon, W. W., 639 Tucker, J. S., 320

Tucker, W. H., 315 Tuck, R., 134 Tuke, D. H., 497 Tuke, W., 497 Turing, A. M., 629 Turner, R. S., 241 Tweney, R. D., 271

Ulrich, R., 449 Ungerer, G. A., 265 Urbach, P., 117 Urban, W. J., 325 Urbina, S., 326 Ussher, J., 300

Wagner, Richard, 226

Weber, E., 386

Weber, I., 221

Weber, E. H., 251, 261, 667

Vaihinger, H., 285, 292, 346, 582, 669 Van den Haag, E., 361 Vander Bos, G. R., 650 Van Loon, R. J. P., 582 Vatz, R. E., 487 Vaughan, M. E., 449 Viner, R., 554 Viney, W., 373, 498, 584 Vives, J. L., 104 Voeks, V. W., 441 Voltaire, 135, 188

Wakefield, J. C., 615, 651 Wallace, A. R., 299, 333 Wallace, R. A., 613 Waller, N. G., 619 Walter, H.-J., 460 Washburn, M. F., 274, 373, 383, 670 Washington, B. T., 359 Waterfield, R., 30, 31, 33, 37, 38, 41, 42, 43, Watson, J. B., 273, 365, 397-412, 415-417. 422, 427, 428, 436, 450, 497, 585, Watson, J. S., 69-70 Watson, R. I., 82, 99, 184-185, 235, 353, 354, 510 Watson, R. R., 409 Watson, Rosalie, 409 Watts, R. E., 561 Weaver, W., 625

Webster, R., 509, 540, 542 Weidman, N. 326 Weinberg, L. S., 487 Wernicke, C., 249, 261 Welsch, U., 221 Wentworth, P. A., 352 Wertheimer, Max, 457, 459, 463, 474, 485, 585, 670 Wertheimer, Michael, 266, 354, 460, 465, 466, 597, 627 Weyer, I., 495 White, M., 579 White, R. K., 480 Wiener, Norbert, 625, 670 Wiggins, J. G., Jr., 651 Wiggins, O. P., 499 Wilcocks, R., 542 Wilcox, K. J., 618 Wilken, R. L., 77, 78 William of Occam, 91, 97, 666 Williams, M., 542 Williams, R. E., 651 Wilson, C., 584 Wilson, E. O., 301, 613, 614, 654 Wilson, G. T., 449 Wilson, J., 101 Wilson, T. W., 354 Windholz, G., 388, 389 Wingard, D. L., 320 Winter, E. F., 100, 102, 103 Wissler, C., 308 Witmer, L., 500-502, 514, 644, 647, 669 Wittels, F., 559 Wittgenstein, L., 541, 656-658, 664 Wokler, R., 210 Wolff, C., 189 Wolf, T. H., 309, 310, 318 Wolman, B. B., 192 Wood, K., 584 Woodworth, R. S., 368, 375, 383, 405, 437, 467, 669 Workman, L., 615 Wundt, W. M., 262-272, 292, 307, 337,

Xenophanes, 43, 65

644, 668

Yandell, K. E., 143, 144 Yaroshevski, M. G., 387 Yates, F. A., 107 Yerkes, R. M., 323–325, 333, 399, 427, 670 Yonge, C. D., 55 Young–Bruehl, E., 536, 552, 555 Young, T., 239 Youniss, J., 358 Yuen, S., 306

339, 340, 347, 375, 450, 456, 624,

Zaidel, D. W., 612 Zeigarnik, B., 479 Zeigarnik effect, 479, 485 Zenderland, L., 326 Zeno of Elea, 34 Zeno of Citium, 70, 97, 665 Zuckerman, M., 619 Zusne, L., 281, 493, 624

401, 428, 440, 445, 472, 585, 670

• W •

warm filter, 284 waterfall shots, 216 WB/Help/Protect button, 22 white balance adjusting through Shooting menu, 186 bracketing, 161, 196-198 changing settings, 185–188 color temperature, 186–187 control, 22 copying presets, 194-195 correcting colors with, 183-184 creating presets, 190-195 custom presets, 188 direct measurements, 190-191 fine-tuning settings, 188-189 fluorescent bulb type, 187 managing presets, 194 matching to existing photos, 192–193 selecting preset, 193-194

settings, 186 still portraits, 210 Wide Area mode, 174 wide-angle lenses, 180 Windows Explorer, 230 Windows Vista, 227 Windows XP, 227

· X ·

XMP (Extensible Metadata Platform) format, 240 X-Rite, 258

• Z •

0F option, 198
zoom barrel, 14
zoom lenses, 14
zooming in/out, 87–89, 181, 218

Single Frame mode, 56 single-lens reflex (SLR) cameras, 10 single-servo autofocus (AF-S) mode, 171 skin tones, 51 skylight filter, 284 slide show changing displayed information, 269 exiting, 269 overview, 267 pausing, 269 Pictmotion, 269-271 setting up, 268 skipping to next/previous image, 269 slow sync flash mode, 46, 149-151 slow-sync with rear-curtain sync flash, 151 slow-sync with red-eye reduction flash, 151 SLR (single-lens reflex) cameras, 10 Small Picture feature, 262–264 sound recording, 111 Speedlight SB-600 flash, 210 Sports mode. See also Digital Vari-program modes autofocusing, 53 flash, 54 settings, 45 shutter speed, 53 spot metering, 135-136, 307 sRGB color mode, 198-200 SSC filename, 91, 277 standard definition, 272 starburst effect, 291-293 still portraits background, 209 flash, 208-209, 210 framing subject, 211 indoor, 207-208 outdoor, 208-209 shooting, 207–209 white balance, 210 Straighten tool, 279-280 Sub-command dial, 24 sunrise/sunset shots, 216

• T •

telephoto lenses, 51, 180 television, viewing photos on, 271–272

35mm equivalent focal lengths, 180 3F option, 198 Through the Lens (TTL), 46–47, 146-147, 155 thumbnails, multiple, 84-85 TIFF format, 71, 243-244, 248-250 time, 33, 91-92 Timers/AE Lock, 36 tonal range Active D-Lighting, 143-145 brightness histogram, 93 topside controls, 19-20. See also external controls Transfer software. See Nikon Transfer software Trim function, 293-295 tripod, 215–216 TTL (Through the Lens), 46–47, 146–147, two-button reset method, 40 Type C cable, 271

• U •

USB ports, 226

vibration reduction (VR) lenses. See Nikkor 18-105mm AF-S lens video formats, 111 Video mode, 33, 282 viewfinder adjusting focus, 15, 164 grid display, 36 viewing camera settings, 30 warning display, 37 viewing images in Calendar display mode, 86-87 multiple images, 84-85 in Playback mode, 82-84 zooming in, 87-89 ViewNX software. See Nikon ViewNX software vivid color, 201 VR (vibration reduction) lenses. See Nikkor 18-105mm AF-S lens

Retouch menu (continued)
Image Overlay option, 310
Monochrome option, 287–289
Quick Retouch filter, 282–284
Red-Eye Correction filter, 278–279
Side-by-side comparison, 276–277
Straighten tool, 279–280
Trim function, 293–295
RGB format, 94
RGB Histogram mode, 92–94

S (shutter-priority autoexposure) mode, 126, 130, 140, 212 screen display size, 64 Screen Tips labels, 37 SD (Secure Digital) card, 16 self-serve print kiosks, 252 Self-Timer mode, 56, 57 sensor, cleaning, 32, 61, 75–76 sepia effect, 285-287 Setup menu Auto Image Rotation option, 33 Battery Info, 34 Clean Image Sensor command, 32 Eye-Fi upload, 34 firmware version, 34 Format Memory Card command, 32 GPS, 34 HDMI, 33 Image Dust Off Ref Photo feature, 33 Language, 33 LCD Brightness option, 32 Lock Mirror Up for Cleaning, 32 opening, 31 Video Mode, 33 World Time, 33 Shadow Protection option, 247 shadows, 281-282 sharpening, 201 Shooting Data display mode, 95–96 Shooting Information display, 28–30, 37-38, 46-47 shooting settings, monitoring battery status indicator, 30

Control panel, 28

pictures remaining, 30

Shooting Information display, 28–30 viewfinder, 30 shooting techniques action shots, 211-214 close-up shots, 217–219 fireworks, 220 landscape, 214–217 reflective surfaces, 220-221 shooting out car window, 220 shooting through glass, 219–220 still portraits, 206-211 Shooting/Display submenu beep, 36 Exposure Delay mode, 39 File Number Sequence, 37–38 Flash warning, 39 ISO Display and Adjustment, 37 LCD Illumination option, 38 MB-D80 Battery Type option, 39 Screen Tips labels, 37 Shooting Information display, 38 Viewfinder grid display, 36 Viewfinder warning display, 37 Short Edge text box, 266 Shots Remaining value, 17 shutter button continuous low mode, 55 delayed remote, 56 overview, 19 quick response remote, 56 self-timer, 56 single frame, 55 shutter speed. See also focal length action shots, 212 adjusting, 129-130 close-up shots, 218 continuous high mode, 56 flash timing, 149 focusing, 45 ISO and, 123 manual exposure, 130 motion blur, 121–122 overview, 119 shutter-priority autoexposure, 130 Sports mode, 53 Shutterfly, 230, 264 shutter-priority autoexposure (S) mode, 126, 130, 140, 212

focusing points, 43 overview, 49 Release Mode options, 44 settings, 42 taking pictures in, 43-44 Portrait mode. See also Digital Variprogram modes autofocusing, 51 depth of field, 51, 182 flash, 51 settings, 45 skin tones, 51 portrait orientation, 80 portrait photography background, 209 framing subject, 211 indoor, 207-208 outdoor, 208-209 shooting, 207-209 using flash, 208-209, 210 white balance, 210 ports, 226, 228 posterization, 72 ppi (pixels per inch), 63-64 print proportions, 256–257 print quality, 63–64 printer cartridges, 259 printer software, paper setting in, 259 printing DPOF technology, 257 PictBridge technology, 257 print proportions, 256–257 print size, 253-254 resolution, 253-254 retail, 252 syncing monitor colors, 258–260 programmed autoexposure (P) mode, 126, 129-130, 140 Protect status, 90 protecting photos, 104-105

Qual (Quality)/Playback Zoom In button, 23 Quick Adjustment panel, 247–248 Quick Response Remote mode, 56 Quick Retouch filter, 282–284

Rank Items option, 302 rapid-fire shooting, 213 Raw (NEF) format. See NEF (Raw) format raw converter, 72 rear-curtain Sync flash mode, 46, 151 rear-sync flash, 46, 151 recordable DVDs, 230 Red-Eye Correction filter, 278–279 red-eye reduction flash mode, 46, 148-149 reflective surfaces, shooting, 220-221 Release mode button, 20 changing modes, 57 continuous high, 56 continuous low. 55 delayed remote, 56 displaying current mode, 57 point-and-shoot mode, 44 quick response remote, 56 self-timer, 56 single frame, 55 remote control modes, 56-57 Remote On Duration option, 57 repeating flash, 155 Reset command, 39-40 resolution choosing, 67 definition, 62 file size, 64-65 high-speed shooting, 67 overview, 67 print quality, 63-64 print size, 253-254 recommendations, 66-67 screen display size, 64 retail printing, 252 retouch indicator, 90 Retouch menu Color Balance tool, 285-287 Cross Screen filter, 291–293 displaying, 276 Distortion Control filter, 289-291 D-Lighting filter, 281–282 filenames, 277 Filter Effects color tools, 284–285

No Memory Card option, 39 no memory card warning, 37 noise, 61, 122–124, 134 nonrewritable CDs, 230 Normal Area mode, 174 NTSC video standard, 33

online photo-sharing sites, 230, 252, 264 online printing services, 252 On/Off/Illuminate switch, 19 operating system, 227 optical stabilization. See Nikkor 18–105mm AF-S lens orientation, 80–81 outdoor portraits, 208–209 Overview Data mode, 97–98

. p .

P (programmed autoexposure) mode, 126, 129–130, 140 P* symbol, 130 PAL video standard, 33 Pantone, 258 paper setting, 259 Photo Information modes File Information, 90–92 GPS Data, 97 Highlight display, 94–95 overview, 89 Overview Data, 97-98 RGB Histogram, 92-94 Shooting Data display, 95–96 photo paper, 260 photos annotating, 293–295 creating custom folders, 302-304 cropping, 293-295 deleting, 101–103 hiding during playback, 99-101 metadata, 238-240 organizing, 240–241 protecting, 104-105 storing, 230

photo-sharing sites, 230, 252, 264

Photoshop Elements, 229, 243 Pic Meter value, 34 Picasa, 229, 264 PictBridge, 257 Pictmotion. See also slide show adjusting music volume, 269-271 creating, 269-271 exiting playback, 282 pausing/resuming playback, 282 Picture Controls landscape, 202 monochrome, 201-202 neutral, 201 overview, 200-201 portrait orientation, 202 standard, 201 vivid, 201 picture files. See files picture quality color cast, 61 file format, 68–75 image size, 75-76 JPEG artifacts, 61 lens/sensor dirt, 61 noise, 61 pixelation, 61 problems, 60-62 resolution, 62-67 settings, 75-76, 92 pincushion distortion, 289 pixelation, 61, 254 pixels definition, 62 dimensions, 63 file size, 64-66 print quality, 63-64 screen display size, 64 pixels per inch (ppi), 63–64 Playback button, 22 point-and-shoot photography autoexposure meter, 43-44 autofocusing, 45, 48 color, 48 exposure, 48 exposure metering mode, 133 flash modes, 48 Flash options, 44

fine-tune optimal exposure, 137–138 icon, 137 matrix, 135 overview, 134-135 spot, 135–136 Metering Mode button, 20 Microsoft Windows Explorer, 230 Microsoft Windows Vista, 227 Microsoft Windows XP, 227 mireds, 189 mirror lock-up, 32-33 Mode dial, 20 modeling flash, 156, 182 monitor automatic picture rotation, 80-81 automatic shutdown, 36 brightness, 32, 114 calendar view, 85-87 calibrating, 258 file information mode, 90–92 GPS data mode, 97 instant review, 81-82 Live View, 105-114 multiple images, 84–85 overview data mode, 97–98 playback mode, 82–83 RGB histogram mode, 92-95 shooting data display mode, 95-96 zooming in, 87-89 Monitor Off Delay item, 36 monochrome, 201-202 Monochrome option, 285–287 motion blur, 121-122 mounting index, 10 movie recording exposure, 111 file size, 110 focusing, 111 frame rate, 111 maximum length, 110 quality, 110 sound recording, 111 steps in, 112–113 video format, 111 Multi Selector/OK button, 21, 27 multi-image exposure, 310–311 Multiple Exposure (Shooting menu) option, 310

multiple images, viewing, 84–85 My Menu menu, 300–302, 307

NEF (Raw) + JPEG Fine setting, 66, 74–75

• N •

NEF (Raw) + JPEG setting, 74-75 NEF (Raw) format advantages of, 72 bit depth, 72 creative control in, 72 disadvantages of, 72–73 file size, 66, 73 function button, 307 in-camera processing, 242, 244-246 overview, 242 processing, 72–73, 242–243, 247–250 Raw shooting options, 74 resolution, 63 third-party conversion tools, 243-244 neutral density filter, 216 Night Portrait mode, 54–55 nighttime city pics, 216–217 Nikkor 18–105mm AF-S lens autofocusing, 42–43 focusing, 45 overview, 12–13 shutter speed, 122 switching on, 164 Nikon Camera Control Pro software, 242 Nikon Capture NX 2 software, 73, 243 Nikon Speedlight SB-600 flash, 210 Nikon Transfer software downloading photos with, 229, 231-235 overview, 231 preferences, 234–235 renaming files during download, 234 Nikon ViewNX software browsing images with, 235-238 downsizing images with, 265-267 full screen, 237-238 image viewer, 237 organizing pictures in, 240–241 overview, 231 processing Raw (NEF) files in, 242, 247–250 thumbnail grid, 236 viewing comments in, 299 viewing picture metadata in, 238-240

landscape photography
bracketing, 217
bulb mode, 217
ISO setting, 216
magic hours, 217
A mode, 215
nighttime city shots, 216–217
overview, 214
sunrise or sunset shots, 216
tripod, 215–216
waterfall shots, 216
language, 33
large files, disadvantages of, 65
Lastolite, 221
Launch Utility button, 247
LCD Brightness option, 32
LCD Illumination option, 38
lenses. See also Nikkor 18–105mm AF-S lens
attaching, 10–11
autofocusing, 13
changing, 11
dirty, 61, 77
distortion, 289–291
fisheye, 289–291
manual focusing, 13–14
minimum-close focusing distance, 217
removing, 12
setting focus mode, 13–14
telephoto, 180
wide-angle, 180
zooming in and out, 14
Lens-release button, 12, 24
Live View (Lv) button, 21
Live View mode
autofocusing in, 173–176
customizing display, 113–114
disadvantages of, 107
establishing exposure metering mode, 106
framing guides, 114
manual focusing, 106
overview, 105
recording movies in, 110–113
shooting information, 113–114
taking pictures in, 107–110
using for extended period, 106
when to use, 107
Long Edge text box, 266
Long Exposure Noise Reduction option, 134

long lenses, 106, 180 lossy compression, 68, 71, 243, 248 low battery warning, 37 Lv (Live View) button, 21 LZW Compression option, 249

• M •

M (manual exposure) mode, 127, 130 Mac OS X 10 operating system, 227 macro lenses, 219 magic hour, 217 magnification factor, 180 Main command dial, 20 manual exposure (M) mode, 127, 130 manual flash, 155 manual focusing, 165, 213 manual-focus lenses, 164 matrix metering, 135, 307 MB-D80 Battery Type option, 39 memory buffer, 49 memory cards capacity, 66 formatting, 17–18, 32, 104 handling, 18 high-speed, 16 inserting, 18 locking, 18 overview, 16 preventing shooting without, 39 reader, 226-227 removing, 18 risks, 230 slot, 226 Menu button, 22, 26-27 menus accessing recent items, 28 adjusting functions on, 27 changing order of options, 302 custom, 28, 300-302 overview, 26 removing items, 302 selecting, 27 metadata, 238-240 metering mode best practice in, 137 center-weighted, 135

Hi/Lo settings, 133
image noise, 122–124
overview, 120, 130–131
settings, 132–133
shutter speed, 123
ISO Display and Adjustment item
Off (Show Frame Count) option, 131–132
overview, 37
Show ISO Sensitivity option, 132
Show ISO/Easy ISO option, 132
ISO/Playback Zoom Out/Thumbnail button, 22–23
i-TTL (intelligent-Through the Lens), 46–47

• 7 •

JPEG Basic setting, 66, 69 JPEG Fine setting, 66, 69, 75 JPEG format artifacts, 61, 71 bit depth, 72 file size, 68 lossy compression in, 71 saving files as, 71 settings, 69–71 usability, 68 JPEG Normal setting, 66, 69

• K •

kit lens. *See* Nikkor 18–105mm AF-S lens Kodak Gallery site, 230, 264

. [.

Landscape mode. See also Digital Variprogram modes autofocusing, 52 color, 52 contrast, 52 depth of field, 52, 183 flash, 52 settings, 45 using, 215 landscape orientation, 80

Flash Compensation feature, 146, 151 flash memory keys, 230 flash modes fill flash, 147 front-curtain sync, 149 overview, 46–47 rear-curtain sync, 46, 151 rear-sync, 46, 151 red-eye reduction, 148-149 setting, 146-147 slow-sync, 46, 149-151 slow-sync with rear-curtain sync, 151 slow-sync with red-eye reduction, 151 Flash Off setting, 307 Flash/Flash compensation, 23 focal length. See also aperture; lenses 35mm equivalent, 180 depth of field, 177-178 overview, 180 zoom ring, 14 focus lamp, 44 Focus Selector Lock switch, 22, 169 focusing. See also autofocusing aperture setting, 45 autofocus mode, 166-176 basics, 164-166 factors, 45 manual, 165, 213 movie recording, 111 shutter speed, 45 switching modes, 164 vibration reduction, 164 viewfinder, 164 focusing points, 43 focusing ring, 14 folders creating, 240 custom, 302-304 displaying contents of, 240 hiding contents of, 240 moving files, 240 naming, 91, 304 force flash, 147 Format Memory Card command, 17–18, 32 formatting memory cards, 17-18, 32, 104 frame number/total pictures information, 90 frame rate, 111

Framing Grid option, 307
framing guides, displaying, 114
front-curtain sync flash, 149
front-left buttons, 23–24. See also external controls
front-right controls, 24. See also external controls
f-stop, 45, 118–119, 125, 177. See also aperture
Function button, 24, 306–307
Fv (flash value) Lock option, 154, 307–308

GPS (Global Positioning System), 34 GPS Data mode, 97 grain, 122 grayscale images, 201

hard drives, 230 HDMI (High-Definition Multimedia Interface) device, 33, 114, 271, 272 Help screen, 31 Hide Image option, 100–101 hiding photos by dates, 100 individual images, 100 overview, 99 redisplaying hidden photos, 101 High ISO Noise Reduction option, 134 high-bit images, 244 High Definition Multimedia Interface (HDMI) device, 33, 114, 271, 272 Highlight display mode, 94-95 Highlight Protection option, 247 highlights, 94-95 high-speed memory cards, 16 histograms, 92-94 hot shoe, 156

Image Comment feature, 297–299 Image Dust Off Ref Photo feature, 33 image noise, 61, 122–124, 134

multi-image, 310–311 protect status, 90 retouch indicator, 90 shutter speed, 121-122 exposure compensation File Number Sequence option, 37–38, 40 adjusting, 141 applying, 139 image quality, 66, 75–76 easy, 141 movie recording, 110 pixels, 64-65 settings, 138, 141 problems with large files, 65 stops, 138, 141 settings, 75-76 tips, 140 filenames, 91 Exposure Compensation button, 20, 40 Exposure Delay mode, 39 files exposure meter, 127–128 annotating, 293–295 cropping, 293-295 exposure metering mode. See metering custom folders, 302-304 mode exposure value (EV), 138, 152 deleting, 101-103, 241 hiding during playback, 99-101 Extensible Metadata Platform (XMP) metadata, 238-240 format, 240 external controls organizing, 240-241 back-of-the-body, 20-23 protecting, 104-105 selecting, 241 customizing, 305-309 front-left, 23-24 storing, 230 fill flash mode, 46, 147 front-right, 24 Function button, assigning duties to, Filter Effects color tools, 284–285 fireworks, shooting, 220 306-307 OK button, changing function of, 305–306 firmware, 34 on/off switch, adjusting, 305 fisheye filter, 291 flash overview, 18-19 topside, 19-20 adjusting output, 151–153 external flash, 156-157 Auto mode, 48 Close Up mode, 54, 218 Eye-Fi SD cards, 16, 34 commander mode, 155 Eye-Fi upload item, 34 Digital Vari-program modes, 50 disabling, 156 external, 156-157 Landscape mode, 52 Face Detection symbol, 88 locking exposure on subject, 154 Face Priority mode, 174 manual mode, 155 file format modeling, 156, 182 definition, 68 modes, 46-47, 145-151 JPEG, 68-71 in point-and-shoot mode, 44 NEF (Raw), 71–76, 242–250 Portrait mode, 51 File Information mode repeating flash mode, 155 date and time, 91 shutter speed and, 149 filenames, 91 Sports mode, 54 folder names, 91

timing, 149

warning, 39

Flash button, 46

frame number/total pictures, 90

image quality, 92

image size, 92

custom folder, creating, 302–304
custom menu, creating, 28, 300–302
Custom Setting menu
adjusting automatic monitor shutdown, 35
browsing, 35
overview, 35
preventing shooting without memory
card, 39
Reset command, 39–40
restoring default settings, 39–40
shooting and display options, 36–39
cyanotype effect, 285–287

date, 33, 91-92 default settings, restoring, 39-40 Delayed Remote mode, 56 Delete button, 22 deleting photos all photos, 102 batch of selected photos, 102-103, 258 versus formatting, 104 one image at a time, 101–102 depth of field aperture setting, 120-121, 177 camera-to-subject distance, 178 Close Up mode, 54, 182, 218 defined, 45, 176 Landscape mode, 52, 183 large, 176 lens focal length, 177-178 maximum, 179 A mode, 181-182 overview, 176-177 Portrait mode, 51, 182 preview button, 181–182 shallow/small, 176, 179 Depth-of-Field Preview button, 24 digital lens filters, 284-285 Digital Print Order Format (DPOF), 257 digital slide show changing displayed information, 269 exiting, 269 overview, 267 pausing, 269 Pictmotion, 269–271

setting up, 268 skipping to next/previous image, 269 Digital Vari-program modes aperture settings, 45 Auto Flash Off, 50 Close Up, 54 Landscape, 52 limitations, 50 Night Portrait, 54-55 overview, 50 Portrait, 50-51 Sports, 53-54 diopter adjustment control, 15 diopters, 219 dirt, removing, 61, 77 Display Calibration Assistant, 258–259 Distortion Control filter, 289–291 D-Lighting filter, 281-282 D-Lighting HS option, 247 downsampling, 261 dpi (dots per inch), 63-64 DPOF (Digital Print Order Format), 257 drop-off printing services, 252 DSC filename, 91

• E •

18-105mm VR lens. See Nikkor 18-105mm AF-S lens e-mailing pictures creating small copies for, 262-264 downsizing images, 265–267 overview, 260-262 problems with large files, 260-261 size recommendation, 261 EV (exposure value), 138, 152 exposure advanced exposure modes, 126–127 aperture setting, 120-121 Auto mode, 48 balancing, 124-125 bracketing, 158-161 Digital Vari-program modes, 50 image overlay, 310-311 ISO, 122-124 locking, 141-143 movie recording, 111

Calendar view, 84-85 calibration utility, 258 camera auto image rotation, 33 battery info, 34 connecting to computer, 227-228 controls, 19-24 e-mailable copies of images, creating, 262-264 firmware version, 34 formatting memory card, 32 GPS tracking, 34 help screen, 31 image comment, 33 image dust off feature, 33 image sensor, cleaning, 32 language, 33 LCD brightness, 32 menus, 26-28 mirror, locking up for cleaning, 32–33 video mode, 33 world time, 33 Camera Control Pro software, 242 Capture NX 2 software, 73, 243 card reader, 226-227 Center Focus Point option, 307 center-weighted metering, 135, 307 channels, 72, 94 circular polarizing filter, 220 Clean Image Sensor command, 32, 77 clipped highlights, 94 clock, 33 Close Up mode. See also Digital Variprogram modes autofocusing, 54 depth of field, 54, 182 flash, 54 using, 218 close-up shots depth of field, 218 flash, 218 indoor, 219 macro lens, 219

minimum close-focusing distance of lens, 217 A mode, 218 shutter speed, 218 zooming in/out, 218 Cloud Dome, 221 CLS (Creative Lighting System), 157 color Auto mode, 48 balance, 285-287 converting to monochrome, 286-289 correcting with white balance, 183-184 digital lens filters, 284–285 Digital Vari-program modes, 50 Landscape mode, 52 overview, 183 Picture Controls, 200-203 Color Booster slider, 247 color cast, 61 color intensifiers, 284 color management controls, 260 color space, 198-200, 250 color temperature, 183, 186-187 colorimeter, 258 command dials, customizing, 309 commander mode, 155 Compression Ratio slider, 266 computers connecting camera to, 227-228 controlling camera by, 242 memory card slot, 226 monitor, calibrating, 258 operating system, 227 transferring photos to, 228–230 USB port, 226 Continuous High mode, 56 Continuous Low mode, 55 continuous-servo autofocus (AF-C) mode, 171 contrast, 52 Control panel, 19, 28 Creative Lighting System (CLS), 157 crop factor, 180 cropping, 293-295 Cross Screen filter, 291–293 CSC filename, 91, 277

Autofocus mode selecting, 47 adjusting, 172 settings, 42 AF-A mode, 171 AF-C mode, 171 AF-S (single-servo autofocus), 171 settings, 172 autofocus-assist (AF-assist) illuminator, AVI format, 111 autofocusing. See also focusing AF-A mode, 171 · 13 · AF-area mode, 166–171 AF-C mode, 171 AF-S mode, 171 backlight, 38 Auto mode, 45, 48-49 choosing combinations, 172 Close Up mode, 54 banding, 72 Landscape mode, 52 Live View mode, 173–176 locking, 173 battery moving subjects, 172 overview, 45 level, 227 Portrait mode, 51 setting, 13, 165 Sports mode, 53 bit depth, 72 still subjects, 172 autofocus/manual (AF/M) switch, 24 autofocus-silent wave (AF-S) lenses, 13, 164. See also Nikkor 18-105mm AF-S lens Auto/Manual focus switches, 14 automatic exposure modes Auto Flash Off, 50 Auto, 42-45, 48-50 autoexposure meter, 43-44 autotocusing, 45, 48 Close Up, 54 color, 48 options, 160 Digital Vari-program, 49-55 exposure, 48 Flash options, 44, 46–47 focusing points, 43 Landscape, 52 Night Portrait, 54-55 buffer, 49 overview, 49 Portrait, 50-52 Release, 44, 55-57

selecting, 47 settings, 42 Sports, 53–54 taking pictures in, 43–44 automatic rotation, enabling, 80–81 auto-servo autofocus (AF-A) mode, 171 AV (audio/visual) port, 271 AVI format, 111

b2F option, 198 back-of-the-body controls, 20–23. See also external controls barrel distortion, 289 Bat Meter data, 34 information, 34 status indicator, 30 Battery Age readout, 34 BKT (Bracket) button, 24, 159-161 black-and-white warning, 37 blown highlights, 94 Bracket (BKT) button, 24, 159-161 bracketing. See also exposure +2F option, 160 -2F option, 160 3F option, 160 Active D-Lighting, 160 automatic, 158 disabling, 161 landscape photography, 217 overview, 158 progress indicators, 159 turning on, 158-159 white balance, 161, 196–198 Brightness histogram, 93 bulb mode, 119, 217 burst mode, 55

Index

Numerics

0F option, 198 3F option, 160, 198 18–105mm VR lens. *See* Nikkor 18-105mm AF-S lens 35mm equivalent focal lengths, 180

• A •

A (aperture-priority autoexposure) mode, 127, 130, 140, 181–182, 215, 218 a2F option, 198 ACR (Adobe Camera Raw) converter, 243 action shots. See also Sports mode continuous settings, 213 ISO setting, 212 manual focusing, 213 overview, 211 rapid-fire shooting, 213 shutter speed, 212 shutter-priority exposure, 212 Active D-Lighting, 143–145, 160 Active Folder screen, 304 Adobe Camera Raw (ACR) converter, 243 Adobe Photoshop Elements, 229, 243 Adobe RGB color mode, 198-200 advanced exposure modes, 126–127, 133 AE Lock (Hold) option, 308 AE Lock Only option, 308 AE/AF Lock option, 308 AE-L/AF-L button, 21, 141-143, 307-309 AF (autofocus) lenses, 13, 42, 164 AF Mode/Reset button, 20, 40 AF-A (auto-servo autofocus) mode, 171 AF-area mode 3D tracking, 168 auto area, 168 depth of field, 167 dynamic area, 167-168 function button, 307

overview, 166-167 setting, 168-170 single focus point, 170-171 AF-assist (autofocus-assist) lamp, 24, 43 AF-C (continuous-servo autofocus) mode, 171 AF/M (autofocus/manual) switch, 24 AF-ON option, 308 AF-S (autofocus-silent wave) lenses. 13. 164. See also Nikkor 18-105mm AF-S lens AF-S (single-servo autofocus) mode, 171 annotating images, 297-299 anti-shake. See Nikkor 18-105mm AF-S lens aperture. See also focal length adjusting, 129-130 depth of field, 120-121, 177 manual exposure, 130 A mode, 130 overview, 45, 118-119 aperture-priority autoexposure (A) mode. 127, 130, 140, 181-182, 215, 218 artifacts, 71 Assign Func. Button option, 306 audio/visual (AV) port, 271 Auto Flash mode, 46 Auto Flash Off mode, 50 Auto FP option, 157 Auto Image Rotation option, 33, 80–81 Auto mode autoexposure meter, 43-44 Autofocus options, 45, 48-49 color, 48 exposure, 48 Flash options, 44, 48 focusing points, 43 overview, 49 Release Mode options, 44 settings, 42 taking pictures in, 43–44 autoexposure meter, 43-44 autofocus (AF) lenses, 13, 42, 164

On the surface, both options sound kind of cool. The problem is that you can't control the opacity or positioning of the individual images in the combined photo. For example, you might assume that you could use this feature to create one of those old-fashioned "two views" portrait composites, with one area of the picture showing a frontal view of the subject and another showing a profile shot. But this really works well only if the background in both images is a solid color (black works well), and you compose your two shots so that the subjects don't overlap in the combined photo. Otherwise, you get the ghostly portrait effect like what you see in my example.

In the interest of reserving space in this book for features that I think you will find much more useful, I leave you to explore these two on your own. (The manual explains the steps involved in using each of them.) I think, however, that you'll find photo compositing much easier and much more flexible if you do the job in your photo editing software.

Two Roads to a Multi-Image Exposure

The D90 offers two features that enable you to merge two photographs into one:

- ✓ Multiple Exposure (Shooting menu): With this option, you can combine your next two or three shots. After you enable the option and take your shots, the camera merges them into one NEF (Raw) file. The three shots used to create the composite aren't recorded and saved separately.
- ✓ Image Overlay (Retouch menu): This option enables you to accomplish the same thing, but with two Raw images that already exist on the memory card. I used this option to combine a photo of a werewolf friend, shown on the top left in Figure 11-16, with a nighttime garden scene, shown on the top right. The result is the ghostly image shown beneath the two originals. Oooh, scary!

Figure 11-16: Image Overlay merges two Raw (NEF) photos into one.

After highlighting the option you want to use, press OK.

The information that I give in this book with regard to using autofocus and autoexposure assumes that you stick with the default setting. So if you change the button's function, remember to amend my instructions accordingly.

On a related note, my instructions also assume that the Shutter Release Button AE-L option, found on the Timers/AE Lock submenu of the Custom Setting menu, is set to its default, which is Off. At that setting, pressing the shutter button halfway locks focus but not exposure. If you turn the feature on, your half-press of the shutter button locks both focus and exposure.

Customizing the command dials

Okay, let me say up front that I present this option to you only in the interest of complete coverage of all your customization choices. But I really suggest that you do not take advantage of this particular feature, which enables you to change the function of the main command dial (on the back of the camera) and the subcommand dial (front of the camera). If you do, not only will the instructions in this book be off base, but so will all the instructions in the camera manual.

Not convinced? Well, you can explore the options by opening the Custom Setting menu, opening the Controls submenu, and then selecting the Customize Command Dials option. There, you find three settings, each of which controls a different aspect of how the command dials behave. Be sure to read about the many ramifications of each choice in the camera manual before you change any from their default settings, which are shown in Figure 11-15.

Figure 11-15: Just because you can customize the command dials doesn't mean you should.

Normally, autofocus and autoexposure are locked when you press the button, and they remain locked as long as you keep your finger on the button. But you can change the button's behavior. To access the available options, open the Custom Setting menu, navigate to the Controls submenu, press OK, and then highlight Assign AE-L/AF-L Button, as shown on the left in Figure 11-14. Press OK to display the options shown on the right in the figure.

Figure 11-14: You can set the AE-L/AF-L button to lock autoexposure only if you prefer.

The options produce these results:

- ✓ **AE/AF Lock:** This is the default setting. Focus and exposure remain locked as long as you press the button.
- ✓ AE Lock Only: Autoexposure is locked as long as you press the button; autofocus isn't affected. (You can still lock focus by pressing the shutter button halfway.)
- ✓ **AF Lock Only:** Focus remains locked as long as you press the button. Exposure isn't affected.
- ✓ AE Lock (Hold): This one locks exposure only with a single press of the button. The exposure lock remains in force until you press the button again or the exposure meters turn off.
- ✓ AF-ON: Pressing the button activates the camera's autofocus mechanism. If you choose this option, you can't lock autofocus by pressing the shutter button halfway.
- ✓ Fv Lock: If you don't have any use for the autofocus/autoexposure locking options, this choice may come in handy. You can set the button to instead lock the flash value, a feature explored in Chapter 5. You then can set the Fn button, which normally handles that Fv Lock, to some other operation. See the preceding section for details.

screen shown on the right in the figure. Here's a quick description of the possible settings. (Scroll the display to uncover the options at the end of the list, not shown in the figure.)

- Framing Grid: If you select this option, pressing the Fn button while rotating the main command dial toggles the viewfinder grid on and off. See Chapter 1 for more about the grid.
- ✓ AF-Area Mode: At this setting, you can press the button and rotate the main dial to change the AF-Area mode. Chapter 6 explains that option, which is related to autofocusing.
- Center Focus Point: Pressing the button while rotating the main command dial switches the center focus point option from the normal to wide area setting. Again, see Chapter 6 to find out more about that setting.
- FV Lock: This is the default setting; you press the button to lock the current flash exposure value. See Chapter 5 for more about flash.
- ✓ Flash Off: At this setting, you can temporarily disable the flash by pressing the Fn button as you press the shutter button. See Chapter 5 for more information about flash photography.
- ✓ Matrix Metering/Center-Weighted Metering/Spot Metering: These three options set the camera to the selected metering mode while the button is pressed. You can adjust the metering mode only in the P, S, A, and M exposure modes, so, naturally, the button relates only to those modes if you choose one of these settings. And the options are dimmed on the Assign Function Button list in any other modes. See Chapter 5 for an explanation of metering modes.
- Access Top Item in My Menu: If you create a custom menu, as explained earlier in this chapter, you can set the Fn button to display the menu and immediately highlight the first item on the menu.
- → NEF (RAW): This setting relates to the Image Quality option, introduced in Chapter 3. If you set that option to JPEG Basic, Fine, or Normal and then press the Fn button, the camera records two copies of the next pictures you shoot: a JPEG version plus a second image in the NEF format. Press the button again or turn off the camera to stop recording the NEF version.

After selecting the function you want to assign, press OK to lock in your choice.

Changing the function of the AE-L/AF-L button

Set just to the right of the viewfinder, the AE-L/AF-L button enables you to lock focus and exposure settings when you shoot in autoexposure and autofocus modes, as explored in Chapters 5 and 6.

Once again, you make the call via the Controls submenu of the Custom Setting menu. Highlight OK Button (Shooting Mode), as shown on the left in Figure 11-12, and press OK to display the three options shown on the right. Highlight your choice and press OK to wrap things up.

Figure 11-12: These options affect the result of pressing the OK button in shooting mode.

Assigning a duty to the Function button

Tucked away on the right-front side of the camera, just under the autofocus-assist lamp, the Function (Fn) button is set by default to activate the Fv Lock function (Flash Value Lock, detailed in Chapter 5). But if you don't use that function often, you may want to assign some other purpose to the button.

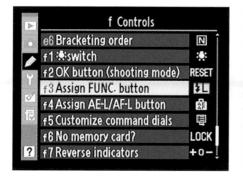

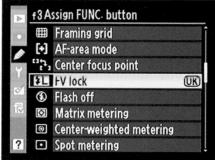

Figure 11-13: You can assign any number of jobs to the Function button.

You establish the button's behavior via the Assign Func. Button option, found on the Controls submenu of the Custom Setting menu and shown on the left in Figure 11-13. After highlighting the option, press OK to display the

Customizing External Controls

When your camera ships from the Nikon factory, the buttons and command dials are set up to work as described throughout this book. You can, however, assign different functions to three buttons, as well as to the two command dials. You can even alter the performance of the little switch on the On/Off button that lights up the control panel.

The next sections explore your options.

Adjusting the On/Off switch

Normally, rotating the power switch past On to the position marked by the little light bulb icon temporarily illuminates the control panel. But you also can use the switch to light up the control panel and bring up the Shooting Information display at the same time.

I personally don't see much benefit in making this change, seeing as how you can simply press the Info button to display the Shooting Information screen. But if you disagree, visit the Custom Setting menu, choose the Controls submenu, and press OK. Highlight the Switch option, as shown on the left in Figure 11-11, and press OK to display the second screen in the figure. Highlight the second option and press OK again.

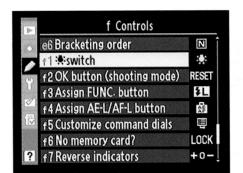

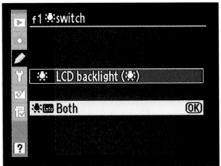

Figure 11-11: You can light up both the Control panel and Shooting Information screen with the On/Off switch.

Changing the function of the OK button

By default, pressing the OK button when you're in picture-taking mode automatically selects the center focus point. I think that's a fairly handy feature, but if you prefer, you can tell the camera that you instead want it to highlight the active focus point when you press the button. Or you can disable the button during shooting altogether. (It retains its normal function during picture playback and for choosing items from menus.)

Use these techniques:

- To enter a letter, highlight it by using the Multi Selector. Then
 press the Qual button.
- To move the text cursor, press and hold the ISO button and then press the Multi Selector in the direction you want to move the cursor.
- To delete a letter, place the cursor under it and press the Delete button.
- 5. After creating your folder name, press OK to complete the process and return to the Shooting menu.

The folder you just created is automatically selected as the active folder, as shown on the right in Figure 11-9.

If you take advantage of this option, remember to specify where you want your pictures stored each time you shoot: Select Active Folder from the Shooting menu and press OK to display the screen shown on the left in Figure 11-10. Highlight Select Folder and press the Multi Selector right to display a list of all your folders, as shown on the right. Highlight the folder that you want to use and press OK. Your choice also affects which images you can view in Playback mode; see Chapter 4 to find out how to select the folder you want to view.

Figure 11-10: Remember to specify where you want to store new images.

If necessary, you can rename a custom folder by using the Rename option on the Active Folder screen. (Refer to the left screen in Figure 11-10.) The Delete option on the same screen enables you to get rid of all empty folders on the memory card.

Whatever your folder-naming idea, you create custom folders like so:

1. Display the Shooting menu and highlight Active Folder, as shown on the left in Figure 11-8.

Figure 11-8: You can create custom folders to organize your images right on the camera.

- 2. Press OK to display the screen shown on the right in Figure 11-8.
- 3. Highlight New and press the Multi Selector right.

You see a keyboard-style screen similar to the one used to create image comments, as described at the start of the chapter. The folder-naming version appears on the left in Figure 11-9.

Figure 11-9: Folder names can contain up to five characters.

4. Enter a folder name up to five characters long.

You can reorder the menu items and remove items as follows:

- Change the order of menu options. Display your custom menu and highlight Rank Items, as shown on the left in Figure 11-7. You then see a screen that lists all your menu items in their current order. Highlight a menu item, as shown on the right in the figure, press OK, and then use the Multi Selector to move it up or down the list. Press OK to lock in the new position of the menu item. When you're happy with the order of the menu items, press the Multi Selector left to return to the My Menu screen.
- Remove menu items. Again, head for the My Menu screen. Select Remove Items and press the Multi Selector right. You see a list of all the current menu items, with an empty box next to each item. To remove an item, highlight it and press the Multi Selector right. A checkmark then appears in that item's box. After tagging all the items you want to remove, highlight Done and press OK.

Figure 11-7: Choose Rank Items to change the order of menu items.

Creating Custom Image Folders

By default, your camera initially stores all your images in one folder, which it names 100NCD90. Folders have a storage limit of 999 images; when you exceed that number, the camera creates a new folder, assigning a name that indicates the folder number — 101NCD90, 102NCD90, and so on.

If you choose, however, you can create your own, custom-named folders. For example, perhaps you sometimes use your camera for business and sometimes for personal use. To keep your images separate, you can set up one folder named DULL and one named FUN — or perhaps something less incriminating, such as WORK and HOME.

4. Highlight Add Items and press OK.

Now you see a list of the five main camera menus, as shown on the right in Figure 11-5.

5. Highlight a menu that contains an option you want to add to your custom menu and then press the Multi Selector right.

You see a list of all available options on that menu, as shown in Figure 11-6. (If you select the Custom Setting menu, you have to first select the submenu that contains the option you want to put on your menu.)

Figure 11-6: Highlight a menu item and press OK to add it to your custom menu.

A few items can't be added to a custom menu. A little box with a slash through it appears next to those items.

6. To add an item to your custom menu, highlight it and press OK.

Now you see the Choose Position screen, where you can change the order of your menu items. For now, just press OK to return to the My Menu screen; you can set up the order of your menu items later. (See the list following these steps.) The menu item you just added appears at the top of the My Menu screen.

7. Repeat Steps 4-6 to add more items to your menu.

When you get to Step 5, a check mark appears next to any item that's already on your menu.

After creating your custom menu, you can access it by pressing the Menu button and choosing the Recent Settings/My Menu screen. (If you want to switch to the Recent Settings menu, select Choose Tab to display the right screen shown in Figure 11-4 and then select Recent Settings.)

Creating Your Own Menu

Keeping track of how to access all of the D90's options can be a challenge, especially when it comes to those that you adjust through menus. To make things a little easier, you can build a custom menu that holds up to 20 of the options you use most frequently. Check it out:

1. Display the Recent Settings/My Menu menu, as shown on the left in Figure 11-4.

Figure 11-4: You can create a custom menu to hold up to 20 of the settings you access most often.

- 2. Scroll to the bottom of the menu, highlight Choose Tab, and press OK. You see the second screen shown in Figure 11-4.
- Highlight My Menu and press OK.
 The main My Menu screen appears, as shown on the left in Figure 11-5.

Figure 11-5: Select Add Items to add options to your custom menu.

To delete a letter, move the cursor under the offending letter and then press the Delete button.

7. To save the comment, press OK.

You're returned to the Image Comment menu.

8. Highlight Attach Comment and press the Multi Selector right to put a check mark in the box.

The check mark turns the Image Comment feature on.

9. Highlight Done and press OK to wrap things up.

You're returned to the Setup menu. The Image Comment menu item should now be set to On.

The camera applies your comment to all pictures you take after turning on Image Comment. To disable the feature, revisit the Image Comment menu, highlight Attach Comment, and press the Multi Selector right to toggle the check mark off.

To view comments in Nikon ViewNX, display the Metadata tab. (Click the tab on the left side of the program window.) Select an image by clicking its thumbnail. The Image Comment text appears in the File Info 2 section of the tab, as shown in Figure 11-3. (If the panel is closed, click the little triangle next to File Info 2.) See Chapter 8 for more details about using ViewNX.

Figure 11-3: Comments appear with other metadata in Nikon ViewNX.

in Nikon ViewNX, which ships free with your camera, or Capture NX 2, which you must buy separately. The comments also appear in some other photo programs that enable you to view metadata.

Here's how the Image Comment feature works:

1. Display the Setup menu and highlight Image Comment, as shown on the left in Figure 11-1.

Figure 11-1: You can tag pictures with text comments that you can view in Nikon ViewNX.

- 2. Press OK to display the right screen in the figure.
- 3. Highlight Input Comment and press the Multi Selector right.

Now you see a keyboard-type screen like the one shown in Figure 11-2.

- 4. Use the Multi Selector to highlight the first letter of the text you want to add.
- QUAL
- 5. Press the Qual button to enter that letter into the display box at the bottom of the screen.
- 6. Keep highlighting letters and pressing the Qual button to continue entering your comment.

Figure 11-2: Highlight a letter and press the Qual button to enter it into the comment box.

Your comment can be up to 36 characters long.

To move the text cursor, press and hold the ISO button as you press the Multi Selector in the direction you want to shift the cursor.

Ten Special-Purpose Features to Explore on a Rainy Day

In This Chapter

- ▶ Adding text comments to images
- Creating a custom menu and image-storage folder

- Changing the function of some controls
- Combining two (or three) photos into one

onsider this chapter the literary equivalent of the end of one of those late-night infomercial offers — the part where the host exclaims, "But wait! There's more!"

The ten features covered in these pages fit the category of "interesting bonus." They aren't the sort of features that drive people to choose one camera over another, and they may come in handy only for certain users, on certain occasions. Still, they're included at no extra charge with your camera purchase, so check 'em out when you have a few spare moments. Who knows; you may discover that one of these bonus features is actually a hidden gem that provides just the solution you need for one of your photography problems.

Annotate Your Images

Through the Image Comment feature on the Setup menu, you can add text comments to your picture files. Suppose, for example, that you're traveling on vacation and visiting a different destination every day. You can annotate all the pictures you take on a particular outing with the name of the location or attraction. You can then view the comments either

Now you see a screen similar to the one in Figure 10-21. The yellow highlight box indicates the current cropping frame. Anything outside the frame is set to be trimmed away.

Figure 10-21: You can crop to three different aspect ratios: 3:2, 4:3, or 5:4.

3. Rotate the main command dial to change the crop aspect ratio.

The selected aspect ratio appears in the upper-right corner of the screen, as shown in Figure 10-21.

4. Adjust the cropping frame size and placement as needed.

The current crop size appears in the upper-left corner of the screen. (Refer to Figure 10-21.) You can adjust the size and placement of the cropping frame like so:

- *Reduce the size of the cropping frame*. Press and release the ISO button. Each press of the button further reduces the crop size.
- Enlarge the cropping frame. Press the Qual button to expand the crop boundary and leave more of your image intact.
- *Reposition the cropping frame*. Press the Multi Selector up, down, right, and left to shift the frame position.

5. Press OK to trim the image.

Figure 10-20: Cropping creates a better composition and eliminates background clutter.

With the Trim function on the Retouch menu, you can crop a photo right in the camera. Note a few things about this feature:

- You can crop your photo to three different aspect ratios: 3:2, which maintains the original proportions and matches that of a 4 x 6-inch print; 4:3, the proportions of a standard computer monitor or television (that is, not a wide-screen model); and 5:4, which gives you the same proportions as an 8 x 10-inch print. If your purpose for cropping is to prepare your image for a frame size that doesn't match any of these aspect ratios, crop in your photo software instead.
- For each aspect ratio, you can choose from six crop sizes. The sizes are stated in pixel terms for example, if you select the 3:2 aspect ratio, you can crop the photo to measurements of 3424 x 2280 pixels, 2560 x 1704 pixels, 1920 x 1280 pixels, 1280 x 856 pixels, 960 x 640 pixels, and 640 x 424 pixels.
- After you apply the Trim function, you can't apply any other fixes from the Retouch menu. So make cropping the last of your retouching steps.

- 1. Display your photo in single-image view and press OK to launch the Retouch menu.
- 2. Highlight Trim and press OK.

You can also press and hold the Qual button to temporarily view your image in full-screen view. Release the button to return to the normal preview.

5. Highlight Save and press OK to create your star-crossed image.

Keep in mind that the number of starbursts the filter applies depends on your image. You can't change that number; the camera automatically adds the twinkle effect wherever it finds very bright objects. If you want to control the exact placement of the starbursts, you may want to forgo the in-camera filter and find out whether your photo software offers a more flexible star-filter effect. (You can also create the effect manually by painting the cross strokes onto the image in your photo editor.)

Cropping Your Photo

To *crop* a photo simply means to trim away some of its perimeter. Cropping away excess background can often improve an image, as illustrated by my original butterfly scene, shown in Figure 10-19, and its cropped cousin, shown in Figure 10-20. When shooting this photo, I couldn't get close enough to the butterfly to fill the frame with it, and as a result, the original composition suffers. Not only is there too much extraneous background, you can see the foot of another photographer in the upper-right corner. So I simply cropped the image to the composition you see in Figure 10-20.

Figure 10-19: The original contains too much extraneous background.

Traditional photographers create this effect by placing a special filter over the camera lens; the filter is sometimes known as a Star filter instead of a Cross Screen filter. With your D90, you can apply a digital version of the filter via the Retouch menu, as follows:

- 1. Display your photo in single-image playback mode and press OK to call up the Retouch menu.
- 2. Highlight Filter Effects and press OK.
- 3. Highlight Cross Screen and press OK.

You see the screen shown in Figure 10-18. The preview shows you the results of the Cross Screen filter at the current filter settings.

Figure 10-18: You can play with four filter settings to tweak the effect.

4. Adjust the filter settings as needed.

You can adjust the number of points on the star, the strength of the effect, the length of the star's rays, and the angle of the effect. Just use the Multi Selector to highlight an option and then press the Multi Selector right to display the available settings. Highlight your choice and press OK. I labeled the four options in Figure 10-18.

To update the preview, highlight Confirm and press OK.

Figure 10-16: Use the Distortion Control filter to reduce barrel or pincushion distortion.

✓ **Fisheye:** After you highlight the filter name and press OK, you see a screen similar to the right one in Figure 10-16. This time, the scale at the bottom of the image indicates the strength of the distortion effect, however. Press the Multi Selector right or left to adjust the amount. Then press OK to create the fisheye copy.

Adding a Starburst Effect

Want to give your photo a little extra sparkle? Experiment with your D90's Cross Screen filter. This filter adds a starburst-like effect to the brightest areas of your image, as illustrated in Figure 10-17.

Figure 10-17: The Cross Screen filter adds a starburst effect.

Slight barrel distortion

After Distortion Correction filter

Figure 10-15: Barrel distortion makes straight lines appear to bow outward.

If you do notice a small amount of distortion, the Retouch menu offers a Distortion Control option that can help remove it. I applied the filter to create the second version of the subject in Figure 10-15, for example. Less helpful, in my opinion, is a related filter, the Fisheye filter, that actually creates distortion in an attempt to replicate the look of a photo taken with a fisheye lens.

The extent of the in-camera adjustment you can apply is fairly minimal. Additionally, I find it a little difficult to gauge my results on the camera monitor because you can't display any sort of alignment grid over the image to help you find the right degree of correction. For those reasons, I prefer to do this kind of work in my photo editor. Wherever you make the correction, understand that distortion correction filters crop away part of your existing scene as part of the alteration, just like the Straighten tool, covered earlier in this chapter.

All that said, the first step in applying either filter is to display your photo in single-image playback mode and then press OK to display the Retouch menu. Highlight the filter you want to use and press OK again. From that point, the process depends on which of the two filters you're using:

✓ **Distortion Control:** After you press OK to select the filter, you see the screen shown on the left in Figure 10-16. For some lenses, an Auto option is available; as its name implies, this option attempts to automatically apply the right degree of correction. If the Auto option is dimmed or you prefer to do the correction on your own, choose Manual and press OK to display the right screen in the figure. The little scale under the image represents the degree and direction of shift that you're applying. Press the Multi Selector right to reduce barrel distortion; press left to reduce pincushioning. Press OK when you're ready to make your corrected copy of the photo.

1. Display your photo in single-image view and press OK to bring the Retouch menu to life, as shown on the left in Figure 10-14.

Figure 10-14: Select a filter and press OK to start the process.

- 2. Highlight Monochrome and press OK to display the three effect options, as shown on the right in the figure.
- Highlight the effect that you want to apply and press OK.You then see a preview of the image with your selected photo filter applied.
- 4. To adjust the intensity of the sepia or cyanotype effect, press the Multi Selector up or down.

No adjustment is available for the black-and-white filter.

5. Press OK to create the monochrome copy.

Removing (or Creating) Lens Distortion

Certain types of lenses can produce a type of distortion that causes straight lines in a scene to appear curved. Wide-angle lenses, for example, often create *barrel distortion*, in which objects at the center appear to be magnified and pushed forward — as if you wrapped the photo around the outside of a sphere. The effect is perhaps easiest to spot in a rectangular subject like the oil painting in Figure 10-15. Notice that in the original image, on the left, the edges of the painting appear to bow slightly outward. *Pincushion distortion* affects the photo in the opposite way, making center objects appear smaller and farther away, as if you wrapped the photo around the inside of a sphere.

You can minimize the chances of distortion by researching your lens purchases carefully. Photography magazines and online photography sites regularly measure and report distortion performance in their lens reviews.

Figure 10-13: You can create three monochrome effects through the Retouch menu.

I prefer to convert my color photos to monochrome images in my photo editor; going that route simply offers more control, not to mention the fact that it's easier to preview your results on a large computer monitor than on the camera monitor. Still, I know that not everyone's as much of a photo editing geek as I am, so I present to you here the steps involved in applying the Monochrome effects to a color original in your camera:

Figure 10-12: Press the Multi Selector to move the color-shift marker and adjust color balance.

4. Use the Multi Selector to move the black square in the direction of the color adjustment you want to make.

Press up to make the image more green, press right to make it more red, and so on. The histograms on the right side of the display show you the resulting impact on overall image brightness, as well as on the individual red, green, and blue brightness values — a bit of information that's helpful if you're an experienced student in the science of reading histograms. (Chapter 4 gives you an introduction.) If not, just check the image preview to monitor your results.

5. Press OK to create the color-adjusted copy of your photo.

Creating Monochrome Photos

With the Monochrome Picture Control feature covered in Chapter 6, you can shoot black-and-white photos. Technically, the camera takes a full-color picture and then strips it of color as it's recording the image to the memory card, but the end result is the same.

As an alternative, you can create a black-and-white copy of an existing color photo by applying the Monochrome option on the Retouch menu. You can also create sepia and *cyanotype* (blue and white) images via the Monochrome option. Figure 10-13 shows you examples of all three effects.

Original image

Skylight filter

Warm filter

Color Balance filter, shifted to blue

Figure 10-11: Here you see the results of applying two Filter Effects adjustments and a Color Balance shift.

Take these steps to give it a whirl:

- Display your photo in single-image playback mode and press OK.
 Up pops the Retouch menu.
- 2. Highlight Color Balance, as shown on the left in Figure 10-12.
- 3. Press OK to display the screen shown on the right in the figure.

The important control here is the color grid in the lower-left corner. When the little black box is in the center of the grid, as in the figure, no color-balance adjustment has been applied.

Figure 10-10: You can choose from six effects that mimic traditional lens filters.

As an example, Figure 10-11 shows you an original image and three adjusted versions. As you can see, the Skylight and Warm filters are both very subtle; in this image, the effects are most noticeable in the sky. The fourth example shows a variation that I created by using the Color Balance filter, explained in the next section. For that example, I shifted colors toward the cool (bluish) side of the color spectrum.

Follow these steps to apply the Filter Effects color tools:

- 1. Display your photo in single-frame playback mode and press OK to display the Retouch menu.
- 2. Highlight Filter Effects and press OK.

You see the list of available filters. (Refer to Figure 10-10.)

3. Highlight the filter you want to use and press OK.

The camera displays a preview of how your photo will look if you apply the filter.

4. To apply the Skylight or Warm filter, press OK.

Or press the Playback button if you want to cancel the filter application. You can't adjust the intensity of these two filters.

5. For the color-intensifier filters, press the Multi Selector up or down to specify the amount of color shift. Then press OK.

Manipulating color balance

The Color Balance tool enables you to adjust colors with more finesse than the Filter Effects options. With this filter, you can shift colors toward any part of the color spectrum. For example, you can make colors a little greener or a lot greener, a lot more yellow or less yellow, and so on. I used the filter to create the fourth image in Figure 10-11, creating a version of the scene that contains cooler — bluer — hues.

Figure 10-9: Press the Multi Selector up or down to adjust the amount of the correction.

Two Ways to Tweak Color

Chapter 6 explains how to use your camera's White Balance and Picture Control features to manipulate photo colors. But even if you play with those settings all day, you may wind up with colors that you'd like to tweak just a tad.

You can boost color saturation with the Quick Retouch filter, explained in the preceding section. But that tool also adjusts contrast and, depending on the photo, also applies a D-Lighting correction. With the Filter Effects and Color Balance tools, however, you can manipulate color only. The next two sections tell all.

Applying digital lens filters

Shown in Figure 10-10, the Filter Effects option offers five color-manipulation filters that are designed to mimic the results produced by traditional lens filters. (The sixth filter on the menu, Cross Screen, is a special-effects filter that you can explore later in this chapter, in the section "Adding a Starburst Effect.") These color-shifting filters work like so:

- Skylight filter: This filter reduces the amount of blue in an image. The result is a very subtle warming effect. That is, colors take on a bit of a reddish cast.
- Warm filter: This one produces a warming effect that's just a bit stronger than the Skylight filter.
- Color intensifiers: You can boost the intensity of reds, greens, or blues individually by applying these filters.

Retouch filter. Again, shadows got a slight bump up the brightness scale. But the filter also increased color saturation and adjusted the overall image to expand the tonal range across the entire brightness spectrum, from very dark to very bright. In this photo, the saturation change is most noticeable in the yellows and reds of the tree bud. (The sky color may initially appear to be less saturated, but in fact, it's just a lighter hue than the original, thanks to the contrast adjustment.)

To try the filter out, display your photo in single-image playback mode and press OK to bring up the Retouch menu. Highlight Quick Retouch, as shown on the left in Figure 10-9, and press OK to display the second screen in the figure.

As with the D-Lighting filter, you can set the level of adjustment to Low, Normal, or High. Just press the Multi Selector up or down to change the setting. (For my example photos, I applied both the D-Lighting and Quick Retouch filters at the Normal level.) Press OK to finalize the job and create your retouched copy.

Note that the same issues related to D-Lighting, spelled out in the preceding section, apply here as well: You can't apply the Quick Retouch filter to monochrome images. Additionally, you can't apply the Quick Retouch filter to a retouched copy that you created by applying the D-Lighting filter, and vice versa. However, you can create two retouched copies of your original image, applying D-Lighting to one and Quick Retouch to the other. You then can use the Side-by-side comparison feature to compare the retouched versions to see which one you prefer.

Original

D-Lighting

Quick Retouch

Figure 10-8: Quick Retouch brightens shadows and also increases saturation and contrast, producing a slightly different result than D-Lighting.

Figure 10-7: Apply the D-Lighting filter via the Retouch menu.

Select the level of adjustment by pressing the Multi Selector up or down.

You get three levels: Low, Normal, and High. I used High for the repair to my balloon image.

QUAL

To get a closer view of the adjusted photo, press and hold the Qual button. Release the button to return to the two-thumbnail display.

4. To go forward with the correction, press OK.

The camera creates your retouched copy.

Note that you can't apply D-Lighting to an image if you captured the photo with the Picture Control feature set to Monochrome. (See Chapter 6 for details on Picture Controls.) Nor does D-Lighting work on any pictures to which you've applied the Quick Retouch filter, covered next, or the Monochrome filter, detailed a little later in this chapter.

Boosting Shadows, Contrast, and Saturation Together

The Quick Retouch filter increases contrast and saturation and, if your subject is backlit, also applies a D-Lighting adjustment to restore some shadow detail that otherwise might be lost. In other words, Quick Retouch is sort of like D-Lighting Plus. Well, kind of, anyway.

Figure 10-8 illustrates the difference between the two filters. The first example shows my original, a close-up shot of a tree bud about to emerge. I applied the D-Lighting filter to the second example, which brightened the darkest areas of the image. In the final example, I applied the Quick

Shadow Recovery with D-Lighting

In Chapter 5, I introduce you to a feature called Active D-Lighting. If you turn on this option when you shoot a picture, the camera captures the image in a way that brightens the darkest parts of the image, bringing shadow detail into the light, while leaving highlight details intact. It's a great trick for dealing with high-contrast scenes or subjects that are backlit.

You also can apply a similar adjustment after you take a picture by choosing the D-Lighting option on the Retouch menu. I did just that for the photo in Figure 10-6, where strong backlighting left the balloon underexposed in the original image.

D-Lighting, High

Figure 10-6: An underexposed photo (left) gets help from the D-Lighting filter (right).

Here's how to apply the filter:

- 1. Display your photo in single-image mode and then press OK to display the Retouch menu.
- 2. Highlight D-Lighting, as shown on the left in Figure 10-7, and press OK.

You see a thumbnail of your original image along with an after thumbnail, as shown in the second image in Figure 10-7.

In order to achieve this rotation magic, the camera must crop your image and then enlarge the remaining area — that's why the after photo in Figure 10-4 appears to contain slightly less subject matter than the original. (The same cropping occurs if you make this kind of change in a photo editor.) The camera updates the display as you rotate the photo so that you can get an idea of how much of the original scene may be lost.

Here's how to put the tool to work:

- 1. Display the photo in single-image playback mode and then press OK to get to the Retouch menu.
- 2. Highlight Straighten, as shown on the left in Figure 10-5, and press OK.

Now you see a screen similar to the one on the right in the figure, with a grid superimposed on your photo to serve as an alignment aid.

Figure 10-5: Press the Multi Selector right or left to rotate the image in increments of .25 degrees.

3. To rotate the picture clockwise, press the Multi Selector right.

Each press spins the picture by about .25 degrees. You can achieve a maximum rotation of five degrees. The yellow pointer on the little scale under the photo shows you the current amount of rotation.

- 4. To rotate in a counter-clockwise direction, press the Multi Selector left.
- 5. When things are no longer off-kilter, press OK to create your retouched copy.

If the in-camera red-eye repair fails you, most photo editing programs have redeye removal tools that should enable you to get the job done. Unfortunately, no red-eye remover works on animal eyes. Red-eye removal tools know how to detect and replace only red-eye pixels, and animal eyes typically turn yellow, white, or green in response to a flash. The easiest solution is to use the paintbrush tool found in most photo editors to paint in the proper eye colors.

Straightening Tilting Horizon Lines

I seem to have a knack for shooting with the camera slightly misaligned with respect to the horizon line, which means that photos like the one on the left in Figure 10-4 often wind up crooked — in this case, everything tilts down toward the right corner of the frame. Perhaps those who say I have a cockeyed view of life are right? At any rate, my inability to "shoot straight" makes me especially fond of the Straighten tool on the Retouch menu. With this filter, you can rotate tilting horizons back to the proper angle, as shown in the right image in the figure.

Straightened

Figure 10-4: You can rotate crooked photos back to a level orientation with the Straighten tool.

Removing Red-Eye

From my experience, red-eye is not a major problem with the D90. Typically, the problem occurs only in very dark lighting, which makes sense: When little ambient light is available, the pupils of the subjects' eyes widen, creating more potential for the flash light to cause red-eye reflection.

If you spot a red-eye problem, however, give the Red-Eye Correction filter a try:

1. Display your photo in single-image view and press OK.

The Retouch menu appears over your photo.

Highlight Red-Eye Correction, as shown on the left in Figure 10-3, and press OK.

If the camera detects red-eye, it applies the removal filter and displays the results in the monitor. If the camera can't find any red-eye, it displays a message telling you so.

Note that the Red-Eye Correction option appears dimmed in the menu for photos taken without flash.

3. Carefully inspect the repair.

Press the Qual button to magnify the display so that you can check the camera's work, as shown on the right in Figure 10-3. To scroll the display, press the Multi Selector up, down, right, or left. The yellow box in the tiny navigation window in the lower-right corner of the screen indicates the area of the picture that you're currently viewing.

4. If you approve of the correction, press OK twice.

The first OK returns the display to normal magnification; the second creates the retouched copy.

If you're not happy with the results, press OK to return to normal magnification. Then press the Playback button to cancel the repair.

Figure 10-3: An automated red-eye remover is built right into your camera.

2. Press OK.

A variation of the Retouch menu appears superimposed on the image, as shown on the right in Figure 10-1.

Side-by-side comparison

D-Lighting

@ Zoom

the retouched version, on the right.

Done

3. Highlight Side-by-side and press OK.

Now you see the original image in the left half of the frame, with the retouched version on the right, as shown in Figure 10-2. At the top of the screen, you see labels that indicate the Retouch tools you applied to the photo (D-Lighting, in the figure).

If you created multiple retouched versions of the same original, you Figure 10-2: The original appears on the left; can compare all the versions. First, press the Multi Selector right or left to surround the After

image with the yellow highlight box. Now press the Multi Selector up and down to scroll through all the retouched versions.

€ Move

4. To temporarily view the original or retouched image at full-frame view, use the Multi Selector to highlight its thumbnail and then press and hold the Qual button.

Release the button to return to Side-by-side view.

To exit Side-by-side view and return to single-image playback, press OK.

All retouched copies are saved in the JPEG file format and assigned a filename that begins with one of the following three-letter codes:

- SSC: Used for photos that you crop using the Trim function.
- **CSC:** Indicates that you applied one of the other Retouch menu corrections.

As a reminder, original photos have filenames that begin either with DSC or _DSC. (The underscore at the front of the filename tells you that you recorded the photo using the Adobe RGB color mode, an option you can explore in Chapter 6.)

The specific file numbers of retouched copies don't match those of the original, however, which can be a little confusing. Instead, the first retouched copy is assigned the file number 0001, the second, 0002, and so on.

Applying the Retouch Menu Filters

When you apply a correction or enhancement from the Retouch menu, the camera creates a copy of your original photo and then makes the changes to the copy only. Your original is preserved untouched.

You can take advantage of most Retouch menu features in two ways:

Display the menu, select the tool you want to use, and press OK. You're then presented with thumbnails of your photos. Use the Multi Selector to move the yellow highlight box over the photo you want to adjust and press OK. You next see options related to the selected tool.

✓ Switch the camera to Playback mode, display your photo in single-frame view, and press OK. (Remember, you can shift from thumbnail display to single-frame view simply by pressing the OK button.) The Retouch menu then appears superimposed over your photo. Select the tool you want to use and press OK again to access the tool options. I prefer the second method, so that's how I approach things in this chapter, but it's entirely a personal choice.

The one Retouch menu feature you can't access by using the first technique is the Side-by-side comparison option. This feature enables you to compare the original image and the retouched version side by side on the monitor. Here's how it works:

1. Display either the original or edited picture in single-image view, as shown on the left in Figure 10-1.

See Chapter 4 if you need help with picture playback.

Figure 10-1: In single-image playback mode, press OK to superimpose the Retouch menu over the photo.

Ten (Or So) Fun and Practical Retouch Menu Features

In This Chapter

- Removing red-eye
- Straightening crooked horizon lines
- ▶ Tweaking exposure and color
- Fixing lens distortion
- ▶ Adding a starburst effect
- Cropping away excess background

very photographer produces a clunker image now and then. When it happens to you, don't be too quick to reach for the Delete button, because many common problems are surprisingly easy to fix. In fact, you often can repair your photos right in the camera, thanks to tools found on the Retouch menu. You can even create some special effects with a couple of the menu options.

This chapter offers step-by-step recipes for using ten of these photo-repair and enhancement features. Additionally, I received special dispensation from the *For Dummies* folks to start things off with an additional section that summarizes tips that relate to all the Retouch menu options. In the words of Nigel Tufnel from the legendary rock band Spinal Tap, "This one goes to 11!"

In this part ...

n time-honored For Dummies tradition, this part of the book contains additional tidbits of information presented in the always popular "Top Ten" list format. Chapter 10 shows you how to do some minor picture touchups, such as cropping and adjusting exposure, by using tools on your camera's Retouch menu. Following that, Chapter 11 introduces you to ten camera functions that I consider specialty tools — bonus options that, while not at the top of the list of the features I suggest you study, are nonetheless interesting to explore when you have a free moment or two.

Part IV The Part of Tens

"If I'm not gaining weight, then why does this digital image take up 3 MB more memory than a comparable one taken six months ago?" Before connecting your camera, double-check the following menu options, both on the Setup menu and shown in Figure 9-15:

- ✓ Video Mode: You get just two options here: NTSC and PAL. Select the video mode that is used by your part of the world. (In the United States, Canada, and Mexico, NTSC is the standard.)
- HDMI: Unless you have trouble, stick with the Auto setting; the camera then automatically selects the right format for the HD device you're using. You also can select from four different formats, if you feel comfortable doing so.

Figure 9-15: The options related to television playback live on the Setup menu.

Whether you go high def or regular def — what the industry now wants us to call *standard definition* — turn the camera off before connecting the devices. For a regular video connection, note that the white plug carries the audio signal and the yellow one carries the video signal. With HDMI, everything goes through a single connector, and as soon as the two are linked, you can view your photos only on the HDMI screen.

When the two devices are connected, turn the camera and TV or video device on. At this point, you need to consult your TV manual to find out what channel to select for playback of signals from auxiliary input devices like your camera. After you sort that issue out, you can control playback using the same camera controls as you normally do to view pictures and movies on your camera monitor. You can also run slide shows by following the steps outlined in the two preceding sections in this book.

7. Highlight Effects and press the Multi Selector right or press OK to display the transition options.

As with the soundtrack feature, you have five choices. There's no way to preview the effects, so just highlight the one that sounds the coolest to you and press OK.

8. To play the show, highlight Start and press OK.

After you show is rolling, use these techniques to control it:

- Adjust music volume. Press the Qual button to raise the volume, press the ISO button to lower it. At the lowest volume setting, sound is disabled altogether.
- ✓ Pause/resume playback. Press OK. The screen then gives you two options: Restart and Exit. Highlight Restart and press OK.
- **Exit playback.** You've got these options:
 - To return to full-frame, still-photo playback mode, press the Playback button.
 - To return to the Playback menu, press the Menu button. Or press OK, highlight Exit, and press OK again.
 - To return to picture-taking mode, press the shutter button halfway.

Viewing Your Photos on a Television

Tired of passing your camera around to show people your pictures or Live View movies on the monitor? Why not display them on a television instead? Your D90 is equipped with both an HDMI outlet, or port, for connecting the camera to a highdefinition TV (or other video device), and an AV (audio/visual) port, for connecting the camera to a regular TV or video device. Both ports are tucked under the little rubber cover on the left-rear side of the camera and highlighted in Figure 9-14. A cable for making a regular video connection is included in the camera box. (It's the cable that has two plugs at one end, one white and one vellow.) For HDMI connections, you need to purchase a cable. You need something called a *Type C* cable.

Figure 9-14: You can connect your camera to a television for big-screen playback.

- 2. Press OK to display the second screen shown in the figure.
- 3. Highlight Select Pictures and press the Multi Selector right or press OK.

You then see the screen shown in Figure 9-13.

4. Select the photos you want to include.

You can go one of three ways here:

show. Press the Multi Selector right to display thumbnails of your images, move the yellow highlight box over an image, and press the ISO button to tag it as slide-show worthy. A checkmark appears in the corner of the thumbnail of selected photos.

Pictmotion

Select pictures

Selected

ALL AII

DATE Select date

To temporarily view the selected photo at a larger size, press and hold the Qual button. Release the button to return to the normal display.

- Select Date: Use this option if you want to include all pictures that were taken on a specific date. After highlighting the option, press the Multi Selector right to display a list of dates. Highlight a date and press the Multi Selector right again to put a checkmark in the box next to the date.
- All: To include all photos, highlight the All option.

Whichever option you select, any pictures that you hid using the Hide Image feature aren't included in the show. And if you created custom image folders, only those in the currently active folder are available. For more on both issues, check out Chapter 4.

- 5. After selecting photos, press OK to return to the main Pictmotion options screen. (Refer to the right image in Figure 9-12.)
- 6. Choose your background music.

To do so, highlight the Background Music option and press the Multi Selector right or press OK. You can choose from five soundtrack options; highlight the one you want to use and press OK.

Unfortunately, there's no "sound off" option, but you can shut off the music during playback. (See the list following these steps.)

During the show, you can control playback as follows:

- ✓ Pause the show. Press OK. Select Restart and press OK to begin displaying pictures again.
- **Exit the show.** You've got three options:
 - To return to full-frame, regular playback, press the Playback button.
 - To return to the Playback menu, press the Menu button.
 - To return to picture-taking mode, press the shutter button halfway.
- Skip to the next/previous image manually. Press the Multi Selector or rotate the main command dial.
- Change the information displayed with the image. Press the Multi Selector up or down to cycle through the info-display modes. (See Chapter 4 for details on what information is provided in each mode.)

Creating Pictmotion slide shows

Also found on the Playback menu, the Pictmotion option enables you to create a slide show that's a little fancier than the Slide Show option discussed in the preceding section. You can select specific photos to include, choose from a handful of instrumental songs to use as a musical background, and also select from a couple of different transition effects, which control how one photo disappears from the screen and the next one appears.

Take these steps to try it out:

1. Display the Playback menu and highlight Pictmotion, as shown on the left in Figure 9-12.

Figure 9-12: A Pictmotion slide show includes music and transition effects.

Setting up a simple slide show

Follow these steps to create a basic slide show that automatically displays all photos on the memory card, one by one, on your camera monitor.

One caveat before you start: If you hid any pictures using the Hide Image feature, they are not displayed during the show. See Chapter 4 for details on this feature and how to "unhide" any hidden photos.

1. Display the Playback menu and highlight Slide Show, as shown on the left in Figure 9-11.

Figure 9-11: Choose Slide Show to set up automatic playback of all pictures on your memory card.

- 2. Press OK to display the Slide Show screen shown on the right in Figure 9-11.
- 3. Highlight Frame Interval and press the Multi Selector right.

On the next screen, you can specify how long you want each image to be displayed. You can set the interval to 2, 3, 5, or 10 seconds.

4. Highlight the frame interval you want to use and press OK.

You're returned to the Slide Show screen.

5. To start the show, highlight Start and press OK.

The camera begins displaying your pictures on the camera monitor.

When the show ends, you see a screen offering three options: You can choose to restart the show, adjust the frame interval, or exit to the Playback menu. Highlight your choice and press OK.

If you do, the resized file goes into that subfolder, which you can name by clicking the Naming Options button.

9. (Optional) Specify a filename for the resized copy.

If you want to put the small copy in the same folder as the original, the program protects you from overwriting the original by automatically assigning a slightly different name to the copy. By default, the program uses the original filename plus a two-number sequential tag: If the original filename is DSC_0186.jpg, for example, the small-copy filename is DSC_0186_01.jpg. You can change a couple of aspects of this filenaming routine by selecting the Change File Names check box and then clicking the Naming Options button and adjusting the settings in the resulting dialog box. After making your wishes known, click OK to return to the Convert Files dialog box.

If you *don't* store the copy in the same folder as the original, the program doesn't alter the filename of the copy automatically. That can lead to problems down the road because you will end up with two files, both with the same name but with different pixel counts, on your computer. In this scenario, be sure to input your own filenames for your copies.

10. Click the Convert button to finish the process.

ViewNX also offers an e-mail wizard that enables you to resize and send photos by e-mail in one step. If you use this feature, however, you don't create an actual small-size copy of your file; the program simply reduces the size of the file temporarily for e-mail transmission. Also, the wizard works only with certain e-mail programs. On the plus side, the wizard permits you to send a photo at a much smaller size than you can create with the Convert Files feature. For more details, check out the ViewNX Help system.

Creating a Digital Slide Show

Many photo editing and cataloging programs offer a tool for creating digital slide shows that can be viewed on a computer or, if copied to a DVD, on a DVD player. You can even add music, captions, graphics, special effects, and the like to jazz up your presentations.

But if you want to create a basic slide show in a hurry, your D90 actually offers you two different ways to create one. The first, called Pictmotion, enables you to add music and transition effects. You can also select specific photos on the memory card to include in the show. The other option simply displays all photos on the card, with no sound or transition effects. Either way, you can create and run the slide show right on your camera. And by connecting your camera to a television, as outlined in the last section of this chapter, you can present your show to a whole roomful of people.

The next two sections explain how to create and play both types of slide shows.

3. Select JPEG from the File Format drop-down list, as shown in the figure.

The other format option, TIFF, is a print format. Web browsers and e-mail programs can't display TIFF images, so be sure to use JPEG.

4. Select the Change the Image Size check box.

Now the Short Edge and Long Edge text boxes become available.

5. Type the desired pixel count of the longest side of your picture into the Long Edge box.

The program automatically adjusts the Short Edge value to keep the resized image proportional. (The image is not cropped to a 4:3 perspective as it is when you use the Small Copy feature on the camera's Retouch menu.)

Again, to ensure that the picture is viewable without scrolling when opened in the recipient's e-mail program, I suggest that you keep the Long Edge value at 640 pixels or less.

6. Adjust the Compression Ratio slider to set the amount of JPEG file compression.

As Chapter 3 explains, a greater degree of compression results in a smaller file, which takes less time to download over the Web, but it reduces image quality. Notice that as you move the slider to the right, the resulting quality level appears above the slider. For example, in Figure 9-10, the level is Excellent Quality.

Because the resolution of your image already results in a very small file, you can probably use the highest quality setting without worrying too much about download times. The exception is if you plan to attach multiple pictures to the same e-mail message, in which case you may want to set the slider a notch or two down from the highest quality setting.

7. Select the next three check boxes (Remove Camera Setting Information, Remove XMP/IPTC Information, and Remove ICC Color Profile), as shown in Figure 0 10.

When selected, the three options save the resized picture without the original image metadata, the extra text data that your camera stores with the image. (Chapter 8 explains.) Including this metadata adds to the file size, so for normal e-mail sharing, strip it out. The exception, of course, is when you want the recipient to be able to view the metadata in a photo program that can do so.

8. Set the file destination.

In layman's terms, that just means to tell the program the location of the folder or drive where you want to store your downsized image file. The current destination appears just to the left of the Browse button. To choose a different folder, click that Browse button.

By selecting the Create a New Subfolder for Each File Conversion check box, you can create a new subfolder within your selected storage folder.

Downsizing images in Nikon ViewNX

You can also create a low-resolution, JPEG copy of your image in ViewNX. However, be aware that the program restricts you to a minimum size of 320 pixels along the photo's longest side. If you need a smaller version, use the in-camera Small Picture option to create the copy instead. Or, if you own a photo editing program, investigate its image-resizing capabilities; you likely can create the small copy at any dimensions you like.

Assuming that the 320-pixel restriction isn't a problem, the following steps show you how to create your small-size copy in ViewNX. You can use this process to create a small JPEG copy of both JPEG and NEF (Raw) originals.

1. Select the image thumbnail in the main ViewNX window.

Chapter 8 explains how to view your image thumbnails, if you need help. Just click a thumbnail to select it.

2. Choose File⇔Convert Files.

You see the dialog box shown in Figure 9-10. (As with other figures, this one shows the box as it appears in Windows Vista; it may appear slightly different on a Mac or in other versions of Windows, but the essentials are the same.)

Convert Files					•
File Format: JPEG T					
Use LZW Compression					
Original Image Size: 4288 x 2848	pixels				
✓ Change the image size					
	Long Edge:	640	pixels -		
	Short Edge:	425	pixels -]	
Quality: Excellent Quality					
a contract of					U
Remove camera setting infor	mation				
Remove XMP/IPTC information	on				
Remove ICC color profile					
Save in: C:\Users\Julie King\Pictures					Browse
Create a new subfolder for each file conversion				Naming Options	
Change file names				Naming Options	
Total Number of Files: 1	Conv	ert	7	Cancel	

Figure 9-10: You also can use ViewNX to create a small-sized JPEG copy for e-mail sharing.

If you want to create small copies of several photos on your memory card, you can go another route: Take the camera out of Playback mode and then display the Retouch menu. Select the Small Copy option and press OK. You're then presented with a Choose Size option; choose that option to specify the pixel count for your small copies. After doing so, press OK, choose the Select Image option, and press OK again to display thumbnails of all your pictures. Move the yellow highlight box over a thumbnail and press the ISO button to "tag" the photo for copying. (You see a little icon in the top-right corner of the thumbnail; press the button again to remove the tag if you change your mind.) After selecting all your pictures, press OK to display the copy-confirmation screen; highlight Yes and press OK once more to wrap things up.

When you view your small-size copies on the camera monitor, they appear surrounded by a gray border, as shown in Figure 9-9. A tiny Retouch icon appears on the display as well, as labeled in the figure. Note that you can't zoom in to magnify the view of small-size copies as you can your original images.

Pictures that you create using the Small Picture feature are given filenames that start with the letters SSC. The camera automatically assigns a filenumber (the number is different from that of your original file, unfortunately).

Figure 9-9: The gray border indicates a smallsize copy.

Online photo sharing: Read the fine print

If you want to share more than a couple of photos, consider posting your images at an online photo-album site instead of attaching them to e-mail messages. Photo-sharing sites such as Shutterfly, Kodak Gallery, and Picasa all enable you to create digital photo albums and then invite friends and family to view your pictures and order prints of their favorites.

At most sites, picture-sharing is free, but your albums and images are deleted if you don't order prints or make some other purchase

from the site within a specified amount of time. Additionally, many free sites enable you to upload high-resolution files for printing but then don't let you retrieve those files from the site. (In other words, don't think of album sites as archival storage solutions.) And here's another little bit of fine print to investigate: The membership agreement at some sites states that you agree to let the site use your photos, for free, for any purpose that it sees fit.

3. Press OK to display the Retouch menu over your image, as shown on the left in Figure 9-8.

Figure 9-8: The Small Picture feature creates a low-resolution, e-mail-friendly copy of a photo.

4. Highlight Small Picture and press OK or press the Multi Selector right.

You see the screen shown on the right in the figure. You can choose from three size options (stated in pixels) for your small copy.

5. Highlight the size you want to use for your copy.

For pictures that you plan to send via e-mail, choose either 640×480 or 320×240 pixels unless the recipient is connected to the Internet via a very slow, dial-up modem connection. In that case, you may want to go one step down, to 160×120 pixels. (The display size of the picture may be quite small at that setting however, depending on the resolution of the monitor on which the picture is viewed.)

If you're a math lover, you may have noticed that all the size options create pictures that have an aspect ratio of 4:3, while your original images have an aspect ratio of 3:2. The camera trims the small-copy image as needed to fit the 4:3 proportions. Unfortunately, you don't have any input over what portion of the image is cropped away.

6. Press OK or press the Multi Selector right.

You see a screen asking you to confirm that you want to create a small copy.

7. Highlight Yes and press OK.

The camera duplicates the selected image and downsamples the copy (eliminates pixels) to achieve the size you specified in Step 5. Your original picture file remains untouched.

Figure 9-7: Keep e-mail pictures to no larger than 640 pixels wide or tall.

The next two sections walk you through the steps for both ways of creating your e-mail images. You can use the same steps, by the way, for sizing images for any onscreen use, whether it's for a Web page or multimedia presentation. You may want your copies to be larger or smaller than the recommended e-mail size for those uses, however.

One last point about onscreen images: Remember that pixel count has *absolutely no effect* on the quality of pictures displayed onscreen. Pixel count determines only the size at which your images are displayed.

Creating small copies using the camera

To create small, e-mailable copies of your images without using a computer, use your camera's Small Picture feature. Here's how:

- 1. Press the Playback button to set your camera to playback mode.
- 2. Display the picture in single-image view.

If the monitor currently displays multiple thumbnails, just press the OK button to switch to single-image view.

Figure 9-6: The attached image has too many pixels to be viewed without scrolling.

In general, a good rule is to limit a photo to no more than 640 pixels at its longest dimension. That ensures that people can view your entire picture without scrolling, as in Figure 9-7. This image measures 640 x 428 pixels. As you can see, it's plenty large enough to provide a decent photo-viewing experience. On a small monitor, it may even be too large.

This size recommendation means that even if you shoot at your D90's lowest Image Size setting (2144 x 1424 pixels), you need to dump pixels from your images before sending them to the cyber post office. You have a couple of options for creating an e-mail-sized image:

- ✓ Use the Small Picture feature on your camera's Retouch menu. This feature enables you to create your e-mail copy right in the camera.
- Downsample the image in your photo editor. *Downsampling* is geekspeak for dumping pixels. Most photo editors offer a feature that handles this process for you. Use this option if you want to crop or otherwise edit the photo before sharing it.

- ✓ Your photo paper is low quality. Sad but true: The cheap, store-brand photo papers usually don't render colors as well as the higher-priced, name-brand papers. For best results, try papers from your printer manufacturer; again, those papers are engineered to provide top performance with the printer's specific inks and ink-delivery system.
- Your printer and photo software are fighting over color-management duties. Some photo programs offer features that enable the user to control how colors are handled as an image passes from camera to monitor to printer. Most printer software also offers color-management features. The problem is, if you enable color-management controls both in your photo software and your printer software, you can create conflicts that lead to wacky colors. So check your photo software and printer manuals to find out what color-management options are available to you and how to turn them on and off.

Even if all the aforementioned issues are resolved, however, don't expect perfect color matching between printer and monitor. Printers simply can't reproduce the entire spectrum of colors that a monitor can display. In addition, monitor colors always appear brighter because they are, after all, generated with light.

Finally, be sure to evaluate your print colors and monitor colors in the same ambient light — daylight, office light, whatever — because that light source has its own influence on the colors you see.

Preparing Pictures for E-Mail

How many times have you received an e-mail message that looks like the one in Figure 9-6? Some well-meaning friend or relative has sent you a digital photo that is so large that it's impossible to view the whole thing on your monitor.

The problem is that computer monitors can display only a limited number of pixels. The exact number depends on the monitor's resolution setting and the capabilities of the computer's video card, but suffice it to say that the average photo from one of today's digital cameras has a pixel count in excess of what the monitor can handle. Figure 9-6, for example, shows you how much of a 6-megapixel image is viewable when displayed in a typical e-mail program window.

Figure 9-5: Mac users can take advantage of the operating system's built-in calibration tool.

One of your printer cartridges is empty or clogged. If your prints look great one day but are way off the next, the number-one suspect is an empty ink cartridge or a clogged print nozzle or head. Check your manual to find out how to perform the necessary maintenance to keep the nozzles or print heads in good shape.

If black-and-white prints have a color tint, a logical assumption is that your black ink cartridge is to blame, if your printer has one. But the problem is usually a color cartridge instead. Most printers use both color and black inks even for black-and-white prints, and if one color is missing, a tint results.

When you buy replacement ink, by the way, keep in mind that third-party brands, while they may save you money, may not deliver the performance you get from the cartridges made by your printer manufacturer. A lot of science goes into getting ink formulas to mesh with the printer's ink-delivery system, and the printer manufacturer obviously knows most about that delivery system.

✓ You chose the wrong paper setting in your printer software. When you set up your print job, be sure to select the right setting from the paper-type option — glossy, matte, and so on. This setting affects how the printer lays down ink on the paper.

To allow yourself printing flexibility, leave at least a little margin of background around your subject when you shoot, as I did for the example in Figure 9-4. Then you don't clip off the edges of the subject no matter what print size you choose. (Some people refer to this margin padding as *head room*, especially when describing portrait composition.)

Get print and monitor colors in synch

Your photo colors look perfect on your computer monitor. But when you print the picture, the image is too red, or too green, or has some other nasty color tint. This problem, which is probably the most prevalent printing issue, can occur because of any or all of the following factors:

Your monitor needs to be calibrated. When print colors don't match what you see on your computer monitor, the most likely culprit is actually the monitor, not the printer. If the monitor isn't accurately calibrated, the colors it displays aren't a true reflection of your image colors.

To ensure that your monitor is displaying photos on a neutral canvas, you can start with a software-based calibration utility, which is just a small program that guides you through the process of adjusting your monitor. The program displays various color swatches and other graphics and then asks you to provide feedback about what you see on the screen.

If you use a Mac, the operating system offers a built-in calibration utility, called the Display Calibrator Assistant; Figure 9-5 shows the welcome screen that appears when you run the program. (Access it by opening the System Preferences dialog box, clicking the Displays icon, clicking the Color button, and then clicking the Calibrate button.) You also can find free calibration software for both Mac and Windows systems online; just enter the term *free monitor calibration software* into your favorite search engine.

Software-based calibration isn't ideal, however, because our eyes aren't that rellable in judging color accuracy. For a more accurate calibration, you may want to invest in a device known as a *colorimeter*, which you attach to or hang on your monitor, to accurately measure and calibrate your display. Companies such as Datacolor (www.datacolor.com), Pantone (www.pantone.com), and X-Rite (www.xrite.com) sell this type of product along with other tools for ensuring better color matching.

Whichever route you go, the calibration process produces a monitor *profile*, which is simply a data file that tells your computer how to adjust the display to compensate for any monitor color casts. Your Windows or Mac operating system loads this file automatically when you start your computer. Your only responsibility is to perform the calibration every month or so, because monitor colors drift over time.

DPOF, PictBridge, and computerless printing

Your D90 offers two technologies, called DPOF (dee-poff) and PictBridge, that enable you to print images directly from your camera or memory card, without using the computer as middle-machine. In order to take advantage of direct printing, your printer must also support one of the two technologies, and you must capture the images in the JPEG file format, which I explain in Chapter 3. (You can also capture the photo in the Raw format and then use your D90's in-camera conversion tool to make a JPEG copy suitable for direct printing.)

DPOF stands for Digital Print Order Format. With this option, accessed via your camera's Playback menu, you select the pictures on your memory card that you want to print, and you specify how many copies you want of each image. Then, if your photo printer has an SD Card slot and supports DPOF, you just pop the memory card into that slot. The printer reads your "print order" and outputs just the requested copies of your selected images. (You use the printer's own controls to set paper size, print orientation, and other print settings.)

PictBridge works a little differently. If you have a PictBridge-enabled photo printer, you can

connect the camera to the printer using the USB cable supplied with your camera. A PictBridge interface appears on the camera monitor, and you use the camera controls to select the pictures you want to print. With PictBridge, you specify additional print options, such as page size and whether you want to print a border around the photo, from the camera as well.

Both DPOF and PictBridge are especially useful in scenarios where you need fast printing. For example, if you shoot pictures at a party and want to deliver prints to guests before they go home, DPOF offers a quicker option than firing up your computer, downloading pictures, and so on. And if you invest in one of the tiny portable photo printers on the market today, you can easily make prints away from your home or office — you can take both your portable printer and camera along to your regional sales meeting, for example.

For the record, I prefer DPOF to PictBridge because with PictBridge, you have to deal with cabling the printer and camera together. Also, the camera must be turned on for the whole printing process, wasting battery power. But if you're interested in exploring either printing feature, your camera manual provides complete details.

Your camera's Trim feature, found on the Retouch menu, enables you to crop your photo, but only to proportions of 3:2, 4:3, and 5:4. See Chapter 10 for information. For other proportions, most photo-editing programs offer very simple cropping tools. You also can usually crop your photo using the software provided at online printing sites and at retail print klosks. But if you plan to drop off your memory card of original pictures at a lab, be aware that your pictures will be cropped if you select a print size other than 4×6 .

Allow for different print proportions

Unlike many digital cameras, your D90 produces photos that have an aspect ratio of 3:2. That is, pictures are 3 units wide by 2 units tall — just like a 35mm film negative — which means that they translate perfectly to the standard 4-x-6-inch print size. (Most digital cameras produce 4:3 images, which must be cropped to fit a 4-x-6-inch piece of paper.)

If you want to print your digital original at other standard sizes — 5×7 , 8×10 , 11×14 , and so on — you need to crop the photo to match those proportions. Alternatively, you can reduce the photo size slightly and leave an empty margin along the edges of the print as needed.

As a point of reference, Figure 9-4 shows you a 3:2 original image. The red outlines indicate how much of the original can fit within a 5-x-7-inch frame and an 8-x-10-inch frame.

8 x 10 frame area

Figure 9-4: Composing your shots with a little head room enables you to crop to different frame sizes.

50 ppi

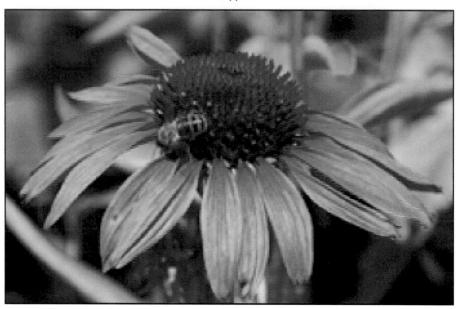

Figure 9-2: At 50 ppi, the image has a jagged, pixelated look.

50 ppi resampled to 300 ppi

Figure 9-3: Adding pixels in a photo editor doesn't rescue a low-resolution original.

If your print size does exceed your pixel supply, one of two things must happen:

- ✓ The pixel count remains constant, and pixels simply grow in size to fill the requested print size. And if pixels get too large, you get a defect known as *pixelation*. The picture starts to appear jagged, or stairstepped, along curved or digital lines. Or at worst, your eye can actually make out the individual pixels, and your photo begins to look more like a mosaic than, well, a photograph.
- The pixel size remains constant, and the printer software adds pixels to fill in the gaps. You can also add pixels, or *resample the image*, in your photo software. Wherever it's done, resampling doesn't solve the low resolution problem. You're asking the software to make up photo information out of thin air, and the result is usually an image that looks worse than it did before resampling. You don't get pixelation, but details turn muddy, giving the image a blurry, poorly rendered appearance.

Just to hammer home the point and remind you one more time of the impact of resolution picture quality, Figures 9-1 through 9-3 show you the same image as it appears at 300 ppi (the resolution required by the publisher of this book), at 50 ppi, and resampled from 50 ppi to 300 ppi. As you can see, there's just no way around the rule: If you want the best quality prints, you need the right pixel count.

300 ppi

Figure 9-1: A high-quality print depends on a high-resolution original.

Preventing Potential Printing Problems

Boy, I love a good alliteration, don't you? Oh, just me, then. Anyway, as I say in the introduction to this chapter, a few issues can cause hiccups in the printing process. So before you print your photos, whether you want to do it on your own printer or send them to a lab, read through the next three sections, which show you how to avoid the most common trouble spots.

Match resolution to print size

Resolution, or the number of pixels in your digital image, plays a huge role in how large you can print your photos and still maintain good picture quality. You can get the complete story on resolution in Chapter 3, but here's a quick recap as it relates to printing:

- ✓ On the D90, you set picture resolution via the Image Size option, which you can adjust either via the Shooting menu or by pressing the Qual button and rotating the main command dial. (Again, see Chapter 3 for specifics.) You must select this option *before* you capture an image, which means that you need some idea of your ultimate print size before you shoot. And if you crop your image, you eliminate some pixels, so take that factor into account when you do the resolution math.
- For good print quality, the *minimum* pixel count (in my experience, anyway) is 200 pixels per linear inch, or 200 ppi. That means that if you want a 4-x-6-inch print, you need at least 800 x 1200 pixels.
- Depending on your printer, you may get even better results at 200+ ppi. Some printers do their best work when fed 300 ppi, and a few (notably, some from Epson) request 360 ppi as the optimum resolution. However, going higher than that typically doesn't produce any better prints.
 - Unfortunately, because most printer manuals don't bother to tell you what image resolution produces the best results, finding the right resolution is a matter of experimentation. (Don't confuse the manual's statements related to the printer's *dpi* with *ppi*. DPI refers to how many dots of color the printer can lay down per inch; many printers use multiple dots to reproduce one image pixel.)
- ✓ If you're printing your photos at a retail kiosk or at an online site, the printing software that you use to order your prints should determine the resolution of your file and then guide you as to the suggested print size. But if you're printing on a home printer, you need to be the resolution cop. (Some programs, however, do alert you in the Print dialog box if the resolution is dangerously low.)

So what do you do if you find that you don't have enough pixels for the print size you have in mind? You just have to decide what's more important, print size or print quality.

Printing Possibilities: Retail or Do-It-Yourself?

Normally, I'm a do-it-yourself type of gal. I mow my own lawn, check my own tire pressure, hang my own screen doors. I am woman; hear me roar. Unless, that is, I discover that I can have someone *else* do the job in less time and for less money than I can — which just happens to be the case for digital photo printing. Although I occasionally make my own prints for fine-art images that I plan to sell or exhibit, I have everyday snapshots made at my local retail photo lab.

Unless you're already very comfortable with computers and photo printing, I suggest that you do the same. Compare the cost of retail digital printing with the cost of using a home or office photo printer — remember to factor in the required ink, paper, and your precious time — and you'll no doubt come out ahead if you delegate the job.

You can choose from a variety of retail printing options, as follows:

- ✓ Drop-off printing services: Just as you used to leave a roll of film at the photo lab in your corner drug store or camera store, you can drop off your memory card, order prints, and then pick up your prints in as little as an hour.
- ✓ Self-serve print kiosks: Many photo labs, big-box stores, and other retail outlets also offer self-serve print kiosks. You insert your memory card into the appropriate slot, follow the onscreen directions, and wait for your prints to slide out of the print chute.
- ✓ Online with mail-order delivery: You can upload your photo files to online printing sites and have prints mailed directly to your house. Photo-sharing sites such as Shutterfly, Kodak Gallery, and Snapfish are well-known players in this market. But many national retail chains, such as Ritz Cameras, Wal-Mart, and others also offer this service.
- Online with local pickup: Here's my favorite option. Many national chains enable you to upload your picture files for easy ordering but pick up your prints at a local store. This service is a great way to share prints with faraway friends and family, by the way. I can upload and order prints from my desk in Indianapolis, for example, and have them printed at a store located a few miles from my parents' home in Texas.

For times when you do want to print your photos on your own printer, you can do so through Nikon ViewNX. However, I find the ViewNX printing options both more complex and more limited than those in other programs, which is why I opted not to cover them in this book. I suggest that you instead print from whatever photo editing program you use or from the software provided by your printer manufacturer.

Printing and Sharing Your Pictures

In This Chapter

- ▶ Setting the stage for great prints
- Looking at retail printing options
- Preparing a picture for the Web
- Creating a slide show
- Viewing images on a TV

hen my first digital photography book was published, way back in the 1990s, consumer digital cameras didn't offer the resolution needed to produce good prints at anything more than postage-stamp size — and even then, the operative word was "good," not "great." And if you did want a print, it was a pretty much a do-it-yourself proposition unless you paid skyhigh prices at a professional imaging lab. In those days, retail photo labs didn't offer digital printing, and online printing

services hadn't arrived yet, either.

Well, time and technology march on, and, at least in the case of digital photo printing, to a very good outcome. Your D90 can produce dynamic prints even at large sizes, and getting those prints made is easy and economical, thanks to an abundance of digital printing services now in stores and online.

That said, getting the best output from your camera still requires a little bit of knowledge and prep work on your part. To that end, this chapter tells you exactly how to ensure that your picture files will look as good on paper as they do in your camera monitor.

In addition, this chapter explores ways to share your pictures electronically. First, I show you how to prepare your picture for e-mail — an important step if you don't want to annoy friends and family by cluttering their inboxes with ginormous, too-large-to-view photos. Following that, you can find out how to create digital slide shows and view your pictures and Live View movies on a television.

The first two check boxes relate to data that you can view on the Metadata tab in ViewNX; earlier sections of this chapter give you the lowdown. The ICC profile item refers to the image color space, which is either sRGB or Adobe RGB on your D90. Chapter 6 explains the difference.

9. Select a storage location for the processed TIFF file.

In Windows, the current drive and folder location appears in the area highlighted in Figure 8-19. On a Mac, the location is displayed inside a white box in the same general area of the dialog box. On either type of system, you can change the storage destination by clicking the Browse button and then selecting the drive and folder where you want to put the file.

By selecting the Create a New Subfolder for Each File Conversion check box, you can put your TIFF file into a separate folder within the destination folder. If you select the box, click the Naming Options button and then specify how you want to name the subfolder.

10. Specify whether you want to give the processed TIFF a different filename from the original Raw image.

To do so, select the Change File Names check box and then click the Naming Options button and enter the name you want to use.

If you don't change the filename, ViewNX gives the file the same name as the original Raw file. But you don't overwrite that Raw file because you are storing the copy in a different file format (TIFF). In Windows, the filename of the processed TIFF image has the three-letter extension TIF.

11. Click the Convert button.

A window appears to show you the progress of the conversion process. When the window disappears, your TIFF image appears in the storage location you selected in Step 10.

Figure 8-19: To retain the best image quality, save processed Raw files in the TIFF format.

6. Deselect the Use LZW Compression option, as shown in the figure.

Although LZW Compression reduces the file size somewhat and does not cause any quality loss, some programs can't open files that were saved with this option enabled. So turn it off.

7. Deselect the Change the Image Size check box.

This step ensures that you retain all the original pixels in your image, which gives you the most flexibility in terms of generating quality prints at large sizes. For details on this issue, check out Chapter 3.

8. Deselect each of the three Remove check boxes.

If you select the check boxes, you strip image metadata — the extra text data that's stored by the camera — from the file. Unless you have some specific reason to do so, clear all three check boxes so that you can continue to access the metadata when you view your processed image in programs that know how to display metadata.

Figure 8-18: Display the Quick Adjustment panel to tweak Raw images before conversion.

4. To save the processed file, choose File Convert Files.

Or just click the Convert Files button on the toolbar at the top of the program window. Either way, you see the Convert Files dialog box, shown in Figure 8-19.

5. Select TIFF (8 Bit) from the File Format drop-down list.

You also can opt for TIFF (16 Bit) or JPEG, but I don't recommend it. TIFF (16 Bit) can cause problems when you try to open the file in certain photo editing and organizing programs. And saving in the JPEG format applies *lossy compression*, thereby sacrificing some image quality. If you need a JPEG copy of your processed Raw image for online sharing, you can easily create one from your TIFF version by following the steps laid out in Chapter 9.

Processing Raw files in ViewNX

In ViewNX, you can convert your Raw files to either the JPEG format or, for top picture quality, to the TIFF format. (See Chapter 3 if you're unsure about the whole concept of file format and how it relates to picture quality.)

Although the ViewNX converter isn't as full-featured as the ones in Nikon Capture NX 2, Adobe Photoshop Elements, and some other photo editing programs, it does enable you to make some adjustments to your Raw images. Follow these steps to try it out.

1. Click the thumbnail of the NEF (Raw) image to select it.

2. Display the Quick Adjustment tab by clicking its tab on the left side of the program window.

I labeled the tab in Figure 8-18. The tab provides access to a few controls for fine-tuning your image. You can adjust exposure compensation, white balance, and assign a Picture Control, such as Landscape or Monochrome. Each time you adjust a setting, the preview updates to show you the results.

A couple of options may require some explanation:

- Launch Utility button: This button, located under the Picture Control option, opens the Picture Control Utility, where you can define your own Picture Controls. I don't get into this advanced function in this book, but if you're curious, open the utility and then click the Help button at the bottom of the window.
- **Highlight Protection/Shadow Protection/D-Lighting HS:** Try using these options to recover hidden shadow and highlight detail.
- **Color Booster:** This slider (at the bottom of the panel, not visible in Figure 8-18) enables you to increase saturation. But if you select the People button under the slider, skin tones are left alone. Choose Nature to adjust the saturation of all colors in the photo.

If you want more details about these or any other of the options, choose Help ViewNX Help to open the Help system, and then display the Help pages related to the Quick Adjustment tab.

3. Click the Apply button at the bottom of the Quick Adjustment area.

screen shown in Figure 8-16. Use the Multi Selector to highlight the setting you want to use and press OK to return to the main Raw conversion screen.

Rather than detailing all the options here, the following list points you to the chapter where you can explore the settings available for each:

- Image Quality: See the Chapter 3 section related to the JPEG quality settings for details on this option.
- *Image Size:* The first part of Chapter 3 explains this one.
- White Balance: Check out Chapter 6 for details about White Balance options.
- Exposure Compensation: With this option, you can adjust image brightness by applying exposure compensation, a feature that I cover in Chapter 5.
- *Picture Control:* This option enables you to adjust color, contrast, and image sharpness. For a review of the available settings, see the last part of Chapter 6.

7. When you finish setting all the conversion options, highlight EXE on the main conversion screen. (Refer to Figure 8-15.) Then press OK.

The camera records a JPEG copy of your Raw file and displays the copy in the monitor. To remind you that the image was created with the help of the Retouch menu, the top-left corner of the display sports the little Retouch icon, and the filename of the image begins with CSC rather than the usual DSC, as shown in Figure 8-17. See Chapter 4 for details about filenaming conventions used by the D90.

Figure 8-16: Select the setting you want to use and press OK.

Figure 8-17: Filenames of processed RAW images start with CSC.

- 1. Press the Playback button to switch to playback mode.
- 2. Display the picture you want to process in the single-image (full frame) view.

If necessary, you can shift from thumbnails view to single-image view by just pressing the OK button. Chapter 4 has more playback details.

3. Press the OK button.

The Retouch menu then appears atop your photo, as shown in Figure 8-14.

Figure 8-14: In single-image playback mode, press OK to display the Retouch menu over your photo.

4. Use the Multi Selector to scroll to the NEF (RAW) Processing option, as shown in Figure 8-14.

The option is on the second screen of the Retouch menu.

5. Press OK to display your processing options, as shown in Figure 8-15.

This screen is command central for specifying what settings you want the camera to use when creating the JPEG version of your Raw image.

6. Set the conversion options.

Along the right side of the screen, you see a vertical column offering five conversion options, which I labeled in Figure 8-15. To establish the setting for an option, use the Multi Selector to highlight it and then press OK. You then see the available settings for the option. For example, if you highlight the first option, Image Quality, and press OK, you see the

Figure 8-15: Specify the conversion settings here.

- Some Raw converters give you the option of creating a 16-bit image file. (A bit is a unit of computer data; the more bits you have, the more colors your image can contain.) Although you can create 16-bit TIFF files, many photo editing programs either can't open them or limit you to a few editing tools, so I suggest you stick with the standard, 8-bit image option. Your image will contain more than enough colors, and you'll avoid potential conflicts caused by so-called high-bit images.
- Resist the temptation to crank up color saturation too much. Doing so can actually destroy image detail. Likewise, be careful about overdoing sharpening, or you can create noticeable image defects. Chapter 6 offers some additional information about sharpening and saturation to help you find the right amounts of each.

Processing Raw images in the camera

Scroll past the initial screen of options on the Retouch menu, and you come to a menu item called NEF (Raw) Processing. With this feature, you can process Raw files right in the camera — no computer or other software required.

I want to share two reservations about this option:

- First, you can save your processed files only in the JPEG format. As discussed in Chapter 3, that format results in some quality loss because of the file compression that JPEG applies. You can choose the level of JPEG compression you want to apply during Raw processing; you can create a JPEG Fine, Normal, or Basic file. Each of those settings produces the same quality that you get when you shoot new photos in the JPEG format and select Fine, Normal, or Basic from the Image Quality menu.
 - Chapter 3 details the JPEG options, but, long story short, choose Fine for the best JPEG quality. And if you want to produce the absolute best quality from your Raw images, use a software solution and save your processed file in the TIFF format instead.
- You can make adjustments to exposure, color, and a few other options as part of the in-camera Raw conversion process. Evaluating the effects of your adjustments on the camera monitor can be difficult because of the size of the display, so for really tricky images, you may want to forgo incamera conversion and do the job on your computer, where you can get a better view of things. If you do go the in-camera route, make sure that the monitor brightness is set to its default position so that you aren't misled by the display. (Chapter 1 shows you how to adjust monitor brightness.)

That said, in-camera Raw processing offers a quick and convenient solution when you need JPEG copies of your NEF images for immediate online sharing. (JPEG is the standard format for online use.) Follow these steps to get the job done:

✓ Use Nikon Capture NX 2 or a third-party Raw conversion tool. For the most control over your Raw images, you need to open up your wallet and invest in a program that offers a truly capable converter. Nikon offers such a program, called Nikon Capture NX 2, which sells for about \$180. Figure 8-13 gives you a look at the Capture NX 2 Raw converter window.

Another (and less costly option) that I frequently recommend is Adobe Photoshop Elements, which sells for about \$90 (www.adobe.com). It includes the Adobe Camera Raw converter, known in the industry as ACR, which is widely considered one of the best available. (*Note:* The converter in Elements doesn't offer all the bells and whistles of the version of ACR provided with Photoshop, however.) In addition, Elements is designed for the novice photo editing enthusiast, so it includes lots of helpful onscreen guides, whereas Capture NX 2 is geared more to the advanced digital photographer.

Figure 8-13: Nikon Capture NX 2 is one option for gaining more control over your Raw conversions.

If you do opt for a third-party conversion tool, check the program's Help system for details on how to use the various controls, which vary from program to program. The following general tips apply no matter what converter you use, however:

Whenever possible, save your processed files in a nondestructive format such as TIFF. For top quality, don't save originals in the JPEG format, which applies *lossy compression*. You can read about the potential damage to image quality that lossy compression creates in Chapter 3. If you need a JPEG image to share online, Chapter 9 shows you how to create a duplicate of your original, converted image in that format.

Using your mouse as a shutter button

Nikon offers a piece of specialty software known as Nikon Camera Control Pro 2, which sells for about \$180. With this program, you can use your computer to operate your camera.

While your camera is connected to your computer, the software displays a window that contains clickable controls for adjusting all the standard camera settings, from aperture to white balance. When you get those options established, you click another button to record whatever scene is in front of your camera lens.

What's the point? Well, Camera Control Pro is great in scenarios that make having a live photographer close to the subject either difficult or dangerous — for example, trying to get a shot of a chemical reaction in a science lab or capture an image of an animal that's shy around humans. Additionally, the software enables easy time-lapse photography, enabling you to set the camera to take pictures automatically at specified intervals over a period of minutes, hours, or even days.

Processing Raw (NEF) Files

Chapter 3 introduces you to the Camera Raw file format, which enables you to capture images as raw data. The advantage of capturing Raw files, which are called NEF files on Nikon cameras, is that you make the decisions about how to translate the raw data into an actual photograph. You can specify attributes such as color intensity, image sharpening, contrast, and so on — all of which are handled automatically by the camera if you use its other file format, JPEG. You take these steps by using a software tool known as a *Raw converter*.

The bad news: Until you convert your NEF files into a standard file format, you can't share them online or print them from most programs other than Nikon ViewNX. You also can't get prints from most retail outlets or open them in many photo-editing programs.

To process your D90 NEF files, you have a couple of options:

- ✓ **Use the in-camera processing feature.** Through the Retouch menu, you can process your Raw images right in the camera. You can specify only limited image attributes (color, sharpness, and so on), and you can save the processed files only in the JPEG format, but still, having this option is a nice feature. See the next section for details.
- ✓ Process and convert in ViewNX. ViewNX also offers a Raw processing feature. Again, the controls for setting picture characteristics are a little limited, but you can save the adjusted files in either the JPEG or TIFF format. The last section of this chapter walks you through this option.

Figure 8-12: I prefer to sort my images into folders based on subject.

- ✓ Delete a file. In Windows, click the thumbnail and then choose Edit Delete or press the Delete key. On a Mac, choose Edit Move to Trash or press %+Delete. You then see a message asking you to confirm that you really want to trash the file. Click Yes to move forward.
- ✓ Protect or unlock photos. If you used the Protect feature on your camera's Playback menu to "lock" a file, a process you can explore in Chapter 4, you need to remove the protection if you want to edit the image in your photo software. To do so, choose File

 Protect Files

 Unprotect.
 - You also can protect files in ViewNX; just choose Protect from the File Protect Files submenu. A little key icon then appears on the thumbnail to remind you that the file is now protected from editing or erasing. If you later want to delete the file, you must first unprotect it.
- ✓ Select multiple files for moving, deleting, or other actions. Click the thumbnail of the first image and then Ctrl+click (Windows) or ૠ+click (Mac) the rest. To select all images in the current folder, press Ctrl+A (Windows) or ૠ+A (Mac.)

The XMP/IPTC Information part of the Metadata panel gives you access to the ViewNX keywords, tags, and rating functions. These functions, along with the program's search feature, provide you with various tools that make locating specific pictures easier, including the option to search for pictures based on the shooting date.

In case you're curious, IPTC refers to text data that press photographers are often required to tag onto their picture files, such as captions and copyright information. XMP refers to a data format developed by Adobe to enable that kind of data to be added to the file. IPTC stands for International Press Telecommunication Council; XMP stands for Extensible Metadata Platform.

Organizing pictures

When you download files from your camera using Nikon Transfer, you can specify where on your computer's hard drive you want to store them. After you get the files on your system, you can further organize them in ViewNX. You can create new folders and subfolders, move images from one folder to another, rename and delete files, and more.

To begin organizing your files, first display the Folders panel by clicking its tab on the left side of the program window. In this panel, you can see and manage the contents of all the drives and folders on your computer. From here, you can set up and rearrange your storage closet as follows:

- ✓ Hide/display the contents of a drive or folder. See a little plus sign (Windows) or right-pointing triangle (Mac) next to a drive or folder? Click it to display the contents of that storage bin. A minus sign (Windows) or a down-pointing triangle (Mac) means that the drive or folder is open; click that minus sign or triangle to close the drive or folder.
- Create a new folder. First, click the drive or folder where you want to house the new folder. For example, if you want to create it inside your Pictures or My Pictures folder, click it. Icons representing all the tolders and files currently found within that folder then appear in the thumbnail area.

Next, choose Filet New Folder. An icon representing the new folder should then appear, with the name box activated, as shown in Figure 8-12. Type the folder name and press Enter.

- You can create as many new folders and subfolders as you like. I prefer to organize my images according to subject matter for example, in Figure 8-12, I created a folder called Indianapolis and then created several folders inside, each dedicated to different locations in the city.
- Move a file from one folder to another. First, display that file's thumbnail in the browser. Then drag the thumbnail to the destination folder in the Folder pane.

Reviewing this data is a great way to better understand what settings work best for different types of pictures, especially when you're just getting up to speed with aperture, shutter speed, white balance, and all the other digital photography basics. To get the full story on how each setting affects your pictures, see Chapters 5 and 6.

To view the metadata in ViewNX, first select an image by clicking its thumbnail in the ViewNX browser window. Then click the Metadata tab on the left side of the window or choose Window ∴ Metadata. The metadata information then comes to the forefront, as shown in Figure 8-11.

The metadata is divided into several sections of related capture settings: File Info 1, File Info 2, Camera Info, Exposure, Flash, and so on. To hide or display a section, click the triangle next to it. You may need to use the scroll bar along the right side of the panel to view all the available information. Note that Nikon supplies ViewNX with cameras other than the D90, and some categories of data apply only to those other models.

Metadata tab

Figure 8-11: Inspecting metadata is a great way to see what settings work best for different subjects and lighting conditions.

view, click the thumbnail and then press the letter F. For movies, controls for starting the movie playback appear under the preview. (Click the little triangle to begin playback; click the neighboring square to stop it.)

In Full Screen view, as in the other views, you can magnify still photos by dragging the Zoom slider. To view additional photos at full-screen size, click the Previous and Next arrows under the image display. To return to the main browser window, just click the window's close button or choose a display option from the Display Options drop-down list, labeled in Figure 8-10.

Viewing picture metadata

When you snap a still photo with your D90, the camera includes in the picture file some extra data that records all the critical camera settings that were in force. This data, known by nerds as *metadata*, also includes the capture date and time. And, if you take advantage of the Image Comment feature that I cover in Chapter 11, you can even store a brief bit of custom text, such as the shooting location or subject.

Figure 8-10: Click the arrows to scroll through your photos in full-screen view.

- Image Viewer: This option displays your files as shown in Figure 8-9. Small thumbnails appear along the top of the pane; the selected thumbnail appears in the larger preview area underneath. Use these maneuvers to inspect your images:
 - To select an image or movie file, just click its thumbnail.
 - Magnify or reduce the size of photo thumbnails and the preview by using the Zoom sliders labeled in Figure 8-10. For a movie file, the size of the preview automatically changes to fill the preview area as you adjust the thumbnail size.
 - Drag in the large preview to scroll the display as needed to view hidden parts of a photo.
 - To scroll through your files, click the little arrows under the large preview, labeled Previous and Next in the figure.

Figure 8-9: Change to Image Viewer display to see picture and movie files in filmstrip style.

✓ Full Screen: Want to see a photo at full-screen size, as shown in Figure 8-10? If you're working in Thumbnail Grid view, just double-click the picture thumbnail. In Image Viewer view, first click the thumbnail to display it in the large preview. Then double-click the large preview. Or, in either

Figure 8-8 offers a look at the ViewNX window as it appears by default in Windows Vista. The Mac version is nearly identical, although it features the usual Mac look and feel instead of the Microsoft Windows design.

On either type of system, you can customize a variety of aspects of the window layout by using the options on the View and Window menus.

To start viewing your pictures, first display the Folders panel along the left side of the program window, as shown in Figure 8-8. (Just click the tab, labeled in the figure.) Now open the folder that holds the photos you want to view. If you came to ViewNX directly after downloading pictures via Nikon Transfer, the folder that holds the new images should already be selected for you. Thumbnails of those images then appear on the right side of the program window. For a movie, you see a thumbnail representing the first shot in the recording.

Figure 8-8: You can browse and organize your photos using Nikon ViewNX.

By opening the View menu, you can choose from three different viewing options, which work as follows:

✓ Thumbnail Grid: This is the default layout, shown in Figure 8-8. You can adjust the size of the thumbnails by dragging the Zoom slider, labeled in the figure.

you can view and organize your images. (That's assuming that you installed ViewNX, of course.) If you want to use a program other than ViewNX for that task, open the drop-down list, click Browse, and select the program from the dialog box that appears. Click OK after doing so. And if you don't want Nikon Transfer to close after downloading, uncheck the Quit Nikon Transfer Automatically After Transfer option.

Figure 8-7: Control other aspects of the program's behavior via the Preferences tab.

Your choices remain in force for any subsequent download sessions, so you don't have to revisit this tab unless you want the program to behave differently.

9. When you're ready to start the download, click the Start Transfer button.

It's located in the lower-right corner of the program window. After you click the button, the Process bar in the lower-left corner indicates how the transfer is progressing. Again, what happens when the transfer completely depends on the choices you made in Step 8; by default, Nikon Transfer closes, and ViewNX opens, automatically displaying the folder that contains your just-downloaded images.

Browsing images in Nikon ViewNX

Nikon ViewNX is designed to do exactly what its name suggests: enable you to view and organize the pictures that you shoot with your D90. You also can view other photos — pictures you scanned, received from friends via e-mail, or took with a different camera, for example. The only requirement is that the file format is one that ViewNX can read; for still photos, that means JPEG, TIFF, or NEF, which is the Nikon flavor of Camera Raw. (Chapter 3 explains file formats.) The program also can play the AVI movie files that you create with your D90. For a complete rundown of supported file formats, check the Appendix section of the built-in program Help system.

You don't have to stick with this default location — you can put your pictures anywhere you please. But because most photo programs automatically look for pictures in these standard folders, putting your pictures there just simplifies things a little down the road. *Note:* You can always move your pictures into other folders after you download them if needed, too. The upcoming section "Organizing pictures" explains how to do so in Nikon ViewNX.

6. Specify whether you want the pictures to be placed inside a new subfolder.

If you select the Create Subfolder for Each Transfer option, the program creates a new folder inside the storage folder you selected in Step 5. Then it puts all the pictures from the current download session into that new subfolder. You can either use the numerical subfolder name the program suggests or click the Edit button to set up your own naming system. If you created custom folders on the camera memory card, an option you can explore in Chapter 11, select the Copy Folder Names from Camera check box to use those folder names instead.

7. Tell the program whether you want to rename the picture files during the download process.

If you do, select the Rename Photos During Transfer check box. Then click the Edit button to display a dialog box where you can set up your new filenaming scheme. Click OK after you do so to close the dialog box.

8. Click the Preferences tab to set the rest of the transfer options.

Now the tab shown in Figure 8-7 takes over the top of the program window. Here you find a number of options that enable you to control how the program operates. Most of the options are self-explanatory, but a couple warrant a few words of advice:

- Launch automatically when device is attached. Deselect this check box if you don't want Nikon Transfer to start every time you connect your camera to your computer or insert a memory card into your card reader.
- *Transfer new photos only.* This option, when selected, ensures that you don't waste time downloading images that you've already transferred but are still on the memory card.
- Delete original files after transfer. Turn this option off, as shown in Figure 8-7. Otherwise, your pictures are automatically erased from your memory card when the transfer is complete. You should always check to make sure the pictures really made it to the computer before you delete them from your memory card. (See Chapter 4 to find out how to use the Delete function on your camera.)
- Open destination folder with other application after transfer. By default, Nikon Transfer shuts itself down when the file download is complete, and Nikon ViewNX then starts automatically so that

Downloading and Organizing Photos with the Nikon Software

Remember unpacking your camera box when you first brought home your D90? Did you notice a CD-ROM called Nikon Software Suite? If you haven't already done so, dig out that CD and pop it into your computer's CD drive. Then install the following two programs:

- ✓ **Nikon Transfer:** This program assists you with the process of transferring pictures from your camera or memory card to the computer.
- Nikon ViewNX: After downloading your files, you can view and organize your picture files using this program. You also can print and e-mail your photos from ViewNX.

Note that this book features Nikon Transfer version 1.2 and Nikon ViewNX version 1.2, which were the most current at the time of publication. If you own an earlier version of these programs, visit the Nikon Web site to install the updates. (To find out what version you have installed, open the program. Then, in Windows, choose Help⇔About. On a Mac, choose the About command from the Nikon Transfer or Nikon ViewNX menu.)

The next several sections give you the most basic of introductions to using Nikon Transfer and ViewNX. If you want more details, just look in the Help system built into the programs. (Click the Help menu to access the system.)

Before you move on, though, I want to clear up one common point of confusion: You can use the Nikon software to download and organize your photos and still use any photo-editing software you prefer. And to do your editing, you don't need to re-download photos — after you transfer photos to your computer, you can access them from any program, just as you can any file that you put on your system. In fact, you can set things up so that you can select a photo in ViewNX and then open that picture in your chosen photo editor with a click or two. You can find details in the ViewNX Help system (open the program and then choose Help ViewNX Help); look for the section called "Setting Up ViewNX."

Downloading with Nikon Transfer

The following steps explain how to download new pictures to your computer using Nikon Transfer:

1. Attach your camera or insert a memory card into your card reader, as outlined in the first part of this chapter.

Depending on what software you have installed on your system, you may see the initial Nikon Transfer window, as shown in Figure 8-5.

Nothing happens. Don't panic; assuming that your card reader or camera is properly connected, all is probably well. Someone simply may have disabled all the automatic downloaders on your system. Just launch your photo software and then transfer your pictures using whatever command starts that process. (I show you how to do it with Nikon Transfer later in the chapter; for other programs, consult the software manual.)

As another option, you can use Windows Explorer or the Mac Finder to drag and drop files from your memory card to your computer's hard drive. Whether you connect the card through a card reader or attach the camera directly, the computer sees the card or camera as just another drive on the system. So the process of transferring files is exactly the same as when you move any other file from a CD, DVD, or other storage device onto your hard drive.

In the next sections, I provide details on using Nikon Transfer to download your files and Nikon ViewNX to view and organize your pictures. Remember, if you use some other software, the concepts are the same, but check your program manual to get the small details. In most programs, you also can find lots of information by simply clicking open the Help menu.

Safeguarding your digital photo files

To make sure that your digital photos enjoy a long, healthy life, follow these storage guidelines:

- Don't rely on your computer's hard drive for long-term, archival storage. Hard drives occasionally fail, wiping out all files in the process. This warning applies to both internal and external hard drives.
- Camera memory cards, flash memory keys, and other portable storage devices are similarly risky. All are easily damaged if dropped or otherwise mishandled. And being of diminutive stature, these portable storage options also are easily lost.
- The best way to store important files is to copy them to nonrewritable CDs. (The label should say CD-R, not CD-RW.) Look for quality, brand-name CDs that have a gold coating, which offer a higher level of security than other coatings.

- Recordable DVDs offer the advantage of holding lots more data than a CD. However, be aware that the DVDs you create on one computer may not be playable on another because multiple recording formats and disc types exist. DVD minus, DVD plus, dual-layer DVD, and so on. If you do opt for DVD, look for the archival, gold-coated variety, just as for CDs.
- Online photo-sharing sites such as Shutterfly, Kodak Gallery, and the like aren't designed to be long-term storage tanks for your images. Consider them only a backup to your backup, and read the site terms carefully so that you understand how long the site will hold onto your files if you stop buying prints and other products. Also investigate whether the terms of membership give the site permission to use and distribute your photos without your say-so. In other words, the fine print is important.

Here are the most common possibilities and how to move forward:

On a Windows-based computer. a Windows message box similar to the one in Figure 8-4 appears. Again, the figure shows the dialog box as it appears on a computer running Windows Vista. Whatever its design, the dialog box suggests different programs that you can use to download your picture files. Which programs appear depend on what you have installed on your system; if you installed Nikon Transfer, for example, it should appear in the program list, as in the figure. In Windows Vista, just click the transfer program that you want to use. In other versions of Windows, the dialog box may sport an OK button; if so, click that button to proceed.

Figure 8-4: Windows may display this initial boxful of transfer options.

If you want to use the same program for all of your transfers,

select the Always Do This for This Device check box, as shown in the figure. The next time you connect your camera or insert a memory card, Windows will automatically launch your program of choice instead of displaying the message box.

An installed photo program automatically displays a photo-download wizard. For example, the Nikon Transfer downloader or a downloader associated with Adobe Photoshop Elements, Picasa, or some other photo software may leap to the forefront. On a Mac, the built-in iPhoto software may display its auto downloader. (Apple's Web site, www. apple.com, offers excellent video tutorials on using iPhoto, by the way.)

Usually, the downloader that appears is associated with the software that you most recently installed. Each new program that you add to your system tries to wrestle control over your image downloads away from the previous program.

If you don't want a program's auto downloader to launch whenever you insert a memory card or connect your camera, you should be able to turn that feature off. Check the software manual to find out how to disable the auto launch.

4. Insert the smaller of the two plugs on the USB cable into the USB port on the side of the camera.

The slot is hidden under a little rubber door on the left side of the camera, as shown in Figure 8-3.

5. Plug the other end of the cable into the computer's USB port.

If possible, plug the cable into a port that's built into the computer, as opposed to one that's on your keyboard or part of an external USB hub. Those accessory-type connections can sometimes foul up the transfer process.

6. Turn the camera on.

What happens now depends on whether you connected the camera to a Windows-based or Mac computer and what photo software you have installed on that system. The next section explains the possibilities and how to proceed with the image transfer process.

Figure 8-3: The USB slot is hidden under the rubber door on the left side of the camera.

7. When the download is complete, turn off the camera and then disconnect it from the computer.

I repeat: Turn off the camera before severing its ties with the computer. Otherwise, you can damage the camera.

Starting the transfer process

After you connect the camera to the computer (be sure to carefully follow the steps in the preceding section) or insert a memory card into your card reader, your next step depends, again, on the software installed on your computer and the computer operating system.

I prefer to use a card reader because when you transfer via the camera, the camera must be turned on during the process, wasting battery power. If you want to transfer directly from the camera, however, the next section explains some important steps you need to take to make that option work. For help using a card reader, skip ahead to "Starting the transfer process" to get an overview of what happens after you insert the card into the reader.

Connecting the camera and computer

You need to follow a specific set of steps when connecting the camera to your computer. Otherwise, you can damage the camera or the memory card.

Also note that in order for your camera to communicate with the computer, Nikon suggests that your computer be running one of the following operating systems:

- Windows Vista 32-bit Home Basic, Home Premium, Business, Enterprise, or Ultimate edition
- Windows XP with Service Pack 3, Home or Professional edition
- Mac OS X 10.3.9, 10.4.11, or 10.5.3

If you use another OS (operating system, for the non-geeks in the crowd), check the support pages on the Nikon Web site (www.nikon.com) for the latest news about any updates to system compatibility. You can always simply transfer images with a card reader, too.

With that preamble out of the way, here are the steps to link your computer and camera:

If the battery is low, charge it before continuing. Running out of battery power during the transfer process can cause problems, including lost picture data. Alternatively, if you purchased the optional AC adapter, use that to power the camera during picture transfers.

- 2. Turn on the computer and give it time to finish its normal startup routine.
- 3. Turn the camera off.

One note before you dig in: Most figures in this chapter and elsewhere feature the Windows Vista operating system. If you use some other version of Windows or own a Mac, what you see on your screen may look slightly different but should contain the same basic options unless I specify otherwise.

Sending Pictures to the Computer

You can take two approaches to moving pictures from your camera memory card to your computer:

- Connect the camera directly to the computer. For this option, you need to dig out the USB cable that came in your camera box. Your computer must also have a free USB slot, or *port*, in techie talk. If you're not sure what these gadgets look like, Figure 8-1 gives you a look. The little three-pronged icon, labeled in Figure 8-1, is the universal symbol for USB.
- ✓ Transfer images using a memory card reader. Many computers now also have slots that accept common types of memory cards. If so, you can simply pop the card out of your camera and into the card slot instead of hooking the camera up to the computer.

As another option, you can buy stand-alone card readers such as the SanDisk model shown in Figure 8-2. This particular model accepts a variety of memory cards, including the SD card used by your D90. Check your printer, too; many printers now have card slots that serve the purpose of a card reader.

Figure 8-1: You can connect the camera to the computer using the supplied USB cable.

Courtesy SanDisk Corporation

Figure 8-2: A card reader offers a more convenient method of image transfer.

Downloading, Organizing, and Archiving Your Picture Files

In This Chapter

- ▶ Transferring pictures to your computer
- ▶ Using Nikon Transfer and ViewNX to download and organize photos
- Processing NEF (Raw) files
- ▶ Keeping your picture files safe from harm

or many novice digital photographers (and even some experienced ones), the task of moving pictures to the computer and then keeping track of all of those image files is one of the more confusing aspects of the art form. And frankly, writing about the download and organizing process isn't all that easy, either. (I know, poor me!) The problem is that providing you with detailed instructions is pretty much impossible because the steps you need to take vary widely depending on what software you have installed on your computer and whether you use the Windows or Macintosh operating system.

To give you as much help as I can, however, this chapter shows you how to transfer and organize pictures using the free Nikon software that came in your camera box. After exploring these discussions, you should be able to adapt the steps to any other photo program you may prefer. This chapter also covers a few other aspects of handling your picture files, including converting pictures taken in the NEF (Raw) format to a standard image format.

In this part . . .

ou've got a memory card full of pictures. Now what? Now you turn to the first chapter in this part, which explains how to get those pictures out of your camera and onto your computer and, just as important, how to safeguard them from future digital destruction. After downloading your files, head for Chapter 9, which offers step-by-step guidance on printing your pictures, sharing them online, and even viewing them on your television.

Part III Working with Picture Files

"Try putting a person in the photo with the product you're trying to sell. We generated a lot of interest in our eBay listing once Leo started modeling my hats and scarves."

A more reliable option for shooting small reflective objects is to invest in a light cube or light tent such as the ones shown in Figure 7-14, from Cloud Dome (www.clouddome.com) and Lastolite (www.lastolite.com), respectively. You place the reflective object inside the tent or cube and then position your lights around the outside. The cube or tent acts as a light diffuser, reducing reflections. Prices range from about \$50 to \$200, depending on size and features.

Cloud Dome, Inc.

Lastolite Limited

Figure 7-14: Investing in a light cube or tent makes photographing reflective objects much easier.

- technique at the zoo to capture the snake image you see in Figure 7-13.
- ✓ Shooting out a car window: Set the camera to shutter-priority autoexposure or manual mode and dial in a fast shutter speed to compensate for the movement of the car. Oh, and keep a tight grip on your camera.
- Shooting fireworks: First off, use a tripod; fireworks require a long exposure, and trying to handhold your camera simply isn't going to work. If using a zoom lens, zoom out to the shortest focal length. Switch to manual focusing and set focus at infinity (the farthest focus point possible on your lens). Set the exposure mode to manual, choose a relatively high f-stop setting say, f/16 or so and start a shutter speed of 1 to 3 seconds. From there, it's simply a matter of experimenting with different shutter speeds.

Figure 7-13: He's watching you . . .

Be especially gentle when you press the shutter button — with a very slow shutter, you can easily create enough camera movement to blur the image. If you purchased the accessory remote control for your camera, this is a good situation in which to use it.

You also may want to enable your camera's Long Exposure Noise Reduction feature because a long exposure also increases the chances of noise defects. See Chapter 5 for details. (Keep the ISO Sensitivity setting low to further dampen noise.)

✓ Shooting reflective surfaces: In outdoor shots taken in bright sun, you can reduce glare from reflective surfaces such as glass and metal by using a *circular polarizing filter*, which you can buy for about \$40. A polarizing filter can also help out when you're shooting through glass.

But know that in order for the filter to work, the sun, your subject, and your camera lens must be precisely positioned. Your lens must be at a 90-degree angle from the sun, for example, and the light source must also be reflecting off the surface at a certain angle and direction. In addition, a polarizing filter also intensifies blue skies in some scenarios, which may or may not be to your liking. In other words, a polarizing filter isn't a surefire cure-all.

- When shooting indoors, try not to use flash as your primary light source. Because you'll be shooting at close range, the light from your flash may be too harsh even at a low Flash Compensation setting. If flash is inevitable, turn on as many room lights as possible to reduce the flash power that's needed even a hardware-store shop light can do in a pinch as a lighting source. (Remember that if you have multiple light sources, though, you may need to tweak the white balance setting.)
- ✓ To really get close to your subject, invest in a macro lens or a set of diopters. A true macro lens,

which enables you to get really, really close to your subjects, is an expensive proposition; expect to pay around \$200 or more. But if you enjoy capturing the tiny details in life, it's worth the investment.

For a less expensive way to go, you can spend about \$40 for a set of diopters, which are sort of like reading glasses that you screw onto your existing lens. Diopters come in several strengths -+1, +2, +4, and so on — with a higher number indicating a greater magnifying power. I took this approach to capture the extreme close-up in Figure 7-12, attaching a +2 diopter to my lens. The downfall of diopters, sadly, is that they typically produce images that are very soft around the edges, as in Figure 7-13 — a problem that doesn't occur with a good macro lens.

Figure 7-12: To extend your lens' close-focus ability, you can add magnifying diopters.

Coping with Special Situations

A few subjects and shooting situations pose some additional challenges not already covered in earlier sections. So to wrap up this chapter, here's a quick list of ideas for tackling a variety of common "tough-shot" photos:

✓ Shooting through glass: To capture subjects that are behind glass, try putting your lens right flat against the glass. Then switch to manual focusing; the glass barrier can give the autofocus mechanism fits. Disable your flash to avoid creating any unwanted reflections, too. I used this

✓ Take control over depth of field by setting the camera mode to A (aperture-priority autoexposure) mode. Whether you want a shallow, medium, or extreme depth of field depends on the point of your photo. In classic nature photography, for example, the artistic tradition is a very shallow depth of field, as shown in Figure 7-11, and requires an open aperture (low f-stop value). For this image, the f-stop was f/5.6. But if you want the viewer to be able to clearly see all details throughout the frame - for example, if you're shooting a product shot for your company's sales catalog - you need to go the other direction, stopping down the aperture as far as possible.

Not ready for the advanced exposure modes yet? Try Close Up mode instead. (It's the one marked with the little flower on your Mode dial.) In this mode,

Figure 7-11: Shallow depth of field is a classic technique for close-up floral images.

the camera automatically opens the aperture to achieve a short depth of field and bases focus on the center of the frame. As with all the other automatic exposure modes, though, the range of apertures available to the camera depends on the lighting conditions.

- Remember that zooming in and getting close to your subject both decrease depth of field. So back to that product shot: If you need depth of field beyond what you can achieve with the aperture setting, you may need to back away, zoom out, or both. (You can always crop your image to show just the parts of the subject that you want to feature.)
- When shooting flowers and other nature scenes outdoors, pay attention to shutter speed, too. Even a slight breeze may cause your subject to move, causing blurring at slow shutter speeds.
- Use flash for better outdoor lighting. Just as with portraits, a tiny bit of flash typically improves close-ups when the sun is your primary light source. Again, though, keep in mind that the maximum shutter speed possible when you use the built-in flash is 1/200 second. So in very bright light, you may need to use a high f-stop setting to avoid overexposing the picture. If you shoot in an advanced exposure mode (P, S, A, or M), you can also adjust the flash output via the Flash Compensation control. Chapter 5 offers details.

Figure 7-10, taken by my friend Jonathan Conrad. Shutter speed for this image was 5 seconds.

Instead of changing the shutter speed manually between each shot, try *bulb* mode. Available only in M (manual) exposure mode, this option records an image for as long as you hold down the shutter button. So just take a series of images, holding the button down for different lengths of time for each shot. In bulb mode, you also can exceed the standard maximum shutter speed of 30 seconds.

For the best lighting, shoot during the "magic hours." That's the term photographers use for early morning and late afternoon, when the light cast by the sun is soft and warm, giving everything that beautiful, gently warmed look.

Jonathan Conrad

Figure 7-10: A slow shutter also creates neon light trails in city-street scenes.

Can't wait for the perfect light? Tweak your camera's white balance setting, using the instruc-

tions laid out in Chapter 6, to simulate magic-hour light.

✓ In tricky light, bracket exposures. Bracketing simply means to take the same picture at several different exposures to increase the odds that at least one of them will capture the scene the way you envision. Bracketing is especially a good idea in difficult lighting situations such as sunrise and sunset.

Unfortunately, you really can't bracket exposures in the fully automatic exposure modes because you have no way to adjust exposure in those modes.

Capturing dynamic close-ups

For great close-up shots, try these techniques:

Check your owner's manual to find out the minimum close-focusing distance of your lens. How "up close and personal" you can get to your subject depends on your lens, not the camera body itself. is that you need a slower shutter speed to produce a good exposure. If the shutter speed drops below what you can comfortably hand-hold — for me, that's about 1/50 second — use a tripod to avoid picture-blurring camera shake.

No tripod handy? Look for any solid surface on which you can steady the camera. Of course, you can always increase the ISO Sensitivity setting to allow a faster shutter, too, but that option brings with it the chances of increased image noise. See Chapter 5 for details.

For dramatic waterfall shots, consider using a slow shutter to create that "misty" look. The slow shutter blurs the water, giving it a soft, romantic appearance. Figure 7-9 shows you a close-up of this effect. Again, use a tripod to ensure that the rest of the scene doesn't also blur due to camera shake.

Figure 7-9: For misty waterfalls, use a slow shutter speed (and tripod).

In very bright light, you may overexpose the image at a very slow shutter, even if you stop the aperture all the way down and select the camera's lowest ISO setting. As a solution, consider investing in a *neutral density filter* for your lens. This type of filter works something like sunglasses for your camera: It simply reduces the amount of light that passes through the lens so that you can use a slower shutter than would otherwise be possible.

Lat sunrise or sunset, base exposure on the sky. The foreground will be dark, but you can usually brighten it in a photo editor if needed. If you base exposure on the foreground, on the other hand, the sky will become so bright that all the color will be washed out — a problem you usually can't fix after the fact.

Also experiment with different levels of Active D-Lighting adjustment. Chapter 5 explains this feature, which brightens dark areas but doesn't alter highlights, leaving your sky colors intact. You can adjust the setting only in the P, S, A, and M exposure modes, however.

For cool nighttime city pics, experiment with slow shutter. Assuming that cars or other vehicles are moving through the scene, the result is neon trails of light like those you see in the foreground of the image in

Figure 7-7: Although most of the shots were deletable, this one was a keeper.

That said, I can offer a few tips to help you photograph a landscape the way *you* see it:

Shoot in aperture-priority autoexposure mode (A) so that you can control depth of field. If you want extreme depth of field, so that both near and distant objects are sharply focused, as in Figure 7-8, select a high f-stop value. For short depth of field, use a low value.

You can also use Landscape mode to achieve the first objective. In this mode, the camera automatically selects a high f-stop number, but you have no control over the exact value (or certain other picture-taking settings). And in dim lighting, the camera may be forced to select a low f-stop setting.

If the exposure requires a slow shutter, use a tripod to avoid blurring. The downside to a high f-stop

Figure 7-8: Use a high f-stop value (or Landscape mode) to keep foreground and background sharply focused.

or otherwise cavorting, snapping a shot before they do move or change positions is often tough. So if an interaction or scene catches your eye, set your camera into action mode and then just fire off a series of shots as fast as you can.

For example, one recent afternoon, I spotted my furball and his equally fluffy new neighbor introducing themselves to each other through the fence that separates their yards. I ran and grabbed my camera, flipped it into shutter-priority mode, and just started shooting. Most of the images were throwaways; you can see some of them in Figure 7-6. But somewhere around the tenth frame, I captured the moment you see in Figure 7-7, which puts a whole new twist on the phrase "gossiping over the backyard fence." Two seconds later, the dogs got bored with each other and scampered away into their respective yards, but thanks to a fast shutter, I got the shot that I wanted.

Capturing scenic vistas

Providing specific capture settings for landscape photography is tricky because there's no single best approach to capturing a beautiful stretch of countryside, a city skyline, or other vast subject. Take depth of field, for example: One person's idea of a super cityscape might be to keep all buildings in the scene sharply focused. But another photographer might prefer to shoot the same scene so that a foreground building is sharply focused while the others are less so, thus drawing the eye to that first building.

Figure 7-6: I used speed-shooting techniques to capture this interaction between a pair of pups.

Adding flash is a bit tricky for action shots, unfortunately. First, the flash needs time to recycle between shots, so try to go without if you want to capture images at a fast pace. Second, the built-in flash has limited range — so don't waste your time if your subject isn't close by. And third, remember that the fastest shutter speed you can use with the built-in flash is 1/200 second, which may not be high enough to capture a quickly moving subject without blur. If you want additional shutter-speed flexibility, you need to use an external flash head that supports the Nikon Creative Lighting System options. (See Chapter 5 for details.)

If you do decide to use flash, you must bail out of Sports mode; it doesn't permit you to use flash.

4. For rapid-fire shooting, set the Release mode to one of the Continuous settings.

In both modes — Continuous High and Continuous Low — you can capture multiple images with a single press of the shutter button. As long as you hold down the button, the camera continues to record images. The exact number of frames per second depends on settings you can read about at the end of Chapter 2.

5. For fastest shooting, switch to manual focusing.

Manual focusing eliminates the time the camera needs to lock focus in autofocus mode. Chapter 1 shows you how to focus manually, if you need help.

If you do use autofocus, try these two autofocus settings for best performance:

- Set the AF-area mode to Dynamic Area.
- Set the Autofocus mode to AF-C (continuous-servo autofocus).

Chapter 6 details these autofocus options.

6. Turn off Image Review and Active D-Lighting to speed up the camera even more.

You turn off Image Review via the Playback menu. Turning the option off can help speed up the time your camera needs to recover between shots. Active D-Lighting, introduced in Chapter 5, also increases the time the camera needs to record the image; you can turn off this feature via the Shooting menu or through the Quick Settings display. (To get to the Quick Settings display, press the Info button twice.)

7. Compose the subject to allow for movement across the frame.

In my example images, for instance, I zoomed out to a wide view so that my subject wouldn't fly out of the frame.

Using these techniques should give you a better chance of capturing any fast-moving subject. But action-shooting strategies also are helpful for shooting candid portraits of kids and pets. Even if they aren't currently running, leaping,

1/125 second

1/320 second

Figure 7-5: Raising the shutter speed produced the blur-free image on the right.

Along with the basic capture settings outlined in Table 7-1, try the techniques in the following steps to photograph a subject in motion:

1. Set the Mode dial to S (shutter-priority autoexposure).

In this mode, you control the shutter speed, and the camera takes care of choosing an aperture setting that will produce a good exposure.

If you aren't ready to step up to this advanced exposure mode, explained in Chapter 5, try using Sports mode, detailed in Chapter 2. But be aware that you have no control over many other aspects of your picture (such as white balance, flash, and so on) in that mode.

2. Rotate the main command dial to select the shutter speed.

(Refer to Figure 7 1 to locate shutter speed in the Control panel, view-finder, and Shooting Information display.) After you select the shutter speed, the camera selects an aperture (f-stop) to match.

What shutter speed do you need exactly? Well, it depends on the speed at which your subject is moving, so some experimentation is needed. But generally speaking, 1/500 second should be plenty for all but the fastest subjects (race cars, boats, and so on). For very slow subjects, you can even go as low as 1/250 or 1/125 second.

3. Raise the ISO setting or add flash to produce a brighter exposure, if needed.

In dim lighting, you may not be able to get a good exposure without taking this step; the camera simply may not be able to open the aperture wide enough to accommodate a fast shutter speed. Raising the ISO does increase the possibility of noise, but a noisy shot is better than a blurry shot.

A good general rule is to position your subjects far enough from the background that they can't touch it. If that isn't possible, though, try going the other direction: If the person's head is smack up against the background, any shadow will be smaller and less noticeable. For example, you get less shadowing when a subject's head is resting against a sofa cushion than if that person is sitting upright, with the head a foot or so away from the cushion.

Frame the subject loosely to allow for later cropping to a variety of frame sizes. Your D90 produces images that have an aspect ratio of 3:2. That means that your portrait perfectly fits a 4-x-6-inch print size but will require cropping to print at any other proportions, such as 5 x 7 or 8 x 10. Chapter 9 talks more about this issue.

Figure 7-4: To eliminate harsh lighting and strong shadows (left), I used bounce flash and moved the subject farther from the background (right).

Capturing action

A fast shutter speed is the key to capturing a blur-free shot of any moving subject, whether it's your tennis-playing teen, a spinning Ferris wheel, or, as in the case of Figure 7-5, a butterfly dancing from flower to flower. In the left image, a shutter speed of 1/125 second was too slow, resulting in some slight blurring of the butterfly. For the right image, I bumped the shutter speed up to 1/320 second, which "froze" the butterfly.

- Pay attention to white balance if your subject is lit by both flash and ambient light. If you set the white balance setting to Auto, as I recommend in Table 7-1, enabling flash tells the camera to warm colors to compensate for the cool light of a flash. If your subject is also lit by room lights or sunlight, the result may be colors that are slightly warmer than neutral. This warming effect typically looks nice in portraits, giving the skin a subtle glow. But if you aren't happy with the result or want even more warming, see Chapter 6 to find out how to fine-tune white balance. Again, you can make this adjustment only in P, S, A, or M exposure modes.
- When flash is unavoidable, try these tricks to produce better results. The following techniques can help solve flash-related issues:
 - *Indoors, turn on as many room lights as possible.* With more ambient light, you reduce the flash power that's needed to expose the picture. This step also causes the pupils to constrict, further reducing the chances of red-eye. (Pay heed to my white balance warning, however.) As an added benefit, the smaller pupil allows more of the subject's iris to be visible in the portrait, so you see more eye color.
 - Try setting the flash to red-eye reduction or slow-sync mode. If you choose the first option, warn your subject to expect both a preliminary pop of light from the AF-assist lamp, which constricts pupils, and the actual flash. And remember that Slow-Sync flash uses a slower-than-normal shutter speed, which produces softer lighting and brighter backgrounds than normal flash. (Chapter 5 has an example.) This mode is available in P and A exposure modes and is also the default setting in Night Portrait mode.

Remember that the slow shutter speed of slow-sync mode means that you should use a tripod and ask your subject to stay very still to avoid blurring.

- For professional results, use an external flash with a rotating flash head. Then aim the flash head upward so that the flash light bounces off the ceiling and falls softly down onto the subject. An external flash isn't cheap, but the results make the purchase worthwhile if you shoot lots of portraits. Compare the two portraits in Figure 7-4 for an illustration. In the first example, the built-in flash resulted in strong shadowing behind the subject and harsh, concentrated light. To produce the better result on the right, I used the Nikon Speedlight SB-600 and bounced the light off the ceiling.
- To reduce shadowing from the flash, move your subject farther from the background. I took this extra step for the right image in Figure 7-4. The increased distance not only reduced shadowing but also softened the focus of the wall a bit (because of the short depth of field resulting from my f-stop and focal length).

shutter speed available when you use the built-in flash is 1/200 second, so in extremely bright light, you may need to stop down the aperture to avoid overexposing the photo. Doing so, of course, brings the background into sharper focus. So try to move the subject into a shaded area instead.

No flash Fill flash

Figure 7-3: To properly illuminate the face in outdoor portraits, use fill flash.

5. Press and hold the shutter button halfway to initiate exposure metering and autofocusing.

Make sure that an active autofocus point falls over your subject. Chapter 6 explains more about autofocus, but if you have trouble, simply set your lens to manual focus mode and then twist the focusing ring to set focus. See Chapter 1 for help with manual focusing.

6. Press the shutter button the rest of the way to capture the image.

Again, these steps just give you a starting point for taking better portraits. A few other tips can also improve your people pics:

✓ Pay attention to the background. Scan the entire frame looking for intrusive objects that may distract the eye from the subject. If necessary, reposition the subject against a more flattering backdrop. Inside, a softly textured wall works well; outdoors, trees and shrubs can provide nice backdrops as long as they aren't so ornate or colorful that they diminish the subject (for example, a magnolia tree laden with blooms).

flash unit in dim lighting. To disable the flash, hold the Flash button down as you rotate the main command dial to select the Off setting.

If flash is unavoidable, see my list of flash tips at the end of the steps to get better results.

Figure 7-1: You can monitor aperture and shutter speed settings in three places.

4. For outdoor portraits, use a flash if possible.

Even in daylight, a flash adds a beneficial pop of light to subjects' faces, as illustrated in Figure 7-3.

In the A exposure mode, you can just press the Flash button on the side of the camera to enable the flash. For daythine portraits, use the fill flash setting. (That's the regular, basic flash mode.) For nighttime images, try red-eye reduction or slow-sync mode; again, see the flash tips at the end of these steps to use either mode most effectively.

Unfortunately, Portrait mode uses Auto flash, and if the ambient light is very bright, the flash may not fire. Switch to an advanced exposure mode (P, S, A, or M) to regain flash control. But do note that whatever exposure mode you use, the top

Figure 7-2: For more pleasing indoor portraits, shoot by available light instead of using flash.

and even some teenagers I know — skip ahead to the next section and use the techniques given for action photography instead.

Assuming that you do have a subject willing to pose, the classic portraiture approach is to keep the subject sharply focused while throwing the background into soft focus. This artistic choice emphasizes the subject and helps diminish the impact of any distracting background objects in cases where you can't control the setting. The following steps show you how to achieve this look:

1. Set the Mode dial to A (aperture-priority autoexposure) and select the lowest f-stop value possible.

As Chapter 5 explains, a low f-stop setting opens the aperture, which not only allows more light to enter the camera but also shortens depth of field, or the range of sharp focus. So dialing in a low f-stop value is the first step in softening your portrait background. (The f-stop range available to you depends on your lens.) Also keep in mind that the farther your subject is from the background, the more blurring you can achieve.

I recommend aperture-priority mode when depth of field is a primary concern because you can control the f-stop while relying on the camera to select the shutter speed that will properly expose the image. Just rotate the subcommand dial to select your desired f-stop. (You do need to pay attention to shutter speed also, however, to make sure that it's not so slow that any movement of the subject or camera will blur the image.)

If you aren't comfortable with this advanced exposure mode, Portrait mode also results in a more open aperture, although the exact f-stop setting is out of your control. Chapter 2 details this mode.

Whichever mode you choose, you can monitor the current f-stop and shutter speed in the Control panel, viewfinder, and Shooting Information display, as shown in Figure 7-1.

2. To further soften the background, zoom in, get closer, or both.

As covered in Chapter 6, zooming in to a longer focal length also reduces depth of field, as does moving physically closer to your subject.

Avoid using a lens with a short focal length (a wide-angle lens) for portraits. They can cause features to appear distorted — sort of like how people look when you view them through a security peephole in a door.

3. For indoor portraits, shoot flash-free if possible.

Shooting by available light rather than flash produces softer illumination and avoids the problem of red-eye. To get enough light to go flashfree, turn on room lights or, during daylight, pose your subject next to a sunny window, as I did for the image in Figure 7-2.

In the A exposure mode, simply keeping the built-in flash unit closed disables the flash. In Portrait mode, the camera automatically pops up the

Recapping Basic Picture Settings

Your subject, creative goals, and lighting conditions determine which settings you should use for some picture-taking options, such as aperture and shutter speed. I offer my take on those options throughout this chapter. But for many basic options, I recommend the same settings for almost every shooting scenario. Table 7-1 shows you those recommendations and also lists the chapter where you can find details about each setting.

Table 7-1	All-Purpose Picture-Taking Settings		
Option	Recommended Setting	Chapter	
Image Quality	JPEG Fine or NEF (Raw)	3	
Image Size	Large or medium	3	
White Balance*	Auto	6	
ISO Sensitivity	200	5	
Autofocus Mode	AF-A (Auto-servo)	6	
AF-Area Mode	Action photos: Dynamic area; all others, Single Point	6	
Release Mode	Action photos: Continuous; all others: Single	2	
Metering*	Matrix	5	
Active D-Lighting*	Auto	5	

^{*}Adjustable only in P, S, A, and M exposure modes.

Setting Up for Specific Scenes

For the most part, the settings detailed in the preceding section fall into the "set 'em and forget 'em" category. That leaves you free to concentrate on a handful of other camera options, such as aperture and shutter speed, that you can manipulate to achieve a specific photographic goal.

The next four sections explain which of these additional options typically produce the best results when you're shooting portraits, action shots, landscapes, and close-ups. I offer a few compositional and creative tips along the way — but again, remember that beauty is in the eye of the beholder, and for every so-called rule, there are plenty of great images that prove the exception.

Shooting still portraits

By *still portrait*, I mean that your subject isn't moving. For subjects who aren't keen on sitting still long enough to have their picture taken — children, pets,

Putting It All Together

In This Chapter

- Reviewing the best all-around picture-taking settings
- Adjusting the camera for portrait photography
- Discovering the keys to super action shots
- Dialing in the right settings to capture landscapes and other scenic vistas
- Capturing close-up views of your subject
- ▶ Shooting through glass, capturing fireworks, and conquering other special challenges

arlier chapters of this book break down each and every picture-taking feature on your D90, describing in detail how the various controls affect exposure, picture quality, focus, color, and the like. This chapter pulls all that information together to help you set up your camera for specific types of photography.

The first section offers a quick summary of critical picture-taking settings that should serve you well no matter what your subject. Following that, I offer my advice on which settings to use for portraits, action shots, landscapes, and close-ups. To wrap things up, the end of the chapter includes some miscellaneous tips for dealing with special shooting situations and subjects.

Keep in mind that although I present specific recommendations here, there are no hard and fast rules as to the "right way" to shoot a portrait, a landscape, or whatever. So don't be afraid to wander off on your own, tweaking this exposure setting or adjusting that focus control, to discover your own creative vision. Experimentation is part of the fun of photography, after all — and thanks to your camera monitor and the Delete button, it's an easy, completely free proposition.

Figure 6-32: Each Picture Control produces a slightly different take on the scene.

for example. Additionally, keep in mind that you can always convert a color image to grayscale, but you can't go the other direction. You can create a black-and-white copy of your color image right in the camera, in fact; Chapter 10 shows you how.

- ✓ Portrait: This mode tweaks colors and sharpening in a way that is designed to produce nice skin texture and pleasing skin tones. (If you shoot in the Portrait or Night Portrait automatic exposure modes, the camera selects this Picture Control for you.)
- Landscape: This mode emphasizes blues and greens. As you might expect, it's the mode used by the Landscape Digital Vari-Program mode.

The extent to which Picture Controls affect your image depends on the subject as well as the exposure settings you choose and the lighting conditions. But Figure 6-32 gives you a general idea of what to expect. As you can see, the differences between the various Picture Controls are pretty subtle, with the exception of the Monochrome option, of course.

Personally, I think that the Standard Picture Control is just ducky, and I rarely use the others. And frankly, I suggest that you do the same. First off, you've got way more important camera settings to worry about — aperture, shutter speed, autofocus, and all the rest. Why add one more setting to your list, especially when the impact of changing it is minimal?

Second, if you really want to mess with the characteristics that the Picture Control options affect, you're much better off shooting in the Raw (NEF) format and then making those adjustments on a picture-by-picture basis in your Raw converter. In Nikon ViewNX, you can even assign any of the existing Picture Controls to your Raw files and then compare how each one affects the image. The camera does tag your Raw file with whatever Picture Control is active at the time you take the shot, but the image adjustments are in no way set in stone, or even in sand — you can tweak your photo at will. (The selected Picture Control does affect the JPEG preview that's used to display the Raw image thumbnails in ViewNX and other browsers.)

For these reasons, I'm opting in this book to present you with just this brief introduction to Picture Controls so that I can go into more detail about functions that I see as more useful (such as the white balance customization options presented earlier). But if you're intrigued, know that you also can create your very own, customized Picture Controls. The camera manual walks you step by step through the process.

Sharpening, in case you're new to the digital meaning of the term, refers to a software process that adjusts contrast in a way that creates the illusion of slightly sharper focus. I emphasize, "slightly sharper focus." Sharpening produces a subtle *tweak,* and it's not a fix for poor focus.

You can select a Picture Control from the Shooting menu, as shown in Figure 6-30, or through the Shooting Information display. To go the second route, press the Info button twice: once to bring up the display and once to activate the Quick Settings strip at the bottom of the screen. Use the Multi Selector to scroll over to the Picture Control option, as shown in Figure 6-31. Press OK to get to the same menu options you see on the right in Figure 6-30.

Either way, you can choose from six Picture Controls, which produce the following results:

- ✓ **Standard:** The default setting for the P, S, A, and M exposure modes, this option captures the image normally that is, using the characteristics that Nikon offers up as suitable for the majority of subjects. You also are assigned this mode if you shoot in the Auto, No Flash, Sports, and Close Up exposure modes.
- ✓ Neutral: At this setting, the camera doesn't enhance color, contrast, and sharpening as much as in the other modes. The setting is designed for people who want to precisely manipulate these picture characteristics in a photo editor. By not overworking colors, sharpening, and so on when producing your original file, the camera delivers an original that gives you more latitude in the digital darkroom.
- Vivid: In this mode, the camera amps up color saturation, contrast, and sharpening.
- Monochrome: This setting produces black-and-white photos. Only in the digital world, they're called grayscale images because a true black-and-white image contains only black and white, with no shades of gray.

I'm not keen on creating grayscale images this way. I prefer to shoot in full color and then do my own grayscale conversion in my photo editor. That technique just gives you more control over the look of your black-and-white

Figure 6-31: You can access the Picture Control options through the Quick Settings display, too.

photos. Assuming that you work with a decent photo editor, you can control what original tones are emphasized in your grayscale version,

SHOOTING MENU	ranconstant -
Set Picture Control	ı ⊆S[
Manage Picture Control	
lmage quality	FINE
lmage size	
White balance	PRE
ISO sensitivity settings	自
Active D-Lighting	B AUTO
Color space	SRGB

Figure 6-29: Choose Adobe RGB for a broader color spectrum.

You can tell whether you captured an image in the Adobe RGB format by looking at its filename: Adobe RGB images start with an underscore, as in _DSC0627.jpg. For pictures captured in the sRGB color space, the underscore appears in the middle of the filename, as in DSC_0627.jpg. See Chapter 4 for more tips on decoding picture filenames.

Taking a Quick Look at Picture Controls

Perched at the top of the Shooting menu, an option called Set Picture Control, shown in Figure 6-30, offers one more way to tweak image sharpening, color, and contrast when you shoot in the P, S, A, and M exposure modes and choose one of the JPEG options or the Image Quality setting, also found on the Shooting Menu.

Figure 6-30: Picture Controls apply preset adjustments to color, sharpening, and other photo characteristics to images you shoot in the JPEG file format.

Figure 6-28: Adobe RGB includes some colors not found in the sRGB spectrum.

Some colors in the Adobe RGB spectrum cannot be reproduced in print. (The printer just substitutes the closest printable color, if necessary.) Still, I usually shoot in Adobe RGB mode because I see no reason to limit myself to a smaller spectrum from the get-go.

However, just because I use Adobe RGB doesn't mean that it's right for you. First, if you plan to print and share your photos without making any adjustments in your photo editor, you're usually better off sticking with sRGB, because most printers and Web browsers are designed around that color space. Second, know that in order to retain all your original Adobe RGB colors when you work with your photos, your editing software must support that color space — not all programs do. You also must be willing to study the whole topic of digital color a little bit because you need to use some specific settings to avoid really mucking up the color works.

If you want to go with Adobe RGB instead of sRGB, visit the Shooting menu and highlight the Color Space option, as shown on the left in Figure 6-29. Press OK to display the screen shown on the right in the figure. Select Adobe RGB and press OK again.

From here on, bracketing works as detailed in the steps at the end of Chapter 5. Rather than repeating everything here, I'll save some page space and provide just a quick summary of how to establish the bracketing settings.

- ✓ To set the number of frames and direction of the bracketing adjustment: Press and hold the BKT button (left-front side of the camera) while rotating the main command dial. For white balance bracketing, the options are as follows:
 - *b2F*: This setting records two frames, one without any adjustment and one shifted toward blue.
 - a2F: Again, you get two frames, but the second is shifted toward amber.
 - *3F*: This setting records three frames, with one neutral, one pushed toward amber, and one shifted toward blue. I used this option to create the candle variations in Figure 6-27.
 - *0F*: Select this setting to turn off bracketing.
- ✓ To set the amount of white-balance adjustment: Press the BKT button and rotate the subcommand dial. Again, you can set the bracketing amount to 1, 2, or 3.

While the BKT button is pressed, you can view both settings in the Control panel and Shooting Info display. When you release the button, you see the same BKT symbol and progress indicator that appears when you bracket exposure settings. (Again, check out Chapter 5 for details.)

After establishing the bracketing parameters, just shoot your bracketed frames. Bracketing remains in force until you disable it (by setting the frame number to 0F).

Choosing a Color Space: sRGB vs. Adobe RGB

By default, your camera captures images using the *sRGB color mode*, which simply refers to an industry-standard spectrum of colors. (The *s* is for *standard*, and the RGB is for red-green-blue, which are the primary colors in the digital color world.) The sRGB color mode was created to help ensure color consistency as an image moves from camera (or scanner) to monitor and printer; the idea was to create a spectrum of colors that all of these devices can reproduce.

However, the sRGB color spectrum leaves out some colors that *can* be reproduced in print and onscreen, at least by some devices. So as an alternative, your camera also enables you to shoot in the Adobe RGB color mode, which includes a larger spectrum (or *gamut*) of colors. Figure 6-28 offers an illustration of the two spectrums.

4. Select Auto Bracketing Set, as shown on the left in Figure 6-27, and press OK.

You see the screen shown on the right in the figure.

5. Select WB Bracketing and press OK.

The bracketing feature is now set up to adjust white balance between your bracketed shots. (Exposure, flash, and Active D-Lighting are not bracketed.)

Figure 6-26: I used white balance bracketing to record three variations on the subject.

e Bracketing/flash	
e1 Flash shutter speed	1/60
e2 Flash cntrl for built-in flash	TTL\$
e3 Modeling flash	0FF
e4 Auto bracketing set	AE\$
e5 Auto FP	0FF
e6 Bracketing order	Z
f1 ∰switch	::::
? f2 OK button (shooting mode)	RESET

Figure 6-27: Your first step is to set the Auto Bracketing Set option to WB Bracketing.

Bracketing white balance

Chapter 5 introduces you to your camera's automatic bracketing feature, which enables you to easily record the same image at several different exposure settings. In addition to being able to bracket autoexposure, flash, and Active D-Lighting settings, you can use the feature to bracket white balance.

Note a couple of things about this feature:

- ✓ You can bracket JPEG shots only. You can't use white balance bracketing if you set the camera's Image Quality setting to either Raw (NEF) or Raw+Fine. And frankly, there isn't any need to do so because you can precisely tune colors of Raw files when you process them in your Raw converter. Chapter 8 has details on Raw processing.
- You can apply white balance bracketing only along the blue-to-amber axis of the fine-tuning color grid. You can't shift colors along the green-to-magenta axis, as you can when tweaking a specific white balance setting. (For a reminder of this feature, refer to the earlier section "Fine-Tuning white balance settings".)
- You can shift colors a maximum of three steps in either direction. This gives you half the level of adjustment as when you fine-tune white balance. (For those familiar with traditional lens filters, each step on the axis is equivalent to a filter density of five mireds.)

When you use white-balance bracketing, you can request that the camera record the bracketed images so that they are progressively more blue or more amber. Or you can record one image that's pushed toward blue and another that leans toward amber. Regardless, you also get one shot that's "neutral" — that is, recorded at the current white balance setting, without any adjustment.

I used white balance bracketing to record the three candle photos in Figure 6-26. For the blue and amber versions, I set the bracketing to shift colors the maximum three steps. As you can see, even at that maximum setting, the color differences between the shots are subtle. In this photo, I find the differences most noticeable in the color of the backdrop.

To apply white balance bracketing, you first need to take these steps:

- 1. Set your camera to the P, S, A, or M exposure mode.
 - White balance options are available only in these modes.
- 2. Set the Image Quality setting to one of the JPEG options (Fine, Normal, or Basic).
 - You can adjust the setting through the Shooting menu. (See Chapter 3 for a full explanation of the JPEG options.)
- 3. Display the Custom Setting menu, select the Bracketing/Flash submenu, and press OK.

Figure 6-24: To create an additional direct-measurement preset, first copy the existing one from d-0 to another slot (d1-d4).

- 4. Press the ISO button to display the menu shown on the right in the figure.
- 5. Highlight Copy d-0 and press OK.

You're returned to the preset thumbnails screen, and your original d-0 preset now occupies both d-0 and the slot you selected in Step 3. You can now create your second direct-measurement preset, which will take over the d-0 position.

Finally, you also can add a brief text comment to describe each preset. For example, you might add the label "home studio" to one preset and "work studio" to another to help you remember which is which. The label then appears with the preset thumbnail, as shown in Figure 6-25.

To enter a comment, take the exact same steps as you do to copy a preset, but instead of choosing Copy d-0 in Step 5, select Edit Comment and press the Multi Selector right. You then see a screen where you can enter your text. The specific text-entry steps are the

Figure 6-25: Enter text labels that describe each preset.

same as you use for entering image comments, which I detail in Chapter 11, so I won't repeat them here.

✓ Use the White Balance option on the Shooting menu. Open the Shooting menu, select White Balance, press OK, highlight PRE (Preset Manual) and press the Multi Selector right. You then see the screen that contains thumbnails for all your presets. (Refer to the left screen in Figure 6-23.) Use the Multi Selector to place the yellow highlight box over the preset you want to use and then press OK. You're taken to the fine-tuning screen that appears any time you select a white balance setting from the menu; press OK to exit the screen without adjusting the setting.

Managing presets

Just to recap this whole white balance preset deal:

- ✓ You can create up to five presets, which take the names d-0 through d-4.
- ✓ Preset d-0 is always used for the most recent preset you created through the direct measurement method (where you take a photo of a reference card).
- ✓ Presets d-1 through d-4 can be assigned to presets based on photos.
- If you want to create more than one preset through direct measurement, you can copy the existing d-0 setting to one of the other four preset slots before doing another direct measurement. This feature is very handy if you regularly use different studio or lighting setups, by the way. You can create one direct-measurement preset for a home studio, for example, and another for a work studio.

- 1. Select the White Balance option on the Shooting menu and press OK.
- 2. Select PRE (Preset Manual), and press the Multi Selector right.

You see the thumbnails representing the five presets. For example, the left image in Figure 6-24 shows the d-0 position held by an existing direct-measurement preset and d-1 held by a preset based on a photo.

3. Highlight the slot where you want to copy your d-0 preset.

Use the Multi Selector to place the yellow highlight box around the slot. In the figure, I selected an empty slot (d-2), but you can also copy over an existing preset. (The preset that has the yellow label — d-1 in the figure — represents your current white balance setting; it doesn't relate to this operation.)

Figure 6-23: Select Preset d-1 through d-4; d-0 is reserved for direct-measurement presets.

0...

5. Press the ISO button.

Now you see the menu shown on the right in Figure 6-23.

6. Highlight Select Image and press the Multi Selector right.

You see thumbnails of your photos.

- 7. Use the Multi Selector to move the yellow highlight box over the picture you want to use as your white balance photo.
- 8. Press OK.

You're returned to the screen showing your white balance preset thumbnails. The thumbnail for the photo you selected in Step 7 appears as the thumbnail for the preset slot you chose in Step 4.

9. Press Menu to return to the Shooting menu.

The white balance setting you just created is now selected.

If you press OK instead of the Menu button in Step 8, you can access the fine-tuning color grid, described in the earlier section "Fine-tuning white balance settings."

Selecting a preset

After creating white balance presets, select the one you want to use in two ways:

✓ **Use the WB button together with the command dials.** First, select PRE as the white balance setting by pressing the WB button as you rotate the main command dial. Keep holding the button and rotate the subcommand dial to cycle through the available presets (d-0 through d-4). The number of the selected preset appears in the Control panel and Shooting Information display while the button is pressed.

Each time you go through these steps, your d-0 preset is replaced by the new white balance data you record. However, you can preserve your original preset by copying it to one of the other preset slots. See the upcoming section "Managing presets" for details on how to copy your preset as well as how to select it when you're ready to shoot.

Matching white balance to an existing photo

Suppose that you're the marketing manager for a small business, and one of your jobs is to shoot portraits of the company big-wigs for the annual report. You build a small studio just for that purpose, complete with a couple of photography lights and a nice, conservative beige backdrop.

Of course, the big-wigs can't all come to get their pictures taken in the same month, let alone on the same day. But you have to make sure that the colors in that beige backdrop remain consistent for each shot, no matter how much time passes between photo sessions. This scenario is one possible use for an advanced white balance feature that enables you to base white balance on an existing photo.

Basing white balance on an existing photo works well only in strictly controlled lighting situations, where the color temperature of your lights is consistent from day to day. Otherwise, the white balance setting that produces color accuracy when you shoot Big Boss Number One may add an ugly color cast to the one you snap of Big Boss Number Two.

To give this option a try, follow these steps:

1. Copy the picture that you want to use as the reference photo to your camera memory card, if it isn't already stored there.

You can copy the picture to the card using a card reader and whatever method you usually use to transfer files from one drive to another. Copy the file to the folder named DCIM, inside the main folder, named 100NCD90 by default. (See Chapter 8 for help with working with files and folders.)

- 2. Open the Shooting menu, highlight White Balance, and press OK.
- 3. Select PRE (Preset Manual) and press the Multi Selector right.

You must scroll to the second page of White Balance settings to uncover the PRE setting. After you press the Multi Selector right, the screen shown on the left in Figure 6-23 appears. The five thumbnails represent the five preset slots, d-0 through d-4.

4. Use the Multi Selector to highlight any preset except d-0.

The d-0 preset is always used for white balance settings you create by taking a picture of a reference card, as described in the preceding section.

1. Set the camera to the P, S, A, or M exposure mode.

If the exposure meter reports that your image will be under- or overexposed at the current exposure settings, make the necessary adjustments now. (Chapter 5 tells you how.) Otherwise, the camera won't be able to create your custom white balance preset.

2. Frame your shot so that the reference card completely fills the viewfinder.

3. Press the WB button while rotating the main command dial to choose the PRE (Preset Manual) white balance setting.

You see the letters PRE in the white balance area of the Control panel, as shown in Figure 6-22, as well as in the Shooting Information display.

4. Release the button and then immediately press and hold it again until the letters PRE begin flashing in the Control panel.

You can also see the flashing letters in the viewfinder.

5. Release the WB button and take a picture of the gray card before the PRE warning stops flashing.

You've got about six seconds to snap the picture.

If the camera is successful at recording the white balance data, the letters Gd flash in the viewfinder. In the Control panel, the word Good flashes. If you instead see the message $No\ Gd$, try adjusting your lighting and then try again.

When you create a preset this way, the camera automatically stores your setting as Preset d-0. (The other presets are named d-1 through d-4.) So any

time you want to select and use the preset, press the WB button and rotate the main command dial to select PRE, as in Step 3. Then rotate the subcommand dial while pressing the button to select d-0, as shown in Figure 6-22. (The Shooting Information display shows the same data when you press the WB button.) You also can select the preset through the White Balance option on the Shooting menu; see the upcoming section "Selecting a preset" for a few critical details on that method.

Figure 6-22: Preset d-0 is always used for the most recent direct-measurement preset.

Figure 6-21: You can apply a shift along the blue/amber axis just by rotating the subcommand dial while pressing the WB button.

Creating white balance presets

If none of the standard white balance settings do the trick and you don't want to fool with fine-tuning them, take advantage of the PRE (Preset Manual) feature. This option enables you to do two things:

- Base white balance on a direct measurement of the actual lighting conditions.
- Match white balance to an existing photo.

You can create and store up to five custom white balance presets, which are assigned the names d-0 through d-4. The next two sections provide you with the step-by-step instructions; following that, you can find out how to select and manage your presets.

Setting white balance with direct measurement

To use this technique, you need a piece of card stock that's either neutral gray or absolute white — not eggshell white, sand white, or any other close-but-not-perfect white. (You can buy reference cards made just for this purpose in many camera stores for under \$20.)

Position the reference card so that it receives the same lighting you'll use for your photo. Then take these steps:

3. Fine-tune the setting by using the Multi Selector to move the white balance shift marker in the color grid.

The grid is set up around two color pairs: Green and Magenta, represented by G and M; and Blue and Amber, represented by B and A. By pressing the Multi Selector, you can move the adjustment marker around the grid.

As you move the marker, the A–B and G–M boxes on the right side of the screen show you the current amount of color shift. A value of 0 indicates the default amount of color compensation applied by the selected white balance setting. In Figure 6-20, for example, I moved the marker two levels toward amber and two levels toward magenta to specify that I wanted colors to be a tad warmer.

If you're familiar with traditional colored lens filters, you may know that the density of a filter, which determines the degree of color correction it provides, is measured in *mireds* (pronounced *my-redds*). The white balance grid is designed around this system: Moving the marker one level is the equivalent of adding a filter with a density of 5 mireds.

4. Press OK to complete the adjustment.

After you adjust a white balance setting, an asterisk appears next to that setting in the White Balance menu. In the Control panel and Shooting Information display, you instead see a pair of triangles to indicate the adjustment.

If you want to apply a white balance shift on only the blue-to-amber axis, you don't have to go through the Shooting menu. Instead, press and hold the WB button and then rotate the subcommand dial. You see the amount of adjustment in the Control panel and Shooting Information display, as shown in Figure 6-21, while the button is pressed. An a value indicates a shift toward the amber direction; a b value, towards blue. For example, in the figure, the b5 value shows that I shifted the setting five steps toward blue (b). The two-triangle symbol reminding you of the adjustment also appears.

Here's one other tip specifically related to shifting white balance along the blue-to-amber axis: By using a feature called white balance bracketing, you can automatically record your picture with and without that shift. You can even record one picture with no shift, one with an amber shift, and one with a blue shift. See the later section "Bracketing white balance" for details.

Creating a custom white balance preset: The PRE (Preset Manual) option enables you to create and store a precise, customized white balance setting, as explained in the upcoming "Creating white balance presets" section. This setting is the fastest way to achieve accurate colors when your scene is lit by multiple light sources that have differing color temperatures.

Your selected white balance setting remains in force for the P, S, A, and M exposure modes until you change it. So you may want to get in the habit of resetting the option to the Auto setting after you finish shooting whatever subject it was that caused you to switch to manual white balance mode.

Fine-tuning white balance settings

You can fine-tune any white balance setting (Daylight, Cloudy, and so on). For the greatest amount of control, make the adjustment as spelled out in these steps:

- 1. Display the Shooting menu, highlight White Balance, and press OK.
- 2. Highlight the white balance setting you want to adjust, as shown on the left in Figure 6-20, and press OK.

Now you're taken to a screen where you can do your fine-tuning, as shown on the right in Figure 6-20.

If you select Fluorescent or K (Choose Color Temperature), you first go to a screen where you select a specific type of bulb or Kelvin color temperature, as covered in the preceding section. After you highlight your choice, press OK to get to the fine-tuning screen. For custom presets that you create, you must select the preset you want to use and press OK. (See the next section for an explanation of presets.)

White balance shift marker

Figure 6-20: You can fine-tune the white balance settings via the Shooting menu.

Figure 6-18: You can set white balance to a specific Kelvin temperature by using the K setting.

You also can set the temperature through the White Balance option on the Shooting menu. If you do, you see the fine-tuning screen after you select the temperature and press OK. Again, just press OK to exit the screen without making any adjustment.

✓ Specifying a fluorescent bulb type: For the Fluorescent setting, you can select from seven types of bulbs. To do so, you must go through the Shooting menu. Select Fluorescent as the White Balance setting and then press OK to display the list of bulbs, as shown in Figure 6-19. Select the option that most closely matches your bulbs and then press OK. Press OK again, and you're taken to the fine-tuning screen. If you don't want to make any further adjustment, just press OK once more to return to the Shooting menu.

After you select a fluorescent bulb type, that option is always used when you use the WB button to select the Fluorescent white balance setting. Again, you can change the bulb type only through the Shooting menu.

Figure 6-19: You can select a specific type of fluorescent bulb.

Table 6-1	Manual White Balance Settings
Symbol	Light Source
*	Incandescent
\\\\\\\\\\\\\\\\\\\\\\\\\\\\\\\\\\\\\\	Fluorescent
*	Direct sunlight
4	Flash
2	Cloudy
1 /1.	Shade
K	Choose color temperature
PRE	Custom preset

The quickest way to change the setting is to press and hold the WB button as you rotate the main command dial. But note these factoids:

- Adjusting white balance through the Shooting menu: You also can change the white balance setting from the Shooting menu. After highlighting the White Balance setting, press OK to display the list of options. Highlight the one you want to use and press OK. For all settings except PRE (Preset Manual), K, and Fluorescent, you're taken to a screen where you can fine-tune the amount of adjustment the camera applies to colors. See the next section for details. If you don't want to make any adjustment, just press OK.
- ✓ Specifying a color temperature through the K white-balance setting: If you know the exact color temperature of your light source perhaps you're using some special studio bulbs, for example you can tell the camera to balance colors for that precise temperature. (Well, technically, you have to choose from a preset list of temperatures, but you should be able to get close to the temperature you have in mind.) First, select the K white balance setting. (K for Kelvin, get it?) Then, while pressing the WB button, rotate the subcommand dial to set the color temperature, which appears at the top of the Control panel and Shooting Information display, as shown in Figure 6-18.

Figure 6-16: Multiple light sources resulted in a yellow color cast in Auto white balance mode (left); switching to the Incandescent setting solved the problem (right).

Changing the white balance setting

The current white balance setting appears in the Control panel and Shooting Information display, as shown in Figure 6-17. The settings are represented by the icons you see in Table 6-1.

Figure 6-17: These icons represent the current white balance setting.

with a higher number meaning hotter. Instead, the terms describe the visual appearance of the light. Warm light, produced by candles and incandescent lights, falls in the red-yellow spectrum you see at the bottom of the Kelvin scale in Figure 6-15; cool light, in the blue-green spectrum, appears at the top of the Kelvin scale.

At any rate, most of us don't notice these fluctuating colors of light because our eyes automatically compensate for them. Except in very extreme lighting conditions, a white tablecloth appears white to us no matter whether we view it by candlelight, fluorescent light, or regular houselights.

Similarly, a digital camera compensates for different colors of light through a feature known as *white balancing*. Simply put, white balancing neutralizes light so that whites are always white, which in turn ensures that other colors are rendered accurately. If the camera senses warm light, it shifts colors slightly to the cool side of the color spectrum; in cool light, the camera shifts colors the opposite direction.

The good news is that, as with your eyes, your camera's Auto white balance setting tackles this process remarkably well in most situations, which means that you can usually ignore it and concentrate on other aspects of your picture. But if your scene is lit by two or more light sources that cast different colors, the white balance sensor can get confused, producing an unwanted color cast like the one you see in the left image in Figure 6-16.

I shot this product image in my home studio, which I light primarily with a couple of high-powered photo lights that use tungsten bulbs, which produce light with a color temperature similar to regular household incandescent bulbs. The problem is that the windows in that room also permit some pretty strong daylight to filter through. In Auto white balance mode, the camera reacted to that daylight — which has a cool color cast — and applied too much warming, giving my original image a yellow tint. No problem: I just switched the white balance mode from Auto to the Incandescent setting. The right image in Figure 6-16 shows the corrected colors.

There's one little problem with white balancing as it's implemented on your D90, though. You can't make this kind of manual white balance selection if you shoot in the Auto mode or the Digital Vari-Program scene modes. So if you spy color problems in your camera monitor, you need to switch to either P, S, A, or M exposure mode. (Chapter 5 details all four modes.)

The next section explains precisely how to make a simple white balance correction; following that, you can explore some advanced white balance options.

- select an appropriate f-stop depends on the lighting conditions. If you're shooting in Landscape mode at dusk, for example, the camera may have to open the aperture to a wide setting to produce a good exposure.
- ✓ For greater background blurring, move the subject farther from the background. The extent to which background focus shifts as you adjust depth of field also is affected by the distance between the subject and the background. For increased background blurring, move the subject farther in front of the background.

Controlling Color

Compared with understanding some aspects of digital photography — resolution, aperture and shutter speed, depth of field, and so on — making sense of your camera's color options is easy-breezy. First, color problems aren't all that common, and when they are, they're usually simple to fix with a quick shift of your D90's white balance control. And getting a grip on color requires learning only a couple of new terms, an unusual state of affairs for an endeavor that often seems more like high-tech science than art.

The rest of this chapter explains the aforementioned white balance control, plus a couple of menu options that enable you to fine-tune the way your camera renders colors. For information on how to use the Retouch menu's color options to alter colors of existing pictures, see Chapter 10.

Correcting colors with white balance

Every light source emits a particular color cast. The old-fashioned fluorescent lights found in most public restrooms, for example, put out a bluish-greenish light, which is why our reflections in the mirrors in those restrooms always look so sickly. And if you think that your beloved looks especially attractive by candlelight, you aren't imagining things: Candlelight casts a warm, yellow-red glow that is flattering to the skin.

Science-y types measure the color of light, officially known as *color temperature*, on the Kelvin scale, which is named after its creator. You can see the Kelvin scale in Figure 6-15.

When photographers talk about "warm light" and "cool light," though, they aren't referring to the position on the Kelvin scale — or at least not in the way we usually think of temperatures,

Figure 6-15: Each light source emits a specific color.

ISO Sensitivity setting; if you instead are using Auto ISO adjustment, the camera may adjust the ISO setting instead of shutter speed. (Chapter 5 explores the whole aperture/shutter speed/ ISO relationship.)

Press the Depth-of-Field Preview button to get an idea of how your **f-stop will affect depth of field.** When you look through your viewfinder and press the shutter button halfway, you can get only a partial indication of the depth of field that your current camera settings will produce. You

can see the effect of focal length and the camerato-subject distance, but because the aperture is always fully open until you actually take the picture, the viewfinder doesn't show you how your selected f-stop will affect depth of field.

By using the Depth-of-Field Preview button on your camera, however, you can preview the f-stop's impact. Almost hidden away on the front of your camera. the button is labeled in Figure 6-14. (I removed the lens for the picture to make the button easier to see.) When you press the button, the camera temporarily sets the aperture to your selected f-stop so that you can preview depth of field. At small

Depth-of-Field Preview button

Figure 6-14: Press this button to get a preview of the effect of aperture on depth of field.

apertures (high f-stop settings), the viewfinder display may become quite dark, but this doesn't indicate a problem with exposure — it's just a function of how the preview works.

In P, S, A, and M exposure modes, you can tell the camera to emit a socalled modeling flash when you preview depth-of-field and have flash enabled. By default, the modeling flash is turned off; if you want to experiment with this feature, visit the flash discussion in Chapter 5 for details.

✓ Portrait and Close Up modes are designed to produce shallow depth of field; Landscape mode is designed for large depth of field. You can't adjust aperture in these modes, however, so you're limited to the setting the camera chooses. In addition, the extent to which the camera can Just to avoid a possible point of confusion that has arisen in some of the classes I teach: When I say *zoom in*, some students think that I mean to twist the zoom barrel *in* toward the camera body. But in fact, the phrase *zoom in* means to zoom to a longer focal length, which produces the visual effect of bringing your subject closer. This requires twisting the zoom barrel of the lens so that it extends further *out* from the camera. And the phrase *zoom out* refers to the opposite maneuver: I'm talking about widening your view of the subject by zooming to a shorter focal length, which requires moving the lens barrel *in* toward the camera body.

Greater depth of field:

Select higher f-stop Decrease focal length (zoom out) Move farther from subject

Shorter depth of field:

Select lower f-stop Increase focal length (zoom in) Move closer to subject

Figure 6-13: Your f-stop, focal length, and shooting distance determine depth of field.

Here are a few additional tips and tricks related to depth of field:

✓ Aperture-priority autoexposure mode (A) enables you to easily control depth of field. In this mode, detailed fully in Chapter 5, you set the f-stop, and the camera selects the appropriate shutter speed to produce a good exposure. The range of aperture settings you can access depends on your lens.

Even in aperture-priority mode, keep an eye on shutter speed as well. To maintain the same exposure, shutter speed must change in tandem with aperture, and you may encounter a situation where the shutter speed is too slow to permit hand-holding of the camera. Lenses that offer optical image stabilization, or vibration reduction (VR lenses, in the Nikon world), do enable most people to use a slower shutter speed than normal, but double-check your results just to be sure. Or use a tripod for extra security. Of course, all this assumes that you have dialed in a specific

Fun facts about focal length

Every lens can be characterized by its *focal length*, or in the case of a zoom lens, the range of focal lengths it offers. Measured in millimeters, focal length determines the camera's angle of view, the apparent size and distance of objects in the scene, and depth of field. According to photography tradition, a focal length of 50mm is described as a "normal" lens. Most point-and-shoot cameras feature this focal length, which is a medium-range lens that works well for the type of snapshots that users of those kinds of cameras are likely to shoot.

A lens with a focal length under 35mm is characterized as a *wide-angle* lens because at that focal length, the camera has a wide angle of view and produces a large depth of field, making it good for landscape photography. A short focal length also has the effect of making objects seem smaller and farther away. At the other end of the spectrum, a lens with a focal length longer than 80mm is considered a *telephoto* lens and often referred to as a *long lens*. With a long lens, angle of view narrows, depth of field decreases, and faraway subjects appear closer and larger, which is ideal for wildlife and sports photographers.

Note, however, that the focal lengths stated here and elsewhere in the book are so-called 35mm

equivalent focal lengths. Here's the deal: For reasons that aren't really important, when you put a standard lens on most digital cameras, including your D90, the available frame area is reduced, as if you took a picture on a camera that uses 35mm film negatives (the kind you've probably been using for years) and then cropped it.

This so-called *crop factor*, sometimes also called the *magnification factor*, varies depending on the digital camera, which is why the photo industry adopted the 35mm-equivalent measuring stick as a standard. With the D90, the cropping factor is roughly 1.5. So the 18–105mm kit lens, for example, actually captures the approximate area you would get from a 27–160mm lens on a 35mm film camera. In the figure here, for example, the red outline indicates the image area that results from the 1.5 crop factor.

Note that although the area the lens can capture changes when you move a lens from a 35mm film camera to a digital body, depth of field isn't affected, nor are the spatial relationships between objects in the frame. So when lens shopping, you gauge those two characteristics of the lens by looking at the stated focal length — no digital-to-film conversion math is required.

Photo courtesy Chuck Pace

Aperture, f/5.6; Focal length, 183mm

Figure 6-12: Zooming to a longer focal length also reduces depth of field.

Together, these three factors determine the maximum and minimum depth of field that you can achieve, as illustrated by my clever artwork in Figure 6-13 and summed up in the following list:

- ✓ To produce the shallowest depth of field: Open the aperture as wide
 as possible (the lowest f-stop number), zoom in to the maximum focal
 length of your lens, and get as close as possible to your subject.
- ✓ **To produce maximum depth of field:** Stop down the aperture to the highest possible f-stop number, zoom out to the shortest focal length your lens offers, and move farther from your subject.

Aperture, f/13; Focal length, 92mm

Figure 6-11: A lower f-stop number (wider aperture) decreases depth of field.

For more technical details about focal length and your D90, see the sidebar "Fun facts about focal length."

Camera-to-subject distance: As you move the lens closer to your subject, depth of field decreases. This assumes that you don't zoom in or out to reframe the picture, thereby changing the focal length. If you do, depth of field is affected by both the camera position and focal length.

for example, a classic technique is to use a short depth of field, as I did for the photo in Figure 6-9. This approach increases emphasis on the subject while diminishing the impact of the background. But for the photo shown in Figure 6-10, I wanted to emphasize that the foreground figures were in St. Peter's Square, at the Vatican, so I used a large depth of field, which kept the background buildings sharply focused and gave them equal weight in the scene.

So exactly how do you adjust depth of field? You have three points of control: aperture, focal length, and camera-to-subject distance, as spelled out in the following list:

Aperture setting (f-stop):

The aperture is one of three exposure settings, all explained fully in Chapter 5. Depth of field increases as you stop down the aperture (by choosing a higher f-stop number). For shallow depth of field, open the aperture

Figure 6-10: A large depth of field keeps both foreground and background subjects in focus.

(by choosing a lower f-stop number). Figure 6-11 offers an example; in the f/22 version, focus is sharp all the way through the frame; in the f/13 version, focus softens as the distance from the center lure increases. I snapped both images using the same focal length and camera-to-subject distance, setting focus on the center lure.

✓ **Lens focal length:** In lay terms, *focal length* determines what the lens "sees." As you increase focal length, measured in millimeters, the angle of view narrows, objects appear larger in the frame, and — the important point for this discussion — depth of field decreases. Additionally, the spatial relationship of objects changes as you adjust focal length. As an example, Figure 6-12 compares the same scene shot at a focal length of 127mm and 183mm. I used the same aperture, f/5.6, for both examples.

Whether you have any focal length flexibility depends on your lens: If you have a zoom lens, you can adjust the focal length — just zoom in or out. (The D90 kit lens, for example, offers a focal range of 18–105mm.) If you don't have a zoom lens, the focal length is fixed, so scratch this means of manipulating depth of field.

To zoom out, press the ISO button. Or press OK to return to normal magnification.

If focus is incorrect, release the shutter button and try again.

6. To record the picture, press the shutter button the rest of the way.

You can use these same steps to establish your initial focusing point when recording movies. Release the shutter button after focus is established and then press OK to start recording.

For both still and movie photography, though, be aware that there is no such thing as continuous autofocusing in Live View mode. After you press the shutter button halfway to set focus, focus is locked. In still photography mode, you must release the shutter button and then press it halfway again to adjust the focus point. In movie mode, you must stop recording, reset focus, and start the recording anew. For moving subjects, then, manual focusing makes life a lot easier.

Manipulating Depth of Field

Getting familiar with the concept of depth of field is one of the biggest steps you can take to becoming a more artful photographer. I introduce you to depth of field in Chapters 2 and 5, but here's a quick recap just to hammer home the lesson:

- ✓ Depth of field refers to the distance over which objects in a photograph appear sharply focused.
- With a shallow, or small, depth of field, distant objects appear more softly focused than the main subject (assuming that you set focus on the main subject, of course).
- ✓ With a large depth of field, the zone of sharp focus extends to include objects at a distance from your subject.

Which arrangement works best depends entirely on your creative vision and your subject. In portraits,

Aperture, f/5.6; Focal length, 300mm

Figure 6-9: A shallow depth of field blurs the background and draws added attention to the subject.

set on the closest one.) If you don't see the highlight, the camera can't detect your subject's face, and it will set focus on the center of the frame.

Figure 6-8: You see the Live View focusing frame only in the Wide Area and Normal Area autofocusing modes.

2. Adjust the autofocus mode if necessary.

Just press the AF button while rotating the main command dial to cycle through your options. (You also can set the mode via the Live View Autofocus option, found on the Autofocus section of the Custom Setting menu. But that method requires exiting Live View mode.)

3. For Wide Area and Normal Area focusing, move the focusing frame over your subject.

First, make sure that the Focus Selector Lock (refer to Figure 6-5) is set to the unlock position — the white circle, rather than the L. Then press the Multi Selector to move the focusing frame.

4. Press the shutter button halfway to focus.

When focus is set, the focusing frame or face-highlight box turns green. If the camera can't establish focus, the focusing frame or face-highlight box blinks red.

5. (Optional) Magnify the display to check focus.

Press the Qual button to zoom in and get a close-up look at your subject. In Normal Area and Wide Area mode, you can press the Multi Selector to scroll the display if needed. In Face Priority mode, the camera automatically keeps the face in the highlight box centered on the monitor.

As I mention in the Chapter 4 discussion, the simplest and most reliable focusing choice is to focus manually. That said, you can use autofocus in Live View mode if you prefer.

If you do try Live View autofocusing, first set aside all the autofocusing information presented heretofore in this chapter. All the settings related to normal autofocusing — AF-area mode, Autofocus mode, and the like — are irrelevant. Instead, you can choose from the following three autofocusing methods:

✓ Face Priority: Designed for portrait shooting, this mode attempts to hunt down and lock focus on faces when you press the shutter button halfway. This setting is chosen by default if you set the exposure Mode dial to the Portrait or Night Portrait setting.

✓ Wide Area: In this mode, you use the Multi Selector to move a little rectangular focusing frame around the screen to specify your desired focusing spot. When you press the shutter button halfway, the camera tries to lock focus on objects within the focusing frame. This mode is the default for all exposure modes except Portrait, Night Portrait, and Close Up modes.

✓ Normal Area: This mode works the same way as Wide Area autofocusing but uses a smaller focusing frame. The idea is to enable you to base focus on a very specific area. It's the default mode for pictures you take in the Close Up exposure mode.

With such a small focusing frame, however, you can easily miss your focus target when handholding the camera. If you move the camera slightly just as you're locking focus, and the focusing frame shifts off your subject as a result, focus will be incorrect. So for best results, use a tripod in this mode.

To use Live View autofocusing, first set the switch on your lens, the camera body, or both to the autofocus position. Remember, which switches you need to set depends on your lens, see the first acction of this chapter for details. Then take these steps:

1. Press the Lv button (on the back of the camera, above the Multi Selector) to switch to Live View shooting.

The viewfinder turns off, and your subject appears on the monitor, as shown in Figure 6-8. Note the following focus-related doodads:

- In the upper-right corner, you see an icon representing your selected autofocus mode.
- For Wide Area and Normal Area autofocus, you see the rectangular focusing frame, labeled in the figure. (The figure shows the frame at the size it appears in Wide Area mode.)
- In Face Priority mode, a yellow highlight appears around the subject's face. (For scenes containing more than one person, focus is

Using autofocus lock

When you set your camera's Autofocus mode to AF-C (continuous-servo autofocus), pressing and holding the shutter button halfway initiates autofocus. But focusing is continually adjusted while you hold the shutter button halfway, so the focusing distance may change if the subject moves before you press the shutter button the rest of the way to take the picture. The same is true if you use AF-A mode (auto-servo autofocus) and the camera senses movement in front of the lens, in which case it shifts to AF-C mode and operates as I just described. Either way, the upshot is that you can't control the exact focusing distance the camera ultimately uses.

Should you want to lock focus at a specific distance, you have a couple of options:

- Focus manually.
- Change the Autofocus mode to AF-S (single-servo autofocus). In this mode, focus is locked when you press and hold the shutter button halfway.

Use autofocus lock. First set focus by pressing the shutter button half-way. When the focus is established at the distance you want, press and hold the AE-L/AF-L button, located near the viewfinder. Focus remains set as long as you hold the button down, even if you release the shutter button.

Keep in mind, though, that by default, pressing the AE-L/AF-L button also locks in autoexposure if you're shooting in the P, S, or A autoexposure modes. (Chapter 5 explains.) You can change this behavior, however, setting the button to lock just one or the other. Chapter 11 explains this option as well as a couple other ways to customize the button's function.

For my money, manual focusing is by far the easiest solution. Yes, it may take you a little while to get comfortable with manual focusing, but in the long run, you really save yourself a lot of time fiddling with the various autofocus settings, remembering which button initiates the focus lock, and so on. Just be sure that you have adjusted the viewfinder diopter to your eyesight, as explained in Chapter 1, so that there's not a disconnect between what you see in the viewfinder and where the camera is actually focusing. After a little practice, focusing manually will become second nature to you.

Autofocusing in Live View mode

Chapter 4 covers the basics of shooting in Live View mode, which enables you to compose your shots by using the camera monitor instead of the view-finder. You can opt for Live View shooting for taking still pictures, and you're required to use it to record movies.

The current Autofocus mode setting appears in the Control panel and Shooting Information display, as shown in Figure 6-7. To adjust the setting, press and hold the AF button (on top of the camera) as you rotate the main command dial. While the button is pressed, all other setting data disappears from the Control panel and Shooting Information display. Release the AF button after you select the setting you want to use.

Figure 6-7: The Autofocus mode determines whether focus is locked when you press the shutter button halfway.

Choosing the right autofocus combo

You'll get the best autofocus results if you pair your chosen Autofocus mode with the most appropriate AF-area mode, because the two settings work in tandem. Here are the combinations that I suggest for the maximum autofocus control:

- For still subjects, use Single Point as the AF-area mode and AF-S as the Autofocus mode. You then select a specific focus point, and the camera locks focus on that point at the time you press the shutter button half-way. Focus remains locked on your subject even if you reframe the shot after you press the button halfway. (It helps to remember the s factor: For still subjects, Single Point and AF-S.)
- For moving subjects, set the AF-area mode to Dynamic Area and the Autofocus mode to AF-C. You still begin by selecting a focus point, but the camera adjusts focus as needed if your subject moves within the frame after you press the shutter button halfway to establish focus. (Think motion, dynamic, continuous.)

Again, though, if you're not ready to delve into the whole issue, the default settings work pretty well for most shooting situations. For Autofocus mode, the default is AF-A; for AF-area mode, the default settings are Single Point for Close Up mode; Dynamic Area for Sports mode; and Auto-area for all other modes.

When should you use the wide area? Well, it's designed for subjects that don't fit under the normal area marks or for subjects that are moving just slightly, and so might slip out of that normal area boundary. Think of a two-person portrait shot, for example, or perhaps a photo of someone delivering a speech from a lectern. Frankly, I don't dig this far into the autofocusing weeds, though. If the camera can't lock focus using the Normal Zone setting, I just switch to manual focusing — it's a much faster, and easier, solution. And if you forget that wide-area focusing is enabled, you may have trouble focusing on smaller, nonmoving subjects the next time you use center-point autofocus.

Changing the Autofocus mode setting

The Autofocus mode setting determines what happens after you press the shutter button halfway to establish initial focus. There are three mode settings, which work as follows:

AF-S (single-servo autofocus): In this autofocus mode, which is geared to shooting stationary subjects, the camera locks focus when you depress the shutter button halfway.

Use this mode if you want to frame your subject so that it doesn't fall under an autofocus point: Compose the scene initially to put the subject under a focus point, press the shutter button halfway to lock focus, and then reframe to the composition you have in mind. As long as you keep the button pressed halfway, focus remains set on your subject.

- ✓ AF-C (continuous-servo autofocus): In this mode, which is designed for moving subjects, the camera focuses continuously for the entire time you hold the shutter button halfway down. Focus is adjusted as necessary up to the time you take the shot. If you want to lock focus at a certain distance, you must press the AE-L/AF-L button, as described in the section, "Using autofocus lock," later in this chapter.
- ✓ AF-A (auto-servo autofocus): This mode is the default setting. The camera analyzes the scene and, if it detects motion, automatically selects continuous-servo mode (AF-C). If the camera instead believes you're shooting a stationary object, it selects single-servo mode (AF-S). This mode works pretty well, but it can get confused sometimes. For example, if your subject is motionless but other people are moving in the background, the camera may mistakenly switch to continuous autofocus. By the same token, if the subject is moving only slightly, the camera may not make the switch.

In the Auto and Digital Vari-Program exposure modes, the Autofocus mode is reset to AF-A whenever you rotate the Mode dial to a different setting.

- 2. Press the shutter button halfway and release it to engage the exposure meters.
- 3. Use the Multi Selector to select a focus point.

The currently selected point is surrounded by brackets, as shown on the right in Figure 6-5.

A couple of tips about this process:

- To lock the selected focus point: If you want to ensure that an errant press of the Multi Selector doesn't select a different point, set the Focus Selector Lock to the L position. Just remember to return the switch to its other position if you want to select a different focus point.
- ✓ To quickly select the center focus point: Press OK. No need to cycle your way through all the other focus points to get to the center.
- ✓ To change the focus-point wrapping style: Okay, so here's an obscure customization option for you: Normally, when you select one of the outermost focus points, pressing the Multi Selector one more notch in the direction of that point has no effect. For example, if the top center point is selected, pressing the Multi Selector up accomplishes nothing. However, you can adjust this behavior so that the point selection "wraps around" the screen — so pressing the Multi Selector when that top center focus point is selected jumps you to bottom center focus point, and vice versa.

If you're into this level of control, you adjust the setting via the Custom Setting menu. Open the Autofocus submenu and then look for the Focus Point Wrap-Around option. Again, the default setting is No Wrap.

Changing the size of the center focus point

When you base autofocus on the center focus point, you can request that the camera does its thing based on a wider-than-normal area of the frame. Figure 6-6 shows you the difference between the normal and wide settings.

To make the adjustment, navigate to the Custom Setting menu and then to the Autofocus submenu. Press OK, highlight Center Focus point, and press OK again to access the two settings. The Normal Zone option is the default (smaller zone) setting.

Figure 6-6: You can adjust the size of the center focus point.

Figure 6-4: The AF-area mode setting lives on the Autofocus submenu of the Custom Setting menu.

If you find yourself changing the AF-area mode regularly, you can make it easier to access by setting the Fn (Function) button on the front of the camera to bring up the menu options. Or you can create a custom menu and put the option on the menu. Chapter 11 provides information about both features.

Selecting a single focus point

In any AF-area mode except Auto-area, take these steps to select a focus point:

1. Be sure that the Focus Selector Lock is set to the position shown on the left in Figure 6-5.

That is, align the switch with the white circle and not the L.

Figure 6-5: Set the Focus Selector Lock to this position if you want to select a specific focus point.

the brackets surrounding your selected focus point don't move if the camera shifts to a different point to focus, but the focus shift is happening just the same.

AUTO |

✓ **Auto Area:** The camera analyzes the objects under all 11 autofocus points and selects the one it deems most appropriate. This mode is the default setting for all exposure modes except the Close Up mode and Sports mode.

Note that in the Control panel, the icon for this mode shows all focus points surrounded by brackets, as shown on the left in Figure 6-3, reminding you that the camera may select any of the 11 points. In the Shooting Info display, you don't see the brackets, but the word Auto appears with the icon, as shown in the margin here and on the right in the figure.

3D ++++ ++6+3++ +++ ✓ 3D Tracking: This one is a variation of Dynamic Area autofocusing — well, sort of. As with Dynamic Area mode, you start by selecting a single focus point (surrounded by brackets in the displays) and then press the shutter button halfway to set focus. But the goal of this mode is to maintain focus on your subject if you recompose the shot after you press the shutter button halfway to lock focus. Again, you have to set the Autofocus mode to AF-A or AF-C for this focus adjustment to occur.

The only problem is that the way the camera detects your subject is by analyzing the colors of the object under your selected focus point. So if not much difference exists between the subject and other objects in the frame, the camera can get fooled. And if your subject moves out of the frame, you must release the shutter button and reset focus by pressing it halfway again.

The 3D Tracking display icon looks identical to the Dynamic Area icon in the Control panel. In the Shooting Information display, a 3D label appears, as shown in the margin here.

If you're feeling overwhelmed by all of your autofocus options (not to mention all the other D90 features), Auto-area produces good results for most subjects. Personally, however, I rely on the first two modes because if the Auto mode makes the wrong focus assumptions, there's no way to select a different focus point. So for still subjects, I stick with Single Point focus; for moving subjects, I go with Dynamic Area.

Whatever your conclusions on the subject, the next two sections show you how to adjust the AF-area mode and select a specific focus point.

Changing the AF-area mode setting

To set the AF-area mode, open the Custom Setting menu and then select the Autofocus submenu. Press OK, highlight AF-area mode, as shown on the left in Figure 6-4, and then press OK again to display the available options, as shown on the right. Highlight your choice and press OK.

Figure 6-3: The symbol for the current AF-area mode appears here.

You can choose from four settings, which work as described in the following list and are represented in the displays by the accompanying icons. (Note that the icons look slightly different depending on where you view them. The ones in the margins here are shown as they appear in the Shooting Information display.)

CO

✓ **Single Point:** This mode is designed for shooting still subjects. You select one of the 11 focus points, and the camera sets focus on the object that falls within that point. (See the upcoming section "Selecting a single focus point" for specifics on how to designate your chosen point.) The camera uses this mode by default when you shoot in the Close Up exposure mode.

In the Control panel and Shooting Information display, the little brackets in the AF-area mode icon show you which point is selected. For example, an icon like the one you see in the margin here tells you that the center point is selected.

+ + + + + + + + + + ✓ **Dynamic Area:** In this mode, designed for shooting moving subjects, you select an initial focus point, just as in Single Point mode. But if the subject within that focus point moves after you press the shutter button halfway to set focus, the camera looks for focus information from the other focus points. The idea is that the subject is likely to wind up within one of the 11 focus areas. It's the default setting when you shoot in the Sports exposure mode.

However — and this is a biggie — in order for the automatic focus adjustment to occur, you also must set the Autofocus mode option (explained next) to either AF-A or AF-C. (AF-A is the default.) If you instead set that option to AF-S, which is designed for shooting still subjects, the camera sticks with the initial focus point you select, even if the subject moves before you take the picture.

In the displays, the icon for this mode looks similar to the one in the margin here. Your selected focus point is surrounded by brackets, but you also see little plus signs marking the other points. Note that

Shutter speed and blurry photos

A poorly focused photo isn't always related to the issues discussed in this chapter. Any movement of the camera or subject can also cause blur. Both of these problems are related to shutter speed, an exposure control that I cover in Chapter 5. Be sure to also visit Chapter 7, which provides some additional tips for capturing moving objects without blur.

If for some reason you don't want the active focus points to turn red when you press the shutter button halfway, you can disable the feature. Display the Custom Setting menu, display the Autofocus submenu, and set the AF Point Illumination option to Off. To return to the original setup, set the option to Auto. (The third setting, On, also produces the red highlights, but they aren't adjusted to provide contrast with the background, as they are in Auto mode.)

Adjusting Autofocus Performance

You can adjust a number of aspects of your camera's autofocusing system, but the two most important autofocusing decisions you need to make are:

- ✓ How the active focus point is selected (AF-area mode): You can select a single focus point or tell the camera to consider all 11 focusing points and then automatically choose the one it thinks is appropriate. You make this call through the AF-area mode option, which is tucked away on the Autofocus submenu of the Custom Setting menu.
- Whether focus is locked when you press the shutter button halfway (Autofocus mode): You can tell the camera to lock focus at that moment or continuously adjust focus as needed up to the time you actually take the picture. You control this option through the Autofocus mode setting.

The following sections fill in the details of these two options and also explain a few less critical autofocusing settings.

Understanding the AF-area mode setting

The AF-area mode option determines which of the 11 focusing points the camera uses to establish focus. (The *AF* in AF-area mode stands for *autofocus*). You can view the current setting in the Control panel and Shooting Information display, as shown in Figure 6-3.

4. Frame the picture so that your subject falls under one of the 11 autofocus points.

The autofocus points are represented by the little black rectangles in the viewfinder.

To set focus in autofocus mode, press and hold the shutter button halfway down.

Depending on the lighting conditions, the camera's AF-assist illuminator on the front of the camera may emit a beam to help the autofocus system find its target. (If the light becomes a distraction, you can disable it through the Built-in AF-assist illuminator option, found on the Autofocus submenu of the Custom Setting menu. But the camera may have trouble locking focus, so you may need to focus manually.)

When focus is established, the focus lamp in the viewfinder lights. The viewfinder indicators briefly turn red, and one or more of the focus points appears sur-

Focus lamp

Figure 6-2: The brackets indicate the active focus points.

rounded by brackets, as shown in Figure 6-2. Those brackets indicate the active focusing points; any objects that fall under those points are in focus.

The part of the frame the camera uses to establish focus depends on the current *AF-area mode*. To find out more about this issue, including how to select the focus point you want to use, check out the next section.

6. To set focus manually, twist the focusing ring on the lens.

Even in manual mode, you can get some focusing help from the camera. When turning the focusing ring, press the shutter button halfway. If the object in an active autofocus point comes into focus, the viewfinder's focus lamp lights up. For this feature to work, however, your lens must offer a maximum aperture of at least f/5.6.

7. Depress the shutter button fully to take the picture.

Reviewing Focus Basics

I touch on various focus issues in Chapters 1, 2, and 5. But just in case you're not reading this book from front to back, here's a recap of the basic process of focusing with your D90.

These steps assume that Live View, introduced in Chapter 4, is not enabled. Focusing works a little differently in Live View mode; see the upcoming section "Autofocusing in Live View mode" for details.

1. If you haven't already done so, adjust the viewfinder focus to accommodate your eyesight.

You accomplish this by using the diopter adjustment dial, located on the top-right edge of the little rubber eyepiece that covers the viewfinder. Chapter 1 details this step.

2. Set the focusing switch(es) to manual or automatic focusing.

Depending on the type of lens you're using, you need to set a switch on the lens, on the camera body, or both. (Figure 6-1 highlights the body switch and the lens switch as it appears on some Nikon lenses, including the 18–105 AF-S lens sold in the D90 kit.)

- AF-S lenses: AF-S refers to a specific type of autofocus lens sold by Nikon (the 18–105mm kit lens falls into this category). To focus manually, set the lens switch to the M position. For autofocusing, set the lens switch to A.
- *AF lenses*: Set both the lens and body switches to your desired focus mode.

Figure 6-1: Depending on your lens, you set the focus mode (manual or auto) on the lens, the camera body, or both.

Manual-focus lenses: Set the switch on the camera body to M. (You can't autofocus with these lenses.)

3. For handheld shooting, turn on Vibration Reduction.

For sharper handheld shots, set the VR switch on the kit lens to On, as shown in Figure 6-1. If you use another lens that offers image stabilization (it may go by a name other than Vibration Reduction), check the lens manual to find out how to turn the feature on.

Manipulating Focus and Color

In This Chapter

- ▶ Controlling the camera's autofocusing performance
- ▶ Using autofocus in Live View mode
- ▶ Understanding focal lengths, depth of field, and other focus factors
- Exploring white balance and its affect on color
- Investigating other advanced color options

o many people, the word *focus* has just one interpretation when applied to a photograph: Either the subject is in focus or it's blurry. And it's true — this characteristic of your photographs is an important one. There's not much to appreciate about an image that's so blurry that you can't make out whether you're looking at Peru or Peoria.

But an artful photographer knows that there's more to focus than simply getting a sharp image of a subject. You also need to consider *depth of field*, or the distance over which objects remain sharply focused. This chapter explains all the ways to control depth of field, how to use your D90's advanced autofocus options, and how to take advantage of autofocus in Live View mode.

In addition, this chapter dives into the topic of color, explaining your camera's white balance control, which compensates for the varying color casts created by different light sources. You also can get my take on the other advanced color options on your D90, including the Color Space option and Picture Controls, in this chapter.

5. To adjust the amount of shift between each frame, rotate the subcommand dial while pressing the BKT button.

This step doesn't apply to Active D-Lighting bracketing; you can only record the shots with or without the filter enabled.

For exposure and flash bracketing, the adjustment increments are based on the current setting of the EV Steps for Exposure Control option, located on the Custom Setting menu. The earlier section, "Applying Exposure Compensation," introduces you to this menu. By default, the option is set to increments of one-third stop, but if you want a larger variation between each bracketed shot, you can change the menu setting to 1/2 stop (0.5). Just remember that the selected setting affects the amount of adjustment when you apply Exposure Compensation as well as Flash Compensation, also covered earlier in this chapter.

For white balance (WB) bracketing, you can shift the white balance in increments of 1, 2, or 3, with each step making the picture either progressively more amber or more blue. Again, see Chapter 6 for the details that will make that feature clear.

6. Release the BKT button to return to shooting mode.

The bracketing frame and increment settings then disappear from the Control panel and Shooting Information display; the bracketing indicator remains, along with the BKT icon.

7. Take your first shot.

After you take the picture, the bracketing progress indicator updates to show you how many more shots are left in the series. For example, if you are bracketing three frames, the notch at the 0 position disappears.

8. Take the remaining shots in the series.

When the series is done, the indicator scale returns to its original appearance, and you can then begin shooting the next series of bracketed shots.

9. To disable bracketing, press the BTK button and rotate the main command dial until the number of frames returns to 0.

Don't be put off by the length of these steps, by the way. Although describing the feature takes quite a few words, using bracketing really isn't all that complicated. It's just a matter of remembering to select which feature you want to bracket — and then keeping an eye on that bracketing progress indicator to see where you are in any particular bracketed series.

For exposure and flash bracketing, the options that appear when you rotate the dial are as follows:

- 3F: Choose this option to take three frames: one without any adjustment, one at a slightly reduced setting, and one at an increased setting. For example, if you choose the AE bracketing option to adjust exposure between frames, the camera records the first shot at whatever aperture, shutter speed, and so on that you set before taking the shot. Then it creates a second image that's slightly brighter, and a third that's slightly darker.
- +2F: This option records just two frames per bracketed series: One uses your original settings, and one adjusts the selected option to the positive side of the scale. For the AE bracketing option, for example, the second frame produces a brighter exposure than the first.
- -2F: This one gives you the same thing as the +2F option, but the setting that's being bracketed is reduced for the second frame. So this time, bracketing exposure produces a darker photo for the second frame.

For Active D-Lighting bracketing, press the BKT button and rotate the command dial to display the letters ADL in the Control panel. For this type of bracketing, the camera always records two frames: One with the filter turned off and one with the filter applied at the current Active D-Lighting setting (which you control through the Shooting menu). For white balance bracketing, you can shift colors toward blue or toward amber; see the white-balance section of Chapter 6 for details.

The bracketing progress indicator changes depending on which of the frame options you choose. In the Control panel, the scale looks as shown in Figure 5-35 when you enable the three-frame bracketing option for exposure bracketing, for example. For the +2 option, the negative side of the scale disappears; for the -2 option, the positive side is hidden. In the Shooting Information display, the notches under the meter show you how many frames are enabled. For three frames, you see three notches, as shown in the figure. The notch at the zero point represents the neutral shot — the one that will be recorded with no adjustment.

All this assumes that you use the default setting for the Bracketing Order option on the Bracketing/Flash submenu, however. If you prefer, you can reverse the order in which the positive- and negative-value shots are recorded by choosing the second of the two Bracketing Order settings.

You can adjust exposure (AE), flash, white balance (WB), or Active D-Lighting (ADL). Or you can bracket exposure and flash together by choosing the AE & Flash option.

Even though the exposure-related option is called AE (for autoexposure), it works in M (manual exposure) mode.

BKT

3. To turn on bracketing, press and hold the BKT button as you rotate the main command dial.

The BKT button's just below the Flash button, on the left-front side of the camera. The current bracketing settings appear in the Control panel and Shooting Information screen, as shown in Figure 5-35. After you rotate the main command dial, the little bracketing symbol shown in the figure appears to let you know that bracketing is enabled. The bracketing symbol also appears in the viewfinder, but the exact settings do not.

Figure 5-35: Rotate the main command dial while pressing the BKT button to turn auto bracketing on and off.

That little meter-like thing under the BKT symbol in the Control panel and the larger meter in the Shooting Information are the *bracketing progress indicators*. They're there to let you know which shot in your bracketed series you're about to take next. More on this issue in Step 7.

To change the number and type of frames recorded in each series of bracketed shots, keep pressing the BKT button and rotate the main command dial.

Bracketing Exposures

Many professional photographers use a strategy called *bracketing* to ensure that at least one shot of a subject is properly exposed. They shoot the same subject multiple times, slightly varying the exposure settings for each image.

To make bracketing easy, your D90 offers *automatic bracketing*. When you enable this feature, your only job is to press the shutter button to record the shots; the camera automatically adjusts the exposure settings between each image.

The D90, however, takes things one step further than most cameras that offer automatic bracketing. In addition to bracketing exposure, you can bracket flash power or the amount of Active D-Lighting that's applied. And when you're concerned about color, you can instead choose to bracket white balancing, an adjustment that you can explore fully in Chapter 6.

To try out bracketing, take these steps:

1. Set your camera to the P, S, A, or M exposure mode.

You can't take advantage of the feature in the Auto or Digital Vari-Program modes.

2. Specify the Auto Bracketing Set option.

This option tells the camera which exposure or color feature you want to adjust between shots. Display the Custom Setting menu, select Bracketing/Flash, and press OK. Then highlight Auto Bracketing Set, as shown on the left in Figure 5-34, and press OK again to display your choices, shown on the right in the figure.

Figure 5-34: Before enabling auto bracketing, select the exposure or color feature you want the camera to adjust between shots.

can with a built-in flash. And with flash units like the one in Figure 5-32, you can rotate the flash head so that the flash light bounces off a wall or ceiling instead of hitting your subject directly. This results in softer lighting and can eliminate the harsh shadows often caused by the strong, narrowly focused light of a built-in flash. (Chapter 7 offers an example of the difference this lighting technique can make in portraits.)

You gain yet another benefit with Nikon flash heads that support the company's Creative Lighting System (CLS) features: By enabling an option called Auto FP, found on the Flash/Bracketing submenu of the Custom Setting menu (see Figure 5-33), you can use a shutter speed faster than the 1/200-second limit of the built-in flash. In fact, you can use shutter speeds as high as 1/4000 second! That flexibility gives you a great advantage when you want to use flash outside during bright sunshine. Say you're shooting a

portrait, for example, and you want to use a low f-stop value to achieve a short depth of field and blur the background. At the 1/200-second limit, the open aperture is likely going to overexpose the photo, even if you select the lowest possible ISO. But with a top shutter speed of 1/4000 second, you should be able to open the aperture to a nice, wide, portrait-friendly setting. (Do note that if you want to use this feature, however, you must shoot in the P. S. A. or M exposure modes.)

If you do purchase an external flash, I highly recommend that you visit a good camera store, where the personnel can help you select the right

Figure 5-32: You can mount a flash head via the hot shoe on top of the camera.

| → Bracketing/flash | |
|-----------------------------------|-------|
| e1 Flash shutter speed | 1/60 |
| e2 Flash cntrl for built-in flash | TTL\$ |
| e3 Modeling flash | 0FF |
| ě4 Auto bracketing set | AE |
| *E5 Auto FP | ON |
| e6 Bracketing order | N |
| f1 ∰switch | ::: |
| ? f2 OK button (shooting mode) | RESET |

Figure 5-33: For some Nikon flash units, enabling this option allows you to use shutter speeds faster than the standard 1/200-second maximum.

unit for the kind of flash work you want to do. You may also want to dig into some of the many books that concentrate on flash photography and the Nikon Creative Lighting System. There's a lot more to that game than you may imagine, and you'll no doubt discover some great ideas about lighting your pictures with flash. You can start with Chapter 7, which provides some specific examples of how to get better flash results when you shoot portraits, whether you go with the built-in flash, an external flash, or, my favorite, no flash.

Because these are advanced, special-purpose functions, I'll limit myself to making you aware of them here and referring you to the manual for specifics on the settings available in each mode.

Using the Fn button to disable flash for the next shot

In Chapter 11, you can find out how to assign different functions to the Fn (function) button, which it tucked away on the right-front side of the camera. One of your options is to set the button to temporarily prevent the flash from firing. You have to hold down the button while pressing the shutter button to make it work, though, and I find that maneuver difficult. So instead, I either select the Off flash setting when working in the fully automatic exposure modes or simply close the flash unit when working in P, S, A, or M modes. That leaves the Fn button free to handle some other operation, such as Flash Exposure lock, explained earlier.

Firing a modeling flash

Chapter 6 introduces you to your D90's Depth-of-Field Preview button, which enables you to preview through the viewfinder how your selected aperture setting will affect depth of field. You can set up the button to also emit a *modeling flash* when you check depth of field.

When you enable this feature, the flash emits a repeating, strobe-like series of flash light while you press the button. The idea is to enable you to preview how the light will fall on your subject. However, living subjects aren't likely to appreciate the feature — it's a bit blinding to have the flash going off repeatedly in your face. So I personally leave the feature off.

If you do want to enable it, you can do so through the Modeling Flash option, found on the Bracketing/Flash submenu of the Custom Setting menu.

Using an external flash head

In addition to its built-in flash, your camera has a *hot shoe*, which is photogeek terminology for a connection that enables you to add an external flash head like the one shown in Figure 5-32. The figure features the Nikon Speedlight SB-600, which currently retails for about \$200. (The hot shoe is covered by a little cap when you first get the camera; you have to remove it to add your flash.)

Although not the cheapest of accessories, an external flash may be a worthwhile investment if you do a lot of flash photography. For one thing, an external flash offers greater power, enabling you to illuminate a larger area than you

Exploring a few additional flash options

For most people, the flash options covered to this point in the chapter are the most useful on a regular basis. But your D90 does offer a few other flash options that some photographers may appreciate on occasion, so the next three sections provide a quick look-see.

Changing to manual, repeating, or commander flash mode

If you dig into the Bracketing/Flash submenu of the Custom Setting menu, you come across a setting called Flash Cntrl (Control) for Built-In Flash, as shown in Figure 5-31. Normally, your flash operates in the TTL, or *Through the Lens*, mode, in which the camera automatically determines the right flash output for you.

Figure 5-31: You can set flash power manually through this menu.

However, if you're an advanced flash user, you may want to explore the other options:

- ✓ Manual: In this mode, you can select a specific flash power, with settings ranging from full power to 1/128 power. (If you're hip to rating flash power by Guide Numbers, the manual spells out the ratings for the built-in flash.)
- ✓ Repeating Flash: If you select this mode, the camera fires the flash repeatedly as long as the shutter is open. The resulting picture looks as though it was shot with a strobe light. In other words, this is a special-effects function.
- ✓ Commander Mode: This mode is relevant only if you own external flash heads that you want to use as off-camera light sources. If you do, you can use the built-in flash to trigger (command) the firing of the external heads. The external heads must be designed to work in this way, of course.

Locking flash exposure on your subject

At times, the composition of a scene can cause the camera's flash meter to set the flash power incorrectly for your subject. For example, if you're photographing someone with pale skin who's dressed in all black, the camera may "see" all that black and deliver a flash power that's too strong to properly light the face. Flash power can also be miscalculated if your main subject occupies a very small part of the frame, is off-center, or both.

To address this problem, you can use a feature called *flash value lock*, or Fv Lock in Nikon terminology. When you take advantage of this option, you can ensure that the flash power is set for the most important part of the scene.

By default, the Fn (function) button, located on the front-right side of the camera just under the AF-assist lamp, is assigned the task of locking the flash value. As spelled out in Chapter 11, however, you can assign a different operation to the button; if you've taken that step, revisit the chapter to find out how to reset the button to the flash-exposure lock setting. You alternatively can program the AE-L/AF-L button to perform this task if you want to use the Fn button for some other purpose; again, see Chapter 11 for details. Assuming that one of the buttons is geared to the flash locking function, take these steps to use it:

Frame the shot so that your subject is in the center of the viewfinder.
 You can adjust composition after locking the flash power if you want.

2. In P, S, A, or M mode, press the Flash button to pop up the built-in flash.

In the Auto, Portrait, Close Up, and Night Portrait modes, the flash will pop up automatically when you take the next step, assuming that the ambient light is sufficiently dim. If it's not, the camera won't let you use flash. (Flash is never available in the other fully automatic modes.

- Press and hold the shutter button halfway to engage the exposure meter and, in autofocus mode, to set focus.
- 4. Press the button that was assigned the Fv Lock function.

The flash fires a little preflash to determine the correct flash power. When flash power is locked, the letter L appears next to the flash symbol in the viewfinder.

5. Recompose the picture if desired and then take the shot.

To release the flash value lock, just press the assigned button again.

As for boosting the flash output, well, you may find it necessary on some occasions, but don't expect the built-in flash to work miracles even at a Flash Compensation of +1.0. Any built-in flash has a limited range, and you simply can't expect the flash light to reach faraway objects. In other words, don't even try taking flash pictures of a darkened recital hall from your seat in the balcony — all you'll wind up doing is annoying everyone.

With that preface in mind, you can enable Flash Compensation by first pressing the Flash button to pop up the built-in flash. Then press and hold the button as you rotate the subcommand dial. As long as you hold the button, the Flash Compensation setting appears in the Control panel and Shooting Information display, as shown in Figure 5-30. In the viewfinder, the current setting takes the place of the usual frames-remaining value, and a plus or minus sign also appears to indicate whether you're dialing in a positive or negative value.

Figure 5-30: Rotate the sub-command dial while pressing the Flash button to adjust flash power.

After you release the Flash button, you see just the Flash Compensation icon in all three displays. To check the specific compensation value, press and hold the Flash button.

As with Exposure Compensation, any flash-power adjustment you make remains in force, even if you turn off the camera, until you reset the control. So be sure to check the setting before you next use your flash.

This feature works just like Exposure Compensation, discussed earlier in the chapter, except that it enables you to override the camera's flash-power decision instead of its autoexposure decision. As with Exposure Compensation, the Flash Compensation settings are stated in terms of EV $(exposure\ value)$ numbers. A setting of 0.0 indicates no flash adjustment; you can increase the flash power to EV +1.0 or decrease it to EV -3.0.

As an example of the benefit of this feature, look at the carousel images in Figure 5-29. The first image shows you a flash-free shot. Clearly, I needed a flash to compensate for the fact that the horses were shadowed by the roof of the carousel. But at normal flash power, as shown in the same image, the flash was too strong, creating glare in some spots and blowing out the highlights in the white mane, as shown in the middle image. By dialing the flash power down to EV –0.7, I got a softer flash that straddled the line perfectly between no flash and too much flash.

No flash

Flash EV 0.0

Flash EV -0.7

Figure 5-29: When normal flash output is too strong, dial in a lower Flash Compensation setting.

- **Rear-curtain sync:** In this mode, available only in shutter-priority (S) and manual (M) exposure modes, the flash fires at the very end of the exposure, just before the shutter closes. The classic use of this mode is to combine the flash with a slow shutter speed to create trailing-light effects like the one you see in Figure 5-28. With rear-curtain sync, the light trails extend behind the moving object (my hand, and the match, in this case), which makes visual sense. If instead you use slow-sync flash, the light trails appear in front of the moving object.
- ✓ Slow-sync with rear-curtain sync: Hey, not confusing enough for you yet? This mode enables you to produce the same motion trail effects as with rear-curtain sync, but in the P and A exposure modes.

Figure 5-28: I used rear-curtain flash to create this candle-lighting image.

✓ **Slow-sync with red-eye reduction:** In P and A exposure modes, you can also combine a slow-sync flash with the red-eye reduction feature. Given the potential for blur that comes with a slow shutter, plus the potential for subjects to mistake the prelight from the AF-assist lamp for the real flash and walk out of the frame before the image is actually recorded, I vote this flash mode as the most difficult to pull off successfully.

Note that all of these modes are somewhat tricky to use successfully, however. So have fun playing around, but at the same time, don't feel too badly if you don't have time right now to master these modes plus all the other exposure options presented to you in this chapter. In the meantime, do a Web search for slow-sync and rear-sync image examples if you want to get a better idea of the effects that other photographers create with these flash modes.

Adjusting flash output

When you shoot with your built-in flash, the camera attempts to adjust the flash output as needed to produce a good exposure. But if shoot in the P, S, A, or M exposure modes and you want a little more or less flash light than the camera thinks is appropriate, you can adjust the flash output by using a feature called *Flash Compensation*.

The benefit of this longer exposure is that the camera has time to absorb more ambient light, which in turn has two effects: Background areas that are beyond the reach of the flash appear brighter; and less flash power is needed, resulting in softer lighting.

The downside of the slow shutter speed is, well, the slow shutter speed. As discussed earlier in this chapter, the longer the exposure time, the more you have to worry about blur caused by movement of your subject or your camera. A tripod is essential to a good outcome, as are subjects that can hold very, very still. I find that the best practical use for this mode is shooting nighttime still-life subjects such as the one you see in Figure 5-27.

Some photographers, though, turn the downside of slow-sync flash to an upside, using it to purposely blur their subjects, thereby emphasizing motion.

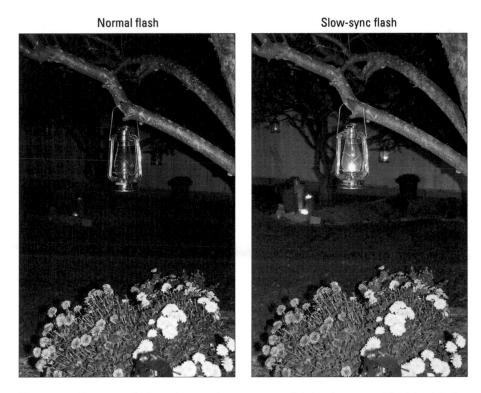

Figure 5-27: Slow-sync flash produces softer, more even lighting than normal flash in nighttime pictures.

In sync: Flash timing and shutter speed

In order to properly expose flash pictures, the camera has to synchronize the timing of the flash output with the opening and closing of the shutter. For this reason, the range of shutter speeds available to you is more limited when you use flash than when you go flash-free.

When you use the built-in flash, the maximum shutter speed is 1/200 second. The minimum shutter speed varies depending on your exposure mode, as follows:

- P, A, Auto, Portrait, Child modes: 1/60 second
- Close Up mode: 1/125 second
- ✓ Nighttime Portrait mode: 1 second
- ✓ S mode: 30 seconds
- M mode: 30 seconds (unless you use bulb mode, in which the shutter stays open as long as you hold the shutter button down)

In P and A exposure modes, you have the option of specifying the minimum shutter speed that the camera can select in the red-eye reduction mode and the special sync modes described in the section "Slow-sync and rear-sync flash." The default setting is 1/60 second, but you can go as low as 30 seconds. To change the setting, go to the Custom Setting menu and look for the Flash Shutter Speed option, found on the Bracketing/Flash submenu.

If you use an external flash, you can increase the maximum shutter speed to as high as 1/4000 second. However, this option is available only with certain Nikon flash units; for details, see "Using an external flash," later in this chapter.

If all else fails, check out Chapter 10, which shows you how to use the built-in red-eye removal tool on your camera's Retouch menu. Sadly, though, this feature removes only red-eye, not the yellow/green/white eye that you get with animal portraits.

Slow-sync and rear-sync flash

In fill flash and red-eye reduction flash modes, the flash and shutter are synchronized so that the flash fires at the exact moment the shutter opens.

Technical types refer to this flash arrangement as front-curtain sync.

Your D90 also offers four special-sync modes, which work as follows:

Slow-sync flash: This mode, available only in the P and A exposure modes, also uses front-curtain sync but allows a shutter speed slower than the 1/60 second minimum that is in force when you use fill flash and red-eye reduction flash.

Figure 5-26: Adding flash resulted in better illumination and a slight warming effect.

Red-eye reduction flash

Red-eye is caused when flash light bounces off a subject's retinas and is reflected back to the camera lens. Red-eye is a human phenomena, though; with animals, the reflected light usually glows yellow, white, or green.

Man or beast, this issue isn't nearly the problem with the type of pop-up flash found on your D90 as it is on non-SLR cameras. The D90's flash is positioned In such a way that the flash light usually doesn't hit a subject's eyes straight on, which lessens the chances of red-eye. However, red-eye may still be an issue when you use a lens with a long focal length (a telephoto lens) or you shoot subjects from a distance.

40

If you do notice red-eye, you can try the red-eye reduction mode, represented by the icon shown in the margin here. In this mode, the AF-assist lamp on the front of the camera lights up briefly before the flash fires. The subject's pupils constrict in response to the light, allowing less flash light to enter the eye and cause that glowing red reflection. Be sure to warn your subjects to wait for the flash, or they may step out of the frame or stop posing after they see the light from the AF-assist lamp.

For an even better solution, try the flash-free portrait tips covered in Chapter 7. If you do a lot of portrait work that requires flash, you may also want to consider an external flash unit, which enables you to aim the flash light in ways that virtually eliminate red-eye.

the list of available flash modes doesn't include two options available in the fully automatic exposure modes: Auto, in which the camera makes the decisions about when to fire the flash, and Off. Instead, if you don't want the flash to fire, simply keep the flash unit closed.

The camera does give you a little auto-flash input though: By default, the flash symbol in the viewfinder blinks in the P, S, and A modes if the camera thinks you need to use flash. If you prefer not to have that input, you can turn off the warning. Just visit the Custom Setting menu, navigate to the Shooting/ Display submenu, and set the Flash Warning option to Off.

Fill flash

The fill flash setting is represented by plain-old lightning bolt symbol you see in the margin bore. (Figure 5.25 at in the margin here. (Figure 5-25 shows you the symbol as it appears in the Control panel and Shooting Information display.) You can think of this setting as "normal flash" — at least in the way that most of us think of using a flash.

You may also hear this mode called *force* flash because the flash fires no matter what the available light, unlike in the auto flash mode provided for the fully automatic exposure modes, in which the camera decides when flash is needed. In fill flash mode, the flash fires even in the brightest daylight which, by the way, is often an excellent idea.

Yep, you read me correctly: Adding a flash can really improve outdoor photos, even when the sun is at its sunniest. Just as an example, Figure 5-26 shows a floral image taken both with and without a flash. The small pop of light provided by the built-in flash is also extremely beneficial when shooting subjects that happen to be slightly shaded, such as the carousel horses featured in the next section. For outdoor portraits, a flash is even more important; Chapter 7 discusses that subject.

Using a flash in bright sunlight also produces a slight warming effect, as illustrated in Figure 5-26. This color shift occurs because when you enable the flash, the camera's white balancing mechanism warms color slightly to compensate for the bluish light of a flash. But because your scene is actually lit primarily by sunlight, which is not as cool as flash light, the white balance adjustment takes the image colors a step warmer than neutral. If you don't want this warming effect, see Chapter 6 to find out how to make a manual white balance adjustment.

Do note, however, that when you use the built-in flash, you're restricted to a top shutter speed of 1/200 second. That means that in very bright sun, you may need to stop down the aperture significantly or lower ISO, if possible, to avoid overexposing the image. See the sidebar "In Sync: Flash timing and shutter speed," later in this chapter, for details on shutter-speed ranges available for flash photography.

When you shoot in the advanced exposure modes, you have much more control over your flash than when you use the fully automatic modes covered in Chapter 2. First, you gain access to flash modes not available in the full-auto modes. Even better, you can adjust the strength of the flash by using a feature called *Flash Compensation*.

The rest of this chapter explains how to use these flash functions and also offers some tips on getting better results in your flash pictures. Be sure to also visit Chapter 7, where you can find additional flash and lighting tips related to specific types of photographs.

Setting the flash mode

To raise the built-in flash in P, S, A, and M exposure modes, press the Flash button on the front-left side of the camera. You then can view the current flash mode in the Control panel and Shooting Information display, as labeled in Figure 5-25. In the viewfinder, you see a simple lightning-bolt icon when flash is enabled, as shown in the figure. To change the flash mode, hold the Flash button down as you rotate the main command dial. Again, you can see the specific modes only in the Control panel and Shooting Information display.

The TTL label you see in the flash area of the Shooting Information display stands for *through the lens* and reflects the default flash-control behavior, in which the camera sets the proper flash power for you. For a look at your other options, see the section "Changing to manual, repeating, or commander flash mode," later in this chapter.

Figure 5-25: You can verify the flash mode in the Control panel and Shooting Information display.

Your flash mode choices break down into three basic categories, described in the next sections: fill flash; red-eye reduction flash; and the sync modes, slow-sync and rear-sync, which are special-purpose flash options. Note that

Press the Info button to bring up the Shooting Information display on the monitor. Then press the Info button again to activate the Quick Settings strip of options at the bottom of the screen, as shown in Figure 5-24. Use the Multi Selector to highlight the Active D-Lighting option, as shown in the figure, and then press OK. You're then taken to the menu screen that contains the Active D-Lighting settings (the right screen in Figure 5-23).

Figure 5-24: Press the Info button twice to access the D-Lighting option from the Shooting Information display.

If you're not sure how much adjustment to apply, try out the Active

D-Lighting *bracketing* feature. With this option, you take multiple shots of the subject, and the camera automatically selects a different Active D-Lighting adjustment for each shot. You then can decide which image you prefer. See the last section in this chapter for details about bracketing with the D90.

As helpful as it is, Active D-Lighting does have one drawback: The camera needs a few seconds to do its shadow-recovery work. And during that time, you can't take another shot. Unfortunately, that makes Active D-Lighting a hindrance when you're capturing action or otherwise need to fire off shots in rapid succession. If you decide you're better off not using the feature, just set the option to Off via the Shooting menu or Shooting Information display.

Remember, too, that the camera's Retouch menu offers a D-Lighting filter that applies a similar adjustment to existing pictures. (See Chapter 10 for help.) Some photo editing programs, such as Adobe Photoshop Elements and Photoshop, also have good shadow and highlight recovery filters. In either case, when you shoot with Active D-Lighting disabled, you're better off setting the initial exposure settings to record the highlights as you want them. It's very difficult to bring back lost highlight detail after the fact, but you typically can unearth at least a little bit of detail from the darkest areas of the image.

Using Flash in P, S, A, and M modes

Sometimes, no amount of fiddling with aperture, shutter speed, and ISO produces a bright enough exposure — in which case, you simply have to add more light. The built-in flash on your D90 offers the most convenient solution.

In the past, you had to choose between favoring the highlights or the shadows. But thanks to a feature than Nikon calls Active D-Lighting, you have a better chance of keeping your highlights intact while better exposing the darkest areas. In my seal scene, turning on Active D-Lighting produced a brighter rendition of the darkest parts of the rocks and the seals, for example, and yet the color in the sky didn't get blown out as it did when I captured the image with Active D-Lighting turned off. The highlights in the seal and in the rocks on the lower-right corner of the image also are toned down a tad in the Active D-Lighting version.

Active D-Lighting actually does its thing in two stages. First, it selects exposure settings that result in a slightly darker exposure than normal. This half of the equation guarantees that you retain details in your highlights. Without that adjustment, the brightest areas of the image might be overexposed, leaving you with a batch of all-white pixels that really should contain a range of tones from light to lighter to white. So a cloud, for example, would appear as a big white blob, with no subtle tonal details to give it form. After you snap the photo, the second part of the process occurs. During this phase, the camera applies an internal software filter to brighten only the darkest areas of the image. This adjustment rescues shadow detail, so that you wind up with a range of dark tones instead of a big black blob.

You can turn Active D-Lighting on and off in two ways:

Select Active D-Lighting from the Shooting menu, as shown on the left in Figure 5-23. Press OK to display the second screen in the figure, where you can specify the amount of D-Lighting adjustment. At the Auto setting, the camera determines how much adjustment is needed. If you prefer to take control, you can select from one of the other four settings (Extra High, High, Normal, and Low). Press OK to enable the adjustment for your next shot.

Figure 5-23: At the Auto setting, the camera automatically applies the amount of Active D-Lighting adjustment as it sees fit.

By default, this step locks both exposure and focus for as long as you press the button, even if you release the shutter button. (AE-L stands for autoexposure lock; AF-L, for autofocus lock.) But if you dig into the Custom Setting menu, you can change the button's function. You can set the button to lock only exposure, for example, or only focus, instead of locking both as it does by default. Chapter 11 offers details.

Expanding Tonal Range with Active D-Lighting

A scene like the one in Figure 5-22 presents the classic photographer's challenge: Choosing exposure settings that capture the darkest parts of the subject appropriately causes the brightest areas to be overexposed. And if you instead "expose for the highlights" — that is, set the exposure settings to capture the brightest regions properly — the darker areas are underexposed.

Active D-Lighting Off

Automatic Active D-Lighting On

Figure 5-22: Active D-Lighting enabled me to capture the shadows without blowing out the highlights.

For most situations, this approach works great, resulting in the right settings for the light that's striking your subject at the moment you capture the image. But on occasion, you may want to lock in a certain combination of exposure settings. Here's one such scenario: Suppose that you're shooting several images of a large landscape that you want to join together into a panorama in your photo editor. Unless the lighting is even across the entire landscape, the camera's autoexposure brain will select different exposure settings for each shot, depending on which part of the scene is currently in the frame. That can lead to weird breaks in the brightness and contrast of the image when you seam the image together. And if it's the f-stop that's adjusted, you may notice shifts in depth of field as well.

The easiest way to lock in exposure settings is to switch to M (manual) exposure mode and use the same f-stop, shutter speed, and ISO settings for each shot. But if you prefer to stay in P, S, or A mode, you can press the AE-L/AF-L button to lock exposure and focus simultaneously. Here's the technique I recommend:

1. Set the metering mode to center-weighted or spot metering.

Just press the button shown in the margin here while rotating the main command dial to select the metering mode. You can read more about metering modes earlier in this chapter.

2. Set the AF-area mode option to the Single Point setting and then use the Multi Selector to select your desired focus point.

This step tells the camera which part of the frame you want to use for establishing focus and, if you use spot metering, also determines which part of the frame the camera uses to calculate exposure.

The AF-area mode option is found on the Autofocus submenu of the Custom Setting menu; after choosing Single Point, you can use the Multi Selector to choose a focusing point. See Chapter 6 for more details.

3. Frame your shot so that the subject appears under the selected focus point and then press and hold the AE-L/AF-L button.

The button's just to the right of the viewfinder.

While the button is pressed, the letters AE-L appear at the left end of the viewfinder to remind you that exposure lock is applied.

4. Reframe the shot if desired and take the photo.

Be sure to keep holding the AE-L/AF-L button until you release the shutter button!

By default, Exposure Compensation settings are provided in increments of onethird of a stop. For example, you can shift from EV 0.0 to 0.3, 0.7. 1.0, and so on. If you want a more pronounced result from each step up or down the EV ladder, you can set the mechanism to increments of one-half stop instead. Then the settings become EV 0.0, 0.5, 1.0, and so on. Make the adjustment via the EV Steps for Exposure Control option on the Metering/Exposure submenu of the Custom Settings menu, shown in Figure 5-21.

Figure 5-21: You can set the Exposure Compensation option to adjust exposure in one-half stops rather than one-third stops if you prefer.

- ✓ Right below that menu option, you see one called Easy Exposure Compensation. If you enable this feature, you can adjust the Exposure Compensation setting simply by rotating the subcommand dial. In aperture-priority exposure mode, you then use the main dial instead of the subcommand dial to change the f-stop. I advise against enabling this feature: You can easily rotate the dial by mistake and not realize that you adjusted the setting.
- Finally, if you don't want to fiddle with Exposure Compensation, just switch to Manual exposure mode M, on the Mode dial and select whatever aperture and shutter speed settings produce the exposure you're after. Exposure Compensation has no effect on manual exposures; again, that adjustment is made only in the P, S, and A modes.

Using Autoexposure Lock

To help ensure a proper exposure, your camera continually meters the light in a scene until the moment you depress the shutter button fully and capture the image. In autoexposure modes — that is, any mode but M — it also keeps adjusting exposure settings as needed to maintain a good exposure.

For example, say that you set your camera to shutter-priority autoexposure (S) mode and set the shutter speed to 1/125 second. The camera immediately reports the f-stop that it considers appropriate to expose the scene at that shutter speed. But if the light in the scene changes or you reframe your shot before snapping the picture, the camera may shift the f-stop automatically to make sure that the exposure remains correct.

Figure 5-20: The plus/minus symbol tells you that Exposure Compensation is being applied.

Your Exposure Compensation setting remains in force until you change it, even if you power off the camera. So you may want to make a habit of checking the setting before each shoot or always setting the value back to EV 0.0 after taking the last shot for which you want to apply compensation.

Here are a few other tips about Exposure Compensation:

- How the camera arrives at the brighter or darker image you request through your Exposure Compensation setting depends on the exposure mode:
 - In A (aperture-priority autoexposure) mode, the camera adjusts
 the shutter speed but leaves your selected f-stop in force. Be
 sure to check the resulting shutter speed to make sure that it
 isn't so slow that camera shake or blur from moving objects is
 problematic.
 - In S (shutter-priority autoexposure) mode, the opposite occurs:
 The camera opens or stops down the aperture, leaving your selected shutter speed alone.
 - In P (programmed autoexposure) mode, the camera decides whether to adjust aperture, shutter speed, or both.
 - In all three modes, the camera may also adjust ISO if you have Auto ISO enabled.

Keep in mind that the camera can adjust f-stop only so much, according to the aperture range of your lens. And the range of shutter speeds, too, is limited by the camera itself. So if you reach the ends of those ranges, you either have to compromise on shutter speed or aperture or adjust ISO.

EV +1.0

Figure 5-19: For a brighter exposure, raise the EV value.

团

To apply Exposure Compensation, hold down the Exposure Compensation button, found near the shutter button. All data except the Exposure Compensation value then disappears from the Control panel and is dimmed in the Shooting Information display. In the viewfinder, the frames-remaining value is replaced by the Exposure Compensation value. While holding the button, rotate the main command dial to adjust the EV value. Note that the exposure meter in the viewfinder and Shooting Information display will appear to indicate that you're shifting away from the exposure the system thinks is optimal; ignore it. If you liked what the camera thought about the exposure, you wouldn't be using Exposure Compensation.

After you release the button, a little plus/minus symbol (the same one that decorates the button itself) appears in the Control panel, Shooting Information display, and viewfinder, as shown in Figure 5-20, to remind you that Exposure Compensation is in force. At any time, you can redisplay the selected value by pressing the Exposure Compensation button.

(manual) exposure mode, the change affects the reading that the exposure meter reports. I really discourage you from making this adjustment — it's too easy to forget that the shift is in place. You still can tweak the exposure results you get in the autoexposure modes; just use Exposure Compensation, explained next. In manual mode, just adjust the shutter speed, f-stop, or ISO to fine-tune exposure.

Applying Exposure Compensation

When you set your camera to the P, S, or A modes, you can enjoy autoexposure support but still retain some control over the final exposure. If you think that the image the camera produced is too dark or too light, you can use a feature known as *Exposure Compensation*.

This feature enables you to tell the camera to produce a darker or lighter exposure than what its autoexposure mechanism thinks is appropriate. Best of all, this feature is probably one of the easiest on the whole camera to understand. Here's all there is to it:

✓ Exposure compensation settings are stated in terms of EV values, as in +2.0 EV. Possible values range from +5.0 EV to −5.0 EV. (The EV stands for exposure value.)

Each full number on the EV scale represents an exposure shift of one stop. In plain English, that means that if you change the exposure compensation setting from EV 0.0 to EV -1.0, the resulting exposure is equivalent to adjusting the aperture or shutter speed to allow half as much light into the camera as at the current setting. If you instead raise the value to EV +1.0, the exposure is equivalent to adjusting the settings to allow twice the light.

- A setting of EV 0.0 results in no exposure adjustment.
- ✓ For a brighter image, raise the EV value. The higher you go, the brighter the image becomes.
- ✓ For a darker image, lower the EV value.

As an example, take a look at the first image in Figure 5-19. The initial exposure selected by the camera left the balloon a tad too dark for my taste. So I just amped the Exposure Compensation setting to EV \pm 1.0, which produced the brighter exposure on the right.

Figure 5-18: The metering mode icon appears in the Control panel and Shooting Information display.

In theory, the best practice is to check the metering mode before you shoot and choose the one that best matches your exposure goals. But in practice, that's a bit of a pain, not just in terms of having to adjust yet one more capture setting but in terms of having to *remember* to adjust one more capture setting. So here's my advice: Until you're really comfortable with all the other controls on your camera, just stick with the default setting, which is matrix metering. That mode produces good results in most situations, and, after all, you can see in the monitor whether you disagree with how the camera metered or exposed the image and simply reshoot after adjusting the exposure settings to your liking. This option, in my mind, makes the whole metering mode issue a lot less critical than it is when you shoot with film.

The one exception to this advice might be when you're shooting a series of images in which a significant contrast in lighting exists between subject and background, as in my examples here. Then, switching to center-weighted metering or spot metering may save you the time of having to adjust the exposure for each image. You may also want to investigate the section "Expanding Tonal Range with Active D-Lighting," which tells you about a camera feature that can help you record brighter shadows without losing highlights.

One final — and important — point about metering: An option called Fine-Tune Optimal Exposure, found on the Exposure/Metering submenu of the Custom Setting menu, enables you to fiddle with the metering system beyond just specifying the size of the center-weighted metering area. For each metering mode, you can specify that you always want a brighter or darker exposure than what Nikon's engineers determined to be optimal when developing the camera. In essence, you're recalibrating the meter. Although it's nice to have this level of control, making this change affects all shots you take in automatic exposure modes and semi-automatic modes (P, S, and A). In M

- If you choose the Auto-area mode, in which the camera chooses the focus point for you, exposure is based on the center focus point.
- If you use any of the other AF-area modes, which enable you to select a specific focus point, the camera bases exposure on that point.

Because of this autofocus/autoexposure relationship, it's best to switch to one of the AF-area modes that allow focus-point selection when you want to use spot metering. In the Auto-area mode, exposure may be incorrect if you compose your shot so that the subject isn't at the center of the frame.

As an example of how metering mode affects exposure, Figure 5-17 shows the same image captured at each mode. In the Matrix example, the bright background caused the camera to select an exposure that left the statue quite dark. Switching to center-weighted metering helped somewhat, but didn't quite bring the statue out of the shadows. Spot metering produced the best result as far as the statue goes, although the resulting increase in exposure left the sky and background monument a little washed out.

Matrix metering

Center-Weighted metering

Spot metering

Figure 5-17: The metering mode determines which area of the frame the camera considers when calculating exposure.

You don't have a choice of metering modes in Auto mode or any of the Digital Vari-Program scene modes; the camera automatically uses matrix mode for all shots. But in P, A, S, or M modes, you can specify which metering mode you prefer. Just press and hold the Metering mode button as you rotate the main dial to cycle through the three options. The icon for the selected mode appears in the Control panel and Shooting Information display, as shown in Figure 5-18.

settings that the camera chooses in the fully automatic shooting modes (Auto, Portrait, and so on) as well as in the semi-auto modes (P, S, and A).

Your D90 offers three metering modes, described in the following list and represented in the Control panel and Shooting Information display by the icons you see in the margins:

Matrix: The camera analyzes the entire frame and then selects an exposure that's designed to produce a balanced exposure.

Your camera manual refers to this mode as 3D Color Matrix II, which is simply the label that Nikon created to describe the specific technology used in this mode.

(0)

✓ **Center-Weighted:** The camera bases exposure on the entire frame but puts extra emphasis — or *weight* — on the center of the frame.

Normally, the area that's given priority in this mode is about 8mm in diameter, which is represented by the circle in the viewfinder, labeled in Figure 5-15. However, in the P. S. A. and M. exposure modes, you can alter the critical metering area to 6mm or 10mm. The option to do so is called Center-Weighted Area and lives on the Metering/Exposure street of the Custom Setting menu, as shown in Figure 5-16. Note that the size of the metering circle in the viewfinder does not change; it always reflects the default, 8mm area.

Spot: In this mode, the camera bases exposure entirely on a circular area that's about 3.5mm in diameter. The exact location used for this pin-point metering depends on an autofocusing option called the AF-area mode. Detailed in Chapter 6, this option determines which of the camera's 11 focus points the autofocusing system uses to establish focus. Here's how the setting affects exposure:

Figure 5-15: In center-weighted metering, the camera gives priority to objects that fall under the circle.

Figure 5-16: You can adjust the size of the area that's given extra weight when you use center-weighted metering.

Dampening noise

Noise, the digital defect that gives your pictures a speckled look (refer to Figure 5-6), can occur for two reasons: a high ISO speed and a long exposure time.

The D90 offers two noise-removal filters, one designed to help eradicate ISO-related noise and another to dampen the type of noise that occurs during long exposures. You can enable both filters through the Shooting menu, shown in the left image here. Or you can access the controls from the Shooting Information display. Press the Info button twice to shift the display into Quick Settings mode. The Long Exposure Noise Reduction option is the first setting on the left, as shown on the right in the figure here, the High ISO Noise Reduction option lives right next door. After highlighting the option, press OK; you're then taken to the menu screen that contains the relevant settings.

If you turn on Long Exposure Noise Reduction, the camera applies the filter to any pictures taken at shutter speeds of longer than 8 seconds. For High ISO Noise Reduction, choosing High, Normal, or Low applies the filter at ISO

determines the strength of the filter. If you choose Off, the camera actually still applies a tiny amount of noise removal, but only when you shift into the Hi ISO settings (Hi 0.3 or greater).

Before you enable noise reduction, be aware

settings of 800 or higher; the setting you choose

Before you enable noise reduction, be aware that doing so has a few disadvantages. First, the filters are applied after you take the picture, as the camera processes the image data. (While the filter is being applied, the message "Job nr" appears in the viewfinder and Control panel, in the area normally reserved for the shutter speed and aperture.) The time needed to apply the filter can slow down your shooting speed.

Second, noise-reduction filters work primarily by applying a slight blur to the image. Don't expect this process to totally eliminate noise, and do expect some resulting image softness. You may be able to get better results by using the blur tools or noise-removal filters found in many photo editors, because you can blur just the parts of the image where noise is most noticeable — usually in areas of flat color or little detail, such as skies.

Choosing an Exposure Metering Mode

To fully interpret what your exposure meter tells you, you need to know which *metering mode* is active. The metering mode determines which part of the frame the camera analyzes to calculate the proper exposure. The metering mode affects the exposure-meter reading as well as the exposure

Muto ISO in advanced exposure modes. In the advanced exposure modes (P, S, A, and M), Auto ISO doesn't appear on the ISO settings list. However, you still can enable Auto ISO as sort of a safety net. Here's how it works: You dial in a specific ISO setting — say, ISO 200. If the camera decides that it can't properly expose the image at that ISO given your current aperture and shutter speed, it automatically adjusts ISO as necessary.

Figure 5-14: In advanced exposure modes, you can set limits for Auto ISO override.

To get to this option, first select the ISO Sensitivity Settings on

the Shooting menu. (Refer to Figure 5-13.) Then press OK to display the screen shown in Figure 5-14, and set ISO Sensitivity Auto Control to On.

Next, use the Maximum Sensitivity and Minimum Shutter Speed options, also shown in Figure 5-14, to tell the camera exactly when it should step in and offer ISO assistance. With the first option, you specify the highest ISO setting the camera may select when it does override your ISO decision. The second option sets the minimum shutter speed at which the ISO override engages. For example, you can specify that you want the camera to amp up ISO if the shutter speed drops to 1/40 second or below. This second option only affects shots you take in the P and A exposure modes, however.

If the camera is about to override your ISO setting, it alerts you by blinking the ISO Auto label in the viewfinder and Control panel. And in Playback mode, the ISO value appears in red if you view your photos in the Shooting Information display mode. (Chapter 4 has details.)

To disable Auto ISO override, just reset the ISO Sensitivity Auto Control to Off.

✓ Hi/Lo settings: The specific ISO values presented to you range from 200 to 3200. But if you scroll past those settings, you discover three more settings in each direction: Hi 0.3, Hi 0.7, and Hi 1.0; and Lo 0.3, Lo 0.7, and Lo 1.0. These settings, in order, translate to ISO values of about 160, 125, and 100 at the low end and 4000, 5000, and 6400 at the high end.

Choosing ISO 3200 pretty much ensures a noisy image (refer to Figure 5-6), and shifting into the Hi settings just makes things worse. If cranking up ISO is the only way to capture the image, and you'd rather have a noisy picture than no picture, go for it. Otherwise, adjust shutter speed and aperture to get the exposure you want instead.

Also check out the upcoming sidebar "Dampening Noise" for features that may help calm noise somewhat.

Not to complicate matters — well, okay, I guess I'm about to do just that — but if you're working in the P, S, A, or M exposure modes, you have the option of selecting a specific ISO value *and* enabling Auto ISO override as a backup. If you go this route, the Auto ISO label appears as usual, but pressing the ISO button shows the specific value you selected. Clear as mud? See the next bulleted list for information that may help.

Regardless, you adjust the setting by rotating the main command dial while pressing the ISO button.

- ✓ Show ISO Sensitivity: If you choose this option, the ISO value permanently replaces the frames-remaining value in the Control panel and viewfinder. Again, rotate the main command dial while pressing the ISO button to adjust the ISO value. You must visit the Shooting Information screen to see the frames-remaining value.
- Show ISO/Easy ISO: This setting also displays the ISO value instead of the frames-remaining number in the Control panel and viewfinder. But instead of pressing the ISO button to adjust the setting, you can just rotate the main command dial in the A exposure mode or the sub-command dial in the P and S modes. In all the other exposure modes, you press the ISO button and rotate the main command dial. I find all that a little complicated, but you be the judge.

Whichever display option you select, you also can adjust ISO via the ISO Sensitivity Settings option on the Shooting menu, as shown in Figure 5-13. I find that sticking with the default ISO display option — Off (Show Frame Count) — and then using the ISO button/main dial maneuver is faster, however.

Keep the following factoids in mind about the ISO settings themselves:

Figure 5-13: You also can adjust ISO via the Shooting menu.

Vari-Program modes: In these exposure modes, the list of ISO settings includes Auto ISO. Select this option if you want the camera to take the ISO reins entirely.

a smaller aperture (higher f-stop number) because less light is needed to expose the image.

You can adjust ISO in any exposure mode. Moreover, you can specify how you want to display and adjust the ISO value. To make that call, open the Custom Setting menu, navigate to the Shooting/Display submenu, highlight ISO Display and Adjustment, and press OK to display the three options shown in Figure 5-11.

Figure 5-11: You can choose from three options for displaying and adjusting ISO.

Here are your choices:

✓ Off (Show Frame Count): In this mode, which is the default setting, the ISO value always appears in the Shooting Information display, as shown on the right in Figure 5-12. (Press the Info button to bring up the display.) If you set the ISO value to the Auto setting, an option discussed fully in the next section, you also see an Auto ISO label next to the frames-remaining value in the viewfinder and Control panel. (Refer to Figure 5-10, in the preceding section.)

Figure 5-12: At the default ISO display/adjustment setting, you press the ISO button and rotate the main command dial to change the ISO setting.

An asterisk (*) appears next to the P exposure mode symbol in the upperleft corner of the Shooting Information display after you rotate the main command dial to indicate that you adjusted the aperture/shutter speed settings from those the camera initially suggested. In the Control panel, a P* symbol appears right under the shutter speed to provide the same alert. To get back to the initial combo of shutter speed and aperture, rotate the main command dial until the asterisk disappears from the Shooting Information display and the P* disappears from the Control panel.

✓ S (shutter-priority autoexposure): In this mode, you select the shutter speed. Just rotate the main command dial to get the job done.

As you change the shutter speed, the camera automatically adjusts the aperture as needed to maintain what it considers the proper exposure. Remember that as the aperture shifts, so does depth of field — so even though you're working in shutter-priority mode, keep an eye on the f-stop, too, if depth of field is important to your photo. Also note that in extreme lighting conditions, the camera may not be able to adjust the aperture enough to produce a good exposure at your current shutter speed again, possible aperture settings depend on your lens. So you may need to compromise on shutter speed (or in dim lighting, raise the ISO).

✓ A (aperture-priority autoexposure): In this mode, you control aperture, and the camera adjusts shutter speed automatically. To set the aperture (f-stop), rotate the sub-command dial.

When you stop down the aperture (raise the f-stop value), be careful that the shutter speed doesn't drop so low that you run the risk of camera shake if you handhold the camera — unless you have a tripod handy, of course. And if your scene contains moving objects, make sure that when you dial in your preferred f-stop, the shutter speed that the camera selects is fast enough to stop action (or slow enough to blur it, if that's your creative goal). These same warnings apply when you use P mode, by the way.

- M (manual exposure): In this mode, you select both aperture and shutter speed, like so:
 - To adjust shutter speed: Rotate the main command dial.
 - To adjust aperture: Rotate the sub-command dial.

Keep in mind that when you use P, S, or A modes, the settings that the camera selects are based on what it thinks is the proper exposure. If you don't agree with the camera, you have two options: You can switch to manual exposure mode and simply dial in the aperture and shutter speed that deliver the exposure you want; or if you want to stay in P, S, or A mode, you can tweak exposure using the Exposure Compensation feature, explained later in this chapter.

Controlling 150

The ISO setting, introduced at the start of this chapter, adjusts the camera's sensitivity to light. At a higher ISO, you can use a faster shutter speed or

Setting 150, Aperture, and Shutter Speed

The next sections detail how to view and adjust these three critical exposure settings. Remember, you can adjust ISO in any exposure mode, but to control aperture (f-stop) or shutter speed, you must switch to one of the four advanced exposure modes (P, S, A, or M).

Adjusting aperture and shutter speed

You can view the current aperture (f-stop) and shutter speed in the Control panel, viewfinder, and Shooting Information display, as shown in Figure 5-10. (Press the Info button to display the Shooting Information screen.)

Figure 5-10: Look for the current f-stop, shutter speed, and ISO settings here.

Shutter speeds are presented as whole numbers, even if the shutter speed is set to a fraction of a second. For example, the number 125 indicates a shutter speed of 1/125 second. When the shutter speed slows to 1 second or more, quote marks appear after the number — 1" indicates a shutter speed of 1 second, 4" means 4 seconds, and so on.

To select aperture and shutter speed, start by pressing the shutter button halfway to kick the exposure system into gear. You can then release the button if you want. The next step depends on the exposure mode, as follows:

✓ P (programmed auto): In this mode, the camera shows you its recommended f-stop and shutter speed when you press the shutter button halfway. But you can rotate the main command dial to select a different combination of settings. The number of possible combinations depends upon the aperture settings the camera can select, which in turn depend on the lighting conditions and your lens.

In the S and A exposure modes, the meter appears when the camera thinks you're heading for an exposure problem. If your exposure settings are so far off that the exposure indicator bumps up against the limits of the meter, you get an extra warning: In S mode, the words Hi or Lo take the place of the f-stop value to warn you about overexposure and underexposure, respectively. In A mode, the warning message instead occupies the space normally reserved for the shutter speed.

If you're so inclined, you can customize the meter in the following ways:

- ✓ **Adjust the meter shutoff timing.** The meter turns off automatically if you don't press the shutter button for a period of time 6 seconds, by default. You can adjust the shut-off timing through the Auto Meter-Off Delay option, found on the Timers/AE Lock submenu of the Custom Setting menu, as shown on the left in Figure 5-9. Keep in mind that shorter delay times conserve battery power.
- ✓ Reverse the meter orientation. You can flip the meter so that the positive (overexposure) side appears on the right and the negative (underexposure) side falls on the left. This option also lies on the Custom Settingmenu, but on the Controls submenu. Look for the Reverse Indicators option, as shown on the right in the figure.

Keep in mind that the meter's suggestion on exposure may not always be the one you want to follow. For example, you may want to shoot a backlit subject in silhouette, in which case you *want* that subject to be underexposed. In other words, the meter is a guide, not a dictator. In addition, remember that the exposure information the meter reports is based on the *exposure metering mode*, which determines which part of the frame the camera considers when calculating exposure. At the default setting, exposure is based on the entire frame, but you can select two other metering modes. See the upcoming section "Choosing an Exposure Metering Mode" for details.

Figure 5-9: You can customize the behavior of the exposure meter.

- against allover blur that can result from camera shake when you're hand-holding the camera.
- ✓ ISO affects the camera's sensitivity to light. A higher ISO makes the camera more responsive to light but also increases the chance of image noise.

So when you boost that shutter speed to capture your soccer subjects, you have to decide whether you prefer the shorter depth of field that comes with a larger aperture or the increased risk of noise that accompanies a higher ISO.

Everyone has their own approach to finding the right combination of aperture, shutter speed, and ISO, and you'll no doubt develop your own system as you become more practiced at using the advanced exposure modes. In the meantime, here's how I handle things:

- ✓ I always use the lowest possible ISO setting unless the lighting conditions are so poor that I can't use the aperture and shutter speed I want without raising the ISO.
- ✓ If my subject is moving (or might move, as with a squiggly toddler or antsy pet), I give shutter speed the next highest priority in my exposure decision. I might choose a fast shutter speed to ensure a blur-free photo or, on the flip side, select a slow shutter to intentionally blur that moving object, an effect that can create a heightened sense of motion. (The waterfall photo in Chapter 7 offers an example of the latter technique.)
- For images of non-moving subjects, I make aperture a priority over shutter speed, setting the aperture according to the depth of field I have in mind. For portraits, for example, I use a wide-open aperture (low f-stop number) so that I get a short depth of field, creating a nice, soft background for my subject. For landscapes, I go the opposite direction, stopping down the aperture as much as possible to capture the subject at the greatest depth of field.

Putting the f (stop) in focus

One way to remember the relationship between f-stop and depth of field, or the range of distance over which objects remain in sharp focus, is simply to think of the f as standing for focus. A higher f-stop number produces a larger depth of field, so if you want to extend the zone of sharp focus to cover a greater distance from your subject, you set the aperture to a higher f-stop. Higher f-stop number, greater zone of sharp focus.

Please don't share this tip with photography elites, who will roll their eyes and inform you that the f in f-stop most certainly does not stand

for focus but for the ratio between the aperture size and lens focal length — as if *that's* helpful to know if you're not an optical engineer. (Chapter 6 explains focal length, which *is* helpful to know.)

As for the fact that you *increase* the f-stop number when you want a *smaller* aperture, well, I'm still working on the ideal mnemonic tip for that one. But try this in the meantime: Lower f-stop, larger aperture. Or maybe the opposite: Raise the f-stop to reduce the aperture size and restrict the light. (As I said, I'm working on it.)

Figure 5-6: Noise becomes more visible as you enlarge your images.

Doing the exposure balancing act

As you change any of the three exposure settings — aperture, shutter speed, and ISO — one or both of the others must also shift in order to maintain the same image brightness. Say that you're shooting a soccer game, for example, and you notice that although the overall exposure looks great, the players are appearing slightly blurry at your current shutter speed. If you raise the shutter speed, you have to compensate with either a larger aperture, to allow in more light during the shorter exposure, or a higher ISO setting, to make the camera more sensitive to the light — or both.

As the preceding section explains, changing these settings impacts your image in ways beyond exposure. As a quick reminder:

- Aperture affects depth of field, with a higher f-stop number producing a greater zone of sharp focus.
- Shutter speed affects whether motion of the subject or camera results in a blurry photo. A faster shutter "freezes" action and also helps safeguard

shutter to capture the flower without blur. I opened the aperture to f/6.3, which was the maximum on the lens I was using, to allow as much light as possible into the camera. Even so, I needed a shutter speed of 1/40 second to expose the picture at ISO 200 — and that shutter speed wasn't fast enough to catch the swaying flower without blur, as shown on the left in the figure. Using the lowest ISO (ISO 100) would have made the situation that much worse. By raising the ISO to 400, I was able to use a shutter speed of 1/80 second, which captured the flower cleanly.

Fortunately, you don't encounter serious noise on the D90 until you really crank up the ISO. In fact, you may even be able to get away with ISO 3200 if you keep your print or display size small. But as with other image defects, noise becomes more apparent as you enlarge the photo. To prove the point, Figure 5-6 shows you magnified views of a bit of the rose scene captured at ISO 200 through 3200. Noise also is easier to spot in areas of flat color than in areas of busy detail or rough texture, where it can hide a little more.

Long story short, understanding how aperture, shutter speed, and ISO affect your image enables you to have much more creative input over the look of your photographs — and, in the case of ISO, to also control the quality of your images. (Chapter 3 discusses other factors that affect image quality.)

ISO 200, f/6.3, 1/40 second

ISO 400, f/6.3, 1/80 second

Figure 5-5: A higher ISO enabled me to select a shutter speed fast enough to capture a blur-free flower shot on a windy day.

If your picture suffers from overall image blur, as in Figure 5-4, where even stationary objects appear out of focus, the camera itself moved during the exposure. As you increase the exposure time (by selecting a slower shutter speed), you increase the risk of this problem because you have to keep the camera still for a longer period of time. Most people enter the camera-shake zone at speeds slower than about 1/50 second, although some people have steadier hands than others. I'm not one of them, as my 1/20 second handheld example in Figure 5-4 shows.

Some Nikon lenses, including the 18–105mm kit lens, offer *vibration reduction*, which is designed to help compensate for small amounts of camera shake. If you're using a lens from another manufacturer, the feature may go by the name *image stabilization* or something similar. Whatever you call it, this option can enable

f/13, 1/20 second, ISO 200

Figure 5-4: Slow shutter speeds increase the risk of all-over blur caused by camera shake.

you to capture sharp images at slightly slower shutter speeds than normal when handholding the camera. On the D90 kit lens, just set the VR switch on the side of the lens to the On position to enable vibration reduction.

See Chapter 6 for tips on solving other focus problems and Chapter 7 for more help with action photography.

✓ **ISO affects image noise.** As ISO increases, making the image sensor more reactive to light, you increase the risk of producing a defect called *noise*. This defect looks like sprinkles of sand and is similar in appearance to film *grain*, a defect that often mars pictures taken with high ISO film. Noise can also be caused by very long exposure times.

Ideally, then, you should always use the lowest ISO setting on your camera to ensure top image quality. But sometimes, the lighting conditions simply don't permit you to do so and still use the aperture and shutter speeds you need. Take the rose images in Figure 5-5, for example. Here again, a mild breeze was blowing, so I knew I needed a fast

- background in the first image, taken at an aperture setting of f/5.6, appears noticeably softer than in the right example, taken at f/13. Aperture is just one contributor to depth of field, however; see Chapter 6 for the complete story.
- ✓ **Shutter speed affects motion blur.** At a slow shutter speed, moving objects appear blurry, whereas a fast shutter speed captures motion cleanly. Compare the tall foreground grass in the images in Figure 5-3, for example. A brisk wind was blowing when I took these pictures, and as a result, the foreground grass is captured without blur only at the 1/160 second shutter speed used for the left image. How fast a shutter speed you need to freeze action depends on the speed of the subject, of course.

f/5.6, 1/160 second, ISO 200

f/13, 1/60 second, ISO 400

Figure 5-3: Stopping down the aperture (by choosing a higher f-stop number) increases depth of field, or the zone of sharp focus.

✓ ISO (controls light sensitivity): ISO, which is a digital function rather than a mechanical structure on the camera, enables you to adjust how responsive the image sensor is to light. The term ISO is a holdover from film days, when an international standards organization rated each film stock according to light sensitivity: ISO 200, ISO 400, ISO 800, and so on. Film or digital, a higher ISO rating means greater light sensitivity, which means that less light is needed to produce the image, enabling you to use a smaller aperture, faster shutter speed, or both.

On the D90, you can select ISO settings ranging from 100 to a whopping 6400. (The high and low ends of the scale are named Lo 1 and Hi 1, respectively.)

Distilled down to its essence, the image-exposure formula is just this simple:

- Aperture and shutter speed together determine the quantity of light that strikes the image sensor.
- ✓ ISO determines how much the sensor reacts to that light.

The tricky part of the equation is that aperture, shutter speed, and ISO settings affect your pictures in ways that go *beyond* exposure. You need to be aware of these side effects, explained in the next section, to determine which combination of the three exposure settings will work best for your picture.

Understanding exposure-setting side effects

You can create the same exposure with many combinations of aperture, shutter speed, and ISO. You're limited only by the aperture range allowed by the lens and the shutter speeds and ISO range offered by the camera.

But as I hinted in the preceding section, the settings you select impact your image beyond mere exposure, as follows:

✓ **Aperture affects depth of field.** The aperture setting, or f-stop, affects *depth of field*, which is the range of sharp focus in your image. I introduce this concept in Chapter 2, but here's a quick recap: With a shallow depth of field, your subject appears more sharply focused than faraway objects; with a large depth of field, the sharp-focus zone spreads over a greater distance.

As you reduce the aperture size — or *stop down the aperture*, in photo lingo — by choosing a higher f-stop number, you increase depth of field. As an example, take a look at the two images in Figure 5-3. For both shots, I established focus on the foreground grass. Notice that the

f-stops, and are expressed with the letter f followed by a number: f/2, f/2, f/2, and so on. The lower the f-stop number, the larger the aperture, and the more light is permitted into the camera, as illustrated by Figure 5-2.

The range of possible f-stops depends on your lens and, if you use a zoom lens, on the zoom position (focal length) of the lens. When you use the 18-105mm lens that Nikon bundles in the D90 kit, you can select apertures from f/3.5-f/22 when zoomed all the way out to the shortest focal length, 18mm. When you zoom in to the maximum focal length, 105mm, the aperture range is f/5.6-f/36. (See Chapter 6 for a discussion of focal lengths.)

➤ Shutter speed (controls duration of light): Set behind the aperture, the shutter works something like, er, the shutters on a window. When you aren't taking pictures, the camera's shutter stays closed, preventing light from striking the image sensor, just as closed window shutters prevent sunlight from entering a room. When you press the shutter button, the shutter opens briefly to allow light that passes through the aperture to hit the image sensor.

The length of time that the shutter is open is called the *shutter speed* and is measured in seconds: 1/60 second, 1/250 second, 2 seconds, and so on. Shutter speeds on the D90 range from 30 seconds to 1/4000 second when you shoot without the built-in flash. If you do use the built-in flash, the range is more limited; some external flash heads permit a faster shutter speed, however. See the sidebar "In sync: Flash timing and shutter speed," later in this chapter, for information.

Should you want a shutter speed longer than 30 seconds, manual (M) exposure mode also provides a feature called *bulb* exposure. At this setting, the shutter stays open indefinitely as long as you press the shutter button down.

Figure 5-2: A lower f-stop number means a larger aperture, allowing more light into the camera.

You'll not only gain the power to resolve just about any exposure problem, but also discover ways to use exposure to put your own creative stamp on a scene.

To that end, this chapter provides everything you need to know to really exploit your D90's exposure options, from a primer in exposure science (it's not as bad as it sounds) to explanations of all the camera's exposure controls. In addition, because some controls aren't accessible in the fully automatic exposure modes, this chapter also introduces you to the four advanced modes, P, S, A, and M.

Introducing the Exposure Trio: Aperture, Shutter Speed, and 150

Any photograph, whether taken with a film or digital camera, is created by focusing light through a lens onto a light-sensitive recording medium. In a film camera, the film negative serves as that medium; in a digital camera, it's the image sensor, which is an array of light-responsive computer chips.

Between the lens and the sensor are two barriers, known as the *aperture* and *shutter*, which together control how much light makes its way to the sensor. The actual design and arrangement of the aperture, shutter, and sensor vary depending on the camera, but Figure 5-1 offers an illustration of the basic concept.

The aperture and shutter, along with a third feature known as *ISO*, determine *exposure* — what most of us would describe as the picture's overall brightness and contrast. This three-part exposure formula works as follows:

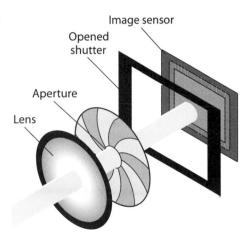

Figure 5-1: The aperture size and shutter speed determine how much light strikes the image sensor.

Aperture (controls amount of light): The aperture is an adjustable hole in a diaphragm set just behind the lens. By changing the size of the aperture, you control the size of the light beam that can enter the camera. Aperture settings are stated as f-stop numbers, or simply

Getting Creative with Exposure and Lighting

In This Chapter

- ▶ Understanding the basics of exposure
- Exploring advanced exposure modes: P, S, A, or M?
- ▶ Choosing an exposure metering mode
- ▶ Tweaking autoexposure with Exposure Compensation
- ► Taking advantage of Active D-Lighting
- Using flash in the advanced exposure modes
- ▶ Creating a safety net with automatic bracketing

nderstanding exposure is one of the most intimidating challenges for the new photographer. Discussions of the topic are loaded with unfamiliar, techy-sounding terms — aperture, metering, shutter speed, ISO, and the like. Add the fact that your D90 offers oodles of exposure controls, all sporting equally foreign names, and it's no wonder that most people throw up their hands and decide that their best option is to simply stick with the Auto exposure mode and let the camera take care of all exposure decisions.

You can, of course, turn out super shots in Auto mode.
And I fully relate to the exposure confusion you may be feeling — I've been there. But from years of working with beginning photographers, I can promise that when you take things nice and slow, digesting just a piece of the exposure pie at a time, the topic is not nearly as complicated as it seems on the surface. And I guarantee that the payoff will be well worth your time and brain energy.

In this part . . .

s nice as it is to be able to set your D90 to automatic mode and let the camera handle most of the photographic decisions, I encourage you to also explore the advanced exposure modes (P, S, A, and M). In these modes, you can make your own decisions about the exposure, focus, and color characteristics of your photo, which are key to capturing an image as you see it in your mind's eye. And don't think that you have to be a genius or spend years to be successful — adding just a few simple techniques to your photographic repertoire can make a huge difference in how happy you are with the pictures you take.

The first two chapters in this part explain everything you need to know to do just that, providing both some necessary photography fundamentals as well as details about using the advanced exposure modes. Following that, Chapter 7 helps you draw together all the information presented earlier in the book, summarizing the best camera settings and other tactics to use when capturing portraits, action shots, landscapes, and close-up shots.

Part II Taking Creative Control

"Remember, when the subject comes into focus, the camera makes a beep. But that's annoying, so I set it on vibrate."

Display Framing Guides: This mode displays a grid over the image, as shown on the right in the figure. The grid is helpful when you need to precisely align objects in your photo. But note that in this mode, you cannot zoom the display to check focusing.

Figure 4-34: Press the Info button to change the Live View display mode.

You also can adjust the brightness of the monitor. To do so, press and hold the Playback button to display a little brightness scale on the right side of the monitor, as shown in Figure 4-35. Press the Multi Selector up or down to move the brightness indicator on the scale. Release the Playback button to exit the monitor-adjustment mode and hide the brightness scale.

If you connect your camera to an HDMI (High-Definition Multimedia Interface) device, you no longer see the live scene button and then press the Multi Selector up on your camera monitor. Instead, the view is displayed on your video device. In that scenario, the arrangement of the shooting information on the screen is slightly different but contains the same basic data.

Figure 4-35: Press and hold the Playback or down to adjust the monitor brightness in Live View mode.

7. Press the Lv button to exit Live View mode and return to normal shooting.

To play your movie, press the Playback button. In single-image playback mode, you can spot a movie file by looking for the little movie-camera icon in the top-left corner of the screen, as shown in Figure 4-32. You also can view the length of the movie in the area indicated in the figure. Press OK to start playback.

In the thumbnail and Calendar playback modes, you see little filmstrip dots along the edges of movie files, as shown in Figure 4-33. This time, press OK twice: once to shift to singleimage view and again to start movie playback.

Chapter 9 explains how to connect your camera to a television so you can play your movies "on the big screen."

Customizing the Live View display

Whether you are shooting movies or still photos, you can choose the following three Live View display styles.

lowing three Live View display styles. Press the Info button to cycle between the different displays.

- ✓ **Display Shooting Information:** In this mode, which is the default, your monitor displays the data shown earlier, in Figure 4-29. (Some data disappears if you start recording a movie; refer to Figure 4-31.)
- ✓ Hide Shooting Information: Select this mode to hide everything that normally appears atop your image except the icon that represents your chosen exposure mode, as shown on the left in Figure 4-34. You also may see the red rectangle that represents the autofocusing frame; see the section "Taking pictures in Live View mode" for details.

Figure 4-32: The little movie camera symbol tells you you're looking at a movie file.

Figure 4-33: Thumbnails bordered by filmstrip dots are movie files.

To try out movie recording, first set your camera to manual focusing and, if you're not using a tripod, turn on Vibration Reduction (or whatever form of image stabilization your lens offers). Then take these steps:

1. Set your movie preferences through the Movie Settings option on the Shooting menu.

The first part of this section explains your options.

- 2. Press the Lv button to switch to Live View mode.
- 3. Compose your shot.
- 4. Set focus.

You can use the techniques outlined in the preceding section to magnify the display to check focus if needed.

5. Press OK to begin recording.

A red Rec symbol begins flashing at the top of the monitor, as shown in Figure 4-31. As recording progresses, the area labeled Time Remaining in the figure shows you how many more seconds of video you will be able to record. (The length is dependent on the movie-quality settings you choose and the amount of space on your memory card.) If you enabled sound, you also see the microphone symbol, as shown in the figure.

Figure 4-31: The red Rec symbol flashes while recording is in progress.

- Frame rate: The *frame rate* determines the smoothness of the playback. At all three Quality settings, the frame rate is 24 frames per second, or fps. By contrast, the standard frame rate for television-quality video is 30 frames per second, so expect your movies to play a little less smoothly than your favorite sitcoms.
- ✓ **Sound recording:** You can record sound or shoot a silent movie; make the call via the Movie Settings option on the Shooting menu (shown in Figure 4-30).

- If you enable sound, note the position of the microphone: It's the little three-holed area just beneath the Mode dial, on the front of the camera. Make sure that you don't inadvertently cover up the microphone with your finger. And keep in mind that anything *you* say will be picked up by the mike along with any other audio present in the scene.
- ✓ Video format: Movies are created in the AVI format, which means you can play them on your computer using most movie-playback programs. If you want to view your movies on a TV, you can connect the camera to the TV, as explained in Chapter 9. Or if you have the necessary computer software, you can convert the AVI file to a format that a standard DVD player can recognize and then burn the converted file to a DVD disk. You also can edit your movie in a program that can work with AVI files.

So far, so good. None of the aforementioned details is terribly unusual or complicated. Where things get a little tricky for the would-be filmmaker are in the areas of focus and exposure:

- Focusing: As with regular Live View photography, you can use autofocusing to establish initial focus on your subject before you begin recording. But after recording begins, the autofocus system lays down and plays dead. So unless you're recording a static subject say, a guitar player sitting on a stool or a speaker at a lectern opt for manual focusing. You can then adjust focus manually any time during the recording.
 - If you plan to also zoom in and out, give yourself some time to practice before the big event. It's a bit of a challenge to zoom and focus at the same time, especially while holding the camera in front of you so that you can see the monitor. (A tripod makes the maneuver slightly easier.)
- Exposure: The camera automatically sets exposure based on the light throughout the entire scene. You can't adjust exposure in any way, and any exposure options currently selected for regular photography don't apply. On a more positive note, the exposure settings used by the camera in movie mode tend to deliver a fairly large depth of field, or zone of sharp focus, which means that your subject can probably move at least a short distance from your original focusing point and not fall too badly out of

focus. (Chapter 5 explains how exposure settings affect depth of field.)

You see your just-captured picture on the monitor for a few seconds, as usual. Then the Live View preview returns, and you're ready to take the next shot.

10. To exit the Live View preview, press the Ly button.

You can then return to framing your images through the viewfinder.

Recording movies

Your D90 offers a first-ever feature for digital SLR cameras: the ability to record digital movies. Although recording live action with a D90 involves a few limitations and difficulties that you don't experience with a real video camera, it's a fun option to have onboard nonetheless.

Before I give you the specifics, here's the broad overview of D90 movie making:

Movie quality: Select this option from the Movie Setting option on the Shooting menu, as shown in Figure 4-30. The settings determine the frame size and aspect ratio of the movie: 320 x 216 pixels, for a 3:2 aspect ratio (the same aspect ratio as your D90 still images); 640 x 424, also a 3:2 aspect ratio; and 1280 x 720, which gives you a 16:9 aspect ratio, which is found on many new TV sets and computer monitors.

The higher the pixel count, the larger you can display the movie on a TV or monitor before you see the quality of the playback deteriorate. But a higher Quality setting also produces a larger file, eating up more of your memory card, and reduces the maximum length of the movie you can record, as outlined next.

Maximum movie length/file size: If you select the highest movie resolution (1280 x 720 pixels), your movie can have a maximum length of five minutes and a maximum file size of 2GB. At the two lower-resolution settings, you're still restricted to 2GB file sizes, but the movies can run as long as 20 minutes. Of course, you must have 2GB of empty memory card space to store the movie.

Figure 4-30: Specify movie quality and sound recording options via the Shooting menu.

- The bottom of the screen displays the metering mode, shutter speed, aperture, and ISO Sensitivity settings. (Chapter 5 details these settings.) The Shots Remaining value tells you how many more pictures will fit on the memory card.
- One row up, a few symbols appear to remind you what buttons to push to activate certain functions. For example, the first symbol indicates that you can adjust monitor brightness by pressing the Playback button, as described at the end of this chapter.
- The icon in the upper-left corner represents the exposure mode (Auto, P, A, Portrait, and so on).
- The upper-right corner displays the current Image Size, Image Quality, and White Balance settings. (Chapter 3 explains the first two; Chapter 6 explains White Balance.) The remaining two symbols, not labeled in Figure 4-29, relate to movie recording, explained in the next section.
- The red rectangle, labeled Autofocus frame in the figure appears as a result of choosing the Wide Area autofocusing option in Step 1. If you instead select Normal Area, you see a smaller rectangle. More on what you actually do with that rectangle in Step 7.

The figure shows the default monitor setup; you can adjust what data is displayed by using the options explained at the end of this chapter.

- 5. Frame the shot.
- 6. Turn the lens focusing ring to set initial focus.

7. Press the Qual button to magnify the view and refine focus, if needed.

Pressing the button zooms the display, with each press giving you a closer look at the shot. As when you magnify an image when you're viewing photos in Playback mode, a small thumbnail in the corner of the monitor appears, with the yellow highlight box indicating the area that's currently being magnified. To scroll the display and check another part of the image, press the Multi Selector to move the red focusing frame over the area you want to inspect. (Here's where that Live View Autofocus setting selected in Step 1 becomes important: If it's set to Face Priority, you can't scroll the display to view specific parts of the picture.)

To reduce the magnification, press the ISO button. When you're happy with the focus, press OK to return to full-frame view.

8. Press the shutter button halfway to initiate exposure metering.

If needed, you can adjust exposure in P, S, and A modes by using Exposure Compensation. In Manual (M) exposure mode, you can adjust shutter speed and f-stop as usual. (Chapter 5 spells out exposure details.) In the fully automatic exposure modes, you can't adjust exposure.

9. Depress the shutter button fully to take the shot.

control when you check your focus later, in Step 7. So select either of the other two options.

2. Set the camera to manual focusing mode.

Chapter 1 details the process, which varies depending on the type of lens you use. For Nikkor AF-S lenses like the 18–105mm kit lens bundled with the D90, set the A/M switch on the lens to M.

3. If you're not using a tripod, turn on Vibration Reduction.

For the kit lens, set the VR switch on the lens to On.

4. Press the Lv button on the camera back.

You hear a clicking sound as the camera shifts to Live View. The scene in front of the lens appears on the monitor, as shown in Figure 4-29, and you no longer can see anything through the viewfinder.

Figure 4-29: In Live View mode, you can compose your image on the monitor.

Along with your image, you see a bunch of shooting data. You can control what data is displayed by adjusting the settings explained in the last section of this chapter. But in the default view, shown in the figure, you see the following information:

Aiming the lens at the sun or other bright lights also can damage the camera. Of course, you can cause problems doing this even during normal shooting, but the possibilities increase when you use Live View. You not only can harm the camera's internal components but also the monitor.

Live View also presents the two additional disadvantages which, in this case, are the same as for a point-and-shoot camera. First, any time you use the monitor, you put extra strain on the battery. So keep an eye on the battery status icon to avoid running out of juice at a critical moment. Second, the monitor can wash out in bright sunlight, making it difficult to compose outdoor shots.

This list of caveats doesn't mean that I'm telling you not to use Live View. But for normal photography — that is, still shooting rather than movie recording — you shouldn't envision Live View as a full-time alternative to using the viewfinder. Rather, think of it as a special-purpose tool that can help in situations where framing with the viewfinder is cumbersome.

I find Live View most helpful for still-life, tabletop photography, especially in cases that require a lot of careful arrangement of the scene. For example, I have a shooting table that's about waist high. Normally, I put my camera on a tripod, come up with an initial layout of the objects I want to photograph, set up my lights, and then check the scene through the viewfinder. Then there's a period of refining the object placement, the lighting, and so on. If I'm shooting from a high angle, requiring the camera to be positioned above the table and pointing downward, I have to stand on my tiptoes or get a stepladder to check things out through the viewfinder between each compositional or lighting change. At lower angles, where the camera is tabletop height or below, I have to either bend over or kneel to look through the viewfinder, causing no end of later aches and pains to back and knees. With Live View, I can alleviate much of that bothersome routine (and pain) because I can usually see how things look in the monitor no matter what the camera position.

With that lengthy preamble out of the way, the following section provides a primer in standard Live View shooting. Following that, you can find details about movie recording and discover a few ways to customize the Live View display.

Taking pictures in Live View mode

The following steps walk you through the process of Live View photography. For reasons explained in the preceding introduction to Live View shooting, manual focusing is recommended, so the steps assume that you stick with that focusing choice.

1. Open the Custom Setting menu, select the Autofocus submenu, and set the Live View Autofocus option to Normal Area or Wide Area.

Okay, I know I just said that these steps assume that you're going to focus manually. But for reasons I won't get into, setting the Live View Autofocus option to the third available choice, Face Priority, limits your

You need to know a few points about Live View as it's provided on your camera:

- ✓ Manual focusing is recommended. You can autofocus, but manual focusing usually offers faster, more precise results. And if you don't use a Nikon AF-S lens, the camera may have difficulty autofocusing at all in Live View mode. See Chapter 1 for an explanation of AF-S and other lens types.
- Continuous autofocusing isn't possible. In normal shooting, you can set the camera to continually adjust focus automatically up to the moment you fully depress the shutter button to record your picture. (See Chapter 6 for details.) This autofocus feature helps ensure that moving subjects remain sharply focused even after you initially establish focus by pressing the shutter button halfway.

When you use autofocus in Live View mode, focus is always locked when you press the shutter button halfway. For still photography, you can always release the button and reset focus if needed, assuming that your subject isn't moving so quickly that you don't have time to do so. But when you use autofocusing in movie mode, you can't adjust the focus point after recording begins. (Some lenses, however, do enable you to twist the manual focusing ring after setting focus initially with autofocus; check your lens manual to find out if you have that option.)

- ✓ You can't access the Shooting Information display. You can still view camera settings on the control panel, however, and a few settings are displayed with the image on the monitor.
- You must establish the exposure metering mode before switching to Live View mode. You can't change this exposure control, explained in Chapter 5, without shifting out of Live View mode.
- ✓ You must be extra careful to keep the camera steady. Just as with a pointand-shoot camera, holding the camera out in front of you to capture the image can cause camera shake that can blur your image. But with an SLR, the risk is greater because of the added weight of the camera and lens. And if you use a so-called *long lens* — a telephoto or zoom lens that extends to a long focal length — the potential for camera shake is compounded. So for best results, mount the camera on a tripod when you use Live View.
- ✓ Using Live View for an extended period can harm your pictures and the camera. When you work in Live View mode, the camera's innards heat up more than usual, and that extra heat can create the right electronic conditions for *noise*, a defect that gives your pictures a speckled look. (Chapter 5 offers more information.)

Perhaps more critically, the increased temperatures can damage the camera itself. For that reason, Live View is automatically disabled after one hour of shooting — or earlier, if a critical heat level is detected. In extremely warm environments, you may not be able to use Live View mode for very long before the system shuts down.

Anyway, protecting a picture is easy:

- 1. Display or select the picture you want to protect.
 - In single-image view, just display the photo.
 - In 4/9/72 thumbnail mode, use the Multi Selector as needed to place the yellow highlight box over the photo.
 - In Calendar view, highlight the date that contains the image and then press the ISO button to jump to the scrolling list of thumbnails. Then move the highlight box over the image.

WB

2. Press the WB button.

See the tiny key symbol that appears on the button? That's your reminder that you use the button to lock a picture. After you press the button, the same symbol appears on the image display, as shown in Figure 4-28.

3. To remove protection, display or select the image and press the WB button again.

One word of caution: If you apply the Hide Image tag to a photo as well as the Protect tag and you then remove the Hide Image tag, you

Figure 4-28: Press the WB button to prevent accidental deletion of the selected image.

also remove the Protect tag. See the earlier section "Hiding Photos during Playback" for an explanation of the Hide Image feature.

Exploring Live View Shooting

If you've used a compact, point-and-shoot digital camera, you may be used to composing your pictures on the camera monitor rather than by looking through the viewfinder. In fact, many compact cameras no longer even offer a viewfinder, which is a real shame, in my opinion. Why? Because when you use the monitor to frame the image, you must hold the camera away from your body, a posture that increases the likelihood of blurry images caused by camera shake. When you use the viewfinder, you can brace the camera against your face, creating a steadier shooting stance.

Due to some design complexities that I won't bore you with, most digital SLR cameras do not enable you to preview shots on the monitor. Your D90, however, does offer that feature, known as $\mathit{Live View}$ in dSLR nomenclature. The D90 also uses Live View when you record movies.

Deleting versus formatting: What's the diff?

In Chapter 1, I introduce you to the Format Memory Card command, which lives on the Setup menu and erases everything on your memory card. What's the difference between erasing photos by formatting and by choosing Delete from the Playback menu and then selecting the All option?

Well, first, if you happen to have stored other data on the card, such as, say, a music file or a picture taken on another type of camera, you need to format the card to erase everything on it. You can't view those files on the monitor, so you can't use Delete to get rid of them.

Also keep in mind that the Delete function affects only the currently selected folder of

camera images. As long as you use the default folder system that the camera creates for you, however, "currently selected folder" is the same as "all images." The section "Viewing Images in Playback Mode," earlier in this chapter, talks more about this issue; Chapter 11 explains how to create custom folders.

One final — and important — note: Although using the Protect feature (explained elsewhere in this chapter) prevents the Delete function from erasing a picture, formatting erases all pictures, protected or not. Formatting also wipes out any photos you hid by using the Hide Image feature.

Protecting Photos

Formatting your memory card, however, *does* erase even protected pictures. See the nearby sidebar for more about formatting.

The picture protection feature comes in especially handy if you share a camera with other people. You can protect pictures so that those other people know that they shouldn't delete your super-great images to make room on the memory card for their stupid, badly photographed ones. (This step isn't foolproof, though, because anyone can remove the protected status from an image.)

Perhaps more importantly, when you protect a picture, it shows up as a read-only file when you transfer it to your computer. Files that have that read-only status can't be altered. Again, anyone with some computer savvy can remove the status, but this feature can keep casual users from messing around with your images after you've downloaded them to your system. Of course, *you* have to know how to remove the read-only status yourself if you plan on editing your photo in your photo software. (*Hint:* In Nikon ViewNX, you can do this by clicking the image thumbnail and then choosing File©Protect Files©Unprotect.)

You then have two options for specifying which photos to erase:

Select photos one-by-one. To go this route, highlight Selected and press the Multi Selector right to display a screen of thumbnails, as shown in Figure 4-27. Use the Multi Selector to place the yellow highlight box over the first photo you want to delete and then press the ISO button, shown in the margin here. A little trash can icon, the universal symbol for delete, appears on the thumbnail. as shown in the figure. If you change your mind, press the ISO button again to remove the Delete tag from the image.

Figure 4-27: Use the ISO button to tag pictures you want to delete.

For a closer look at the selected image, press and hold the Qual button. When you release the button, the display returns to normal thumbnail view.

Frase all photos taken on a specific date. This time, choose Select Date from the main Delete screen. Press the Multi Selector right to display a list of dates on which you took the pictures on the memory card. Highlight a date and press the Multi Selector right. A little checkmark appears in the box next to the date, tagging all images taken on that day for deletion. To remove the check mark and save the photos from the digital dumpster, press the Multi Selector right again.

Can't remember what photos are associated with the selected date? Press the ISO button to display thumbnails of all the images. You can then press the Qual button to temporarily view a selected thumbnail at full-size view. To return to the date list, press the ISO button again.

After selecting the photos or a shooting date, press OK to start the Delete process. You see a confirmation screen asking permission to destroy the images; select Yes and press OK. The camera trashes the photos and returns you to the Playback menu.

You have one alternative way to quickly erase all images taken on a specific date: In the Calendar display mode, you can highlight the date in question and then press the Delete button instead of going through the Playback menu. You get the standard confirmation screen asking you whether you want to go forward. Press the Delete button again to dump the files.

If you accidentally erase a picture, don't panic — you may be able to restore it by using data-restoration software such as MediaRecover (\$30, www. mediarecover.com) or Lexar Image Rescue (also about \$30, www.lexar.com). But in order to have a chance, you must not take any more pictures or perform any other operations on your camera while the current memory card is in it. If you do, you may overwrite the erased picture data for good and eliminate the possibility of recovering the image.

Deleting all photos

To erase all pictures, display the Playback menu and highlight Delete, as shown in the first image in Figure 4-26. Press OK to display the options shown in the second image. Highlight All and press the Multi Selector right. You then see a screen that asks you to verify that you want to delete all of your images. Select Yes and press OK.

Figure 4-26: To delete all photos, use the Delete option on the Playback menu.

If you create custom image folders, a feature I cover in Chapter 11, be aware that this step deletes only pictures in the folder that is currently selected via the Playback Folder option on the Playback menu. See the section "Viewing Images in Playback Mode," earlier in this chapter, for information.

Deleting a batch of selected photos

To erase multiple photos — but not all of them — display the Playback menu, highlight Delete, and press OK. You see the Delete screen shown in the second image in Figure 4-26.

Redisplay all hidden images. To redisplay all hidden pictures quickly, choose Deselect All from the Hide Image screen. Press the Multi Selector right to display a screen that asks you to confirm your decision. Highlight Yes and press OK to make it so.

A couple of fine points about this feature: First, your hidden images remain viewable from within the Hide Image screens. (So make sure your boss doesn't have time alone with your camera.) Second, if you want to delete hidden photos by using the Delete feature, explained next, you first need to remove the Hide Image tags. Or you can format your memory card, which wipes out all photos, hidden or not. See Chapter 1 for details on card formatting.

Deleting Photos

You can erase pictures from a memory card when it's in your camera in three ways. The next sections give you the lowdown. (Or is it the down low? I can't seem to keep up.)

If you hid an image by using the Hide Image feature or locked the file by using the Protect feature, you must remove the Hide Image or Protect tag from the file before you can delete the image. Details about hiding and protecting files are lurking elsewhere in this chapter.

Deleting images one at a time

The Delete button is key to erasing single images. But the process varies a little depending on which Playback display mode you're using, as follows:

- In single-image view, you can erase the current image by pressing the Delete button.
- ✓ In thumbnail view (displaying 4, 9, or 72 thumbnails), use the Multi Selector to highlight the picture you want to erase and then press the Delete button.
- In Calendar view, first highlight the date that contains the image. Then press the ISO button to jump to the scrolling list of thumbnails, highlight a specific image, and press Delete.

After you press Delete, you see a message asking whether you really want to erase the picture. If you do, press the Delete button again. Or, to cancel out of the process, press the Playback button.

See the earlier section, "Viewing Images in Playback Mode," for more details about the display modes.

Now you have three choices — the first two let you select which photos to hide, and the third one brings them back from hiding:

Select individual images to hide. Highlight Select/Set and press the Multi Selector right to display thumbnails of your photos, as shown in Figure 4-24. Use the Multi Selector to move the yellow box over the photo you want to hide.

Next, press the ISO button, shown in the margin here, to tag the thumbnail with a little Hide Image icon, as shown in the figure. To remove the tag, just press the button again.

Hide Image icon

Figure 4-24: Press the ISO button to add the Hide Image tag to the selected photo.

While you're inspecting thumbnails, you can press and hold the Qual button to temporarily dis-

play the selected image in full-frame view. When you release the button, the display returns to normal thumbnail view.

After you tag all the images you want to hide, press OK to return to the Playback menu.

Hide all photos shot on a specific date. If all the embarrassing images were taken on the same day, you can save time by using the Select Date option. (Refer to the right screen in Figure 4-23.) After you choose the option, you see a list of dates, as shown in Figure 4-25. Highlight a date and press the Multi Selector right to put a checkmark in the box next to the date. Now all images from that day are hidden. To remove the checkmark and redisplay the photos, press the Multi Selector right again.

Figure 4-25: You can quickly hide all photos taken on a certain date.

You can view thumbnails of all the pictures taken on a date by highlighting the date and pressing the ISO button. You can then temporarily display a single image at full-size view by moving the yellow highlight box over the image thumbnail and pressing the Qual button. To return to the date list view, press OK. Press OK again to return to the Playback menu.

Figure 4-22: Look at this row for details about advanced color settings.

Hiding Photos during Playback

Let's say that your memory card contains 100 pictures. You shot about 50 at a meeting held during a business convention, and another 50 at the wild after-meeting party. You want to show your boss the ones where you and your co-workers look like responsible adults, but you'd rather not share the photos documenting your less-than-businesslike side. You could always delete the party photos; the next section shows you how. But if you want to keep them — you never know when a good blackmail picture will come in handy — you can simply hide those images during playback.

The key to this trick is the Hide Image option on the Playback menu. After highlighting the option, as shown on the left in Figure 4-23, press OK to display the right screen in the figure.

Figure 4-23: The Hide Image function lets you prevent photos from appearing during normal picture playback.

data, see the earlier section "File Information mode." (As always, the Protect status and Retouch Indicator icons appear only if you used those two features; otherwise, the area is empty.)

To sort out the maze of other information, the following list breaks things down into the five rows that appear under the image thumbnail and histogram. In the accompanying figures, I include all possible data simply for the purposes of illustration; if any of the items don't appear on your screen, it simply means that the relevant feature wasn't enabled when you captured the shot.

- ✓ Row 1: This row shows the exposure-related settings labeled in Figure 4-20, along with the focal length of the lens you used to take the shot. Chapter 5 details the exposure settings; Chapter 6 introduces you to focal length.
- ✓ Row 2: This row contains a few additional exposure settings, labeled in Figure 4-21. On the right end of the row, the Comment and GPS labels appear if you took advantage of those options when recording the shot. (You must switch to the Shooting Data mode or GPS mode, respectively, to view the actual comment and GPS data.)
- **Row 3:** The first three items on this row, labeled in Figure 4-22, relate to color options explored in Chapter 6. The last item indicates the Active D-Lighting setting, another exposure option discussed in Chapter 5.
- ✓ Rows 4 and 5: The final two rows of data (refer to Figure 4-19) show the same information you get in File Information mode, explained in the preceding section.

Figure 4-20: Here you can inspect major exposure settings along with the lens focal length.

Figure 4-21: This row contains additional exposure information.

GPS Data mode

This display mode is available only if the image you're viewing was shot with the optional Nikon GPS (Global Positioning System) attached.

If you use the GPS unit, this display mode shows you the latitude, longitude, and altitude information recorded with the image file. You also see the date and time of the shot along with the standard Frame Number/Total Pictures numbers, the Protect Status icon, and the Retouch Indicator icon, all explained in the earlier section "File Information mode." The data screen appears in the same fashion as in Shooting Data mode, superimposed over your image.

Overview Data mode

This mode is the second of the two default photo-information modes. (Meaning, you don't have to enable it via the Display Mode option on the Playback menu to use it.) In this mode, the playback screen contains a small image thumbnail along with scads of shooting data — although not quite as much as Shooting Data mode — plus a Brightness histogram. Figure 4-19 offers a look.

Figure 4-19: In Overview Data mode, you can view your picture along with the major camera settings you used to take the picture.

The earlier section "Reading a Brightness histogram" tells you what to make of that part of the screen. Just above the histogram, you see the Protect Status and Retouch Indicator, while the Frame Number/Total Pictures data appears in the upper right-corner of the image thumbnail. For details on that

Figure 4-18: You can view the camera settings used to capture the image in Shooting Data display mode.

Most of the data here won't make any sense to you until you explore Chapters 5 and 6, which explain the exposure, color, and other advanced settings available on your camera. But I do want to call your attention to a couple of factoids now:

- ✓ The top-left corner of the monitor shows the Protect Status and Retouch Indicator icons, if you used the protect or retouch features. Otherwise, the area is empty. (See the earlier section "File Information Mode" for details about these particular features.)
- ✓ The current frame number, followed by the total number of images on the memory card, appears in the lower-right corner of the display.
- ✓ The Comment item, which is the final item on the third screen, contains a value if you use the Image Comment feature on the Setup menu. I cover this option in Chapter 11.
- ✓ If the ISO value on Shooting Data Page 1 (the first screen in Figure 4-17) appears in red, the camera is letting you know that it overrode the ISO Sensitivity setting that you selected in order to produce a good exposure. This shift occurs only if you enable automatic ISO adjustment. See Chapter 5 for details.

a variety of light shades are instead totally white. For example, in a cloud image, pixels that should be light to very light gray become white due to overexposure, resulting in a loss of detail in those clouds.

In Highlight display mode, areas that are totally white blink in the camera monitor. Like RGB Histogram mode, the Highlight mode is provided because simply viewing the image Isn't always a reliable way to gauge exposure. To use it, however, you must follow the instructions laid out in the earlier section "Viewing Picture Data" to enable the mode.

Along with the blinking highlight warning, Highlight display mode presents the standard bits of information in this mode: the Protect Status, Retouch Indicator, and File Number/ Total Pictures values, all explained in the earlier section "File Information mode." The label *Highlights* also appears to let you know the current display mode, as shown in Figure 4-17.

I suggest that you check both the Brightness histogram offered in RGB Histogram display mode and the Highlight display, though, when you're concerned about overexposure. If an

image contains only a small area of blown highlights, the histogram may indicate a very small pixel population at the brightest end of the spectrum, leading you to assume that you're okay in the exposure department. But if those blown highlights happen to fall in an important part of your image — someone's face, for example — they can wreck your picture.

Shooting Data display mode

Before you can access this mode, you must enable it via the Display Mode option on the Playback menu. See the earlier section, "Viewing Picture Data," for details. After turning on the option, press the Multi Selector down to shift from Highlights mode to Shooting Data mode.

In this mode, you can view three screens of information, which you toggle between by pressing the Multi Selector up and down. Figure 4-18 shows you the three screens, referred to in the Nikon manual as Shooting Data Page 1, 2, and 3.

Understanding RGB histograms

When you view your images in RGB Histogram display mode, you see two histograms: the Brightness histogram, covered in the preceding section, and an RGB histogram, shown in close-up view in Figure 4-16.

To make sense of the RGB histogram, you first need to know that digital images are called *RGB images* because they are created out of three primary colors of light: red, green, and blue. The RGB histogram shows you the brightness values for each of those primary colors.

By checking the brightness levels of the individual color components, sometimes referred to as color *channels*, you can assess the picture's color saturation levels. If most of the pixels for one or more channels are clustered toward the right end of the histogram, colors may be oversaturated, which destroys detail. On the flip side, a heavy concentration of pixels at the left end of the histogram indicates an image that may be undersaturated.

Figure 4-16: The RGB histogram can indicate problems with color saturation.

A savvy RGB histogram reader also can spot color-balance issues by looking at the pixel values. But frankly, color-balance problems are fairly easy to notice just by looking at the image itself on the camera monitor. And understanding how to translate the histogram data for this purpose requires more knowledge about RGB color theory than I have room to present in this book.

For information about manipulating color, see Chapter 6.

Highlight display mode

One of the most difficult photo problems to correct in a photo editing program is known as *blown highlights* in some circles and *clipped highlights* in others. In plain English, both terms mean that *highlights* — the brightest areas of the image — are so overexposed that areas that should include

The core of this display mode, though, are those chart-like thingies, officially called *histograms*. You actually get two types of histograms: The top one is a Brightness histogram; the three others are collectively called an RGB histogram.

QUAL The next two sections explain what you can discern from the histograms. But first, here's a cool trick to remember: If you press the Qual button while in this display mode, you can zoom the thumbnail to a magnified view. The histograms then update to reflect only the magnified area of the photo. To return to the regular view and once again see the whole-image histogram, press OK.

Reading a Brightness histogram

You can get an idea of image exposure by viewing your photo on the camera monitor. But if you adjust the brightness of the monitor or the ambient light affects the display brightness, you may not get the real story. The Brightness histogram provides a way to gauge exposure that's a little more reliable.

Labeled in Figure 4-14 and shown enlarged in Figure 4-15, the Brightness histogram indicates the distribution of shadows, highlights, and midtones (areas of medium brightness) in your image.

The horizontal axis of the histogram represents the possible picture brightness values — the maximum tonal range, in photography-speak — from the darkest shadows on the left to the brightest highlights on the right. And the vertical axis shows you how many pixels fall at a particular brightness value. A spike indicates a heavy concentration of pixels. For example, in Figure 4-15, the histogram shows a large supply of pixels clustered in the range just above medium brightness, but very few in the deepest shadows.

Keep in mind that there is no one "per-

Figure 4-15: The Brightness histogram

indicates tonal range, from shadows on the left to highlights on the right.

fect" histogram that you should try to achieve. Instead, interpret the histogram with respect to the distribution of shadows, highlights, and midtones that comprise your subject. You wouldn't expect to see lots of shadows, for example, in a photo of a polar bear walking on a snowy landscape. Pay attention, however, if you see a very high concentration of pixels at the far right or left end of the histogram, which can indicate a seriously overexposed or underexposed image, respectively. To find out how to resolve exposure problems, visit Chapter 5.

- ✓ **Image Quality:** Here you can see which Image Quality setting you used when taking the picture. Again, Chapter 3 has details, but the short story is this: Fine, Normal, and Basic are the three JPEG recording options, with Fine representing the highest JPEG quality. The word *Raw* indicates that the picture was recorded in the Nikon Camera Raw format, NEF.
- ✓ Image Size: This value tells you the image resolution, or pixel count. See Chapter 3 to find out about resolution.

RGB Histogram mode

Press the Multi Selector down to shift from File Information mode to this mode, which displays your image in the manner shown in Figure 4-14. (Remember: You can view your picture in this mode only if you enable it via the Display Mode option on the Playback menu. See "Viewing Picture Data," earlier in this chapter, for help.)

Figure 4-14: Histogram mode presents exposure and color information in chart-like fashion.

Underneath the image thumbnail, you see just a few pieces of data. As with File Information mode, you see the Protect Status and Retouch Indicator icons if you used those features. Beneath that, you see the White Balance settings used for the shot. (White balance is a color feature you can explore in Chapter 6.) Along the bottom row of the display, you see the camera name along with the Frame Number/Total Pictures data, also part of the standard File Information display data.

Underneath the image, you can view these details:

Folder Name: Folders are named automatically by the camera unless you create custom folders, an advanced trick you can explore in Chapter 11. The first camera-created folder is named 100NCD90. Each folder can contain up to 9999 images; when you exceed that limit, the camera creates a new folder and assigns the next folder number: 101NCD90, 102NCD90, and so on.

✓ **Filename:** The camera also automatically names your files. Filenames end with a three-letter code that represents the file format, which is either JPG (for JPEG) or NEF (for Camera Raw) for still photos. Chapter 3 discusses these two formats. If you record a movie (a project you can explore near the end of this chapter), the file extension is AVI, which represents a digital-movie file format. If you create a dust-off reference image file, an advanced feature designed for use with Nikon Capture NX 2, the camera instead uses the extension NDF. (Because this software must be purchased separately, I don't cover it or the dust-off function in this book.)

The first three letters of filenames also vary. Here's what the possible three-letter codes indicate:

- *DSC*: This code means normal, plain-old picture file.
- SSC: This trio appears at the beginning of files that you create with the Small Picture option on the Retouch menu. Chapter 9 discusses this feature.
- CSC: This code is used for images that you alter using other Retouch menu features. For example, I applied the D-Lighting correction feature to the image in Figure 4-13, so the filename begins with CSC, and the Retouch Indicator appears in the top-left corner of the monitor.
- _ (underscore): If you change the Color Space setting on the Shooting menu to the Adobe RGB color profile, a topic you can investigate in Chapter 6, an underscore character precedes the filename. (The exception is for dust-off reference photos, which don't use the underscore.) For photos taken in the default color profiles (sRGB), the underscore appears after the three-letter code, as in DSC_.

Each image is also assigned a four-digit file number, starting with 0001. When you reach image 9999, the file numbering restarts at 0001, and the new images go into a new folder to prevent any possibility of overwriting the existing image files. For more information about file numbering, see the Chapter 1 section that discusses the File Number Sequence option.

✓ Date and Time: Just below the folder and filename info, you see the date and time that you took the picture. Of course, the accuracy of this data depends on whether you set the camera's date and time values correctly, which you do via the Setup menu. Chapter 1 has details.

File Information mode

In this display mode, the monitor displays the data shown in Figure 4-13.

Figure 4-13: In File Information mode, you can view these bits of data.

The following bits of info appear at the top of the monitor:

- ✓ Protect Status: A little key icon indicates that you used the camera's file-protection feature to prevent the image from being erased when you use the camera's Delete function. See "Protecting Photos," later in this chapter, to find out more. (Note: Formatting your memory card, a topic discussed in Chapter 1, does erase even protected pictures.) This area appears empty if you didn't apply protection.
- ✓ Retouch Indicator: This icon appears if you used any of the Retouch menu options to alter the image. (I cover most Retouch features in Chapter 10.) Again, no icon means that you didn't retouch the photo.
- Frame Number/Total Pictures: The first value here indicates the frame number of the currently displayed photo; the second tells you the total number of pictures on the memory card. In Figure 4-13, for example, the image is number 94 out of 94.

- want to go from full-frame view to one of the thumbnail views or Calendar view. (In shooting mode, the button accesses the ISO Sensitivity control, an exposure feature covered in Chapter 5.)
- ✓ Return to full-frame view. When you're ready to return to the normal magnification level, you don't need to keep pressing the ISO button until you're all the way zoomed out. Instead, just press the OK button, which quickly returns you to the standard, full-frame view.

Viewing Picture Data

In single-image picture view, you can choose from five Photo Information modes, each of which presents a different set of shooting data along with the image. To cycle between the different modes, press the Multi Selector up or down.

Note, though, that three of the five modes are disabled by default. To enable them, display the Playback menu and highlight Display Mode, as shown on the left in Figure 4-12. Press OK to display the second screen you see in the figure. To toggle a display mode on, highlight it and then press the Multi Selector right. A check mark then appears in the box for the selected option. After turning on the options you want to use, highlight Done and press OK again to return to the Playback menu. If you decide that you don't care for one of these three modes, just reverse the process.

Figure 4-12: You must enable some of the information display modes via the Playback menu.

The next sections explain exactly what details you can glean from each display mode. I present them here in the order they appear if you cycle through the modes by pressing the Multi Selector down. You can spin through the modes in the other direction by pressing the Multi Selector up.

The yellow outline in this picturein-picture image indicates the area that's currently consuming the rest of the monitor space. Use the Multi Selector to scroll the yellow box and display a different portion of the image. After a few seconds, the navigation thumbnail disappears; just press the Multi Selector in any direction to redisplay it.

Face Detection symbol

Magnified area

Figure 4-10: Use the Multi Selector to move the yellow outline over the area you want to inspect.

Figure 4-11: If the camera detects faces, you can rotate the sub-command dial to automatically zoom the display to more closely inspect each subject.

zoomed, you can rotate the main command dial to display the same area of the next photo at the same magnification. So if you shot the same subject several times, you can easily check how the same details appear in each one.

✓ Zoom out. To zoom out to a reduced magnification, press the ISO button, shown in the margin here. This button also sports the magnifying glass symbol, but this time with a minus sign to indicate that it reduces the display size. That little grid-like thingy next to the magnifying glass reminds you that the button also comes into play when you

4. To temporarily display a larger view of the selected thumbnail, hold down the Qual button.

The image filename appears under the larger preview, as shown in Figure 4-9. When you release the button, the large preview disappears, and the calendar comes back into view.

5. To jump back to the calendar and select a different date, press the ISO button again.

You can just keep pressing the button to jump between the calendar and the thumbnail strip as much as you want.

Figure 4-9: Press and hold the Qual button to temporarily view the selected image at a larger size.

6. To exit Calendar view and return to single-image view, press OK.

If you press OK while a date is selected, the camera displays the first picture taken on that day in single-image view. Pressing OK while the thumbnail strip is active displays the currently selected photo instead. Either way, if you want to return to Calendar view, you have to press the ISO button four times to cycle from full-frame view through the different thumbnail display modes.

Zooming in for a closer view

After displaying a photo in single-frame view, you can magnify it so that you can get a close-up look at important details, such as whether someone's eyes are closed in a portrait. Here's the scoop:

Zoom in. Press the Qual button, shown in the margin here. You can magnify the image to a maximum of 13 to 27 times its original display size, depending on the resolution (pixel count) of the photo. Just keep pressing the button until you reach the magnification you want.

Note the magnifying glass icon on the button face — the plus sign in the middle is your reminder that this button enlarges the image in playback mode. (In shooting mode, the button accesses the Image Quality and Size settings, thus its official text label.)

✓ **View another part of the magnified picture.** When an image is magnified, a little navigation thumbnail showing the entire image appears briefly in the lower-right corner of the monitor, as shown in Figure 4-10.

Displaying photos in Calendar view

In Calendar display mode, you see a little calendar on the monitor, as shown on the left in Figure 4-8. By selecting a date on the calendar, you can quickly navigate to all pictures you shot on that day. (An empty date indicates that your memory card doesn't contain any photos from that day.)

Figure 4-8: Calendar view makes it easy to view all photos shot on a particular day.

The key to navigating Calendar view is the ISO button:

1. Press the ISO button as needed to cycle through the thumbnail display modes until you reach Calendar view.

If you're currently viewing images in full-frame view, for example, you need to press the button four times to get to Calendar view.

2. Using the Multi Selector or main command dial, move the yellow highlight box over a date that contains an image.

In Figure 4-8, for example, the 25th day of October is selected. (The number of the month appears in the top-left corner of the screen.) After you select a date, the right side of the monitor displays a vertical strip of thumbnails of pictures taken on that date.

3. To view all thumbnails from the selected date, press the ISO button again.

Now the vertical thumbnail strip becomes active, and you can scroll through the thumbnails by pressing the Multi Selector up and down. A second highlight box appears in the thumbnail strip to indicate the currently selected image.

Figure 4-7: You can view 4, 9, or 72 thumbnails at once.

In any of the thumbnail display modes, use these techniques to navigate your photo collection:

- Scroll through your pictures. Rotate the main command dial or press the Multi Selector right or left.
- ✓ **Select an image.** As you scroll through your pictures, a yellow highlight box indicates the currently selected image. For example, in Figure 4-7, Image 52 is selected. To select a different image, use the main command dial or Multi Selector to scroll the display until the highlight box surrounds the image.
- ✓ View the selected image at the full-frame size. Press the OK button.

 After you return to full-frame view, pressing OK displays the Retouch menu over your photo. See Chapter 10 for a look at some of the picture fixes you can apply to your photo from the Retouch menu.

Figure 4-6: Navigate and inspect your photos using these controls.

Viewing multiple images at a time

Along with viewing images one at a time, you can choose to display 4, 9, or 72 thumbnails, as shown in Figure 4-7. Just press the ISO button, shown in the margin here and labeled Zoom out/Thumbnail display in Figure 4-6. Press once to cycle from single-picture view to 4-thumbnail view, press again to shift to 9-picture view, and press once more to bring up those itty-bitty thumbnails featured in 72-image view. Press yet again, and you shift to Calendar view, a nifty feature explained in the next section.

QUAL To reduce the number of thumbnails, press the Qual button, shown clinging to the margin here and labeled Zoom In in Figure 4-6. Or to jump immediately to single-frame view without having to cycle back through all the display modes, just press the OK button.

You also can create custom folders through that same menu option. (See Chapter 11 for specifics.) If you do, you need to tell the camera whether you want to view only pictures in the current folder or in all folders. To do so, display the Playback menu and highlight Playback Folder, as shown on the left in Figure 4-5. Press OK to display the screen shown on the right in the figure. Select All to view all folders; select Current to view only the active folder. Press OK to exit the screen.

Figure 4-5: If you create custom folders, specify which folder you want to view.

Again, this step applies only if you create custom folders. If you let the camera handle all folder-creation duties, you can view all pictures on the card regardless of the Playback Folder setting.

2. Press the Playback button, labeled in Figure 4-6.

The monitor displays the last picture you took, along with some picture data, such as the frame number of the photo. To find out how to interpret the picture information and specify what data you want to see, see the upcoming section "Viewing Picture Data."

To scroll through your pictures, rotate the main command dial or press the Multi Selector right or left.

I highlighted the dial and Multi Selector in Figure 4-6.

To return to picture-taking mode, press the shutter button halfway and then release it.

These steps assume that the camera is currently set to display a single photo at a time, as shown in Figure 4-6. You can also display multiple images at a time, as explained next.

Figure 4-3: To adjust the length of the instant-review period, visit the Custom Setting menu.

Disable instant review: Because any monitor use is a strain on battery power, consider turning off instant review altogether if your battery is running low. You turn off the feature via the Image Review option on the Playback menu, shown in Figure 4-4. To turn off the feature, first display the Playback menu. Then highlight Image Review, as shown in Figure 4-4. Press OK, highlight Off, and press OK once more. You can still view your pictures by pressing the Playback button at any time.

Figure 4-4: Head for the Playback menu to disable instant review altogether.

Viewing Images in Playback Mode

To take a look at the pictures on your camera memory card, take these steps:

1. If you created custom image folders, specify which ones you want to view. Otherwise, skip to Step 2.

Your D90 normally organizes pictures automatically into folders that are assigned generic names: 100NCD90, 101NCD90, and so on. You can see the name of the current folder by looking at the Active Folder option on the Shooting menu. (The default folder name appears as just NCD90 on the menu.)

Figure 4-2: Visit the Setup and Playback menus to enable image rotation.

2. Display the Playback menu and select the Rotate Tall option, as shown on the right in Figure 4-2.

Select On if you want the camera to read the orientation data and rotate vertical pictures. Select Off if you prefer not to rotate the photos during playback. The images are still rotated automatically in photo programs that can read the orientation data in the file.

Shooting with the lens pointing directly up or down sometimes confuses the camera, causing it to record the wrong data in the file. If that issue bothers you, turn off Auto Image Rotation on the Setup menu before you shoot the pictures. The camera then won't record the orientation information as part of the picture file.

Disabling and Adjusting Instant Review

After you take a picture, it automatically appears briefly on the camera monitor. By default, this instant-review period lasts four seconds. But you can customize this behavior in two ways:

Adjust the length of the instant-review period: Display the Custom Setting menu, highlight the Timers/AE Lock submenu, and then press OK to display the screen shown on the left in Figure 4-3. Highlight Monitor Off Delay and press OK again to get to the second screen in the figure. Highlight Playback and then press the Multi Selector right to access the timing options (not shown in the figure). You have six choices, ranging from four seconds to 10 minutes. Highlight the timing option you want to use and then press OK to lock in your choice.

Enabling Automatic Picture Rotation

When you take a picture, the camera can record the image *orientation* — whether you held the camera normally, creating a horizontally oriented image, or turned the camera on its side to shoot a vertically oriented photo. This bit of data is simply added into the picture file.

During playback, the camera reads the data and automatically rotates the image so that it appears in the upright position, as shown on the left in Figure 4-1. The image is also automatically rotated when you view it in Nikon ViewNX, Capture NX 2, and some other photo programs that can interpret the data.

Figure 4-1: You can display vertically oriented pictures in their upright position (left) or sideways (right).

Official photo lingo uses the term *portrait orientation* to refer to vertically oriented pictures and *landscape orientation* to refer to horizontally oriented pictures.

Automatic rotation is turned on by default with the D90. But if you prefer to turn the feature off, you can. Your vertically oriented pictures then appear sideways, as shown on the right in Figure 4-1.

To check or adjust the status of automatic rotation, you need to visit two menus:

1. On the Setup menu, select Auto Image Rotation, as shown in the left image in Figure 4-2.

You need to scroll to the second screen of the menu to get to the Auto Image Rotation option. If you select On, the rotation data is added to the picture file. Select Off to leave the data out.

Monitor Matters: Picture Playback and Live View Shooting

In This Chapter

- Exploring picture playback functions
- Deciphering the picture information displays
- Understanding the exposure histogram
- ▶ Deleting bad pictures and protecting great ones
- ▶ Using the monitor as viewfinder in Live View mode
- Recording digital movies

ithout question, my favorite thing about digital photography is being able to view my pictures on the camera monitor the instant after I shoot them. No more guessing whether I captured the image I wanted or I need to try again, as in the film era. And no more wasting money on developing and printing pictures that stink.

Of course, with the D90, you can use the monitor not only to review your photos, but also to *preview* them. That is, if you turn on Live View shooting, you can use the monitor instead of the viewfinder to compose your shots. And once in Live View mode, you also can record short digital movies — an exciting new option that the D90 brings to digital SLR photography.

Because all these functions involve some of the same buttons, bells, and whistles, I cover them together in this chapter. In addition, this chapter explains how to delete pictures that you don't like and protect the ones you love from accidental erasure. (Be sure to also visit Chapter 9, which covers some additional ways to view your images, including how to create slide shows and display your photos and movies on a television screen.)

Maintaining a pristine view

Often lost in discussions of digital photo defects — compression artifacts, pixelation, and the like — is the impact of plain-old dust and dirt on picture quality. But no matter what camera settings you use, you aren't going to achieve great picture quality with a dirty lens. So make it a practice to clean your lens on a regular basis, using one of the specialized cloths and cleaning solutions made expressly for that purpose.

If you continue to notice random blobs or hair-like defects in your images (refer to the last example in Figure 3-1), you probably have a dirty image sensor. That's the part of your camera that does the actual image capture — the digital equivalent of a film negative, if you will.

Your D90 offers an automated, internal sensorcleaning mechanism. By default, this automatic cleaning happens every time you turn the camera on or off. You also can request a cleaning session at any time via the Clean Image Sensor command on the Setup menu. (Chapter 1 has details on this menu option.)

But if you frequently change lenses in a dirty environment, the internal cleaning mechanism may not be adequate, in which case a manual sensor cleaning is necessary. You can do this job yourself, but...I don't recommend it. Image sensors are pretty delicate beings, and you can easily damage them or other parts of your camera if you aren't careful. Instead, find a local camera store that offers this service. In my area (central Indiana), sensor cleaning costs from \$30–\$50.

One more cleaning tip: Never — and I mean never — try to clean any part of your camera using a can of compressed air. Doing so can not only damage the interior of your camera, blowing dust or dirt into areas where it can't be removed, but also crack the external monitor.

Figure 3-7: The current Image Size and Quality settings appear on the Control panel and Shooting Information display.

QUAL The quickest way to adjust the settings is to press the Qual button, shown in the margin here. As soon as you press the button, all other settings disappear from the Control panel and are dimmed in the Shooting Information display. While continuing to press the button, rotate the main command dial (on the back of the camera) to cycle through the available combinations of Image Size and Image Quality settings — Raw, Large/Fine, Large/Normal, Raw+JPEG Fine, and so on.

As an alternative, you can adjust the settings via the Shooting menu, shown in Figure 3-8. Here, you set the Image Size and Image Quality options independently of each other. Remember that when you choose the Raw (NEF) format, you don't need to worry about the Image Size setting — the camera captures all Raw images at the Large resolution. If you go with one of the Raw+JPEG options, the Image Size setting affects the JPEG version only.

Figure 3-8: You also can set Image Size and Image Quality via the Shooting menu.

Again, adjusting the Image Size or Image Quality setting changes the picture file size, which changes the

number of new shots you can fit on the current memory card. You can monitor the remaining card capacity in the Shots Remaining area of the Control panel and Shooting Information display. (It reads 276 in Figure 3-7.)

My take: Choose JPEG Fine or NEF (Raw)

At this point, you may be finding all this technical goop a bit much — I recognize that panicked look in your eyes — so allow me to simplify things for you. Until you have time or energy to completely digest all the ramifications of JPEG versus Raw, here's a quick summary of my thoughts on the matter:

- If you require the absolute best image quality and have the time and interest to do the Raw conversion, shoot Raw. See Chapter 8 for more information on the conversion process.
- If great photo quality is good enough for you, you don't have wads of spare time, or you aren't that comfortable with the computer, stick with JPEG Fine.
- If you don't mind the added file-storage space requirement and want the flexibility of both formats, choose Raw+JPEG. If you need your JPEGs to exhibit the best quality, go with Raw+JPEG Fine.
- If you go with JPEG only, stay away from JPEG Normal and Basic. The tradeoff for smaller files isn't, in my opinion, worth the risk of compression artifacts. As with my recommendations on image size, this fits the "better safe than sorry" formula: You never know when you may capture a spectacular, enlargement-worthy subject, and it would be a shame to have the photo spoiled by compression defects. If you select Raw+JPEG, of course, this isn't as much of an issue because you always have the Raw version as backup if you aren't happy with the JPEG quality.

Setting Image Size and Quality

To sum up this chapter: The Image Size and Image Quality options together determine the quality of your pictures and also play a large role in image file size. Choose a high Image Quality setting (NEF or JPEG Fine) and the maximum Image Size setting (Large), and you get top-quality pictures and large file sizes. Combining the lowest Quality setting (JPEG Basic) with the lowest Size setting (Small) greatly shrinks files, enabling you to fit lots more pictures on your memory card, but it also increases the chances that you'll be disappointed with the quality of those pictures, especially if you make large prints.

You can monitor the Image Size and Image Quality settings in the Control panel and Shooting Information display (which you bring up by pressing the Info button). Figure 3-7 shows you where to look.

your deepest shadows. With JPEG, the camera makes those decisions, which can potentially limit your flexibility if you try to adjust exposure in your photo editor later. And the extra bits in a Raw file offer an additional safety net because I usually can push the exposure adjustments a little further in my photo editor if necessary without introducing banding.

I also go Raw if I know that I'm going to want huge prints of a subject. But keep in mind: I'm a photography geek, I have all the requisite software, and I don't really have much else to do with my time than process scads of Raw images. Oh, and I'm a bit of a perfectionist, too. (Although I'm more bothered by imperfections than I am motivated to remove them. A lazy perfectionist, if you will.)

If you do decide to try Raw shooting, you can select from four options on your D90's Image Quality menu:

- ✓ NEF (RAW): This setting produces a single Raw file. Again, you don't have a choice of Image Size settings; the camera always captures the file at the maximum resolution (12.2 MP).
- ✓ NEF (RAW)+JPEG Fine, Normal, or Basic: You also can choose to capture the image as both a NEF file and a JPEG file, and you can specify whether you want the JPEG version recorded at the Fine, Normal, or Basic setting. (You can also set the resolution of the JPEG file at Large, Medium, or Small.) Of course, with two files, you consume more space on your camera memory card.

I often choose the Raw+JPEG Fine option when I'm shooting pictures I want to share right away with people who don't have software for viewing Raw files. I upload the JPEGs to a photo-sharing site where everyone can view them, and then I process the Raw versions of my favorite images for my own use when I have time. Having the JPEG version also enables you to display your photos on a DVD player or TV that has a slot for an SD memory card — most can't display Raw files but can handle JPEGs. Ditto for portable media players and digital photo frames.

If you choose to create both files, note a couple of things:

- When you view your pictures on the camera, you see only the JPEG version.
- ✓ If you delete the JPEG version using the camera's Delete function, the NEF file is erased as well. (After you transfer the two files to your computer, deleting one doesn't affect the other.)

Chapter 4 explains more about viewing and deleting photos; see the upcoming section "Setting Image Size and Quality" to find out how to specify the size for your JPEG files.

✓ To get the full benefit of Raw, you need software other than Nikon ViewNX. The ViewNX software that ships free with your camera does have a command that enables you to convert Raw files to JPEG or to TIFF, introduced in the preceding section. However, this free tool gives you limited control over how your original data is translated in terms of color, exposure, and other characteristics — which defeats one of the primary purposes of shooting Raw.

Nikon Capture NX 2 offers a sophisticated Raw converter, but it costs about \$180. (Sadly, if you already own Capture NX, you need to upgrade to version 2 to open the Raw files from your D90.) If you own Adobe Photoshop or Photoshop Elements, however, you're set; both include the converter that most people consider one of the best in the industry. Watch the sale ads, and you can pick up Elements for well under \$100. You may need to download an update from the Adobe Web site (www. adobe.com) to get the converter to work with your D90 files.

Of course, the D90 also offers an in-camera Raw converter, found on the Retouch menu. But although it's convenient, this tool isn't the easiest to use because you must rely on the small camera monitor when making judgments about color, exposure, sharpness, and so on. The incamera tool also doesn't offer the complete cadre of features available in Capture NX 2 and other converter software utilities.

Chapter 8 offers more information on the in-camera conversion process and also offers a look at the converter found in ViewNX.

✓ Raw files are larger than JPEGs. The type of file compression that Raw applies doesn't degrade image quality, but the tradeoff is a larger file. In addition, Nikon Raw files are always captured at the maximum resolution available on the camera, even if you don't really need all those pixels. For both reasons, Raw files are significantly larger than JPEGs, so they take up more room on your memory card and on your computer's hard drive or other picture-storage device.

Are the disadvantages worth the gain? Only you can decide. But before you make up your mind, refer to Figure 3-6 and compare the JPEG Fine example with its NEF (Raw) counterpart. You may be able to detect some subtle quality differences when you really study the two, but a casual viewer likely would not, especially if shown the entire example images at normal print sizes rather than the greatly magnified views shown in the figure. I took Figure 3-5, for example, using JPEG Fine.

That said, I do shoot in the Raw format when I'm dealing with tricky lighting because doing so gives me more control over the final image exposure. For example, if you use a capable Raw converter, you can specify how bright you want the brightest areas of your photo to appear and how dark you prefer

Raw is popular with advanced, very demanding photographers, for these reasons:

- ✓ **Greater creative control:** With JPEG, internal camera software tweaks your images, making adjustments to color, exposure, and sharpness as needed to produce the results that Nikon believes its customers prefer. With Raw, the camera simply records the original, unprocessed image data. The photographer then copies the image file to the computer and uses special software known as a *raw converter* to produce the actual image, making decisions about color, exposure, and so on at that point. The upshot is that "shooting Raw" enables you, and not the camera, to have the final say on the visual characteristics of your image.
- ✓ Higher bit depth: Bit depth is a measure of how many distinct color values an image file can contain. JPEG files restrict you to 8 bits each for the red, blue, and green color components, or channels, that make up a digital image, for a total of 24 bits. That translates to roughly 16.7 million possible colors. On the D90, a Raw file delivers a higher bit count, collecting 12 bits per channel.
 - Although jumping from 8 to 12 bits sounds like a huge difference, you may not really ever notice any difference in your photos that 8-bit palette of 16.7 million values is more than enough for superb images. Where having the extra bits can come in handy is if you really need to adjust exposure, contrast, or color after the shot in your photo editing program. In cases where you apply extreme adjustments, having the extra original bits sometimes helps avoid a problem known as *banding* or *posterization*, which creates abrupt color breaks where you should see smooth, seamless transitions. (A higher bit depth doesn't always prevent the problem, however, so don't expect miracles.)
- Best picture quality: Because Raw doesn't apply the destructive compression associated with JPEG, you don't run the risk of the artifacting that can occur with JPEG.

But of course, as with most things in life, Raw isn't without its disadvantages. To wit:

You can't do much with your pictures until you process them in a Raw converter. You can't share them online, for example, or put them into a text document or multimedia presentation. You can print them immediately if you use Nikon ViewNX, but most other photo programs require you to convert the Raw files to a standard format first. So when you shoot Raw, you add to the time you must spend in front of the computer instead of behind the camera lens.

casual snapshot is going to turn out to be so great that you want to print or display it large enough that even minor quality loss becomes a concern. And of all the defects that you can correct in a photo editor, artifacting is one of the hardest to remove. So if I shoot in the JPEG format, I stick with Fine.

I suggest that you do your own test shots, however, carefully inspect the results in your photo editor, and make your own judgment about what level of artifacting you can accept. Artifacting is often much easier to spot when you view images onscreen. It's difficult to reproduce artifacting here in print because the print process obscures some of the tiny defects caused by compression.

If you don't want *any* risk of artifacting, bypass JPEG altogether and change the file type to NEF (Raw). Or consider your other option, which is to record two versions of each file, one Raw and one JPEG. The next section offers details.

Whichever format you select, be aware of one more important rule for preserving the original image quality: If you retouch pictures in your photo software, don't save the altered images in the JPEG format. Every time you alter and save an image in the JPEG format, you apply another round of lossy compression. And with enough editing, saving, and compressing, you *can* eventually get to the level of image degradation shown in the JPEG example in Figure 3-1, at the start of this chapter. (Simply opening and closing the file does no harm.)

Always save your edited photos in a nondestructive format. TIFF, pronounced *tiff*, is a good choice and is a file-saving option available in most photo editing programs. Should you want to share the edited image online, create a JPEG copy of the TIFF file when you're finished making all your changes. That way, you always retain one copy of the photo at the original quality captured by the camera. You can read more about TIFF in Chapter 8, in the section related to processing Raw images. Chapter 9 explains how to create a JPEG copy of a photo for online sharing.

NEF (Raw): The purist's choice

The other picture file type you can create on your D90 is called *Camera Raw*, or just *Raw* (as in uncooked) for short.

Each manufacturer has its own flavor of Raw. Nikon's is called NEF, so you see the three-letter extension NEF at the end of Raw filenames.

Figure 3-6: Here you see a portion of the tower at greatly enlarged views.

Even at the greatly magnified size, it takes a sharp eye to detect the quality differences between the Raw and Fine images. When you carefully inspect the Normal version, you can see some artifacting start to appear; jump to the Basic example, and compression artifacting becomes fairly obvious.

Nikon chose to use the Normal setting as the default on the D90. I suppose that's okay for everyday images that you don't plan to print or display very large. And because file size shrinks as you apply more compression, Normal enables you to fit more photos on your memory card than Fine or NEF (Raw).

For my money, though, the file-size benefit you gain when going from Fine to Normal isn't worth even a little quality loss, especially with the price of camera memory cards getting lower every day. You never know when a

- **JPEG Fine:** At this setting, the compression ratio is 1:4 that is, the file is four times smaller than it would otherwise be. In plain English, that means that very little compression is applied, so you shouldn't see many compression artifacts, if any.
- ✓ JPEG Norm: Switch to Norm (for Normal), and the compression ratio rises to 1:8. The chance of seeing some artifacting increases as well.
- ✓ JPEG Basic: Shift to this setting, and the compression ratio jumps to 1:16. That's a substantial amount of compression and brings with it a lot more risk of artifacting.

Note, though, that even the JPEG Basic setting on your D90 doesn't result in anywhere near the level of artifacting that you see in my example in Figure 3-1. Again, that example is exaggerated to help you to be able to recognize artifacting defects and understand how they differ from other image-quality issues.

In fact, if you keep your image print or display size small, you aren't likely to notice a great deal of quality difference between the Fine, Normal, and Basic compression levels, although details in the Fine version may appear slightly crisper than the Normal and Basic options. It's only when you greatly enlarge a photo that the differences become apparent.

Take a look at Figures 3-5 and 3-6, for example. I captured the scene in Figure 3-5 four times, keeping the resolution the same for each shot but varying the Image Quality setting. For the photo you see in Figure 3-5, I used the JPEG Fine setting. I thought about printing the three other shots along with the JPEG Fine example, but frankly, you wouldn't be able to detect a nickel's worth of difference between the examples at the size that I could print them on this page. So Figure 3-6 shows just a portion of each shot at a greatly enlarged size. The first three images show the JPEG Fine, Normal, and Basic shots; for the fourth image, I used the NEF (Raw) setting, which applies no compression. (Note that during the process of converting the Raw image to a print-ready file, I tried to use settings that kept the Raw image as close as possible to its JPEG cousins in all aspects but quality. But any variations in exposure, color, and contrast are a result of the conversion process, not of the format per se.)

Figure 3-5: This subject offered a good test for comparing the Image Quality settings.

Understanding the Image Quality Options

If I had my druthers, the Image Quality option on the D90 would instead be called File Type, because that's what the setting controls.

Here's the deal: The file type, more commonly known as a file *format*, determines how your picture data is recorded and stored. Your choice does impact picture quality, but so do other factors, as outlined at the beginning of this chapter. In addition, your choice of file type has ramifications beyond picture quality.

At any rate, your D90 offers the two file types common on most of today's digital cameras: JPEG and Camera Raw, or just Raw for short, which goes by the specific moniker NEF on Nikon cameras. The next sections explain the pros and cons of each format. If your mind is already made up, skip ahead to "Setting Image Size and Quality," near the end of this chapter, to find out how to make your selection.

Don't confuse *file format* with the Format Memory Card option on the Setup menu. That option erases all data on your memory card; see Chapter 1 for details.

IPEG: The imaging (and Web) standard

Pronounced *juy-peg*, this format is the default setting on your D90, as it is for most digital cameras. JPEG is popular for two main reasons:

- Immediate usability: All Web browsers and e-mail programs can display JPEG files, so you can share them online immediately after you shoot them. The same can't be said for NEF (Raw) files, which must be converted to JPEG files before you can share them online. And although you can view and print Raw files in Nikon ViewNX without converting them, many third-party photo programs don't enable you to do that. You can read more about the conversion process in the upcoming section "NEF (Raw): The purist's choice."
- ✓ Small files: JPEG files are smaller than NEF (Raw) files. And smaller files consume less room on your camera memory card and in your computer's storage tank.

The downside — you knew there had to be one — is that JPEG creates smaller files by applying *lossy compression*. This process actually throws away some image data. Too much compression leads to the defects you see in the JPEG Artifacts example in Figure 3-1.

Fortunately, your camera enables you to specify how much compression you're willing to accept. The Image Quality menu offers three JPEG settings, which produce the following results:

- For everyday images, Medium (6.9 MP) is a good choice. I find 12.2 MP, which you get at the Large setting, to be overkill for most casual shooting, which means that you're creating huge files for no good reason. Keep in mind that even at the Medium setting, your pixel count (3216 x 2136) exceeds what you need to produce an 8-x-10-inch print at 200 ppi.
- Choose Large (12.2 MP) for an image that you plan to crop, print very large, or both. The benefit of maxing out resolution is that you have the flexibility to crop your photo and still generate a decent-sized print of the remaining image. For example, I shot the left photo in Figure 3-4 at the zoo. (What, you think I can afford an arctic safari or something?) Even with a powerful zoom lens, I couldn't get close enough to fill the frame with the bear's head, which was my compositional goal. Shooting at the highest resolution enabled me to crop the photo and still have enough pixels left to produce a great print, as you see in the right image.
- Reduce resolution if shooting speed is paramount. If you're shooting action and the shot-to-shot capture time is slower than you'd like that is, the camera takes too long after you take one shot before it lets you take another dialing down the resolution may help. Also see Chapter 7 for other tips on action photography.

After you decide which resolution setting is right for your picture, visit the section "Setting Image Size and Quality," later in this chapter.

Figure 3-4: Capture images that you plan to crop and enlarge at the highest possible Image Size setting.

How many pictures fit on my memory card?

That question is one of the first asked by new camera owners — and it's an important one because you don't want to run out of space on your memory card just as the perfect photographic subject presents itself.

As explained in the Image Size and Image Quality discussions in this chapter, image resolution (pixel count) and file format (JPEG or Raw) together help determine the size of the picture file which, in turn, determines how many photos fit in a given amount of camera memory. (The actual file size of any image also depends on a few other factors, including the level of detail and color in the subject.)

On the D90, file sizes range anywhere from 16.9MB (megabytes) to 0.4MB, depending on the combination of Image Size and Image Quality settings you select. That means the capacity of a 2GB (gigabyte) memory card ranges from 89 pictures to a whopping 3800 pictures, again, depending on your Size/Quality settings.

The table here shows the file sizes for just some Size/Quality combinations; you can find a table that lists all the possibilities in your camera manual if you're curious.

| Image Quality + Image Size = File Size | | | | | |
|--|--------|--------|--------|--|--|
| Image Quality | Large | Medium | Small | | |
| JPEG Fine | 6.0MB | 3.4MB | 1.6MB | | |
| JPEG Normal | 3.0MB | 1.7MB | 0.8MB | | |
| JPEG Basic | 1.5MB | 0.9MB | 0.4MB | | |
| NEF (Raw) | 10.8MB | NA* | NA* | | |
| NEF + JPEG Fine | 16.9MB | 14.4MB | 12.4MB | | |

^{*}NEF (Raw) images are always captured at the Large size; for NEF+JPEG, user can set size for the JPEG image.

Resolution recommendations

As you can see, resolution is a bit of a sticky wicket. What if you aren't sure how large you want to print your images? What if you want to print your photos *and* share them online?

Personally, I take the "better safe than sorry" route, which leads to the following recommendations about the Image Size setting:

Always shoot at a resolution suitable for print. You then can create a low-resolution copy of the image in your photo editor for use online. Chapter 9 shows you how.

Figure 3-3: The low resolution of this image (450 x 300 pixels) ensures that it can be viewed without scrolling when shared via e-mail.

Large files present several problems:

- You can store fewer images on your memory card, on your computer's hard drive, and on removable storage media such as a CD-ROM.
- The camera needs more time to process and store the image data on the memory card after you press the shutter button. This extra time can hamper fast-action shooting.
- When you share photos online, larger files take longer to upload and download.
- When you edit your photos in your photo software, your computer needs more resources and time to process large files.

To sum up, the tradeoff for a high-resolution image is a large file size. But note that the Image Quality setting also affects file size. See the upcoming section "Understanding the Image Quality Options" for more on that topic. The upcoming sidebar "How many pictures fit on my memory card?" provides additional thoughts about the whole file-storage issue.

| Table 3-2 | Pixel Requirements for Traditional Print Sizes | | |
|----------------|--|--------------------|--|
| Print Size | Pixels for 200 ppi | Pixels for 300 ppi | |
| 4 x 6 inches | 800 x 1200 | 1200 x 1800 | |
| 5 x 7 inches | 1000 x 1400 | 1500 x 2100 | |
| 8 x 10 inches | 1600 x 2000 | 2400 x 3000 | |
| 11 x 14 inches | 2200 x 2800 | 3300 x 4200 | |

Even though many photo-editing programs enable you to add pixels to an existing image, doing so isn't a good idea. For reasons I won't bore you with, adding pixels — known as *resampling* — doesn't enable you to successfully enlarge your photo. In fact, resampling typically makes matters worse. The printing discussion at the start of Chapter 9 includes some example images that illustrate this issue.

Pixels and screen display size

Resolution doesn't affect the quality of images viewed on a monitor, television, or other screen device as it does printed photos. What resolution *does* determine is the *size* at which the image appears.

This issue is one of the most misunderstood aspects of digital photography, so I explain it thoroughly in Chapter 9. For now, just know that you need way fewer pixels for onscreen photos than you do for printed photos. For example, Figure 3-3 shows a 450-x-300-pixel image that I attached to an e-mail message.

For e-mail images, I recommend a maximum of 640 pixels for the picture's longest dimension. If your image is much larger, the recipient can't view the entire picture without scrolling the display.

In short, even if you use the smallest Image Size setting on your D90, you'll have more than enough pixels for onscreen use, whether you display the picture on a computer monitor, a digital projector, or television set — even one of the new, supersized high-definition TVs. Again, Chapter 9 details this issue and also shows you how to prepare your pictures for online sharing.

Pixels and file size

Every additional pixel increases the amount of data required to create a digital picture file. So a higher-resolution image has a larger file size than a low-resolution image.

In the table, the first pair of numbers shown for each setting represents the image *pixel dimensions* — that is, the number of horizontal pixels and the number of vertical pixels. The values in parentheses indicate the total resolution, which you get by multiplying the horizontal and vertical pixel values. This number is usually stated in *megapixels*, abbreviated MP for short. One megapixel equals 1 million pixels. (I rounded off the MP values in the table.)

Note, however, that if you select Raw (NEF) as your file format, all images are captured at the Large setting. You can vary the resolution only if you select JPEG as the file format. The upcoming section "Understanding the Image Quality Options" explains file formats.

So how many pixels are enough? To make the call, you need to understand how resolution affects print quality, display size, and file size. The next sections explain these issues, as well as a few other resolution factoids.

If you're already schooled on the subject and just want to know how to select a resolution setting on your D90, skip to "Setting Image Size and Quality," near the end of this chapter, for specifics.

Pixels and print quality

When mulling over resolution options, your first consideration is how large you want to print your photos, because pixel count determines the size at which you can produce a high-quality print. If you don't have enough pixels, your prints may exhibit the defects you see in the pixelation example in Figure 3-1, or worse, you may be able to see the individual pixels, as in the right example in Figure 3-2.

Depending on your photo printer, you typically need anywhere from 200 to 300 pixels per linear inch, or *ppi*, of the print. To produce an 8-x-10-inch print at 200 ppi, for example, you need 1600 horizontal pixels and 2000 vertical pixels (or vice versa, depending on the orientation of your print).

Table 3-2 lists the pixel counts needed to produce traditional print sizes at 200 ppi and 300 ppi. But again, the optimum ppi varies depending on the printer — some printers prefer even more than 300 ppi — so check your manual or ask the photo technician at the lab that makes your prints. (And note that ppi is *not* the same thing as *dpi*, which is a measurement of printer resolution. *Dpi* refers to how many dots of color the printer can lay down per inch; most printers use multiple dots to reproduce one pixel.)

In other words, don't consider Figure 3-1 as an indication that your D90 is suspect in the image quality department. First, *any* digital camera can produce these defects under the right circumstances. Second, by following the guidelines in this chapter and the others mentioned in the preceding list, you can resolve any quality issues that you may encounter.

Considering Resolution (Image Size)

Like other digital devices, your D90 creates pictures out of *pixels*, which is short for *picture elements*. You can see some pixels close up in the right example of Figure 3-2, which shows a greatly magnified view of the eye area in the left image.

Figure 3-2: Pixels are the building blocks of digital photos.

You specify the pixel count of your images, also known as the *resolution*, via the Image Size control. The D90 offers three Image Size settings: Large, Medium, and Small; Table 3-1 lists the resulting resolution values for each setting.

| Table 3-1 | | |
|-----------|------------------------------|--|
| Setting | | |
| Large | 4288 x 2848 pixels (12.2 MP) | |
| Medium | 3216 x 2136 pixels (6.9 MP) | |
| Small | 2144 x 1424 pixels (3 MP) | |

Each of these defects is related to a different issue, and only one is affected by the Image Quality setting on your D90. So if you aren't happy with your image quality, first compare your photos to those in the figure to properly diagnose the problem. Then try these remedies:

- ✓ Pixelation: When an image doesn't have enough pixels (the colored tiles used to create digital images), details aren't clear, and curved and diagonal lines appear jagged. The fix is to increase image resolution, which you do via the Image Size control. See the next section, "Considering Resolution (Image Size)," for details.
- ✓ **JPEG artifacts:** The "parquet tile" texture and random color defects that mar the third image in Figure 3-1 can occur in photos captured in the JPEG (*jay-peg*) file format, which is why these flaws are referred to as *JPEG artifacts*. This is the defect related to the Image Quality setting; see "Understanding the Image Quality Options" to find out more.
- ✓ **Noise:** This defect gives your image a speckled look, as shown in the lower-left example in Figure 3-1. Noise can occur with very long exposure times or when you choose a high ISO Sensitivity setting on your camera. You can explore both issues in Chapter 5.
- ✓ **Color cast:** If your colors are seriously out of whack, as shown in the lower-middle example in the figure, try adjusting the camera's White Balance setting. Chapter 6 covers this control and other color issues. Note, though, that you can control white balance only when you shoot in the advanced exposure modes (P, S, A, and M).
- Lens/sensor dirt: A dirty lens is the first possible cause of the kind of defects you see in the last example in the figure. If cleaning your lens doesn't solve the problem, dust or dirt may have made its way onto the camera's image sensor. See the sidebar "Maintaining a pristine view," elsewhere in this chapter, for information on safe lens and sensor cleaning.

When diagnosing image problems, you may want to open the photos in ViewNX or some other photo software and zoom in for a close-up inspection. Some defects, especially pixelation and JPEG artifacts, have a similar appearance until you see them at a magnified view. (See Part III for information about using ViewNX.)

I should also tell you that I used a little digital enhancement to exaggerate the flaws in my example images to make the symptoms easier to see. With the exception of an unwanted color cast or a big blob of lens or sensor dirt, these defects may not even be noticeable unless you print or view your image at a very large size. And the subject matter of your image may camouflage some flaws; most people probably wouldn't detect a little JPEG artifacting in a photograph of a densely wooded forest, for example.

A word of warning before you dive in: This stuff may be a little confusing at first. In fact, I pretty much guarantee it. Some math is even involved, which is usually against my principles. On top of that, discussions of picture quality and size involve lots of technical terms, such as pixels, resolution, JPEG compression, and the like.

So take it slowly, and if your eyes start to glaze over, put the book down and come back later for another go-round. It may require a few reads of this chapter, but before long, you'll feel confident about controlling these important aspects of your pictures.

Diagnosing Quality Problems

When I use the term *picture quality*, I'm not talking about the composition, exposure, or other traditional characteristics of a photograph. Instead, I'm referring to how finely the image is rendered in the digital sense.

Figure 3-1 illustrates the concept: The first example is a high-quality image, with clear details and smooth color transitions. The other examples show five common digital-image defects.

Figure 3-1: Refer to this symptom guide to determine the cause of poor image quality.

Controlling Picture **Quality and Size**

In This Chapter

- ▶ Reviewing factors that lead to poor photo quality
- Exploring resolution, pixels, and ppi
- ▶ Calculating the right resolution for traditional print sizes
- ▶ Deciding on the best file format: JPEG or NEF?
- ▶ Picking the right JPEG quality level
- ▶ Understanding the tradeoff between picture quality and file size

lmost every review of the D90 contains glowing reports about the camera's top-notch picture quality. As you've no doubt discovered for yourself, those claims are true, too: This baby can create large, beautiful images.

What you may *not* have discovered is that Nikon's default Image Quality setting isn't the highest that the D90 offers. Why, you ask, would Nikon do such a thing? Why not set up the camera to produce the best images right out of the box? The answer is that using the top setting has some downsides. Nikon's default choice represents a compromise between avoiding those disadvantages while still producing images that will please most photographers.

Whether that compromise is right for you, however, depends on your photographic needs. To help you decide, this chapter explains the Image Quality setting, along with the Image Size setting, which is also critical to the quality of images that you print. Just in case you're having quality problems related to other issues, though, the first section of the chapter provides a handy quality-defect diagnosis guide.

When you use Self-Timer or the remote control modes, you should remove the little rubber cup that surrounds the viewfinder and then insert the viewfinder cover that shipped with your camera. (Dig around in the accessories box — the cover is a tiny black piece of plastic, about the size of the viewfinder.) Otherwise, light may seep into the camera through the viewfinder and affect exposure. You can also simply use the camera strap or something else to cover the viewfinder in a pinch.

You can see which Release mode is currently selected by inspecting the Control panel or Shooting Information display; look for the Release mode symbol in the areas highlighted in Figure 2-12. (Remember that pressing the Info button brings up the Shooting Information display.)

Figure 2-12: You can check the current Release mode in the Control panel and Shooting Information display.

To change the mode, press and hold the Release Mode button on top of the camera (shown in the margin here). As soon as you press the button, all settings except the Release mode disappear from the Control panel and are dimmed in the Shooting Information display. While continuing to press the button, rotate the main command dial (on the back of the camera) to cycle through the available Release mode settings.

Your selected Release mode stays in force until you change it. However, the camera cancels out of the remote control modes if it doesn't receive a signal from the remote after about one minute. You can adjust this timing through an option on the Timers/AE Lock submenu of the Custom Setting menu. Select the Remote On Duration option and press OK to reveal the available options. The maximum delay time is 15 minutes; keep in mind that a shorter delay time saves battery life. After the delay time expires, the camera resets itself to either Single or one of the continuous modes, depending on which mode you last used.

Continuous High: This mode works just like Continuous Low except that it has a maximum frames-per-second rate of four to five frames. You can't adjust the maximum rate for this mode.

Both of the Continuous modes are designed to make it easier for you to capture action. But keep in mind that the actual number of frames you can record per second depends in part on your shutter speed. At a slow shutter speed, the camera may not be able to reach the maximum frame rate. (See Chapter 5 for an explanation of shutter speed.)

Self-Timer: Want to put yourself in the picture? Select this mode, press the shutter button, and run into the frame. As soon as you press the shutter button, the autofocus-assist illuminator on the front of the camera starts to blink, and the camera emits a series of beeps (assuming that you didn't disable its voice, a setting I cover in Chapter 1). A few seconds later, the camera captures the image.

At the default settings, the capture-delay time is 10 seconds, and the camera records one shot for each press of the shutter button. But you can adjust both the delay time and the number of images recorded by visiting the Custom Setting menu. After you pull up the menu, choose the Timers/AE Lock submenu and then select the Self Timer option, as shown on the left in Figure 2-11. Press OK to access the options, shown on the right in the figure.

You can select a capture-delay time of 2, 5, 10, or 20 seconds and set the number of images recorded between 1 and 9.

Delayed Remote and Quick Response Remote: The final two Release mode settings relate to the optional Nikon wireless remote-control unit. If you select Delayed Remote, the camera snaps the picture two seconds after you press the shutter-release button on the remote unit. If you select Quick Response Remote, the image is captured immediately.

Figure 2-11: You can adjust the self-timer capture delay via the Custom Setting menu.

I cover the issue of long-exposure and slow-sync flash photography in detail in Chapter 5. For now, the critical thing to know is that the slower shutter speed means that you probably need a tripod. If you try to handhold the camera, you run the risk of moving the camera during the long exposure, resulting in a blurry image. Enabling the vibration reduction (VR) feature of your lens, if available, can help, but for nighttime shooting, even that may not permit successful handheld shooting. Your subjects also must stay perfectly still during the exposure, which can add to the challenge.

Autofocusing in this mode works the same way as in Auto mode, described earlier in this chapter.

Changing the (Shutter Button) Release Mode

In addition to all its other mode settings — exposure modes, focus modes, flash modes, and the like — your D90 offers a generically named but critical setting called Release mode. This setting determines how you trigger the actual image capture and what happens after you take that step. You have the following options:

✓ **Single Frame:** This setting, which is the default, records a single image each time you press the shutter button completely. In other words, this is normal-photography mode.

Continuous Low: Sometimes known as *burst mode*, this mode records a continuous series of images as long as you hold down the shutter button. At the default setting, Continuous Low mode can capture a maximum of three frames per second. But you can change the maximum capture number to 1, 2, or 4 frames per second. Just open the Custom Setting menu, select the Shooting Display submenu, and then select item d6, CL Mode Shooting Speed, as shown in Figure 2-10.

Figure 2-10: You can specify the maximum frames-per-second rate for Continuous Low Release mode.

Flash: The built-in flash is disabled. That can be a problem in low-light situations, but it also enables you to shoot successive images more quickly because the flash needs a brief period to recycle between shots. If you own an external flash unit, however, you can use it in Sports mode if you like; just be aware that you may sacrifice in the speed-shooting department because of the necessary flash-recycle time. Additionally, you may be limited to a maximum shutter speed of 1/200 second, depending on the flash: Chapter 5 has tips on this subject.

Sometimes, allowing a moving object to blur can actually create a heightened sense of motion — an artistic choice that you can't make in Sports mode. For more control over shutter speed, try out S mode (shutter-priority autoexposure), explained in Chapter 5.

Close Up mode

Switching to Close Up mode doesn't enable you to focus at a closer distance to your subject than normal as it does on some non-SLR cameras. The closefocusing capabilities of your camera depend entirely on the lens you bought, so check your lens manual for details.

Close Up mode does affect your pictures in a couple of ways, however:

✓ **Depth of field:** Close Up mode, like Portrait mode, selects an aperture setting designed to produce short depth of field, which helps keep background objects from competing for attention with your main subject. As with Portrait mode, though, how much the background blurs varies depending on the available light (which determines the aperture setting the camera can use), the distance between your subject and the background, as well as the lens focal length, explained in Chapter 6.

- ✓ Autofocusing: At the default autofocusing settings, focus is automatically locked on the object at the center of the frame when you press the shutter button halfway.
- Flash: You can set the Flash mode to Auto, Auto with Red-Eye Reduction, and Off. (I urge you, though, to be very careful about using the built-in flash when you're shooting a person or animal at close range — that strong burst of light isn't healthy for the eyes.)

Chapter 7 offers additional tips on close-up photography.

Night Portrait mode

This mode is designed to deliver a better-looking flash portrait at night (or in any dimly lit environment). It does so by constraining you to using Auto Slow Sync, Auto Slow Sync with Red-Eye Reduction, or Off flash modes. In all three flash modes, the camera selects a shutter speed that results in a long exposure time. That slow shutter speed enables the camera to rely more on ambient light and less on the flash to expose the picture, which produces softer, more even lighting.

Sports mode

Sports mode activates a number of settings that can help you photograph a moving object, whether it's an athlete, a race car, or a romping dog like the one in Figure 2-9. Here's what you need to know:

Shutter speed: In order to catch a moving subject without blur, you need a fast shutter speed. So in Sports mode, the camera automatically chooses that fast shutter speed for you.

Understand, though, that in dim lighting, the camera may not be able to select a very fast shutter speed and still deliver a good exposure. And because getting a good exposure trumps all, the shutter speed the camera uses may not be fast enough to "freeze" action, especially if your subject is moving very quickly.

Figure 2-9: To capture moving subjects without blur, try Sports mode.

In Figure 2-9, the camera selected a shutter speed that did, in fact, catch my furkid in mid-romp, although if you look very closely, you can see some slight blurring of his beard. Because of the very bright light, the camera also selected a small aperture setting, which produces a large depth of field — so the grass in the background is as sharply focused as that in the foreground. To fully understand these issues, explore Chapters 5 and 6.

Autofocusing: In Sports mode, the autofocus system works as it does when you shoot in Auto mode and the camera detects motion: That is, it automatically selects the focus point, but focus isn't locked when you press the shutter button halfway, as it is in Portrait and Landscape mode. Instead, the camera continually adjusts focus up to the time you fully depress the shutter button and take the shot.

If your subject moves after you press the shutter button halfway, be sure that you adjust the framing so that the subject remains under one of the focus points. Otherwise, the camera may not lock focus on the subject correctly.

Landscape mode

Whereas Portrait mode aims for a very shallow depth of field (small zone of sharp focus), Landscape mode, which is designed for capturing scenic vistas, city skylines, and other large-scale subjects, goes the other route, selecting an aperture setting (f-stop) that produces a large depth of field. As a result, objects both close to the camera and at a distance appear sharply focused. Figure 2-8 offers an example. For this picture, I set focus on the tree on the far right side of the frame. Notice that the tree on the far left appears nearly as sharp, despite its distance from my established focus point.

Note these other factoids about Landscape mode:

Popth of field: As with Portrait mode, the camera manipulates depth of field by adjusting the aperture setting (f-stop). To produce the larger depth of field, the camera tries to use a high f-stop value, which means

Figure 2-8: Landscape mode produces a large zone of sharp focus and also boosts color intensity slightly.

a very small aperture. But in dim lighting, the camera may be forced to open the aperture to allow enough light into the camera to properly expose the photo, so the depth of field may not be enough to keep the entire landscape in sharp focus. (Again, Chapter 5 offers a primer on aperture; Chapter 6 fully explains depth of field.)

- ✓ Color and contrast: This mode boosts color saturation and contrast slightly to produce the kind of bold, rich hues that most people prefer in landscape pictures. In addition, greens and blues are empahsized. If you want more control, switch to an advanced exposure mode (P, S, A, or M) and see Chapter 6 for details.
- Autofocusing: Autofocusing works just as for Auto mode, described earlier in this chapter.
- ✓ Flash: The built-in flash is disabled, which is typically no big deal:

 Because of its limited range, a built-in flash is of little use when shooting most landscapes anyway. However, if you attach an external flash unit, you can use it in this mode. (Chapter 5 discusses external flash units.)

Depth of field: This mode is designed to produce a short depth of field (zone of sharp focus) so that your subject is sharp but the background is blurry, as illustrated in Figure 2-7. However, the camera achieves the shorter depth of field by opening the aperture to a wide setting (low f-stop number). In very bright lighting, the camera may be forced to "stop down" the aperture to a higher f-stop number, which reduces the amount of background blurring. (Chapter 5 explains aperture and f-stops, if those terms are new to you.)

You can maximize the blurring by moving your subject as far as possible from the background and by using a lens with a long focal length, better known as a *telephoto* lens. For example, if you own the 18–105mm kit lens, zoom all the way to the 105mm focal length to

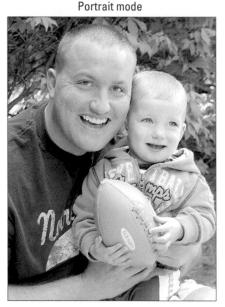

Figure 2-7: Portrait mode produces a softly focused background.

maximize background blurring. See Chapter 6 for an explanation of focal length and the complete scoop on how to manipulate depth of field.

- ✓ Skin tones: In this mode, the camera tweaks color, sharpness, contrast, and a few other picture characteristics in a way designed to produce natural skin tones. If you don't like the results, you must switch to P, S, A, or M exposure mode, all of which enable you to fine-tune these aspects of your picture. See Chapters 5 and 6 for details.
- Autofocusing: Autofocusing works as in Auto mode, described earlier in this chapter.
- ✓ Flash: You can choose from Auto, Auto with Red-Eye Reduction flash, or Off. You can't access Fill Flash mode, which means that you can't add flash if the camera doesn't think extra lighting is needed. This restriction can be problematic when shooting outdoor portraits, which often benefit from a small pop of flash light even in bright sunlight. See Chapter 7 for an example as well as some other tips on shooting portraits by flash light.

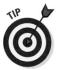

Digital Vari-Program modes

In Auto mode, the camera tries to figure out what type of picture you want to take by assessing what it sees through the lens. If you don't want to rely on the camera to make that judgment, your D90 offers six Digital Vari-Program modes, which are designed to automatically capture specific scenes in ways that are traditionally considered best from a creative standpoint. For example, most people prefer portraits that have softly focused backgrounds. So in Portrait mode, the camera selects settings that can produce that type of background.

All the Digital Vari-Program modes share a few limitations:

- **Exposure:** As with Auto mode, the camera takes complete control of exposure, with the exception of the ISO Sensitivity setting, introduced in the preceding section and detailed in Chapter 5.
- Color: You can't tweak color, either. Some modes manipulate colors in ways that you may or may not appreciate, and you're stuck if you have a color cast problem.
- Flash: Available flash options vary depending on the Digital Vari-Program mode you select, but none of the modes offers complete flash flexibility.

In the next sections, you can read about the unique features of each of the Digital Vari-Program modes. To see whether you approve of how your camera approaches the different scenes, take some test shots. If you aren't happy with the results, you can switch to one of the advanced exposure modes (P, S, A, or M) and then check out Chapters 5–7 to find out how to manipulate whatever aspect of the picture isn't to your liking.

Auto Flash Off mode

The Auto Flash Off mode delivers the same results as Auto mode but ensures that the flash doesn't fire. In other words, think of this mode as a faster alternative to selecting Auto mode and then changing the flash setting to Off. From a practical standpoint, this mode provides an easy way to ensure that you don't break the rules when shooting in locations that don't permit flash: museums, churches, and so on.

Portrait mode

As its name suggests, this mode is designed for shooting portraits. It affects your photos in a couple of ways:

What does [r 12] in the viewfinder mean?

When you look in your viewfinder to frame a shot, the initial value shown in brackets at the right end of the viewfinder display indicates the number of additional pictures that can fit on your memory card at the currently selected Image Size and Image Quality settings. (Chapter 3 explains those settings.) For example, in the left viewfinder image below, the value shows that the card can hold 612 more images.

As soon as you press the shutter button half-way, which kicks the autofocus and exposure mechanisms into action, that value changes to instead show you how many pictures can fit in the camera's *memory buffer*. In the right image here, for example, the r 12 value tells you that 12 pictures can fit in the buffer. This number also varies depending on the size and quality settings you use. (The dot at the left end of the display is the focus lamp, which lights when focus is achieved.)

So what's the buffer? It's a temporary storage tank where the camera stores picture data until it has time to fully record that data onto the camera memory card. This system exists so that you can take a continuous series of pictures without having to wait between shots until each image is fully written to the memory card.

When the buffer is full, the camera automatically disables the shutter button until it catches up on its recording work. Chances are, though, that you'll very rarely, if ever, encounter this situation; the camera is usually more than capable of keeping up with your shooting rate.

For more information about rapid-fire photography, see the section on action photography in Chapter 7. And for help translating all the other viewfinder information, check out Chapters 5 and 6.

125 F5.6 48(612)

125 F5.8

ISO[[-:2]

I purposely didn't include an example of a photo taken in Auto mode because, frankly, the results that this setting creates vary widely depending on how well the camera detects whether you're trying to shoot a portrait, landscape, action shot, or whatever, as well as on lighting conditions. But the bottom line is that full auto is a one-size-fits-all approach that may or may not take best advantage of your camera's capabilities. So if you want to more consistently take great pictures instead of merely good ones, I encourage you to explore the exposure, focus, and color information found in Part II so that you can abandon this mode in favor of modes that put more photographic decisions in your hands.

Remember that in any of these exposure modes, you have the option to focus manually or take advantage of autofocusing.

Auto mode

AUTO In Auto mode, represented on the Mode dial by the icon you see in the margin here, the camera selects all settings based on the scene that it detects in front of the lens. Your only job is to lock in focus, either by using the autofocus technique that I outline at the beginning of the chapter or by using the manual-focusing method explained in Chapter 1.

Auto mode is great for casual, quick snapshooting. But keep these details in mind:

- **Autofocusing:** At the default settings, autofocusing works like so:
 - The camera analyzes the scene and then selects which of the 11 autofocus points to use when establishing focus.
 - If the subject isn't moving, focus remains locked as long as you hold the shutter button halfway down. But if the camera detects motion, it continually adjusts focus up to the time you press the button fully to record the picture. To ensure that focus is correct. you must keep your subject within the area of the viewfinder covered by the focusing points.

Chapter 6 explains how to modify these autofocusing characteristics. (Look for the sections related to the AF-area mode and Autofocus mode options.) But you may find it easier to simply switch to manual focusing if you have trouble getting the camera to autofocus on your subject.

- Flash: You have only three flash mode choices: Auto, Auto with Red-Eye Reduction, and Off. (See Table 2-1 for a reminder of what these modes do.) You can't enable the flash if the camera's autoexposure meter doesn't sense that additional light is needed.
- Color: You can't adjust color. If the image displays a color cast, you must switch to a mode that enables you to adjust the White Balance setting, covered in Chapter 6.
- **Exposure:** You have access to only one exposure-adjustment option, ISO Sensitivity. This setting determines the light sensitivity of the camera or, to put it another way, how much light is needed to properly expose the image. By default, this option is set to Auto, and the camera adjusts the ISO Sensitivity as needed. For more information about how ISO affects your pictures — and why you may want to select a specific ISO setting — visit Chapter 5.

Figure 2-5: Look in these spots to check flash status.

Now for the bad news: When you do try to change the flash mode, you'll quickly discover that you have access to only a couple of flash modes when you shoot in the automatic exposure modes covered in this chapter. Additionally, you don't have access to flash compensation, which enables you to diminish or strengthen the burst of light the flash produces, as well as a few other flash features your camera offers. Bummer, as the youngsters say.

The upcoming sections tell you which flash modes are available in each of the fully automatic exposure modes. For more details about flash photography, see Chapter 5.

Exploring Your Automatic Exposure Options

You can choose from seven fully automatic exposure modes, all of which you access via the Mode dial on the top of the camera, shown in Figure 2-6.

The next sections provide details on each of these options. For information about the four other settings on the Mode dial — P (programmed autoexposure), S (shutter-priority autoexposure), A (aperture-priority autoexposure), and M (manual exposure) — see Chapter 5.

Figure 2-6: You can select from seven fully automatic, point-and-shoot photography modes.

Using Flash in Automatic Exposure Modes

The built-in flash on your D90 offers a variety of different modes. Table 2-1 offers a quick-reference guide to the six basic modes. In addition to these basic modes, the camera also offers some combo modes, such as Auto with Red-Eye Reduction, Slow Sync with Red-Eye Reduction, and the like.

| Table 2-1 Flash Mode Quick-Reference Guide | | | | |
|--|-------------------|---|--|--|
| Symbol | Flash Mode | What It Does | | |
| A AUTO | Auto | Fires the flash automatically if the camera thinks the ambient light is insufficient | | |
| 4 | Fill | Fires the flash regardless of the ambient light | | |
| (| Off | Disables the flash | | |
| 40 | Red-Eye Reduction | AF-assist lamp lights briefly before the flash goes off to help reduce red-eye reflections | | |
| \$ SLOW | Slow Sync | Results in a longer-than-normal exposure time so that the background is Illuminated by ambiont light and the foreground is lit by the flash | | |
| REAR | Rear-Curtain Sync | Causes illuminated, moving objects (suc
as car head lamps) to appear as long,
trailing fingers of light | | |

You can check the current flash mode in the control panel and the Shooting Information display, as shown in Figure 2-5. (To display the Shooting Information screen, press the Info button.) The viewfinder display doesn't advise you of the specific flash mode but instead just shows the universal lightning bolt icon when the flash is enabled, as shown in the figure, and turns off the icon when the flash is disabled.

The letters *TTL* that appear with the flash mode icon in the Shooting Information display stand for *Through the Lens*, which relates to the fact that at the default flash settings, the camera determines how much flash power is needed by metering the light coming through the lens. Nikon's version of this flash-metering system is officially named *i-TTL*, with the *I* standing for *intelligent*.

To change the flash mode, press and hold the Flash button on the side of the camera as you rotate the main command dial. (That's the one on the back of the camera.)

✓ **Autofocus options:** You can choose to focus manually or take advantage of autofocusing in any exposure mode. If you go the autofocus route, you can customize the behavior of the autofocus system through options discussed in Chapter 6. Instructions in this chapter assume that you stick with the default autofocus options.

But understand that in some cases, no amount of fiddling with the autofocus settings will help your camera lock focus where you intend. Some subjects just give autofocusing systems fits: Highly reflective objects, subjects behind fence bars, and scenes in which little contrast exists between the subject and the background are just a few potential problem areas.

My advice? If the autofocus mechanism can't lock on to your subject after a few seconds, just switch to manual focusing and be done with it. See Chapter 1 for a primer in manual focusing.

More focus factors to consider

When you focus the lens, either in autofocus or manual focus mode, you determine only the point of sharpest focus. The distance to which that sharp-focus zone extends from that point — what photographers call the depth of field — depends in part on the aperture setting, or f-stop, which is an exposure control. Some of the D90's Digital Vari-Program autoexposure modes are designed to choose aperture settings that deliver a certain depth of field.

The Portrait setting, for example, uses an aperture setting that shortens the depth of field so that background objects are softly focused — an artistic choice that most people prefer for portraits. On the flip side of the coin, the Landscape setting selects an aperture that produces a large depth of field so that both foreground and background objects appear sharp.

Another exposure-related control, shutter speed, plays a focus role when you photograph moving objects. Moving objects appear blurry at slow shutter speeds; at fast shutter speeds, they appear sharply focused. On your D90, the camera chooses a fast shutter speed in Sports shooting mode.

A fast shutter speed can also help safeguard against allover blurring that results when the camera is moved during the exposure. The faster the shutter speed, the shorter the exposure time, which reduces the time that you need to keep the camera absolutely still. If you're using the Nikon D90 kit lens, you can also improve your odds of shake-free shots by enabling the vibration reduction (VR) feature. (Set the switch on the lens to the On position.) For a very slow shutter speed, using a tripod is the best way to avoid camera shake; be sure to turn the VR off when you do so.

Keep in mind, too, that the range of f-stops and shutter speeds the camera can select in any of the automatic exposure modes depends on the lighting conditions. When you're shooting at night, for example, the camera may not be able to select a shutter speed fast enough to stop action even in Sports mode.

If you want to manipulate focus and depth of field to a greater extent than the automated exposure modes allow, visit Chapter 6. For an explanation of the role of shutter speed and aperture in exposure, check out Chapter 5.

In the display at the bottom of the viewfinder, the green focus lamp, labeled in the figure, lights to give you further notice that focus has been achieved.

The autoexposure meter continues monitoring the light up to the time you take the picture, so the f-stop and shutter speed values in the viewfinder may change if the light shifts.

3. Press the shutter button the rest of the way down to record the image.

While the camera sends the image data to the camera memory card. the memory card access lamp lights, as shown in Figure 2-4. Don't turn off the camera or remove the memory card while the lamp is lit, or you may damage both camera and card.

When the recording process is finished, the picture appears briefly on the camera monitor. If the picture doesn't appear or you want to take a longer look at the image, see Chapter 4 for help.

for details.

Release mode options: The steps here assume that you are using the default Release mode, in which the camera records a single image with each press of the shutter button. For a look at other options — continuous (burst mode) shooting, self-timer shooting, and remotecontrol shooting — see the section, "Changing the (Shutter Button) Release

Focus lamp

Figure 2-3: The green light indicates that the camera has locked focus on the objects under the bracketed focusing points.

Figure 2-4: The memory card access lamp lights while the camera sends the picture data to

Unless you are using a tripod, also set the VR (vibration reduction) switch to the On setting, as shown in Figure 2-1. This feature is designed to produce sharper images by compensating for camera movement that can occur when you handhold the camera. Again, Figure 2-1 features a Nikon VR lens; for other lenses, check your lens manual for details about using its vibration reduction feature, if provided.

Your camera is now set up to work in the most automatic of automatic modes. Follow these steps to take the picture:

1. Looking through the viewfinder, frame the image so that your subject appears under one of the 11 focusing points, as shown in Figure 2-2.

The focusing points are those tiny rectangles you see clustered near the center of viewfinder. I labeled one of the little guys in the figure.

2. Press and hold the shutter button halfway down.

The camera's autofocus system begins to do its thing. In dim light, a little lamp located on the front of the camera, just to the left of the shutter button, may shoot out

Figure 2-2: The small rectangles in the viewfinder indicate autofocus points.

a beam of light. That lamp, called the *autofocus-assist illuminator*, helps the camera measure the distance between your subject and the lens so that it can better establish focus.

At the same time, the autoexposure meter analyzes the light and selects initial aperture (f-stop) and shutter speed settings, which are two critical exposure controls. These two settings appear in the viewfinder; in Figure 2-2, the shutter speed is 1/320 second, and the f-stop is f/5.6. (Chapter 5 explains these two options in detail.) The built-in flash may pop up if the camera thinks additional light is needed.

When the camera has established focus, all the focus points briefly blink red, and one or more of the points appears red and surrounded by red brackets, as shown in Figure 2-3. The focusing points that are hugged by those rectangles represent the areas of the frame that are now in focus.

In addition, this chapter reviews flash options available to you in automatic modes and covers techniques that enable you to get the best performance from your camera's autofocus and autoexposure systems.

Note that this chapter covers normal, through-the-viewfinder still photography. For help with shooting in Live View mode, where you compose pictures using the monitor instead of the viewfinder, or shooting movies, visit the end of Chapter 4.

Getting Good Point-and-Shoot Results

Your D90 offers several automatic photography modes, all of which I explain later in this chapter. But in any of those modes, the key to good photos is to follow a specific picture-taking technique.

AUTO To try it out, set the Mode dial on top of the camera to Auto, as shown in the left image in Figure 2-1. Then set the focusing switch on the lens to the A (autofocus) position, as shown in the right image in Figure 2-1. The figure and these instructions assume that you're using the kit lens — the Nikkor 18–105mm AF-S lens bundled with the D90. For an AF lens, also set the body switch to the AF position, as shown in the figure. If you use some other lens, see Chapter 1 for information about autofocusing and manual focusing.

Auto/Manual focus switches

Figure 2-1: Choose these settings for fully automatic exposure and focus.

Taking Great Pictures, Automatically

In This Chapter

- Shooting your first pictures
- Setting focus and exposure automatically
- ▶ Using flash in automatic exposure modes
- ▶ Getting creative by using Digital Vari-Program modes
- ▶ Changing from single-frame to continuous shooting
- Exploring self-timer and remote-control photography

re you old enough to remember the Certs television commercials from the 1960s and '70s? "It's a candy mint!" declared one actor. "It's a breath mint!" argued another. Then a narrator declared the debate a tie and spoke the famous catchphrase: "It's two, two, two mints in one!"

Well, that's sort of how I see the Nikon D90. On one hand, it provides a full range of powerful controls, offering just about every feature a serious photographer could want. On the other, it offers automated photography modes that enable people with absolutely no experience to capture beautiful images. "It's a sophisticated photographic tool!" "It's as easy as 'point and shoot'!" "It's two, two, two cameras in one!"

Now, my guess is that you bought this book for help with your camera's advanced side, so that's what other chapters cover. This chapter, however, is devoted to your camera's simpler side. Because even when you shoot in automatic exposure and focus modes, following a few basic guidelines can help you get better results. For example, your camera offers a variety of automatic exposure modes, some of which may be new to you. The mode affects the look of your pictures, so this chapter explains those options.

To restore critical picture-taking settings *without* affecting options on the Custom Setting menu, you can instead use the so-called *two-button reset* method: Press and hold the Exposure Compensation button and the AF button simultaneously for longer than two seconds. (The little green dots near the buttons are a reminder of this function.)

One fly in the ointment to remember — and it's a pretty big, ugly, hairy fly: After you restore the camera defaults, be sure that you also revisit the File Number Sequence option on the Shooting/Display submenu of the Custom Settings menu. The default setting, Off, is Not a Good Thing; turn the option On to avoid file-number confusion. See the earlier section "Customizing shooting and display options" for details. (You don't have to take this step if you use the two-button reset method of restoring defaults.)

- Exposure Delay Mode: If you turn this option on, the camera waits to record your picture until about one second after you press and release the shutter button. What's the point? Well, a tiny mirror inside the camera moves every time you press the shutter button to take a picture. For shots that require a long exposure time, there is a slight chance that the vibration caused by that mirror movement will blur the picture. So by delaying the actual image capture a little, the odds of that mirror-related blur are lessened. For normal shooting, leave this one at its default setting, Off. And check out Chapter 2 for information on using the camera's self-timer function as an alternative option when you want to delay the shutter release.
- ✓ Flash warning: When you shoot in the advanced exposure modes (P, S, A, and M), the camera displays a blinking flash symbol (a little lightning bolt) in the viewfinder if it thinks you need to use the flash. If this warning annoys you, set this option to Off.
- MB-D80 Battery Type: You don't need to worry about this control unless you buy the optional MB-D80 battery adapter that enables you to power your camera with AA batteries. If you go that route, select this option to specify which type of AAs you're using. And be sure to read the manual for a list of what AA batteries are acceptable, as well as some other details about using them.

Preventing shooting without a memory card

If you explore the Controls submenu of the Custom Setting menu, you find an option called No Memory Card. Keep this one set at the default (Release Locked), which disables the shutter button when no memory card is in the camera. If you set it to Enable Release, you can take a temporary picture, which appears in the monitor with the word "Demo" but isn't recorded anywhere. (The feature is provided mainly for use in camera stores, enabling salespeople to demonstrate the camera without having to keep a memory card installed.)

The other options on this menu enable you to change the function of various buttons as well as the command and sub-command dials. Chapter 11 provides details, but while you're working with this book, leave all these options at their default settings so that things operate as I describe.

Restoring default settings

You can quickly reset all the Custom Setting menu options to their original, factory default settings by choosing the Reset command at the top of the menu. (Refer to Figure 1-22). Press OK to display a confirmation screen that asks whether you really want to go forward with the reset; highlight Yes and press OK again.

Adjusting automatic monitor shutdown

To help save battery power, your camera automatically shuts off the monitor after a period of inactivity. You can specify how long you want the camera to wait before taking that step. Open the Custom Setting menu, choose Timers/AE Lock, and press OK. Then highlight Monitor Off Delay, as shown on the left in Figure 1-24, and press OK to display the second screen in the figure, where you can specify the auto-off timing for picture playback, menu displays, and the Shooting Information display. Additionally, you can adjust the length of time the camera displays a picture immediately after you press the shutter button, known as the Image Review period. Chapter 4 talks more about viewing your photos.

Figure 1-24: Visit the Timers/AE Lock submenu to adjust the timing of automatic monitor shut-off.

Customizing shooting and display options

Visit the Shooting/Display submenu (refer to Figure 1-23) to tweak various aspects of how the camera communicates with you, as well as to control a couple of basic shooting functions. Check out the following options:

- ▶ Beep: By default, your camera beeps at you after certain operations, such as after it sets focus when you shoot in autofocus mode. If you're doing top-secret surveillance work and need the camera to hush up, set this option to Off. On the Shooting Info and Control panel displays, a little musical note icon appears when the beep is enabled. Turn the beep off, and the icon appears in a circle with a slash through it.
- ✓ Viewfinder grid display: You can display tiny gridlines in the viewfinder by setting this option to On. The gridlines are a great help when you need to ensure the alignment of objects in your photo — for example, to make sure that the horizon is level in a landscape.

As for the Reset option, it enables you to assign the first file number (which ends in 0001) to the next picture you shoot. Then the camera behaves as if you selected the On setting.

Should you be a really, really prolific shooter and snap enough pictures to reach image 9999 in folder 999, the camera will refuse to take another photo until you choose that Reset option and either format the memory card or insert a brand new one.

Shooting Information Display: Normally, the camera tries to make the data on the display easier to read by automatically shifting from black text on a light background to light text on a black background, depending on the ambient light. If you prefer one display style over the other, visit this menu item and highlight Manual, as shown on the left in Figure 1-26. Press OK to display the screen shown on the right, and then select either Dark on Light (for dark lettering on a light background) or Light on Dark (for light lettering on a dark background). Press OK again to make the change. If you want to go back to the default setting, select Auto from the first screen (shown on the left in the figure).

In this book, I show the Shooting Information screen using the Dark on Light display because it reproduces better in print.

LCD Illumination: This setting affects a backlight that can be turned on to illuminate the Control panel. When the option is set to Off, as it is by default, you can illuminate the panel briefly by rotating the On/Off switch past the On setting, to the little light bulb marking. The backlight turns off automatically a few seconds after you release the switch.

If you instead set the LCD Illumination option to On, the backlight comes on automatically anytime the exposure meters are activated (which happens when you press the shutter button halfway). See Chapter 5 for more about the exposure meters. Be aware that this option consumes more battery power than simply using the On/Off switch to light up the panel when you really need it.

Figure 1-26: This book uses the Dark on Light option when showing the Shooting Information display.

- ✓ **ISO Display and Adjustment:** Normally, the frame count area of the Control panel and viewfinder indicate how many shots will fit in the remaining space on your memory card. But if you prefer, you can use this display space to instead show the current ISO setting. See Chapter 5 for the complete story on this option.
- ✓ Viewfinder warning display: You can ask the camera to display the following extra symbols in the viewfinder, as illustrated in Figure 1-25:
 - Black-and-white: Turn this option on to display a B/W symbol when you enable the Monochrome (black-and-white) Picture Control. You can read about Picture Controls and other color options in Chapter 6.

Figure 1-25: You can display a low-battery warning in the viewfinder.

- Low battery: If you turn on this option, a picture of a nearly empty battery appears when your camera battery is about to poop out.
- No memory card: This warning, when enabled, lets you know that you forgot to put a memory card in the camera. (You can also simply take a quick look at frames-remaining area of the viewfinder or Control panel; it displays the symbol [-E-] when the memory card slot is empty.)
- ✓ Screen Tips: If you don't want to see the little help labels that appear when you select certain options in the Shooting Information display, turn this option off. For a look at what I'm talking about, revisit Figure 1-17.
- File Number Sequence: This option controls how the camera names your picture files. When the option is set to Off, as it is by default, the camera restarts file numbering at 0001 every time you format your memory card or insert a new memory card. Numbering is also restarted if you create custom folders (an advanced option covered in Chapter 11).

Needless to say, this setup can cause problems over time, creating a scenario where you wind up with multiple images that have the same filename — not on the current memory card, but when you download images to your computer. So I strongly encourage you to set the option to On. Note that when you get to picture number 9999, file numbering is still reset to 0001, however. The camera automatically creates a new folder to hold for your next 9999 images.

Chapter 1: Getting the Lay of the Land

Browsing the Custom Setting menu

Displaying the Custom Setting menu, whose icon is a little pencil, takes you to the screen shown in Figure 1-22. Here you can access six submenus that carry the labels A through F. Each of the submenus holds clusters of options related to a specific aspect of the camera's operation. Highlight a submenu and press OK to get to those actions, as shown in Figure 1-23.

Figure 1-22: The Custom Setting menu contains six submenus (A through F).

Figure 1-23: Highlight a submenu and press OK again to access the available settings.

In the Nikon manual, instructions sometimes reference these settings by a menu letter and number. For example, "Custom Setting a1" refers to the first option on the Autofocus submenu. I try to be more specific in this book, however, so I use the actual setting names. (Really, we've all got enough numbers to remember, don't you think?)

With that clarification out of the way, the following sections describe only the customization options related to basic camera operations. Turn to the index for help locating information about other Custom Setting options.

Battery Info: Select this option to view detailed information about your battery, as shown in Figure 1-21. The Bat Meter data shows you the current power remaining as a percentage value, and the Pic Meter value tells you how many times you've pressed and released the shutter button since the last time you charged the battery. The final readout, Battery Age, lets you know how much more life you can expect out of the battery before it can no longer be recharged. When the display gets toward the right end

Figure 1-21: You can check the health of your battery via the Battery Info menu item.

of the little meter, marked with the number 4, it's time to buy a new battery.

- ✓ **GPS:** If you purchase the optional Nikon GPS tracking unit for your camera, this menu item holds settings related to its operation. This book doesn't cover this accessory, but the manual that comes with the unit explains everything you need to know about using it.
- Eye-Fi upload: Your camera can work with some Eye-Fi memory cards, whileli enable you to send your pictures over a wireless network to your computer. If you do put one of the cards in the camera, this menu option contains settings for making the transfer.

Unfortunately, Eye-Fi cards are significantly more expensive than regular cards — about \$80 for a 2MB card. But if you do use the cards and you find yourself in a situation where wireless devices are not allowed, choose Disable from the Eye-Fi upload menu to shut off the signal. For the whole story on Eye-Fi, including help with setting up your wireless transfers, visit the company's Web site at www.eye.fi.

Firmware Version: Select this option and press OK to view what version of the camera firmware, or internal software, your camera is running. You see three separate firmware items, A, B, and L. At the time this book was written, all three items were in version 1.0.0.

Keeping your camera firmware up-to-date is important, so visit the Nikon Web site (www.nikon.com) regularly to find out whether your camera sports the latest version. You can find detailed instructions on how to download and install any firmware updates on the site.

- camera to avoid camera shake when shooting long-exposure images, note that in this case, the lock-up feature is provided for cleaning purposes only. You can't take pictures on the D90 while the mirror lock-up is engaged.
- ✓ Video Mode: This option is related to viewing your images on a television, a topic I cover in Chapter 9. Select NTSC if you live in North America or other countries that adhere to the NTSC video standard; select PAL for playback in areas that follow that code of video conduct.
- ✓ HDMI: See Chapter 9 for information about this setting, which relates to options involved with connecting your camera to an HDMI device.
- World Time: When you turn on your camera for the very first time, it automatically displays this option and asks you to set the current date and time. Keeping the date/time accurate is important because that information is recorded as part of the image file. In your photo browser, you can then see when you shot an image and, equally handy, search for images by the date they were taken.
 - Also, if you see the message "Clock" blinking in the Control panel, the internal battery that keeps the clock running is depleted. Simply charging the main camera battery and then putting that battery back in the camera sets the clock ticking again, but you need to reset the camera time and date.
- Language: You're asked to specify a language along with the date and time when you fire up your camera for the first time. Your choice determines the language of text on the camera monitor. Screens in this book display the English language, but I find it entertaining on occasion to hand my camera to a friend after changing the language to, say, Swedish. I'm a real yokester, yah?
- Image Comment: See Chapter 11 to find out how to use this feature, which enables you to add text comments into a picture file. You then can read that information in Nikon ViewNX, the software that shipped with your camera. (The text doesn't actually appear on the image itself.)
- Auto Image Rotation: Keep this option set at the default setting (On) so that the image is automatically rotated to the correct orientation (horizontal or vertical) in playback mode. The orientation is recorded as part of the image file, too, so the auto-rotating also occurs when you browse your image thumbnails in ViewNX. *Note:* The rotation data may not be accurate for pictures that you take with the camera pointing directly up or down. See Chapter 4 for more about picture playback.
- ✓ **Image Dust Off Ref Photo:** This specialty feature enables you to record an image that serves as a point of reference for the automatic dust-removal filter available in Nikon Capture NX 2. I don't cover this accessory software, which must be purchased separately, in this book.

Figure 1-20: Visit the Setup menu to start customizing your camera.

Here's a quick rundown of each menu item:

- ✓ Format Memory Card: You can use this command to format your memory card, which wipes all data off the card and ensures that it's properly set up to record pictures. Or, for quicker results, you can use the two-button formatting process outlined in the earlier section, "Working with Memory Cards."
- LCD Brightness: This option enables you to make the camera monitor brighter or darker. If you take this step, keep in mind that what you see on the display may not be an accurate rendition of the actual exposure of your image. Crank up the monitor brightness, for example, and an underexposed photo may look just fine. So I recommend that you keep the brightness at the default setting (0). As an alternative, you can display the *histogram*, an exposure guide that I explain in Chapter 4, when reviewing your images.
- ✓ Clean Image Sensor: Your D90 is set up at the factory to perform an internal cleaning routine each time you turn the camera on or off. This cleaning system is designed to keep the image sensor that's the part of the camera that actually captures the image free of dust and dirt.
 - By choosing the Clean Image Sensor command, you can perform a cleaning at any time, however. Just choose the command, press OK, select Clean Now, and press OK again. You also can tell the camera to perform automatic cleaning only at startup, only at shutdown, or never; to do so, select Clean At Startup/Shutdown instead of Clean Now. Then press the Multi Selector right, highlight the cleaning option you prefer, and press OK.
- Lock Mirror Up for Cleaning: This feature is necessary when cleaning the camera interior an operation that I don't recommend that you tackle yourself because you can easily damage the camera if you don't know what you're doing. And if you've used mirror lock-up on a film

Asking Your Camera for Help

Programmed into your camera's internal software is a handy information help line — a great tool for times when you forget the purpose of a particular feature or would like a little picture-taking guidance. This digital 411 offers assistance in several ways:

✓ If you see a small question mark in the lower-left corner of a menu, press and hold the WB button to display information about the current shooting mode or selected menu option. For example, Figure 1-19 shows the Help screen associated with the Picture Control setting. If you need to scroll the screen to view all the Help text, keep the button depressed and scroll by using the Multi Selector. Release the button Figure 1-19: Press and hold the WB button to to close the information screen.

? Set Picture Control

Choose how new photos will be processed according to the type of scene or your creative intent. Each Picture Control can be fine-tuned for more precise control over such settings as contrast and saturation. Standard: Standard processing for a balanced effect.

display onscreen help.

Little tip flags appear on the Shooting Information display when you access certain options. (Refer to Figure 1-17.) If you don't want to see the tips, you can turn them off via the Custom Setting menu. as explained later in this chapter.

Reviewing Basic Setup Options

Your camera offers scads of options for customizing its performance. Later chapters explain settings related to actual picture taking, such as those that affect flash behavior and autofocusing. The rest of this chapter details options related to initial camera setup, such as setting the date and time, adjusting monitor brightness, and the like.

Cruising the Setup menu

Start your camera customization by opening the Setup menu. It's the menu marked with the little wrench icon, as shown on the left in Figure 1-20. Scroll down the menu using the Multi Selector to display the second screen of the menu, shown on the right.

By pressing the Info button again, you switch the display to Quick Settings mode. In this mode, you can access additional camera settings, represented by the icons at the bottom of the screen. Press the Multi Selector left or right to highlight the icon for the setting you want to adjust — a little label appears to tell you what each icon means, as shown in Figure 1-17. Press OK to jump directly to the menu where you can change the setting.

✓ Viewfinder: You can view some camera settings in the viewfinder as well. For example, the data in Figure 1-18 shows the current shutter speed, f-stop, ISO setting, and number of shots remaining. The exact viewfinder information that appears depends on what action you're currently undertaking.

If what you see in Figures 1-15 through 1-18 looks like a big confusing mess, don't worry. Many of the settings relate to options that won't mean anything to you until you make your way through later chapters and explore the

Figure 1-17: Press the Info button twice to access more options via the Quick Settings display.

Figure 1-18: You also can view some camera information at the bottom of the viewfinder.

advanced exposure modes. But do make note of the following two key points of data that are helpful even when you shoot in the fully automatic modes:

- ✓ Battery status indicator: A full battery icon like the one in Figures 1-15 and 1-16 shows that the battery is fully charged; if the icon appears empty, go look for your battery charger.
- ▶ Pictures remaining: Labeled in Figures 1-15 and 1-16 and also visible in the viewfinder in Figure 1-18, this value (276, in the figures) indicates how many additional pictures you can store on the current memory card. If the number exceeds 999, the value is presented a little differently. The initial K appears above the value to indicate that the first value represents the picture count in thousands. For example, 1.0 K means that you can store 1,000 more pictures (K being a universally accepted symbol indicating 1,000 units). The number is then rounded down to the nearest hundred. So if the card has room for, say, 1,230 more pictures, the value reads as 1.2K.

As shown in Figure 1-16, this screen displays the current shooting settings at a size that's a little easier on the eyes. Depending on the ambient light, the display either shows black text on a light background, as shown here, or white on black. See the section "Customizing shooting and display options" for information on how to adjust the display if you prefer one color scheme over the other.

Figure 1-15: Rotate the On/Off switch to the light bulb position to illuminate the Control panel.

Figure 1-16: Press the Info button to view picture-taking settings on the monitor.

To quickly access your 20 most recent menu items or create a custom menu: The sixth menu is actually two menus bundled into one. The Recent Settings menu, shown in Figure 1-14, provides a list of the 20 menu items you ordered most recently. So if you want to adjust those settings, you don't have to wade through all the other menus looking for them — just head to this menu instead.

Through the Choose Tab option at the bottom of the menu, you can switch to the My Menu screen. From there, you can

Figure 1-14: The Recent Settings menu offers quick access to the last 20 menu options you selected.

create your own custom menu that contains your favorite options. Chapter 11 details the steps involved in making and using your menu. The My Menu screen also contains a Choose Tab option so that you can switch back to the Recent Settings menu at any time.

The menu icon changes depending on which of these two functions is active; Table 1-1 shows both icons.

Monitoring Shooting Settings

Your D90 gives you the following three ways to monitor the most critical picture-taking settings.

✓ Control panel: The LCD panel on top of the camera offers an array of shooting data, as shown on the left in Figure 1-15. Remember that you can illuminate the panel temporarily by rotating the On/Off switch past the On position to the little light bulb marker, shown on the right in the figure, and then releasing the switch. (You also can turn on the illumination for a longer period of time; see the upcoming section "Customizing shooting and display options" for details.)

✓ Shooting Info display: If your eyesight is like mine, making out the tiny type on the Control panel can be difficult. Fortunately, you can press the Info button to display the Shooting Information screen on the monitor.

I explain all the important menu options elsewhere in the book; for now, just familiarize yourself with the process of navigating menus and selecting options therein. The Multi Selector, shown in Figure 1-9, is the key to the game. You press the edges of the Multi Selector to navigate up, down, left, and right through the menus.

In this book, the instruction "Press the Multi Selector left" simply means to press the left edge of the control. "Press the Multi Selector right" means to press the right edge, and so on.

Here's a bit more detail about the process of navigating menus:

- ✓ **To select a different menu:** Press the Multi Selector left to jump to the column containing the menu icons. Then press up or down to highlight the menu you want to display. Finally, press right to jump over to the options on the menu.
- ✓ To select and adjust a function on the current menu: Again, use the Multi Selector to scroll up or down the list of options to highlight the feature you want to adjust and then press OK. Settings available for the selected item then appear. For example, if you select the Image Quality item from the Shooting menu, as shown on the left in Figure 1-13, and press OK, the available Image Quality options appear, as shown on the right in the figure. Repeat the old up-and-down scroll routine until the choice you prefer is highlighted. Then press OK to return to the previous screen.

In some cases, you may see a right-pointing arrowhead instead of the OK symbol next to an option. That's your cue to press the Multi Selector right to display a submenu or other list of options.

Figure 1-13: Select the option you prefer and press OK again to return to the active menu.

Ordering from Camera Menus

You access many of your camera's features via internal menus, which, conveniently enough, appear when you press the Menu button. Features are grouped into six main menus, described briefly in Table 1-1.

| Table 1-1 | D90 Menus | |
|-----------|-----------------------------|--|
| Symbol | Open This Menu | to Access These Functions |
| P | Playback | Viewing, deleting, and protecting pictures |
| Ω | Shooting | Basic photography settings |
| 0 | Custom Setting | Advanced photography options and some basic camera operations |
| Y | Setup | Additional basic camera operations |
| Ø | Retouch | Built-in photo retouching options |
| | Recent Settings/
My Menu | Your 20 most recently used menu options or your custom dosigned menu |

After you press the Menu button, you see on the camera monitor a screen similar to the one shown in Figure 1-12. Along the left side of the screen, you see the icons shown in Table 1-1, each representing one of the available menus. The icon that is highlighted or appears in color is the active menu; options on that menu automatically appear to the right of the column of icons. In the figure, the Shooting menu is active, for example.

Menu icons

Figure 1-12: Highlight a menu in the left column to display its contents.

Figure 1-11: You can assign the Function button to perform any of 10 operations.

- ✓ BKT (Bracket) button: This button is key to enabling automatic bracketing, a feature that simplifies the job of recording the same subject at various exposure, flash, and white balance settings. Chapter 5 details flash
 and exposure bracketing; Chapter 6 discusses white balancing.
- Lens-release button: You press this button before removing the lens from your camera. See the first part of this chapter for help with mounting and removing lenses.
- ✓ **AF/M (autofocus/manual) switch:** This switch comes into play if you use certain types of lenses. See the earlier section "Setting the focus mode (auto or manual)" for the short story; see Chapter 6 for help with autofocus.

Make note, too, of the tiny microphone perched just above the D90 label. Be careful not to obscure the microphone with your finger when you're recording a movie, a subject you can explore in Chapter 4.

Front-right controls

Wrapping up the list of external controls, the front-right side of the camera offers the following features. Figure 1-11 shows this part of the camera without a lens attached to make this foursome easier to see.

- Sub-command dial: This dial is the counterpart to the main command dial on the back of the camera. As with the main dial, you rotate this one to select certain settings, usually in conjunction with pressing another button.
- ✓ **AF-assist lamp:** In dim lighting, a beam of light shoots out from this little lamp to help the camera's autofocus system find its target. In general, leaving the AF-assist option enabled is a good idea, but if you're doing a lot of shooting at a party, wedding, or some event where the light from the lamp may be distracting, you can disable it through an option on the Custom Setting menu. Chapter 6 explains this and other autofocus features.
- when pressed. (See Chapter 5 for details on this flash feature.) But if you don't use that feature often, you can use the button to perform one of nine other operations. Chapter 11 provides the details on changing the button's purpose. (*Note:* All instructions in this book assume that you haven't changed the function, however.)
- ✓ Depth-of-Field Preview button: By pressing this button, you can see how different aperture settings affect depth of field, or the zone of sharp focus in your image. Chapter 5 explains aperture settings and Chapter 6 delves into depth of field.

In playback mode, pressing the button enables you display multiple image thumbnails on the screen and to reduce the magnification of the currently displayed photo. See Chapter 4 for a complete rundown of picture playback options.

QUAL

Qual (Quality)/Playback Zoom In button: In playback mode, pressing this button magnifies the currently displayed image and also reduces the number of thumbnails displayed at a time. Note the plus sign in the middle of the magnifying glass — plus for zoom in.

In picture-taking mode, pressing the button gives you fast access to the Image Quality and Image Size options, both of which you can explore in Chapter 3.

As for the monitor, I show it in this book without its protective plastic cover. But when the camera isn't in use, it's a good idea to keep the cover on to protect the screen from scratches and other damage.

Front-left buttons

On the front-left side of the camera body, shown in Figure 1-10, you find the following controls:

✓ Flash/Flash compensation:

Pressing this button pops up the camera's built-in flash (except in automatic shooting modes, in which the camera decides whether the flash is needed). By holding the button down and rotating the main command dial, you can adjust the flash mode (normal, red-eye reduction, and so on). In advanced exposure modes (P. S. A, and M), you also can adjust the flash power by pressing the button and rotating the subcommand dial. (That's the dial just below the shutter button.) See Chapter 5 for all things flash related.

Auto/Manual focus switch

Lens-release button

Figure 1-10: Press the Flash button to pop up the built-in flash.

Focus Selector Lock switch: Just beneath the Multi Selector, this switch relates to the camera's autofocusing system. When the switch is set to the position shown in Figure 1-9, you can use the Multi Selector to tell the camera to base focus on a specific focusing point. Setting the switch to the L position locks in the selected point. See Chapter 6 for details on all this focusing stuff.

✓ **Info button:** In addition to viewing current camera settings on the Control panel, you can press this button to display the Shooting Information screen on the camera monitor. The screen not only gives you an easier-on-the-eyes view of the camera settings but also enables you to adjust some settings more quickly than by using the camera menus. See the upcoming section "Monitoring Shooting Settings" for details.

✓ Delete button: Sporting a trash can icon, the universal symbol for delete, this button enables you to erase pictures from your memory card. Chapter 4 has specifics.

Playback button: Press this button to switch the camera into picture review mode. Chapter 4 details the features available to you in this mode.

Menu button: Press this button to access menus of camera options. See the next section for details on navigating menus.

WB/Help/Protect button: This button serves several purposes:

- White balance control: For picture-taking purposes, the button's main function is to access white balance options, a topic you can explore in Chapter 6.
- *Help:* You also can press this button to display helpful information about certain menu options. See "Asking Your Camera for Help," later in this chapter, for details.
- Protect: In playback mode, pressing the button locks the picture file hence the little key symbol that appears on the button face so that it isn't erased if you use the picture-delete functions. (The picture is erased if you format the memory card, however.) See Chapter 4 for details.

✓ ISO/Playback Zoom Out/Thumbnail button: In picture-taking mode, pressing this button accesses the ISO setting, which controls the camera's sensitivity to light. Chapter 5 has details.

✓ **AE-L/AF-L button:** When you're taking pictures in some automatic modes, you can lock in your focus and exposure settings by pressing and holding this button. Chapter 5 explains why you may want to do so.

You can adjust the performance of the button as it relates to locking focus and exposure, too. Instructions in this book assume that you stick with the default setting, but if you want to explore your options, see Chapter 11.

- Lv (Live View) button: You press this button as the first step in recording a movie or taking advantage of Live View shooting, in which you can use the monitor to compose your shots. Chapter 4 introduces you to both Live View features.
- Multi Selector/OK button: This dual-natured control, labeled in Figure 1-9, plays a role in many camera functions. You press the outer edges of the Multi Selector left, right, up, or down to navigate camera menus and access certain other options. At the center of the control is the OK button, which you press to finalize a menu selection or other camera adjustment. See the next section for help with using the camera menus.

Figure 1-9: You use the Multi Selector to navigate menus and access certain other camera options.

Metering Mode button: Press this button to select an exposure metering mode, which determines what part of the frame the camera considers when calculating exposure. Chapter 5 has details.

The little red Format label above the button reminds you that you can press this button together with the Delete button — which also sports the label — to quickly format a memory card. See the earlier section "Working with Memory Cards" for details.

✓ Exposure Compensation button: This button activates a feature that enables you to tweak exposure when working in three of your camera's autoexposure modes: programmed autoexposure, aperture-priority autoexposure, and shutter-priority autoexposure, represented by the letters P, S, and A on the camera Mode dial. Chapter 5 explains.

✓ Release Mode button: With this button, you can switch from normal shooting, where you take one picture with each press of the shutter button, to one of the camera's other modes, including Self-Timer mode. See the end of Chapter 2 for a look at all your options.

✓ **AF Mode/Reset button:** Press this button to access the Autofocus mode setting, which affects your camera's autofocus performance. Check out Chapter 6 for an explanation of the available modes.

See the little green dot above this button and the Exposure Compensation button? The dots are a reminder that pressing these two buttons simultaneously for more than two seconds restores the most critical picture-taking options to their default settings. See "Restoring default settings," at the end of this chapter, for more on this topic.

✓ **Mode dial:** With this dial, labeled in Figure 1-8, you set the camera to fully automatic, semi-automatic, or manual photography mode. The little pictographs, or icons, represent the Nikon Digital Vari-Program modes, which are automatic settings geared to specific types of photos: action shots, portraits, landscapes, and so on. Chapter 2 details the Digital Vari-Program and Auto modes; Chapter 5 explains the four others (P, S, A, and M).

Back-of-the-body controls

Traveling over the top of the camera to its back side, shown in Figure 1-9, you encounter the following controls:

Main command dial: After you activate certain camera features, you rotate this dial, labeled in Figure 1-9, to select a specific setting. For example, to choose a White Balance setting, you press the WB button as you rotate the main command dial. (Chapter 6 explains white balancing.)

One note before you move on: Many of the buttons perform multiple functions and so have multiple "official" names. The WB (white balance) button, for example, is also known as the Help button and the Protect button. In the camera manual, Nikon's instructions refer to these multi-tasking buttons by the name that's relevant for the current function. I think that's a little confusing, so I always refer to each button by the first moniker you see in the lists here.

Topside controls

Your virtual tour begins with the bird's-eye view shown in Figure 1-8. There are a number of controls of note here:

Figure 1-8: The tiny pictures on the Mode dial represent special automatic shooting modes.

- Control panel: On the D90, you can view basic camera settings on this topside LCD panel or on the main monitor. See the upcoming section "Monitoring Shooting Settings" for more info.
- ✓ On/Off/Illuminate switch and shutter button: Okay, I'm pretty sure you already figured this combo button out. But check out Chapter 2 to discover the proper shutter-button-pressing technique you'd be surprised how many people mess up their pictures because they press that button incorrectly. And note that if you want to illuminate the Control panel, you just rotate the On/Off switch past the On position to the little light-bulb icon. Release the switch to return to shooting; the Control panel will dim to its normal state after a few seconds.

If you insert a memory card and see the letters *For* in the Shots Remaining area of the Control panel, you must format the card before you can do anything else.

✓ Removing a card: After making sure that the memory card access light is off, indicating that the camera has finished recording your most recent photo, turn the camera off. Open the memory card door, as shown in Figure 1-5. Depress the memory card slightly until you hear a little click and then let go. The card should pop halfway out of the slot, enabling you to grab it by the tail and remove it.

When no card is installed in the camera, the symbol [-E-] appears in the Control panel and viewfinder.

- Handling cards: Don't touch the gold contacts on the back of the card. (See the left card in Figure 1-7.) When cards aren't in use, store them in the protective cases they came in or in a memory card wallet. Keep cards away from extreme heat and cold as well.
- Locking cards: The tiny switch on the left side of the card, labeled *lock switch* in Figure 1-7, enables you to lock your card, which prevents any data from being erased or recorded to the card. Press the switch toward the bottom of the card to lock the card contents; press it toward the top of the card to unlock the data.

Figure 1-7: Avoid touching the gold contacts on the card.

You can protect individual images from accidental erasure by using the camera's Protect feature, which is covered in Chapter 4.

Exploring External Camera Controls

Scattered across your camera's exterior are a number of buttons, dials, and switches that you use to change picture-taking settings, review and edit your photos, and perform various other operations. In later chapters, I discuss all your camera's functions in detail and provide the exact steps to follow to access them. This section provides just a basic road map to the external controls plus a quick introduction to each.

Safeguarding your memory cards — and the images you store on them — requires just a few precautions:

- ✓ **Inserting a card:** First, be sure that the camera is turned off. Then put the card in the card slot with the label facing the back of the camera, as shown in Figure 1-5. Push the card into the slot until it clicks into place; the memory card access light (circled in Figure 1-5) blinks for a second to let you know the card is inserted properly.
- ✓ Formatting a card: The first time you use a new memory card or insert a card that has been used in other devices (such as an MP3 player), you should format it. Formatting ensures that the card is properly prepared to record your pictures.

Formatting erases *everything* on your memory card. So before formatting, be sure that you have copied any pictures or other data to your computer.

You can format a card in two ways:

 Simultaneously press and hold the Delete and Metering Mode buttons. See the little red Format labels next to the buttons? They're reminders that you use these buttons to quickly format a memory card. Hold the buttons down for about two seconds, until vou see the letters For blink in the Control panel on top of the camera, as shown in Figure 1-6. The other data visible is the Shots Remaining value, which indicates how many pictures you can fit on the memory

Figure 1-6: To format a memory card, press the Delete and Metering Mode buttons until you see this message in the Control panel; then press both buttons again.

card at the current Image Quality and Image Size settings — 290, in the figure.

While the display is blinking, press and release both buttons again. When formatting is complete, the *For* message disappears, and the Control panel display returns to normal. (See the upcoming section "Monitoring Shooting Settings" for more about the Control panel.)

• Choose the Format command from the Setup menu. The upcoming section "Ordering from Camera Menus" explains how to work with menus. When you select the command, you're asked to confirm your decision to format the card. Highlight Yes and press the OK button to go forward.

Working with Memory Cards

Instead of recording images on film, digital cameras store pictures on memory cards. Your D90 uses a specific type of memory card called an SD card (for Secure Digital), shown in Figures 1-5 and 1-7. You can also use the new, high-capacity Secure Digital cards, which are labeled SDHC, as well as Eye-Fi SD cards, which enable you to send pictures to your computer over a wireless network. (Because of space limitations, I don't cover Eye-Fi connectivity in this book; if you want more information about these cards, you can find it online at www.eye.fi.)

Memory card access light

Figure 1-5: Insert the card with the label facing the camera back.

Do you need high-speed memory cards?

Memory cards are categorized not just by their storage capacity, but also by their data-transfer speed. SD cards (the type used by your D90) fall into one of three *speed classes*, Class 2, Class 4, and Class 6, with the number indicating the minimum number of *megabytes* (units of computer data) that can be transferred per second. A Class 2 card, for example, has a minimum transfer speed of 2 megabytes, or MB, per second. Of course, with the speed increase comes a price increase.

Photographers who shoot action benefit most from high-speed cards — the faster data-transfer rate helps the camera record shots at its maximum speed. Users who shoot at the highest resolution or prefer the NEF (Raw) file format

also gain from high-speed cards; both options increase file size and, thus, the time needed to store the picture on the card. (See Chapter 3 for details.) As for picture downloading, how long it takes for files to shuffle from card to computer depends not just on card speed, but also on the capabilities of your computer and, if you use a memory card reader to download files, on the speed of that device. (Chapter 8 covers the file-downloading process.)

Long story short, if you want to push your camera to its performance limits, a high-speed card is worth considering, assuming budget is no issue. Otherwise, even a Class 2 card should be more than adequate for most photographers.

Adjusting the Viewfinder Focus

Tucked behind the right side of the rubber eyepiece that surrounds the viewfinder is a tiny dial called a *diopter adjustment control*. With this control, labeled in Figure 1-4, you can adjust the focus of your viewfinder to accommodate your eyesight.

Figure 1-4: Use the diopter adjustment control to set the viewfinder focus for your eyesight.

If you don't take this step, scenes that appear out of focus through the viewfinder may actually be sharply focused through the lens, and vice versa. Here's how to make the necessary adjustment:

- 1. Remove the lens cap from the front of the lens.
- 2. Look through the viewfinder and concentrate on the little black markings shown on the right side of Figure 1-4.

The little rectangles represent the camera's autofocusing points, which you can read more about in Chapters 2 and 6. The four curved lines represent the center-weighted metering area, which relates to an exposure option you can explore in Chapter 5.

3. Rotate the diopter adjustment dial until the viewfinder markings appear to be in focus.

The Nikon manual warns you not to poke yourself in the eye as you perform this maneuver. This warning seems so obvious that I laugh every time I read it — which makes me feel doubly stupid the next time I poke myself in the eye as I perform this maneuver.

If you have trouble focusing, you may be too close to your subject; every lens has a minimum focusing distance. You may also need to adjust the viewfinder to accommodate your eyesight; see the next section for details.

Some lenses, including the D90 kit lens, enable you to use autofocusing to set the initial focusing point and then fine-tune focus manually. Check your lens manual for information on how to use this option, if available. With the kit lens, you set the lens switch to the A position and then press the shutter button halfway to autofocus. Then you simply twist the focusing ring to adjust focus further, if needed.

Zooming in and out

If you bought a zoom lens, it has a movable zoom barrel. The location of the zoom barrel on the D90 kit lens is shown in Figure 1-3. To zoom in or out, just move that zoom barrel forward and backward.

The numbers on the zoom ring, by the way, represent *focal lengths*. I explain focal lengths in Chapter 6. In the meantime, just note that when the lens is mounted on the camera, the number that's aligned with the lens mounting index (the white dot) represents the current focal length. In Figure 1-3, for example, the focal length is 35mm.

Figure 1-3: On the 18–105 kit lens, the manual-focusing ring is set near the back of the lens, as shown here.

check the manual. For the 18–105 kit lens, Nikon does recommend setting the switch to the Off position for tripod shooting, assuming that the tripod is "locked down" so the camera is immovable.

If you use a non-Nikon lens, the vibration reduction feature may go by another name: *image stabilization, optical stabilization, anti-shake, vibration compensation,* and so on. In some cases, the manufacturers may recommend that you leave the system turned on or select a special setting when you use a tripod, so be sure to check the lens manual for information.

Chapter 6 offers more tips on achieving blur-free photos, and it also explains focal length and its impact on your pictures. See Chapter 5 for an explanation of shutter speed.

Setting the focus mode (auto or manual)

Your camera can accept a variety of lenses, but only two types of lenses permit you to take advantage of autofocusing: AF lenses and AF-S lenses. (The 18–105mm kit lens falls into the AF-S category.)

The AF stands for *autofocus*, as you may have guessed. The S stands for *silent wave*, a Nikon autofocus technology.

For times when you attach a lens that doesn't support autofocusing or the autofocus system has trouble locking on your subject, you can focus manually by simply twisting a focusing ring on the lens barrel. The placement and appearance of the focusing ring depends on the lens; Figure 1-3 shows you the one on the kit lens.

Take these steps to try out manual focusing:

1. Set the camera to manual focus mode.

The procedure depends on the type of lens, as follows:

- *AF-S lenses:* Set the switch on the lens itself to M, as shown in Figure 1-3. Note that the figure shows the switch as it appears on the D90's kit lens; if you use a different lens, check the lens instruction manual if you have trouble finding the switch. (It may carry the label AF/MF instead of A/M.)
- *AF lenses*: For this type of lens, two switches are involved. First, set the lens switch to M, as just described. Then look for the AF-M switch on the camera body it's located just below the lens-release button, as labeled in Figure 1-3. Flip the switch to M for manual focusing.
- All other lenses: Set the switch on the camera body to M.
- 2. While looking through the viewfinder, twist the focusing ring to adjust focus.

Removing a lens

To detach a lens from the camera body, take these steps:

- 1. Locate the lens-release button, labeled in Figure 1-2.
- 2. Grip the rear collar of the lens.

In other words, hold on to the stationary part of the lens that's closest to the camera body and not the movable focusing ring or zoom ring, if your lens has one.

3. Press the lens-release button while turning the lens clockwise until the mounting index on the lens is aligned with the index on the camera body.

The mounting indexes are the little guide dots labeled in Figure 1-1. When the dots line up, the lens should detach from the mount.

4. Place the rear protective cap outo the back of the lens.

Vibration Reduction switch

Lens-release button

Figure 1-2: Press the lens-release button to disengage the lens from the mount.

If you aren't putting another lens on the camera, cover the lens mount with the protective cap that came with your camera, too.

Using a VR (vibration reduction) lens

If you purchased the D90 camera kit — that is, the body-and-lens combination put together by Nikon — your lens offers a feature called *vibration reduction*. On Nikon lenses, this feature is indicated by the initials *VR* in the lens name.

Vibration reduction attempts to compensate for small amounts of camera shake that are common when photographers handhold their cameras and use a slow shutter speed, a lens with a long focal length, or both. That camera movement during the exposure can produce blurry images. Although vibration reduction can't work miracles, it does enable most people to capture sharper handheld shots in many situations than they otherwise could.

However, when you use a tripod, vibration reduction can have detrimental effects because the system may try to adjust for movement that isn't actually occurring. That's why your kit lens — and all Nikon VR lenses — have an On/Off switch, which is located on the side of the lens, as shown in Figure 1-2. Whether you should turn off the VR feature, though, depends on the specific lens, so

Figure 1-1: When attaching the lens, align the index markers as shown here.

5. Turn the lens in a counter-clockwise direction until the lens clicks into place.

To put it another way, turn the lens toward the side of the camera that sports the shutter button, as indicated by the red arrow in the figure.

6. On a lens that has an aperture ring, set and lock the ring so the aperture is set at the highest f-stop number.

Check your lens manual to find out whether your lens sports an aperture ring and how to adjust it. (The D90 kit lens doesn't.) To find out more about apertures and f-stops, see Chapter 5.

Always attach (or switch) lenses in a clean environment to reduce the risk of getting dust, dirt, and other contaminants inside the camera or lens. Changing lenses on a sandy beach, for example, isn't a good idea. For added safety, point the camera body slightly down when performing this maneuver; doing so helps prevent any flotsam in the air from being drawn into the camera by gravity.

comfortable with your camera's buttons and dials as you are with the ones on your car's dashboard. This chapter also guides you through the process of mounting and using an SLR lens, working with digital memory cards, navigating your camera's menus, and customizing basic camera operations.

Getting Comfortable with Your Lens

One of the biggest differences between a point-and-shoot camera and an SLR (single-lens reflex) camera is the lens. With an SLR, you can swap out lenses to suit different photographic needs, going from an extreme close-up lens to a super-long telephoto, for example. In addition, an SLR lens has a movable focusing ring that gives you the option of focusing manually instead of relying on the camera's autofocus mechanism.

Of course, those added capabilities mean that you need a little background information to take full advantage of your lens. To that end, the next four sections explain the process of attaching, removing, and using this critical part of your camera.

Attaching a lens

Whatever lens you choose, follow these steps to attach it to the camera body:

- 1. Remove the cap that covers the lens mount on the front of the camera.
- 2. Remove the cap that covers the back of the lens.
- 3. Hold the lens in front of the camera so that the little white dot on the lens aligns with the matching dot on the camera body.

Official photography lingo uses the term *mounting index* instead of *little white dot*. Either way, you can see the markings in question in Figure 1-1.

Note that the figure (and others in this chapter) shows you the D90 with its so-called "kit lens" — the 18–105mm Vibration Reduction (VR) zoom lens that Nikon sells as a unit with the body. If you buy a lens from a manufacturer other than Nikon, your dot may be red or some other color, so check the lens instruction manual.

4. Keeping the dots aligned, position the lens on the camera's lens mount as shown in Figure 1-1.

When you do so, grip the lens by its back collar, not the movable, forward end of the lens barrel.

Getting the Lay of the Land

In This Chapter

- Attaching and using an SLR lens
- Adjusting the viewfinder to your eyesight
- Working with memory cards
- ▶ Getting acquainted with your camera
- ▶ Selecting from menus
- Displaying onscreen help
- Customizing basic operations

still remember the day that I bought my first SLR film camera. I was excited to finally move up from my one-button point-and-shoot camera, but I was a little anxious, too. My new pride and joy sported several unfamiliar buttons and dials, and the explanations in the camera manual clearly were written for someone with an engineering degree. And then there was the whole business of attaching the lens to the camera, an entirely new task for me. I saved up my pennies a long time for that camera — what if my inexperience caused me to damage the thing before I even shot my first pictures?

You may be feeling similarly insecure if your Nikon D90 is your first SLR, although some of the buttons on the camera back may look familiar if you've previously used a digital point-and-shoot camera. If your D90 is both your first SLR and first digital camera, you may be doubly intimidated.

Trust me, though, that your camera isn't nearly as complicated as its exterior makes it appear. With a little practice and the help of this chapter, which introduces you to each external control, you'll quickly become as

In this part . . .

aking sense of all the controls on your D90 isn't something you can do in an afternoon — heck, in a week, or maybe even a month. But that doesn't mean that you can't take great pictures today. By using your camera's point-and-shoot automatic modes, you can capture terrific images with very little effort. All you do is compose the scene, and the camera takes care of almost everything else.

This part shows you how to take best advantage of your camera's automatic features and also addresses some basic setup steps, such as adjusting the viewfinder to your eyesight and getting familiar with the camera menus, buttons, and dials. In addition, chapters in this part explain how to obtain the very best picture quality, whether you shoot in an automatic or manual mode, and how to use your camera's picture-playback and Live View features.

Part I Fast Track to Super Snaps

Practice, Be Patient, and Have Fun!

To wrap up this preamble, I want to stress that if you initially think that digital photography is too confusing or too technical for you, you're in very good company. *Everyone* finds this stuff a little mind-boggling at first. So take it slowly, experimenting with just one or two new camera settings or techniques at first. Then, each time you go on a photo outing, make it a point to add one or two more shooting skills to your repertoire.

I know that it's hard to believe when you're just starting out, but it really won't be long before everything starts to come together. With some time, patience, and practice, you'll soon wield your camera like a pro, dialing in the necessary settings to capture your creative vision almost instinctively.

So without further ado, I invite you to grab your camera, a cup of whatever it is you prefer to sip while you read, and start exploring the rest of this book. Your D90 is the perfect partner for your photographic journey, and I thank you for allowing me, through this book, to serve as your tour guide.

- ✓ I apply this icon either to introduce information that is especially worth storing in your brain's long-term memory or to remind you of a fact that may have been displaced from that memory by some other pressing fact.
- When you see this icon, look alive. It indicates a potential danger zone that can result in much wailing and teeth-gnashing if ignored.

Additionally, I need to point out three additional details that will help you use this book:

- Other margin art: Replicas of some of your camera's buttons also appear in the margins of some paragraphs. I include these to provide a quick reminder of the appearance of the button being discussed.
- ✓ **Software menu commands:** In sections that cover software, a series of words connected by an arrow indicates commands that you choose from the program menus. For example, if a step tells you to "Choose File⇔Convert Files," click the File menu to unfurl it and then click the Convert Files command on the menu.
- ✓ Camera firmware: Firmware is the internal software that controls many of your camera's operations. This book was written using version 1.0.0 of the firmware, which was the most current version at the time of publication.

Occasionally, Nikon releases firmware updates, and it's a good idea to check out the Nikon Web site (www.nikon.com) periodically to find out which any updates are available. (Chapter 1 tells you how to determine which firmware version your camera is running.) Firmware updates typically don't carry major feature changes — they're mostly used to solve technical glitches in existing features — but if you do download an update, be sure to read the accompanying description of what it accomplishes so that you can adapt my instructions as necessary.

About the Software Shown in This Book

Providing specific instructions for performing photo organizing and editing tasks requires that I feature specific software. In sections that cover file downloading, archiving, printing, and e-mail sharing, I selected Nikon ViewNX and Nikon Transfer, both of which ship free with your camera and work on both the Windows and Mac operating systems.

Rest assured, though, that the tools used in ViewNX and Nikon Transfer work very similarly in other programs, so you should be able to easily adapt the steps to whatever software you use. (I recommend that you read your software manual for details, of course.)

Part 111: Working with Picture Files

This part of the book, as its title implies, discusses the often-confusing aspect of moving your pictures from camera to computer and beyond.

- Chapter 8, "Downloading, Organizing, and Archiving Your Picture Files," guides you through the process of transferring pictures from your camera memory card to your computer's hard drive or other storage device. Look here, too, for details about using the D90's built-in tool for processing files that you shoot in the Nikon Raw format (NEF). Just as important, this chapter explains how to organize and safeguard your photo files.
- Chapter 9, "Printing and Sharing Your Pictures," helps you turn your digital files into "hard copies" that look as good as those you see on the camera monitor. This chapter also explains how to prepare your pictures for online sharing, create digital slide shows, and, for times when you have the neighbors over, display your pictures and movies on a television screen.

Part 1V: The Part of Tens

In famous *For Dummies* tradition, the book concludes with two "top ten" lists containing additional bits of information and advice.

- Chapter 10, "Ten (Or So) Fun and Practical Retouch Menu Features," shows you how to fix less-than-perfect images using features found on your camera's Retouch menu, such as automated red-eye removal. You also find out how to apply color effects and perform a few other photo-enhancement tricks.
- Chapter 11, "Ten Special-Purpose Features to Explore on a Rainy Day," presents information about some camera features that, while not found on most "Top Ten Reasons I Bought My D90" lists, are nonetheless interesting, useful on occasion, or a bit of both.

Icons and Other Stuff to Note

If this isn't your first *For Dummies* book, you may be familiar with the large, round icons that decorate its margins. If not, here's your very own icondecoder ring:

- ✓ A Tip icon flags information that will save you time, effort, money, or some other valuable resource, including your sanity.
- Lots of information in this book is of a technical nature digital photography is a technical animal, after all. But if I present a detail that is useful mainly for impressing your technology-geek friends, I mark it with this icon.

Part 1: Fast Track to Super Snaps

Part I contains four chapters that help you get up and running with your D90.

- Chapter 1, "Getting the Lay of the Land," offers a tour of the external controls on your camera, shows you how to navigate camera menus to access internal options, and walks you through initial camera setup and customization steps.
- Chapter 2, "Taking Great Pictures, Automatically," shows you how to get the best results when using the camera's fully automatic exposure modes, including the Digital Vari-Program scene modes such as Sports mode, Portrait mode, and Landscape mode.
- Chapter 3, "Controlling Picture Quality and Size," introduces you to two camera settings that are critical whether you shoot in automatic or manual mode: the Image Size and Image Quality settings, which control resolution (pixel count), file format, file size, and picture quality.
- Chapter 4, "Monitor Matters: Picture Playback and Live View Shooting" offers just what its title implies. Look here to find out how to review your photos and how to take pictures using your monitor to compose the scene that is, how to use the D90's Live View mode to shoot both still photos and record short digital movies. This chapter also discusses how to delete unwanted images and protect your favorites from accidental erasure.

Part 11: Taking Creative Control

Chapters in this part help you unleash the full creative power of your D90 by moving into semiautomatic or manual photography modes.

- Chapter 5, "Getting Creative with Exposure and Lighting," covers the all-important topic of exposure, starting with an explanation of three critical exposure controls: aperture, shutter speed, and ISO. This chapter also discusses your camera's advanced exposure modes (P, S, A, and M); explains exposure options such as Active D-Lighting, automatic exposure bracketing, metering modes, and exposure compensation; and offers tips for using the flash.
- Chapter 6, "Manipulating Focus and Color," provides help with controlling those aspects of your pictures. Head here for information about your camera's many autofocusing options, for tips on how to manipulate depth of field (the zone of sharp focus in a picture), and for details about color controls such as white balance.
- Chapter 7, "Putting It All Together," summarizes all the techniques explained in earlier chapters, providing a quick-reference guide to the camera settings and shooting strategies that produce the best results for specific types of pictures: portraits, action shots, landscape scenes, close-ups, and more.

Introduction

ikon. The name has been associated with top-flight photography equipment for generations. And the introduction of the D90 has only enriched Nikon's well-deserved reputation, offering all the control a die-hard photography enthusiast could want while at the same time providing easy-to-use, point-and-shoot features for the beginner.

In fact, the D90 offers so *many* features that sorting them all out can be more than a little confusing, especially if you're new to digital photography, SLR photography, or both. For starters, you may not even be sure what SLR means or how it affects your picture taking, let alone have a clue as to all the other techie terms you encounter in your camera manual — *resolution*, *aperture*, *white balance*, and so on. And if you're like many people, you may be so overwhelmed by all the controls on your camera that you haven't yet ventured beyond fully automatic picture-taking mode. Which is a shame because it's sort of like buying a Porsche and never actually taking it on the road.

Therein lies the point of *Nikon D90 For Dummies*: Through this book, you can discover not just what each bell and whistle on your camera does, but also when, where, why, and how to put it to best use. Unlike many photography books, this one doesn't require any previous knowledge of photography or digital imaging to make sense of things, either. In classic *For Dummies* style, everything is explained in easy-to-understand language, with lots of illustrations to help clear up any confusion.

In short, what you have in your hands is the paperback version of an in-depth photography workshop tailored specifically to your Nikon picture-taking powerhouse.

A Quick Look at What's Ahead

This book is organized into four parts, each devoted to a different aspect of using your camera. Although chapters flow in a sequence that's designed to take you from absolute beginner to experienced user, I've also tried to make each chapter as self-standing as possible so that you can explore the topics that interest you in any order you please.

The following sections offer brief previews of each part. If you're eager to find details on a specific topic, the index shows you exactly where to look.

| Chapter 10: Ten (Or So) Fun and Practical | |
|--|------------|
| Retouch Menu Features | 2/5 |
| Applying the Retouch Menu Filters | |
| Removing Red-Eye | 278 |
| Straightening Tilting Horizon Lines | 279 |
| Shadow Recovery with D-Lighting | |
| Boosting Shadows, Contrast, and Saturation Together | |
| Two Ways to Tweak Color | 284 |
| Applying digital lens filters | 284 |
| Manipulating color balance | |
| Creating Monochrome Photos | 287 |
| Removing (or Creating) Lens Distortion | 289 |
| Adding a Starburst Effect
Cropping Your Photo | |
| Chapter 11: Ten Special-Purpose Features to Explore on a Rainy Day | 297 |
| Annotate Your Images | 297 |
| Creating Your Own Menu | |
| Creating Custom Image Folders | 302 |
| Customizing External Controls | 305 |
| Adjusting the On/Off switch | 305 |
| Changing the function of the OK button | |
| Changing the function of the OK button | 206 |
| Assigning a duty to the Function button | |
| Assigning a duty to the Function button
Changing the function of the AE-L/AF-L button | 307 |
| Assigning a duty to the Function button | 307
309 |
| Assigning a duty to the Function button
Changing the function of the AE-L/AF-L button | 307
309 |

| Chapter 7: Putting It All Together | 205 |
|---|-----|
| Recapping Basic Picture Settings | |
| Setting Up for Specific Scenes | 206 |
| Shooting still portraits | 206 |
| Capturing action | 211 |
| Capturing scenic vistas | 214 |
| Capturing dynamic close-ups | 217 |
| Coping with Special Situations | 219 |
| Part III: Working with Picture Files | 223 |
| Chapter 8: Downloading, Organizing, | |
| and Archiving Your Picture Files | 225 |
| Sending Pictures to the Computer | 226 |
| Connecting the camera and computer | 227 |
| Starting the transfer process | 228 |
| Downloading and Organizing Photos with the Nikon Software | |
| Downloading with Nikon Transfer | |
| Browsing images in Nikon ViewNX | |
| Viewing picture metadata | |
| Organizing pictures | |
| Processing Raw (NEF) Files | 242 |
| Processing Raw images in the camera | 244 |
| Processing Raw files in ViewNX | 241 |
| Chapter 9: Printing and Sharing Your Pictures | 251 |
| Printing Possibilities: Retail or Do-It-Yourself? | 252 |
| Preventing Potential Printing Problems | 253 |
| Match resolution to print size | 253 |
| Allow for different print proportions | 256 |
| Get print and monitor colors in synch | 258 |
| Preparing Pictures for E-Mail | 260 |
| Creating small copies using the camera | |
| Downsizing images in Nikon ViewNX | 265 |
| Creating a Digital Slide Show | 267 |
| Setting up a simple slide show | |
| Creating Pictmotion slide shows | |
| Viewing Your Photos on a Television | 271 |

Table of Contents

| Introduction | . 1 |
|---|-----|
| A Quick Look at What's Ahead | 1 |
| Part I: Fast Track to Super Snaps | |
| Part II: Taking Creative Control | |
| Part III: Working with Picture Files | |
| Part IV: The Part of Tens | |
| Icons and Other Stuff to Note | |
| About the Software Shown in This Book | ر |
| Practice, Be Patient, and Have Fun! | 4 |
| Tractice, Be Fattern, and Trave Fattern | 0 |
| Part 1: Fast Track to Super Snaps | . 7 |
| Chapter 1: Getting the Lay of the Land | 9 |
| Getting Comfortable with Your Lens | 10 |
| Attaching a lens | |
| Removing a lens | |
| Using a VR (vibration reduction) lens | |
| Setting the focus mode (auto or manual) | |
| Zooming in and out | 14 |
| Adjusting the Viewfinder Focus | 15 |
| Working with Memory Cards | 16 |
| Exploring External Camera Controls | |
| Topside controls | 19 |
| Back-of-the-body controls | 20 |
| Front-left buttons | 23 |
| Front-right controls | 24 |
| Ordering from Camera Menus | |
| Monitoring Shooting Settings | 28 |
| Asking Your Camera for Help | |
| Reviewing Basic Setup Options | 31 |
| Cruising the Setup menu | 31 |
| Browsing the Custom Setting menu | 35 |
| Chapter 2: Taking Great Pictures, Automatically | |
| Getting Good Point-and-Shoot Results | |
| Using Flash in Automatic Exposure Modes | 46 |

Publisher's Acknowledgments

We're proud of this book; please send us your comments through our online registration form located at $\label{located} \begin{tabular}{ll} http://dummies.custhelp.com. For other comments, please contact our Customer Care Department within the U.S. at 877-762-2974, outside the U.S. at 317-572-3993, or fax 317-572-4002. \\ \end{tabular}$

Some of the people who helped bring this book to market include the following:

Acquisitions and Editorial

Project Editor: Kim Darosett **Executive Editor:** Steven Hayes

Copy Editor: Heidi Unger Technical Editor: David Hall

Editorial Manager: Leah Cameron
Editorial Assistant: Amanda Foxworth

Sr. Editorial Assistant: Cherie Case

Cartoons: Rich Tennant (www.the5thwave.com)

Composition Services

Project Coordinator: Patrick Redmond

Layout and Graphics: Stacie Brooks,
Carrie A. Cesavice, Reuben W. Davis,
Ronald Terry, Erin Zeltner

Proofreaders: John Greenough, Betty Kish

Proofreaders: John Greenough, Betty Kish **Indexer:** Broccoli Information Management

Publishing and Editorial for Technology Dummies

Richard Swadley, Vice President and Executive Group Publisher

Andy Cummings, Vice President and Publisher

Mary Bednarek, Executive Acquisitions Director

Mary C. Corder, Editorial Director

Publishing for Consumer Dummies

Diane Graves Steele, Vice President and Publisher

Composition Services

Gerry Fahey, Vice President of Production Services

Debbie Stailey, Director of Composition Services

About the Author

Julie Adair King is the author of many books about digital photography and imaging, including the best-selling Digital Photography For Dummies. Her most recent titles include a series of guides to popular digital SLR cameras, including Nikon D60 For Dummies and Nikon D40/D40x For Dummies. Other works include Digital Photography Before & After Makeovers, Digital Photo Projects For Dummies, Julie King's Everyday Photoshop For Photographers, Julie King's Everyday Photoshop Elements, and Shoot Like a Pro!: Digital Photography Techniques. When not writing, King teaches digital photography at such locations as the Palm Beach Photographic Centre. A graduate of Purdue University, she resides in Indianapolis, Indiana.

Author's Acknowledgments

I am extremely grateful to the team of talented professionals at John Wiley and Sons for all their efforts in putting together this book. Special thanks go to my awesome project editor, Kim Darosett, who is the type of editor that all authors hope for but rarely experience: supportive, skilled, and amazingly calm in the face of any storm, including my not infrequent freakouts. I also owe much to the rest of the folks in both the editorial and art departments, especially Heidi Unger, Rashell Smith, Shelley Lea, Steve Hayes, Andy Cummings, and Mary Bednarek.

Thanks, too, to Jonathan Conrad for providing the awesome nighttime shot for Chapter 7, and to agent extraordinaire, Margot Maley Hutchison, for her continuing help and encouragement. And last but not least, I am also indebted to technical editor Dave Hall, without whose insights and expertise this book would not have been the same.

Nikon® D90 For Dummies®

Published by Wiley Publishing, Inc. 111 River Street Hoboken, NJ 07030-5774

www.wilev.com

Copyright © 2009 by Wiley Publishing, Inc., Indianapolis, Indiana

Published by Wiley Publishing, Inc., Indianapolis, Indiana

Published simultaneously in Canada

No part of this publication may be reproduced, stored in a retrieval system or transmitted in any form or by any means, electronic, mechanical, photocopying, recording, scanning or otherwise, except as permitted under Sections 107 or 108 of the 1976 United States Copyright Act, without either the prior written permission of the Publisher, or authorization through payment of the appropriate per-copy fee to the Copyright Clearance Center, 222 Rosewood Drive, Danvers, MA 01923, (978) 750-8400, fax (978) 646-8600. Requests to the Publisher for permission should be addressed to the Permissions Department, John Wiley & Sons, Inc., 111 River Street, Hoboken, NJ 07030, (201) 748-6011, fax (201) 748-6008, or online at http://www.wiley.com/go/permissions.

Trademarks: Wiley, the Wiley Publishing logo, For Dummies, the Dummies Man logo, A Reference for the Rest of Us!, The Dummies Way, Dummies Daily, The Fun and Easy Way, Dummies.com, Making Everything Easier, and related trade dress are trademarks or registered trademarks of John Wiley & Sons, Inc. and/or its affiliates in the United States and other countries, and may not be used without written permission. Nikon is a registered trademark of Nikon Corporation. All other trademarks are the property of their respective owners. Wiley Publishing, Inc., is not associated with any product or vendor mentioned in this book.

LIMIT_OF LIABILITY/DISCLAIMER OF WARRANTY: THE PUBLISHER AND THE AUTHOR MAKE NO REPRESENTATIONS OR WARRANTIFS WITH RESPECT TO THE ACCURACY OR COMPLETENESS OF THE CONTENTS OF THIS WORK AND SPECIFICALLY DISCLAIM ALL WARRANTIES, INCLUDING WITH-OUT LIMITATION WARRANTIES OF FITNESS FOR A PARTICULAR PURPOSE. NO WARRANTY MAY BE CREATED OR EXTENDED BY SALES OR PROMOTIONAL MATERIALS. THE ADVICE AND STRATEGIES CONTAINED HEREIN MAY NOT BE SUITABLE FOR EVERY SITUATION. THIS WORK IS SOLD WITH THE UNDERSTANDING THAT THE PUBLISHER IS NOT ENGAGED IN RENDERING LEGAL, ACCOUNTING, OR OTHER PROFESSIONAL SERVICES. IF PROFESSIONAL ASSISTANCE IS REQUIRED, THE SERVICES OF A COMPETENT PROFESSIONAL PERSON SHOULD BE SOUGHT. NEITHER THE PUBLISHER NOR THE AUTHOR SHALL BE LIABLE FOR DAMAGES ARISING HEREFROM. THE FACT THAT AN ORGANIZATION OR WEBSITE IS REFERRED TO IN THIS WORK AS A CITATION AND/OR A POTENTIAL SOURCE OF FURTHER INFORMATION DOES NOT MEAN THAT THE AUTHOR OR THE PUBLISHER ENDORSES THE INFORMATION THE ORGANIZATION OR WEBSITE MAY PROVIDE OR RECOMMENDATIONS IT MAY MAKE. FURTHER, READERS SHOULD BE AWARE THAT INTERNET WEBSITES LISTED IN THIS WORK MAY HAVE CHANGED OR DISAPPEARED BETWEEN WHEN THIS WORK WAS WRITTEN AND WHEN IT IS READ.

For general information on our other products and services, please contact our Customer Care Department within the U.S. at 877-762-2974, outside the U.S. at 317-572-3993, or fax 317-572-4002.

For technical support, please visit www.wiley.com/techsupport.

Wiley also publishes its books in a variety of electronic formats. Some content that appears in print may not be available in electronic books.

Library of Congress Control Number: 2009920036

ISBN: 978-0-470-45772-6

Manufactured in the United States of America

 $10 \ 9 \ 8 \ 7 \ 6 \ 5$

Nikon° D90 FOR DUMMIES°

by Julie Adair King

Wiley Publishing, Inc.